NATIVE ART OF THE NORTHWEST COAST

# A HISTORY OF CHANGING IDEAS

And, as they lifted
their voices together and sang
The great Thunderbird lept from
the floor and danced for them.

NATIVE ART OF THE NORTHWEST COAST

# A HISTORY OF CHANGING IDEAS

Edited by Charlotte Townsend-Gault, Jennifer Kramer, and Ḳi-ḳe-in

UBC PRESS VANCOUVER TORONTO

22 21 20 19 18 17 16 15 14 13     5 4 3 2 1

Printed in Canada on acid-free paper

LIBRARY AND ARCHIVES CANADA CATALOGUING IN PUBLICATION

Native art of the Northwest Coast: a history of changing ideas / edited by Charlotte Townsend-Gault, Jennifer Kramer, and Ḳi-ḳe-in.

Includes bibliographical references and index.
Issued in print and electronic formats.
ISBN 978-0-7748-2049-3 (bound). – ISBN 978-0-7748-2050-9 (pbk). –
ISBN 978-0-7748-2051-6 (pdf). – ISBN 978-0-7748-2052-3 (epub).

1. Indian art – Northwest Coast of North America – History. 2. Indians of North America – Northwest Coast of North America – History. 3. Indians of North America – Northwest Coast of North America – Social life and customs. I. Townsend-Gault, Charlotte, editor of compilation. II. Kramer, Jennifer, editor of compilation. III. Ḳi-ḳe-in, 1948-, editor of compilation

E78.N78N37 2013                 704.03'9707111                 C2013-903560-5
                                                                 C2013-903561-3

UBC Press gratefully acknowledges the financial support for our publishing program of the Government of Canada (through the Canada Book Fund), the Canada Council for the Arts, and the British Columbia Arts Council.

This book has been published with the help of a grant from the Canadian Federation for the Humanities and Social Sciences, through the Awards to Scholarly Publications Program, using funds provided by the Social Sciences and Humanities Research Council of Canada.

Additional grants have been received from the following:
  Art Books program of the Canada Council for the Arts
  Audain Foundation for the Visual Arts in British Columbia
  Audrey Hawthorn Fund for Publications at the UBC Museum of Anthropology
  Department of Anthropology at the University of British Columbia
  Hampton Research Fund of the University of British Columbia
  Killy Foundation
  Jack and Maryon Adelaar
  Michael and Sonja Koerner Charitable Foundation
  Michael O'Brian Foundation for the Arts
  Millard Meiss Publication Fund of the College Art Association

# Contents

Contents with Excerpts Listed                                      ix

List of Figures                                                    xxix

Preface                                                            xxxiii

Introduction: The Idea of Northwest Coast Native Art                1
*Charlotte Townsend-Gault, Jennifer Kramer, and Ḳi-ḳe-in*

1   Interpreting Cultural Symbols of the People from the Shore      15
    *Daisy Sewid-Smith*

2   Ḥilth Hiitinkis – From the Beach                               26
    *Ḳi-ḳe-in*

3   Haida Cosmic                                                   31
    *Michael Nicoll Yahgulanaas*

4   From Explorers to Ethnographers, 1770-1870                     46
    *Ira Jacknis*

5   Thresholds of Meaning: Voice, Time, and Epistemology in        92
    the Archaeological Consideration of Northwest Coast Art
    *Andrew Martindale*

6   Objects and Knowledge: Early Accounts from Ethnographers, and  128
    Their Written Records and Collecting Practices, ca. 1880-1930
    *Andrea Laforet*

7   "That Which Was Most Important": Louis Shotridge on Crest Art  166
    and Clan History
    *Judith Berman*

8   Anthropology of Art: Shifting Paradigms and Practices, 1870s-1950  203
    *Bruce Granville Miller*

9 | Going by the Book: Missionary Perspectives | 234
*John Barker*

10 | The Dark Years | 265
*Gloria Cranmer Webster*

11 | Surrealists and the New York Avant-Garde, 1920-60 | 270
*Marie Mauzé*

12 | Northwest Coast Art and Canadian National Identity, 1900-50 | 304
*Leslie Dawn*

13 | Art/Craft in the Early Twentieth Century | 348
*Scott Watson*

14 | Welfare Politics, Late Salvage, and Indigenous (In)Visiblity, 1930-60 | 379
*Ronald W. Hawker*

15 | Form First, Function Follows: The Use of Formal Analysis in Northwest Coast Art History | 404
*Kathryn Bunn-Marcuse*

16 | Democratization and Northwest Coast Art in the Modern Period: Native Emissaries, Non-Native Connoisseurship, and Consumption | 444
*Judith Ostrowitz*

17 | History and Critique of the "Renaissance" Discourse | 487
*Aaron Glass*

18 | Starting from the Beginning | 518
*Marianne Nicolson*

19 | Shifting Theory, Shifting Publics: The Anthropology of Northwest Coast Art in the Postwar Era | 549
*Alice Marie Campbell*

20 | Value Added: The Northwest Coast Art Market since 1965 | 590
*Karen Duffek*

21 | "Where Mere Words Failed": Northwest Coast Art and Law | 633
*Douglas S. White*

22 | Art for Whose Sake? | 677
*Ḳi-ḳe-in*

23 | "Fighting with Property": The Double-Edged Character of Ownership | 720
*Jennifer Kramer*

**24**   Museums and Northwest Coast Art                                    757
         *Aldona Jonaitis*

**25**   Collaborations: A Historical Perspective                           785
         *Martha Black*

**26**   Pushing Boundaries, Defying Categories: Aboriginal Media           828
         Production on the Northwest Coast
         *Kristin L. Dowell*

**27**   Art Claims in the Age of *Delgamuukw*                              864
         *Charlotte Townsend-Gault*

**28**   Stop Listening to Our Ancestors                                    936
         *Paul Chaat Smith*

**29**   NWC on the Up ... Load: Surfing for Northwest Coast Art            947
         *Dana Claxton*

**30**   The Material and the Immaterial across Borders                     963
         *Charlotte Townsend-Gault*

         Works Cited                                                        995

         Notes on Contributors                                            1046

         Index                                                            1056

# Contents with Excerpts Listed

Introduction: The Idea of Northwest Coast Native Art    1
   *Charlotte Townsend-Gault, Jennifer Kramer, and Ḵi-ḵe-in*

1   Interpreting Cultural Symbols of the People from the Shore    15
   *Daisy Sewid-Smith*

2   Ḥilth Hiitinkis – From the Beach    26
   *Ḵi-ḵe-in*

3   Haida Cosmic    31
   *Michael Nicoll Yahgulanaas*

4   From Explorers to Ethnographers, 1770-1870    46
   *Ira Jacknis*

   4.I   Donald C. Cutter, ed. 1969. "Journal of Fray Juan Crespi Kept during    54
   the Same Voyage [of the *Santiago*] – Dated 5th October, 1774." In *The*
   *California Coast: A Bilingual Edition of Documents from the Sutro Collection*

   4.II   James Cook. 1785. *A Voyage to the Pacific Ocean, Undertaken, by the*    57
   *Command of His Majesty for Making Discoveries in the Northern*
   *Hemisphere ...*

   4.III   William Beresford [George Dixon]. 1789. *A Voyage round the World;*    60
   *But More Particularly to the North-West Coast of America: Performed in*
   *1785, 1786, 1787, and 1788, in the "King George" and "Queen Charlotte,"*
   *Captains Portlock and Dixon*

   4.IV   Joseph Ingraham. 1971. *Journal of the Brigantine Hope on a Voyage to the*    61
   *Northwest Coast of North America, 1790-92*

   4.V   Mary Malloy. 2000. *Souvenirs of the Fur Trade: Northwest Coast Indian*    62
   *Art and Artifacts Collected by American Fur Traders, 1788-1844*

   4.VI   Charles Pierre Claret Fleurieu. 1801. *A Voyage round the World, Performed*    63
   *during the Years 1790, 1791, and 1792, by Étienne Marchand, Preceded by a*
   *Historical Introduction, and Illustrated by Charts, etc.*

4.VII   Henry R. Wagner and William A. Newcombe, eds. 1938. "The Journal   66
        of Jacinto Caamaño." *British Columbia Historical Quarterly*

4.VIII  José Mariano Moziño. 1970. *Noticias de Nutka: An Account of Nootka Sound*   68
        *in 1792*

4.IX    Charles F. Newcombe, ed. 1923. *Menzies' Journal of Vancouver's Voyage,*   71
        *April to October 1792*

4.X     George Vancouver. 1798. *A Voyage of Discovery to the North Pacific and*   72
        *round the World ... Performed 1790-1795, with the "Discovery" and the "Chatham"*
        *under Cpt. George Vancouver*

4.XI    Hilary Stewart, ed. 1987. *The Adventures and Sufferings of John R. Jewitt:*   73
        *Captive of Maquinna*

4.XII   Gary E. Moulton, ed. 1990. *The Journals of the Lewis and Clark*   74
        *Expedition,* Volume 6, *November 2, 1805–March 22, 1806*

4.XIII  William Fraser Tolmie. 1963. *The Journals of William Fraser Tolmie,*   77
        *Physician and Fur Trader*

4.XIV   Ivan Veniaminov. 1984. "Notes on the Koloshi." In *Notes on the Islands*   78
        *of the Unalashka District*

4.XV    Horatio Hale. 1846. "Northwestern America." In *Ethnography and*   81
        *Philology*

4.XVI   J. Russell Harper, ed. 1971. *Paul Kane's Frontier; Including* Wanderings   83
        of an Artist among the Indians of North America, *by Paul Kane*

4.XVII  James Gilchrist Swan. 1857. *The Northwest Coast; or, Three Years'*   85
        *Residence in Washington Territory*

4.XVIII James Gilchrist Swan. 1870. *The Indians of Cape Flattery, at the*   87
        *Entrance to the Strait of Fuca, Washington Territory*

**5**  Thresholds of Meaning: Voice, Time, and Epistemology in the Archaeological   92
       Consideration of Northwest Coast Art
       *Andrew Martindale*

5.I     Harlan I. Smith. 1917. "The Use of Prehistoric Canadian Art for   101
        Commercial Design." *Science*

5.II    Anne Brower Stahl. 2002. "Colonial Entanglements and the Practice   101
        of Taste: An Alternative to Logocentric Approaches." *American*
        *Anthropologist*

5.III   John E. Robb. 1998. "The Archaeology of Symbols." *Annual Review*   102
        *of Anthropology*

5.IV    Franz Boas. 1902. "Some Problems in North American Archaeology."   104
        *American Journal of Archaeology*

5.V      Marius Barbeau. 1929. *Totem Poles of the Gitksan, Upper Skeena River,*      104
         *British Columbia*

5.VI     Charles E. Borden. 1983. "Prehistoric Art of the Lower Fraser      105
         Region." In *Indian Art Traditions of the Northwest Coast*

5.VII    Roy L. Carlson. 1983. "Change and Continuity in Northwest Coast      107
         Art." In *Indian Art Traditions of the Northwest Coast*

5.VIII   George F. MacDonald. 1983. *Haida Monumental Art: Villages of the*      108
         *Queen Charlotte Islands*

5.IX     Wilson Duff. 1975. *Images: Stone: BC – Thirty Centuries of Northwest*      111
         *Coast Indian Sculpture. An Exhibition Originating at the Art Gallery of*
         *Greater Victoria*

5.X      Kenneth M. Ames and Herbert D. Maschner. 1999. *Peoples of the*      112
         *Northwest Coast: Their Archaeology and Prehistory*

5.XI     Gary Coupland. 2006. "A Chief's House Speaks: Communicating      114
         Power on the Northern Northwest Coast." In *Household Archaeology on*
         *the Northwest Coast*

5.XII    Kenneth M. Ames. 1996. "Archaeology, Style, and the Theory of      116
         Coevolution." In *Darwinian Archaeologies*

5.XIII   Alan D. McMillan. 1999. *Since the Time of the Transformers*      119

5.XIV    Andrew Martindale and Irena Jurakic. 2006. "Identifying Expedient      121
         Glass Tools in a Post-Contact Tsimshian Village." *Journal of*
         *Archaeological Science*

5.XV     Aubrey Cannon. 2002. "Sacred Power and Seasonal Settlement on the      123
         Central Northwest Coast." In *Beyond Foraging and Collecting:*
         *Evolutionary Change in Hunter-Gatherer Settlement Systems*

5.XVI    Susan Marsden. 2002. "Adawx, Spanaxnox, and the Geopolitics of the      125
         Tsimshian." *BC Studies*

**6**  Objects and Knowledge: Early Accounts from Ethnographers, and Their      128
       Written Records and Collecting Practices, ca. 1880-1930
           *Andrea Laforet*

6.I      James Swan, Port Townsend, Washington Territory. 1861. Letter to      137
         Spencer F. Baird, Smithsonian Institution, Washington DC, 11 January

6.II     Franz Boas. 1887. "The Occurrence of Similar Inventions in Areas      138
         Widely Apart." Letters to the Editor, *Science*

6.III    Otis T. Mason. 1887. "The Occurrence of Similar Inventions in Areas      139
         Widely Apart." Letters to the Editor, *Science*

6.IV     Franz Boas. 1888. "Gleanings from the Emmons Collection of      140
         Ethnological Specimens from Alaska." *Journal of American Folk-Lore*

| | | |
|---|---|---|
| 6.v | Douglas Cole. 1985. *Captured Heritage: The Scramble for Northwest Coast Artifacts* | 141 |
| 6.vi | George Dorsey. 1899. "Notes on the Anthropological Museums of Central Europe." *American Anthropologist* | 141 |
| 6.vii | Franz Boas. 1899. Letter to George Hunt, 12 January | 142 |
| 6.viii | Franz Boas. 1900. Letter to John Swanton, 5 June | 142 |
| 6.ix | Franz Boas. 1900. Letter to John Swanton, 5 June | 143 |
| 6.x | Edward Sapir. 1911. "An Anthropological Survey of Canada." *Science* | 144 |
| 6.xi | Douglas Cole. 1985. *Captured Heritage: The Scramble for Northwest Coast Artifacts* | 144 |
| 6.xii | Edward Sapir. 1911. Letter to Charles F. Newcombe, 19 December | 145 |
| 6.xiii | Edward Sapir. 1925. Letter to Harlan I. Smith, 23 June | 145 |
| 6.xiv | Edward Sapir. 1913. Letter to James Teit, 7 May | 146 |
| 6.xv | Edward Sapir. 1914. Letter to James Teit, 4 September | 146 |
| 6.xvi | James Teit. 1914. Letter to Edward Sapir, 21 September | 147 |
| 6.xvii | James Teit. 1915. Letter to Edward Sapir, 2 February | 147 |
| 6.xviii | Edward Sapir. 1915. Letter to James Teit, 9 February | 148 |
| 6.xix | George Hunt. 1904. Letter to Franz Boas, 24 May | 148 |
| 6.xx | George Hunt. 1904. Letter to Franz Boas, 6 December | 149 |
| 6.xxi | Harlan I. Smith. 1928. Letter to Diamond Jenness, 5 July | 149 |
| 6.xxii | Edward Sapir. 1915. Letter to James Teit, 10 February | 149 |
| 6.xxiii | James Teit. 1915. Letter to Edward Sapir, 19 February | 150 |
| 6.xxiv | Edward Sapir. 1915. Letter to James Teit, 8 March | 151 |
| 6.xxv | James Gilchrist Swan. 1870. *The Indians of Cape Flattery, at the Entrance to the Strait of Fuca, Washington Territory* | 151 |
| 6.xxvi | George T. Emmons. 1907. *The Chilkat Blanket* | 152 |
| 6.xxvii | James Teit. 1900. *The Thompson Indians of British Columbia* | 153 |
| 6.xxviii | Franz Boas. 1909. *The Kwakiutl of Vancouver Island* | 155 |
| 6.xxix | John Reed Swanton. 1905. *Contributions to the Ethnology of the Haida* | 155 |
| 6.xxx | Franz Boas. 1897. *The Social Organization and the Secret Societies of the Kwakiutl Indians. Based on Personal Observations and on Notes Made by Mr. George Hunt* | 157 |
| 6.xxxi | Herman Karl Haeberlin, James Teit, and Helen Roberts. 1928. *Coiled Basketry in British Columbia and Surrounding Region* | 157 |
| 6.xxxii | Charles F. Newcombe. Ca. early 1900s. Labels prepared for the Field Museum | 159 |

6.XXXIII    Charles F. Newcombe. 1905. Letter to Jasper Turner, 10 February    161

6.XXXIV    Virginia Dominguez. 1986. "The Marketing of Heritage." *American*    161
*Ethnologist*

6.XXXV    Douglas Cole. 1991. "Tricks of the Trade: Some Reflections on    162
Anthropological Collecting." *Arctic Anthropology*

6.XXXVI    Richard Handler. 1992. "On the Valuing of Museum Objects."    163
*Museum Anthropology*

6.XXXVII    Aldona Jonaitis, ed. 1995. *A Wealth of Thought: Franz Boas on Native*    164
*American Art*

**7**    "That Which Was Most Important": Louis Shotridge on Crest Art and Clan    166
History
*Judith Berman*

7.I    Louis Shotridge. N.d. "The House of Sáanaxeit in Dream Land (from    176
Whence Come the Origin of Design – Especially the Eye Motif)"

7.II    Louis Shotridge. N.d. "Notes on the Origin of the Ceremonial Robe    179
Called 'Chilkat Blanket'"

7.III    Louis Shotridge. N.d. "X'etidus'óowu, the Founder of Chilkat Whale    186
House"

7.IV    Louis Shotridge. N.d. "Remodeling of the 'Rain Storm'"    190

7.V    Louis Shotridge. 1928. "The Emblems of the Tlingit Culture." *Museum*    191
*Journal*

**8**    Anthropology of Art: Shifting Paradigms and Practices, 1870s-1950    203
*Bruce Granville Miller*

8.I    Edward Burnett Tylor. 1871. *Primitive Culture*    213

8.II    Lewis Henry Morgan. 1877. *Ancient Society: Researches on the Lines of*    214
*Human Progress from Savagery, through Barbarism, to Civilization*

8.III    J.W. Powell. 1885. "From Savagery to Barbarism. Annual Address of    216
the President." *Transactions of the Anthropological Society of Washington*

8.IV    J.W. Powell. 1887. "Museums of Ethnology and Their Classification"    217
(Letter to the Editor). *Science* / Franz Boas. 1887. "Museums of
Ethnology and Their Classification" (Letter to the Editor). *Science*

8.V    Franz Boas. 1955. Preface. In *Primitive Art*    219

8.VI    Alfred Louis Kroeber. 1956. "The Place of Boas in Anthropology."    222
*American Anthropologist*

8.VII    William Healy Dall. 1884. "On Masks, Labrets, and Certain Aboriginal    223
Customs, with an Inquiry into the Bearing of Their Geographical

Distribution." In *Third Annual Report of the Bureau of Ethnology to the Secretary of the Smithsonian Institution, 1881–1882*

8.VIII   Alfred Louis Kroeber. 1923. "American Culture and the Northwest Coast." *American Anthropologist*   225

8.IX   William H. Holmes. 1906. "Decorative Art of the Aborigines of Northern America." In *Anthropological Papers Written in Honor of Franz Boas*   226

8.X   Herman Karl Haeberlin. 1918. "Principles of Esthetic Form in the Art of the North Pacific Coast: A Preliminary Sketch." *American Anthropologist*   227

8.XI   Thomas Talbot Waterman. 1923. "Some Conundrums in Northwest Coast Art." *American Anthropologist*   227

8.XII   Ruth Benedict. 1934. *Patterns of Culture*   228

8.XIII   Marcel Mauss. 1967. *The Gift: Forms and Functions of Exchange in Archaic Societies*   229

8.XIV   Marcel Griaule. 1950. *Arts of the African Native*   231

9   Going by the Book: Missionary Perspectives   234
    *John Barker*

9.I   Ivan Veniaminov. 1984. "Notes on the Koloshi." In *Notes on the Islands of the Unalashka District*   243

9.II   William Henry Collison. 1916. *In the Wake of the War Canoe*   246

9.III   Charles Harrison. 1925. *Ancient Warriors of the North Pacific: The Haidas, Their Laws, Customs and Legends, with Some Historical Account of the Queen Charlotte Islands*   248

9.IV   Thomas Crosby. 1907. *Among the An-Ko-Me-Nums or Flathead Tribes of the Pacific Coast*   250

9.V   George P. Castile, ed. 1985. *The Indians of Puget Sound: The Notebooks of Myron Eells*   253

9.VI   Livingston F. Jones. 1914. *A Study of the Thlingets of Alaska*   255

9.VII   Martha Black. 1997. *Bella Bella: A Season of Heiltsuk Art*   259

9.VIII   John Veillette and Gary White. 1977. *Early Indian Village Churches: Wooden Frontier Architecture in British Columbia*   260

9.IX   Ronald William Hawker. 1991. "A Faith of Stone: Gravestones, Missionaries, and Culture Change and Continuity among British Columbia's Tsimshian Indians." *Journal of Canadian Studies*   262

10   The Dark Years   265
    *Gloria Cranmer Webster*

**11** | Surrealists and the New York Avant-Garde, 1920-60    270
Marie Mauzé

11.I    Roberto Sebastián Matta Echaurren. 1987. *Entretiens morphologiques:*    275
*Notebook no. 1, 1936-1944*

11.II   Kurt Seligmann. 1939. "Le mât-totem de Gédem Skanísh (Gyaedem    276
Skanees)." *Journal de la société des américanistes*

11.III  Wolfgang Paalen. 1994. "Voyage Nord-Ouest." *Pleine Marge*    282

11.IV   Claude Lévi-Strauss. 1982. "The Art of the Northwest Coast at the    286
American Museum of Natural History." In *The Way of the Masks*

11.V    Georges Duthuit. 1974. "Le don Indien sur la Côte Nord-Ouest de    289
l'Amérique (Colombie britannique)." In *Représentation et présence:*
*Premiers écrits et travaux, 1923-1952*

11.VI   André Breton. 1985. "Note sur les masques à transformation de la Côte    291
Pacifique Nord-Ouest." *Pleine Marge*

11.VII  Edmund Carpenter. 1976. "Collecting Northwest Coast Art." In *Indian*    294
*Art of the Northwest Coast: A Dialogue on Craftsmanship and Aesthetics*

11.VIII Wolfgang Paalen. 1943. "Totem Art." *Dyn*    298

11.IX   Barnett Newman. 1946. Foreword. In *Northwest Coast Indian Painting*    300

11.X    Barnett Newman. 2002. "The Ideographic Picture." In *Barnett Newman*    302

**12** | Northwest Coast Art and Canadian National Identity, 1900-50    304
Leslie Dawn

12.I    Duncan Campbell Scott. 1913. "British Columbia." In "Indian Affairs,    308
1867-1912." Chapter 4 of Volume 7 of *Canada and Its Provinces: A History*
*of the Canadian People and Their Institutions by One Hundred Associates*

12.II   Duncan Campbell Scott. 1913. "The Future of the Indian." In "Indian    312
Affairs, 1867-1912." Chapter 4 of Volume 7 of *Canada and Its Provinces:*
*A History of the Canadian People and Their Institutions by One Hundred*
*Associates*

12.III  Harlan I. Smith. 1917. "The Use of Prehistoric Canadian Art for    313
Commercial Design." *Science*

12.IV   News stories on Barbeau lectures at UBC from *The Ubyssey*. 1926.    315
"Dr. Barbeau Gives First Lecture: The Plastic and Decorative Arts of
the Northwest Coast Tribes," 26 October; "Lectures Concluded by
Dr. Barbeau," 2 November

12.V    [François] Thiébault-Sisson. 1927. "La première exposition d'art    317
Canadien à Paris." In *Exposition d'art Canadien*

12.VI      Gaston Varenne. 1927. Review. *Amour de l'art*                        318

12.VII     Eric Brown. 1927. Introduction. In *Exhibition of Canadian West Coast*   318
           *Art – Native and Modern*

12.VIII    Marius Barbeau. 1927. "West Coast Indian Art." In *Exhibition of*        319
           *Canadian West Coast Art – Native and Modern*

12.IX      A.Y. Jackson. 1927. "Rescuing Our Tottering Totems: Something about      321
           a Primitive Art, Revealing the Past History of a Vanishing Race."
           *Maclean's Magazine*

12.X       Marius Barbeau. 1928. Introduction. In *The Downfall of Temlaham*        325

12.XI      Harlan I. Smith. 1927. "Preserving a 'Westminster Abbey' of Canadian     327
           Indians: Remarkable Totem Poles Now under Government Care."
           *Illustrated London News*

12.XII     United States. 1935. Indian Arts and Crafts Act.                         329

12.XIII    Canada. 1938. An Act to Amend the Indian Act.                            332

12.XIV     M.S. Todd, Indian Agent at Alert Bay. 1938. Letter to Major D.M.         333
           MacKay, Indian Commissioner for British Columbia

12.XV      C.T. Loram and T.F. McIlwraith. 1943. Introduction. In Part 9, "Arts     336
           and Crafts of the Indian." In *The North American Indian Today: University*
           *of Toronto-Yale University Seminar Conference (Toronto, September*
           *4-16, 1939)*

12.XVI     Graham McInnes. 1939. "Indian Art." In *A Short History of Canadian Art*  337

12.XVII    News stories on Gitsegukla potlatch. 1939. "Old Time Potlatch Held at     339
           Kitseguckla – Police Investigated," *Omineca Herald;* "Prosecution May
           Follow Potlatch, Event at Kitseguckla Was on Big Scale to Demand
           Attention of Police Court," *Smithers Interior News*

12.XVIII   Emily Carr. 1942. Letter to Alice Ravenhill, 17 March                    341

12.XIX     Harry B. Hawthorn. 1948. Foreword. In *Report on Conference on Native*    342
           *Indian Affairs at Acadia Camp, University of British Columbia, Vancouver,*
           *B.C., April 1, 2 and 3, 1948*

12.XX      Royal Commission on National Development in the Arts, Letters and         343
           Sciences. 1951. "Indian Arts and Crafts." In *Report of the Royal*
           *Commission on National Development in the Arts, Letters and Sciences,*
           *1949-1951*

13    Art/Craft in the Early Twentieth Century                                      348
           *Scott Watson*

13.I       Ellen Neel. 1948. Presentation to the Conference. In *Report on Conference*   355
           *on Native Indian Affairs at Acadia Camp, University of British Columbia,*
           *Vancouver, B.C., April 1, 2 and 3, 1948*

13.II     Harlan I. Smith. 1923. *An Album of Prehistoric Canadian Art*     364

13.III     G.H. Raley. 1936. "Suggesting a New Industry out of an Old Art:     368
BC Indians Revive Their Dying Skill to Become Revenue-Producing
Artisans?" *Vancouver Daily Province,* 9 May

13.IV     Alice Ravenhill. 1942. "Pacific Coast Art: The Striking Aboriginal     372
Art of the Pacific Coast Indians Furnishes Plenty of Inspiration to
Commercial Designers of the Present Day." *The Beaver*

**14**     Welfare Politics, Late Salvage, and Indigenous (In)Visiblity, 1930-60     379
      *Ronald W. Hawker*

14.I     Alaska Steamship Company. Ca. 1906. *Alaska Indian Basketry*     383

14.II     Thomas Deasy. 1918. Letter to Duncan Campbell Scott, Deputy     383
Superintendent General of Indian Affairs, Ottawa, 4 May

14.III     Duncan Campbell Scott. 1926. Letter to Diamond Jenness, Chief,     385
Division of Anthropology, Victoria Memorial Museum, Ottawa, 5 May

14.IV     G.H. Raley. 1935. "Important Considerations Involved in the Treatise     386
on 'Canadian Indian Art and Industries'"

14.V     G.H. Raley. 1935. "Canadian Indian Art and Industries: An Economic     394
Problem of Today." *Journal of the Royal Society of Arts*

14.VI     Society for the Furtherance of British Columbia Indian Arts and     395
Welfare. 1939. "Objects of the Society"

14.VII     Alice Ravenhill. 1947. "Address to the Royal Commission of Senators     395
and Members of the House of Commons Appointed to Inquire into All
Phases of the Affairs of Canadian Indians in May and October 1946"

14.VIII     Alice Ravenhill. 1951. *Alice Ravenhill: The Memoirs of an Educational*     396
*Pioneer*

14.IX     Albert Shea. 1952. *Culture in Canada: A Study of the Findings of the*     401
*Royal Commission on National Development in the Arts, Letters and Sciences*
*(1949-1951)*

14.X     William Reid and anonymous carver. 1955. Quoted in *The Indians of*     402
*British Columbia: A Survey of Social and Economic Conditions: A Report*
*to the Minister of Citizenship and Immigration*

14.XI     George Manuel and Michael Posluns. 1974. *The Fourth World: An Indian*     402
*Reality*

**15**     Form First, Function Follows: The Use of Formal Analysis in Northwest     404
Coast Art History
      *Kathryn Bunn-Marcuse*

15.I     Franz Boas. 1927. "Art of the North Pacific Coast of North America."     414
In *Primitive Art*

15.II    Herman Karl Haeberlin. 1918. "Principles of Esthetic Form in the Art    422
of the North Pacific Coast: A Preliminary Sketch." *American Anthropologist*

15.III    Bill Holm. 1965. *Northwest Coast Indian Art: An Analysis of Form*    423

15.IV    Bill Holm. 1981. "Will the Real Charles Edensaw Please Stand Up?    425
The Problem of Attribution in Northwest Coast Indian Art." In *The
World Is as Sharp as a Knife: An Anthology in Honour of Wilson Duff*

15.V    Michael M. Ames. 1992. *Cannibal Tours and Glass Boxes: The    429
Anthropology of Museums*

15.VI    Charlotte Townsend-Gault. 2000. "A Conversation with Ki-ke-in."    431
In *Nuu-Chah-Nulth Voices, Histories, Objects and Journeys*

15.VII    Bill McLennan and Karen Duffek. 2000. "The Language of Painting."    433
In *The Transforming Image: Painted Arts of Northwest Coast First Nations*

15.VIII    Karen Duffek. 2004. "The Present Moment: Conversations with *guud    437
san glans*, Robert Davidson." In *Robert Davidson: The Abstract Edge*

15.IX    Nika Collison. 2006. "Everything Depends on Everything Else." In    440
*Raven Travelling: Two Centuries of Haida Art*

**16**    Democratization and Northwest Coast Art in the Modern Period: Native    444
Emissaries, Non-Native Connoisseurship, and Consumption
*Judith Ostrowitz*

16.I    Wilson Duff. 1953. "Potlatch Transcript. Mungo Martin's Thunderbird    450
Park Potlatch, December 13-15, 1953"

16.II    Bill Holm. 1965. *Northwest Coast Indian Art: An Analysis of Form*    458

16.III    Doris Shadbolt. 1967. Foreword. In *Arts of the Raven: Master Works by    467
the Northwest Coast Indian*

16.IV    Bill Holm and William [Bill] Reid. 1975. *Form and Freedom: A Dialogue    469
on Northwest Coast Indian Art*

16.V    E.Y. Arima and E.C. Hunt. 1975. "Making Masks: Notes on Kwakiutl    475
'Tourist Mask' Carving." In *Contributions to Canadian Ethnology*

16.VI    Peter L. Macnair, Alan L. Hoover, and Kevin Neary. (1980) 1984.    482
*The Legacy: Tradition and Innovation in Northwest Coast Indian Art*

**17**    History and Critique of the "Renaissance" Discourse    487
*Aaron Glass*

17.I    Clive Cocking. 1971. "Indian Renaissance: New Life for a Traditional    494
Art." *UBC Alumni Chronicle*

17.II    Joan Vastokas. 1975. "Bill Reid and the Native Renaissance." *Artscanada*    499

17.III  Karen Duffek. 1983. "The Revival of Northwest Coast Indian Art." In *Vancouver: Art and Artists 1931-1983*  508

17.IV  Marcia Crosby. 1991. "Construction of the Imaginary Indian." In *Vancouver Anthology: The Institutional Politics of Art*  513

17.V  Ḳi-ḳe-in (Ron Hamilton). 1991. "Box of Darkness." *BC Studies*  515

**18**  Starting from the Beginning  518
       *Marianne Nicolson*

18.I  Clellan Stearns Ford, ed. (1941) 1968. *Smoke from Their Fires: The Life of a Kwakiutl Chief*  532

18.II  Agnes Alfred. 2004. *Paddling to Where I Stand: Agnes Alfred, Qwiqwasutinuxw Noblewoman*  534

18.III  Harry Assu and Joy Inglis. 1989. *Assu of Cape Mudge: Recollections of a Coastal Indian Chief*  537

18.IV  James P. Spradley, ed. (1969) 1972. *Guests Never Leave Hungry: The Autobiography of James Sewid, a Kwakiutl Indian*  538

18.V  Margaret Anderson and Marjorie Halpin, eds. 2000. *Potlatch at Gitsegukla: William Beynon's 1945 Field Notebooks*  540

18.VI  Margaret Blackman and Florence Edenshaw Davidson. 1985. *During My Time: Florence Edenshaw Davidson, a Haida Woman*  541

18.VII  Keith Thor Carlson, ed. 1997. *You Are Asked to Witness: The Stó:lō in Canada's Pacific Coast History*  543

18.VIII  Delgam Uukw. 1992. "Delgam Uukw Speaks." In *The Spirit in the Land: The Opening Statement of the Gitksan and Wet'suwet'en Hereditary Chiefs in the Supreme Court of British Columbia*  544

18.IX  Doreen Jensen and Polly Sargent. 1986. "David Gladstone." In *Robes of Power: Totem Poles on Cloth*  546

**19**  Shifting Theory, Shifting Publics: The Anthropology of Northwest Coast Art in the Postwar Era  549
       *Alice Marie Campbell*

19.I  Marius Barbeau. 1957. *Haida Carvers in Argillite*  563

19.II  Dorothy Bestor. 1965. Oral History Interview with Erna Gunther for the Smithsonian Archives of American Art. Conducted at the University of Washington, 23 April  565

19.III  Erna Gunther. 1966. *Art in the Life of the Northwest Coast Indian: With a Catalog of the Rasmussen Collection of Northwest Indian Art at the Portland Art Museum*  566

19.IV     Wilson Duff. 1964. *The Indian History of British Columbia,* Volume 1,          566
          *The Impact of the White Man*

19.V      Marjorie M. Halpin. 1973. "The Tsimshian Crest System: A Study Based           567
          on Museum Specimens and the Marius Barbeau and William Beynon
          Field Notes"

19.VI     Wayne Suttles. 1987. "Productivity and Its Constraints: A Coast Salish         569
          Case." In *Coast Salish Essays*

19.VII    Margaret B. Blackman. 1976. "Creativity in Acculturation." *Ethnohistory*      573

19.VIII   Michael M. Ames. 1981. "Museum Anthropologists and the Arts of                574
          Acculturation on the Northwest Coast." *BC Studies*

19.IX     Claude Lévi-Strauss. 1982. *The Way of the Masks*                             576

19.X      Edwin S. Hall, Jr., Margaret B. Blackman, and Vincent Rickard. 1981.          577
          *Northwest Coast Indian Graphics: An Introduction to Silk Screen Prints*

19.XI     Karen Duffek. 1983. "The Contemporary Northwest Coast Indian Art              577
          Market"

19.XII    James Clifford. 1997. "Four Northwest Coast Museums: Travel Reflec-           579
          tions." In *Routes: Travel and Translation in the Late Twentieth Century*

19.XIII   Michael E. Harkin. 1999. "From Totems to Derrida: Postmodernism               580
          and Northwest Coast Ethnology." *Ethnohistory*

19.XIV    Aldona Jonaitis. 1995. "The Boasian Legacy in Northwest Coast Art             582
          Studies." In *A Wealth of Thought: Franz Boas on Native American Art*

19.XV     Marjorie M. Halpin. 1994. "A Critique of the Boasian Paradigm for             584
          Northwest Coast Art." *Culture*

19.XVI    Kirk Dombrowski. 2002. *Against Culture: Development, Politics, and            585
          Religion in Indian Alaska*

19.XVII   Jennifer Kramer. 2006. *Switchbacks: Art, Ownership, and Nuxalk               587
          National Identity*

**20**    Value Added: The Northwest Coast Art Market since 1965                        590
          *Karen Duffek*

20.I      Wilson Duff. 1964. *The Indian History of British Columbia,* Volume 1         605

20.II     James P. Spradley, ed. (1969) 1972. *Guests Never Leave Hungry: The           608
          Autobiography of James Sewid, a Kwakiutl Indian*

20.III    Roy Henry Vickers. 1977. Introduction. In *Northwest Coast Indian Artists     610
          Guild: 1977 Graphics Collection*

20.IV     Joe David. 1978. Introduction. In *Northwest Coast Indian Artists Guild:      612
          1978 Graphics Collection*

20.V      Ashley Ford. 1979. "Indian Art Attracts Investment Interest." *Financial      614
          Post*

20.VI     Art Perry. 1979. "West Coast Prints: For Soul or for Sale?" *Vancouver Province*    616

20.VII    Tony Hunt and Jo-Anne Birnie Danzker. 1983. "Personal Perspectives." In *Vancouver: Art and Artists 1931-1983*    618

20.VIII   Doreen Jensen. 1988. "Commissioned Art Work: Is This the New Standard of Artistic Prominence?"    620

20.IX    Peter L. Macnair. 1994. "Northwest Coast Indian Art for Sale: A Long Tradition." In *Life of the Copper: A Commonwealth of Tribal Nations*    622

20.X     Charlotte Townsend-Gault. 2000. "A Conversation with Ki-ke-in." In *Nuu-Chah-Nulth Voices, Histories, Objects and Journeys*    625

20.XI    Charlotte Townsend-Gault. 2004. "Circulating Aboriginality." *Journal of Material Culture*    627

20.XII    Harmer Johnson. 1981. "Auction Block." *American Indian Art Magazine*    629

20.XIII   Harmer Johnson. 2007. "Auction Block." *American Indian Art Magazine*    631

**21**   "Where Mere Words Failed": Northwest Coast Art and Law    633
      *Douglas S. White*

21.I     George C. Clutesi. 1947. "The Urge to Create." *Native Voice: Official Organ of the Native Brotherhood of British Columbia*    650

21.II    Government of Canada. 1884. House of Commons Debate on Indian Act Potlatch Prohibition    652

21.III    Indian Act. 1884. Potlatch Prohibition Provisions    656

21.IV    George C. Clutesi. 1969. *Potlatch*    657

21.V     Douglas Cole and Ira Chaikin. 1990. *An Iron Hand upon the People: The Law against the Potlatch on the Northwest Coast*    659

21.VI    H.W. Janson. 1986. *The History of Art*    663

21.VII    George III. 1763. Royal Proclamation    664

21.VIII   Douglas Treaties. 1851    666

21.IX    Constitution Act. 1867    667

21.X     Constitution Act. 1982    668

21.XI    Supreme Court of Canada. 2006. *R. v. Sappier*; *R. v. Gray*    668

21.XII    United Nations. 2007. Declaration on the Rights of Indigenous Peoples    671

**22**   Art for Whose Sake?    677
      *Ḳi-ḳe-in*

22.I     John Meares. 1790. *Voyages Made in the Years 1788 and 1789 from China to the North-West Coast of America*    692

22.II    José Mariano Moziño. (1803) 1970. *Noticias de Nutka: An Account of*    694
*Nootka Sound in 1792*

22.III    Gilbert Malcolm Sproat. (1868) 1987. *The Nootka: Scenes and Studies of*    696
*Savage Life*

22.IV    James Gilchrist Swan. 1870. *The Indians of Cape Flattery, at the Entrance*    698
*to the Strait of Fuca, Washington Territory*

22.V    Johan Adrian Jacobsen. (1884) 1977. *The Alaskan Voyage 1881-1883: An*    702
*Expedition to the Northwest Coast of America*

22.VI    Robert Bruce Inverarity. 1950. *Art of the Northwest Coast Indians*    704

22.VII    Philip Drucker. 1951. *The Northern and Central Nootkan Tribes*    707

22.VIII    George Clutesi. 1967. *Son of Raven, Son of Deer: Fables of the Tseshaht*    707
*People*

22.IX    George Clutesi. 1969. *Potlatch*    709

22.X    David W. Ellis and Luke Swan. 1981. *Teachings of the Tides: Uses of*    713
*Marine Invertebrates by the Manhousat People*

22.XI    Bill Holm. 1983. *Box of Daylight: Northwest Coast Indian Art*    715

22.XII    Steven C. Brown. 1995. "Observations on Northwest Coast Art: North    716
and South." In *The Spirit Within: Northwest Coast Native Art from the*
*John H. Hauberg Collection*

22.XIII    Nuu-chah-nulth Tribal Council. 1999. Quoted in *HuupuKʷanum · Tupaat*
*– Out of the Mist: Treasures of the Nuu-Chah-Nulth Chiefs*    718

22.XIV    Ḳi-ḳe-in. 2000-1. "Book Review of *Out of the Mist: Treasures of the*    719
*Nuu-Chah-Nulth Chiefs* by Martha Black." *BC Studies*

**23**    "Fighting with Property": The Double-Edged Character of Ownership    720
*Jennifer Kramer*

23.I    John C. Beaglehole, ed. 1967. *The Journals of Captain James Cook on*    731
*His Voyages of Discovery*. Volume 3, part 1, *The Voyage of the* Resolution
and Discovery, *1776-1780*

23.II    Franz Boas. 1897. *The Social Organization and the Secret Societies of the*    731
*Kwakiutl Indians. Based on Personal Observations and on Notes Made by*
*Mr. George Hunt*

23.III    Marcel Mauss. 1967. *The Gift: Forms and Functions of Exchange in Archaic*    733
*Societies*

23.IV    Ruth Benedict. 1934. *Patterns of Culture*    734

23.V    Thomas F. McIlwraith. (1948) 1992. *The Bella Coola Indians*    737

23.VI    Georges Bataille. 1991. *The Accursed Share: An Essay on General Economy.*    738
Volume 1, *Consumption*

23.VII    Helen Codere. 1950. *Fighting with Property: A Study of Kwakiutl Potlatching and Warfare, 1792-1930*     739

23.VIII    Wilson Duff, ed. 1959. *Histories, Territories and Laws of the Kitwancool*     740

23.IX    Task Force on Museums and First Peoples. 1992. *Turning the Page: Forging New Partnerships between Museums and First Peoples*     743

23.X    Weavers' Circle. 1993. "Weavers' Statement, August 1993"     745

23.XI    Nora Marks Dauenhauer. 1995. "Tlingit *At.oów:* Traditions and Concepts." In *The Spirit Within: Northwest Coast Native Art from the John H. Hauberg Collection*     747

23.XII    gii-dahl-guud-sliiaay (Terri-Lynn Williams-Davidson). 1995. "Cultural Perpetuation: Repatriation of First Nations Cultural Heritage." *UBC Law Review*     748

23.XIII    Patrick Walker and Clarine Ostrove. 1995. "The Aboriginal Right to Cultural Property." *UBC Law Review*     750

23.XIV    Thérèse Rigaud. 2002. *Translating Haida Poetry: An Interview with Robert Bringhurst*     751

23.XV    Andrea Laforet. 2004. "Narratives of the Treaty Table: Cultural Property and the Negotiation of Tradition." In *Questions of Tradition*     753

23.XVI    Naxaxalhts'I (Albert "Sonny" McHalsie). 2007. "We Have to Take Care of Everything that Belongs to Us." In *Be of Good Mind: Essays on the Coast Salish*     754

**24**    Museums and Northwest Coast Art     757
    *Aldona Jonaitis*

24.I    Michael M. Ames. 1992. "How Anthropologists Stereotype Other People." In *Cannibal Tours and Glass Boxes: The Anthropology of Museums*     763

24.II    Aldona Jonaitis. 1991. "Chiefly Feasts: The Creation of an Exhibition." In *Chiefly Feasts: The Enduring Kwakiutl Potlatch*     767

24.III    Patricia Pierce Erikson. 2004. "'Defining Ourselves through Baskets': Museum Autoethnography and the Makah Cultural and Research Center." In *Coming to Shore: Northwest Coast Ethnology, Traditions, and Visions*     770

24.IV    Delores Churchill. 2002. "Weaving Stories of Art." In *On Aboriginal Representation in the Gallery*     774

24.V    William Wasden Jr. 2011. "Talks with the Artists and Pauline Alfred." In *The Power of Giving: Gifts in the Kwakwa̱ka'wakw Big House from the Canadian Northwest Coast and at the Saxon Rulers' Court in Dresden*     778

24.VI    Aaron Glass. 2011. "Objects of Exchange: Material Culture, Colonial Encounter, Indigenous Modernity." In *Objects of Exchange: Social and Material Transformation on the Late Nineteenth-Century Northwest Coast*     779

**25** | Collaborations: A Historical Perspective                                    785
        *Martha Black*

25.I     Richard Inglis, quoted in Robert A. Janes and Martha A. Peever. 1991.    795
         "Partnerships: Museums and Native Living Cultures." *Alberta Museums
         Review*

25.II    Royal BC Museum. 2004. "Aboriginal Material Operating Policy"            796

25.III   Jay Stewart and Robert Joseph. 2000. "Validating the Past in the        798
         Present: First Nations' Collaborations with Museums." *Cultural Resource
         Management*

25.IV    *Victoria Daily Colonist*. 1933. "Propose Novel Indian Village"          798

25.V     British Columbia Provincial Museum. 1952 and 1953. *Annual Reports*      799

25.VI    Wilson Duff, ed. 1959. *Histories, Territories and Laws of the Kitwancool*  803

25.VII   Richard I. Inglis and Donald N. Abbott. 1991. "A Tradition of           806
         Partnership: The Royal British Columbia Museum and First Peoples."
         *Alberta Museums Review*

25.VIII  Jay Stewart and Robert Joseph. 2000. "Validating the Past in the        807
         Present: First Nations' Collaborations with Museums." *Cultural Resource
         Management*

25.IX    Peter L. Macnair, Bill Reid, and Tony Hunt. 1983. "The Legacy:          808
         Through the Eyes of the Artists"

25.X     Gloria Cranmer Webster. 1983. "Address, April 15"                       809

25.XI    Alan L. Hoover and Richard Inglis. 1990. "Acquiring and Exhibiting a    810
         Nuu-chah-nulth Ceremonial Curtain." *Curator*

25.XII   Martha Black. 2001. "HuupuKʷanum · Tupaat – Out of the Mist: Treasures  811
         of the Nuu-Chah-Nulth Chiefs." In *The Manual of Museum Exhibitions*

25.XIII  Julia Harrison. 2005. "Shaping Collaboration: Considering Institutional 814
         Culture." *Museum Management and Curatorship*

25.XIV   Alan L. Hoover. 2000. "Public Policies and Private Worlds: Protocol     815
         – 'Telling People What You Are Doing before You Do It'"

25.XV    Julia Harrison. 2005. "What Matters: Seeing the Museum Differently."    816
         *Museum Anthropology*

25.XVI   Canada, British Columbia, and Nisga'a Nation. 1998. *Nisga'a Final      817
         Agreement*

25.XVII  Anthony A. Shelton. 2008. "Reply: The Curator as Witness." *Museum      819
         Management and Curatorship*

25.XVIII Andrea Laforet. 2008. "'We Are Still Here!' Consultation and            820
         Collaboration in the Development of the First Peoples' Hall at the
         Canadian Museum of Civilization." In *The Culture of the North Pacific*

*Region: Museum and Indigenous Culture. Proceedings of the 22nd
International Abashiri Symposium*

25.XIX  *'Nłuut'iksa Łagigyedm Ts'msyeen: Treasures of the Tsimshian from the*  822
        *Dundas Collection.* 2007

**26**  Pushing Boundaries, Defying Categories: Aboriginal Media Production on the  828
        Northwest Coast
        *Kristin L. Dowell*

26.I    Faye Ginsburg. 1991. "Indigenous Media: Faustian Contract or Global  838
        Village?" *Cultural Anthropology*

26.II   Catherine Russell. 1999. *Experimental Ethnography: The Work of Film in*  840
        *the Age of Video*

26.III  Rosalind C. Morris. 1994. "Celluloid Savages: Salvage Ethnography and  843
        the Narration of Disappearance." In *New Worlds from Fragments: Film,*
        *Ethnography, and the Representation of Northwest Coast Cultures*

26.IV   Chief Dan George. 1967. "Lament for Confederation"  845

26.V    Rosalind C. Morris. 1994. "Remembering: The Narratives of Renewal."  846
        In *New Worlds from Fragments: Film, Ethnography, and the Representation*
        *of Northwest Coast Cultures*

26.VI   *First Nations Drum.* 2000. "Barb Cranmer: Messenger of Stories"  849

26.VII  Lawrence Abbott and Sandra Osawa. 1998. "Interview: Sandy Osawa."  851
        *American Indian Quarterly*

26.VIII Dana Claxton. 2005. "Re:Wind." In *Transference, Tradition, Technology:*  855
        *Native New Media Exploring Visual and Digital Culture*

26.IX   Loretta Todd. 2005. "Polemics, Philosophies, and a Story: Aboriginal  858
        Aesthetics and the Media of This Land." In *Transference, Tradition,*
        *Technology: Native New Media Exploring Visual and Digital Culture*

**27**  Art Claims in the Age of *Delgamuukw*  864
        *Charlotte Townsend-Gault*

27.I    Lawrence Paul Yuxweluptun. 1992. "Lawrence Paul Yuxweluptun."  878
        In *Land, Spirit, Power: First Nations at the National Gallery of Canada*

27.II   Lawrence Paul Yuxweluptun. 1995. "Artist's Statement." In *Lawrence*  879
        *Paul Yuxwelputun: Born to Live and Die on Your Colonialist Reservations*

27.III  Scott Watson. 1995. "The Modernist Past of Lawrence Paul  881
        Yuxweluptun's Landscape Allegories." In *Born to Live and Die on Your*
        *Colonialist Reservations*

27.IV   James Tully. 1995. *Strange Multiplicity: Constitutionalism in an Age of*  883
        *Diversity*

27.V      Wii Muk'willixw (Art Wilson). 1996. Introduction. In *Heartbeat of the*      884
          *Earth: A First Nations Artist Records Injustice and Resistance*

27.VI     Andrew Hunter. 1996. "Thou Shalt Not Steal: Lawrence Paul      885
          Yuxweluptun and Emily Carr"

27.VII    Doreen Jensen. 1996. "Metamorphosis." In *Topographies: Aspects of*      889
          *Recent B.C. Art*

27.VIII   David Gladstone. 1997. Exhibition text panels for *Through My Eyes:*      892
          *Northwest Coast Artifacts as Seen by Contemporary Northwest Coast People*

27.IX     Marcia Crosby. 1997. "Lines, Lineage and Lies, or Borders, Boundaries      893
          and Bullshit." In *Nations in Urban Landscapes: Faye Heavyshield, Shelley*
          *Niro, Eric Robertson*

27.X      Joseph Gosnell. 1998. Speech to the BC Legislature on the occasion of      895
          the ratification of the Nisga'a Treaty

27.XI     Debra Sparrow. 1998. "A Journey." In *Material Matters: The Art and*      897
          *Culture of Contemporary Textiles*

27.XII    Robert Joseph. 1998. "Behind the Mask." In *Down from the Shimmering*      899
          *Sky: Masks of the Northwest Coast*

27.XIII   Tanya Bob, with Dempsey Bob. 2000. "The Art Goes Back to the      902
          Stories: A Sourcebook on the Work of Tahltan/Tlingit First Nations
          Artist Dempsey Bob"

27.XIV    Michael Kew. 2000. "Traditional Coast Salish Art." In *Susan Point:*      903
          *Coast Salish Artist*

27.XV     Chief Sam Dixon, speaking for Chief Alex Frank Sr. 1999. "The      907
          HuupuK$^w$anum of the Sitakanim (Frank) Family, Tla-o-qui-aht." In
          *HuupuK$^w$anum · Tupaat – Out of the Mist: Treasures of the Nuu-Chah-Nulth*
          *Chiefs*

27.XVI    Joe David, with Karen Duffek. 2000. "*Tla-Kish-Wha-to-Ah*, Stands      908
          with His Chiefs: From an Interview with Joe David." In *Nuu-Chah-*
          *Nulth Voices, Histories, Objects and Journeys*

27.XVII   Lynn Hill. 2000. "Curator's Statement." In *Raven's Reprise*      911

27.XVIII  Alice Campbell. N.d. "The Spectre of Tradition"      912

27.XIX    Michael Nicoll Yahgulanaas. 2001. "Notes on a Tale of Two Shamans –      914
          *Ga Sraagaa Sdang*." In *A Tale of Two Shamans*

27.XX     Michael M. Ames. 1999. "How to Decorate a House: The Renegotiation      916
          of Cultural Representations at the University of British Columbia
          Museum of Anthropology." *Museum Anthropology*

27.XXI    Robert Davidson. 2004. "The Present Moment: Conversations with      917
          *guud san glans*, Robert Davidson." In *Robert Davidson: The Abstract Edge*

27.XXII   Robert Davidson. 1991. From a speech originally delivered in Old      919
          Massett. In *Raven Travelling: Two Centuries of Haida Art*

27.XXIII  Miles Richardson. 2004. "On Its Own Terms." In *Bill Reid and Beyond:*    919
*Expanding on Modern Native Art*

27.XXIV  Guujaaw. 2004. "Man, Myth or Magic?" In *Bill Reid and Beyond:*    921
*Expanding on Modern Native Art*

27.XXV  Loretta Todd. 2004. "Beyond." In *Bill Reid and Beyond: Expanding on*    921
*Modern Native Art*

27.XXVI  Aaron Glass. 2004. "Return to Sender: On the Politics of Cultural    922
Property and the Proper Address of Art." *Journal of Material Culture*

27.XXVII  Tsaqwassupp (Art Thompson), with Taiaiake Alfred. 2005. "My    925
Grandmother, She Raised Me Up Again." In *Wasase: Indigenous*
*Pathways of Action and Freedom*

27.XXVIII  Marianne Nicolson. 2005. "*Bax wana tsi':* The Container for Souls"    927

27.XXIX  Cuauhtémoc Medina. 2005. "High Curios." In *Brian Jungen*    929

27.XXX  Jennifer Kramer. 2006. *Switchbacks: Art, Ownership, and Nuxalk*    932
*National Identity*

**28** | Stop Listening to Our Ancestors    936
*Paul Chaat Smith*

28.I  Richard I. Inglis, James C. Haggarty, and Kevin Neary. 2000. "Balancing    940
History: An Emerging First Nations Authority." In *Nuu-Chah-Nulth*
*Voices, Histories, Objects and Journeys*

28.II  Marcia Crosby. 1991. "Construction of the Imaginary Indian." In    944
*Vancouver Anthology: The Institutional Politics of Art*

**29** | NWC on the Up ... Load: Surfing for Northwest Coast Art    947
*Dana Claxton*

29.I  Skeena Reece. 2009. Artist's Statement    955

29.II  Ahasiw Maskegon-Iskwew. 2005. "Drumbeats to Drumbytes: The    958
Emergence of Networked Indigenous Art Practice." *ConunDrum Online*

29.III  Ahasiw Maskegon-Iskwew. 2005. "Drumbeats to Drumbytes:    959
Globalizing Networked Aboriginal Art." In *Transference, Tradition,*
*Technology: Native New Media Exploring Visual and Digital Culture*

29.IV  Victor Masayesva. 2000. "Indigenous Experimentalism." In *Magnetic*    960
*North*

29.V  Mike Patterson. 2003. "First Nations in Cyberspace: Two Worlds and    961
Tricksters Where the Forest Meets the Highway"

**30** | The Material and the Immaterial across Borders    963
*Charlotte Townsend-Gault*

30.I        Rosita Worl. 2000. "The Dakl'aweidi *Keet Naa S'aaxw:* A Killerwhale        980
           Clan Hat." In *Celebration: Restoring Balance through Culture*

30.II       Karen Duffek. 2006. "Bridging Knowledge Communities at the UBC        983
           Museum of Anthropology"

30.III      Larry McNeil. 2009. "*Fly by Night Mythology:* An Indigenous Guide to        986
           White Man, or How to Stay Sane When the World Makes No Sense."
           In *Alaska Native Reader*

30.IV       Sonny Assu (Gwa'gwa'da'ka). 2006. Artist's Statement        988

30.V        Don Yeomans. 2006. "The Impulse to Create. " In *Raven Travelling:*        990
           *Two Centuries of Haida Art*

30.VI       Paul Chaat Smith. 2007. "The Terrible Nearness of Distant Places:        991
           Making History at the National Museum of the American Indian." In
           *Indigenous Experience Today*

30.VII      Mique'l Askren. 2008. "Memories of Fire and Glass: B.A. Haldane, 19th        993
           Century Tsimshian Photographer." In *Visual Currencies: Reflections on*
           *Native American Photography*

## List of Figures

*Frontispiece:* Thunderbird drawn by Ḵi-ḵe-in in 2010. After listening to Anton Bruckner's Seventh Symphony (1882), Ḵi-ḵe-in drew this image on the front page of the orchestral score that he was following.

| | | |
|---|---|---|
| 4.1 | John Webber, *An Inside View of the Natives' Habitations,* 1778, pen, ink, and watercolour | 60 |
| 4.2 | Knob-top whaling chief's hat collected by Lewis and Clark in Oregon, ca. 1805 | 76 |
| 4.3 | Paul Kane, *Interior of a Lodge with Indian Woman Weaving a Blanket,* 1847, pencil and watercolour | 84 |
| 4.4 | *Chenook Canoe Bought from Kape,* line drawing from Swan, *The Northwest Coast,* 1857 | 87 |
| 4.5 | *Wooden Bowls of Maple or Fir Knots,* line drawings from Swan, *The Indians of Cape Flattery,* 1870 | 89 |
| 6.1 | Wooden bowls, line drawings from Swan, *The Indians of Cape Flattery,* 1870 | 151 |
| 6.2 | *Batten and Weave Forming Upper Border of Blanket,* line drawing from Emmons, *The Chilkat Blanket,* 1907 | 153 |
| 6.3 | Original drawings of objects from Teit, *The Thompson Indians of British Columbia,* 1900 | 154 |
| 6.4 | Spliced piece of kelp line and two reels of bark string, line drawings from Boas, *The Kwakiutl of Vancouver Island,* 1909 | 156 |
| 6.5 | *Heraldic Column from Xumta'spē,* line drawing from Boas, *The Social Organization and the Secret Societies of the Kwakiutl Indians,* 1897 | 158 |
| 6.6 | Interior Salish coiled basket and pattern, line drawings from Teit, *Coiled Basketry in British Columbia and Surrounding Region,* 1928 | 159 |
| 7.1 | Louis Shotridge, photograph | 167 |
| 7.2 | Ranking lineages of the Stikine Naanyaa.aayí, the Chilkat Gaanaxteidí, and the Chilkat Kaagwaantaan, ca. 1700 to ca. 1900 | 169 |
| 7.3 | Klukwan Kaagwaantaan Killer Whale House screen, drawing | 175 |
| 7.4 | Lax Kw'alaams Nagwinaks screen, drawing | 175 |

| | | |
|---|---|---|
| 7.5 | Chilkat blanket, line drawing from Emmons, *The Chilkat Blanket*, 1907 | 180 |
| 7.6 | Two poles in Wrangell, Alaska, ca. 1900, photograph | 181 |
| 7.7 | Tlingit Whale House, ca. 1890, photograph | 190 |
| 9.1 | Rev. J.B. McCullagh "in the Dress of an Indian Medicine Man," photograph | 239 |
| 9.2 | Frederick Alexcee, baptismal font, 1886, paint, metal, and wood | 241 |
| 9.3 | David Neel, *Residential School Transformation Mask*, 1990 | 244 |
| 11.1 | Gédem Skanísh totem pole, ca. 1870, photograph | 279 |
| 12.1 | Kwakwaka'wakw memorial pole raised in Gwayi village to commemorate the death of King George V, 1936, photograph | 331 |
| 12.2 | Two monumental poles carved by Mungo Martin, New York World's Fair, 1939, photograph | 334 |
| 13.1 | Alice Ravenhill, design drawings from *A Corner Stone of Canadian Culture*, 1944 | 352 |
| 13.2 | Rev. George H. Raley, photograph | 354 |
| 13.3 | Kwakwaka'wakw artist Ellen Neel presents "Totemland" pole to ballerina Maria Tallchief, 1961, photograph | 357 |
| 15.1 | Cover of Bill Holm's *Northwest Coast Indian Art: An Analysis of Form*, 1965 | 407 |
| 15.2 | Lyle Wilson, *Ode to Billy Holm ... Lalooska ... Duane Pasco ... and Jonathon Livingston Seagull*, 1980, etching | 408 |
| 15.3 | *Chilkat blanket*, line drawing from Boas, *Primitive Art*, 1927 | 416 |
| 15.4 | *Dish made of the horn of a bighorn sheep, Tlingit*, line drawing from Boas, *Primitive Art*, 1927 | 416 |
| 15.5 | *Carved trays*, line drawings from Boas, *Primitive Art*, 1927 | 416 |
| 15.6 | *Painted legging with design representing a beaver sitting on a man's head, Haida*, line drawing from Boas, *Primitive Art*, 1927 | 417 |
| 15.7 | *Painting for a house front placed over the door, representing the beaver, Kwakiutl Indians*, line drawing from Boas, *Primitive Art*, 1927 | 417 |
| 15.8 | *Styles of tails, Kwakiutl; above bird, below sea mammals*, line drawing from Boas, *Primitive Art*, 1927 | 417 |
| 15.9 | *Front, reverse, and side of a painted box*, line drawing from Boas, *Primitive Art*, 1927 | 418 |
| 15.10 | *Design elements from Tlingit blankets*, line drawing from Boas, *Primitive Art*, 1927 | 419 |
| 15.11 | *Painted boxes*, line drawing from Boas, *Primitive Art*, 1927 | 421 |
| 15.12 | John Cross, argillite platter, carving | 428 |
| 15.13 | Robert Davidson, *kugann jaad giidii*, 1983, painting, acylic on paper | 439 |
| 16.1 | Mildred Hunt, wearing a Chilkat robe, participates in a Woman's Dance, 1953, photograph | 451 |

| 16.2 | Mungo Martin working on a totem pole in Thunderbird Park, Victoria, BC, 1957, photograph | 451 |
| 16.3 | Woven blanket, Chilkat, drawing from Holm, *Northwest Coast Indian Art*, 1965 | 460 |
| 16.4 | Woven spruce hat, Haida, drawing from Holm, *Northwest Coast Indian Art*, 1965 | 461 |
| 16.5 | Woven spruce root hat, Haida, drawing from Holm, *Northwest Coast Indian Art*, 1965 | 462 |
| 16.6 | Woven spruce root hat, Tlingit, drawing from Holm, *Northwest Coast Indian Art*, 1965 | 462 |
| 16.7 | Pipe carved in the form of a raven, wood, abalone inlay | 471 |
| 16.8 | Earl Muldoe, Tsimshian Wolf headdress, 1970 | 484 |
| 17.1 | The three "renaissance" men – Mungo Martin, Bill Reid, and Robert Davidson – in their ceremonial regalia, photographs | 491 |
| 18.1 | George Hunt and family with Franz Boas in Fort Rupert, 1894, photograph | 524 |
| 18.2 | Charles James Nowell and family members, photograph | 527 |
| 18.3 | David Gladstone of the Heiltsuk Nation wearing a button robe, photograph | 547 |
| 21.1 | A boy stands in front of potlatch screens at Ahahswinis, ca. 1920, photograph | 641 |
| 22.1 | James Gilchrist Swan, "Thunder-Bird of the Makahs," line art from Swan, *The Indians of Cape Flattery*, 1870 | 681 |
| 22.2 | Various styles of Nuuchaanulth masks, drawings from Swan, *The Indians of Cape Flattery* | 683 |
| 22.3 | *P'aatlp'aaya* at Nuuchaanulth potlatch feast, etching from Moziño, *Noticias de Nutka*, 1803 | 691 |
| 22.4 | *K̲iitsak̲suu-ilthim*, or "ceremonial screens," that were part of Chuuchk̲amalthnii's bighouse at Aswinis | 706 |
| 22.5 | Huupach'esat-ḥ headdress, ca. 1910 | 717 |
| 23.1 | Mask of Nō′lis, Kwakwa̲ka̲'wakw, drawing from Boas, *The Social Organization and the Secret Societies of the Kwakiutl Indians*, 1897 | 721 |
| 26.1 | Edward Curtis, still from 1914 film *In the Land of the Head Hunters* | 831 |
| 26.2 | Michael MacDonald, *Electronic Totem*, 1987 | 856 |
| 27.1 | Lawrence Paul Yuxweluptun, *Inherent Visions, Inherent Rights*, 1992, virtual reality installation (two details) | 870 |
| 27.2 | Anne Ramsden, *Mask*, 1988 | 871 |
| 27.3 | Eric Robertson, *Shaking the Crown Bone*, 2000, installation | 872 |
| 27.4 | Lawrence Paul Yuxweluptun, *Leaving My Reservation and Going to Ottawa for a New Constitution*, 1986, acrylic on canvas | 873 |
| 27.5 | Susan Point, *Spawning Salmon*, 1996, House of Héwhíwus, Sechelt, BC, photograph | 876 |

| | | |
|---|---|---|
| 29.1 | Peter Morin, "One of the Older Stories," from online exhibition *Two Worlds*, 2006 | 951 |
| 29.2 | Gord Hill, "Winalagalis Wants You" and "500+ Years of Indigenous Resistance!" from online exhibition *Two Worlds*, 2006 | 952 |
| 29.3 | Cover of *RedWire* magazine, October 2008 | 953 |
| 29.4 | Nicholas Galanin, stills from *Tsu Heidei Shugaxtutaan*, Parts I and II, 2006 | 955 |
| 29.5 | Skeena Reece, "Welcome Performance" during FUSE at the Vancouver Art Gallery, 2009, photograph | 957 |
| 30.1 | Wii Muk'willixw (Art Wilson), *Mockery*, 1996, acrylic paint | 965 |
| 30.2 | "Louisa Assu and Agnes Alfred at the Kwagiulth Museum, Cape Mudge," 1986, photograph | 967 |
| 30.3 | Beau Dick, *Masks*, 2004, installation view of *Supernatural*, curated by Roy Arden at the Contemporary Art Gallery, Vancouver | 969 |
| 30.4 | Marianne Nicolson, *Baxwana'tsi: The Container for Souls*, 2006, engraved glass, cedar, light fixtures | 969 |
| 30.5 | Debra Sparrow, applied image for Pamina's costume, *The Magic Flute*, 2007 | 971 |
| 30.6 | Stan Douglas, still from video installation *Nu·tka·*, 1996 | 972 |
| 30.7 | Jeff Wall, *Hotels, Carrall Street*, 2007, transparency in lightbox | 973 |
| 30.8 | Brian Jungen, *Field Work*, 1999, installation view at Charles H. Scott Gallery | 979 |
| 30.9 | Sonny Assu, *Coke Salish*, 2006, duratrans and lightbox | 979 |
| 30.10 | B.A. Haldane, *Young Girls with Model Totem Pole*, photograph | 994 |

## Preface

This volume sets out to both record and scrutinize definitions of Northwest Coast Native art and its boundaries. While confirming the richness of this art, these pages reveal the ways in which conflicts, on the one hand, and an excess of enthusiasm, on the other, have relegated key aspects of its history, including the dynamic of cultural encounter and the work of some individuals, to relative obscurity.

Many classics of the literature are represented here. Some of them recur in different contexts throughout this book, which is fitting since arguing for one way of reading, or looking, or valuing is not its intention. The classics appear alongside lesser known sources and interpretations that have at some point been obscured or forgotten but that reveal the archaeology of knowledge and serve here as historiographic counterpoint.

As with Indigenous people, Indigenous knowledge was, through much of the nineteenth and twentieth centuries, submerged, if not actively suppressed, from the public sphere in British Columbia. In the late 1960s, the disparity between the easy accessibility of books and catalogues stemming from the unconstrained scholarly work enabled by the Northwest Coast archive and the relative invisibility of Native cultural production in Vancouver was striking and troubling. It was this disparity that gave rise to the idea for this book.

In the 1950s, Vancouver had acquired the dubious moniker "Totemland," linking the place, via the visually spectacular, to the Native. At the same time, the lives and works of Ellen Neel, Mungo Martin, and Bill Reid were beginning to have public effect. So too were alliances among Native people, such as the Native Indian Brotherhood founded in 1944, helping them to deal with, and to resist, the exceptional conditions under which they lived – imposed by the 1876 Indian Act and the system of Indian residential schools. In this setting, Doug Cranmer opened The Talking Stick in 1962, one of the first Native-run galleries in Canada. A few years later, new work by George Clutesi and Robert Davidson with older pieces from the collection at the University of British Columbia's

Museum of Anthropology went on view at Expo '67 in Montreal. Even so, Native art and imagery were not, as they are now, an omnipresent part of the urban fabric – central to land claims, commerce, the 2010 Vancouver Winter Olympics, and doctoral dissertations. They were, rather, the stuff of First Nations lives, apparently lived out of sight in a city that had grown up heedlessly on unceded Native land.

The uneasy relationship between Native lives and representations of the Native, neatly encapsulated by "Totemland," has also always been evident in writing – historical, ethnographic, sociological, art historical, biographical, and autobiographical – that for better or worse constitutes a Native archive of sorts. In recording memory, this archive has shaped it. But there are signs of change. An early paragraph in *Standing Up with Ga'axsta'las: Jane Constance Cook and the Politics of Memory, Church, and Custom*, written collaboratively by anthropologist Leslie Robertson and the Kwagu'ł Gix̱sa̱m Clan (2012, 30), gives a clear account of the shifting and productive relationship possible between a group of Indigenous people and the published archive:

> Recounted in conversations and regenerated in new publications, academic representations are alive. They are a potent medium through which people evaluate sometimes difficult pasts and re-examine individual lives alongside renewed customary activities. As subjects and as readers, Kwakwa̱ka̱'wakw peoples are no strangers to literature and scholarship. Indeed, a constructive dialogue about past events and persons in Kwakwa̱ka̱'wakw territories takes place, in part, by discussing the ways they are inscribed in published works. Perhaps several decades ago it might have been possible to ignore this shared literary sphere, but today scholarly works have a noted presence in public memory and in the lived experience of 'na̱'mima members.

Looking for support for the idea of this book, an anthology that aims to situate the published archive historically, Charlotte Townsend-Gault turned to Gloria Cranmer Webster, who warned that it would be "an enormous challenge." However, she did not say that it was not worth doing. As the plan for this project took shape, Jennifer Kramer and Ḵi-ḵe-in joined as co-editors. Kramer's long relationship with the Nuxalk community in Bella Coola, where she learned of ambivalence around the values of cultural treasures, so often termed "art," led to her book *Switchbacks*. And this project would have gone nowhere without Ḵi-ḵe-in's encyclopedic knowledge and the constant if gentle chiding of his non-Native friends.

Initially, the format of the book was modelled on *Art in Theory 1900-1990: An Anthology of Changing Ideas* (Harrison and Wood 1992), the first in a successful series of art history concordances published by the Open University in the United Kingdom. The topics under which the materials for our book were assembled similarly attempt to identify the dominant themes, the significant historical breaks, and the knowing recursive deployment of themes and histories that uniquely characterize that time/space known as "the Northwest Coast." Discussions that began in Charlotte Townsend-Gault's graduate seminar at UBC in 1998 on the role of historiography in the course of Native art and its reception led to formative suggestions for our themes from Aaron Glass and Kimberly Phillips, who were graduate students at the time. As for our contributors, we have been able to draw on the expertise of an extraordinary range of acknowledged experts. There are of course absent voices, just as there are neglected themes. This we regret. The project is ambitious, but it would be absurdly hubristic to claim total inclusivity.

Several contributors to this volume also consider the difficult matter of defining what, and where, "the Northwest Coast" actually is – among them, from their different perspectives, Bruce Miller, Ira Jacknis, and Kristin Dowell. In the broadest sense, we have worked with the larger topographical region extending from northern Alaska to the Columbia River in the south. Distinct human populations both do and do not correspond with this region; they have been mapped onto it by others. Some claims to sovereignty over historical territories, or parts of them, as in the Nisga'a Final Agreement of 2000, are now honoured, in other cases less so. The history of the definition is itself inseparable from the idea that the anthology attempts to explore.

Most chapters consist of an introductory essay followed by excerpts from the literature, with each excerpt preceded by its own introduction. With expert guidance from a diversity of authors giving their own reasons for the directions taken, the emphases given, and the connections made, readers can move back and forth between introductory essay and excerpt, to compare their own responses to that of their guide, to follow up on the cross-references, to turn to the illustrations for delight or for detail. This makes for a volatile experience, and, in the process, readers should be prepared to encounter new ideas about the old ones and interpretations that unsettle the conventions that have become part of "the idea of Northwest Coast Native art." A complete bibliography appears at the end of the book.

A stimulating result of inviting people with a diversity of backgrounds and approaches to shape themes in their own ways is that some chapters have no

excerpts. One chapter is simply visual. The contributors in these chapters tell their own stories, reminding us that knowledge does not necessarily reside with the printed word. Native peoples in many parts of the world have pointed to the incompatibilities between their ways of organizing knowledge and those that a book can encompass. Nor can it be said any longer, if it ever could, that a book is the ultimate recourse of the knowledge seeker. The web that has been cast over the globe has changed everything.

Throughout this volume, the terms "Indian," "Native," "First Nations," "Indigenous," and "Aboriginal" are found. Variations are inevitable in the textual history presented, and nothing has been done to standardize their use across the introductory essays to the chapters written by the contributing editors. From the extracts, it is abundantly clear that the variant uses and abuses of the terms by which people know themselves and are known by others are markers of the history of the discourse as much as they indicate any current differences. For the rendering of Native words, the book follows the orthographies specified by its contributors and as they occur in individual excerpts. Ḳi-ḳe-in himself prefers Nuuchaanulth, while elsewhere the more usual Nuu-chah-nulth is used. Every reasonable attempt has been made to secure permission to reproduce all material used. If there are errors or omissions, they are wholly unintentional, and we would be grateful to learn of them.

This book aims to confont the disturbing disjunctures between a dominant idea of art perceived as external or culturally detached, Indigenous epistemologies, and apparently intractable political and racial realities. It brings together multiple voices that are not aligned to any one message. Unsurprisingly, for an endeavour of this scale, with its commitment to consultation, what has emerged may not be exactly the book originally envisaged. However, its detailed readings amply demonstrate the mutability of the idea of art and how, where, when, and by whom its production and reception have been valued.

NATIVE ART OF THE NORTHWEST COAST

# A HISTORY OF CHANGING IDEAS

CHARLOTTE TOWNSEND-GAULT,
JENNIFER KRAMER, AND ḲI-ḲE-IN

## Introduction

*The Idea of Northwest Coast Native Art*

"Northwest Coast Native art" has proved to be a powerful idea, both contingent and essential, assuming many guises over the centuries. Since the mid-1700s, objects deriving from the cultures of the northeast coast of the Pacific Ocean have been displayed and exchanged, desired and classified and interpreted, stolen and confiscated, bought, sold, and displayed again in many parts of the world. The subject of this book is the fluctuating history of the idea that these objects are "art" as it has unfolded over the past 250 years or so. Its premise is that the idea of Northwest Coast Native art has been historically constructed through texts as much as through the global diaspora of the objects themselves. This is also a contested idea because for many Indigenous people the term "art" is itself problematic, an external imposition. But equally, for First Nations as for others, the idea of art has been accepted as conferring high value on the objects and ceremonials of their cultures. Any idea of art must involve ideas about its audience. If the term "art" confers a universal status, it should make no difference to what culture the audience belongs. But this is contested too.

The unequal power relations of transcultural encounter have suppressed Indigenous epistemologies and ontologies. As both Canada and the United States shifted from colonial to colonizing status, social relations between Native and non-Native remained chronically asymmetrical. Liberal democracies have complex, often hidden, limits to their defining tolerance, limits that all members have a role in setting. Conflicting definitions of "art" are entangled in a history of shifting ideas about racial and cultural difference as represented in state policy and legislation, in the political life of institutions, and in disciplinary histories – anthropology, archaeology, social geography, history, art history, and law. These, in turn, are inseparable from the history of museums, schools, universities, and systems of support and patronage, both public and private. *Native Art of the Northwest Coast: A History of Changing Ideas* aims to provide something of this backstory. As Ḳi-ḳe-in reminds us, this story of conflicting definitions includes, to take just one example, the consequences recognized in the recent

British Columbia Supreme Court decision (2009) that Nuu-chah-nulth people have, and have always had, the "right" to fish for all species and trade in them: "Fish has always been one of the foundations of our economy and lifestyle and is represented in countless sung, sculpted, woven, danced, painted, dramatically enacted forms." The decision at trial recognized the pre-contact practices of the Nuu-chah-nulth and their overwhelming degree of dependence on fisheries resources for food and trade.[1]

"Since the premise of this book is to account for some of the history of a contested field," says Ḳi-ḵe-in, "it is necessary to show that the problem itself is, and has been, one of naming. The very language embeds a history of the ideas of a particular moment. There is a history of terms associated with looking at this material, all of them burdened with meanings."

The literature on the Indigenous cultures of the Northwest Coast of North America is vast, varied, and unevenly known. Some texts have become familiar, even canonical, and widely available; some are more quoted than consulted, more often referred to than read; some are out of print or buried in obscure places. Sources having a bearing on "Northwest Coast Native art" are by no means confined to those that are ostensibly about art in any straightforward way. Taken together they amount to an unstable archive that has tended to privilege some modes of thought over others. Oral histories, unwritten memory, even where their significance is recognized, have often been marginalized by those who produced the texts, categorized the objects, assigned their values, and left the records.

This work of critical historiography revisits the archive and attempts two things: to make accessible for the first time in one place a broad selection of the 250 years of writings on Northwest Coast "art" with excerpted and cited sources covering both published and unpublished materials, secondary references, policy documents, and some texts not previously available in English; and to provide historical context for the production and interpretation of the texts in order to show something of how a body of knowledge has been shaped. The intent is to complicate the tendency to make Northwest Coast art into a spectacular but one-dimensional monolith that obscures and reduces the values of the societies of origin and ignores the wider histories of thought that have contributed to its production. It may not be possible to redress, let alone undo, the suppressions of the past or to fully recognize the omissions that persist into the present of Northwest Coast studies. But it is possible to show something of how diverse intellectual traditions, which in some tragic respects are at odds, influence, stimulate, and clash with each other. Without the exchanges, both violent and subtle,

that happen between people of different cultures, a situation unchanged by the Internet, this would be an empty book, a vacuous project.

There are many ways to organize an anthology. This one, which responds to Aboriginal critiques of colonial knowledge formations, also takes into account approaches emerging from the work of Michel Foucault, Edward Said, and the school of subaltern studies in South Asia. Influential through the latter decades of the twentieth century, these approaches demonstrated how unequal power relations create hierarchies of knowledge. The so-called writing culture movement stressed the extent to which hierarchies were reinforced through certain privileged modes of communication – such as writing. Text-based knowledge or discourse could benefit from some destabilizing: "The meaning of the text is the sum of its misreadings," as Stephen Tyler (1986, 135) expressed the matter in his chapter in *Writing Culture: The Poetics and Politics of Ethnography*. Preferring the more inclusive "archive" over "discourse," the scheme eventually decided upon was to approach the archive roughly chronologically but under headings that, because they overlap, would draw attention to shifting intellectual, aesthetic, and disciplinary paradigms. Wishing to avoid both an institutional and a singular authorial voice, the problem was how to represent this diversity with any accuracy without lapsing into postmodern relativism. A possible solution was to invite commentary from a number of people who would bring vastly different perspectives and personal histories to the project. As the scope of the project expanded, the number of contributors grew to twenty-eight. They were invited to adjust the topics and dates assigned to them as they thought appropriate, to make their own selections of material, and to contextualize and comment in their own manner. They – artists, art historians, anthropologists, archaeologists, curators, and others – have scrutinized the implication of explorers, historians, anthropologists, archaeologists, romantics, surrealists, speculators, artists, and curators in the production of Northwest Coast Native art. The results are variously personal, scholarly, political, polemical, and combinations of all of these. Some of the contributors identify overlooked materials or occluded histories. Some provide alternative narratives that overturn the aesthetic nostrums of the past or the pieties of collaboration that have characterized the early years of the twenty-first century. Some would have nothing to do with the idea of the Native as disempowered victim.

Among the consequences of this format is the rather rare opportunity to encounter variously exegetical, historiographical, or oppositional readings alongside the established foundational texts and others far less known. It becomes apparent that some interpretations have been oppressed and others privileged,

while others are forgotten, have become unfashionable, or lie dormant. Through its diversity and overlaps, its internal contradictions and disagreements, the anthology aims to work against the institutionalization of a body of knowledge. Fundamental to the contestation of the field, then, is that oral history, unwritten memory, disputed and non-standardized values have always been at play and have always been underrepresented. This book, this text, enfolds many other texts, but part of its self-critique is its recognition that cultural treasures or objectifications of culture, visual signs, or crest designs are themselves carriers of meaning articulated in ways that cannot be put into words in any language. Although a number of the essays encompass a disciplinary canon, the cumulative effect should be the opposite of canonical. In this way, some of the critical work is done by the compilation itself.

The Northwest Coast is hardly alone in its need for such critical scrutiny. Mohawk art historian Deborah Doxtator (1997, 37) had the fate of a continent in mind when she wrote the following:

> It is as though thousands of years of Indigenous peoples constructing, interacting with, interpreting, and reflecting cultural metaphors (on the land, in North America) never really happened or is somehow "unknowable" because it is articulated from a different intellectual tradition reflecting different knowledge structures. Along with the devaluation of (our) history colonialism has also devalued Indigenous intellectual thought, and in many cases fails to see it as an intellectual tradition at all.

More recently, Paul Chaat Smith (2007, 382), a curator at the National Museum of the American Indian in Washington, DC, and a contributor to this volume, has written of the role of Native intellectuals that "we must be really good at reading a really really bad map."

Subjecting the accumulating archive of the Northwest Coast art idea to reflexive analysis is not new. As an early example, Nuu-chah-nulth artist, scholar, and orator George Clutesi's book *Potlatch* (1969) arose from his own negotiated relation with the white man's values and ways of expressing them. Erna Gunther's *Indian Life on the Northwest Coast of North America, as Seen by the Early Explorers and Fur Traders during the Last Decades of the Eighteenth Century* (1972) brought together eighteenth-century explorers' accounts of what they saw and how they interacted with the people they encountered. In her seminal "Creations of Mystics and Philosophers: The White Man's Perceptions of Northwest Coast Indian Art from the 1930s to the Present," Aldona Jonaitis (1981) shows how

successive layers of outsider interpretation had accumulated. "Outsiders" are found in various places, as Graeme Chalmers (1995) points out in "European Ways of Talking about Northwest Coast First Nations." In "Potlatch and Totem: The Attraction of America's Northwest Coast," Isabelle Schulte-Tenckhoff (1988) argues that contemporary tourism can only ever replicate the skewed power relations established at first contact by outsiders intent on discovering either the "noble" or the "ignoble" savage. John Sutton Lutz's *Makúk: A New History of Aboriginal-White Relations* (2008) represents the growing recognition that ideas do not merely "shift" but also emerge from complex, often transcultural, relationships.

In their survey of the history of ethnological research, included in the venerable *Handbook of North American Indians*, volume 7, *The Northwest Coast*, Wayne Suttles and Aldona Jonaitis (1990, 81) write that "'Northwest Coast art' as a subject for analysis and theoretical discussion has generally meant the art of a region extending from the Tlingit southward at most as far as the Nootkan and Coast Salish tribes." Significantly, the term appears in quotation marks, the authors recognizing that the time was past, if it ever existed, for an unproblematized, blanket term, even one that was an accolade and that would be thought by some as conferring status. Daisy Sewid-Smith's article "In Time Immemorial" (1991) presages other work by First Nations writers, giving less entangled accounts of what is being interpreted and for whom. In the film *Box of Treasures* (Olin 1983), which deals with the Kwakwa̱ka̱'wakw value system that underlies the U'mista Cultural Centre at Alert Bay, Gloria Cranmer Webster is rueful about the disjuncture between the amount of "anthropology" done on the Kwakwa̱ka̱'wakw and the low level of public comprehension. The chequered history of film's attempt to raise this level is the subject of Rosalind Morris's *New Worlds from Fragments: Film, Ethnography, and the Representation of Northwest Coast Cultures* (1994). Christopher Bracken's *The Potlatch Papers: A Colonial Case History* (1997) is the most thoroughgoing analysis to date of the way in which texts – in this case the administrative records concerning potlatching – produce their own subject. Daniel Francis's *The Imaginary Indian: The Image of the Indian in Canadian Culture* (1992) and Marcia Crosby's "Construction of the Imaginary Indian" (1991) articulate a problem of which many were already well aware. Crosby's widely cited text appeared in *Vancouver Anthology: The Institutional Politics of Art*. Edited by the artist Stan Douglas (1991), the collection aimed, in the spirit of its moment, to scrutinize self-reflexively the histories of its own formation. Fallout from the deconstructionist tendency is also evident in Margaret Dubin's telling "Sanctioned Scribes: How Critics and Historians

Write the Native American Art World" (1999) and "'The Foundation of All Future Researches': Franz Boas, George Hunt, Native American Texts, and the Construction of Modernity," by Charles Briggs and Richard Bauman (1999).

Although, until recently, the published record has been to a large extent the product of outsiders' and colonizers' preconceptions, it also records something of what Native people were prepared to disclose about their cultures and, as Marianne Nicolson shows in this volume, is used recursively by First Nations stimulated to learn and provoked to correct. French philosopher Jacques Derrida, in his influential analysis of what he took to be a universal tendency, *Archive Fever: A Freudian Impression* (1996), was not thinking of ethnically based distinctions. Consider the critical mining of the archive in the work of Native artists as different from one another as Marianne Nicolson and Robert Davidson or Larry McNeil and Brian Jungen. Consider exhibitions such as *It Is Written in the Earth* (1997) and *From under the Delta* (1998), designed to show that an archive of a different sort resides in objects, technologies, and materials. In other words, as Ḵi-ḵe-in says, "people stand in very different relations to these texts, this history. They read things differently at different times in their lives. Some of these texts are now being mined for new meanings and new information, helping land claims, or spiritual practice." Consider too Nicholas Galanin's work (see Claxton, this volume) *Tsu Héidei Shugaxtutaan*, which mixes a Tlingit raven dance with a contemporary "robot" dance and translates as "we will again open this container of wisdom that has been left in our care."

Increasingly, and in ways that may be related to the acknowledgment of "pre-existing Aboriginal rights" in Section 35 of Canada's Constitution Act, 1982, First Nations are insisting that Native art has meaning because it meets their own social or political or personal needs. As Chief Robert Joseph (1998, 18) writes in the catalogue for *Down from the Shimmering Sky: Masks of the Northwest Coast*, "the masks of the Indigenous peoples of the Pacific Northwest Coast are powerful objects that assist us in defining our place in the cosmos, in a world of endless change and complexity, masks offer a continuum for native people to acknowledge our connection to the universe." A growing number of publications, documentaries, and websites initiated by a First Nation or band are telling their histories, recapturing their memories, and asserting their rights, among them *Na Amwaaltga Ts'msiyeen* (Kelly and Marsden et al. ca. 1992), *Bringing Our Ancestors Home: The Repatriation of Nisga'a Artifacts* (Nisga'a Tribal Council 1998), *From Time before Memory: The People of K'amligihah'haahl* (ca. 1996), and *Musqueam: A Living Culture* (2006).

For these reasons, this book, which both records and critiques the formation of the idea of Northwest Coast Native art, opens with an acknowledgment of the

significance of oral history. Daisy Sewid-Smith (Chapter 1) performs something of an opening ceremony for this volume in her own distinctive Kwakwa̱ka'wakw voice. Speaking or writing only for her own nation accords with protocol, but doing so also offers a sharp corrective to the entrenched notion of some generic and hypothetical "Northwest Coast." She points out, without needing to disclose details, how what has been known as "Kwakiutl art" to generations of admiring outsiders is grounded in Kwakwa̱ka'wakw social and cosmological beliefs and how closely the two are linked. Sewid-Smith brings her characteristic close attention as an experienced participant scholar to her account of colonial incursions that is both nuanced and unforgiving.

Ḵi-ke-in's "Hilth Hiitinkis – From the Beach" (Chapter 2) eloquently expresses the need to understand the Nuu-chah-nulth traditional belief system in order to comprehend the integrated values of reciprocity, responsibility, ownership, and authority that are embodied in Nuu-chah-nulth tangible and intangible cultural belongings. Reflecting on the superficial understandings of Nuu-chah-nulth material culture and social organization by explorers, missionaries, and collectors, Ḵi-ke-in offers a corrective: "What follows comes from our villages, it was and is our position." This is the position shared by many First Nations artists working in diverse media who are seeking renewed, and new, connections to the material cultures of their pasts and who have become more outspoken on the limiting effects of the categories of art. A related challenge with which this volume contends has been how to recognize the oral and visual transmission of knowledge in a predominantly text-based record. Declining to share more "encounter stories," Michael Nicoll Yahgulanaas (Chapter 3) has produced a graphic account for this volume that encapsulates some core Haida values in a form that tries to accommodate the oral and the visual. His publication *Red: A Haida Manga* (2009), whose book form must be dismantled in order to be "read" correctly, reveals specifically Haida ways of being.

Ira Jacknis (Chapter 4) offers a substantive overview of the first century of contact between European explorers/settlers and the peoples of the Northwest Coast. He explains how these scenarios of early interaction "demanded a kind of basic definition and categorization, for the arts as well as fundamental human traits," but often produced shallow and partial understandings of Native artifacts due to language barriers and brief exchanges. Jacknis outlines why certain types of objects (e.g., chiefs' clothing, women's labrets, kerfed boxes) received the most attention in published diaries, drawings, and curiosity collections, and he notes the sustained interest in tracing the first recorded sightings of totem poles.

Given the history of complex linkages between art and archaeology on the Northwest Coast, Andrew Martindale (Chapter 5) considers the current tendency

to move away from the determinist view – that is, that things generate culture – toward more contextual interpretations of the relations among humans, things, and meanings. These are negotiated through practice and agency. In providing a history of archaeology on the Northwest Coast, Martindale queries the extent to which it parallels the history of local research on specific sites and in specific cases. He works with the idea that, as meanings are negotiated, art may be an agent of translation across otherwise "untranslatable space."

Andrea Laforet (Chapter 6), herself a museum professional and seasoned negotiator at treaty tables and over repatriation issues, complicates the idea that the "problem" of collecting emerges from encounters between knowledge paradigms and conflicting mandates. Her experience of the *realpolitik* of current negotiations over value leads her to search the texts, the correspondence, and the records for the "intertexts" where those values became inscribed. Importantly, she shows how collecting has its own history, affected by personal, institutional, national, and international relations.

Judith Berman (Chapter 7) provides an in-depth analysis of the motivations and methods of Tlingit cultural intermediary Louis Shotridge when he worked as exhibit preparer, ethnographer, collector, and curator for the University of Pennsylvania Museum in Philadelphia between 1905 and 1932. Shotridge's primary methodology was storytelling, using clan histories to illustrate Tlingit values and to convey the interrelations of crest art (*at.oow*) and genealogy. Shotridge was always concerned to show that object movements, iconography, and art styles, along with Tlingit travel, trade, and intermarriage, were the result of conscious decisions by living individuals, not abstract cultural beliefs. Berman argues that it is in the details of Shotridge's writings that his strategies emerge.

Tracing the establishment of anthropology as a discipline from 1870 to 1950, anthropologist Bruce Granville Miller (Chapter 8) chronicles the theoretical debates among comparative evolutionism, Boasian historical particularism, and Maussian exchange theory as they affect the interpretation of the arts of the Northwest Coast. Miller discusses the significance, in the United States, of anthropology beginning as a museum-based discipline but moving to the university in the mid-twentieth century (a trajectory that is now beginning to reverse). Methodologically, he explicates the Boasian and Maussian theoretical legacies by showing the generative linkages between mentor and pupil and their impacts on the analysis of *l'art nègre*.

John Barker (Chapter 9) persuasively argues for studying the missionary record for what it can tell us about the rapid changes to Native life and art. However discredited today, missionaries were both witnesses and participants, and their chronicles provide access to historical viewpoints. Barker makes the important

point that, while missionaries often demanded the destruction of Northwest Coast material culture as part of conversion, many were collectors themselves or aided those who wished to collect. They were also responsible for circulating photographs and drawings of Native objects in missionary newsletters and slide-shows, thus inadvertently raising the level of non-Native awareness of this material culture.

Gloria Cranmer Webster (Chapter 10) writes from the position of an insider who has lived the legacy of "the dark years" (1920-45) – "a [rattle] shaker among many [rattle] readers." She vividly chronicles the effects of missionization, residential schooling, wage labour, and the anti-potlatch law on the Kwakwaka'wakw. But she asserts that through all these depleting experiences her people persevered in their arts and ceremonies through artistic lineages and underground potlatching. Her words serve as historical witness, but they activate as well as recount, incarnating and calling upon the power of her people.

Among the several sections of the anthology devoted to the consequences of modernity, notably when it is counterpoised with "primitivism," Marie Mauzé (Chapter 11) offers a comprehensive overview of the connections among Surrealist artists, active in Paris and New York, the intellectual and other influences on them, and the enormous influence that they had, in turn, on the interpretation of Native art, which continues today.

Leslie Dawn (Chapter 12) mines the archival record to reveal the ties between Northwest Coast Native art and the formation of Canadian national identity. Significantly, he pushes back the date of the non-Native recognition of the "revival of Northwest Coast art" to 1939 – the year when the Canadian government commissioned Mungo Martin to carve totem poles for the New York World's Fair. He explores how the perception of Aboriginal people as figures of social decrepitude morphed to the point where they became national icons in the representation of Canadian identity. This, he shows, emerged from the desire to incorporate Northwest Coast art into Canadian patrimony in the 1920s.

Scott Watson (Chapter 13) has long been interested in the relationship, largely submerged, but nevertheless influential, between Native art and the development of a modernist artistic culture in Vancouver, which apparently ignored the Native work but was in fact indebted to it. Most specifically, the Arts and Crafts movement, imported from Europe, imbricated Native signs and designs into its pedagogy. That this was ostensibly thought to benefit Native school children should not disguise the fact that paternalism toward others is closely connected with benefit for those in authority, helping to secure their positions and to provide them with history and continuity. Relatively little of this history has been published to date, especially in comparison to other issues covered in this book.

Ronald W. Hawker (Chapter 14) traces an often forgotten period in Canadian history (1930-60) when non-Native social reformers promoted the production and sale of Northwest Coast Native art to alleviate Depression-era reserve poverty and to serve as a platform from which to fight for the expansion of Native rights. Interestingly, this institutionalization of the "curio" market for Native profit brought government agencies, such as the Department of Indian Affairs, into working partnerships with museums, anthropologists, and educators. It also served to move the meaning of Native objects from Native belief systems to Western notions of art and artifact. Hawker concludes by arguing for the influence that these social reformers had on Northwest Coast Native art in the years that followed, even if it has gone unrecognized.

Kathryn Bunn-Marcuse (Chapter 15) has the task of tracking the origins, development, and consequences of form, formalism, and formalist analysis, which have insinuated themselves into every aspect of the production and reception of Northwest Coast art, defining it for some and diminishing it for others. Formalism is inseparable from the modernist project; it is also inseparable from notions of standards, materials, and techniques. As an authority on the silver bracelets of the region, she provides a revealing history of technique.

Standing in productive relationship to Bunn-Marcuse's chapter is that of Judith Ostrowitz (Chapter 16), who attends to the period from 1953 to 1984. Ostrowitz is one of several contributors who assess the force of modernity, its "intellectual, scientific, political, and artistic concepts," and its democratizing strategies on the Northwest Coast. Specifically, she considers the conflict that modernist formalism brought to the fore over access to the increasingly formalized, and thus increasingly organized, declarations of cultural expressions and values.

"Renaissance" is one of the several recurring tropes of Northwest Coast Native art that sheds more heat than light. In tracking specific textual references, Aaron Glass (Chapter 17) submits the term to a historical scrutiny, weighs the effect of its relationship to the European Renaissance, and shows how it has been used to both positive and negative effect. In a field of discourse not noted for its criticality, the notion of "rebirth" that presumes a "death" has been used to mobilize a critique that extends far beyond the realm of art.

Marianne Nicolson (Chapter 18) highlights the Native contribution to the ethnographic record and the importance of auto-ethnography with particular reference to the Kwakwa̱ka̱'wakw. She emphasizes that telling one's own story, which includes placing oneself within an extensive genealogy of ancestors, is essentially a traditional act of Native cultural production, not a foreign ethnographic one (even if written). Significantly, she establishes that all Kwakwa̱ka̱'wakw

artistic activity is autobiographical and happens within a web of ancestral rela-
tions. Therefore, she argues that counter-hegemonic Indigenous thought and
writing can be supplemented by Native auto-ethnographies to encourage cul-
tural continuity and maintenance of community norms.

Alice Marie Campbell (Chapter 19) tracks the shifting relationships between
anthropological theory and anthropological practice in the Northwest Coast re-
gion during the postwar period. She traces the regionalization of Northwest
Coast anthropological production and argues that regional anthropologists in
the early postwar period responded to locally derived urgencies in order to secure
support, and relevance, in the region. One of the results of this was an effective
opting out of contemporary anthropological debates; another was the formation
of a determining binary between "empirical" or "applied" and "critical" ana-
lytical directions that has been, and continues to be, unproductive.

The commercial success of the art, developing exponentially at all levels in
British Columbia and Alaska, has been skirted in the literature, which prefers to
lend a higher tone to the legitimizing of Native art. Karen Duffek (Chapter 20)
shows that market forces have long been a determining factor in the directions
taken by "Northwest Coast art," and she establishes a place for this tendency in
the growing transnational discussion on commoditization and the relationship
between the Indigenous and tourism-derived economy.

Writing as a member of the Snuneymuxw First Nation and as a lawyer,
Douglas S. White (Chapter 21) analyzes the documents that have controlled
Native lives since the late eighteenth century, including "that extraordinary
piece of legislation," the Indian Act and its amendments. He also shows how,
in his personal experience, these documents have failed to exert control. First
Nations have been caught up in the process of using the instruments of the state
to challenge it. Increasingly, they are successful. In a comparable way, Native
"art" is using the system of art to challenge and enrich the global art arena.

In Chapter 22, Ki-ke-in asks the crucial question for whom is all this North-
west Coast art writing done? He answers definitively that it is not for his people,
the Nuu-chah-nulth. Tracing the creative output of explorers, colonial agents,
anthropologists, art historians, and museum curators as they write on Nuu-
chah-nulth culture, Ki-ke-in exposes motivations that are mostly self-serving,
lack a holistic understanding of Nuu-chah-nulth beliefs and values, and are usu-
ally detrimental, whether intentionally or not, to the Nuu-chah-nulth. He con-
cludes with the changes wrought by Nuu-chah-nulth writers authorizing their
own texts.

"Property" is one of the terms that appears to have a translatable equivalence
across cultures, but, in its usage, the "untranslatable space," which Martindale

refers to in his reflections on the translation of meanings in the discourse around objects, is much in evidence. Property is a status-conferring notion, like art, but this is deceptive. Pursuing her study of variant values within specific communities and enriched by an appreciation of their display in museum settings, Jennifer Kramer (Chapter 23) draws reflexively on a Kwakwaka'wakw trope of "fighting with property." Implying the competitive display and exchange of status-enhancing wealth, or "property," she uses the trope to show how notions of reciprocity, or failed reciprocity, also form the dynamic of the scholarly debate.

The historical objectification process in "classic" displays of Northwest Coast culture, exemplified by Boas's Northwest Coast Hall at the American Museum of Natural History in New York, serves as the launching position for Aldona Jonaitis's synopsis of the academic and Indigenous critiques that transformed North American museum exhibitions into collaborative spaces of shared authority (Chapter 24). The growth of repatriation requests and tribal museums is tied to the recognition that objects are "wrapped" in different meanings through their cultural biographies and may not be adequately interpreted in European-based museums. In order for the significance of colonization, globalization, and Indigenous cultural authority to be conveyed, the non-Native museum visitors' experiential and didactic needs in the collaborative museum space should not be overlooked.

Martha Black (Chapter 25) dispels the commonly held notion that collaborative museology had its origins in the 1990s. Instead, she recalls that Native involvement with Northwest Coast museological representation began in the late nineteenth century with Native ethnographic collaborators and, by the 1950s and 1960s, was well established at the British Columbia Provincial Museum (now the Royal British Columbia Museum) and UBC's Museum of Anthropology. While dissecting the postcolonial discourse that assumes unequal power relations between ethnographers and collaborators, Black reveals the multiple agendas, sometimes overlapping, sometimes at odds, for continuing with collaborative museum exhibitions, documentation projects, and object care and handling standards in the present. She argues that museum processes must be made more visible to guard against further miscommunications and misunderstandings.

Kristin L. Dowell (Chapter 26) argues for the important place of Aboriginal filmmaking in this anthology while balking at the restrictive definitions of Northwest Coast art. She calls for the study of cultural mediation (media processes) over media productions as the key to evaluating the redemptive possibilities of Aboriginal filmmaking. Dowell demonstrates that Aboriginal filmmaking is activism as much as it is art making, if not more so, and that it can be revolutionary because it frees Native artists from reproducing aesthetic canons. Through a

chronological and causative history of Vancouver's Aboriginal filmmaking environment, Dowell demonstrates the opportunities for mixed-blood, two-spirited, or young filmmakers to represent their identities in this new medium.

In Chapter 27, Charlotte Townsend-Gault draws on the idea that "claims" derive from rights in order to give an account of the directions taken by the "claims" made for "art." Since the Supreme Court of Canada's *Delgamuukw* decision in 1997, these claims are made by First Nations. Nationalist essentialisms, expedient and protectionist, involve both an expansion and a critique of the visual and lead to other kinds of contestations between those for whom there is a correct, or controllable, way of doing things and those for whom adaptation to change and contingency is both inevitable and desirable.

Paul Chaat Smith (Chapter 28) weighs the fashion for identity politics and finds it wanting. He suggests that contemporary transcultural discourse may be stuck. In asking why this should be so, he takes into account Marcia Crosby's epochal version of some of the widely recognized disjunctures between representation and reality and then considers the potential of initiatives such as that expressed in the Yuquot Agenda Paper as a possible way forward.

Dana Claxton (Chapter 29) shows that sites for display, discussion, and distortion are expanding exponentially on the Web. Large parts of the archive in any medium can now be accessed online. There are inventive new modes for interacting with it and thus of passing on and developing cultural understanding. As Ḳi-ḳe-in says, "there is a whole bunch of young Native people out there who don't know how to operate in a discussion like this. They type more naturally than they talk. It's what they do. But we need them." They are texting and chatting and arguing via Bebo, MySpace, Facebook, and other interactive social sites in the blogosphere, where young artists and many others are finding new ways to work out what the idea of Northwest Coast art means to them.

Yet the Web's allure should not be allowed to disguise the warped kind of recognition, or non-recognition, that current arrangements give to Native artists, particularly women artists. Claxton's account of the speed and multifariousness of what the Web can offer to Indigenous cultures is poised between anxiety about vulnerability and enthusiasm about its potential to circulate intangibles.

Townsend-Gault's final chapter, "The Material and the Immaterial across Borders," takes into account the incursions of international boundaries and some of the effects of unmarked borders – those between disclosure and disguise – on the course and discourses of Native art.

An important goal of this book has been to ensure that the contemporary work done by artists and scholars in this region receives recognition and that the debates and arguments swirling around it carry on, even when – and especially

when – they disrupt the canon. Some of the most significant artists to have emerged recently as inheritors, reinterpreters, and disrupters of the Northwest Coast idea are featured here – among them Lawrence Paul Yuxweluptun, Marianne Nicolson, Debra Sparrow, Brian Jungen, Shawn Hunt, Nicholas Galanin, and Michael Nicoll Yahgulanaas. Their family histories and backgrounds may be diverse, but they are all engaged in reviving the agency of Indigenous art and extending its reach within Canadian and international art contexts. As this book goes to press, the Idle No More movement, a resurgence of the struggle against the political and ethical consequences of colonization, is bringing out the enormous creative vitality of Indigenous people in Canada and around the world. In realigning the aesthetic and the political, it is, once again, transforming the idea of Northwest Coast Native art.

NOTE

1   The Aboriginal right to harvest fish from traditional territories was upheld, along with a right to sell fish, though this is not an unrestricted commercial right, being limited to what is required for subsistence. In 2011, the Court of Appeal restricted the right to fish or harvest to species traditionally caught or harvested by the Nuu-chah-nulth. The trial court made no ruling on Aboriginal title, on the ground that it was not necessary to do so. Implementation will depend on negotiations with Canada and, as appropriate, British Columbia.

# 1 | Interpreting Cultural Symbols of the People from the Shore

This chapter will focus on traditional knowledge of what is now known as "Northwest Coast Native art." The word *art* is not in the vocabulary of my nation, the Kʷakʷakəwakʷ. My goal is to demonstrate how my people saw their own culture and traditions and how these traditions often clashed with those of the newcomers. I will endeavour to divulge the knowledge of cultural symbols, history, and legends given to me by my mentors, my two grandmothers, Daisy Roberts and Agnes Alfred. The traditions and culture that I will focus on will be those of my own people, the Kʷakʷakəwakʷ. Protocol states that you must speak only about your own customs, practices, and doctrines. Many people of other Indigenous groups, however, will relate to the ideas, principles, and teachings that I mention in this chapter.

The Kʷakʷakəwakʷ was an oral society living on the Northwest Coast of British Columbia, Canada. The closest we ever got to a writing system was through picture writing on rocks and wood. You had to possess the knowledge of how to interpret symbols to be able to read them, and for the most part this knowledge has faded into antiquity as more and more of our knowledgeable ones have passed on.

In 1884, the Canadian government passed a law forbidding us, as Indigenous people, from practising our cultural heritage. This law was not dropped until 1951. Many Kʷakʷakəwakʷ went to prison because they were defying this legislation. They did not feel a foreign government had a right to prevent them from practising their ancient traditions, including what they now call the potlatch and the ceremonial dances performed during this event. The Kʷakʷakəwakʷ believed that these ancient traditions were given to them by the Creator of humankind and the universe, and no one but the Creator could take them away. The only time our people were permitted to wear their traditional regalia and masks in this period was when the government was trying to impress a visiting dignitary or dignitaries. We became an exhibition for the world, enticing and entertaining the general public, usually with words like "come and see the vanishing race."

The following generations no longer followed the ancient ways because of the influence of the churches, governments, and residential schools. They no longer followed our ancient laws or protocols because they were taught that it was evil to do so. This applied to our language as well. Many parents no longer passed cultural knowledge to the next generation for fear of being arrested. This was the beginning of the deterioration of ancient Kʷakʷakəwakʷ knowledge.

When it comes to Northwest Coast paintings and carvings today, there are two views. The first view is that of the non-Indigenous and the non-traditionalist. They view the paintings and carvings merely as Northwest Coast art, and it gives pleasure to the senses. The second view is that of our ancestors and our traditionalists. These paintings and carvings are our "ǩikəsʔuw," our ancestral treasures. They are so valuable, precious, and rare because they reveal the secrets of the past.

When non-Indigenous people, and some of our own non-traditionalists, take cognizance of what we now know as "Northwest Coast Native art," they scrutinize and they analyze the object or painting as you would a Rembrandt. They study the light, the shade, the brush strokes, and then they proceed to interpret what they are viewing in European art terms. They see the paintings, carvings, and dances as visual art and nothing more. As with a Rembrandt painting, the carver or painter determines the value of his creation; and as with a Rembrandt, the appraisal of the object or painting becomes greater in value after the artist's death. These objects and paintings are coveted and collected throughout the world as works of art.

To the traditional Indigenous Kʷakʷakəwakʷ, our carvings and representations are not just art objects or paintings. They are alive: they teach, they reveal knowledge of the past. The symbols and carvings cause a spasmodic action in the brain, and torrents of stories and meanings flow to the surface of our remembrance. They explain our existence in the universe. They reveal who we are, where we originated, who our ancestors were, and whom and what they encountered.

One of my mentors, Daisy Roberts, once said to me that non-Indigenous art was "mute"; in other words, it did not tell one's history or story. In non-Indigenous art, it is the artwork that is important, not the person, model, or scenery that has been captured on canvas or sculptured in wood, clay, plastic, metal, or stone. Otherwise, we would not be asking these questions: Who was Mona Lisa? Why is she smiling? What is her secret?

The non-Indigenous people are no longer the only ones creating "mute" objects and paintings; many of the Kʷakʷakəwakʷ no longer follow protocols of the

ancient carvers or painters. Like the non-Indigenous people, their paintings and carvings no longer tell a story. Very seldom do you now see a human face on the chest of a Thunderbird carving or painting or on the tail of a Killer Whale. To the ancients, this design expressed the humanism of our first ancestors and the understanding that they could transform at will from human to bird, mammal, or other animal. Many contemporary Kʷakʷakəwakʷ painters and carvers seem to feel that they must please the public. Because these painters and carvers no longer follow the ancient ways, we are not only deprived of the ancient styles of painting, carving, and dancing, but we are also deprived of the ability to interpret and reveal the true history of our people as signified by such objects and presentations.

Indigenous carvers and painters started creating their work for the many tourists that came into our country. For this market, they made small objects such as painted clamshells, miniature paddles, miniature masks, and totem poles – insignificant objects. Although some carvers and painters secretly worked for the underground potlatch network during the potlatch prohibition, many were no longer hired by chiefs to carve and paint for them, as they had in the past, for fear that they would be arrested. When some of them were caught creating a ceremonial object, they quickly passed it off as tourist art. The Indian agents offered to market these objects for them, and soon many larger items found their way into the tourist trade. This opened the door to commercialism, and soon even older ceremonial masks, screens, totems were being sold to meet the demands of art collectors and curio seekers. From this potlatch prohibition period, many carvers and painters became well known as "Northwest Coast artists." Willie "Smokey Top" Seaweed and Art Shaughnessy came out of the underground potlatch network, and later other well-known artists emerged, such as Ellen Neel, Mungo Martin, Jimmy Dick, and Chief Henry Speck. For the most part, these old Northwest Coast artists have been forgotten and are never referred to when contemporary Northwest Coast artists are mentioned. There were, and are, many other talented individuals, but there are too many to list in this chapter.

Many young artists have come to take on the mindset of their European counterparts. In 1998-99, a few of them decided to go to court to see how they could copyright their work. I received a telephone call from a very distressed elder wanting me to meet with him immediately. He reminded me that no emblem, crest, or design from our people belonged to any individual artist, because that particular individual did not create it. Rather, such designs belong to the people as a whole. They belong to all the Kʷakʷakəwakʷ still living today.

This elder wanted us to look into this situation and to see how we could prevent this from going to court. A few of us met to discuss what kind of problem it would create, not only for our own people, but also for the other nations in Canada and the United States who also have a claim to the Thunderbird, Eagle, and Frog. Word got out that we were concerned about this court case and the ramifications that would follow. To our relief, the court case never materialized, and it was never spoken of again, as decreed by one of the traditionalist chiefs:

Lam maʔax̌s ǧʷałła Gigaǧamēy,
Ǧʷalla xux̌ ʔitʔid ǧʷaǧʷixsʔallas sa,
Heʔəm!
*It is completed Chiefs,*
*Let no one speak of it again,*
*That is it!*

The Kʷakʷakəwakʷ laws state that, when a decree has been spoken, you will not regurgitate the event; otherwise, the incident will never truly be resolved, and you will have created hatred and animosity for years to come. This decree was considered very serious. The injured party may break a copper against your family for breaking this law. In some cases, and with the permission of the chief that gave the decree, you may mention the event, and the useful knowledge that was gained, for teaching purposes, but names are never mentioned. It is not important who was involved in this court case. Mentioning names would serve no purpose. What is important is that some European laws will not work within the Kʷakʷakəwakʷ social structure.

We gained much useful knowledge when we were looking into this matter. We found that the majority of Indigenous peoples around the world were faced with the European copyright problem. The "intellectual property law" was explained to us by those who were struggling with the same problem: an individual's intellect and knowledge cannot be claimed by another individual for gain or profit because that intellect and knowledge do not belong to the claimant.

Communal property belongs to a clan or community that shares the same ancestor. Symbols and figures that are carved on totem poles, talking sticks, feast dishes, and house designs come from the ancestral history, as do clan dances that dramatize the history of the clan. Personal property belongs to the immediate family. The husband acquires certain property through marriage. The dowry from the wife may consist of coppers, names, positions, and dances. These dances have been acquired through vision quest, not from ancestral dances. Vision quest dances are the only dances that could be given as dowries. The

dowry is for the children, and the husband will initiate the children into these vision quest dances as well as the ancestral dances. If a person has no blood ties to these ancestral dances, he is forbidden to touch them. If he breaks this law, he is called "gəltgəltċanna" or "long armed." Dowry dances belong to the children alone, and they cannot be shared with any relatives.

The Kʷakʷakəwakʷ Nation recorded their history in many symbolic ways. I have already mentioned five of them, but I would like to give an example of these same symbolic representations and how they were used to record the history of the clans and families.

## TOTEM POLE

When traditionalists observe a totem pole, they are not watching for brush strokes, colours, or how the pole was carved. They look at it to see what story it will reveal. If they know the totem owner personally, they will probably know how to interpret the figures, thereby revealing the owner's past.

Totem poles are carved from large cedar logs. In the past, only the nobility had houses and totem poles. These totem poles are read from the bottom to the top. The bottom figure is the foundation and is referred to as the first figure, for it is read first. The chiefs in the past considered this to be the most important position. They would often laugh when they heard the adage "he is the lowest man on the totem pole" when someone was referring to a person he considered inferior.

In our traditions, the bottom position is usually reserved for a few select figures: the Grizzly Bear holding a copper to denote that the totem owner has strength, power, and wealth; the Dᶻunuq̓ʷq̓ʷa (Black Giantess of the woods) to show the chief's gigantic achievements and, therefore, his greatness; or a figure of a man representing the paternal patriarch that survived the flood.

The figures of Grizzly Bear and Dᶻunuq̓ʷq̓ʷa may appear on your totem pole as part of your historical recitation. Many ancestors claim they have encountered Grizzly Bear and Dᶻunuq̓ʷq̓ʷa. These figures would wear or hold something to clearly show whom they are representing.

In my lineage, we have a story that tells how one of my ancestors went out looking for Dᶻunuq̓ʷq̓ʷa to acquire certain supernatural items. When he reached his destination, he did not find the Giantess, but he did find a cradle with an infant Dᶻunuq̓ʷq̓ʷa lying in it. He knew the mother was hiding, so he kept pinching the infant's toe to make the baby cry. The Giantess finally called out and asked my ancestor what she could give him to stop tormenting the baby. My ancestor told the mother Dᶻunuq̓ʷq̓ʷa what supernatural gifts he wanted. The pinching of

the toe continued until he received the supernatural objects he was seeking. The figure that would be carved to represent this story on a totem pole for my lineage would be a female Dᶻunuq̓ʷq̓ʷa with large breasts holding a Dᶻunuq̓ʷq̓ʷa baby.

Ċeqqamēy of the Qʷiqʷasuťinux̌ʷ was another ancestor of mine. He was told by a spiritual being to prepare for a great flood that was coming. He was told to hollow out a giant cedar tree and seal himself in the tree with his family. While he was sealed inside the cedar tree, he was taught the cedar bark ceremony by this spiritual being. He was also taught to weave the cedar bark and was told to make himself cedar bark neck, arm, and leg rings. He was also told to weave a very large cedar bark head ring, with men's faces on the front, back, and sides of the head ring. This is how he was dressed when he emerged from the giant cedar tree after the flood waters receded, singing his sacred song. The figure that would be carved at the first position of our pole to represent this story would be a figure of Ċeqqamēy wearing a very large cedar bark headdress.

The ancestor of the Nunəmasəqolis clan of the Ławiċis of Turner Island sought refuge during the flood on a ledge on top of a large mountain. The flood waters reached his chin, but he held his head up, looking up to the sky. He saw a large butterfly approach him, and the butterfly rested on his head. The figure that would be carved to represent this story would be a man with a butterfly sitting on his head. This man is Numas, the ancestor of the Nunəmasəqolis or Butterfly clan.

Another ancestor of mine is Sənx̌ēy. This is my mother's clan. Sənx̌ēy claimed that he came from the sun. When you see a figure of a sun on a totem pole, you know this figure represents Sənx̌ēy, the ancestor of the Sənx̌ēm or Sun clan. Many tribes will have this figure on their totem poles because the Sənx̌ēm clan of Fort Rupert scattered when the Maʔəmtagilla clan chief was killed by another clan chief at Cax̌is (Fort Rupert) around 1851, causing a large riot. This incident forced the Sənx̌ēm clan members to join their mothers' clans in other tribes. All Sənx̌ēm clan members are related, regardless of their tribal affiliations. This is what we call Nəmmima or Kinsman. Nəmmima comes from the word Nəmmaxəs, which means "similar or alike, they are related by blood."

The Kʷakʷakəwakʷ did not have a writing system to record their history, but they did have their totem poles. The first Europeans said that the poles were idols and that we worshipped them. Many totem poles were destroyed because of this false notion. Totem poles were symbolic books that unveiled the past. If it was not for a totem pole, we would not know about a creature called the Həmmaʔa. The knowledgeable ones said it was a very large lizard. They said it looked like the present-day crocodile. Some Big House poles were moved to

Gilford Island from Wakeman Sound some years ago. A figure of a Həmmaʔa is carved on one of the poles. This tells me that an ancestor of the pole owner encountered such a creature, probably during the Mesozoic period or dinosaur age. This would be a period preceding our great deluge, or Yex̌ʷəxsa. This creature was feared by everyone, and it was appropriately called Həmmaʔa, which means "devourer" or "to eat up greedily."

Other figures will appear on a pole revealing the history of the pole owner. One of the figures will be the maternal patriarch who survived the flood or some other figure that represents the owner's mother's history. On many poles, you will see bird figures: Thunderbird, Qulus, Dᶻunna, Huxʷhuxʷ, or Eagle. These figures represent the bird men that the paternal ancestors encountered immediately after the great deluge. The figure of the bird men is placed at the top of the totem pole. These bird men became our ancestors, because they married the daughters of the patriarchs. Not all paternal ancestors encountered bird men. Some encountered a Wolf, Killer Whale, or Supernatural Men.

## TALKING STAFF

The talking staff of a chief is a miniature totem pole. It will reveal the same types of figures and the same story as his large totem pole. He had this staff with him at his potlatches, for in earlier times the chief had to recite the history of his lineage to the gathering in order to validate who he was. Each figure brings back the power of remembrance so that he could accurately tell his history to the people. The staff inspires the speaker, and the speaker reveals the history, and that is why we call it Yaq̓əntp̓iq or talking staff.

## FEAST DISHES

Some of the feast dishes or house dishes were carved with the same figures that a chief would have on his totem pole and talking staff, and they would relate the same story. Other feast dishes carried designs that were obtained by supernatural encounters. Some feast dishes were given away as marriage dowries.

## HOUSE DESIGNS

In earlier times, only the clan chief would have designs on the front boards of his house. This design also represented his clan's history, depicting, for example, the first ancestor after the flood or the bird man that married his daughter. The design

might be a Thunderbird, Qulus, Dᶻunna, Wolf, Killer Whale, or Sun, and such designs became known as the clan crests. Many houses had no designs on the front boards, but they might have carved figures around the edge of the roof, or in some cases they would just have a totem pole placed on each side of the door. Again, such representations were obtained through supernatural encounters.

## DANCES

It is during our ceremonial dances that these ancient carved figures on the totem poles come to life. The dancers dramatize the stories of these figures in songs and carefully choreographed traditional dances. The ancient stories will come to life, revealing the chief's lineage, back to the distant past, for all those who have come to witness the event.

One of the stories I loved to hear as a child was the Madəm story of the Ṅiṅəlḱinux̌ʷ clan of the Nəmǧis. The Nəmǧis now live at Alert Bay, but they once lived along the Nimpkish River. The Ṅiṅəlḱinux̌ʷ clan lived at the head of the river at a place called Ṅiṅəlgas.

Apparently, a young man from this clan was mistreated by his father. He was unhappy and depressed, so he decided to Tuyagga. Tuyagga, to our people, was to go into the forest and let the elements determine your fate. This was the practice in ancient times. Often the individuals who did this would have a supernatural experience or vision during such a time, and they would return to their village with a new song and dance from their experiences. This is what happened to the young man in the Ṅiṅəlḱinux̌ʷ story. In his despair, apparently, the young man wandered around the Nəmǧis Valley until he came to a mountain referred to as X̌ʷillamigix̌λey or "a mountain that has a crystal summit." At one time, this mountain had a great landslide, and crystal rocks were everywhere at the back side of the mountain.

When the young man returned to his village at Ṅiṅəlgas after his experience, he related this story to his clan. He told how he had been so despondent that he just wandered around, not caring where he was going. Suddenly, he found himself at X̌ʷillamigix̌λey, at the landslide, where he encountered what he called a screaming covered flying vehicle. This screaming covered flying vehicle flew him away. He was flown to the house of the child of the flyer of the world. Then he was conveyed to the lower world and then to the northern end of the world. Eventually, he was returned to X̌ʷillamigix̌λey at the landslide area. This is when he composed a chant telling of his experience. When he returned home to Ṅiṅəlgas, he sang his chant for the Ninoǧad or wise ones. (This is what the ancients

called their singers and composers.) He told them how the dance was to be performed and how the dancer was to dress. The dancer would wear a cedar bark skirt, a cedar bark neck ring, and a cedar bark head ring that had a wooden antenna with a spinning crystal on the tip of the antenna. The dance was to be performed with the hands on each side of the hips, with the palms open. Then the hands would be moved back and forth to the beat of the drums. This was to signify the readiness to fly. When the beat of the drums changed, the dancer would lift his hands just in front of the shoulders, palms open. He would then move in an anti-clockwise direction, forming a large circle. This was to signify that the flight was now beginning. The dancer would move in a very fast spring step. He would keep his hands in front of the shoulders, palms open. This signified flight. He told his clan chief that this dance was called the Madəm, which means "a device used for flying." The Madəm dancer was to sing his chant before he appeared, and the Ninoǧad would start singing his song.

Many centuries have passed since this young man's encounter with the Ǧalissalasǧəm, the screaming covered flying vehicle, and since he composed his historic chant. This song is still sung to this day by the Nəmǧis singers.

The song tells the experience of the young man from N̓iṅəlgas. This song was recorded by Franz Boas as dictated by N̓əmugʷis in 1900. I would like to include this version of the song in this chapter, because it was dictated by a member of the N̓iṅəlk̓inuk̓ʷ clan. Whenever I use the Franz Boas texts, I always use the Kʷak̓ʷalla version, and then I translate it, and this is what I have done with this song. I have given the text and page number for those who wish to check the accuracy of my translation. The writing system I use is the International Phonetic Alphabet, similar to that used by Franz Boas.

*Madəm Song*

Haane, haane, ane,
Lax̌ dən λax̌ʷsid̓əlissa q̓ʷəmxax̌əl X̌ʷillamigix̌λey;
*Haane, haane, ane,*
*I went and stood at the foot of the landslide at Crystal Top Mountain;*

Hane, hane, hana, hayi
Ṗaλəlid̓əmx dən, qən lex dən laga?ayuw lax̌ hanis gukʷ, lax̌ gukʷk̓ʷa ni x̌ʷənukʷk̓ʷa
    Matmatəligəs nalla.
*Hane, hane, hana, hayi*
*I was flown away, until I reached a house sitting on land, the house of the child of the*
    *flyer of the world.*

Hane, hane, hana, hayi

Q̓aney yuxʷ dən, qən lex dən q̓anelagilid̵ᶻəm lax̌ gʷabaliċis nalla.
*Hane, hane, hana, hayi*
*They soared with me, they soared with me to the north end of the world.*

Hane, hane, hana, hayi
He x̌uw ƛi ǧʷix̌s si, x̌əns ʔix̌ʔaxsuw wax̌ x̌əns, hayigēy suw wax̌ gən ʔolek ċeqqa, ya, yiwo, yiwo, gən ʔolek pəx̌əlla, nikiɬ ɬən nəmuxʷ ʔəm nawalakʷ.
*Hane, hane, hana, hayi*
*So that is what it is, the dance we enjoy so much, whom I imitate when I have a winter dance, ya, yiwo, yiwo, for I am a true shaman, for this is the reason why I feel that I am the only supernatural one.*

Gən la yuɬ ɬik bibənaqolid̵ᶻəmma, gən ʔolek pəx̌əlla.
*Because I was flown to the lower world, for I am a true shaman.*

Nikiɬ ɬən nəmux̌ʷ ʔəm nawalakʷ, x̌ən nikiɬ ɬən nəmuxʷ ʔəm nawalakʷ d̵ᶻiy ya, gən la ʔuɬ ɬik p̓aƛəksalid̵ᶻəm, hamadəkʷsalid̵ᶻəm, sən ǧalissalasǧəm, x̌ən ċex̌dəmǩən na, lagəlid̵ᶻəmx̌ gən ʔolek ċeqqa, ya, yiwo, yiwo.

*This is the reason why I feel I am the only supernatural one, this is the reason why I feel I am the only great supernatural one, because I was flown away, flown away dumbfounded, by my screaming covered flying vehicle, who is now my winter garment, making my winter dances impressive, ya, yiwo, yiwo.*

[Franz Boas and George Hunt, *Kwakiutl Tales,* Columbia University Contributions to Anthropology 2 (New York: Columbia University Press, 1910): 98-100, Kʷak̓ʷalla version.]

I chose this particular story because it clearly shows how the story, chant, song, and dance are interconnected and how all these are connected to the ceremonial regalia worn by the dancer. And there are other versions of this story, which Franz Boas also recorded (Boas and Hunt 1910, 96-106).

We encourage the new talented Kʷakʷakəwakʷ artists to create their marketed art based on our ancient crests, emblems, etc. But we want them always to remember that these symbolic representations belong to all of us, as well as to the ancient ones, and to all the generations yet to come. What concerns the traditionalists – those of us who still live by the laws of our ancestors – is that this new wave of ideas and concepts is trickling into our Big House ceremonies. Our customs and traditions are slowly eroding. Even the potlatch prohibition did not cause this degree of damage. The ancient ones had no problem adhering to their customs and traditions because they followed certain protocols. These protocols have been followed for thousands of years. Our knowledgeable ones saw to it that every law and protocol relating to our customs and traditions was adhered to. Custom is the habitual practice of a community or a people. In other

words, an activity or action is practised so frequently that it becomes almost automatic. Tradition is the knowledge, doctrines, customs, practices, and protocols that have been transmitted from generation to generation over long periods of time. So if we are no longer following the ancient ways, should we continue to refer to our symbolic representations as customs and traditions, or is it now more correct to call it Kʷakʷakəwakʷ art?

## 2 | Ḥilth Hiitinkis – From the Beach[1]

From the earliest documented days of exploration along our coast and up until today, Maatmalthnii (white people) have been writing about Nuuchaanulth singing, dancing, formal speaking, face painting, weaving, painting, dance masks, carving, and other forms of creative expression. In the 1770s, Spanish, British, and American sea captains and other officials often documented in their journals their appreciation for Nuuchaanulth singing. They also noted their negative reactions to some of our traditions. At the same time, they collected large numbers of decorated Nuuchaanulth objects of all sorts to take home with them. Some of these early visitors were only ashore briefly, and we know their primary purpose was not the accurate description of Nuuchaanulth culture. Others were on scientific expeditions led by highly educated men instructed to observe the people and customs they encountered in strange lands. However, in more than two hundred years of observing, collecting, theorizing, and writing about these objects of ours, there has not yet been an in-depth investigation of their deepest and broadest context.

None of the Maatmalthnii who make it their business to study and write about Northwest Coast material culture has conducted a thorough investigation of the belief systems in which these objects functioned and continue to function. Today we have numerous publications that analyze in detail the structure and surface decoration of endless "Northwest Coast Indian artifacts." What these beautiful objects mean; what they symbolize; how the ceremonies and rituals they were, and are, used to benefit our communities; and how they point toward our complex and appropriate coastal belief systems remain unsolved, even mostly unprobed, mysteries for the public.

In the earliest stages of interaction, and as commerce developed, getting to a place of understanding each other must have been a problem exacerbated by the lack of a common language shared by Nuuchaanulthat-ḥ and Europeans. To an extent, this problem was overcome when some of the early observers who left records had learned enough of the Nuuchaanulth language to ask complex and

more probing questions and took the time to check their information for accuracy. The Spanish botanist José Mariano Moziño offers a good example of the richness available to investigators, even as early as 1792, when he resided at Yuukwaat from 29 April to 21 September. He produced *Noticias de Nutka: An Account of Nootka Sound in 1792* (1970), which, long before the development of anthropology, was essentially the first ethnography of a Northwest Coast First Nation.

When Juan Pérez visited the West Coast in 1774, he had on board a Catholic priest, Fr. Juan Crespi, but it was not until a century later, in September 1874, that the Belgian priest Fr. Augustus Brabant arrived in Ḥeshkwii-at-ḥ territory to establish the first Christian mission on the Westcoast. Much has been written about the negative attitudes of missionaries during this time toward Native peoples all over the world. This condescending missionary attitude extended to all manifestations of their cultures as well. Brabant left ample evidence in his writings that he believed he and other whites were the superiors of the people he was sent to Christianize and civilize. During his first twenty-five years among the Ḥeshkwii-at-ḥ, various mission schools, industrial schools, and boarding schools proliferated across the country. In 1900, Brabant finished building and opened the first of three Indian residential schools to be established on the Westcoast.

While these dramatic social changes were taking shape, a range of individuals continued to collect decorated basketry, paintings, and wood carvings in Nuuchaanulth villages along the extent of our coast. Ironically, the very ones who believed that potlatching was an evil excess, and that ceremonial paraphernalia were the works of the devil, also collected masks, rattles, drums, whistles, headdresses, and a wide range of other decorated material created for use in ceremonial and ritual settings.

Given that all Nuuchaanulth communities today have fluent English speakers in them, capable of answering any questions, it seems to be an obvious omission and a travesty that deeply meaningful and potentially fruitful questions have not been thoroughly investigated and remain unanswered. If members of the public are to understand First Nations peoples, it is imperative that they have a sense of the appropriateness, the complexity, and the sophistication of our traditional belief system and how it manifests itself in our behaviour; the manufacture of objects and their use in ceremonial and ritual settings; and, importantly, the nature of our traditional legal system, judicial system, and notions of ownership regarding territories and resources. The answers to the same questions might create some understanding and ease political tensions between the original inhabitants of our coast and the newer populations. I am talking here about aspects of Nuuchaanulth culture that Cook and his officers didn't see, may not have

wanted to see, and so did not write about in their journals. They are aspects of the broad background from which sprang the material now exhibited as examples of the Nuuchaanulth style of Northwest Coast art.

Of most interest to me is that area, within the scope of all writing about Nuuchaanulth culture to date, that forms its greatest lacuna. It is the underlying force behind all Nuuchaanulth action. Of course, I am talking here about our traditional belief system and its expression throughout the range of cultural activities. In our own system, the known universe is divided into four realms: the under-sea world, the on-the-land world, the in-the-sky world, and the world beyond-the-horizon. Each of these realms is overseen by a great and powerful *ch'iḥaa* or spirit. These four Great Spirit Chiefs affect every aspect of every event in our experience at every moment. Our society is traditionally a very hierarchical one, and our spirit world reflects this state of affairs. We believe that everywhere in the physical world there are greater and lesser, stronger and weaker, helpful and potentially harmful *ch'iḥaa*. We believe that in winter these mostly invisible *ch'iḥaa* draw closer to us. As well, at the time of any death among us, the *ch'iḥaa* of the recently deceased linger near their family members and former home. We believe that maintaining a careful and respectful relationship with the *ch'iḥaa* around us, most particularly our deceased close relatives, can bring us good luck, great strength, and a fuller life. These spirits can enhance the quality of our lives.

We believe that everything we enjoy in our lives is a gift bestowed on us by one of the four Great Spirit Chiefs. Our tradition is that, at the time of death, the *thli'maḳstii*, the life force, of the recently deceased begins a long journey, travelling beneath the sea, over the land, into the sky, and beyond the horizon. Ultimately, the *thli'maḳstii* ends up among the stars that form Taa'winisim, the Milky Way. Those left behind to finish with life in this world can pray for and receive assistance from our relatives in the spirit world.

All of this is important in understanding Nuuchaanulth culture generally and ceremonial and ritual life in particular. No true understanding of our ceremonials, rituals, or the vast range of items associated with them can be achieved without an understanding of the belief system that gave birth to them. Any other investigation of these very deep matters is bound to miss the mark completely or come to only a shallow understanding. Captain Cook and other early visitors to our villages were only capable of, and interested in, seeing Nuuchaanulth people and culture in a very limited way. It remains for people from our own community to enhance the picture he and many others since his time have been sketching.

Traditional law would be another area worthy of deep and protracted investigation. Perhaps most Canadians do not know that Nuuchaanulth people historically had policing, a judiciary system, and a most sophisticated and inclusive system of ownership and title. In the first place, the entire sea and land territory and everything in it are vested in the Taayii Ḥa'wilth, the King, of each community. Lesser chiefs enjoy almost exclusive rights to more limited and specific parcels of territory and the resources therein. Every citizen has a role to play extracting resources for the benefit of the entire local group, and every citizen owes allegiance and a share of those resources to the titled owner. In turn, our Ḥa'wiiḥ have a responsibility to manage the resources for the greatest benefit of all their people. Furthermore, our Ḥa'wiiḥ have huge responsibilities to their people in all ceremonial and ritual settings. Reciprocity is built into our system in that all families are expected to contribute when their chiefs host potlatches. In turn, our Ḥa'wiiḥ are expected to look after the initiation and naming of all their people. This is no small undertaking but rather a commitment extending over a lifetime, covering events such as birth, naming of a baby, a feast when the umbilical cord falls off, celebration of a child attaining his or her own mind, survival of any near-death experience, coming of age, marriage, initiation into dancing societies, apology feasts, cleansing feasts, a season of superabundance of particular resources, death, and Thlaaḳt'uultha (end of grief) feasts.

Traditionally decorated bighouses, ceremonial canoes, crest poles, painted ceremonial curtains, massive communal feast dishes, carved and painted treasure chests, masks, and rattles, as well as intangibles such as names, titles, and songs, all function to highlight our belief system and demonstrate ownership and authority over territory and resources. These are very complex systems that developed nowhere else in the world but here and are appropriate for our communities. My only intention here is to introduce what has been missed in the literature. Each of these specific topics is deserving of a book-length study of its own.

Today, when we Nuuchaanulth people assemble in bighouses, church halls, and gymnasiums to sing songs that our families have been singing for millennia; when we dress in cedar bark skirts and sea otter robes, in blue jeans and satin shawls bedecked with sequinned designs; when we distribute to our guests Hudson's Bay blankets, Tupperware bowls, and fifty-dollar bills; when we celebrate the range of events in a human life from birth to death; when we do all of these things and many, many more, we are acting out our faith that our ways continue to have validity in a world now complicated by religions and laws not always appropriate to our territories or to the point of view of our people standing on our beaches.

NOTE

1 I use this title because it captures a number of things at one time: the word *ḥilth* means "from" and *hiitinkis* means "the beach." Since all of our saltwater villages are fronted by beaches, the title states that this is where we always were, and what follows comes from our villages; it was and is our position.

## 3 | Haida Cosmic

The Haida manga presented in this chapter provides a glimpse into cosmology and consciousness. This short work, a series of visual notes, is a simple path skirting the edges of a vast and complex forest. While I rely on observations, recollections, and those few gifts I recognize from among the many given to me by dear old friends, this summary must be claimed as only one man's notion of a Haida map, of a pathway, that is artfully disguised as forest.

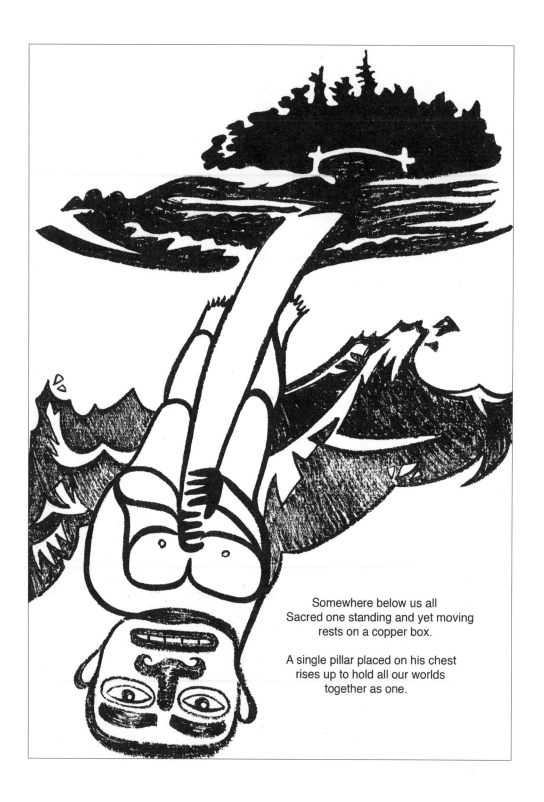

Somewhere below us all
Sacred one standing and yet moving
rests on a copper box.

A single pillar placed on his chest
rises up to hold all our worlds
together as one.

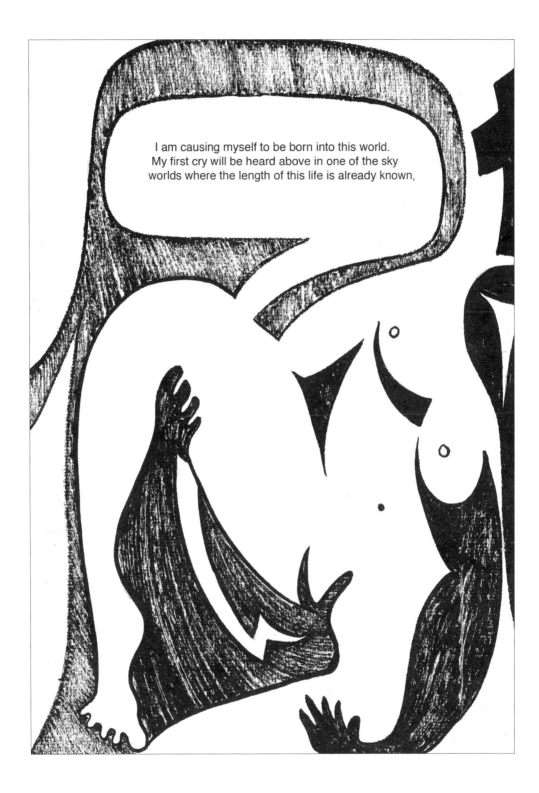

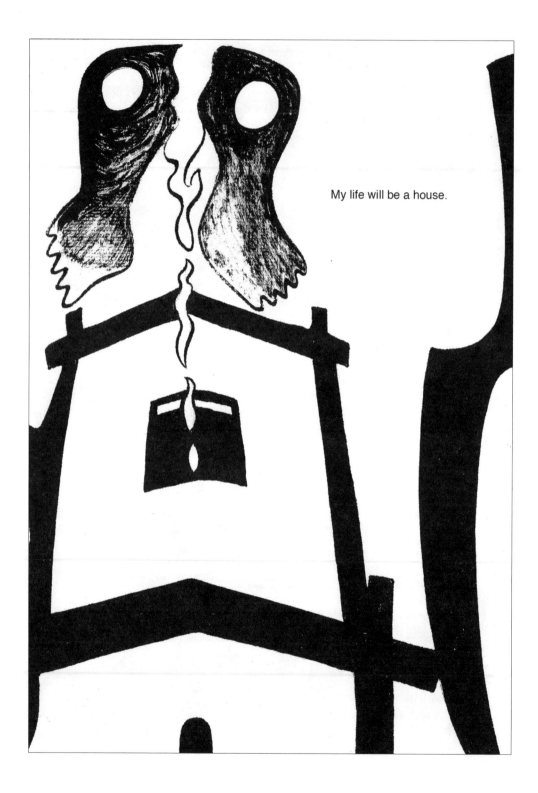

My life will be a house.

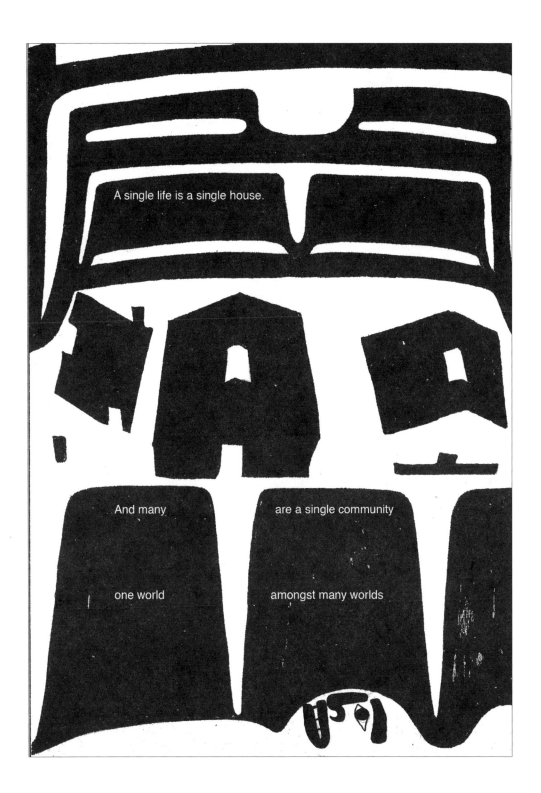

A single life is a single house.

And many          are a single community

one world          amongst many worlds

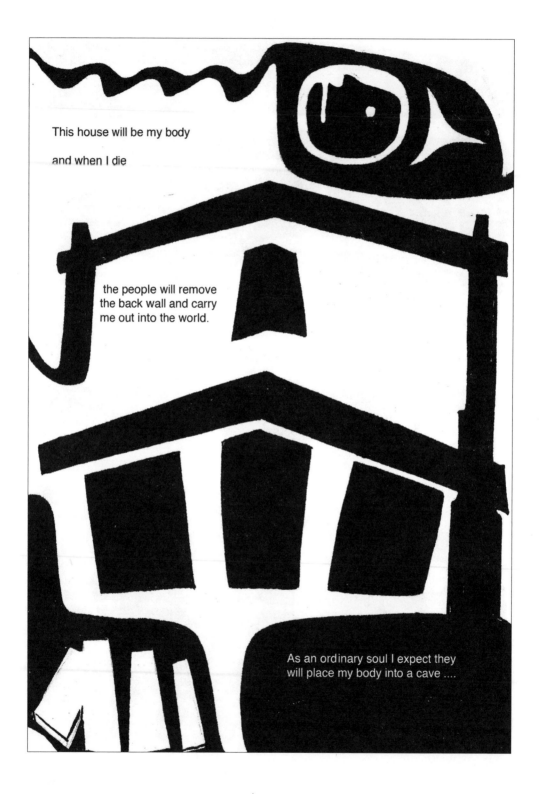

This house will be my body

and when I die

the people will remove
the back wall and carry
me out into the world.

As an ordinary soul I expect they
will place my body into a cave ....

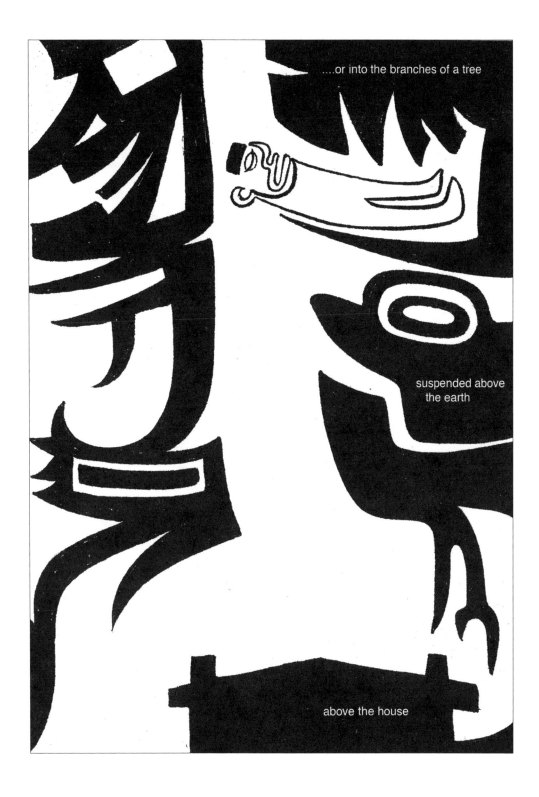

....or into the branches of a tree

suspended above
the earth

above the house

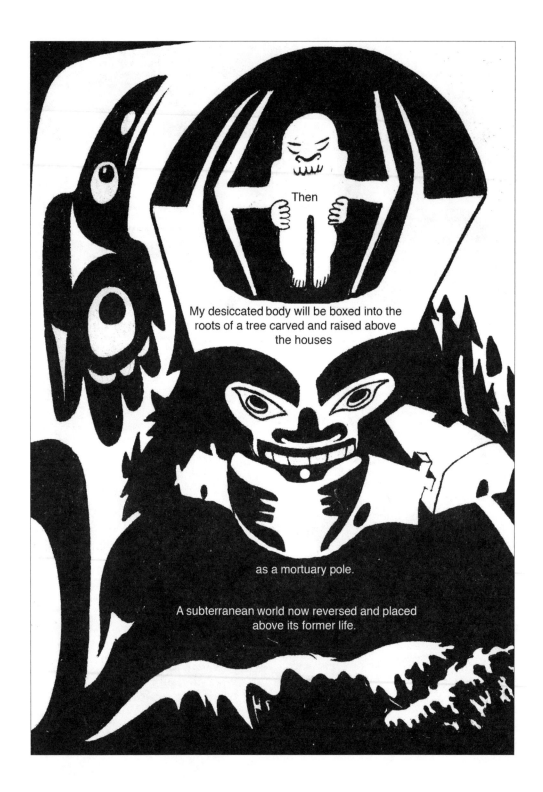

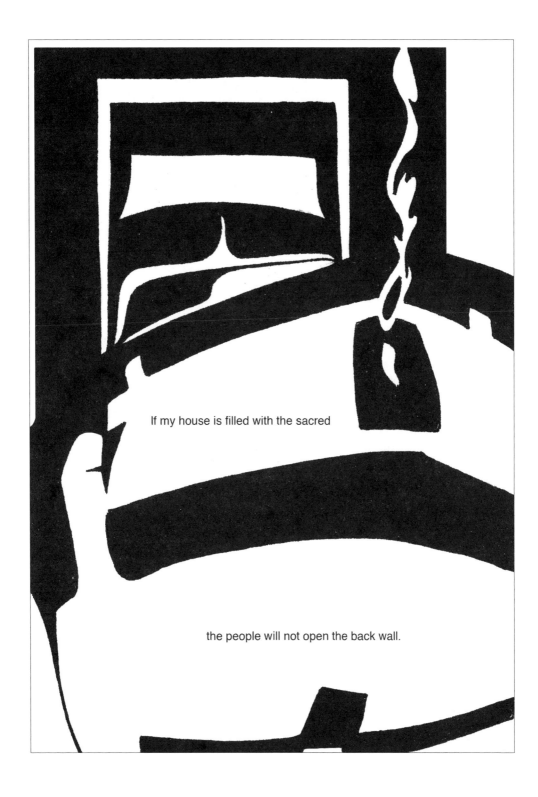

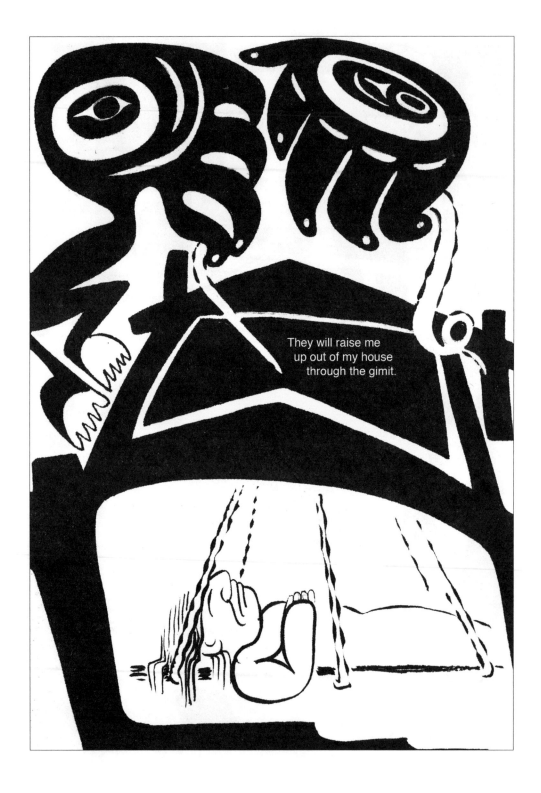

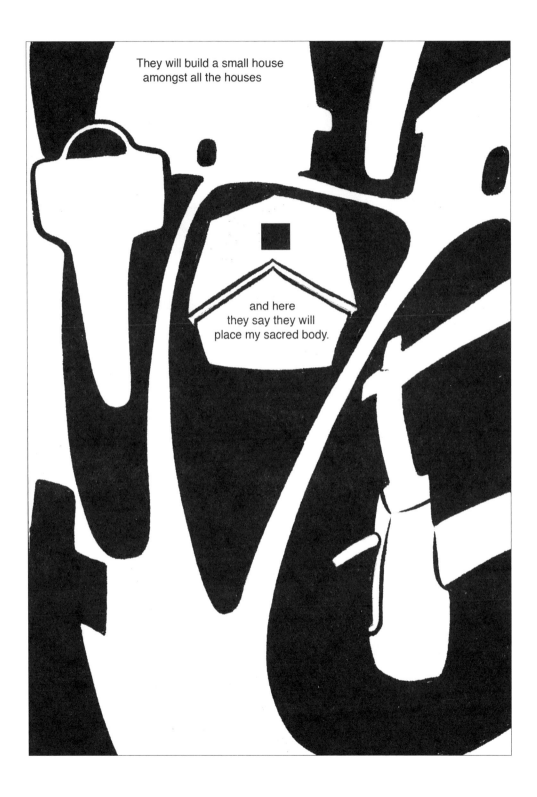

There are worlds above and below us
and all are held together by a single central shaft
resting on the chest of a supernatural one

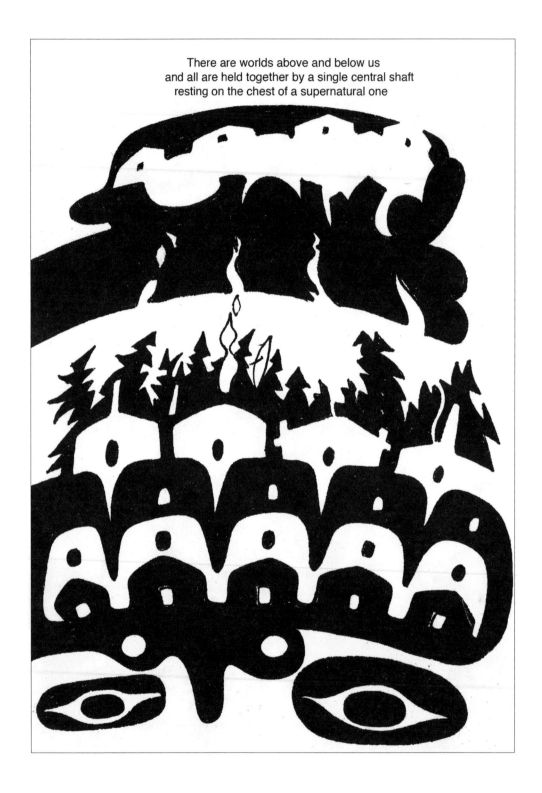

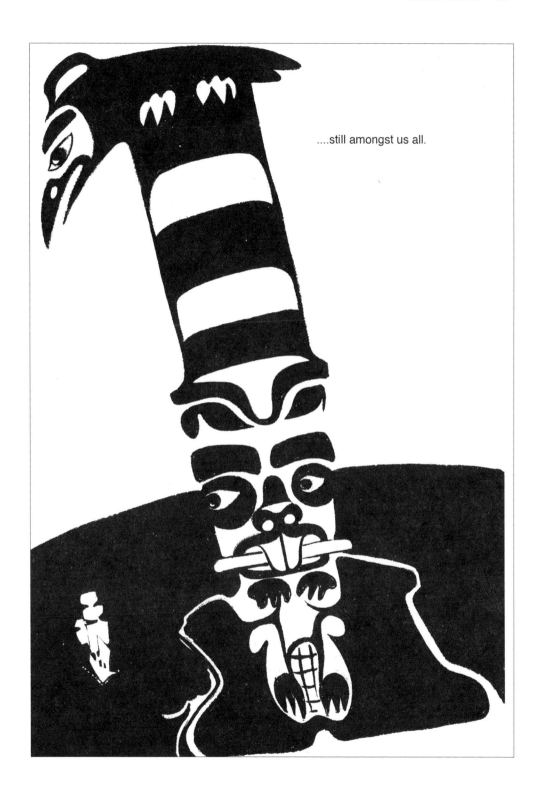

....still amongst us all.

IRA JACKNIS

# 4 | From Explorers to Ethnographers, 1770-1870

There once was a time when the great art styles of Northwest Coast Native peoples, developed over several millennia, were unknown to outsiders. It was during the great age of exploration in the eighteenth century that Europeans discovered these wondrous and sophisticated objects. While some of their initial impressions were favourable, in every case the distinctive forms were unfamiliar and strange. During the following century, foreign visitors would come to appreciate and learn more about the art. This chapter traces the first century of the encounter from this "exotic" point of view.[1]

## SPACE: NATIVE REGIONS AND CULTURES

Of course, there is nothing natural about what scholars today call the "Northwest Coast." Drawing, however, on over a century of anthropological practice and discussion, we can define the region as the land occupied by those Aboriginal peoples living along the coastal strip from Yakutat Bay in Alaska through British Columbia and Washington State to the southern border of Oregon (Suttles 1990a; see also Gunther 1972; Vaughan and Holm 1982; Suttles 1990b; S.C. Brown 1998, 2000b; Malloy 2000). Even within this fairly coherent region, there is a substantial diversity of Native cultures. In choosing these selections, I have made an effort to include as wide a range as possible. Accordingly, these selections include accounts of most of the major groups of the region, including the Tlingit, Tsimshian, Haida, Heiltsuk, Kwakwaka'wakw (Kwakiutl), Nuu-chah-nulth (Nootka), Coast Salish, and Chinook.

For reasons of historical accident, the Nuu-chah-nulth of Nootka Cove are overemphasized here, especially at the beginning, during the lucrative fur trade, while the Tsimshian and Nuxalk (Bella Coola) are underemphasized. There is also a stress on the early period, especially around 1791-92, when European countries competed over sovereignty and commerce. Almost all succeeding

explorers were familiar with the accounts of their predecessors, which they tend-ed to confirm, deny, or correct.

TIME: PERIODIZATION

This chapter takes us from the earliest explorers' accounts to the beginnings of systematic ethnography and collection.[2] This period of one century – from 1774 to 1871 or about 1770 to 1870 – may be thought of as the "prehistory" of the professional description, collection, and study of Northwest Coast Native art.

Western contact with Northwest Coast Native peoples occurred over re-peated waves. The earliest known European expedition to the region was the 1741 voyage of Vitus Bering and Aleksei Chirikov, exploring for Russia. Chirikov got as far south as Tlingit territory on Baranof Island, Alaska, but his encounter with the Native inhabitants was inconclusive.[3] The first direct exchange be-tween Europeans and the First Peoples of the Northwest Coast came in 1774: the Spaniard Juan Pérez Hernández encountered the Haida around Dixon Entrance [4.1], followed by the Nuu-chah-nulth (making, as well, the region's first known artifact collection; cf. Lohse and Sundt 1990, 88; see Ḵi-ḵe-in, Chapter 22, this volume).

In 1778, James Cook made the first British contact in Nootka Sound, repre-senting the first European landfall on the British Columbia coast, before head-ing to Prince William Sound, Alaska [4.11]. In 1786, Frenchman Jean-François Galaup de La Pérouse visited the northern coast, spending time among the Tlingit at Lituya Bay, Alaska. The first American contact came in 1788, with the Boston traders Robert Gray and John Kendrick, who made a series of exped-itions from 1787 to 1793, visiting Nootka Sound in 1788 and discovering the mouth of the Columbia River in Oregon in 1792. Following their initial forays, the Russians returned to Alaska, sending Yuri Lisianskii on the nation's first circumnavigation in 1803-6.

Around 1785, there was a marked shift from explorers representing diverse European countries (including Spain and France as well as Russia) to a maritime fur trade dominated by England and the United States. Soon visitors came by land: Alexander Mackenzie made the first continental crossing in 1792, reporting on the Nuxalk (Bella Coola), and the team of Meriwether Lewis and William Clark were the second, visiting the region in 1805-6.

Despite some transient outposts, effective European settlement in the region began in 1799 with the establishment of the Russian fort at Sitka, Alaska. Around 1820, the settlement period in British Columbia began; initial settlements soon

led to the union of the North West Company and the Hudson's Bay Company in 1821. In this chapter, each of the relevant colonial nationalities is represented: Russian, Spanish, British, French, American, and Canadian.

By about 1870, a century after the first contacts, the Northwest Coast had changed substantially. First, there were several moments of socio-political definition: 1848 (Oregon becomes a territory, with statehood in 1859), 1853 (Washington becomes a territory, with statehood in 1889), 1866 (British Columbia becomes a province), 1867 (Alaska is purchased from Russia, becoming a territory, with statehood in 1959), and 1871 (British Columbia confederates with Canada).

At the same time, the 1870s marked the beginning of systematic ethnographic study by men such as George G. Gibbs, James G. Swan [4.XVII, 4.XVIII, 22.IV], and George M. Dawson (see Laforet, this volume). In fact, the work of Americans such as Gibbs and Swan was transitional. Their earlier writings of the 1850s and 1860s were essentially settler and travel accounts, while their later reports read more like the efforts of systematic ethnographers.

This first century of reportage actually falls rather neatly into two halves: a period of exploration (1770-1820), with commentary included here by Juan Crespi (1774) [4.I], James Cook (1778) [4.II], George Dixon (1787) [4.III], Joseph Ingraham (1791) [4.IV, 4.V], Charles Pierre de Fleurieu (1791) [4.VI], Jacinto Caamaño (1792) [4.VII], José Mariano Moziño (1792) [4.VIII, 22.II], George Vancouver and Archibald Menzies (1792) [4.IX, 4.X], John Jewitt (1803-5) [4.XI]; and Meriwether Lewis and William Clark (1805-6) [4.XII]; and a period of settlement (1820-70), with observations by William F. Tolmie (1834) [4.XIII], Ivan Veniaminov (1834-38) [4.XIV, 9.I], Horatio Hale (1841) [4.XV], Paul Kane (1847) [4.XVI], and James G. Swan (1852-55, 1859-66) [4.XVII, 4.XVIII, 22.IV].

SOURCES: AUTHORSHIP AND TEXTUAL GENRES

The selections included in this chapter reveal great differences, depending on the identities of their authors, the nature of their revisions for publication, and their relationships to alternative representational media.

Like all writing, these accounts vary according to the professions of their authors and their motivations. The reports of common sailors tended to be descriptive, while those of their captains were more concerned with issues of sovereignty and trade. Merchants, such as Dixon or Ingraham, naturally noted the willingness of Native peoples to trade domestic artifacts as well as furs. Maritime expeditions often carried scientists of various sorts, who frequently did double duty as physicians; Menzies, Moziño, and the later fur trader Tolmie were all trained as

physicians, and each combined his ethnological studies with botany. Their scientific impulses often resulted in detailed and thorough reports. At the same time, many expeditions were accompanied by official artists, such as John Webber on the Cook voyage. Later, independent artists such as Paul Kane and George Catlin made their own trips to record Native peoples. These artists (as well as Juan Crespi) have left us telling insights into how Northwest Coast peoples viewed European painting.[4] Finally, Fleurieu's volume stands out for its more philosophical musings on the origins of the region's art, which is not surprising, perhaps, from a government minister of noble blood who was obviously well educated.

For the most part, these were *not* professional observers or collectors, and their accounts of Northwest Coast Natives were incidental to another, primary mission. Consequently, their texts tend to be short and superficial. Because chiefs were usually the first to board a trading ship, we have many descriptions of chiefly ceremonial attire and deportment. Often it was only the striking or curious things – such as women's labrets – that earned commentary. Also, as a number of explorers noted, because of language barriers, many questions about meaning and intent remained unanswered. Because of these limitations, during this first century there were relatively few accounts of art making, or actual behaviour, as opposed to contemplation of the finished objects.

On the other hand, a few observers did write long, detailed comments. Naturally, they were produced by those who were able to spend longer periods on the coast. Some come from extended trips, such as the five-month visit of José Moziño, or the two-plus years of captivity of John Jewitt, both in Nootka Cove. Others, especially in later years, were produced by settlers such as William Tolmie or James Swan. Moziño, Jewitt, and Swan published book-length versions of their observations. The descriptions of canoe carving by Moziño and Swan – half a century apart – make a nice contrast; although both are detailed, Swan's is even more thorough. And as early as 1846, Hale was attempting a more comparative synthesis of the region, contained in a volume entitled *Ethnography and Philology*. These were thus steps on the road to the professionalization of anthropology and the general salvage surveys by men such as George Dawson and Franz Boas (see Laforet, this volume; Miller, this volume).

Furthermore, in considering these selections, it is important to bear in mind the distinction between accounts written by first-hand witnesses and those rewritten by various literary agents. According to publishing conventions in the late eighteenth century, observations by uneducated sailors had to be reshaped by trained writers, so most of the explorers' accounts published in their own time were rewritten. Some of these accounts – those of Cook and Fleurieu, for

example – were taken from official expedition reports, a distinct genre. Although based on ships' logs, their observations were regularly embellished in response to popular concerns. Others, however (e.g., those here by Ingraham and Tolmie), are taken from manuscript diaries, journals, or letters. They were not published until years later, generally in the twentieth century, from a scholarly impulse to make available as complete a range of historical source material as possible. While it is frequently not possible to trace the alteration of a manuscript as it goes through the publication process, it is reasonable to expect that, the more "processing" occurs, the further from the observed reality the report is likely to be, and the more it will be shaped by the interests of a projected audience.

The textual accounts considered here must also be related to alternative historical media: artifact collections (preserved in museums) and drawings (in museums and archives), followed in later periods by photographs and then films and sound recordings. Interestingly, there is no one-to-one relationship between them. Some encounters, such as the Cook voyage, are represented by all three forms – texts, drawings, and artifacts – although there are sometimes disjunctions among them. That is, for any given topic, such as Haida argillite or free-standing totem poles, one sometimes finds firmly dated pictures with no accompanying text, or artifacts with neither texts nor pictures, and so on. To form a complete picture of the encounter, it is necessary to consult an array of overlapping sources – a standard art historical method.[5]

## CONTENT: ANTECEDENTS OF SCHOLARLY CONCERNS

At all moments in the encounter with the arts of the Northwest Coast, but especially at the onset, it has been necessary for observers to define the status of these objects. During this period of first contact, to what could Northwest Coast artifacts be compared? Should they be considered trading goods, curiosities, specimens, material culture, craft, art, or native patrimony? Obviously, such formulations involve the matching of Indigenous aesthetic systems to Euro-American ones, all of which have certainly shifted radically from 1774 to the present.

A consideration such as this, essentially defined by looking backward from the present, inevitably raises the issue of "firstness." This effort involves a kind of "upstreaming." We know the story of collecting and of later scholarship, but when do some of the basic concerns of the literature first appear?[6]

One way to begin is by tracing the first observations of distinctive forms of Northwest Coast art, such as kerfed boxes, Chilkat blankets, ceremonial masks,

painted house fronts, or free-standing totem poles. For a long time, both critical and scholarly attention has been focused on painted and carved wood, but during the first century observers commented on a wide range of object-types. The most common descriptions were naturally of the more domestic things that would be most apparent to a superficial observer who did not speak the language and did not spend much time in the place. Among the first object-types noted were canoes, clothing, and personal adornment, all visible in shipboard encounters. Due to the common visits of chiefs, ceremonial items such as masks and rattles were seen from the time of the first voyages. Slightly later, after explorers had ventured into villages, they noted totem poles, burials, and houses and their contents, which included domestic items such as tools and weapons, baskets and boxes.

Without a doubt, the object that attracted the most notice was the labret disk worn in the lower lip by the local women, first noticed by Crespi in 1774, as well as by Dixon and Ingraham, among many others (Malloy 2000, 7-8). From the start, observers also noted the distinctive Northwest Coast technique of kerfed box construction. Although both Crespi and Moziño recognized that boxes were sewn together at corners, without nails, a fuller description of their actual construction had to await Swan in the 1860s. Woven wool blankets were mentioned by many early explorers, among them Crespi, La Pérouse, Beresford, Fleurieu, Caamaño, and Vancouver. Understandably, masked performances were not commonly observed in this first century, but there were a number of important instances, such as Cook's brief exposure to chiefly masks, Caamaño's detailed account, Tolmie's report of movable mask parts, as well as Swan's Makah summary (1870, 69-70).

The historical question that has generated the most discussion in the scholarly literature of Northwest Coast art concerns the antiquity of totem poles and other monumental forms such as house frontal painting and canoes. They could only be documented in texts and drawings, since they were too large to be collected on early ships, and the poles of the time no longer exist *in situ*.[7] Although there are many reports of painted house fronts and carved interior house posts, there are relatively few observations of large, free-standing totem poles, and most of them seem to have been used as house entrances. Tlingit mortuary poles were seen at Lituya Bay, Alaska, by La Pérouse (1786) and Malaspina (1791); while frontal poles at the Haida village of Dadens were observed by Fleurieu, Ingraham, and Bartlett (Cole and Darling 1990, 132; McLennan and Duffek 2000, 277; Jonaitis and Glass 2010). Painted house fronts were seen by Caamaño among the southern Tsimshian and by Vancouver among the Kwakwa̱ka̱'wakw and Coast Salish.

The aesthetic status of Northwest Coast artifacts was perceived from the beginning, although the scope and application of the terms "painting," "sculpture," and even "art" were not always apparent. Remarkably, most early commentators had high praise for the form and appearance of these objects. Many admired them, finding them to be elegant, well designed, well executed, well proportioned, and neatly finished and carved, and they found their makers to be ingenious and industrious.[8] Although both Menzies and Vancouver thought that the frontal paintings on Kwakwaka'wakw houses were "rude," they found their appearance "picturesque," a key term in contemporary British aesthetics. It took a later commentator, James Swan, to remark that a canoe he had purchased was "a beauty." The most lavish praise for Northwest Coast artifacts probably came from Fleurieu. Among the Tlingit, he thought, "every man is a painter and sculptor." And he felt much the same about the Haida, astonished at the genius for painting and sculpture among a nation of hunters; he was particularly impressed with their skillful architecture, especially given the resources that they had available. Although he claimed that Haida sculpture "cannot undoubtedly be compared" to the masterpieces of ancient Greece and Rome, Italy, and France, that is just what he went on to do.

Not all was praise, however. Jewitt thought face painting among the Nuu-chah-nulth gave them a "grotesque appearance." Nor was Moziño won over, finding their carved house posts to be "deformed" and "grotesque" and the painting on a box "monstrous" and "extremely ugly." Overall, he concluded, "their writing and painting are very crude. Not only are these arts not in their infancy among them; to speak with exactness, they do not exist even in embryo."

Early observers noted both two- and three-dimensional art styles, but the structure and coherence of graphic styles eluded them. Despite all the discussion of meaning, no observer in this first century seems to have grasped the existence and integrity of the formline system, as demonstrated by Franz Boas and Bill Holm. These commentators thought the designs were weird and striking but did not see how they all fit into a tight formal system. In quoting the surgeon's detailed discussion of a Haida painted panel, Fleurieu seems to have struggled to describe its split representation and tapering motifs, but without an analytic or formal vocabulary he could only conclude that the "proportions were tolerably well observed" and that it was executed with "taste and perfection."

Although early explorers saw a fairly wide range of artifacts, for the most part, with their limited language skills and time for observation, they could only guess at the meanings and uses of these objects. Almost all the early commentators – including Crespi, Cook, Dixon, Fleurieu, and Vancouver – were able to

tease out the basic iconography, identifying representations of humans, animals, birds, and fish. What puzzled them were the underlying meanings or associations of these figures. Several (Dixon, Fleurieu, Vancouver) mention "hieroglyphics," which seem to have been on the minds of Europeans even before the 1799 discovery of the Rosetta Stone.

What were these decorative objects used for? Cook wondered if Nuu-chah-nulth masks were ceremonial or practical, and he, Moziño, and Jewitt speculated on the religious nature of their house posts. Bemoaning the language barrier, Fleurieu raised the same question for Haida decoration before concluding that they were not religious but largely commemorative. Swan devoted a great effort to exploring the meaning and iconography of Makah designs, which he decided were generally not religious but associated with their owners. Because he spoke the language, Veniaminov was able to grasp the fundamentals of the Tlingit crest system, with its structured visual expressions of moieties, lineages, and house groups.

Clearly, first contact demanded a kind of basic definition and categorization for the arts as well as fundamental human traits. As Lamb (1984, 1: 139) has noted, almost every group was compared to the Nootka (Nuu-chah-nulth), one of the first peoples to be contacted and then visited by nearly all the early explorers; the houses of other Native groups were either like or unlike theirs. Crespi related Haida artifacts to those seen by the captain in China and the Philippines, and Dixon thought their jasper blades were like those of New Zealanders. Moziño, a Mexican, naturally compared the crafts he saw to those of Mexican natives. Fleurieu's comparisons were the most diverse, ranging from the ancient Romans, Gauls, and Druids to modern Mexicans and Europeans.

Many observers tried to tease out the ultimate history of what they saw before them. Fleurieu thought that Tlingit art "announces a long employment of the useful arts." Concluding that their art is "far from being in its infancy," Dixon cited Cook's report of iron tools, concluding from their style that their blades must have been traded from the Russians. In fact, the first explorers were surprised to find Northwest Coast peoples using ornaments and tools of iron and copper. At contact, most Native blades were formed of stone, bone, shell, and teeth, but they did have bits of iron and steel as well as copper ornaments (B. Holm 1990a, 603-4). Their sources are not known for sure: some came from intertribal trade across the continent, some came from meteoric iron, and some were probably salvaged from drift wreckage from Asia.

Looking from the opposite direction, it is interesting to see how quickly Natives incorporated Euro-American items from trade. When Cook and the

English visited the Nuu-chah-nulth and Haida, they had already been contacted by the Spanish, and there had been even earlier Russian contact. By the time Lewis and Clark made the first American transcontinental expedition in 1805, they found that the local Chinook had already been exposed to about one hundred visits by maritime merchants. These early exchanges of materials, tools, and forms only accelerated during the first century of contact.

## Conclusion

Compared to what came after, though, the first century of Euro-American contact with Northwest Coast art was partial and shallow. The region's art was not well collected, described, or understood by outsiders, but, at the same time, the First Nations were left relatively free to develop their cultures on their own terms. After 1870, as First Nations of the region were incorporated into colonial structures, their artifacts were created under conditions of unequal power and cultural oppression (Fisher 1992; cf. Cole and Darling 1990; Clayton 2000).[9] The century discussed in this chapter thus represents a special moment in time, when Northwest Coast Native art forms were first captured in what has now become more than two centuries of cultural imbrication.

### PÉREZ EXPEDITION: JUAN CRESPI, 1774

**4.I. Donald C. Cutter, ed. 1969. "Journal of Fray Juan Crespi Kept during the Same Voyage [of the *Santiago*] – Dated 5th October, 1774."** In *The California Coast: A Bilingual Edition of Documents from the Sutro Collection*. Translated and edited in 1891 by George Butler Griffin; re-edited with an emended translation, annotation, and preface. Norman: University of Oklahoma Press, 235, 237, 239.

Over three days, 18-20 July 1774, Spanish navigator Juan Pérez Hernández (ca. 1725-75) became the first European to meet with the First Peoples of the Northwest Coast. Just off Langara Island, at the north end of Haida Gwaii (the Queen Charlottes), Pérez anchored at a place that he called Santa Margarita, now known as Cloak Bay. After a short visit with a group of canoe-borne Haida, he travelled across the waters of Dixon Entrance, where he traded with a larger group of Kaigani Haida at Cape Muzon, the southern point of Dall Island, which he called Santa Maria Magdalena. Following this, Pérez visited the Nuu-chah-nulth of Nootka Sound.

One of the best accounts from the expedition was that of Juan Crespi (1721-82), the Franciscan chaplain (cf. Gunther 1972, 5-12). Although the Pérez crew did not go ashore, they were able to describe a wide range of objects. As the very

first description of Northwest Coast art objects, this is simply an astonishing account; many of these objects had no direct counterparts in European culture. There are comments on decoration as well as form, technique, and function. In addition to reports of trading and collecting, Crespi described a reverse encounter with European painting.

[21 July 1774.] These canoes came alongside without their occupants manifesting the least distrust, they singing and playing instruments of wood fashioned like drums or timbrels, and some making movements like dancing. They drew close to the ship, surrounding her on all sides and presently there began between them and our people a traffic, and we soon knew that they had come for the purpose of bartering their effects for ours. The sailors gave them knives, old clothing and beads, and they in return gave skins of the otter and other animals unknown, very well tanned and dressed; coverlets of otter skins sewn together so well that the best tailor could not sew them better; other coverlets, or blankets of fine wool, or the hair of animals that seemed like wool, finely woven and ornamented with the same hair of various colors; principally white, black and yellow, the weaving being so close that it appeared as though done on a loom.

All these coverlets have around the edge a fringe of some thread twisted, so that they are very fit for tablecloths, or covers, as if they had been made for that purpose. They gave us, also, some little mats, seemingly made of fine palm leaves, wrought in different colors; some hats made of reeds, some coarse and others of better quality, most of them painted, their shape being, as I have said, conical with a narrow brim, and having a string which passing under the chin keeps the hat from being carried away by the wind. There were obtained from them, also, some small wooden platters, well made and ornamented, the figures of men, animals and birds being executed, in relief or by incising, in the wood; also some wooden spoons, carved on the outside and smooth within the bowl, and one rather large spoon made of a horn, though we could not tell from what animal it came.

There were obtained from them two boxes made of pine, each about a *vara* [almost one metre] square, of boards well wrought and instead of being fastened together with nails, they were sewed with thread at all the corners. They have neither hinges nor locks, but the cover comes down like that of a trunk with a fastening like that of a powder chest; and they are rather roughly fashioned within, but outside are well made and smooth, the front being carved with various figures and branches, and inlaid with marine shells in a manner so admirable that we could not discover how the inlay was made. Some of these figures are painted in various colors, chiefly red and yellow. In all the canoes we saw these boxes and some of them were nearly a yard and a half

long and of proportionate width. They use them for guarding their little possessions and as seats when paddling. They gave us, also, some belts very closely woven of threads of wool or hair, and some dried fish of the kind I mentioned yesterday. It is apparent that they have a great liking for articles made of iron for cutting, if they be not small. For beads they did not show a great liking. They accepted biscuit and ate it without the least examination of it.

As I have said, these Indians are well built; their faces are good and rather fair and rosy; their hair is long, and some of them were bearded. All appeared with the body completely covered, some with skins of otter and other animals, others with cloaks woven of wool, or hair which looked like fine wool, and a garment like a cape and covering them to the waist, the rest of the person being clothed in dressed skins or the woven woolen cloths of different colors in handsome patterns. Some of these garments have sleeves; others have not. Most of them wore hats of reeds, such as I have described. The women are clothed in the same manner. They wear pendent from the lower lip, which is pierced, a disk painted in colors, which appeared to be of wood, slight and curved, which makes them seem very ugly, and, at a little distance they appear as if the tongue were hanging out of the mouth. Easily, and with only a movement of the lip, they raise it so that it covers the mouth and part of the nose. Those of our people who saw them from a short distance said that a hole was pierced in the lower lip and the disk hung therefrom. We do not know the object of this; whether it be done to make themselves ugly, as some think, or for the purpose of ornament. I incline to the latter opinion; for, among the heathen found from San Diego to Monterey, we have noted that, when they go to visit a neighboring village, they paint themselves in such a manner to make themselves most ugly. We saw that some of the men were painted with red ochre of a fine tint.

Although we invited these Indians to come aboard ship they did not venture to do so, except two of them, who were shown everything and who were astonished at all they saw in the vessel. They entered the cabin and we showed them the image of Our Lady. After looking at it with astonishment, they touched it with the hand and we understood that they were examining it in order to learn whether it were alive ...

It astonished us, also, to find that the women wore rings on their fingers and brace-lets, of iron and of copper. These things I saw on several women, and the sailors who saw them nearer assured me that there was a women who had five or six rings of iron and of copper on the fingers of her hands. We saw these metals, though not to any great amount, in their possession, and we noted their appreciation of these metals, especially for large articles and those meant for cutting. The Captain, who spent a great deal of time in China and the Philippines, says that they greatly resemble the Sangleyes of the Philippines. It is certain that the weaving of the fine little mats resemble those that come from China.

**JAMES COOK: 1778**

**4.II. James Cook. 1785.** *A Voyage to the Pacific Ocean, Undertaken, by the Command of His Majesty for Making Discoveries in the Northern Hemisphere ...* 2nd ed. Vol. 2, bk. 4, chaps. 2-3. London: G. Nicol and T. Cadell, 306-7, 317-18, 326-27.

Although James Cook (1728-79) was not the first European explorer on the Northwest Coast, his visit in 1778 has achieved almost mythic resonance, in part because he belonged to the nation that eventually took possession of most of the region. The famed English naval officer visited the coast on the last of his three voyages of exploration. Over about a month (29 March-26 April), Cook observed the Mowachaht summer village of Yuquot, located at Nootka Sound along the west coast of Vancouver Island. Later he visited the Eskimo and Eyak of Prince William Sound and Cook Inlet, Alaska.

After a narrative of his now-famous visit to a Nuu-chah-nulth house on 22 April, Cook summarized his observations of the local material culture (cf. J.C.H. King 1999).[10]

[Masks.] Thus dressed, they have a truly savage and incongruous appearance; but this is much heightened, when they assume what may be called their monstrous decorations. These consist of an endless variety of carved wooden masks or visors, applied on the face, or to the upper part of the head or forehead. Some of these resemble human faces, furnished with hair, beards, and eye-brows; others, the heads of birds, particularly of eagles and quebrantahuessos [vultures]; and many, the heads of land and sea animals, such as wolves, deer, and porpoises, and others. But, in general, these representations much exceed the natural size; and they are painted, and often strewed with pieces of the foliaceous *mica*, which makes them glitter, and serves to augment their enormous deformity. They even exceed this sometimes, and fix on the same part of the head large pieces of carved-work, resembling the prow of a canoe, painted in the same manner, and projecting to a considerable distance. So fond are they of these disguises, that I have seen one of them put his head into a tin kettle he had got from us, for want of another sort of mask. Whether they use these extravagant masquerade ornaments on any particular religious occasion, or diversion; or whether they be put on to intimidate their enemies when they go to battle, by their monstrous appearance; or as decoys when they go to hunt animals, is uncertain. But it may be concluded, that if travellers or voyagers, in an ignorant and credulous age, when many unnatural or marvelous things were supposed to exist, had seen a number of people decorated in this manner, without being able to approach so near as to be undeceived, they would readily have believed, and in their relations would have attempted to make others believe, that there existed a race of beings, partaking of the

nature of man and beast; more especially, when, besides the heads of animals on the human shoulders, they might have seen the whole bodies of their men-monsters covered with quadrupeds' skins.

...

[House posts.] But, amidst all the filth and confusion that are found in the houses, many of them are decorated with images. These are nothing more than the trunks of very large trees, four or five feet high, set up singly or by pairs at the upper end of the apartment, with the front carved into a human face, the arms and hands cut out upon the sides and variously painted; so that the whole is a truly monstrous figure. The general name of these images is *Klumma,* and the names of two particular ones which stood abreast of each other, three or four feet asunder in one of the houses, were *Natchkoa* and *Matseeta.* Mr. Webber's view of the inside of a Nootka house, in which these images are represented, will convey a more perfect idea of them than any description. A mat, by way of curtain, for the most part hung before them, which the natives were not willing at all times to remove; and when they did unveil them, they seemed to speak of them in a very mysterious manner. It should seem that they are at times accustomed to make offerings to them, if we can draw this inference from their desiring us, as we interpreted their signs, to give something to these images when they drew aside the mats that covered them. It was natural, from these circumstances, for us to think that they were representations of their gods, or symbols of some religious or superstitious object; and yet we had proofs of the little real estimation they were in, for with a small quantity of iron or brass, I could have purchased all the gods (if their images were such) in the place. I did not see one that was not offered to me; and I actually got two or three of the very smallest sort.

...

[Art.] Their manufactures and mechanic arts are far more extensive and ingenious, whether we regard the design or the execution, than could have been expected from the natural disposition of the people, and the little progress that civilisation has made amongst them in other respects ...

To their taste or design in working figures upon their garments, corresponds their fondness for carving, in everything they make of wood. Nothing is without a kind of frieze-work, or the figure of some animal upon it; but the most general representation is that of the human face, which is often cut out upon birds, and the other monstrous figures mentioned before; and even upon their stone and their bone weapons. The general design of all these things is perfectly sufficient to convey a knowledge of the object they are intended to present; but the carving is not executed with the nicety that a dexterous artist would bestow even upon an indifferent design. The same, however, cannot be said of many of the human masks and heads, where they show themselves to be ingenious sculptors. They not only preserve, with exactness, the general

character of their own faces, but finish the more minute parts with a degree of accuracy in proportion, and neatness in execution. The strong propensity of this people to works of this sort is remarkable, in a vast variety of particulars. Small whole human figures; representations of birds, fish, and land and sea animals; models of their household utensils and of their canoes, were found among them in great abundance.

The imitative arts being nearly allied, no wonder that, to their skill in working figures in their garments, and carving them in wood, they should add that of drawing them in colours. We have sometimes seen the whole process of their whale-fishery painted on the caps they wear. This, though rudely executed, serves, at least, to show, that though there be no appearance of the knowledge of letters amongst them, they have some notion of a method of commemorating and representing actions, in a lasting way, independently of what may be recorded in their songs and traditions. They have also other figures painted on some of their things; but it is doubtful if they ought to be considered as symbols, that have certain established significations, or only the mere creation of fancy and caprice.

Yuquot was also described by the expedition artist John Webber (1751-93) in a letter to John Douglas, the editor of the book about Cook's third voyage, 31 December 1783. Webber's drawings were the first images of Northwest Coast houses, interior as well as exterior. Here Webber recounts his experiences drawing some house posts while visiting the village with Cook.

After having made a general view of their habitations, I sought for an inside which might furnish me with sufficient matter to convey a perfect idea of the mode in which these people live. Such was soon found. While I was employed, a man approached me with a large knife in his hand, seemingly displeased, when he observed that my eyes were fixed on two representations of human figures, which were placed at one end of the apartment, carved on planks, of a gigantic proportion, and painted after their custom. However, I took as little notice of him as possible, and proceeded; to prevent which, he soon provided himself with a mat, and placed it in such a manner as to hinder my having any longer a sight of them. Being pretty certain that I could have no future opportunity to finish my drawing, and the object being too interesting to be omitted, I considered that a little bribery might probably have some effect. Accordingly I made an offer of a button from my coat, which being of metal, I thought they would be pleased with. This, instantly, procured the desired effect. For the mat was removed, and I was left at liberty to proceed as before. Scarcely had I seated myself and made a beginning, when he returned and renewed his former practice, continuing it till I had parted with every single button; and when he saw that he had completely stripped me, I met with no further obstruction.

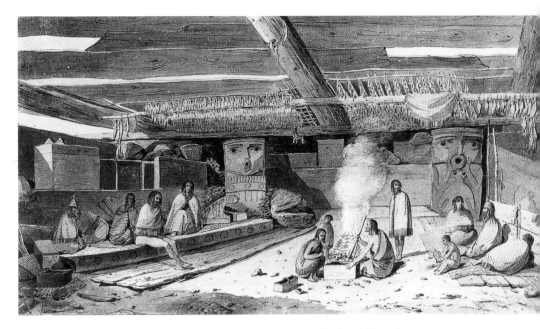

**FIGURE 4.1** John Webber, *An Inside View of the Natives' Habitations,* April 1778. Pen, ink, and water-colour, 30.8 cm x 63 cm. Webber was the official artist on Captain Cook's expedition and provided some of the first documented illustrations of Northwest Coast houses, such as this one at Nootka Sound. Peabody Museum of Archaeology and Ethnology, Harvard University, acc. no. 41-72-10/499.

## DIXON EXPEDITION: WILLIAM BERESFORD, 1787

**4.III. William Beresford [George Dixon]. 1789.** *A Voyage round the World; But More Particularly to the North-West Coast of America: Performed in 1785, 1786, 1787, and 1788, in the "King George" and "Queen Charlotte," Captains Portlock and Dixon.* 2nd ed. London: George Goulding, 242-44.

What we now call Haida Gwaii was christened the Queen Charlotte Islands by English seaman and trader George Dixon (ca. 1755-ca. 1800), after the name of his ship. Backed by London merchants, Dixon and his fellow captain Nathaniel Portlock had first arrived in Alaska in 1786. After returning the following season, Dixon was able to circumnavigate Haida Gwaii during July and early August. Although he traded extensively among the Haida, Dixon did not venture off the ship into any villages, as he had done on his Tlingit sojourn in Alaska. The account of the expedition was published in 1789, and although it bore Dixon's name on the title page it was, in fact, ghostwritten by William Beresford, a member of the crew. Dixon was a keen observer of the local material culture; like many, he was disgusted by the women's labrets, which he mentioned three times (Beresford 1789, 171-72).

Besides the ornaments already mentioned, the Indians are very fond of masks or visors, and various kinds of caps, all of which are painted with different devices, such as birds, beasts, fishes, and sometimes representations of the human face; they have likewise many of these devices carved in wood, and some of them far from being ill executed.

These curiosities seem to be greatly valued, and are carefully packed in neat square boxes, that they may the more conveniently be carried about.

Whenever any large party came to trade, these treasures were first produced, and the principal persons dressed out in all their finery before the singing commenced ...

Whether or no they make use of any hieroglyphics to perpetuate the memory of events, I cannot say, though their numerous drawings of birds and fishes, and their carved representations of animals and human faces, might, perhaps, warrant a supposition of the kind. Many of these carvings are well proportioned, and executed with a considerable degree of ingenuity, which appears rather extraordinary amongst a people so remote from civilized refinement. But then we must consider that this art is far from being in its infancy; a fondness for carving and sculpture was discovered amongst these people by Captain Cook: iron implements were then also in use; and their knives are so very thin that they bend them into a variety of forms; which answer their every purpose nearly as well as if they had recourse to a carpenter's tool chest. At what period iron was introduced on the coast is very uncertain, but it must doubtless be a considerable time ago; and I may venture to assert that their implements are not of English manufacture, so that there is little doubt of their being obtained from the Russians. The only implements I saw, (iron excepted) was a hoe made of jasper, the same as those used by the New Zealanders.

The ingenuity of these people is not confined to devices in wood, or drawings on bark; they manufacture a kind of variegated blanket or cloak, something like our horse cloths; they do not appear to be wove, but made entirely by hand, and are neatly finished: I imagine these cloaks are made of wool collected from the skins of beast killed in the chace; they are held in great estimation, and only wore on extraordinary occasions.

### JOSEPH INGRAHAM: 1791

**4.IV. Joseph Ingraham. 1971.** *Journal of the Brigantine Hope on a Voyage to the Northwest Coast of North America, 1790-92.* Edited by Mark D. Kaplanoff. Barre, MA: Imprint Society, 101, 103.

One of the first descriptions of a free-standing totem pole came from American merchant captain Joseph Ingraham (1762-1800). In 1788, Ingraham had served as mate on the first American ship to visit the Northwest Coast, commanded by Captain Kendrick. Three years later, he returned as master of a trading vessel

out of Boston. On 10 July, near the beginning of his two-month stay, Ingraham went ashore at the Haida village of Dadens on Langara Island, the same area visited by Pérez and Crespi. In fact, Dadens was the most frequently visited and described village in the area during the late eighteenth century (G.F. MacDonald 1983a, 195). Ingraham's journal, decorated with his drawings, remained unpublished until 1971. In addition to his general comments describing trading and labrets, his account of totem poles has since become a classic instance in the scholarly literature.

[10 July 1791.] The songs as well as the people resembled those I had seen to the south on my last voyage, except that most of the women had a piece of wood in their under lip which resembles a small shelf when the mouth is shut or may be kept up against the tip of the nose which may occasionally serve to keep the wind out of their mouths. When it falls down, it entirely covers the chin and exposes the teeth of the lower jaw. Upon the whole it seems as strange a fancy as was ever adopted by the human species and, however consonant with their own ideas of beauty, was to me a most shocking sight.

...

After the vessel was fast, I went in the boat accompanied by Cow [Gao, a ranking chief at Cloak Bay] to view two pillars which were situated in the front of a village about a quarter of a mile distant from our vessel on the north shore. They were about forty feet in height, carved in a very curious manner indeed, representing men, toads, etc., the whole of which I thought did great credit to the natural genius of these people. In one of the houses of this village the door was through the mouth of one of the before mentioned images. In another was a large square pit with seats all around it sufficient to contain a great number of people, built in such a manner as not to obstruct each other's sight. It seemed intended for some exhibition, perhaps dancing or boxing.

**4.V. Mary Malloy. 2000.** *Souvenirs of the Fur Trade: Northwest Coast Indian Art and Artifacts Collected by American Fur Traders, 1788-1844.* Cambridge, MA: Peabody Museum Press, Harvard University, 18.

The same house frontal pole was noted by two other explorers at about the same time as Ingraham: Étienne Marchand and John Bartlett. On 18 June 1791, American trader John Bartlett sketched it in his journal, the earliest known drawing of a Haida pole (Jonaitis and Glass 2010, 22), along with this comment:

We went ashore where one of their winter houses stood. The entrance was cut out of a large tree and carved all the way up and down. The door was made like a man's

head and the passage into the house was between his teeth and was built before they knew the use of iron.

## MARCHAND EXPEDITION: C.P. CLARET FLEURIEU, 1791

**4.VI. Charles Pierre Claret Fleurieu. 1801.** *A Voyage round the World, Performed during the Years 1790, 1791, and 1792, by Étienne Marchand, Preceded by a Historical Introduction, and Illustrated by Charts, etc.* Vol. 1. Translated by C.P. Claret Fleurieu. London: T.N. Longman, 344-46, 384-85, 401-5, 417-19.

One of the most interesting of the early accounts of Northwest Coast art was generated by the expedition of French explorer Étienne Marchand (1755-93). Marchand's stated goal of trading in furs on the Northwest Coast was largely unsuccessful, but the published journals were full of informative detail. Because Marchand died soon after his return, the official report of the voyage was written by naval officer and minister Charles Pierre Claret, Comte de Fleurieu (1738-1810), who had accompanied the expedition.[11] Fleurieu's account is notable in the literature of the time for its comparative and philosophical musings.

Marchand's first encounter on the coast came among the Tlingit at Norfolk (Sitka) Sound, which he called Tchinkitanay.

[7 August 1791.] The Tchinkitanayan is industrious, active, laborious and skillful. Different works in wicker plaited with a sort of elegance, cloaks of spun hair, woven in a workman-like manner, intermixed with pieces of otter-skin, and extremely well calculated as a preservative from the cold; the dressing and tanning of skins; various works of sculpture and painting – every thing announces a long employment of the useful arts, and a knowledge of those which are merely agreeable.

The taste of ornament prevails in all the works of their hands; their canoes, their chests, and different little articles of furniture in use among them, are covered with figures which might be taken for a species of hieroglyphics: fishes and other animals, heads of men, and various whimsical designs, are mingled and confounded in order to compose a subject. It, undoubtedly, will not be expected that these figures should be perfectly regular, and the proportions in them exactly observed; for here, every man is a painter and sculptor; yet they are not deficient in a sort of elegance and perfection. But these paintings, these carvings, such as they are, are seen on all their furniture. Is this general taste simply produced and kept alive by the want of occupying the leisure of a long winter, if, however, winter leaves them leisure? Or rather does not its principle arise from the ancient state of their society, which is lost to us in the obscurity of their origin?

...

They do various kinds of sculpture and painting and everything announces a long employment of the useful arts ... Canoes, chests and all other articles are covered with designs of fish, animals and heads of men ... Are these hieroglyphic figures to the Tchinkitanayans a species of writing? It is well known that hieroglyphics were the first writing of several nations: they are the universal written language: this is truly the art of painting the thought, of speaking to the eyes; and every one, at the sight of the object, emits the sounds which it is agreed to employ for speaking to the ear.

On 22 August 1791, Marchand sighted Haida Gwaii, where the French traded for about ten days. At Cloak Bay, the party went ashore at the village of Dadens. Here Fleurieu (1801, 401-3) described their permanent winter houses in fine detail before elaborating on the "entrance-door of these edifices." This, in turn, was the occasion for a discussion of the uses and possible origins of Haida art.

It imitates the form of a gaping human mouth, or rather that of a beast, and it is surmounted by a hooked nose, about two feet in length, proportioned, in point of size, to the monstrous face to which it belongs ... Over the door, is seen the figure of a man carved, in the attitude of a child in the womb, and remarkable for the extreme smallness of the parts which characterize his sex; and above the figure, rises a gigantic statue of a man erect, which terminates the sculpture and the decoration of the portal; the head of this statue is dressed with a cap in the form of a sugar-loaf, the height of which is almost equal to the figure itself. On the parts of the surface which are not occupied by the capital subjects, are interspersed carved figures of frogs or toads, lizards, and other animals, and arms, legs, thighs, and other parts of the human body: a stranger might imagine that he saw the *ex voto* suspended to the door-case of the niche of the *Madona*.

On comparing these pieces of sculpture to those large pictures which had been seen the day before in a place which appears consecrated to a Supreme Being, we should be tempted to believe that these various figures are emblems which are connected with the religion of this people. But how inquire into the matter when the voyager is ignorant of the language of the country? All that Captain Chanal and his party could comprehend from the answers which the chief of the district who accompanied them, was pleased to give to questions that they had endeavoured to make them understand, is that the erect figure, placed above each portal, and to which every thing that is below appears to serve as a pedestal, is the image of a chief who was held [in] veneration in the country. It is recalling the arts to their real institution, to appropriate them to honour virtue, and to perpetuate the memory of men who have deserved well of their fellow-creatures.

These works of sculpture cannot undoubtedly be compared, in any respect, to the master-pieces of which ancient Rome stripped Greece, and of which Italy, in her turn, has been stripped by France; but can we avoid being astonished to find them so numerous on an island which is not perhaps more than six leagues in circumference, whose population is not extensive, and among a nation of hunters? And is not our astonishment increased, when we consider the progress this people have made in architecture? What instinct, or rather what genius it has required to conceive and execute solidly, without the knowledge of the succours by which mechanism makes up for the weakness of the improved man those edifices, those heavy frames of buildings of fifty feet in extent by eleven in elevation? Men who choose not to be astonished at any thing will say: The beaver also builds his house: yes, but he does not adorn it, but nature has given to the beaver the instrument necessary for building it: she has certainly placed the man of the forests in the middle of the material with which he constructs his; but he has been under the necessity of creating, of varying the tools without which he could not employ those materials! A sharp stone, hafted on a branch of a tree, the bone of a quadruped, the bone of one fish, the rough skin of another; instruments more fit to exercise patience then to help industry, and which would have been ineffectual in seconding his efforts, if fire which he discovered, and the action of which he learnt to regulate and direct, had not come to the assistance of genius of which he is the image, and of art which executes through the impulse of genius. When we examine the whole of the operations necessary for contriving to finish one of the edifices which I have just described; when we reflect on this assemblage of useful arts and of those which are merely agreeable, we are forced to acknowledge that these arts have not taken birth in the small island where they are cultivated: they come from a greater distance.

Comparing the Haida winter and summer houses to those of the Kamchatkans, Fleurieu (1801, 405-6) speculated that the Natives of the region had travelled from Asia to Mexico and then back to the Northwest Coast. An encounter with a large painted panel stimulated his wonder.

The habitations are, in general, painted and decorated in various ways; but what was particularly remarkable in that which the French visited, was a picture somewhat like those which they had seen in the sort of redoubt erected in the small island of the Strait, which occupied the head of the apartment, as is seen suspended in the drawing rooms in Spain, over the *Estrada*, the picture of the immaculate conception. Surgeon Roblet has described this production of the fine arts of the North-West Coast of America. "Among a great number of figures very much varied, and which at first

appeared to me," says he, "to resemble nothing, I distinguished in the middle a human figure which its extraordinary proportions, still more than its size, render monstrous. Its thighs extended horizontally, after the manner of tailors seated, are slim, long, out of all proportion and form a carpenter's square with the legs which are equally ill-made; the arms extended in the form of a cross, and terminated by fingers slender and bent. The face is twelve (French) inches, from the extremity of the chin to the top of the forehead, and eighteen inches from one ear to the other; it is surmounted by a sort of cap. Dark red," adds he, "apple green and black are here blended with the natural colour of the wood, and distributed in symmetrical spots, with sufficient intelligence to afford at a distance an agreeable object."

From the description which Surgeon Roblet gives us of this picture, it might be imagined that it resembles those shapeless essays of an intelligent child, who undertakes, without principles, to draw the objects which present themselves to his sight; I remark, however, that the voyagers who have frequented the different parts of the North-West Coast, often saw there works of painting and sculpture in which the proportions were tolerably well observed, and the execution of which bespoke a taste and perfection which we do not expect to find in countries where the men seem still to have the appearance of savages. But what must astonish most ... is to see paintings every where, every where sculpture, among a nation of hunters.

### JACINTO CAAMAÑO: 1792

**4.VII. Henry R. Wagner and William A. Newcombe, eds. 1938. "The Journal of Jacinto Caamaño."** Translated by Harold Grenfell. *British Columbia Historical Quarterly* 2, 4: 288-92.

Jacinto Caamaño Moraleja (1759-1825?), one of the last of the Spanish explorers on the Northwest Coast, was sent to survey the shores of southeastern Alaska. In 1792, he visited Haida Gwaii and the adjacent mainland down to northern Vancouver Island, producing the first extended description of the Tsimshian and Haisla peoples.

On 28 August 1792, Caamaño visited the southern Tsimshian village of Citeyats (Ksidiya'ats), on Pitt Island.[12] His lengthy and wonderfully detailed account included a long description of a chief's ceremonial dance (cf. Gunther 1972, 106-9). It was perhaps the first extended description of a Northwest Coast masked dance. Caamaño described the chief's frontlet headdress, movable masks, and puppets as well as painted house fronts (but no free-standing totem poles).

Jammisit [the local chief] came to visit me in the afternoon, accompanied by upwards of forty of his relatives, all singing and bringing feathers. He, together with his nearest relations, arrived in one of two canoes lashed alongside each other. Jammisit's

head appeared from behind a screen formed of brilliantly white deerskin; on it, accordingly as the action demanded or his own particular fancy dictated, he would place various masks or heads of the different animals that he proposed to imitate; the deerskin serving as a curtain by which he was entirely hidden when he wished, unseen to put on or change one of these masks or faces. They remained alongside thus for some time, singing and continuing their antics, until Jammisit with great eagerness explained that he was come to conduct me to his village. Curiosity to see it, as well as the fete for which such extensive preparations were being made, induced me to comply with his entreaties ... [Caamaño was carried to the village in a deerskin litter.]

The moment that I placed myself on the deerskin, these six fellows hoisted my 150 lb. carcass on to their shoulders and carried me at a run across the shingle and up the pretty steep slope leading from it to the village, whither they brought me at a surprising speed. To pass through the narrow doorway of the chief's house, over which was painted a huge mask, it was necessary to make a litter or hammock of the deerskin ... [Caamaño was carried into the house.] Once inside, I tried to get on my feet, but this they would not allow before bringing me to the place prepared for my seat, which was to the right of the entrance. The seat was formed of a case or chest, raised higher than those for the others, fitted for only one person, and covered with a new mat; while a similar one was spread before it. The seats for my officers, ranged on either hand of mine, were made in similar manner; those for my men, were formed of mats spread out on the floor ... Jammisit began to emit piercing howls in a pitiful key; after which, throwing back his head as if about to faint, he sat down, clutching at the collar laces of his cloak, as if wishing to throw it off. Several of his family nearby, who were watching to give him any help that might be necessary, when they noticed this, gathered around him forming a screen so that he might not be seen changing his garments in which some of the others were assisting him.

So soon as he had put on the ones in which he was to show himself, they would break up and sit down out of his way, leaving only a couple of his nearest relations standing by ready to help him as he might require. When he was ready, these also left him, and the actor arose.

On his head was a large well-imitated representation of a seagull's head, made of wood and coloured blue and pink, with eyes fashioned out of polished tin; while from behind his back stuck out a wooden frame covered in blue cloth, and decked out with quantities of eagles' feathers and bits of whale bone, to complete the representation of the bird. His cloak was now of white calico, bearing a blue flowered pattern, trimmed with a brown edging. Round his waist hung a deerskin apron falling to below the knee, whose fringe or flounce was made from narrow strips of the same leather, everyone being split into two tails, each of which carried half the hoof of a deer. Over this apron or kilt he wore another, shorter, one, of blue jean ornamented with numerous

metal buttons arranged symmetrically, and two rows of antelope hide pendants or tassels, each finished off with an eagle's claw. On his legs were deer skin leggings, tied behind with four laces, ornamented with painted masks and trimmed with strips of hide carrying claws. Clad in this weird rattling rig, he then began to leap and cut capers, reminding one of a rope-dancer trying his rope ... As he finished and sat down, those attending him took off his mantle, and wiped the sweat from his face and body, while others held up a hide to screen his following change of attire from the general view. During this interval, which proved a short one, two tubs or small troughs were brought in, filled with freshly boiled fish for our refreshment though few of us tried it.

The old chief having recovered from his exhaustion due more to his age than the exercise, and being now dressed in the costume for this next performance, the curtain was drawn, and he appeared with a half-length wooden doll on his head.

Two Indians at some distance behind him, who endeavoured to conceal their actions, then proceeded – by means of long fishing rods – to open and close the eyes of the doll, and raise its hands, in time to another tune that was struck up, while the dancer himself imitated the movements of the doll's face, which was sufficiently frightful in appearance, being coloured black and red, and furnished with an owl's beak and nostrils. For this scene, he wore a bear skin cloak, with the remainder of his costume as before. So soon as the music ceased, his attendants again hid him from sight. Before long, however, he again appeared, this time wearing a heavy wooden mask on his head, of which the snout, or upper jaw, was moveable. He also carried a blue cloth mantle, such as distinguishes the chiefs, and the timbrel (or "jingles") that my men had noticed when they were captured ... [The chief danced until he fainted but was revived.] These attentions soon revived him, though groaning heavily. He was then led to his seat, his mask and mantle taken off, and the latter exchanged for the one he had earlier worn.

### BODEGA Y QUADRA EXPEDITION: JOSÉ MARIANO MOZIÑO, 1792

**4.VIII.  José Mariano Moziño. 1970.** *Noticias de Nutka: An Account of Nootka Sound in 1792.*
Translated and edited by Iris Higbie Wilson. Monographs of the American Ethnological Society 50. Seattle: University of Washington Press, 18-19, 39, 44, 49-50, 15.

One of the most interesting and certainly lengthier reports of an early explorer was the journal written by José Mariano Moziño (1757-1820?), a Mexican-born botanist on the expedition of Juan de la Bodega y Quadra (1743-94).[13] Bodega y Quadra had been sent to help settle the dispute between Spain and Britain over the "ownership" of Nootka Sound and adjacent territory. He met with George Vancouver in 1792, but the issue was not finally settled until three years later. Moziño was able to spend five months (29 April-21 September) among the

Nuu-chah-nulth at Nootka Sound. Because of his scientific interests and his par-
tial knowledge of the language, his report is one of the most complete ethnog-
raphies prior to the great age of systematic collection. Among its interests are his
aesthetic comments and his correction of Cook (see Figure 22.3).

[Houses and furnishings.] The intermediate beam is supported by some thick,
cylindrical columns of the same pine [cedar], on which are sculptured human faces
deformed by the size and grotesqueness of their features. These are given the name
of *Tlama*. The first travelers assumed that these figures were objects of superstitious
worship, and I also suspected the same until informed otherwise by the Indians them-
selves. I learned that they were nothing more than a simple decoration, and if by
chance a figure had some significance, it was purely that given to it by the man whose
labor had brought the [sculptured] tree to the place in which it was found.

Around the inside of the house are placed, some on top of others, a multitude of
boxes of various sizes and commonly of one piece. Their lids consist of a plank that
runs along two open grooves on the upper and inside parts. When the boxes are
composed of various pieces, they are very firmly fitted together, and each piece is
interlocked with the others in the same manner as those of our carpenters. The exter-
ior is often decorated with molding inlaid with the teeth of different animals. Here
they keep their capes, their masks, and, in general, all the belongings they consider
worthwhile ...

In the best place in the house is found an oblong box a little more than two yards
in length and half that in width. On the inside is painted a monstrous figure with a
human face, but extremely ugly, with very long arms, claws like an eagle's, and feet
like those of a bear. It is used for religious purposes to which I will refer later.

...

At other times the *tais* [chief] says his prayers inside his own house in order to ward
off, by these means, the storms which impede the *meschimes* [commoners] from going
out to fish and to their other work. Enclosing himself in the large box or niche of
which I spoke before, he hits the boards of first one side and then the other very
forcefully with his hands and shouts his prayers at the top of his lungs.

...

[Carpentry.] The small number of men, and the simplicity of the life they lead, does
not provide opportunity for many artisans or even for a variety of occupations. Those
of the men are carpentry, fishing, and hunting; those of the women are spinning and
weaving. They learn everything appropriate to their sex. Carpenters use only fire,
shells, and flints as tools. In order to uproot a tree, they set it on fire at the base. Then
they pull off the bark, and if they want to make boards they insert wedges in sections
parallel to its axis using the same technique as that of the Mexicans in fashioning the

narrow little boards which they call *tlajamanil* [strips of wood used as shingles for roofs in rural areas of Mexico]. A beam has the entire thickness of the pine tree without the bark, and it requires no more work than uprooting it, cleaning it of the bark, and placing it on the site where it is needed. The construction of their boxes and canoes is work that demonstrates their great patience. [The canoes] are usually of a single piece and in order to hollow out the tree from which they make them they apply fire gently on one side, scraping out the charred parts with their shell knives and thus wearing away the cavity until it has the dimensions they want to give it. When this has been accomplished they turn the tree over to its opposite side and in the same manner cut and shape it to form the keel. The drawing [not found] represents better than I can explain it the graceful lines they have.

...

[Weaving and other crafts.] The sedentary arts consist solely of spinning and weaving, and constitute the daily occupation of the women. In spinning, they have no equipment other than their muscles and fingers to unite the fibers of cedar [bark], wool, and otter hair. With these they first form a thick strand, which they afterward narrow and lengthen, winding it onto a small bar about one foot long which they turn above a small plank with the same dexterity and agility our Indian women use in their *malacates* [in Mexico a spindle whorl; here a kind of spindle or bobbin].

The looms for weaving textiles are very simple. They hang the warp from a horizontal cane at a height of four and one-half feet from the ground, and with only their fingers, moving with swiftness, flexibility, and extraordinary deftness, they make up for all the tools that would make this work less cumbersome. They have patterns for making hats and capes; they begin both of them with a closely woven center, and weave the ends of the threads around the edges. For sleeping mats they use no more equipment than do our Indians of Xochimilco. The mats are too coarse, either because the cattails do not lend themselves to finer work, or perhaps because they do not take much trouble in weaving them. Cured leather of all kinds is very good; the skins remain entirely soft and can be folded as easily as those of the most skillful tanners.

They work very little with metals. They cut copper into narrow strips, bend back the edges, and curve them to form bracelets and so forth; or without bending them they make the small cylinders which they hang from their ears and the ends of their hair. They lack whetstones upon which to sharpen their iron instruments, and thus are content to make a point by the force of their blows. They drill perfectly well the small snailshells and the blunted tips of Venus [dentalium] shells, of which they make the same use our ladies do of pearls. Their writing and painting are very crude. Not only are these arts not in their infancy among them; to speak with exactness, they do not exist even in embryo.

...

[Hats.] To protect themselves from the sun, they wear hats or caps of badger or raccoon skin. But more common are two kinds of hats woven over appropriate molds from tule or very flexible cattails joined with narrow strips taken from the ribs of a feather. This forms a white background on which the designs with which they are decorated stand out. These are always representations of the equipment used in fishing for whales. The shape of the hat is like a truncated cone, more or less elevated, upon which the nobles superimpose another small one that terminates in a sharp point. Those of the commoners are of a coarser material and have no designs; both affix their hats with chin stays or straps of any kind of cord.

### VANCOUVER EXPEDITION: GEORGE VANCOUVER AND ARCHIBALD MENZIES, 1792

**4.IX.  Charles F. Newcombe, ed. 1923. *Menzies' Journal of Vancouver's Voyage, April to October 1792.*** Archives of British Columbia, Memoir no. 5. Victoria, BC: Archives of British Columbia, 87.

During his extensive voyages around the island that would eventually take his name, the English naval officer George Vancouver (1757-98) became the first European to encounter the Kwakwaka'wakw. Vancouver, who had sailed with Cook on his third voyage, spent three seasons on the Northwest Coast, 1792-94. Before his death soon after his return, he had almost completed a lengthy report of his explorations; it can be supplemented with the journal kept by the expedition's surgeon and naturalist, Scotsman Archibald Menzies (1754-1842).

Proceeding up Johnstone Strait, Vancouver's ship came to Whulk (Xwalkw), a Kwakwaka'wakw village at the mouth of the Nimpkish River. According to Menzies, the chief of this village was Cathlagees, while Vancouver gave his name as Cheslakees. Both men had difficulty understanding that the Kwakiutl were different from the Nootka. To some extent, however, the confusion was understandable, as the Nimpkish River was the traditional Kwakwaka'wakw trade route to the Nuu-chah-nulth, a related Wakashan people.

[20 July 1792.] In the afternoon I went with Cap^t Vancouver & some of the Officers accompanied by the Chief to the Village called *Whannoc*, we found it pleasantly situated, exposed to a Southern Aspect on the sloping bank of a small creek well sheltered behind by a dense forest of tall Pines. The houses were regularly arranged & from the Creek made a picturesque appearance by the various rude paintings with which their fronts were adorned. On our approach to the landing place in the two Boats, several of the Natives assembled on the Beach to receive us, & conducted us very orderly through every part of the Village, where we observed that the Houses were built much in the same manner as at Nootka, but much neater, & the Inhabitants being of the same Nation differed very little either in their manners or dress from

the Nootka Tribe. Several families lived in common under the same roof, but each had their sleeping place divided off & screened in with great deceny, & with a degree of privacy not attended to in the Nootka habitations. The Women were variously employd, some in culinary occupations, others were engaged in Manufacturing of Garments Mats & small Baskets & they did not fail to dun us for presents in every House we came to in a manner which convincd us that they were not unaccustomd to such Visitants. Buttons Beads & other Trinkets were distributed amongst them, & so eagerly solicitous were they for these little articles of ornament that our pockets were soon emptied of them, & tho they were free & unreserved in their manners & conversation, yet none of them would suffer any of our people to offer them any indecent familiarities, which is a modesty in some measure characteristic of their Tribe.

**4.X. George Vancouver. 1798.** *A Voyage of Discovery to the North Pacific and round the World ... Performed 1790-1795, with the "Discovery" and the "Chatham" under Cpt. George Vancouver.* 3 vols. London: Printed for G.G. and J. Robinson and J. Edwards, 1: 346-47.

Captain Vancouver himself also commented on these paintings in an interesting example of variant yet related reports.

Accompanied by some of the officers, Mr. Menzies, and our new guest *Cheslakees*, I repaired to the village ... The houses, in number thirty-four, were arranged in regular streets; the larger ones were the habitations of the principal people, who had them decorated with paintings & other ornaments, forming various figures, apparently the rude designs of fancy; though it is by no means improbable, they might annex some meaning to the figures they described, too remote, or hieroglyphical, for our comprehension. The house of our leader *Cheslakees* was distinguished by three rafters of stout timbers raised above the roof, according to the architecture of Nootka, though much inferior to those I had there seen in point of size; the whole, from the opposite side of the creek, presented a very picturesque appearance.

The houses were constructed after the manner of Nootka, but appeared rather less filthy, and the inhabitants were undoubtedly of the same nation, differing little in their dress, or general deportment. Several families lived under the same roof; but their sleeping apartments were separated, and more decency seemed to be observed in their domestic economy, than I recollected to be the practice at Nootka. The women, who in proportion appeared numerous, were variously employed; some in their different household affairs, others in the manufacture of their garments from bark and other materials; though no one was engaged in making their woolen apparel, which I much regretted. The fabrication of mats for a variety of purposes and a kind of basket, wrought so curiously close, as to contain water like an earthen vessel without the least

leakage or drip, comprehended the general employment of the women, who were not less industrious than ingenious.

### JOHN JEWITT: 1803-5

**4.XI.  Hilary Stewart, ed. 1987. *The Adventures and Sufferings of John R. Jewitt: Captive of Maquinna.*** Seattle: University of Washington Press; Vancouver: Douglas and McIntyre, 84-85. Reprinted with the permission of Douglas and McIntyre, an imprint of D&M Publishers Inc.

One of the most dramatic of the early descriptions of Northwest Coast peoples was that of a young American sailor, John Rodgers Jewitt (1783-1821). Jewitt had been the blacksmith on the trading ship *Boston,* attacked in 1803 by the Nuu-chah-nulth at Nootka Sound. Along with a companion, Jewitt was captured and detained for two years and four months before he was rescued by a passing ship. His brief journal, published in 1807, was expanded by ghostwriter Richard Alsop into *A Narrative of the Adventures and Sufferings of John R. Jewitt.* Since its publication in 1815, it has remained the principal Northwest Coast contribution to the extensive literary genre of Indian captivity narratives.

Jewitt's account was generally similar to Moziño's, though perhaps a little more detailed. Jewitt agreed with Moziño that the carved house posts were considered ornamental, not religious, contra Captain Cook. Jewitt's *Narrative* contained a long description of material culture (Stewart 1987, 68-96). This excerpt, on face painting, is a good indication of the aesthetic sense and customs of the Nuu-chah-nulth. Face and body painting, which could not be collected, was poorly documented in early drawings, most of which were in black and white.

Though the women, as I have said, make but little use of paint, the very reverse is the case with the men. In decorating their heads and faces they place their principal pride, and none of our most fashionable beaus, when preparing for a grand ball can be more particular: For I have known Maquina [the local chief] after having been employed for more than a hour in painting his face, rub the whole off and recommence the operation anew when it did not entirely please him. The manner in which they paint themselves frequently varies, according to the occasion, but it oftener is the mere dictate of whim. – The most usual method is to paint the eye-brows black, in form of a half moon, and the face red in small squares, with the arms and legs and part of the body red; sometimes one half of the face is painted red in squares, and the other black; at others, dotted with red spots, or red and black instead of squares, with a variety of other devices, such as painting one half of the head and body red, and the other black. But a method of painting which they sometimes employed, and which they were much more particular in, was by laying on the face a quantity of bear's

grease of about one eighth of an inch thick; this they raised up into ridges resembling a small bead in joiner's work, with a stick prepared for the purpose, and then painted them red, which gave the face a very singular appearance. On extraordinary occasions, the king and principal chiefs used to strew over their faces, after painting, a fine black shining powder, procured from some mineral, as Maquina told me it was got from the rocks. This they call *pelpelth* [black mica], and value it highly, as, in their opinion, it serves to set off their looks to great advantage, glittering, especially in the sun, like silver. – This article is brought them in bags by the *Newchemass* [probably the 'Namgis Kwakwaka'wakw], a very savage nation who live a long way to the North, from whom they likewise receive a superior kind of red paint, a species of very fine and rich ochre, which they hold in much estimation.

Notwithstanding this custom of painting themselves, they make it an invariable practice, both in summer and winter, to bathe once a day, and sometimes oftener; but as the paint is put on with oil, it is not much discomposed thereby, and whenever they wish to wash it off, they repair to some piece of fresh water and scour themselves with sand or rushes.

In dressing their heads on occasion of a festival or visit, they are full as particular, and almost as long, as in painting. The hair, after being well oiled, is carefully gathered upon the top of the head and secured by a piece of pine or spruce bough with the green leaves upon it. After having it properly fixed in this manner, the king and principal chiefs used to strew all over it the white down obtained from a species of large brown eagle, which abounds on this coast, which they are very particular in arranging so as not to have a single feather out of place, occasionally wetting the hair to make it adhere. This, together with the bough, which is sometimes of considerable size, and stuck over the feathers by means of turpentine [probably a resinous glue from a spruce tree], gives them a very singular and grotesque appearance, which they, however, think very becoming, and the first thing they do on learning the arrival of strangers is to go and decorate themselves in this manner.

## MERIWETHER LEWIS AND WILLIAM CLARK: 1805-6

**4.XII. Gary E. Moulton, ed. 1990. *The Journals of the Lewis and Clark Expedition*. Vol. 6, *November 2, 1805–March 22, 1806*.** Lincoln: University of Nebraska Press, 215-16, 246, 335-36.

In the late fall of 1805, the American army officers Meriwether Lewis (1774-1809) and William Clark (1770-1838) finally completed their long trip across the continent. Their so-called Corps of Discovery had been charged by President Thomas Jefferson to survey the newly acquired territories west of the Mississippi. During their winter at Fort Clatsop, at the mouth of the Columbia River, they were able

to make important observations of the local Lower Chinook.[14] Among their better ethnographic comments in the region were observations of canoes, house construction, and clothing (Moulton 1990, 262-72, 318, 432-36). They also recorded this nice description of baskets, bowls, and other culinary items.

[Lewis. 17 January 1806.] The Culinary articles of the Indians in our neighbourhood consist of wooden bowls or throughs, baskets, wooden spoons and woden scures or spits. Their wooden bowls and troughs are of different forms and sizes, and most generally dug out of a solid piece; they are ither round or simi globular, in the form of a canoe, cubic, and cubic at top terminating in a globe at bottom; these are extreemly well executed and many of them neatly carved the larger vessels with handholes to them; in these vessels they boil their fish or flesh by means of hot stones which they immerce in the water with the article to be boiled. they also render the oil of fish or other anamals in the same manner. their basekets are formed of cedar bark and beargrass so closely interwoven with the fingers that they are watertight without the aid of gum or rosin; some of these are highly ornamented with strans of beargrass which they dye of several colours and interweave in a great variety of figures; this serves them the double perpose of holding their water or wearing on their heads; and are of different capacites from that of the smallest cup to five or six gallons; they are generally of a conic form or reather the segment of a cone of which the smaller end forms the base or bottom of the basket. these they make very expediciously and dispose off for a mear triffle. it is for the construction of these baskets that the beargrass becomes an article of traffic among the natives. this grass grows only on their high mountains near the snowey region; the blade is about 3/8 of an inch wide and 2 feet long smoth pliant and strong; the young blades which are white from not being exposed to the sun or air, are those most commony employed, particularly in their neatest work. Their spoons are not remarkbable nor abundant, they are generally large and the bole brawd [a passage on the method of cooking fish and meat with skewers] ... a small mat of rushes or flags is the usual plate or dish on which their fish, flesh, roots or burries are served. they make a number of bags and baskets not watertight of cedar bark, silk-grass [probably dogbane or Indian hemp], rushes, flags and common coarse sedge. in these they secure their dryed fish, rooots, buries, &c. − .

Perhaps the most distinctive item encountered by Lewis and Clark on the coast was the onion-domed whalers' hats. Traded from Nuu-chah-nulth peoples in the north, they were described by Moziño and depicted in many Spanish drawings made in Nootka Cove (McLaughlin 2003, 93-103). From their description, it is not clear if Lewis and Clark understood this northern source.

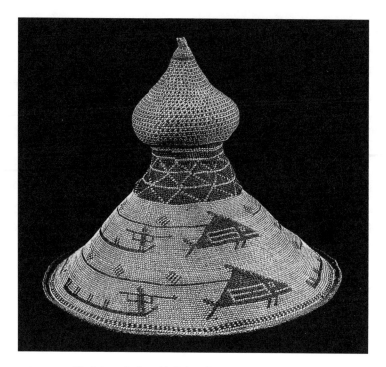

**FIGURE 4.2** Knob-top whaling chief's hat. Spruce root, cedar bark, surf grass, and unidentified hide, 27 x 22.5 cm. Lewis and Clark collected this Makah or Nuu-chah-nulth hat from the Lower Chinook in the Clatsop region of Oregon between November 1805 and March 1806. Peabody Museum of Archaeology and Ethnology, Harvard University, acc. no. 99-12-10/53079.

[Clark. 29 January 1806.] Maney of the nativs of the Columbia were hats & most commonly of a conic figure without a brim confined on the head by means of a String which passes under the chin and is attached to the two opposit Sides of a Secondary rim within the hat – ; the hat at top termonates in a pointed knob of a conic form ... these hats are made of the bark of Cedar and beargrass wrought with the fingers So closely that it Casts the rain most effectually in the Shape which they give them for their own use or that just discribed, on these hats they work various figures of different colours, but most commonly only black and white are employed. these figures are faint representations of the whales, the Canoes, and the harpooners Strikeing them. Sometimes Square diamonds triangle &c (cf. Lewis's version, 30 January, p. 249).

...

[Lewis. 22 February 1806.] We were visited today by two Clatsop women and two boys who brought a parsel of excellent hats made of Cedar bark and ornamented with beargrass. two of these hats had been made by measures which Capt Clark and myself had given one of the women some time since with a request to make each of us a hat; they fit us very well, and are in the form we desired them. we purchased all their hats

and distributed them among the party. the woodwork and sculpture of these people as well as these hats and their waterproof baskets evince an ingenuity by no means common among the Aborigines of America.

## WILLIAM F. TOLMIE: 1834

**4.XIII. William Fraser Tolmie. 1963.** *The Journals of William Fraser Tolmie, Physician and Fur Trader.* Vancouver: Mitchell Press, 294-95, 297.

As the nineteenth century wore on, the land-based fur-trading stations began to attract permanent settlers. One of the earliest and most important in British Columbia was William Fraser Tolmie (1812-86). This Scottish-born physician and trader was noted for his reports on the local First Nations and his related artifact collections. Arriving in Oregon country in 1833, Tolmie first served at the Hudson's Bay Company posts at Fort Vancouver, Fort Nisqually, and Fort McLoughlin. In 1859, he settled permanently in (Fort) Victoria. In his later years, Tolmie occupied himself with ethnology, botany, farming, and politics. In 1884, George M. Dawson published his Indian vocabularies.

During his time at Fort McLoughlin, British Columbia (1833-36), Tolmie attended a potlatch at a village, "situated at the head of Kyeet's Cove," in Milbanke Sound.[15] Fort McLoughlin (Bella Bella) had been established on Milbanke Sound by the HBC only the year before. With the notable exception of Caamaño, such extensive details of masked performance are rare in earlier explorer accounts. This excerpt from Tolmie's journal focuses on the setting and initial preparations for the dance.

[27 November 1834.] Led by [Chief Qunnalashoot] to the Conjuring House, a large building cleared of inhabitants for the occasion. On each side was a rude seat extending the length of the building, elevated about 4 feet above the ground & capable of accommodating three rows of sitters. It was composed of broad cedar boards, supported by round poles driven into the ground. Supported also by these posts were broad boards placed on edge & reaching from the floor to the horizontal boards forming seats, between those at intervals were small doorways which led I fancy to the dormitories of the inmates. A wall of painted boards reaching from the floor to the level of eaves extending from side to side & having a small door way in centre, formed a screen behind which the actors & artists prepared for the evening's entertainment. Was introduced into this Sanctum Sanctorum by Q. as a mark of distinction none but chiefs being so honored. The apartment was narrow but extended the breadth of the house – it was filled up on one side with oil boxes & on the other by boards & an immense chest of foreign manufacture containing masks. In the centre of room

glimmered a small fire & on the back wall of house there was a doorway communicating externally. Seated around the fire with brush & pallet were several artists giving the finishing stroke to the masks – others were daubing their faces with paint, which they applied by means of a small leathern bag everted. Others again were in the hands of Peruquiers whose office it was to adorn the well greased hair of their customers with down – these functionaries take a quantity of down between the thumb & fingers & holding it close to the head, blow vigorously – what does not adhere to the greasy hair, is in respiring drawn into the mouth of the blower, to the imminent danger of his choking. While the inmates of the Green Room were thus employed in the outer apartment, a large fire had been kindled around which the savages were singing & dancing. All the masks were representations of the "human face divine" except one which resembled that of the Falco Leucocephalus [bald eagle] & beset with the tail feathers of that bird radiating from its edge all around – it was called Tech te cheinny & seemed to be held in great reverence – they said chiefs alone were permitted to inspect it and that a common man beholding it dies, or is killed – by pulling a string which the wearer can do with his mouth, two pieces of shining brass are made to pass from within over the eye, like the film of a bird's eye – a rude wooden horn was occasionally blown & was believed without to be the voice of the Tech-te-cheinny. Common masks called Nawilock ["supernatural treasure"], other articles of dress displayed were blankets made from the wool of the Mountain Goat of a pretty pattern – colours black and yellow – a leathern kilt called Youchstiga, hung round with three rows of thimbles said to have been received from Vancouver by [chief] Kyeet. Leathern leggings reaching from below knee to ancle [sic] adorned with porcupine quills.

…

Wowialla's one of the largest houses measured 45 feet in length & 54 in breadth – all the houses had a seat or bench on each side, similar to that in theatre, & on these were piled chests, hampers, & other baggage. The number present at the Masquerade I suppose to be 300 or 350.

**IVAN VENIAMINOV: 1834-38**

**4.XIV. Ivan Veniaminov. 1984. "Notes on the Koloshi." Originally written in 1840.** In *Notes on the Islands of the Unalashka District*. Edited, with an introduction, by Richard A. Pierce; translated by Lydia T. Black and R.H. Geoghegan. Alaska History no. 27. Fairbanks: Elmer E. Rasmuson Library Translation Program, University of Alaska; Kingston, ON: Limestone Press, 383-85, 422-23, 400, 404, 406-7. Courtesy of University of Alaska Press.

Among the most important descriptions of the Tlingit produced during the Russian-American period were those published by Ivan Veniaminov, later St.

Innocent (1797-1879). A Russian Orthodox missionary, Veniaminov served in Alaska for thirty-seven years. After ten years working in the Aleutians, he was transferred in 1834 to the town of Novo-Arkhangel'sk (Sitka). His 1840 study, very comprehensive and detailed, was devoted mostly to the Aleut, but at the end was a section on the Tlingit: "Notes on the Koloshi."

Veniaminov's comments were based on four years of intensive study among the Tlingit around Sitka. Particularly when compared to observations by maritime fur traders, Veniaminov's account was relatively meagre in its portrait of Tlingit appearances and material culture, but it excelled in its description of their religion and social customs. His long residence, his knowledge of the language, and his professional interest combined to make his account of Tlingit religious art decades ahead of its time. Among the highlights are descriptions of the clan and crest system, potlatch ceremonies, and shamanism and shamanic art.[16]

[Moieties and clans.] The Koloshi divide themselves, and all inhabitants of the mainland from Yakutat even down to New Albion [California], into two main clans [or moieties]. One of these is called the Raven or El [Tlingit, *Yéil*] moiety, the other Kuch [*Gooch*] of Kanúk [*Ganook*] moiety ... [17]

Presently, the raven is called by the first of these names, while wolf is called by the second. But under the name Yeil, or the raven, is understood not the bird raven but a person who bore such a name. The Koloshi of the wolf moiety acknowledge as their first ancestor not the beast wolf, but also a person, someone named Kanuk ...

The Koloshi of either moiety when speaking about members of the opposite moiety, but not face-to-face, refer to them by the term kunétkanagí, which means "not one of ours" or "stranger" [translated in modern Tlingit as "of the other, opposite moiety"] ...

Each of the two moieties is divided into several clans called by a name which is the name of some animal, bird, fish or other fauna. The Koloshi of the wolf moiety, or better said of the Kanuk one, have six principal clan names, as follows: wolf, bear, eagle, killer whale, shark, and murrelet ...  The Koloshi of the raven or Yeil moiety have the following principal clan names: raven, frog, goose, sea lion, owl, and coho (or silver salmon); they have other names as well ...

Every clan of each moiety is further subdivided into several families or lesser clans [or lineages] which are named according to barabora [dwelling, or house groups] or to the settlement ...  There are extraordinarily many such local names ...

All clans of each moiety have their own clan insignia which during great festivals or celebrations called qkhatash [*x'ádaa sheeyí*] are placed either outside, in front of the dwelling or inside, in the front corner; or occasionally, the person in charge of the celebration wears a special clan outfit.

These insignia or crests represent the animal by which the clan is known; they are made either of wood or of the skin of the very same animal they represent; they do not change and may not pass from one clan to another. Thus, for example, the Kukhontan [*Kaagwantaán*] have as their crest the images of the wolf and the eagle; the Tekuiaty and Nangag [*Teikweidí* and *Naanyaa.aayí*], the bear; Taklkiuati and Kashkikitan [*Dakl'aweidí* and *Kayashkahittaan*] – the killer whale; Nushkittan and Ittletan [*Woshkeetaan* and *Hittleintaan*] – the eagle and murrelet; and the Tutsittan [*Toos'hit tuan*] have the shark crest.

According to these crests, a Kolosha [a Tlingit] often refers to his clan by the name of the animal they represent, as, for instance, the killer whale clan, the bear clan, eagle clan, and so on.

Veniaminov discussed the three principal Tlingit festivals: the wake or memorial feast, the major potlatch, and the ceremony "for the sake of the children." The second, Qkhatashi (*x'ádaa sheeyí*, "to raise the dead"), was a common occasion for the erection of grave markers.

[Festivals.] The barabora [dwelling] where the festival is to be given is cleaned as much as possible. Occasionally, a new one is built. Outside over the door and also inside at the front, the clan crest that is the image of the animal after which the clan is named, is represented. For example, the Kukhontany [*Kaagwantaán*] picture the wolf or the eagle; the Tekuiati [*Teikweidí*] – the bear, and so on ...

On the last evening, when the guests finish their dancing and singing, the main sponsor of the festival retires to his own corner, and there puts on the sacral costume of his clan which may be worn only on such an occasion, never otherwise. If the owner of such costume or his heirs do not have the means to stage the festival, such costumes may rot away without ever being used. On the other hand, the Sitkha Koloshi have the occasion to don such costumes when they attend the dances held aboard the ships arriving from Russia.

The sacral costume may be of various kinds. Among the Koloshi of the Kukhontan clan this costume consists of a wolf skin, complete, with tail, paws and head, with teeth made of wood or even of copper. The Frog clan makes a large wooden hat, on which is the image of a frog, very large one, and a cape also with an image of the frog, which is decorated with various ornaments, such as thongs, ermine [Veniaminov's note: Among some, ornaments include large quantities of human teeth as trophies], and so on.

...

[Shamans and Shamanism.] To be a Shaman means to have under one's own control several spirits (the Yeik), to call them and know how to make proper contortions

when summoning them. To discern the unknown, to avert misfortune and calamities through the Yeik, is the goal of Shamanism. The healing of sicknesses, however, is not always the business of a Shaman.

Almost always, Shamanism is hereditary. Shamanism is inherited together with all the appurtenances, or as my interpreter says, the instruments of Shamanism, i.e., masks, drums, thongs, etc., by the Shaman's son or grandson. Consequently, not everyone who desires to be a Shaman and even not every one among the Shaman's heirs can become one of the latter, only those who receive the Yeik or are able to see them can do so.

...

[A Shaman at Chilkat] is famous because he has in his possession, as is attested by eyewitnesses (among whom is also my interpreter) a mask representing a Takiyeik [*dáagi yéigi*], a land spirit whose one side, the left one, turned to stone, while the other, to this day, remains soft. The masks are ordinarily made from red alder. This marvelous occurrence, the petrification of a mask ... happened relatively recently, and not only with the mask alone: the staff which is used during shamanistic séances and allegedly even part of the ermine skin which is usually attached to such staff, also became stone.

All those who have seen this wondrous mask assert that, indeed, it has one half of wood, soft, and the other half completely of stone. At least, one cannot cut it with a knife and it breaks like a rock; besides, in appearance it is different from the other half, though by not much. The cause of such petrification is the insolence of the Yeik whom this mask represents, in attempting to penetrate into the dwellings of the mighty Yeil, or, to put it differently, to reach the head of the river Nass.

Each Shaman has several shamanistic implements, but this particular Shaman has several chests full. All of these chests are kept in the forest and are brought out only when there is to be a shamanistic séance. The quantity of the instruments is a measure of power and might of the Shaman.

...

[Séances.] During the shamanistic séance, the Shaman frequently changes the masks he wears. First of all he wears the mask of that particular Yeik whom he sees first, and then changes the masks in the same order as other Yeik appear to him, as these masks represent particular Yeik.

### WILKES EXPEDITION: HORATIO HALE, 1841

**4.XV. Horatio Hale. 1846. "Northwestern America."** In *Ethnography and Philology*. Vol. 6 of the United States Exploring Expedition, 197-225. Philadelphia: Printed by C. Sherman, 197, 216-17.

The United States Exploring Expedition (1838-42), under the direction of naval officer Charles Wilkes (1798-1877), marked America's first official global

reconnaissance. In 1841, the US Ex. Ex. (as it was called) spent six months travelling – overland as well as by sea – from Puget Sound to San Francisco. In addition to records on the local Coast Salish and Chinook people, the team returned with two hundred objects, some from the more northerly peoples of the Northwest Coast, that they were able to purchase from Hudson's Bay Company employees. Among these objects were an important representation of the relatively novel art of Haida argillite. They became part of the US National Museum, now the Smithsonian Institution (Kaeppler 1985, 142-47). In fact, the Wilkes expedition was probably more significant for its collection of artifacts and linguistic materials than for its own observations of Native peoples and art.

Accompanying the mission was Horatio Hale (1817-96), a young Harvard graduate who would go on to a career as a lawyer and amateur ethnologist. During the expedition, Hale focused primarily on language. He formed a generally negative view of the people of the coast, although he modified this opinion in later life (Joyce 2001, 138, 157-61). This passage from the expedition's final report presents Hale's summary of the more northerly Northwest Coast peoples. Although Hale made a few comments on their appearance and behaviour, he had little more to say about their artifacts. However, his positive comments on Haida argillite are among the earliest on the art form.

> In the long and narrow section of this continent included between the Rocky Mountains and the Pacific, and extending from the country of the Esquimaux on the north to the Californian peninsula on the south, there are found, perhaps, a greater number of tribes speaking distinct languages than in any other territory of the same size in the world. Not only do these tribes differ in their idioms, but also in personal appearance, character, and usages. For convenience of description, however, they may be arranged under four classes or divisions, each of which includes a number of tribes resembling one another in certain general traits.
>
> 1. *The Northwest division.* The tribes of this class inhabit the coast between the peninsula of Alaska, in latitude 60° and Queen Charlotte's Sound, in latitude 52°. This part of the country was not visited by us, and the information obtained concerning it was derived chiefly from individuals of the Hudson's Bay Company ...
>
> From the accounts received concerning them, they would appear to be rather an ingenious people. They obtain copper from the mountains which border the coast, and make of it pipe-bowls, gun-charges, and other similar articles. Of a very fine and hard slate they make cups, plates, pipes, little images, and various ornaments, wrought with surprising elegance and taste. Their clothing, houses, and canoes, display like ingenuity, and are well adapted to their climate and mode of life. On the other hand, they are said to be filthy in their habits, and of a cruel and treacherous disposition.

...

[Lower Chinook.] The Chinooks are less ingenious than the natives of the Northwest Coast, but are far superior to those of California. They make houses of wide and thick planks, which they chip with much labor from the large pines with which their country abounds. A single trunk makes one, or, at the most, two planks. The houses are of an oblong shape, with two rows of bunks or sleeping-places on each side, one above the other, like berths in a ship. Their canoes, which are made of hollowed trees, are sometimes of great size. They are of elegant shape, oblong, narrow, and sharp, and are light enough to live in a rough sea, where a boat would be swamped; but they require constant watchfulness, to guard against their upsetting. The habits of the Chinooks, like those of the northern coast-tribes, show a people accustomed to derive their subsistence from the sea, and adverse to wandering upon land. They differ widely, in this respect, from the Californians, who subsist upon acorns and the seeds of plants, build temporary huts of brushwood and straw, and are constantly on the move from place to place.

## PAUL KANE: 1847

**4.XVI. J. Russell Harper, ed. 1971. *Paul Kane's Frontier; Including* Wanderings of an Artist among the Indians of North America, *by Paul Kane*.** Edited with a biographical introduction and a catalogue raisonné. Austin: Published for the Amon Carter Museum, Fort Worth, and the National Gallery of Canada by the University of Texas Press, 100-2.

In 1859, Canadian painter Paul Kane (1810-71) published an entertaining and informative account of his travels across Canada between 1845 and 1848. He was born in Ireland and raised in Toronto (then called York), and his trip to paint the Natives was essentially a tour of Hudson's Bay Company posts. Between April and early June 1847, he visited Fort Victoria on southern Vancouver Island. Using it as a base, Kane made about 100 sketches in the region, including the adjacent British Columbia mainland and Washington Territory (Harper 1971, 22). Most of his local reports concern the Central Coast Salish, although precisely which group is unclear (some of the confusion is due to the fact that many editorial hands played a role in transforming Kane's manuscripts into the printed version; cf. MacLaren 2007).[18] The following excerpt features Kane's observations of Coast Salish blankets, the subject of one of his best-known paintings (cf. Harper 1971, 261; Gustafson 1980, 80-81, 83; Lister 2010, 274-75).

The lodges are built of cedar like the Chinook lodges, but much larger, some of them being sixty or seventy feet long.

The men wear no clothing in summer, and nothing but a blanket in winter, made either of dog's hair alone, or dog's hair and goosedown mixed, frayed cedar-bark, or

wildgoose skin, like the Chinooks. They have a peculiar breed of small dogs with long hair of a brownish black and a clear white. These dogs are bred for clothing purposes. The hair is cut off with a knife and mixed with goosedown and a little white earth, with a view of curing the feathers. This is then beaten together with sticks, and twisted into threads by rubbing it down the thigh with the palm of the hand, in the same way that a shoemaker forms his waxend, after which it undergoes a second twisting on a distaff to increase its firmness. The cedar bark is frayed and twisted into threads in a similar manner. These threads are then woven into blankets by a very simple loom of their own contrivance. A single thread is wound over rollers at the top and bottom of a square frame, so as to form a continuous woof through which an alternate thread is carried by the hand, and pressed closely together by a sort of wooden comb; by turning the rollers every part of the wool is brought within reach of the weaver; by this means a bag is formed, open at each end, which being cut down makes a square blanket. The women wear only an apron of twisted cedar-bark shreds, tied round the waist and hanging down in front only, almost to the knees. They how-ever, use the blanket more than the men do, but certainly not from any feeling of delicacy ...

I was indebted to the superstitious fears which they attached to my pictures for the safety and ease with which I mingled amongst them. One of them gave me a great deal of annoyance by continually following and watching me wherever I went, for the

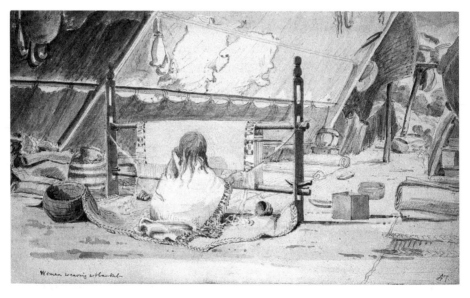

**FIGURE 4.3** Paul Kane, *Interior of a Lodge with Indian Woman Weaving a Blanket,* 1847. Watercolour and pencil on paper, 14 x 23.8 cm. Kane travelled independently to create pictorial and written accounts of Central Coast Salish life in the Fort Victoria area of Vancouver Island. Stark Museum of Art, Orange, Texas, 31.78.73.

purpose of warning the other Indians against my sketching them, telling them that it would expose them to all sorts of ill luck. I repeatedly requested him to desist, but in vain. At last I bethought me of looking steadily at himself, paper and pencil in hand, as if in the act of taking his likeness; when he became greatly alarmed, and asked me what I was about. I replied, "I am taking a sketch of you." He earnestly begged of me to stop, and promised never to annoy me again.

These Indians have a great dance, which is called "The Medicine Mask Dance"; this is performed both before and after any important action of the tribe, such as fishing, gathering camas, or going on a war party, either for the purpose of gaining the goodwill of the Great Spirit in their undertaking, or else in honour of him for the success which has attended them. Six or eight of the principal men of the tribe, generally medicine-men, adorn themselves with masks cut out of some soft light wood with feathers, highly painted and ornamented, with the eyes and mouth ingeniously made to open and shut. In their hands they hold carved rattles, which are shaken in time to a monotonous song or humming noise (for there are no words to it) which is sung by the whole company as they slowly dance round and round in a circle.

### JAMES G. SWAN: 1852-55, 1859-66

**4.XVII. James Gilchrist Swan. 1857. *The Northwest Coast; or, Three Years' Residence in Washington Territory.*** New York: Harper and Brothers, 78-82.

James Gilchrist Swan (1818-1900) was an American ethnographer and man of many trades, among them oysterman, customs inspector, secretary to a congressional delegate, journalist, reservation school teacher, lawyer, judge, school superintendent, railroad promoter, and natural historian. But above all, Swan was an author. He arrived in the region – Washington Territory – in 1852, and he remained there until his death. His ethnological researches were devoted primarily to the local Coast Salish around his several homes in Washington, but he also wrote about the Makah and Haida.

Swan's first book, published in 1857, contained a fine account of the construction of a canoe. It was carved by members of the mixed Lower Chinook-Lower Chehalis community living in Willapa Bay (then known as Shoalwater Bay), Washington Territory – Swan's home between 1852 and 1853. As his account mentions, Swan bought another canoe from Kape, a chief of the Quinault, who lived just north of the Chehalis. This excerpt is significant as an early and detailed account of artistic behaviour, the actual production of an object. The general process of handling the large trunks applied more generally to the construction of monumental carving, such as houses and totem poles, in addition to canoes. Swan was also sympathetic and praised what he saw.

He [Chief Kape] came in a large canoe, which he wished to sell me, and as I wanted one of that description, I purchased his ... The canoe which I had purchased was a beauty. She was *forty-six feet long* and *six feet wide,* and had thirty Indians in her when she crossed the bar at the mouth of the Bay. She was the largest canoe that had been brought from up the coast, although the Indians round Vancouver's and Queen Charlotte's Islands have canoes capable of carrying one hundred warriors. These canoes are beautiful specimens of naval architecture. Formed of a single log of cedar, they present a model of which a white mechanic might well be proud.

The other canoes are the forms used by the Indians about Fuca Straits and farther north, as being best adapted for rough water, and the Cowlitz canoe, which is mostly used on the rivers of the interior. The broad bow of the latter form is to enable the Indian to have a firm footing while he uses his pole to force the canoe over the rapids. The paddle is the shape used by the Indians in deep water, and is different from the Chenook paddle, which is notched at the end.

The manufacture of a canoe is a work of great moment with these Indians. It is not every man among them that can make a canoe, but some are, like our white mechanics, more expert than their neighbors. A suitable tree is first selected, which in all cases is the cedar, and then cut down. This job was formerly a formidable one, as the tree was chipped around with stone chisels, after the fashion adopted by beavers, and looks as if gnawed off. At present, however, they understand the use of the axe, and many are expert choppers. When the tree is down, it is first stripped of its bark, then cut off into the desired length, and the upper part split off with little wedges, till it is reduced to about two thirds the original height of the log. The bows and stern are then chopped into a rough shape, and enough cut out of the inside to lighten it so that it can be easily turned. When all is ready, the log is turned bottom up, and the Indian goes to work to fashion it out. This he does with no instrument of measurement but his eye, and so correct is that, that when he has done his hewing no one could detect the least defect. When the outside is formed and rough-hewn, the log is again turned, and the inside cut out with the axe. This operation was formerly done by fire, but the process was slow and tedious. During the chopping the Indian frequently ascertains the thickness of the sides by placing one hand on the outside and the other on the inside. The canoe is now again turned bottom up, and the whole smoothed off with a peculiar-shaped chisel, used something after the manner of a cooper's adze. This is a very tiresome job, and takes a long time. Then the inside is finished, and the canoe now has to be stretched into shape. It is first nearly filled with water, into which hot stones are thrown, and a fire at the same time of bark is built outside. This in a short time renders the wood so supple that the centre can be spread open at the top from six inches to a foot. This is kept in place by sticks or stretchers, similar to the method of a boat's thwarts. The ends of these stretchers are fastened by means of withes made

CHENOOK CANOE BOUGHT FROM KAPE.

**FIGURE 4.4** *Chenook canoe bought from Kape,* 1857. Original line drawing. James G. Swan, an ethnographer and Indian Agent, published this drawing of a canoe bought from Chief Kape of the Quinault people alongside a descriptive account of the construction of canoes on the Northwest Coast. From James Gilchrist Swan, *The Northwest Coast; or, Three Years' Residence in Washington Territory* (New York: Harper and Brothers, 1857), 79.

from the taper ends of cedar limbs, twisted and used instead of cords. When all is finished, the water is emptied out, and then the stem and head-pieces are put on. These are carved from separate sticks, and are fastened on by means of withes and wooden pegs or tree-nails. After the inside is finished to the satisfaction of the maker, the canoe is again turned, and the charred part, occasioned by the bark fire, is rubbed with stones to make the bottom as smooth as possible, when the whole outside is painted over with a black mixture made of burned rushes and whale oil. The inside is also painted red with a mixture of red ochre and oil. The edges all round are studded with little shells, which are the valve joint of the common snail, and, when brass-headed nails can be obtained, they are used in profusion. This description I give is of the making of a canoe near my house, and I saw the progress every day, from the time the tree was cut down till the canoe was finished. This was a medium sized canoe, and took three months to finish it.

**4.XVIII. James Gilchrist Swan. 1870. *The Indians of Cape Flattery, at the Entrance to the Strait of Fuca, Washington Territory.*** Smithsonian Contributions to Knowledge, Vol. 16, article 8. Washington, DC: Smithsonian Institution, 7, 9-10, 42-43.

In 1870, Swan published the first book-length ethnography of a Northwest Coast people; it was devoted to the Makah, whom he had first visited in 1859. After repeated visits to Cape Flattery, Washington, during the next three years, he settled on the reservation in 1861, where he worked as a school teacher between 1862 and 1866. His monograph is full of detail, including one of the first descriptions of the actual construction of a kerfed box as well as information on its trade and acculturation. There is an excellent description of tools and their use (Swan 1870, 33-35).[19] Anticipating the hands-on approach of Bill Holm, who learned to

replicate Northwest Coast artistic practices, Swan experimented with alder bark dyes and drew for Makah patrons (cf. Miles 2003).

Picture Writing. – In almost every lodge may be seen large boards or planks of cedar carefully smoothed and painted with rude designs of various kinds. With one exception, however, I have found nothing of a legendary or historic character, their drawings being mostly representations of the private totem or tamanous [Chinook jargon, "supernatural power"] of individuals, and consisting of devices rarely understood by their owners and never by any one else. The exception referred to is a representation of the thunder-bird (T'hlu-kluts), the whale (chet-up-uk), and the fabulous animal supposed by the natives to cause lightning (Ha-hék-to-ak). This painting is on a large board in the lodge of one of the chiefs of Neeah Bay, and was executed by a Clyoquot Indian named "Chá-tik," a word signifying painter or artist. A painting is termed Cha-tái-uks, and writing Chá-tātl.

...

Among the most remarkable specimens of their painting which I have seen, was a design on the conical hats worn during rain, and another on a board in a chief's lodge, afterwards placed at the base of a monument erected over his body. The circular design for the hat was said to represent a pair of eyes, a nose, and mouth. The other was a rude one, in which eyes are very conspicuous. The form of these designs is a distinctive feature in Indian painting, but I never could learn that they attached any more meaning to them than we do to the designs on a shawl border, or the combinations of a calico pattern artist.

I have painted various devices for these Indians, and have decorated their ta-ma-na-was masks; and in every instance I was simply required to paint something the Indians had never seen before. One Indian selected from a pictorial newspaper a cut of a Chinese dragon, and another chose a double-headed eagle, from a picture of an Austrian coat-of-arms. Both these I grouped with drawings of crabs, faces of men, and various devices, endeavoring to make the whole look like Indian work; and I was very successful in giving the most entire satisfaction, so much so that they bestowed upon me the name of Chā-tic, intimating that I was as great an artist as the Chā-tic of Clyoquot. In the masks I painted, I simply endeavored to form as hideous a mixture of colors as I could conceive, and in this I again gave satisfaction.

...

Boxes, Baskets, Mats, &c. – Vessels for carrying water, and large boxes for containing blankets or clothing, are made in the following manner: a board as wide as the box is intended to be high, is carefully smoothed with a chisel, then marked off into four divisions, and at each of the marks cut nearly in two. The wood is then wet with warm

Fig. 29.

Fig. 30.

**Wooden bowls of maple or fir knots.**

**FIGURE 4.5** *Wooden bowls of maple or fir knots,* 1870. Original line drawings. Bowls like those depicted are made from the wood of maple, fir, cedar, or alder trees. From James Gilchrist Swan, *The Indians of Cape Flattery, at the Entrance to the Strait of Fuca, Washington Territory,* Smithsonian Contributions to Knowledge, Vol. 16, article 8 (Washington, DC: Smithsonian Institution, 1870), 43. Originally Figures 29 and 30.

water, and gently bent around until the corners are fully formed. Thus three corners of the box are made, and the remaining one formed by the meeting of the two ends of the board, is fastened by wooden pegs. The bottom is then tightly fitted in by pins, and the box is made. The water box or bucket consists of one of these, and the chest is simply two large boxes, one shutting down over the other. These boxes are manufactured principally by the Clyoquot Indians, very few being made by the Makahs, on account of the scarcity of good cedar. They procure these by barter, and every lodge has a greater or less number of them according to the wealth of the occupants. Many have trunks purchased from the whites, either of Chinese or American manufacture, but although they can readily supply themselves at cheap rates with these as well as with water pails, they prefer those used by their ancestors. Wooden bowls and dishes are usually manufactured from alder ... Some are of an oblong shape and used as chopping trays ... The wood of the alder, when freshly cut, is soft and white and easily worked, but a short exposure to the air hardens and turns it to a red color. The bark chewed and spit into a dish forms a bright red dye pigment of a permanent color, which is used for dyeing cedar bark or grass. I have tried to extract this color by other means, but find that no process produces so good a dye as chewing. Alcohol gives an orange color, and boiling water, dark brown or black. I think, however, if it were macerated or ground in warm water, with, perhaps, the addition of certain salts, a very useful dye might be obtained.

Bowls are sometimes made of knots taken from decayed logs of maple or fir.

NOTES

1 As other chapters (e.g., Sewid-Smith, Ḵi-ḵe-in, Berman) in this volume demonstrate, the "view from the ship" outlined here must be countered by the Aboriginal "view from the shore."

2 This periodization is reflected in the chapters in the *Handbook of North American Indians*, vol. 7 (Suttles 1990a), including those by Suttles and Jonaitis (1990), Lohse and Sundt (1990), and Cole and Darling (1990).

3 Often those who were truly the first to see or do something do not get credit for it because of accidents of historical memory. For instance, accounts of early voyages of the Russians and Spanish were either not published at all or were in languages unknown to western Europeans, who came to possess the lands in question (e.g., the English with British Columbia) and were thus given the opportunity to write its history (see Gibson 1993).

4 Both Webber and Kane report some surprise at, and discomfort with, the act of being sketched.

5 The visual records of drawings have been excluded here for practical reasons (see Henry 1984). For the relationship of these written observations to trading and artifact collecting, see Cole (1985), Lohse and Sundt (1990), and Jonaitis (this volume).

6 The following discussion is based primarily on the selections included in this chapter. While many of the most important observations are included, it cannot be fully comprehensive.

7 James G. Swan was the first to collect totem poles, house fronts, and large canoes. He did so for exhibition at the US Centennial Exposition in 1876 (Lohse and Sundt 1990, 89). These collections also marked the beginning of systematic collecting.

8 Crespi thought that Haida "coverlets of otter skins [were] sewn together so well that the best tailor could not sew them better." Cook found Nuu-chah-nulth masks to be "well-designed and executed," while Dixon agreed that the designs on Haida wood carvings were "far from being ill executed." He went on to say that "many of these carvings are well proportioned, and executed with a considerable degree of ingenuity, which appears rather extraordinary amongst a people so remote from civilized refinement." Their cloaks, he thought, were "neatly finished." Ingraham noted that the Haida poles "did great credit to the natural genius of these people," while Fleurieu thought that Tlingit wickerwork was plaited "with a sort of elegance." Vancouver thought that Kwakwa̲ka'wakw weavers were "industrious" and "ingenious." Lewis thought that the Chinook wooden bowls were "extremely well executed" and "neatly carved" and that their woodwork, sculpture, and basketry "evince an ingenuity" rare among Native Americans. To Hale, the northern people were "rather ingenious," and Haida argillite was "wrought with surprising elegance and taste."

9 Of course, the colonial situation discussed here has parallels in many other parts of the world; particularly relevant are the many writings of Nicholas Thomas (e.g., 1991, 2003).

10 For this presentation, I am using an edition of the published version of Cook's expedition, which first appeared in 1784, since it has long been the most common and familiar version. Readers who wish to read Cook's own journals should consult the standard contemporary edition (Beaglehole 1967, 314-20).

11 Perhaps because they were following Gunther's error (1972, 119, 130), almost every recent commentator has attributed these remarks to Marchand, but the published text clearly

explains that Fleurieu authored the report (Fleurieu 1801, cxxi-cxxviii). Fleurieu states that, in fact, as Marchand's journal was unavailable to him, he had to use the journals of Captain Victor-Prospere Chanal and the surgeon Claude Roblet. He also clearly mentions the addition of his own commentary.

12  Today it is not clear which village Caamaño visited. The editors of his account, Wagner and Newcombe (1938, 287), identify the village as Citeyats, at the southeastern end of Pitt Island. This location, and Caamaño's description, suggest southern Tsimshian, but as McLennan and Duffek (2000, 277) note this is the boundary of Tsimshian and Haisla territory, and Chief Jammisit's village could be either.

13  Moziño's name is given as Mociño in some sources.

14  Although a paraphrased selection of Lewis and Clark's journals was published in 1814, most of them were not made available until 1904. Their artifact collections were dispersed to many museums, although most are now preserved in the Harvard Peabody Museum (McLaughlin 2003).

15  Unfortunately, it is not clear which village Tolmie visited. Among the possible locations for the village of Chief Kyete (also given as Kiete, Kielt, Kyeet, Kyelte, Kyetes, Kyets) are Kaeite Point at the junction of Lama Passage and Fisher Channel on Hunter Island, a short distance from the site of the village of Howeet; the old village of Bella Bella on Denny Island; the village of Koqui on Seaforth Channel at the northwest coast of Dufferin Island; and the village of 'Qábá (Kokyet) on Yeo Island (Malloy 1998, 193).

16  The many underlinings and parenthetical additions of Russian and Tlingit terms have been mostly omitted here.

17  According to Veniaminov's editors, this moiety division applied only to the Tlingit around Sitka. Among the northern Tlingit, the two moieties were associated with the raven and eagle.

18  As Grant Keddie (2003, 30) observes, "a great deal of confusion has surrounded the locations of the villages in Paul Kane's paintings of First Peoples around Fort Victoria. This is due to a lack of knowledge of the Inner Harbour Clallam villages, the misuse of names, editorial errors in Kane's book, *Wanderings of an Artist*, and his practice of painting composite scenes based on earlier drawings." While most of the Native people living around Fort Victoria were Songhees Salish, around the middle of the nineteenth century a group of Clallam moved from northern Washington, across the Juan de Fuca Strait. Settling in two villages on the Inner Harbour, they intermarried with the Songhees, a related Central Coast Salish people. At least some of Kane's pictures of house interiors depict the Clallam villages.

19  For instance, "the workman invariably drawing the knife toward instead of thrusting it from him" (Swan 1870, 34).

ANDREW MARTINDALE

# 5 | Thresholds of Meaning

*Voice, Time, and Epistemology in the Archaeological
Consideration of Northwest Coast Art*

One of the facets of the Indigenous metaphor of the knife's edge in lived experience (Duff 1996, 10; Boas 1889, 238; Bringhurst 1999, 373) that Duff (1983) explored in his final publication was the balance between understandings that are general to all humans, or at least easily translatable across cultural differences, and those that are particular to the cultural community from which they emerged. This metaphor has particular resonance in archaeology, where the difference between what is part of our common humanity and what is particular to the legacy of specific cultural histories is both nuanced and profound, rewarding balance but always with the potential for creating division by separation across untranslatable space. A consideration of art in the endeavour of archaeology usefully begins with this fundamental issue.

## ART IN EARLY NORTHWEST COAST ARCHAEOLOGY

Indeed, the history of Northwest Coast archaeology is something of an exploration of this divide. Archaeology is materialist by definition. This implies the theoretical assumption that the phenomenological experiences, physical constraints, and circumstances of life influence the cognitive and ideational foundations of culture. The trend in archaeology has been to expand beyond earlier deterministic associations, in which circumstance results in culture, toward contextual interpretations, in which people negotiate cultural understandings through practice and agency. In the former approach, "art" is what remains after functional and utilitarian interpretations are exhausted. This suggests both that art is symbolic and that art and utility are somewhat mutually exclusive. The generalizable view that derives from this is that, since all humans encode meaning analogously, the role of the archaeologist is to decode the form and content of symbolic language. In the latter approach, archaeologists have begun to explore the artistry of the quotidian, the fleeting, and the parochial, to move beyond a simplistic

equation of symbolism and meanings and toward a discussion of "culture" as a complex web of conscious and non-discursive meanings generated by individuals but with resonance across communities. While this creates an arguably artificial divide between discursive and non-discursive meanings, it presents a welcome sophistication to normativism (the expectation that cultural identity derives from adherence to cultural norms), one that accepts that, since the nature of understanding is complex, the archaeological study of meaning, and thus of art, is necessarily also complex.

The archaeological conception of what constitutes "art" thus has an ontological trajectory that coincides with both the theoretical developments of the discipline and the history of research by Northwest Coast archaeologists. Northwest Coast history extends back at least 10,000 years, and future research will likely identify both earlier inhabitants and ancestral links to other areas, such as Pleistocene populations in the unglaciated south and northward around the Pacific Rim. In each context, archaeologists assume some form of cultural continuity from original populations to the present-day Indigenous communities. In part, this derives from the material and aesthetic continuity evident in the archaeological record.

The earliest archaeological efforts of Harlan I. Smith (1899a, 1899b, 1900, 1906, 1909, 1925a, 1925b, 1927a, 1927b), Charles Hill-Tout (1903, 1912, 1930), Wilson Duff (1955, 1956, 1963), and Philip Drucker (1943) were very much in step with American anthropology in the early twentieth century, which had been profoundly influenced by Franz Boas. The Boasian enterprise is known for its examination of particular contextual understandings under the rubric of cultural relativism (see Laforet, this volume; Miller, this volume). What is less commonly recognized are the Boasians' embedded generalized assumptions about human psychology in the operation of societies (Stocking 1974). Smith was perhaps the most direct source of this influence in his role as the archaeologist on the Boas-led Jesup North Pacific Expedition of 1897-1900. Smith's later role as the head of the archaeology division of the Geological Survey of Canada (now part of the Canadian Museum of Civilization) established a national interest in Northwest Coast First Nations, their material culture, and their pasts. Although an archaeologist, Smith exemplified the holistic approach to anthropology characteristic of Boas, exploring the ethnographic, historical, material, and ancient worlds of First Nations through film, photography, and museology as well as archaeology. To Smith, the division between archaeology and anthropology was primarily epistemological: archaeology was restricted to material remains, a limit that could be overcome by understanding the ethnology of humans and the ethnography of local communities.

The earliest literature on Northwest Coast material objects uses the concept of art as a synonym for endeavour, craftwork, or industry. Art was the application of skill that included both the creation of objects of utility and the aesthetics of their form. Thus, we find Boas (1916, 56-57) referring to woodworking/ zoomorphic realism and weaving/geometric shapes as men's and women's arts respectively. Smith (1899a, 536) is more specific, restricting the concept of art to the symbolic adornment of otherwise utilitarian objects, such as zoomorphic designs on war clubs. For early archaeologists, art was self-evident: it was the formal, stylistic communication and traditional aesthetic expression that coincided with idealized "cultures." In this view, art, like early-twentieth-century conceptions of culture, was an expression of solidarity and distinction perpetuated through time as cultural tradition.

Drucker's work mirrored Smith's, for Drucker was an anthropologist with a strong interest in archaeology. A student of Boas's protege Alfred Kroeber, Drucker also enjoyed a long career at national museums: the US National Museum and the Smithsonian's Bureau of American Ethnology. His research moved seamlessly between ethnography and archaeology. His later work ([1955] 1963, 1965; Drucker and Heizer 1967) segued into the mid-century anthropological practice of studying Northwest Coast Indigenous society through the principles and structures at the root of cultural expressions. Driven by the theoretical legacy of Rivers's (1914) genealogical method, Malinowski's (1926) cultural logics, and Radcliffe-Brown's (1930-31) social structure, mid-century anthropology analyzed the expectation that human society was organized by some inner logic that could be deduced from patterns of behaviour, kinship, language, or symbolism. Northwest Coast archaeology was built on the twin assumptions that cultural traditions were foundationally a structuring logic that defined distinct peoples' ways-of-knowing and ways-of being and that expressions such as art were the material manifestations encoding such logics.

One consequence of these assumptions is that the history of archaeological work on the Northwest Coast has been closely associated with ethnography, much of it conducted in the early twentieth century. As a result, many of the ethnographic sources referred to by archaeologists subscribed to a normative view expressed through the concept of culture areas. Argued most clearly by Kroeber (1920) and Julian Haynes Steward (1950), culture areas are the environmental loci of shared cultural logics that define human organizational patterning. The expectation was that culture represented a suite of norms and rules embedded in behaviour and gesture and thus materiality – assumptions that archaeologists enthusiastically pursued. Where archaeologists saw links between

utilitarian objects and functional adaptation, anthropologists tended to focus on "high art" as the definitive expression of cultural meanings. What constitutes high art is elusive; it has been defined variously as sacred (Jonaitis 1988, 129), mythological (Gunther 1966, 10), or symbolic (B. Holm 1987), and the objects that it produces represent the treasures of collectors. The line between tool and art is blurred, though, as Bill Holm (1983a, 88) notes: "Many of these utilitarian implements are the art objects of today's collections."

However, the normative approach focused on description based on the expectation that order existed within cultures and that the nature of that order defined cultural boundaries and history. That cultures are entities with logics to be decoded has been a prevalent assumption in the anthropology of Northwest Coast peoples (Gunther 1966; B. Holm 1965; Lévi-Strauss 1982; Rosman and Rubel 1971; Seguin 1985). And the idea that culture, especially other people's culture, is coherent is a satisfying view for an outsider. While anthropologists and art historians inevitably begin with an external perspective, archaeologists are the ultimate outsiders since the subjects of their study are long dead. It is no wonder, then, that the idea that a cultural code could be manifest in art became popular among archaeologists.

### Mid-Century Archaeology: Art as a Symbolic Language

For much of the latter half of the twentieth century, archaeological interpretations of art tended to assume that art was either epiphenomenal to the critical aspects of culture, which were seen as primarily economic, or the expression of a cultural system of meanings. This period marked a schism between some forms of anthropology and archaeology in North America. As anthropologists were questioning the utility of essentializing cultural experiences into a suite of shared norms, archaeologists were continuing the tradition of doing so, often through comparisons to ethnographic sources, in an effort to explain the adaptive function of historically visible collective traits. Although an enthusiasm for objectivity of observation and the expectation of certainty in interpretation emerged, few Northwest Coast archaeological projects were as scientistic as those critiqued by Kehoe (1998) as representative of the New Archaeology. Instead, Borden (1947, 1955, 1956, 1960, 1968, 1976, 1979, 1983) [5.vi], R.L. Carlson (1960, 1970, 1979, 1983a, 1983c, 1983d, 1983e, 1996a, 1996b, 1998) [5.vii], Donald and Mitchell (1975), Fladmark (1975, 1979a, 1979b, 1982, 1986, 1990, 1993), Hobler (1970, 1976, 1978), G.F. MacDonald (1983a, 1983b), MacDonald and Borden (1969), MacDonald and Cybulski (2001), MacDonald and Inglis (1981)

[5.VIII], D.H. Mitchell (1968a, 1968b, 1970, 1971, 1972, 1979), and Mitchell and Donald (1985, 1988) were willing to use scientific methods to explore the past but were not content to be limited by the constraints of proof.

The most pervasive analogy in the archaeology of art from this time was linguistic. Here art is both idiomatic (following B. Holm 1965, 1987) and engendered in a culturally circumscribed suite of aesthetic and symbolic rules. This operationalizes art as a technologically effected expression of symbolic ideology, visible in a variety of material media from which the grammars of its meaning can be decoded. The analogy coincides with the archaeological use of patterns of diagnostic linguistic and material traits as proxies for cultural affinity. It includes the sense that art matures through time: simple when it starts out, later becoming complex – a progression that is linked to both the paucity of expressive data in the earliest times and a lingering, teleological expectation that history is progressive. It also demystifies artistic expression and turns it into a form of pseudo-language, creating satisfying though simplistic and functional assumptions of unambiguous and standard meanings. Although teleological, there is abundant empirical evidence that distinct cultural communities are conversant in shared patterns of symbolic communication; despite the potential for dynamic and infinitely varied expression, people seem to reify artistic metaphors. This is exemplified in Roy Carlson's (1983b) seminal *Indian Art Traditions of the Northwest Coast* [5.VI], though its roots extend back to much of the postwar era. Most of the articles from this book and this era assume that, as Carlson notes (1983a, 198), art is the material form of an artistic intent. Art is conceived of, somewhat naively, as symbolism and communication through material media. Archaeologists recognize the less permanent manifestations of art in, for example, ritual and performance but necessarily focus on media that hold material expressions. In this view, each cultural community subscribed to its own symbolic and artistic logic that derived from its understanding of cosmological order (see, e.g., Duff 1975 [5.IX]; G.F. MacDonald 1983a [5.VIII]; J. Miller 1997).

These assumptions permit a projection of the contemporary socio-political context into the past, so that what seems to define Haida artistic traditions, for example, also defines the Haida cultural area in archaeology. The exact nature of this link has been the subject of much critique in archaeology, as it appears to have deontological merit but with a logic that remains difficult to define (Moss 2004, 2010). Most culture area definitions are selected suites of what are referred to as "diagnostic" material traits that co-occur in space and time. While it is relatively easy to show that such selectivity is not representative of the population of traits, modern communities have both historical and phylogenetic-like antecedents that seem to explain the archaeological data. Thus, archaeologists can

benefit from working backward through time by assuming that the language of material expression and art changes only slowly and that the symbolism of ancient materials can be interpreted with reference to contemporary and ethnographic works. Such an approach separated art from adaptive and economic subsistence behaviours that permitted survival and generated political and social order. Thus, the archaeology of art was a specialized field applied to particular non-functional objects, often using a less deterministic logic than was used for more core aspects of culture, which was defined, following Steward (1955), as materials and behaviours linked to energy capture.

## Contemporary Themes in the Archaeology of Northwest Coast Art

These foundational efforts cultivated a burgeoning field of dynamic scholarship from the 1980s onward, which has been summarized by R.L. Carlson (1983b) and Fladmark (1993) and in two recent overviews by Matson and Coupland (1995) and Ames and Maschner (1999) [5.x]. Whether working in culture resource management, academia, or government, Northwest Coast archaeologists have always seemed to be able to root themselves in the archaeological sciences while casting their eyes beyond the material and nomothetic to examine, though with less certainty, the symbolic and historical. Especially in the exploration of art and symbolism, archaeologists have transcended the limits of certainty and explored, as R.L. Carlson (1983a, 197) noted, "the works of long dead peoples whose creations cannot be observed in use and who can't be asked" [5.VII].

Perhaps the recognition of the complexity of the endeavour and the capacity for balance within it was derived somewhat from the observation that Northwest Coast peoples confounded the simple progressive schemes of naive evolutionary approaches developed during the New Archaeology period. Perhaps it was the long legacy of ethnographic and ethnohistoric sources against which the materiality of the past was compared. Most influential, I think, was the robust scrutiny brought upon archaeologists by the descent communities themselves, relatives and bearers of the cultural legacy that archaeology has explored in the Indigenous communities of the West Coast. This latter point has challenged the foundations of both archaeological practice and its interpretative frameworks by placing archaeology within the sphere of Western colonialism and its many deleterious legacies. As Susan Roy (2008) argues, the practice of archaeology has long been seen as a violation of Indigenous rights by First Nations, an unwanted intrusion into both the material and the historical pasts. The greatest burden of archaeology's colonial past is its myopic claim that archaeologists are more authentic and

more accurate narrators of history than the descent communities themselves. This rendered the practice of archaeology simplistic, removed people from the subject of history, and alienated the archaeological study of the material past from the Indigenous study of the historical past. The asymmetrical power resources of the two communities long placed a naive science of archaeology above the long and complex oral histories of Northwest Coast Indigenous peoples. As the power dynamic shifted in the rest of Canadian society, often through litigation rather than governmental policy, Indigenous voices gained influence within archaeology.

The result is a diverse contemporary context, one in which archaeological practitioners and their audiences are well aware of its balanced edges, "tensions" in Matthew Johnson's (1997) language, between science and history, European and Indigenous, local and global, adaptive and political, archaeological and historical, artistic and utilitarian. This latter point is both controversial and a fruitful point of departure in a discussion of contemporary theory regarding the archaeological considerations of art.

Matson and Coupland's (1995) comprehensive analysis of Northwest Coast archaeology addresses the theme of art cautiously and sparingly, a tacit recognition of the subject's complexity. In this contemporary analysis, art is no longer a diagnostic element of cultural identity. Nor is it definitive of either spiritual roles or encoded cosmologies. Instead, the volatility of the individual artist's motivations is recognized, though not fathomed. Art becomes a subject about which archaeology is uncertain, and the authors retreat somewhat to the familiar terrain of comparison to ethnographically known meanings or distributional observations of frequency in the archaeological record and association with other data such as burials.

Contemporary theoretical trends have moved away from determinism, initially in an antagonistic manner, and more recently as an elaboration and expansion of ideas of both adaptive necessity and general processualism (Moss 2010; Cannon 1998, 2002 ) [5.xv]. Art is no longer a distinct category of either human conceptualization or archaeological interpretation. Rather, the artistry of both symbolic/expressive and technical/material gestures is recognizable in the commonplace and everyday. This view was not absent from earlier work, and modern archaeological interpretation simply blurs the previous distinction between art and everyday life. In 1983, George MacDonald famously recognized the artistry and symbolism of Haida plank houses as both a vessel and a medium for containing and displaying the crest images that linked the household to the spiritual world and lineage history. MacDonald realized that living in a symbolic metaphor was to inhabit an understandable version of the cosmological principles

that underpinned Indigenous society and belief (MacDonald 1983a, 18) [5.VIII]. Contemporary archaeology builds on this insight, viewing art not as a medium for symbolism but as a multifaceted exploration of meaning that permeates the conscious and the habitual of life.

One figure who deserves as much credit as anyone for inspiring and illustrating the artistry of everyday technology is Hilary Stewart (1973, 15), whose body of work represents the often unacknowledged archaeologist's bible of objects:

> In the past, the social and spiritual order of the Indians was visually confirmed through their art. It was seen in totem poles and house posts, which bore the crests of their owners; in elaborate masks and intricately carved goat horn spoons; in tobacco mortars wrought from stone, a delicate pendant made from bone or antler; in magnificent ermine-trimmed headdresses, and spindle whorls enriched with symbolic carving on both sides ... Most of these paintings portrayed the crests of their owners, often declaring their owner's lineage, wealth and status. Some had mythical value alone, although a great love of decoration is shown by its abundant use.

The implications of this recasting of the concept of art from a trait developed and learned by a community of people to an expression of identity arising in part from habitual and routinized activities of individuals are subtle but profound. This recasting erodes the reification and exclusiveness of artistry and removes it somewhat from the domain of social distinction by implying that art is not only the product of the skilled, the specialist, the creative, or the aristocracy. Art as a concept becomes democratized, and one might argue, self-reflexively, that this theorizing is itself situated in a late-twentieth-century anthropological concern for locating marginal voices in human history. In addition, it expands the artistic motivation away from explicit commentary of artistic-voice-to-artistic-audience and into the less overt arena of aesthetics, tastes, preferences, and concepts of appropriateness and belonging. The power of such doxic/non-discursive assumptions in directing human behaviour and creating communities of shared expectations has, in archaeology, invoked the seminal work of Bourdieu (1977, 1984, 1998) and, to a lesser extent, Giddens (1984). It implies that "identity" is conversant with a suite of expected patterns and rules born of a dynamic and continually reasserted and recontextualized dialectic between individuals and groups and between individuals and their anticipation of the patterns of group structure. The negotiation of such rules or structures produces a fluidity to the associations of material patterns and cultural meanings and, at the same time, permits the persistence of long-term aesthetic trends. Redefining art as the essence

of everyday life seems to be less about an archaeological effort to devalue the artistic impulse for creation and more about highlighting the role of the audience in artistic expression. The result is not a community in which everyone is necessarily an artist but communities in which everyone learns the conscious and unstated rules of meaning that both define the translation of gestures and provide conversance with the motifs and meanings out of which symbolic and expressive artistic acts are intelligible. Art can then be thought of as not only the creation of an artistic statement but also the subsequent and generative role that such gestures as iterations of meaning produce within the audience, potentially in directions not anticipated by the artist. Art is thus conceivable as the poetics of everyday life.

Contemporary archaeologists are willing at least to consider, if not to employ, a more complicated model of human identity and meaning (see, e.g., Mackie 2003), thereby expanding their analysis of the nature of art. Building on, rather than contradicting, earlier work, this approach recognizes that art — and, by extension, culture — are complicated. Culture can still productively be thought of as including encoded meanings. However, the idea that such patterns exist as unambiguous referents or standards has long since faded. The role of meaning is now seen to exist at the level of intentional communication and at the level of unacknowledged consequences. Neither guarantees that the intent of an artistic gesture will necessarily be translated and transmitted. Meanings are instead dynamic and negotiated; the code, like language itself, morphs continually through use. All actions and things become symbols, each with its own changing and complex suite of meanings. Those meanings differ from person to person and even, for an individual, from context to context. Add to this complexity the idea that some meanings are non-discursive — that is, they are assumed but rarely scrutinized consciously — and the world of meanings and their transmission become almost infinitely complex, even within small, stable communities. The question is not so much "what do the patterns mean?" as "how, given the extraordinary volatility of difference, does any pattern appear at all?" The answer, as Ricoeur (2004) argues, lies in communication and reflection. We may not understand the meanings of things the same way, but as we translate, communicate, and observe the effects of our efforts on ourselves and others we begin to triangulate common understandings with others. This confidence is fragile, however, and needs continual reinforcement through use in ritual or ceremony, in seeing or holding, in teaching or learning. Ricoeur argues that consensus can also be imposed and that standards of meaning and identity are thus tied to expressions of power. Archaeologists have explored this aspect of symbolism more

than others on the Northwest Coast, but the future likely will include more complicated examinations of how people, for a time at least, come to share the belief in the meaning of art.

In many ways, the modern archaeological view of art is a continuation of earlier efforts through a re-examination of the edge between the particular and the general. The debate has expanded beyond cultural affinities and now explores the links between individuals and individual acts and collective cultural patterns across space and over time. Within this interwoven tapestry of gesture and interpretation, moments and trends that are translatable into an archaeological perspective exist as both culturally meaningful and artistic, although they are necessarily arbitrary. Despite the dialectical nature of such a view, the principles of the endeavour would not be unfamiliar to Duff. The voice of the artist can still be heard even as our conception of who is artistic, and the medium through which the voice is expressed, expand.

**5.I. Harlan I. Smith. 1917. "The Use of Prehistoric Canadian Art for Commercial Design."**
*Science* 46, 1177: 60-61.

Harlan I. Smith's (1872-1940) effort in 1917 to pique commercial advertisers' interest in the use of Indigenous images in general and the archaeological collection of the Government of Canada in particular is jarring by today's standards. His open-for-business appropriation of indigeneity can be subjected to the familiar presentist critique of ethnocentric colonialism and the historicist defence of reflecting the views of his day. There is, I think, a more profound thesis in Smith's endeavour, one that lingers in archaeological analyses of Indigenous art. For Smith, Indigenous art included both consciously constructed symbols, what he referred to as "motives," and "material unsurpassed in distinctiveness."

> The Archaeological office of the Geological Survey, Department of Mines, Ottawa, is now prepared to show to Canadian manufacturers and their commercial artists a very complete series of several hundred examples of motives for decorative and symbolic designs and trade marks, although it has no facilities for making designs ... The fossils, animals, flowers, leaves, fruits, etc., and especially the historic objects from Indians found only in Canada would no doubt supply other motives capable of use as the lotus blossom has supplied innumerable designs used throughout much of the world.

**5.II. Anne Brower Stahl. 2002. "Colonial Entanglements and the Practice of Taste:**
**An Alternative to Logocentric Approaches."** *American Anthropologist* 104, 3: 827.

Although out of chronological order, it is useful to establish early on the contemporary views on both meaning, as discussed by Anne Brower Stahl (b. 1954), below, and its causalities, as discussed by Robb, following. "Art," as conceived in the Euro-Canadian vernacular, includes the recognized works of artists; contemporary materialist studies now assume that quotidian objects were both artistic and distinctive of their cultural tradition. Today this is framed, as Stahl explains, as the logocentric versus aesthetic interpretation of meanings in things.

> Late 20th-century anthropology has privileged language and linguistic signification as a site of culture making. Although deeply rooted in the Cartesian mind/body split, this logocentric view has more proximate roots in the diverse legacies of Saussurean linguistics, semiotics, dialogic approaches, discursive perspectives, and a conviction that cultural worlds, like texts, are open to decoding or exegesis through reading. Whether language is viewed as a positive creative force or rather more negatively, it has come to occupy a central place in anthropological inquiry. So too has meaning. Although seldom defined, meaning is often linked to linguistic signification and therefore ideation. Yet the last two decades have witnessed the emergence of alternative perspectives that capture other ways of "being-in-the-world" and work to overcome the Cartesian distrust of sensory experience. Shaped by debates in phenomenology, existential and Marxist philosophy, these diverse perspectives work against the privileging of language by attending to the embodied practices of everyday life as a site of culture making. This has brought welcome attention to object worlds as an active force in social life and fostered the development of a sensorial anthropology attentive to the embodied pathways through which culture is constructed and experienced.

**5.III. John E. Robb. 1998. "The Archaeology of Symbols."** *Annual Review of Anthropology* 27: 330-31.

The division between the conscious and the non-discursive remains, even as John E. Robb dispenses with the objective/subjective distinction. What persists is an appreciation of both the complexity of interpretation in material studies and the necessity of engaging, at least to some degree, the fundamental philosophical assumptions at the root of human identity.

> The archaeology of symbols has been parochialized into gender studies, political studies, cosmological reconstructions, and so on. But symbolic systems work because of the coherent ties between different kinds of meanings, which make political participation compelling, identity meaningful, and ritual effective. Moreover, archaeologists have often studied obvious, iconic symbols but have little sense of the broad range of

meanings with which humans invest the material world. In keeping with this, many believe that symbolic archaeology is exceptionally difficult and that few archaeologists study it – a puzzling belief, because a complete archaeological bibliography on symbols could include several thousand works ...

With only material remains to deal with, our inferences must be anchored with artifacts. However, this idea is easily conflated with others less sound. In contrast to a long scholarly tradition in which the symbol consists of the unity of referent and meaning, our folk model regards symbols as material "containers" that convey tidy "packages" of information. The material/meaning dichotomy is further conflated with folk distinctions between a visible, tangible material world and invisible ideas and feelings, between "hard" scientific approaches and "soft" humanistic approaches, and between "objective" knowledge and "subjective" opinion. The effect is a theoretical sleight of hand transmuting methodological materialism into a theoretical materialism in which signs speak for themselves to the degree that we think they are purely material. The best demonstration of this effect is the double standard we use for judging an archaeological interpretation, based on our prior opinion about its materiality. If we understand how a prehistoric rock carving was made technologically without knowing why it was made culturally, the effort is considered a failure and symbolic archaeology is pronounced impossible. But if we understand how prehistoric people produced their food technologically without knowing the cultural reasons why they produced what and how much they did in the way they did, the effort is considered a successful demonstration of economic archaeology; never mind that we have reduced a complex, value-laden set of social relations to a simple faunal inference. The archaeological world is a cultural world, and by dividing it into a priori categories of material and symbolic, we deny the degree to which things like economy are fundamentally cultural and things like ideas are embodied in material practices.

In many ways, the question is not whether we can find symbols archaeologically, but whether we can find anything cultural that is not symbolic. Many powerful symbols in any culture are the commonest things: bread, water, houses, the river, and the hills beyond. Powerful symbols are not irrational and ethereal but are often highly rationalized and concrete: Money is a symbol rather than mere gold, paper, or numbers in an account. Nor can the symbolic aspect of these things be magically separated from a logically prior economic or material use; indeed much of our modern, supposedly rational economy is structured by massive efforts to protect symbolically important things – the environment, the small farm, the family home. But, having inextricably entangled the material and the mental, once we get beyond the superficial level, all fields of anthropological inquiry converge in similar epistemological constraints.

**5.IV. Franz Boas. 1902. "Some Problems in North American Archaeology."** *American Journal of Archaeology* 6, 1: 1, 6.

Archaeology emerged as a modern discipline in the nineteenth century from its philosophical roots in the post-Enlightenment rise of academics as middle-class, European professionals (Trigger 2006). The early American archaeological perspective developed out of anthropology. Franz Boas (1858-1942) saw archaeology as supplementing the ethnological endeavour: useful primarily as a means of consolidating the characteristics of particular cultures and tracing their antiquity into the past through consistency in materiality. As an extension of the Boasian school, early archaeological analysis of Indigenous peoples embodied both the expectation of rationalism in all phenomena and the exoticism of all things Indigenous.

> We find in America, almost exclusively, remains of people unfamiliar with the art of writing, and whose history is entirely unknown. The problem, therefore, with which we are dealing is allied to the problem of the prehistoric archaeology of the Old World. The method that is pursued in dealing with the ancient remains of the lake-dwellers, of the kitchen-middens, and of other prehistoric sites, of which we have no literary knowledge, must be pursued in investigations in American archaeology. But even in this case the conditions are not quite comparable. The ancient culture of the people who left their remains in Europe has completely disappeared, and has given way to civilization of modern type. It seems probable that the remains found in most of the archaeological sites of America were left by a people similar in culture to the present Indians. For this reason, the ethnological study of the Indians must be considered as a powerful means of elucidating the significance of archaeological remains. It is hardly possible to understand the significance of American archaeological remains without having recourse to ethnological observations, which frequently explain the significance of prehistoric finds.

...

> We may expect that if archaeology in America is applied hand in hand with ethnological and linguistic methods, it will be a most powerful help in unravelling the history of our continent.

**5.V. Marius Barbeau. 1929. *Totem Poles of the Gitksan, Upper Skeena River, British Columbia*.** Anthropology Series no. 12, Bulletin no. 61. Ottawa: National Museum of Canada, 6, 11.

The Boasian assumptions tended to inculcate essentialism in cultures: the belief that a culture, especially that of an Indigenous people (incorrectly thought of as

simplistic), was reducible to a suite of diagnostic traits spanning language, arts, crafts, economics, physical body types, and society. Early-twentieth-century archaeologists worked from these assumptions: that culture is synonymous with spatial distribution of material traits and that such traits are divisible into utilitarian objects and high art. Many early works nevertheless exceeded the tendency to simplify culture and marginalize archaeology. In his discussion of Gitksan ceremonial poles, Marius Barbeau (1883-1969) recognized that the pole was the medium for the crest-image, an iconic symbol of identity and history (Barbeau 1929, 6, 11). However, since neither ceremonial poles nor heraldic crests were used by Salishian peoples in the south, this focus created a bias toward northern art styles.

> The fanciful figures on totem poles were not pagan gods or demons, as is often supposed. They consisted of symbols that can be compared with European heraldry, and as a rule illustrated familiar myths or tribal recollections. They were not worshipped – indeed, the West Coast natives hardly knew of any form of worship. For their implications alone were they held sacred.
>
> ...
>
> The symbols in the heraldry of the Gitksan families, as illustrated poles, are one and all derived from their habitat and their rich mythology or folk-lore ... Animals constitute the predominant theme. Monsters with animal features, human-like spirits, and semi-historical ancestors occupy the second place. Objects, devices, masks, and charms come third; last of all, plants and sky phenomena. It is doubtful whether the people in whose memories the poles were erected, were ever depicted on the poles in the earlier days, though we find four instances of this kind – all quite recent.
>
> The sundry objects, devices, and masks that complete the assortment of native crests are: masks or spirit-names, house-front devices, headdresses, canoes, magic, weapons, small human-like beings, and many other like objects.

**5.VI. Charles E. Borden. 1983. "Prehistoric Art of the Lower Fraser Region."** In *Indian Art Traditions of the Northwest Coast.* Edited by Roy L. Carlson. Burnaby, BC: Archaeology Press, Simon Fraser University, 134-35, 139.

Charles E. Borden (1905-78) was in some ways the father of BC archaeology. His long career was marked by both a passion for excavation and a superlative capacity for finding order in archaeological materials. Most of the chronological sequences still in use throughout the Northwest Coast were devised by Borden. His comprehensive summary of the art of the lower Fraser Valley (1983) set out the extant data but did not frame a definition of art or its role in culture. Questions

of meaning arose when objects were either similar to those known ethnographic-
ally or appeared to invoke some general human sentiment.

Certainly the most remarkable art object from the Developmental Period is an
anthropomorphic sculpture from the St. Mungo component of the Glenrose site ...
Based on the antler tine, the sculpture depicts the head and legless torso of a human
figure carefully carved in considerable detail with special emphasis on the face.
Deeply gouged almond-shaped eyes slant upward and outward. Eyebrows and nose
together form a single unit, which is carved in prominent relief. Broad lips in low
relief form an oval, slightly open mouth, and excessively long jaw lines converge
to form a sharply pointed chin. The hair is drawn firmly upward over the rounded
crown of the head into a flat-topped knot which is tightly constricted at the base.
The resulting groove may have served for the attachment of a thong. Demonstrating
a long persisting trend in Northwest Coast art is the emphasis on the head which,
together with the top knot, accounts for well over half of the entire figure. By con-
trast, the torso seems to have been of little importance to the artist. The only details
shown on it are the tightly flexed arms and flat open hands, both firmly pressed
against the chest. Gouged into the distal end of the back of the artifact is an open
socket, the dimensions of which suggest that the object was intended as a haft for
a beaver-incisor carving tool.
    The recovery of this skilfully sculptured human figurine from an early context
like the St. Mungo phase comes as a surprise. It is the oldest anthropomorphic sculp-
ture known in the Pacific Northwest to date ...  In sum, we perceive during the
Developmental Period the appearance of certain important technological innovations
as well as others of an aesthetic and perhaps cult significance which presage the start-
ling and almost explosive cultural developments of the ensuing centuries ...
    The Climax Period encompasses several regionally and temporally separable
phases. Virtually coinciding in time are the Baldwin phase in the Canyon and the
Locarno Beach phase in the Delta region. Both probably had their inception shortly
before 1000 B.C. ...
    New in the Baldwin phase are carvings of vertebrate animals, both real and fantas-
tic in soft stone, such as phyllite, steatite and fine-grained sandstone. Some are simple
outline carvings, others are sculptures in the round. Occasionally no details other than
the outline are rendered, as, for instance, in a flat, cut-out cookie-like representations
of what is probably meant to be a bear.

...

These sculptures of the Baldwin phase artists reflect a growing interest in depicting
the natural and imaginary creatures that dominated the thoughts and anxieties of their

society. Bear ceremonialism is clearly indicated. Suggested also is a ritual preoccupation with death although the nature and significance of this cult must remain unknown. Despite certain incipient stylistic traits that become important in later Northwest Coast art, such as the x-ray representation of internal organs and skeletal structures, the occasional emphasis on the eyes and the head at the expense of other parts of the body, on the whole, Baldwin phase art seems still considerably removed from what one would readily recognize as Northwest Coast art. It seems highly likely that Baldwin phase groups also used other materials such as bone, antler and wood for their artistic creations. Since none of these materials have survived in the acid soil it is fortunate indeed that these people also turned to various stones as media for their artistic endeavours as well as for their numerous and varied personal ornaments.

**5.VII.  Roy L. Carlson. 1983. "Change and Continuity in Northwest Coast Art."** In *Indian Art Traditions of the Northwest Coast.* Edited by Roy L. Carlson. Burnaby, BC: Archaeology Press, Simon Fraser University, 197-98, 204.

Roy L. Carlson (b. 1930) is the founding figure in modern Northwest Coast archaeology. His interest in art is intriguing since the majority of his work focused on more orthodox archaeological data: subsistence remains and technology. His work illustrates the holism that has emerged in Northwest Coast archaeology, the willingness to follow data in whatever direction it leads, drawing on whatever explanatory sources are appropriate. This selection, from his seminal 1983 edited volume, presents one of the clearest discussions of the nature and challenge of studying art in the archaeological record.

All art, or at least the kind of art found archaeologically, has form, and some has meaning. Form is obvious in that it can be seen and felt, and while it may be perceived differently by different people, it is nevertheless there visually and tactilely. Meaning, on the other hand, is more ephemeral and is relative to context. The "meaning" of an object to an art historian in the context of development of a particular art tradition is quite different from the "meaning" of such a piece in the context of the particular culture which produced it. There are also universal "meanings" such as the sexual meanings, the hidden agenda, as pointed out in Duff's analysis of Northwest Coast art. However, it is neither the art historical meanings, nor the universals, but the particular culturally specific meaning that I refer to here, and call symbolic meaning.

Symbolic meaning is actually a form of communication in which a form tells the viewer something more than that it is long and narrow or short and oval, something more specific than a universal reaction, something which relates to a system or subsystem of the culture from which stemmed this thing *we* classify as art. While it is

possible to observe form, it is necessary to elicit symbolic meaning, and ask, "What does this mean?"...

Most Northwest Coast art objects were symbols of power. This power was based on a spiritual encounter either by the current owner of the symbol or his ancestor. Spirits were potentially present in all natural phenomena including plants and animals, and it is the latter which were most commonly represented in art. Localized practices involving this basic belief in spirits were found in all coastal regions. Guardian spirits, shamanic spirits, secret society spirits and crest spirits constitute categories in which most spirits can be conceptualized and related to variations in belief and practice among different groups, even though these categories are not mutually exclusive, would probably not have been recognized by the bearers of ethnographic Northwest Coast culture, and do not include all Northwest Coast religious phenomena. We learn from ethnography that art communicated in these four areas, and that they were the stimuli to artistic production. The most economical hypothesis is that such was also the case in prehistoric times ...

Style is a function of art as a communicative device in nonliterate cultures. In order to serve as communication art must be culturally specific, and be maintained without radical alterations. In order to function as a way to communicate meaning, style must of necessity change only slowly and thus perpetuate meaning. There are really only two major styles on the Northwest Coast, a southern and a northern. Both illustrate spirits or ancestors manifested in human or animal form. The similarities between them are related in part to common materials and techniques and in part to the belief systems shared throughout the coast. The differences are less in actual content than in the forms of the motifs and their spatial inter-relationships on the field of design.

...

Why specific art traditions originate is always conjectural, although evidence from nonliterate cultures the world over is that such art usually relates to the belief system which in turn arose as part of man's attempts to explain and control his world. A basic belief in spirit power and control through shamanistic practices were probably part of the belief system of the earliest inhabitants of the Northwest Coast. As populations and food surpluses grew and life became patterned around intensive food gathering in spring, summer and fall, the winter became free for shamanic performances, dances and potlatches which integrated belief with art and fostered the development of the art tradition. The masterpieces of historic tunes came from simple beginnings. Only further archaeological research will provide more definite glimpses of the intervening steps.

**5.VIII. George F. MacDonald. 1983. *Haida Monumental Art: Villages of the Queen Charlotte Islands.*** Vancouver: UBC Press; Seattle: University of Washington Press, 3, 6, 18.

George F. MacDonald (b. 1938) expressed his vision most comprehensively in his analysis of Haida architecture as monumental art. The world of the Haida is woven throughout with their cosmological understanding. This both defines who they are and explains the meanings of the patterns in their lives and symbols. The power of MacDonald's argument began with his choice of subject matter. Architecture is the product of both conscious design and unconscious habit. Space becomes place when people feel comfortable, a comfort that Giddens (1984) associated with a sense of belonging and appropriateness. Thus, architecture both expresses and inculcates meaning.

To the Haida, their world was like the edge of a knife cutting between the depths of the sea, which to them symbolized the underworld, and the forested mountainsides, which marked the transition to the upper world. Perhaps because of their precarious position, they embellished the narrow human zone of their villages with a profusion of boldly carved monuments and brightly painted emblems signifying their identity. Throughout their villages these representations of the creatures of the upper and lower worlds presented a balanced statement of the forces of their universe. Animals and birds represented the upper world of the forest and the heavens, while sea mammals, particularly killer whales, and fishes symbolized the underworld. The transition between realms was bridged by such amphibians as frogs, beavers, and otters. Hybrid mythological creatures, such as sea grizzlies and sea wolves, symbolized a merging of several cosmic zones.

The complex appearance of the villages challenged the early travellers to attempt portrayals in words or drawings. They usually fell back on trite descriptions such as "a forest of totem poles" or pen sketches of single carved poles or an individual house. Even the best draftsmen seemed incapable of portraying the confusing mass of sculptured detail in the tight perspective of the European style. It was not until the advent of portable photographic apparatus in the mid-nineteenth century that the means of conveying the grandeur of these villages was at hand.

...

The Haida cosmos is divided into three zones: the sky world, the earth, and the underworld. The Haida conceive of the earth as a flat, circular form over which hangs a solid firmament, very like a bowl inverted over a plate. The earth consists of two islands: Haida Land (the Queen Charlotte Islands) and Seaward Country (the mainland).

Haida Land is supported by a supernatural being called Sacred-One-Standing-and-Moving who rests on a copper box. On his breast is a pole or pillar that supports Haida Land and extends through a hole in the top of the firmament into the sky world above. When he moves, an earthquake results. The pole he supports can also be

visualized as a great cedar tree that grows at the centre of Haida Land. The image of a cosmic tree, while not unique to the Haida, is elaborated among them to be a living being that serves to unite the three main zones of the cosmos: its roots penetrate into the underworld; its trunk extends from the earth; and its branches spread into the firmament.

Power flows through the world pole, and attached to its top are strings that reach to every village in Haida Land. These strings regulate the weather. On the domestic scale, the world pole or tree is represented by the house pole, which is also thought to be a ceremonial conduit of power. When a pole is raised, the ropes used to raise it symbolize the strings attached to the world pole, and their movement during a pole-raising is closely observed ...

At times the vault of heaven is thought of as an enormous skin tent, since the northern lights are explained as "The Skin of the Sky is Burning." At other times it is said to be like an enormous plank house, into which the sun enters through the front door each morning and leaves by a back door at night. The stars are explained as the light of the sun coming through holes in the roof of the celestial house, as the sun circles back overhead to its starting point at the front of the house. The Haida kept calendars by marking the place on the house wall where sunlight from a crack in the opposite wall fell each day of the year.

...

The plank house reflected the Haida concepts of transformation from one realm of creation to another and of personification of inanimate objects. It could function in the secular realm as a dwelling as well as in the spiritual realm as a ceremonial centre. It was the abode of the living as well as of their ancestors. In symbolic terms, it became a manifestation of the ancestors. On ceremonial occasions one entered into the body of the ancestor through its mouth, the oval door, which is most obvious in house-front paintings, or emerged through the vagina of the ancestress, such as the displayed woman on Chief Gold's house front. However, house-front paintings are rare among the Haida, and entry to the house was generally through the oval entry-way into the stomach of the crest animal at the base of the frontal pole. Nevertheless, the symbolism of entering into the realm of the ancestors was the same ... Lineage houses among the Haida symbolized the corporate image of the house group, and entering into it marked a clear transition from the profane world to the spiritual world of the ancestors, bringing the Haida into intimate association with their cultural traditions.

At the same time the house was a manifestation of the cosmos. It was truly a world symbol, as was the tipi, the pit house, the kiva, and like structures of other tribal societies. The house was the container of human social life in the same way that the universe was the container of the natural world. The logical cross-reference between

the dwelling and the universe, or between culture and nature, was common to all pre-literate societies. The house structure could be comprehended by the individual, while the cosmos could not, so it helped man's system of cognition (individual as well as cultural) to impose the structure of the house, with its floor, supports, and protective roof, on the universe with its pillars and vault of heaven.

**5.IX. Wilson Duff. 1975.** *Images: Stone: BC – Thirty Centuries of Northwest Coast Indian Sculpture. An Exhibition Originating at the Art Gallery of Greater Victoria.* Saanichton, BC: Hancock House, 12-14.

No one searched for the code to Northwest Coast meaning more forcefully than Wilson Duff (1925-76). This excerpt captures the most clearly framed vision of culture and art as logic, the belief in which requires that, like mathematics, it must be solvable.

Images seem to speak to the eye, but they are really addressed to the mind. They are ways of thinking, in the guise of ways of seeing. The eye can sometimes be satisfied with form alone, but the mind can only be satisfied with meaning, which can be contemplated, more consciously or less, after the eye is closed ...

The question I must ask is "what do they mean?" and it is a question that demands answers in words, the language of thinking. It is a hazardous enterprise for one who values a reputation for scholarly discipline, because of course, we do not really "know" what they "mean." It would be difficult enough – and terribly disconcerting – to explain what the images of our own culture "mean," because most of the meanings, most of the time, are left below or beyond the view of ordinary consciousness. It is doubly difficult to explain the images of a different culture, whose unspoken visions and premises we may not share. Not having the answers and not even sure how to ask the questions, I am being presumptuous in saying anything at all about other peoples' symbols. But I think it is a risk worth taking, because it is being taken in an attempt to burst the chains of a long-felt frustration, a frustration which I am not alone in feeling.

Meaning is a system of inner logic, which resides in the style and the internal structure of individual works of art. It is as though each is an equation wrapped as a single bundle. It constructs its statements on the interplay between its parts, and between the literal and metaphoric images of its images. It uses inherent structural and conceptual dualisms in the artifacts and the images: outside-inside, head-body, front-back, part-whole, and so on. Different artifact types, such as bowls, spoons, daggers, rattles, houseposts, lend their structure to the exploration of different kinds of equations ...

I would say that the artist-thinkers of the Northwest Coast had created a sort of "mathematics of the concrete," which by the time the white man arrived had become

an "advanced mathematics." Northwest Coast art, in addition to its previously recognized functions of representation and decoration, had come to be an arena for abstract thinking, a half-secret dialogue, a self-conscious system for diagramming logical paradoxes, and therefore a medium for exploring by analogy the living paradoxes in myth and life.

**5.X.  Kenneth M. Ames and Herbert D. Maschner. 1999.** *Peoples of the Northwest Coast: Their Archaeology and Prehistory.* London: Thames and Hudson, 245-47, 248. Reprinted by kind permission of Thames and Hudson.

The somewhat irreverent tone used by Kenneth M. Ames and Herbert D. Maschner captured a common archaeological exasperation with art: it is obviously meaningful, but every attempt to discern this meaning seems only to complicate matters. Their admirable solution is a concise and descriptive summary of general trends while identifying a few possible explanatory forces.

### THE DEVELOPMENT AND ORIGINS OF NORTHWEST COAST ART

This section has a very bold heading, one which we cannot really live up to. However, some comments are possible. Our intention is first to summarize what is known about the history of representation, composition, and technique, and then to hazard some discussion of art's evolution.

#### REPRESENTATION

The earliest art is generally quite naturalistic. Some of the most complexly stylized (and completely uninterpretable) motifs are not present until the Late Pacific period. In fact, the corpus of decorated objects lacks many of the stylized representations generally considered diagnostic of the idiom. This may reflect the regional sample, which is small and almost entirely from the south, where the art was less stylized than in the north. As we noted at the beginning of the chapter, many people's expectations of the entire idiom are based on the northern style.

Both anthropomorphic and zoomorphic figurines are present from the Early Pacific on. The variety of creatures expands in later periods but this may simply reflect larger samples in the later periods. There are shifts through time and space ...

#### COMPOSITION

The available art of the Archaic period does not display any distinctively Northwest Coast rules of composition, though the rock-art motif at the Long Lake site demonstrates that deeply cut negative and positive spaces and curvilinear designs are quire ancient in western North America. By the middle of the Middle Pacific, primary

formlines are present from Oregon to Prince Rupert Harbor and, in the case of the whalebone club at the Boardwalk site, were clearly being used to structure a composition. However, formlines in the north may not have taken on their Early Modern period form until AD 1000 to 1200. Polyvalent meanings, or "visual punning," are clearly present in the Middle Pacific period, and possibly even in the Early Pacific. Margaret Holm sees evidence for Coast Salish-style compositions in the Gulf of Georgia during the Marpole phase. It seems likely that the rules of composition of Northwest Coast art crystallized by AD 1. That they were maintained over the new two millennia with only minor changes represents a significant research problem. Artistic stability, which might imply cultural stability, needs explanation.

*TECHNIQUES*

Carving is quite ancient in Cascadia. The early antler carvings show that most of the basic carving and woodworking techniques existed in the Early Pacific period, if not earlier. It is not until the Middle Pacific period that sites commonly contain a range of heavy-duty woodworking tools. The early development of stone working methods may simply have been accomplished by transferring antler carving skills to soft stone, such as soapstone and steatite. The rare wooden objects, such as the Hoko River mat creaser, the Lachane handle, and most importantly, the Skagit atlatl, demonstrate the high quality of woodcarving skills in use during the Middle Pacific period. Knut Fladmark and his colleagues (who dated the Skagit atlatl) suggest that the skills shown are commensurate with carving large wooden pieces, such as totem poles. As noted at the beginning of this chapter, there is no evidence for poles prior to AD 1788. Stone sculpture seems to flourish during the past two millennia, though the basic pecking technique was in use by 7000 BC. Stone sculpture was perhaps fueled by application of the grinding and pecking methods used to make heavy stone tools, such as mauls, pile drivers, large adz blades and so on. A key question in the development of Northwest Coast art, and in the evolution of technique, is when did metal tools become available along the coast? The presence of an iron adz blade in Cathlapotle at AD 1400-1500 suggests that such tools were being used along the coast well before contact with Europeans as argued by Philip Drucker 50 years ago.

While the data are thin, three regional styles appear to be present by sometime between AD 1 and 500 – north coast, Gulf of Georgia and Lower Columbia River. It is likely then that the others, including west coast, were present as well. The Gulf of Georgia and Lower Columbia River styles have been linked to the modern Salish and Chinookans respectively. The distribution of whalebone club styles and the figurine complex also suggests the formation of regional interaction spheres by this time ...

This information does not tell us what the ultimate "origins" of the art idiom are: where did the rules of composition and representation originate, where did the motifs

come from? The most likely answer is that they came from the Northwest Coast, developing out of more ancient local traditions.

...

Roy Carlson and George MacDonald may be correct in their view that the roots of Northwest Coast [art] lie in shamanism, and this may provide insights into the meaning of the art. However, it does not tell us how and why it developed the way it did: why the regional differences developed (unless shamanism in each area was practiced differently); why the rules of composition seem to have been tighter in the north than in the south, why the southern art was generally more naturalistic, why there was a southern and a northern formline, rather than just one, and why there seems to have been more variability in the art in the south, among many other questions we could ask.

The idiom clearly developed hand-in-hand with the evolving status system (the practice of shamanism on the coast probably changed through time as well). Regional exchange and interaction were central to the development of the status system, and regional differences in the art reflect the same impetus that led to the regional marking of people by labret wear, cranial deformation, and tattooing. The full idiom of Northwest Coast art emerged during the Middle Pacific at the same time as the ancient status of "labret wearer" was being absorbed into the new, wealthier elite of the Late Middle Pacific. The presence of specialists must also have profoundly affected the history of the art, through the development of techniques and refinement of tools and knowledge not otherwise possible, and perhaps even the development of local "schools" of specialists.

The production of art by specialists might also have affected how objects were evaluated by their audience. During the Early Modern period masks and other carvings were displayed and were central parts of rituals. Competition among elite members and the specialists who produced the objects (these individuals may very well have been one and the same) might have rapidly led to the formalization of the rules of composition and even to more highly stylized forms.

Then why the differences between north and south? Does this imply that there were no specialists in the south, where the art seems to have been more variable, more naturalistic? It may imply fewer specialists, though there is certainly evidence for specialists in the Marpole phase. It suggests a somewhat different role for the art in the south, where it may have played a greater part in funerary ritual than in the north.

---

**5.XI. Gary Coupland. 2006. "A Chief's House Speaks: Communicating Power on the Northern Northwest Coast."** In *Household Archaeology on the Northwest Coast.* Edited by Elizabeth A. Sobel, D. Ann Trieu Gahr, and Kenneth M. Ames. Ann Arbor: International Monographs in Prehistory, 80-83.

That cultural systems of meaning may not represent homogeneous entities is implicit in Carlson's ideas of art as representation of power. In his analysis of household architecture, Gary Coupland (b. 1953) moved beyond the objects and toward the social processes that they represent. Houses were frequently the location of much art, an aspect that Coupland included in his argument that they were canvases on which negotiations of power and authority were conducted.

Recent studies of the built environment have shown that non-verbal expressions of wealth, social identity, and power relations are commonly invested in domestic architecture. Houses are particularly effective non-verbal communicators of these types of messages for several reasons. First, as message senders, houses create no ambiguity as to subject. As containers of people, houses are perfect signifiers of their occupants. Thus, the message issuing from the house can only be about those who live in it.

Second, house messages typically reach a large audience. As highly visible, enduring features of the cultural landscape, houses are capable of communicating information about their occupants to a large group of "outsiders" (i.e., people outside the household) and, because of the relative longevity of some houses, the message may be communicated for long periods of time, generations or more.

Third, because house forms can be modified through structural changes, or even completely rebuilt, the content of the message communicated by the house to outsiders can change. For example, if the social identity of the house owner changes – perhaps due to an improvement in his or her social standing or rank within the community – a conspicuous addition to the house, or construction of a new house, draws attention to the change in status, providing what Douglas and Isherwood call "marking services" and what Blanton calls "indexical communication." A renovation or new house is also a statement of the house owner's power. Anyone wishing to build a large, impressive house must have the power to mobilize a large labor force, often including unskilled workers and skilled specialists. As Trieu shows, no single task on the Northwest Coast required greater mobilization of labour and resources than house building. Those involved in building the house expected to be feasted and rewarded by the owner for their work. In the construction of large houses, each stage of the work was celebrated by a feast, which necessitated the outlay of great wealth by the owner and his family.

Finally, houses communicate meaning to "insiders" (members of the household) as well as to outsiders. As with all architecture, houses organize and partition social space, thereby structuring social relations. This organization of space, as Rapoport, Blanton, and many others have noted, is invariably consistent with overarching cultural codes and cosmological principles. Thus, for its occupants, the house becomes a

medium of symbolic communication that constantly imparts "high-level meanings," or what Blanton calls "canonical communication." By restricting or enabling access to objects, information and other people, houses structure and reinforce relations of power. As Blanton shows in his cross-cultural study, the symbolism of house space is particularly powerful in multigenerational households, such as those of the Northwest Coast, where there exists "a hierarchical structuring of space that sanctifies certain persons and/or activities." Restrictions on space use within the house may be based on gender, age, or rank, and are often legitimated by cosmological principles that are held in common by members of the household. These space use restrictions are often manifest in "left-right," "front-back," or "public/private" distinctions within the house, wherein certain areas of the house are reserved for (or off limits to) certain individuals or groups.

**5.XII. Kenneth M. Ames. 1996. "Archaeology, Style, and the Theory of Coevolution."** In *Darwinian Archaeologies.* Edited by Herbert D.G. Maschner. New York: Plenum Press, 123-27. With kind permission from Springer Science and Business Media. Reprinted courtesy of Kenneth M. Ames.

The generalizing metaphor of our age is evolution through competitive selection, whether it derives from applications of biological models or Marx's dialectical materialism. Modern cultural evolutionists have responded to the history of critique by producing more sophisticated models. Dual inheritance is the most recent of these, now undergoing rigorous testing and resulting in a burgeoning literature. Early on in its history, Kenneth M. Ames attempted an explanation of Northwest Coast art in this vein. The utility of the model is clear; what is uncertain is whether its fundamental causality of competitive optimization is as universal as assumed. I like the spirit of Ames's effort: if it can help to explain the past, it is worth serious consideration.

> Northwest Coast art, or elements of it, may be among the oldest art styles ... still being produced in the world. It is possible to establish minimal ages for some elements of Northwest Coast art.
>
> 1. Joined nose and eyebrows in relief produced by carving away surrounding material (the creation of negative space). Eyes are also in relief. The earliest known example is an antler handle radiometrically dated to between 3000 and 1500 B.C. ... The design element is both geographically widespread and of great time depth.
> 2. Human and animal figures are commonly joined or intermingled. Antler spoons recovered from the Pender Island Site in southern British Columbia display zoomorphic elements joined at the mouth. Carlson has dated these spoons to 1650 B.C. ...

3. Bilateral symmetry and "visual punning." A common feature of the historic art is splitting an animal or human form down its middle and showing the two sides in profile, sometimes facing each other, sometimes facing away. Motifs were polyvalent in meaning, and several forms or elements were combined onto one. A sea mammal bone club displaying these characteristics from southern British Columbia has been AMS dated to 1895 ...

4. Some of the form-line conventions described by Holm for the 19th century art, specifically the "split U-form" design, are present on an elaborately carved atl atl with a date of A.D. 210-440. This piece also has interlocked motifs, in this case a sea-monster (?) interlocked with a human face, as well [as] symbolism which is readily connected to 19th century themes ...

5. Materials recovered from wet sites such as Lachane and Hoko River, as well as isolated pieces like the atl atl described above, clearly indicate that the carving skills and techniques of the 19th century carvers were in use at least 2000 years ago.

... Northwest Coast art has not been static over the last 4000 years. Some motifs have appeared and disappeared; some categories of decorated objects have appeared and disappeared. In the same way, labrets were originally worn along the entire coast by both sexes; historically the practice was limited to high-status women on the southern coast.

... Within the coevolutionary framework laid out in this paper, a number of problems arise with regard to Northwest Coast art, given the foregoing discussions. I do not have answers for these questions, but they suggest fertile and substantive research directions:

1. What are the memes and allomemes being transmitted from generation to generation? Can we discern changes in the information content of the memes? For example, Northwest Coast woodworking techniques are independent of the art style, which can be executed in stone, wood, bone, and now in gold and silver among other media. On the other hand, there are some motifs which seem to appear only in stone, for example. What this question requires are data on variation in form, media, and technique which are not currently available. It also requires information on the sampling problems which structure our current data base. An artifact sample of 18,000 tools recovered from nine sites in Prince Rupert Harbor, British Columbia, contains less than 300 objects of stone and bone with any decoration at all. Why so few? Most decorated objects were wooden and so do not commonly preserve in archaeological sites. In addition, there is evidence that some classes of stone objects were disposed away from residential sites. A

coevolutionary approach requires that we control as much of the potential sources of variation and error as possible.

2. What nonconveyance forces have been at work (e.g., innovation, synthesis, migration, diffusion, or cultural drift)? [In models of cultural evolution, "nonconveyance forces" are the sources of cultural variation.] These may be the forces crucial to understanding the regional patterns of Northwest Coast art already described. This also raises issues about innovation, culture contact, and diffusion which have not been fashionable during the past three decades. It is in this context that issues of cultural drift become important, rather than in the single context of style versus function.

3. What conveyance forces have been acting on Northwest Coast art (transmission, natural selection, cultural selection)? Boyd and Richerson's indirect bias mode of transmission provides a basis for constructing hypotheses about transmission effects. The art may have been an indicator trait (as it currently is) in the *indirect transmission* of crucial Northwest Coast cultural practices – the art may in fact have functioned as an indicator trait for the transmission of sets of cultural values, for other memes in other words.

In this case, as social evolution proceeded on the coast, and stratification evolved, the art continued to play its role in the transmission of socially important memes, but those memes changed. Carlson has argued that art was originally shamanic, as much of it was in the 19th century. If this is so, the art was simply co-opted for the transmission of other memes when social stratification evolved, in a manner analogous to the co-option by natural selection of social interaction for the transmission of culture.

It is also within this problem that we address the question of the *locus* of cultural selection – what are the relevant reference groups? During the late prehistoric and early historic periods we can frame questions about the roles of title holders who commissioned pieces, the specialized carvers who executed them, and the rest of the population that witnessed the results. Indeed, a significant question becomes who produced the art? This is of course relevant to questions about relationships between social evolution and the organization of production (e.g., full-time versus part-time specialists). But it also may be significant for the transmission of the art, and the nature of the culture selection acting on the art. A narrowly based guild of carvers could affect variation in a manner similar to Sackett's isochrestic style, and the differences between north and south reflect the number of specialized carvers.[1] Another way to phrase that question is whether cultural selection acting on the art was through choice or imposition, and if imposition, was it from the title holders, the artists, or the rest of society. This could be tested by examining the manner in which the art varied prior to the evolution of social stratification and/or craft specialization, and after their evolution.

**5.XIII. Alan D. McMillan. 1999.** *Since the Time of the Transformers.* Vancouver: UBC Press, 160-69.

Few archaeologists have combined the lessons of contemporary archaeological theorizing with the capacity to say sensible things about the past as productively as Alan D. McMillan (b. 1945). His ongoing research on the west coast of Vancouver Island has combined scientific archaeology, ethnohistory, Indigenous oral literature, and collaboration with First Nations in an effort to achieve the most basic of archaeological goals: a better understanding of the past. His work on art has been both long-standing and diverse, but I have selected this passage dealing with cosmology for its balance of caution and ambition.

Glimpses into how people in the past perceived their relationship with the supernatural world may be found in the images they created. These include carved bone and stone objects occasionally found in West Coast sites, abundant wooden artworks recovered from the waterlogged house deposits at Ozette, and the painted or carved images left on the rocks at a number of locations in Nuu-chah-nulth, Ditidaht, and Makah territories. With some caution, several archaeological sites can also be considered ritual places that reflect ancient belief systems.

An underlying theme in Nuu-chah-nulth life is the ritual necessity of preparing and purifying the body prior to any important undertaking. This included fasting, sexual continence, and ceremonial bathing, often scrubbing the flesh with hemlock boughs until it bled. Whaling was one of the most supernaturally charged activities and required the most elaborate ritual preparation. The whaler might retire to an isolated location, where rituals could be carried out in secret. Human corpses or skeletal elements and carved wooden representations of humans and whales were used in the rituals performed at such locations ...

In addition to the ritual preparation prior to whaling, there was the ceremonial treatment of the whale following a successful hunt. Mention has already been made to the ritual welcoming of the whale and the removal of the whale's saddle to the home of the whaling chief. The presence of a carved wooden effigy of a whale saddle in the house deposits at Ozette shows that this practice extends back into precontact times. Sea otter teeth inset into the side of the wooden effigy outline the image of the Thunderbird (*tuta* or *tutuut-sh*) with the Lightning Serpent (*ḥiy'itl'iik*). In Nuu-chah-nulth mythology, Thunderbirds preyed on whales, hurling the Lightning Serpents as their harpoons. The frequent association of Thunderbird, Whale, and Lightning Serpent is a prominent feature of ethnographic Nuu-chah-nulth and Makah art, symbolically reflecting the cultural importance placed on whaling ...

Depictions on artworks recovered archaeologically may also reflect such ritualistic practices. Small carvings in stone, bone, or antler, however, are rare in West Coast

sites. The decorated handles of whalebone clubs from Yuquot and Macoah, the former with a simple bird-like head and the latter with the stylized Thunderbird characteristic of historic Nuu-chah-nulth examples, have already been mentioned. Such images reflect the importance of supernatural power in military endeavours. A small stone carving of a whale was recovered from late precontact deposits at T'ukw'aa, as was a small zoomorphic bone pendant (possibly representing the Thunderbird), a bone fragment with an incised eye design, and a bone cut-out figure possibly representing a stylized whale's tail. An incised zoomorphic antler figure, possibly the handle of a comb, came from Late Period deposits at Ch'uumat'a. A cut-out bone figure of the Thunderbird, in typical Nuu-chah-nulth style, was excavated in historic levels at Yuquot. Among several decorated objects from the Ozette midden trench was a bone comb with an incised human face. The relative paucity of such artworks reflects factors of preservation, as most artistic production was in wood.

The waterlogged deposits at Ozette clearly demonstrate the wealth of decorated objects that were part of Makah households in late precontact times. Boxes, bowls, clubs, tool handles, and other implements were embellished with fine carving, in a style characteristic of historic Nuu-chah-nulth and Makah art. Thunderbirds and wolves are depicted on a large incised and painted plank panel, while the outline image of a whale covers another. Thunderbirds and whales reflect the importance of whaling, while Wolf was the dominant supernatural figure in the most important Nuu-chah-nulth and Makah ceremonial. Owls, dreaded by the Makah as transformed spirits of the dead, are carved on both ends of a slender wooden club. As this shows no evidence of actual use, it may have been a ceremonial object. Human figures are also well represented in the artwork at Ozette.

One of the most enigmatic of archaeological site types, and one which holds the promise of casting light on past belief systems, is the category of "rock art" ...

Some rock art images may reflect specific myths or traditions. Marshall, for example, interprets a pictograph site (DkSp 31) in Hisnit Inlet, Nootka Sound, in such a manner. The site consists of two anthropomorphic faces with radiating lines, suggesting sun figures. These may relate to the story of Umiq, the founding ancestor of the local group that occupied Hisnit Inlet. In this story, as originally recorded by Curtis, Umiq was impregnated by a supernatural being and gave birth to four children, including a boy whose "face was of dazzling brilliance." The location and nature of this pictograph strongly suggest that it depicts an element of Umiq's story ...

Carlson has attempted to establish a chronology for rock art styles based on comparison with art from dated archaeological contexts. The bold curvilinear style of carving that characterizes the Sproat Lake and Nanaimo images is linked to art recovered from Marpole period sites in the Strait of Georgia. Through this analysis, Carlson places the Sproat Lake petroglyphs in the period between 2500 BP and 1000 BP.

Questions of the function and meaning of rock art defy complete resolution, and certainty no one explanation encompasses all known rock art sites. Shamanism undoubtedly provides the underlying motivation behind the creation of many rock art images. Shamanic rituals, however, involved secret knowledge, and many of the rock art sites are in such prominent and public locations that other explanations must be sought. A similar motivation involves ritual attempts to gain supernatural control over the creatures and wealth of the sea. This fits well with the Ditidaht and Makah petroglyphs, with their open-ocean locations and frequent depictions of whales and fish, but cannot explain all images at these sites. One of the Nootka Sound pictography (DjSo 1) is on a prominent rock face overlooking a rockshelter burial site and may have served as a grave marker or memorial. The large prominent petroglyph sites near the villages of Clo-oose and Ozette could possibly have functioned as boundary markers. Whatever the immediate motivation, the rock art sites symbolized the fundamental values of Nuu-chah-nulth, Ditidaht, and Makah society, including the vital role of whaling, sexuality, and the myths of founding ancestors.

**5.XIV. Andrew Martindale and Irena Jurakic. 2006. "Identifying Expedient Glass Tools in a Post-Contact Tsimshian Village."** *Journal of Archaeological Science* 33, 3: 424-26.

This excerpt from my own work with colleague Irena Jurakic is a discussion of the meaning behind the appearance of hybrid glass artifacts in the postcontact Northern Tsimshian village site of Ginakangeek. Our assumption was that everyday activities are artistic in the sense that they are part of the reflection and negotiation of meaning that occur within and between people. Hybrid objects – and one could argue that all constructions are hybrids – highlight the ongoing and pervasive nature of these symbolic conversations.

On one level, glass tools at Ginakangeek represent a continuation of the traditional practice of making expedient lithic tools from local materials. Although the Northern Tsimshian are well known for their elaborate and substantial groundstone artifacts, expedient flaked stone tools are common throughout the 5000 years of archaeological history in the area ... Stone traditionally used for expedient flaking was relatively rare in Northern Tsimshian territory, and there are several examples of broken groundstone tools being reused as expedient flake tools. Glass represents a functionally equivalent alternative to which people turned as it became more common.

However, if functionality and technological tradition were the only motivating factors in the development of glass tools, we might expect to see evidence of their use from the earliest examples of broken glass in the archaeological record. Instead, glass fragments were present at Ginakangeek more than 50 years and perhaps up to 100 years before there was evidence that they were used as tools ...

... It is possible to consider the cultural symbolism of this suite of material changes in terms of post-contact Northern Tsimshian history. The benefits of European goods and trade were obvious to indigenous leaders from the earliest contact. As a consequence, European items became associated with power and prestige, and were material iterations of a long history of social distinction. During the early years of the fur trade, successful indigenous leaders were able to forge alliances between interior groups, who supplied furs, and European traders. This was a time of economic growth for the Northern Tsimshian and their neighbors that is associated with the development of paramount chiefdoms. However, by the late 19th century, the move toward regionalization had dissipated as NW Coast indigenous peoples confronted many deleterious effects of European contact. The Tsimshian regional chiefdom collapsed in the 1860s and was replaced by a more traditional ranked system of village groups.

These political changes and the recasting of leadership values from aggrandizement to cohesion appear to correspond with the material developments at Ginakangeek, and in a general sense, may offer some explanation. The trend away from fineware ceramics may reflect a shift in the use of European goods from objects of status to functional tools. The modest rebound in groundstone technology may correspond with a wider social affinity for traditional ways that echoed the political reordering of the late 19th century. The return to plant foods may be an effort toward economic autonomy from the Euro-Canadian market economy. Finally, the emergence of broken glass as tools may reflect both Tsimshian familiarity of European goods and their desire to distinguish themselves from European values by recycling broken objects in a manner that was both unfamiliar to Europeans and somewhat contrary to the consumer aesthetic of the market economy. Part of a leader's role in the late 19th century was to reconstruct traditional values and maintain a cultural identity independent of European influence. Leaders today, like their traditional forebears, are recognized for their frugality and managerial qualities. Material gestures of groundstone and glass tool manufacturing may have been both an effort to reclaim aspects of the pre-contact culture as well as to construct an identity of leadership that contrasted with the wealth and excesses of the early contact period.

Whether this example of material hybridity is illustrative of broader, post-contact themes is unclear. While there is some merit in interpreting the Ginakangeek data as a form of creolization, the dynamic hybridity of late 19th century Northern Tsimshians and Europeans seems particular to this local history. It is probable that the frugal use of material resources among Northern Tsimshians is partly the reflection of a long-standing indigenous tradition of economic prudence. It is also possible that the use of European materials by indigenous people in traditional technologies and social settings encodes a form of resistance to or rejection of European power and influence by the subsumation of European material symbols within an indigenous artifact taxonomy.

What is clear is that people borrow, trade, reject and resuscitate cultural meanings associated with material culture when these objects come to embody significant themes in their cultural identity. As such, the interpretation of material histories will always change when viewed through the shifting contexts of the colonial encounter. Although these shifting viewpoints are numerous, when they become sufficiently widespread and ingrained they can produce observable patterns in the archaeological record.

**5.XV.  Aubrey Cannon. 2002. "Sacred Power and Seasonal Settlement on the Central Northwest Coast."** In *Beyond Foraging and Collecting: Evolutionary Change in Hunter-Gatherer Settlement Systems.* Edited by Ben Fitzhugh and Junko Hanbu. New York: Kluwer/Plenum, 332-36. With kind permission of Springer Science and Business.

Archaeologists interested in complex cultural themes generally take the easiest route by focusing on recent time periods, eras for which the data are more abundant, the preservation is best, and the comparison with the ethnohistory is most clear. The ambition of a complicated understanding of history is tested most rigorously in the distant past, when the archaeological record is frequently limited to economic, demographic, and environmental clues. In his work, Aubrey Cannon has consistently sought a historical reality in the distant past. This discussion of settlement economics and ritual illustrates the capacity for exploring meaning and artistry even in the absence of objects of art.

On a broad scale, the history of settlement on the central coast embodies many of the themes commonly described in general evolutionary terms. The region witnessed an increase in the number of settlements and in the complexity of the settlement system over time. The seasonal availability and distribution of resources dictated the basic pattern, and social constraints and opportunities shaped later developments. Using only a rough chronology and limited evidence of seasonal activity, it would be easy to attribute this overall pattern to long-term population growth or regional circumscription that resulted in a gradual shift from small-scale, residentially mobile populations toward larger and more logistically organized populations. The actual history of settlement based on well-dated sites and the relative abundance of seasonally restricted resources is far more complex.

... The direct archaeological evidence is of a history of a settlement pattern that does not conform to any apparent corresponding change in material conditions, though the pattern itself is readily attributable to material and social conditions at any given point in its history. A continuous process of population growth is certainly not evident in the long-term paucity of major residential sites before 500 B.C. Nor is it evident in their punctuated expansion or subsequent stability. Whether or not migration was a factor in the relatively rapid increase in village settlements, the population

resident at Namu clearly had not taken advantage of existing environmental opportunities to expand its numbers by establishing villages at suitable locations available in the vicinity. There is also no evidence of regional environmental changes that would have resulted in enhanced resource productivity at any of these alternative village sites. Local environmental changes at Namu that resulted in periodic failure of the salmon fishery also did not result in total abandonment of that location in favour of demonstrably more productive locations nearby. Defensive considerations have been cited in other regions of the coast as the cause of later village amalgamation. These could be considered a factor in maintaining a stable village residence at Namu, but there is no direct evidence to support such a claim for the earlier Namu occupation. It also seems incongruous to suggest greater concern for defence at a time when population density was so much lower than it was later when a greater variety of locations was used.

A more plausible alternative to this range of potential materialist explanations is that long-term stability in the settlement system, which is evident in the archaeological record, was structured by a system of belief and ritual practice. Failure of the salmon fishery at Namu, a periodic event more common after 500 B.C. and clearly evident in the archaeological evidence, contradicted the structural expectations of ritual and belief. This contingency would give some individual agents opportunity and reason to redefine and ultimately to restore the structure by establishing winter villages at new locations, an action also evident in the archaeological record. The enduring structure of belief and ritual then acted to maintain the stability of a new pattern of multiple winter village settlements in the region after 500 B.C., a pattern which again is evident archaeologically.

... I am suggesting that agents that acted in response to archaeologically documented events in Namu's history, or shortfalls in salmon productivity, ultimately altered the history of settlement in the region but preserved the structural basis of the settlement system. The cultural perception that salmon shortages were contradictory to the ritual basis of the permanent winter village, which was designed to ensure the abundance of resources, resulted in resolving the contradiction by establishing new villages. The foundation of new villages as ritual and residential centers, however, was based on the same structures of cultural perception and belief that originally had been responsible for Namu's long history as a permanent winter village. These enduring structures that involved seasonal ritual re-enactment of the supernatural encounters that ensured continuing resource abundance also subsequently ensured the stability and permanence of the new villages. The history of settlement expansion, in other words, was the product of the same structures that normally acted to constrain such expansion. The expansion itself was simply the resolution of enduring structures and contradictory events.

Events and their impact on existing structures of thought and action create the forms of change that we ultimately observe in the archaeological record. The advantage of taking such structures, events, and actions into consideration in the present case is the enhanced ability to account for the particular character of historical developments, while also accounting for the influence of a broad range of environmental, social, and ideological factors. Explanations of historical developments in hunter-gatherer settlement in most regions are likely to require similar considerations beyond what has so far been the focus of archaeological models. Archaeological evidence may not be particularly well suited to recognition of the conceptual schemes that influence settlement systems, but such schemes are not as inaccessible as some would suggest. Arguably, they become increasingly evident from the inability of simpler models to account fully for the richness of the archaeological data.

**5.XVI. Susan Marsden. 2002. "Adawx, Spanaxnox, and the Geopolitics of the Tsimshian."** *BC Studies* 135: 101-4.

Part of the recognition of the complex relationship among spirituality, art, and history emerged from the study of Indigenous history and oral records, one of the central repositories of Indigenous scholarship. Susan Marsden has been foremost in this work and in the comparison between the archaeological and oral records. Many archaeologists find both inspiration and opportunities for testing the archaeological record within Indigenous literature. This excerpt is both a forceful defence of the endeavour and a caution against simply mining such texts for archaeological-like data. Archaeology sets for itself the most complicated of tasks – at times an impossible ambition – to understand and explain the cultural histories of peoples from the usually unrepresentative fragments of their material worlds. It is useful to think of this as part of a larger, interdisciplinary endeavour.

While oral histories from Northwest Coast societies can be difficult to understand, it is nevertheless possible to acquire the linguistic, geographical, historical and cultural knowledge necessary to appreciate them. Unfortunately, the postmodern position that questions the very possibility of cross-cultural communication tends to limit efforts at understanding and is itself a construct of non-indigenous societies. The cultural institutions that underlie Northwest Coast oral history, on the other hand, assume cross-generational and cross-cultural communication and include a sophisticated system of encoded knowledge to facilitate it.

The Tsimshian oral narratives, or *adawx,* addressed in this paper are presented as cases in point. They reveal an unexpected view of the geopolitics of the Tsimshian

and of the nature of aboriginal title. While all adawx concern territory in one way or another, and rarely can be understood without relevant geographical knowledge, few deal as specifically as these with the geography and geopolitics of the Tsimshian or reveal as much about their intellectual and spiritual content. At the same time, these adawx, as all adawx, are also powerful records of important periods in history. Much of this can be brought to light and (one would hope) find its place in mainstream historical, geographical, and legal discourse.

A brief examination of two central concepts introduces the discussion. The concept of Northwest Coast adawx should be set apart from the general concept of oral history. Adawx are oral records of historical events of *collective* political, social, and economic significance, such as migration, territorial acquisition, natural disaster, epidemic, war, and significant shifts in political and economic power. Adawx also contain *limx'ooy,* ancient songs expressing loss endured during times of hardship, and give rise to visual images – *ayuks,* or crests – represented on poles and on ceremonial regalia. While specific to a lineage and passed from generation to generation within the lineage, adawx are *formally acknowledged by the society as a whole* and *collectively represent the authorized history of the nation.* In every generation, adawx are reaffirmed in feasts, during which chiefs recount their lineages' adawx in the presence of chiefs from their own and other nations.

The geographical concept of *spanaxnox* refers to certain topographic features in which the *naxnox,* the spirit, or power, in the land is manifested. At these locations, as in many indigenous geographies, space becomes sacred – an opening, or gateway, between the human and spirit worlds. Spanaxnox are therefore literally *homes of spirit beings,* but they are also the spirits indwelling in the topography; that is, they are *spirits, or spirit beings, of place.* The Tsimshian, whose lives are intertwined with the landscape, form intimate and abiding relations with the spanaxnox of their territories. In fact, through human eyes, the spanaxnox inhabit a parallel world of socially organized beings who, like their human counterparts, acquire crests, engage in ceremony, and feast amongst themselves. For example, Lutguts'm'aws, a spanaxnox along the lower Skeena River, is a chief who lives in the largest house at the centre of "a great village with many beautiful houses all with brilliant house-front paintings." Just as a chief in the human world embodies the identity and power of his lineage, or house, so the spanaxnox expresses the identity and power of the landscape, or territory. Humans and spanaxnox therefore share the same cultural realm and, when they meet, interact as they would in either world.

The adawx addressed here reveal the complexity of the concept of spanaxnox and, in so doing, the intricacy of the interplay between the Tsimshian and the landscape they inhabit. Too often this interplay has been thought to preclude ownership. In fact,

the interpenetration of humans and territory in Tsimshian society deepens the concept of ownership and reveals a territorial system that has important implications for the understanding of aboriginal rights and title.

NOTE

1 "Isochrestic style" includes aesthetic choices that emerge in individuals out of habit and tradition.

ANDREA LAFORET

# 6 | Objects and Knowledge

*Early Accounts from Ethnographers, and Their Written Records and Collecting Practices, ca. 1880-1930*

The dance between objects and knowledge that began in the European record with the first exchanges between Aboriginal visitors and Russian, Spanish, and English sailors continued and diversified in the ethnographic record developed between the mid-1880s and 1930. During these years, the "artificial curiosities" acquired by Fray Juan Crespi, James Cook, José Mariano Moziño, and others (see Jacknis, this volume; Ḳi-ḳe-in, Chapter 22, this volume) were supplemented in the public record by collections that came to be distributed among the Smithsonian Institution (US National Museum of Natural History), the American Museum of Natural History, the Field Museum, the British Columbia Provincial Museum (now Royal British Columbia Museum), and the National Museum of Canada (formerly the Victoria Memorial Museum [1912-27], now the Canadian Museum of Civilization). While these and other museums, such as the Museum of the American Indian (now National Museum of the American Indian) and the Royal Ontario Museum, acquired collections that reflected the interests and opportunities of explorers, missionaries, householders, non-resident connoisseurs, and merchants, these five museums are distinctive in that they have at their core collections developed with the express intention of assembling a documented record of cultural production.[1]

Through this period, which began a century after the arrival of the first European explorers, and nearly thirty years after the inception of settlement, the cultural knowledge and practices that had originated in Aboriginal societies prior to European settlement were perceived to be imperilled. Aboriginal populations themselves were seen to be declining sharply. The timely collection of objects, images, and information was considered to be critical to the construction of an enduring record that was itself perceived as part of a worldwide effort to document, classify, and ultimately explain the development of life and the distribution of societal similarities and differences. In the inaugural volume of the *Journal of American Folklore* in the late 1880s, Franz Boas (1888b, 6) noted

that, "to take a wider view, humanity is a whole, the study of which is rendered possible only by [a] record of every part of that whole."

The ethnographic approach was largely retrospective. The objects collected included contemporary material but were generally restricted to those that could illuminate aspects of Aboriginal life that had endured since the arrival of Europeans. Collecting was the assembling of an aggregate of related objects from which information and insight could be derived about past societal practice. In this, several strands in the development of European thought in the eighteenth and early nineteenth centuries came together: the development of natural history studies, the formulation of scientific methodology, and the acceptance of the need to make information available to a broadly defined public (Hooper-Greenhill 1992). Collections made by James Swan in the 1860s and 1870s for the Smithsonian [6.I, see also 4.XVII, 4.XVIII, 22.IV], by Adrian Jacobsen in the early 1880s for Berlin, and by George Dawson in the 1870s as part of the Geological Survey of Canada laid the foundation for an ethnographic record. Collecting as an ethnographic practice began to be fully realized with the arrival of Franz Boas on the coast in 1886 and was curtailed, although not fully concluded, in the late 1920s, just before the onset of the Great Depression. Documented collections contributed to the development of systematic representation of Northwest Coast societies, based, sometimes very closely, on the contributions of First Nations individuals and framed in terms accessible to Europeans. Boas's early thinking was influenced by Adolph Bastian, a leading German ethnologist and founder of the Museum fur Volkerkunde in Berlin, who considered the collections acquired by that museum to be "*elementargedanken,* the basic ideas of mankind, as well as their expression in multiformed *volkergedanken* in various geographical areas of the world" (Cole 1985, 57, 58). George Dorsey (1899, 1900, 1901) echoed these ideas in three early articles in the *American Anthropologist,* in which he articulated the basis for systematic collecting of artifacts for museums. Artifacts, collected and documented by ethnographers in the field, were to represent the works of man and, by their visible differences, exemplify the differences between cultures. Dorsey (1899, 465) wrote that "it should be the object of the present generation of museum men to collect material from the different races of the earth, and to classify and exhibit it as such" [6.VI].

Although the curio collections of explorers and collections reflecting the life experiences of private, non-Aboriginal individuals also entered museums before and during this time, the driving force of scientific collecting was antithetical to the concept of curio and was intended to transcend the personal. Collections,

ideally gathered according to established criteria concerning age and use, were assemblages that, even when apart from their society of origin, could be seen to carry within them the key to understanding systematic practice and, behind that practice, systematic thought [6.xxxvii]. As Ruth B. Phillips (1995, 106) has pointed out, "[the] project of ethnological collecting rested on the assumption that ethnicity and material culture were isomorphically related." Because artifacts were to be unwritten documents of culture, the collecting process was intended to be comprehensive, as systematic as possible given the uncertainties of funding and the existence of a significant competitive market in objects of Aboriginal origin, and inclusive of all kinds of material culture from ritual to utilitarian objects.

Franz Boas dominated this period as philosopher, practitioner, and supervising mentor, and through the Jesup Expedition and his relationship with Edward Sapir and Harlan Smith of the National Museum of Canada, as well as James Teit, his influence was profound in Canada. In Canada, both the National Museum collection and the ethnographic record were shaped by Sapir, who, while close to Boas, exercised his own perspective and authority [6.x] and by Marius Barbeau, whose training and focus were different from those of Boas and his students. Boas, Sapir, Barbeau, and Smith all had training in anthropology and developed ethnographic monographs and papers in addition to collecting.[2] Boas made a small collection for the National Museum of Canada early in his career, but his primary contribution, along with George Hunt's, was to the American Museum of Natural History. Hunt also contributed to the Field Museum collection. Alone among these men, Smith worked both as an archaeologist and as an ethnographer. He collected only for those institutions for which he worked, the American Museum of Natural History and the National Museum of Canada. Barbeau collected primarily for the National Museum of Canada, although he sent some material to New York. Sapir collected only for the National Museum of Canada.

Adrian Jacobsen, James Swan, George T. Emmons, Charles F. Newcombe, George Hunt, and James Teit constituted a continuum of collectors without formal academic training in ethnology who were able to make a contribution through independent work. Teit's work was conducted exclusively in the interior of the province, rather than on the coast, but Teit is included here because his collecting and writing exemplify the goals and character of the ethnography of this period. Of these collectors, Jacobsen had the most limited contribution. Boas began his career supplementing the documentation that Jacobsen made for Adolph Bastian at the Museum fur Volkerkunde in Berlin. The others assembled

collections that, because of their associated documentation, constitute significant records in the history of particular First Nations – for example, the collections of Makah basketry Swan assembled in the 1860s and 1870s, the Tlingit collections Emmons assembled, and Hunt's collections of Kwakwa̱ka'wakw and Nuu-chah-nulth material. Newcombe, trained as a medical doctor, collected primarily, but not solely, among the Haida and Nuu-chah-nulth. Teit worked among the Nlaka'pamux, Stl'atl'imx, Secwepemc, and other Interior Salish peoples, contributing both well-documented collections and ethnographic monographs.

Hunt's voice is heard quietly but consistently through the pages of *Ethnology of the Kwakiutl (Based on Data Collected by George Hunt)* (Boas 1921). Other First Nations people with a profound impact on both the museum and the ethnographic record included Henry Tate, who contributed to *Tsimshian Mythology* (Boas 1916); William Beynon, who worked closely with Barbeau; and Titlnitsa and James Paul Xixne', of the Nlaka'pamux, who worked closely with Teit (see Nicolson, this volume). Still others made objects on commission directly for museum collections, and many others who made objects for sale in media ranging from sculpture to basketry are represented in museums through their works as well as through the field notes, photographs, audio recordings, and films made by ethnographers.

The major ethnographic collections took shape in a roughly chronological order between the 1880s and 1930 but with significant overlap during the 1890s and the first five years of the twentieth century. The principal vehicle for ethnographic collecting under Boas's direction was the Jesup Expedition, which brought significant collections to the American Museum of Natural History between 1890 and 1905. Within the Jesup Expedition, the primary engine of ethnographic collecting was the association between Boas and Hunt. Boas's graduate student John R. Swanton collected relatively few objects during his time among the Haida in 1900, although he commissioned models to illustrate information about totem poles and lineage history [6.VIII]. Like Boas, Harlan Smith worked both on the coast and in the interior of British Columbia. He made archaeological collections for the American Museum of Natural History among the Nlaka'pamux, and ethnological collections among the Nuxalk (Bella Coola) and Coast Salish, working under Boas's close direction and maintaining a correspondence with Boas from British Columbia. Boas and Hunt worked together to assemble Nuxalk and Kwakwa̱ka'wakw collections, while Hunt worked alone but in correspondence with Boas to collect Kwakwa̱ka'wakw material as well as material from Nootka Sound (Nuu-chah-nulth) [6.XIX, 6.XX]. In conjunction

with Emmons's catalogues of Tlingit collections, the collections made by Boas, Hunt, and Smith became the documented core of the collections of the American Museum of Natural History.

The point of inception for the Field Museum in Chicago was the World's Columbian Exposition of 1893. George Dorsey oversaw the museum's subsequent collection of Northwest Coast material. Dorsey made one trip to the Queen Charlotte Islands. In contrast to the scientific objectives presented in his publications (Dorsey 1899, 1900, 1901), he often collected surreptitiously and without regard for systematic documentation. Between 1894 and 1907, the Field Museum's collection was augmented primarily by Charles F. Newcombe, George T. Emmons, and George Hunt. The museum purchased several Tlingit collections from Emmons and Kwakwaka'wakw materials from Hunt. Newcombe worked on contract over a period of several years, both collecting additional material and organizing the collection.

Although the National Museum of Canada had existed as part of the Geological Survey of Canada since 1856, systematic collecting began with the establishment of the anthropology division in 1910. Collections made between 1911 and 1930 by Edward Sapir, Marius Barbeau, Harlan I. Smith, Thomas F. McIlwraith, and James Teit supplemented collections developed by the Geological Survey of Canada in the 1880s and collections made independently by Charles F. Newcombe between 1895 and 1909 [6.XII-6.XVIII]. Sapir collected objects from the Nuu-chah-nulth villages in which he did ethnographic and linguistic work, compiling detailed catalogue records. Barbeau made significant collections among the Haida, the Coast Tsimshian, and the Gitksan. Smith collected Haida material and in the early 1920s returned to Bella Coola to document Nuxalk material culture in a project intended to complement McIlwraith's research on social organization. McIlwraith also made collections for the National Museum. Teit worked on contract for the National Museum, concentrating largely on the Nlaka'pamux.

These ethnographers approached the task of cultural documentation in slightly different ways. The concern expressed by Boas in recording the context of use for the material he acquired in Nuhwitti on his first collecting expedition was sustained through his career and imparted to Hunt, Swanton, and others who collected under his direction (Cole 1985). Hunt made relatively brief records for objects collected but included Kwakwala terms and details of social context and technique. American Museum of Natural History catalogue records indicate that Hunt collected certain items of basketry precisely because they represented certain kinds of stitches.

Emmons's notes specify purpose, technique, native term, place of collection, and, often, actual place of origin if it was known to be different from place of collection (American Museum of Natural History catalogues 19 and E). Like virtually all collectors of his day, Emmons also collected unfinished basketry to show technique and materials. He used catalogue notes for specific items to provide more general information.

Documentation for Newcombe's collections is generally found in the lists Newcombe submitted with materials purchased by museums and in the notebooks he kept during his collecting expeditions. He recorded provenance and date of collection and, occasionally, the name of the maker or owner. His own catalogue numbers survive in these lists and can at times be used in conjunction with his field notes to determine more precisely the context in which specific objects were collected. Newcombe corresponded with the First Nations people whose work he purchased,[3] but he generally omitted references to individuals from his notes and photograph captions. He collected existing material and commissioned some new work.

Smith appears to have concentrated on assembling collections from what was available rather than commissioning new work. His catalogue records identify the object and often the vendor but are spare in terms of context. His true medium was photography, and he left a legacy of dynamic, well-documented images of the Aboriginal people with whom he worked.[4] Newcombe and Barbeau also left substantial photographic legacies. Although Barbeau published extensively, his detailed records of his collections – including the identities of the people from whom he acquired the material as well as more general information about the manufacture and purpose of the object – are perhaps his most useful legacy.

Concern for the overall documentary quality of the collection being assembled, as opposed to particular objects, emerges in correspondence between Sapir and Newcombe that dealt with exchanges, the meaning of "duplicates," and the building of a collection. Late in 1912, Newcombe wrote to Sapir suggesting that the National Museum might wish to exchange Tsimshian objects, of which it had several examples, for archaeological specimens from the British Columbia Provincial Museum.[5] He noted that most of the "duplicate" archaeological specimens would also be from the Tsimshian region. Sapir replied that he would consider exchange of Tsimshian items if Newcombe would say just which items the Provincial Museum needed, but he added that the national museum had so little from any one area that it could not really afford to make exchanges. He was willing, nonetheless, to go ahead if the exchanged material was mostly archaeological, and if Smith chose it, although Smith was also not much in favour of

exchanges. Sapir went on to echo an earlier statement made by Boas about duplicates. "As regards duplicates, you realize yourself that part of the purpose of a scientific museum is to house a considerable number of duplicates of any type of object in order to make it possible to determine the range of variation of that type, also the extent to which it is truly typical."[6]

The collections most frequently represented through illustration in ethnographies of the day are the Berlin Museum fur Volkerkunde, the US National Museum (Smithsonian), the American Museum of Natural History, and the National Museum of Canada. In comprehensive monographs, such as Teit's *The Thompson Indians of British Columbia* (1900) [6.xxvii], and in monographs on specific topics, such as Boas's *The Social Organization and the Secret Societies of the Kwakiutl Indians. Based on Personal Observations and on Notes Made by Mr. George Hunt* (1897b) [6.xxx], the discourse concerning objects focused on their function rather than on their formal or aesthetic properties. However, in the early twentieth century, comprehensive monographs were also serving as vehicles for presentation of specific aspects of material culture. Teit's *The Shuswap* (1909) contains a definitive essay on birch bark basketry, and his "Notes on the Chilcotin," published as part of *The Shuswap,* contains the only published comprehensive discussion of Chilcotin basketry and design.

Monographs of special focus published around the turn of the twentieth century formed a particular kind of bridge between ethnographic description and collections and, taking function for granted, narrowed the perspective to design and form. Boas's *Primitive Art* ([1927] 1955) and Barbeau's 1920s studies of totem poles (1929) were preceded by monographs on single topics, such as Livingston Farrand's *Basketry Designs of the Salish Indians* (1900), Otis T. Mason's "Aboriginal American Basketry: Studies in a Textile Art without Machinery" (1904), George T. Emmons's *The Basketry of the Tlingit* (1903) and *The Chilkat Blanket* (1907) [6.xxvi], and Herman Karl Haeberlin's essay on Northwest Coast design, "Principles of Esthetic Form in the Art of the North Pacific Coast: A Preliminary Sketch" (1918) [8.x, 15.11].

By the mid-1920s, ethnographic projects on the coast, as elsewhere, were beginning to be framed in such a way that objects had less prominence as anthropology at large shifted its gaze away from material culture (Sturtevant 1969). Thomas F. McIlwraith's major ethnography, *The Bella Coola Indians* (1948), was begun in the 1920s in conjunction with a project of the National Museum of Canada, which foresaw three separate studies, focusing on language (Sapir), material culture (Smith), and social organization (McIlwraith). Of the three, McIlwraith's study was the only one to be completed. Sapir was unable to begin the work, and Smith did not publish a comprehensive report, although his field

notes and photographs were archived by the National Museum of Canada. The original formulation of this project certainly combined three of the four standard fields in anthropology, but it may also have signalled a departure from the comprehensive monograph that characterized the ethnography of the Jesup Expedition.

Neither collecting nor the construction of a comprehensive ethnographic record was pursued in the same way in the later twentieth century as it had been in the early decades. Boas's move to Columbia University in 1905 coincided with a shift in his focus that may, paradoxically, have been prompted by the American Museum of Natural History administration's refusal to give priority to the analysis of documented collections in the development of exhibitions (Jacknis 1996a). Mid-twentieth-century ethnographic treatment of material culture was developed by ethnographers based in museums, through publications,[7] and, in the latter half of the century, in museum exhibitions that were generally, but not exclusively, intended to be long-term, comprehensive, retrospective statements.[8] In the late twentieth century, objects in collections also became a focus of study, either in the context of eighteenth-century and early-nineteenth-century European explorations of the coast (Kaeppler 1978a, 1978b; J.C.H. King 1981; Gunther 1972) or through formal analysis, as subjects of archaeological methodology (J.M. Jones 1976) or studies in the developing Northwest Coast art history that followed the publication of Bill Holm's *Northwest Coast Indian Art: An Analysis of Form* (1965) [15.III, 16.II].

The study of collecting and the collection as social phenomena began to take shape only in the later twentieth century, nearly one hundred years after Boas arrived in Victoria. In regard to the Northwest Coast, this new emphasis coincided with the academic analysis of colonialism as a major force in the creation of British Columbia and Canada (Fisher 1992; see Campbell, this volume; White, this volume; Townsend-Gault, Chapter 27, this volume) and followed substantial research and publication aimed at defining the inequality in the social, economic, and political relations between Aboriginal and non-Aboriginal people (Hawthorn, Belshaw, and Jamieson 1958; Duff 1964b; H.B. Hawthorn 1966-67). The clause banning the potlatch had been quietly dropped from the Indian Act in 1951, but there was a greater academic and public awareness of its effects (Cole and Chaikin 1990) [21.IV]. The persistent issue of land claims, left unsettled for more than a century, had been underlined by the *Calder* case (1973) in the Supreme Court of Canada[9] as well as by contentious legal issues surrounding Aboriginal rights to hunt and fish. Although the idea that Aboriginal cultural practices were endangered had not faded entirely from academic or popular view, the Aboriginal population itself was demographically young and growing,

a situation quite different from that noted by early collectors. By this time, Boas had been dead for about forty years and was becoming a historical figure (Rohner 1969) in a way that transcended the memoirs of students or the retrospective debates about the merits of his approach and insights.

The reflection on collecting was a global academic phenomenon, with contributions from Jean Baudrillard (1968), Richard Handler (1992), Susan Stewart (1984), James Clifford (1988a), and Susan M. Pearce (1995), among many others. Within British Columbia, the most influential critique of the historical collecting process was Douglas Cole's *Captured Heritage: The Scramble for Northwest Coast Artifacts* (1985) [6.v, 6.xi], a study based on archival files relating to collectors and collecting after the manner of *Foreign Devils on the Silk Road* (Hopkirk 1980). For the most part a narrative history structured as a series of chronicles gathered around particular initiatives and personalities, Cole's book is an archival journey driven by a particular theme. Its main title, *Captured Heritage,* serves as an overarching synoptic narrative (see Clifford 1986 – ethnography as allegory) that reinforces and in some ways supersedes the discussion in the text. Although Cole was aware of the many purposes for which collections were made, the motives of the various participants, and the conceptual contexts of their interactions, the polyvalence of his discussion is overwhelmed by the theme of frenzied, unthinking acquisition, which is supported throughout the text by literary devices, such as the frequent repetition of the word *scramble*. Museums figure prominently in the book, but Cole provides little analysis of what was actually collected or the documentary character of the collections that resulted from various initiatives.

*Captured Heritage* sparked a discussion that took place largely through reviews of the book, but it created a persistent and broadly held impression that the development of museum collections constituted an impropriety in the historical relationship between Aboriginal and non-Aboriginal people in British Columbia and elsewhere. Cole himself was rather startled that *Captured Heritage* had led to the conclusion that museum collections had been illegally acquired. In the original edition, he wrote that "most of the ethnological material which left the coast was purchased at prices mutually agreed upon by vendor and vendee. The collecting process was a trading relationship affected by normal economic factors of supply and demand, competition, accessibility, costs of transportation, by wars and trade cycles, by ethnological fashion and museum budgets" (1985, 310). He also endeavoured to address this in a response to various reviews of the book, but to little effect. The overall impact of *Captured Heritage* and its reception was to occlude the history and character of documentary collections and the intellectual environment in which Boas, his colleagues, and students worked. Boas's approach to ethnography and collecting incorporated the idea (strongly

held in his time) that it was imperative to preserve the historical and ideational connection between objects and the societies within which they originated. This approach set the ethnographic collection and study of objects strongly against curio hunting and antiquarianism. Boas's overtures to formalism can be read as an extension of the study of the object in context that Boas had advocated in his argument with Mason forty years earlier [6.II, 6.III]. Cole's narrative sprang from the perceptions of a different century.

In the quest to assemble collections as comprehensive documents of culture, the early ethnographers succeeded in inscribing BC First Nations nineteenth-century and early-twentieth-century material history into a record as significant to knowledge of the history of particular First Nations communities and societies as it is to the history of First Nations art and to the history of First Nations at large. In the early twenty-first century, the concepts that have animated the recent discussion on the nature of objects – for example, the social life of things, the biography of objects, inalienable wealth, and cultural property – are all in play in the discourse surrounding this record, along with the paradigms of antiquarianism, preservation, cultural documentation, and fine art familiar to Boas and his contemporaries (see Campbell, this volume; Kramer, this volume; Jonaitis, this volume). As both museums and the living descendants of those who originated the objects in Northwest Coast collections address the local and global challenges and possibilities created by the collections, the legacy of ethnographic collecting is constantly defined and redefined in terms of current issues that are sometimes consonant with one another, sometimes in competition with one another, but can never be quite the same as those perceived by the Aboriginal and non-Aboriginal people who contributed to the development of the collections.

**6.I. James Swan, Port Townsend, Washington Territory. 1861. Letter to Spencer F. Baird, Smithsonian Institution, Washington, DC, 11 January.** National Museum of Natural History, Smithsonian Institution, Accession 53.

James Gilchrist Swan (1818-1900), who left his business and family in Boston for a sojourn on the West Coast that lasted the rest of his life, was an early contributor to the collections of the Smithsonian Institution. His earliest collections were of natural history specimens, and he moved seamlessly from the collection of shells and birds to the collection of ethnographic objects. His early collections complemented those of the geologist George Gibbs (1815-73). The Smithsonian's interest in collecting reflected the primacy of research, completeness, and comprehensiveness. Swan, who had no formal scientific training, expressed his own

interest in science in a series of letters to the secretary of the Smithsonian Institution, Spencer F. Baird.

> I thank you for your kind expressions relative to my getting an appointment on the coast as enabling me to continue scientific research but I fear that with the present state of the political affairs of the country there is but a very faint chance for my being put into any position on the coast where I can assist either the Smithsonian Institution or the Indian Bureau unless some scientific friends wanted to take the matter up.
>
> I have long considered the extreme northwest coast of this Territory as possessing remarkable attraction to the scientific world. It is from this stand point that I hope as my friend Mr. Schoolcraft expressed to me to find the connecting link (if one is to be found) that will connect the chain of evidence to prove whether or not the aborigines did originally migrate from Asia or whether as many scientific minds concede they are indigenous to the soil.
>
> ... for the past nine years I have made the study of the habits, manners and customs of the coast Indians a specialty.

**6.11. Franz Boas. 1887. "The Occurrence of Similar Inventions in Areas Widely Apart." Letters to the Editor, *Science* 9, 226: 485-86.**

An idea expressed at the beginning of the major period of ethnographic collecting and persisting, in various ways, through the twentieth century concerned the ability of the object to serve as a scientific document. In 1887, Franz Boas (1858-1942) and Otis T. Mason (1838-1908), an ethnologist at the Smithsonian Institution, engaged in a public argument about the relationship of ethnological phenomena, including objects, to science. Neither doubted the ability of the object to serve as a document, but they differed profoundly as to whether ethnographic objects could be treated in the same way, and according to the same scientific assumptions, as biological specimens. Mason was a strong proponent of the biological model. Boas advocated the search for meaning within the historical and social context of the object.

> We have to study each ethnological specimen individually in its history and in its medium, and this is the important meaning of the "geographical province" which is so frequently emphasized by A. Bastian. By regarding a simple implement outside of its surroundings, outside of other inventions of the people to whom it belongs, and outside of other phenomena affecting that people and its productions, we cannot understand its meaning. The only fact that a collection of implements used for the

same purpose, or made of the same material, teaches, is that man in different parts of the earth has made similar inventions, while, on the other hand, a collection representing the life of one tribe enables us to understand the single specimen far better. Our objection to Mason's idea is, that classification is not explanation.

His method, as far as applied to objects which have a close connection with each other, is very good. The collection of moon-shaped Eskimo knives or labrets from North-west America, has given us great pleasure, and enables us to trace the distribution of those implements; but even they do not fully answer the purpose of ethnological collections ... We want a collection arranged according to tribes, in order to teach the peculiar style of each group. The art and characteristic style of a people can be understood only by studying its productions as a whole.

New York, May 18

**6.III. Otis T. Mason. 1887. "The Occurrence of Similar Inventions in Areas Widely Apart."**
Letters to the Editor, *Science* 9, 226: 534-35.

In his reply, Mason, jousting with Boas, advanced a charmingly simplistic, totalizing view that emphasized the diversity of perspectives that could be brought to bear on museum collections while completely omitting the perspective and involvement of Aboriginal people.

... 2. All curators of anthropological specimens must recognize the following classic concepts: material, race, geographical areas, social organizations, environment, structure and function, and evolution or elaboration. Besides these, there are other minor concepts which enter into a more minute classification.

3. Every scientific anthropologist charged with a great collection has in his own mind decided the order in which these concepts should be considered in the distribution of material, and I consider this the greatest blessing to science. If all the museums in the world were arranged upon the same plan, only one set of philosophical problems could be considered, and the study would be correspondingly circumscribed. If, however, such a measure becomes necessary, I sincerely hope the plan will be that of the national museum at Washington. Let it be distinctly kept in mind that the only difference among curators is the degree of prominence given to each concept.

Replying to Mason (587-89), Boas affirmed that ethnological collections, the ethnological museum, and ethnography were wholly imbricated one with another. This is a clear statement of his larger purpose in assembling, presenting, and studying collections.

My view of the study of ethnology is this: the object of our science is to understand the phenomena called ethnological and anthropological, in the widest sense of these words, – in their historical development and geographical distribution, and in their physiological and psychological foundation.

... It is my opinion that the main object of ethnological collections should be the dissemination of the fact that civilization is not something absolute, but that it is relative, and that our ideas and conceptions are true only so far as our civilization goes. I believe that this object can be accomplished only by the tribal arrangement of collections. The second object, which is subordinate to the other, is to show how far each and every civilization is the outcome of its geographical and historical surroundings. Here the line of tribal arrangement may sometimes be broken, in order to show an historical series of specimens; but I consider this latter point of view subordinate to the former, and should choose to arrange collections of duplicates for illustrating those ideas, as it were, as an explanation of the facts contained in the tribal series. Of course, it is generally impossible to do this, on account of the lack of specimens, or, more frequently, on account of the lack of our knowledge; but it is my ideal of an ethnological museum.

**6.IV.  Franz Boas. 1888. "Gleanings from the Emmons Collection of Ethnological Specimens from Alaska."** *Journal of American Folk-Lore* 1, 3: 215-19.

In an early issue of the *Journal of American Folklore,* Boas noted the American Museum of Natural History's acquisition, in 1888, of a collection of Tlingit objects by George T. Emmons (1852-1945). By this time, the collections of George Gibbs and James Swan were already in place in the Smithsonian. Emmons's first collection was, in effect, a well-documented private collection, but Boas saw in the conjunction of documentation and object a means of preserving and presenting ethnographic knowledge. Emmons's collection was later joined in the American Museum of Natural History by a series of documented collections from the Northwest Coast generated through the ethnographic work of the Jesup North Pacific Expedition, which Boas supervised and in which he participated.

The American Museum of Natural History at New York has recently purchased a very complete collection of ethnological specimens, collected by Lieutenant Emmons during a five years' stay in Alaska. It is of great value to the student of American folk-lore, as the collector has taken great pains to ascertain the meaning of the various implements, particularly of the carvings, and as he has recorded the traditions referring to them. The specimens were collected among the various tribes of the Tlingit,

and an examination of the collection will repay the student and materially increase our knowledge of this remarkable nation.

It will be seen from these brief remarks that the collection embodies a vast amount of new information regarding the folk-lore and customs of the Tlingit and we wish through these lines to call attention of ethnologists to the rich source of information laid open to them.

### 6.V.  Douglas Cole. 1985. *Captured Heritage: The Scramble for Northwest Coast Artifacts.*

Vancouver: Douglas and McIntyre, 106, 107, 108. © 1985 by Douglas Cole, published by Douglas and McIntyre, an imprint of D&M Publishers Inc. Reprinted with permission from the publisher.

In his own early field collecting, Boas's goal was the exemplification of thought and practice, not antiquity per se. This approach emphasized documentation of the practical and intellectual context as a component of the collecting process. It also opened the door to the commissioning of new work produced according to established patterns. As Douglas Cole (1938-97) wrote,

> Boas brought to his Nuwitti collecting the sensitivities of a seasoned fieldworker and the discriminating taste of an experienced ethnographer and museum man. This latter was a new element to coastal collecting. Swan had had sensitivity and Jacobsen a hardy ingenuity, but neither had the respect for artifacts as scientific specimens and ethnological examples which Boas, as one of Bastian's bright young men, possessed. This affected both what and how he bought.
>
> ...
>
> The objects [collected at Nuhwitti] were not curios; they were objects whose significance, as he later wrote [Boas 1907, 928], came from the thoughts clustered around them.
>
> ...
>
> [At Nuhwitti,] [Boas] also put two women to work weaving mats and blankets for him.

### 6.VI.  George Dorsey. 1899. "Notes on the Anthropological Museums of Central Europe."

*American Anthropologist* n.s. 1: 465.

George Dorsey (1868-1931) of the Field Museum subscribed generally to this principle, although he took a particularly evolutionary view. In three early articles in *American Anthropologist*, Dorsey (1899, 1900, 1901) articulated the basis for systematic collecting of artifacts for museums. Artifacts, collected and documented by ethnographers in the field, were to represent the works of man and, by their visible differences, exemplify the differences among cultures. Artifacts were to be unwritten documents of culture.

It should be the object of the present generation of museum men to collect material from the different races of the earth, and to classify and exhibit it as such.

**6.VII. Franz Boas. 1899. Letter to George Hunt, 12 January.** American Museum of Natural History Accession Records, Accession 1899-50.

In the ethnography that Boas developed in the years following his first visit to the Northwest Coast, his view and reporting were retrospective, with a focus on reconstructing the life of the mid-1800s or earlier. Boas wrote to his collaborator George Hunt (1854-1933) in 1899:

The best thing you can do would be to sit down and think what the Kwakiutl used for cooking, including every thing from beginning to end, then what they used for wood-working, for painting, for making basket-work, for fishing, for hunting etc. In order to help you in this matter I am sending you a list of the ordinary household things that we have in this museum.

**6.VIII. Franz Boas. 1900. Letter to John Swanton, 5 June.** American Museum of Natural History, Division of Anthropology, Accession 1901-31.

For his doctoral student John Swanton (1873-1958), beginning fieldwork among the Haida, Boas provided a letter containing detailed instructions concerning the questions Swanton was to endeavour to answer. The letter made clear Boas's concerns over comprehensiveness and detail and information relating to the meanings of things as much as the things themselves.

In regard to specimens, I wish to call your attention to the following. I desire to have, if you can get it, a series of good models of houses, totem-poles, memorial columns, and graves, with fullest description of the significance of all carvings. I wish you to obtain for the Museum one large good totem-pole, one memorial column, and if possible, one grave-post; also painted planks, if any can be found. As to other speci-mens, every thing that you can get fully described will be highly desirable, particu-larly old painted blankets and dance-aprons with description, and ivory attachments of shamans' dresses with explanation of their significance, also stone charms and amulets used by the people, carved goat-horn spoons if fully explained or if particu-larly good, masks if fully explained, rattles also if fully explained. Please inquire particularly in regard to the significance of the raven rattle with hawk face on its lower side and the lying figure on its back? What is the legend of the origin? How are they used and how are they held in dances? What is the difference between these rattles and the round rattles, most of which represent birds or heads? Are they used in

different ceremonials? What is the use of the rattle set with puffin-beaks? What is the significance of the clapper, most of which represent the killer-whale? Specimens of all of these, if fully explained, are desirable. A series of whistles with explanations would also be good to have. Do you consider the flageolet as an imitation of European patterns or as their own invention? Please inquire particularly in regard to hammered copper figures. The Haida used to make small figures out of copper nuggets. We should like very much to have some of these. Inquire in all detail in regard to the ancient use of so-called tobacco. It is said that the Indians used to raise a plant, which may have been a poppy, which they mixed with lime made of burnt shells. What can you learn about the origin of the use of copper plates? Have these copper plates individual names? How are they treated? How is their value determined? Does their value increase when they are used in a number of potlatches? Try to collect traditions regarding visits to the future world and visits of the shamans to that world. Please try to get explanations of as many paintings and carvings as you can with special reference to their system of conventionalism. The edges of blankets and old painted mats are good subjects for this inquiry. It may also be a good plan to get a good Indian artist to make drawings for you and to tell you what they mean. It seems that on some of their basketry the Haida use geometrical figures. If so, try to ascertain what these figures signify. You will find such woven geometrical figures on mats made by a different stitch in weaving, and on baskets made by means of dyed roots.

**6.IX. Franz Boas. 1900. Letter to John Swanton, 5 June.** American Museum of Natural History, Division of Anthropology, Accession 1901-31.

In the original letter, this excerpt appears before the one that appears above [6.VIII] .

In investigating this matter it should be borne in mind that the name of the Eagle people, G it'ins, may possibly be derived from a Tsimshian stem, "g it" in Tsimshian meaning people. I believe one of the best ways of investigating this matter will be the collection of traditions, and the fullest possible explanation of carvings on totem-poles and on smaller objects on which the crest is marked. It is also necessary to investigate what relation the various carvings on the totem-poles possess. Probably they do not all belong to the same family, or do you find any totem-poles that represent the complete myth? It would be well to obtain a number of well-carved models of authentic totem-poles with full explanation. Any other objects, such as masks, head-dresses, spoons, boxes, etc., bearing carvings representing crests, will also be of great importance. You will take along before your departure a considerable number of drawings of such objects. Please try to obtain the explanation of all of these.

**6.X. Edward Sapir. 1911. "An Anthropological Survey of Canada."** *Science* 34, 884: 792, 793.

Apart from the American Museum of Natural History, the museum that most immediately felt the effect of the Boasian philosophy was the National Museum of Canada (then the Victoria Memorial Museum) in Ottawa. In 1911, Boas's student Edward Sapir (1884-1939), the first director of the newly constituted Anthropology Division, published an article in *Science* that became a virtual mandate for the ethnological work of the museum for the next eighty years. Sapir's focus was the resolution of various ethnological issues relating to the history and character of Aboriginal societies in Canada through the application of the techniques of ethnology, archaeology, physical anthropology, and linguistics. The collecting of objects was an associated form of collecting ethnological data – data that he and his contemporaries believed would soon disappear.

> In the West Coast area many cultural problems likewise await investigation. Only of the Kwakiutl can it be said that we have a really exhaustive series of studies, due to Dr. Boas's many years of research, accessible to the student. For the Haida and Tlingit much of fundamental value has been already published, notably by Dr. Swanton, yet here our knowledge is less complete. Of other important tribes of the area, (Bella Coola, Bella Bella, Tsimshian, Coast Salish and Nootka) we are relatively uninformed, except in regard to particular points here and there. Further research on these latter tribes will not only serve to give us a more complete picture of the distinctive culture of this region, but may cause us to modify somewhat our idea of certain fundamental elements of the culture.
>
> ...
>
> Now or never is the time in which to collect from the natives what is still available for study. In some cases a tribe has already practically given up its aboriginal culture and what can be obtained is merely that which the older men still remember and care to impart. With the increasing material prosperity and industrial development of Canada the demoralization or civilization of the Indians will be going on at an ever increasing rate. No shortsighted policy of economy should be allowed to interfere with the thorough and rapid prosecution of the anthropological problems of the dominion. What is lost now will never be recovered again.

**6.XI. Douglas Cole. 1985.** *Captured Heritage: The Scramble for Northwest Coast Artifacts.*
Vancouver: Douglas and McIntyre, 2. © 1985 by Douglas Cole, published by Douglas and McIntyre, an imprint of D&M Publishers Inc. Reprinted with permission from the publisher.

The development of a collection took place in the context of exchanges between Aboriginal owners and non-Aboriginal collectors, between collectors and

institutions, and between Aboriginal entrepreneurs and non-Aboriginal entrepreneurs. By the time Sapir published his article in *Science,* the trade in objects between Aboriginal people and Europeans had been in progress for at least 135 years.

> The lively market in curiosities that sprang up in the coves and on the beaches of the north Pacific coast in the eighteenth century showed some features that would mark the entire history of the collecting process. One of the most striking was the keen trading abilities of the natives. Pérez was the first but not the last to note that the Indians were accomplished traders. The Nootkan who greeted Cook's *Discovery* as she came into the Sound offered his hat and other things for sale when he had finished his welcoming speech. Midshipman Edward Rioux and his mates were at once convinced that these people "were no novices at that business." The stratagems of the practiced trader were immediately recognizable, even where they differed slightly from European custom. Malaspina, echoing George Dixon, wrote that "they not only keep hidden the goods which they intend to trade, but also never act with greater indifference than at those times." The Tlingit would delay, often over an hour, before even uncovering the pelt, doll, or spoon which they then offered for everything within view.

**6.XII. Edward Sapir. 1911. Letter to Charles F. Newcombe, 19 December.** Canadian Museum of Civilization, Edward Sapir Correspondence, Catalogue Number 1-A-236M, Box 630, File 52. © Canadian Museum of Civilization.

> Our West Coast material, owing largely to the purchase of some of your own collections, is good as far as Kwakiutl, Haida and Tsimshian are concerned but we could well afford to get plenty more material from the Nootka, Coast Salish, Bella Coola, and Tlingit, not to speak of the interior tribes of British Columbia. I hope that as you obtain information in regard to desirable collections, whether from the west coast or other parts of Canada, you will bear us in mind as possible purchasers and drop me a line in regard to them. We are yet very far from the stage at which we can say "enough." Of course you understand that we do not want to go on collecting halibut hooks and Tsimshian horn spoons ad infinitum.

**6.XIII. Edward Sapir. 1925. Letter to Harlan I. Smith, 23 June.** Canadian Museum of Civilization, Edward Sapir Correspondence, Catalogue Number 1-A-236M, Box 633, File 40-41. © Canadian Museum of Civilization.

> [M]y own tendency is to purchase rather than not to buy, if there is doubt, as first-class Indian material is always a value for a museum even if one pays a little higher he is glad as time goes on to have the material.

**6.XIV. Edward Sapir. 1913. Letter to James Teit, 7 May.** Canadian Museum of Civilization, Edward Sapir Correspondence, Catalogue Number 1-A-236M, Box 635, File 12-17. © Canadian Museum of Civilization.

James Teit (1864-1922) worked on contract with both Franz Boas and Edward Sapir. He also assembled collections that he offered to Sapir for the National Museum of Canada. The museum's ability to collect depended not only on the availability of collections but also on the larger economic and political environment.

Dr. Boas has asked me whether I would care to purchase some seventy or eighty baskets that you have on hand and that you have been using for your paper on basketry. Could you kindly give me some idea of this collection, and whether you think it will duplicate to any extent what we already have on hand and what is to be included in your forthcoming Thompson River shipment? Dr. Boas specified that he would have to reserve the right to make use of these baskets. I do not know what he means but presumably he has reference to photographing them or making drawings from them for your paper. If so, I think it would be best to have all that kind of work done before we take over the baskets, should it seem advisable to purchase them. I will want to have a good deal of photographing of specimens done here for various lines of work which we have in progress, and as the Photographic Department is always more or less rushed, I should not like to encumber them with more work than is really necessary. Please let me know what tribes are represented in your collection.

**6.XV. Edward Sapir. 1914. Letter to James Teit, 4 September.** Canadian Museum of Civilization, Edward Sapir Correspondence, Catalogue Number 1-A-236M, Box 635, File 12-17. © Canadian Museum of Civilization.

World War I intervened, redirecting government funds and curtailing the museum's expenditures.

I regret, of course, very much that the present necessity of economizing has compelled me to write you some time ago that we could not at this moment consider purchase of your second Thompson River collection. I do not believe that it would be possible to have the Auditor General pass an item for insurance of your specimens, particularly as technically such material would not be our property at the time that it is insured. I think it would be simpler if you simply shipped us your material and allowed us to hold it for you until such time as we could purchase it.

**6.XVI.  James Teit. 1914. Letter to Edward Sapir, 21 September.** Canadian Museum of Civilization, Edward Sapir Correspondence, Accession Number 75/158, Catalogue Number 1-A-236M, Box 635, File 12-17. © Canadian Museum of Civilization.

Were I in an easier condition financially I would not hesitate to do this even if I had to wait a year or more for the money, but I am so placed that I may have to use the collection as an asset to draw money on. If things continue normal as they have been lately I probably will not require to do this, but if any abnormal conditions arise such as sickness in my family &c I will have to depend on getting back my money by selling the collection as quickly as I can and wherever I can. For this reason I do not care to let it out of my hands without receiving the money for it. Possibly elsewhere I might get a rather bigger figure for it than I am charging you, but I do not consider this as I am not out for profit and as I stated before I am anxious that you should get it as it is certainly required by you to fill a gap which should be filled and later on will be much more difficult to fill than at the present time.

**6.XVII.  James Teit. 1915. Letter to Edward Sapir, 2 February.** Canadian Museum of Civilization, Edward Sapir Correspondence, Accession Number 75/158, Catalogue Number 1-A-236M, Box 635, File 12-17. © Canadian Museum of Civilization.

As Teit tried to place the collection elsewhere, his correspondence with Sapir raised the issues of antiquarianism, the relationship of objects to knowledge, and the practicalities of representing the knowledge of an earlier day through objects purchased or commissioned in the present.

I tried to sell my collection to Mr. Heye in New York but he is willing only to buy those things in it which have actually been in use no matter how good the others are, and he proposes to have them sent to him for inspection first. I don't mind sending them for inspection as much but think that his buying only things which have seen actual service is not on the whole the best method of showing the old culture of an area. Specimens in use now a days are generally more or less modified and not true types of the old culture although of course they have their value. It would be impossible to get a clear and full idea of the *old* material culture of this area (or I suppose now a days any area except the Eskimo) by purchasing specimens only of the things now in use. The only way to do is to obtain from the Indians who have the knowledge specimens made by them which are true copies of the things formerly in use. Most of my collection consists of this kind of material, the specimens having been used only to the extent to show they were actually serviceable such as some kinds of

tools, and games &c. and clothes worn a time or two at a dance or a gathering or for the taking of pictures and then sold to me. The same styles of clothes (in most cases) would not be made for continued use by the Indian now a days. For instance men's buckskin clothes now a days for actual use consists of fringed pants and chapps, long & short coats, vests, and shirts every one of which is entirely new form copied from the whites or old styles very much modified. No old style shirts are used at all excepting rarely only in dances &c. I do not intend to split the collection in the way Mr. Heye would like nor go to the trouble of shipping him specimens on approval except I am absolutely forced to it by necessity.

**6.XVIII. Edward Sapir. 1915. Letter to James Teit, 9 February.** Canadian Museum of Civilization, Edward Sapir Correspondence, Catalogue Number 1-A-236M, Box 635, File 12-17. © Canadian Museum of Civilization.

I am not surprised to learn that Mr. Heye did not wish to take your collection as it was, but wanted to eliminate all objects that had been in use. This is one of his well known hobbies. You understand, of course, that Mr. Heye is far from being what we call a scientific collector. He is, after all is said and done, a curio collector on a vast scale. He would be the last man that I should care to dispose of scientific material to. As I happen to know he is not always very scrupulous in his methods of amassing material either.

**6.XIX. George Hunt. 1904. Letter to Franz Boas, 24 May.** American Museum of Natural History, Accession 1904-41.

Like Teit, George Hunt worked independently and collected both objects and information. In 1904, Hunt acquired the Yuquot whalers' shrine for the American Museum of Natural History. One of the largest and most complex assemblages of objects collected during this period, composed of sculptures of human figures, small sculptures of whales, and human skulls, the shrine was a ritual site belonging to one or more chiefs who had the right to hunt whales or to cause whales to die and drift to rest along a certain stretch of shoreline (Jonaitis 1999).

My Dear Dr. F. Boas,
... all the chiefs at Notka [sic] went out on the schooners to Hunt for Fur-seals and now I would only have to wait for them to come [home] for they could not sell anything without asking there [sic] Head Man first. I will write and let you know what the chief will say about the Whaling House on the West Coast whether he will sell it or not.

**6.XX. George Hunt. 1904. Letter to Franz Boas, 6 December.** American Museum of Natural History, Accession 1904-41.

In this mail I have sent you 26 Pages of what a Man's wife has to know about cuting [sic] a salmon into *Xamas* or Dryed salmon and what she has to Do with the Rest of the Eateble on the salmons Body. I think you will like to Read it for I Did Not know that a yallnEklwenox or a man who goes out to catch salmon in these Rivers has to have a wife who got to know so Much. For she has to know all about cuting all kind of salmon and How to cure them. All what you will find on these 26 Pages this is only about *gwaxnes* or Dog Salmon. Now I am writing about the Indian women cooking all about salmon first. I sent a Letter to Nootka a few Days ago and my man wants me to go to see him for he said that he has Brought all the Emeges [sic] and House out of the Lake. And are Ready to Be Out on Bord the steamer and if he Don't send it away this month I will Have to go, yet he told me on his last letter that he will send it away on the first Boat that comes his last letter Dated 27th of last month so I think that the collection is gone By this time.

**6.XXI. Harlan I. Smith. 1928. Letter to Diamond Jenness, 5 July.** Canadian Museum of Civilization. Diamond Jenness Correspondence, Catalogue Number 1-A-164M, Box 657, File 50-51. © Canadian Museum of Civilization.

While many Aboriginal artists and artisans made and sold their work independently, Alfred Adams, a Haida merchant and entrepreneur, shipped a substantial number of basketry hats from the Queen Charlotte Islands to purchasers outside. Smith (1872-1940) wrote from the field to Diamond Jenness (1886-1969), then head of the Anthropology Division of the National Museum of Canada.

[Adams] is on his (fourth, I believe) annual trip to wholesale baskets &c. He says so far he loses some but hopes to establish a market with some big firm such as Hudson's Bay. (I suggested Hudson's Bay to him 2 years ago) so as to help his people & to keep alive the art. I got a few baskets from him for the museum.

**6.XXII. Edward Sapir. 1915. Letter to James Teit, 10 February.** Canadian Museum of Civilization, Edward Sapir Correspondence, Catalogue Number 1-A-236M, Box 635, File 12-17. © Canadian Museum of Civilization.

The anti-potlatch clause was not dropped from the Indian Act until 1951 and was in force through the main period of collecting. In 1922, a prosecution under this clause resulted in William Halliday, an Indian Agent for the Department of Indian Affairs, confiscating regalia belonging to Kwakwa̱ka̱'wakw families from

Alert Bay and Cape Mudge. Halliday sold a portion of the material to George Heye of the Heye Foundation in New York (now the National Museum of the American Indian, Smithsonian Institution). A second portion was transferred on loan by Duncan Campbell Scott, the Deputy Superintendent of Indian Affairs, to the Royal Ontario Museum. The objects that were sent to the Department of Indian Affairs in Ottawa and retained there were transferred on loan to the Victoria Memorial Museum, where they were accepted by Edward Sapir, whose own opposition to the anti-potlatch law had been expressed through letters solicited from leading anthropologists and sent to Scott in 1915.[10] In 1978, the Victoria Memorial Museum's descendant, the National Museum of Canada, agreed to return the objects to two museums, the U'mista Cultural Centre in Alert Bay and the Kwakiutl Museum in Cape Mudge.

Dear Mr. Teit

You doubtless remember that when out in Alberni I wrote to you in regard to the potlatch excitement. The matter seems of late to have taken a somewhat concrete form, and has been referred by the Deputy Superintendent General of Indian Affairs, Mr. D.C. Scott, to our Division for advice. Among other things, I am desirous of obtaining a number of statements from various anthropologists who have had first hand acquaintance with the potlatch as to their opinion on the subject, the emphasis being, of course, put on the injustice that would be done the Indians by ruthless abolition of the custom. I shall, therefore, be much obliged to you if you can let me have a statement, in letter form, as to your point of view.

Yours very sincerely,

**6.XXIII. James Teit. 1915. Letter to Edward Sapir, 19 February.** Canadian Museum of Civilization, Edward Sapir Correspondence, Accession Number 75/158, Catalogue Number 1-A-236M, Box 635, File 12-17. © Canadian Museum of Civilization.

Dear Dr. Sapir,

I enclose some ten short pages in connection with the Potlatch. Perhaps I have covered too much ground but then you did not hold me to any particular points and I thought it would not hurt the Ind. Department to know a good deal ... Some of the Indians are after me pretty often for their photos so please hurry them up a little if it is possible ...

P.S. I have seen Dr. McKenna one of the Commissioners on Ind. Affairs for B.C. several times and have had a number of talks with him re the potlatch &c & he is in favour of annulling the law against it. Prob. he has brought influence to bear on Mr. Scott & so the latter has approached you.

**6.XXIV. Edward Sapir. 1915. Letter to James Teit, 8 March.** Canadian Museum of Civilization, Edward Sapir Correspondence, Catalogue Number 1-A-236M, Box 635, File 12-17. © Canadian Museum of Civilization.

Dear Mr. Teit,

Thank you for your potlatch letter, which I had copied and forwarded to Mr. Scott.[11] I have no doubt that it will help along the good cause.

**6.XXV. James Gilchrist Swan. 1870. *The Indians of Cape Flattery, at the Entrance to the Strait of Fuca, Washington Territory.*** Smithsonian Contributions to Knowledge, Vol. 16, article 8. Washington, DC: Smithsonian Institution, 42.

James Gilchrist Swan first published an account of his experiences on the west coast of the United States in 1857. Through his work and residence at Neah Bay and Port Townsend, and through his correspondence with and collecting for the Smithsonian Institution, Swan developed a strong interest in the culture of the Native American people of the Olympic Peninsula. His 1870 ethnography was the work of a sojourner with scientific ambitions, and his text presented ethnographic description with journalistic immediacy. It reflected the fact that, in the late nineteenth and early twentieth centuries, the development of collections and the development of ethnographies followed roughly parallel courses.

BOXES, BASKETS, MATS &C. – Vessels for carrying water, and large boxes for containing blankets or clothing, are made in the following manner: a board as wide as the box is intended to be high, is carefully smoothed with a chisel, then marked off into four divisions, and at each of the marks cut nearly in two. The wood is then wet with

Fig. 25.

Fig. 26.

**FIGURE 6.1** Wooden bowls, 1870. Original line drawings. James Gilchrist Swan collected and documented many ethnographic artifacts used by the Makah. He writes that these bowls were manufactured principally by the Clayoquot Indians, because the Makah had little access to good cedar. From James Gilchrist Swan, *The Indians of Cape Flattery, at the Entrance to the Strait of Fuca, Washington Territory*, Smithsonian Contributions to Knowledge, Vol. 16, article 8 (Washington, DC: Smithsonian Institution, 1870), 42. Originally Figures 25 and 26.

warm water, and gently bent around until the corners are fully formed. Thus three corners of the box are made, and the remaining one formed by the meeting of the two ends of the board, is fastened by wooden pegs. The bottom is then tightly fitted in by pins, and the box is made. The water box or bucket consists of one of these, and the chest is simply two large boxes, one shutting down over the other. These boxes are manufactured principally by the Clyoquot Indians, very few being made by the Makahs, on account of the scarcity of good cedar. They procure these by barter, and every lodge has a greater or less number of them according to the wealth of the occupants. Many have trunks purchased from the whites, either of Chinese or American manufacture, but although they can readily supply themselves at cheap rates with these as well as with water pails, they prefer those used by their ancestors. Wooden bowls and dishes are usually manufactured from alder.

**6.XXVI. George T. Emmons. 1907. *The Chilkat Blanket.* With Notes on the Blanket Designs by Franz Boas.** In *Memoirs of the American Museum of Natural History.* Vol. 3, part 4. New York: American Museum of Natural History, 338.

Originally an officer in the United States Navy, George T. Emmons arrived on the coast thirty years after Swan and spent his formative years not in Washington Territory but in Alaska. Like Swan, he had trained in the eastern United States for one profession and lived much of his life on the West Coast pursuing another. In his publications *The Chilkat Blanket* and *Basketry of the Tlingit,* connoisseurship, collecting, and ethnography converged.

The cutting of the warp being completed, each bundle of lengths is middled and hung over the head line, and sorted to its length, gradually decreasing from the middle to either end; and the lacing of fine cord or split spruce-rout is rove off, which attaches the head line to the head batten, when the body of the blanket may be said to be set up ready for the weaver, who has abstained from food on the day she accomplishes this work, as she must also do on the day she commences to weave.

All now being in readiness, with the warp hanging in position, the weaver seats herself on a goat or caribou skin before the loom in the characteristic Tlingit pose, – the knees drawn up to the chin, the feet close to the body, the shoulders inclining forward, and the arms around the knees, – and proceeds to secure the warp in place by means of one or two lines of plain two-stranded woof-twining around each double-warp element close up to the head line, over which they are hung (Fig. 536, A [Figure 6.2]); but in the case of the extreme outer warp-strands – which do not enter into the weave proper, but go to form the ornamental border-braiding – a greater number are enclosed in each twining. This weave – wactu qaki ("close-together

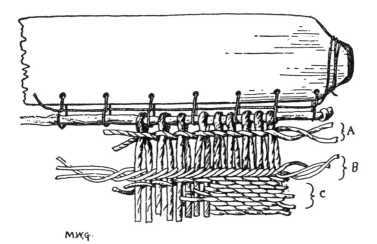

Fig. 536.   Batten and Weave forming Upper Border of Blanket.

**FIGURE 6.2** *Batten and weave forming upper border of blanket,* 1907. Original line drawing. George T. Emmons, an independent photographer with no formal training in ethnology, collected and documented Tlingit basketry and blanket-weaving practices. From George T. Emmons, *The Chilkat Blanket,* in *Memoirs of the American Museum of Natural History,* Vol. 3, part 4, Jesup North Pacific Expedition (New York: American Museum of Natural History, 1907), 338. Originally Figure 536.

work"), from the closeness of the texture – forms the standard stitch in Tlingit basketry, but is only used in succession in some very fine old specimens of blanket-work, in the white-ground figures, as a relief to the general diagonal effect of the body-weave.

**6.XXVII. James Teit. 1900.** ***The Thompson Indians of British Columbia.*** In *Memoirs of the American Museum of Natural History.* Vol. 2, part 4, Jesup North Pacific Expedition. [New York: Knickerbocker Press], 213. Courtesy of American Museum of Natural History.

In the early twentieth century, objects were integrated into ethnographic representation in several ways, for example as components of general monographs on Aboriginal societies, as specific foci within general ethnographies, and in monographs on specific aspects of material culture.

Like Swan and Emmons, James Teit had spent his early life far from western North America and had no early training in anthropology. Unlike them, he had married into an Aboriginal society, and in his work he was supervised, although at a distance, by Franz Boas.

One of the earliest general ethnographies to be published within the canon established by the Jesup Expedition, Teit's *The Thompson Indians of British Columbia* exemplified the integration of material objects as components of

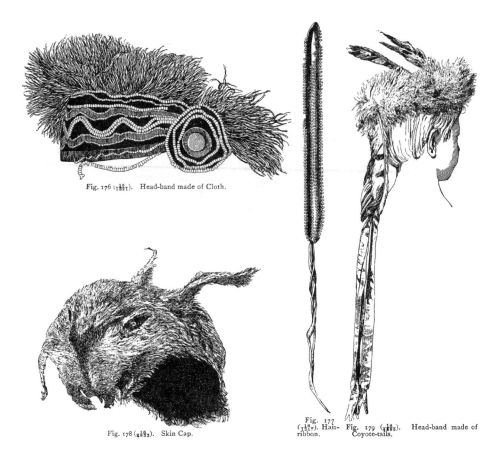

Fig. 176 ($\frac{16}{1541}$).   Head-band made of Cloth.

Fig. 178 ($\frac{16}{1633}$).   Skin Cap.

Fig. 177 ($\frac{16}{1547}$). Hair-ribbon.

Fig. 179 ($\frac{16}{1585}$).   Head-band made of Coyote-tails.

**FIGURE 6.3** Original drawings of objects from the Teit ethnography. The functionality, rather than the materiality, of the "head-band made of cloth," "skincap," and "head-band ribbon with coyote-tails" and feathers is emphasized in these drawings. From James Teit, *The Thompson Indians of British Columbia*, in *Memoirs of the American Museum of Natural History*, Vol. 2, part 4, Jesup North Pacific Expedition, edited by Franz Boas (New York: American Museum of Natural History, 1900), 212-13. Originally Figures 176-79.

ethnographic representation. Writing thirty years after the compilation of Swan's *Indians of Cape Flattery*, Teit used the past tense.

> Caps made of skins of various animals, such as beaver, deer, fox, lynx, loon, hawk, and eagle, were frequently worn. Sometimes the head-skin of the animal served as a cap (Fig. 178 [Figure 6.3]), while the skins of smaller animals were worn so that the head formed the front of the hat, and the tail hung down behind. Many men wore caps made of the skin of the animal that was their guardian spirit. Fig. 179 [Figure 6.3] shows a head-band made of two coyote-tails, and decorated with chicken-hawk

feathers, Red and green ribbons are tied to the back feathers. The front of the band is daubed with red ochre.

Hunters and warriors wore more elaborate head-dresses. Fig. 179 [Figure 6.3] represents a hunter's head-band. It is made of coyote-skin daubed with red ochre. In front is a cross-piece of horsehair, buckskin fringe, and eagle-down. The buckskin fringe is daubed with red; and the body of the horsehair is dyed yellow in a decoction of lichens, while the tips are dyed red. The feathers on top of the band represent deer's ears.

**6.XXVIII. Franz Boas. 1909. *The Kwakiutl of Vancouver Island.*** In *Memoirs of the American Museum of Natural History.* Vol. 8, part 2, Jesup North Pacific Expedition. Leiden: E.J. Brill; New York: G.E. Stechert, 382. Courtesy of American Museum of Natural History.

The association between Boas and Hunt informed much of the Kwakwaka'wakw ethnography published during these decades, but its results in terms of the integration of material culture into ethnographic representation were most clearly seen in *The Kwakiutl of Vancouver Island*. A spliced piece of kelp line, now in the American Museum of Natural History (16/2140), and two reels of bark string (16/5957 and 16/2197) illustrate the making of trolling lines and techniques for splicing pieces of wood. The tense, once again, is present.

Trolling-lines are made of young kelp (Fig. 72 [Figure 6.4a]). These lines are prepared by men. The kelp is dried over a fire of alder picked up as driftwood on the beach. The kelp shrinks to a very even thickness, the fibre twisting to a certain extent. The method of splicing parts of the fish-line is shown in the illustration.

For tying, thread of nettle-fibre, made as described before, is used. For holding splices of wood, the bark of *Primus emarginata, v. villosa Sudw* (ɬE'nᵉwum) is used. It is peeled in spiral lines around the tree, a cut slanting upward being first made. It is kept wound up on reels (Fig. 73 [Figure 6.4b]).

For tying harpoon-heads, nettle-fibre unspun, or porpoise-sinew, is used. Sewing is done with deer-sinew. The holes for passing the thread through are made with awls made of the ulna of the deer or of splinters of bone.

**6.XXIX. John Reed Swanton. 1905. *Contributions to the Ethnology of the Haida.*** In *Memoirs of the American Museum of Natural History.* Vol. 8, part 1, Jesup North Pacific Expedition. Leiden: E.J. Brill; New York: G.E. Stechert, 128-29. Courtesy of American Museum of Natural History.

*Contributions to the Ethnology of the Haida* reflects the care John Reed Swanton took to carry out the instructions Boas had provided at the inception of his fieldwork in 1900.

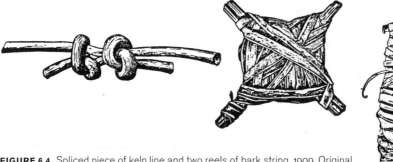

**FIGURE 6.4** Spliced piece of kelp line and two reels of bark string, 1909. Original line drawings. Boas illustrated how trolling lines stored on bark reels were made by splicing dried kelp together. From Franz Boas, *The Kwakiutl of Vancouver Island,* in *Memoirs of the American Museum of Natural History,* Vol. 8, part 2, Jesup North Pacific Expedition (Leiden: E.J. Brill; New York: G.E. Stechert, 1909), 382. Originally Figures 72 and 73.

In addition to the main house-pole, the greatest chiefs had an inside pole. This was placed in the middle of the rear part of the house, the seat just in front of it being that always reserved for the highest in rank ...

The original of Fig. 8 was obtained for the American Museum of Natural History by Dr. Newcombe. Although it was the inside pole of a house at Skedans, it belonged to William and Timothy Tait of Ninstints, who derived the right to it through their mother. The upper figure is an eagle, the lower a cormorant, – both crests of the Eagle clan, and probably in this case of the Ninstints Git'ins.

Figs. 9 and 10 represent inside house-poles which formerly stood at Skidegate, but are now in the vestibule of the Provincial Museum of British Columbia at Victoria. I obtained two explanations of the carvings, – one from Tom Stevens, chief of Those-born-at-Rose-Spit, whose family has long intermarried with those of Skidegate; and a second from Amos Russ, whose parents belonged to the chief families of Skidegate. These agree in their explanations of the designs on the first, except that Tom Stevens gave the name of the chief who owned it as Ga'nxuat, and Amos Russ as Do'ganakilas ("though youngest, must be obeyed"); but both were said to have been chiefs of the Giti'ns. At the top of this pole (fig. 9) is a raven, represented, as is often the case, with frogs coming out of its mouth; under this is a boy, said to be introduced merely to fill up space, and below that, a thunder-bird with a common whale in its talons. Thunder-birds were supposed to feed upon whales. The raven is a valued crest of the Giti'ns; but the thunderbird-was a Raven crest, and perhaps belonged to the house-owner's wife.

The name of the chief in whose house the original of fig. 10 stood is given by Amos Russ as Minit or Ka'na, and by Tom Stevens as Q!a'moti (or Q!a'moxdi). He belonged to the same family as the owner of the preceding. At the top of this pole is an eagle,

crest of the Eagle clan; but my informants differed regarding the rest of the design. Amos Russ explained it as a representation of Gunanasî'mgît's wife being carried off by the killer-whale, the woman's face showing just below the eagle's beak, and the whale's blow-hole being represented by a small face above the face of the killer-whale. Tom Stevens, however, explained the large figure at the bottom as that of a grisly bear, presumably meaning thereby the sea grisly bear; and the small figure over it as the sea-ghost (tca'gan q!a'txuna-i) which usually rides upon its back. The woman's face he left unexplained; and I am inclined to think that he is in error, and that Amos Russ's explanation is the correct one. The killer-whale (or sea grisly bear) may have been a crest of the house-owner's wife.

**6.XXX. Franz Boas. 1897.** *The Social Organization and the Secret Societies of the Kwakiutl Indians. Based on Personal Observations and on Notes Made by Mr. George Hunt.* In *Annual Report of the US National Museum for 1895.* Washington, DC: US Government Printing Office, 379.

In this text, Boas and Hunt provided a richly detailed, descriptive chronicle in which genealogy, ceremony, song, and object were interwoven. For the illustrations, Boas used line drawings of objects in the US National Museum (Smithsonian) and the Royal Ethnographical Museum of Berlin as well as "sketches" that look remarkably like precise, detailed drawings of objects seen at the World's Columbian Exhibition in 1893. The illustrations for this work included and contextualized objects collected by Boas, Swan, and Jacobsen.

Figure 21 [Figure 6.5] represents a totem pole, which was standing until a few years ago in front of a house in Xumta'spē (Newettee [Nuhwitti]). The crest belongs to the subdivision G·'ēk·'ō'tē of the clan G·î'g·îlqam. According to the legend, these people are the descendants of G·'ō'tē, the son of K·ēpusalaōqoa, the youngest daughter of Kuē'xag·ila, the son of Hātaqa, the daughter of O''meaL ... They have, the Ts'ō'noqoa, a man split in two, another man, wolf, beaver, and the sea monster ts'ē'qie for dishes. A man named NE'mqEmalîs married a daughter of the G·'ēg·'ō'tē chief, and he had all these dishes made. Later on, a man named Qoayō'LElas married NE'mqEmalîs's cousin. Then he was told to unite the dishes and to carve a totem pole. He did so. The second figure from below is placed upside down because the dish was in the back of the man, while all the others were in the bellies of the carvings. This history may also explain the fact that all the figures are separated on this column, while in most other totem poles they overlap, one holding the other or one standing on the other.

**6.XXXI. Herman Karl Haeberlin, James Teit, and Helen Roberts. 1928.** *Coiled Basketry in British Columbia and Surrounding Region.* In *Forty-First Annual Report of the Bureau of American Ethnology.* Washington, DC: US Government Printing Office, 269.

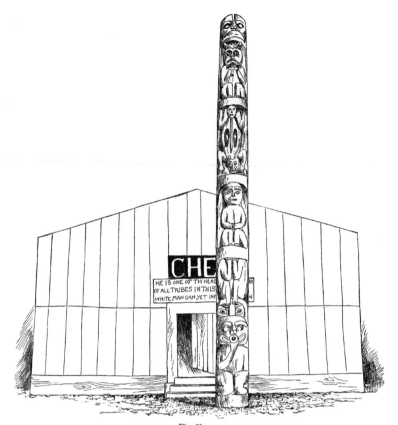

Fig. 21.
HERALDIC COLUMN FROM XUMTA'SPĒ.

**FIGURE 6.5** *Heraldic column from Xumta'spē*, 1897. Original line drawing. Boas's book on the Kwakw̲a̲ka'wakw illustrates how poles depict family histories, like the pole shown here, which once stood in front of a house in the village of Xumta'spē. From Franz Boas, *The Social Organization and the Secret Societies of the Kwakiutl Indians. Based on Personal Observations and on Notes Made by Mr. George Hunt*, in *Annual Report of the US National Museum for 1895* (Washington, DC: US Government Printing Office, 1897; reprinted by Johnson Reprint, New York, 1970), 380. Originally Figure 21.

*Coiled Basketry in British Columbia and Surrounding Region,* based posthumously on the work of James Teit and Herman Karl Haeberlin (1891-1918), and compiled with the help of ethnomusicologist Helen Roberts (1888-1985), not only catalogued Interior Salish basketry techniques and design motives but also provided a detailed examination of issues in design faced by basket makers.

Figure 56 is taken from a basket whose maker was far too ingenious to wrestle with corner problems. That she could have done so better, perhaps, than most of her fellow workers is demonstrated by her remarkably well placed designs and even work. Undoubtedly she preferred a vertical alignment for the loose ends of the superposed

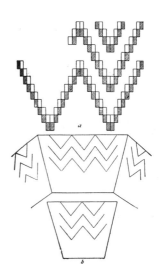

**FIGURE 6.6** Interior Salish coiled basket and pattern, 1928. Original line drawings. The Interior Salish basketry depicted here shows designs and techniques used in basketry from this region. From James Teit, *Coiled Basketry in British Columbia and Surrounding Region,* in *Forty-First Annual Report of the Bureau of American Ethnology* (Washington, DC: US Government Printing Office, 1928), 269. Originally Figure 56.

zigzags rather than the compromises which might have been necessary at the corners. Doctor Haeberlin remarks concerning it as follows:

This basket and its ornamentation are most beautifully made. The regularity shown by the exact measurements proves that in a basket of this kind the surface as such is ornamented and that great pains have been devoted to the task of dividing the surface correctly.

Sketch a, Figure 56 [Figure 6.6], is a reproduction of a section of the pattern, showing the careful nature of the work.

**6.XXXII. Charles F. Newcombe. Ca. early 1900s. Labels prepared for the Field Museum.** CF Newcombe Haida Industries, Vol. 38, Folder 2 (old notebook 47); C.F. Newcombe, Kasaan Notebook, Newcombe Family Papers, BC Archives.

For some collectors, catalogue records served as the primary vehicle for ethnographic documentation. In the labels that he prepared for the Field Museum collection, Charles F. Newcombe (1858-1924) provided a detailed description of the manufacture of mats.

Mats Legus
Made of narrow strips of the inner bark of the red cedar. All are made in two halves and fold down the middle where the warp strands are joined together by a single row

of 2 ply twined stitching. For the most part the weave is the simple checker, but where it is desired to emphasize the design the diagonal or skip-stitch is resorted to. The black lines are produced by the use of strips of bark previously soaked in mud and the orange color by the use of strands dyed with a decoction of alder bark. The smaller sizes are spread upon the ground & used as table cloths. The larger are used as bedding or for wrapping up various articles when traveling, or for covering the body when sitting in canoes in wet weather.

Newcombe collected mat frames (looms) in two sizes. Both were identified by the term "sitskagit."

79474  For making the small mats used when eating or gambling. Two upright sticks for setting in the ground and a cross piece over which the warps of the mat are passed during the progress of the work. [Haida Kasaan, Alaska CFN Coll 1902]

79475  Large mat frame sitskagit. Used when making the mats bedding or wrapping mats. Haida Kasaan CFN Coll 1902

Newcombe also collected examples of cedar bark in several thicknesses as well as the Haida terms that identified them.

79468  Red cedar bark skeluts
The inner layer has been removed. In this form bark is used for making light temporary packing cases. Kasaan CFN 1902

79469  Red cedar bark kutse
The outer part of the inner layer of the bark. Stronger and coarser than the layers next to the tree. Used for the coarser kinds of basketry.

79470  Red cedar bark. Used for making cordage when cut into strips and twisted.

79471  Inner bark of red cedar (ījitlu)
When cut into narrow strips is used for finer cordage and is also made into matting.

79472  Red cedar bark as first removed from the tree.

79487  Large mat of red cedar bark showing process of manufacture. One side finished but ends of weft strands have not been cut off. The other side shows the upper part of the mat finished as far as the 22nd row of strands forming one band of the pattern, & ½ of the second band is also complete. The work proceeds from left to right. A loop of the weft is passed over the bundle of strands forming a roll at the

vertical edge of the mat and is fastened down by the one row of simple twining that starts from the backbone of the mat. Black of natural colored strands are inserted where the pattern requires. On reaching the right hand side of the mat the ends of the weft are turned inwards away from the maker and fastened round a similar roll on that edge by a similar twined weave. The ends of the mat are similarly secured, but there is no roll to turn round. The warp ends are bent diagonally from right to left & flattened by a simple twine. Haida Kasaan, Alaska CFN coll 1902

**6.XXXIII. Charles F. Newcombe. 1905. Letter to Jasper Turner, 10 February.** Newcombe Family Papers, BC Archives.

Ethnographic collecting generally preceded the development of publications. Less frequently, a publication suggested the direction for developing a collection. Desiring to make the Field Museum collection of Nuu-chah-nulth objects as complete as possible, and assisted by a descriptive analysis of eighteenth-century whalers' hats recently completed by Charles Willoughby (1903), Newcombe attempted to commission a new hat in the eighteenth-century style from a Nuu-chah-nulth basket maker. He wrote to Jasper Turner, the brother of Dr. Atliu, with whom he had travelled to the World's Fair in Portland in 1904.

> It will be very good if you can get someone to make the old style of hat I spoke to you about. To make it easier I am sending more drawings.

**6.XXXIV. Virginia Dominguez. 1986. "The Marketing of Heritage."** *American Ethnologist* 13, 3: 548.

Eighty years later ethnological interest had shifted away from the assembling of collections and toward a retrospective examination of the contexts of collecting and a consideration of the collecting initiative and process in terms of theory current in the late twentieth century. Douglas Cole's *Captured Heritage: The Scramble for Northwest Coast Artifacts* (1985) was both vehicle and catalyst for this discussion. Reviewers of *Captured Heritage* tended to focus on the title and the primary theme, and they used the occasion to advance and discuss current ideas concerning collections and the object. In a review article, Virginia Dominguez wrote the following.

> I cannot help but see in this vivid description of what today looks like a mass frenzy confirmation of many of Foucault's claims about the nature of ethnology and the very conditions of its possibility. Ethnological collecting rested on the belief that "it is necessary to use the time to collect before it is too late" (p. 50). Too late for what?

There is a historical consciousness here of a special sort. We hear an urgency in the voices of the collectors, a fear that we will no longer be able to get our hands on these objects, and that this would amount to an irretrievable loss of the means of preserving our own historicity. There is a twofold displacement here. Objects are collected no longer because of their intrinsic value but as metonyms for the people who produced them. And the people who produced them are the objects of examination not because of their intrinsic value but because of their perceived contribution to our understanding of our own historical trajectory. It is a certain view of "man" and a certain view of "history" that make this double displacement possible.

"Man" must mean human beings in all their variations, each with a specific position in space and time and, therefore, a relationship to modern Euro-American people. "Man" must also mean a historical and historicized being, shaped not just by the circumstances of his or her creation but rather continually shaped throughout history. "Man" must additionally mean a thinking being able to represent him- or herself in the product of his or her labor. But herein lie three of the paradoxes of ethnological collecting – that in intending to depict other cultures it is seeking to complete a depiction of our own, that it rests on a strong historical consciousness but concentrates its work on peoples perceived to be without history (Wolf 1982), and that it continually depicts "man" as subject – objectifier, creator, producer – but transforms him into an object and vehicle of knowledge.

**6.XXXV. Douglas Cole. 1991. "Tricks of the Trade: Some Reflections on Anthropological Collecting."** *Arctic Anthropology* 28, 1: 49-50. Reproduced by permission of the University of Wisconsin Press.

In this essay, Douglas Cole responded to analyses of collecting that depended on revisionist views of the role of Aboriginal people in collecting or reflected late-twentieth-century philosophical perspectives unknown at the time collecting took place.

Certainly [collections] can be seen as a product of a colonial encounter, an unequal trading relationship in which, in the long run, the terms of trade were stacked in favor of the dominating economic system. Yet even that view lacks the whiff of field reality: that Natives entered the art and artifact market themselves, often exploited it for their own needs, and often welcomed the opportunities which it offered. Adrian Jacobsen found two West Coast villages so enthusiastic at the prospect of sales that they interrupted their winter dances to bring out their goods. George Dawson, engaged in a geological survey of the Queen Charlotte Island, bought a few items offered by Chief Skedans and soon found himself "besieged by Indians with various things to sell."...

In all this criticism, it is therefore important to maintain perspective. Indians were also participants in the process. They had their own interests, their own values, and their own needs. The most easily collected materials were household items which, with the availability of new goods and materials, had become obsolete. Horn spoons, stone tools, Native bristle brushes, wood bowls, cooking baskets, cedarbark mats, bows and arrows, were falling out of use by the time museum collectors arrived. They were willingly, probably eagerly, sold. Collectors gave them a value which, like yesterday's newspapers, they had lost ... This view [that collections are thefts and trophies of domination] of the collector and the museum risks not merely making a travesty of the truth and of libeling quite decent collectors [most of them all the more vulnerable because they are dead]. More seriously, there is a danger of patronizing arrogance in viewing Natives as naïve victims of exploitative Westerners ... Traditional societies may not have been capitalist societies, but they were never noncommercial ones. Indians of the Northwest Coast were, from their first encounter with Europeans, famous for their trading ability, even notorious for their sharp practices. They had been involved in commercial exchanges since time immemorial. They knew how to trade, how to swing a deal to their advantage, how to capitalize upon a field collector's haste, how to endow an article with a sacred function it may not have possessed, even how to fake new for old. Acculturation only increased their ability to trade well with Europeans. Indeed, there is probably a bias in our sources. Collectors willingly volunteered their success stories, of how they got something for a bargain price; they were less likely to record instances where they came out losers, where they were bilked by Natives. Indeed, some never realized that they had been had.

... Appropriation, "to make one's own," is also used more broadly, more ambiguously ... This mode of thought has become almost fashionable. It seems part of a continuing self-criticism among anthropologists and tribal-art historians, a trend to which curators have also become extremely sensitive ... The very point, made so similarly by Dominguez, MacClancy, Clifford, and Price, is itself a product of a particular phase of the experience of Western postcolonial intellectuals. It could not have been made in the West of the 1920s nor, of course, in any non-Western area before at least 1950, if it appears even now.

**6.XXXVI. Richard Handler. 1992. "On the Valuing of Museum Objects."** *Museum Anthropology* 6, 1: 21.

*Captured Heritage* and its reviews introduced late-twentieth-century philosophic questions into museum collecting's early-twentieth-century equation but left the connection between object and originating society undisturbed at the core of the various arguments. In "On the Valuing of Museum Objects," Richard Handler took issue with this.

There is an enduring tension, in the museum world and beyond, between the idea that the value of objects is relative and contingent, and the idea that true value is based upon universal criteria and is intrinsic to the object itself.

In what follows, I will both explore this tension and argue in favor of a particularly "strong" version of the relativistic position. A strong relativism bluntly states that objects have no intrinsic value or meaning. The treasures that museums collect – "masterpieces" of the fine and decorative arts, ethnographic and scientific specimens, historically illustrative artifacts, documents, natural curiosities – have no intrinsic value or significance apart from the particular social contexts in which we may encounter them. To be meaningful, objects must be surrounded by other objects, by words, by human activity. Without meaningful human activity to create and recreate values, objects are meaningless. The Mona Lisa has no intrinsic aesthetic qualities, no essential beauty or value, no place in "the history of art" apart from the socially transmitted – and therefore always changing – discourse of human beings who attend to it.

**6.XXXVII.  Aldona Jonaitis, ed. 1995.** *A Wealth of Thought: Franz Boas on Native American Art.* Seattle: University of Washington Press; Vancouver: Douglas and McIntyre, 330.

In this text, Aldona Jonaitis provided a retrospective assessment of the approach of Boas a century after he inaugurated the Jesup Expedition.

Boas's efforts to salvage what was disappearing sometimes led to his dismissing what remained. Adherence to what I might call the "purity paradigm" prevented him from recognizing some very creative responses to the acculturative process. In his analysis of the Chilkat blanket, Boas mentions and then disregards the more contemporary versions of these textiles in which the formal conventions are dismantled. And in *Primitive Art*, he refers to the influence of European ware on Native art as "contamination." It is worth noting, however, that despite this, Boas uses models of totem poles, silver bracelets, and argillite carvings as major examples in his analysis of Northwest Coast art. Although he said that he privileged history in his interpretation of culture, he sometimes chose to ignore the history that continued after contact with non-Natives. Although he himself was unable to envision the perpetuation of the Indian cultures he and his colleagues studied, he did lay the groundwork for later investigations of how artworks reflect ongoing Native accommodation to the situation in the colonial and postcolonial world.

NOTES

1   Although the Northwest Coast component of the collection of the Heye Foundation was assembled at this time, I have omitted it from the list. It contains works that are highly

significant to both the history and the art history of the peoples of the coast but frequently lack documentation. The collections of the Royal Ontario Museum are largely those developed by missionaries and other sojourners. The collections of the University of British Columbia Museum of Anthropology are also significant but were developed outside the 1880-1930 time frame.

2   Smith's training was primarily in archaeology and, on the whole, was less comprehensive than the education that prepared Boas, Sapir, and Barbeau for their work. Smith received on-the-job training while working at the American Museum of Natural History under Boas's close supervision.

3   In 1904, Mary Dickson wrote to Newcombe from Skidegate, enclosing six mats she had made, as well as one from Agnes Russ, at a dollar apiece and offering to make more. She added, "and I will attach names to them." Add Mss 1077, Vol. 2, File 47, BC Archives.

4   Smith's work was featured in the exhibit *Emergence from the Shadow: First Peoples' Photographic Perspectives*, curated by Jeffrey Thomas, at the Canadian Museum of Civilization from October 1999 to January 2002.

5   Newcombe to Sapir, 11 December 1912, Canadian Museum of Civilization collection.

6   Sapir to Newcombe, 21 December 1912, Canadian Museum of Civilization collection.

7   See, for example, Wilson Duff's *The Upper Stalo* (1952), an ethnography following the form and spirit of the early-twentieth-century ethnographies to examine a region in which virtually every early ethnographer had travelled but which had not been studied.

8   The development of museum exhibitions in the second half of the twentieth century is another topic, but major ethnographic exhibitions in Canadian institutions include *Children of the Raven* (National Museum of Man, 1975); the new UBC Museum of Anthropology, opened in 1976; and *The First Peoples* (British Columbia Provincial Museum, 1977). Although all of these exhibitions had the illumination of cultural understandings and practices among their primary goals, they were also created with a consciousness that the objects included were the products of a strong aesthetic understanding. "Ethnography" and "art" were intertwined in these exhibits. *People of the Potlatch* (UBC Museum of Anthropology, 1956), a temporary exhibition developed by the UBC Museum of Anthropology and shown in the Vancouver Art Gallery, participated in the understandings that underlay ethnographic exhibitions but foreshadowed the fine art exhibitions that followed on the coast, beginning with *Arts of the Raven*, also shown in the Vancouver Art Gallery, in 1967.

9   *Calder v. Attorney-General of British Columbia*, [1973] S.C.R. 313 (1973), Supreme Court of Canada (31 January 1973).

10   See Marius Barbeau Correspondence, Folder Edward Sapir (1911-1920), Box B237 f.6, Canadian Museum of Civilization.

11   See also ibid.

# 7 | "That Which Was Most Important"

*Louis Shotridge on Crest Art and Clan History*

The past few decades have brought a growing appreciation of the role that Aboriginal cultural experts have, from the outset, played in North Pacific Coast studies. Three early Native or part-Native fieldworkers who generated substantial bodies of written work – George Hunt, William Beynon, and Louis Shotridge (Figure 7.1) – particularly stand out in the history of the field. Of these ethnographic contributions, however, Shotridge's writings have remained little known, despite his familiarity in the literature as a museum collector (recent exceptions are Milburn 1997; Dauenhauer and Dauenhauer 2003; S.C. Brown 2005).

Louis Shotridge (Stoowukáa, ca. 1886-1937), a Tlingit from Klukwan, Alaska, began his relationship with the University of Pennsylvania Museum (UPM) in 1905. From 1912 to 1932, he was employed full time as an exhibit preparer, ethnographer, collector, and curator on the UPM staff (see Louis Shotridge Correspondence [LSC], UPM Archives; Milburn 1997, 113-30). During the years 1917 to 1931, he purchased a collection of Tlingit artifacts for the UPM that is unparalleled in quality and documentation.[1] He also published a number of articles on Tlingit art and culture, and he completed significant portions of at least one monograph.[2] The relative obscurity of his ethnographic writings in comparison with those of Hunt and Beynon arises in part from the limited availability of his publications, in part from the small percentage of his ethnographic writings that did see print, and in part from the loss of most of his field notes and unpublished manuscripts following his death in 1937, at around age fifty-five (Twelfth Census [TWC] of the United States [1900], National Archives; R.L. Wolfe to Horace Jayne, 16 August 1937, LSC). Shotridge is also distinguished from Hunt and Beynon by the degree of independence he enjoyed as an ethnographer and collector; the persistent controversy with regard to his purchase and removal of revered clan heirlooms; and the nature of his interpretive endeavours away from the field, which included writing for museum publications, curating

**FIGURE 7.1** Louis Shotridge, also known as Stoowukáa, was a collector and cultural intermediary of Tlingit descent who collected many Tlingit artifacts for the University of Pennsylvania Museum. UPM Photo Archives, S5-14848.

museum exhibits for non-Native audiences, lecturing to the general public, and conducting school tours (the UPM was then and is still one of the most popular destinations for school field trips in Philadelphia).

Shotridge was born to the Kaagwaantaan clan of Klukwan, also called Chilkat, more specifically to that clan's Long Dorsal Fin House (*Ligooshi Hít*) (Olson

1967, 77-78; Durlach 1928, 174-77; "History and Organization," Unpublished
Ethnographic Notes [UEN]; Milburn 1997, 44).[3] He was a descendant of some
seven generations of marriage between the ranking lineages of the G̲aanax̲teidí,
Kaagwaantaan, and Naanyaa.aayí clans (Figure 7.2). Despite this distinguished
ancestry, and the fact that Shotridge himself later fell heir to the position of Fin
House master, he evinced almost contradictory attitudes toward traditional
Tlingit life. Unlike Hunt and Beynon, Shotridge abandoned many of his trad-
itional chiefly responsibilities – became, in his own words, "negligent in [his]
duties" ("Organization," UEN). An officer and later president of the Alaska Na-
tive Brotherhood, he belonged to a group of prominent Native men and women
who argued that the best future for the Tlingit lay in modernization and edu-
cation. But while he himself felt that Tlingit culture had fallen into a state of
irretrievable decay, he was extremely proud of the past achievements of that cul-
ture, and he believed that modernization should not be embraced at the expense
of traditional Tlingit "character," cultural values, or language (Shotridge 1917,
110-11; 1919a, 56-58; Milburn 1997, 337-38).

As both ethnographer and curator, Shotridge came to be acutely conscious of
his role as cultural intermediary. He hoped to remedy the descriptions of the
Tlingit by non-Native outsiders in which, he wrote, Tlingit culture had been
reduced to "puerile" and "childish" form and that "conveyed all but that which
was most important" (Shotridge 1928, 350, 351). Although trained by both Franz
Boas and UPM director George Byron Gordon, Shotridge was not primarily
interested in interpreting Tlingit material culture through the categories of
North American scholarship. His chief interpretive goals were rather to illumin-
ate essential Tlingit values and champion the worth of Tlingit culture to the
widest possible non-Native audience, thereby bringing "the true character" of
the Tlingit "into the white man's light" (352).

To accomplish this, Shotridge used two complementary strategies in his arti-
cles, lectures, and exhibit texts. First, he sought to relocate the Tlingit within the
frame of reference of his white North American audience. Shotridge has been
criticized for his sometimes obscure or archaic English (e.g., Dauenhauer and
Dauenhauer 2003, 172), but this usage is just one aspect of a set of systematic
translation choices through which he attempted to reframe the Tlingit as com-
parable to the valorized classical cultures ancestral to the West. For example, he
terms the Klukwan Guteel and Xutsx̲án ("Cannibal") carvings the "Posts of
the *Manes*," in analogy to the Latin *manes*, ancestors' spirits to whom the Romans
offered food ("Public School Lectures: [untitled fragments]," UEN). Mythical
personages become deities in a Tlingit pantheon: Tl'enax̲x̲éedak̲, whose scratch-
es bring wealth, becomes the "goddess of Fortune"; Sáanax̲eit, the Southeast

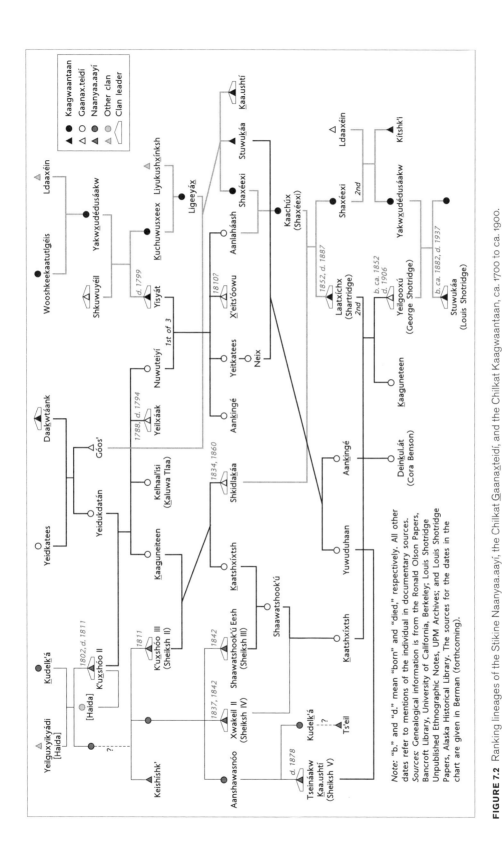

**FIGURE 7.2** Ranking lineages of the Stikine Naanyaa.aayí, the Chilkat G̲aanax̲teidí, and the Chilkat Kaagwaantaan, ca. 1700 to ca. 1900.

*Note:* "b." and "d." mean "born" and "died," respectively. All other dates refer to mentions of the individual in documentary sources.
*Sources:* Genealogical information is from the Ronald Olson Papers, Bancroft Library, University of California, Berkeley; Louis Shotridge Unpublished Ethnographic Notes, UPM Archives; and Louis Shotridge Papers, Alaska Historical Library. The sources for the dates in the chart are given in Berman (forthcoming).

Wind, is the "god of Storm"; Yukis'kukéik is the "god of the tides" (Shotridge 1928, 355; "Beliefs: The Goddess of Fortune," UEN; "Raven's Headdress" and "Yuqis'-kuqék," Alaska Historical Library [AHL]). Shotridge's use of obsolete forms such as "whilom," "yare," and "in eyre" similarly models the archaic style preferred by translators of classical literature in his day (e.g., Euripides 1891; Sophocles 1912; Lucretius Carus 1921).

Second, Shotridge moved his audience into the Tlingit frame of reference, usually by kindling their identification with exemplary Tlingit men and women and, through that, their admiration for Tlingit values. Storytelling was a key tactic here. In one lecture for Philadelphia school children, for example, Shotridge described a first encounter with Europeans in which the Tlingit initially believe they are confronting a dangerous monster: "I imagined myself instead of Táanax, walking out from the forest with no defense or means of escape ... [But] so it was ever in a real man's mind: 'Some one must sacrifice in order to insure safety for all'" ("Public School Lectures: First White Man," UEN).

The ratio of narrative to exposition in Shotridge's writings is relatively large, and most of his narrative is drawn from Tlingit oral tradition. Shotridge made use of both *tlaagu,* stories of remote myth times, and *sh kalneek,* stories about clan ancestors in the human era. Both genres were regarded by traditional Tlingit as being true narratives, and each clan possessed both kinds of stories about its unique past (De Laguna 1972, 1: 210-11; Richard Dauenhauer, personal communication to author, 17 April 2007). In deploying these stories to illustrate Tlingit values and "character," Shotridge was in fact using them to perform one of their traditional functions (J. Berman 2004, 141-46; Milburn 1997, 259). The stories, however, possessed deeper significance for him as well as for other Tlingit.

Clan myths and histories are, as the Dauenhauers have written, in large part about the events through which the Tlingit acquired things of enduring importance. Told "so that all people will know who they are" (Dauenhauer and Dauenhauer 1987, 25-26, 8; Dauenhauer 1995, 23; Olson 1967, vi), they express a fundamental sense of rootedness in the past that anchors life and identity in the present. Traditional history does not, however, take shape only as narrative. Important deeds of the past are also embodied in and commemorated by — "borne" or "carried" by in Shotridge's metaphor — *at.óow,* or validated crest art, as well as by genres of song, dance, and oratory in which such art might be used (Shotridge 1920, 11; 1919b, 44; Dauenhauer 1995, 22).[4] Shotridge saw important crest objects as highly condensed mnemonics; they were, he wrote (paraphrasing George T. Emmons), "a system of picture writing" in which "the history of

my people has been preserved and transmitted through centuries" (Shotridge 1928, 352; Emmons 1907, 347).

For Shotridge, the "true character" of the Tlingit, "that which was most important" about their life and culture, was revealed at this intersection of crest art and traditional narrative, and explicating *at.óow* and the histories they embodied came to be the core of his interpretive project (Shotridge to Gordon, 7 January 1924, LSC; on this subject, see also Dauenhauer and Dauenhauer 1990, 14-153). Shotridge doubtless absorbed the standards for object documentation held by the ethnologists who trained him, as Milburn has argued. But, unlike Boas, who was seeking to build representative collections that also showed variability, or Shotridge's supervisor, UPM director George Byron Gordon, who was interested in craftsmanship and aesthetic qualities as much as cultural significance, Shotridge himself never showed more than a cursory interest in objects that were not associated with culturally relevant history (Milburn 1997, 128; Cole 1985, 152-54; King and Little 1986, 22, 38-39; J. Berman 1998). And in sharp contrast to Boas's own Northwest Coast curatorial and editorial practice, Shotridge sought, through his exhibit strategies and interpretive writings, to keep crest objects and their narratives together.

Shotridge did not, however, treat the two categories of traditional narrative equally, departing from the Boasian preference for myth in favour of histories of the human era. He did often provide brief descriptions of the myths linked to clan crests, but in his exhibit labels and other interpretive texts he focused on what he saw as a crest's moral rather than mythic associations: the Kiks.ádi Frog, for instance, was an "emblem of persistence," the L'uknax̱.ádi Raven represented "culture," and the Kaagwaantaan Wolf stood for "courage" ([1929-31 exhibit labels], Shotridge Miscellaneous Records [SMR]; Shotridge 1928, 351, 353). This tactic seems to have arisen, at least in part, from his recognition of the more complex problem of presenting "the true conception" of Tlingit myths to his non-Native audience ("Mythology: The Journey of Raven," "Raven in Eyre," and "History: X̱'e·ts'uwu," UEN). As Toelken (2003, 15, 138) has noted about Native myth in general, such stories rarely make explicit the moral issues they dramatize. Tlingit histories of the human era – like similar genres elsewhere on the Northwest Coast – focus far more transparently on human virtues and failings.

While *at.óow* in general "carry" clan history, some of Shotridge's narratives have as their subjects the origins and histories of specific objects; they are of particular interest as expressions of what Shotridge hoped to communicate about crest art. The selections of his writings presented here are all concerned with

crest objects from the Tlingit town of Klukwan (Chilkat). The subjects include, *inter alia,* the first chilkat textiles (lower case used here for the adjective signifying technique to avoid confusion with the geographical designation); the Gaanaxteidí Whale House posts and Rain Screen; and the Kaagwaantaan Fin House Eagle staff-head and hat.[5] Most of the selections [7.1-7.IV] are taken from the fragments of Shotridge's unpublished monograph preserved at the UPM; the final one [7.V] reprints a 1928 article in which Shotridge also sets forth his curatorial agenda and discusses his reinstallation in that year of the museum's "Tlingit Hall."

Missing from the texts of these narratives, but forming their essential armatures, are the deep and detailed genealogical data that his Tlingit sources passed on to Shotridge along with the histories ("History," UEN; Shotridge Papers, AHL). Genealogy, as Nora Dauenhauer (1995, 23) has said, "holds the system together," connecting *at.óow* and their histories to present-day individuals. Some of the genealogical context for the selections is represented in Figure 7.2. Characters from the narratives who appear in this chart include the Stikine trader K'uxshoo II; K'uxshoo's son Yeilxáak, head of the Klukwan Gaanaxteidí; K'uxshoo's daughter K'aluwa Tláa, the pioneering weaver; and K'uxshoo's grandsons X'eits'óowu and Shkidlakáa, successive Gaanaxteidí clan leaders linked to the creation of the Whale House posts and Rain Screen. These men and women were, not coincidentally, among Shotridge's own ancestors.

Shotridge, as Milburn (1997, 264, 274-75) has noted, hoped to present what his own people considered significant about Tlingit art. She has argued (337-38) that, through the detailed histories he recorded, his collection came to serve as "a metonym for the existing fabric of Tlingit society" (see also Dauenhauer and Dauenhauer 2003, 170). But it is by looking in the opposite direction, from abstraction back toward the details, that the full extent of his contribution can be appreciated. Tlingit people, it seems clear, told clan histories then as now – and embodied and memorialized them in art objects – not only because they represented Tlingit social structure in general terms but also because they dramatized moral and spiritual issues, because they were about ancestors and events that were important to remember, *because* of the details.

The details of Shotridge's narratives are what is likely to be of greatest interest to outside researchers as well. The genealogical component of clan history offers one instance. Since it is possible to link some men and women in Figure 7.2 to early written records, genealogy allows a rough dating of the crest objects associated with them. These dates, incidentally, show a close correspondence to those that S.C. Brown (1987, 158, 164-65; 2005, 52-53), for one, has suggested on stylistic grounds.

But the narrative content of the histories also deserves attention. Even though we have multiple, and at times conflicting, versions of some events, the stories serve as a pointed reminder that, since Aboriginal views of art and history shaped Native actions in the past, the creation and movement of objects, styles, and iconography were no more random occurrences then than they would be today. They were a consequence of unique individuals acting within a comprehensible framework of social identities, clan alliances, and trading partnerships.

Shotridge's several histories featuring the Stikine trader K'uxshoo II, said to be responsible for bringing many objects to Klukwan from the south, provide an excellent example of both of these points (K'uxshoo also appears in "History: [untitled]" and "Emblems: Gìdjùk-an-yádì," UEN). K'uxshoo's enterprise in trading was crucial to the movement of these objects, but so were his marriages to a Klukwan Raven House woman, on the one hand, and a Haida woman, on the other; his own father was said to be Haida as well ("History: Genealogy," UEN). Since K'uxshoo's son Yeilxáak was, in turn, married to the daughter of a Dry Bay L'uknax.ádi noble, the immediate relatives of these two men formed a network stretching from Haida Gwaii almost to Yakutat (De Laguna 1972, 1: 135; Shotridge 1919b, 46; Swanton 1909, 161-62). K'uxshoo's Tsimshian connections were also significant: because of a hereditary trading partnership, shared names and crests, and (the Tsimshian said) generations of mutual adoption, the 'Wiiseeks House of the Ginaxangiik, later Lax Kw'alaams (Fort Simpson) Killer Whales, was so close to K'uxshoo's Mud Shark lineage that it was "like another part of the same House" (Cove and MacDonald 1987, 38-52,187-93). His Kitkatla trading relationships are murkier, but they may have involved the local branch of 'Wiiseeks's lineage, the House of Ts'ibasaa.

K'uxshoo's kin network and trading partnerships were not just conduits for the physical movement of objects. They were also factors in the shaping of the life experiences of his Gaanaxteidí children, who would have spent their early years in their father's house at Kals'el Aan and likely returned thereafter. There they would have met the Tsimshian visitors. K'uxshoo may also have taken his children with him on his trading expeditions, as Shotridge's father did with Shotridge himself ("Public School Lectures: Alaska – The Country and Its People," UEN). Repeated intermarriage between Mud Shark and the Klukwan Raven (and its successor, Whale) Houses, and the enduring partnership of the Naanyaa.aayí with Tsimshian Killer Whales, ensured continuity of these connections from generation to generation. Significantly, of the two artists to whom the Whale House Rain Screen is attributed, one, Shkidlakáa, was the son, brother-in-law, and grandson of Naanyaa.aayí clan leaders. The other artist, X̱'eits'óowu, grew up in the Kaagwaantaan Killer Whale House where, according to Emmons,

the first chilkat weavers (one evidently his mother) lived after their marriage to his father (Emmons 1907, 342; "History: Genealogy," UEN; Ronald Olson Papers [ROP], Bancroft Library, University of California, Berkeley).

These relationships and sets of life experiences help us to understand the iconographic and stylistic connections among some of the most famous objects of Northwest Coast art. One example is the relationship between the Klukwan Kaagwaantaan Killer Whale House screen (Figure 7.3) and the Lax Kw'alaams Nagwinaks screen (Figure 7.4) (owned by Tsimshian Killer Whales), which, S.C. Brown (2005, 57) has argued, were painted by the same artist. Another is the similarity, noted by Brown and others, between the aforementioned Nagwinaks painting and the final form of the Whale House Rain Screen (Figure 7.7) as revised by Shkidlakáa (G.F. MacDonald 1984; McLennan and Duffek 2000, 79; S.C. Brown 2005). Finally, they suggest a context in which the meaning of the Rain Screen, never adequately accounted for, might become transparent.[6]

One purpose of the clan histories is to relate ancestral acquisitions of things of value, and in the "Chilkat Blanket" narrative [7.II] what is acquired for the Gaanaxteidí are the Beaver apron and Rain Storm robe themselves – unique and valuable objects. Additional *at.óow* that might subsequently have resulted from this history include a number of Gaanaxteidí Beaver crest objects that came into existence from the last quarter of the eighteenth century on, some visible in the widely published Winter and Pond photos of the Whale House (Figure 7.7).

The climax of the narrative, however, is the presentation of K'aluwa Tláa's copy of the Rain Storm robe, representing the advent of the southeast wind. With regard to that event, we can point to only one possible commemorative *at.óow* – the object that Shotridge himself titles the "Rain Storm" screen (Shotridge to Gordon, 27 January 1923, LSC) [7.II, 7.IV]. Emmons, the main published source on the Rain Screen, did not explicitly name its central figure Sáanaxeit, the rain storm wind, but rather called it the "rain spirit" (Emmons 1916, 23; 1991, 63).[7] That these were one and the same, however, may have been self-evident to Emmons's Klukwan sources; the inherent connection between the southeast wind and rain storms is clear from both Tlingit comments about everyday life and Tlingit and Tsimshian myth (De Laguna 1972, 2: 804-5, 817; Emmons 1991, 427; Swanton 1909, 219; Boas 1916, 121-25, 131, 274; Cove and MacDonald 1987, 47-49, 328).[8]

Which brings us to one final point about Shotridge's histories. These narratives do not just provide evidence of "what happened" – how objects might have travelled or which objects with what iconography might have been made by whom. They also remind us that Indigenous notions of history can *drive* "what

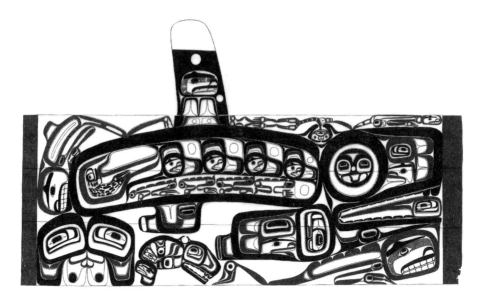

**FIGURE 7.3** Klukwan Kaagwaantaan Killer Whale House screen. This rendition (by Lyle Wilson) of a screen from the Klukwan Kaagwaantaan Killer Whale House is based on a photograph, PN 1649, from the Royal BC Museum collection. In the collection of the UBC Museum of Anthropology.

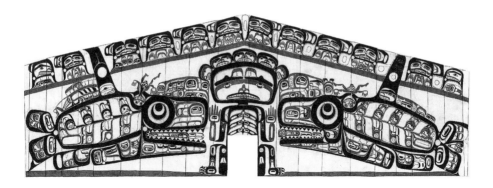

**FIGURE 7.4** Lax Kw'alaams Nagwinaks screen. This rendition (by Lyle Wilson) of a screen depicts Nagwinaks, chief of the undersea, along with other sea dwellers. The original screen is in the Smithsonian Institution's Museum of Natural History. In the collection of the UBC Museum of Anthropology.

happened." Tlingit *at.óow* commemorate events from clan histories, and in cases in which those histories are concerned with the origins of crest objects – as, we may hypothesize, the Rain Storm screen refers to the mastery of chilkat weaving by G̲aana̲xteidí women, through which further wealth and prestige accrued to their lineage and clan – the objects themselves can commemorate the evolution, as we might now phrase it, of Northwest Coast art.

**7.I. Louis Shotridge. N.d. "The House of Sáanax̱eit in Dream Land (from Whence Come the Origin of Design – Especially the Eye Motif)."** From "Trade," UEN, Louis Shotridge Collection, UPM Archives.

In this text, Shotridge linked the overall development of Northwest Coast design – especially, it would seem, the distributive type of composition – to an unnamed Tsimshian girl's dream of a visit to the house of the Southeast Wind. The comment about the Rain Storm robe in excerpt 7.II – "outcome of the dream of a maiden" – suggests that his sources also connected the dream to the act of creating that robe. This and 7.II invite comparison to the various chilkat origin stories recorded by Emmons (1907, 330, 342, 345-46; see 6.XXVI). Interestingly, in one of Emmons's histories, the young first weaver bore the title "Hiyouwasclar." Translated by Emmons as "Rain Mother," this term apparently derived from Tsimshian *haaywaas* ("southeast wind, rain wind") and Tlingit *tláa* ("mother") and may refer to her role as weaver of a "Rain Wind" robe (342, 345, 397, Figure 580).[9]

> It was not customary, among both the Tlingit and the Tsimshian peoples, for a maid, or a woman who has not arrived at maturity, to make known her dreams. This reserve was due not to a reverence for, or fear of that which was mysterious, hence it was not superstition, but rather an observance of the unspoken rule for personal etiquette. There has been told, however, an occasion when an exception was made ... The account of the dream was told in the following manner:
>
> ... "Upon entering of my soul," thus the maid told, "on to the land beyond, I stood on a well beaten path. This path led straightway to the edge of the sea. I looked here and I looked there, but there was no other way. Presently I moved ahead down on the only path. This was wholly against my will. I wanted to turn aside, but it seemed that all my power of resistance had abandoned me, and another power had entered to take control of my feet and moved them to advance. On and on until I could not shorten the steps any more ... Then that mysterious power roused to drive out all fears for a moment. And with the last step the great ocean raised its extensive 'lips.'
>
> "Thence, the beaten path still continued, and I followed on until I came to a vast expanse where for a moment there settled on me a wearied sensation: a lack of definiteness of scene. In spite of my knowledge that I have now passed beneath the ocean I was in an arid surrounding. Once more I was seized by fear, but I did not have power to call for a help. Thus, this faltering of courage was due perhaps to the irresolute nature of my sex ... Very gradually there came to my ears a murmuring sound, which presently turned out to be a song. Upon my recovery, I looked in [the] direction whence the singing came.

"Behold, there stood a great house, in a surrounding which I could not decipher, but the house was there, appeared as if it had grown out of the huge boulder which projected out on the hither corner. This obstructed my clear view of the entrance. It seems there was no foundation, as all else, like the interior space, was blended into nothingness. Thus, there was none to draw my attention from all that was displayed upon the house-front.

"From the peak down the gable extending down on both sides of the doorway were arranged figures, all lay in grotesque positions. Amongst these composite figures there stood out to stare that which seemed to be eyes, strange eyes of various sizes, and these were all rolled hither and thither as if they were searching for my presence. Presently all these mixture of figures began to form into one great object. It seemed that the figures never shifted at all, they remained where I had beheld them, only I seem to recognize that they were all there as a part of this great being. I thought that the wings and the claws were moving and alive, and at last there was indeed its great head, and on this the broad mouth, and the big eyes moved. Gradually I began to see that these various sizes of eyes were those of the imps which represented life in the joints of the limbs, each of a size in proportion with its allotted place. Finally the gigantic object on the wall moved as if it was in an effort to fly away, but it was put there by some mysterious mind, and there it was destined to remain.

"At last my person was slowly moved thither, and as the road which lay between me and the living wall was shortened, the peak of the wall began to vanish into the haze of atmosphere as if the wall was making a stretch into the heaven, and I thought that the great living wall, at last, had succeeded in broken loose from the mysterious hold. All at once this scene was changed in range and size. Right close before me appeared, to screen off all else, another face similar to that of the house front, only formed on a smaller dimensions. This one appeared with an expression as if suppressing a desire to talk, and when it failed to express itself in words it only moved closer, this I felt was to indicate to my mind this thought: 'Bear henceforth in thine mind the impression of my presence.' Beneath the figure there was hung a horizontal concave line – border of a garment – from which were streaming long strands of sea weed, and this in turn was formed like the fringe on the hem of a dress of the Northern woman. My eyes were attracted to the top of this vision, and there atop, moved by life, was a naked trunk of a body, and then a face of a man. Whence this gigantic man came I could not apprehend. He was looking down on me. I wanted to be frightened, but it seemed that even to make a move or to utter a sound was impossible. When I recovered some relief I saw that I had been deceived by the design on his breech-covering.

"And with my eyes stayed on the well-formed matured face all else vanished. For what seemed to be a time without end, I held my breath under that longevous scrutiny.

I felt rushed over my face that evocable expression as if to challenge this massive figure to speak first what he had to say. This was a sensation which bespoke my first courage in the scene, and it seemed there reentered into my person a spirit which spurred my feeling to show my outward appearance to be all the more bold.

"'Ha, my fair maid, me thinks that thou shouldst give way to a yaup from fright, indeed thou hath shown well in the presence of Sáanaẋeit the boldness which is attributed to thy people.'

"So this is Sáanaẋeit, the great God of the Wind which comes in from the retreat of the sun's trail. In the serenity the voice of this great being seemed to have echoed through the blankness.

"'Come,' he continued, 'within these walls are enclosed that which thou should bear forth in thine young memory.'

"With this he stepped down from a higher level, and made a turn toward the entrance of the house, and jerked his head in beckoning me to follow. With his back turned to me, I had a view of the robe which was hung from his shoulders. I thought this was made of a tanned hide. On this there embraced in position another figure, and all the joints in the limbs of it also were inhabited by imps, each of which crouched in as if [it] feared a fall out of place. Like a great drum the door made a sound as it swung to bid us enter.

"All feeling of precaution seemed to have vanished as I entered, and in disregard of my host I stood within that which opened like a little world of wonder. At present I cannot recall all at once that which I beheld within but they will eventually make themselves known to my mind. Few objects, however, made that impression which could not be effaced. In the rear of the great hall there was fixed a broad wall, and over the face of this there appeared a monstrous being similar to that which I had seen upon the wall in front. The eyes on the many faces about this also appeared to be alive. On either side of the wall there stood gigantic figures, and looking up along one I saw that these were stood as pillars to support the great beams of the roof. Following the reach of the beams, their front ends lay atop figures similar to those in the rear.

"Along the side walls of the room, there were square chests, piled up high. Each of these bore more faces, and there appeared many eyes. It seemed that wherever I looked, there were eyes staring at me. Before all these open eyes, I seemed to feel my person was pierced from all directions, and my blood began to rush as if it were in search for an escape from being shed forth from life. Now I could not see the great chief, nor can I say whence came his voice when he at last spoke and said these words:

"'Ha, thou fair wench, the good goddess of design hath at last yclept to thine faith, and choose thee to bear forth to man all that which will baffle time's tyrannic claim. In sooth, new things will come and these will pass whence they came. Thine people

shall leave and take, and thou shall be yare to take, for that which thou feignest shall be deemed inept for that which will come forth from time.'

"So you see, even when it was yet a dream our art was destined to be borne only to where it would be no longer consonant with a man's reason.

"As the great lord spoke his last words, all at once I realized that I had stood abrim of a crater. The floor of the hall fell away from the level on which I stood. This area was like an abyss. I could not see the lower level, but this great pit was impaled with a wall which was embanked in four series of terraces – narrow levels arranged one above the other, and up the face of each wall there lay in position a monstrous sea animal of species unknown to me, but all these lay in an indolent attitude, and appeared indifferent to my presence. As I looked this whole area still fell deeper and deeper, likewise my own breath began to be heavy, as if it was drawn in with the sinking of the floor. I could no longer fathom the depth of the great pit, and my own breath when I woke in this, my own land.

"Now I have borne this to thine knowledge, my good mother, but I could feign none to understand the significance of all that which has been revealed to such conscience as I had in dream land."

Thence, man applied his skill to carve, paint and weave designs as derived from the scene in the dream of this unknown maid ...

**7.II. Louis Shotridge. N.d. "Notes on the Origin of the Ceremonial Robe Called 'Chilkat Blanket."** From "Textile," UEN, Louis Shotridge Collection, UPM Archives.

This history describes the means by which two very early chilkat textiles, the Beaver apron and the Rain Storm robe, came into the possession of the Klukwan G̲aanax̲teidí and how their weaving techniques were mastered. While the events of the preceding narrative took place in an indeterminate historical time space, the Tlingit characters here, with the exception of Weihá's G̲aanax̲teidí wife, can be firmly located in genealogy (Figure 7.2). Weihá himself may have been the 'Sulchukan man whose grandson of the same name became town chief of Masset in the 1840s (Blackman 1981, 115; G.F. MacDonald 1983a, 136, 142-44). Regarding K'ux̲shoo's Kitkatla host, the name K'uhéigoo is at present unidentifiable, although in excerpt 7.v an earlier chief of that name seems to head the Kitkatla Eagles.

The original Beaver apron is apparently that shown in Figure 7.7. According to Emmons, Figure 7.5 depicts the first chilkat robe created (copied) by Klukwan women (Emmons 1907, Figure 580; Wyatt 1989, 127).[10] It does not much resemble Shotridge's description of the Rain Storm robe, but it does bear an intriguing

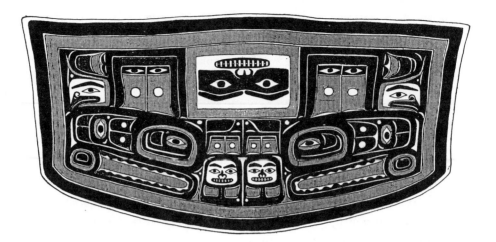

**FIGURE 7.5** Chilkat blanket, 1907. Original line drawing. This image of a Chilkat blanket shows a crest consisting of two killer whale heads and is reminiscent of the Tsimshian Double-Headed Monster crest described by Marius Barbeau (1950, 1: 369). From George T. Emmons, *The Chilkat Blanket*, in *Memoirs of the American Museum of Natural History*, Vol. 3, part 4, Jesup North Pacific Expedition (New York: American Museum of Natural History, 1907), 387, Figure 580.

relationship to the Double (Killer) Whale crest of K'uxshoo's Mud Shark lineage (Figure 7.6), which may in turn be related to the Double-Headed Monster crest of the Kitkatla and Lax Kw'alaams Killer Whales (S.C. Brown 1994, 77; Barbeau 1950, 1: 369). The possible double-fin element on the robe, along with the double fins on the central figure of the Rain Screen, does suggest an iconographic origin among the various multi-dorsal-finned undersea chiefs of Tsimshian and Haida myth. Emmons's "G̲unaakadeit" chilkat origin myths and Shotridge's Sáanax̱eit narrative may ultimately derive from one of these stories. And note that, as girls often stayed with their parents until marriage, the puberty seclusion of the young weaver K̲'aluwa Tláa likely took place in her father's house, not in Klukwan.

S'ageidí K'ideit "Beaver Breech-covering," also known as Yáx̱jidusné (Exemplar), is one of the most important objects among the Chilkat Whale House family collection of native arts. The *k'ideit* ... being the original piece, after which the first ceremonial robe had been made, was indeed an object of pride of the owners.

In presence of the immediate development of this form of native art, the S'ageidí K'ideit remains without a rival in having the honor of being a paragon of beauty in textile art throughout the whole of the Tlingit land in spite of all attempts made by various expert weavers to create its match. The workmanship on this very old specimen indeed justifies its claim to the highest place of the art of this nature. Every item of form in design and colour of this piece has in it the true element of the old-time

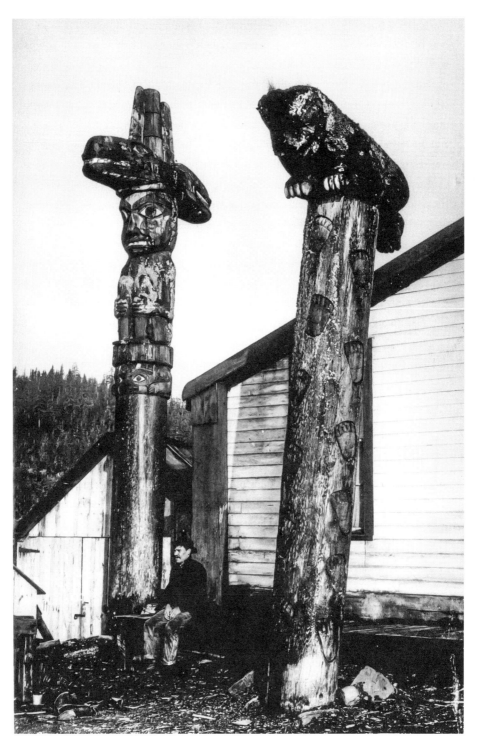

**FIGURE 7.6** This photo by Lloyd Winter and Percy Pond, taken ca. 1900, shows two poles in Wrangell, Alaska. A "Double Killer Whale" carving sits at the top of the left pole. Alaska Historical Library, PCA-87-115.

native art. It presents in all its features the highest development of textile art at the time of its creation, and even at the present time it is the one piece which will compare well with the best products of other lands.

The S'ageidí K'ideit was obtained from the Haida people of one of the divisions on the Queen Charlotte archipelago, and as will be seen in the story about its disposal, the Haida owners had preferred the Tlingit as its permanent owners. As to the age and the maker of the piece no one living can tell. The story about the acquisition was related by Ycilxáak of Chilkat, the last of the recognized chiefs of the once great Gaanaxteidí Clan.[11] For the sake of clear interpretation of the Tlingit thought I frequently have to employ forms that convey most faithfully the thought, and sacrifice the original idioms which are peculiar to the translation of the native tongue. Hence the absence of the quotation marks in the following narrative:

The existence of the S'ageidí K'ideit was not generally known among the Tlingit people, until K'uxshoo II of the Naanyaa.aayí party brought it to Chilkat. From the day of its arrival the piece was indeed an object of admiration, but for some years no one ever thought of making one like it, even among those women who were in a position to do such work. In those days it seemed that all fine work of this nature was left only for the daughters of the rich. The reason for this may have been that the women of the poorer class could not afford to spare the time for doing things besides those they had to do for immediate use.

Only for the jealousy which existed between the Tsimshian and the Haida peoples, we might never have had the honor of being the makers of the *Naxein* (Chilkat Blanket). In the beginning it was jealousy which led this style of weaving to us, and by their foresight of important things the Chilkat made a popular thing of it.

K'uxshoo II was the son of a Haida chief, therefore he was familiar with affairs upon his father's land. In his day the half-Haida was known as one of the greatest traders of the Tlingit nation, and he appeared at the beginning of the foreign influence upon our land. During his earlier days, for many years this man carried on a lively trade between the Haida, the Tsimshian and the Tlingit, particularly the Chilkat people. In exchange for objects of barter that this man brought from the southern people, the Chilkat people gave him moose hide, beaver pelts, robes of skins of the foxes, marmot and the interior underground squirrel. The moose hide then was something like the paper money of the present time, only the hides were valued according to sizes and quality. Most of the fire arms and the various sorts of objects of iron that are found in the possession of the Chilkat leading family are those same pieces brought here by K'uxshoo, mostly for Kakáayi, his brother-in-law.

It was on one of his usual trips to the "Out-land" that K'uxshoo halted for a brief visit at the town of K'uhéigoo, a well-known Tsimshian chief. K'uxshoo of course was received and entertained in a style [that] befitted his station in life. It was told that

the two chiefs were very familiar with each other, and their greetings here were nothing more than a friendly meeting. After the informal feasting was over the two men talked about the current events and new things of the moment, [and] it was then the host must have thought of his latest acquisition, an addition to his collection of objects of art, and then the ceremonial robe was brought out for the inspection of the visiting chief. When the wonderful robe was unfolded and spread out, K'uxshoo stiffened and straightened in his sitting position; as if to blow through it held his clenched fist to his mouth; cocked his head to one side and then moved backward as if to focus his view at a right range. "My blanket, my friend – it represents the Rain Storm. In truth the great Sáanax̱eit (the god of Storm) is known to make his grand appearance always with the rain as a forerunner, and all creatures would flee to their hiding to make way for his approach. It is the result of a mere woman's effort, the outcome of the dream of a maiden, and I have it only for a show," said the Tsimshian chief.

For a moment K'uxshoo was silent, still held his position of inspection, as if ignoring his host's presentation, when he spoke. "It is admirable – My friend this shall be mine – " Nothing then can escape K'uxshoo, for he was a rich nobleman, and had the reputation of one who would have the object of his desire regardless of cost and difficulty. But this time it would seem that the great trader made a deal which cost him not only a great sum of property, but a great amount of the blood of his father's people.

By some means the Tsimshian chief had learned of a box of *tínx* (a red berry sometimes called "squirrel berry," found only on high land)[12] among the things that the Tlingit visitor was taking to Weihá, one of the great chiefs of the Haida nation. The *tínx* being a delicacy, at that time, imported from Chilkat only for the rich chiefs of the south, constituted the important part of the cargo. And when the Tlingit trader made a bid on this robe the Tsimshian smiled over his thought – this was a moment of a splendid opportunity in which to deride his rival Weihá, and [he] was determined to prevent, at all cost, the box of *tínx* from reaching the party for whom it was intended.

So it came about that K'uxshoo wanted the "Rain Storm" robe, and K'uhéigoo wanted the box of *tínx*. It was said that the property which K'uxshoo offered in exchange for the ceremonial robe was an amount sufficient to pay for anything in the nature of this unique robe, but the owner made it known to his guest that unless the box of *tínx* was included in the deal he would not agree to the exchange. This demand was indeed a surprise to K'uxshoo, and not until he agreed to include the "mere" box of berries, did he realize the meaning of the Tsimshian's desire for the possession of the box of berries – he knew then the purpose for which the Tsimshian wanted the berries.

So it would seem that the motive of the serious war, between the two powerful tribes, which followed, was a box of berries. But the Tsimshian and the Haida were

never friendly. From the time they had knowledge of each other's presence the two peoples were always in a rival attitude, and as [much of a] trifle as being deprived of enjoying the sweet berries may seem, it proved to be a mighty good excuse for starting the trouble which had so long been impending.

Since he gave up the present which he had carried for his Haida friend, K'uxshoo had to change his plan of travel, and instead of continuing on his intended visit to his father's land the trader started out on his return journey to the north. The trader's failure in fulfilling his promised visit to Weihá only added more to the enraged feeling of the Haida chief, for he soon learned the reason for K'uxshoo's failure in coming to his land.

The Tsimshian chief may have been satisfied with his scheme in disappointing his rival, but he only added more to the sting caused by it when he remarked, while partaking of the berries: "Ha, if only Weihá could see me now. Methinks the old greasy face would swallow hard." These few words of taunt found wings and rushed to the ears of Weihá, and when he learned this, it was as much as the Haida chief could bear of the abuses imposed upon him by his rival, and the war spirit broke through the last bar in his heart.

Immediately upon his decision, Weihá set out for the main land to pay his respects to K'uhéigoo, and there the Tsimshian warriors were overpowered. In this first battle Weihá slew his rival chief. After it was all over, the stomach of K'uhéigoo was cut out; and like that of a halibut this was inflated, and out in the middle of the Nass River the Haida anchored the stomach of his insulting rival Tsimshian, and there it floated at a point where the Nisga'a could not miss but see it. This act predominated among all abuses suffered during the serious war which followed.

Weihá knew that the Tsimshian people will never rest until they took his life in return for that of the rival chief, therefore he decided to fix things so that nothing important should fall into the hands of the enemy party, and upon his return home the rich chief called a council, and before his people brought out all the objects that represented various events in the making of their history. Among the most important objects in the collection was the S'ageidí K'ideit which represented the first of its kind. How and where the Haida got this piece no one knew, but it was stated that it was by this that the Tsimshian "Rain Storm" ceremonial robe was made. Of course it is known that the design on this form of art was the outcome of a dream of a Tsimshian maid, and it is likely that this people made also the original piece.

After he made known to his people his intention, Weihá placed a beautiful headdress, one which represented the Gunaakadeit, on the fire. Now the great chief had two wives, the elder of these was his own people, and the younger was no other than Yeitkatees of the Chilkat Whale House family, and it was the elder wife who went forth and took the headdress from the fire, and in like manner the Haida woman rescued

the other important objects, but when she reached to take the S'ageidí K'ideit the chief, with his walking stick, checked his wife and said: "This you are not to take." Right then Yeitkatees came forth and took the object from the fire, the chief did not interfere, but allowed his Tlingit wife to rescue the object. It is said that it was in a woven bark case when it was put on the fire, hence its escape from possible damage. All this sounds like a well-rehearsed act, and I think that the chief had all these planned. So it seemed that the S'ageidí K'ideit was rescued from a total destruction to be Yáxjidusné upon another land. Thus, in its original home, the art of weaving in wool came to its end with the two great chiefs, but to appear once more, only in a more appreciative attitude, upon a land where all objects representing culture were received with open arms.

As it was stated, the woven object remained in Chilkat only as an object of admiration, and no one ever thought of making one like it until K'aluwa Tláa, who was K'uxshoo's daughter, was old enough to take up the woman's art. It was during the period of her confinement in puberty that the maiden, in a secret manner, practiced on the weave of the "Rain Storm," and after months of raveling and reweaving succeeded in learning the weave of the intricate twists of strands in the design. The maiden's secret for two long winters was known only to her mother and attending servants, and persons who were employed in making patterns and preparing of the materials. It was because of her undertaking that the confinement of the maiden was prolonged to sixteen months, hence her reputation as one who observed to the full extent the customs imposed upon a girl at puberty, and it was said that within this length of time K'aluwa Tláa made and finished the first "Chilkat Blanket."

Immediately upon its completion this first "Chilkat Blanket" was put away, and not to be shown until an appropriate occasion occurred. Thus, for many years, the existence of the new ceremonial robe remained a secret until peace was decided upon after a long siege of war between the Gaanaxteidí and the Lukaax.ádi clans. At that time the most important person of the four men taken as hostages from among the Lukaax.ádi was Kutax'teek who was named Goox Kuwaakaan, "Slave Deer" (Kuwaakaan "Deer" is a name of a harmless animal applied to one taken as a hostage). It was an ancient custom that a hostage was given a name which implied either some meek or harmless animal or something pertaining to current events. Some of these that became popular were "The Humming Bird," "The Salmon," "The Fish Hawk," "The Canoe," and in recent years "The Steamboat." All these characters were imitated with much skill in the solo dance of the hostage, and each was usually performed to its own song.

On this particular occasion Kutax'teek was named "The Slave" (meaning, the noted warrior had been a slave to the affairs of his own party). I wondered just how such a character as a slave could be imitated in a solo dance, but it was told that the

popular man imitated with great skill a stupid person in servitude, one who has been rebuked by a dissatisfied master. They say the great house shook continuously from the stamping of feet of the crowd of admirers during his performance.

The formal peace dance was usually performed within the blazing of the evening fire which lasted about four hours, and while each performer "sang his own song" (i.e., the dance songs are the same in number as the performers) the hostage or the hostages stood in the back-ground, and faced the audience only during each song, but turned their backs with a conclusion, and their parts were performed as a finale of each ceremony. After one solemn song which was of his own clan, the hostage then comes forward to dance to a song of rejoicing, while the performers accompany him in a half-circle formation.

It was preceding the solemn part of the hostage that customary speaking parts were performed, in this Yeilxáak, the master of ceremony, came to the front and spake his part in this wise: "My Slave, he did not answer, where could he be? Me thinks the stupid slave is now about some unheard of mischief. Make way, let me look for his whereabouts." With this the performer elbowed his way into the crowd of performers, continuing with his lines he went on: "Ah, here he is, the indolent slave. Come and give account of yourself." At this point Yeilxáak led his Slave Deer to the front. This part was unusual, for the hostage was supposed to be in his place in the back row until it was time for him to dance, but the master of ceremony had a purpose.

In the presence of the great Chilkat audience stood Ḵutax'teek the hostage who represented the covenant of absolute peace between the two great clans. The hostage, as he appeared, was indeed like an indolent slave, adorned in a robe of skins of the underground squirrel which had not been new for many winters. For a moment the people wondered about the reason for adorning the distinguished person in such a fashion, but such thoughts, at once, turned to a surprise when the old gopher robe was removed. There was shone forth, like the rays of the rising sun, a like creation which the people had never viewed. When the hostage made a turn to perform his solemn part, the design of this wonderful robe was in full view of the audience, and at this moment Yeilxáak pronounced the name of the creation, and quoted K'uhéigoo the Tsimshian chief: "Rain Storm, this robe of my Deer. In advance of Sáanaxeit comes this storm to clear away all foul matter out of the way of the great chief of the south wind."

Thus, the "Chilkat Blanket" in this ceremonious manner made its first appearance on the land from which, eventually, [it] received its permanent name.

**7.III. Louis Shotridge. N.d. "X̱'etidus'óowu, the Founder of Chilkat Whale House."** From "History," UEN, Louis Shotridge Collection, UPM Archives.

This narrative of the founding of the Whale House, and the commissioning of its four famous posts, presents a complex example of how clan history, in the most inclusive sense, is embodied in *at.óow*. Shotridge shows that the G̲aanax̲teidí leader X̲'eits'óowu (the short form of X̲'etidus'óowu) deliberately linked mythic narrative to contemporary local lineage relationships, combining the whole in one physical structure whose symbolism is both commemorative of their collective histories and constitutive of a new political union.

The recent and perhaps still ongoing conflict between the G̲aanax̲teidí and Dry Bay L'uknax̲.ádi, in which X̲'eits'óowu's predecessor Yeilx̲áak I was said to have died, may have spurred X̲'eits'óowu's interest in a defensive union (Olson 1967, 8; de Laguna 1972, 1: 274-75; Swanton 1909, 161-65; Shotridge 1919b, 45-46; 1928, 353). Yeilx̲áak had in his lifetime rebuilt Raven House, and several Native sources identified K̲aajisdu.áx̲ch, the artist whom X̲'eits'óowu commissioned to create the Whale House posts, as having also carved Yeilx̲áak's Raven House posts (Olson 1967, 8, 38; Barbeau 1950, 1: 358-61; see also S.C. Brown 1987, 167).

Steven C. Brown (1987, 172-73) has suggested that another Klukwan work of this Stikine artist is the Lord of Hawks headdress (Object NA10832, UPM) (see also "Emblems: Gìdjùk-an-yádì," UEN). According to Shotridge, the Stikine trader Kux̲shóo II brought this headdress to Klukwan, where he sold it to his son-in-law Yisyát – X̲'eits'óowu's father.

> X̲'etidus'óowu II was a man to be admired as a leader of men. He possessed a thinking power that none of his successors approached; he was the outstanding figure among the Chilkat patriots, and to his magnanimous policy was credited the foundation of the G̲aanax̲teidí power. The G̲aanax̲teidí, as the composition of its name implies (from within G̲aanax̲.ádi), was a party, only a small one to begin with, which wandered away from the G̲aanax̲.ádi at Tongass, the main body to which it had been a part, and during its migration up along the coast a number of other small groups joined it, and these came on to the head of the Lynn Canal in its company. Among themselves the immigrating groups referred to one another by certain names, each of which had derived from the geographic position whence the bearer had come.
>
> For a time, after the G̲aanax̲teidí made its settlement at the place which is now known as Klukwan, on Chilkat River, no one ever thought of forming the various small groups into one body, until X̲'eits'óowu II stepped into the leadership of the leading group, and it was with him the most important part of the G̲aanax̲teidí history began.
>
> Eventually the leading group grew to such a body of men that it was necessary to build another house. This move was made, however, not only because of increase in

number, but the members developed into different ranks. Such was the motive of the foundation of the Whale House. The foundation of the new house was an opportunity for X̲'eits'óowu II to put to test his great plan – to strengthen his own party by making the other small groups combine with it, so that this new division will have a defensive power. The members of the other groups, then, did not know enough to appreciate the meaning of [this] organization, until the time came for them to realize the danger of an attack by other comers to the region.

The foundation of the Whale House in Chilkat, indeed, set an example not only for the [Chilkat] division, but for many other as well. The whole thing was operated in such a magnanimous manner that the different groups were not at all aware of the astute man's intention until each became a part of the great G̲aanax̲teidí clan. As already stated, it was thought that the Whale House was to be built only as an annex to the Raven clan, dedicated to commemorate the incident from which the clan had adopted the Whale as its emblem, and to accommodate the different classes of members, but, as was learned later, there was a deal more than that to the founder's plan.

In carrying out his plan X̲'eits'óowu II began by holding a council with the different groups that lived in company of his own. When they all were seated, he laid before them his plan. "Shakak̲wáan, T'ix̲'.eidí, Lawyik.eidí, and G̲aanax̲teidí," [he said,] addressing the different groups. "Together we came to the land of our choice, and here we are destined to remain. By our own making we may enjoy our lives together, or we might prefer to remain indifferent of one another's company. But why should we not be all friends? Before us flows Chilkat; together we drink of it, and together partake of its bounties, in peace. Indeed, the good goddess of Fortune has looked upon us with favor. But to maintain this peaceful life we must create some sort of defense, lest some one else will take from us that which we enjoy. We should stand together, each man in place like a timber of a well-constructed stockade; unless we form such a defence the inmates of Klukwan are still exposed to the danger of an attack."

The foregoing, is all that was remembered of X̲'eits'óowu's address at the first council of the G̲aanax̲teidí Clan. The members of the three allied groups were not educated enough to appreciate the gist of the idea, but it seemed that there was none else to do but to accept the proposal of the chief; in a half-hearted manner the elders of the groups acceded – they had no more to do than to follow the leader.

In his own way X̲'eits'óowu was educated – he was well versed on conditions of affairs of the Tlingit world, and he knew all the persons of importance in the various divisions, and in turn the astute man was well known, therefore, he was in a position to call on anyone from most any Tlingit town.

K̲aajisdu.áx̲ch II, of Shtax̲' Héen Kiks.ádi [clan] was well known in the Tlingit world, for his unusual skill in carving wood. Shtax̲' Héen (Stikine River) was a great

paddling distance from Chilkat, but Ḵaajisdu.áxch was the only one then who could fill well the requirements of the Ḡaanax̱teidí project in Chilkat, hence, distance was no obstacle to X̱'eits'óowu, when he requested the service of the great carver.

It was in the spring of the year when the messengers, from Chilkat, arrived in Ḵals'el Aan, an old town now known as "Old Wrangell." The mission of the party was, of course, well known to the Shtax̱'héen Ḵwáan, for the news of the Ḡaanax̱teidí Chilkat affairs were then far-reaching in the Tlingit world, therefore the messenger party was received in a manner that befitted a representative of the great chief, but in order to avoid unnecessary delay the customary receptions were made brief, for the travelers were taking advantage of the fair condition of the weather. Ḵaajisdu.áxch himself had been informed that his services were to be called for from Chilkat, therefore he was prepared, and awaited only the arrival of the message, so immediately following the brief reception the party set out on its return voyage to Chilkat.

From the moment the messenger party left the shore of Ḵals'el Aan, an elder, who had came along for just such purpose, began to relate to the chief of wood carvers "The Journey of the Raven," that noble old legend which stands as a foundation to all that pertains to the creation of important things in the Tlingit world. At each camp, all the way, Ḵaajisdu.áxch whittled away at the thick piece of bark of the cotton wood, as he listened to the narrator. Thus, by the time the small party approached Chilkat the master carver had fashioned the models of the four house pillars that were to be the masterpieces of all carved wood in the country.

One year, thence, in Chilkat Whale House stood Ḵaajisdu.áxch II, the greatest carver of wood in the history of the Tlingit people. Passing around, in course of the sun, [he] pronounced the names of the four pillars that he had just finished, starting with the one placed on the Northern corner. "This, oh chief, is the 'Tree of Worm.'" Then he passed on to the one on the Eastern corner. "This is the Raven – for the sake of justice the creator of things deceived the gods." And again he passed on to the one on the Southern corner. "This one is the Whale, when the Raven flew into the stomach of the great chief of the sea." At last he passed to the front of the one on the Western corner. "This one is the Black-skinned Giant, the Champion of Physical Strength." Ḵaajisdu.áxch then turned to face the chief, and said: "Oh chief, no genius lives who can do justice to the working power of a noble mind, yet withal I offer to thine hand these, the result of a humble attempt, but because of their owner I should have a hope that these posts shall serve their purpose." Thence, these few modest words remained in company of the greatest pieces in history of the Tlingit art in wood carving.

During the ceremony of the dedication of the Whale House, the four different groups, that were to form the Ḡaanax̱teidí, were each assigned its place in the new council house. The Lawyik.eidí was allotted its place by the Tree of Worm; the

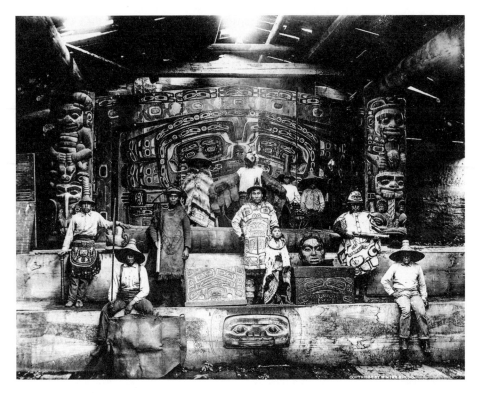

**FIGURE 7.7** Tlingit Whale House, ca. 1890. Commercial photographers Winter and Pond took this photo, which shows G̲aanax̲teidí men in clan regalia, the Rain Screen, and two of the four house posts described in 7.III: "the Tree of Worm" and "the Raven." Alaska Historical Library, PCA-87-010.

Shaka̲kwáan, by the Raven-the-Artificer; the G̲aanax̲teidí proper took its place by the Whale post, and the T'ix'.eidí was assigned its place by the Black-skinned Giant.

Thus, the different groups became as one body, regardless of origin. Though each resided in its own house, to the last, they were all represented in the Whale House, and looked to this in a manner something like a state does its capital home. This was the manner in which the G̲aanax̲teidí of Chilkat acquired the reputation of being the most successful party in the region.

**7.IV. Louis Shotridge. N.d. "Remodeling of the 'Rain Storm.'"** From "History," UEN, Louis Shotridge Collection, UPM Archives.

The possible connection of the Klukwan Rain Screen with excerpts 7.I and 7.II is discussed above. As Figure 7.2 shows, the two artists associated with the "Rain Storm" screen, X̲'eits'óowu and Shkidlak̲áa, were the children of Yeilx̲áak's sisters; there seems to have been a significant age difference between them.

Shotridge typed this short text in quotes, but he did not indicate whose words he was quoting.

"There was a gradual improvement upon everything which had created to represent our own culture. Among our own household it was X̱'etidus'óowu II, who brought about ideas each of which in turn developed into something of importance. At the time this providential man founded the Whale House he placed in it a wooden screen or partition which was painted to represent the 'Rain Storm.' The man at that time must have been satisfied with the creation which appeared to have been the outcome of a longevous daydream, and there lived no genius then who would dare to criticize the 'master piece.' But when Shkidlaḵáa III succeeded the famous lord of Klukwan, [he] found the house-screen in place, like many other objects, in an unfinished manner.

"The new master, who himself was a noted carver of wood, was never at ease about the crude form in which the object of the family pride was represented, until, at last, he had it taken down ... In a manner of a gifted artist the critical master began to arrange his bark patterns over the surface of the screen. Thus it was in accord with such skillful mind that the Rain Storm design was carved on the screen. And to this day there has appeared no artist who is gifted enough to criticize the outcome of Shkidlaḵáa's idea."

**7.V. Louis Shotridge. 1928. "The Emblems of the Tlingit Culture."** *Museum Journal* 19, 4: 350-77. Illustrations and captions omitted.

In 1927, Shotridge was recalled to Philadelphia because, with the death of his mentor Gordon, there was no one with sufficient expertise on the UPM staff to curate the North American collections (Jane M. McHugh to Shotridge, 6 June 1927, LSC). In 1928, Shotridge's new "Tlingit Hall" was installed, and the article reprinted below served as his introduction to the new exhibit.

The history that Shotridge embedded in it must have held special significance for him, as it dealt with the origin of his own name. This history, concerned in part with one of the objects in that installation, the Eagle staff-head (NA9468, UPM), took place some generations earlier than the preceding ones, and the specific genealogical links to the era of K'uxshoo II were not preserved. The first Kaagwaantaan to construct a lineage house at Klukwan was said to be K'uxshoo's father-in-law, a man named Daaḵwtáank (Shotridge 1919b, 44; "History: The First Council House of the Chilkat Kàguàn-tà·n" and "Genealogy," UEN).

Recently the Museum placed on exhibition in the Tlingit Hall of the American Section a collection of objects, the greater part of which is shown as representative of the native art of the Tlingit nation. Some of the pieces are unique in character, others grotesque in form, and some of them may appear, to a stranger, as if they had served in a fantastic masquerade. But if one makes a close examination he will readily discover

in most of the fine old pieces the aesthetic emotions that played the main part in their creation.

The more important part of the collection consists of objects carved of wood but there are also fine examples of weaving, embroidery, and drawing. All of these display sufficient evidence of a well-developed aesthetic sense in the mind of the native artist; instantly it becomes evident that the taste for ornamentation, here, is not rudimentary. The intent of the maker is obvious, a distinguishing quality which marks a difference between the things shown here and things of the same nature that are produced in other parts of our land.

To know the better side of the American Indian one must learn more about his moods and emotions. Of the more important groups of aborigines, the Tlingit tribe of the southeastern coast of Alaska appears to be one of the least known. And until ethnological investigators followed the trail of the straggling natives into the most remote parts, the character of the people was not clear for the reports of the early European explorers had conveyed all but that which was most important.

Immediately after the discovery of the existence of rich furs and gold and of the salmon which abound in this northern land, a profound change took place in the life of the natives; more strange people came who eventually took command of everything. But it is to be regretted that this dominant race of people made no authentic study of the Tlingit until long after the time of the latter's confounding by the engulfing foreign influence, when "evil water" (whiskey) and greed of trade had debauched the native ideals.

Hence, the Tlingit appeared in most publications as debased characters. But the determination to investigate did not wane, thanks to the very few qualified men who camped upon the trail of the truth of things and to the very generous persons who, from time to time, supplied funds in support of expeditions.

The lack of reliable native interpreters is now the greatest handicap to all careful scientific research. Hence the puerile form in which most of the important legends have gone into record. A Tlingit who has felt the thrill of the true quality of the old legends will experience only a feeling of indignation when reading such childish presentations of that which he has cherished. Personally, I feel, after long holding my peace, at last compelled to voice my true feelings. I realize of course that only a skilful writer of the English language can do justice to the true spirit of my people and the lack of such a qualification has always been my handicap. Being thus unprepared, I can only do the next best thing and take advantage of an opportunity which has offered itself to illustrate the true psychology of my people by the simple means of their native art.

Like all men who have a desire to accomplish something, I experienced disappointments and discouragements but by the unfailing support and constant encouragement

of the late Dr. George Byron Gordon I was put in a position to present to the public view this collection of objects, each of which has long held the unlimited reverence of my people, an esteem inspired only by those objects which are sacred to man.

It was only through a claim to some distant relationship that I was, at last, permitted to open the old chests and to take out and carry away from their sanctuaries the fine old pieces that had not seen daylight since the white man's religion and law had supplanted those of the natives.

A stranger cannot very well appreciate the part which these old symbolic objects played in the life of the Tlingit until he has some idea of the social system of the people, so that it is very necessary to present a brief outline of this.

From the time that Tlingit history first records their settlement in Alaska, the people have existed as two great bodies ... for convenience each moiety will be here referred to as a nation ... Both nations were at first agglomerations of independent groups which are termed clans. A clan is a subdivision comprising a number of household groups and known by a name which in turn is derived from the subdivision's original geographic location.

With the development of culture, ... the creation of objects called totems and the adoption of some living thing by which one might be identified became necessary. The immediate presence of the raven, whale, beaver, eagle, bear, wolf, and other denizens of the forest and sea of the region, and the Tlingit knowledge of their peculiarities, explain the prominent part they play in the mythology and arts of the people. It is by this system of picture-writing in graphic and plastic arts that the history of my people has been preserved and transmitted through centuries.

So here they are. I hope to live to see the day when these old things will help to bring the true character of their makers into the white man's light.

THE EXHIBITION OF THE TLINGIT COLLECTION

In arranging the collection here displayed, the most important specimens are placed, as nearly as space permits, in the order of their rank. In the several cases are grouped objects illustrating the various phases of the life of the people; examples of fine carving in wood, wearing apparel, exhibitions of the arts of weaving in wool and porcupine-quill embroidery, feast dishes, war implements and trophies, paraphernalia of the shaman or medicine-man, ceremonial masks, and a complete collection of ceremonial headdresses. In a small case lies the great hat of Shaxéexi, the first woman diplomat, and in another the relics of S'eiltín, the famous "Bride of Tongass." Of the important pieces, the fine old headdress called "The Lord of Hawks," which formerly held in its clutches the fate of unfortunate slaves, and the Ganook Hat, which represents the most ancient being in Tlingit mythology, are the most noteworthy. But each is important enough to be treated by itself.

In a case on the right side of the center aisle as one enters the Tlingit Hall, stands forth like a herald who has an important message to convey the Raven Hat of the Laayineidí nation, representing culture; next in order is the Whale, an emblem of greatness, used as a crest object by the leading clan; here is also the Sea-lion, an emblem of endurance; and then the Frog, an emblem of persistence pertaining to the Kiks.ádi clan.

On the left side, appearing as if it had always gazed upon the ocean, indifferent to all curious eyes, stands the Eagle, also in the form of a ceremonial hat, the emblem of the Shangukeidí nation and signifying determination. Next in order is the Grizzly-bear, an emblem of power, representative of the Teikweidí clan, and then the Wolf, the emblem of the Kaagwaantaan clan and signifying courage. The old hats and helmets, indeed, portray well the symbolic ideas of their owners, for each clan, in its own geographic location, contributed its share towards the success of the nation of which it was a part. There are also other representations but we mention here only the most important pieces in order to explain the object of their presence.

According to the legends that refer to these old ceremonial hats, each clan well earned its possession, since to establish such in its rank had demanded much sacrifice, not only of personal comfort but even of life itself when it was necessary. Therefore it was a natural thing that as the people grew and spread wide over the region, an attitude of local patriotism overshadowed the feeling of kinship and disputes over ownership of emblematic objects became menace to all peaceful divisions. These disputes more than once developed into serious warfare that for a time threatened the further existence of the weaker communities. At the same time men of sound reasoning and the rich, in a more intelligent manner, procured the ownership of rights and claims to those things which were deemed most honorable in the native mind.

The old Raven Hat, if it could but talk, could tell much about thirty years' struggle of the G̲aanax̲teidí of Chilkat with their former kin the L'uknax̲.ádi of Sitka. In the dispute between these two powerful clans to determine which held absolute right to the custodianship of the national emblem, the G̲aanax̲teidí are said to have shown greater proof of being the original body. Hence, the Raven appears among the L'uknax̲.ádi possessions only as a symbol of alliance and is known by a characteristic name.

The popular Raven appears also among nearly every important division but usually in an unobtrusive manner corresponding to the means by which it was acquired. It is a common trait of human nature for every man to have the feeling of being a great chief in his own house, and, whatever its nature, probably his account of the origin of his possession resounded only within his own walls. But it was the general attitude of the people that counted for most in determining the soundness of a claim

to ownership of an important crest object. Such were the conditions under which the Laayineidí emblem grew into popularity.

The Eagle emblem, however, was established in a more sensible and peaceful manner in spite of the fact that at the beginning its owners appeared with an aggressive attitude, and the Eagle to the last was honored on account of the history of its establishment. When I first listened to the legend relating how the Shangukeidí obtained undisputed ownership of the Eagle I could not help but admire the astute mind of Chief Stoowukáa and I feel honored and proud of being born of a mother who could bestow such a personal name upon her son. This incidental admission will explain my claim to some relationship with nearly every important Tlingit family.

One bright summer day in Chilkat I sat, squatting on the ground, the kodak with which I had just taken a photograph of the Chilkat Eagle Hat lying on my lap; I dared not make a move that might interrupt the aged Kaagwaantaan who inhaled the pleasant air in a man's daydream of the glory of the past as he recited, with unconcealed pride, the part that his ancestors played in establishing the national emblem, occasionally pointing to the old ceremonial hat where it lay on a log as he went on to tell the story of the Eagle emblem.[13]

In this study of Tlingit mythology, it is interesting to note the narrator's preliminary remarks and his personal opinion on different subjects. In rewriting the following legend, except in expressions where obsolete forms of English have to be employed, I use freely words that convey more clearly the interpretation of the Tlingit thought.

### THE PURCHASE OF ABSOLUTE RIGHT TO THE EAGLE EMBLEM

"My lad! You ask me to tell you by what means the Eagle became the object of our pride. I cannot blame you for not knowing the main source of this pride because I know that your family were always modest and refrained from telling you, at an early age, anything which might cause you to have a feeling of superiority over your fellow men; but you have now grown to manhood and it is time for you to know why you bear the name Stoowukáa.

"I myself spent all of my young days in your grandfather's house; Laatxíchx (Shotridge) had many men under his authority but I was always his favorite. Thus I had the privilege of learning the ways of a nobleman as well as the true circumstances of the foundation of our party. But I never like to tell these because those of us who have given so much for our own cause cannot bear the thought that that which was uppermost in our minds is no longer consonant with the spirit of modern times. But this is true to the prophecy of Sáanaxeit (God of Storm), who appeared in a dream to a virgin to give his warning: 'In sooth, new things will come and the old will pass

whence they came. Thy people shall leave the old and take the new for that which thou now honorest shall be deemed unfit for that which will come forth from time.'

"From the day of creation we have been enlightened by intelligent dreams. Thus our walks in life, more or less, were guided by them. But forgive me, my lad, I have wandered away from my story.

"In truth, from the beginning the Eagle ranked high in the esteem of our party. But once ambitious men began, what was there to hinder them? The Eagle was put on a hat in one town and perhaps on a ceremonial staff in another, each assuming its right to ownership, a right which had derived its origin from a myth of an ancestor who fed the eagles when distressed by famine. But you yourself have learned, lad, that an important object cannot be acquired merely by feeding fish to the birds.

"Thus the Shangukeidí went on, very much contented with their idea of virtue, although well aware that the Tsimshian Teikweidí were then claiming their own Eagle as the most important object in the Tsimshian land.

"In the meantime your own ancestor, Yoowuk, grew into manhood. The man, indeed, was one born for a purpose and he never failed in his mission; possibly he was one who would now be spoken of as 'lucky.' Even while a youth the good goddess of fortune was constantly by his fire. It seems there was nothing that this man could not have; all sources of riches yielded to his bidding. Why was this man successful? It is said that it was the rule of his early manhood to serve his fellow men and his generosity was limited only by his physical strength and ability.

"Thus Yoowuk became a man of wealth at an early age. But for a time he did not know what to do with his great amount of property. It was not then as it is now (1915), when there are candy, gold teeth, neckties, and whiskey for which money can be spent freely. A foolish young man now should not wonder why he follows a dog-trail in life; he has nothing and merely looks for a bone that someone may cast away. But here I go away again from my story.

"It was generally expected that the young chief would use his great wealth in placing himself in a high station in life. He consulted men of sound reasoning and they all advised him according to the current customs of that time. One man perhaps suggested that he call together great men of other towns and in their presence bring forth his daughter and put a mark upon her to bear throughout her life." (In the coming-out into society of a woman of caste, the lobes of her ears were perforated during the ceremony and pendants, indicating the rank of the wearer, were inserted.) "Another suggested this and another that but all these ideas did not find comfort in the mind of this modest man.

"One early dawn, in his sleeping-chamber, Yoowuk talked to his wife. Possibly the woman complained of being kept awake by her restless husband and they were heard to say:

"'What can be in your mind-vision to cause you to be so sleepless?'

"'It was the Eagle. It seemed to take a firm hold on my mind and as much as I tried I could not sleep after it entered there.'

"'What sort of an eagle should so take a grip on your foolish brain? You have been dreaming of the poor old bird that we once helped in landing his salmon.'

"The woman knew well the working power of her husband's mind and that he was not the kind to be wasting thoughts on a fisher-eagle but, like most cherished young wives, she wished to make fun of her beloved husband.

"That morning, before the first meal of the day, the local council of the Shangukeidí sat by the morning fire of Yoowuk, nodding their old heads up and down as a sign of their approval of the plan which the young chief laid before them. After a long silence an elder spoke up:

"'You have spoken that which is now fixed in your mind, who is there to change it and tell the outcome of it? But the goddess of fortune is always known to be present wherever a noble mind forms the destiny of man. Therefore, Yoowuk, go and follow that which your true mind dictates and may this same good goddess of fortune smile on you in your undertaking.'

"The question of the Eagle emblem was ever uppermost in the minds of the councilmen, hence the elder spoke their unanimous approval.

"Our party, at that time, was residing at Clay-point Fort (... on the shore of Icy Strait) and it was from that place that Yoowuk put his canoe in the water and paddled away to the land of the Tsimshian ... No, indeed, he was not alone. It is by custom that only the main canoe of an important party is mentioned. The young chief required two great canoes merely to carry the property that he took along to offer in exchange for the right to the Eagle. Yes, there were many other canoes. They say it was something like a great war party.

"They were skilful paddlers, those old-time men. It was then not as it is now, when one can take his bag and walk onto a steamboat and, while enjoying a soft comfortable bed, arrive at a great paddling distance. It is all wonderful, this new life, but such a soft life has much impaired men's abilities. Who is there now with a mind firm enough to paddle to the other end of the world in order to satisfy the need of his people? Indeed the land of the Tsimshian is at a great distance. I have known just such paddling myself when I went on one of Laat_xích_x's visits thither. But it was not too far for a man of determination.

"So on paddled the Shangukeidí braves as each stroke drew them nearer to the object of their desire. The party made a pause at this and at that town and in each a wish for their speed to success was expressed. I think it was from among the Tongass division of our party that an important person was taken aboard and it is said that this

was the man who performed the office of interpreter between the Tlingit and the Tsimshian people.

"K'uhéigoo, the great Tsimshian Teiḵweidí chief, resided at Gitḵxaała, the old town near the mouth of Jin Heen (Skeena River), where our ancestors resided for so many generations.[14] In the hands of this man lay the fate of the Shangukeidí Eagle.

"'It may be that K'uhéigoo himself does not know that we now have made the Eagle an object of importance in our own land, or possibly the man is well informed concerning the former relationship of his people and ours, for there has been no record of an adverse attitude on the part of the Tsimshian towards our free use of the object.' Such were the thoughts of our men as their party approached the land of the Tsimshian ...

"From time unknown it had been the custom of a party, on an important mission, to halt at the approach to its destination and prepare itself for a reception. Thus, the sun being yet high above the horizon when the Shangukeidí party arrived at the approach to Gitḵxaała, a camp for the night was called here. By a great fire that evening, each man spoke forth that which he had formed in his own mind and from all these thoughts was arranged an oration to be delivered in introducing the mission of the party.

"The daily life was well begun when the arrival of the Tlingit was noted at Gitḵxaała. There was a confusion – this house and that were thrown open and from within the inmates rushed forth, as in response to a call of alarm. Meanwhile, in the manner of a peace party at the end of a great war, the arrivals lay afloat in the presence of the crowds of people that gathered in front of the town. All at once the clamor of excitement was hushed, and a voice was heard:

"'Which of our friends have thus journeyed hither to honor us with this unexpected visit?'

"In answer to the inquiry the spokesman of the visitors spoke:

"'From Clay-point Fort these thy descendants have journeyed to thy presence.'

"And then the speaker continued and delivered his well-rehearsed speech. Behold, my lad, I am no longer young and my own grandfather was even older than I am now when he recited to me this old story and I forget even important things. Hence, I can repeat only the important parts of the speech that was given there.

"'My grandfather K'uhéigoo,' the speaker began.

"'Thy grandfather would listen to thy words,' a voice answered.

"'What is foremost in a man's mind when he realizes, when confronted with a duty which no man could avoid, that he has reached the limit of his knowledge of life? Through want of a plain path he is confused. Indeed, a man in such a position is once more an infant who cries out for his wants; he may cry for that which is good to the taste, he looks to some one whom he knows to supply these wants, and he is made

happy through affection. It is in like manner, with the feeling of an infant, that thy grandson Yoowuk has come to thy presence; he craves not that which is good to the taste but that which is the desire of a man.'

"'What is there to hinder a man's progress when he journeys on a right trail of life? He is bound for the desired end. But he who sets forth to find must make a mark by which those who follow may be guided. Thy grandchildren, from their land, have now set forth upon this trail of life and are determined to reach the desired end. In thy hands, O chief, lies the object by which these, thy descendants, will bear in mind the Great Shell from which they came. Man knows no honor greater than that which these thy grandsons would bestow upon thee – the privilege of fulfilling the desire which is uppermost in their minds.'

"The purpose of the Shangukeidí journey thither was no trifling matter; there was not a town in which this could remain unknown. Therefore even the youths at Gitḵxaała understood the meaning of the speech. During the brief silence that followed there were messengers who rushed here and there, apparently delivering some whispered opinions.

"'Thou nobleman, thy grandfather has heard thy noble thought.' And here the speaker turned his face and called out some names:

"'... Indeed, we have been honored by the visit of the noble. Go thither! Let these your friends come to the warmth of our fires; they must be fatigued by their long journey.'

"In response to the call a group of young men came forward, and the baggage of the visitors was immediately carried away to different houses. But there were two canoes, each bearing a full load, well manned, still afloat beyond reach. After the other canoes were emptied and pushed aside, Yoowuk stepped ashore and, empty-handed, was led to the abode of the town chief.

"On the upper dais of the great room stood our ancestor Yoowuk. And there before him, within those walls, was a little world of wonder. The Eagle appeared on all sides; the great bird was carved, in various characters, on the house-pillars, the house-screens, the retaining timbers, and on the many chests. Here was, indeed, the House of the Eagles. For a moment Yoowuk felt sad, not because of disappointment, but because he thought of the comparison between this display and the style in which the object was shown at his own home. He thought of the original Eagle of his ancestors which had been borne through so many changes of life; how small it seemed now! Then he was aroused by another thought. Insignificant as it might seem, this piece had been a cause of the foundation of his party.

"From his seat at the rear of the huge fire rose K'uhéigoo, the great chief. Who is there to imitate the manner of such a nobleman? Like the peaceful flow of a mighty river his words were spoken and these could not be turned back. They say the man

was not of great stature. The corners of his noble forehead were like bays and a great beard hung down upon his chest. What a character! I often wonder why our own men never wore such a sign of distinction. I myself, unconsciously, pluck out the hairs as soon as one appears on my chin. With open arms he pointed to the seat he had just vacated and spoke:

"'My grandson, welcome to the house of thy grandfathers, and here is thy seat. Who is there to sit in the Eagle House with more grace than thou?'

"Then Yoowuk was surprised; this was, in truth, a turn of affairs contrary to that for which he was prepared and there remained no way in which to offer his well-rehearsed speech of presentation. He had planned to offer his own 'presents' first, but he was beaten in this. After he was seated, Yoowuk, in a confused manner, spoke:

"'In thy house, my grandfather, there is plenty and thou shouldst wish for nothing more. Yet I bring to thy hands some things, not because thou art in need of these things but because they are products of my own land. In those canoes yonder, my grandfather, are pieces of fur that may add more to thy comfort and there are also men (slaves) whom I, personally, have trained to attend to thy wants.'

"On that great face, which was lifted high and moved about as if to make certain that all those present had heard, was a broad smile when K'uhéigoo spoke his acceptance:

"'In truth, my grandson, when a man is at my age he looks only for that which offers him more comfort. Ha! And thou hast brought me these things? Indeed, thou hast come at an opportune moment; henceforth I shall feel secure against man's pity when I take the seat of the aged.'

"Again the lord of the town looked about and called out the names of his chosen men:

"'... Go, fetch these things that my grandson has brought for me.'

"When the things were carried in, there were bundles of various sizes, of fur of the sea-otter, beaver, marten, fox and ermine. There were also bundles of moose-hides and behind this great pile of property stood, in order, a well-selected group of young slaves; they say these were one count (twenty) in number.

"In those days the exchanging of important things was done in a respectful manner. And every service was performed in like manner. A man of high character was never known to name or set a price upon his skill or labor and it was according to his own sense of honor, too, that a man expressed his thanks. But now, if the iron dollars are not sufficient in number, we cannot get that which we desire.

"A year, perhaps, had passed when our party called together people from other towns to celebrate the dedication of the new Eagle House at Clay-point Fort. The last ceremony was then drawing to a close, each of our men had sung his song (term for offer of contribution), and it was about dawn of the next day when Yoowuk stood by

the great pile of his own property. On his head was placed the new Eagle Hat – the same one there before you. In concluding his speech, before the distribution of the main offering among the guest party, personal names were bestowed on those members in whom all hopes of progress were then centered, names to commemorate important events which had occurred in our affairs. At last the spokesman announced the new name for the young chief:

"'Henceforth this man shall be no longer Yoowuk but he shall be called Sitoowu-ḵaa (Astute Man). Teiḵweidí! Neixadi! Neis.ádi! Yanyeidí! and Chookaneidí! (Original clans.) In your firm grasp is now the object of your desire. Who is there to dispute your claim to its ownership when ye bear forth into life the Eagle? But before we raise our heads in pride it is proper that we give honor to the noble mind which is the source of one's pride. We have learned that where even a crafty mind fails, a generous mind succeeds. Surely there never was a decision made with more wisdom than that of this man when he decided to clear away the feeling of embarrassment.'

"Now, my lad, I have conveyed to your mind the source of our pride and you bear that same name, the mention of which brings back to the mind of a true man the history of its origin. Many men bore this name before you – noblemen, indeed, who did honor to it. And when I hear about your journeys to the far corners of the strange world, I would, only in silence, invoke some unseen power to grant you success and bear the name clear of disgrace and shame."

The Tlingit definition of the term Sitoowu-ḵaa does not exactly correspond with "wisdom," which the name is supposed to imply, for "wisdom" in Tlingit cannot very well form a personal name, and the use of the allied word "astute" is more convenient of pronunciation. Hence, the employment of Sitoowu-ḵaa (Stoowuḵáa), regardless of its native definition; but the true interpretation of the name is "Wise Man."

Modern influence has now silenced our native life because of our nonconformity and this old hat, likewise, has ceased to inspire patriotism. Hence we can do no more than recite the story of its origin.

NOTES

I would like to thank Alex Pezzati, Research Archivist at the University of Pennsylvania Museum Archives, for his indefatigable assistance over many years in locating Shotridge materials and with innumerable other archival queries; Steve Brown for the information and insights he has provided in our intermittent but always fascinating correspondence; and Christopher Roth for his patient responses to my many inquiries regarding Tsimshian names, hereditary privileges, and correct spellings. Gunalchéesh also to Nora and Richard Dauenhauer and James Crippen for their assistance with several troublesome Tlingit words and names, but any errors committed with Tlingit transcriptions are my own doing.

1 The UPM has received several NAGPRA (Native American Graves Protection and Repatriation Act, 1990) repatriation requests for objects purchased by Shotridge, including a claim for the forty-four objects of his "Snail House Collection" from the T'akdeintaan clan of Hoonah, AK (forty-four represents the number of catalogue entries, not individual items, which have been tallied in various ways). As of December 2011, the UPM had repatriated eight objects to Hoonah and was still negotiating over the remainder.

2 Shotridge's surviving unpublished writings are found in the Alaska Historical Library (Louis Shotridge Papers), Juneau, AK (AHL), as well as in several collections at the UPM Archives: Louis Shotridge Unpublished Ethnographic Notes (UEN), Louis Shotridge Miscellaneous Records (SMR), with some notes also in the UPM Photo Archives and the Mounted Print Collection.

3 Shotridge's lineage affiliation has been given a variety of incorrect identifications in the literature, with the exception of Durlach (1928) and Milburn (1997, 44).

4 Shotridge does not use the Tlingit term in his writings, although *àtú*, glossed as "emblem," appears in the grammar and lexicon he worked on with Boas (Boas 1917, 157).

5 Milburn (1997) included narratives 7.II and 7.III as appendices to her dissertation, and S.C. Brown (2005, 50-51) published narrative 7.IV.

6 See S.C. Brown (2005) for a summary of attempts.

7 See Keithahn (1963, 122); Jonaitis (1986, 114), where Emmons's "rain spirit" interpretation is dismissed.

8 Boas's English translations refer to the "South Wind," but the storm this personage creates is a southeasterly gale.

9 In these selections, I have regularized Shotridge's punctuation and spelling, modernized his orthography, corrected a handful of grammatical lapses, and made occasional cuts, indicated by ellipses, but I have otherwise left his wording unchanged. Titles are Shotridge's own.

10 Emmons found this robe in the custody of Laatxíchx in Fin House, where it was interpreted as a Killer Whale design. See also Emmons (1907, 342, 345-46, 390; 1991, 224).

11 This Yeilxáak was head of the Klukwan Raven House in the first decades of the twentieth century.

12 The Tlingit lexicon of Shotridge and Boas (1917, 125) glosses this as kinnikinnick, *Arctostaphylus uva-ursi*.

13 The "aged Kaagwaantaan" was likely Yisyát Benson, master of Shotridge's own Fin House.

14 The spelling of Kitkatla (Shotridge's "Git-gahtl") given here is the current Tsimshian one; the spelling of Skeena River is Tlingit.

8 | **Anthropology of Art**

*Shifting Paradigms and Practices, 1870s–1950*

The period from the 1870s to 1950 opened with a dispute in North America be-tween advocates of the paradigm of unilineal cultural evolutionism, in particular the director of the US Bureau of Ethnology, and advocates of an approach em-phasizing cultural historicism and relativism, organized around Franz Boas. In France, a structuralist tradition developed in which art was seen within the con-text of the exchange of goods and spiritual essences. These theoretical debates were matched with institutional changes as the centre of gravity of anthropology slowly shifted from museums and quasi-government institutions to newly es-tablished university departments (Hinsley 1981; Jacknis 1985). Both of these de-velopments influenced how material culture and art, and Northwest Coast art in particular, were understood within anthropology. Continued shifts in anthropo-logical theorizing yielded new perspectives on art in the twentieth century as psychological issues came to the fore and were then discarded, as competing versions of structuralism rose and fell, and as North American anthropology moved into a period of emphasis on culture as holistic and cultural traits as understood in functional terms. By the end of this period, the evolutionist and world-scale comparative approach, which characterized so much of social sci-ence at the beginning, had been replaced by a largely ahistorical and functional-ist emphasis on the local. Even in North America, Boasian-inspired anthropology was in retreat.

## THE CULTURE AREA

In the late nineteenth century, North American anthropologists were strug-gling to make sense of the great mass of new data regarding the many Indigenous communities, all of which appeared to the mainstream population to be heading toward extinction. As a consequence, great attention was given to salvaging information about these cultures before the opportunity was lost. At the same

time, anthropologists devised various organizing schemes to compete with clas-
sifications based on cultural evolution. The most widely acclaimed was the idea
of the culture area, a continent-wide classification system that did not require the
implicit judgments about intellect and morality that often underpinned evolu-
tionary schemes but focused on regional continuities in adaptation to the en-
vironment and in culture. Otis T. Mason's 1896 North Pacific Coast culture area
included the coastal area from the Columbia River in the south to Yakutat Bay
in the north, bounded by the Pacific Ocean to the west and the mountain ranges
(Cascade, Coast, and others) to the east. This took in all of the peoples from
the Tlingit to the Chinook. Boas (1891) had earlier distinguished a North Pacific
Coast culture area without elaborating an entire continental system. Others have
employed this culture area concept, although various boundaries have been pro-
posed. Notably, Alfred Louis Kroeber (1923b), focusing on environmental and
cultural features, extended the culture area south to the lower Klamath of north-
west California, and Harold E. Driver (1961) later extended the boundary north
to the Eyak.

The anthropological culture area concept has had important implications for
the understanding of art. Kroeber (1923a, 1923b) [8.VIII] and others added the
idea of sub-areas within the North Pacific culture area characterized by varia-
tions in "cultural intensity" and with particular sub-regions constituting a cul-
tural climax. In Kroeber's view, the Coast Salish peoples, for example, occupied
a backwater, and the northern maritime tribes, such as the Tlingit and Haida,
represented the cultural climax, as indicated by their vigorous art. This approach
echoes the popular idea that the northern tribes, with their impressive totem
poles, chiefly systems, theatrical winter ceremonials, and large-scale art, were
superior intellectually and morally to those in the earlier and more intensively
colonized areas to the south. It also reflects the anthropological interest of the
period in the historical origins of cultures and was tied to theories regarding
the comparative development of coastal societies and interior societies, which
were considered materially and socially simpler. Those groups thought to have
migrated retained some interior features and acquired other features from the
long-established and culturally superior coastal people. In effect, the climax
areas were regarded as the centres of cultural production from which ideas dif-
fused to the marginal, less-well-developed areas. Clark Wissler (1917, 215; see
also 1914), for example, regarded the northern sub-area as the "type" that defined
the Northwest Coast generally and held that the "art, social, and ceremonial
traits of the North thin out as we move southward." But Boas (1938, 671) argued
against identifying particular groups as marginal and others as focal.

### Evolutionism and the Bureau of Ethnology

During the period from the late 1880s to the 1920s, prior to the establishment of a university-based professional anthropology as advocated by Boas (Jacknis 1985, 75), anthropology in North America was dominated by museums and quasi-governmental institutions. Prominent among them in the United States was the Bureau of Ethnology and the US National Museum – later the Smithsonian. The Bureau of Ethnology was established in 1879 with a $20,000 grant from Congress, during the final phase of the military pacification of American Indians, and was directed by John Wesley Powell, the American "discoverer" of the Grand Canyon, who imposed the evolutionist framework developed by Lewis Henry Morgan in his 1877 monograph *Ancient Society: Researches on the Lines of Human Progress from Savagery, through Barbarism, to Civilization*, with some slight revisions (Powell 1899, 695-745) [8.III]. Morgan attempted to capitalize on the vast new stores of information about the "uncivilized" peoples of his day as it came in from explorers, travellers, and missionaries, some of whom filled out ethnographic questionnaires, and from ethnographers themselves. He created a scheme of social evolution, dividing humanity into stages of lower, middle, and upper savagery and barbarism and civilization [8.II].

Morgan was a New York state lawyer who had worked for Seneca (Iroquoian) clients and, surprised and intrigued by the complexity of their kinship and political systems, had attempted to explain the differences among groups and to assign an appropriate status to what he regarded as the almost civilized Iroquois. His work influenced Marx and Engels through his emphasis on a material concept of history by linking technology with changes in social organization. He focused on the singularity of humanity, which caused him to believe that development occurs similarly everywhere, and expressed this in a unilineal theory of evolution. In particular, he followed changes in the forms of subsistence practice, marriage and family life, and property concepts through time. The different epochs were themselves associated with particular advances in art. What Morgan (1877, 10) termed the upper status of savagery, for example, "commenced with the invention of the bow and arrow, and ended with the invention of the art of pottery." Furthermore, "all such tribes, then, as never attained to the art of pottery will be classed as savages, and those possessing this art, but who never attained a phonetic alphabet and the use of writing will be classed as barbarians. The first sub-period of barbarism commenced with the manufacture of pottery, whether by original invention or adoption" (10) And, later in the text, "the introduction of the ceramic art produced a new epoch in human progress in the direction of an improved living and increased domestic conveniences" (14). But

Morgan assigned little weight at all to aesthetics in his scheme for humankind's ascent to civilization, and by "art" he meant "the art of" making something, such as pottery and ceramics, but also government, bows and arrows, cultivation, and so on. His scheme, however, did point to the importance of material culture in human evolution and to particular arts as diagnostic of change.

Working from this perspective, then, the bureau (renamed the Bureau of American Ethnology, or BAE, in 1897) undertook a comprehensive survey of American Indians, including the arts. Director Powell suggested that William Healey Dall study the masks of the Pacific Coast. Dall's subsequent 1884 contribution to the 1881-82 third annual report of the BAE was entitled "On Masks, Labrets, and Certain Aboriginal Customs, with an Inquiry into the Bearing of Their Geographical Distribution," and the underpinning of his work was the view that "one who had thoroughly mastered [the study of masks] would be possessed of the keys to the greater part of the mystery which locks us from the philosophical, religious, and social developments of uncivilized or savage man" (73) [8.VII].

Dall's work was evolutionist, comparative, and classificatory. However, Dall tied the distribution of features of material culture to geographic and linguistic data, in addition to his evolutionary stance, a position that Powell disavowed. Dall (1884, 74-76) advanced ten propositions about the evolution of the mask, suggesting that an object that protected the face gradually became associated less with "mechanical" values and more with symbolic and spiritual ideas, particularly the idea of superhuman qualities and totemic beings. He included labrets in his study, comparing the use of labrets in Africa, Mexico, and the Pacific Coast and noting that their use "declines with contact with civilization" (78). He observed that Tlingit were restricted from the wearing of labrets, an indication that the Tlingit had advanced beyond promiscuous rights (82), a stage of human development in evolutionary modelling.

But Dall (1884, 109) also noted the context of the use of masks, described a Nuu-chah-nulth masked dance performance, and made an association between Makah masks and winter ceremonials and guardian spirits. Mask use, he said, was "another of the links which bind diverse Western American nations into a mysterious partnership" (120).

FRANZ BOAS, THE CRITIQUE OF EVOLUTIONISM, AND THE AMERICANIST TRADITION

Franz Boas, known today as the "father of North American anthropology," entered the North American scene in 1886 after meeting a group of Bella Coola

(Nuxalk) dancers, brought to Berlin by Johann Jacobsen, and after studying Jacobsen's writings on the Northwest Coast. In his 1886 trip to North America, Boas met members of several Northwest Coast communities. He returned six more times by 1897, working with nearly every group. As he developed his own approach, he was heavily influenced by his German professors and a German intellectual tradition that remained outside Anglo-American theorizing about the evolution of civilization. Among his influences was Adolph Bastian, who argued for the psychic unity of humankind, for the importance of fieldwork methodology for generating cross-cultural data, and for understanding variation in human culture as the outcome of historical accident.

Boas engaged in intellectual repartee with his counterparts in American anthropology, particularly the members of the Bureau of Ethnology and the US National Museum (Kuper 1988, 236) [8.IV]. In simplest terms, cultural evolutionists of various stripes proposed that differences among groups of humans could be understood by reference to their stage of development toward civilization. Boas proposed instead that these evolutionary schemes were empirically flawed and that difference could be understood by examining diffusion and focusing on local development (although Darnell [1999] argues that the Bureau of Ethnology and the Boasians overlapped in perspective, differing more with the emerging British social anthropology tradition than they did internally).

In 1896, Boas published "The Limitations of the Comparative Method," referring to the methods of evolutionists, and followed this with *The Mind of Primitive Man* (1911), in which he laid out his new paradigm more clearly (Silverman 2005, 261). His new paradigm emphasized fieldwork and empiricism, and a reliance on elder testimony and the recording of texts, rather than participant observation in communities. In fact, Boas carried out much of his research in canneries, which employed Indians seasonally, rather than in home communities themselves. He advocated for research conducted in Indigenous languages, in part for the insights he believed he could gain into the mental states of his informants. An important feature of the new Americanist tradition was the use of field assistants who were Aboriginal peoples themselves and who heavily influenced the interpretations of Aboriginal cultures. Some of them became anthropological researchers in their own right, notably Boas's collaborator George Hunt, of Tlingit and British descent, who worked with and married into the Kwakwa̲ka̲'wakw community (see Nicolson, this volume). Kroeber's comment on Hunt's work is excerpted [8.VI].

CULTURE AND PSYCHOLOGY

Boas emphatically rejected evolutionism because he believed that Northwest

Coast communities were the products of their own particular histories and that Indigenous arts could be understood in the larger attempt to study culture, the newly minted anthropological concept advanced in Great Britain by E.B. Tylor (1871) and others [8.I]. For Boas and his followers, culture, not race, was the primary force influencing human behaviour. Boas's approach to culture led to studies that tracked the movement of designs within a culture area and to studies of the form and media of art. However, the more conjectural and arbitrary culture area concept risked obscuring the role of influences across cultural boundaries, and the studies of form and media were descriptively rich but ahistorical and isolationist (Dobkins 2004, 215).

Interest in the psychic unity of humankind led Boas to address psychological questions and individual creativity within an art tradition. He was the first to systematically study Northwest Coast art, initially arguing against the idea that art developed from realism to abstraction, instead claiming that particular conventions resulted from attempts by artists to portray all of the essential characteristics of an animal through distortions such as "split representation" (Suttles and Jonaitis 1990, 82; see also Halpin (1994) [19.xv] for a critique of the Boasian approach and an argument for ambiguity and instability in design as opposed to rule following; see also Jonaitis (1995) [19.xiv], who points to Boas's recognition of the contributions of individual artists). Later Boas ([1927] 1955, 285) reconstructed the history of the art in the region and identified an older, geometric style. In integrating the psychological and the creative dimensions of art, he provided an alternative to evolutionist perspectives on art [8.v, 15.I].

Boas's students working in the early twentieth century, especially from 1910 to the 1930s, including Herman Karl Haeberlin, T.T. Waterman, and Ruth Bunzel, emphasized the field method of participant observation, even learning art techniques and eliciting the viewpoints of artists themselves. Haeberlin, writing in the *American Anthropologist* in 1918, called on important features of the Boasian approach in his look at Northwest Coast art [8.x]. He wrote from a "culture history" perspective and advocated for the establishment of a scientific basis for the study of aesthetics. Aesthetics, he wrote, is not merely the "fanciful study of metaphysical postulates" (258), or the study of individuals, but is rather about *culture history* and the artistic principles characteristic of certain cultural groups or epochs or schools of artists. The culture history approach he proposed examined the *relations* of forms, rather than the contents, in the art products typical of the culture area. For example, Haeberlin compared the forms of the mouth in Northwest Coast totem poles, house fronts, canoes, dishes, spoons, and other pieces to the forms of eyebrows to reveal aesthetic principles of art. Similarly,

the relation of lines to surfaces, or combinations of different figures, or the adaptation of surfaces to subject matter were all in play (see Bunn-Marcuse, this volume).

Haeberlin (1918, 262) hoped to attain culture historical depth "by comparing stylistic form relations of the cultural center with those of the marginal areas ... Certainly the waning away of the principles of the esthetic form, which are valid among the Haida, as we proceed southward to the Kwakiutl and finally to the Nootka and Salish tribes, and northwest to the northern Tlingit." While Haeberlin argued for the importance of determining those stylistic elements typical of the culture area, he also argued for understanding the role of the individual artist [8.x].

Another student of Boas, T.T. Waterman, writing in *American Anthropologist* in 1923, pointed to the importance of consulting Aboriginal people about their art and paid attention to exaggerated symbolic features of art and to understanding migration and diffusion [8.xi]. The result of this process of symbolic representation, according to Waterman, was an art in which particular symbols came to stand in for an entire animal. In this view, artists show what they know is there, not what is visible. But Waterman believed that variation in form in Northwest Coast art and architecture must also be understood in reference to quite different forces. Echoing arguments about culture areas, he argued that the gable-type house was once distributed along the whole coast, and the later distribution reflected the introduction of simpler and cruder Salish house types, brought in from the interior plateau.

William H. Holmes, successor to Powell as head of the BAE, took a position that combined features of evolutionary and Boasian thought. In his contribution to the 1906 volume *Anthropological Papers Written in Honor of Franz Boas*, a chapter entitled "Decorative Art of the Aborigines of Northern America," he wrote that it is not essential that theories of the evolution of ornaments be considered in treating the decorative arts of North America [8.ix]. Still, Holmes's work was not without evolutionary overtones. Holmes differentiated between semi-civilized peoples of Middle America and civilized ones, and he observed that the earliest manifestations of embellishment were "probably of instinctive kinds ... in which design had no part" (179) and that geometric ornamentation would arise early in the stages of culture progress (185). His approach was comparative and built on the idea that "native ornament may be considered with respect to method of execution or utilization of elements" (180). Furthermore, he distinguished classes of "motives" for ornamentation, specifying interest in technical features, in the aesthetic, ideographic, and sacred. Although a member of the

BAE, Holmes shared a diffusionist and historical particularist viewpoint with Boas. To Holmes, while comparison was helpful, evolutionary explanation was inadequate to examine ornamentation, and he instead pointed to the forces of diffusion and environment.

In the same 1906 volume, Clark Wissler, in his chapter "A Psycho-Physical Element in Primitive Art," argued for the importance of psychological elements in understanding the art of the peoples of North America. Wissler was educated as a psychologist but took a course with Boas and later served under him as an assistant in ethnology at the American Museum of Natural History in 1902, succeeding him as curator. The fit was a good one because Boas himself gave great attention to psychology. Wissler attempted to refute the contemporary theory that representational art precedes ornamentation "in the normal development of the race" (189): at first, people draw well or realistically, but gradually drawing degenerates into angular form until it becomes pure ornamentation. Wissler believed that in western America there was no necessary connection between objective forms of design and the object represented. All designs were once realistic forms of animals, which became misrepresented when they were borrowed by other tribes. Wissler argued that designs are synthetic in origin, built out of simple elements, and independent of all representative forms. This, he believed, fit better with ideas of the human mind. "Man begins with scratches and ends with ornamentation" (190-91), he wrote, and "once man caught the idea of representing a mental copy of objects by marks ... representative art was born, and could be handed on by imitation" (ibid.).

The Boasian paradigm, with its dual emphasis on history and psychology, moved in the direction of the latter in the 1920s with the second generation of students of Boas, who were influenced by psychoanalysis and Gestalt psychology but who now regarded diffusionism and trait-list historicism as less than enticing (Silverman 2005, 267). These students helped to develop culture and personality studies. Margaret Mead ([1928] 1961) undertook the study of adolescence in Samoa, hoping to advance cultural explanations, dispute universalistic biological understandings, and enter into the mental life of the society. Ruth Benedict (1934), heavily influenced by her reading of Northwest Coast ethnography, took this even further in advancing an argument for an anthropological focus on the integrated patterning of society. In her book *Patterns of Culture*, she argued that cultures could be seen as personalities writ large, emphasizing particular dominant themes, with cultures providing the "raw material of which the individual makes his life" (251-52). This was the strongest expression of the cultural relativism of the Boasian school. Benedict compared the creation of styles of art within a culture to the integration of culture itself [8.XII, 23.IV].

MARCEL MAUSS AND FRENCH STRUCTURALISM

The Americanist tradition building from Boas was not the only national tradition of scholarship that influenced understandings of Northwest Coast art. The sociologist Marcel Mauss followed in the French philosophical tradition running from Montesquieu through Turgot, Condorcet, St. Simon to Comte and Mauss's uncle, Émile Durkheim. The leading figure of his day, Mauss examined archaic societies, following in the Durkheimian tradition of looking at society as a totality, deriving meaning from complex concrete reality. Mauss's book *The Gift: Forms and Functions of Exchange in Archaic Societies*, published in French in 1923-24 and in English in 1954, with a revised edition in 1967 [8.XIII, 23.III], was not primarily about art or aesthetics but presented a perspective on Northwest Coast societies that incorporated this topic into his "total" analysis. Mauss's work was a direct inspiration to Claude Lévi-Strauss (see Mauzé, this volume; Campbell, this volume), whose formal structural analyses heavily influenced views of Northwest Coast culture and art in the second half of the twentieth century. Mauss's method called for a careful comparison of archaic societies based on documentation and philology and rejected evolutionary logic even while embedding it in the structure of his argumentation.

Mauss (1967, 1) understood the potlatch as a total social phenomenon in which "all kinds of institutions find simultaneous expression: religious, legal, moral, and economic. In addition, the phenomena have their aesthetic aspect and they reveal morphological types." Central to this is the practice of giving, accepting, and returning gifts, which appears to be voluntary but is not. This practice was termed "total prestation." Among the Northwest Coast peoples, according to Mauss, material and moral life was exemplified in a form of gift-exchange in which the objects of exchange themselves are animated, potent, and named and are never completely separated from those who give them. For Tlingit, Haida, and Tsimshian societies, Mauss wrote, the potlatch was the same as gift-exchange elsewhere except for the unusual emphasis on violence, rivalry, and antagonism (33). The potlatch, the pre-eminent institution of gift-exchange in archaic societies, in Mauss's terms the "monster child of the gift system" (41), was "religious, mythological, and shamanistic because the chiefs taking part are incarnations of gods and ancestors, whose names they bear, whose dances they dance and whose spirits possess them" (36). Furthermore, the gifts that must be exchanged "have a virtue of their own which causes them to be given and compels the making of counter-gifts" (37).

The power of the objects in exchange acts to sacralize property and wealth is represented in immortal beings such as "Property Woman," known by various

names in the different communities. The precious family objects constitute the "magical legacy of the people" (Mauss 1967, 42), derived from the founding hero of the clan, to whom the spirits gave them in mythological encounter. The objects are kept in magical boxes, hidden in the longhouses, themselves endowed with powerful personalities and containing the owner's soul. These objects of wealth are decorated. Mauss described various objects and their spiritual and symbolic dimensions. Decorated coppers are, he said, the most important articles in potlatching and, like spoons and dishes, have names and personalities and their own magical values and virtues. They, too, are circulated and bring cohesion to the community.

## Marcel Griaule, Ethnography, and Surrealism

But while French theorists were inspired by the Northwest Coast and by research there, particularly the work of Boas, ethnographic research was tied to its colonies. Marcel Griaule, a student of Mauss, developed methods of ethnographic fieldwork and collecting during a period of enthusiasm for *l'art nègre* and the primitive, developments stimulated by French colonies in Africa (Parkin 2005, 202). The term *l'art nègre* embraced American jazz and voodoo ritual but, significantly, also came to include pre-Columbian artifacts and postcontact artifacts, such as those from the Northwest Coast. Griaule is best known for his fieldwork with the Dogon of the French Sudan (now Mali) and his study of synchronic cultural patterns and emphasis on initiation rituals as a means of entering into Indigenous cultures. His highly publicized nine-member ethnographic Mission Dakar-Djibouti in the early 1930s returned with 3,500 objects bound for what became a chic exhibit in the Trocadero museum (later the Musée de l'Homme), a museum that attracted Pablo Picasso and other leading artists. Here ethnography was considered a process of collection of "dead" objects that, if authentic and autonomous, could be restored to life by documentation (Clifford 1988b, 66-67; Griaule 1950) [8.XIII].

These objects fed a European appetite for exotic artifacts and supported the convergence of Cubist and Surrealist aesthetics and ethnographic practice, which "attacks the familiar" and remains in tension with anthropological humanism, which attempts to familiarize (Clifford 1988b, 145). "Reality ... could never again be seen as simple or continuous, describable empirically or through induction" (134). The artifacts also contributed to the application of the culture area concept to sub-Saharan Africa (56). The art of the Dogon, including their oral traditions, if not their culture as a whole, was thought to be fully developed and worthy of esteem. Surrealists also discovered Northwest Coast art during

and after World War II (Jonaitis 1995, 321), collecting Eskimo and Northwest Coast art in New York (Clifford 1988b, 238-39; see also Mauzé, this volume). Twentieth-century French anthropologists and European artists shared an interest in Northwest Coast cultural and aesthetic practices, as well as those of Africa, and these interests helped to transform theories of exchange, the idea of culture, ethnographic collection and curation, and ethnographic methods and to launch modern art through Cubism and Surrealism.

## CONCLUSION

The period of the 1870s to the middle of the twentieth century saw the birth of anthropology as a viable and visible academic discipline. The new discipline developed differently in various locations, but as a whole it moved away from viewing cultural evolutionism as providing suitable explanations for social and cultural variation. Alternative approaches were developed, including Boasian historical particularism, with its psychological overtones, and French structuralism, which themselves suggested approaches to art. Both Americanist and French anthropologists gave particular attention to the Northwest Coast societies and their expressive cultures in building their theories.

---

**8.I. Edward Burnett Tylor. 1871. *Primitive Culture.*** London: J. Murray, 1.

Edward Burnett Tylor (1832-1917), born in London to Quaker parents, was influenced by Darwin's theories of biological evolution in developing his own theories of cultural evolution. He established "culture" as central to the emerging field of anthropology and hoped to establish the study of culture as a scientific enterprise. He helped to create the curriculum for anthropological studies at Oxford and served as a professor of anthropology there from 1896 to 1909. His most notable book was *Primitive Culture* (1871), in which he gave a new anthropological definition to culture.

> Culture or Civilization, taken in its wide ethnographic sense, is that complex whole which includes knowledge, belief, art, morals, law, custom, and any other capabilities and habits acquired by man as a member of society. The condition of culture among the various societies of mankind, in so far as it is capable of being investigated on general principles, is a subject apt for the study of laws of human thought and action. On the one hand, the uniformity which so largely pervades civilization may be ascribed, in great measure, to the uniform action of uniform causes: while on the other hand its various grades may be regarded as stages of development or evolution, each

the outcome of previous history, and about to do its proper part in shaping the history of the future. To the investigation of these two great principles in several departments of ethnography, with especial consideration of the civilization of the lower tribes as related to the civilization of the higher nations, the present volumes are devoted.

**8.II. Lewis Henry Morgan. 1877.** *Ancient Society: Researches on the Lines of Human Progress from Savagery, through Barbarism, to Civilization.* New York: Henry Holt and Company, v-viii.

Lewis Henry Morgan (1818-81), a lawyer, befriended the young Seneca man Ely S. Parker, who influenced his study of the Iroquois and led to the publication of *The League of the Ho-dé-no-sau-nee* (1851). Morgan's classic work, *Ancient Society* (1877), was a compilation and synthesis of a great mass of new information about the peoples of the world in the period after Morgan researched the Iroquoian kinship system and struggled to place the Iroquois within his scheme of cultural evolution. Although he was not the first to suggest a tripartite scheme of evolution, his ideas of savagery, barbarism, and civilization, with sub-stages, became the most influential in late-nineteenth-century anthropology, particularly influencing J.W. Powell and some (but not all) of the members of the Bureau of American Ethnology. Morgan's approach became the subject of critique by Franz Boas. This excerpt is the preface to *Ancient Society*.

> The great antiquity of mankind upon the earth has been conclusively established. It seems singular that the proofs should have been discovered as recently as within the last thirty years, and that the present generation should be the first called upon to recognize so important a fact.
>
> Mankind are [sic] now known to have existed in Europe in the glacial period, and even back of its commencement, with every probability of their origination in a prior geological age. They have survived many races of animals with whom they were contemporaneous, and passed through a process of development, in the several branches of the human family, as remarkable in its courses as in its progress.
>
> Since the probable length of their career is connected with geological periods, a limited measure of time is excluded. One hundred or two hundred thousand years would be an un-extravagant estimate of the period from the disappearance of the glaciers in the northern hemisphere to the present time. Whatever doubts may attend any estimate of a period, the actual duration of which is unknown, the existence of mankind extends backward immeasurably, and loses itself in a vast and profound antiquity.
>
> This knowledge changes materially the views which have prevailed respecting the relations of savages, to barbarians and of barbarians to civilized men. It can now be

asserted upon convincing evidence that savagery preceded barbarism in all the tribes of mankind, as barbarism is known to have preceded civilization. The history of the human race is one in source, one in experience, one in progress.

It is both a natural and a proper desire to learn, if possible, how all these ages upon ages of past time have been expended by mankind; how savages, advancing by slow, almost imperceptible steps, attained the higher condition of barbarians; how barbarians, by similar progressive advancement, finally attained to civilization; and why other tribes and nations have been left behind in the race of progress – some in civilization, some in barbarism, others in savagery. It is not too much to expect that ultimately these several questions will be answered.

Inventions and discoveries stand in serial relations along the lines of human progress, and register its successive stages; while social and civil institutions, in virtue of their connection with perpetual human wants, have been developed from a few primary germs of thought. They exhibit a similar register of progress. These institutions, inventions and discoveries have embodied and preserved the principal facts now remaining illustrative of this experience. When collated and compared they tend to show the unity of origin of mankind, the similarity of human wants in the same stages of advancement, and the uniformity of the operations of the human mind in similar conditions of society.

Throughout the latter part of the period of savagery and the entire period of barbarism, mankind in general were organized in gentes, phratries and tribes. These organizations prevailed throughout the entire ancient world upon all the continents, and were the instrumentalities by means of which ancient society was organized and held together. Their structure, and relations, as members of an organic series, and the rights, privileges and obligations of the member of the gens, and of the members of the phratry and tribe illustrate the growth of the idea of government in the human mind. The principal institutions of mankind originated in savagery, were developed in barbarism, and are maturing in civilization.

In like manner, the family has passed through successive forms, and created great systems of consanguinity and affinity which have remained to the present time. These systems, which record the relationships existing in the family of the period, when each system respectively was formed, contain an instructive record of the experience of mankind while the family was advancing from the consanguine, through intermediate forms, to the monogamian.

The idea of property has undergone a similar growth and development. Commencing at zero in savagery, the passion for the possession of property, as the representative of accumulated, subsistence, has now become dominant over the human mind in civilized races.

The four classes of facts above indicated, and which extend themselves in parallel lines along the pathways of human progress from savagery to civilization, form the principal subjects of discussion in this volume.

There is one field of labour in which, as Americans, we have special interest as well as a special duty. Rich as the American continent is known to be in material wealth, it is also the richest of all the continents in ethnological, philosophical and archaeological materials, illustrative of the great period of barbarism. Since mankind were one in origin, their career has been essentially one, running in different channels upon all continents, and very similarly in all the tribes and nations of mankind down to the same status of advancement. It follows that the history and experience of American Indian tribes represent, or less nearly, the history and experience of our own remote ancestors when in corresponding conditions. Forming a part of the human record, their institutions, arts, inventions and practical experience possess a high and special value reaching far beyond the Indian race itself.

When discovered, the American Indian tribes represented three distinct ethnical periods, and more completely than they were elsewhere then represented upon the earth. Materials for ethnology, philology and archaeology were offered in unparalleled abundance; but as these sciences scarcely existed until the present century, and are but feebly prosecuted among us at the present time, the workmen have been unequal to the work. Moreover, while fossil remains buried in the earth will keep for the future student, the remains of Indian arts, languages and institutions will not. They are perishing daily, and have been perishing for upwards of three centuries. The ethnic life of the Indian tribes is declining under the influence of American civilization, their arts and languages are disappearing, and their institutions are dissolving. After a few more years, facts that may now be gathered with ease will become impossible of discovery. These circumstances appeal strongly to Americans to enter this great field and gather its abundant harvest.

ROCHESTER, New Yong [sic], March, 1877.

**8.III. J.W. Powell. 1885. "From Savagery to Barbarism. Annual Address of the President."**
*Transactions of the Anthropological Society of Washington* 3 (6 November 1883–19 May 1885): 612-13, 614.

J.W. Powell (1834-1902) was a Civil War veteran, director of the US Geological Survey from 1881 to 1894, and director of the Bureau of American Ethnology. His "Annual Address of the President" for 1883 was one of a series of publications in which he made clear his approach to anthropology and his idea of culture and the arts. He noted his reliance on Morgan and specified ways in which he differed. Powell later added a fourth stage of human progress to those of savagery, barbarism, and civilization.

It is a long way from savagery to civilization. In the attempt to delineate the progress of mankind through this long way, it would be a convenience if it could be divided into clearly defined states. The course of culture, which may be defined as the development of mankind from savagery to civilization, is the evolution of the humanities – the five great classes of activities denominated arts, institutions, languages, opinions, and intellections. Now if this course of culture is to be divided into stages, the several stages should be represented in every one of the classes of activities. If there are three stages of culture, there should be three stages of arts, three stages of institutions, three stages of language, three stages of opinions, and three stages of intellections.

Three such culture stages have been recognized by anthropologists, denominated Savagery, Barbarism, and Civilization. But they have been vaguely characterized and demarcated. Savagery has been considered a low state of culture, barbarism a middle stage of culture, and civilization a high stage of culture ... It is intended on this occasion simply to characterize Savagery and Barbarism, and to define the epoch of transition. To this end it will be necessary to set forth the characteristics of savage art as opposed to barbaric art, and the nature of the change.

...

The most noteworthy attempt hitherto made to distinguish and define culture-stages is that of Lewis H. Morgan, in his great work entitled "Ancient Society." In it these three grand periods appear – Savagery, Barbarism, and Civilization – each with sub-divisions. Morgan recognized the importance of arts as the foundation of culture, and his "ethnic periods," as he calls them, are based on art development. With him, Savagery embraces all that stage of human progress extending from the beginning of the history of man, as distinguished from lower animals, to the invention of pottery. Barbarism then succeeds and extends the invention of the alphabet. He adds that among some peoples hieroglyphic writing takes the place of phonetic writing, and civilization begins at this time ... In some of Morgan's works he connects the evolution of institutions with the development of arts, but to an imperfect degree, and without explaining their interdependence.

**8.IV. J.W. Powell. 1887. "Museums of Ethnology and Their Classification."** Letters to the Editor. *Science* 9, 227: 612-13 / Franz Boas. 1887. **"Museums of Ethnology and Their Classification."** Letters to the Editor. *Science* 9, 227: 613-14.

J.W. Powell and Franz Boas, the two main competitors for setting the direction of North American anthropology at the turn of the century, debated in the pages of *Science,* advancing their notions of how museum exhibitions ought to be conceived and, less directly, contesting the underlying model of what anthropology was about and how Indigenous peoples might be understood. In 1887, for

example, the two adversaries set out their opinions in letters to the editor of the journal. In the following letter, Powell refuted ideas of museum presentation based on tribal groupings, which themselves have linguistic and geographic affinities, as culture area theory supposed. He persisted in a view of humanity as a single unit, as in theories of cultural evolution.

POWELL

The article of Dr. Boas, to which you call attention in your note to myself, treats of two distinct subject: first, the interpretation of similarities; and second, the best method of grouping archaeological objects in the museum ...

The functions of a museum are twofold: first as a repository of materials for the investigator; second, as an objective exemplification of some system of knowledge pertaining to the subject ...

Now, Dr. Boas offers a system or plan for the arrangement of the materials which relate to the pre-Columbian peoples of America and their descendents. He would have them arranged by tribes. On the discovery of America there were probably more than twenty-five thousand tribes inhabiting the country, each a little band of people ... But probably within the first year [after contact], changes were made in some of these bodies-politic: some coalesced by treaty or conquest ... so that a hundred years after the discovery of America it is not probable that there existed any one tribe which could claim to be the pure and simple descendent, without loss, admixture, or change, of any tribe existing at the time of discovery ... This means simply that under primitive and under modern conditions alike there has been no permanent tribal organization ... A museum collected to represent the tribes of America ... would have very little scientific value.

But if a classification of the tribes of North America were possible, the archaeologic collections actually made in the country could not be relegated to them, for the tribes have been forever migrant.

In this connection it is sufficient to say, that, as there is and can be no ethnic classification of the tribes of America, so there can be no classification of their art on that basis. Yet we might classify their arts in a museum on the basis of classes derived from linguistic affinities; but it would be wholly arbitrary, and lead to no valuable results ...

Dr. Boas suggests a geographic distribution in a manner which makes it appear that he considers a geographic classification to be essentially the same as an ethnographic classification, but the two are altogether different things.

*The unity of mankind is the greatest induction of anthropology.* [emphasis added]

Washington, June 11 [1887] J.W. Powell.

Franz Boas (1858-1942) was born in Germany and received his doctorate there in physics. During postdoctoral research in Baffin Island in 1883, he moved toward the study of anthropology and non-Western peoples. He was the founder of the first Department of Anthropology in the United States at Columbia University and influenced a generation of scholars and beyond. Boas's letter to the editor of *Science*, published in the same volume as that of Powell, referenced the continuing debate.

BOAS

A few words more on Major Powell's remarks on the classification of tribes and the alleged impossibility of arranging a tribal museum. The problem has been solved by numerous museums, even much larger than the national museum. The ideal plan of their arrangement is to exhibit a full set of a representative of an ethnical group, and to show slight particularities in small special sets. Experience shows this can be done with collections from all parts of the world without over-burdening the collection with duplicates, and without making artificial classifications – only by grouping the tribes according to ethnic similarities.

New York, June 18 [1887] Dr. Franz Boas.

**8.V. Franz Boas. (1927) 1955. Preface. In *Primitive Art*.** New York: Dover, 1-2, 4-7.

The preface to *Primitive Art* summarized Boas's approach to art, especially as it related to the Northwest Coast culture area. By this point, however, Boas had broadened his comparative frame of reference.

This book is an attempt to give an analytical description of the fundamental traits of primitive art. The treatment given to the subject is based on two principles that, I believe, should guide all investigations into the manifestations of life among primitive people: the one the fundamental sameness of mental processes in all races and in all cultural forms of the present day; the other, the consideration of every cultural phenomenon as the result of historical happenings.

There must have been a time when man's mental equipment was different from what it is now, when it was evolving from a condition similar to that found among the higher apes. That period lies far behind us and no trace of a lower mental organization is found in any of the extant races of man. So far as my personal experience goes and so far as I feel competent to judge ethnographical data on the basis of this experience, the mental processes of man are the same everywhere, regardless of race and culture, and regardless of the apparent absurdity of beliefs and customs.

Some theorists assume a mental equipment of primitive man distinct from that of civilized man. I have never seen a person in primitive life to whom this theory would apply. There are slavish believers in the teachings of the past and there are scoffers and unbelievers; there are clear thinkers and muddleheaded bunglers: there are strong characters and weaklings.

The behavior of everybody, no matter to what culture he may belong, is determined by the traditional material he handles, and man, the world over, handles the material transmitted to him according to the same methods.

Our traditional experience has taught us to consider the course of objective events as the result of definite, objective causation. Inexorable causality governs here and the outer world cannot be influenced by mental conditions. Hence our hesitating wonder at the phenomena of hypnotism and suggestion in which these lines seem no longer sharply drawn. Our cultural environment has impressed this view upon our minds so deeply that we assume as a fundamental fact that material phenomena, particularly outside of the field of human behavior, can never be influenced by mental, subjective processes. Still, every ardent wish implies the possibility of fulfilment and prayers for objective benefits or for help do not differ in principle from the attempts of primitive man to interfere with the uncontrollable course of nature. The credulity with which fantastic theories bearing upon health are accepted, the constant rise of religious sects with abstruse dogmatic tenets, as well as the fashions in scientific and philosophic theory prove the weakness of our claim to a rational view of the world.

Anyone who has lived with primitive tribes, who has shared their joys and sorrows, their privations and their luxuries, who sees in them not solely subjects of study to be examined like a cell under the microscope, but feeling and thinking human beings, will agree that there is no such thing as a "primitive mind," a "magical" or "prelogical" way of thinking, but that each individual in "primitive" society is a man, a woman, a child of the same kind, of the same way of thinking, feeling and acting as man, woman or child in our own society.

...

The second fundamental point to be borne in mind is that each culture can be understood only as an historical growth determined by the social and geographical environment in which each people is placed and by the way in which it develops the cultural material that comes into its possession from the outside or through its own creativeness. For the purpose of an historical analysis we treat each particular problem first of all as a unit, and we attempt to unravel the threads that may be traced in the development of its present form. For this reason we may not start our inquiries and interpretations, as though the fundamental thesis of a single unilineal development of cultural traits the world over, of a development that follows everywhere the same lines, had been definitely proven. If it is claimed that culture has run such a course, the assertion

must be proven on the basis of detailed studies of the historical changes in single cultures and by the demonstration of analogies in their development.

It is safe to say that the critical study of recent years has definitely disproved the existence of far reaching homologies which would permit us to arrange all the manifold cultural lines in an ascending scale in which to each can be assigned its proper place.

On the other hand dynamic conditions exist, based on environment, physiological, psychological, and social factors, that may bring forth similar cultural processes in different parts of the world, so that it is probable that some of the historical happenings may be viewed under more general dynamic viewpoints.

But historical data are not available and when prehistoric research does not reveal sequences of cultural changes, the only available method of study is the geographical one, the study of distribution. This has been emphasized in the last third of the past century by Friedrich Ratzel. It has probably been most rigidly developed in the United States. I illustrated this method in 1891 by a study of the distribution of folk tales in North America and it has become more and more the method of analytical study of cultural forms.

Its very fruitfulness, however, has led to extremes in its application that should be guarded against. I pointed out, in print in 1911 and often before and since that time in speaking, that there is a certain homology between universal distribution of cultural facts and their antiquity. The fundamental principle involved in this assumption was fully discussed by Georg Gerland in 1875, although we are hardly ready to accept his conclusions. The data of prehistoric archaeology prove that some of these universal achievements go back to paleolithic times. Stone implements, fire and ornaments are found in that period. Pottery and agriculture, which are less universally distributed, appear later. Metals, the use of which is still more limited in space, are found still later.

Recent attempts have been made to raise to a general principle this point of view which, with due caution, may be applied here and there. Herbert Spinden in his reconstruction of American prehistoric chronology, Alfred Kroeber in his analysis of cultural forms of the Pacific Coast, and quite recently Clark Wissler have built up, founded on this principle a system of historic sequences that appear to me as quite untenable. That widely distributed cultural traits develop special forms in each particular area is a truism that does not require any proof. That these local developments may be arranged in a chronological series, that those of the most limited distribution are the youngest, is only partially true. It is not difficult to find phenomena that center in a certain region and dwindle down at the outskirts, but it is not true that these invariably arise on an ancient substratum. The converse is often true, that an idea emanating from a center is diffused over a wide area. Neither may the origin always be looked for in the area of the strongest development. In the same way as we find

animals surviving and flourishing in regions far distant from the locality in which they developed, so cultural traits may be transferred and find their highest expression in regions far away from their origin. The bronze castings of Benin; the wood carvings of New Zealand; the bronze work of ancient Scandinavia; the giant stone work of Easter Island; the early cultural development of Ireland and its influences over Europe are examples of this kind.

... It has often been observed that cultural traits are exceedingly tenacious and that features of hoary antiquity survive until the present day. This has led to the impression that primitive culture is almost stable and has remained what it is for many centuries. This does not correspond to the facts. Wherever we have detailed information we see forms of objects and customs in constant flux, sometimes stable for a period, then undergoing rapid changes. Through this process elements that at one time belonged together as cultural units are torn apart. Some survive, others die, and so far as objective traits are concerned, the cultural form may become a kaleidoscopic picture of miscellaneous traits that, however, are remodelled according to the changing spiritual background that pervades the culture and that transforms the mosaic into an organic whole. The better the integration of the elements the more valuable appears to us the culture. I believe that it may be said that the coherent survival of cultural features that are not organically connected is exceedingly rare, while single detached elements may possess marvellous longevity.

In the present book the problem of growth of individual art styles will be touched upon only incidentally. Our object is rather an attempt to determine the dynamic conditions under which art styles grow up. The specific historical problem requires much fuller material than what we now possess. There are very few parts of the world in which we can trace, by archaeological or comparative geographical study, the growth of art styles. Prehistoric archaeology in Europe, Asia, and America shows, however, that, as general cultural traits are in a constant state of flux, so also do art styles change and the breaks in the artistic life of the people are often surprisingly sudden. It remains to be seen whether it is possible to derive generally valid laws that control the growth of specific art styles, such as Adama van Scheltema has tried to derive for North European art. With increasing technical skill and perfection of tools, changes are bound to occur. Their course is determined by the general cultural history of the people. We are not in a position to say that the same tendencies, modified by local historical happenings, reappear in the course of art development everywhere.

**8.VI. Alfred Louis Kroeber. 1956. "The Place of Boas in Anthropology."** *American Anthropologist* 58, 1: 151-52.

George Hunt (1854-1933) was the son of a Tlingit mother and British father. Hunt collaborated as an informant, translator, and co-author with Boas over a forty-five-year period, 1888-1933, and *Kwakiutl Texts* (Boas and Hunt 1905 and 1906) was largely derived directly from Hunt's writing. Boas's influential former student Alfred Louis Kroeber wrote of Boas's relationship with Hunt and Hunt's own contribution in a 1956 obituary. Kroeber's comments reveal the extent of the critiques of Boas in the years following his death in 1942.

> The strictures of Boas' Kwakiutl ethnography seem largely to reduce to a charge that he did what seemed feasible and important to him, and not what his critics would have preferred him to do. First of all, he gathered an enormous corpus of data – pretty much unexampled, at least in America. Second, much of this was collected and written by Hunt in Kwakiutl; and, in line with his method and principles, Boas left it unaltered. It is presented, not as the final truth on Kwakiutl culture as a whole, but as voluminous documents on particulars in the culture as known and understood by a member of it. If this resulted in an overemphasis on the upper classes to the detriment of the lower, or if it often presented expected or ideal behaviors rather than actual ones, well – that is how the data came.

**8.VII. William Healy Dall. 1884. "On Masks, Labrets, and Certain Aboriginal Customs, with an Inquiry into the Bearing of Their Geographical Distribution."** In *Third Annual Report of the Bureau of Ethnology to the Secretary of the Smithsonian Institution, 1881-1882*, J.W. Powell, Director. Washington, DC: Government Printing Office, 73-75.

William Healy Dall (1845-1927) was born in Boston and became a noted naturalist and polymath. He served with the US Coast Survey and the US Geological Survey, among other agencies, with trips to Siberia and Alaska, and he made significant contributions to ethnography. Powell induced him to study masks, which he studied in detail on the Northwest Coast. The following excerpts show in detail a nineteenth-century cultural evolutionary approach to art.

> Some years since, at the suggestion of the Director of the Bureau of Ethnology, I took up the subject of masks, with special relation to those of the Pacific coast of America. Circumstances prevented an immediate prosecution of the work to a close; meanwhile, in 1878, I had the opportunity of examining material bearing on this topic contained in the principal museums of Great Britain and of Northern Europe, except Russia. The study of these collections resulted in a conviction that the subject was one of deeper import, and more widely extended ramifications than I had, up to that time, had any conception of; and that one who had thoroughly mastered it would be possessed of

the keys to the great part of the mystery which locks us from the philosophical reli-
gious and social development of uncivilized or savage man ...

The word mask, according to Webster, is derived from Arabic, meaning a thing which
excites ridicule or laughter; that this, however, is a comparatively modern conception
of the mask idea in the course of the development of culture, will, I think, on con-
sideration appear certain.

The ultimate idea of a mask is a shield or protection for the face; probably first
held in the hand.

The adaptation of it to the form of the face and its support upon the head or shoul-
ders were probably subsequent to the introduction of peep-holes, but must have been
nearly or quite coincident with the use of a breathing hole.

As a protection, its appearance or ornamentation originally must have been quite
secondary in its importance to impenetrability, or mechanical protectiveness.

If communities agreed among themselves, and differed from outsiders in the form
or appearance of their masks, the characteristics of the mask-form adopted by any
group of peculiar ferocity or powers, would begin to have a moral value apart from
its capability of arresting or diverting missiles. The terror inspired by the wearers
would begin to be associated with their panoply.

With the adaptation of the mask to the head and shoulders, a reduction in weight,
and consequently of resisting power would be necessary. Its moral value due to its
capacity for inspiring terror would constantly tend to increase, as compared with its
defensive usefulness.

With the realization of this fact, devices to add to the frightfulness would multiply
until the mechanical value would be comparatively unimportant. It is to be borne in
mind that it is the lowest grades of culture which are in question.

With this growth individual variation would come into play; each warrior would
bear a more or less personal device. If remarkable for destroying enemies of the tribe,
or for the benefits resulting to it from his prowess, death, lapse of time, and traditions,
snowball-like accreting as they descended, would tend to the association of super-
human qualities (in form of hero-myth) with him and with his distinctive battle
emblem or device. It his device were derived or conventionalized from some preda-
tory, shrewd, or mysterious animal, a mental blending of the ideals of each might be
expected, and the seeds sown of a totemic or polytheistic system.

With the advance of culture, in its feeble beginnings, humorous perceptions are
well known to be of relatively slow development. However, we can perceive that,
with the growth of supernaturalism, the emblem of the hero, already merged in the
hero-myth, would, from the first, be associated with any formal recognition by the

community of its relations to the supernatural. Thus masks would take their place among religious paraphernalia, not only of the community in its general direct relations to the supernatural, but in the probably earlier form of such relations through an intermediary individual, in the form of a shaman or his logical predecessors in culture.

On the other hand, it may be supposed that the exhibition of a device popularly associated with ill-success, cowardice, or incapacity in its owner, while liable in time of war to excite aversion, contempt, or even hostility in the other members of the community, might well provoke in time of peace the milder form of ridicule, closely allied to scorn, which seems in savagery to constitute the sole rudiment of humor; and that, in time, a certain set of devices, originally segregated in some such manner from the generality, might come to be typical of buffoonery, and to be considered as appropriate to public amusement and rollicking communal games.

From such beginnings the application of masks to the purposes of secret societies, associations, or special classes of the community in their formal relations to the rest, or to outsiders, is easy to imagine ... The transition to that stage of culture where masks are merely protections against recognition on festive occasions, or the vehicle of practical jokes at the hands of children or uneducated adults, is long, but presents no difficulties.

**8.VIII. Alfred Louis Kroeber. 1923. "American Culture and the Northwest Coast."** *American Anthropologist* 25, 1: 7-8, 12-13, 16.

Alfred Louis Kroeber (1876-1960) was born in New Jersey and received his PhD at Columbia University under the guidance of Franz Boas. He established the anthropology program at the University of California-Berkeley and was one of the prominent anthropologists of the first half of the twentieth century, known particularly for his salvage anthropology and development of the culture area concept. Kroeber regarded the Northwest Coast culture area as distinct, lacking many of what he regarded as the generic traits of American Indian culture but with a notable material and expressive culture. He viewed the surrounding areas as inferior culturally.

It is the thesis of the following pages to demonstrate that essentially Northwest Coast culture shares with American culture only basic universal elements presumably derived from Asia; that it lacks regularly the generic American elements that were developed on American soil and became diffused; and that what is specific in it is either a direct outgrowth on the spot from a relatively undifferentiated primitive American culture or the result of later Old World influences.

...

We come now to culture traits peculiar to the Northwest Coast, or at most extending beyond it to a few adjacent tribes. Two distributions of arts recently worked out by Waterman and Wissler seem significant in this connection and will serve as an introduction to this part of the discussion. They are the plank house and a group of ornamental twining techniques, whose areas coincide almost exactly and are both surrounded by a much larger belt, extending from the Southwest to Asia, in which an equivalent element holds sway.

...

Surrounding the Northwest Coast lie a series of low-grade, neutrally colored cultures – those of the California-Great Basin, Plateau, and parts of the Mackenzie-Yukon and Eskimo areas – which evince some infection from the Northwest, a paucity of specific self-developments, and a diluted relationship to Middle America. They are cultural hinterlands.

**8.IX.  William H. Holmes. 1906. "Decorative Art of the Aborigines of Northern America."**

In *Anthropological Papers Written in Honor of Franz Boas.* New York: G.E. Stechert, 188.

William H. Holmes (1846-1933) was trained in art and became interested in a wide range of topics, especially Aboriginal decorative art and paleolithic technology. He held many government and academic appointments, including service with the US Geological Survey and the US National Museum as curator of Aboriginal ceramics, becoming head curator of anthropology there in 1897. He succeeded J.W. Powell as chief of the Bureau of American Ethnology, acting in this capacity from 1902 to 1907. In this excerpt, Holmes noted that, while comparison is helpful, evolutionary explanation is inadequate to examining ornamentation. He directed attention to the forces of diffusion and environment.

Generally speaking, it may be said that each tribe employs in its ornament a group of elements or motives, ideographic and non-ideographic, more or less distinctly its own and variously derived, and having characteristics determined largely by the grade and kind of culture and the nature of the immediate environment. The ornament of one tribe acts upon that of a neighboring tribe, and is reacted upon according to the degree of tribal intimacy and culture relationship, and the motives with or without their associated significance pass from one to the other, undergoing changes more or less radical, and giving rise to endless variants. The ornamental art of any tribe is thus, as a rule, highly composite in style and significance, being derived through a plexus of channels, and conditioned at all times by the particular environment ... *Approach the*

*subjects of origin and significance with due caution. He should remember that an identical or closely analogous conventional form may have diverse origins; and that the exact significance of a given ornament, formal or graphic, must be sought, not in analogous devices of other peoples, and not in explanations previously obtained, but from the particular tribe, clan, or individual found using it; and that a search for ultimate meanings is fraught with peculiar difficulties, if not necessarily futile.* [emphasis added]

**8.X. Herman Karl Haeberlin. 1918. "Principles of Esthetic Form in the Art of the North Pacific Coast: A Preliminary Sketch."** *American Anthropologist* 20: 263-64.

Herman Karl Haeberlin (1891-1918) was born in Ohio but studied in Germany, where he met Boas in 1913. He later studied under Boas at Columbia University and developed his interest in psychological issues. His first work concerned decorative arts of the Pueblos. In this article for *American Anthropologist*, he called for researchers to look at art beyond simply considering what typified the culture area, broaching the issue of individual achievement.

We are likely to look on primitive art as simply an ethnographic element and to limit our study to its relations with the other elements of a cultural unit. This I have called the extensive line of research ... But in the study of primitive art it is just this biographical feature of the history of modern art that we need for stimulation. *We tend too much towards conceiving the art of a primitive people as a unit instead of considering the primitive artist ... It is necessary to study how the individual artist solves specific problems of form relations ...* A purely ethnological point of view in the study of primitive art is inadequate. We need a broader culture-historical outlook. [emphasis added]

**8.XI. Thomas Talbot Waterman. 1923. "Some Conundrums in Northwest Coast Art."** *American Anthropologist* 25, 4: 435.

Thomas Talbot Waterman (1885-1936), a native Missourian, studied under Boas, receiving a PhD in 1913. He later taught at the University of California-Berkeley, the University of Washington, and elsewhere, and he had a wide range of interests, from place name studies and house types to Pueblo pottery ornamentation. In his obituary of Waterman, A.L. Kroeber (1937, 527) wrote that he was "brilliant, incisive, colorful, rarely systematic ... but extraordinarily stimulating." Following Boas, Waterman observed that art on the Northwest Coast emphasized "exaggerated traits, or 'symbols.'" He provided an explanation for this in his 1923 article for *American Anthropologist*.

It is of course to be borne in mind that the Indian has an entirely different philosophy concerning the animals from anything we know. In the Indian's mind the animal is a powerful being, with supernatural attributes, who is able to turn himself into human form by the simple process of taking off his animal skin ... From the artistic standpoint it has this curious result: an Indian, being very literal-minded, represents the animal as he thinks him to be. He therefore mixes up human and animal traits in one carving.

**8.XII. Ruth Benedict. 1934. *Patterns of Culture.*** Boston: Houghton Mifflin, 47-48.

Ruth Benedict (1887-1948) was born in New York State and received a PhD at Columbia University in 1923, under Boas, and joined the faculty that year. Benedict advanced an idea of culture as patterned and, to a lesser or greater extent, integrated into a whole. *Patterns of Culture*, her 1934 book, advanced her theoretical proposition through three case studies, including the Northwest Coast. These coastal societies, she wrote, were Dionysian in nature, with a culture (she wrote of it as a single culture composed of many tribes) that emphasized the ecstatic and the megalomaniac. Art, like other social institutions, fit this general pattern. Benedict observed that the creation of styles of art within a culture parallels the integration of culture itself.

This integration of cultures is not in the least mystical. It is the same process by which a style in art comes into being and persists. Gothic architecture, beginning in what was hardly more than a preference for altitude and light, became, by the operation of some canon of taste that developed within its technique, the unique and homogeneous art of the thirteenth century. It discarded elements that were incongruous, modified others to its purposes, and invented others that accorded with its taste ... There was no conscious choice, and no purpose. What was at first no more than a slight bias in local forms and techniques expressed itself in more and more forcibly, integrated itself in more and more definite standards, and eventuated in Gothic art.

What has happened in the great art-styles happens also in cultures as a whole. All the miscellaneous behavior directed toward getting a living, mating, warring, and worshipping the gods, is made over into consistent patterns in accordance with unconscious canons of choice that develop within the culture. Some cultures, like some periods of art, fail of such integration, and about many others we know too little to understand the motives that actuate them. But cultures at every level of complexity, even the simplest, have achieved it. Such cultures are more or less successful attainments of integrated behavior, and the marvel is that there can be so many of these possible configurations.

**8.XIII. Marcel Mauss. 1967.** *The Gift: Forms and Functions of Exchange in Archaic Societies.*
Translated by Ian Cunnison. New York: Norton, 4-5, 33-34, 43-44, 76-77. First published in English in 1954. Reproduced by permission of Taylor & Francis Books, UK.

Marcel Mauss (1872-1950) studied comparative religion and was a member of the group of French scholars known as the Année Sociologique. He served as chair of sociology at the Collège de France, Paris, and was most noted for his classic work, *The Gift*. He was a student of his uncle, Émile Durkheim, and influenced future generations of French structuralists, including Claude Lévi-Strauss, Marcel Griaule, and many others. In *The Gift*, Mauss gave considerable attention to the Northwest Coast potlatch, and consequently the art of the region, in developing his theories of exchange. He wrote that the potlatch entailed three obligations: to give, to receive, and to repay (37). Mauss drew out in detail the implications of the potlatch system for aesthetics. In particular, one of the objects circulated in this system, the "copper," had significant aesthetic properties.

In the systems of the past we do not find simple exchange of goods, wealth and produce through markets established among individuals. For it is groups, and not individuals, which carry on exchange, make contracts, and are bound by obligations; the persons represented in the contracts are moral persons – clans, tribes, and families; the groups, or the chiefs as intermediaries for the groups, confront and oppose each other. Further, what they exchange is not exclusively goods and wealth, real and personal property, and things of economic value. They exchange rather courtesies, entertainments, ritual, military assistance, women, children, dances, and feasts; and fairs in which the market is but one element and the circulation of wealth but one part of a wide and enduring contract. Finally, although the prestations and counter-prestations take place under a voluntary guise they are in essence strictly obligatory, and their sanction is private or open warfare. We propose to call this the system of *total prestations*. Such institutions seem to us to be best represented in the alliance of pairs of phratries in Australian and North American tribes, where ritual, marriages, succession to wealth, community of right and interest, military and religious rank and even games all form part of one system and presuppose the collaboration of the two moieties of the tribe. The Tlingit and Haida of North-West America give a good expression of the nature of these practices when they say that they "show respect to each other."

But with the Tlingit and Haida, and in the whole of that region, total prestations appear in a form which, although quite typical, is yet evolved and relatively rare. We propose, following American authors, to call it the *potlatch*.

...

The potlatch, so unique as a phenomenon, yet so typical of these tribes, is really nothing other than gift-exchange. The only differences are in the violence, rivalry and antagonism aroused, in a lack of jural concepts, and in a simpler structure. It is less refined than in Melanesia, especially as regards the northern tribes, the Tlingit and the Haida, but the collective nature of the contract is more pronounced than in Melanesia and Polynesia. Despite appearances, the institutions here are nearer to what we call simple total prestations. Thus the legal and economic concepts attached to them have less clarity and conscious precision. Nevertheless, in action the principles emerge formally and clearly.

There are two traits more in evidence here than in the Melanesian potlatch or in the more evolved and discrete institutions of Polynesia: the themes of credit and honour.

...

The large *abalone* shells, the shields covered with them, the decorated blankets with faces, eyes, and animal and human figures embroidered and woven into them, are all personalities. The houses and decorated beams are themselves beings. Everything speaks – roof, fire, carvings, and paintings ...

Ceremonial dishes and spoons decorated and carved with the clan totem or sign of rank, are animate things. They are replicas of the never-ending supply of tools, the creators of food, which the spirits gave to the ancestors. They are supposedly miraculous. Objects are confounded with the spirits who made them, and eating utensils with food. Thus Kwakiutl dishes and Haida spoons are essential goods with a strict circulation and are carefully shared out between the families and clans of the chiefs ...

Decorated coppers are the most important articles in the potlatch, and beliefs and a cult are attached to them. With all these tribes copper, a living being, is the object of cult and myth. Copper, with the Haida and Kwakiutl at least, is identified with salmon, itself an object of cult. But in addition to this mythical element each copper is by itself an object of individual beliefs. Each principal copper of the families of the clan chiefs has its name and individuality ...

Coppers have also a virtue which attracts other coppers to them, as wealth attracts wealth and as dignity attracts honours, spirit-possession and good alliances. In this way they live their own lives and attract other coppers.

...

The facts we have studied are all "total" social phenomena ... Some of the facts presented concern the whole of society and its institutions ... Others, in which exchanges and contracts are the concern of individuals, embrace a large number of institutions.

These phenomena are at once legal, economic, religious, aesthetic, morphological and so on. They are legal in that they concern individual and collective rights, organized and diffuse morality; they may be entirely obligatory, or subject simply to praise or disapproval. They are at once political and domestic, being of interest both to

classes and to clans and families. They are religious; they concern true religion, animism, magic and diffuse religious mentality. They are economic, for the notions of value, utility, interest, luxury, wealth, acquisition, accumulation, consumption and liberal and sumptuous expenditure are all present, although not perhaps in their modern senses. Moreover, these institutions have an important aesthetic side which we have left unstudied; but the dances performed, the songs and shows, the dramatic representations given between camps or partners, the objects made, used, decorated, polished, amassed and transmitted with affection, received with joy, given away in triumph, the feasts in which everyone participates – all these, the food, objects and services, are the source of aesthetic emotions as well as emotions aroused by interest.

**8.XIV.  Marcel Griaule. 1950. *Arts of the African Native.*** London: Thames and Hudson, 15, 16, 17, 18, 21, 23, 24. Reprinted by kind permission of Thames and Hudson.

Marcel Griaule (1898-1956) was a student of Paul Rivet and Marcel Mauss and was influenced by Mauss's ideas regarding research methodology. Griaule led the Dakar-Djibuti expedition and influenced the development of visual anthropology. He is perhaps best known for his work on the cosmology of the Dogon of Mali. His approach to his ethnographic work with the Dogon was revealed in his discussions of art. He rejected amateur ethnographic and travel writing and argued for a detailed, field-based ethnographic approach that placed art objects in a particular context, paying attention to gesture and speech at the rituals in which the objects were used and the interpretations given by community members themselves. His approach, however, was ahistorical.

Americanist and French approaches to anthropology developed differently but overlapped in their interest in the societies of the Pacific Coast and the influence of Northwest Coast art. Griaule's ethnographic practices and exhibitions at the Trocadero museum influenced European surrealists, who were later attracted to Northwest Coast materials during World War II.

The following excerpts from *Arts of the African Native* reveal his approach to ethnography and epistemological issues in the anthropology of art.

It is some decades ago since Negro Art emerged from beneath the shadow to which – perhaps out of contempt – it had been relegated by snobbishness, commerce and even by science ...

Distorted by those with too much or too little information, used as a bludgeon or reduced to subtleties which it did not fundamentally possess, it has come to the rescue of new ideas and contributed to the shattering of classical canons. It has made a lasting impression on the theatre, the film, music, sculpture and painting.

...

This movement has, of course, made quite a stir in the world of aestheticists and ethnographers ...

We have realized that Negro art cannot be treated like our own art. It was felt that it was too pregnant with the dark past which it has inherited for ordinary criticism and that traditional art developments were insufficient for its enjoyment ... In reality, Negro art is beyond our horizons. It is steeped in a climate of which we have no experience, and about which, in spite of appearances, we have only a minimum of factual data.

Nevertheless, there are minds (and for some years they have been more and more numerous) who have confronted the sea of ethnographic facts, that is to say, the glass-cases of museums and the bound volumes of well-stocked libraries. Unhindered by dilettante curiosity, they tried to formulate laws which they thought they could extract from what they called the total view of unmechanised civilizations. They persistently applied themselves to the question of the origins of these civilizations because they had at their disposal fragmentary, scattered and dubious data.

...

And among these seekers after the truth, a small number reached the conclusion that a complete synthesis will only be possible in the distant and perhaps unattainable future, when each civilization, each city and each nomadic group has furnished as much serious material for research purposes as the Mediterranean peoples have done. Up to the present, our need for simplification, our haste to speculate, our lack of time, has forced us into comic abstractions ...

...

In other words, it is impossible to study the problem of Negro art directly and in its entirety. On the contrary, it would seem desirable to approach certain aspects of it which are now known, and which been the subject of profound studies by specialists skilled in modern methods of observation. To undertake it, it would be necessary to possess precise and complete documentation about at least one aesthetic activity related to its religious background. This documentation would have to be composed not only of minutes about the manufacture and fabrication of certain ritual objects, but also of minutes about the actual rites in which they were used, with due attention paid to the nuances hidden in every gesture and in every word. Such documentation exists about a people in the loop of the Niger, who, sheltered in inaccessible screes of cliffs, have preserved their traditions and techniques down to the present day.

...

In addition we must fight against our complacent indifference, which is in contrast to the attitude of the native to his own productions. We must admit that it will always be artificial to discourse on these subjects as long as we have not at out disposal means of

determining with certainty the reactions of the creator and the user to the works of his own country.

...

It is not a matter of saying what we think about Negro art, but what the Negroes think about it themselves.

...

No chronology will be attempted ... And if we admit that Africa is the land of conservatism, we shall agree that, for this very reason, the best way to reconstruct the past is to study the actual products of living artists and artisans who are, for the most part, still steeped in the traditions which are the objects of our researches.

We shall also neglect a theoretical obstacle which is none the less serious. When we try to apply the theories of aestheticists to Negro art, we see that it is most often created and reproduced in conditions to which we are not accustomed. Its aims, media and products are primarily religious. Thus there is a sort of wilful misunderstanding in speaking of an art which should be separated from the intentions of its users, in order to comply with our definitions. But we have no intention to making such a separation. On the contrary we want to try to reconstruct the spiritual climate of this activity and to be free to consider it as what it is above all: an art utilitarian to a great extent, religiously speaking, yet marked by preoccupations which are none the less aesthetic for being highly spiritual.

## 9 | Going by the Book

*Missionary Perspectives*

Including a chapter on missionaries in a book on the art of the Indigenous peoples of the Northwest Coast may well strike many readers as an outrageous waste of valuable space. Christian missionaries of the colonial period do not enjoy a positive reputation concerning their attitudes toward Indigenous art, but the picture is especially bleak on the coast. Across the region, conversion was often marked by a particularly severe repression of customary ceremonials and large-scale abandonment of precontact lifestyles and material culture. In many places, totem poles were cut down and chopped up into firewood, and masks and shamanistic paraphernalia were smashed or tossed into bonfires in orgies of Christian revivalism [19.XVI]. Much of what was not destroyed outright was abandoned to rot away in the forests or sold to outsiders, including missionaries, some of whom amassed large personal collections. In Canada, missionaries took a leading role in convincing the federal government to ban the potlatch and spirit dancing. Mission-run schools, both local and residential, instilled a deep sense of shame in pupils concerning their cultural heritage while encouraging and often coercing them to take up new occupations at the bottom of the colonial workforce, as unskilled labourers and domestic servants.

This is not an attractive picture. Yet there are compelling reasons to resist the urge simply to condemn and move on. However regrettable their excesses or obnoxiously ethnocentric their attitudes concerning Indigenous culture to modern ears, missionaries were both key participants in and witnesses to the transition of Native groups on the coast from autonomous nations to government wards and, finally, to the early moments of cultural and political revivalism in the 1960s. (While evangelists from Pentecostal and fundamentalist sects continue to proselytize, by the early 1970s the mainline churches had entered a post-missionary phase in which local congregations and often Indigenous clergy had assumed control over their own affairs.) The voluminous reports, diaries, letters, and publications written by the early missionaries contain invaluable evidence of the changing nature of Aboriginal aesthetic culture from the high point of its

nineteenth-century efflorescence, through its subsequent suppression, to its re-emergence as valued contemporary art a century later [9.v, 9.vi]. On top of this, several prominent missionaries became enthusiastic collectors of Native art and thus managed to preserve, in private collections and museums, some of what was being destroyed or abandoned in the villages [9.iii, 9.vii]. The writings and collections also provide invaluable insight into the developing attitudes of colonial agents toward the Indigenous peoples of the coast, which appear to modern scholarship as far more varied and contested than previously assumed [9.i, 9.ii]. Finally, and most importantly, the re-examination of the missionary record in conjunction with oral histories from Indigenous elders is beginning to shed light on the neglected topic of Indigenous perspectives and motivations. The more we learn about the missionary period, the more we come to appreciate that Indigenous peoples were active players in their own histories and that they put their new religious identity to creative as well as destructive uses [9.vi, 9.vii].

*preservation + collection*

*Bring it back to the FN perspective*

Christian missions were relatively late arrivals on the Northwest Coast (Duff 1964b; Grant 1984). Russian Orthodox missionaries began working among the Tlingit in 1834 [9.i] but saw only modest results for several decades (Kan 1999). Roman Catholic missionaries travelled widely through what is now Washington State and southern British Columbia during the late 1830s and 1840s, conducting mass baptisms, but only established a firm presence from the 1850s. Their work remained limited to Coast Salish and Nuu-chah-nulth populations in the south, among the peoples most dramatically impacted by European settlement (Lemert 1955). Serious Protestant efforts date precisely from the arrival of William Duncan at Fort Simpson in October 1857 on behalf of the Anglican Church Missionary Society (CMS). Although he was never ordained, Duncan dominated the ranks of missionaries on the northern coast through his long career as the controversial and increasingly autocratic founder of the model village of Metlakatla (Murray 1985; Usher 1974). More quietly, the Anglicans began successful missions among the Haida, Nisga'a, and Kwakwaka'wakw nations (E.P. Patterson 1982). During the 1870s, under the leadership of Thomas and Emma Crosby, Methodist missionaries undertook a vigorous program of itinerancy along the northern coast, making effective use of Native evangelists, which resulted in the establishment of new churches among the Tsimshian, Heiltsuk, Nuxalk, Nisga'a, and southern Haida (Bolt 1992; Hare and Barman 2006). Presbyterians made major inroads among the Tlingit of Alaska from 1877, under the energetic leadership of Sheldon Jackson (Lazell 1960). Far to the south on Puget Sound, a lone Congregational missionary, Myron Eells, enjoyed less success but witnessed the emergence of the only independent Native church to appear anywhere on the coast, the Indian Shaker Church (Castile 1982).

The missions arrived during a period of enormous upheaval. The lucrative fur trade had enriched many chiefly families, leading to an efflorescence of ceremonialism, monumental carving, and other aesthetic forms. At the same time, Native societies were devastated by waves of epidemics that in places reduced populations by as much as 90 percent and by increased violence due to alcoholism and the availability of guns. The steady encroachments of Euro-Canadian settlers and the creation of the reserve and reservation systems added to the catastrophe. In such circumstances, it is hardly surprising that many Natives were receptive to the missionary message of a new life. For many, no doubt, conversion was a pragmatic choice. Alone among the newcomers, the missionaries offered practical training in skills, such as boat building, that were valuable in the emerging cash economy; education in the white man's language and knowledge; and some measure of protection against disease through vaccinations. Yet many Natives were clearly drawn to Christian teachings as well, some becoming missionaries themselves. While there were traditionalist holdouts who defiantly held to the ways of their ancestors, and a great many more converts who quietly participated to varying degrees in potlatches and other Indigenous ceremonies, by the turn of the century the churches were firmly established, with the majority of Native peoples at least nominally Christian (Fisher 1977, 10).

While willing to make use of certain aspects of Native society, particularly the authority of chiefs, the early missionaries assumed that conversion to Christianity entailed a near complete break with the past, including traditional material culture [9.IV]. In its place, converts adopted European clothing, built neat Victorian single-family cottages or duplexes, and pledged to obey rules set up by elected councils and enforced by Native police. In some places, this was a drawn-out process. Some forty years after most of the Nuxalk converted to Christianity, a handful of elderly traditionalists still lived in the decaying longhouses of the old village at Bella Coola (Barker and Cole 2003). Elsewhere, converts abandoned the old villages to create new settlements organized around prominent Native-built churches [9.VIII]. The moment of conversion and subsequent revivals, however, were in places – perhaps many places – marked by the deliberate destruction of cultural objects. Soon after his arrival in Port Simpson in 1874, for instance, Thomas Crosby encouraged a systematic replacement of communal longhouses, which resulted in the wholesale destruction of mortuary poles and painted house fronts. At Crosby's urging, a new council went house to house to collect shamanistic paraphernalia, much of which was burned (Neylan 2003, 255).

It is far from clear how directly other missionaries were involved in such attacks. Often they apparently were not aware of what some of the more zealous converts were doing in the name of Christianity and civilization (cf. Corbey

2003). Still, the rhetoric of Christian conversion delivered a clear message for many converts. Consider the testimony of Grace Stephens, daughter of Haida Methodist evangelists Amos and Agnes Russ:

> There's a lot of old lodges still there and a lot of totem poles, and my father, being the chief's son, had lots to say about a lot of the totem poles. The missionaries, of course, at the time said that they had to do away with all those old things, and they were heathenish and everything, and I remember my father cutting down beautiful totem poles and cutting them up for kindling wood and firewood. He wanted to do away with all those old things if they were going to become Christians. (quoted in Neylan 2003, 256)

As late as 1918, according to Barbeau (1929, 1), Christian zealots destroyed totem poles along the Naas River and in Port Simpson.

An examination of missionary sources reveals a more complex set of attitudes toward Northwest Coast art than the moments of destruction seem to indicate. Many missionaries wrote appreciatively of the technical skill and beauty of Indigenous carving, jewellery making, basketry, and painting. Some, such as Charles Harrison [9.11] and Myron Eells [9.v], developed an ethnographic interest in the traditional cultures of the people they had come to change and wrote valuable accounts (Barker 2007). Most missionary observers, such as Thomas Crosby and William Duncan, saw the old skills as providing a strong foundation for the new "civilized" life that converts were to embrace [9.IV]. The point is that the missionary portrayal of the pre-Christian life of the Indians was by no means unremittingly negative. Condemnations of the potlatch, ceremonials, and shamanism were mixed in their accounts with praise, particularly of technical skills and ingenuity of subsistence techniques, which they thought revealed that the Natives possessed inner characteristics that would make them strong Christians once they were made aware of the "error of their ways."

Missionaries played yet another key role with long-term consequences: they collected Northwest Coast artifacts [9.III, 9.VII]. The rush to amass collections for the new public museums of Europe and North America was, at times, considerably facilitated by missionaries (Black 1997; Cole 1985). Being on the spot, they were in an excellent position to seek and acquire pieces desired by both public and private institutions and collectors. The money, in turn, was rolled back into the mission or, in some cases, supported the missionary's retirement. Both Duncan and Crosby for a time maintained something like a mail-order service for collectors, sending out lists of available artifacts and prices. Between the two of them, they probably stripped Port Simpson of at least a third of the

objects that left the community (J. MacDonald 1990). A number of mission-
aries also built up their own collections. Among the largest was that amassed
by Sheldon Jackson, who recruited Presbyterian missionaries spread along
the Alaskan coast to collect on his behalf (Cole 1985, 75-76). Most materials left
the area, but Jackson is notable for establishing a small museum in Sitka, which
opened in 1890 and continues to operate to this day (Corey 1987; Hinckley 1964;
Lee 1999). George H. Raley, the long-serving principal of the Coqualeetza
Residential School at Sardis, British Columbia, prominently displayed tradition-
al objects at the entrance to the school, later donating his large collection to the
University of British Columbia (Raibmon 1996). Another important collection,
of Heiltsuk (Bella Bella) objects, was sold by the Methodist missionary-
physician Dr. R.W. Large to the Ontario Provincial Museum in the early part of
the twentieth century. Martha Black's (1989, 1997) superb modern studies of the
collection housed at the Royal Ontario Museum, based in part on Large's docu-
mentation, suggest that missionary and museum archives may well contain cru-
cial yet still undiscovered information about the condition of Northwest Coast
art and artists during a critical period of transition [9.VII].

Even as they condemned much of the Indigenous culture they encountered,
missionaries were responsible for widely disseminating images and information
about Northwest Coast peoples to an enormous audience. Missionary magazines
and books were amply illustrated with drawings and photographs of totem poles,
customs, and customary objects, usually with brief captions and no further dis-
cussion in the text. Two missionaries, Thomas Crosby and J.B. McCullagh, went
even further, donning Indian costumes for studio portraits (Figure 9.1). Such
images, along with the collections of material objects, no doubt served as silent
testimony to the missionaries' presumed expertise on Native culture as well as
demonstrated their authority to cleanse it of its heathen content. At the same
time, however, the sheer quantity of the images and their prominence in the mis-
sionary literature suggest a compelling if unacknowledged fascination with the
art itself. To an unknown extent – for the subject remains to be investigated – the
missionary publications played a role in creating a popular image of Northwest
Coast peoples in association with a distinct form of art that was, ironically, being
systematically displaced at the time. The same, of course, was true for other
areas of the world in which missionaries laboured among Indigenous people
(Johnston 2003; Street 1975).

The Indigenous peoples of the Northwest Coast were not passive recipients
of the enormous changes and challenges unleashed by the arrival of Europeans.
They responded and undertook initiatives in ways that made sense to them.
Susan Neylan's (2003) groundbreaking research has revealed the extent to which

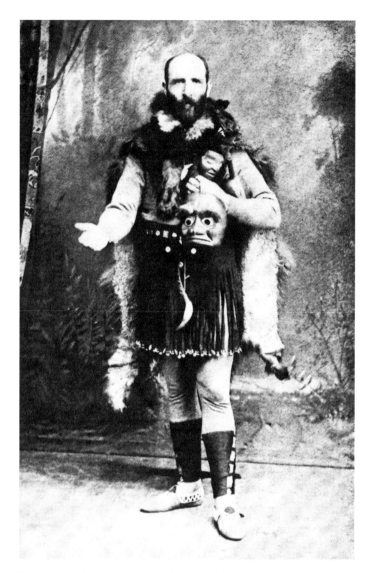

**FIGURE 9.1** This studio portrait of the Reverend J.B. McCullagh shows him "in the Dress of an Indian Medicine Man." From J.W.W. Moeran, *McCullagh of Aiyansh* (London: Marshall Brothers, 1923), 76.

the relatively rapid acceptance of Christianity on the coast depended upon Native missionaries, quickly trained and often acting with little oversight from their white superiors. There can be little doubt that these evangelists, as well as ordinary converts, made sense of Christian dogmas and histories in terms of their own cultural notions of spirituality. In 1922, anthropologist T.F. McIlwraith was frustrated by the degree to which recollections of traditional Nuxalk religion had become "tinged" by Christian teachings among some of his informants (Barker and Cole 2003, 49). No doubt such syncretism was common. The early

*Christian beliefs mixed in with their own*

success of men such as Duncan and Crosby depended not just on Native evangelists but also on the support of chiefs, who were their main source of artifacts as well. Joanne MacDonald (1990) suggests that the act of destroying or surrendering objects may not have been entirely without a cultural logic that provided meanings invisible to the missionaries. She notes that among "many people of the Northwest Coast there appears to have been the belief that the power of objects could be transferred to the spirit world by smoke" (200). She also makes the intriguing suggestion that Coast Tsimshian may have perceived the early missionaries in terms of their own cultural conceptions of power. The shift of loyalties from shamans and pagan chiefs to missionaries and their chiefly allies entailed a ceremony of destruction of the old ceremonial objects and adoption of European-style material culture. "Perhaps the 'emptying of the House' at the succession of a new chief in the traditional system made it easier for the chiefs to meet the demands of the new religion. It can also be observed that by giving up their crest objects (or destroying them) the Indians were making a deeper commitment to Christianity than previously expected" (210).

Many converts enthusiastically embraced the new life offered by the missions, at least initially (Rettig 1980). Whole villages were created or rebuilt, largely at Native expense and using local labour. Conversion left its most lasting mark in the scores of wooden churches erected in Indian villages along the coast, following designs set by the missionaries but executed by Native craftsmen [9.VIII]. A mania developed for uniformed brass bands, particularly in the northern Protestant areas (Black 1997, 36; Drew 1971). In the south, converts enthusiastically participated in colourful Passion plays performed in the larger Catholic villages. Underlying many of these changes, however, were important continuities. In particular, the Indigenous ranking system remained strong (Tennant 1990, 78). The families of chiefs tended to dominate the Christian elite, and in short order Christian celebrations, such as Christmas and Easter, took on potlatch-like characteristics, with leaders validating their political status by hosting ceremonies and giving away gifts (Blackman 1977, 52). Graphic arts tended to be suppressed in church contexts, although the imprint of Northwest Coast aesthetics is clearly visible in a famous baptismal font carved by a Tsimshian artist in 1886 for the Port Simpson Methodist church (Figure 9.2). Funerary art, on the other hand, provided a new outlet for traditional designs [9.IX]. Gravestones bearing crest designs became common, while a few wealthier families sponsored larger monuments bearing designs reminiscent of the old mortuary poles erected upon the deaths of chiefs (Blackman 1973; Hawker 1991).

By the early twentieth century, the missionary effort on the coast was in serious decline, short of staff and funding as the mission societies turned their

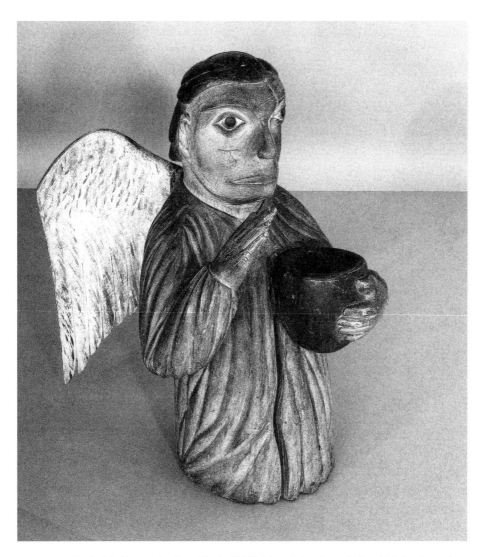

**FIGURE 9.2** Frederick Alexcee, baptismal font, 1886. Paint, metal, and wood. The child of an Iroquois father and a Tsimshian mother, Alexcee (or Alexie, 1853-ca. 1944) originally trained as a *halaayt* carver making secret society paraphernalia. He spent the latter part of his career carving tourist curios and making paintings of traditional life. First Nations aesthetics are evident in the baptismal font he created for the Methodist church at Port Simpson (Hawker 2003, 64-65). UBC Museum of Anthropology, A1776a-c.

attention to overseas fields, particularly in Asia (Grant 1984). The withdrawal of missionaries may have reduced some of the pressure against Indigenous ceremonials, particularly in remote villages. Tragically, the same period ushered in the most devastating assault yet upon Indigenous cultures, languages, and persons in the form of centralized residential schools, sponsored by the state and run by the missions. Long after the Canadian government quietly dropped the

potlatch ban in 1951, residential schools on the coast and elsewhere continued to tear children from their home communities in a misguided attempt at forced assimilation, leaving many wounds that continue to fester.

While endorsing the program of assimilation, a few missionaries took a paternalistic interest in Native "arts and crafts," which continued to be made to sell to tourists and collectors [9.VII]. The principal of Coqualeetza Residential School went even further. In the 1920s, George Raley introduced Native carving (of miniature totem poles) and basketry into the school curriculum. Inspired by the example of the "Indian New Deal" during the Depression in the United States, he became a passionate and prominent advocate for the promotion and effective marketing of Native arts and crafts, which he saw as the key solution to the problem of Indian welfare [13.III, 14.IV, 14.V]. Ronald William Hawker (2003, 66-67) argues that, while Raley received some government support, his main contribution was to foster a perception of Native art as belonging to the contemporary world rather than a dying past, which helped to open the path toward the establishment of the provincial totem-pole-salvage and carver-training programs of the 1940s and 1950s.

Ironically, as the assault on Indigenous culture and art eased in the second half of the century, the revival of Native ceremonials and associated art in some instances received its initial boost from local churches. In the early 1960s, the United Church Women's Guild in Bella Coola undertook a program of relearning old dances and songs from elders and documentary records in order to stage fundraisers for the local church. Far from being opposed, they were encouraged by the church. Margaret Siwallace, a leader of the revival, remarked to anthropologist Margaret A. Stott (1975, 103) that

> sometimes I wish the white man had never come to the valley. I just don't understand you people. Used to be the church – everybody kept telling us to forget everything. So pretty soon nobody does anything anymore. Nobody carves, nobody dances, we forgot the songs. And now all of a sudden a woman comes – it wasn't you, it was a woman in the church – and keeps saying, "Why don't you make baskets like you used to? How can you forget it?" I just don't understand you white people.

Siwallace's frustration is understandable. Across the region beginning in the late 1960s, a new generation of ministers and priests enthusiastically encouraged the incorporation of Indigenous ceremonials and art into Christian services and churches. During fieldwork in Nisga'a villages along the Naas River in the mid-1990s, I often heard elderly people complain about the shift in church attitudes.

Over the years, an accommodation had been worked out by which "traditional" dress and ceremonial activities, while attended and blessed by clergy, occurred outside the church and church services. While the Nisga'a elders were proud of their traditions, they felt uncomfortable wearing button blankets into the church and thus breaking with what had been a long-standing church convention.

The missionary period has left an ambiguous legacy, not least in terms of art. The former mission churches have taken large strides to acknowledge the excesses of the past and to foster an open synthesis of Indigenous spiritual traditions and Christianity. Visitors to Christian services in Native communities are likely to find traditional crests adorning the walls of the church and the clergy – many of them Indigenous themselves – wearing vestments incorporating Native designs. They are also likely to encounter small congregations made up mainly of elderly members. Many Aboriginal people have rejected Christianity entirely, although an increasing number of mostly younger people are drawn to Pentecostal churches, whose enthusiastic forms of worship are often combined with indifference, if not hostility, to Indigenous cultural expression. While it cannot be said to be a major theme, the missionary legacy has also provided subject matter for a number of Northwest Coast artists. The most notable among them is Kwakwaka'wakw artist David Neel, whose stunning *Residential School Transformation Mask* speaks eloquently of the endurance of Indigenous spirituality through the assaults of the missionary period (Figure 9.3).

**9.I. Ivan Veniaminov. 1984. "Notes on the Koloshi." Originally written in 1840.** In *Notes on the Islands of the Unalashka District*. Edited, with an introduction, by Richard A. Pierce; translated by Lydia T. Black and R.H. Geoghegan. Alaska History no. 27. Fairbanks: Elmer E. Rasmuson Library Translation Program, University of Alaska; Kingston, ON: Limestone Press, 427-28. Courtesy of the University of Alaska Press.

Fr. Ivan Veniaminov (1797-1879) was the most celebrated of the pioneer missionaries of the Russian Orthodox Church in Alaska. An effective parish priest and administrator, he is best known for his detailed study of Aleut language and culture, compiled while he worked as a missionary on the Aleutian Islands from 1824 to 1834. In 1834, Veniaminov was reposted to Novo-Arkhangel'sk (Sitka), where he resided for the next four years. His administrative duties prevented him from engaging in as deep an involvement with the Tlingit as he had with the Aleut – he never mastered the language, for instance. Still, Veniaminov made the effort to visit Tlingit in their homes, treating his informants with respect, and they in turn shared their cultural knowledge with him. The result was a short but ethnographically rewarding essay surveying Tlingit social organization, language,

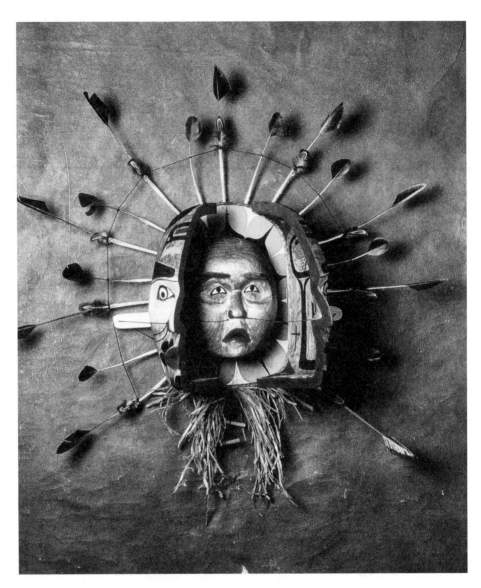

**FIGURE 9.3** David Neel, *Residential School Transformation Mask,* 1990. Red cedar, feathers, cedar bark, paint, hinges, and twine, 36 x 25 x 20 cm (closed) and 89 x 94 x 23 cm (open). This mask by Kwakwaka'wakw artist David Neel shows the impact of the missionary period on First Nations individuals and communities. From Gary Wyatt, *Spirit Faces: Contemporary Masks of the Northwest Coast* (Vancouver: Douglas and McIntyre, 1994), 128. Courtesy of David Neel.

and culture, with a particular focus on religion. It was, however, very much a product of its time and author. For Veniaminov, the Tlingit's technical and artistic achievements revealed their underlying character, in particular their intelligence and thus, one supposes, their potential receptivity to Christianity and "civilization."

### REMARKS ON ABILITIES AND CHARACTER OF THE KOLOSHI [TLINGIT]

The Koloshi, according to my observation, could be, and probably in time will be, the dominant people of all the North Americans, from Bering Strait to the California Sound and perhaps even beyond. Even at their present level, they are better by far in respect to their capabilities. True, the Koloshi do not possess some good and commendable qualities such as the Aleuts have; but then they excel all in their enterprise, acumen and natural inclination to trade. Having these capabilities and, in time, acquiring further education or acquaintance with our concepts and knowledge, they will reach a much higher level in comparison with all other surrounding peoples.

*Intelligence [smyshlennost']*. In order to formulate a conception of the mental capabilities of the Koloshi, it is necessary to look at their own products: canoes [*baty*], blankets or capes [cloaks – *plashchi*], spears, various sculptured figures and so on.

Their canoes [*baty*], no matter how large, are constructed out of a single tree trunk and almost always without additional built-on parts [*nadelki*]. Each canoe, though most comfortable for storage and setting into motion, preserves to greater or lesser degree the qualities necessary for sailing at sea and for speed.

The capes [cloaks – *plashchi*] or blankets of the Koloshi, which are made from the undercoat of goats [*koẓii pukh* – lit. goat's down] worked into varicolored yarns, with various very harmonious design in their own customary [style] and to their own taste, astonish by the art with which they are finished, and that without the benefit of aid of any machinery. The same applies to the preparation of the yarn, dyeing, and so on, all of which is their own invention, borrowed from no one.

In order to bring these handicrafts to the state of perfection in which we find it nowadays, without any aid from other peoples, more than ordinary intelligence [native wit] is needed. True, need and experience are great teachers capable of instructing the greatest simpleton. But in order to be able to learn only through experience, and then only through experience achieve perfection, or the very limit of possible improvement especially of items without which one can do very well and which can be replaced by others (for example, a blanket could be replaced by an animal skin) – for this, intelligence is needed.

Much greater evidence of the Koloshi intelligence is to be found, however, in their art of manufacturing their spears and daggers, originally from copper, later on from iron. This art is much more complex than manufacture of canoes or blankets.

After this it is not even necessary to speak of their art of sculpture (of slate and wood) which in comparison with other North Americans, may be declared to be perfect. Also not surprising is the fact that many of the Koloshi are able to understand – and do – much: joinery [carpentry] for example, vegetable gardening enterprise and so on.

**9.II. William Henry Collison. 1916. *In the Wake of the War Canoe.*** New York: E.P. Dutton, 135-36, 137-40.

Following the examples set by John Williams and David Livingstone, missionary memoirs became popular forms of literature in the nineteenth and early twentieth centuries. They catered to a public equally fascinated by "primitive" exotica, adventure, and stirring tales of the progress of "civilization." William Henry Collison's *In the Wake of the War Canoe* stood apart from others produced on the Northwest Coast in several respects. During a career that spanned four decades, Collison (1847-1922) pioneered missions among the Haida, the Nisga'a, the Gitksan, and the Tsimshian on behalf of the Church Missionary Society. Intermixed with his recollections of his mission work were often keen if brief observations of Native life before it had been utterly transformed by disease and interference from Europeans. The following excerpt describes aspects of a large potlatch Collison witnessed at Masset in 1876 or 1877.

Many of the dancers wore head-dresses and wooden masks of various patterns, but in every case the mask or head-dress indicates the crest to which the wearer belongs. Thus the masks and head-dresses worn by the members of the eagle crest bear a resemblance to the eagle either by the likeness of the nose to the eagle's hook-shaped beak, or by the white eagle feathers surmounting the mask. The members of the finback-whale crest wear masks surmounted by a large fin; whilst the wolf, the bear, and the frog are all well represented by the members of the crests of which these are the sign.

It is not a little significant, however, to find how very closely the use of the ermine skin by the Indians of all the tribes on the north-west coast approaches the use of it in the state dresses of royalty and nobility in England. The higher the rank of an Indian chief, the greater the number of ermine skins he is entitled to wear attached to his *shikeed*, or dancing dress, and hanging from it down his back, in rows of three to six in width. The Master of the Robes in the English court is careful that neither duke, earl, or knight may adorn himself with more ermine skins than is permitted by court etiquette. And, as it cannot be said that the Indians have adopted the custom from the whites, and we hesitate to admit that the whites have acquired it from the Indians, we can only recognise in it the similarity of human nature, and admit that here, indeed, the extremes meet in the tastes and adornments of the highest civilisation and the gay trappings of the untutored Indian chief.

...

The first item in the program of this great "potlatch" to which these visitors had been invited was the erection of a great totem or crest pole. Among all the tribes on the

coast, none surpassed the Haida in the construction and erection of these totems. In this, and in the designing and finishing of their large war canoes, the Haida excelled all the coast tribes, whether in British Columbia or on the Alaskan coast. They had one natural advantage, in the very fine cedar trees which were to be found on their islands.

A tree, proportionate to the dimensions of the totem required, and free from large knots or blemishes, was first selected, roughly prepared, and conveyed to the camp. Then the chief of a crest differing from that of the chief for whom the totem was to be carved, was invited to enter upon the work. If he was not sufficiently skilful himself, he called one or more of the most skilful of his own crest to assist him in the undertaking. Having received instructions as to the various figures to be represented, their number and order, proceeding from base to top, the workmen commenced operations.

In the carving of a totem pole very often a legend or tradition in which the ancestors of the chief and his crest were the chief actors is selected, and thus the totem is but an illustration of the legend. In some villages may be seen totems surmounted by figures resembling men wearing tall hats. This indicates that the owner's ancestor or ancestors first saw the white men who are here represented. Standing by a skilled carver on one occasion who had been engaged to carve a very elaborate totem, I was surprised at the apparently reckless manner in which he cut and hewed away with a large axe as though regardless of consequences. "Where is your plan?" I inquired. "Are you not afraid to spoil your tree?" "No," he replied; "the white man, when about to make anything, first traces it on paper, but the Indian has all his plans here," as he significantly pointed to his forehead.

Having cut out the outline roughly with the axe, he then proceeded to finer workmanship with an adze, on my last visit I found him polishing off a perfect pattern with the dried skin of the dog-fish, which is much more effective for this purpose than sandpaper. When it is remembered that formerly all such work as the preparation and carving of their totem poles, the construction of their well-proportioned canoes, and the building and decoration of their dwellings, were executed with stone tools, it will appear less surprising that they can accomplish such work now with the improved tools and implements, which the white man has introduced. The chief or chiefs who are engaged to carve the totem or crest pole are not paid until the "potlatch" takes place. They are then rewarded, not according to their time and labour, but rather according to their rank and the amount of property at the disposal of the chief for distribution to those who have been invited.

But there were yet other customs among the Haida connected with the "potlatch." One of these was tattooing. I had occasion to enter a lodge one morning shortly before a "potlatch" took place, and was not a little surprised to see all around the

lodge men in every attitude undergoing this painful operation, some of the chest, some on the back, and others on the arms, all being tattooed with the figures peculiar to their own crest, which in this instance was the eagle and beaver, as they belonged to the eagle crest.

The operators were evidently quite expert in their work. Each of them had a number of thin strips of wood of various widths, in which needles were firmly fixed as teeth in a comb. Some of these sticks had but two or three needles, others more, according to the width of the pattern or device to be marked. The peculiar sound caused by such a number all pricking the skin of their subjects caused quite a nervous sensation in the bystander. Blood was flowing freely from many of them, and that it was rather a painful process was evidenced by their faces. Many were smoking, thus seeking to conceal their misery and console their feelings with the pipe. Others had their lips firmly compressed, but not one by either sign or sound indicated the painfulness of the process. That the subsequent suffering when inflammation had set in was severe I discovered by a number of them coming to me for some application to subdue the swelling and soothe the irritation. This was caused by the poisonous colours which had been rubbed in.

Not a few of the Haida had their faces tattooed when I first went among them, and these reminded me strongly of the Maories of New Zealand, but the few of these who now remain are ashamed of the disfigurement, especially on embracing Christianity. When the "potlatch" took place these men who had been thus tattooed were rewarded by receiving blankets or other property proportionate to the honour which they had thus rendered to the chief. But yet worse practices were sometimes resorted to in the erection of the totem at a "potlatch." It was not uncommon formerly, when the opening had been dug out in which the totem was to be erected, to bind one or more slaves, either male or female, and cast them alive into the opening. Then, amidst shouting and clamour which drowned the cries of the victims, the great totem was hoisted up into position by hundreds of helpers and the opening around it filled in with stones and earth firmly beaten down.

**9.III.  Charles Harrison. 1925.** *Ancient Warriors of the North Pacific: The Haidas, Their Laws, Customs and Legends, with Some Historical Account of the Queen Charlotte Islands.* London: H.F. and G. Witherby, 86-88.

Missionaries produced – and indeed continue to produce – significant contributions to the study of the languages and cultures of Indigenous peoples around the world (Barker 1997; Harries 2005). Such works stand apart from the more common missionary memoirs in that their authors attempt, not entirely successfully, of course, to give value-free descriptions of the societies under observation. The

Northwest Coast produced two missionary ethnographers of note after Veniaminov: Charles Harrison and Myron Eells, both excerpted in this section. Harrison (1861-?) produced a grammar and several articles on Haida culture based on his work on behalf of the Church Missionary Society in Masset during the 1880s. He was forced out of the mission in the early 1890s because of his heavy drinking and because he backed William Duncan of Metlakatla in his fight against William Ridley, the new bishop of the Diocese of Caledonia. Harrison remained in the Queen Charlottes, where he lived out the remainder of his life as a part-time minister, a magistrate, and a land speculator. *Ancient Warriors,* which appeared toward the end of his life, was a compendium of previously published and unpublished papers dealing with various aspects of Haida life and the natural history of the islands.

In this excerpt, Harrison describes several masks that he purchased, probably in the 1880s, on behalf of E.B. Tylor of Oxford University, the most famous anthropologist of the time. He also refers to the writer Hutton Webster, whose *Primitive Secret Societies* was published in 1908.

### CEREMONIAL MASKS

A vast amount of research has been carried out among the primitive races of the earth as well as through the literature of more civilized people in connection with ceremonial intended to propitiate the spirits of the dead, but the subject is too great to do otherwise than give it a mere reference.

The origins of mythology of any particular tribe are not easy to fathom, but as Webster says, the fact remains that the dramatization of their ancient legends constituted to the people of North West America a religion quite as powerful and impressive as that of the Christian religion to the average civilized person.

As in many other parts of the world masks and other paraphernalia were used to intensify effect and to inspire awe; the Haidas also exercised great ingenuity on the masks and at their sacred ceremonies. A collection of these obtained by the author for Professor Tylor can be seen at Oxford.

The *Nīkils-tlas* mask was the most important, inasmuch as it represented that important creature, the raven, the mythological beliefs regarding which have already been described. The mask depicted the raven's head with an Indian standing on top and a human face in miniature in the centre of the forehead. The symbolism it was intended to convey being the raven as the creator or perhaps the original ancestor of man and the raven's male slave. Another mask of this class represents the raven with a human head and strings attached by which the lips could be opened at will, doubtless when oracular statements were made by the wearer.

The *Lthwō-gī-gē* or *Stlē-whul* mask was adorned with swan's feathers and was used in what is often termed the ghost dance. It was supposed to represent an evil mythological monster which swooped down and carried off young people who then became like their captor.

The ceremonial at which this was used took place in a dark hut and its big red eyes were made visible by a torch held in front of each. Strings were manipulated so as to impart a movement to the mask, and a low chant went on the while.

Another mask was that of a raven's head with an attachment of marten skin; it was used by the Shaman of the village upon the occasion of the ceremonial dance organized by the raven clan; this mask was at least one hundred and sixty years old.

Perhaps little less notable was the frog's head mask, which was an important "property" in the dances of the frog clan. The lower jaw of this was operated by the wearer, and a grating sound was produced which was believed to be like the croaking of a frog. The wearer of the mask would carry in his hand the carved figure of a frog squatting on a bear's head, and this formed the handle of a dagger which was made of a piece of steel plundered long ages ago from a trading vessel. Its significance was to the effect that the man belonged to the frog totem and his wife to that of the bear.

To another class of ceremonial belongs the salmon dance which took place when these fish were scarce. A chief would be selected for the leading part, and he would wear a mask with two red spots on the forehead, three black marks on the left cheek and black and red dots on the right. In his hand he carried a carved representation of a salmon. Accompanied by the Shaman he would proceed to the beach followed by the people; he would then dance and sing, and then the Shaman would invoke the water spirits and beg them to bring back the salmon.

Another mask represented the most powerful Shaman whose memory tradition preserved. It was small and so was not worn on the face but on the breast of Shaman of later days, for it was believed that the spirit of their distinguished ancestor would guide them aright.

Even women on occasions wore masks, but they were only assumed by those who aspired to magic power. Such a one, when impelled to prophecy, painted her face blue and black and donned her mask which represented, in an exaggerated fashion, the facial contortions such a woman would exhibit when temporarily possessed.

Another mask was said to represent the face of a deceased person of a distant tribe. It was painted grey, and gave the impression of the grimness of death. The natives alleged that it was little used, for but few had the hardihood to perform the dreaded death dance.

**9.IV. Thomas Crosby. 1907. *Among the An-Ko-Me-Nums or Flathead Tribes of the Pacific Coast*.** Toronto: William Briggs, 102-6.

Missionary publications on Indigenous people addressed several audiences and served a number of purposes, but none mattered more than the home churches and the need to raise funds in support of overseas missions. Thomas Crosby (1840-1914) wrote two books on the Methodist mission in British Columbia (1907, 1914) that were fairly typical of mission propaganda of the early twentieth century, placing the stalwart man of God as a calm centre in the midst of the stormy seas of rampant pagan excesses and the equally great danger posed to the Native's soul by corrupt white men. While Crosby condemned Native ceremonials, he praised the "natural" musical ability demonstrated by the Indians. This, too, was a common feature of missionary propaganda. Such works titillated readers with often breathless descriptions and copious illustrations of "savage" ceremonials and art, which converts freely abandoned for Christianity and civilization. At the same time, the Native, even in a "savage state," had to be shown to possess positive characteristics, to actually be redeemable. In contrast to missionary ethnographies and the better memoirs, works such as Crosby's contain little of ethnographic value. However, they are important for what they reveal of contemporary European attitudes toward Aboriginal peoples, particularly the paternalistic stance assumed by most missionaries, as well as for clues of the great changes occurring at the time.

"An-ko-me-num" was Crosby's rendering of a variant of Halkomelem, the language of the central Coast Salish people in southern British Columbia, among whom the Methodists began working in the early 1860s.

MUSIC AND DANCING

The readiness with which the Indians pick up our beautiful hymn tunes and learn to play our musical instruments has been remarked. Indeed, these people are naturally very musical, and in their heathen state were passionately fond of singing their own native melodies. Of songs they had a great variety: war songs, marriage songs, songs for feats and public gatherings, mourning songs for the dead, songs when the fish came, dancing songs, canoes songs, and many others. When we asked the old dance-song maker where they got their music, he replied:

"We get it from the wind in the trees, from the waves on the sea-shore, from the rippling stream, from the mountain side, from the birds, and from the wild animals."

As for musical instruments, we are all familiar with the simple Indian drum, made by stretching a deerskin tightly over a hoop. Besides this they used as a drum a big square box, painted in different colors, with figures of birds and animals upon it.

When the drummer was at work crowds would accompany him, beating time with sticks upon boards. The sound was weird in the extreme, if heard at the dead of night, coupled with the shouts of the heathen dancers.

Besides the drums were rattles of various shapes, used by the chiefs and conjurers, and pipe whistles – indeed, whistles of many kinds, imitating birds and animals – some of which were used by the hunters in pursuit of game.

With much of their music is associated their pagan dancing. There are professional dancers among the tribes, who as a rule are identified with the clans of the medicine men. The heathen dances are very fascinating to the heathen mind, and in nothing is the "backsliding" of the Indian more noticeable than in his return to the dance.

At the dancing season certain persons become possessed, or as the An-ko-me-nums say, "the you-an, or dance-spirit, is on them." They dream dreams and see visions, and move about in a hypnotic state, unable, or at least declining, to work, and roaring out at intervals a sort of mournful sobbing, "Oh-oh-oh-oh-oh." Then they go from house to house, hunting up every kind of food they can get hold of, and gorging themselves many times a day. At night these dancers, all daubed and plastered with grease and paint, would gather in the large houses, where the people were assembled, and work themselves up into a frenzy, prancing up and down and round about, performing numerous contortions. Then they would break out in song, or in monotonous recitation relate their dreams and visions and tell many weird tales. Then round and round, and up and down again, they would prance, until they dropped from sheer exhaustion, or fell, perhaps, into the fire, and another took their place. All this time the onlookers watched and listened to the chanting and the story, or screamed and pounded in frantic accompaniment to the dancing.

The heathen dance is certainly demoralizing, and, like everything of heathenism, is of the devil.

### WHITE MAN'S DANCE VS. INDIAN DANCE

Early in my stay at Nanaimo four or five of the leading chiefs came to me with the proposition that if I would allow them to go on with their potlatching and wild dancing every day in the week, they would come to church and rest on Sunday.

"No, you had better stop all your heathenism," was my answer.

Nothing daunted, they came back again later. Now they would all be good on Sabbath and stand by me if they could dance. It was not very bad, and they had to keep up a little of what their fathers told them. And if I would not speak against it or pray against it they would all be good soon and would have all their children go to school.

"No, I cannot have anything to do with the old way, the dance, the potlatch, etc., it is all bad," I said.

Then they whispered to each other, "Oh, he is like a post; you cannot move him."

To give an idea of the scenes witnessed on these dancing occasions: Old Sna-kwe-multh, a man who had been taken a slave by some northern tribe, but who had found his way home, wished to demonstrate his bravery. At a great feast he came rushing

in half naked and danced before the people. As his frenzy increased he slashed at his thighs with some kind of sharp instrument, and then with both hands caught up his own blood and drank it, to prove himself a brave.

A number of white men, who had been witnesses of the shameful scene, ran out and cried, "The devil is in the man."

I denounced the custom and pleaded with them to give it up. Speaking to the old Chief Squen-es-ton, I said, "You must stop it. It is of the devil."

"Oh," said he, "the white man's dance worse than the Indian's dance."

"How do you make that out?" I said.

"Oh, Indian man, alone, dance all round the house and sit down. And then Indian woman she dance all round and she sit down. But white man take another man's wife and hug her all round the house."

What could I say to the argument? What would you say?

**9.V.  George P. Castile, ed. 1985.** *The Indians of Puget Sound: The Notebooks of Myron Eells.* Seattle: University of Washington Press, 225, 230-31, 241.

By most measures, the missionary career of Myron Eells (1843-1907) would be regarded as a failure. While many members of the Twana and Klallam communities on Puget Sound were eager to take up Christianity, Eells set such a high standard for admission to the Congregationalist Church that frustrated would-be converts were eventually inspired to create their own church, the Indian Shaker Church (Castile 1982). What he lacked in ability as an evangelist, however, Eells made up for as an enthusiastic student of Indian life, including its material culture. He amassed a large collection of Indian material, much of which is housed at Whitman College today. He was also a prolific writer, publishing more than a hundred articles and books dealing with the Coast Salish peoples of Puget Sound and the missionary history of Washington State as well as more than a thousand newspaper columns and a massive number of letters. Over the course of two decades, between 1876 and 1894, Eells compiled a thousand-page handwritten manuscript, much of it describing the material culture of the Puget Sound Indians. This was eventually published in a handsome volume edited by George Pierre Castile in 1985, richly illustrated with photographs of objects from Eells's own collection.

Living close to Indigenous societies, and often learning their languages (although Eells failed in this respect as well), missionaries were frequently the most intimate or sole witnesses to these cultures during the early colonial period. His interests in Indian material culture were broad and inclusive; Eells sought not only "traditional" art pieces for his collection but also many examples of

contemporary crafts, including crude beadwork and school boy drawings. His writings and collections thus provide unique clues to the ways in which local artisans adjusted to the critical changes occurring at the time.

### ART

There is no special class of artists among them as there is among the tribes to the north in British Columbia; still, they make considerable work that is quite artistic on baskets, cloth, leather, wood, etc.

   Their work as a general thing does not equal that of more northern tribes, but is fully equal to that of the tribes east and south. Little, however, is wasted on the desert air or made merely for ornament, but it is generally put on some useful article.

### ON BASKETS

All of the figures on these are woven in with colored grass ...

   The Clallams and tribes farther up the Sound import bottles made by the Makahs and Quinaielts, bottles of various sizes, from vials to quart junk bottles, covered with fine grasswork, which are beautifully figured. These are covered simply for the beauty of it or for sale.

### ON CLOTH

The straps, with which they carry their baskets and other loads are ornamented by weaving different colored cloth strings into the strap as it is made. These are common to all the tribes on the Sound, and might be largely multiplied.

   Their fancy rugs are also covered with figures, woven in. In the one drawn two dogs are seen; on others I have seen a dog, a tree, chicken, deer, and some soldiers. Many more illustrations might be given. In some of them the figures mean something and are quite distinct; in others, they mean nothing and are often blended together.

   Their shot pouches of cloth are sometimes covered with bead work, though not often. It is said that formerly, after the whites first came, they ornamented with beads to a great extent, but of late the art is almost entirely neglected.

   Pin cushions of patch work and patch work quilts, some of which are very artistic, are becoming common. I have seen a pin cushion made by an Indian girl, between the sides of a clam shell, which are well done. In mittens they often knit figures, though they are rarely of any significance.

...

### ON WOOD

Carvings. These are quite common. Sometimes it is done for mere amusement. Occasionally the handle of a fish spear is ornamented. On a long board, formerly on

a house at Dungeness, were carvings which were supposed to represent moons and cats. No one now knows when they were made. An Indian, who had a grandson, married, said that they were there when he was a boy. They are flat, intaglio, half an inch deep. The house was destroyed a few years ago, and I secured a part of the board ...

A Clallam chief at Elwhat, Cultus John, had a few years ago two large side posts in his house, 2 to 2½ feet wide and 6 or 8 inches thick, each carved so as to represent a large man, one of whom held a frog in his hands. The work was excellently done by a regular carver of the Nittinat tribe of British Columbia. On account of the death of his son, the chief destroyed his house, but moved the posts to the grave, where they remained a few years. The last time I visited the place the chief had died, and the posts were gone ...

The post was about 10 inches thick. One of the carvings represented a man, who held in his hands clasped on his stomach, a frog, 18 inches long by 11 wide. The other represented a woman, who was a trifle longer than the man. A mask was nailed on the side of the forehead of each, projecting in front, one representing the face and head of a pig, the other of a bird. Another opening and shutting mask was divided, one half being nailed on the other side of each forehead.

...

*ON PAPER*

I have included a nondescript animal drawn by a Twana school boy ...

In 1879 I found with a Clallam man, Jim Quimmiak, at Clallam Bay, who had never been at school, an old book with over thirty drawings in it, some of which show good natural artistic ability. A number of these are inserted here [as illustrations accompanying the original manuscript].

In comparing the artistic work of the Twanas and Clallams, I am led to think that in the basket and cloth weaving, the latter are the more skilfull, and the Chehalis Indians excel the Twanas in this respect, both being excelled by the Quinaielt and Makahs on the coast. Both in carving and bead work the Clallams excel. This is not strange, as they have more intercourse with the skilled carvers of the northern tribes of British Columbia.

**9.VI.  Livingston F. Jones. 1914.** *A Study of the Thlingets of Alaska.* New York: Fleming H. Revell, 66-71.

Presbyterian missionary Livingston Jones (1865-1928) wrote his book on the Tlingit for a broad popular audience. Drawing upon his own observations as well as published sources, he aimed to present a rounded picture of the society.

Superficial, crudely opinionated, and drawing on evolutionary speculations that were already outdated, Jones's study nevertheless provides valuable snippets of information on the ways in which Tlingit were adapting various aspects of their cultural heritage during the early years of the twentieth century, including matters of personal style and ceremonial decoration. The quotation concerning labrets is from Maturin M. Ballou's *New Eldorado: A Summer Journey to Alaska* (1889).

Their love of ornamentation is innate, but they are not peculiar in this. The farther down the scale of civilization the more pronounced is this characteristic, and it is carried in some instances to a ludicrous excess.

The Thlingets of to-day are not so given to personal ornamentation as they were a few years ago. Their taste in this respect, as in others, is constantly improving. Formerly their decorations were excessive, ludicrous and grotesque. Rings were worn not only on the fingers but in the ears and the nose. The cartilage in the nose of every Thlinget is punctured for nose rings, but these were worn only in dancing. Earrings are yet commonly worn by females. They were worn by men a few years ago, but now you rarely see one with them. At dances men, women and children wear them. Some men have three punctures for rings in each ear, one in the lobe, one in the middle, and one at the top. There are ear-drops made from shark's teeth that are highly prized. They are triangular in shape, and are worn only at dances. The upper end is usually mounted with gold or silver.

Every Thlinget child has his ears and nose pierced for rings the day he is born. Yarn or grass is put in the opening to keep it from growing together. In earlier years rings were worn in the ears and nose, not only for ornamentation, but to show that the child's parents were not poor. If a child had no ring or jewellery of any kind he was looked down upon and his people were despised.

In early times earrings were made of copper, silver and gold, and in shape were round, excepting the shark tooth pendant. To-day the style of earring or pendant varies, as they have a wide range from which to select.

The women and girls are very fond of the finger-ring (*tlaka-keas*) and the bracelet (*keas*). Even to this day women may be seen with rings on every finger of each hand and several bracelets on each wrist. These are made by native silversmiths out of silver and gold coin. The coin is melted and pounded into shape and then all kinds of totemic designs are carved on them. Some of the bracelets are more than an inch wide, and made not only of silver but of pure gold. The latter range in value from twenty to forty dollars each.

Until recently they preferred silver jewellery to gold. Now that they know the value of gold, they esteem the gold jewellery more highly.

Neck chains and stick-pins are commonly worn. Formerly necklaces were made of shark's teeth, shells, pretty beads and stones. While bead necklaces are still worn, they are being gradually supplanted by gold ones. Both gold and silver pins are made in all kinds of designs (chiefly totemic) by native silversmiths. Coin is invariably used by native artists for all jewellery.

The ordinary native is as well satisfied with a brass pin studded with glass gems as with one of pure gold studded with diamonds. The glitter is the chief consideration. But the better educated and more refined will not wear tawdry jewellery.

Their rings and bracelets are worn at all times ; they never lay them off for drudgery or dirty work, not even when they go about with bare legs and feet.

The labret is a piece of bone or silver varying in size according to the rank of the person wearing it, that is inserted into the lower lip just below the mouth. It is worn as a sign of womanhood. Some assert that its original object was to keep women from talking, and that if a woman, while scolding, dropped her labret from her lip, she was considered beaten and disgraced. We have asked not a few natives if this be true, and all we have consulted have repudiated the story and insisted that it is worn as a badge of womanhood.

Only women of high caste are allowed to wear it. Slaves were strictly forbidden its use. As the woman who wears the labret grows older, its size is increased, so that a woman's age may be known from the size and kind of labret she wears. In some old women they are an inch long and a quarter of an inch wide. They certainly do not enhance a woman's looks, but on the contrary give her a hideous appearance.

"The author," writes Ballou, "has seen all sorts of rude decorations employed by savage races, but never one which seemed quite so ridiculous or so deforming as the plug (labret) which many of these women of Alaska wear thrust through their lower lips. The plug causes them to drool incessantly through the artificial aperture, though it is partially stopped by a piece of bone, ivory, or wood, formed like a large cuff-button, with a flat-spread portion inside to keep it in position. This practice is commenced in youth, the plug being increased in size as the wearer advances in age, so that when she becomes aged her lower lip is shockingly deformed."

It is only just to state that this custom, so far as the Thlingets are concerned, is a thing of the past.

Tattooing on some portions of the body was once a very common form of adornment, but is seldom, if at all, resorted to in this age. Only high-caste natives were permitted to have their bodies tattooed. Professional tattooers were employed to do this, and were paid large sums for their work. A feast was invariably given in honor of the occasion, which exalted the one tattooed in the public esteem.

Streaking the face with paint was another way they had of adorning the person – a custom no longer practised except for dancing. When this was done the tribal mark of

the individual had to be used. For instance, a member of the Whale-killer (Keet) tribe wore a mark down the cheek and one at right angles to this across the chin. This marking represented the jaw of the Keet (grampus), and showed to the public that the one thus marked was of the Keet tribe. A member of the Crow (Yalkth) tribe had a line drawn on each side of the nose beginning at the inner corner of the eye and angling down the cheek. This represented the beak of the crow.

Even now many of the women paint their faces solidly with a kind of lampblack made of soot and grease. This is done, however, not for ornamentation, as it makes them hideous-looking in the extreme, but for the double purpose of protecting their faces from mosquitoes and sunburn.

In former years their dress was gorgeously adorned with beads, buttons and abalone. At one time the abalone shell was to the natives what diamonds are to the white people. Many carvings were inlaid with it. To this day it is highly prized, and used for ornamentation. In the days of slavery slaves were traded for it.

Dancing blankets and cloaks are elaborately ornamented with buttons and beads, making some of them very expensive. Beads are commonly used to ornament moccasins, pouches and wall pockets that are made from deer and moose hide. The beautiful green found on the head of the mallard drake is very commonly used for adorning articles. The head is skinned and the entire patch of green kept intact.

Our white sisters cannot criticise them for this since they are so fond of adorning their own bonnets with the plumage of birds. Native women do not use the mallard plumage for adorning hats or bonnets, but for the decoration of pouches and wall-pockets.

Most of the natives are slow of movement and lacking in grace, but some have fine form and carriage. Some of the young women are exceedingly attractive.

With them, as with white people, we find the attractive and the repulsive, the neat and the tidy, the respectable and the vulgar, the clean and the filthy.

The Thlinget's standard of beauty is very different from that of the white man. Men whom we would consider extremely ugly are very much admired by Thlinget women. The large mouth, thick lips and coarse features appeal to the average native. It would seem that the more hideous the face the more it is admired by the average Thlinget. The natural, soft, subdued olive complexion of the average Thlinget young woman is very pleasing.

The half-breeds are invariably bright and good-looking. Some of them are really handsome. They dress in good taste and present a good appearance. They are inclined to affiliate more with the white people than with the natives. It seems, indeed, to be their natural place and it is so accepted. They seek education and many of them after schooling drop into good positions among the white people. Some of them have shown

high ability and are now in positions of responsibility. Possessing, as a rule, a captivating personality, they seemingly have but little trouble to find a place in the world.

**9.VII. Martha Black. 1997. *Bella Bella: A Season of Heiltsuk Art.*** Vancouver: Douglas and McIntyre, 53-54, 55. © Martha Black. Published by Douglas and McIntyre, an imprint of D&M Publishers Inc. Reprinted with permission from the publisher and the author.

Missionaries' ethnographic collections have become the object of scholarly interest in recent years, not only for what can be discovered about the objects through a close study of archival documents, but also for what they reveal about the collectors themselves and the changing conditions under which Native art was produced during the early colonial period (Gardner 2006; Lawson 1994). While several missionaries acquired and sold artifacts from their stations on the Northwest Coast, few maintained good records, making it difficult today to trace the provenance of many objects. The collection of Heiltsuk objects held by the Royal Ontario Museum is significant not only for its quality but also because the collector kept detailed notes. The Reverend Dr. R.W. Large (1873-1920) worked as a missionary physician at the Methodist mission at Bella Bella from 1898 to 1910 and later in the Prince Rupert area. He sold two ethnographic collections to the (then) Ontario Provincial Museum in 1901 and 1906, including both older and commissioned pieces. Drawing in part on Large's records, Martha Black's *Bella Bella* contributes a sensitive and wide-ranging historical review that leads readers into the worlds of the Heiltsuk and the Methodist missionaries who lived among them; the circumstances that resulted in certain kinds of artifacts making their way to museum repositories; and, most notably, a portrait of five Heiltsuk carvers from the early twentieth century. In the following excerpt, we get a glimpse into the regional artifact market during a period in which traditional objects were becoming increasingly scarce and valuable.

THE PRICES OF ARTIFACTS

Large believed that he was gathering the last examples of the old way of life at Bella Bella. On the subject of commissioning models and replicas, he said in 1907: "the old ones who really know how to make those things are fast dying off," and in 1920 he said that the traditional carving and painting skills would "be a lost art with the young people." As the demand continued and the supply was thought to be dwindling, the prices of the artifacts increased. Large said that his last collection – the one that he offered to Currelly of the [Royal Ontario Museum] – was expensive, "as there have been a number of American and Canadian collectors in the field."

Other factors affected the prices of artifacts. One was the state of the Heiltsuk economy – people sold artifacts when they needed cash. "The fact of the matter is that the Indians have made so much money at fishing, trapping and making things for tourists of late, that it has been practically out of the question to get them to undertake such work as you desire," wrote Large from Port Essington with regard to the proposed commissioning of the life-size Haida group. At the same time, Large noted that the coastal economy changed rapidly: "From present appearances the salmon run this year will be small, and as the prices of skins have dropped considerably, prospects are better of getting the Indians to do some work [carving] at reasonable prices."

The fluctuating income of the natives influenced their willingness to sell. Large was able to purchase two house posts from 'Qélc for Franz Boas ... in 1900 ... and presumably the matching poles for the OPM [Ontario Provincial Museum] ... , for $20 a pair – the owners needed money then and had to sell. When the OPM asked Large to acquire another pole in 1907, however, he could not persuade the owners to sell the pole that he wanted because they had no need of cash at that time. There were so few poles left in the area that Large thought he would have to travel to the Queen Charlotte Islands in order to buy one ...

The sale of art work could be very lucrative. At Bella Coola, Dr. J.C. Spencer related that a "very clever" wood carver and silversmith renounced Christianity, "went back among his heathen friends," and was able to make a "considerable amount of money [carving] such things as headdresses, masks, whistles, etc." for native ceremonies. The curio trade could be profitable as well. "Although they have not yet fully learned the value of their wares, anxious curio-seekers are rapidly teaching them, and it is not uncommon to be asked twenty-five dollars for a basket or a hat," lamented one visitor to the coast. For a basket, [Thomas] Crosby asked as much as $50 to $80, which was thought to be very high. The Kwakwaka'wakw woman's hat from Fort Rupert in Large's collection was considerably less. It has a price of $5 painted inside the brim. In 1909 Large noted that a Bella Bella woman paid $5 for "an extreme picture hat something of the Gainsborough style" which was ordered from a catalogue, so perhaps the Kwakwaka'wakw hat was priced at the going rate for fancy hats.

**9.VIII. John Veillette and Gary White. 1977.** *Early Indian Village Churches: Wooden Frontier Architecture in British Columbia.* Vancouver: UBC Press, 20-21.

Conversion on much of the Northwest Coast involved the acceptance of European forms of material culture largely at the expense of the converts themselves, who paid for wood, cloth, tools, and other materials and provided much of the labour. Perhaps the most distinct sign of conversion was the wooden

churches that came to dot the villages along the coast. While the missionaries remained firmly in control of the style, the buildings were nonetheless the creations of Native artisans, who regarded them with pride. The churches ranged in size from simple, single-roomed affairs to a massive building at Duncan's Metlakatla that was for some years the largest church north of San Francisco.

For most Indians the construction of even the smallest wooden church was a matter of great importance. As one observer wrote in 1896, "A great many little wooden churches, sometimes as far as fifty miles distant form any other town, spring up in the missions. The Indians support their own churches now, and take great delight in building them. They have been known to take such an active interest in the erection of a chapel that the hammers were heard pounding the whole night through, while the dedication of a bell in the little steeple and its first deep-toned tollings as it rung out in the keen, still atmosphere inspired the natives with a mad revelry peculiar to the race and never to be forgotten."

Missionary participation in church building was often great. Because they wanted the churches to conform to prescribed liturgical and architectural traditions, they either gave Indian builders very specific instructions, personally supervised the initial and final stages of construction, or took up tools themselves and worked alongside native carpenters.

Native Indians, of course, were often master builders in their own right. Although some interior Indians had no tradition of working with wood and had to be taught by missionaries, most of the province's natives had at least some familiarity with carpentry, and the Indians of the coast were particularly skilled. Missionaries at once recognized their abilities and had little difficulty in directing native builders toward the construction of frame churches. As the Anglican clergyman the Reverend B. Appleyard noted in 1899, "The Indian is a born carpenter; as a child he takes to tools as a duck takes to water; whatever we see around us bears witness to his skill ... [his] faculty for imitating and picking up practical knowledge is wonderful; anything [he sees] done [he] will reproduce without trouble."

With such skilled carpenters at hand, missionaries were often content to give hand-drawn sets of building plans to native workmen who could follow them with little difficulty ...

It was not at all unusual for Indian builders to copy particular churches they had seen. When the Roman Catholic Indians of Bonaparte built a church in 1890, they based their design on the Belgian architect Joseph Bouillon's Sechelt church of 1889. Similarly, the second Anglican church at Gitlakdamix was modeled on Prince Rupert's Anglican Cathedral, built in 1912-25 to the specifications of Toronto architects Gordon and Helliwell.

As a rule, when the missionaries produced original plans for Indians to follow, they simply put their impressions of European and eastern Canadian buildings on paper. As they did so, they discarded unessential features and made minor alterations. Pattern books, parish histories, and other publications offered a wealth of architectural detail for imitation, but missionaries apparently used them not as basic plans but as sources of inspiration for decorative detail. With access to these pattern books and builders' guides, Indian craftsmen in British Columbia first armed themselves with modern chisels, fretsaws, planes, and other tools and then produced a wide variety of innovative "gingerbread" decoration for their churches.

**9.IX. Ronald William Hawker. 1991. "A Faith of Stone: Gravestones, Missionaries, and Culture Change and Continuity among British Columbia's Tsimshian Indians."** *Journal of Canadian Studies* 26, 3: 85-86

Conversion on the Northwest Coast involved constant adjustments and compromises. While the pioneer missionaries were for the most part uncompromisingly opposed to the old way of life, they could not fully control how local peoples perceived the new regime. Some Indians steadfastly rejected Christianity, while others slipped back and forth between attending church services and participating in banned ceremonials. But even among those who remained faithful members of the new congregations, old cultural patterns had a tendency to re-assert themselves. Thus, even as the traditional potlatch was suppressed on the north coast, essential aspects of it re-emerged in Christian mortuary practices. Missionaries were especially dependent on the continuing support of chiefs. It is not entirely surprising, then, that chiefly families found ways of validating and enhancing their rank in Christianized forms: by becoming leaders of lay religious organizations, by entering the ministry, and by merging their new leadership status with that inherited through their families. Gravestones provided an especially attractive site for this merging of Christian and ancestral identities. In this excerpt, Ronald William Hawker (1963- ) describes two of the more striking monuments he documented in Tsimshian, Nisga'a, and Gitksan communities.

At the end of the article, Hawker (1991, 99) commented that such monuments have been dismissed "as examples of the degeneration of Indian culture. It would be more constructive to view them as examples of the tenacity of Northwest Coast native culture." Like research focused on missionaries, research on the Indigenous experience and appropriation of Christianity on the coast is still very much in its infancy. Hawker's important study suggests that, even in the darkest days of cultural repression, Native artistry found an outlet within the churches.

The role of Indigenous artistic forms and ceremonialism in the far more accepting atmosphere of churches today is a subject that also cries out for exploration.

Because native society has undergone such tremendous changes since European contact, it is tempting to suggest that the missionaries stifled Indian culture. While the potlatch legislation of 1884, which outlawed the important Northwest Coast communal feast, reflected the attitudes of certain Indian agents and missionaries, the more successful missionaries provided a context in which native culture could be retained and incorporated into Christianity. In order to avoid offending the Indians to the point of hindering evangelization, many missionaries chose not to push sensitive issues or teachings like the potlatch legislation. In fact, the potlatch proved to be a custom capable of modification to suit changing standards of conduct called for by non-Indian society. At Metlakatla, the gap felt by the renunciation of the potlatch was filled to some extent by the communal celebrations of Christmas, the New Year and the Queen's Birthday ...

Other examples of native tradition used in a Christian context are evident. At the Nisga'a village of Aiyansh, extemporaneous prayers were said by an elder before and after the sermon. In Kincolith and elsewhere, services were held in the vernacular language. In Greenville, a drum would beat continuously during a service. The first chapel at Metlakatla was dominated by two traditional carved poles on either side of the altar. Evidence suggests that the missionaries practiced a limited tolerance towards the indigenous social and cultural forms and to a certain extent worked at implementing a kind of Christianity capable of adjusting to Tsimshian custom.

The effective compromise of cultures which shows up in Tsimshian funerary art can again be illustrated by an example from Hazelton ... Hazelton's marble monument dedicated to the memory of Daniel Skawil originally consisted of three superimposed sections. The superimposition of major figures, whose compositional separation is clearly defined, is a traditional trait. The major figure is located at the bottom. Its head is exaggerated, making it the centre of focus for the entire monument. The figure, however, is incomplete. The bottom part of its torso melts into the stepped base bearing the inscription. This is unusual since the figure in Northwest Coast art, while sometimes abstracted, is always depicted whole. The bottom figure has elongated arms with its elbows drawn tight against its sides. The hands are pressed against the chest and the fingers are curved with the palms facing outwards. While this is a traditional position, the artisan has paid careful attention to the subtle shapes and curves of the muscles under the skin. Such attention to anatomical detail gives the piece a more veristic feeling that is especially evident in the facial features. The shape

of the face, the wide naturalistic mouth with the finely sculpted lips, the curve of the cheekbones and nose, the unstylized eyes and the textured short hair all add an almost strange sense of realism to the otherwise distorted body.

The same combination of traditional composition and naturalistic detailing can be seen in the band of smaller figures above the main figure's head. These small figures lend a sense of scale. They have exaggerated heads, clasped, elongated arms, legs drawn up tight against their chests, and naturalistic facial features. At one time a sculpted frog perched above this band. Unfortunately, it has been lost.

The syncretistic quality in the style of the monuments shows up repeatedly. As the Skawil and Akdeeza monuments evince, they are firmly rooted in the Northwest Coast artistic tradition, yet their execution has been tuned by the heightened naturalism of Western art. The extreme sense of realism in the Skawil and Akdeeza monuments might suggest that they were sculpted for a native client by a Euro-Canadian artisan using a native model; however, there are other examples of monuments where the sculpture is more stylized in the Tsimshian tradition thus indicated a native as the artist responsible.

NOTE

I am very grateful for many helpful corrections, suggestions, and images from Alice Campbell, Charlotte Townsend-Gault, Jennifer Kramer, Bill McLennan, and an anonymous reviewer for UBC Press. Remaining errors in fact and interpretation are my responsibility alone.

# 10 | The Dark Years

In the early 1970s, I was an assistant curator at the Museum of Anthropology, University of British Columbia. One day Wilson Duff came into the museum with one of his graduate students, picked up a raven rattle, and showed it to me, saying, "isn't it beautiful?" I agreed that it was. Then he asked, "but how do you read it?" Impatiently, I answered, "Wilson, I don't read rattles, I shake them." In this volume, I write as a shaker among many readers. To add to the challenge of this task, I speak Kwak'wala, a language that has no words for "art" or "artist." There is a suffix, -*inuxw*, that tells you that a person is good at something, which could be carving, singing, fishing, or any other activity.

Mistakenly called the "Kwakiutl" by the white people for a long time, we are the Kwakwaka'wakw – that is, all of the people who speak Kwak'wala. Newcomers assumed that, since the people who lived in Tsaxis (Fort Rupert) were Kwakiutl, all the other villages were occupied by Kwakiutl. In fact, there were twenty-three groups in our language area, all of whom had their own names and lived in their own territories, covering most of northern Vancouver Island, the mainland, and the islands between. Our closest neighbours are the Nuu-chah-nulth, on the west coast of Vancouver Island, and the Awik'inuxw of Rivers Inlet. Wilson Duff estimated that in 1835, when the first local census was recorded, the total population for our language area was 10,700. By 1885, the population had declined to 3,000 as a result of epidemics of smallpox, influenza, and other diseases. A few villages died out completely, while survivors from others moved to neighbouring communities.

The arrival of the newcomers, mainly English and Scots, brought gradual change, with trade goods, such as blankets, replacing furs for giving away at potlatches. Early photographs show bundles of blankets in stacks one hundred high. Thousands would be given away at a single potlatch. Melton cloth, decorated with pearl buttons, was also in demand. As their primary goal was profit, the traders had no interest in "civilizing the heathen," as the missionaries who followed the traders did. Such "saviours" were not always successful, as was the

case with the Order of Oblates, who attempted to establish a mission in Fort Rupert in 1863. This was soon abandoned, as the Kwakwaka'wakw were not interested in being saved.

The Oblates were followed by Alfred J. Hall, an Anglican priest, who also gave up on Fort Rupert. In 1881, Hall moved to Alert Bay, where two entrepreneurs were establishing a fish-processing plant that needed a labour force. He persuaded my father's people, the 'Namgis, to move from their traditional home at the mouth of the Gwa'ni river to work in the cannery. In a short time, Hall established a small school, which soon became St. Michael's Indian Residential School, housing about three hundred boys and girls, many from areas as far from Alert Bay as Nisga'a and Haida territories. Not only could the children not speak English to their teachers and supervisors; they were also unable to speak to each other, because of their differing native languages. Some students were the children of newly converted Christians, some were orphans, and others were forcibly taken from their homes. These students spent half a day in classrooms; the rest of their day they worked on the missionaries' farm. The missionaries' goal was to turn the children into farmers, an absurd idea that failed. Coastal people had always depended on the sea, which provided them with most of what they needed.

At the end of their time in the Indian residential school, children returned to their villages as near strangers to their culture, brainwashed into believing that everything traditional, including their native languages, was evil. Tragically, some of the girls who came out of Indian residential schools were completely unable to adjust to village life, drifted away to cities like Vancouver and Victoria, and became prostitutes. It was not until I heard stories about these girls that I understood why my grandmother, who had never been to school, kept telling me, when I was younger, that I was headed for trouble if I spent too much time reading. She was connecting reading with school, which meant trouble.

The law prohibiting potlatches was first enacted in 1884 as a result of pressure from missionaries and Indian Agents, who saw the practice as heavy competition to their goal of "civilizing the heathen." There is a strong suggestion that those who readily became Christians did so as a way to avoid meeting their potlatch obligations, which in some cases involved large amounts of money and/or goods. A number of the newly converted acted as witnesses for the Crown during the 1922 potlatch trials, which followed my father's 1921 potlatch. The purpose of the 1921 potlatch was to "finish," as the ceremony was called – that is, for my father to divorce his wife, who was unable to bear children. Years later a man confessed to my father that he had been an informant for the police and asked for forgiveness. My father told him it was too late.

Nowhere else on the Northwest Coast was there such a mass arrest. William Halliday, the local Indian Agent at the time, was so sure that this would mean the end of potlatching that he reported to his superiors in Ottawa that the problem for missionaries and government agents was solved. Most of those arrested were the highest-ranking people of different tribes. Twenty-two men and women were sentenced to two months in prison for "serious" offences such as making speeches, singing, dancing, and giving and receiving gifts. The humiliation they suffered during their imprisonment – chiefs were forced to herd swine – added greatly to the darkness of those years.

The interpreter at the trial was a Christian convert who – when the magistrate asked, "how do you plead, guilty or not guilty?" – said to the accused, who spoke no English, "he wants to know if you were there." The accused would reply, "yes." The interpreter would then tell the magistrate that the plea was guilty. Those found guilty were given a choice – they could serve their time in jail or give up their treasures, including masks, rattles, and coppers. Most of the surrendered treasures were shipped to the national museum in Ottawa, since moved to Gatineau, Quebec. From there, part of the collection was sent to the Royal Ontario Museum in Toronto, with a small number of objects being bought by George Heye for his museum in New York.

There was strong opposition from some of the Kwakwaka'wakw people involved, as in the case of a man who nailed his copper to the underside of his kitchen table so that it would not be taken.

Although our old people referred to this time, 1920-45, when everyone feared being arrested for potlatching, as the "Dark Years," the ceremonies continued among people who resisted conversion to Christianity. What Halliday did not realize was that, rather than disappearing forever, the potlatch went underground, with events being held in remote villages during stormy weather. Even if the police knew, they were unable to travel. There is a story about one of our white relatives, who was the engineer for the Indian Agent's boat. As they were approaching a village, he saw smoke coming out of only one house and knew there was a potlatch in progress. He disabled the engine long enough for villagers to return to their homes. One man, in his rush to make things appear normal, had neglected to wash the charcoal off his face and was strolling casually down the path, with his hands in his pockets, much to the amusement of the rest of the villagers.

With the surrender of treasures following the 1922 potlatch trials, there was a need for replacement masks, rattles, etc. Although the treasures had gone to museums far away, the right to display them remained with those who had been coerced into giving them up. Among the carvers, now well known, who created

new ceremonial gear were Mungo Martin, Willie Seaweed, Charlie George, Bob Harris, Arthur Shaughnessy, Charlie James, Charlie G. Walkus, and Tom Patch Wamiss. There were others much less known but just as productive. Willie Seaweed was from Blunden Harbour, Charlie George from Smiths Inlet, both villages renowned for producing the best carvers, singers, and dancers. They were always hired by the people of Fort Rupert to take care of potlatches, because they were most knowledgeable about proper Kwakwaka'wakw procedures. Unfortunately, in the early 1960s, the Department of Indian Affairs moved them to a new reserve adjacent to Port Hardy, a white town, where they lost their independence and creativity, succumbing to the litany of social problems that plague many Native communities to this day. About this time, boys collected horse clam shells, on which they painted designs to sell to the tourists who arrived every summer. Women began hooking rugs with designs, using strips of discarded clothing. Designs also appeared in embroidered and crocheted forms, produced by women.

The world kept changing for our people, with increasing dependence on the white man's economy. The men became commercial fishermen or loggers; the women worked in canneries, often far from home, where they interacted with other cultural groups. After fishing season each year, many went south to pick hops in northern Washington State. One result of these shared economic experiences was the exchange of cultural material, often songs for lahal, a bone game played by most people on the coast. Money earned from fishing, logging, and hop picking often went to finance the secret potlatches of those who refused to give up their traditional ceremonies.

It is ironic, given the missionaries' opposition to everything traditional, that, when the present St. Michael's Residential School was built in 1929, two totem poles were erected at the entrance to its driveway. As well, the bishop of the Diocese of Columbia accepted the gift of a totem pole from Charlie James, another well-known carver of our area, as a token of his gratitude to the church for educating his children in St. Michael's Indian Residential School.

Charlie James may have been the first carver in Alert Bay to produce model totem poles, which found a ready market among cruise ship passengers. Other carvers who became involved in producing such poles lacked James's experience and talent. James showed the same care and attention to detail in his larger and smaller works. Carvers of later generations and from other communities, which had no tradition of totem poles, often referred to such small poles as "idiot sticks."

Early museum accession records rarely include the dates when objects were made, but it can be assumed that many of them came out of the Dark Years,

partly because of the long-standing reputations of known carvers, who are re-membered to this day. Some of the memorial poles standing in the cemetery in Alert Bay were erected during the Dark Years, including those carved by Arthur Shaughnessy and Willie Seaweed. In addition to the underground potlatches being carried out during the beginning of the Dark Years, the ongoing tradition of carving was another symbol of the determination of our people to carry on, despite the increasing pressure from outside to abandon the old ways. While some of the best examples of our "art" from that period may now be in faraway museums, our creative output never died, as it did in other cultural areas. Nor have we suffered to the same extent as other Northwest Coast societies, some of whom have had to "reinvent" their ceremonies.

In 1990, to celebrate the tenth anniversary of its opening, the U'mista Cultural Centre produced an exhibit, *Mungo Martin: A Slender Thread*, which acknow-ledged the significant contribution that Mungo Martin made to the survival of our "art." His apprentices, including Henry Hunt, Tony Hunt, and Doug Cranmer, became instructors at 'Ksan, where the Gitksan people had lost much more than we did. Not only did Mungo Martin pass on his carving skills, but he also left a huge legacy in the form of traditional stories and songs, which young people today have learned. During the Dark Years, Mungo, along with the others mentioned earlier, indeed was a "slender thread," one of the few slender threads holding it all together for us.

As mentioned above, one of Mungo's successors was my brother, the late Doug Cranmer, born in 1927, who continued the tradition of teaching, not only in 'Ksan, but also in Alert Bay, in preparation for the construction of the U'mista Cultural Centre. Some of his students have gone on to establish reputations as "artists." One of them, Richard Sumner, was commissioned to make a bent box to hold the ashes of the late Bill Reid, as no Haida carver was available to do that.

We can take great pride in the legacy that our old people (not "elders" – our language does not have a word for that) left us, and we are grateful that they persisted and resisted all the negative influences during the Dark Years.

MARIE MAUZÉ

# 11 | Surrealists and the New York Avant-Garde, 1920-60

Surrealism, a literary and artistic movement, was born in France in the early 1920s, arising from the traumatic experience of World War I, a few years after the poet Tristan Tzara launched Dada from Switzerland. Under the leadership of André Breton, the Surrealists, who were primarily writers, poets, and painters, searched for alternatives to escape the depressing reality of everyday life and the sterile influence of the rational Western world. As Breton remarked in the *Surrealism Manifesto* (1924), Surrealism aimed to recapture the imagination in a reaction against what was perceived as an impoverishment of thought after centuries of rationalism had stifled spontaneous expression of human sensitivity. According to the Surrealists, one way to liberate humanity from the control exerted by reason was to explore dreams, which they believed to be the source of the creative powers of the unconscious mind.

To strengthen their nascent philosophy, the Surrealists expanded Freud's theories of the unconscious with themes developed by James Frazer's *The Golden Bough: A Study in Magic and Religion* (1890) and Lucien Lévy-Bruhl's *The Mind of the Primitive Man* (1922), which emphasized both the prominent role of dreams in so-called primitive life and humanity's harmonious relationship with the universe. The Surrealists believed that "primitive man" lived in a world in which myth was not separated from daily life and in which visions bore testimony to the presence of ancestors and spirits among human beings, whether in mundane or in ritual life. In the *Second Surrealism Manifesto* (1930), Breton declared that Surrealism's motivation was to find and fix "the point of the mind at which life and death, the real and the imagined, past and future, the communicable and the incommunicable, high and low, cease to be perceived as contradictions" (1993, 63, 117-18). The impossible synthesis of domains that appeared contradictory to the Western world was achieved in the art of the so-called primitive peoples, in which there was no separation – or so the Surrealists thought – between the material and the immaterial, between real life and dreams, two contradictory states that together can be conceived as expressing a "kind of absolute reality"

– that is, a "surreality." Breton insisted that there existed deep affinities between primitive thought and Surrealist thought because both wanted to overthrow the hegemony of consciousness and daily life in order to conquer the realm of "revelatory emotion" (1993, 193).

As early as the 1920s, the Surrealists were attracted to Oceanic art but, as was aptly noted by Elizabeth Cowling in her important essay "The Eskimos, the American Indians and the Surrealists" (1978), they also appreciated Northwest Coast and Yup'ik plastic expressions. "The Surrealist Map of the World," published in a special issue of the Belgian journal *Variétés* (1929), reveals the geography of their imagination. In the northern hemisphere, Alaska, home of the Yupiit and the Tlingit, and the Queen Charlotte Islands (Haida Gwaii), inhabited by the Haida, are given prominence, as are Labrador and Greenland. South of the equator, the Pacific islands are well represented, Australia is smaller than New Guinea, and Easter Island is given great importance (Mauzé 2004b, 2008b).

During the thriving years of Surrealism, the strong interest in primitive art was expressed in individual or group activities such as collecting, exhibitions, and publication of non-Western material in art magazines and journals, including *Documents* (1929-30), edited by Georges Bataille, who was briefly linked with the Surrealist group in the mid-1920s (see Kramer, this volume) [23.VI]. A major show, *L'exposition surréaliste d'objets* (1936), staged by Breton at the gallery of the famous art dealer Charles Ratton, featured a seemingly heterogeneous grouping of Cubist and Surrealist works, ready-mades, found objects, curiosities of natural and artificial manufactures, and pieces from Oceania and the Americas. Distinctions between Western and non-Western, utilitarian and ritual, found and made artifacts were erased in a radical way to reveal the poetic energy of the latent powers inherent in them.

When the Surrealists were exiled in New York during World War II (1941-46), they rediscovered the great variety and inventiveness of Northwest Coast plastic expression in the city's ethnographical museums – the Museum of the American Indian and the American Museum of Natural History as well as the Brooklyn Museum. Breton and his friends Max Ernst, Yves Tanguy, Roberto Matta, Enrico Donati, and Isabelle Waldberg, the art critics Georges Duthuit and Robert Lebel, and the anthropologist Claude Lévi-Strauss were frequent visitors to the Northwest Coast Indian Hall at the American Museum of Natural History. They marvelled at the richness of its collections – the monumental heraldic poles, the legendary Haida canoe, and the many cases filled with hundreds of artifacts of various kinds – which stood in sharp contrast to the very meagre collections in French museums. Once in New York, they devoted themselves to collecting objects they bought in curio shops. Julius Carlebach, an

antique dealer on Third Avenue, played a key role in providing the passionate European collectors with "wonderful things" from Ali Baba's cave: the George Heye Museum of the American Indian. Heye willingly sold items from his collection that he considered duplicates and therefore of no scientific value. Matta vividly remembered the day in 1943 when he and his friends visited the Bronx warehouse of the museum to select several pieces, which then passed through the hands of Carlebach [11.1]. Max Ernst, a privileged client of the dealer, acquired through him a full-size Kwakwaka'wakw pole from the Brooklyn Museum (Mauzé 2004b, 2006, 2008b).

The 1940s were indeed an ideal period for the private acquisition of Native Amerindian objects, which were considered ethnographic artifacts and had almost no value. With scarce means, the Surrealists managed to gather small but high-quality collections, sharing among themselves the pieces available on the market. Two latecomers to the Surrealist circle, Kurt Seligmann and Wolfgang Paalen, chose to travel to British Columbia and Alaska, respectively, in 1938 and 1939, to study what was left of Native cultures and to collect artifacts. Seligmann bought several ceremonial pieces during his stay among the Gitksan, including the best-preserved pole that was still standing in the Wetsuwet'en village of Hagwilget. His story of the pole shows the scientific concern of the field ethnographer [11.11]. Paalen was also looking for old and authentic objects, disregarding the ugly souvenir totem poles and argillite carvings. He put together a remarkable collection that he acquired from local curio shops and dealers (Mauzé 2008a) [11.111].

The Surrealists exported their collective activities to New York in the form of exhibitions and publications. In the fall of 1942, the show *First Papers of Surrealism*, designed by Marcel Duchamp, had the same feel as *L'exposition surréaliste d'objets* of 1936; it presented a juxtaposition of paintings, collages, and non-Western objects from the collections of Breton, Ernst, and Lévi-Strauss in a space delineated by a web of twine. Breton and Duchamp (1942, n.p.) wrote that "Surrealism is only trying to rejoin the most durable traditions of mankind. Among the primitive peoples art always goes beyond what is conventionally and arbitrarily called the 'real.' The natives of the Northwest Pacific coast, the Pueblos, New Guinea, New Ireland, The Marquesas, among others, have made *objets* which Surrealists particularly appreciate."

While the Surrealists expressed their appreciation by collecting Northwest Coast masterworks and exhibiting them in galleries or their private homes with other types of objects to create dynamic sets of meanings among them, they did not leave a large body of texts explaining their relationship to Northwest Coast

or Yup'ik art. However, Lévi-Strauss, although not formally a member of the Surrealist group, acknowledged the very essence of Northwest Coast art in his famous 1943 article "The Art of the Northwest Coast at the American Museum of Natural History" [11.IV]. His essay was followed by others, such as the one by Georges Duthuit (1974), published when he came back from exile [11.V], and that of Breton (1985), which first appeared in a short-lived journal of medicine in 1950 [11.VI]. The three authors marvelled at the extraordinary capacity of Northwest Coast art to express the transformation of beings into others, a process deeply grounded in the "life of myth." In that regard, transformation masks were admired not so much for their aesthetic qualities as for their force of suggestion, which triggered the desire, shared by all peoples, to become another being. The Surrealists' enthusiasm was shared by only a small audience, but the Surrealists made an important contribution to the history of Western sensitivity to Native American art (Mauzé 2004b, 2012) [11.VII].

*Dyn* (1942-44), a Surrealist journal published in Mexico City by Wolfgang Paalen, presented the group's perspectives on Native art. In his preface to the "Amerindian number," a special issue of *Dyn* (4-5), Paalen (1943, 7) argued for the integration of the arts of Asia, Africa, and Oceania, along with the "enormous treasure of Amerindian forms," into the consciousness of modern art. He singled out Northwest Coast art for its marvellous richness and its unsurpassable aesthetic qualities, which placed it among "the greatest achievements of all times." In "Totem Art" [11.VIII], the core article of this issue, Paalen explored the foundations of Northwest Coast art and the complex meanings of totemic images, subjects of his long-term research that he was determined to share with his fellow artists, poorly read as they were in the cultures of the Northwest Coast. While he clearly perceived the organic links among art, social organization, and worldview, he felt rather pessimistic about the future development of Northwest Coast art, which, according to him, was on the verge of degenerating into tourist art. Paalen was aware of the social, political, and cultural predicament of Northwest Coast societies, whose culture was being destroyed by "continued religious persecution" (17). In castigating the disruptive influence of Western civilization on non-Western peoples, Paalen joined the Surrealist political stand against colonialism put forward by Breton, Louis Aragon, Paul Eluard, and others who in 1931 signed the petition "Ne visitez pas l'exposition coloniale" (Mauzé 2008a).

*Dyn* was read by young New York avant-garde artists such as Jackson Pollock, Adolf Gottlieb, Mark Rothko, and Barnett Newman, who were stimulated by the Surrealist gaze on Native American art. Paalen's theory perfectly fit the ideas that the New York School artists were developing to create a new aesthetics that

was free of the provincial spirit of eighteenth- and nineteenth-century American painting and free from European artistic influence. Primitive art of the Americas provided the answer to the challenge faced by the modern artists, as it was viewed as a truly original art born and developed without the benefit of European history (see Dawn, this volume). Moreover, its spiritual meaning and mythical content were seen as particularly appropriate to express the fears and emotions of all humanity – a task that was more pertinent than ever at a time in history dominated by human irrationality. Espousing Paalen's argument, the artists of the New York School proclaimed their brotherhood with the primitive artists and their aim to create a universal art, one based on the integration of modern and Amerindian art.

Their search for universal models led them also to the theories of Carl Jung, which explicitly posited the existence of a collective unconscious with a repertoire of archetypal ideas and images shared with, and therefore understandable by, all human beings, regardless of time, space, and culture. The avant-garde artists made this theory their own and insisted on the ahistorical ties that joined primitive and modern artists in their use of eternal symbols. By the same token, ancient or primitive myths, unchanging in substance and accounting for humankind's basic emotions, were seen as valid means to express the emotions of modern humanity. Myths were necessary to creation. The Surrealists claimed to be myth-makers themselves, with the aim of translating emotions into images.

Several factors converged to turn New York into a centre for primitive art amateurs in the 1940s. Of course, the Surrealists brought with them their passion for non-Western art and were busy assembling collections, but at the same time a new interest, which had been building for over two decades, materialized in shows organized in museums or galleries. The Museum of Modern Art (MoMA) devoted three major exhibitions, *Twenty Centuries of Mexican Art* (1940), *Art of the South Seas* (1941), and *Indian Art of the United States* (1941), to Amerindian and Oceanic art, and they played an important role in changing the perception of so-called primitive art among the general public and the artistic community (see Ostrowitz, this volume). The latter exhibit was a key event for Pollock, for example.

The New York artists made their own contributions as well, and Barnett Newman appears as the main promoter of Native American art among them. In 1944, he organized a fairly important exhibition of pre-Columbian objects for the Wakefield gallery, which gained favourable press coverage. His enthusiastic commitment to primitive art was jeopardized by the National Museum of Natural History's rejection of his proposal to exhibit examples of contemporary works in the museum. Newman's idea was to provide an inversion of the recent

exhibitions at the MoMA and to highlight the direct association between Native American and modern art. His show entitled *Northwest Coast Indian Painting*, which inaugurated the Betty Parsons Gallery in 1946, made up for the disappointment. The exhibition featured some twenty pieces, four lent by Max Ernst and sixteen borrowed from the American Museum of Natural History. Among them was a painted house front that conveyed for Newman what he considered the Native sense of "pure painting." As indicated by the title of the exhibit, Newman favoured painting and low-relief carving to purely sculptural forms. In this particular context, the word *painting* referred to the stylized representations of supernatural beings and totemic monsters that peopled Northwest Coast mythology. These representations were rendered in abstract designs on the flat surfaces of various types of ceremonial artifacts (e.g., masks or Chilkat blankets). Newman distinguished between a geometrical shape that functioned as a pure abstraction and the same shape in Northwest Coast art, where it was a "living thing" and impregnated with emotions. He perceived Northwest Coast art as a parallel to the type of art claimed as such by his fellow artists – that is, an art that goes beyond abstraction to express ideas and feelings [11.IX]. His only contemporary art exhibition, *The Ideographic Picture*, was held a few months later, also at the Betty Parsons Gallery. Although it may have given the viewer a feeling of heterogeneity, the show was representative of the new American painting that drew its creative impulse from primitive art [11.x].

As summarized by W. Jackson Rushing in *Native American Art and the New York Avant-Garde: A History of Cultural Primitivism* (1995), the artists were influenced by the plastic qualities of Native American art and paid homage to its creative power in their works and statements. Their primitivism was expressed in the borrowing of painting techniques or the incorporation of images into their works of the early 1940s, but it went far beyond pure imitation or specific stylistic influences. Their appropriation of Amerindian artistic and spiritual paradigms contributed to a new trend in American artistic modernity.

**11.I. Roberto Sebastián Matta Echaurren. 1987.** *Entretiens morphologiques: Notebook no. 1, 1936-1944* **[Interviews Morphological: Notebook 1, 1936-1944].** Edited by Germana Ferrari Matta. London: Sistan; Paris: Filipacchi, 149. Translated by Natasha Nobell.

A newcomer to the Surrealist movement that he joined in Paris in 1937 at the urging of Breton, Chilean-born artist Roberto Sebastián Matta Echaurren (1911-2002) played a vital role within the community of exiled Surrealists in New York for nearly ten years (1939-48). He actively contributed to the construction of social and artistic relationships with the young generation of American artists,

especially the Abstract Expressionists Arshile Gorky, Mark Rothko, William Baziotes, Willem de Kooning, and Jackson Pollock. In 1942, he showed his work at the *First Papers of Surrealism* exhibition, among others. Matta Echaurren shared his émigré friends' passion for Northwest Coast and Yup'ik pieces. In a lively account, he told the story of a memorable escapade (probably in September 1943) to the storehouse of the Museum of the American Indian (the Heye Foundation) in the Bronx, where the visitors could freely pick and choose among the dazzling riches before them with the complicity of the keeper.

> In New York there was a guy called Karl Bach [Carlebach] who ran a tiny "flea market" where we would find primitive artifacts whenever we stopped by. We asked him where his stock came from and he told us that he had a friend who was the curator of the storehouse at the "Hyde Foundation" [Heye Foundation]. We pricked up our ears and invited him and his friend for a cocktail at Peggy's [Guggenheim]. He brought the curator and we bribed him with "old fashions" [sic]. The following morning we left in two taxis: Breton, Duthuit, Lebel, Max Ernst, Lévi-Strauss and I found ourselves in Ali Baba's cave. If we so desired, with a little tact of course, we could buy anything for between 140 and 200 dollars. I bought the most expensive and biggest piece. The Eskimo mask that I lost in the course of my wanderings and found again in the 1950s at Robert and Nina Lebel's home. Duthuit bought a transformation mask, and I never saw another one similar to it. Breton had chosen an asymmetrical mask with an eye that blinks and a tube-like nose. For us it was the discovery of the Northwest Coast.

**11.II.  Kurt Seligmann. 1939. "Le mât-totem de Gédem Skanísh (Gyaedem Skanees)" [The Totem Pole of Gédem Skanísh (Gyaedem Skanees)].** *Journal de la société des américanistes* 31: 121-28. Translated by Solen Roth.

The Swiss painter Kurt Seligmann (1900-62) was the first Surrealist artist to undertake a trip to the Northwest Coast. He travelled to the Upper Skeena region of British Columbia in the summer of 1938, with a mandate from the Musée de l'Homme in Paris to bring a totem pole back to France. With the moral support of the ethnologist Marius Barbeau, he was able to secure a sixteen-metre memorial pole from the Wetsuwet'en village of Hagwilget at a time when Native peoples of this area resisted the Canadian government policy of salvaging totem poles. The supposedly "tallest totem pole in Europe" was erected in front of the Parisian museum in January 1939. Seligmann's article does not have the elegiac quality of the Surrealist writing on non-Western cultures but reflects his concern as an ethnographer to provide an accurate account of the circumstances of the

acquisition of the monumental sculpture, its history, and its meaning. Remarkably, he never failed to mention the sources of his data, whether the names of his Gitksan and Wetsuwet'en collaborators or those of ethnologists (Mauzé 2008a). His field research was completed by the publication of two short texts appearing in the review *XXe siècle* (1938) and the last issue of the avant-garde journal *Minotaure* (1939).

### THE GÉDEM SKANÍSH TOTEM POLE (GYAEDEM SKANEES)

The Indians call the pole Krikiet or Keïgiet, in reference to the mythical giant who was killed by a Morice Town hunter. This hunter wounded the only vulnerable part of the giant's body, the palm of his hand in which his heart beats.

Keïgiet means "like a man." Indeed, aside from his gigantic dimensions and his beak-shaped nose, he looked human, which is how he is represented on the totem pole.

Keïgiet had kidnapped the hunter's wife to eat her roasted, and this misdemeanour cost him his life.

One would think the narrative would end here: the woman has been burnt to death, and Keïgiet has been killed by the arrows of the hunter, who returns to his hut. However, the Indians' taste for complications, cruelty and the supernatural has not yet been appeased.

When Keïgiet abducted the woman from the hut, the hunter's little boy, only a few years old at the time, was contaminated by the giant's magical powers and was turned into a maleficent monster.

The monster-baby tore out his father's eyes and tongue and went to Morice Town to inflict this treatment on all the villagers. He was about to cook these tongues and eyes when two young girls came out of their hiding place to stop him. By doing so, they broke the taboo of puberty according to which they should stay shut away, the very taboo that had spared them the other villagers' fate. The maleficent powers of Hwotsi (menstruations) overpowered the supernatural forces bestowed on the baby by Keïgiet. The young girls burnt him in the embers he had prepared for his abominable feast; his entire body was consumed with the exception of his lips, out of which flew clouds of mosquitoes that have been tormenting human beings ever since. The victims were given back their tongues and eyes and immediately resuscitated.

Gédem Skanísh raised the Keïgiet totem pole in commemoration of these events, as he believed he was related to the woman killed by the mythical giant. It is possible that his ancestors had taken Keïgiet as totemic emblem out of pride that one of their family members had interacted with this supernatural being.

Though Gédem Skanísh was originally Tsetsaut, he bears a Gitksan name that signifies "mountain man." For a relatively long time, Gédem Skanísh lived with his family in Carrier territory, in the ravine formed by Bulkley torrent as it flows into the

Skeena (Pl. I, B-C [Figure 11.2b; C not included here]). He erected the totem pole in this location, in front of his house.

It is important to note that this Tsetsaut family joined the Carrier Indians and was much influenced by their neighbouring Gitksan tribe, adopting its culture and letting a Gitksan family – the Kuinu, of Gitwinlkúl – absorb them, after one of their subsequent migrations.

These migrations and changes of nationality were frequent for the Indians of the western coast of North America.

Gédem Skanísh's house was adorned with carvings and innumerable painted eyes, an allusion to the misdeeds of the "monster-baby" who had torn out the eyes of the inhabitants of Morice Town. The house was called the House of the Eyes, Kenérh l'Aïerh or Kenéarh-Thlaï-Iarh.

However, Mountain Man's entire family could not fit in the House of the Eyes, and it was flanked by two other houses, the House of the Rock, Tserhál-Kaïérh, and the House Near the Fire, Kuán-Beáïerh.

The occupants of the House of the Rock were called Uídarh-Kiet; those of the House of Fire, Uídarh-Kuats.

Arhtinié, a small chief and relative of Gédem Skanísh, lived near the three main houses.

It is the occupants of the House Near the Fire who adopted the supernatural otter Uí-Uótsrh as their magical name or "spirit name." The otter is represented on the totem pole; its origin has been forgotten.

Elders described to me with much enthusiasm the Mountain Man's three beautiful houses. The other houses located in the ravine no longer exist. Only four of these totem poles are still standing (Pl. II, C [not included here]).

The few houses of the Carrier village of Hágwelget stand side by side near the ravine, on top of the hillside. A suspension bridge overhangs the deep ravine, not far from the location where the little Indian bridge stood forty years ago. There are photographs of this bridge, a remarkable specimen of primitive architecture.

The hillside opposite Hágwelget is Gitksan territory. The ravine is a natural border in between these two peoples.

Of the four totem poles still in place in 1938, two have disappeared: Gédem Skanísh's pole, the most well carved and tallest one, has been sent to Paris; the Anhlárh pole was taken down by a storm during the night of September 3 to 4, 1938.

The Keïgiet pole caught my attention because of its antiquity, attested by several indicators. Infestations have disintegrated the base and the top of the pole, attacking and reducing to dust the wood between its heart and its exterior strata.

The part that had suffered most was the character at the top of the pole, which seems to represent the "monster-baby." Important consolidation work had to be done

**FIGURE 11.1** Gédem Skaních totem pole, ca. 1870 (shown in A and to the right in B). Red cedar, 16 metres tall. Carved by Samali of Hágwelget and Tsiebása of Gitsegyú. This memorial pole from the Upper Skeena, collected by Kurt Seligmann in 1938, was erected in 1939 at the Musée de l'Homme in Paris and was eventually transferred to the Musée du quai Branly. It was originally raised in the ravine of Hágwelget by Chief Gédem Skaních, sometime before 1870. Photograph by Kurt Seligmann. From Kurt Seligmann, "Le mât-totem de Gédem Skaních (Gyaedem Skanees)," *Journal de la société des américanistes* 31: 121-28 (Pl. I, A and B).

in order to preserve it (Pl. II, 1 [not included here]). The disintegration of the part that was driven into the ground was such that the pole would most certainly only have stayed erect for a few more years. The pole was sheltered in the ravine, as rain waters did not stagnate on this inclined terrain. This fact is of importance for the evaluation of the pole's age.

While on most totem poles of British Columbia, in particular those of the coast, figures are carved next to one another, stacked or even intertwined, those of the Keïgiet pole are separated. The characters are superposed but their shapes do not form a continuous and tense rhythm as is found on more recent poles, carved in a sophisti-cated – yet often conventional – style. It is not evident that coherence was given much consideration; rather, the carvings are placed so that someone standing at the bottom of the pole could distinguish them. The faces look like masks fixed to the tree; the

character under the otter (Keïgiet?) (Pl. I, A [Figure 11.1a]), probably Samalí's work, is carved in the Gitksan's most primitive style. This style should not be confused with the lack of skill demonstrated by some recent poles. The latter poles are roughly cut rather than carved, demonstrating the extent to which the Gitksan have forgotten their tradition.

The man with the necklace indicating his rank in the secret society of which he is a member (Pl. II, C [not included here]) is wearing a sleeveless blouse, a piece of clothing that was worn prior to the settlement of the White man in 1867, when a fort was built in Hazelton.

I am convinced that this is not a reconstitution. In other words, it is not that a character dressed the ancient way has been represented on the totem pole after White settlement. Though I cannot be entirely sure of this fact, I believe the pole was raised before the definitive adoption of the White man's clothing, in other words before the beginning of the nineteenth century and the construction of the fort in Hazelton. This character (Keïgiet) has a nose so curved that it enters his mouth. He is wearing Athapascan style moccasins and pants. At his feet is a parallelepiped, a sort of box I imagine is supposed to contain ceremonial objects.

The character beneath him represents Keïgiet (Pl. II, D [not included here]); his hands are raised up to his chin, palms turned outwards. In between his thighs, he holds a small head – in all likelihood, the monster-baby's head.

The representation of Keïgiet at the base of the pole has been mutilated. One can see the trace of a small head on his chest, probably similar to the one held by the Keïgiet represented above.

The object carved above the lower Keïgiet's head is a headdress of a secret society in which Gédem Skanísh was high ranked.

The three noses that were originally in the rectangular holes have fallen out. A few elders remembered the shape of the noses. The drawings they made when interviewed separately were strikingly similar. I hired Tom Campbell (Ludketzíes), who carved two totem poles, to reconstitute the lost noses.

The Keïgiet pole has a beautiful patina, from silver-grey to copper-brown. In addition to its natural tints, few traces of color are visible. Originally, only some parts were coloured, brows, pupils, lips, nostrils, for example. These were painted in two or three tones with a salmon egg- and chewed cedar bark-based preparation. Red and black were favourites.

Light traces of red are still visible on the otter's nose. Tied to the otter's tail are fragments of a braided cedar bark rope (moólok) that was probably used to raise the totem pole.

In order to facilitate transport, the side of the pole without figures was carved out up to the level of the otter. This part is roughly carved; despite the wood's disintegration,

tool marks are visible. The figures are carved with precision; the edges are sharp, the shapes well delineated. Everything indicates that the carving was done with metal tools.

The acquisition of the totem pole was preceded by long negotiations. Its owners were the Indians of Morice Town and Hágwelget. Gédem Skanísh's descendents in Gitwinlkúl did not come forth as ancient right holders. They may have lost these rights as they have acquired other crests and are now part of another family. It is unlikely that they did not hear of our negotiations: news travels fast among the Indians.

Totem poles are the property of all the members of a totemic family. Each member can refuse to let their pole be removed; these individuals' rights are, to a large extent, respected and protected by the White man's law. However, people of the same group often disagree with one another, which makes things particularly difficult. Previous disputes are reactivated and negotiations often degenerate into quarrels over inheritance rights.

It is difficult to bring together all the owners of a totem pole; there are always some who are away hunting, fishing, or who are on the road simply to satisfy a hereditary desire to travel.

Individuals sometimes come forward claiming that they have not been reimbursed by the totem pole's proprietors for a potlatch that one of their ancestors had given long ago, and try to prevent the removal of the pole that testifies to the celebration of this past event. Indeed, in the absence of a written language, totem poles serve the community as reminders of these distribution feasts and of the debts that ensued. Thus potlatches that had been forgotten for a quarter of a century are later used as arguments.

Captain Mortimer, Indian agent and tutor of the region, convened a meeting in Morice Town to identify the owners of the pole. The meeting was very animated: almost every villager claimed to have rights to the Keïgiet pole and declared that they would not let it be taken away unless each and every one of them was compensated.

Donald Grey, Sun chief in Hágwelget, was opposed to the pole's removal as well, claiming to defend his people's interest. He even threatened to provoke an uprising if we were to lay hands on the pole.

I was able to calm him down and to eliminate those whose claims were too vague. After long negotiations, I reduced the number of claimants to six: Arthur Michell (Hágwelnerth), Jimmy Michell (Sámar San), Joe Nass (Gútelek), Round Lake Jonny, Little Denis and Philip Austin (Kakhl).

These Indians are all of the frog-raven clan (larhséliu). Their clan chief is Hlengwa of Kitwangá (Gitksan territory). Hágwelnerth seems to be the supreme chief (family chief) of their totemic family. Three giants are represented on his ceremonial cloak.

Sámar San, Gútelek and Kakhl appear to be house-chiefs. Little Denis and Round Lake Jonny seem to be ordinary members of the family. Compensations were granted to each of them in proportion to their social rank.

The deal was sealed by raising hands. We repeated this gesture in the presence of the Indian agent in charge of the pole's exportation permit, which is never granted without permission from the Department of Indian Affairs in Ottawa. The response came by telegram within five days. Usually such formalities would have taken a considerable amount of time, far beyond the duration of my stay in Canada.

There is no question that the acquisition of the Keïgiet pole would have been impossible without the Canadian authority's benevolence.

**11.III.  Wolfgang Paalen. 1994. "Voyage Nord-Ouest."** *Pleine Marge* 20 (1994): 14-15, 15-16, 16-17, 19-20, 20-21, 23-24, 29-30, 30, 31. His original diary written during his trip to British Columbia and Alaska was first published in *Pleine Marge* in December 1994. Translated by Natasha Nobell.

Wolfgang Paalen (1905-59) painted *Totemic Landscape of My Childhood* and *Fata Alaska* in 1937, the same year he joined the Surrealist group. Both paintings feature columns of a totemic type, an early unconscious sign of his voyage to the "primitive" Northwest Coast that he undertook in the summer of 1939 with his wife, Alice Rahon, and a close friend, Eva Sulzer, the Swiss photographer, who documented the trip in over three hundred photographs. His daily notations — whether simple anecdotes or more philosophical thoughts — revealed his fascination with the landscapes of British Columbia and Alaska and his passionate interest in collecting Northwest Coast artifacts, whatever the means. His diary provided the material he used to write "Paysage totémique," which appeared in four instalments in his Mexico City-based avant-garde journal *Dyn* (1, 2, 3, 1942; 6, 1944) [11.VIII] (see also Kloyber 2000). Excerpts of "Voyage on the Northwest Coast of America" were first published in German in Christian Kloyber's *Wolfgang Paalen: Zwischen Surrealismus und Abstraktion* (1993, 195-203).

*Winnipeg*
Fortress of tedium. A true stronghold of tedium ... I hear about the stores of the Hudson Bay Company, which has a big shop for crooworks [sic] in town. There I find a small historical exhibition, meager and thought-provoking. A magnificent Chilkat blanket with two heads; a beautiful copper plate. A splendid buffalo pelt, very rare specimen, almost blond, silky and curly. It belonged to the Indian Chief Crowfoot, who gave it to one of the Company's chief-traders as a wedding gift. What's more, Crowfoot made every effort to keep his Indians quiet during the building of the railway, for which he was rewarded with a standing life-time ticket, a ticket he is wearing

rather conspicuously across his shoulder in an old photo; beautiful raven's head. Astonishing document: a canoe with the Company's insignia travels the rapids of a river (which river?) the men manning the paddles coiffed like movers in Paris. The man being ferried to some factory or faraway place is young and energetic; his head covered by an astonishing grey top hat whose aerodynamic brim emphasizes in a most astounding and convincing way the audacity of the enterprise and the rapidity of the movements. The following day we rummage through the attics – so wonderfully evocative – of the Company's warehouse. Lovely aroma of roasted coffee, tea ... Remnants of old sail boats, old canoes, one made of ash bark. The head of a wolf carved out of a whale bone, stained red, with copper eyes. In a corner I find a relatively large and good copper plate, but without an etching on it. It is for sale, I buy it for $25.

...

*In the train from Jasper to Prince Rupert*
*Jasper*
*The first outdoor totem pole.*
The scenery becomes very beautiful, from Jasper onwards. Jade green water. Big firs, cedars. Dead grey trees. Small sandy shores littered with branches, dead trees. Marshes, waters, wild ducks, moorhens. Real log-houses. Woodcutters in lumber-jackets. The Fraser River. McBride: a half-hour stop. Wooden houses – very pretty. The houses are cream and red. The scent of forest and grass. It's perfectly still, the most beautiful green color, velvety grey-green (like in my paintings), green on old gold. Later, facing the sun, an odd prismatic cloud in the sky, beautiful, like a diminu-tive, diurnal aurora borealis. Astonishingly, the scenery resembles that of my paint-ings more and more; here are the big forests of my dreams, the big forests of North America I always wanted to see. The burnt trees, the roots fanned out in the air. The grey trees, bare (ask about the cause [worms?]). Memory of the castle in Silesia which had become visible after the invasion of worms. Silvery fox forest, porcupine forest (porcupines, porcupine-knives, Jack London), cloud-like forest. (It's better to paint the clouds than ... the sky). The clouds (mist) get caught up in it like the wool of wild sheep (goats, whose wool is used to make those Chilkat blankets). Goat River Station, goat, it resembles chamois – ... lackeys behind the old Duchess of Cumber-land's coach.

...

On the Fraser River I see, in the middle of the forest, a totem pole which strikes me as very beautiful, I want to call to the others but I am not – once I get a little closer – entirely certain anymore whether it's a totem pole or a burnt tree. Impossible to know for certain. I know that the Canadian National Railway put one somewhere in the forest (if I recall correctly) but there – it's unlikely. Dead tree on which sits a raven. From a certain distance, impossible to distinguish between dead trees and totem

poles. Is that the solution for the time being? ... The buffalo at Altamira [implied] by the relief in the ceiling of the cave? Image or apparition – art as objectification of desire, visualization of desire. Is the source of art this type of automatism?

...

*Prince Rupert*
Arrived at around 3 in the morning, Saturday the 17th. Spent the night on the train. Sunday the 18th.

Train of rain.

First gathering of totem poles. Paint not too bad, indispensable for preserving them, but could perhaps be substituted with a varnish. Breakfast at the "Commodore Café."

...

Small museum of P.R. Reverend (Pierce), half Tsimshian, his father came with the first Scottish boat going directly to Hudson Bay. 84 years old. "Official guide." Solely interested in reciting his lines as a guide, sad old parrot. Explains the origins of the totem poles by way of the tattoos that the Indians saw on white sailors, which says it all! A preposterous story about a cannibal incident that he claims to have seen when he was a young boy. (Very depressed afterwards, thinking about the unpleasant side of this type of research, of excavations, etc.)

Very beautiful Haida mask. Beautiful thunderbird mask. Rain. Found a beautiful copper plate at Heilbronner's, smaller than the one without an etching from Winnipeg, but with a beautiful engraved design, bought for 26 $. Also bought a necklace made of whalebone – necklace which Giacometti could have made while he was creating The Palace at 4 am. A funny little hotel, as though suited to a naval officer. Experiencing culture shock in Prince Rupert. Monday morning, departure on the "Prince Robert," on the C.N.R. Departure resembled a circus.

Toward Ketchikan. Islands, always wonderfully wild, completely uninhabited, the forest is darker, more lichen-colored than in Canada.

Evening, around 7 o'clock in Ketchikan. Lovely little port, bustling with activity: a curio-shop decorated with whalebones. Pruel's store. Large ceremonial hat with a fish, which he does not want to sell; a simple box: $20. Large copper plate, the etching entirely damaged, one side replaced (repaired): $75. Visit to the Indian school, the mass manufacturing of awful little totem poles, slippers, etc. everywhere. Rather pretty new poles on the graves, by the side of the road.

Forest with silvery grey trees, in the same range altogether as very old whalebones. Remarkably twisted trees, "natural" totem poles ("ready-mades"). Exactly in the

same vein as some of my paintings – even before I could utter the slightest comment about this similarity, Alice and Eva had "recognized" it.

...

Small shack-like museum. Pretty Eskimo masks, large fragmentary sculptures. A magnificently wild forest, ruined from the outset by dreadful new totem poles, as ugly as bowling pins. We go by a hangar where one is being manufactured, smeared in glossy paint and equipped with a "fresh paint" sign.

"The German who doubts nothing." The Jew who doubts. The German and the Jew. The problem of faith.

Reconstruction of the small, octagonal log-house fort of ... with mortar.

Visit to an eminently Russian curio-shop. A former femme fatale whose tone is solemn. A good Chilkat blanket. Not for sale, but tomorrow the "circumstances" will perhaps have changed. Speaks of other interesting objects, but which are also trapped in this complex grid of "circumstances." She shows us a simple, white fox skin, but not before spreading out several meters of scarlet velvet, in a manner of pomp and circumstance. We christen her the tsarina of grand circumstance. Samovar, Russian boxes, copper.

"Parlors": taverns with small, swiveling chairs around a long table and, on the other side, wooden compartments like the third-class compartments on German trains. An atmosphere of gold rush fever. Adventurous-looking men wearing big rubber boots ... with incredibly blue eyes, features like Wallace Beery.

Haley, an old gold digger, calls out to me in the street, he has heard that I'm looking for "Indian relics." Seems like a wheeler-and-dealer. For $30 he sells me a carved whalebone, very beautiful old piece. Very difficult to determine what it could have been used for (Rasmussen, in Wrangell, will tell me later that he believes it was a charm belonging to an "Indian Doctor"). A very old piece, made from a bone which had not been boiled. For the last 50 years, the blubber of whales has been boiled off, leaving the bones much whiter and drier. This piece, furthermore, must have been kept inside a house in order to preserve some of its oil, making it look like a grey stone with a yellowish tinge. Bought a bowl made of whalebone, a wooden ceremonial hat (most beautiful) and a very beautiful Tlingit headdress, from an Indian chief married to a white woman. Lovely wooden chest at Haley's.

   Works of art are traps set for life – if the trap is well set, life is snared within it forever.

...

The W.C.W. store [refers to Walter C. Waters, the owner of a curio shop in Wrangell, Alaska], a real treasure trove – one can find everything here: Tlingit and Haida ceremonial masks, Chilkat blankets, narwhal teeth, Eskimo kayaks, Eskimo tools and pipes, countless mammoth teeth or tusks, an indefinable object which I assume to be part of a kayak. To my query, W. replies with an evasive grunt – later he explains that it's the penis of a whale, something he could not tell me in front of the ladies.

In the other store: a medicine-doctor outfit (mask of a dead slave), headdresses, canoe paddles. A canoe slender as a Viking ship. An old structure made of light wood from which emanates the same air of grotesque despair as that found in certain of Max Ernst's older paintings and collages.

...

In old Wrangell there is only one totem pole left, topped by a bear covered in a thick fur of moss. Under the cover of a real jungle of (here, a drawing), a few planks as whitened as bones.

...

Discovery of the Indian Doctor's tomb. A kind of small, perfectly square log-house. Waters and his sons are surprised, having known about another one nearby, looted long ago. This tomb is perfectly intact. Must be much more than 100 years old. The big cedar trunks, worm-eaten and the color of antique bronzes, give way easily. The Waters family simultaneously attacks the tomb from below and above without a moment's hesitation. The old man quickly entered the tomb and his sons pick over this ... loot which he passes to them through a hole made underneath: remains of red cedar bark material, remains of a hat, of a Chilkat blanket, little bird bones probably left by a beaver or some ferret, totally worm-eaten remains of wooden chests, the rotten wood having become phosphorescent, wood reduced to tinder by centuries of rain.

**11.IV.  Claude Lévi-Strauss. 1982. "The Art of the Northwest Coast at the American Museum of Natural History."** In *The Way of the Masks*. Translated by Sylvia Modelski. Seattle: University of Washington Press; Vancouver: Douglas and McIntyre, 3-8. Originally published as *La voie des masques* (Geneva: Skira, 1975). Essay originally published in English in *Gazette des beaux-arts* 24 (1943): 175-82.

Influenced by the emotional Surrealist approach to non-Western arts, Claude Lévi-Strauss (1908-2009) contributed a very personal and poetic essay on the Northwest Coast collections at the Museum of the American Indian, which he discovered at the beginning of his American exile (1941-44). In this paper, he not only foretold the recognition of Northwest Coast art by connoisseurs, artists, and art historians but also praised the nature of this art for its capacity to allow the process of transformation to happen and make visible what is hidden. His

narrative gave life to the carved creatures and granted them attitudes and intentions as if they were human beings. In his own way, Lévi-Strauss paid homage to the Northwest Coast artists credited as "prophets and virtuosos." This essay initiated his further scholarly research in which he explored the structural relationship between Northwest Coast aesthetics and the system of beliefs and mythology underpinning artistic practices.

"There is in New York," I wrote in 1943, "a magic place where the dreams of childhood hold a rendezvous, where century-old tree trunks sing and speak, where indefinable objects watch out for the visitor, with the anxious stare of human faces, where animals of superhuman gentleness join their little paws like hands in prayer for the privilege of building the palace of the beaver for the chosen one, of guiding him to the realm of the seals, or of teaching him, with a mystic kiss, the language of the frog or the kingfisher. This place, on which outmoded but singularly effective museographic methods have conferred the additional allurements of the chiaroscuro of caves and the tottering heap of lost treasures, may be seen daily from ten to five o'clock at the American Museum of Natural History. It is the vast ground-floor gallery devoted to the Indians of the Pacific Northwest Coast, an area extending from Alaska to British Columbia.

"Surely it will not be long before we see the collections from this part of the world moved from ethnographic to fine arts museums to take their just place amidst the antiquities of Egypt or Persia and the works of medieval Europe. For this art is not unequal to the greatest, and, in the course of the century and a half of its history that is known to us, it has shown evidence of a superior diversity and has demonstrated apparently inexhaustible talents for renewal.

"This century and a half saw the birth and flowering of not one but ten different art forms: from the hand-woven blankets of the Chilkat (a craft unknown in the region until the beginning of the nineteenth century), which immediately attained the highest perfection in textile art by using only sharp yellow extracted from moss, black drawn from cedar bark, and the coppery blue of mineral oxides, to the exquisite argillite sculptures given the high gloss of black obsidian (verging on the knickknack, they illustrate the flamboyant decadence that befalls an art suddenly in possession of steel tools, which in their turn destroy it), passing through the mad vogue, lasting only a few years, of dance headdresses emblazoned with carved faces set against a mother-of-pearl background and encircled with fur or white down from which ermine pelts cascade like curls. This unceasing renewal, this inventive assuredness that guarantees success wherever it is applied, this scorn for the beaten track, bring about ever new improvisations which infallibly lead to dazzling results – to get any idea of them, our times had to await the exceptional destiny of a Picasso. With this difference, however:

that the daring feats of a single man, which have been taking our breath away for the past thirty years, were already known and practiced by a whole indigenous culture for one hundred and fifty years or even longer. For there is no reason for us to think that the development of this multiform art has not maintained the same rhythm since its remotest origins, which are still unknown. A few stone objects excavated in Alaska, however, prove that this powerfully idiosyncratic art – easily recognized in even its archaic form – dates from an ancient epoch, a phrase given here the relative value it must assume when applied to American archaeology.

...

"For the spectator at initiation rites, the dance masks (which opened suddenly like two shutters to reveal a second face, and sometimes a third one behind the second, each one imbued with mystery and austerity) were proofs of the omnipresence of the supernatural and the proliferation of myths. Upsetting the peace of everyday life, the masks' primal message retains so much power that even today the prophylactic insulation of the showcases fails to muffle its communication. Stroll for an hour or two across this hall so thick with 'living pillars.' By way of another correspondence, the words of the poet* translate exactly the native term designating the sculptured posts used to support house beams: posts that are not so much things as living beings "with friendly eyes," since in days of doubt and torment, they too let out 'confused words,' guide the dweller of the house, advise and comfort him, and show him a way out of his difficulties. Even now, one would have to make an effort to recognize the dead tree trunks within the pillars and to remain deaf to their stifled voices; just as it would be difficult not to perceive, here and there behind the showcase glass, a sombre face, the 'Cannibal Raven' clapping its beak like wings, or the 'Master of the Tides' summoning forth the ebb and flow with a wink of its ingeniously articulated eyes.

For nearly all these masks are simultaneously naive and ferocious mechanical contraptions. A system of ropes, pulleys, and hinges can cause mouths to mock a novice's terrors, eyes to mourn death, beaks to devour him. This unique art's representations lend the contemplative serenity of the statues found in Chartres cathedral and in Egyptian tombs with the artifices of the carnival. ... Look closely at the storage boxes, carved in bas-relief and highlighted in black and red: the ornamentation seems purely decorative. But traditional canons make it possible for a bear, a shark, or a beaver to be reproduced here without any of the constraints that usually bridle the artist. For the animal is represented simultaneously in full face, from the back, and in profile; seen from above and below, from the outside and from within. Using an extraordinary mixture of formalism and realism, a surgeon-draftsman has skinned and boned the animal, removed its entrails, and reconstituted a new creature, all of whose anatomical points coincide with the parallelepiped planes of the box, thus making an object which is simultaneously a box and an animal, and at the same time, one or

several animals and a man. The box speaks, it watches efficiently over the treasures that have been entrusted to it in a corner of the house. Furthermore, everything in the house points to the fact that the dwelling is believed to be the carcass of a still larger animal, which one enters through the door, its gaping mouth. In the interior, a forest of symbols, both human and non-human, rise up in a hundred different, sometimes amiable, sometimes tragic, forms."

---

\* Charles Beaudelaire (1821-67), whose celebrated poem "*Correspondances*" inspired the Symbolist movement later in the nineteenth century. The quoted words in this paragraph come from the sonnet's first quatrain, freely translated here.

> La Nature est un temple où de vivants piliers
> Laissent parfois sortir de confuses paroles;
> L'homme y passé à travers des forêts de symboles
> Qui l'observent avec des regards familiers.

> *Nature is a temple where living pillars*
> *Sometimes let out confused words;*
> *Man journeys through it as if across forests of symbols*
> *That observe him with friendly eyes.*

**11.V.  Georges Duthuit. 1974. "Le don Indien sur la Côte Nord-Ouest de l'Amérique (Colombie britannique)"** [The Gift among the Indians of the Northwest Coast of America]. In *Représentation et présence: Premiers écrits et travaux, 1923-1952*. Paris: Flammarion, 315-19. © Flammarion 1974. Originally published in the Surrealist journal *Labyrinthe* 18 (1946). Translated by Natasha Nobell.

Son-in-law of Henri Matisse, the French art critic and writer Georges Duthuit (1891-1973) was part of the circle of artists and intellectuals who regrouped around André Breton during the American exile of 1941-46. Working with Lévi-Strauss and Breton for the US Office of War Information, Duthuit, like his friends, developed a passion for Northwest Coast masks. He acquired several from the antique dealer Julius Carlebach, one of which is a remarkable Kwakwaka'wakw transformation mask. Duthuit's unknown essay compares with that of Lévi-Strauss in its poetic evocation of the mythological creatures embodied in masterpieces that, in a ceremonial context, become alive. The text is a perfect illustration of the Surrealist vision, which sought to reconcile opposites. The second part of Duthuit's paper analyzes the potlatch from a "Bataillian" perspective, according to which it is best characterized as an institution of ostentatious rivalry (see Kramer, this volume) [23.VI].

It is said that totem poles live for about one hundred years. Spiked with fins, with the beaks of predatory birds, swollen by carnivorous nostrils and amphibian eyelids, combining human traits with those of the raven, the killer whale, the moon or the

sun, they stand as reigning family trees, as badges of honour – and yet never reach high enough. These memorial columns of legend and ostentation were felled, abandoned, sold, in the prime of life between 1880 and 1900, in accordance with the orders of the gospel of the humble and the poor, eventually introduced in these regions, and closely followed by the civil code supported by a vigilant administration. Some totem poles continue to decay in their native country, desolate when darkness retreats, on a deserted shore or at the outermost bounds of the snow, against the steely mantle of the pine trees. Mr Kurt Seligmann, painter of turmoil, armour and dreams, dragged one of these heraldic trunks all the way to Paris, and at what cost! Standing today under a portico at the Trocadéro, it provides, by virtue of its staunch independence, an element of well-deserved shame to the bas-reliefs and other nudes which embellish the walls of this seemingly modern establishment [see 11.11].

Beavers build capitals, the king dwells in the stomach of the fish, the horn spoon chatters with the fire and the roof beam, the copper moans, little leaves clap their hands, the moss tells the lover his true love's name, at dawn in the forest the bird flutters about from its nest to the ground and lowers its head, tilting it from side to side before collecting its food, to listen to what the earth tells it. The young man returns to his tribe and through dance and song reveals to his people that which the earth and the bird have taught him, at dawn in the forest. He is able to vanquish evil spells, to subdue the shadowy and nebulous specters which pursue or elude him, chain them to the giant tree, affix them, as dreadful high relief carvings or as broad lifelike planes, to the heart of the maternal cedar, guardians now of the village and the home; or simply to hollow out two holes, to incise a groove into the bone of a deer or a whale, performing from that moment on, as prescribed by the gods, in a realm where dream and reality, and the familiar and the mysterious meet, the transformation of animal into man and man into spirit.

Music and choreography come to the assistance of magic; perhaps they are magic itself. The seer, the doctor, the lawmaker in his restful place, the shaman, by blowing into the mouth of the patient, does not always return a lost soul. But for he who can see by looking and hear by listening, the drum and the rattle and the frenzied gesticulations may unite, beyond the ravaged flesh and the wounded will, the disconnected forces of his universe made of waves and foliage. Since these rhythmic shouts and frenzied yet measured movements elate the healthy by leading them to the edge of trance and the raptures of communion, it is not entirely impossible that the calls of the sorcerer, his exhilaration and his transport into rapture can also revive the faltering body, awakening it confusedly to the murmurs, the growls, the false silences, the thundering footsteps on the paths used for fishing or ambushes – for what solace? To heal what? We are unaware of this rhythmic power which the Indian closes in on

and harnesses with wonderfully sharp senses, not like someone casually strolling to the post office or the church, but like the rabbit, his ears pricked up, his eyes wide open, in prodigious solitude, sensitive to the most secret vibrations of the morning, or like certain people of the maquis always being watched, always lying in wait and who, suddenly, pierced by the faintest hint of sound and omen, would open themselves to nature and become poets.

A conjuring trick can reach where magic, music and choreography cannot. It is a common occurrence in this region of rain-washed air, astonishing in its clearness, and deep, lush expanses of forest, to practice a terrifying homeopathy of illusions and conjuring tricks. If the cannibal woman, coming out of the woods at regular intervals, supposedly terrifies the young novice sent to win her favor, upon initiation he will probably only bite a dummy. At the end of the meal two robust fellows plunge arrows into each other's thighs, all the while vociferating that they have never felt better: the arrows are fakes. A poor wretch is decapitated, but it is a painted, wooden head which falls from her shoulders. Masks of horror and dread distress the children, never those who wear the masks or have seen them being made ... In the obscure light of resin torches and the convulsive din of these scenes of trickery, the first European explorers were duped, as though hypnotized. They find the astonishing and barbaric stunts to be appalling. It is the Englishman who lacks humor and the Spaniard who lacks a sense of the theatrical, not the Indian. Nevertheless, one of these explorers became suspicious.

**11.VI. André Breton. 1985. "Note sur les masques à transformation de la Côte Pacifique Nord-Ouest"** [Note on the Transformation Masks of the Pacific Northwest Coast]. *Pleine Marge* 1: 9-15. Originally published in *Neuf: Revue de la maison de la médecine* (1 June 1950): 36-41. Later published in *Oeuvres complètes*, Vol. 3, ed. Marguerite Bonnet, 1029-33 (Paris: Gallimard [Bibliothèque de la Pléiade], 1999). Translated by Natasha Nobell.

In his *Conversations* (1993), André Breton (1896-1966) mentioned several times his interest in Northwest Coast art. However, this note is the only one he wrote on the topic. In his essay on transformation masks, Breton elaborated on the meaning of these masks in the context of Surrealist sensitivity. From it, one can see why this type of object with movable parts, which, when open, reveal two or more beings in succession, fascinated Breton and his friends. When originally published, the text was preceded by "Chief's Song, Kwakiutl Poem," itself composed of short excerpts from Franz Boas's ethnographic writings (Mauzé 1994). It was illustrated with drawings from Boas's *Social Organization and the Secret Societies of the Kwakiutl Indians* (1897b) as well as by photographs of pieces acquired by Breton and Duthuit in New York from Carlebach in the 1940s. The

essay remained unknown until it was reprinted in *Pleine Marge*. "Note on the Transformation Masks of the Pacific Northwest Coast" is a key article in understanding the significance of Northwest Coast art in Surrealist thought and the importance of Breton's voice.

There is no doubt that masks, such as they are presented to the viewer in a museum of ethnology, are but rarely fully understood and appreciated in this manner. The general public does not pay them close attention and is unable to focus on anything but the most striking, uncommon and superficial features – the public's attention becoming weary and ironically condescending at best. Specialists value the masks solely as evidence: that which appeals to them, above all, is coordinating these types of evidence in order to establish connections and filiations, to provide curiously missing reference points throughout the centuries-old history of human migration. They emphasize the successive, and not the affective. Even collectors, whom we would assume (at least at first) to be keenly receptive to masks remaining "charged," among other objects combining magic and primitive art, by virtue of the exchange networks they create, are dragged down by deviations of the worst kind, victims of market-driven esthetic conventions which cause them to hover eternally around the same objects (here, for example, Pahouin artifacts). Issues of antiquity (everything being relative), of "patina," of "finish," of "formal" achievement, of highly valued materials (gold, as usual, above all else), obstruct the route of the great adventure of the mind as traced out by primitive objects. Such a pursuit, which one should be able to conduct endlessly from one to the other, revealing man's major preoccupations throughout space and time, could not, a priori, be more captivating. But for those devoted to this quest, I don't know any that comes to a more sudden end.

Even if it may sadden some pseudo-amateurs who esteem above all else questions of "haute époque," of trend and well-established commercial value, one can legitimately maintain that the culmination of instinctive forces, leaning towards their explosion and their imaginative blossoming – that which in fact matters – must be looked for elsewhere. One must note that the primitive art objects containing these forces are generally no more than one century old, they enjoy very little renown, and for the most part they are made of a material not considered precious (wood is not prestigious enough because of its relative youth). In my estimation, certain Melanesian objects from the Bismarck Archipelago as well as some Northwest Coast Indian artifacts fall into this category.

Among the latter, the place of honour undoubtedly goes to transformation masks of Kwakiutl and Haida origin. These masks are characterized by the ability of some of their parts to pivot on themselves in such a manner that they modify the configuration of the whole and, if need be, invert its meaning. Prosaically speaking, it is true that to

do this they are simply obeying a command from the human hand, as strings are being pulled. The effect achieved is striking nonetheless. The impact of the unexpected, which plays such a great role in modern artistic creation, is called upon here as nowhere else. The virtue of the object considered resides above all in the possibility of a sudden transition from one appearance to another, from one meaning to another. There is no other static work, no matter how great its reputation, which could bear comparison with its connection to life (and to anxiety).

It is the Haida mask which is pictured on the cover of "Neuf," and whose extraordinarily hard and focused gaze can be covered with turquoise eyelids. Another mask is likely to move and snap its jaws, while the blink of the eye represents the transition from the sun to the moon. Or yet another where the outer image of the irritated ancestor opens up to his peaceful image, flanked on the lateral shutters by hands distributing gifts. We present here some of the most beautiful examples of these works, little known in France and elsewhere very rare.

To talk about the ornamentation of these masks, at first glance very complex and specific to the mode of figuration and expression of the Northwest Coast, would be to go beyond the scope of this short article. Leonhard Adam has pointed out the analogies existing between this art and that of ancient China. Claude Lévi-Strauss reports his conclusions in this way: "The two arts operate on: (a) intense stylization; (b) schematics, or symbolism, which are expressed by the emphasis on characteristic traits or the addition of significant attributes (thus, in Northwest Coast art, the beaver is denoted by the stick he carries in his paws); (c) representation of the body by a double image; (d) dislocation of details arbitrarily isolated from the whole; (e) representation of 'one' individual seen straight on by 'two' profiles; (f) very elaborate symmetry which often highlights the asymmetry in the detail; (g) illogical transformation of details into new elements (thus, a paw becomes a beak, an eye motif is used to signal a joint, or vice versa); (h) intellectual rather than intuitive representation, the skeleton or the internal organs taking over the representation of the body."

It goes without saying that whoever overlooks these references would struggle to interpret the psychological process which governs the making of transformation masks in British Columbia. I leave it to those more competent than me to establish what to make of this particularly agonizing dualism which opposes summer to winter, the matriarchy of the north to the patriarchy of the south (with marked indecision on Vancouver Island), social categories, one of which resorts to all sorts of intimidation tactics to maintain its oppression of others. Of course this desire to intimidate at any cost, which takes, in the manner of exchange, the highly paradoxical form of the potlatch, is expressed in art through the transformation mask, which must first make people believe in the wrath of the ancestors and then that the tribute from the weak has been accepted ... However, another factor also intervenes as a function of this

dualism which affects both the material and social conditions of life. The strength of antagonisms maintains for the Kwakiutl the creation of a sort of Protean ancestor, of which, to our mind, the double or triple mask is the material projection of multi-form spirituality. Thus the power of the art which animates these masks, and the secret of profound resonance that they evoke in us, might stem from the fact that in the lyrical reduction of an initiation ceremony – from fish to bird, from bird to man – they embrace one of the greatest human achievements by realizing a transformation not only in thought but in action.

**11.VII.  Edmund Carpenter. 1976. "Collecting Northwest Coast Art."** In *Indian Art of the Northwest Coast: A Dialogue on Craftsmanship and Aesthetics* [originally published as *Form and Freedom: A Dialogue on Northwest Coast Indian Art,* 1975]. Edited by Bill Holm and Bill Reid. Seattle: University of Washington Press, 9-11, 12-13.

Written for the exhibition *Form and Freedom,* organized at Rice University in Houston, Texas, in 1975, this essay introduced the discussion between art histor-ian Bill Holm (b. 1925) and Haida artist Bill Reid (1920-98) on Northwest Coast aesthetics and craftsmanship. Ted Carpenter (1922-2011) clearly claimed sub-jectivity as a mode of appreciation, castigating the seemingly objective anthro-pologist's approach, which contributed to relegating non-Western objects to the category of ethnographic specimens. Beyond the anecdote of the Surrealists "hunting" for objects in New York antique shops in the 1940s, Carpenter cele-brated their understanding of the punning nature of Northwest Coast art and their intuitive capacity for selecting masterpieces that would meet the standards of Native artists (see Ostrowitz, this volume) [16.IV].

The term "primitive art" legitimately applies, I think, to the art of the Pacific North-west, not because that art was unsophisticated, but because its makers believed their ancestors lived in a primitive, mythological age, and they sought to reaffirm, perhaps reawaken, that reality by re-presenting it in art, drama, myth.

It was an age, they believed, of extraordinary events and noble deeds, when men lived as equals with animals and mythic beasts, and the play of Raven and Eagle, Frog and Beaver, Thunder-bird and Whale, established all that was to be.

When depicting that reality, Northwest Coast artists often showed two beings simultaneously occupying a single space by sharing various parts. Such visual puns did more than express complexity: they depicted transformation. Before one's eyes, Bear became Wolf, then Bear again. The image didn't change, of course. What changed was the observer's organization of its parts. But the effect was one of transformation.

This was wholly consistent with Northwest Coast thought. A Kwakiutl legend tells of the mythologic hero who appears first as a whale and later as a man disembarking from the whale, which is no longer himself but his canoe. When he meets the local chief and his daughter, whom he wishes to marry, he presents them with the whale, which has returned to its animal nature at the end of its third transmutation.

This single feature, above all others, proved to be the one most difficult for early anthropologists to understand. When told a carving represented a bear and later told it represented a whale, they assumed there must be an error.

It remained for the Surrealists to explain this seeming contradiction. One day in the early 1940s, on Third Avenue in New York, Max Ernst passed a shop displaying a few pieces of tribal art. The African pieces – so attractive to the Cubists – didn't interest him, but a Northwest Coast spoon did. The spoon was being sold as part of a collection of spoons from many lands. Ernst proposed, instead, to buy a collection of Northwest Coast art, and the dealer agreed to assemble one.

When Kurt Seligmann saw Ernst's new collection, he offered to reveal the source of his witchcraft illustrations in exchange for the shop's address. Ernst declined, judging the exchange uneven.

It was only a matter of days, however, before a determined André Breton located that shop. Soon the whole group of Surrealists, who were then refugees in New York – Ernst, Breton, Matta, Tanguy, Seligmann, Martins, Donati – and many of their friends – Lévi-Strauss, Vanetti, Lebel, Duthuit, Reis – began to frequent "that shop on Third Avenue," buying in particular Northwest Coast, Eskimo, and Melanesian pieces. This emphasis was hardly coincidental. Northwest Coast, Eskimo, and Melanesian artists, perhaps more than any others, save the Surrealists themselves, emphasized visual puns, and it was visual puns the Surrealists collected.

During the last twenty-five years, I've examined most of the collections and talked to most of their owners. Their selections were uniformly good, yet only Lévi-Strauss, among them, was ethnologically knowledgeable. Apparently they approached these pieces directly, judging them in terms of inherent qualities. However unscholarly that approach, it resulted in superb collections.

When I compare their selections with specimens I've seen decorating anthropologists' homes or illustrating their textbooks, I can't help asking, "Why did anthropological methods fail here?" Anthropologists, I think, were preoccupied with processes, not drama; concerned with relationship, not being. They were convinced value lay in function. They saw tribal art as a variant of material culture and they used it to answer questions about evolution and diffusion. Later they became interested in art's social or psychic "functions."

Anthropologists like to say that the study of tribal art begins with this question: What did this art mean to the people for whom it was originally intended? Yet it is

precisely here their methods betray them, often leaving them in possession of – or in defense of – souvenirs. The Surrealists, by contrast, chose masterworks as judged by the tribes that produced them.

Of course, great material was more readily available in the 1940s than now. But souvenirs and minor pieces still dominated the market, including the Third Avenue shop. The Surrealists bypassed all that and chose works both genuine and outstanding according to the standards of their makers.

They went further: they guided Julius Carlebach, the dealer on Third Avenue, in his purchases. "His only interests," recalls Claude Lévi-Strauss, "were old German chinaware and quaint curios of the *Gemütlich* type. Even when we put him on the right track, he never had more than two or three pieces of tribal art at one time."

Most of these came from the Museum of the American Indian. The Surrealists began to visit the Bronx warehouse of that Museum, selecting for themselves, concentrating on a collection of magnificent Eskimo masks. These huge visual puns, made by the Kuskokwim Eskimo a century or more ago, constituted the greatest collection of its kind in the world. But the Museum Director, George Heye, called them "jokes" and sold half for $38 and $54 each. The Surrealists bought the best. Then they moved happily through Heye's Northwest Coast collection, stripping it of one masterwork after another.

Several of them, including Max Ernst, with Barnett Newman writing the catalog, then arranged an exhibit entitled "Northwest Coast Indian Painting." It was held in 1946 at the Betty Parsons Gallery, New York. There they displayed pieces from their own collections, plus eighteen borrowed from the American Museum of Natural History.

The American Museum of Natural History offered a curious paradox. On public display was an incredible wealth of Northwest Coast art. Yet every piece was classified and labeled as a scientific specimen. Tribal carvings were housed with seashells and minerals as objects of natural history. Art was displayed in the Metropolitan Museum. Far more than Central Park separated these collections. Part of the gap derived from the anthropologists' insistence that ethnological specimens had meaning solely in terms of the social matrices from which they came.

The very accessibility of this great collection reinforced that classification, preventing viewers from experiencing these objects artistically. By taking them off display in one part of New York and putting them on display a mile away, the Surrealists declassified them as scientific specimens and reclassified them as art.

Would the Surrealists have been equally discriminating with Tibetan or West African art? Probably not. What was crucial here was an outlook they shared with tribal punsters. That outlook had nothing to do with origins or meanings or functions. It lay at a deeper level, ultimately in a way of being. Claude Lévi-Strauss, alone

among anthropologists in his understanding of Northwest Coast art, wrote of, "This dithyrambic gift of synthesis, the almost monstrous faculty to perceive as similar what all other men have conceived as different." When he entered the Northwest Coast gallery of the American Museum of Natural History, he saw more than household gear.

...

Anthropologists helped Lévi-Strauss place these pieces in historical perspective; Baudelaire and the Surrealists helped him appreciate them as art: "These objects – beings transformed into things, human animals, living boxes – seem as remote as possible from our own conception of art since the time of the Greeks. Yet even here one would err to suppose that a single possibility of the aesthetic life had escaped the prophets and virtuosos of the Northwest Coast. Several of those masks and statues are thoughtful portraits which prove a concern to attain not only physical resemblance but the most subtle spiritual essence of the soul. The sculptor of Alaska and British Columbia is not only the sorcerer who confers upon the supernatural a visible form but also the inspired creator, the interpreter who translates into eternal chefs d'oeuvre the fugitive emotions of man."

Finally, Lévi-Strauss gives a resume of a Tlingit legend recorded by Swanton, entitled "The Image that Came to Life." It tells "the story of a young chief desperately in love with his wife who dies of an illness in spite of the care of the best shamans. The inconsolable prince went from carver to carver begging them to carve a portrait of his wife, but no one could attain a perfect likeness. Finally he met one who said to him: 'I have seen your wife a great deal walking along with you. I have never studied her face with the idea that you might want someone to carve it, but I am going to try if you will allow me.' The carver began the work, finished the statue and when the young chief got inside his house he saw his dead wife sitting there, just as she used to look. Filled with a melancholy joy he asked the carver the price of this work. But the carver, sorry to see this chief mourning for his wife, said: 'It is because I felt badly for you that I made it; so don't pay me too much for it.' But the chief paid him very well, both in slaves and in goods. The chief had the feeling that his wife had come back to him and treated the image just like her, dressing it in his wife's clothes. One day he had the impression that the statue began to move and from that moment examined it attentively every day, for he thought that at some time it would come to life. But, although the image daily grew more like a human being and was unquestionably living, it could neither move nor speak. Some time later the image gave forth a sound from its chest, like that of crackling wood, and the man knew that it was ill. When he had it removed from its accustomed place he found a small red cedar tree growing there on the top of the flooring. He left it until it grew to be very large, and it is because of this that cedars on the Queen Charlotte Islands are so good. When people

there find a good tree they say, 'This looks like the baby of the chief's wife.' The image, however, never became really alive and the nostalgic conclusion of the story is imprinted with respect for the autonomy of the work of art, for its absolute independence in face of every sort of reality: 'Every day the image of the young woman grew more like a human being, and when they heard the story, people from far and near came in to look at it, and at the young cedar tree growing here, at which they were much astonished. The woman moved around very little and never was able to talk, but her husband dreamed what she wanted to tell him. It was through his dreams that he knew she was talking to him.'"

**11.VIII. Wolfgang Paalen. 1943. "Totem Art."** *Dyn* 4-5: 7-8, 12-14.

The Austrian-born Wolfgang Paalen (1905-59), an amateur scholar and passionate collector, explored the antiquity and the meaning of Northwest Coast art in this important essay, and he discussed the totemic foundations of Northwest Coast art, calling on both a psychological and an evolutionist approach. He gave a Surrealist resonance to his writing when he speculated that dualities are abolished in totem art, a theme common to several of the texts presented in this section, and when he denounced the destructive impact of Western civilization on Native cultures and the persecution of Indigenous peoples by the Canadian government, the Surrealists being radical in their opposition to colonialism (Mauzé 2008a). The essay, which influenced the avant-garde generation of New York artists, appeared in the special "Amerindian Number" (December 1943) of *Dyn*, an interdisciplinary journal (1942-44), illustrated with photographs by Eva Sulzer as well as photographs of artifacts from Paalen's own collection, some of which were collected on his 1939 trip to British Columbia and Alaska. A facsimile edition of *Dyn*, *Wolfgang Paalen's Dyn: The Complete Reprint*, was published by Christian Kloyber in 2000.

On the Northwest Coast of the American continent, between a tempestuous sea and a virgin forest, there arose an art with the profile of a bird of prey; masks, heraldic columns, torchlight dances, myths of the killer-whale and the thunder-bird tell us of a great savage life in which man and the elements, man and his dream, beast and man mingled in wars and loves without quarter. An autochthonous and fascinating art if there ever was one, but more ignored by the public than that of central Africa. Its only creations that are more widely known are the monumental, memorial columns called totem poles, without doubt its most distinctive achievements. Although the totemic element can be found in the art of all peoples, here it constitutes the clearly predominant characteristic. That is why I shall give the name of TOTEM ART to the

art of British Columbia and of the Southeast of Alaska, the art of the Indians of this Northwest Coast which borders the Pacific between Juan de Fuca Strait and the Bay of Yakutat. There will be included then, under this name (going from South to North) the art of the Cowichan Indians (Coast Salish), the Nootka, Kwakiutl, Tsimshian, Haida and Tlinghit, the principal groups of tribes, which in spite of notable differences, present a cultural unity which distinguishes them clearly from all other Indians. Their art occupies a place perfectly circumscribed in the Amerindian world, and ought no longer to be confused with that of the Eskimo from which it is essentially different. Which is not surprising, for the American Eskimos (whose relationship with the circumpolar peoples of the old world is proved) are so distinct physically and culturally from all the Indians that it would be better to include them with the tribes of Greenland and of the Siberian shore of the Bering sea in a separate group.

...

Seeing that the art of the totem poles was fully established in the 18th Century, it is more than probable that at this epoch there already existed ancient poles. Besides, Malaspina, in the above citation, speaks of old sepulchral monuments. And as the poles last on an average from 80 to 100 years (there is even some testimony for longer survival) the first explorers, consequently, might have seen some that dated from around 1700. But one would without doubt commit a serious error in supposing that this date could mark the beginning of the monuments. Rooted in the ancestor cult, these memorial columns later take on more and more an heraldic signification, but it would be wrong to want to see no more in them than a simple "coat of arms." "The family crest was shown at the top and sometimes also at the base and throughout the length of the pole, but generally the intermediate figures illustrated a legend, a hero tale of early life, or some other important family happening," says Lieut. George T. Emmons. One will understand that such monuments, true vertebral columns of the myths and landmarks of social life were not invented from one day to another, that they were, through their very function, fashioned as much by custom as by invention. Whoever has studied ancient cultures that are well known chronologically knows how slowly hieratic styles evolve, that the evolution of certain traits of the Romanesque and the Gothic required centuries. And the evolution is still slower in the styles that correspond to the more primitive societies, in which their elaboration is a collective task of many generations. It is therefore very moderate to count, from the proved appearance of the poles, two hundred years back as the approximate time of their evolution: which takes us back to the 16th Century. Which evidently implies, moreover, that at this period Totem Art must have been already well developed in order to conceive such monumental tasks. This view is confirmed by the fact that the objects collected within the last 150 years have not changed in style; that even while degenerating under white influence this art has preserved its characteristic features. The

sculptured wooden bowl which the Haida gave to Dixon in 1786 is similar to pieces of this kind collected a hundred years later, and to the few good similar pieces that I still saw in the possession of the Indians. The magnificent ceremonial cloaks, summarily designated under the name of "Chilcat Blanket," which stirred the admiration of the first explorers, were finally supplanted toward the 1880s by coarse work of industrial wool and crude colors – but their pattern has not changed. According to the Tsimshian myth, it was Yehl, the promethean raven, who taught men these fine weaves of the wool of the mountain-goat, woven on a woof of cedar bark and dyed with copper oxyde, with the yellow of lichen, and the black of hemlock. La Perouse (1786) compares them to the beautiful French tapestries; and before him, Cook and Quiros and Miranda speak of them with admiration. "Their design is always animal in form and totemic in character; and it is through this system of picture-writing in the plastic arts that the history of these peoples has been preserved and transmitted through centuries," says G.T. Emmons. In an art that was an integral part of life, our distinctions between values that are "plastic" and those that are simply decorative, have no meaning; all objects of Totem Art bear the seal of the same severe and powerful rhythm that ordered the existence of these peoples. The surface of a box sufficed for the inscription of compositions of a marvelous richness ... Many of the achievements of their art and crafts that can not even be enumerated here have not been surpassed in any other culture. The statues of Kwakiutl chiefs called "Potlatch Figures," would merit a separate study; several of them could be ranked with the most powerful works of Byzantine art ... The mask of the dead man ... is not surpassed by any of the most poignant expressions of suffering in Christian art. The greatest subtlety is often shown in the frontal pieces of the sumptuous ceremonial headdresses called "amalaid." On page 23 ... can be seen a masterpiece of the kind, remarked particularly by Franz Boas some forty years before I acquired it on Vancouver Island from the descendants of one of the principal Kwakiutl chiefs. The use of the beautiful mother-of-pearl which adorns these headdresses (as well as many other objects) was already mentioned by Dixon and before him in the Pena y Crespi Journal, 1774 [4.1]. In no other art can there be found an equivalent of the strange rattles of the Raven-Sun type, and it is only in certain modern sculptures that one can find analogies to their surprising spatial conception.

**11.IX. Barnett Newman. 1946. Foreword. In *Northwest Coast Indian Painting.*** New York: Betty Parsons Gallery. © 2011 The Barnett Newman Foundation, New York / Artist Rights Society (ARS), NY.

An artist dedicated to primitive art, Barnett Newman (1905-70) assembled some twenty-eight Northwest Coast pieces for the inaugural exhibition of the Betty

Parsons Gallery. The pieces were presented, as contemporary paintings would have been, affixed to the wall. In the introduction to the catalogue, the word *painting* referred to the sophisticated tradition of two-dimensional designs with geometric shapes and winding lines (later called formlines, a term coined by Bill Holm [1965]) found on crests and ceremonial Northwest Coast objects. The author's main argument was that Northwest Coast abstract symbols were not decorative but had content, thus establishing the grounds for the defence of modern abstract art. Meaning was claimed as a common characteristic for both types of non-representational art. Moreover, primitive art and modern art stood out as independent from European tradition.

It is becoming more and more apparent that to understand modern art, one must have an appreciation of the primitive arts, for just as modern art stands as an island of revolt in the stream of Western European aesthetics, the many primitive art traditions stand apart as authentic aesthetic accomplishments that flourished without benefit of European history.

On the American continent, along the Pacific coastline of Canada and Southern Alaska there emerged such an art, a valid tradition that is one of the richest of human expressions. Yet the art of the Northwest Coast Indian, if known at all, is invariably understood in terms of the totem pole. In assembling this exhibition of Northwest Coast painting, in honor of the opening of the new Betty Parsons Gallery (Mrs. Parsons must be congratulated for her long devotion to both modern and primitive art), I have been eager to shift the focus to this little known work, which many anthropologists claim antedated the totem pole sculpture. Whether it did or not, it constitutes one of the most extensive, certainly the most impressive, treasuries of primitive painting that has come down to us from any part of the globe.

It is our hope that these great works of art, whether on house walls, ceremonial shaman frocks, and aprons, or as ceremonial blankets, will be enjoyed for their own sake, but it is not inappropriate to emphasize that it would be a mistake to consider these paintings as mere decorative devices; that they constitute a kind of heightened design. Design was a separate function carried on by the women and took the form of geometric, non-objective pattern. These paintings are ritualistic. They are an expression of the mythological beliefs of these peoples and take place on ceremonial objects only because these peoples did not practice a formal art of easel painting on canvas.

Here, then, among a group of several peoples the dominant aesthetic tradition was abstract. They depicted their mythological gods and totemic monsters in abstract symbols, using organic shapes, without regard to the contours of appearance. So strict was this concept that all living things were shown "internally" by means of bisection. It is this bisection of the animal showing both parts of it that gives the illusion of

symmetrical pattern. Their concern, however, was not with the symmetry but with the nature of organism; the metaphysical pattern of life.

There is an answer in these works to all those who assume that modern abstract art is the esoteric exercise of a snobbish elite, for among these simple peoples, abstract art was the normal, well-understood, dominant tradition. Shall we say that modern man has lost the ability to think on so high a level? Does not this work rather illuminate the work of those of our modern American abstract artists who, working with the pure plastic language we call abstract, are infusing it with intellectual and emotional content, and who, without any imitation of primitive symbols, are creating a living myth for us in our own time?

**11.X.  Barnett Newman. 2002. "The Ideographic Picture."** In *Barnett Newman.* Edited by Ann Temkin. Philadelphia: Philadelphia Museum of Art in association with Tate Publishing, 30. Originally published as the foreword to *The Ideographic Picture* (New York: Betty Parsons Gallery, 1947). © 2010 The Barnett Newman Foundation, New York / Artist Rights Society (ARS), NY.

Newman organized the exhibition *The Ideographic Picture,* featuring contemporary paintings by his fellow American artists and himself, as the counterpart of *Northwest Coast Indian Painting,* which he had assembled just three months earlier in the same gallery. In the brochure, he repeated his central argument about the direct relationship between Native American and contemporary art and the "meaningfulness" of abstract art. He posited a parallel based on the concept of the "ideograph" (a symbol representing an idea) between the creative act of the Kwakiutl (Kwakwaka'wakw) artist painting on a hide and that of the abstract painter:

Ideograph: A character, symbol or figure which suggests the idea of an object without expressing its name.

Ideographic: Representing ideas directly and not through the medium of their names; applied specifically to that mode of writing which by means of symbols, figures or hieroglyphics suggests the idea of an object without expressing its name.

— *The Century Dictionary*

Ideograph: A symbol or character painted, written or inscribed, representing ideas.

— *The Encyclopaedia Britannica*

The Kwakiutl artist painting on a hide did not concern himself with the inconsequentials that made up the opulent social rivalries of the Northwest Coast Indian scene, nor did he, in the name of a higher-purity, renounce the living world for the meaningless materialism of design. The abstract shape he used, his entire plastic language, was directed by a ritualistic will towards metaphysical understanding. The everyday realities he left to the toymakers; the pleasant play of non-objective pattern to the women basket weavers. To him a shape was a living thing, a vehicle for an abstract thought-complex, a carrier of the awesome feelings he felt before the terror of the unknowable. The abstract shape was, therefore, real rather than a formal "abstraction" of a visual fact, with its overtone of an already known nature. Nor was it a purist illusion with its overload of pseudo-scientific truths.

The basis of an aesthetic act is the pure idea. But the pure idea is, of necessity, an aesthetic act. Here then is the epistemological paradox that is the artist's problem. Not space cutting nor space building, not construction nor fauvist destruction; not the pure line, straight and narrow, nor the tortured line, distorted and humiliating; not the accurate eye, all fingers, nor the wild eye of dream, winking, but the idea-complex that makes contact with mystery – of life, of men, of nature, of the hard, black chaos that is death or the grayer, softer chaos that is tragedy. For it is only the pure idea that has meaning. Everything else has everything else.

Spontaneous, and emerging from several points, there has arisen during the war years a new force in American painting that is the modern counterpart of the primitive art impulse. As early as 1942, Mr. Edward Alden Jewell was the first publicly to report it. Since then, various critics and dealers have tried to label it, to describe it. It is now time for the artist himself, by showing the dictionary, to make clear the community of intention that motivates him and the colleagues. For here is a group of artists who are not abstract painters, although working in what is known as the abstract style.

Mrs. Betty Parsons has organized a representative showing of this work around the artists in her gallery who are its exponents. That all of them are associated with her gallery is not without significance.

## 12 | Northwest Coast Art and Canadian National Identity, 1900-50

In the half century between 1900 and 1950, the official concept of a Canadian national identity went through profound changes. So too did the role of Native peoples, cultures, and arts within that construction. The shifts in the relationships between these two elements did not form a linear evolution. Rather, these developments, which occurred along many fronts, were contested, complex, and uneven. It can be said, however, that the discursive frameworks first formulated in the opening decades of the century for knowing both "Canada" and the "Indian" gradually fragmented, ruptured, and gave way. By mid-century, each had undergone a complete reversal.

This eventuality was not foreseen. Instead, each of these constructions – and the relationships between them – were deemed stable and fixed. In the first three decades – that is, until the early 1930s – those in charge of formulating a Canadian national identity confidently conceived of it as largely monocultural and based on English precedents. It was assumed that immigrant groups from Europe and elsewhere, as well as Indigenous populations, would be assimilated into that dominant model, which would prevail by dint of its inherent superiority.

During these first decades, and in keeping with this vision, the various First Nations groups that had existed within Canada for millennia were given little or no role in the new formations and representations of the nation except to act out their own disappearance. Indeed, under the policies of the poet/bureaucrat Duncan Campbell Scott, who served from 1913 to 1932 as deputy superintendent general of the Department of Indian Affairs, the period was marked by an ever more concerted effort by the state to resolve the "Indian question" by forcibly suppressing all continuing manifestations of Native cultures (see Hawker, this volume). Increasingly restrictive legislation was accompanied by widespread proclamations that the arts and cultures of Canada's Indigenous peoples were extinct. This concept of disappearance, assumed to be a given truth, was persuasive but especially in texts underwritten by government agencies. In the early stages, it could be found both in the legislation, especially that which concerned

land claims, and in Scott's own poetic productions. Later it would appear in the writings of Marius Barbeau, the chief ethnographer at the National Museum of Canada, who produced widely circulated popular and scholarly works based on this premise [12.IV, 12.VIII, 12.X]. The voices of the Native peoples, or any other oppositional or dissenting positions, were largely excluded from these texts. Native peoples were admitted to the nation as citizens only insofar as they were prepared to give up any aspects of their "Indianness" and to become "Canadian." The two designations were mutually exclusive. One could not be both.

On the artistic front, a new Canadian identity was invested in the landscapes of the Group of Seven, which since about 1913 had been promoted by the National Gallery of Canada as exemplars of a truly Canadian style of painting. It is generally acknowledged that their empty wilderness landscapes, based on British traditions, removed the "Indian" from the image of the emerging nation and cast the country as depopulated and awaiting colonial expansion and re-territorialization. In fact, the terms used to describe these "new" landscapes colonized those usually reserved for Native peoples. That is, it was now the Group of Seven that was called "native," "indigenous," and "autochthonic." Such designations assumed the possibility of an essentialized and unmediated relationship with the vacant land, represented as raw nature, that was similar to that thought to have been formerly experienced by Native peoples. This quality was believed to separate Group of Seven landscapes from European conventions and make them unique and different – that is, "Canadian."

Within this new identity of the nation, the "virility" of the Group of Seven's imagery was contrasted with the assumed "decrepitude" of Native cultures. Both were also seen as being rooted in the land, albeit with one present and the other absent.

Although these concepts were widely promoted and accepted, they ultimately proved to be highly unstable. Challenges that could not be easily dismissed began to arise at precisely the moment at which each seemed most secure. Problems were particularly apparent with the peoples of the Northwest Coast, who persisted with unresolved territorial claims. Here, potlatches and other traditional activities were ongoing among several groups despite attempts to prohibit ceremonial activity through the potlatch ban, which for various reasons had been largely ineffectual since its passing in 1884. In other words, there was evidence of cultural vitality and continuity rather than disappearance. In 1918, upon Scott's recommendation, Indian agents were given the power not only to prosecute cases but also to impose sentences, thereby circumventing the leniency shown by local courts. This power was quickly put into effect as evidenced by the subsequent widespread and well-known prosecutions, confiscations, and harsh sentences of the early 1920s (see Cranmer Webster, this volume).

This contest was also played out in the arts, especially during the second half of the 1920s when there was a call, largely on the part of Barbeau, to incorporate Native art, and particularly the totem poles and territories of the Gitksan, as part of Canada's patrimony [12.X, 12.XI]. The move not only to suppress or deny any current cultural Native productions but also to claim all of that which still existed as part of the nation's heritage, and as a source of inspiration for non-Native artists and writers, had the advantage of allowing Native arts a place while at the same time pronouncing them dead and part of the past. The National Gallery and the National Museum, sharing premises (in both senses of the term) at this time, worked together on the project. The claims were put forward in 1927 in two collaborative exhibitions, one held in the spring in Paris, one in the fall and winter in Canada. In both, Northwest Coast material was paired with Group of Seven works. Although these innovative displays gave Canada a position of leadership in recognizing Native art as "art" rather than ethnographic curiosity, the results – in terms of the organizers' objectives – were disastrous. The French critics appreciated the Native material more than the Group of Seven works, from which they withheld the sought-for recognition of mastery, modernism, and nationalism, and raised doubts about the effectiveness of their paintings to represent a nation [12.V, 12.VI]. The second exhibition, held in Canada, was also problematic [12.VII, 12.VIII]. No immediate follow-ups occurred after the second exhibition had run its course. For the next ten years, Native arts were excluded from the representation of the nation.

By the late 1930s, several important changes had taken place. The Group of Seven had begun to lose its hegemonic position in the artistic representation of Canada, and the concept of a monocultural national identity had begun to fragment. Radio was becoming more important than the visual arts as a common cultural expression linking the vast and diverse areas of the nation. John Murray Gibbon's vision of Canada as a "cultural mosaic" allowed for regional and ethnic variations to exist and persist as contributions to a broader notion of national identity. Under this new formulation, the monoculturalism of the 1920s was gradually supplanted by a more pluralistic and multicultural concept. In the face of irrefutable empirical evidence, the position of the state on the question of the presence of Native cultures and peoples began to shift. With increased First Nations organization, such as the establishment of the Native Brotherhood of British Columbia, the concept of disappearance was no longer viable. In its place was substituted the idea of a "revival," which saw Native arts in particular as miraculously returning to life from a moribund state and taking an active place within this mosaic (see Glass, this volume).

The first indications of what amounted to a complete reversal in the state's position on the "Indian question" were appearing by the end of the 1930s and were linked to the economic situation during the Depression. The federal government initiated a project designed to reduce the number of Native people on welfare. Primarily devoted to sponsoring arts and crafts, the project involved encouraging the production of objects that could be identified as generically "Indian" and readily sold to the public [12.xiv]. Although the actual application of the initiative on the Northwest Coast was limited, it did have important consequences. In 1939, in an unprecedented move that acknowledged the continuity of Native carving traditions on the Northwest Coast, the federal government commissioned two new monumental poles from a living Native artist, the Kwakwaka'wakw master carver Mungo Martin [12.xv]. They represented the nation at the Canadian Pavilion of the New York World's Fair. Validation of this new position for Native art and culture did not go uncontested, however. At the same time, ceremonial activity among the Gitksan of the Upper Skeena River, which had continued, despite official discouragement, in the 1920s and had increased in the 1930s, met with renewed suppression, just as federally funded ethnographic activity was about to return to the area after the hiatus of the Depression.

Nonetheless, over the following decades, the principle of a "revival" of Native cultures and arts gradually prevailed. The success of this transition rested on a coordinated program that began to produce a renovated Canadian culture that could embrace and foster the recognition and production of Native art within the construction of the country's national identity. Insofar as the "revival" was predicated on the assumed "death" of Native cultures, it did not challenge the preceding discourse. Continuity was discounted as a possibility, but certain fundamental changes were integral to the program. The new audiences for Native arts were seen as non-Native consumers. Native arts were thus heralded as commodities managed within a capitalist system, whose sale could enhance the economic position of an otherwise disadvantaged group, rather than as objects reaffirming ancient social structures and ceremonies. Deprived of their initial social context, they were to be viewed for purely aesthetic enjoyment. The program was based on earlier, successful American models, although the latter viewed Native traditions as continuous and ongoing. It embraced many levels of government, institutions, and individuals but was primarily acted out in Vancouver and Victoria. Although interrupted during World War II, it was officially ratified in 1951 at the federal level by the Massey Report. Living, albeit "revived," Native arts were officially, if tentatively, given a place within the new, pluralistic

national identity as expressed in the arts of the nation. Also in 1951, the Indian Act was revised to remove the clause forbidding traditional ceremonial activity.

The texts that follow are intended to give some insight into how these positions, and the transitions between them, were formulated and negotiated. These brief selections cannot give the entire spectrum of views that circulated at the various periods, but they can, I think, assist in pointing out certain milestones, prevailing directions, and contested positions that have defined the parameters of discussions on the relationships between Canada's national identity and Native arts.

**12.I. Duncan Campbell Scott. 1913. "British Columbia."** In "Indian Affairs, 1867-1912." Chapter 4 in *The Dominion: Political Development, Part 2.* Volume 7 of *Canada and Its Provinces: A History of the Canadian People and Their Institutions by One Hundred Associates.* General editors Adam Shortt and Arthur G. Doughty. Toronto: Publishers' Association of Canada, 606-10.

Duncan Campbell Scott (1862-1947) was both a poet of some renown and the deputy superintendent general of the Department of Indian Affairs, a position he assumed in 1913. In the latter capacity, he was in charge of formulating and implementing state policies, notably revisions to the Indian Act that were intended to ensure the suppression of Native ceremonies such as the potlatch and all forms of dancing or use of ceremonial regalia, the enforced enrolment of Native children in residential schools, the denial of Native land claims, and the destruction of all Native cultures and identities, which he thought were doomed in any event. Conversely, he believed that his own poetry contributed to the emerging and vital national culture of Canada. At times, he employed Native subjects in his poetry. In almost all cases, his Native poems invoked themes of death and disappearance, sentimentalized through the tropes of Victorian literary conventions. The sentimentality of his poetry lies in apparent opposition to the severity of his department's policies on Native peoples, but the first underpinned (and reinforced) the objectives of the second. Art and legislation, then, worked in concert to ensure that his message reached a variety of audiences in order to achieve its maximum effect.

In 1912, Scott contributed a summary section on Canada's Native peoples to a multivolume edition that was meant to frame the "History of the Canadian People and Their Institutions." Here he separated out the First Nations of British Columbia for special consideration. Rather than defining their distinctive characteristics, he expounded at length on what he saw as the major problems confronting the governments of both the Dominion and BC, namely, ongoing Native land claims complicated by the lack of treaties ceding land, as existed in

the rest of Canada. He saw this lack as producing "unfortunate" problems for the present, which would continue into the future. Within this context, Scott also noted the persistence of traditional ceremonial activity, which he generalized as the "pot latch" (sic), but in assuming an inexorable process of "civilizing" assimilation he saw this as being resolved through attrition. In the same context, he also remarked on the merit of the artistic traditions but gave little other comment. They were linked, however, to land claims through the context. Since, for Scott, the "Indian question" in British Columbia was primarily one of finding ways to deny land claims, these considerations nuanced every action of his department. His main concern, then, lay in outlining the state's strategy and rationale for claiming that treaty negotiations were not legally necessary here, as they had been in the rest of the Dominion, and for pursuing a goal of complete assimilation, which would result in the disappearance of all aspects of Native identity and culture and obviate the need for treaties. As one of the earliest statements of the policies that Scott would attempt to enforce over the next two decades with increasingly draconian measures, this excerpt indicates the degree to which his assessment of the situation had already been determined and his view of the role that Northwest Coast Native peoples would play within it and the construction of the nation – that is, none.

## BRITISH COLUMBIA

The Indians whose territory lies west of the Rocky Mountains between the mountains and the Pacific Ocean, in the Province of British Columbia, are in many respects the most interesting natives in Canada. They belong to six linguistic stocks: Tsimshean, Kwatkinte-Nootka, Haida, Kootenay, Dene and Salish, and these stocks are again divided into many groups.

Space cannot be given to anthropological details; the pages to be devoted to the whole period now under review might readily be filled with a study of these interesting people. It would be unfair to bring into too great prominence their outstanding merits, as but little attention has been given to similar characteristics of the Algonquin and Iroquois stocks. It may briefly be said, however, that they excel in the domestic arts, and that their canoes, utensils, basketry and weapons have an artistic as well as a utilitarian value. They respond quickly to training and education, and speedily adopt the customs of civilization.

In the Far West there had been no well-defined Indian policy before the creation of the colony of British Columbia. The early traders and the Hudson's Bay Company dealt with the Indians as opportunists. They met from day to day any difficulties that arose, and overcame by immediate methods the menace of war or sudden adverse turns of the trade. The Hudson's Bay Company was nowhere stronger, better organized, or

commanded by more virile officers than on the Pacific coast and in the mountain interior, and there, as elsewhere, the company treated the Indians with a measure of fairness nicely calculated to meet its own special interests. It had no motive beyond that of getting the highest profits, and no rule which could not be reversed when the jealousies of the trade demanded such reversal. It is useless, therefore, to search for any broad view of the Indian question during the regime of the Hudson's Bay Company. While the company held Vancouver Island under the charter of 1849, ten reserves were set apart on the island and conveyed to the Indians in 1850-51-52. In 1858, however, when British Columbia was established as a crown colony, we find coming into the Indian question the views of the British government. When James Douglas (afterwards Sir James) received his instructions as governor of this colony, he was advised to consider the best and most humane means of dealing with the native Indians, and that it should be an invariable condition, in all bargains or treaties with the natives for the cession of land possessed by them, that subsistence should be supplied to them in some other form.

The policy adopted in British Columbia was in some respects unfortunate. Many present-day complications would have been avoided if definite cessions of territory had been arranged after the model of the treaties and surrenders which had been established by usage in Canada. But it must be admitted that in British Columbia geographical and ethnological conditions were obstructions to cessions of large districts, and Governor Douglas simply went on making small land grants to the Indians out of their domain without recognizing or otherwise compensating them for their title to that domain. Without a definite bargain between the crown and the Indians, the Indians, as time goes on, become the prey to their own desire for gain. Education and experience show them that in the public lands they have a vast and rich estate which their ancestors never alienated; often they become the victims of designing persons who heighten these feelings and are quick to seize upon the legal points and press them. We shall see how this failure to obtain cession of territory in British Columbia is now causing administrative difficulties.

Although the Indian title was not recognized as worthy to be the subject of treaty between contracting parties, the motives which governed the setting apart of the reserves were commendable. Permanent village sites, fishing stations and burial grounds, cultivated lands and all the favourite resorts of the tribes (to use the terms of Sir James Douglas) were secured to them, and they were legally authorized to acquire property in land either by direct purchase or by the operation of the pre-emption laws of the colony on the same terms as the colonists.

When British Columbia entered Confederation the documents did not fail to mention the Indians. The imperial order-in-council of May 16, 1871, clause 13, provided that

the charge of the Indians and the trusteeship and management of the land reserved for their use and benefit shall be assumed by the Dominion Government, and a policy as liberal as that hitherto pursued by the British Columbia Government shall be continued by the Dominion Government after the union. To carry out such policy, tracts of land of such extent as it has hitherto been the practice of the British Columbia Government to appropriate for that purpose, shall from time to time be conveyed by the Local Government to the Dominion Government in trust for the use and benefit of the Indians on application of the Dominion Government; and in the case of disagreement between the two Governments respecting the quantity of such tracts of land to be so granted the matter shall be referred to the decision of the Secretary of State for the Colonies.

By clause 10 of the address embodied in the schedule, section 91 of the British North America Act, 1867, which assigned to the exclusive legislative authority of the parliament of Canada "Indians, and Lands reserved for the Indians," became applicable as between the Dominion and British Columbia.

Owing to the vagueness of such general terms, before many years had passed the difficulties surrounding administration became apparent. It was hard to measure present by past liberality, and to limit and parcel the obligations upon the Dominion by the previous action of the provincial government. The land allotments were especially difficult, and after much discussion were finally regulated by joint action of both governments in 1875. The insertion of a clause in the joint order-in-council admitting a reversionary interest of the province in lands set apart as Indian reserves has been productive of administrative difficulties, as the consent of the province must be sought and obtained before the Dominion can grant title to any Indian lands. The Indian estate cannot, therefore, be managed freely, and the Indians who are intelligent and well aware of the strength of their claims have a double grievance – the alienation of a large and valuable province without compensation except reserves, and the denial of the full enjoyment of these reserves.

These matters are now engaging the attention of the Dominion and provincial governments, and a solution of the problem may be arrived at before long.

Although the Dominion government had no treaty obligations to fulfil, the scale of Indian support has been a fairly liberal one, and in furnishing free medical attendance, in the establishment of hospitals, in the encouragement of agriculture and, even more largely, in the provision of education, federal appropriations have been employed. The enormous expense for food which has been incurred on the plains owing to the disappearance of the buffalo, and the natural hatred of the plains Indian for labour, were, in British Columbia, entirely absent, and what has there been spent is not, in the main, for subsistence for the Indian, but for management and for Indian advancement.

The excellent physique of the Indians of this province and their willingness to work have made them a valuable asset in the labour market. In the salmon canneries, hop-fields and fruit farms they are constantly engaged in congenial employment, and even in the more arduous toil of the packer, miner, or navvy their labour is in demand. Despite this intermingling with the white people, and despite the efforts of missionaries and educators, many of the degrading native customs still exist. The hold of the "pot latch" and other wasteful feasts is, however, gradually weakening. Any one who desires to understand the social progress of which these Indians are capable, and also the strength of their attachment to an adopted religion, should study the history of the Metlakatla settlement under the Rev. George Duncan.

**12.II.  Duncan Campbell Scott. 1913. "The Future of the Indian."** In "Indian Affairs, 1867-1912." Chapter 4 in *The Dominion: Political Development, Part 2.* Volume 7 of *Canada and Its Provinces: A History of the Canadian People and Their Institutions by One Hundred Associates.* General editors Adam Shortt and Arthur G. Doughty. Toronto: Publishers' Association of Canada, 622-23.

THE FUTURE OF THE INDIAN

In concluding this general survey of the relation of the government to the Indians a few words should be devoted to the future of the tribes. The paternal policy of protection and encouragement has been pursued from the earliest times; what is to be the final result? It is clear that we are possessed of facts which enable us to reply to the question with some degree of confidence. To possess ourselves of the key to the answer, it is only necessary to contrast the present condition of any Indian community in Ontario or Quebec with its past condition, and also to endeavour to realize the vicissitudes through which it has struggled. We find that from very wretched beginnings and amid all the dangers surrounding their position many of these bands have progressed until their civil and social life approximates closely to that of their white neighbours. The poorest and most shiftless Indians are not worse off than the paupers who are dependent upon the charity of villages and cities, and those who are at the top of the Indian social scale live with the same degree of assured comfort which is enjoyed by the white workman and small farmer. Above these two classes there is another division within the Indian population, small as yet, but constantly growing – the class of well-educated, enterprising and ambitious Indians who really belong to the life of the nation in no restricted sense.

The degree of general progress which makes it possible thus to divide and classify the Indian population of the older provinces has been developed within less than a century, and in this relatively short time we have arrived within measurable distance of the end. The happiest future for the Indian race is absorption into the general population, and this is the object of the policy of our government. In the Indian

communities now under discussion we see the natives advanced more than half-way towards the goal, and the final result will be this complete absorption. The great forces of intermarriage and education will finally overcome the lingering traces of native custom and tradition. It may be some time before reserves disappear and the Indian and his lands cease to be marked and separated. It would be foolish to make this end in itself the final object of the policy. The system of reserved lands has been of incalculable benefit to the Indians, who require secure foothold on the soil, and great caution should be shown in regard to any plans for separating the Indian from his land or for giving him power to alienate his inheritance. There is nothing repugnant to the policy which is being carried out or to the exercise of useful citizenship in the idea of a highly civilized Indian community living upon lands which its members cannot sell.

There is no reason why the Indians of the West, who have been subject to the policy of the government for less than fifty years, and who have made remarkable advances, should not follow the same line of development as the Indians of the old Province of Canada. They have like difficulties to overcome, and the forces which work towards their preservation are similar; they should have the same destiny.

**12.III. Harlan I. Smith. 1917. "The Use of Prehistoric Canadian Art for Commercial Design."** *Science* 46, 1177: 60-61.

Within the growing climate of nationalism that developed during World War I, serious thought was given to finding ways of marking a distinct Canadian identity. This had already been fostered in the fine arts through the emergence and valorization of the artists who would become the Group of Seven. At the level of applied arts, however, Native imagery was seen as having potential for forming part of Canada's self-image through its appropriation by industry and craft. Harlan I. Smith (1872-1940), an archaeologist with the National Museum, did extensive work on the West Coast, including supervising the Gitksan totem pole restoration project in the mid-1920s. Since the mid-1910s, he had advocated the use of prehistoric Native designs in order to foster a new, uniquely Canadian, type of industrial design. The idea was discussed at various times throughout the following decade but was not put into practice much, except in some graphic designs in which West Coast art motifs appeared and, of course, in Emily Carr's now famous pottery. Smith published several articles, and a handbook for use by industry, promoting the possibility.

### THE USE OF PREHISTORIC CANADIAN ART FOR COMMERCIAL DESIGN

The Archaeological office of the Geological Survey, Department of Mines, Ottawa, is now prepared to show to Canadian manufacturers and their commercial artists a very

complete series of several hundred examples of motives for decorative and symbolic designs and trade marks, although it has no facilities for making designs. These motives are all from prehistoric Canadian art and handiwork. Such archaeological material supplies not only the oldest human decorative material from Canada, but material unsurpassed in distinctiveness. The fossils, animals, flowers, leaves, fruits, etc., and especially the historic objects from Indians found only in Canada would no doubt supply other motives capable of use ...

Eighteen manufacturers, representing six totally different industries, a museum and an art school have already applied for copies of these motives. This is over 20 per cent of those informed of the opportunity and one firm has already sent two representatives from Toronto to Ottawa to look into the matter. They express themselves as surprised at the quantity and usefulness of the material and have already selected motives for their designers to use.

This seems to prove that there is a demand for motives or inspiration for new and characteristic Canadian designs and trade marks. This demand we may expect to grow at the close of the war, when Canada makes special efforts to stand on an even footing with other countries in producing manufactures recognized all over the world as individually and characteristically her own.

These motives may be used as they are or may be conventionalized or dissected or multiplied or developed in several of these ways. Designers may use them as inspiration for designs which may be applied to fronts of buildings, gargoyles, fountains, terra cotta, pottery, china, ornamental work, cast iron railings, stoves, carpets, rugs, linoleum, wall paper, stencils, dress fabrics, lace, embroidery, neckware, umbrella handles, jewelry, brooches, silverware, knife, fork and spoon handles, belt buckles, hat pins, book covers, tail pieces, toys[,] souvenirs, trade marks and many other lines of work.

It is hoped to publish drawings of these motives as soon as the drawings can be made. Each drawing will be labeled as to what the specimen is, where it was found, where it is now, its size, material, and, to a certain extent, with the region in which the type of motive is found ...  The actual specimens are scattered in this museum, the Provincial Museum at Toronto, Provincial Museum at Victoria, the Museum of the Natural History Society, St. John, New Brunswick, the Provincial Museum at Halifax, the American Museum of Natural History, New York, the Museum of the University of Pennsylvania, the British Museum and museums in San Francisco, Florence, Italy, Berlin, Germany and elsewhere.

If this publication is issued it will no doubt be sent to every large library, every member of Parliament, every newspaper in Canada, probably, to all Canadian manufactures using designs and certainly to all such manufacturers who express the need for it.

**12.IV. News stories on Barbeau lectures at UBC from *The Ubyssey*. 1926.** "Dr. Barbeau Gives First Lecture: The Plastic and Decorative Arts of the Northwest Coast Tribes," 26 October; "Lectures Concluded by Dr. Barbeau," 2 November. *Ubyssey* archives, http://ubcpubs.library.ubc.ca/?db=ubyssey.

In the fall of 1926, after a field season among the Gitksan on the Upper Skeena River, Marius Barbeau (1883-1969) visited the University of British Columbia, where he delivered a series of five lectures on Northwest Coast Native arts and cultures. Given his position as ethnologist with the Victoria Memorial Museum (which the following year became the National Museum of Canada), his comments reflected the state's position that these cultures and arts were irrevocably and irretrievably dying, without the hope of revival, a position he espoused at every possible opportunity. Where he offered something new was in claiming that the remaining remnants – in particular totem poles but also other objects – were being lost to their rightful owner – not the nation or Native groups but the province of British Columbia. Inasmuch as Barbeau had been actively collecting in the area for over a decade and had been the agent by which many objects had left the region for points in eastern Canada and abroad, the irony of his position is inescapable but was probably intended to help ingratiate himself with his potential employers (he was seeking the chair at a proposed anthropology department) and to call attention to the federal government's attempt to restore the totem poles in the Gitksan villages, which he showed extensively in his lantern slide presentations. His comments were reported in the university newspaper, *The Ubyssey*. The two segments reprinted here report on the first and last of his lectures. The first lecture dealt with the arts; the second with songs; the third with social and economic life, especially the potlatch; and the fourth with his theory on the Asiatic origins of the Northwest Coast peoples. The fifth, entitled "The White Man vs. the Indian," recounted in vivid terms what is now seen as a standardized "fatal narrative" of contact, in which Indigenous cultures are assumed inevitably to perish after contact. (See also *The Ubyssey*, "Dr. Barbeau Gives Two Addresses on Indians: Speaks on Social and Economic Life of North American Indians – Origin of B.C. Indians Also Discussed," 29 October 1926.)

That B.C. is being rapidly stripped of its totem-poles, masks, and other precious objects wrought by the coast Indians, was the statement made by C. Marius Barbeau in his lecture, "The Plastic and Decorative Arts of the Northwest Coast Indians," which took place in Applied Science 100 last Thursday afternoon.

Dr. Barbeau, who is a prominent ethnologist, and the author of "Indian Days in the Canadian Rockies," told his audience of the removal or destruction of practically all the valuable monuments left by the West Coast tribes. Many have been removed to

museums in Eastern Canada, the United States, and Europe. Others have been destroyed by Indians themselves, who, prompted by religious frenzy, decided to do away with anything that seemed pagan. Some districts, formerly rich in relics of Indian art, are now bare, shorn of their precious heritage. British Columbia should endeavor to get a share of what remains, as most of it rightfully belongs to her.

With the aid of lantern slides, Dr. Barbeau described these precious carvings and decorations, which should have been British Columbia's proudest asset. Explaining why so much was achieved by the natives, he said that Indian art was essentially practical and not a mere luxury. It was part of their lives. Fantastic house-poles embodied their crests. Certain carved or painted animals belonged exclusively to certain families, and are found not only on masks and totems but also on garments and kitchen utensils. The designs probably had an Asiatic origin, formed from ideas brought when the tribes migrated from Asia. As the years wore on, each artist striving to surpass the other in uniqueness, the designs became more and more exaggerated, and resembled less the animals which they originally represented. Thus art flourished until the advent of the white man. Seeing no hope for the future, the Indians lost interest in their carving and painting – and their art, now, is dead forever.

...

"The results of the white man's coming have been ruinous and devastating for the native tribes of British Columbia," Dr. Barbeau said in his concluding lecture, "The White man vs. the Indian," given last Wednesday afternoon.

The white man's arrival had been foretold for years by Indian medicinemen and when Cook and Vancouver landed they were astonished at the lack of surprise showed by the natives. Hunters and free-traders had visited the prairies and even preceded Thompson and McKenzie over the Rockies so that rumours must have spread to the coast peoples. An interesting fact mentioned by the lecturer was that members of one or two tribes had come into contact with Christians and brought back a curious mixture of Indian superstition and Christian ritual as a new religion for their people.

"The natives of the west coast were eagerly looking for any trade contacts with the circumnavigators of the day. The outcome of these relations and contacts between a superior and an inferior people has been a gradual disappearance of the material culture of the Indians. The native costumes gave place to clothes, native weapons to guns and even native foods gave way in favor of foods used by the white man." In fact, their whole way of living has been turned upside down and the result is only a poor imitation of the way a white man lives.

"Contacts with the whites were fatal to native pride and ethics at a very early date," said the lecturer. A definite moral decline took place and is still going on. Missionaries did go among the Indians but in most cases they did more harm than good. For instance, in the boarding-schools for girls the children are taken from the tribe at a very early

age. They grow up with no contact with the outside world or their own people. As a result they develop no mental or moral stamina and become a drag on whatever community may receive them when they leave schools.

In conclusion Dr. Barbeau said that the white invasion had practically caused the destruction of the Indian race. We have taken their lands and their culture and destroyed what would have been a resource to the country had it been allowed to live.

### 12.V. [François] Thiébault-Sisson. 1927. "La première exposition d'art Canadien à Paris."
In *Exposition d'art Canadien.* Paris: Musée du Jeu de Paume, 16. Translated by the author.

Yet another channel for including Native imagery in Canada's national image was through the exhibition of Native art. In early 1927, the National Gallery of Canada, under the directorship of Eric Brown (1877-1939), produced a large exhibition of Canadian art displayed in the heart of Paris at the Musée du Jeu de Paume, adjacent to the Louvre. This show foregrounded Tom Thomson and the Group of Seven as representatives of Canadian imagery, but it also included James Wilson Morrice, a recently deceased Canadian expatriate whose works included aspects of the French avant-garde, and a small selection of carvings by Native groups from the Northwest Coast. The latter were selected by ethnologist Marius Barbeau, who was aware of the growing international appreciation of this material as art. In fact, at a time when "primitive" arts were enjoying a widespread enthusiasm in many areas of Parisian society, including among the recently formed Surrealists, the French critics tended to appreciate both Morrice and the Native works more than those of the Group of Seven, whom they called "primitives," in the sense of naive and untrained, and from whom they withheld approbation for their mastery and modernity. This response was viewed with embarrassment by the Canadian organizers. As a consequence, the history of this important exhibition, which brought Native works together with those of the Group of Seven for the first time in an international context, was suppressed and, until recently, seldom mentioned. The two reviews included here indicate some of the level of appreciation from the French critics.

THIÉBAULT-SISSON

At this exhibition, you will encounter, alongside paintings and some exceptional sculptures, some very interesting specimens of a truly autochthonic art, dating back many centuries – painted wooden masks, tribal and Indian family totems showing workmanship of an exceptional level of perfection, a pronounced decorative character, and a taste for stylization, which is anything but commonplace. The similarity and the appearance of kinship between these specimens of Indian art and Negro art, or that of

the ancient Aztecs, is obvious but the art of the Canadian tribes goes further and is indicative of a relatively more advanced civilization. It is interesting to observe that this taste for stylization and this strong decorative instinct is encountered among the essential characteristics of the young Canadian painting. This is, for our archaeologists, a subject for passionate discussion. Meanwhile, see and judge for yourself [see Barbeau partial translation in 12.VIII].

**12.VI. Gaston Varenne. 1927. Review.** *Amour de l'art,* May, n.p. Original in French.

GASTON VARENNE

The interesting exhibit of Canadian art organized at the Jeu de Paume attempted to communicate an idea of what the arts of the indigenous tribes living in the Canadian Northwest might have been like. These are not the products of an ancient civilization. The several totem poles, the masks or the sculptures grouped in a single case do not date back more than a century. The totem poles speak a language that is as mysterious as was the language of heraldry in our own culture. We can understand somewhat better the argillite sculptures, although sorcery plays a considerable role in their meaning. Some of these are relatively realist, for example one that represents a bald elderly white man. The realism of this popular art is complemented by a stylization of forms that in fact simply represents an inability to copy nature more perfectly. Finally, use of clear coloring focused on bright tones enhances both masks and totem poles. Against a snowy background, these must take on a striking decorative value.

All in all, the applied art of these Canadian tribes is far from attaining the value accorded, in the New World, to Mexican art and Peruvian art, which archaeologists have finally started to study methodically, and which have already revealed astonishing richness.

**12.VII. Eric Brown. 1927. Introduction. In *Exhibition of Canadian West Coast Art – Native and Modern.*** Ottawa: National Gallery of Canada, 2.

Eric Brown (1877-1939), director of the National Gallery, and Marius Barbeau worked jointly on this landmark exhibition, shown in Ottawa, Toronto, and Montreal in late 1927 and early 1928. Brown avoided any reference to the preceding Jeu de Paume exhibition and marked the Canadian exhibition as the first occasion of the juxtaposition of Native art and modern works by artists such as members of the Group of Seven and Emily Carr (for whom this was her eastern debut). He was adamant that the "national forces" that produced the Native pieces had disappeared, replaced by the new national imagery of the Group of Seven.

The purpose of the Trustees of the National Gallery in arranging this exhibition of West Coast Indian Art combined with the work of a number of Canadian artists who, from the days of Paul Kane to the present day, have recorded their impressions of that region is to mingle for the first time the art work of the Canadian West Coast tribes with that of our more sophisticated artists in an endeavour to analyse their relationships to one another, if such exist, and particularly to enable this primitive and interesting art to take a definite place as one of the most valuable of Canada's artistic productions.

The Indian sense of creative design and high craftsmanship was at its best as deeply rooted in his national consciousness as ever has been our sense of traditional art, and in his weapons, architecture, ornaments and utensils produced from the materials to his hand, we can see how ably and seriously he has held to them so long as his national consciousness and independence remained. The disappearance of these arts under the penetration of trade and civilization is more regrettable than can be imagined and it is of the utmost importance that every possible effort be made to retain and revivify whatever remnants still exist into a permanent production, however limited in quantity. Enough however remains of the old arts to provide an invaluable mine of decorative design which is available to the student for a host of different purposes and possessing for the Canadian artist in particular the unique quality of being entirely national in its origin and character.

That such use of it can be made can be clearly seen in the work of Miss Emily Carr, of Victoria, B.C., whose study of the country covers a long period of years, and whose pictures of it and designs translated into pottery, rugs and other objects form one of the most interesting features of the exhibition.

The National Gallery takes this opportunity of expressing its warmest thanks to the National Museum, Ottawa, the Royal Ontario Museum, Toronto, The Art Association and McGill University, Montreal, whose generous co-operation have made the exhibition possible.

**12.VIII. Marius Barbeau. 1927. "West Coast Indian Art."** In *Exhibition of Canadian West Coast Art – Native and Modern.* Ottawa: National Gallery of Canada, 3-4.

Barbeau's text differed from Brown's on several key points, including his appreciation of the differing styles separating the Native pieces and his recognition of the work as art rather than craft. Barbeau attempted to integrate the Native works into a Canadian national heritage through their links to the land – a direct reference to the Group of Seven paintings, also included in the exhibition.

WEST COAST INDIAN ART

The decorative arts of the West Coast tribes of British Columbia have achieved worldwide fame. They are extensively represented in the state museums of Europe and

America. And they favourably compare with the well-known aboriginal arts of Mexico, Africa and the South Seas. Thiébault-Sisson, the French art critic, wrote last year: "Between the specimens of Canadian West Coast art and those of the Bantus of Africa or of the ancient Aztecs of Mexico, there is an obvious analogy. They seem related to each other. Yet, the art of the Canadian tribes has advanced further than the others and discloses a much finer culture" [see translation in 12.v].

It is in their carvings, their paintings and their textiles, as illustrated in this exhibition, that the native artists manifest their amazing sense of decorative fitness and beauty. Their art was no idle pursuit for them or their tribesmen, but fulfilled an all-essential function in their everyday life. Their houses, ceremonial costumes, utensils and weapons had to be decorated in traditional style; and their heraldic emblems had to be displayed on their house fronts and their totem poles. This explains the extreme complexity of the art and its development among a people whose numbers were limited and whose life was beset by many hardships.

The style and contents of this native art varies from tribe to tribe. The North and the South stand in marked contrast. Their local traditions and aims differed. The skill of their craftsmen was hardly comparable. The Haidas, the Tsimsyan and the Tlingit, to the north, were by far the best carvers and weavers. Their style was smooth, elaborate and refined. Their most accomplished artists have left works of art that count among the outstanding creations of mankind in the sphere of plastic or decorative beauty. The southern tribes, on the other hand (the Kwakiutl and Nootka), could not boast of like refinement. The beings they represent on their belongings often are monsters; their features are highly conventional and grotesque. When they depict animals, the contortions of the face and the body usually belong to caricature rather than sincere realism. This contrast between the northern and southern areas on the coast is fundamental, and it is based upon cultural differences that are racial and ancient.

A commendable feature of this aboriginal art for us is that it is truly Canadian in its inspiration. It has sprung up wholly from the soil and the sea within our national boundaries. Grizzly bears, beavers, wolves, whales, salmon, seals, eagles and ravens constitute its most familiar themes. Cedar trees, walrus tusks, moose hides and mountain-goat hair serve as raw materials. And it is remarkable how skilfully the native artists have adapted their designs to the exacting nature of their materials, while striving to serve a public purpose that constantly stimulated their originality and taxed their creative talents to the utmost.

The Indian specimens displayed in this Exhibition mostly belong to the collections of the National Museum of Canada, the Royal Ontario Museum of Archaeology, the McGill University Museum and the Art Gallery of Montreal. They were collected

from 1875 to the present day by students of West Coast ethnology, principally Dr. G.M. Dawson, whose McGill University collection is one of the most valuable, C.F. Newcombe and Marius Barbeau.

**12.IX. A.Y. Jackson. 1927. "Rescuing Our Tottering Totems: Something about a Primitive Art, Revealing the Past History of a Vanishing Race."** *Maclean's Magazine,* 15 December, 23.

At the same time as the *West Coast Art – Native and Modern* exhibition in Ottawa, A.Y. Jackson (1882-1974), a prominent member of and spokesperson for the Group of Seven, published an article on his experiences in the Upper Skeena Valley, where he and other Canadian artists had been encouraged by Marius Barbeau to travel and paint the picturesque landscapes, villages, and poles of the Gitksan people who resided there, as part of a new Canadian imagery. Jackson's article contained many of the tropes for representing the state of Native culture, including the assertion of its death and the imminent disappearance of the last remnants, in this case focusing on the poles. But above all it declared, to a popular and widespread audience, that the Native poles were now the property of Canadian authorities and the subject of Canadian national artists, especially the Group of Seven. In this, as in other ways, it mimicked the statements of Barbeau.

Science and art have joined hands in the little village of Kitwanga past which the Skeena River runs ever hurrying to the sea, its cold gray waters teeming with salmon fighting their weary way upstream, kept alive by some hazy vision of gentler waters and a gravel bed on which to lay their eggs before the life ebbs out of them. Along this river, once a great highway for the Indian tribes, there are many evidences of villages that tell of an active and numerous people. Now it is becoming a white man's country and the totem poles forlorn are about all that is left to speak of the greater days.

For years, the totem poles have been tumbling down. Many carefully sawed down to be shipped to far away museums, even to Europe, some to be set up in city streets. Others at the behest of fervent missionaries burned as relics of paganism. A lumberman told me of making a raft out of them, no other sticks being available, while others a prey of time or the elements come crashing down and the undergrowth swallows them up. On the Queen Charlotte Islands and all along the coast of British Columbia once the villages bristled with this strange form of art, now scattered and gone. But up the Skeena, totem pole art developed later than on the coast and also survived longer. In the meanwhile, the general attitude towards art after the assaults of post-impressionism and cubism has become less orthodox and it is realized that the totem pole represents something more than just a heathen idol.

Recently, an American art critic made the statement that the only native art in Canada was the totem pole. He might very well have made the same statement concerning the art of his own country, as taking it by and large, American art exhibits no definite departure from the European tradition, but rather a greater insistence on a conformance to its canons on the part of American art critics.

But the totem pole, after being treated with contempt for years, is now to receive all the aids of modern science for its preservation, and two government experts have been working for months with a gang of skilled men, Mr. Harlan Smith, of the Archeological Department, and Mr. T.B. Campbell, one of the engineers of the Canadian National Railways who has charge of reconstructions of these Indian monuments.

The poor Indian is amazed and rather suspicious. He has seen his race exploited, his hunting grounds taken away, his fishing grounds invaded by Japanese. He has seen his people dwindle until the great warlike tribes who roamed the west coast are but pitiful remnants. And now that he has decided to be a white man and forget his past, get a motor boat or a cheap car and play a trombone in the village band, along come archeologists, ethnologists, anthropologists, and other erudite individuals, with them camera men, writers and painters, and the inferiority complex which has infected him for many moons vanishes in the face of all this sudden interest in him. He is drawn, photographed, measured and interviewed, his family history is written down together with anything he remembers of legends or folk lore or songs; then if he owns a totem pole he is asked if he will allow it to be repainted and a nice concrete base put around it. Why shouldn't he be suspicious?

The writer, when sketching totem poles in one village, noticed the local chiefs looking unkindly at him. Finally, one came up and said the chiefs did not want anything done to the poles. He explained that: "white man always make money out of Indian, Indian get nothing. One man write big book full of pictures sell that book fifty cents. Indian get nothing." He was no doubt referring to Marius Barbeau's *Indian Days*. But this interest in the west coast Indian promises several kinds of results. The younger Indian is inclined to belittle his ancestry, ignore his history and legends and often even his native tongue; as one Indian said to me regretfully: "We are no longer Indians and we are not white men, I dunno what we are."

The west coast Indians were remarkable creative artists, totem poles were a late development. No thorough search for earlier work has yet been made, but a stone carving, discovered near Hazelton under several feet of gravel, goes to prove that important discoveries will be made, and masks and head gear, painted drums, shawls, baskets and other things show designs of very distinctive quality. The totem poles along the Skeena are a remarkable collection, less extravagant than the Alaska poles

but carved with bold assurance and endlessly varied in design. There are bears and thunder birds, mountain goats, frogs, eagles, owls, ravens, and many other motifs. There are over a hundred of them, and to restore them all will take some years.

When one considers that many of the totem poles had already fallen over, many of them rotten at the base or hollow inside; that they are carved out of immense cedar which required scores of Indians to move and erect, a few of the difficulties of repairing them may be imagined. The poles are sawn off at the base and very carefully lowered to the ground, the centre is hollowed out and a new, well creosoted cedar pole driven in. The whole pole is soaked with linseed oil, painted as far possible in its original color and re-erected on a concrete foundation, the whole weight being taken by the new pole. In some cases, the restoring is so perfectly done that there is no visible evidence of it, and yet the pole has been given another hundred years lease of life.

Indian legends describe this totem pole country as a kind of paradise, which was lost to the Indians through disobedience, a story similar to our garden of Eden. In the background there is too the great mass of Rocher de Boule, the mountain on which the Indians say their canoes rested when the flood subsided. As to whether the totem pole is the only native art in Canada there is room for controversy.

Besides the restoration of totem poles it is hoped that effort will be made to preserve some of the Indian cemeteries. The grave-houses are comparatively modern and yet show an amazing number of architectural forms which no one has quite accounted for. Russian and Chinese influence seems to have pervaded the ones at Hazelton and Kishiox [sic]. They are all wood and rapidly rotting away. The Indian now having adopted the white man's tomb stones is not desirous that they should be preserved. Mr. Marius Barbeau, whose researches into the origins of Canadian life, habit, and customs have been as unflagging as they have been productive of stimulated interest in this wonderful country of ours, has considered the possibility of rebuilding several of the old houses at Kitselas. There are Indians living who remember the details of construction. In a few cases the main supports are still standing so that there would be no great difficulty to overcome in making the Skeena country a centre for the study of the west coast Indian, and at the same time it is quite the most accessible country in America for such study. Here is a country rich in what most of Canada is lacking, a background. It has a history of invasion and conquest, adventures, myths and legends old enough for history and legend to become one. The whole setting is dramatic; its sharp peaks, its rustling rivers, its gorges, the possession of which meant their chief food, the salmon, and over it all the steady pressure of northern tribes fighting their way southward. And yet along with this there is an imaginative side of life that delighted in dances and ritual, in painting, weaving and carving or other forms of art of

which the totem pole was the last to develop. Now embedded in concrete these poles stand on the banks of the Skeena a monument to a vanishing race, and the scale of them and the boldness of the conception make one feel that these people were not without an element of greatness.

Now a word about Mr. Marius Barbeau, to whom reference already has been made. He is Dominion ethnologist, attached to the Victoria Museum, Ottawa, and it was he who first conceived the idea of preserving some of this country's monuments for coming generations to see. Mr. Barbeau's chief work is in giving this country a background. He works along no rigid line. One day we find him measuring up an old church, digging into its neglected archives and telling the curé all about its history. The next day he is finding out what he can about some early wood sculptor who never signed his work, or tracing up the history of some kind of weaving peculiar to a certain district, or how the Harvey family became French Canadians a hundred years ago. Or he stops some old fellow on the road and says: "Good day. What's your name! Your people lived here long? Your grandfather cleared the ground? Yes. I suppose he knew a lot of the old songs. What ones? Can you remember, go on sing," and out comes the little red note book and another song goes down in shorthand.

Sometimes it's a find, but now, with over two thousand collected and new ones getting rare, it probably will be a variation of one that is recorded at Ottawa. Place names and locally used terms are subject for inquiry, too. So often in Canada we call a village or a street after the real estate agent who subdivided it when it might have marked a spot where some pioneer first dug in his spade after weeks of hardship and danger a hundred years earlier.

All over Canada there is unrecorded history, forgotten monuments, crafts and arts that once flourished but now are lost. In our present hurry each generation is careless about the previous generations [sic] accomplishments. Up to the present Mr. Barbeau has concerned himself mostly with the earlier races – Canada, the Indian and the French Canadian – but he does not limit his enthusiasm to them alone. He has, for example, a keen desire to go to Nova Scotia later, to take up more work in Gaspé where the population, French Canadians, Scotch and Channel Islanders, have held on to old traditions and customs. It is a work which does not end but continually opens up new trails. When first he went to the west coast it was believed that American and other scientists had found out all there was to know and had cleaned up all that was worth owning in the way of Indian art, but through Mr. Barbeau's efforts Ottawa now possesses a collection of West coast art that ranges from fish hooks to totem poles. Patiently, but persistently, he has hunted up every Indian in the country who might tell him something of history[,] legend or customs and as only the old Indians know or remember, and are sometimes unfriendly or suspicious particularly of government officials, Mr. Barbeau has had to be tactful and good humoured.

Today, as the theory develops that this country was the highway of successive migrations from Asia, interest in its history will go on increasing. Mr. Barbeau has the happy faculty of creating enthusiasm and of bringing to our attention the fact that our past is not as meagre as it seems.

### 12.X. Marius Barbeau. 1928. Introduction. In *The Downfall of Temlaham*. Toronto: Macmillan, v-viii.

Barbeau advocated the appropriation of Native arts, myths, and music, especially those from the Northwest Coast, into the patrimony and heritage of the nation. Although he repeatedly stated that these arts and cultures were dead, he also saw them as a uniquely national source of inspiration for non-Native artists, writers, and musicians producing a vital Canadian culture. The publication of his *The Downfall of Temlaham*, based on a combination of Gitksan histories and myths, demonstrated how this joint program of decrepitude and vitality could be put into effect. The book was illustrated with images by artists whom Barbeau had sponsored to travel to the Skeena Valley, such as Langdon Kihn, A.Y. Jackson, Edwin Holgate, Anne Savage, and Emily Carr, all of whom were featured in the 1927 *West Coast Art – Native and Modern* exhibition. The paintings were used within the book to give the impression that they accurately represented the last remnants of a disappearing race. The book thus brought the concept of the ultimate and inevitable death of Native cultures to the widest possible audience.

When the American Indians first encountered the White Man, their surprise was complete, overwhelming. They acclaimed him as a godly spirit from the blue sky; or else, mistaking him for a demon out of the dark caves in the Levant, they endeavoured to check his progress.

A quarrel over the meaning of his advent soon sundered them into factions, a quarrel that embittered the lives of multitudes through generations. Was he the forerunner of a new Golden Age, or a mere self-seeker whose taints and contaminations would spell ruin and death in the long run? Time alone could tell. Even the seers disagreed among themselves, and their forecasts baffled their followers. Ancestral wisdom had run to the end of its tether. The fools, everywhere countless among mankind, plunged headlong into an era of momentous changes. They survived not, most of them, to mourn the downfall of their nations.

Kamalmuk and Sunbeams – the characters of our truthful story – like so many others, misinterpreted the trend of their destiny. They did not understand the curse that had crept insidiously into their lives. Nor could any one else have conjured wiser counsels in their stead.

Husband and wife though they were, and highborn in their tribes, they soon grievously fell out, never to reunite. Their conflict was not their own at bottom, but the inexorable travail of fate in distracted souls, the souls of a conquered race. In the White Man, Kamalmuk saluted a redeemer, while Sunbeams vowed her obedience to naught else but the teachings of her pagan forefathers. Blindly they went on their way, forever apart, amid pitfalls; he, bold and venturesome, from a race of ancient Siberian nomads migrating southwards under the banner of the Wolf; she, a native of the American soil, proud and vindictive, whose inherited symbols were the Fireweeds, the Sun and the Rainbow. As soon as he beheld the white supermen, he decided to become one of them, to acquire their might and share their treasures. More wary, she spurned such temptations, satisfied as she was with the ancient heirlooms of her kin. The ties that bound them together could not withstand the impact of conflicting ambitions and bitter trials. Too frail, they snapped when Fate knocked at the door and propounded a new riddle. And Fate, perforce, solved the riddle for them in the end.

Even before the White Man caused the downfall of the native village-dwellers, they had known strife in the heart of their homeland. Wars, since the dawn of ages, had devastated their settlements; misfortunes had scorched their souls.

For a millenium, their ancestors long ago thrived in pristine innocence and peace. The tribes of man lived side by side in Arcadian friendliness. The villages of Keemelay and Kunradal prospered on the heights of Temlaham, a native Garden of Eden on the banks of the Skeena. Their blissful existence lasted only till the day when illicit love marred their felicity, aroused the wrath of the river spirits and invited untold disasters. A forgetful posterity, after a miraculous redemption, relapsed into evil ways and brought about the downfall of Temlaham. The Golden Age came to an end and the people dispersed throughout the country for a livelihood. Temlaham to this day has remained an awe-inspiring place and a forlorn symbol of happiness lost through sin and folly.

But the real downfall happened only when the White Man overran the native races on this continent and conquered their domains to the last mountain preserve. It is a tale of the past centuries east of the Great Lakes, but, in the far-off Canadian Rockies, only of the passing generation. Kamalmuk and Sunbeams fought the battle of their race against the invader of the Skeena only two score years ago. One of them, Sunbeams, still survives, an old woman, a strange, vivid personality, now lost in a world that has rejected her, a world that she will never understand.

The story of Kamalmuk is true to life. It came to us orally from his friends, his relatives, old people all, whose memory still fondly delves in the past. Its pageantry and inherent poetry flow naturally from their authentic source – an ample stock of songs and traditions familiar to this day among the Gitksan of the upper Skeena River,

in British Columbia. Yet, the narrative itself is couched in the author's own style and composition.

The myths of Temlaham, given as a corollary as it were, are traditional recollections in set form. They stand here for the ceremonial account given by Sunbeams, at the Kitwinkul feast in 1887, of the origin of her family emblems and privileges. Their records in our keeping are freely interpreted and paraphrased.

A rich vein for poetic inspiration lies within native themes and surroundings. The writer, the painter and the musician may discover treasures in this virgin field of human endeavour, so far untrodden. In the conflict between aboriginal races and the white conqueror, thinkers and moralists will find wide vistas on every side. The door is wide open for all to enter, who would rather venture into new avenues than blindly follow the herd in the beaten trails. The author and his collaborators – Jackson, Holgate, Kihn, Miss Carr and Miss Savage, a few of whose pictures are here reproduced – may not have advanced far beyond the threshold; but they have enjoyed in their efforts the breath of novelty, independence and a newborn faith, that may some day spread to many of their betters, still to come.

To the National Museum of Canada we acknowledge our debt for our knowledge of the aboriginal sources, which we have ourselves studied at first hand, in the course of several seasons among the natives of the Skeena.

We also extend our grateful thanks to Miss Mabel Williams and Mr. Diamond Jenness, both of Ottawa, for reading, respectively, the narratives of Kamalmuk and of The Retaliation of Keemelay, and offering useful suggestions.

**12.XI. Harlan I. Smith. 1927. "Preserving a 'Westminster Abbey' of Canadian Indians: Remarkable Totem Poles Now under Government Care."** *Illustrated London News,* 21 May, 900-1.

Despite the solidarity among the views of Scott, Barbeau, and Jackson, there were dissenting opinions on the state of Native culture, the value of the potlatch, and, specifically, the Gitksan poles that stood along the railway line from Prince Rupert to Prince George. Because these poles were viewed as a valuable tourist attraction, Harlan I. Smith was charged with undertaking a restoration project in the mid-1920s, sponsored by the Department of Indian Affairs, the Canadian National Railway, and the National Museum. The project was predicated on the idea that the poles must be preserved since the potlatch ban effectively prohibited the raising of new ones. Smith's article was primarily remarkable not only for its elevation of the poles to the stature of a British historical monument central to British national identity but also for what it did not say. In contrast to the statements by Jackson and Barbeau, Smith gave no indication, aside from the headline of government proprietorship, that the poles had lost their cultural place

within Gitksan society at that time or that carving had ceased. Rather, Smith phrased his observations about their social place and their production in the present and named the living individuals who maintained ownership of them and the crests they represented. Smith, it would appear, was not in agreement with Barbeau and Scott on the relationship between the state and Native cultures. There was also no mention of the problems that he had encountered when the Gitksan began using the restoration program to negotiate a change in the potlatch prohibition. Because this was non-negotiable from the government's side, the deadlock led to the disruption and cessation of the program.

> The Indian totem poles of the Pacific coast [of] Canada have long been neglected. Many have fallen and decayed ... But now a change has come. During the past two years, the Canadian Government has been active in trying to save them ... Though large and rough, totem poles are of great interest to the scientific student of totemism, anthropology, and social organization ... The work of preservation and re-erection was begun in 1925 at Kitwanga, in British Columbia, under the Canadian Government's Totem Pole Committee. This Committee has had the whole-hearted support of the Canadian National Railways, especially of its president, Sir Henry Thornton. The totem poles are not gods or idols, as some have thought, but memorial columns carved from a red cedar tree carefully selected and brought to the village. They are made usually with figures arranged one above another, and representing men, eagles, ravens, wolves, bears, starfish, and even inanimate objects. These are the emblems of brotherhoods, clans and families. They illustrate the family history and legends. A totem pole is erected as part of a funeral ceremony after the death of an important person, usually by one of a sister's children ... who inherits the name of the deceased and the seat of honour connected with the name – not a son, as among ourselves, but usually a nephew ... A carver on the father's side of the family is employed to make the pole ... At Kitwanga there are eighteen totem poles and two single totem figures. One represents a mountain lion, the other a crab ... In recent years some of the Indians have been using tombstones bought from white men in place of, or in addition to, totem poles. Many of these show some of the same emblems as those on the totem poles ... One pole at Kitwanga, which is 41 ft high, is named Oanom Keebu, "Pole of Wolf." It was erected in memory of a man having the title, We Clots, "Large White Fish." He belonged to the Lakeebu, "Wolf Brotherhood." The present (1926) holder of the name "We Clots," is known to the white people as Jacob Morgan. The figures on the pole, from the top down, are as follows: Keebu, "Wolf," standing horizontally; Hpeesunt, a woman with her two children, half-bear and half-human, Keebu, "Wolf," with the head down; Teechem Smith, "Ensnared Bear" also represented on the totem poles on each side of this one, which belong to the same brotherhood; Keebu, "Wolf."

Again with its head down, and another Teechum Smith, "Ensnared Bear." The story illustrated by these three poles is as follows: "A chief of the Lakeebu, 'Wolf Brotherhood,' had a beautiful daughter, named Hpeesunt, and two sons, one named Akteeih. Hpeesunt mocked at the bears. The bears in human form pursued her; but one of their leaders, a grizzly bear, protected her, and took her up to his den. She changed into a bear and bore him twin sons, half-human and half-bear. Meanwhile her brothers constantly searched for her ... At last she saw Akteeih searching for her on the mountain far below. She made a snowball and threw it down. He picked it up and observed the impression of her fingers. He found her in the bear's den, killed the bear, and took his sister and her bear-children home. They helped their uncles in hunting and enabled the family of Akteeih to be prosperous in snaring bears" ... No. 4, which is a totem figure, not a pole, represents Hshae, "Mountain-lion," and was carved by Chief Jim Laknitz. It was mounted on a platform in memory of Akteeih ("Having-no-fat-on-him") ... In 1925 the name was borne by a man known to the white people as Charlie Derrick. This is said to be the first mountain-lion ever carved by the Indians of Kitwanga. To win the confidence of the Indians and their consent to the preservation work was the most difficult task ... I quickly discovered that the owners of these poles had objections to our touching them ... One young man said: "These poles are monuments like grave-stones, and we do not want a show made of them for white people to stare at." So I told him of Nelson's Monument, of monuments to those who fell in the recent war, and especially of Westminster Abbey. Only greatly honoured people were allowed to be buried there ... The Kitwanga poles formed the Westminster Abbey of the Indians of Kitwanga, but the totem poles were of wood, and I was afraid they would fall, and become dust of the earth ... In the actual preservation of the decaying totem poles, we had the advice of Mr. T. B. Campbell, special engineer of the Canadian National Railways ... Of the eighteen totem poles and two totem figures at Kitwanga, the Indians gave permission for the preservation of sixteen of the poles and both of the figures. This work at Kitwanga was finished last September. The eighteen poles at Gitsegyucla will next receive attention; later those at Kitselas Canyon ... There are four standing, and three fallen poles at Hazelton, four standing at Hagwilget, twenty-three at Kispiox, and about twenty-eight at Kitwancool — a total of over one hundred, all within fifteen miles of the Canadian National Railway.

**12.XII. United States. 1935. Indian Arts and Crafts Act, s. 2.**

Harlan I. Smith's optimistic predictions were not to be fulfilled. Gitksan resistance to the totem pole restoration project grew when they realized that no changes to the potlatch ban were forthcoming, nor were their land claims to be recognized. The poles at Gitsegyucla were therefore not restored, nor were those

at Hazelton or the other villages at that time. In fact, the entire program to bring Northwest Coast Native arts into the national image, albeit as relics from the past, faltered and failed. Native arts were once again excluded from the national image. There were no immediate follow-ups in Canada to the 1927 exhibitions or to the restoration project. Rather, Barbeau encountered resistance to further initiatives to collect poles and objects for galleries in Toronto and Ottawa. A hiatus followed, in which little was done by the Canadian government.

Across the border to the south, however, things were going in a different direction. Since the 1920s there had been a movement, carried out through the private initiatives of artists, intellectuals, and wealthy supporters, to integrate Native traditional arts, especially those from the Southwest, into the fabric of an Indigenous non-European American cultural identity. In contrast to the view in Canada at the time, these traditions were seen as both living and ongoing – that is, neither moribund nor disappearing. The first stage culminated in the important 1931 Exposition of Indian Tribal Arts, held in New York City. Similar programs developed further in the 1930s under Roosevelt's New Deal policies and John Collier's administration of Indian Affairs when the government took on the task of fostering Native arts primarily for economic reasons. In 1935, the Indian Arts and Crafts Act was passed. Its objective was to establish a Board of Indian Arts and Crafts within the Department of the Interior that would actively promote the production of Native arts. The relevant portion of the act is included here because it soon became the model for a remarkable change in the Canadian national perception of Native arts and of the nation.

An Act

To promote the development of Indian arts and crafts and to create a board to assist therein, and for other purposes ...

Sec. 2. It shall be the function and duty of the Board to promote the economic welfare of Indian tribes and the Indian wards of the Government through the development of Indian arts and crafts and the expansion of the market for the products of Indian art and craftsmanship. In the execution of the function the Board shall have the following powers: (a) To undertake market research to determine the best opportunity for the sale of various products; (b) to engage in technical research and give technical advice and assistance; (c) to engage in experimentation directly or through selected agencies; (d) to correlate and encourage the activities of the various governmental and private agencies in the field; (e) to offer assistance in the management of operating groups for the furtherance of specific projects; (f) to make recommendations to appropriate agencies for loans in furtherance of the production and sale of Indian products; (g) to

create Government trade marks of genuineness and quality for Indian products and the products of particular Indian tribes or groups; to license corporations, associations, or individuals to use them; and to charge a fee for their use; to register them in the United States Patent Office without charge ...

## KWAKW<u>AKA</u>'WAKW MEMORIAL POLE

Despite the prosecutions of the early 1920s, the Kwakw<u>aka</u>'wakw, as well as the Gitksan, kept up their traditional ceremonies and pole raisings. The former also began to search for ways in which they could be directly linked to the nation and the British Empire. In so doing, they could demonstrate their loyalty to the Crown and reposition themselves as valuable citizens of the nation. One example

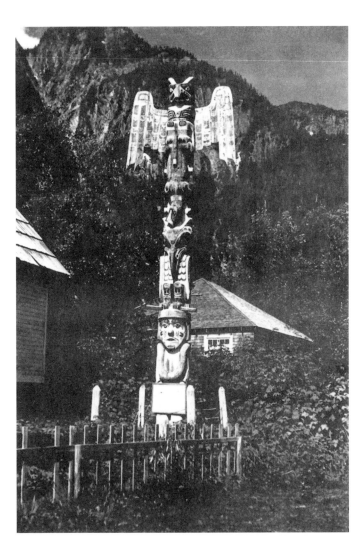

**FIGURE 12.1**
Kwakw<u>aka</u>'wakw memorial pole raised in Gwayi village, Kingcome Inlet, in the spring of 1936 to commemorate the death of King George V. From Bill Holm, *Smokey-Top: The Art and Times of Willie Seaweed,* Thomas Burke Memorial Washington State Museum Monographs 3 (Seattle: University of Washington Press, 1983), 44-45.

of this plan was the erection of a large totem pole to commemorate the death of King George V. This move effectively reversed the situation in which Native culture was appropriated by the nation; instead, imperial figures were appropriated into Native culture. In this sense, the king became a Kwakwaka'wakw chief or noble, with all the responsibilities to his people that this entailed. Traditional ceremonies also accompanied the ascension of the new king, George VI, to the throne. It would have been extremely difficult, if not impossible, for authorities to prosecute such displays, which raised a question: if it was permissible to hold ceremonies celebrating the ascension of the king, then why would the nation view similar ceremonies for the ascension of a chief as illegal? These initiatives must be seen as having some effect on the shifting relationships between the nation and the Native peoples of the West Coast. Indeed, dramatic and substantive changes soon followed.

**12.XIII. Canada. 1938. An Act to Amend the Indian Act. Statutes of Canada, c. 31, s. 94b.**

In 1938, a seemingly modest addition to the Indian Act of Canada signalled the government's complete about-face on its position regarding Native arts and cultures, a shift parallel to developments in the United States. To Section 94 of the act, which dealt with the operation and funding of farms on Indian reserves, was added a supplementary subsection that provided for the loan of money to First Nations groups or individuals for that and similar purposes. The list of similar purposes included "native handicrafts." Although almost buried in the text, the inclusion of these two words marked the beginning of what would later be recognized as the "revival" of First Nations art in Canada. Rather than repressing Native cultures and systematically attempting to destroy them through assimilative programs, such as the potlatch ban, forcible enfranchisement, and compulsory residential school attendance, the Canadian government now began a program to subsidize Native arts. Although far less comprehensive and detailed than the earlier American legislation, this small alteration had immediate and far-reaching effects. The following two years saw a burst of unprecedented activity. Native arts were again included in exhibitions abroad that defined the national image. The Society for the Furtherance of Indian Arts and Crafts (later the BC Indian Arts and Welfare Society) was formed with Alice Ravenhill at its head. The society and Ravenhill promoted Native handicrafts, particularly among Native school children in British Columbia. In Victoria, construction began on Thunderbird Park, which would become one of the loci of the "revival."

2 GEORGE VI.

CHAP. 31. An Act to amend the Indian Act.
*[Assented to 24th June, 1938.]*
HIS MAJESTY, by and with the advice and consent of the Senate and House of Commons of Canada, enacts as follows: –

2. The said Act is further amended by inserting immediately after section ninety four A the following: –

A94B. (1) For the purpose of granting loans to Indian Bands, group or groups of Indians, or individual Indians and for the expenditure of moneys for co-operative projects on their behalf, the Minister of Finance may, from time to time, authorize the advance to the Superintendent General of Indian Affairs out of the Consolidated Revenue Fund of Canada of such sums of money as the said Superintendent General may require to enable him to make loans to Indian Bands, group or groups of Indians or individual Indians, for the purchase of farm implements, machinery, live stock, fishing and other equipment, seed grain and materials to be used in native handicrafts and to expend and loan money for the carrying out of co-operative projects on behalf of the Indians. All expenditures made under such advances shall be made under regulations established from time to time by the Governor in Council and shall be accounted for in the like manner as other public moneys. Any moneys received by the Superintendent General of Indian Affairs from the Indian Bands, group or groups of Indians, individual Indians or co-operative projects, for aid furnished under the provisions of this section shall be remitted by him to the Minister of Finance in repayment of such advances. The amount of outstanding advances to the said Superintendent General including all amounts owing by the Indian Bands, group or groups of Indians, individual Indians or outstanding on co-operative projects shall at no time exceed the sum of three hundred and fifty thousand dollars.

(2) The Superintendent General shall annually prepare a report with regard to loans made under the provisions of subsection one of this section, during the preceding calendar year, and such report shall be laid before parliament within fifteen days or, if parliament is not then sitting, within fifteen days after the beginning of the next session.

**12.XIV.  M.S. Todd, Indian Agent at Alert Bay. 1938. Letter to Major D.M. MacKay, Indian Commissioner for British Columbia, confirming commission of two poles to be carved by Mungo Martin, 25 October.** Library and Archives Canada, RG72.

One of the first substantive actions resulting from the shift in the state's position on Native arts, from suppression to subsidization, can be seen in the surprising

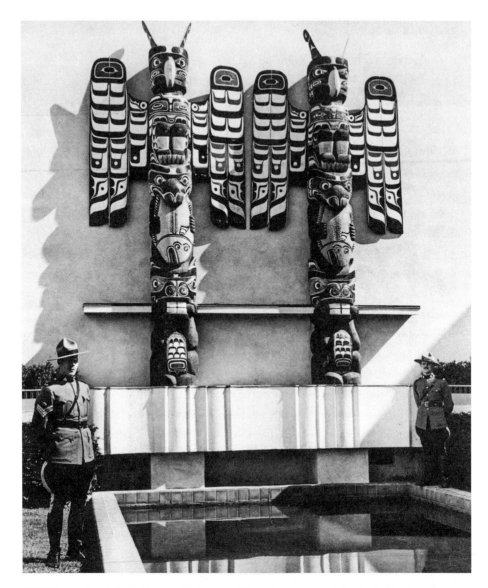

**FIGURE 12.2** Kwagiutl artist Mungo Martin carved these two monumental poles for the Canadian Pavilion at the 1939 World's Fair in New York. From Stanley Appelbaum, *The New York World's Fair, 1939/1940 in 155 Photographs by Richard Wurts and Others* (New York: Dover Publications, 1977), 125. Photographed by Richard Wurts. Courtesy of Dover Publications.

move by Canada's Department of Public Works to commission a practising Native master carver, Mungo Martin (1879?-1962), to carve two large totem poles to be displayed prominently on the exterior of the Canadian Pavilion at the 1939-40 New York World's Fair (Figure 12.2). M.S. Todd, the Indian Agent who penned this letter, had, just a few years previously, reported on surreptitious carving that he wished to suppress, had advocated the confiscation of all surplus

income that any Indian earned on the ground that it could be used for potlatch purposes, and had proposed the confiscation of all traditional ceremonial paraphernalia on the same ground, so this letter demonstrates the speed with which the bureaucracy reversed its course. Public Works had initially intended to use old poles removed from their original sites for the World's Fair, but this proved impossible. Martin carved the twin poles over the winter of 1938-39 in Alert Bay. The commission affirmed that there was a broad knowledge that Kwakwaka'wakw carving traditions were still alive and active and in fact reaching their apogee in certain areas at this time and not in need of a "revival." The conflicted position between the two views – that carving was still being done and that it needed to be revived – was demonstrated by the fate of the poles. After the fair closed, they were not returned to Canada, where they would have become emblems of the continuity of Native traditions. Rather, they were donated to the Parks Department of the City of New York, which then handed them on to a Boy Scout camp in New Jersey, where they remain to this day, albeit in deteriorated condition. Marius Barbeau did not include them in his 1950 comprehensive catalogue of poles, although he did include new poles carved in Alaska in the late 1930s. They consequently fell into obscurity and have been omitted from the narratives of the "revival." Indeed, the federal program did little in the following years to pursue this initiative on the West Coast and offered little in the way of actual support to the BC Indian Arts and Welfare Society, citing the war effort as the major impediment.

Alert Bay, B.C.
October 25, 1938.

Dear Sir:

Replying to your letter No. 180-6283 dated the 14th instant, in respect to a request from the Canadian Government Exhibition Commission for two totem poles, each approximately 17 feet in length, to be used at the New York World's Fair in 1939, I beg to advise you I have gone into this very carefully and find there are no old totem poles of that size in good condition that could be shipped for this purpose.

When it was found impossible to obtain one already carved, I immediately got in touch with one of your best carvers in the Agency, and enclose you herewith a rough sketch drawn by Mungo Martin, Indian of the Kwawkewlth Band, Fort Rupert, who has agreed to carve two totem poles as shown in the enclosed sketch, have them painted properly, crated and delivered to me at Alert Bay, for the sum of $250.00 each. This I consider very reasonable, as some years ago a number of totem poles were sold from this Agency for which the Indians realized $300.00 each.

Mungo Martin has also agreed to carve the double-headed snake with a Thunderbird sitting on top of the arch, for a further $100.00.

If it is the intention of the Canadian Government Exhibition commission to use these totem poles as the entrance to their exhibit, the two totem poles being carved exactly the same, 17 feet high could be placed side by side which would leave a space of approximately sixteen feet for an extrance [sic] to the building. The double-headed snake and Thunderbird could be carved and used as an arch reaching from one totem pole to the other, which would make a very wonderful gateway and extrance [sic] to our Exhibit.

If the Commission only desire the two totem poles, they would cost $500.00 completed and crated, F.O.B., the wharf at Alert Bay. If they would like the double-headed snake and thunderbird it would cost an extra $100.00, but we can give it to you either way you desire.

As the time is short, it will be necessary to have an early answer as the carver will have to locate suitable cedar logs out of which to carve the poles, and I would ask the Department to advise me at an early date so that I can get the Indian to work on them so that they will be completed on time.

I presume the two totem poles will either be sold after the Exhibition or returned to Canada, and kept by the Canadian Government. If they are sold at the end of the World's Fair the Commission would have no difficulty in getting a return of their money, as the poles will be well worth the price paid.

Your obedient servant,
(Sgd.) M. S. Todd

---

**12.XV.  C.T. Loram and T.F. McIlwraith. 1943. Introduction. In Part 9, "Arts and Crafts of the Indian."** In *The North American Indian Today: University of Toronto-Yale University Seminar Conference (Toronto, September 4-16, 1939).* Edited by C.T. Loram and T.F. McIlwraith. Toronto: University of Toronto Press, 316-17. Reprinted with the permission of the publisher.

By 1939, the Canadian program for encouraging the production of Native arts and crafts, as a means of providing income for First Nations peoples on social assistance during the Depression, was in full swing. A cross-border dialogue with colleagues in the United States who were encouraging a similar initiative, but with essential differences, was ongoing. A conference was held in Toronto in 1939 to discuss the relationships among races. The principals from both sides of the border spoke on their respective programs, with the proceedings published in book form in 1943. The introduction to the section on arts and crafts offered insights into the Canadian aspect of these parallel developments. In particular, it outlined the steps to be taken to ensure the successful marketing of the objects

produced and the stipulation that they must be seen as saleable commodities divorced from their traditional cultural meanings.

INTRODUCTION

The depression of the last twelve years has given an impetus to governmental and other agencies concerned with Indian economic problems. The question is often asked: Do their own handicrafts offer a field of economic advantage to the Indians? There can be only a small market for moccasins and other special products, and the amount of goods consumed locally by Indians is likewise restricted. Accordingly, the question becomes: Are Indian products salable in the regular channels of modern North American trade? There has always been a limited demand for baskets, beadwork and other articles as curios, but this has never sufficed to encourage a steady production. Those familiar with the quality of some Indian crafts realize that they have a real value, but this runs counter to the idea that they are just curiosities. If a permanent industry is to be built up, it needs a steady supply of goods of staple quality, and of a type that is suitable for modern conditions. This means that the craftsman must produce goods for their salability, not to satisfy the tradition and aesthetic demands of his own culture. Since articles produced commercially tend to deteriorate in quality, one of the problems is the maintenance of standards under new stimuli. On the other hand, there is the problem of marketing such goods, if produced. Successful sales today require advertisement, efficient and economical means of distribution, and a large-scale organization. Above all, the purchaser must consider his purchase for its intrinsic worth, not for its interest value as an Indian product. Native handicrafts offer possibilities of increasing Indian income, but the road between the individual craftsman and the white consumer is a hard one.

12.XVI. **Graham McInnes. 1939. "Indian Art."** In *A Short History of Canadian Art.* Toronto: Macmillan, 7-11.

One of the principles of the "revival" required that Native art be recognized as having an "intrinsic value" as art rather than craft and that it be brought to the attention of the widest possible audiences through increased visibility. This process had been made problematic by the Parisian debacle of 1927 but was readdressed by 1938 when Northwest Coast Native pieces were again included in an international art exhibition, *A Century of Canadian Art*, organized by the National Gallery of Canada for the Tate Gallery in London, England. Graham McInnes (1912-70), an Australian emigrant who had assisted in publicity for the exhibition, published a brief survey of Canadian art the following year. For the first time in book form, Native arts, and especially Northwest Coast objects, were

included as part of Canada's artistic heritage and occupied the opening chapter, although none was actually illustrated. McInnes confirmed their position as art within the Canadian national context and ratified the arts of the Northwest Coast as the only ones worthy of being designated as art. On the other hand, he hedged on the survival of the traditions and their role in directly influencing non-Native Canadian artists, and he did not mention the possibility of a "revival" or Mungo Martin's poles, then on display in New York City.

INDIAN ART

Lo, the poor Indian! whose untutored mind
Sees God in clouds, or hears him in the wind ...
　*– Alexander Pope, "Essay on Man"*

Of the various Indian nations scattered thinly over what is now Canada at the advent of the white man, only the North West Coast Indians of British Columbia can be said to have produced an art of high aesthetic worth. Elsewhere, domestic utensils, rugs and other textiles have sometimes risen to the level of art, and this is especially true of the Eastern Algonkians. But on the North West coast, totemic art and handicrafts of relatively high order were produced. Though the existence of a fully matured and highly conventionalized art was recorded as far back as the latter part of the eighteenth century, no critical examination of it was made until anthropologists took the field. Their research, coupled with the newly aroused interest in all primitive art, has mostly taken place during the last twenty-five years, and as recently as 1925 it was still fashionable to refer to the art of the West Coast Indians as "grotesque in design and crude in execution."

The lofty, intricately carved totem pole – preserving always its cylindrical mass – bears the same relation to the mountainous, forest-clad landscape as one of MacDonald's rhythmical canvases bears to Algoma, or the low stone church of Quebec bears to the Laurentian hills.

A complex set of heraldic tribal symbols, derived in general from animals, birds and fish, is conventionalized sometimes to the point of geometrical abstraction, and carved out of the cedar trunk in such a way as to remain true to the material from which it is hewn. It was only later that these strong plastic forms, created by the white man's tools, became degraded by the white man's paint. Before Indians learned to outline their forms with cheap house-paint, they erected them from the wood itself, with economy of means and a high regard for the essential shape and quality of the tree.

In other handicrafts, for decorative, domestic and ceremonial purposes, the West Coast Indians also excel. The skill of the woodcarver finds a further field in the fashioning of intricate ceremonial masks, the carving of wooden dishes, horn handles and other domestic utensils; and in all these the same unity of style is evident, for a conventionalized art is easily adapted to any particular material.

This Indian work is obviously outside the main stream of Canadian art, but it is interesting as an example of the work of those who were, after all, the first Canadians. Further, in their reaction to their environment, and their understanding of it, the difference between their work and that of certain contemporary Canadians is fundamentally one of degree only. Finally this art has provided subject matter for a number of Canadian artists.

It will be seen, from this brief survey, that the art of the West Coast Indians is the only one to have influenced, even remotely, the main stream of Canadian art. Nevertheless, from the artistic viewpoint it is worth studying, and it may be mentioned that at the exhibition of Canadian art at Paris in 1927 and at London in 1938, it was thought essential to include West Coast Indian work. Moreover, native crafts in general are in such danger of complete extinction today, that any surviving examples are deserving of close study by all whose view of art is not confined to museum walls.

**12.XVII. News stories on Gitsegukla potlatch. 1939.** "Old Time Potlatch Held at Kitseguckla – Police Investigated." *Omineca Herald,* 29 November, 1; "Prosecution May Follow Potlatch, Event at Kitseguckla Was on Big Scale to Demand Attention of Police Court." *Smithers Interior News,* 6 December, 1.

To call what was happening a "revival" was something of a misnomer in that, in actuality, and as Martin's poles demonstrated, many Native cultures were not as moribund as Barbeau and the state had assumed in the 1920s. Recently, the continuity of Gitksan cultural traditions throughout the 1920s, 1930s, and 1940s has been recognized. Evidence may be found in the recent publication of the field notes of William Beynon (1888-1958), a Native ethnologist working with Barbeau at the time. Beynon's records, which remained largely unknown during Barbeau's lifetime, documented large traditional ceremonies held in the Gitksan village of Gitsegukla in 1945. Yet this was only part of a much broader series of events that had been ongoing throughout the previous two decades. As these reports from two local newspapers indicate, elaborate ceremonies had been taking place throughout the 1930s, with authorities turning a blind eye. Even less well reported was the revival of the repression of these ceremonies in the late 1930s,

when ethnologists such as Barbeau were returning to the field and the Canadian government was revising its position on Native arts and cultures. The newspaper articles from 1939, couched in the jargon of the day, combined with Beynon's notes from 1945, are evidence that far more was going on than has thus far been reported and that this history of continuity needs to be recovered. The articles also indicate the conflicted positions of Canadian authorities over such matters at this time of transition.

OLD TIME POTLATCH HELD AT KITSEGUCKLA — POLICE INVESTIGATED

Some of the native chiefs of the district, most of them in fact, love an old fashioned potlatch, and although this sort of amusement has been practically stamped out, the natives were allowed to get away with an occasional small affair. Recently they got more courage and a couple of weeks ago pulled off a real one. The younger members of the tribes are not in favor of potlatches whatever, and would be glad to see an end of them.

A short time ago chief Dan Cookson died at Kitseguckla and following that occasion some twenty-five chiefs from all parts of the district gathered at Kitseguckla. They were from Hazelton, Glen Vowell, Kispiox, Kitwanga and of course from Kitseguckla. The various reserves had been combed for contributions to the potlatch and a great deal of stuff was secured, including a radio, a couple of cows, thirty moose-skins, another radio and about $470 in cash. A good time was had by all privileged to be present.

Complaints were made to Cons. Olson of the provincial force. He investigated, got statements from various members of the big party, and last week made his report to the district officer in command, Srgt. Hooker of Smithers. The next move will have to come from him.

...

PROSECUTION MAY FOLLOW POTLATCH, EVENT AT KITSEGUCKLA WAS
ON BIG SCALE TO DEMAND ATTENTION OF POLICE COURT

Provincial Police heads, the Indian Department, and possibly the Attorney General's Department, will decide what is to be done as an aftermath of a big potlatch at the Indian villages of Kitseguckla, a few miles west of Hazelton, November 8th and 9th. The scale reached in that potlatch caused police to take action on the matter. While potlatches are illegal, small gatherings for gift making have been more or less tolerated for some time.

At an investigation in Hazelton an Indian witness stated that the Act in this respect was fifty years too old. He outlined the custom in regard to the election of a new chief and intimated that there was no more harm in Indians passing out gifts in such occasions than there was in whites making gifts during the Christmas season.

It is stated that the potlatch was put on by Hazelton and Kitseguckla chiefs following the burial of Chief Dan Cookson on November 7. The presents covered a wide variety, but the leaders were an expensive radio and a sum of $500 in cash. Chiefs and their relatives were the chief beneficiaries.

Provincial police has seized the radio and reported to headquarters. It is believed the prosecutions will be started in the new year.

W.W. Anderson is conducting the inquiry held at Hazelton.

**12.XVIII. Emily Carr. 1942. Letter to Alice Ravenhill, 17 March.** Microfilm reel MS 2720, BC Archives.

As the previous entry indicates, not everyone supported the principle of the "revival." Opposition came from varying sources. Emily Carr (1871-1945), for example, had spoken out publicly against it as early as 1935. Yet both her writings and her art were well positioned to take advantage of the moves to make Northwest Coast art more visible to a wider public. Her paintings of totem poles had been included in one of the first exhibitions of the "revival," held in London, England, in 1938, when they were paired with objects from First Nations peoples of the Northwest Coast, as they had been a decade earlier at *Exhibition of Canadian West Coast Art – Native and Modern* in Ottawa. Carr, however, resisted attempts to associate herself with the program. In 1942, Alice Ravenhill wrote to the artist on behalf of the Indian Arts and Welfare Society, offering Carr an honorary presidency of the organization. Carr declined. Her response indicates that she did not see the continuing vitality of the traditions of Native arts and cultures at this time, viewing them as dead and of the past. This is consistent with the main motifs of her richly imagined memoirs, published under the title *Klee Wyck*, which frequently rehearsed the mortality of Native cultures and Native peoples.

Dear Miss Ravenhill

Will you please thank your society for the honor they confer in asking me to be Honorary President. I have turned the matter in my mind and feel I cannot honourably accept as I am not entirely in sympathy with the idea. From reading Klee Wyck I think you will understand that I love Indians and Indian things but I do not favor a re-hash for the sake of decoration when their great original use is gone. It seems to be an indignity to use them and these totem symbols for ornamentation only. Mind you I have been guilty myself. I used to put Indian designs on pottery where they do not belong. My designs were true and genuine but I came to feel it vulgarized them, pampers the tourist and potters who knew nothing at all about Indian (or any other art) made a horrible mongrel jumble. Neither Indian nor white which so disgusted me I stopped short.

The old totemic art belonged to the past when the Indians had no written language and a man's only way of recording family history and exploits was through carving and painting. The artist did not work for his own glory but in the glory of his totem and his tribe, an art that went to the very root of things. The outer form of a creature matters less than the creatures attributes. He distorted to emphasize. He absorbed his subject and was one with the thing itself while he worked.

This generation of Indian carvers cannot do the same. He no longer *believes* in these old symbols and supernatural beings. He could not represent with the same conviction. He could only make shoddy make-believes. Why try and force them back to what is done with and should be decently folded away. Preserved yes, but cannot be recaptured because of existing conditions. Let them find new expansion in present time and environment. Let Indian art great in the past, stop right there, rather than becoming meaningless ornamentation. Perhaps my ideas are all wrong. I could find nothing in the nativity play, pure white or pure Indian. It seemed forced [?] and false to me. It is difficult to express my meaning but I think you will understand I could not join myself to the society in the furtherance of B.C. Indian Art feeling as I do.

Sincerely yours.

**12.XIX. Harry B. Hawthorn. 1948. Foreword. In *Report on Conference on Native Indian Affairs at Acadia Camp, University of British Columbia, Vancouver, B.C., April 1, 2 and 3, 1948.*** Edited by Harry B. Hawthorn, BC Indian Arts and Welfare Society, and BC Provincial Museum. Victoria: BC Indian Arts and Welfare Society. University of Victoria Archives, BC Indian Arts Society Fonds (AR018), Acc. 1991-085, file 3.20. (The remainder of the report on art, including Neel's speech, is excerpted in Watson, this volume [13.I].)

The actual implementation of the major phase of the "revival" had to wait out the war years and is thus usually incorrectly dated as commencing in about 1950 rather than 1938. When it did fully emerge, both its goals and its structure could be seen as paralleling the American model outlined in the Indian Arts and Crafts Act – that is, it was a complex network of coordinated activities that engaged many institutions, corporations, and individuals. One of the first major studies that occurred was this 1948 conference on Native affairs, which examined one of the "revival's" primary concerns: the potential for Native arts and crafts as possible items for sale to a non-Native market. Significantly, although the mandate for the conference was broad and included health and economics, it did not encompass the potlatch. There were several speakers in the section devoted to arts. Some noted the change that had occurred in the attitude of the state in the previous years and some the difficulty in marketing Native works and the proliferation of cheap Japanese imitations. Of the speakers, undoubtedly the most

eloquent and knowledgeable was Ellen Neel, a Kwakwa̱ka'wakw carver. The granddaughter of Charlie James, she was also related to Mungo Martin. She stressed the fallacy of the idea of a "revival" and claimed that the art was ongoing and living, that it had altered in the past and could do so in the present without losing its essential characteristics. Because her address is included elsewhere [13.1], I have cited only the section of the foreword that addressed the problems associated with art.

> The session on arts and crafts touched on the point that these are values in Indian life which cannot and should not be repressed. One part of the problem posed by Indian art is the question of how the artist is to live. Here the Conference indicated the need for training, for improvements in marketing and for protection. The suggestion was offered that art might be fostered as a supplementary activity. Here also lie the difficult decisions on the relation between the traditional and the modern forms of art. Another value of the arts is their use in schools, as a means of creativity and expression, which can give the child pride in the culture with which he is still partly identified.
>
> Some aspects of Indian culture, such as that grouped around the word potlatch, drew contradictory opinions, and therefore no agreement on the processes of cultivation or replacement. It seemed clear that studies of the actual situation are needed in order to aid the modern Indian in some of his decisions.
>
> It was not possible to spend enough time during the crowded sessions of the Conference to frame and discuss recommendations which would express the sometimes diverging views of all present. The recommendations submitted have in consequence had to come from a special committee of the B.C. Indian Arts and Welfare Society, and could not be referred to the meeting as a whole.
>
> H.B. Hawthorn
> Editor and Conference Chairman

**12.XX. Royal Commission on National Development in the Arts, Letters and Sciences. 1951. "Indian Arts and Crafts."** In *Report of the Royal Commission on National Development in the Arts, Letters and Sciences, 1949-1951.* Ottawa: King's Printer, 239-43.

Probably the most important declaration that living, albeit "revived," Native arts could be integrated into the new postwar idea of Canada's national culture and identity occurred in the report of the Royal Commission on National Development in the Arts, Letters and Sciences, chaired by Charles Vincent Massey (1887-1967). Working from statements such as the earlier Hawthorn report, it proposed, although still with some hesitation, that Native arts could now contribute significantly. This proposal led, in turn, to the remarkable developments

of the following decades. Although the potlatch was not mentioned in the report, the ban against it was subsequently dropped from the Indian Act as a new era began and the "revival" kicked into high gear.

1.   We heard much in our sessions of the Indian peoples who once played such an important part in the history of Canada and who still maintain to some degree separate communities and a distinct way of life throughout the country. That aspect of their life of special interest to us, their arts and crafts, was brought to our attention in sixteen briefs and presentations. We also received an authoritative study on the subject to which we are indebted for much valuable information. We were interested in this matter for its own sake and because it affects the well-being of an important group of Canadian people.

2.   We received information on the arts of various groups of Indians showing how original differences, presumably brought with them on their migration to this continent, have been accentuated by variations of climate, of geography and natural resources in the areas where they made their new homes. We learned of the tribes of the eastern woodlands, the great plains, the interior of British Columbia and the North-West Coast, and of the ingenuity and beauty of their products: basketry of all kinds, leather work, carvings, embroidery, weaving, and silver work in many styles. We heard in detail of the arts and crafts of the Pacific Coast where a highly developed social and economic system was accompanied by the greatest variety and originality in various forms of self-expression ...

We received valuable and important briefs on this matter from the British Columbia Indian Arts and Welfare Society, and local members of the Federation of Canadian Artists who take an interest in Indian work. We also heard from several groups in Alberta, and learned of an important outlet for Indian crafts-manship in New Brunswick. There was general agreement that the younger generation is turning away from the traditional crafts, and that some of the rarer such as the silver work and the argillite carving of the Pacific Coast may disappear completely before long. According to the authors of our special study who based their conclusions on exhaustive inquiries, "Young people do not know this," or "Only a few old people still do it," were recurring refrains in letters sending in information for the report. And again, speaking of the indifference to the past:

"In most sections, the Indian culture was treated with scorn, indifference or hostility, and the objects the Indian made were, at best, regarded as curiosities. Aside from museums and the amateur collector, these objects fell between the indifferent contempt of the European and the apathy of the Indian, who was

confused by his own motives. As a result, one finds again and again in the reports from the Indian Agents: 'Only a very few old women remember this process. The young people don't want to learn.' Or: 'All they are interested in is the money they can get for it. They don't care about craftsmanship'." [from a study by Harry B. and Audrey Hawthorn]

3. Many of the products of the so-called Indian craftsman which do survive are degraded objects mass-produced for the tourist trade, badly carved miniature totem poles, brightly tinted plastic pins ("of Indian make from pressed bone") and other regrettable "Indian" souvenirs made in Japan. Such activities do not always result even in economic benefits for the Indian family, but may instead impose a form of sweated labour on the wife and children.

4. This unsatisfactory state of affairs has led some to believe that, since the death of true Indian arts is inevitable, Indians should not be encouraged to prolong the existence of arts which at best must be artificial and at worst are degenerate. It is argued that Indian arts emerged naturally from that combination of religious practices and economic and social customs which constituted the culture of the tribe and the region. The impact of the white man with his more advanced civilization and his infinitely superior techniques resulted in the gradual destruction of the Indian way of life. The Indian arts thus survive only as ghosts or shadows of a dead society. They can never, it is said, regain real form or substance. Indians with creative talent should therefore develop it as other Canadians do, and should receive every encouragement for this purpose; but Indian art as such cannot be revived.

5. There is, we believe, general agreement that certain forms of Indian art have disappeared finally with the customs that gave rise to them; and that the indiscriminate use of totem poles to advertise gasoline stations does nothing either for the cause of the Indian or for the cause of art. There is no reason, however, for not preserving with care the works of the past which have great significance in anthropology and in the history of primitive art.

6. It has, however, been stated to us by a number of groups and persons that Indian art is of much more than historical interest. We have been frequently reminded that Indians by tradition are craftsmen of a very high order; and that to allow their traditional excellence in technique, their taste and originality in design, and their power of adapting their skills to the use of new materials and to the production of new types of articles to die out for want of encouragement would be to do an injury to all Canadians, Indian and white alike.

7. There need be no danger, it seems, of arts becoming stereotyped which in "workmanship and design rank very high in ... aboriginal arts and crafts." These arts

have for centuries resisted corruption while readily availing themselves of all that the white man could offer in improved tools, materials and even designs. The rapidity and ease with which Indians in the past adopted and used the white man's beads, silks and patterns and made them their own, is well known. Today, we learn, the same process goes on; Indians on Vancouver Island and elsewhere have taken to knitting, using not the designs of the white man, nor even necessarily their own traditional ones. Instead "new traditions are established, portraying flying swallows, deer and similar animals in a new content." We have other evidences of the sense of design which seems to be common to Indian groups which in other ways differ greatly.

8.   We were reminded, however, that the best Indian work can be produced only in certain conditions which now seldom prevail. Some tribes regard certain products as sacred and resent one of their members parting with them even as a gift to a valued friend without a special tribal ritual. Such customs, exceptional though they may be, explain the statement made to us on more than one occasion that Indians do their best work only when it is properly appreciated. Lack of interest on the part of the buyer and the demand for cheap articles have caused that serious degradation in standards of workmanship mentioned to us by certain voluntary groups, especially in British Columbia, which are working to restore them through encouragement and fair prices.

9.   It is perhaps reasonable to assume that the present depression in Indian arts which may result in their disappearance may be attributed in part to tendencies which affect all modern societies: the general mechanization of life, the desire for novelty rather than for quality, the tendency to take the easy, slipshod way ... The Indian ... is often held back by lack of instruction, advice and encouragement, by the feeling that no one wants his best wares and by difficulties in marketing, especially of fine products which must find a special market.

10.   It is these facts which have led voluntary societies to impress upon us the need for help and encouragement. It should be given, it is said, not only for the sake of the Indians but in the interest of all Canadians who are concerned with the lesser arts and crafts. The Indian groups with their ingenuity and taste, their traditional designs, and the special articles which they alone produce, have a valuable contribution to make to this part of Canadian cultural life.

11.   Several suggestions were made about the assistance that might be given: co-operation from the National Gallery in preserving and publicizing Indian designs; travelling exhibitions of Indian work; special instruction; and a study of marketing problems for the different kinds of products. There is general agreement that help, though essential, must be given with much care; otherwise it may do harm, rather than good. High standards of quality must be maintained through interest

and encouragement. The Indians should be reminded of the value of their own traditions and the beauty of their traditional designs but should be free to work in the form and pattern which they prefer. In these ways they may be persuaded to avoid the slavish copying of novelties which attract them, or which they think may be better only because they come from the white man.

12. It has been suggested that the Indian Affairs Branch be encouraged to look after these matters, and that it be provided with the necessary resources. A number of agents of the Branch are interested and helpful, we were told, but there was a general impression that the Branch as a whole has adopted a somewhat negative attitude. No standardized plan can be laid down, but a flexible programme is needed to encourage Indians to produce their best work; publicity and information are needed to enable other Canadians (already, as we have seen, keenly interested in handicrafts) to understand its value. We have even had a suggestion that a special council reporting to the Cabinet be responsible for this work.

13. "The establishment of a national arts and crafts programme is a basic necessity for the development of Indian welfare." This brings us to the welfare of arts and crafts in Canada, a subject which was a matter of concern to a number of societies ... It is suggested in this brief that there is need for a Canadian Council of Amerindian Studies and Welfare to consider every aspect of Indian life and to make suggestions for suitable legislation. Certainly these voluntary groups and individuals which have been trying in a small way to do this very thing seem to agree that the Indian can best be integrated into Canadian life if his fellow Canadians learn to know and understand him through his creative work. They have suggested to us that it is no act of patronizing charity to encourage a revival of the activities of those who throughout our history have maintained craftsmanship at the level of an art.

# 13 | Art/Craft in the Early Twentieth Century

Indian designs can be adapted to make an attractive eye appeal in commodities in the textile, plastic and ceramic industries, in glassware, metalcraft, woodcraft, silverware and jewelry, leather goods, rugs, clothing, carpets and curtains, house decorations, furniture, poster painting and in a hundred different industries Canadian Indian designs could be adapted to advantage.

> — *G.H. Raley, "Suggesting a New Industry out of an Old Art: BC Indians*
> *Revive Their Dying Skill to Become Revenue-Producing Artisans?," 1936*

All we do now is to make totem poles for a living. You can't make much on totem poles.

> — *Leslie John, carver, Nanaimo, 1948*

In Western art institutions, the position of the "crafts" as opposed to the "arts" underwent dramatic shifts in the twentieth century. In the late nineteenth century, the English Arts and Crafts movement (and similar movements throughout Europe and the Americas) established the notion that crafts are an ethical concern, that the well-designed, handmade (or not), useful object adds to individual happiness and helps to create a better society. In industrialized societies, the "arts" are always in ascendance, becoming more abstract, while the "crafts" are always "disappearing" as a condition of mass production. The recovery of the "crafts," and the enfolding of a notion of "arts" within craft, were thought a necessary – and a necessarily futile, one might add – attempt to recover old values, non-alienated forms of labour, old ways of forming a community, old ways of being human. The aesthetic positions of arts and crafts movements addressed what the world of everyday useful things looks like, how they are made, distributed, etc., as moral issues. The handmadeness of craft is its virtue and ethical efficacy. The utopian quality of craft grows in proportion to its failure to displace mass production. The notion that the beautiful and harmonious ought to be embodied in everyday objects took some of its authority from the belief that ancient and primitive societies were saturated by characteristic styles, styles that sprang

from a bond to nature itself. In ancient Egypt, medieval Europe, or old Haida Gwaii, every made object, edifice, and dress looked the part and revealed the whole. In the modern world, however, the disparateness of things indicated a shattered relation to nature and severance from invisible spiritual realms. But the arts and crafts could repair the broken modern world. Thus, there is an ideological nimbus around the idea of craft – evidenced in concepts such as "beauty" and "betterment" – that perhaps shows most starkly when the arts and crafts, in addition to being asked to mend the world, are asked to represent national values, assert cultural essences, and guarantee traditions.

When Europeans encountered the people of the Northwest Coast, they began to document, exploit, destroy, conquer, exterminate, assimilate, educate, reform, and imprison. The Europeans wanted the land and the resources for themselves. But, tentatively at first, more aggressively by the end of the twentieth century, Europeans wanted the arts and crafts of these people whom they otherwise regarded as inferior. They understood through a romantic, classicizing, late-empire lens that Native art was a poetic deed to ownership of the land. How paradoxical that so much of Native arts and crafts production was devoted to exactly that task, establishing title, ownership, and legitimacy (see Ḵi-ḵe-in, Chapter 22, this volume; Kramer, this volume). On this issue, there was an unknowing agreement about the extra-aesthetic value of Native arts and crafts.

Sometime in the late 1960s or early 1970s, a long-standing modernist fancy for crafts evaporated. Art galleries, which had heretofore integrated both craft and design into their programs, banished both, and "art proper" asserted its almost complete hegemony over these spaces and institutions. Artisan skills were sharply devalued in art schools and galleries. No doubt the full workings of this would be best discussed in the context of the rise of conceptual art. What is interesting is that at this very moment, in British Columbia, as the pottery and weaving exhibitions were vanishing from museum exhibition schedules, the "artifacts" of First Nations cultures – handmade demonstrations of artisan skills – appeared in the art gallery under the arts and crafts category of "the well-made object." In short, values that were otherwise in artistic eclipse found safe refuge in First Nations art. All these artistic values have correspondences on the ideological spectrum: highly crafted European art is "conservative," and conceptual, casual gestures are "radical," for example. Except in places such as British Columbia, where they are inverted in the First Nations struggle against colonization ... or are they?

It was once common to say that the 1967 *Arts of the Raven* and 1974 Bill Reid exhibitions at the Vancouver Art Gallery marked the arrival of a renaissance of West Coast Native art and its long-delayed recognition as Art, or art proper, by

the world (see Glass, this volume). It is now clear that what seemed like a dying tradition from Reid's point of view did not necessarily appear so from other vantages and that the "decline" part of the story, an essential prelude to a narrative of renaissance, was not universal and, perhaps, not so steep. We know now that the "arts of the raven" are not a unity, that Haida art is very different from Nuu-chah-nulth art. Furthermore, the cultures at issue are not and were not circumscribed by jurisdictions as recent as Alaska, British Columbia, and Washington State. We also know that, despite the arrival of Native art in the art gallery, it would be a few more decades before it was asked to stay. Not until the 1980s did the Vancouver Art Gallery itself actually begin to collect and research the history it so spectacularly and successfully exhibited in 1967.

My selections for this anthology concern the period before these exhibitions, specifically the first part of the twentieth century. More precisely, I am interested in the effort to use Native arts and crafts to promote other values and agendas than art for art's sake. But I am, a priori, interested in art, the careers of artists, and understanding the range of their activities and work. The art history of Northwest Coast Native art itself in this period has yet to be written, by which I mean there are no art historical monographs on any artists of the period. Recent books by Leslie Dawn (2006), Ron Hawker (2003), and others are creating a new understanding, with new research into the discursive uses to which some Native production was put by interests as vested as government and anthropologists/collectors, to say nothing of educator/missionary collectors. It is impossible to isolate this history from the history of "European" art in the same region. The relationship among cultures, the "ownership" of the land, and the fate of Native arts and crafts is, after all, the subject matter of British Columbia's pioneer modernist, Emily Carr. Her febrile attempts to make craft from Native design [12. XVIII] are collected and coveted today because they still tell Canadians that it is possible to own this land by appropriating Native design. For the first half of the twentieth century in British Columbia, the crafts were dramatically instrumental as both tools of oppression and tools of liberation. They were deployed in programs of forced assimilation, yet they were also used to advance legal and land claims as well as reinvigorate outlawed cultural and political practices. Besides their considerable and much celebrated aesthetic value, their dramatic double-sided historical context makes them highly charged with issues that have still not been resolved at the beginning of the twenty-first century. One might argue that the construction of their aesthetic/artistic worth is both enhanced and vexed by these historical circumstances.

The tangle of notions named by words such as *art* and *craft* is sometimes said to be foreign to the traditional cultures of the coast. But surely these terms circulated

as freely as steel tools and enamel paints by the nineteenth century, whether or not they were attached to the masks, rattles, bowls, baskets, weavings, mural paintings, jewellery, couture, regalia, etc., produced by Native artisans. Charles Edenshaw certainly thought of himself as an artist, and his work was distributed as such. Edenshaw worked at the end of the period that some argue was the height of coastal art.

For the first half of the twentieth century, the potlatch was outlawed (1884-1951), driving the traditional context for the display and exchange of art objects underground (see White, this volume; Cranmer Webster, this volume). The non-Native use of Native arts as tourist curios had another effect on production. The "best" objects had been made for potlatch and other events. They were part of the culture that the government of Canada was trying to destroy. The curio industry was, however, encouraged (see Hawker, this volume). It introduced piecework pay for carving modest replicas or variations of more important things. The commissioning of art objects was rare – but not enough is known about this market. Nor has much attention been paid to hybrid objects, things a cut above curios. The artist Charlie James, known for his totems and paintings, also made high-end furniture with Kwakwa̱ka'wakw designs in the 1920s. As late as 1949, Salish weaver Mrs. Jim Joe worked with Catherine Wisnicki to make a modern chair for the Vancouver Art and Living Exhibition. Hybrid objects would include Emily Carr's faux Native productions, Harlan I. Smith's plaster casts, potter David Lambert's 1950s production, Alice Ravenhill's twee needle-points, and much, much more. Meanwhile, around the same designs and mo-tives, Native artisans produced both tourist curios and high art; the former was encouraged, the latter criminalized unless put to the service of the state. The artists who negotiated this dangerous and contradictory minefield ought to be more studied and celebrated.

By the mid-1930s, advocates of the use of Native arts and crafts to both regu-late Natives and give British Columbia a romantic "haunted" landscape – people such as missionary/collector Reverend George H. Raley – were complaining that pastiches of Native arts and crafts souvenirs, made in Japan, posed a serious threat to an already fragile local industry (Raley 1935, 999). By the end of the 1930s, a group of "do-gooders" led by Alice Ravenhill, a Victorian educator/eugenicist/émigré, formed a society to protect and promote Native arts and crafts [14.VII, 14.VIII]. This BC Indian Arts and Welfare Society (BCIAWS, es-tablished in 1939) even encouraged young artists in residential and day schools through scholarships and exhibitions (Figure 13.1). It may seem paradoxical that these institutions, mandated to assimilate Native children into the labouring classes of Canada and to erase Native culture, language, and land claims, would

# CHART I

Paintings

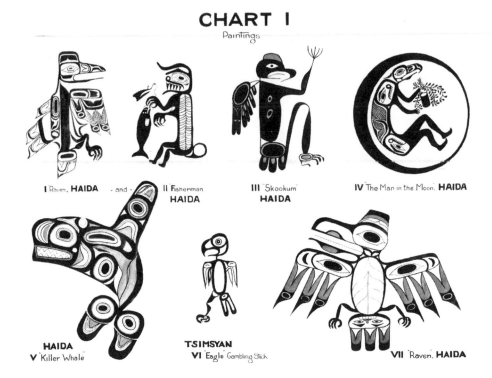

I Raven, **HAIDA** - and - II Fisherman **HAIDA**

III "Skookum" **HAIDA**

IV The Man in the Moon. **HAIDA**

**HAIDA**
V Killer Whale

**TSIMSYAN**
VI Eagle Gambling Stick

VII Raven. **HAIDA**

**FIGURE 13.1** Alice Ravenhill, an educator, author, and founder of the British Columbia Indian Arts and Welfare Society, published these designs, which were later used by Bill Reid in his jewellery making. From Alice Ravenhill, *A Corner Stone of Canadian Culture: An Outline of the Arts and Crafts of the Indian Tribes of British Columbia* (Victoria: British Columbia Provincial Museum, 1944), BC Archives, AA-00162.

promote Native arts and crafts. But here theory was enacted in practice: ideas of "design" were instrumental in detaching art from culture in a specific institutional and legal context. Design was intended as an instrument of cultural genocide. The children were certainly not encouraged to sing, dance, perform theatre with masks, or potlatch. Rather, they were asked to abstract "design" from objects in museums. These objects had been codified in charts produced by the redoubtable Ravenhill (Figure 13.1) and distributed to schools. On the eve of the lifting of the potlatch ban, and in the shadow of World War II, the BCIAWS and the Provincial Museum held a conference at the University of British Columbia (1-3 April 1948). The session "Arts and Handicrafts" is a key document in the history of Native arts and crafts in this province [13.1], and the paper by Ellen Neel, labelled a "woodcarver," is the most revealing and eloquent statement we have of the situation for Native artists and craftspersons circa 1948. The discussion that followed brings to light some of the complexity that animated the non-

Native desire to foster and regulate Native art. As well, a Nanaimo carver, Leslie John, tells us in plain terms what the economy of craft production was like for most producers. As far as I know, these are the earliest texts we have by Native artisans in the twentieth century.

The idea that Native design could be used on non-traditional objects as ornament is probably as old as contact. Although behind the hermetic seal we call contact, what would a non-traditional object be? The notion that the designs on Northwest Coast museum objects could be used to stimulate a design industry is a twentieth-century notion. An early advocate was the American Esther A. Coster (1916), who advocated for the use of Native artifacts as source material for "modern crafts." The American models for an industrialized Native craft industry are discussed at length in Hawker's *Tales of Ghosts: First Nations Art in British Columbia, 1922-1961* (2003). As early as 1917, Harlan I. Smith, working for the Canadian Geological Survey, advocated that Native art be sourced for wide industrial design applications. He developed this idea further in *An Album of Prehistoric Canadian Art* (1923) [13.II]. The significance of his research and position was that he tried to present a picture of precontact Native art. Smith thought it "free from European tradition and so leads to new ideas." His view represents the most extreme use of Native art to reach back to time immemorial to imagine a chthonic beginning of an imagined Canadian race. His work is in concert with the mélange of nationalist and racial fantasies found in F.B. Housser's *A Canadian Movement: The Story of the Group of Seven* (1926). The 1927 National Gallery of Canada *Exhibition of Canadian West Coast Art — Native and Modern* argued for the industrialization of Native design but did not insist that the designs be prehistoric [12.VII, 12.VIII]. The section devoted to "Indian Arts and Crafts" in the 1951 Massey Commission report sums up the positioning of white advocates at the time [12.xx]. It plainly articulates the argument that Native people have an innate capacity for design, emphasizing the creation of the new, rather than the purity of tradition. This part of the Massey report did not result in any action.

Locally, in a 1936 newspaper article, George Raley might have been the earliest to publish a call for Native crafts to be put to the service of creating regional identity [13.III] (Figure 13.2). Raley campaigned seriously for government support of a plan to industrialize Native crafts as the centrepiece of residential school education. The arcane, now quite "dead," voice of empire can be heard in the Smith [13.II], Raley [13.III], and Ravenhill [13.IV] selections. It is the voice of Neel [13.I], ironically speaking from the culture then positioned as dying, that now seems most "alive" and most informed about the issues.

**FIGURE 13.2** Reverend George H. Raley, a United Church minister and residential school principal, collected Northwest Coast art, particularly textiles. Royal British Columbia Museum, PN 22635.

For the non-Native advocates, "design" is to be detached from objects and their contexts (which we must remember were illegal during this period) as a multivalent potential resource. The designs, they supposed, having sprung from nature, like all primitive art merely mediated by its makers, could be used to stake "psychic ownership" on the "wilderness" land of Canada. In a somewhat similar vein, Native designs offered a demonstration of ancient Indigenous culture that could be used to brand Canadian commodities for international trade. While such notions seem deserving of the dustbin of history, they live on. One

sees them in the Vancouver International Airport, where the idea survives that Native art can be used to define and inflect a place otherwise flattened by a rapacious resource industry that still does not recognize the politics and territorial claims of the makers of the objects on display. One sees them in the Rodinesque posthumous exfoliation of the work of Bill Reid. Ironically, one sees them in the chocolate lunar heads designed by Robert Davidson for shops not otherwise given over to cannibalism.

**13.I. Ellen Neel. 1948. Presentation to the Conference.** In *Report on Conference on Native Indian Affairs at Acadia Camp, University of British Columbia, Vancouver, B.C., April 1, 2 and 3, 1948.* Edited by Harry B. Hawthorn, BC Indian Arts and Welfare Society, and BC Provincial Museum. Victoria: BC Indian Arts and Welfare Society. University of Victoria Archives, BC Indian Arts Society Fonds (AR018), Acc. 1991-085, file 3.20.

The BCIAWS conference on Native Indian affairs at the University of British Columbia (1-3 April 1948) opened with a session on arts and handicrafts. Ellen Neel's (1916-1966) remarks are often quoted; her eloquence is a touchstone of the period. Including some of the proceedings that framed Neel's speech displays the interested parties, including anthropologists, church leaders, government officials, and Native groups. Neel was described as a "woodcarver" or "skilled woodcarver" rather than an artist or businesswoman. Her modernity was at odds with the project to salvage an authentic Native art. But for those interested in the salvage project, she had a simple solution – lift the potlatch ban.

The discussion and recommendations that followed were utterly deaf to this suggestion though interesting since they revealed the acute cultural and economic anxiety projected onto Native art in British Columbia circa 1948.

CONFERENCE ON NATIVE INDIAN AFFAIRS

Held at the Youth Training Camp, University of British Columbia, April 2-3, 1948

*April 2nd, 1948*

*MORNING SESSION: ARTS AND HANDICRAFTS*

Chairman: Mrs. A.J. Tullis, President, B.C. Indian Arts and Welfare Society, Victoria. Spokesmen: (10 minute talks)

Mr. A.E. Pickford, Anthropologist, Provincial Museum.

Mrs. Mildred Valley Thornton, Contributor, Vancouver Sun.

Mrs. Ellen Neel, Skilled Woodcarver.

Mrs. J. Godman, Convenor of Handicraft Marketing, B.C. [Indian] Arts and Welfare Society.

*Dr. H.B. Hawthorn, Professor of Anthropology, University of B.C.*

The University of British Columbia extends a sincere welcome to all who are present at this conference. The topics of discussion are the needs of the Native Indians of B.C., and the outcome of the discussions should be a guide to meeting those needs. The idea of such a conference was conceived by the B.C. Indian Arts and Welfare Society; and here today, responding to the Society's invitation, are church leaders, officials of the Branch of Indian Affairs, others interested in Indian Welfare, and, most important of all, representatives of the Native Brotherhood of B.C., of the North American Indian Brotherhood, and other native Indians of British Columbia. It is from you, the Indians of B.C. that the best statement of your needs can come, and the others are gathered in the expectation of hearing this. It is first of all to you that those working in this field will want to address their statements of what they are doing and what they hope to do. For you are the people who will wear the shoe. You alone can say where it fits and where it needs to be changed. And I am confident that you will get results. For in my brief experience of meeting many of the people concerned with the welfare of the B.C. Indian, I have found them to be sincere and unselfish. I have found that they are in this work for the good they can do, and I have not seen anyone getting rich from it. Within the limits of their capacities they will put support behind what the Indians themselves want to do.

*Mrs. Ellen Neel – Woodcarver, Vancouver:* When people talk of my work – it really isn't just mine. My husband helps, and the children are all interested, and it is really a family enterprise.

During the tine I have been selling some of my work and in the course of meeting some of the people who deal in Indian Art work, I have come across some very odd ideas concerning it. When I was asked to speak at this Conference, I saw a golden opportunity to present my side of the picture. Although I haven't sufficient tine to quote exact references, I should like to say that each statement has been fully checked against recognized authority, and is historically true. There is no doubt as to their value to my point, even if the inference I draw be unconventional. This point of mine which I shall endeavor to illustrate deals with an idea that the native art is a dead art and that efforts should be confined to preservation of the old work. To me, this idea is one of the great fallacies where the art of my people is concerned. For if our art is dead, then it is fit only to be notified, packed into mortuary boxes and tucked away into museums. Whereas to me it is a living symbol of the gaiety, the laughter and the love of color of my people, a day to day reminder to us that even we had something of glory and honor before the white man came. And our art must continue to live, for

**FIGURE 13.3** Kwakw<u>aka</u>'wakw artist Ellen Neel (right), niece of carver Mungo Martin and an artist supported by the British Columbia Indian Arts and Welfare Society, presents one of her famed "Totemland" poles to ballerina Maria Tallchief. Vancouver Public Library, photograph #62660; © 1961 Vancouver *Province.*

not only is it part and parcel of us, but it can be a powerful factor in combining the best part of the Indian culture into the fabric of a truly Canadian art form.

When the white man came we had a full and complete art form. Our method of production, however, was a different matter. Slow, tedious, heart-breaking labor went into everything made. Huge cedars were laboriously felled by the chopping of two grooves one above the other with tools made of clam shells and sharpened stones, then splitting off small pieces between the cuts with wooden mallets or clubs. As much as three months was sometimes required to bring down one of these forest giants. After the log was felled and floated to the beach, the carvers began their work. With fire, clam shells and adzes, they wrought their art. For sandpaper they used

tanned shark's hide and the figures took shape gradually under their expert workman-ship. As much as ten years was spent on a single pole.

Then the white man came! He brought with him saws, axes, and hatchets; steel chisels and knives; white, red, green, yellow and black paints. No involved question of propriety was raised as to whether or not the new tools should be used. Rather they were seized upon avidly. And with startling results. With them a tree could be felled in a day. The carving took a quarter of the time; and the paints allowed a wide range of expression not previously possible.

The Golden Age of totem art had arrived. Totems sprouted on every village beach. Chiefs vied each with the other in giving of potlatches. This made work for the artists who flourished now and plied their trade. New forms evolved. In some cases gro-tesque, caricatures, figures of priests, flowers and famous historical figures, such as Abraham Lincoln, were carved into poles. In short the *art was a living art*. New tech-niques were adopted; new material was incorporated; new ideas were welcomed and used. I can find no instance where an idea, a material or a tool was not used simply because it had not been used before.

Unfortunately then began a period in which this growing and living manifestation of my people's artistry was partly destroyed. Because of economic and religious factors too numerous to examine at this time, an attempt was made to suppress the potlatch. This suppression of the potlatch emasculated the creative ability of the whole race. The production of art was so closely coupled with the giving of the pot-latch that without it the art withered and died. Were it not for the interest created by Universities, Museums and the tourists trade we would not have any people capable of producing any of the art. We are gathered at this Conference to attempt to bring about, amongst other things, a resurgence of the creative ability of the Native people. I emphasize at this time my point, and here make it also my plea, if the art of my people is to take its rightful place alongside other Canadian art, it must be a living medium of expression. We, the Indian artists must be allowed to create! We must be allowed to use new and modern techniques; new and modern tools; new and modern materials. For in every instance creative capacity has followed the discovery and use of better material. I do not mean that we should discard the old, only that we be allowed to use the new. Amongst the Indians there is no phase of life, no useful article to which the art was not adapted; there is no phase of life today to which this art cannot contribute.

I should like at this time to examine briefly some of the problems I have met in attempting to produce my work. In my family carving was a means of livelihood. My grandfather was Charlie James the famous Yakuglas. He carved for over 40 years. To his stepson, Mungo Martin he taught the rudiments of his art, and we his grandchildren were brought up literally amongst his work. Totems were our daily fare, they bought our clothing and furnished our food. There was no problem of sale, since his work

was eagerly sought. Now the situation is different. Curio dealers have so cheapened the art in their efforts to satisfy their desire for profit, that I doubt if one could find a single household where the authenticity of the work is important to them. I have striven in all my work to retain the authentic, but I find it difficult to obtain even a portion of the price necessary to do a really fine piece of work. This being so, I do not blame my contemporaries for trying to get enough for their work to live on, even though I believe they are mistaken in cheapening their heritage. Certainly a great work could be performed amongst the Native people if a true appreciation of their art could be instilled into the general public. Only when there is an adequate response to our efforts to retain the best of our art will it be possible to train the younger generation to appreciate their own cultural achievements.

As to the application of the art to everyday living, I believe it can be used with stunning effect on tapestry, textiles, sportswear, and in jewelry. Small pieces of furniture lend themselves admirably to the Indian designs. Public buildings, large restaurants and halls have already begun to utilize some of the art.

In short we need only to have some sort of organization to which architects, builders and manufacturers could come to guarantee authentic reproductions. Both my husband and I stand ready to contribute what we can to any group furthering these aims. We have plans we are willing to share. We believe that the Indian people as a whole would also gladly share if only the dignity and the honor of their personal crests and totems could be preserved.

And so we look confidently to the future which must bring a fuller, a better, a more dignified existence to the Native people of Canada, and I personally look forward to being part of the movement which brings these things to pass.

*Mrs. Tullis:* How do you select and standardize your work?

*Mrs. Godman:* The Society has a trade mark. The Indians send in, for instance, baskets, and anything over $5. I put a trade mark on it if it is up to standard. It must have a true Indian design and must be truly Indian. If it comes in with a rose or a butterfly, or some bird I've never seen, I do not put the trade mark on it. Anybody who buys it knows that it is up to standard when it has our tag, and the Indians too are coming to know the meaning of the tag. Good workers like Mrs. Neel, and Mr. John have the benefit of the trade mark.

*Mrs. Travers:* I have been wondering: has there been any thought of having the Indian people pass on the knowledge of their craft and uses of materials to the white people?

*Mrs. Godman:* I am very much afraid that our patience is not of the variety which would carry on. To make a rug, for instance, takes from 5 weeks to two months. I feel that there are not many things we would really like to make. Baskets are made and

worked wet, and therefore the older workers' hands have passed the stage where they can work baskets.

*Mr. A. Walsh:* There are one or two points I should like to bring out. This Youth Training School of the U.B.C. should be thrown open to Indian craft workers – young boys and girls with Indian carvers, weavers, etc. as instructors.

Marketing the Indians' work might be tied in rather closely with the wide publicity given to the National Parks across Canada. I think that the Department of Mines and Resources should be able to get some estimate of the type and quantity of goods which could be handled in this way so that the Indians would be given an opportunity to complete work on the orders in the winter for traffic in the summer.

The Indian boys' and girls' outlook of the past is lost under the modern system of education. Great people of older days – the orators, craftsmen. If these boys were to be given opportunities in art, drama, at this school here, we would take a big step forward in helping the Indian people.

### DISCUSSION

*Miss Bennett – representing Women's League for Peace and Freedom:* I feel that the people who have been speaking are artists, whose art is more precious than life. It is a crime to sacrifice people for art. The artists are taking over, and therefore an ordinary scrub person has to speak. Art must be used to improve the living of the Indians. We must not sacrifice the Indians in order to keep art artistic. There has been a movement towards mass production in other artistic fields – the great orchestras, etc. are evidences of mass production. Art must be stream-lined in order for it to redound to the welfare of the Indian.

*Mr. Walsh:* This group wouldn't be meeting today if it weren't for the art of the Indian. It has been the one approach for interpreting the culture of the Indian people to the public.

*Mrs. Thornton:* Creative artists in my opinion cannot be streamlined, and art must be made available to all. Therefore try to get the Indians to use the artistic designs for practical purposes, that they may be utilized and appreciated by all people. Keep art pure, and yet keep it available, useful and practicable.

*Dr. H.B. Hawthorn:* I think we agree on the value of art for all people who have the talent, and, further, that with some it might be developed so as to be saleable. Yet I am told that very few Canadian artists can make a living on art. We are proposing to foster and keep alive the teaching of art to Indian children. Are we heading them on to a source of livelihood? Or are we heading them on to a living where they make $1, $2, or $3 a day. I asked some young men why they did not learn the arts of the old

people. They pointed out to me that the old people were making at best $2 to $3 a day, in return for arduous and exacting work.

*Dr. Erna Gunther, Anthropologist, University of Washington:* I feel strongly that Indian art should be kept at a high standard but also realize the economic difficulties in creative art. All our artists find it extremely difficult to make a living. Indian art is a leisure time activity: something that will make an Indian man a supplementary income. A man could make his main living at fishing, say, and could carve in the winter when he is not fishing. He can occupy his leisure months economically and advantageously and yet not depend on his art for his main support. In that way it would probably keep his art on a higher plane than if he were making his living at it. During the slack period of the economic cycle he could be keeping up his art, and he would love something to do in such months. Economic organization is such that we do not have an outlet for Indian art to make them self-supporting. But if we stress art as an educational thing, not only concerned with economic value, but as something they can do with their hands, and in which they express themselves, then not only does the artist benefit, but so does the society in which he lives.

*Mr. H.E. Taylor – Indian Agent, Vancouver, B.C.:* I have had a lot of experience – 20 years – of collecting Indian art and taking it to exhibitions. We must guard against mass production. As soon as you get into mass production you will get away from art. As I understand it, art is an expression of the individual and must come from within. Any addition to native Indian art has to be approached warily. An Indian I knew entered into a contract to produce 100 small totem poles. After he had carved about 30 he was ready to give a large scream and jump into Burrard Inlet. He got fed up. He couldn't sit all day making totem poles for 40 or 50 [cents] a piece. Another time we contracted for 150 napkin rings of birch bark. These were made at 5 [cents] each. There was no art to them. The artists made very little money at it. During the depression when there was no other source of income the Indians had to rely on their art. As soon as wages went up production of articles fell a great deal. They could not afford to sit at home when good wages could be made in the field.

The price of hand-made articles is a deterring factor in their sale. A few years ago we approached the C.P.R. to have them sell gloves, moccasins, etc. in their hotels and depots. A considerable amount of labor is involved in making a pair of gloves. The skin has to be tanned and then worked with beads or embroidery. And in ordinary times you couldn't get more than $2 or $3 for a pair of gloves which involved two days labor. The same thing applies to baskets. Originally this was a utility article. When the white man came along with buckets, and baskets were no longer needed for utility purposes, they couldn't get anything like the price to repay them for the labor involved. It might be a suggestion to discuss the market for gloves and moccasins with the Games Branch.

*Mr. Leslie John, Nanaimo, Carver:* The price of totem pole, I make less than $1.00 a day. If lucky, make $1.25. The more cheap ones – 35 [cents] – make $2.50 a day. That is why I make few well carved totem poles – cannot make more than $1.50. Fishing on the coast was only 3 weeks last year. Don't make enough money in fishing. We might wish that fishing could be every day. I am not feeling well, and my mother is in the hospital. My father is not well. My older brother had a broken back when small. Just my younger brother – 17 years – who is in the woods, and me, to make a living for the family. All we do now is to make totem poles, for a living. You can't make much on totem poles. On good poles you can't make a living and that is the reason we do not make any for the Welfare Society.

*Miss E. Edwards – Seattle:* I am interested in the authenticity of design. But we are looking at one thing when we should be looking at two things. One thing is art. Making a living is another. Children in school would learn art as any other art train- ing. Making a living is something else. But this art can be utilized. An Indian can use his carving ability to make cabinets. He can build good houses. With training he could be a good architect. His art could be developed along practical lines in Vocational Schools. He can use his ability in wood carving and with woodworking materials. He could learn in school the first steps in planing lumber. His ability could be developed and utilized in electrical fields as well.

*Miss E.M. Bruce – Victoria:* The Indian Arts and Welfare Society's definition of authentic art would stop at a particular time, whereas according to Mrs. Neel's state- ment it must be living in order to be art. Can it not move up to the present time and have other forms included in it?

*Mrs. J. Godman:* We must go on with art. We must produce modern art. I feel that any new good art should be included. There should be a committee to pass on it for general use.

*Mrs. Ruth Smith, Editor,* The Native Voice, *Vancouver:* We are forgetting something very important – the protection of Indian arts designs.

*Mr. G. Wilson:* Designs are copyrighted in jewelry work in the SW United States and that prevents cheap imitations. Would it be possible to have the Department of Indian Affairs look into this matter?

*Miss E. Edwards:* Under copyright laws you can get a copyright and someone else can take it, and put another whisker on the cat, and your copyright is useless. There is a lot of pilfering in this regard in the United States. Social calls have the main purpose of stealing one another's ideas. If you buy an article for the mark on it, you know who

has made it, but it doesn't prevent manufacturers from changing the article slightly and putting it on the market. It means that Indians should do superior work, and that the public should be educated to the right thing. I think you have to educate the public to your stamp. In the United States articles are stamped with Genuine Indian Hand-Made, but this is abbreviated to Indian Hand-Made and thus unauthentic substitutes pass for the real thing. The stamp shouldn't be too long.

*Mrs. J. Pelton, Member of Native Sisterhood:* A great many children in native villages are encouraged in this craft work. The men are engaged mainly in fishing and the women spend a great deal of time at home. They do beautiful handwork. In one village they gave their work away, mostly a contribution to Red Cross. Native design was not encouraged, and mostly it was a Canadian design and very little of their own. There was not even an authentic design in the village. The President, Miss Ravenhill, showed them how to reduce their native designs and use them in embroidery etc. Unless our teachers encourage this native design we won't have any future artists.

*Miss M.C. Johnson – Department of Social Work, U.B.C.:* I am most impressed with the feeling of the Conference. With regard to the designs I am reminded of a situation in Eastern Canada when working with New Canadians. Our difficulty was with the younger generation who felt these designs of their parents were something to hide – they wanted something new. We must help them to be proud of their heritage, and become individuals in their own right. Handicrafts are a valuable asset to those in the T.B. hospitals. We have to get enough people who are interested to push this over the top – not simply teachers but people in every avenue. We must help these people to develop their designs and their crafts.

*RECOMMENDATIONS*

*A. Arts And Crafts*
1. Marketing of Handicrafts
   In view of the fact that the B.C. Indian Arts and Welfare [Society] has carried out a sustained experiment in the marketing of Indian Arts and Crafts, we recommend that the Society prepare an evaluation of the experiment with suggestions as to the possibilities for future development and expansion, and that these suggestions be submitted to the Indian Affairs Branch, Ottawa.
2. Sale of Crafts in National Parks
   We recommend that the Department of Mines and Resources be approached with the view of securing its co-operation in the fostering of marketing Native Indian Arts and Crafts through the National Park Service of Canada.

**13.II. Harlan I. Smith. 1923.** *An Album of Prehistoric Canadian Art.* Ottawa: Victoria Memorial
Museum, 1-2, 3, 4-5, 6, 30, 62. © Canadian Museum of Civilization.

Harlan I. Smith's (1872-1940) fantasy of isolating a precontact Native art, un-
contaminated by contact, and then deploying this uncontaminated art to guaran-
tee a Canadian claim on its territory was extravagant to say the least. However,
it is difficult to see how the fine drawings that Smith published could furnish
models for modern design as it was understood in Canada circa 1923.

> Motives for Canadian manufactures are now urgently needed by the many industries
> that are obliged to use designs and trade-marks in producing manufactured articles.
> In some cases the conditions brought about by the war have cut off the sole supply of
> industrial designs. The designs for many industries, such as the textile trades, were
> almost wholly of foreign origin. Consequently, Canada relied on foreigners for them
> and the war having exhausted the energies of many of the European designers, the
> supply has been inadequate. New designs are constantly required and manufacturers
> have been compelled to turn to other sources for them. American designers as a result
> realize, more than ever before, the wealth of motives for designs to be found in North
> American museums among the prehistoric and historic collections of the handiwork
> of the peoples of various countries. Prehistoric Canadian art has been so little applied
> to modern commercial uses that almost all of it is new to the trades and useful to
> commercial artists.
>
> The designs that have been used are almost all based upon motives from Greek,
> Roman, and other European art, and consequently are not distinctively Canadian.
> Owing to the war and the great debt that all the nations have been obliged to assume,
> the competition in manufactured articles with which to pay those debts will be intense,
> and Canada, with its small population and relatively high cost of production, cannot
> successfully compete by duplicating European articles; but must offer for export prod-
> ucts of purely Canadian design, somewhat after the French idea of distinctive styles.
>
> It would seem that the early Indian art of Canada might well serve as a suitable
> starting point for manufacturers in the production of distinctively Canadian designs.
> Not only practical commercial designers, but psychologists also, agree that designs
> cannot be developed without a suitable motive, and that such motive is a most difficult
> thing to get.
>
> This album is, therefore, a contribution to supply the demand that arose during the
> war. The specimens illustrated represent the earliest art of Canada. They are scattered
> in many collections from Victoria and San Francisco to London, Berlin, and Florence,
> as indicated in the legends and the list of collections given on page 18 *et seq.* Only
> some of them have been previously illustrated.

The drawings, which in most of the plates represent the specimens one-half natural size, have been made by W.J. Wintemberg and O.E. Prud'homme, both of the Victoria Memorial Museum. Mr. Wintemberg acted as general assistant in the preparation of the legends, especially in the search for stray and obscure data.

The three hundred and eighty-nine figures in the eighty-four plates of this publication illustrate many different specimens, each showing one or more motives, in some single cases many different motives. Each specimen or every motive on each specimen may inspire, or give rise to, a great many designs. This is illustrated by the prehistoric work itself; for instance, the clubs made of whale's bone illustrated in Plates XXI-XXV. In these the motive is a bird's head capped by a mask representing a bird's head, and this single motive the prehistoric club makers have varied in all the different ways shown.

The series of specimens illustrated is practically a complete exposition of the prehistoric art of Canada, although it does not include all the simplest and crudest art, but only what seemed likely to be of use to manufacturers. It includes also objects – such as arrow-points and pestles – which are generally considered under other subjects than art in descriptions of prehistoric cultures of Canada. They are included here because they have beautiful forms, capable of inspiring useful shapes, designs, and trade-marks for manufactures.

Prehistoric Canadian art objects are found in all parts of southern Canada, that is, in all the parts from which we have adequate collections of prehistoric objects.

The prehistoric art of Canada, like the historic native art, may be classified at least into great groups. These correspond in a general way to the five great modern Indian culture areas of the country, which in turn coincide with five natural divisions, namely, the Pacific coast, the Interior plateau and Mackenzie basin, the Great Plains, the Eastern Woodlands, and the Arctic coast.

...

The art of each regional division as a whole is so distinctive that it can never be mistaken for that of another division by any person acquainted with the art of both. Much less can it be mistaken for the art of distant countries, such as Mexico or Japan. A part of it is common to the art of neighbouring regions, just as the maple and beaver symbols of this Dominion are found beyond the limits of Canada. Only a few pieces of very simple lines or pieces lacking distinctive characteristics might be mistaken for objects from distant places.

...

Prehistoric Canadian art is characterized by asymmetry in one of the three directions; that is, although obverse and reverse may be similar and right and left similar, top and bottom differ in about 99 per cent of the specimens. In this respect the prehistoric motives differ greatly from modern European designs. All is hand work

and so has not the limitations in character found in designs adapted to machine reproduction.

Prehistoric Canadian art has been called crude. Even if this were so, it might still be urged that good design is often evolved from or based on crude beginnings and artists are always searching for basic motives.

The simplicity and freedom of expression of prehistoric Canadian art is what modern craftsmen most need to counteract the tendency to over-decoration, mechanical technique, mathematical monotony, and lack of individuality. It is free from European tradition and so leads to new ideas.

In using motives from prehistoric art, attention must be given to the artistic value of the original specimen; the suitability of the motive to the material and medium to be used, pottery, leather, textiles, metal, wood, cement, etc.; the suitability of the motive to the size, shape, and use of the article to be decorated; the preservation of the original spirit of the motive; and the subordination of the motive to the designer's individuality. The designer may develop the motive by distorting it, conventionalizing it – as the lotus has been conventionalized into innumerable designs – duplicating it, dissecting it, combining dissections, and by various combinations of these methods.

The specimens may be considered as artists' drawings or models and some of them may be reproduced as they are. For instance, the clubs made of whale's bone illustrated in Plates XXI to XXV, may be reproduced as paper cutters; either end of these carvings may serve as models for umbrella and parasol handles; or, perfected in line, they may serve as models for knife, fork, or spoon handles. On the other hand, probably, the specimens will be of greater service if used merely as motives. They will also be of service to art schools in the study of the history of art, so desirable a part of the equipment of a commercial designer.

Designers may wish to represent another view of these specimens. Every artist interprets differently, and expert designers may often want to work from the original specimens instead of from the illustrations. In such cases the album gives a fairly complete idea of what prehistoric Canadian art has to offer and indicates the collection in which each specimen may be seen.

Financially successful use of museum specimens of prehistoric and historic aboriginal art from Peru, Mexico, the United States, Siberia, etc., has been made in recent years by the silk, cotton, and costume industries in the United States.

...

Museum specimens illustrating the art of the natives of America have long been well known and appreciated by students, but have now for the first time come to the notice of a large number of manufacturers who state that they will not again be dependent on foreign motives.

A greater number of motives for designs may be obtained from specimens collected from the modern Canadian Indians than from prehistoric objects excavated from ancient sites in Canada. The modern native art differs somewhat from the prehistoric. It has developed to a considerable extent. It includes other materials, such as silver and iron; and other motives, such as plant forms. These were probably not used until after contact with Europeans. It includes, also, painting, embroidery, applique, and tattooing on materials of perishable nature, such as wood, skin, and fabrics, not represented among the prehistoric specimens.

...

### BRITISH COLUMBIA COAST

#### *MORTARS MADE OF STONE*

Figure 1. Figure of beaver on a mortar made of stone; possibly modern. From Queen Charlotte islands, B.C. Haida Indian area. Collected by J.W. Powell, December 1879. Cat. No. XII-B-318 (76) in Victoria Memorial Museum, Ottawa, Canada; approximately ½ natural size. Note stick being gnawed. Front and rear views are illustrated in Plate IV.

Figure 2. Figure of a toad on a mortar made of stone; possibly modern. From Queen Charlotte islands, B.C. Haida Indian area. Collected by J.W. Powell, December 1879. Cat. No. XII-B-317 (74) in Victoria Memorial Museum. Ottawa, Canada; approximately ½ natural size. Front and rear views are illustrated in Plate VI.

...

### CLUBS MADE OF BONE OF WHALE

A general type of paddle-shaped club with carved handle knob is found on the north Pacific coast of America, from Alaska to Columbia river, but chiefly on western Vancouver island where the type is most uniform. A specialized form of this club and handle knob, known only from Kamloops, is illustrated in Plate XXXVII.

Figure 1. Club made of bone of whale. From Nootka, west coast of Vancouver island, B.C. Collected by Captain Cook. Cat. No. N.W.C. 42 in British Museum; ¼ natural size. After Figure 165a, Smith, Gulf of Georgia, 1907.

Figure 2. Club made of bone of whale. From Nootka, west coast of Vancouver island, B.C. Cat. No. N.W.C. 47 in British Museum; ¼ natural size. After Figure 165b, Smith, Gulf of Georgia, 1907.

Figure 3. Club made of bone of whale. From Nootka, west coast of Vancouver island, B.C. Collected by Captain Cook, 1778. In Ethnographical Museum, Florence; ¼ natural size. After Figure 165d, Smith, Gulf of Georgia, 1907.

Figure 4. Club made of bone of whale inlaid with abalone shell. From Nootka, west coast of Vancouver island, B.C. Collected by Captain Cook. Cat. No. N.W.C. 41 in British Museum; ¼ natural size. After Figure 165f, Smith, Gulf of Georgia, 1907.

**13.III. G.H. Raley. 1936. "Suggesting a New Industry out of an Old Art: BC Indians Revive Their Dying Skill to Become Revenue-Producing Artisans?"** *Vancouver Daily Province*, 9 May.

The idea that disenfranchised people, otherwise being torn from their communities, languages, and cultures by force, can be gainfully employed producing the very culture that is being beaten out of them is an old technique of conquest of Indigenous peoples. G.H. Raley's (1864-1958) proposal was simple: replace the economy of the potlatch with the economy of tourism.

We lift the curtain of history and mentally look down the corridor of time one hundred years and see ourselves on the shores of the North Pacific Coast, the home of the Indian. As traders taking our first trip up the coast and into the villages of the Interior, we have some qualms as to the kind of reception we are going to receive at the hands of the Indian tribes, though we are of pioneer calibre with sympathetic interest in the aborigines.

As we travel our reaction to the picturesque but crude life depicted in the villages is one of astonishment. For instance, in a village near Queen Charlotte Sound we come face to face with a culture unusual – different from anything else in the world. About thirty tribal houses systematically arranged in a row line the beach above the high tide mark, the largest of them painted in weird designs.

Proceeding in a northerly direction, we arrive at a village with large canoes drawn up on the beach and again the unintelligible art is apparent in carved figureheads on the bow, and painted symbols on the sides of the canoes. Strong lines, graceful curves, perfect symmetry and proportion are noticeable in the building of the canoes and indicate craft of perfect buoyancy and seaworthiness. Upon the invitation of the friendly natives we enter one of the tribal houses and in the dim light – for there are no windows – as soon as our eyes get used to the interior, we observe the same method of decoration is in evidence on weapons and articles of household use, but our attention is riveted upon massive posts holding up great beams. On these posts are carved what to us appear distorted human figures.

In our adventure, we cross to the lonely Queen Charlotte Islands about one hundred miles from the mainland. Here we see there has been an evolution in their art from the smaller to the larger and notice a forest of huge poles varying in size from twenty-five to eighty feet in height and from three to five feet in diameter at the base,

like grotesque sentinels guarding the village, facing the beach in front of the houses. These poles are covered with a variety of figures from top to bottom – hundreds of symbols suggesting a bold primitive heraldry, and embrace emblems of animals, spirits in human form, monster birds, spirit eyes, skulls, magic weapons and many other devices incomprehensible to us, evidently carved by masters of the art.

On further observation we notice another type of handiwork produced. The designs instead of being carved on bone, wood or stone, are interwoven patterns of basketry in bright colors. The basket makers express themselves in their work with infinite patience. While on the one hand some are coarse in construction, others are delicately conceived and woven as fine as twilled silk. In addition to the baskets, there is weaving in yarn spun from the wool of the mountain goat. In this, the "piece de resistance" is the Chilkat blanket woven first in British Columbia by the Tsimpshean Indians.

The realization comes to us as we continue our journey through the interior that the Indian, having no written language, is transcribing in the only way he knows, prehistoric stories of fascination and appeal. Nature, in British Columbia especially, has been lavish in providing material for Indian art and handicraft, and has always been a prolific source of inspiration to the creative mind of the Indian artist. Scientific research has since established the fact that the primitive art and handicrafts of the Indians have cultural features which symbolize natural objects in a mystic manner different from the symbolic art in any other part of the world.

We wonder, if we think at all, what has become of this weird work, the first cultural appreciation of nature by the first Canadians. Primitive and prehistoric it may be – but it is art.

Is it lost to Canada and the world of art?

PRIMITIVE CRAFTSMEN MAY WORK AGAIN

Has it become buried under the ruthless advance of our civilization, and did the advent of the white man cause its comparative extinction?

Perhaps, when the Indian first became conscious of the attraction to be found in "things white" he disregarded the former appeal in his own work, and was lured to the bright gewgaws displayed in trading-post stores. In this new enthusiasm he lost interest in his own carvings and weavings, until today we find few who perpetuate the art of their fathers. His cultural activities lost color and appeal in the face of the inhibitions set up by civilization. Gradually, through the influence of contact with other races and the evolution of the native mental attitude, the primitive work of the early days of Canada has dropped almost into oblivion. Not quite, however, for choice specimens have been preserved in the museums of Europe and the United States as well as Canada, and there are still living some skilled workers who take genuine pride

in manufacturing their own artifacts. Sufficient data has been collected, some research work has been done of recent years with the purpose of reviving interest in these all but vanishing arts, and the conclusion come to is that a renaissance is desirable, and it is neither Quixotic nor Utopian to believe that the native people of British Columbia would respond to a lead given by an organized effort to restore their primitive industries. There are valid reasons for an organized effort to revive and industrialize Indian handicrafts.

First – Because we are largely responsible for their decadence. In a mistaken zeal for our civilization when we first occupied the country, we tried to impress the natives with the so-called superiority of all things white, and looked upon things Indian as inferior with this result: The Indian tried to slough off his primitive industries, customs, habits and ethics.

Second – Because the future generation of Canadians will regard us short-sighted and self-centred if we neglect to save the remnant of a culture that is distinctively Canadian, but fast passing beyond the possibility of salvage.

Third – Because the Indian problem today is fundamentally economic and by placing Indian handicrafts on a commercial basis for the economic benefit of the Indians, we would restore cultural, congenial, hereditary occupation without competition and bring to a discouraged race a feeling of competence and self-support in the things they would be proud to do and do well. This in itself would be no small achievement.

There are obstacles, but not insurmountable. For instance, it is suggested that if a satisfactory market were found the native people could not produce in quantity sufficient to supply it. The idea is larger misleading. In these industries all he needs is to work. Nature provides the material, but like his white brother he needs some reward for his work. Hitherto, this incentive has largely been lacking. Supply the stimulus of reward for work and it will be found the Indians will measure up.

In a recent issue of the Toronto Saturday Night, Mr. Donald Buchanan, after referring to the special committee appointed by the Dominion Senate to give intelligent attention to the tourist trade, raised the question: "Can we not develop specialty trades which would supply the tourist with luxury goods individual to Canada? The handicraft industry in the Province of Quebec has made a beginning, both the railways and the Provincial Government have encouraged such developments. The time has come for the Dominion Government to interest itself in the wider aspects of this problem."

It is almost compulsory to continue the work of establishing this industry, inasmuch as there is nothing more individual to Canada than Canadian Indian artifacts as specialty trade in luxury goods and as souvenirs for tourists.

If properly organized, beautiful woven and sewn baskets could be supplied, miniature totem poles in wood, bone and argillite; carved bracelets in gold and silver, etc.

Take the totem pole industry itself. We have only to see the illustrated time tables of transportation companies to realize that tourists who come to Canada are "totem-pole minded," seeking just such souvenirs and are disappointed if they do not find them. This eagerness on the part of the tourist has been so vital that manufacturers have flooded the stores of the principal cities of Europe, the United States and Canada with spurious Oriental and foreign imitations, purporting to be Indian handicraft. Since the trade has proved so lucrative to the manufacturers of such souvenirs, it is not visionary to believe that if the genuine articles were for sale, the tourist trade in Indian art and handicraft would be increased in volume. Tourists want the genuine. Those from Europe enjoy the designs on the curios and are anxious to be acquainted with the cultural background of the Indians. These symbols, if properly explained, tell the tourist something of the traditional legends and the nature of the people whose feelings they express.

DESIGNS SHOULD BE PROTECTED BY LAW

There is another market for this industry other than the tourist trade, namely, that of the manufacturer in commodities where ornamental designs are used extensively and where there is a constant appeal by the public for a change in fashion in design and "ornamentation." Manufacturers the world over complain of the scarcity of available original designs for decorative purposes. Only last year His Majesty the King, then Prince of Wales, addressing a gathering of the Royal Academy of London, said: "Greater attention to the artistic side of industry or design in industry is essential if our manufacturers are to develop their domestic and overseas trade."

Indian designs can be adapted to make an attractive eye appeal in commodities in the textile, plastic and ceramic industries, in glassware, metalcraft, woodcraft, silverware and jewelry, leather goods, rugs, clothing, carpets and curtains, house decorations, furniture, poster printing, and in a hundred different industries. Canadian Indian designs could be adapted to advantage. To how great an extent we shall never know until they have been given a fair trial. They have never had a chance.

How shall we attain the objective of this article and build up in Indian communities self-supporting industries? Such a movement would come under the category of welfare work and as such has a definite place in the affairs of the government. The government, acting as trustee for the people of Canada and guardian of the Indian people, has the final decision as to whether it is in the national interest that official support should be given to a plan for the economic betterment of the Indians by means of their own industries, and if so, to what extent. Should the government in the exercise of its prerogative decide without delay to act in the matter, the future is bright with promise.

TO HELP INDIANS REHABILITATE SELVES

There should be a demonstration of enthusiastic effort on the part of all the friends of the Indians. This could be best effected by means of an organization which would be a vital and visible centre of influence where ideas could be suggested and get in motion, extending to the farthest point of need. It is proposed to establish a Canadian Indian Art and Handicraft League whose object would be to save Canadian Indian handicrafts and create atmosphere and what might be termed "Indian-mindedness" in the people of Canada towards Indian arts and industry and to inspire hope in Indian artisans who still maintain the primitive work, and encourage the newer generation of Indian youth, students and graduates of Indian residential schools in the production of Indian handicraft, and in an appreciation of them as an inheritance from prehistoric times peculiarly their own.

A further object would be to press for legislation which would protect Indian designs from exploitation for commercial purpose by other people than Indians. The league would interest manufacturers in Canada and abroad in the possibility of applying Indian design to useful and ornamental commodities. Such a league would promote modern schemes for displaying, advertising and exhibiting Indian craft and secure the best market possible for the same.

The main object of the league is to help the native people help themselves by the use of that which alone is left to them of their own aboriginal inheritance.

**13.IV. Alice Ravenhill. 1942. "Pacific Coast Art: The Striking Aboriginal Art of the Pacific Coast Indians Furnishes Plenty of Inspiration to Commercial Designers of the Present Day."** *The Beaver* (September): 4-8.

Alice Ravenhill (1859-1954) posed as an expert on Native art, partly to "help," partly to impress. She sent her needlepoint versions of local Native art to Buckingham Palace and was thrilled with a pro forma reply from the court of George and Elizabeth. The contradiction or tension between the idea that Native children have an innate artistic ability to produce authentic Native art and that authentic Nativeness needs to be mediated and regulated loomed large in her writing.

When the Museum of Modern Art in New York held its exhibition of American Indian arts and crafts last year, many commercial designers, as well as students of art, received great inspiration from the variety of forms and colours displayed. The exhibition was divided into two groups. In the first and larger section, nine hundred examples of Indian tribal arts were on view, including murals and other paintings; carvings on bone, ivory and wood; embroideries; quill and bead work; and a wide variety of weaving

and basketry. The second and much smaller group showed applications to present-day uses of these almost untapped sources of designs, collected from the Arctic to New Mexico.

The idea which prompted the organizers of this exhibition had been maturing for some time, awaiting a favourable opportunity to arouse public interest. As a matter of fact, such a proposal was brought forward twenty years ago by Harlan I. Smith, of the National Museum at Ottawa, when he pointed out in a bulletin that the early Indian arts of Canada might well serve as a suitable starting-point for manufacturers in the production of distinctive Canadian designs. And he backed up this novel proposal with practical information on how to overcome difficulties, concluding with a long list of outlets for their employment. The four hundred examples with which he illustrated his points he described as, "in themselves beautiful forms, capable of inspiring useful shapes, designs and trademarks."

The seed sown in this bulletin has germinated very slowly. Possibly the words "prehistoric" and "primitive" applied to art gave the impression of something crude, imperfect, coarse; whereas they refer merely to that period in a people's existence before the keeping of methodical, consecutive records known as history. The point, however, of immediate interest lies in the fact that one half of the eighty-four plates in this volume, which covers the whole of Canada, illustrate specimens from the coast of British Columbia. Here an individual and peculiar form of art, representing animal forms with outstanding skill, was evidently the result of a long period of development by unusually inventive craftsmen.

Much study has been given to these tribes and their arts since the days when first the attention of men was called to them by Captain Cook and his fellow explorers, Spanish and British, a century and a half ago. Their writings showed how intimate was the part played by the arts in every detail of those peoples' lives; but the deeply spiritual beliefs on which those were based were not realized for a long time. Nevertheless, the diaries of these men suffice to show the justness of a recently expressed opinion, that this remote edge of Canada is "one of the most outstanding centres of primitive art in the world."

Up to the present, the origin of this art, as well as that of the very complicated social and financial system with which it was linked, remains what Dr. Jenness of the National Museum recently described as "a mystery, though the spades of archaeologists may at any moment succeed in uncovering new and possibly unexpected clues."

It would be interesting to know, for instance, why these tribes alone of all North American Indians excelled in sculpture and painting of great brilliancy, and what led them to represent animal forms rather than geometrical or floral patterns. They chose the creatures familiar to them in their surroundings: the raven, eagle, hawk, frog, killer whale, bear, wolf, owl, and many more; but they also gave prominence to imaginary

forms, representations of the invisible spirits with which they believed themselves surrounded, and of whose origin and activities we learn something from the fascinating myths which survive.

With great ingenuity these Coast Indians fashioned the bulk of their utensils and implements, even their clothing and bedding, from the wood of the invaluable cedar, and turned stone to account for other needs. They had practically no metals until after contact with the Russians early in the eighteenth century, when the supply was limited to a few sheets of highly prized copper and a very few iron knives.

Thus those artists had to rely for their skilled work upon such unpromising substances as stone, bone, ivory, wood, horn, and a form of slate found only in Queen Charlotte Islands. Paints they prepared from certain ochrous earths, fungi or burnt clam shells; and for polish they used shark- or dog-fish skin or their own hands. Each man had to collect, test, and prepare all his materials, and devise how to surmount every technical difficulty. With the aid of stone adzes or highly treasured jade chisels they pecked, carved, incised, engraved, and inlaid the designs seething in their brains, with only the incisor tooth of a beaver or the tip of an antler for the finest details.

Fortunately, one form of their wealth consisted of richly decorated possessions, and this gave a great stimulus to all forms of their arts. These might consist of such objects as a huge painting of an ancestral adventure on the front of the owner's house, possibly measuring twenty feet by twelve (a custom which long preceded that of the more generally known totem or heraldic poles); or massive inside posts, sculptured with life-sized figures, to support the heavy roof beams. Around the walls might be soon handsomely carved chests, not only for storing everyday necessaries, but filled with highly ornamental equipment for tribal dances and secret society celebrations, and for gifts or display at potlatches or feasts.

Among these there would be elaborate chief's headdresses, sometimes inlaid with iridescent abalone shell, or his ceremonial batons, carved with mythical figures and painted with tribal colours. These were always used with restraint and confined to black, white, dull red, a little dark green or a copperish blue. There might also be buckskin cloaks, the borders painted in a series of delicately drawn birds in flight; and finely carved and polished ivory charms.

What some experts consider the highest development of Northwest Coast art undoubtedly found a place among these treasures in the shape of some of the masks used in ceremonial functions. They would include representations of mythical ancestors or beautifully contoured portraits; enormous bird or animal heads, some grotesque, others realistic or terrifying, with ingenious moving parts controlled by cords. These elaborate masks could move their eyes, open and close their jaws with a snap, lengthen or reduce telescopic noses, flicker quivering tongues or appear to transport themselves unassisted from one person or one part of the house to another. A mask

with the appearance of a bird or animal would split open to reveal a human face within or that of the sun or moon; and when those tricks were intensified by ventriloquism, and the masks were worn by weirdly costumed dancers in the light of flickering flames, they exercised exciting effects on an emotional people.

The form of Northwest Indian art most generally known is that of totem or heraldic poles. Actually it was one of the latest to appear, being long preceded by the housefront paintings already referred to. Those magnificent poles were chiefly used by the two wealthiest tribes, the Haida and Tsimsyan. Their near neighbour, the Kwakiutl, also used them to a lesser extent but never reached the degree of skill attained by the other two. They served the purpose of sign-posts, coats-of-arms, and symbols of the standing of their owners whose house they distinguished, and to which they sometimes formed the entrance through a circular opening in the base of the pole. The upper and lower of the three sections into which these poles were usually divided displayed the crests of the owner and possibly that of his wife, announcing by this means the rank held and the family clan or tribe to which the owner or his wife belonged. The intermediate section was generally filled with representations of an ancestor, or referred to a family myth.

The heraldic or totem poles are often confused with a very similar form of which the use was most prominent among the Tsimsyan – the memorial pole. This was erected after the death of the individual commemorated, often at a little distance from his former home. A third type, the mortuary pole, supported a large chest, in which were enclosed the remains of the dead chief; and the supporting portion was often elaborately carved with the crest of this individual, one of which always appeared on the side of the chest seen by passers-by.

Virtually every possession was decorated, and always with pride in the handicraft exercised, whether it was the wooden pail moulded with steam in which water was carried, or the domestic implements used by tribal women in their many skilled industries, or the wooden helmet or slatted armour of a warrior.

Yet so fertile was the imagination of this "nation of artists," so reliable their memories, so keen their observation, that their myriad representations of fish, birds and animals were rarely if ever duplicated. Selection for all decorative purposes was no careless or random choice. The design was often chosen to increase the efficiency or to suggest the object of the article in question. For instance the heavy stone or bone clubs used to kill large fish, such as halibut, after hauling them into a canoe, would be carved to represent a sea-lion or killer whale, who also killed these fish for food.

Most noteworthy and striking features of all these representations were their vivid realism, their "alive-ness," apparent in the pose of the head, the grip of the claws, the attitude of the wings or the expression of eyes and mouth; and yet they were both conventional in numerous details and definitely symbolic. Balance and symmetry in

design were never overlooked, though often ingenuity was called for to dispose of difficult details, such as fins or limbs, which often appear in the designs, in unexpected relation to the body of fish or animal; and much use was made of single or double curves to fill otherwise awkward corners or blank spaces; for it was customary to cover the whole surface to be decorated, whether the object was flat or round, curved or oblong.

In some cases the animal or bird would be split up the back and then flattened out, showing both profiles of the entire body; in other cases what may be described as a fore-runner of the modern X-ray photograph was employed, showing only the skeleton of the subject and occasional outlines also of the internal organs. Possibly the artist regarded these as equal in beauty and no less interesting than the more familiar external appearance. But though these tribes shared in a common technique and style of design, each was distinguished in its details by individual features, which forbid generalizations. This is one of the chief reasons why, even today, children of one tribe cannot reproduce the forms in which other tribes naturally excel.

For use as symbols these artists searched out the distinctive features of their many subjects and selected these as a means of identification. Thus for the mythical raven a long straight beak is the usual symbol. In the case of the eagle the beak has a downward curve, though quite often if two horns rise from the head it symbolizes a thunderbird and not an eagle. The hawk is known by a beak curved back into the human mouth which is often included; for seeing the intimate relation between men and animals, human features were constantly combined with those of the creature portrayed. Other identifying features are the large incisor teeth and flat scaly tail of the beaver; the large mouth set with teeth and often protruding tongue of the bear; the wide toothless mouth of the frog; the large, square head, round eyes and prominent dorsal fin of the killer whale; the upturned snout, and very small, usually upturned tail and slanting eyes of the wolf.

After the Russians made contact with the coast tribes in 1724, the great demand for furs brought new wealth to the natives. One result was an increase in the production of totem poles, for the newcomers brought with them a large supply of iron knives that greatly facilitated the carving of the huge cedar trunks. Unfortunately, when the missionaries came, they urged the wholesale destruction of totem poles and symbolic masks which they mistook for idols, thereby quite unintentionally cutting away the root of the sources of inspiration which possibly might have formed a link with the unfamiliar spiritual Deity to which they aimed to convert the (to them) depraved and ignorant tribes.

Most regrettably the development of the tourist trade has also resulted in the deterioration of Pacific Coast art. In its early stages it acted as a stimulus, for the few travellers who reached Queen Charlotte Islands, for example, desired souvenirs of

their adventurous journey. This led to the production of finely carved slate models of totem poles, or small, beautifully decorated slate chests, and encouraged quite exquisite engraving on silver bracelets. But as the demand grew, city stores began to stock inexpensive souvenirs, giving a stimulus to the mass production of cheap, inaccurate imitations of so-called totem poles. With characteristic acuteness Japan seized the opportunity to flood the local markets with goods that found a ready sale even when in keen competition with similar products from this continent. The results, like all "bad" art, were feeble, imitative, and lacking in technique. They pandered to the public demand for cheapness, and by taking advantage of the purchasers' ignorance, gave rise to completely false notions about the real character of the original tribal designs.

There never can be even a suggestion that the remarkable arts of the Coast Indians can ever be revived in their original forms, for other causes than those just mentioned encouraged their disappearance at an appallingly rapid rate. Neither would they be in place under modern conditions or adapted to modern requirements. But the United States Indian Arts and Crafts Board has shown that standards of excellence in Indian products can not only be promoted but attained and, what is more, made to pay. The board has developed markets for these goods, provided trademarks and government labels to protect genuine Indian handicrafts, of which a wide variety are now encouraged; and, thanks to the funds available in a wealthy country, has prepared most attractive publications as well as organized exhibitions to arouse appreciation of Indian art objects. The results have created a wide demand from many sources for a supply of those articles, extending from department stores to manufacturers of "mass" supplies.

Fortunately, the seed sown twenty years ago in Canada showed evidence of vitality when a small committee was formed three years ago in Victoria to arouse public interest in preserving the remnants of British Columbian tribal arts. The objects of this committee, known as the Society for the Furtherance of B.C. Indian Arts and Crafts, are definitely constructive, as well as cultural, economic and commercial. Within eighteen months it resulted in the formation of an active branch in the Okanagan district, and hopes exist that in due course another branch may be formed in Vancouver with the support of the University of British Columbia. There are many young Indians awaiting opportunities for the exercise of their abilities in a variety of lines. The work carried on for seven years by Anthony Walsh in the Indian school on the Inkameep, and the influence this example is slowly diffusing elsewhere in the province, evidences the existence of that instinct for line and colour which has been described as ready for expression at a moment's notice: "Give an Indian boy a pot of paint and a brush and watch him decorate a wall. No art school, no prescribed instruction in method or style. Animals, trees, mountains, are stored in his mind, alive, ready to spring out and express themselves in their own vitality and style. Apparently close observation and stored up

knowledge of visible form and colour constitute an integral part of his life." The original paintings of these Inkameep children have carried off the highest awards in competition with schools from all over the British Empire, and three years ago specimens of their work were the first samples from Canadian schools, and those by Indian children, to be selected by the committee of the English Drawing Society, to be shown to the King and Queen. This honour was repeated last spring, even under wartime conditions, when once again these children earned the coveted Silver Stars, the highest award possible.

Hampered by existing conditions and absence of funds, the committee is keenly aware it has barely scratched the surface of the ground to be covered in the promotion of its objects. The need of support from public opinion and of a much more sympathetic relation between the two races are essentials. Meanwhile, the Indian Affairs office at Ottawa is sympathetic towards its aims, and last year commissioned the preparation of twenty large charts showing the range of their forefathers' arts and crafts for circulation in British Columbia Indian schools. (A few of the drawings from these charts have been used to illustrate this article.) Small exhibitions have been held in Vancouver, Victoria, Osoyoos, and Penticton, consisting entirely of original paintings, designs and handicrafts.

The committee has also published two attractive booklets with original illustrations and letterpress from Indian schools, many hundred copies of which have been sold. And in the past few months it has responded to an Empire-wide invitation from the Manchester Cotton Board of England for original native designs to be used in all forms of textiles and fabrics. The specimen samples sent were approved, and a larger selection is being prepared in response to a courteous intimation that these would be welcomed in order to prepare a display for trade representatives. The immediate utilization of these designs is hampered by ever increasing restrictions due to the war, but the committee now hopes to arouse corresponding interest in the east of Canada where the design, style and colour of Canadian fashions are dictated.

RONALD W. HAWKER

## 14 | Welfare Politics, Late Salvage, and Indigenous (In)Visibility, 1930-60

After the end of the American Civil War in 1865 and the Alaska purchase in 1867, development on the north Pacific Coast accelerated with the need to lay down a transportation infrastructure that consolidated the American West. Beginning in the early 1870s, steamships travelling from Olympia in Washington State to Wrangell and Juneau in Alaska created the fabled Inside Passage tours and brought about the regional birth of tourism [14.1]. In 1874, American and European museum collectors began to scour the coast, some hoping to profit from the emergent market in Native objects and others seeking to "salvage" what they believed to be the last authentic remnants of a culture that was about to succumb to industrial modernity (see Laforet, this volume). The combination of increased colonization, tourism, and the rapacious appetite of museum collectors in western North America created a vibrant market for Northwest Coast objects, some of which were manufactured expressly for this external audience (see Cole 1985). This demand for Native objects climaxed around 1904, although Canadian museums did not begin their participation until around 1912. Subsequently, the highs and lows of the economy on the Northwest Coast, and the waning interest of the big American museums, weakened the market.

In Canada, Joseph William Trutch was appointed chief commissioner of Lands and Works for British Columbia in 1864. This appointment represented an emphatic end to the more conciliatory attitude of previous colonial administrators, notably James Douglas, and the beginning of an aggressive bureaucratic approach to colonization based on the denial of Native land rights. After the appointment of Duncan Campbell Scott to the position of deputy superintendent of Indian Affairs in 1913, the federal government tightened its hold on Native peoples. Scott's fierce implementation of the Indian Act led to the Cranmer prosecutions of 1922 and drove the potlatch underground (see Dawn, this volume; Cranmer Webster, this volume). In 1924, in consultation with Diamond Jenness, an anthropologist at the National Museum of Canada, Scott wrote legislation giving the Canadian government effective control over the sale of

Indigenous monuments [14.III]. This amendment to the Indian Act was intended to bolster the collaborative efforts of Indian Affairs, the National Museum, and the Canadian National Railway (CNR) to restore and relocate crest poles along the CNR's Skeena Valley line into Prince Rupert (see Morris 1994; Hawker 2003). However, it also demonstrated the complex complicity of museums with the Department of Indian Affairs in reassigning the meaning of Indigenous objects from within First Nations' belief systems to Western notions of "art" and "artifact" [14.II]. The decade closed with the beginning of the Great Depression, a financial dust storm that devastated life in the resource-dependent Native communities in Canada.

In the 1930s, the combination of an ineffective education system for Native youth, an openly belligerent administrative system based on unfair legislation, poverty, and limited opportunity spawned a reform movement in British Columbia. Across Canada, the emergence of "pan-Indian" political movements, such as the Native Brotherhood in 1931, projected a positive professional image for the non-Native public. Realizing that if they were to achieve political progress they needed the support of non-Native audiences, these organizations used the general interest in Northwest Coast art in a number of cleverly staged events intended to foreground the issues of legislative reform and land rights (see Tennant 1990; Hawker 2003). In the meantime, a parallel movement of church-based and educational reform arose among non-Native people shocked by the destitution on Native reserves, aggravated by the Great Depression. These reformers followed a John Ruskin-influenced Arts and Crafts ideology that saw the guild-like organization of Native arts as an economic salve to the poverty brought on by economic depression and social inequality (see Dawn, this volume).

One of the most prolific, if unpublished, writers during this time was Reverend George Raley, a United Church minister who had served in Port Simpson and then held the position of principal of Coqualeetza Residential School in the Fraser Valley [14.IV, 14.V]. He was an avid collector, and his personal collection later provided much of the backbone of the University of British Columbia Museum of Anthropology's Northwest Coast collection. His personal views on the state of the arts in a number of coastal villages in the mid-1930s provide insight into continuing production during a period largely ignored in Northwest Coast art historiography. Furthermore, Raley foregrounded the importance of textile arts, overshadowed later by wood carving. Of course, his writing is shaped by the unfortunate paternalism of the time, but he also wrote with great passion, and some of his passages were prophetic. Raley's emphasis on using

museum models as quality guides for younger artists in his proposals, his demand for authenticity in form, and his desire to create a respectful understanding of the design vocabulary among the public would all become hallmarks of the so-called renaissance of the 1960s and 1970s (see Glass, this volume) [14.XI].

However, the most directly influential of the non-Native reformers using art as a platform was Alice Ravenhill, an educator based in Victoria who collaborated with the Provincial Museum and sought to bridge institutional gaps among various official agencies (see Watson, this volume) [14.VII, 14.VIII]. She published several significant books during this time, including *The Native Tribes of British Columbia* (1938) and *A Corner Stone of Canadian Culture: An Outline of the Arts and Crafts of the Indian Tribes of British Columbia* (1944). Designs from the latter were used for early jewellery by Haida artist Bill Reid (Shadbolt 1986, 96). Her most important achievement was the founding of the British Columbia Indian Arts and Welfare Society (BCIAWS) in 1939, which sought to put into practice many of the things Raley only theorized about [14.VI]. The BCIAWS championed exhibitions and craft shows, distributed materials and guides among Native producers, founded scholarships for young First Nations artists, and supported the rise of several now well-known individuals, including Judith Morgan, George Clutesi, and Ellen Neel. A branch organization, the Okanagan Society for the Revival of Indian Arts and Crafts, was founded in the interior under the direction of teacher Anthony Walsh, leading to the publication of several illustrated children's books.

The late 1940s and early 1950s comprised a period in which several relevant parliamentary committees were struck, including one to overhaul the Indian Act and a second, the famous Massey Commission, to investigate the state of Canadian arts (see Dawn, this volume) [12.XX, 14.IX]. Both the BCIAWS and its Okanagan counterpart, as well as Ravenhill as an individual, made significant presentations to the committees, thereby making a direct contribution to the shaping of postwar cultural policy.

The climax of the movement was the Conference on Native Indian Affairs held in Vancouver at the University of British Columbia in April 1948 and organized by New Zealand anthropologist Harry B. Hawthorn (see Dawn, this volume) [12.XIX]. It brought together Native political leaders, artists, teachers, health professionals, and church leaders to define the problems and needs of Native communities. Walsh summarized the critical role of art in bringing together the different interests of the reform movement: "This group wouldn't be meeting today if it weren't for the art of the Indian. It has been the one approach for interpreting the culture of the Indian people to the public" (in

Hawthorn, BC Indian Arts and Welfare Society, and BC Provincial Museum 1948, 16). The section on the arts was dominated by a debate on how to encourage the monetary value of the arts and thus re-create the arts as a viable industry [14.x]. However, the speech that perhaps still rings most clearly across time is Kwakwa̱ka'wakw artist Ellen Neel's passionate assertion that Northwest Coast art was alive and well [13.1]. Neel repudiated the main thrust of much of the non-Native hyperbole around Northwest Coast art, attacking the main tenet that it had died and needed to be resurrected. Passionate and articulate, Neel also rejected the limitations of artificial authenticity demanded by many of the non-Native reformers.

The conference brought a group of practising Native artists to the attention of the large public institutions that were enjoying an infusion of postwar funding. The University of British Columbia opened a museum in the same year, which would later transform into the Museum of Anthropology (MOA). The MOA was initially directed by Audrey Hawthorn, Harry Hawthorn's wife, author of *The Art of the Kwakiutl Indians and Other Northwest Coast Tribes* (1967). Under the patronage of civic leaders, such as lumber baron Walter C. Koerner, the MOA became one of the most significant museums specializing in Northwest Coast art in the world. The 1947 opening was celebrated with the purchase of seven paintings by Nuu-chah-nulth artist George Clutesi. The university also commissioned anthropologist Marius Barbeau to purchase a series of crest poles for display in a new "totem pole park" on campus. Ellen Neel was brought in to restore a number of them and introduced university officials to her uncle, Mungo Martin. Martin worked on the restoration for several years and then moved to Victoria, where he was the key figure in the totem pole restoration and artist training program at the city's Provincial Museum, under the direction of Harry Hawthorn's student Wilson Duff. The museum's patronage of Martin opened a new phase in the support of Northwest Coast art and a growth in its popularity among non-Native audiences.

While these social reformers were often ignored in later Northwest Coast art historiography, as a group they influenced the direction the art and its promotion would later follow. If it was not for their groundbreaking interests in organizing both the production of and the demand for Northwest Coast art, institutional programs, such as the Provincial Museum's carver training program, arguably may not have occurred. Responding to the social and political conditions of the Great Depression, they were also part of a larger move toward the institutionalization of art in Canada and an organized campaign calling for the reform of the Indian Act. They were thus connected, if indirectly, to the Native reform movement and its various political organizations.

**14.I.  Alaska Steamship Company. Ca. 1906.** *Alaska Indian Basketry.* Seattle: Alaska Steamship Company, n.p.

The curio market was of enormous importance in propagating the view of Northwest Coast objects as art. When later social reformers were formulating plans to promote Native art during the Great Depression, they sought to reconstruct the conditions of the curio market during its heyday of the 1890s. Although few of the texts from that heyday survive, the reformers frequently referenced the exotic imagery of the curio market in their own writings. The following is an excerpt from a promotional tract published by the Alaska Steamship Company. Although undated, it was likely published between 1900 and 1920.

> You can buy Indian baskets in Seattle, and nearly any Eastern city, but baskets thus obtained lack the value of those bought from the old Indian woman, in the far-off wilds of Alaska. You will prize such acquisitions. Never will you forget that Indian village, with its totem poles and dried fish; its smoky huts and dirty children; its "stolid" citizens and numerous dogs; and the terrible time you had reaching an understanding with the Indian sales lady, and your unsuccessful effort to get a basket or mat at less than the marked price. The basket you bought in Alaska, perhaps at an Indian village in some unfrequented bay … out-values a dozen store baskets.

**14.II.  Thomas Deasy. 1918. Letter to Duncan Campbell Scott, Deputy Superintendent General of Indian Affairs, Ottawa, 4 May.** A copy of this letter was forwarded to Edward Sapir on 17 May 1918. Canadian Museum of Civilization, Edward Sapir Correspondence, Catalogue Number 1-A-236M, Box 633, File 15. © Canadian Museum of Civilization.

The economic value of Northwest Coast objects as art was recognized early on by various traders and agents. In the following excerpt, Masset-based Indian Agent Thomas Deasy (1857-1935) wrote to his new boss Duncan Campbell Scott (1862-1947) in Ottawa, offering to set up a curio store. The offer was turned down, as Scott was under the impression that Deasy was only in it for the money. Nonetheless, it demonstrates a nascent interest in institutionalizing the curio market. This was a common interest among Indian Agents and missionaries, both of whom advocated the replacement of the Indigenous symbolic value of the objects and the rituals that informed them with the commodity value of the objects as products within the capitalist economy.

> Sir:
>
> With further reference to your letter of January 21st last, regarding suggestions about the Indian handicraft, especially pottery, basketry and totem poles, permit me to state

that, during the vacation so kindly granted me, I visited Vancouver, Victoria and Seattle; inspected the work of the Indians, and consulted with the Chief Inspector of Indian Agencies and also with Inspector, Capt. A.M. Tyson.

As you are no doubt aware, I have lived for over half-a-century in British Columbia. I know the Indians well, and talk the Chinook jargon, Totem poles, of wood and polished black slate, basketry, and the other handiwork of the Indians I have specialized in, and know the value of same. Having the largest and best collection of "black slate work," and having sent a large collection of basketry and other work, to the Museum, at Ottawa, shows that I know something of assisting the Indians in disposing of their wares.

In my opinion, it would be advisable to open a place of business in some large city, say Vancouver, or Toronto. I know where 500 baskets can be obtained. I have two hundred pieces of black slate work. Rev. Geo. H. Raley has a good collection of old Indian curios. These might be purchased, and all would be saleable. The three large collections, of the best work of the Indians, can be obtained at a reasonable value.

If the Department decides to assist the Indians, and keep up the manufacture of basketry, totem poles, leather and fur work, and the means of giving the Indians employment during the winter months, I would be pleased to have charge of this work. I understand how to buy from the Indians, at a fair price. I know the value of their work. I have been considering the question of starting operations, on my own behalf, in this line. Having a valuable collection of slate work, and knowing where to purchase basketry, also old "curios," I know that a store, selling these goods, will pay. The few dealers, who now purchase from the Indians, would not be interfered with. The Indians are not manufacturing, as formerly. Dealers pay little to the Indians, and make large profits. The Haidas have almost given up the making of totem poles and basketry, only a few of the old people are now engaging in the work.

In order to start the business, it would require about $5,000, for the 500 baskets, 200 pieces of black slate carvings, and the "curios" owned by Rev. Geo. H. Raley. Everything bought would be saleable, at a profit. With one person in the store, and another out purchasing, the business should bring in good returns, especially during the summer months, when tourists visit the Pacific Coast. Alaska is now reaping the benefit of the work of the Indians. The "Fur" business might also be considered, in connection with a store of this kind. In the sale of Indian work, the natives are exploited. Dealers trade with the Indians, offering them, at times, "shoddy" for their handiwork.

The Haidas have entirely given up the making of wooden Totem poles. They have been selling the old, standing, totem poles, until few of any value remain. They are giving up the slate work. It is a pity that so much of the work of the Indians of this

country has gone to foreign countries. A store, of the kind proposed, would also be a "museum." People visiting the cities are anxious to see the work of the Indians.

Our Indians bring basketry, and other work, to my office; but there is no market here. I am willing to either take charge of a business of this kind, or to enter into partnership, with the Department, in the opening of a store and "museum," in some central city.

**14.III. Duncan Campbell Scott. 1926. Letter to Diamond Jenness, Chief, Division of Anthropology, Victoria Memorial Museum, Ottawa, 5 May.** Canadian Museum of Civilization, Diamond Jenness Correspondence, Catalogue Number 1-A-164M, Box 630, File 2. © Canadian Museum of Civilization.

After confronting resistance from the Tsimshian and Gitksan peoples opposed to the restoration of crest poles along the Canadian National Railway line in the Skeena Valley in the early 1920s, Scott consulted anthropologist Diamond Jenness (1886-1969) in the writing of legislation intended to control the sale of crest poles to outside influences. Canadian officials increasingly recognized the economic and symbolic value of crest poles and, particularly under Scott, attempted to assert increasing control over their location. The letter also demonstrates the pervasive racism of Canadian society, with Scott instructing Jenness on the nuances of language and identity in Canadian law.

Dear Mr. Jenness,

I am sending you herewith a revision of the proposed amendment to the Act regarding totem poles. I think it should be found satisfactory now. I note your objection to the word "person," that it includes Indians, but the interpretation clauses of the Indian Act covers this point, as follows – "a person means an individual other than an Indian."

106A. No title to any Indian grave-house, carved grave-pole, totem-pole, carved house-post or large rock embellished with paintings or carvings on an Indian reserve shall be acquired without the written consent of the Superintendent General of Indian Affairs, and no Indian grave-house, carved grave-pole, totem-pole, carved house-post or large rock embellished with paintings or carvings, on an Indian reserve shall be removed, taken away, mutilated, disfigured, defaced or destroyed without such written consent.

Any person violating any of the provisions of this Section shall be liable on summary conviction to a penalty not exceeding two hundred dollars with costs of prosecution and in default of payment to imprisonment for a term not exceeding three months, and any article so removed or taken away may be seized on the instructions of the Superintendent General and dealt with as he may direct.

**14.IV. G.H. Raley. 1935. "Important Considerations Involved in the Treatise on 'Canadian Indian Art and Industries.'"** Unpublished. BC Archives, Raley Papers, H/D/ R13/R13.3 (II).

In a long, sometimes meandering, sometimes passionate tract, collector and educator George H. Raley (1864-1958) set out his vision for the institutionalization of First Nations art. Raley's ideas are important because many were later adopted, especially in the activities of the BCIAWS and in elements of the totem pole restoration programs run by the University of British Columbia and the BC Provincial Museum after World War II. Raley himself drew on examples from around the British Empire as justification for his plans, noting that Canada generally lagged behind artistic fashion in other parts of the world. He also gave some insight into the number of art producers in several villages at a time normally considered dormant in Northwest Coast art history.

> A revival of Indian art and handicraft as a welfare movement, with wide application, would help the Indians financially, would give a new cultural activity with a sense of accomplishment and improve his social status in the community ...
>
> To initiate and organize the industries will require supervision and financial assistance.
>
> These things should be supplied at the start without grudging in view of the possible benefit to be reaped ... If it is an untrodden path we have to travel – if there is the ghost of a chance of it leading somewhere – we British pride ourselves upon the spirit of adventure ... As Tennyson says we should "leap the rotten poles of prejudice" and do something new, adventuring in reviving primitive crafts for the welfare of our own primitive people ...
>
> It is true the graduates of our schools have not an easy time of it. It could not be otherwise with the present generation. The facts are: He has grown, the people of his village have not. He has advanced intellectually, the people of his village have been intellectually stationary. He finds a conflicting of ideals. His education has changed his social and economic outlook. His attempts to change and improve conditions at his home are sometimes looked upon with disfavour. Being absent for a number of years, he has forgotten the linguistic niceties of his native tongue and his pronunciation is a mark for ridicule. The relationship between him, his family, and his village has been interrupted, he is no longer a part of the social order of the community. It is difficult to follow the old trail and just as hard to blaze a new one. Some naturally take the easier course and swim with the stream. This cannot be said to be the rule. Many resist the downward trend, and without sacrificing the best of their training, are an uplifting force, improving conditions in their villages ...

The danger of reversion to objectionable customs would be lessened rather than increased. Industries would help to socialize the graduate, by a common activity, and re-establish the equilibrium between him and his family and the village group. It would do more. It would give him contact through which he might realize some of his ideals ...

Admitting there has been a large falling off of both men and women engaged in primitive arts and crafts in the past years; admitting the artisan has not been able to secure full time occupation at his craft and that the sale for his merchandise is small compared with what it was up to the time of the depression; there remains still a sufficient number of craftsmen who are producing work of fine quality to make an organized movement for his benefit worthwhile. Take for instance British Columbia, one of the three great cultural regions of the American continent. In every large village are to be found men or women who, on account of necessity, environment, or racial pride, continue to be interested in the development of their arts and crafts.

Being familiar with some of the villages where primitive arts and crafts continue to be a source of culture and income, let me mention some and specify the craft or industry to the best of my knowledge in each case.

The estimated number of craftsmen will be conservative, below rather than above the actual number. It would be subject to revision in the light of further data, should a general survey ... be made.

*Massett*, *Q.C.I.*  Artistic carving is done in argillite, a blue-black unctuous slate, for luxury goods and souvenirs. There are three good carvers amongst the older men. Some gold and silver bracelets come from here. There are some who carve the totem and miniature totems. A fine type of twilled-woven basket from reeds and spruce roots ornamented with totemic designs is made by the women.

*Skidegate*, *Q.C.I.*  Five men here who are carvers in gold, silver, black slate and wood. They are as noted as the Massett Indians for the quality of their workmanship. Some carved spoons are quite valuable, especially those carved from the horn of the mountain goat. Their designs are full of character and background. Real ornaments and luxury goods are made here. Fine basketry is woven from spruce root ornament with painted and woven designs. These have a pleasing and attractive appeal and should be easy to sell if properly represented by capable salesmen ...

The Hydahs are progressive and could be depended on to produce in quantity with proper incentive, for a regular and established market.

*Port Simpson*.  While this place used to be a centre of primitive industry for weaving and basketry of the woven cedar type, little has been done for many years. There

are some who know the arts but the indifference of the whites in the first place, and then disinclination have nearly destroyed initiative. Occasionally a little carving is done ...

*Metlakatla.* This is a smaller village than Port Simpson, near Prince Rupert. Most of the remarks re the Port Simpson handicraft would apply here ...

*Naas River Villages Kincolith, Ankidah, Gwincha, Gitladamix, Greenville, Aiyansh.* There are several villages between the mouth of the river and the upper Naas, where in early days fine weaving, carving and basketry were the chief sources of occupation. Blankets similar to the Chilkat blanket were woven here. Their monster totem poles demonstrated beyond a doubt they were natural craftsmen. At the present time it is quite possible there is more carving of the miniature totem done than for many years. Last year I saw several cleverly carved totems from up-river villages, each having a complete legend. The quality of work was good. Weaving is carried on but not extensively. The work indicates a knowledge of primitive looms and the methods of weaving with a strong well balanced geometric design for ornament. Cedar bark baskets are made by the women in several villages. I personally know seven men who do very creditable work and know the old motifs and designs. There are good possibilities of successful cooperation in any organized movement to save their original crafts.

*Stikine River.* The mouth of the river is in Alaska but up the river in Canada there are a few who make the birch bark basket and weave pack straps with designs similar to those found on the Naas and in the Interior of British Columbia ... The Tahtals are clever at embroidering designs of conventionalized primitive implication on textile fabrics.

*The Skeena River Villages Port Essington, Kitselas, Kitsumkalum, Meanskunisht, Kitwungar, Haʒelton, Kitʒegutla, Hegwilget, Kispioks.* This river is the home of a few remaining totem poles. Formerly, from Kitselas to Kispioks the historic carvers had plenty of work. Today those who carve the miniature totem are few yet sufficient to have kept their own particular designs alive. These designs are different from those of the Naas River.

As the upper river is the country of the birch tree, their containers and baskets are naturally made of that material. There is little ornament. However, their finer baskets are skillfully made and in simple design. Weaving is done and snow shoes manufactured. The motifs and totemic symbols are cleverly executed on poles and in weaving by the Kitzegukla, Kitenmax, Kitwungah and Kispiax tribes.

*Kitamaat Kitlope, Kitkatla, Klemtu.* While there is little carving done at any of these places, there are several known to me in these villages who carve wooden miniature

bowls and dishes with totemic designs. The small totem is carved, small wooden spoons with carved handles of unique shaping is made in some villages. Cedar boxes painted with conventionalized designs show artistic ability. There are several women who weave a fine cedar bark mat and baskets and leggings and arm pieces of the same material. Model or small totems, canoes and paddles are made in these villages.

*Bella Bella, River's Inlet and Smith's Inlet.* While the Hydahs of Queen Charlotte Islands for many years held a monopoly on the carving of silver and gold brace-lets and jewelry, there are at the present time three men who do equally fine carving on the same material. Several do creditable wood carving of the small totem and other articles which would appeal to the tourist trade. Small baskets and some ceremonial pieces are made by the women out of fine cedar bark.

*Bella Coola and Chilcotin.* Here is to be seen a contact between Coast and Interior art, – The Kwaquilth and Salishan. The Coast totem influence is strong at Bella Coola while the crafts of the Interior are also in evidence. The woven cedar bark basket of the Coast made, and also the sewn cedar root basket of the Chilcotins. The cedar root baskets are beautiful specimens of coiled splint foundation type ... The work is carried on by several women and is manufactured for local and their own domestic purposes.

*Alert Bay, Mamilillikula, Kingcome Inlet.* A few good carvers are to be found in the outlying villages around Alert Bay featuring the small totem and the old com-munity house in miniature. Primitive totem designs are seen here, rag and wool-len rugs and mats, the Thunderbird being the most popular design. Some basketry and ceremonial articles are made here. At Alert Bay is a residential school where Indian arts and crafts have been successfully taught to the economic benefit of some of the students.

*Cape Mudge, Campbell River and adjacent villages.* Carving of the totem pole in vari-ous sizes is done here. The design is realistic and primitive. Personally I know of two who can do good work; there may be more. The basketry industry is capable of development.

*West Coast of Vancouver Island.* Perhaps the finest baskets are made here out of reeds, grasses and fine root fibre. Both mats and baskets have symbolic primitive designs skillfully woven in. A few of the women make small baskets and mats so fine that they resemble silk ... Some of the men carve the miniature totem, also masks and ceremonial articles.

*Koksilah, Songhees, Nanaimo and East Coast of Vancouver Island.* A popular industry has been engaged in by the women in these parts, of a strong utility feature – the

Cowichan sweater. The people raise sheep and prepare the fleece, card and spin the wool and knit it into a heavy sweater of conventional design, durable, warm and will shed rain. While there has been a demand for this article both in Canada and England, should a proper, well advertised and organized market be developed and protected for the merchandising of this single Indian craft, employment could be given to hundreds of Indian women. Some carving is done by men.

*Fraser River, Thompson and the Interior Squamish.* In the early days blanket and rug weaving was one of the industries of these people. They were made from a coarse yarn spun from the wool of the mountain goat mixed with dogs' hair. Some of these productions show the influence of Spanish and Mexican designs ... The people are suited to sedentary occupations and it would be quite easy to revive this craft and make an industry which appeals to tourists. The blanket, throw or rug could be woven with as great skill as the famous Navajo blanket. Weaving is being taught the girls of Coqualeetza Residential School on the lower Fraser ... The knitting of the Cowichan sweater has been engaged in for many years by several women in the Fraser Valley where sheep are kept. This knitting is also taught at Coqualeetza Residential School. The Squamish make fine nets from twine woven of nettle fibre.

Perhaps none of the native crafts is so well known and so popular as the Salish coiled sewn basket of British Columbia and the United States. Samples are wanted in the East. They are made by women in nearly every settlement along the Fraser and the Thompson rivers, in the Okanagan and the Kootenays, yet no industry needs to be organized more than this, for the sake of the social and economic welfare of the native women ...

For some years Coqualeetza Residential School at Sardis, B.C. has had the idea that it could help to link the school with the home by means of a development of the arts and crafts of the Indian. We have given pre-vocational instruction in weaving, basket making, carving, art designs with Indian motifs, in a definite way and proved that our training is helpful to the students. To further develop this movement much depends on the Educational Branch of the Indian Department, whose Inspectors have the supervision and direction of the curriculum of the students. It appears to me every school, whether residential or day school, could develop training in Indian crafts so far as regional facilities in art and craft culture make it advisable and conducive to the progress of the student and community.

A most cardinal function of the school, especially (for obvious reasons) where Indian children are concerned, in the teaching of arts and crafts, is quality, – the standard of quality. The school is the place where this should be taught. Design,

material and colour are important but quality is essential. Here the younger generation should learn to appreciate quality of work rather than quantity.

An implication of the school is the teacher. Much will, of course, depend upon the teacher. Teaching traditional Indian art and handicraft has never been required in the schools. Without the cooperation of the teacher in a sympathetic and practical way, little progress will be made ...

To save and develop Indian art and crafts as a welfare movement for the benefit of the Indians is a large undertaking. It is not a one man job. It involves the sympathetic and practical leadership of the Department of Indian Affairs, both at Ottawa and the outside service throughout the country. It involves the active cooperation of all the Churches, scientific cooperation of all the Churches, scientific organizations, schools of commercial art and design, tourist bureaus, the social service council of Canada, transportation companies, etc. It must be removed from all of suspicion of sect or part exploitation, or any selfish ends or motives.

Atmosphere favourable to the movement could be created by a united campaign, setting forth the need. How would a campaign be initiated? Naturally the Indians being wards of the Government, it should automatically start at Ottawa with an engaging program of interesting propaganda, and it has been seriously considered, "A Canadian Indian Art and Handicraft League" be organized ...

As the suggested organization would be a welfare movement with an economic basis for the Indians of Canada, the logical home for such appears to be

OTTAWA
Sponsored by:
THE INDIAN DEPARTMENT

And a suggested name might be:
THE CANADIAN INDIAN ART AND HANDICRAFT LEAGUE

The Objects of the League:
1. To promote a welfare movement among the Indians of Canada, with a cultural and economic basis.
2. To create atmosphere and what might be termed "Indian-mindedness" in the people of Canada, towards Indian arts and crafts and industries.
3. To save from extinction, Canadian Indian arts and handicrafts for Canadians as Canada's original contribution to the world of art.
4. To suggest methods of practical procedure for a Renaissance of Indian arts and handicrafts, with a view to re-establishing the Indian in a congenial occupation, of community interest, or remunerative value and of non-competitive character.

5. To inspire hope and confidence in Indian artisans, who are still known to persevere and maintain primitive industries by genial and helpful sympathetic interest in their crafts.

6. To assist the newer generation of Indian youth in an appreciation of the culture and value of their inheritance from prehistoric times of arts and crafts, peculiarly their own.

7. To encourage students and graduates of Indian residential schools in the production of primitive handicrafts when they leave school and return to their homes on reservations ...

8. To stimulate effort and the production of really good work, by carrying on displays at exhibitions. To offer prizes for competition in the schools, and scholarships for outstanding pupils who would benefit by extra training in a recognized school of applied art ...

9. To recommend the native people to offer for sale, only their best work, inasmuch as only good work, at as reasonable price as possible, can establish a permanent market.

10. To foster the making of small attractive novelties and souvenirs of Indian design, as a means to capture a fair share of the tourist trade.

11. By all legitimate propaganda, suggest that tourists purchase guaranteed Indian handiwork instead of spurious Oriental imitations of Indian handicraft, which are to be found in many stores in the chief cities of Canada. To press for legislation which will protect Indian designs and artifax from exploitation for commercial purposes. (As the main object of this Association is to help the native people to help themselves by means of their own particular crafts, and as it is all that is left to them of their own aboriginal inheritance they should be protected for them.)

12. To promote modern schemes for displaying and advertising Indian crafts and ascertain practical procedure for organized marketing methods and thus prevent economic loss by obsolete modes of barter and sale.

13. To interest manufacturers in Canada and abroad in the possibility of applying Indian designs, realistic and conventional symbols of nature, animate and inanimate, to the decoration of luxury goods, ornamental and useful commercial commodities ...

14. To face the issue with courage and imagination, effort and patience, these are essential to "win through" ...

It is said that Canada has done much for the Indians – true; BUT IT HAS NOT DONE ENOUGH. Canada has solved the problem of his need for educational, missionary and medical requirements, but the problem of his social and economic welfare still

haunts us and it is the object of this organization to restore to the Indians, happiness and contentment, by a solution of this welfare problem ...

It is proposed to have a cooperating institution as is done in several instances of cottage, rural and other associations in Canada, with the Canadian Handicraft Guild, whose headquarters are in Montreal.

The work we do is specialized and requires separate and special supervision – more than it would be possible for the Canadian Handicraft Guild to give. It is unique and differs from other home crafts by its very nature. The work of the European foreigners and that of the Indian do not mix. It may do so in time. There is a psychological barrier we are trying to break down but the time is not yet, and the process will not be hurried ...

A reason for a separate organization which carries with it considerable weight is the impossibility of meeting the demands of time, consideration and supervision which such a program as outlined would impose on the Guild ...

The Indians never had an organized market for the disposal of their merchandise but traded their goods in a very haphazard manner and often did not obtain a fair price, either in cash or barter. They were often exploited. Let me give a few illustrations as to how their trading is done.

The basket-making woman is often seen on the streets of our villages, towns and cities with a clumsily wrapped bundle of baskets for sale. She naturally wants cash, sometimes difficult to get. Rather than not make a sale, she barters them for old, second-hand clothes and learns how to haggle. Now, in the eyes of an intending purchaser the goods are cheapened before they are sold and the Indian woman is led to believe her goods are different from those of the whites and not worth cash, so she has to be content to swap them for food, old clothes or anything ...

A few days ago I found a man whom I knew from Queen Charlotte Islands wandering about the streets of Vancouver, like a man in a dream. He was trying to sell some beautiful argillite miniature totem poles. They were wrapped in a newspaper then over all in a handkerchief – no setting for the exquisite work which would be graceful ornaments in any drawing room ...

The Indian wares are sometimes bought on speculation by hotel proprietors and sold to tourists without any intelligent information as to the why of the strange designs, which, to the average hotel clerk, mean nothing, but to the average tourist is necessary information.

The village store on the reserve takes Indian goods in exchange for groceries or other commodities and disposes of them to private parties or ships them to the cities to be sold in a retail store. By the time they are finally sold the increased sale price is often out of all proportion to the original price paid the producer.

I have seen some curio stores which had plenty of Indian craftsmanship for sale but only one given over entirely to the sale of Indian goods. This store was not a success. Overhead expenses were very heavy and during the early days of the depression had to close out ...

This economic welfare movement should be all inclusive. The organization should be Canada wide. The Indians of the Prairies will furnish a quota of novelty and souvenir merchandise which has been and will continue to be very acceptable to tourists. Under the organized method of development the out-put should be greatly increased and the Indians much the more benefited ...

Nearly every country in the British Empire is engaged in a similar undertaking for native people such as I am proposing for Canadian Indians ...

Our eyes are open to the fact that a dark line of tragedy runs through the history of the Indians to the present time and unless something is done, their future is beset with a forbidding obstacle to progress. No class of people in Canada is subject to so much misunderstanding. Indians have had to drink the cup of humiliations to the dregs. This welfare movement would, at any rate, be a step in the right direction. It would be a welfare movement which would help to bring a great amount of happiness and contentment to them. We have plenty of vain regrets for their weak spots and class cruelty, etc. Sentiment is all right in its place but the time has come when we should transmute sentiment into action.

**14.V. G.H. Raley. 1935. "Canadian Indian Art and Industries: An Economic Problem of Today."** *Journal of the Royal Society of Arts* 83: 999.

In an excerpt from one of his many publications, Raley referred to a frequently cited problem in the 1930s – the influx of imitation products from Japan. It is difficult to determine whether this was simply another facet of the increasing fear of eastern Asia, as Japan continued to expand, or a legitimate problem for the market. At the heart of much of this sort of writing is Canadian cultural protectionism and the potential industrial application of the Northwest Coast design system.

The totemic designs of the northern coast of the Pacific are being manufactured outside Canada in brass, bone, ivory and plaster, and sold to tourists as Indian curios. The Japanese in particular are developing their trade with tourists in Canada in this way ... Indians can do the work as well as the Japanese but, unlike the Japanese, they are not organized for marketing and production. Of course, it is easily understood that there are difficulties of legislation and international relations which might cause a govern-

ment to proceed slowly in attempting higher tariffs to prevent the importation of such goods, but if production could be speeded up and the tourist market supplied by the Canadian Indians, a way should be found to maintain the industry and if the copyright for certain designs were disposed of to large commercial industries, the Indian interest should be guarded and the Indian should reap the benefit.

**14.VI.  Society for the Furtherance of British Columbia Indian Arts and Welfare. 1939. "Objects of the Society."** Victoria, December. Unpublished. BC Archives, BCIAWS Papers Add Mss 2720, n.p.

These are the objectives of the British Columbia Indian Arts and Welfare Society, which continued at least until the 1990s, although its real influence was felt in the late 1940s. Founded by Alice Ravenhill, the BCIAWS was instrumental in raising public consciousness about Northwest Coast art and supported the efforts of a number of important artists, including George Clutesi and Ellen Neel.

1.  To promote the welfare of the Indians, particularly those of British Columbia, by supporting all movements directed towards an improvement in Indian Health, Education and Social Welfare.
2.  To bring to notice of the public, the innate merits and deep-rooted artistic talents of the Indian people by means of Exhibitions of their Arts and Crafts, Folklore, Music, Drama and Dance; and through Meetings, Conferences, Publications, Radio Broadcasts, Television and the Press.
3.  To arouse the Indians themselves to a realization of their true place in the social organization of this country, and to encourage them to work for, and to take advantage of, the opportunities which are offered under the revised Indian Act, and to prepare themselves for community service.
4.  To devote particular attention to the needs of the younger generation of Indian people, and to work in their interest to remove the inequalities of opportunity which still present almost insurmountable handicaps to young Indians trying to enter the occupation of their choice.

**14.VII.  Alice Ravenhill. 1947. "Address to the Royal Commission of Senators and Members of the House of Commons Appointed to Inquire into All Phases of the Affairs of Canadian Indians in May and October 1946."** Victoria, January. Unpublished. BC Archives, SPAM 571A, 17.

An important contribution of the social reformers was their willingness to assert their agenda before the various parliamentary committees struck in the late 1940s. Here Alice Ravenhill (1859-1954) outlined the achievements of the BCIAWS and related them to longer-term objectives for Native arts.

This is not the place to dwell on the sustained efforts for many years past of the B.C. Indian Art and Welfare Society of Victoria to promote the advancement and public appreciation of the Society's objects in the face of many difficulties; but mention is permissible of its worthwhile gains, which include the encouraging support given in 1945 that the Memorial to honor the British Columbia Indians who gave their lives in the late war, should take the practical form of securing funds assisted by the valuable cooperation of the Women's University Club, adequate to endow one (or possibly more) Scholarships to be awarded annually to promising young B.C. Indian artists, to promote the study of former fine old native arts and crafts which have suffered sad degradation by cheap, ignorant, inaccurate attempts at reproduction, either by immature Indian children in residential schools or by cheap commercial imitations, amounting only to misleading caricatures. A further object of the Memorial Fund is to extend opportunities for the development of originality by Scholarship holders in art forms, adapted to modern requirements.

The Society is also making a collection of authentic specimens of B.C. Indian handicrafts which will be held in trust and used solely for demonstration and exhibition purposes. This will be loaned to Government departments and private agencies with the object of demonstrating the characteristics of former B.C. Indian artistic attainments and also to promote the building of an industry of modern high-class native handicrafts. This collection should thus inspire higher standards of craftsmanship by skilled Indian artists today, and should also increase the demand now developing (chiefly among American collectors) for products of real artistic merit. Incidentally also this should materially improve the artistic and economic status of Indian craftsmen.

**14.VIII. Alice Ravenhill. 1951. *Alice Ravenhill: The Memoirs of an Educational Pioneer.***
Toronto: J.M. Dent and Sons, 209-19.

In a chapter from her autobiography, Ravenhill outlined her involvement in the institutionalized development of Northwest Coast art. Rather than simply a nostalgic exercise in self-promotion, this excerpt described the sequence of events and individuals involved. While the movement focused on Native youth, it demonstrated the tacit role that the Provincial Museum, desperately short of the funding necessary to make a direct intervention, played in Ravenhill's marketing efforts.

My interest was first aroused about 1926 in the former arts and crafts among the Indian tribes of British Columbia. This brought me a request from the Women's

Institutes of the Province to give them some guidance in how best to adapt native designs to the making of hooked rugs. My own knowledge of the subject was inadequate to justify undertaking such a responsibility without further study. I therefore asked time for this purpose, and immediately sought help from one of the foremost authorities in the field, Mr. W.A. Newcombe, of Victoria ...

My desire, however, to draw more attention to this storehouse of valuable cultural and commercial resources had been thoroughly aroused. I continued, therefore, to study under Mr. Newcombe's guidance, and I reproduced in needlework a number of B.C. tribal designs, with painstaking attention to all details and colourings, at first on large hooked rugs, and then on bags, book covers, cushions, etc. To each article I attached a label giving the source of the design, its tribal origin, and its significance, and the articles were then placed on sale by the owners of a store in Victoria already laid out to attract tourists. Individual pieces were sent by purchasers to New Zealand, South Africa, and Great Britain, but these accurately reproduced specimens, on the whole, failed to arouse the local interest I desired.

With this in mind I sought permission to speak on the characteristics and claims of these Provincial arts to members of the Island and Victoria Arts and Crafts Society and to the Women's University Club in Victoria. Attendance in both cases was the smallest on record, the more disappointing as Mr. Newcombe had brought exquisite specimens from his superlative private collection for illustrative purposes. Later on a talk I gave to a businessmen's "lunch club" on "An Unrecognized Commercial Asset" met with no greater success. Nevertheless, I just continued to "peg away."

In 1935 a gift from the Carnegie Fund to the Provincial Museum for lectures on its contents to adults and children brought unexpected encouragement in my object – but alas! Only evanescent. The Curator, failing to find a more experienced exponent ... , found himself unwillingly obliged to fall back on me to give the one lecture assigned to the B.C. Indian section of the Museum. Long experience as a lecturer happily stood me in good stead. The wealth of illustrative materials held the interest of the adults and children alike ...

In the fall of 1936 I was asked to give a short introduction to the subjects to the students at the Victoria Normal School. I learned, however, that an eight weeks' course on our B.C. Indians had been recently included in the grade school curriculum, without any authentic guidance being provided for the teachers who had to give it. I ventured to take this up with the Provincial Department of Education and after some months was entrusted with the difficult task of summarizing this unusually intricate subject in a bulletin limited to 30,000 words ...

In due course I submitted the outcome of fourteen months' concentrated effort to Mr. Francis Kermode, then Curator of the Museum, who was generous enough to say

it met a need he had previously been unable to fill when enquirers asked for general information on the subject. For illustrations we used some of the old plates which had appeared in the comprehensive but long out-of-print *Guide to the Anthropological Collection in the Provincial Museum*, prepared by the late Dr. C.F. Newcombe, and published in 1909. So the slim volume entitled *The Native Tribes of British Columbia* appeared in the fall of 1938. Thanks to Dr. Ian MacTaggart Cowan's efforts the Department of Education consented to the publication of several hundred copies for purchase by the public in excess of the first intention to limit the total printing to one copy for each grade school in the Province and one for each of the two Normal Schools ...

As my own interest in the subject grew, I ventured to correspond with well known authorities on the Indians of the Province, such as the Rev. J.G. Goodfellow, of Princeton, B.C., for several years a student of their intricate languages, Dr. Diamond Jenness, for many years anthropologist of the National Museum at Ottawa, and Anthony Walsh, who for ten years gave his whole life and artistic gifts to the Indian children on the Inkameep Reserve, near Oliver, B.C. There Mr. Walsh's methods had brought to the surface the children's inherited ability to devise their own designs in art work ...

It is not therefore surprising that when Anthony Walsh sent examples of the Inkameep children's art to the exhibition of drawings and paintings, open to all the schools of the British Commonwealth and held annually by the Royal Drawing Society in London, these children's spontaneous skill carried off both silver medals and the honor certificates, with the further coveted honor that on the first occasion that the exhibits of Canadian children were selected to be shown the King and Queen at Buckingham Palace, the specimens chosen were from this Indian school in British Columbia. The school also earned the first annual award of the "Chief Oskenonton" Cup for progress in artistic and dramatic attainments in 1941 ...

Thus boys of the Thompson Tribe at the Lytton Residential School teemed with ideas for original, clever black and white illustrations for local legends (a few of which were published by our Society in a booklet *Meet Mr. Coyote*), until a change of principal quenched their budding gifts. At another school, children made delightful original designs when their teacher merely pinned up an outline of a fly, a leaf, or any other familiar object. Specimens of original paintings and carvings from other B.C. Indian schools sent to the All Canada Handicraft Exhibition at Montreal in 1943, also earned many prizes and honor awards, at the present time the Committee of our Society is again making organized efforts to secure the interest of teachers in the Indian Schools in affording outlets for the innate gifts of children under their charge.

From 1934 to 1938 I spent much time in research work in the Provincial Archives, selecting from the vast and little known source fifty or sixty B.C. tribal legends likely

to be attractive in book form to the public. With infinite care I traced tribal illustrations of the mythical birds, animals, fish, and other figures with which these legends are concerned. Regrettably, owing to ever increasing printing and paper costs, the Provincial Museum has found it impossible to publish this collection, which I ventured to call Folk Lore from the Far West ...

Towards the end of that year (1939) Anthony Walsh asked me to arrange for a meeting of a few friends in Victoria to show them samples of the Inkameep School's handicrafts and to read to them the tale of the nativity as told him by "his" children as if the event had taken place on their reserve instead of Palestine. The little meeting was a great success. Those present were unanimous in their opinion that the naïve charm of "The Tale" called for publication. This was made possible by subscription the following year, when *The Tale of the Nativity* appeared as a little book, beautifully illustrated in black and white by a gifted young artist on the reserve, François Batiste by name, though he signs his pictures with his Indian name, Sis-hu-lk ...

Insistently I was urged to form a committee in Victoria with the hope of arousing more interest in our B.C. Indians and their arts and crafts. Repeated requests resulted in the inauguration in January 1940, of "The Society for the Furtherance of B.C. Indian Arts and Crafts," now known as "The Society for B.C. Indian Arts and Welfare." Our objects were summarized as constructive, cultural and economic; these being based on adequate evidence of the inherited artistic gifts and mechanical and manual dexterities latent in young Indians, shown in painting, carving, modeling, in drama, dancing, singing, and also in mechanical abilities of a high order.

Only the following friends responded to our many invitations issued to serve on such an adventurous committee: Major Bullock-Webster, Director of B.C. School and Community Drama; Miss Alma Russell, formerly of the B.C. Archives; Miss Betty Newton, Victoria and Island Arts and Crafts Society; and Madame Sanderson-Mongin, invaluable for her vivid interest and wide social connections, which enabled her to secure for the young Society sufficient funds to publish *The Tale of the Nativity*. The duties of Honorary Secretary devolved to me; and some months later we secured the experienced help of Mr. Douglas Flintoff, who ... gave us great assistance in connection with the reproduction of the black and while illustrations for *The Tale of the Nativity* by the children of the Inkameep Reserve and *Meet Mr. Coyote* from the Indian Residential School at Lytton. In 1941 the committee was strengthened by three valuable additions – Mr. Willard E. Ireland, Provincial Archivist, at once elected chairman; Dr. Clifford Carl, Director of the Provincial Museum, who promptly offered the Society the use of the Museum as its official address; and Mr. A.E. Pickford, who had given much study to Indian life in various parts of the Province, and who prepared a valuable monograph on *Food Plants Used by the Natives of British Columbia*.

In 1942 the Society adopted a constitution and by-laws prepared by Mr. Flintoff and Mr. Pickford; and the Lieutenant-Governor of the Province, the Hon. W.C. Woodward, consented to become the Society's Honorary Patron. The office of Honorary President was kindly accepted by the Rev. J.C. Goodfellow, of Princeton, in the same year. I was elected President in 1943 and in the same year a number of B.C. Indians became Honorary Members of the Society, since when several Chiefs have encouraged the Society by their attendance, and special speakers have assisted the committee in its uphill efforts to arouse more public interest ...

A vigorous offshoot of the Society was started in 1941 by Mr. and Mrs. Albert Millar of Oliver, B.C., where they formed a representative committee, which included three Okanagan Indians. Though sorely diminished by the war, this committee accomplished much work.

Thanks to Captain Gerald Barry, for many years Inspector of Indian Schools in B.C., such strong representations were made early in 1940 on the need for illustrations in Indian schools of the arts and crafts of their forebears that I received a commission from Ottawa to prepare twenty charts, 36 × 30 inches, showing in color and detail specimens of the varied forms the arts and crafts had assumed in the Province. A descriptive handbook was to go with the charts ...

With skilled assistance of Miss Betty Newton, I selected one hundred and fifty examples of these arts and crafts, chiefly from specimens in the Provincial Museum and in the associated handbook I gave details of the tribal origin, significance, and legendary associations of each figure. In nine months I had completed handbook and charts, the latter attracting considerable attention when exhibited in Victoria before being sent to Major McKay, Indian Commissioner in Vancouver, who personally took the portfolio to Ottawa where the contents aroused surprised admiration. Fortunately the charts had been photographed before leaving Victoria, for official notification soon reached me that due to war conditions the charts could not be reproduced nor the handbook published as planned ... I was therefore gratified when Dr. Clifford Carl, Director of the Provincial Museum, published this in condensed form in 1944, with reproductions in black and white under the title, *A Corner Stone of Canadian Culture*.

In August and September, 1941, the Society prepared exhibits of tribal arts and crafts in connection with conventions in Victoria of the Canadian Authors' Association, and the Pacific Northwest Library Association. I was allowed ten minutes to bring before the first of these associations the claims of the Canadian Indians for encouragement and recognition in poetry, drama, and myths. But alas! Those present expressed total ignorance of and indifference to the subject.

Our Society is deeply indebted to Dr. Clifford Carl for many forms of valuable assistance, not least that of offering the facilities of the Museum for what has become

annual exhibitions of original paintings and handicrafts from the B.C. Indian Schools. These exhibitions exemplify the Society's convictions that given provision for training, these survivors of a gifted race could contribute to the progress of our national culture and could do much, also, to uplift their own self-respect.

**14.IX. Albert Shea. 1952.** *Culture in Canada: A Study of the Findings of the Royal Commission on National Development in the Arts, Letters and Sciences (1949-1951).* Toronto: Core, 54-55.

In the final report of the Massey Commission, a section specifically on First Nations art concisely summarized the issues raised by the reform movement and confirmed the role of First Nations art in national culture. One of the commission's western representatives was Norman Mackenzie (1894-1986), president of the University of British Columbia, who directed the university to play a larger role in the study and promotion of First Nations, especially Northwest Coast, art.

Indians still maintain a distinct way of life throughout Canada. There is, however, widespread ignorance of Indian culture, and the meager knowledge Canadians do have is usually derived from erroneous impressions created by the movie and the comic strip. The indifference on the part of the white population is being increasingly reflected by a growing indifference on the part of the Indians themselves. Through neglect and lack of appreciation many of the traditional skills and arts of the Indians are being lost.

There is a belief on the part of some that Indian art is inevitably dying out, and cannot be revived. Certain forms of Indian art, it is true, have disappeared with the ancient customs which gave rise to them, but there is no reason why works of anthropological and historical significance should not be preserved.

Indian art, however, is of more than historical interest, for they have developed a fine technique and originality of design which are highly adaptable to new materials. Appreciation is of the greatest importance to the Indian, and lack of interest and the demand for cheap products have caused a degradation of their work. The Indians should be given aid and encouragement if the country is not to lose this important aspect of Canadian art and craft culture. But aid must be given with care, and high standards must be maintained. Publicity and information is needed to enable their fellow Canadians to understand and appreciate the products of these intellectually, socially, and economically depressed people.

The Commission recommended a council to consider every aspect of Indian life and to suggest legislation.

**14.X. William Reid and anonymous carver. 1955. Quoted in *The Indians of British Columbia: A Survey of Social and Economic Conditions: A Report to the Minister of Citizenship and Immigration.*** Volume 2. Edited by Harry B. Hawthorn, Cyril S. Belshaw, and Stuart M. Jamieson. Vancouver: University of British Columbia, Indian Research Project, 516, 525.

Harry B. Hawthorn (1910-2006) collaborated on a major study of the economic and social status of First Nations peoples in British Columbia, soliciting the opinions of both anonymous and named individuals. Two excerpts are included here. In the first, the young Haida radio announcer and soon to be renowned artist Bill Reid (1920-98) commented on the problems of maintaining authenticity in contemporary art in an interesting companion piece to Ellen Neel's address at the 1948 Indian Affairs conference. He anticipated the emerging issue of authenticity and contemporary art that developed particularly in the 1970s. This was a public conversation in which Reid would be a key participant. In the second excerpt, an anonymous source from the field continued the now two-decade-old chorus citing the low prices for art as an obstacle in its continuation.

In order that this art form be preserved or perpetuated, it would be necessary to re-create the conditions which produced it in the first place. This of course is impossible. Accordingly, I believe, except for the work of the few remaining old carvers, there will never again be any original Indian art on the Coast. There may be artistically worthwhile reproductions, but they will be exactly that, carefully made exact copies, or at the most very slight variations on existing themes. Even to make such reproduction would require first the attaining of great technical skill, and more important, an intimate knowledge of the design principles underlying the old craftsman's work. This, I believe, can only be achieved by understanding of the principles of universal design, achieved in a formal education of some kind ... It makes no more sense to expect a contemporary Indian to become an "Indian artist" than it does to expect a contemporary Greek architect to create a new Parthenon.

...

Whites ask me if carving will die out and I say it will, unless it starts paying. Most young fellows can carve. My boy can carve, but he makes $16 a day in the woods. If we get a steady market at a decent price I'll go right into carving – make maybe $200 or $300 a month – at least $2000 a year.

**14.XI. George Manuel and Michael Posluns. 1974. *The Fourth World: An Indian Reality.*** Don Mills, ON: Collier-Macmillan Canada, 69-70.

In an important counterbalance to the dominant non-Native voices in the reform movement, Shuswap George Manuel (1921-89), co-founder of the Aboriginal

Rights Committee and the North American Indian Brotherhood, contextualized reform and the cultural "renaissance" it seemed to have spawned within the wider political conditions of the First Nations rights movement in this excerpt from his autobiography, co-written with Michael Posluns.

It is very much a mistake to identify the cultural and political renaissance that is going on among Indian societies today with a new Indian resistance. The fact of the matter is that there never was a time since the beginning of colonial conquest when Indian people were not resisting the four destructive forces besetting us: the state through the Indian agent; the church through the priests; the church and state through the schools; the state and industry through the traders.

Today's renaissance can be seen in the resurgence of our languages, in the growth of political institutions both old and new, in the revival of Indian religion in urban Indian centers as well as on the reserves, in the growing number of young people seeking out the wisdom of the grandfathers and finding ways to apply it in their own lives, however different their lives may appear from the old ways. These are the real signs of the renaissance; there is no separation between the cultural artifacts – the drums, totem poles, and moccasins anyone can collect – and the day to day life in which the culture is evident, through work, or family life, words of friendship and music.

The renaissance of today is the fruit of the accumulated labor of our grandfathers. If it appears that we are only now awakening and discovering a new strength, it is because the current climate of political, social and economic forces is allowing what was always beneath the surface to emerge into the light of day.

Above all, the appearance that we are only now coming alive is an illusion created by the press and public institutions, who have for so long warped, distorted, and falsified the story of our resistance.

KATHRYN BUNN-MARCUSE

## 15 | Form First, Function Follows

*The Use of Formal Analysis in Northwest Coast Art History*

In the past few decades, the study of Northwest Coast art has moved away from a formal approach to the art and toward a broader cultural and historical con-textualization of artworks. A conceptual schism has developed in the field be-tween scholars involved in critical theory and those working in "intensively object-based" frameworks. Some question whether formal analysis of the art is relevant in a twenty-first-century context. Just before the Bill Reid symposium in 1999 at the UBC Museum of Anthropology, Marjorie Halpin announced that "formalism is dead" (Karen Duffek, personal communication, 2005). If formal-ism, by definition, demands that considerations of form must trump content or use, then perhaps formalism is dead. But much late-twentieth-century formal analysis embraces a broader view of cultural concerns (Arima 2000b; Black 1997; Duffek 2000; Macnair, Joseph, and Grenville 1998; Townsend-Gault 1994, 4-5; Wright 2001). This chapter proposes that formal analysis can be used in a "formal" approach to art history without acceding to the modernist paradigm of "formalism."

### DEFINITIONS

*Formal analysis* is "the process of describing the overall shape of an item as objectively as possible and with as much detail as possible" (*Concise Oxford Dictionary of Art Terms* 2001). This limited definition mentions shape but should include other formal elements such as balance, line, composition, and colour, among others. Formal analysis is a critical first step in any examination of art-work. It can answer basic questions about a piece. What is it? Where did it come from? And, possibly, who made it and when? These questions must be answered to understand an object as a social, cultural, or commercial production. Artwork cannot be approached at a theoretical level until it is historically situated. To be sure, not every scholar must perform his or her own formal analysis of each

404

object, but previous scholars' formal analyses are a critical foundation that must undergird any contextual consideration of use and meaning.

In contrast, *formalism* is "an artistic and critical approach which stresses form over content in a work of art. According to the formalist doctrine, the qualities of line, colour, and shape are sufficient, and other considerations – be they representational, moral, or social – are deemed redundant or secondary" (*Concise Oxford Dictionary of Art Terms* 2001). On the Northwest Coast, formalism is exemplified by the 1960s-era elevation of Native art to fine art as part of a greater movement to recognize Native culture and rights, while at the same time removing the ethnographic content of the work in exchange for a purely aesthetic appreciation of form (Watson 2004, 211) (see Ostrowitz, this volume; Watson, this volume). Obviously, formal analysis and formalism are not synonymous, even if they stem from a common source.

## FORMAL ANALYSIS: THE INQUIRY BEGINS WITH BOAS

Franz Boas's investigations of the iconographic, formal, historical, and psychological aspects of Northwest Coast art set the stage for all anthropological and art historical studies that followed (Boas and Stocking 1982, 17; Jacknis 1992, 154; Jonaitis 1995, 306). Boas's work – thousands of pages of descriptive text – focused on everything from manufacturing techniques to the details of ceremonial protocol. Boas used formal analysis to explore various theories concerning iconography and meaning, the diffusion of motifs over a geographical area, and ways of seeing and depicting a visual experience. On an iconographic level, Boas was concerned with how to "read" Northwest Coast art: how certain animals were represented; how they could be identified; and, in turn, how decorated objects might be used in crest display and whether representational designs could be abstracted enough to satisfy the needs of owners with different crests or to illustrate certain oral histories [15.1].

Boas acknowledged the importance of the individual in aesthetic choice but did not feature any individual artists, mentioning only the Haida artist Charles Edenshaw by name (Boas [1927] 1955, 158). His student, Herman Karl Haeberlin, asserted that Western methods of biography and attribution could be productively applied to an understanding of aesthetics in primitive art rather than in the service of ethnology [15.11]. His work on Northwest Coast basketry – one of the first studies focusing on individual artists – is particularly notable for selecting female artists, a choice not repeated until Andrea Laforet's work on Isabella Edenshaw (Haeberlin, Teit, and Roberts 1928; Laforet 1990). Later still, in the

1920s and 1930s, Marius Barbeau (1957) interviewed Haida and Tsimshian consultants, resulting in the first book devoted to the biographies of Haida artists and attributions of their work. Barbeau's work, rife with mistakes and misattributions, is nonetheless important for the sheer amount of new information it made available and for taking the first steps toward establishing a process (albeit with flawed results) to attribute particular objects to particular artists trained in particular styles.

It was not until the 1950s that historians and curators began to identify tribal styles rather than simply presenting work as "Northwest Coast" or relying completely on collection information. In that decade, anthropologist Viola Edmundson Garfield and art historian Paul S. Wingert (1951) compiled a stylistic analysis of the sculptural and flat design styles of the northern tribes with a detailed description of Tsimshian style in particular. Twenty-one years later Bill Holm published his seminal essay on Northwest Coast tribal styles in *American Indian Art: Form and Tradition: An Exhibition Organized by the Walker Art Center, Indian Art Association and the Minneapolis Institute of Arts* (1972).

Unquestionably, the most influential work on Northwest Coast art style is Bill Holm's *Northwest Coast Indian Art: An Analysis of Form* (1965) [15.III, 16.II] (see Figure 15.1). It explained northern Northwest Coast design conventions as practised in the nineteenth century and provided a new vocabulary for their elements, such as the "formline" and the "ovoid." It has been thoroughly excerpted and variously summarized (Berlo and Phillips 1998, 183-87; S.C. Brown 1995; Duff 1967; Feest 1980; Jonaitis 1986; Macnair, Hoover, and Neary 1980; H. Stewart 1979a). As well, it has been much loved, much thumbed, and, in recent years, carefully critiqued for its influence on the art form (Bernstein and McMaster 2004, 52; D. Cranmer 2004, 178; M. Crosby 2004, 118-19; J.C.H. King 1997, 88-89; McLennan and Duffek 2000, 112-13 [15.VII]; Townsend-Gault 1994; 2000, 209, 217 [15.VI]). Lyle Wilson's *Ode to Billy Holm ... Lalooska ... Duane Pasco ... and Jonathon Livingston Seagull* (1980; see Figure 15.2) provided a visual critique of the Indian artist as boxed in by academic and legal codifications.

In "Will the Real Charles Edensaw Please Stand Up? The Problem of Attribution in Northwest Coast Indian Art," Holm (1981; see also 1967) used his "formline" vocabulary to analyze and differentiate the works of six nineteenth-century Haida artists [15.IV]. He explained that "one of the few practical ways to pin down an art tradition to a particular place or time is to solidly identify one of the participants in that tradition" (1981, 175). Similarly, Steven C. Brown (1994, 75) succinctly defends attribution as according credit where it is due – to the artist.

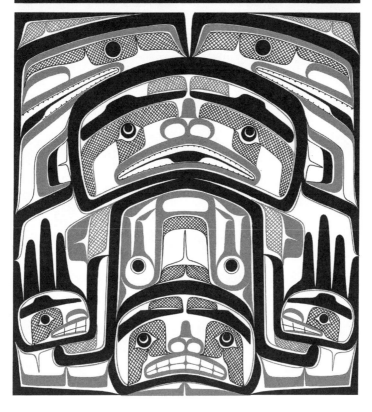

**FIGURE 15.1** Cover of Bill Holm's *Northwest Coast Indian Art: An Analysis of Form.* Published in 1965, this book catalogued what have become known as "the rules" of northern Northwest Coast art style. From Bill Holm, *Northwest Coast Indian Art: An Analysis of Form,* Thomas Burke Memorial Washington State Museum Monographs 1 (Seattle: University of Washington Press, 1965). Courtesy of Bill Holm and University of Washington Press.

The four main uses of formal analysis are to understand (1) an aesthetic system, (2) its chronological development, (3) its geographical (or tribal) variations, and (4) individual artist interpretations. Holm, Wright, Brown, and others have used formal analysis to critically investigate many topics first considered by Boas, including the formal treatment of decorative elements in sculpture and painting (Garfield and Wingert 1951; Holm 1965 [16.11]; B. Reid 2000a) as well as weaving (Gustafson 1980; Haeberlin, Teit, and Roberts 1928; Holm 1982; Laforet 1990, 2000; Samuel 1982, 1987); the individual artist's role in making stylistic

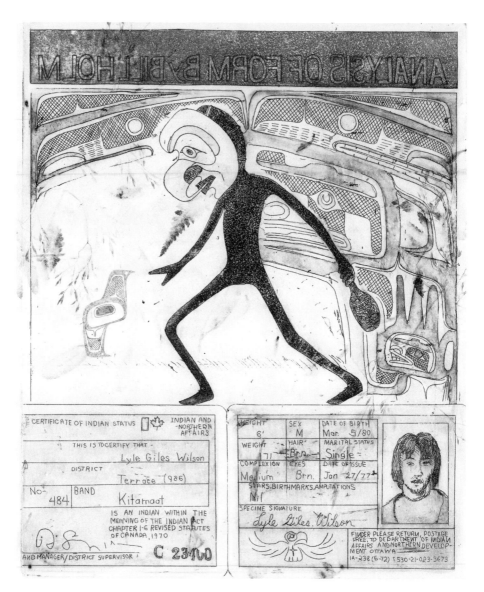

**FIGURE 15.2** Lyle Wilson, *Ode to Billy Holm ... Lalooska ... Duane Pasco ... and Jonathon Livingston Seagull,* 1980. Etching, 50.7 x 40.9 cm. In this work, Wilson questions definitions of authenticity established by non-Native artists, scholars, and governmental agencies. Courtesy of Lyle Wilson and the University of British Columbia Museum of Anthropology, Nb3.1372.

decisions, leading to artist attribution (Black 1997; S.C. Brown 1987, 1994, 2005; Duff 1967; Duffek 2004b [15.VIII]; Gessler 1981; Holm 1981 [15.IV], 1983c; Macnair 2000; Macnair, Joseph, and Grenville 1998; McLennan and Duffek 2000; Nuytten 1982; Wright 1985, 1992, 1998, 2001); design shifts by geographical area and tribal-style analysis (Black 1997; S.C. Brown 1995, 2000a, 2000c;

Feder 1983; Garfield and Wingert 1951; Holm 1983b, 1986, 1987; Lundy 1976); and the historical conditions of stylistic development and the conservatism of certain traditions, suggesting a chronology of development for Northwest Coast art (S.C. Brown 1997, 1998).

## A DETOUR INTO FORMALISM

The first show of Northwest Coast art that focused solely on form was at Betty Parsons Gallery in New York in 1946, organized by Surrealist artists Max Ernst and Barnett Newman (Holm and Reid 1975a, 10-11; see Mauzé, this volume). The influence of formalism was especially apparent in the exhibitions of the 1960s; the visual properties of the art supplanted all cultural concerns, setting the artwork adrift from its ties to territory or chiefly privilege (see Ostrowitz, this volume). During that time, scholarship focusing on individual artists and on the "golden age" of nineteenth-century Northwest Coast art forged a canon of masterworks and a valorization of style based on the works of those masters. This shift from ethnography to a Western art history foregrounding aesthetics over the objects' socio-political meaning has been critiqued by Marcia Crosby (2004, 119) for its creation of the "depoliticized Indian artist" placed in a "lineage of genius and mastery."[1]

The 1967 exhibition *Arts of the Raven*, curated by Bill Holm, Bill Reid, and Wilson Duff, presented artworks in a fine art setting and for the first time included a gallery devoted to a named artist, Charles Edenshaw. The curators redefined the position of Native art as having a universal rather than a local context: "Now these are arts in a different sense. Though truly enough of Indian descent, they are now Canadian art, modern art, fine art" (Duff 1967, n.p.; see Glass, this volume; Watson, this volume) [16.III]. One of the motivations behind the show was to move Native art from the dusty halls of ethnography to the pedestals of the art gallery. This elevation of Native art to fine art was part of a greater political movement to recognize Native cultures and rights. Some view the exhibition's elevation of Native art to fine art status as necessarily stripping away the artworks' ethnographic content (Watson 2004, 211). However, Bill Reid (1967) embraced the universalist interpretation of Northwest Coast art, proposing that the art was an expression of "essential humanity." And when the 1970 exhibition *The Legacy: Tradition and Innovation in Northwest Coast Art* was criticized for a lack of proper social and cultural context, Reid (2000b, 181) defended the presentation of the works as "art ... very high art indeed" in the modernist sense, to be appreciated "on [its] own terms." Recently, *Arts of the Raven* has been criticized as creating a "signification gap" by jumping from the work of

Edenshaw to that of Reid, setting the stage for many later narratives of decline, loss, and recovery (M. Crosby 2004, 118-19; see Glass, this volume).

The formalist texts of the 1960s and 1970s were part of the modernist approach to the visual experience, and "the Modernist position has consistently been to affirm the priority of a supposedly empirical aesthetic experience over a theoretically informed historical understanding" (Harrison and Wood 1992, 6; see Ostrowitz, this volume). Much Northwest Coast art historical and anthropological writing of that time contributed to the promotion of a universalist approach to the work, valuing form and aesthetics over function and social meaning (Duffek 2004b, 81).[2]

## THE SHIFT TOWARD RECONTEXTUALIZATION

By the 1980s, many artists questioned the value of this universalist ideology. Their commercial success gave them the economic resources to be increasingly involved in social and community events for personal and spiritual value. While restoring formal standards was still an artistic goal, ideas about cultural ownership and boundaries were also being restored (Duffek 2004b, 81). Formal analysis continued, especially by Holm's students at the University of Washington, while students of the late Wilson Duff at the University of British Columbia followed his lead into questions of meaning, interpretation, and structural analysis.

Late-twentieth-century critiques of the formalist approach reached back to the work of Boas. In a critical essay contesting his conclusions, Marjorie M. Halpin (1994, 6-7) demonstrated that the connections that Boas made between art and its relationship to oral history and crest display were, "quite simply, wrong." She described specific and local meanings for form that contradict the notion of a "uniform reaction to form" and the ability of experts to accurately "read" Northwest Coast images (see also Campbell, this volume) [19.xv].[3]

With the rise of postmodernism and the New Art History, scholarship that participates in privileging the visual has been inherently suspect as colluding with the aspects of modernism that verge on colonialism. According to art critic Thomas McEvilley, the universalist ideology effaced local knowledge through the use of universalizing standards, and "modernist formalism was thought to contain universal values that Westerners could locate in the works" (quoted in McMaster 1999, 83). If an object documents family and territorial prerogatives, then recasting it as "art" is "an act of suppression, even if it is done in the name of emancipation or cultural recognition" (Watson 2004, 209; see also Ḳi-ḳe-in, Chapter 22, this volume; Kramer, this volume). Formal analysis, then, has had varying ramifications for Northwest Coast art: it has placed an emphasis on

visuality rather than function, it has contributed to an inflated market for the works of certain "master" artists, and it has created expectations of style that contribute to the conservative reputation of Northwest Coast artists among other First Nations artists.

These criticisms have not wholly changed the presentation of Northwest Coast art in museum exhibits. The 2006 Vancouver Art Gallery show, *Raven Travelling: Two Centuries of Haida Art*, curated by a team of both Haida and non-Haida curators, participated in this formal approach to art, highlighting style and mastery over context and social value. The catalogue of the exhibit demonstrated that Holm's terms for, and understanding of, Northwest Coast "formline" design have now been widely adopted throughout the academic and artistic communities. Essays by several of the curators showed a continuing interest in the formal properties of the art, with forays into attribution and a reiteration of the canon of master artists (Macnair 2006), as well as an extension of formal concerns into the arena of intellectual cultural property, with an assertion of the privileged position of Indigenous knowledge (N. Collison 2006 [15.IX]; Townsend-Gault, this volume, Chapter 30).

How can formal analysis be adapted to fit current theoretical and cultural demands? Scholars trained in Holmian analysis often steer clear of interpretation and symbolism. The descriptive nature of the work purports to present itself as apolitical. This raises the question of whether there can be such a thing as a purely descriptive text. It is possible that scholars focusing on formal elements depict Northwest Coast art as *too* simple, falsely extracting artworks from the complex web of social production and colonial collecting practices. But there may also be benefits to this type of analysis. If Northwest Coast art is "ambiguous, ...endlessly variable," and only understandable with family-informed narratives, then purely descriptive texts might avoid the pitfalls of more hermeneutic writings (Halpin 1994, 6).

And while some scholars have formulated questions and methodology according to their own agendas, many contemporary historians believe that their work must contribute to the communities under consideration. Formal analysis can answer questions about artistic lineages and family production that would remain unanswered if artworks with scant collection information remained unanalyzed. In an interview with Charlotte Townsend-Gault (2000, 209, 213-14), Ki-ke-in asserts that what *matters* is "what family, what place, what event, what story that object has to do with" [15.VI]. Hopefully, by providing information on the time and place of creation and the name of the creator, researchers can answer these questions about certain artworks or reunite pieces with the clans and families from which they came.

With the current repatriation of artifacts and artworks to Native communities, attribution and formal analysis are both more relevant and more highly charged than ever. As Native American Graves Protection and Repatriation Act (NAGPRA) issues are resolved in the United States, and as treaty negotiations are ongoing in British Columbia, "attribution based solely on style is a significant and increasingly complex topic [see Kramer, this volume; White, this volume]. What has been largely a theoretical game of attribution now has possible implementations for artifact transfers to First Nations" (Martha Black, personal communication, 2005). The possible ramifications of attribution today require that scholars examine their motivations for formal analysis and the effects that their work can have on Native communities.

Repatriation is not the only community interest that can be served by a formally based art history. Wright's attribution work led to the extensive genealogies presented in *Northern Haida Master Carvers* (2001). Pulling together much archival material in one published source, the book makes previously inaccessible material easily available to community members. Consequently, Wright was asked to serve as a land-claims consultant based on her knowledge of genealogies and chiefly names. Other academics specializing in the formal aspect of Northwest Coast art have also been asked to serve as consultants on land claims. Serving in this capacity directly confronts the assertion that those scholars interested in the formal aspect of the artwork might "miss the connection between the land claims litigations ... and the art" (Watson 2004, 222).

*[handwritten margin note: demonstrating that formal analysis does not negate legal issues]*

Formal analysis can affect the artistic community as well as the academy (see Ostrowitz, this volume). Many Native (and non-Native) art-training programs use Holm's *Northwest Coast Indian Art* (1965). There is no doubt that contemporary artists have adopted Holm's vocabulary and have both supplemented and substituted their own terms. The Western academic practice of formal analysis parallels an analogous process in the Indigenous master/apprentice system, in which artists constantly analyze, interpret, and present design elements and matters of style. Steven Brown's (1987) work as a researcher and artist on the artist Kadjisdu.axch' exemplifies this process, resurrecting a late-eighteenth-century style successfully reinterpreted in Steven Jackson's pole for the Mount Robert's tram station in Juneau, Alaska, in the 1990s.

It is naive to think that there was no discourse on style in the Northwest Coast community of artists and patrons, whether past or present. With a uniform aesthetic spread over such a vast geographical area, there would have been a varied vocabulary to describe the artwork. If there were bark templates for design motifs such as ovoids, eyelid lines, and u-forms (many examples are in museum collections), then there were certainly names for these objects and criteria for

their artistic value (for an example, see S.C. Brown 2005, 50-51). Some may re-peat the epithet "there is no word for art in the [fill in appropriate tribal name] language" and suggest that Holm's invented terminology for the northern Northwest Coast design system is stultifying (M. Ames 1992b, 61-62 [15.V]; Bringhurst and Steltzer 1991, 162; N. Collison 2006 [15.IX]; Jensen 1996, 120; M. Jones 1993, 127; McLennan and Duffek 2000, 112-13 [15.VII]). But we know that there were Indigenous words for certain artistic concepts: in Haida, there were "words to describe aesthetic achievement ... such as *hlgadxuunang* (to carve deeply, i.e., on a pole) and *maats'ilang* (the carving of fine lines on a bracelet)" (N. Collison 2006, 63) [15.IX]; numerous Tlingit terms for design elements were recorded by George T. Emmons (Boas 1927, 253) [15.I]. Nika Collison's (2006, 63) discussion of the importance of Indigenous language provides insights into the depth of aesthetic reflection in a culture in which there was discriminating vocabulary for carving in various media and the nature of different types of carving [15.IX]. Kwakwa̱ka'wakw oral history relates the ancient origins of form-lines as a design left in the sands by receding floodwaters (Chalker, Dubin, and Whiteley 2004). Clearly, the form of the art was discussed.

Given this tangible and linguistic evidence of an Indigenous formalist trad-ition, it is not surprising that some of the best practitioners of formal analysis on the Northwest Coast are not academics but Native artists (Davidson 2013). Robert Davidson's paintings distill onto canvas his years of careful looking and deep thinking about the formal concepts of style itself. His titles suggest experiments with individual design elements: *U Is Transforming* or *Second Variation on Tri-Neg*. Other titles, such as *kugann jaad giidii*, hint at deep connections between form and cultural meaning (Duffek 2004b, 22-23) [15.VIII].[4] Davidson, like other art-ists who participate in performance as well as visual arts, understands the con-nection between the songs and dances of his people and the movement and flow of the formline (Boas 1927, 335 [15.I]; Duffek 2004b, 23-24 [15.VIII]; Holm 1965, 92-93 [15.III]).

Formal analysis is key to an initial examination of an artwork. There are still many unanswered questions about the history of Northwest Coast art. Formal analysis can help to fill some of the gaps. These analyses need not re-create a typology – with all of the inherent restrictiveness that implies – so much as provide insight into a specific historical and artistic situation. A detailed record of the times when and places where objects were produced is of great interest to First Nations during this era of land claims and NAGPRA (Halpin 1994, 10-11). This generation of researchers must determine whether – and, if so, how – a methodology based on formal analysis can address contemporary concerns among Native communities and academics on the Northwest Coast.

**15.I.  Franz Boas. 1927. "Art of the North Pacific Coast of North America."** In *Primitive Art.*
Cambridge, MA: Harvard University Press, 251-54, 275-77, 279-80.

Franz Boas's (1858-1942) early work on Northwest Coast art depended on for-mal analysis of the design elements used in animal representations as applied to two- and three-dimensional objects. By the time Boas published *Primitive Art* in 1927, he had matured into a more holistic view of art and culture, exploring the variety of heraldic expression in the visual arts and suggesting its permeation of more abstract art forms such as literature, music, and dance. This essay showed several aspects of his interpretive style: his stark formal analysis of the design elements of the northern style; his questioning of interpretive alignments be-tween design names and their uses; and his interest in the representative nature of crest art in the service of rank and privilege. The following selections show the open-ended nature of his descriptions and his acceptance of artwork as vari-ably communicative or decorative in nature. Despite his pronouncement of Charles Edenshaw's interpretation of a bentwood bowl as "entirely fanciful," Boas included Edenshaw's reading of the design field, allowing the interpreta-tion to appear in contradiction to his own judgment of it. Boas introduced some of the design elements that Bill Holm expanded on in his 1965 volume [16.II]. A close reading shows Boas's critical insights into the use of those elements and moments of misunderstanding later corrected by Holm. Demonstrated here is Boas's "recurrent theme that uncomplicated answers to questions of meaning simply did not exist" (Jonaitis 1995, 15).

We will turn now to the purely formal side of the treatment of the decorative field. There is a tendency to cover the entire surface with design elements. Vacant places are avoided. When the surface of the object represented has no features that lend themselves to decorative development, the artist resorts to devices that enable him to fill the surface with patterns. On totem poles the bodies of the animals represented occupy considerable space. The monotony of the surface is broken by placing the forelegs and hindlegs across the front of the body, by turning up the tail in front and by adding small animal figures.

Far more important is the application of a great variety of decorative elements, all of which consist of curved lines. The Indians have a decided disinclination to apply equidistant curves. In all work of the better class the lines are so arranged that more or less crescent shaped surfaces result, or that narrow, curved areas, wide in the mid-dle, narrower at the ends, are formed.

The most striking decorative form which is used almost everywhere, consists of a round or oval field, the "eye design." This pattern is commonly so placed that it

corresponds to the location of a joint. In the present stage of the art, the oval is used particularly as shoulder, hip, wrist, and ankle joint, and as a joint at the base of the tail and of the dorsal fine of the whale. It is considered as a cross section of the ball and socket joint; the outer circle the socket, the inner the ball. Often the oval is developed in the form of a face: either as a full face or a profile.

The general disposition of this design demonstrates that the explanation is not by any means always tenable. Thus in the blanket, fig. 205 [Figure 15.3], the eye pattern in the two lower corners has no connection with a joint. In this position, in the mouth of an animal, it is sometimes described as food. The two profile faces higher up on the side of the same blanket, are obviously fillers. They might be replaced by "eye designs." Another instance of similar kind is found on the upper part of the face of the dish fig. 168 [Figure 15.4]. The circular designs shown here might perhaps be interpreted as tail joints, but they are probably decorative elements. The design appears clearly as a filler in fig. 283 [Figure 15.5] at the inner upper corner on the long side of the box, and on the ears of the beaver, fig. 229 [Figure 15.6]. On Chilkat blankets it appears always in fixed positions and in large boxes it is the constant corner design. Its use and interpretation as a joint is presumably related to the frequent ornamental combination shown, for instance, in the feet on fig. 160 [Figure 15.7] and in the tails fig. 193 [Figure 15.8]. The oval represents the joint and the elevated part the limb. These are at the same time formal elements that appear regularly on the lateral border designs on carved boxes (fig. 274 [Figure 15.9]). The eye design appears in a variety of forms ranging from a large double eye to a circular pattern with black center.

Lieutenant Emmons has collected the various design elements as they appear on the blankets and has given the names by which they are designated by the Tlingit (fig. 266 [Figure 15.10]). These names do not fit the explanations given for the whole pattern. The "double eye" (*h*) and the "eye" (*f*) are not always eyes but occur also as joints, (fig. 269 *b* [Figure 7.4]). The profile eye is called the "head of the salmon trout" (*c*). It is used quite generally as the eye of any animal. The "black eye" (*g*), the "nostril" (*l*) and the design called "one in another" (*o*) are practically identical. They are also used as joints. The frequent use of the circular design of light or dark color, set off against a dark or light background indicated that the tribes of the north west coast do not tolerate areas of the same color, the monotony of which is relieved by the insertion of circular designs of contrasting colors. These may be seen on many blanket and box designs (fig. 274 et seq [Figure 15.9]).

The forms called "side holes" (*p*) and "holes," "ends of gambling sticks" or "rain drops" (*q*) have white circles relieving a black background. It is quite evident that these designs also, as parts of the whole design, have not the significance implied in the names, nor do the names explain the reason for their use. The frequent occurrence

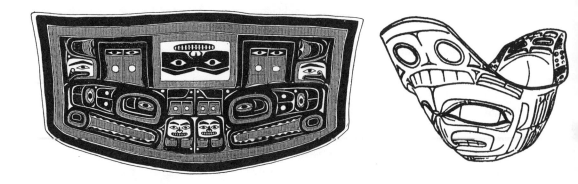

*CLOCKWISE, FROM TOP LEFT:*

**FIGURE 15.3** *Chilkat blanket.* Original line drawing. Boas cites this design as an example of the ambiguous nature of these designs, providing conflicting interpretations of its iconography [see also Figure 7.5]. From Franz Boas, *Primitive Art* (Cambridge, MA: Harvard University Press, 1927), 215, Figure 205.

**FIGURE 15.4** *Dish made of the horn of a bighorn sheep, Tlingit.* Original line drawing. Detailed drawings such as this sketch of a carved dish were used in Boas's formal analysis of Northwest Coast art. From Franz Boas, *Primitive Art* (Cambridge, MA: Harvard University Press, 1927), 191, Figure 168.

**FIGURE 15.5** *Carved trays.* Original line drawings. Designs for the side of a wooden bowl. Boas suggests the circular designs are used simply as "filler" in this bowl, denying their possible representational significance. From Franz Boas, *Primitive Art* (Cambridge, MA: Harvard University Press, 1927), 272, Figure 283.

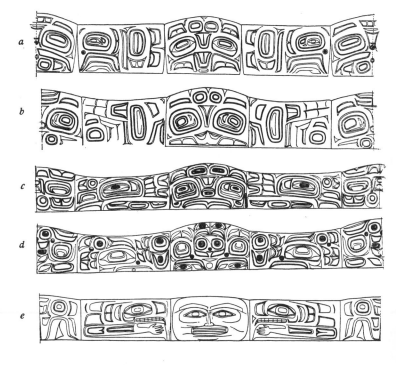

Fig. 283. Carved trays.

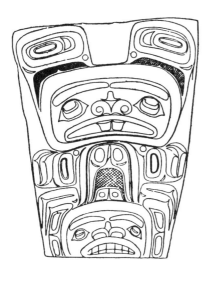

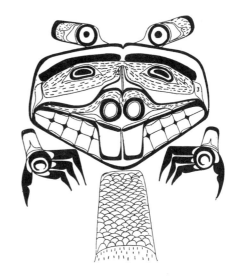

*CLOCKWISE, FROM TOP LEFT:*

**FIGURE 15.6** *Painted legging with design representing a beaver sitting on a man's head, Haida.* Original line drawing. This drawing appeared with Boas's formal analysis of Northwest Coast art. From Franz Boas, *Primitive Art* (Cambridge, MA: Harvard University Press, 1927), 227, Figure 229.

**FIGURE 15.7** *Painting for a house front placed over the door, representing the beaver, Kwakiutl Indians.* Original line drawing. Boas uses this image to highlight the circular designs used on the feet of the beaver. From Franz Boas, *Primitive Art* (Cambridge, MA: Harvard University Press, 1927), 188, Figure 160.

**FIGURE 15.8** *Styles of tails, Kwakiutl; above bird, below sea mammals.* Original line drawings. Boas emphasized the ornamental nature of Northwest Coast design in his descriptions of the use of the circular "eye designs." From Franz Boas, *Primitive Art* (Cambridge, MA: Harvard University Press, 1927), 205, Figure 193.

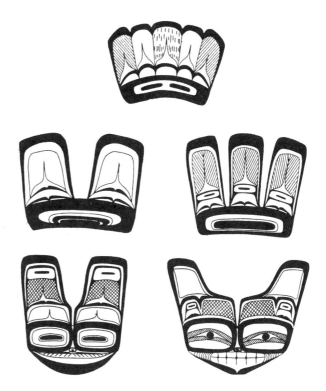

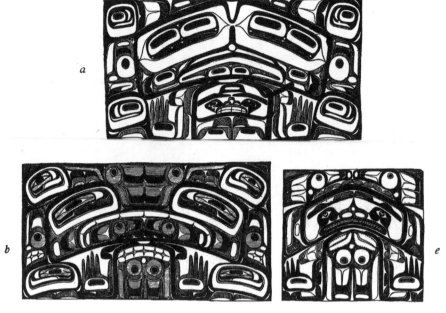

Fig. 274. Front, reverse and side of a painted box.

**FIGURE 15.9** *Front, reverse, and side of a painted box.* Original line drawings. Boas used this image to assert that, although circular designs are often used to represent joints, they are also used as decorative filler, such as on the border of this painted box. From Franz Boas, *Primitive Art* (Cambridge, MA: Harvard University Press, 1927), 263, Figure 274.

of the white circles, both isolated and in lines, (fig. 269) proves that they must be considered primarily as a formal element designed to break large surfaces.

It seems to me most likely that the black or white circular design has been the basis from which the eye design has developed. In the style of the north west coast art, shoulders, hips, hands, and feet form large dark monotonous surfaces. These are broken by a large white circle or oval, which is again varied by a black center. The tendency would also account for the goggle design (fig. 266 *i* [Figure 15.10]). The same desire to relieve the monotony of the cheek surface leads to the insertion of an oval design on the cheek (*k*).

In carved designs these forms are not contrasted by color, but the form alone varies the monotony of the large undecorated surface.

Another characteristic pattern, the narrow crescent, has presumably also originated from the desire to break the monotony of continuous areas. It appears particularly when it is desired to set off two merging patterns against each other. Here also design names obtained by Emmons, "woman's hair ornament" (*r*) and "slit" (*s*) have nothing to do with its function and significance as part of the whole pattern.

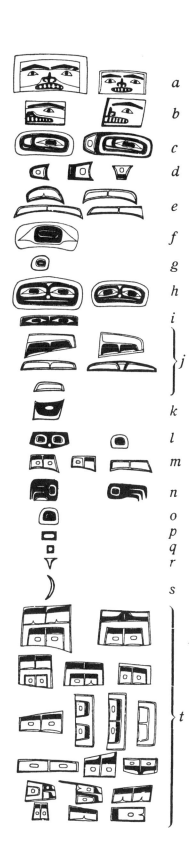

**FIGURE 15.10** *Design elements from Tlingit blankets.* Original line drawings. Design elements found in Tlingit weaving are shown here and discussed in Boas's formal analysis. From Franz Boas, *Primitive Art* (Cambridge, MA: Harvard University Press, 1927), 253, Figure 266.

The most characteristic filler, next to the eye, is a double curve which is used to fill angular and round fields that rise over a strongly or gently curved line. Many fillers of this type have a dark colored band at the upper end, generally rounded in paintings or carvings, square in blankets (see the tail patterns, fig. 193 [Figure 15.8]).

...

The boxes shown in fig. 287 [Figure 15.11] illustrate that still another pattern is used on square boxes ... A distinct wing design appears in the left hand upper rectangle of the fourth side, but otherwise the arrangement of the elements is so arbitrary that a safe interpretation is impossible. It seems plausible that in this case also the attempt at decoration was much more important than the attempt at interpretation. An interpretation was given to me for the box shown in fig. 287 *b* [Figure 15.11]. Although obtained from Charles Edensaw, one of the best artists among the Haida, I consider it entirely fanciful. The first side to the left, corresponds to the third side, which is opposite to it on the box. The second side corresponds to the fourth side. Edensaw explained the design as showing four interpretations of the raven as culture-hero. The upper right hand rectangle of the first side he claimed to represent the head of the raven surmounted by the ear; the large eye to the left of it, in the left hand upper corner, the shoulder and under it the wing and tail. The design in the right hand lower corner he interpreted as the foot; the toes are clearly visible in the lowest right hand corner of this field. He claims that the head turned upside down in the left hand upper rectangle of the second side represents the head of the raven and under it the hand; the raven being conceived as a human being. The rectangle in the upper right hand corner contains the shoulder; the right hand lower corner under it, the tail; and the left hand lower corner, leg and foot.

...

Our consideration of the fixed formal elements found in this art prove that the principles of geometric ornamental form may be recognized even in this highly developed symbolic art; and that it is not possible to assign to each and every element that is derived from animal motives a significant function, but that many of them are employed regardless of meaning, and used for purely ornamental purposes.

The symbolic decoration is governed by rigorous formal principles. It appears that what we have called for the sake of convenience dissection and distortion of animal forms, is, in many cases, a fitting of animal motives into fixed ornamental patterns. We infer from a study of form and interpretation that there are certain purely geometric elements that have been utilized in the symbolic representation. Most important among these are the double curve which appears always as a filler in an oval field with flat base, and the slit which serves to separate distinct curves. The typical eye design is presumably related to the circle and dot and may have developed from the double

Fig. 287.   Painted boxes.

**FIGURE 15.11** *Painted boxes.* Original line drawings. Boas expresses the challenges of interpreting what he saw as arbitrarily arranged design elements on the painted box shown here. From Franz Boas, *Primitive Art* (Cambridge, MA: Harvard University Press, 1927), 276, Figure 287.

tendency of associated geometrical motives with animal forms and of the other, of standardizing forms derived from animal motives as ornamental elements.

The art style can be fully understood only as an integral part of the structure of Northwest coast culture. The fundamental idea underlying the thought, feelings, and activities of these tribes is the value of rank which gives title to the use of privileges, most of which find expression in artistic activities or in the use of art forms. Rank and social position bestow the privilege to use certain animal figures as paintings or carvings on the house front, on totem poles, on masks and on the utensils of every day life. Rank and social position give the right to tell certain tales referring to ancestral exploits; they determine the songs which may be sung. There are other obligations and privileges related to rank and social position, but the most outstanding feature is

the intimate association between social standing and art forms. A similar relation, although not quite so intimate, prevails in the relations of religious activities and manifestations of art. It is as though the heraldic idea had taken hold of the whole life and had permeated it with the feeling that social standing must be expressed at every step by heraldry which, however, is not confined to space forms alone but extends over literary, musical and dramatic expression.

**15.II. Herman Karl Haeberlin. 1918. "Principles of Esthetic Form in the Art of the North Pacific Coast: A Preliminary Sketch."** *American Anthropologist* 20: 260, 263-64.

Just as many of the concerns of twentieth-century anthropologists were forecast by Boas, Herman Karl Haeberlin (1890-1918) also presaged later studies. His call for a study of the characteristic northern Northwest Coast use of line (formline) was fulfilled in Holm's *Northwest Coast Indian Art* (1965), and his interest in the individuality of artists, rather than a tribal "type," was answered in work by Holm, Brown, Wright, Gessler, and others on artist attribution.

> Furthermore, such phenomena are of interest as the curvature of surfaces, and the persistency with which painted lines are given artistic "character" by making them lighter or heavier at different points, as for instance in the outlines of the eyes which represent joints. By such a method of analysis we should arrive at the formulation of a number of esthetic principles which underlie the art of the northwest coast and which have thus far only been "felt." Only after the definite formulation of such principles can we attempt a scientific comparison of the artistic qualities in the style of different cultural groups.

> ...

> The only plea I wish to make is that we study the formal principles in primitive art by methods comparable to those applied in the esthetics of our own. We are likely to look on primitive art simply as an ethnographic element and to limit our study to its relations with the other elements of a cultural unit. This I have called the extensive line of research. By an intensive study of primitive art we became conscious of the essential identity of problems, in primitive art and in our own. Surely both lines of study may become mutually helpful. The study of primitive art has the great advantage of an ethnological perspective in which the cultural relations, I mean borrowings, assimilations, specialization of cultural elements, are far more plastically outlined than they are in the history of our own art. On the other hand the esthetic study of our art is privileged by being able to become individualistic and biographical, so to say, thanks to the detailed documentary evidence bearing on its historical development. It is true that this may become an evil when the student is not able to look beyond the historical

details and to see the broad underlying principles of cultural relations. But in the study of primitive art it is just this biographical feature of the history of modern art that we need for stimulation. We tend too much towards conceiving the art of a primitive people as a unit instead of considering the primitive artist as an individuality. It is necessary to study how the individual artist solves specific problems of form relations, of the combination of figures, and of spatial compositions in order to understand what is typical of an art style. A purely ethnological point of view in the study of primitive art is inadequate. We need a broader culture-historical outlook. It may seem paradoxical, but it is nevertheless true that ethnology becomes the more scientific, the more it forgets that it is a science. Ethnology is a fortuitous unit. It is the culture-historical point of view that counts.

**15.III. Bill Holm. 1965. *Northwest Coast Indian Art: An Analysis of Form.*** Thomas Burke Memorial Washington State Museum Monographs 1. Seattle: University of Washington Press, 92-93. Courtesy of Bill Holm and the University of Washington Press.

*Northwest Coast Indian Art* was the result of a project undertaken by Bill Holm (b. 1925) in the 1960s. After much intense study of many museum collections of Northwest Coast art, he had developed a "feel" [16.II] for the "system of principles that governed certain aspects of Northwest Coast art" (1965, v). At the urging of Erna Gunther, Holm returned to his project and began a systematic analysis, encoding the design data from 400 examples. In hindsight, Holm says, if he had known the book would have such widespread use (it is in its twentieth printing, with over 110,000 copies sold), he would have changed the title to more clearly reflect the geographical and temporal parameters of his study (Holm, personal communication, 2005).

Excerpt 16.II presents the most well-known parts of the book – the "rules" (more aptly termed "conventions") that are often taught in classes on formline design. The conclusion, reproduced here, is a key section of the book and is often overlooked by critics of the formalist approach. In it, Holm wrote of the connection of visual form and kinetic movement – a relationship acknowledged by those who participate in both art forms but one that has not yet been the focus of published scholarship. Holm's rejoinder as to the creativity, sensitivity, and inspiration of master artists confronted those who would reduce Northwest Coast art to a standardized compilation of its constituent parts.

CONCLUSION

It is apparent that there was, on the Northwest Coast, a highly developed system for the organization of form and space in two-dimensional design as an adjunct to the

well-known symbolism. Design ranging from nearly realistic representation to abstraction resulted from the application of the principles of this system. Chief among these principles was the concept of a continuous primary formline pattern delineating the main shapes and elaborated with secondary complexes and isolated tertiary elements. Also important to it was a formalized color usage that prescribed the placement of the three principal colors: black, red, and blue-green. There was a set series of design units which could be arranged and varied in proportion to fit the requirements of space and representation. Important among these were the formline, the formline ovoid, and the U form. To define forms and to maintain the fluidity of design, a group of transitional devices was used. Monotony was minimized by nonconcentricity and avoidance of parallels, as well as by firm semiangularity of curves. A limit to the degree of elaboration was imposed which was independent of the scale of the design.

The total effect of the system was to produce a strong, yet sensitive, division of the given shape by means of an interlocking formline pattern of shapes related in form, color, and scale.

Although it is beyond the scope of this study to deal with the possible origins of development of Northwest Coast two-dimensional art, an interesting possibility of a close kinesthetic relationship of this art to dance movement is worth mentioning. Boas has suggested that there are relationships of this kind.

 Dance contains elements of both the spatial and time arts. Therefore, the principles of the former may be clearly observed in dance forms. Rhythmic movements and rhythmic spatial order, symmetry of position and movement, and emphasis and balance of form are essential in esthetic dance form.

I, myself, have derived a certain physical satisfaction from the muscle activity involved in producing the characteristic line movement of this art, and there can be little doubt that this was true also for the Indian artist. To say that there may be a kinesthetic relationship between this movement and dance movement is not to say that there is any visual or spatial similarity, although there may be, but to a lesser degree. Because of the purely sensory nature of the suggested relationship, it is difficult, if not impossible, for one who has not personally participated in both activities to be aware of it.

Some of the most skillful artists of the southern Kwakiutl are also among the best dancers and song composers, a situation that probably was also true of the northern tribes during their heyday. The interrelationship of the arts has been recognized in other cultures. An East Indian treatise of the sixth century A.D. describes a conversation in which a sage advises a king that he must first learn the theory of dancing before

he can learn the whole meaning of art, since the laws of dancing imply the principles that govern painting.

The constant flow of movement, broken at rhythmic intervals by rather sudden, but not necessarily jerky, changes of motion-direction, characterizes both the dance and art of the Northwest Coast.

Whatever the origins of the art may have been, it is certain that no system could ever, of itself, produce the masterworks of Northwest Coast art, which are the inspiration and the object of this study. As in all art it remained for the imagination and sensitivity of the most imaginative and sensitive of men to give life to a list of rules and principles and produce the wonderful compositions that came from the northern coast. It is precisely because each piece was the creation of the mind of a man that it can be analyzed only superficially in terms of elements and principles, while that quality which raises the best of Northwest Coast design to the status of art remains unmeasured.

**15.IV. Bill Holm. 1981. "Will the Real Charles Edensaw Please Stand Up? The Problem of Attribution in Northwest Coast Indian Art."** In *The World Is as Sharp as a Knife: An Anthology in Honour of Wilson Duff*. Edited by Donald Abbott. Victoria: British Columbia Provincial Museum, 175, 178-79, 192-93, 199. Courtesy of Bill Holm.

In this article, Holm described and differentiated the work of six Haida artists, a study he had begun with a gallery devoted to Charles Edenshaw (ca. 1839-1920) in *Arts of the Raven*. Despite the sixteen-year gap between the two publications, this article pursued some of the goals set out in the earlier exhibition and its accompanying catalogue (Duff 1967; Holm 1981). The identification of "master artists" brought Northwest Coast art (and Northwest Coast art history) into a recognizable framework established in European art history. This was critical during an era when Native American art history was still in its infancy and striving for legitimacy within the field.

Holm's work was similar to that followed in European and African art studies for artist attribution: identifying the hand of an artist through stylistic analysis, gathering works that fit into an oeuvre, and aligning them with the name or pseudonym of a given artist (S. Vogel 1999, 40). While great artists were sought out for chiefly commissions on the Northwest Coast, we are only beginning to glimpse the importance of artists to the status of the artwork (S.C. Brown 2005). Clearly, the lineage history or territorial claims instantiated by the work eclipsed the identity of the creator. Still, artist attribution can help to provide a snapshot of art making at a particular time and place. This scholarship need not

(yet occasionally does) participate in a canon of masterworks contributing to a linear narrative of artistic progression (Phillips 1999, 99). Instead, such work can contribute to specific community and family concerns. This type of information is sought out by the younger generation of artists as well as by First Nations involved in land-claims litigation.

> Does it really matter if an argillite chest was made by Charles Edensaw or Tom Price, or a mask or frontlet was carved by John Robson or Charlie James or Willie Seaweed? None of these artists will profit by the recognition. Just the same I believe there are good reasons why we might want to know and recognize the works of individual artists of the Northwest Coast, whether or not we know their names. For one thing, it's important just to recognize the fact of individual creativity in cultures other than our own. A few years ago I wrote an article about the art of the Kwakiutl master artist, Willie Seaweed. One reason for writing it was to make a point for recognition of the individuality of the "faceless" artists in tribal societies. I believe we slight the creativity of a group of people if we don't recognize the differences in the work of individuals within the group. In our own art tradition the "name's the thing." Names sell. An attribution, accurate or not, to a "name" artist like Willie Seaweed or Charles Edensaw will put extra dollars into a dealer's pocket.
>
> But there's another good reason to spend the time and effort needed to be able to identify individual work. One of the few practical ways to pin down an art tradition to a particular place or time is to solidly identify one of the participants in that tradition. And besides this practical reason, I really would like to know – as well as it's possible to know – who did what. I'd like to be able to look at a fine mask or rattle or painted box and know where it came from. I'd like to be able to recognize the artist in the object, even though I may never be able to know his name. And I want to experience – even though that experience has to be vicarious and imperfect – the choices and decisions that artist made.
>
> I believe it is possible to recognize what those choices were. The more thoroughly we understand the underlying structure of an art tradition the more clearly those choices stand out. Northwest Coast artists worked within regional art traditions which are gradually being more and more clearly defined. The northern two-dimensional aspect of the broad Northwest Coast tradition is so highly structured and logical that even slight individual variations can be recognized easily. But the fact that one piece differs from another isn't enough for attribution. Attribution is possible because artists make discrete choices in what they do or don't do. In northern Northwest Coast two-dimensional art the choices are primarily in the design elements which can be selected from the traditional available supply, the relationship of those elements to each other, and their physical form. The choices aren't limitless – certain elements and certain

relationships must be used or the structure falls apart. Many of the choices made by Northwest Coast artists were, or rather are, intellectually made. Northern two-dimensional art is flourishing again and the best artists are developing individual styles within the system just as their predecessors did. They base their choices on the satisfaction they derive from the appearance of the forms and combinations.

Artists copy one another. If this weren't true there wouldn't be a recognizable art tradition in the world. By copying I mean that they choose what is personally satisfying in the work of other artists and incorporate it into their own work. At the same time they consciously or unconsciously alter these chosen elements and put their own stylistic stamp on their own work. When artists work closely together, especially as master and apprentice or as collaborators (both common on the Northwest Coast) their work is likely to be very similar. So regional styles developed. We can easily tell the difference between Haida totem poles and poles of the Tlingit, Tsimshian or Kwakiutl. At the same time, typical poles of Massett are recognizably different from those of Prince of Wales Island, Skidegate, Tanu and Anthony Island – and those are different from each other. And within these village or regional schools the styles of individuals can be seen.

...

## SIGNIFICANT CHARACTERISTICS

What are the significant characteristics which stamp the work of an artist on the Northwest Coast? Just as the paintings of European artists of the past can be identified by scholarly experts through stylistic clues, the masterpieces of the coast can be separated on the basis of objectively described characteristics. But these characteristics must be significant. That is they must represent choices which each artist makes that are unlike those made by others. There are certain aspects of Northwest Coast art which are of little use in attribution. Subject matter is one of these. Since the artists who produced most of the great pieces were professionals in a very real sense – formally trained, working on commission for others (and paid for their work), and typically producing for chiefs of the opposite phratry – there is very little use in attributing on the basis of crest ownership. On the other hand the same artists, carving argillite and wooden poles for sale to non-Indians, frequently used their own crests and stories as subjects. It is unsafe to rely on subject matter alone as a means of identifying artists.

...

## JOHN CROSS

The artists who drew the 27 tattoo designs published in John Swanton's *Contributions to the Ethnology of the Haida* were all identified by name. The three designs by Edensaw

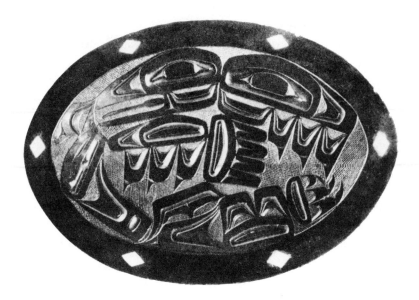

**FIGURE 15.12.**  John Cross, argillite platter. This image demonstrates how the structure of secondary complexes can be used in artist attribution, here examining the ovoids and U-complexes typically seen in John Cross's argillite carving. From Bill Holm, "Will the Real Charles Edensaw Please Stand Up? The Problem of Attribution in Northwest Coast Indian Art," in *The World Is as Sharp as a Knife: An Anthology in Honour of Wilson Duff,* ed. Donald Abbott (Victoria: British Columbia Provincial Museum, 1981), 192, Figure 40. Courtesy of Bill Holm.

are easily recognized, exhibiting the typical characteristics of his style. Five of the drawings were done by Wiha, and the remaining nineteen were the work of John Cross. They are distinctive in several ways. Cross, like John Robson, favoured an unusual cheek structure in his designs in which the form line ovoid of the eyesocket is unbroken (figs. 38, 39, 40 [Figure 15.12; figs. 38 and 39 not shown]). It differs from Robson's solution in having a formline U appended to the ovoid in the cheek area, with the formline of the lower jaw attached to the U. Usually the cheek is elaborated with one or two secondary Us. Teeth are either U form, sharp curved triangles, or a combination of both.

John Cross's two-dimensional compositions are multiangular, with ovoids, Us and related figures moving in every direction over the designed space. Often the tapered, curved legged Us are attached in multiples to ovoids and to other Us. The U complexes are very consistent in their form and detail (fig. 41 [not shown, see Figure 15.12]). The legs are tapered and flare outward as they near the joined formline. Typical elaboration consists of a secondary U or a pair of secondary Us with wide open relief slits at the base, and surrounded by a narrow tertiary U, bevelled outward. Tertiary split Us occur, but infrequently.

Cross's usual ovoids resemble an old northern form with relatively massive, angular formlines, slightly peaked at the top. The nearly concentric inner ovoid fills the available space, leaving a narrow, bevelled tertiary area (fig. 41 [not shown], fig. 22d [not shown, see Figure 15.12]). Eyelid lines are sharply constricted. An unusual form of stylized face was favoured by John Cross as an ovoid elaboration (fig. 22e [not shown]). It features a long eyebrow with central hump and upturned forward end, with a small, narrow eye close under it. A single, lower, eyelid runs closely under the eye.

John Cross's flat designs are almost frantic in their dynamic action. The twists and reverses of flippers, tails and wings are accentuated by their interlocking tapered U forms. He used few variations on his standard design elements, repeating the same U complexes over and over in different proportions and sizes. If a bit of ground along the edge of a platter needed filling, a broad primary U was based on the design edge, enclosing the double secondary U and surrounding bevelled tertiary space. A few other artists used a similar filler in this way, but for Cross it was the usual solution.

...

IS ATTRIBUTION REALLY POSSIBLE?

Is it really possible or practical to attribute authorship of a Northwest Coast art object to an individual artist on the basis of style? I believe it is, with certain obvious limitations. It would be ridiculous to suggest that we could group all Northwest Coast art objects, by artists, without error. Even those artists whose work is best known and most solidly documented produced pieces which must puzzle us. Still there is much which can be identified.

**15.V. Michael M. Ames. 1992. *Cannibal Tours and Glass Boxes: The Anthropology of Museums.*** Vancouver: UBC Press, 60-62.

Michael M. Ames (1933-2006) originally published this essay in *BC Studies* (1981a). It was one of the earliest critiques of the formal analyses of Holm and Boas, asserting that these texts led to a "stereotyping of form and content." Ames's underlying premise suggested that it was the *written* codification of customary artistic practices that resulted in a standardization of the design form. What Ames failed to mention was that the mere act of writing can never be enough to affect cultural change; it must be the interpretation and the utilization of the published work by artists themselves that evoke change. Additionally, the two publications by Boas and Holm have been used by artists over the years more for their prolific illustrations of the artwork than for the descriptive texts about how these works were constructed.

RECONSTRUCTING THE MEANING OF NORTHWEST COAST INDIAN
ARTS AND CRAFTS

Anthropologists produced a distinctive and widely influential interpretation of the material culture collected from the Northwest Coast. This interpretation included both a *codification* of the elements or principles of Northwest Coast Indian design, and a *redefinition* of its meaning or aesthetic quality, from a "primitive" or curio art to a "fine" or "high" art comparable to the arts of western civilization.

The codification of design elements has encouraged a standardization or rationalization of design and technique. The consequences are comparable to customary law being transformed into written law: a general stereotyping of form and content follow. (Another factor that has had a counter-effect is the tendency among some more advanced Indian carvers to accept in part the role model of the "modern artist," who is expected to be individualistic and experimental.) Two anthropologists in particular played leading roles in this codification process: Franz Boas and Bill Holm.

Franz Boas was not the first to do anthropological investigations on the Northwest Coast, nor was he the first to show serious interest in Northwest Coast Indian design; but he did produce one of the single most influential codifications of that tradition, first published in the 1897 *Bulletin of the American Museum of Natural History* and subsequently in Chapter 6 of his *Primitive Art* (1927). He provided a masterful discussion of the elements and principles of Northwest Coast Indian art, such as the oval eye form (now called ovoid), the double curve design, split U's, split representation, and dislocation of parts, along with a set of illustrations that still rank among the best in the literature.

As Helen Codere remarked in her introduction to Boas's *Kwakiutl Ethnography*, "even rather superficial knowledge of the elements of this art and its symbolic and operational conventions, as Boas has analyzed and described them, makes it simple to specify what is wrong with anything that is not, but only purports to be, Northwest Coast art." Codere then went on to make a prophetic statement: "There seems to be no reason why thorough mastery of the details of Boas's analysis, with a requisite technical skill in painting or carving, should not make it possible to produce authentic new Northwest Coast art." She pointed out how this would provide a generative test of the adequacy of Boas's analysis, and this is precisely what has happened.

Bill Holm, of the University of Washington and Thomas Burke Museum, is recognized as the leading analyst of Northwest Coast design. He took codification even further than Boas, at least for two-dimensional or flat design, and produced what has become the standard text studied by both anthropologists and Indian carvers. Holm taught himself how to produce Northwest Coast art, then he taught others, including Indian carvers. He briefly assisted in the development of the 'Ksan style of Northwest

Coast art at Hazelton, British Columbia, for example, which is an amalgam of traditional and anthropologically reconstructed rule-based principles. In fact, in 1966, the year Codere's prophetic statement was published, Holm took his slides and notes to Hazelton and lectured on the elements of Northwest Coast flat design. The codifications produced by Boas and Holm provide the primary criteria according to which the Northwest Coast artist is judged. Indian carvers themselves both learn and teach from the Boas and Holm books.

The second way anthropologists contributed to the reconstruction of the meaning of Northwest Coast Indian art was to promote a change in classification, from the exotic status of "primitive art," where it was compared to other tribal and curio traditions, to the more dignified status of "fine art," where it is now compared with the great traditions held in highest esteem by Western civilization. Lévi-Strauss was perhaps the first anthropologist to propose this redefinition, writing in 1943 that "'certainly the time is not far distant when the collections of the Northwest Coast will move from anthropological museums to take their place in art museums among the arts of Egypt, Persia, and the Middle Ages. For this art is not unequal to those great ones."

On the West Coast since the 1950s a number of people, through their teachings, writings, and exhibits, also promoted this theme of Northwest Coast Indian crafts as fine art. Wilson Duff, curator of anthropology at the Royal Museum of British Columbia (RMBC) and then a professor of anthropology at the University of British Columbia, played an especially important role. One of the more significant exhibits during this period was the 1967 "Arts of the Raven" at the Vancouver Art Gallery, curated by Doris Shadbolt, with the assistance of Duff, Holm, and Haida artist Bill Reid.

In the catalogue prepared for that show, Doris Shadbolt referred to the "shift in focus from ethnology to art" that the exhibit represented. Eight years later, looking back upon that exhibit, Duff wrote that "Arts of the Raven" was the "threshold over which Northwest Coast art has come into full recognition as 'fine art' as well as 'primitive art.'"

**15.VI. Charlotte Townsend-Gault. 2000. "A Conversation with Ki-ke-in."** In *Nuu-Chah-Nulth Voices, Histories, Objects and Journeys.* Edited by Alan L. Hoover. Victoria: Royal British Columbia Museum, 209, 213-14.

This essay from *Nuu-Chah-Nulth Voices, Histories, Objects and Journeys* exemplified the counsel given by the editors of that volume, that the histories of Native peoples were "often written in words that reflect the values and priorities of the non-aboriginal society" (Inglis, Haggarty, and Neary 2000, 7). Ḳi-ḳe-in (Ron Hamilton) provided a stern reminder of the emic privilege of family history and individual relationships above matters of form and aesthetics. He began by

stressing the importance of identity: "Who are you?" is the elemental question. Interestingly, this is the question that some formalist scholars ask of their objects of study. Ḳi-ḳe-in demonstrated the depth of personal and community knowledge that must be brought to bear in order to properly answer this question, transcending the morphic and visual properties of an object. The essay as a whole questioned the concept of "art" as defined by outside authorities.

*Ḳi-ke-in:* External authorities can forever analyse and talk on and on about what they see when they look at an object. Mostly, none of it matters even a little bit to me. Not even a little bit. Because whether or not an object has split U's, or tertiary fields [terms devised by Bill Holm], or can be identified as being by "a great Haida master from Masset in the 1870s" because of similar pieces collected by people that are dated and authenticated ... doesn't affect what it is. Not that much. However, I do want to know what family, what place, what event, what story that object has to do with. What is that rattle about? What is its purpose? What is its use? What is its application? In what instances has it been used in the past?

...

*Ḳi-ke-in:* Well, take this rattle that I have in my house here. It's very precious to me and one of the strings on it is seine twine and one of the things on it is paint. There's cedar bark on it. It's made of wild-cherry wood and it's got some eagle down on it. Well, we could go on endlessly about the quality of the faces and describe the physical nature of this thing forever, and be really cute and relate it to northern things and how it seems to be a copy of northern style design, and imply that those Nuu-chah-nulth people don't know how to draw a proper ovoid so the mouth isn't really an ovoid but it's somewhat reminiscent of more northern style and that kind of stuff. It does nothing to help me understand this. It says nothing about this thing's relationship with myself and my family and others who have held it and used it, and why, and where, and when. But if we look only at these little fluffy things and know that they are eagle down or swan down and talk about that ... that's the stuff that's interesting to me. I don't care if anybody thinks it's perfectly well made and exhibits all of the skills of a great carver. I don't care about any of that. I like that it's very well done. I really do. I like that. There are rattles I've seen that are just about as crude as you could possibly get, which have functioned in a place of need that are every bit as important for the people, and the time, as this rattle is. This has been used in hundreds of potlatches over a very long time. I remember once having Alice Paul, a particularly knowledgeable Hesquiaht elder and accomplished basket-weaver, ask me if I could make a whistle. She said, "I need a whistle during this funeral for what we're going to do." I said, "I can make you a whistle." I immediately grabbed a curved knife and a straight knife and made a whistle that sounded like she wanted it to sound. She

wanted a certain pitch of sound so I made it for her. She liked that. I don't know where that whistle is today or what's happened to it, but it could be in some museum somewhere and called a Hamatsa whistle or something else. Then, again, I know that what I carved it for, what I made it for, was the use that she needed it for, which was dealing with her brother's death. Her brother died and she wanted to acknowledge her brother and to put him away in a respectful way. Part of the process of doing that and acknowledging the change, the transformation from the *kuu-as* (real living human being) that we knew, to *ch'ihaa* (a being of the spirit world), involves ceremonies that deal with our spiritual system. To send him on his way. Likewise, the same woman on another occasion asked me to make a rattle and I had no tools with me. So what I did was, I got a snuff can, some wire and a piece of wood that already existed – I sawed off a piece of a broom handle – that made a perfectly good rattle. Perfectly good functionally. I don't know what anyone else might think about it, but for her, that rattle was used to invoke a spirit, to call her ancestors to her, to come and acknowledge what she was doing and to give her strength when she was doing what she was doing. It satisfied her as much as having proper old things on hand would do. In a more temporal way, this is more pleasing. In a more spiritual sense, the makeshift rattle did absolutely adequately.

Let's say I'm a *ch'ihaa*, someone who no longer wears a body visible to others, I am in the universe, and my sister calls me. Do I, as a spiritual being, care whether she calls me with a beautifully symmetrical, well finished, slightly-northern-looking, somewhat-reminiscent-of-the-master-of-the-Chicago-settee's-work rattle* or calls me with a snuff can with some pebbles in it? Well, I think that all of those things really don't matter. However, in the process of doing it, of calling a *ch'ihaa*, this stuff, this white fluffy down, has great significance. It's not there as a decoration. Some individuals spend a great amount of time walking around in nature picking up nothing but clean eagle down. Have you ever seen a piece of eagle down anywhere in nature? You walk around a long time looking for it.

---

\* This is a designation devised by Bill Holm, and followed by others, to identify work by the hand of a 19th-century Haida artist – which includes a remarkable settee in the Field Museum, Chicago – whose real name has not, to date, been recovered. [From Holm 1981] – CTG.

**15.VII. Bill McLennan and Karen Duffek. 2000. "The Language of Painting."** In *The Transforming Image: Painted Arts of Northwest Coast First Nations.* Vancouver: UBC Press; Seattle: University of Washington Press, 112-13.

In this excerpt, Bill McLennan and Karen Duffek discussed the benefits and limitations that have resulted from Holm's 1965 publication. They queried the effect of a written description of form and explored how this diverges from possible

artistic paradigms within an oral culture. Repeating again the axiom of "no word for art," they pondered whether individual design elements could be conceptualized as separate from the overall design field or whether they were only considered as integral to the object itself. This discussion is contrasted with George T. Emmons's description of the elements in Chilkat blanket design and Franz Boas's notation that the names of the elements were unrelated to their role as constituent parts of a representative image. McLennan and Duffek's questions transcended the simplest critiques of formalist terminology and challenged academics and artists alike to consider matters of form from a multidimensional perspective. In addition to an attention to oral history and language that the authors suggest, one might bring to bear the full sensorium of a specific cultural perspective rather than a Western ocular-centrist bias (Howes 1991; Ong 1991; Phillips 1999, 99).

Despite the cautions that McLennan and Duffek provided in this excerpt, much of the work in *The Transforming Image* was in the formalist tradition of tribal style and artist attribution. The great success of their project was the visual repatriation of images to their originating communities through digital and photographic databases. And while one cannot reconstruct knowledge through formal analysis, new knowledge can be built around an understanding of previous artistic practices (McLennan, personal communication, 2005).

In his 1965 publication *Northwest Coast Indian Art: An Analysis of Form*, Holm not only codified the principles of composition underlying the northern style but also invented the vocabulary with which artists and public alike now speak about its forms. Holm chose to focus his efforts on the relationships among forms rather than the principles of representation, which he considered had been adequately discussed by Boas. He named the formline as the primary element of northern Northwest Coast painting and low-relief carving. This continuous, flowing line swells and narrows in width as it surges through an image, defining and elaborating forms within the composition and creating relationships of positive and negative space. For centuries, northern painters mastered this central concept and revealed its variable interpretations through the nuances of personal style and artistic skill. Yet the primacy of the form line is not always evident to the untrained eye. Even Boas did not recognize this element as providing the essential structure of a composition.

Holm based his understanding of the form line and its principles on a systematic study of late-nineteenth-century painted artifacts in museum collections. He analyzed 400 Haida, Tsimshian, Tlingit, Haisla, Heiltsuk, and Nuxalk objects in order to reconstruct the organizational system on which the art was based and to document the knowledge he had acquired by carving and painting objects in the northern style

himself. (His findings were complemented by those of Bill Reid, who had begun a similar process in the 1950s to reconstruct the formal rules of the Haida tradition by studying, copying, and learning from the work of earlier artists.) Through this process, Holm formulated the canon by which Northwest Coast painting has come to be understood and assessed. He coined descriptive words not only for the formline but also for the integral motifs associated with it, including the ovoid (called the "eye form" by Boas) and variants of the U-form (called the "double curve" by Boas). The shape, colour, and placement of these forms in relation to the total organization of a composition, and the spatial and hierarchical relationships among primary, secondary, and tertiary design units, were diagrammed and defined, providing a new point of departure for the formal analysis of paintings and for insights into the compositional process.

The result of Holm's pioneering work has been twofold. On the one hand, his book helped to re-establish a foundation of practical knowledge about compositional techniques on which a new generation of artists could rely, a generation for which books and museum collections became an essential source of information about nineteenth-century artistic traditions. On the other hand, Holm and Boas both contributed to a standardization of form by codifying, and thereby regulating, the formal attributes of northern painting. Methods of composing images that had been passed down, assimilated, and modified through generations of apprenticeships could now be studied and reproduced from written texts. Forms and principles that Holm had selected as typical became interpreted as ideal; the variability and flexibility emphasized by both Boas and Holm became secondary to the perception that Northwest Coast art could be defined by a prescribed system of rules. "A lot of people followed the book to the letter," says Kwakwaka'wakw artist Doug Cranmer, and "as a result, their work has come out all looking the same." Even as some artists have expanded their knowledge of the northern style and contributed to its deregulation, current understanding of the art is still largely shaped by the language with which we describe it and by an emphasis on rules and formulae as the basis of art making.

In his study of orality, Walter Ong notes, "The spoken word is always an event, a movement in time, completely lacking in the thing-like repose of the written or printed word." Today, we rely on the intervention of the written word to define and delineate the components of a painting tradition that developed within an oral society. In the absence of known Native words to describe the painted forms, terms such as ovoid and formline have become useful descriptive tools. They allow us, for example, to detach the image from an object and dismantle it into named units of form. We can go on to identify such qualities as style and technique by comparing how different artists used these forms along with other compositional devices. Because the terms derive from twentieth-century Western concepts of graphic design, however, they also shift

our focus from a multidimensional view of the painted object – one that not only encompasses visual form but also reaches into the surrounding contexts of oral tradition and history – toward a formalist perception of the work as two-dimensional, an amalgam of design elements rendered in paint on a flat plane. Our view of the object becomes restricted, both literally and figuratively, to its surface.

"I have found no word for art per se in Haida," writes Robert Bringhurst. "I have found no word for formline either. Still less are there terms for the constituent components of the northern formline system. There are also no names, so far as I know, for the parts of speech or the conjugations of the Haida verb. These things, it seems, were not discussed. But they were performed." Can we speak about the "language" of Northwest Coast painting when perhaps no vocabulary existed to describe its parts? For centuries, painters have used, mastered, refined, and elaborated the forms we now call by newly invented terms, but how did painters perceive them? Could a painter from the nineteenth century perceive a composition apart from the three-dimensional object on which it was painted? Could a painting's "elements" be seen as distinct units apart from the whole? Perhaps two-dimensional painted images were able to convey depth, volume, and movement in ways entirely foreign to contemporary eyes. Certainly there existed a visual language and formal tradition based on defined forms and principles that continue to be expressed by artists today. Yet perhaps this is a language in which ovoids and formlines function not only as units of abstract visual form but also as units of thought and perception.

As a contemporary artist, Robert Davidson has developed his own way of speaking about the conventions of Haida form. He also uses the terms "ovoid" and "U-form," describing these shapes as the components of an "alphabet" that can be stretched, pulled, rendered as positives or negatives, and otherwise manipulated with endless possibilities, although within a certain framework of understanding. "If you leave out one part of the composition," he says, "it's like leaving out a note in a song – everybody notices." Davidson views the formline as the "skeleton" of the composition, within which "energy fields" can be directed by creating and balancing positive and negative spaces. His awareness of space – either defined within a shape or surrounding one – extends beyond purely formal concerns to the cultural and ceremonial space within which the composition is meaningful.

Davidson's understanding of a composition's "skeleton" and "energy" hints at a representational dynamic underlying the formal language of painting. Within a composition, individual elements can often be interpreted as stylized versions of eyes, joints, ears, wings, and ribs – or, in some instances, as complete beings within themselves. Boas pointed out the various connections between the "oval form" and an eye, a cross-section of the ball-and-socket joint, and food in the mouth of an animal. He

also listed the Tlingit names for the formal elements of Chilkat robes, as these were collected by Emmons. Although the names included such descriptive terms as "double flicker-feather," "nostril," "rain drops," and "woman's hair ornament," Boas found no consistent connection between the name of an element and its function or significance within the composition. The term "salmon trout's head," still in use today to describe an ovoid form containing a profile face, has similarly remained a conventionalized part of the formal language of painting without necessarily referring to a specific subject. Interestingly, Swanton was told by Haida authorities that there was a name for elements used as space fillers and shaped "according to the whim of the artist": such elements were called *hay'ín dā gAn*, or "instead of a design."

Perhaps the history of painted forms is an evolutionary one, from representational functions to compositional "elements" whose structure remains fixed but whose original meanings have vanished or transformed. As the enduring elements of a visual vocabulary, however, images and their components continue to capture the essentially animated basis of Northwest Coast representation: the predominant reference to the human/animal/mythological form that has long provided painters with a way of representing subjects both visible and based in thought.

**15.VIII.  Karen Duffek. 2004. "The Present Moment: Conversations with *guud san glans*, Robert Davidson."** In *Robert Davidson: The Abstract Edge*. Edited by Karen Duffek; with essays by Karen Duffek and Robert Houle. Vancouver: UBC Museum of Anthropology, in association with the National Gallery of Canada, 22-24, 42.

Karen Duffek's text exemplified a new approach to writing on contemporary Northwest Coast art. It combined an analysis of form in Davidson's paintings with Western art historical criticism as well as artist-informed insight into Indigenous aesthetics and meaning that transcend the visual aspects of his work. The scale and vivid colours of Davidson's paintings direct the viewer to the flat surface of the work; one might expect a return to a Greenbergian formalism as appeared at times in Robert Houle's contribution to this catalogue. However, Duffek (2004b, 12) noted that the Haida visual strategies Davidson uses can effectively engage, subvert, or simply ignore modernist inquiries, even disturbing "the categories by which modern art is understood." In his constant explorations of form, he performs his own formal analysis: rather than "describing the overall shape of an item as objectively as possible" (*Concise Oxford Dictionary of Art Terms* 2001), his paintings describe the elements of the art as subjectively as possible. His works can intervene "in prevailing, limiting understandings of Haida art by countering the idea that it is a closed visual language, a set formula or fully understood tradition" (Duffek 2004b, 17). Duffek's essay approached Haida

abstraction from previously unexplored avenues and built on both formal and exegetic analyses.

The departure evident in *t'siliiaalis* and the works that followed encompasses Davidson's play with scale, volumes of colour and changing spatial relationships. As well, it demonstrates his simultaneous adherence to, and questioning of, the northern style of Northwest Coast painting as it is currently understood. The visual components that comprise this canon are now known almost exclusively by the terms "formline," "ovoid" and "u form," coined by Bill Holm and published in 1965 in his influential book, *Northwest Coast Indian Art: An Analysis of Form*. In the absence of known Haida words to describe the constituent elements of the art, Davidson, too, employs this vocabulary. Yet when he speaks about exploring "beyond the formline" – that is, representing his subject without relying on this complete, continuous (usually black or red) compositional line – he is challenging the assumption that Haida art can be regulated by rigidly defined rules and formulae. He creates paintings that engage, instead, in a dialogue with his own variants of the ovoid (ranging from narrow and elongated to egg-shaped ellipses), the U-shaped form and the three-pointed shape he calls "tri-neg." The so-called "split U," in which the U form is divided by the tri-neg, has taken particular hold in Davidson's imagination. Enlarged, cropped and reshaped, the split U became not only a structural element but an abstracted unit of thought: the central subject of *kugann jaad giidii* [Figure 15.13].

*What I was doing here was playing with the U shape, where one corner is cut off, and playing with the thin red line to help define that U. It's like singing the same song but changing the tune. It's taken me years to know the name of that painting. I'm drawing on what I learned through the k'aawhlaa dance to give name to this image. Naanii danced the k'aawhlaa dance; she would dance behind the blanket and she would just show the mask very briefly. What that demonstrated for us was the belief that spirit beings are shy. So I see this painting as the child of kugann jaad it has no mouth, and all you see are the eyes.*[5]

When Davidson revisited *kugann jaad giidii* twenty years after he painted it, he found that the composition resonated with his current inquiries. The original concept was a purely formalist one: a single element "freed" from the requirements of representation. It embodied the idea of abstract, of disengagement. By naming the untitled study, however, Davidson chose to reconnect the image to a narrative structure and give it a place in the Haida pantheon. This act of naming moves the work toward the edge of abstraction – toward a place of intersection between the autonomous image and the mythic reference, between the idea of compositional space and the cultural space within which it may be made meaningful. In paintings and low-relief carvings created since that time, Davidson continues to move back and forth between abstract and more representational images. Within this spectrum, he engages the

**FIGURE 15.13** Robert Davidson, *kugann jaad giidii*, 1983. Painting, acylic on paper, 76 x 56 cm. Davidson has internalized the Haida art form, creating works that are unlike past forms while respecting the boundaries of Haida artistic convention. UBC Museum of Archaeology, photo Robert Keziere. Courtesy of Robert Davidson.

visual language as a way of exploring both space and metaphor; the art becomes a tool for transforming ideas.

> *Today, as I'm drawing, it's not so structured that I have to put a foot in here or some other part over there. It's more like a dance: just one line playing off another, one colour off another, the negative playing off the positive. When I was learning from Bill Reid, he taught me that you have to have all the parts in an image. But even then, I didn't agree. So I would leave parts out and the more confident I became, the simpler the image became.*

...

"I don't know if they had a dialogue about what they were doing," he muses, "but they were developing these new ideas, these new directions, and then the rug was pulled out from under their feet."

How those distant carvers and painters may have talked about, and thought about, the ideas they were visualizing, are questions that continue to fuel Davidson's own dialogue with the boundaries of Haida art. He counters the notion of a fixed and stable tradition – whether in the language of painting, the mythological repertoire or ceremonial protocol – in ways provoked by the inventiveness of earlier masters, while building dialectically and actively on his experience of the present. There are new

questions, therefore, that Davidson's abstract visualizations raise. How can we talk about this art in terms that are not solely based on a single regime of value or on a duality of contemporary and traditional, but that encompass "alternative ways of being present in" modernity? What would it mean to create integrated understandings about indigenous and Western art traditions, in which Haida philosophies and knowledge contribute to an evolving discourse on contemporary art?

*Nang sdang* is an idea with which Davidson began to experiment several months before he painted the diptych on canvas in 2004. The name comes from his reflection on the Haida concept of sdang, or "two," which might describe the lines that come together to divide a U form. In *nang sdang,* where the image is doubled, the idea of two extends beyond the numeric. Historically, there is the chief's name nan sdins (anglicized as Ninstints), meaning a chief who was equal to two: literally, "one that is two." The idea that one may also be two captures ways of thinking integral to Haida cosmology: that the souls of animals have the appearance of humans and that supernatural creatures may travel from spirit to earthly realms and back again: in other words, that two manifestations of a being can co-exist within one entity. In a manner reminiscent of the overlapping forms on the painted feast dish that inspired Davidson's earlier abstractions, the fine green U complexes in *nang sdang* overlay broad diagonal fields of black and red. The abstraction appears formalist, yet it may also be understood as a metaphor for multiple, or layered, ways of seeing.

**15.IX.  Nika Collison. 2006. "Everything Depends on Everything Else."** In *Raven Travelling: Two Centuries of Haida Art.* Edited by Daina Augaitis. Vancouver: Vancouver Art Gallery; Douglas and McIntyre, 57, 63-65. © 2006 by the Vancouver Art Gallery, published by Douglas and McIntyre, an imprint of D&M Publishers Inc.

Jisgang (Nika Collison, b. 1971) is a member of the Ts'aahl eagle clan and associate curator for the Haida Gwaii Museum at K̲aay Llnagaay. Her discussion of the importance of Indigenous language and its ability to provide insight into ancient concepts within Haida art belied the oft-repeated gloss of "no word for art" and proved the heights of aesthetic dialogue that can be contained within the Haida language. Quoted in the essay, artist Walker Brown insisted on the primacy of the Haida origins of formline design and its ongoing intellectual ownership by Haida artists. This was a bold statement that stood in contrast to written art historical analyses that more often defined a northern Northwest Coast design system over a specifically Haida one. Collison's essay wove together many current concerns for contemporary Haida, including the loss of language and natural resources as well as the encroachment of non-Native commercial interests on

Haida culture. Collison insisted on the link between art and its origins, berating the appropriation of Haida art into a pan-coastal style.

> In our world, it is understood that you cannot separate the land and water; they depend on each other to make the whole. An ancient Haida saying, "everything depends on everything else," drives this point home. In the same way, you cannot separate Haida art from our way of life, for without this context it has little meaning.

*[handwritten margin note: juxtaposed to colonial separation]*

> In today's world, however, our art is often looked at as art for art's sake without consideration of the history behind it. This is not a terrible thing, for Haida art deserves a thorough examination of its structure and composition, and, when skillfully executed, deserves enthusiastic appreciation. Yet there are many more things that should be understood to fully appreciate Haida art. Haida art is part of Haida culture, introduced by the supernaturals and developed by our people over thousands of years. In its truest function, our art represents who we are and where we come from.

…

> In our language, as in many indigenous languages, there is no word for "art" because it cannot be separated from our way of life. It should be noted however, that our language does have words to describe the act of creating art, such as *gyaa k̲'id* (to carve), and *kiiG̲uux̲aay* (to weave) and *k'uudlaan* (to paint). There are also words to describe aesthetic achievement in these media, such as *hlgadxuunang* (to carve deeply, i.e., on a pole) and *maats'ilang* (the carving of fine lines on a bracelet). We even have words to describe the people who create these works, such as *stl'iinl* (those with clever hands, or who are good at whatever they do).

> When looking at the old pieces, it is obvious that these people with clever hands considered aesthetics even when creating objects meant for everyday use – a standard still in place today. Some of our most practical objects – longhouses, canoes and containers – are truly works of art. Today, as in the past, possessing a finely crafted functional or ceremonial object indicates rank and status in our culture.

> Haida artists who have studied and learned from the masterpieces of our ancestors have a way of looking at Haida formline that is completely different from the rest of us. Guujaaw, Gak'yaals K̲'iigawaay clan, artist and president of the Council of the Haida Nation, speaks of "the profound logic that underlies the arrangements and interrelationships of the lines of Haida art, and the ways to entrap the tensions. This is one of the world's most regulated arts. A totem pole, when carved properly, is a complex assemblage of planes where the rule does not have to be understood in order to be received as proper by the mind's eye." The brilliance of a Haida masterpiece is no accident.

…

Haida formline is so popular that it has often been copied or borrowed from. The problem with this is that formline is an intellectual property, as explained by Walker Brown, an emerging artist of the Ts'aahl clan:

> Haida formline can be adapted to fit almost any medium. If taken care of, the form-line will provide income for skilled artisans [for countless years to come]. This formline has been very useful to Haida people and I think it should be considered one of our nation's most valuable assets. This formline is Haida intellectual property; however, certain Tlingit families have the right to work in it as some are descended from early Haida immigrants to their territories ... The introduction of outside ideas and concepts from a variety of sources has contributed to the development of formline. However, the combination of concepts and the principles of the form are distinctly Haida, and were developed on Haida Gwaii.

To get around the issue of intellectual property rights, a new terminology has emerged in the art market for works by artists who have blended various cultural styles or borrowed directly from Haida formline. This recent "northern-style art" or "Northwest Coast-style art" is not a true art form in and of itself. There is Haida art, and there are art forms specific to the various First Nations along the Northwest Coast. While the term "Northwest Coast art" is commonly used to refer to the individual art forms of the Northwest Coast *collectively*, it does not refer to or condone the concept of Northwest Coast-*style* art or northern-*style* art. The artists and buyers of today who perpetuate this myth are doing a disservice to the artistic and cultural legacy of all indigenous cultures. Each nation has its own distinct artistic style and it would be a shame to see these styles mixed together into an art full of unregulated lines and devoid of context simply for the sake of commerce, especially when each nation is working so hard to reclaim and strengthen its individual and unique culture.

NOTES

1 Crosby's writings are part of the wider feminist critiques of art historical methodologies that focused on canons of master artists and linear progressions of style, critiques that called instead for a greater investigation of the social and political forces at work in the production of art.

2 There are notable exceptions to the formalist approach from these years. Holm, despite his renown as a formalist, also produced texts that balanced an interest in aesthetics with function and symbolism (1977, 1986, 1990b).

3 In his notes on blanket designs in Emmons's *The Chilkat Blanket* (1907), Boas acknowledged that the designs were not always "readable" and that imagery and meaning were not always connected (Jonaitis 1995, 18). Nika Collison reiterates Halpin's argument in her 2006 essay on Haida art (63).

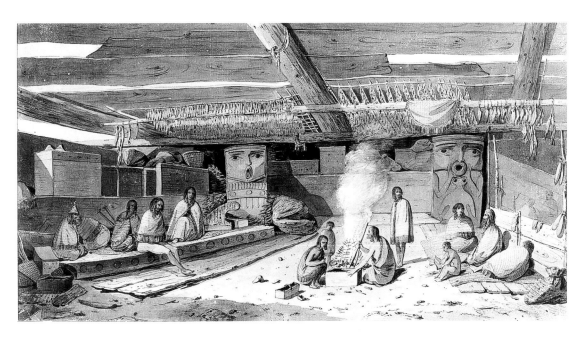

John Webber, *An Inside View of the Natives' Habitations,* April 1778. Pen, ink, and watercolour, 30.8 cm x 63 cm. Webber was the official artist on Captain Cook's expedition and provided some of the first documented illustrations of Northwest Coast houses, such as this one at Nootka Sound. Peabody Museum of Archaeology and Ethnology, Harvard University, acc. no. 41-72-10/499. [See page 60.]

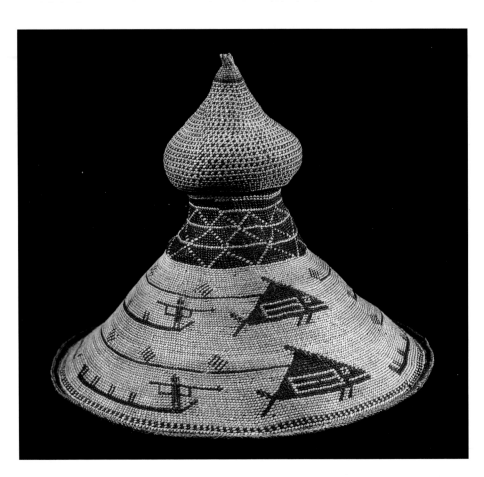

Knob-top whaling chief's hat. Spruce root, cedar bark, surf grass, and unidentified hide, 27 x 22.5 cm. Lewis and Clark collected this Makah or Nuu-chah-nulth hat from the Lower Chinook in the Clatsop region of Oregon between November 1805 and March 1806. Peabody Museum of Archaeology and Ethnology, Harvard University, acc. no. 99-12-10/53079. [See page 76.]

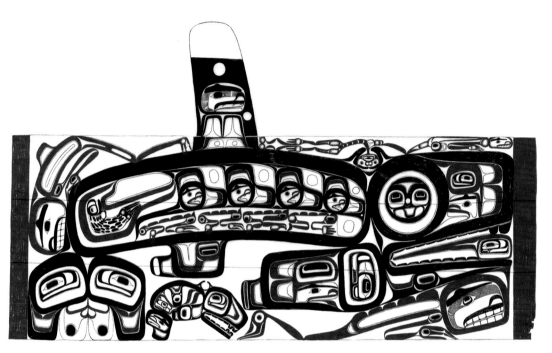

Klukwan Kaagwaantaan Killer Whale House screen. This rendition (by Lyle Wilson) of a screen from the Klukwan Kaagwaantaan Killer Whale House is based on a photograph, PN 1649, from the Royal BC Museum collection. In the collection of the UBC Museum of Anthropology. [See page 175.]

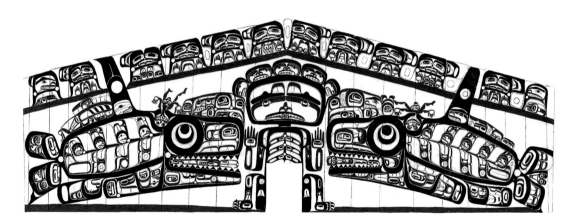

Lax Kw'alaams Nagwinaks screen. This rendition (by Lyle Wilson) of a screen depicts Nagwinaks, chief of the undersea, along with other sea dwellers. The original screen is in the Smithsonian Institution's Museum of Natural History. In the collection of the UBC Museum of Anthropology. [See page 175.]

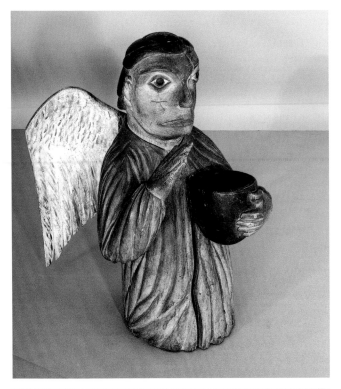

Frederick Alexcee, baptismal font, 1886. Paint, metal, and wood. The child of an Iroquois father and a Tsimshian mother, Alexcee (or Alexie, 1853-ca. 1944) originally trained as a *halaayt* carver making secret society paraphernalia. He spent the latter part of his career carving tourist curios and making paintings of traditional life. First Nations aesthetics are evident in the baptismal font he created for the Methodist church at Port Simpson. UBC Museum of Anthropology, A1776a-c. [See page 241.]

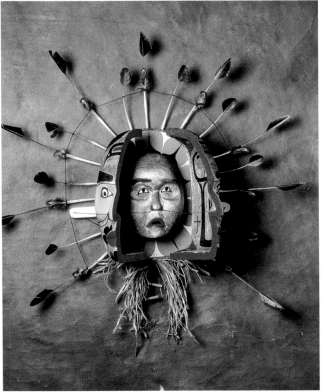

David Neel, *Residential School Transformation Mask,* 1990. Red cedar, feathers, cedar bark, paint, hinges, and twine, 36 x 25 x 20 cm (closed) and 89 x 94 x 23 cm (open). This mask by Kwakwaka'wakw artist David Neel shows the impact of the missionary period on First Nations individuals and communities. From Gary Wyatt, *Spirit Faces: Contemporary Masks of the Northwest Coast* (Vancouver: Douglas and McIntyre, 1994), 128. Courtesy of David Neel. [See page 244.]

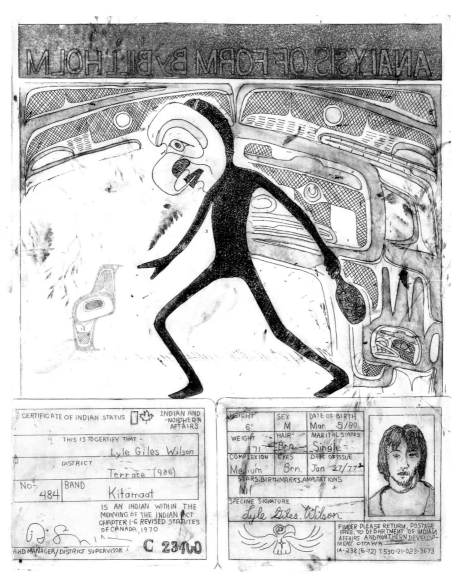

Lyle Wilson, *Ode to Billy Holm ... Lalooska ... Duane Pasco ... and Jonathon Livingston Seagull,* 1980. Etching, 50.7 x 40.9 cm. In this work, Wilson questions definitions of authenticity established by non-Native artists, scholars, and governmental agencies. Courtesy of Lyle Wilson and the University of British Columbia Museum of Anthropology, Nb3.1372. [See page 408.]

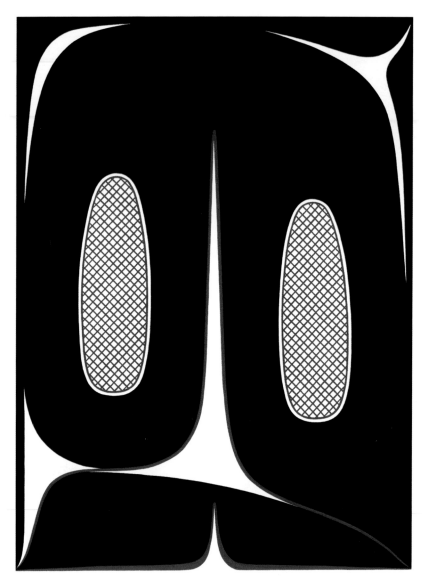

Robert Davidson, *kugann jaad giidii,* 1983. Painting, acylic on
paper, 76 x 56 cm. Davidson has internalized the Haida art
form, creating works that are unlike past forms while respecting
the boundaries of Haida artistic convention. UBC Museum of
Archaeology, photo Robert Keziere. Courtesy of Robert Davidson.
[See page 439.]

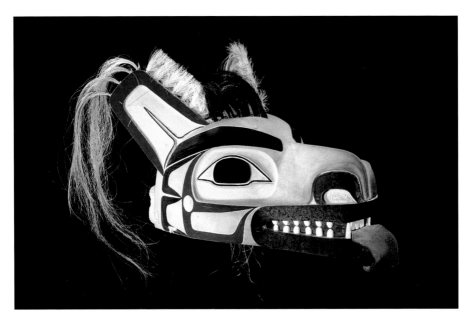

Earl Muldoe, Tsimshian Wolf headdress. 1970. Wood, copper, bone, leather, and hair, 41.8 x 19.6 x 19.1 cm. Royal British Columbia Museum. Courtesy of Earl Muldoe, Gitxsan; image courtesy of Royal BC Museum, RBCM 13917. [See page 484.]

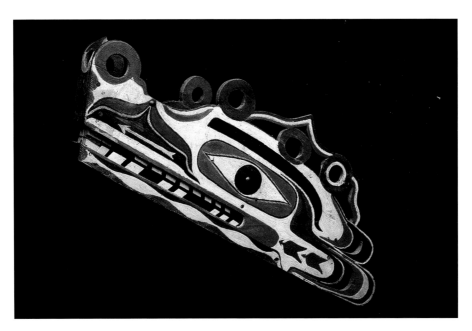

Huupach'esat-ḥ dance headdress from the Tseshaht band of the Nuuchaanulth nation, ca. 1910. Red cedar, brass tacks, paint, 24.1 x 21.6 x 63.5 cm. A Hinkiits headdress made by Hamtsiit, a Yuulthuu-ilthat'h master carver, it was part of the marriage dowry of Annie Tleḥwituu-a when she married Chief Kwitchiinim of Huupach'esat-ḥ, ca. 1910. The mask is currently in the collection of the Seattle Art Museum, listed as *Nuu-Chah-Nulth Hinkeets mask (Hinkeet'sam)*. [See page 717.]

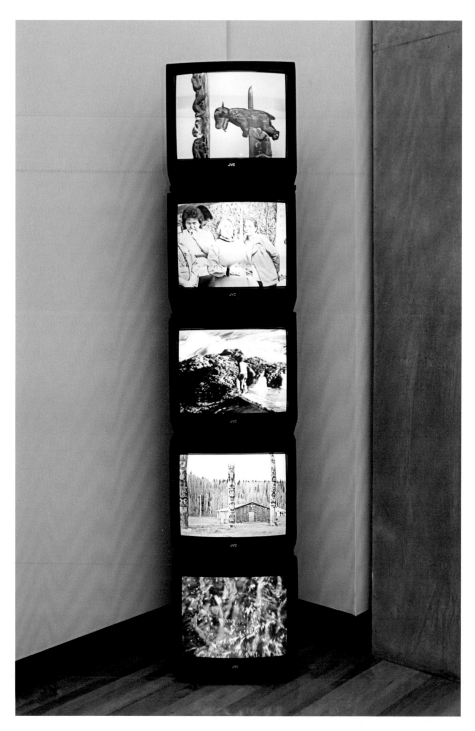

Michael MacDonald, *Electronic Totem,* 1987. Many contemporary First Nations artists employ new media technologies to expand the category of Northwest Coast art into new territory, as MacDonald did in his reinterpretation of the iconic totem pole. Courtesy of the estate of Michael MacDonald/ Vtape and Kamloops Art Gallery. [See page 856.]

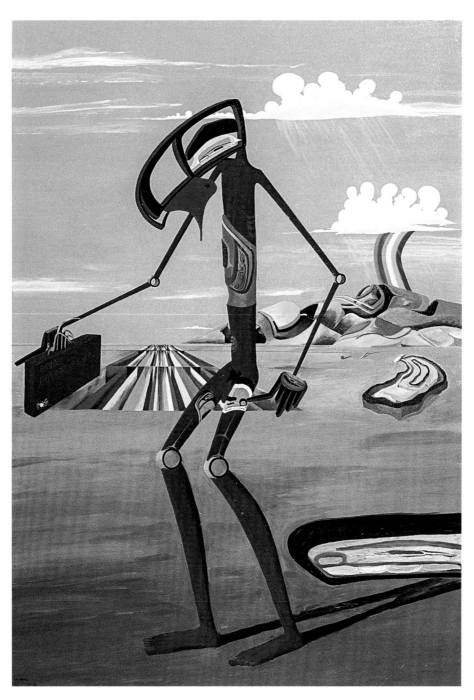

Lawrence Paul Yuxweluptun, *Leaving My Reservation and Going to Ottawa for a New Constitution,* 1986. Acrylic on canvas, 249 x 173 cm. Yuxweluptun's politically charged *Leaving My Reservation ...* , like many of his other works, highlights the bureaucracy of the Indian Act and its inaccessibility to the people it most directly affects, the general First Nations population in Canada. Courtesy of Lawrence Paul Yuxweluptun. [See page 873.]

Cover of *RedWire* magazine (from the 1 October 2008 issue). *RedWire* is a youth-driven magazine published by Indigenous youth. Published both in print and online (http://www.redwiremag.com), the magazine has become an important forum for Aboriginal youth. Courtesy of *RedWire;* artwork courtesy of enpaauk. [See page 953.]

Wii Muk'willixw (Art Wilson), *Mockery,* 1996. Acrylic paint. From Art Wilson, *Heartbeat of the Earth: A First Nations Artist Records Injustice and Resistance* (Gabriola Island, BC: New Society Publishers, 1996), 36. Courtesy of Art Wilson. [See page 965.]

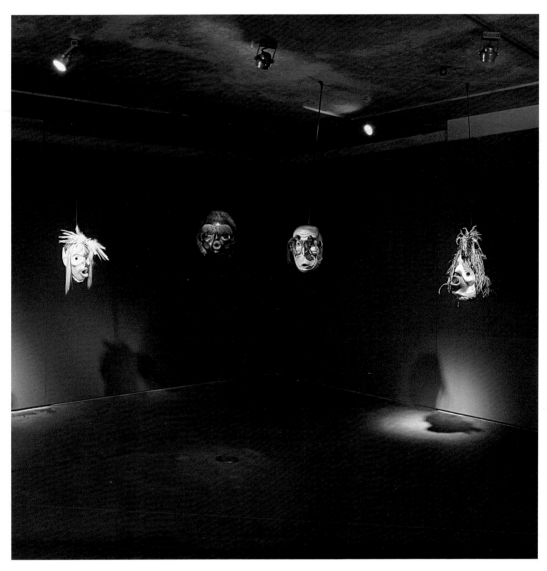

Beau Dick, *Masks*, 2004. Installation view of *Supernatural*, curated by Roy Arden at the Contemporary Art Gallery, Vancouver. This image shows Beau Dick's installation at *Supernatural*, an exhibition that joined artists with dissimilar backgrounds to show the similarities among artists working in the contemporary sphere. Courtesy of the Contemporary Art Gallery. [See page 969.]

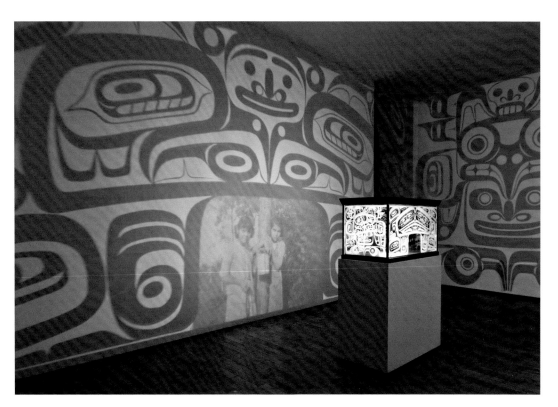

Marianne Nicolson, *Baxwana'tsi: The Container for Souls,* 2006.
Engraved glass, cedar, light fixtures, 54.4 x 51.0 x 103.0 cm. Nicolson's
bent box made of glass envelops viewers in its projection of shadows
and invites them to reflect on and honour the images of Nicolson's
own ancestors being shown. Collection of the Vancouver Art Gallery,
purchased with funds donated by the Audain Foundation; photo: Rachel
Topham, Vancouver Art Gallery. [See page 969.]

Stan Douglas, *Nu·tka·*, 1996. A still from the twenty-minute video installation *Nu·tka·*. Two cameras survey Friendly Cove (so named by Captain James Cook in 1778) in Nuu-chah-nulth territory on the west coast of Vancouver Island, deliberately excluding the Native village of Yuquot. The soundtrack combines Douglas's reconstruction of the troubled musings of Esteban José Martinez and James Colnett, captains of Spanish and English vessels, when, in 1778, their countries were virtually at war over the ownership of western North America. Collection of the National Gallery of Canada. Courtesy of Stan Douglas Studio. [See page 972.]

Jeff Wall, *Hotels, Carrall Street,* 2007. Transparency in lightbox, 248.9 x 312.4 x 26.7 cm. One of several of Wall's works – *The Storyteller* (1986) is another – bringing attention to the ways in which signs of the Native are imbricated in the life of the city of Vancouver. Here, Native history in Canada has been condensed into street art motifs, arguably sentimental, insignificant, and overwhelmed by changes to the urban fabric. But it is precisely their presence that enlivens Wall's picturing of the city's own banality. Collection of White Cube Gallery, courtesy of Jeff Wall. [See page 973.]

Sonny Assu, *Coke Salish,* 2006. Duratrans and lightbox, 56 x 97 x 18 cm. In his work, Assu, a Coast Salish artist, shows the influence of popular culture on contemporary First Nations life, while expanding the accepted definition of First Nations art. Photo Chris Meier. Courtesy of Sonny Assu. [See page 979.]

4   Wright notes the layered nature of this title, as *kugann jaad* is Davidson's Haida term for a creature identified first by Wilson Duff and used to describe a formal element that Duff called "Mighty Mouse" in nineteenth-century Haida art (Wright, personal communication, 2006).

5   Davidson has described *kugann jaad* as a spirit helper, and more particularly as the mouse woman, a spirit being who, in Haida narratives, assists those who are about to cross the boundary between the human and non-human worlds.

JUDITH OSTROWITZ

# 16 | Democratization and Northwest Coast Art in the Modern Period

*Native Emissaries, Non-Native Connoisseurship, and Consumption*

Cross-national standards for the measure of political democracy during the second half of the twentieth century parallel, in some ways, discussions of mass media of the same period. Ideas about disclosure – openness, fairness, and freedom of information as well as freedom of the press – indicate that issues of *access* were, and to some degree remain, idealizations useful for delineating evidence for the equality of nations and individuals with rights to participate in world-system exchanges (Bollen 1998). Marshall McLuhan (1964, 21) had announced, for example, that "the aspiration of our time for wholeness, empathy and depth of awareness is a natural adjunct of electric technology ... We are suddenly eager to have things and people declare their beings totally." However, the technological conditions that enabled greater public dialogue did not completely transform the realities of differential access (see Dowell, this volume; Claxton, this volume). Although authors of the period aspired to and framed a greater potential for engagement, opportunities for full participation in worldwide exchanges remained related to ethnic, class, and gender differences.

In North American and European fine art circles, arguments for the ascendancy of visual phenomena as the proper medium for this engagement, or the potential for unity as associated with modernity, suggested a certain consistency in human perceptual experience. Form, conceived of as distinct from content, became the subject of the most influential art scholarship of the period (see Bunn-Marcuse, this volume). It is useful to look at the work of Rudolph Arnheim, professor of psychology of art at Harvard University from 1968 to 1974, before addressing the sea change in art criticism of the period. Arnheim proposed certain commonalities as the basis of meaning in visual perception. He reported that "translations of the appearance of physical objects into the form appropriate to particular media are not esoteric conventions thought up by artists. They are in common usage everywhere in life" ( [1954] 1974, 141). According to this premise, communications by artists are not the result of intellectual processes but are comprehensible on the basis of new media that in some way parallel the nature

of human perception itself. Although Arnheim explored arguments for learned associations between form and meaning, he believed many expressions to be directly available through the act of perception. This suggested potential for universal communication that, combined with the explosive growth of media in the modern period, would be responsible for the mutual revelations among world citizens considered immanent by McLuhan.

Parallels may be drawn with the projects of certain formalist art critics of the period, such as Roger Fry, Clive Bell, and particularly Clement Greenberg. Greenberg developed ideas about the irreducible nature of visual phenomena as key to the project of mid-century modernists in the West. The proper focus of artists as well as their audiences was supposed to exist within the confines of the picture plane, not directed to representation with all of its far-ranging references to social or historical context. Greenberg ([1960] 1966, 103) claimed that, "whereas one tends to see what is in an Old Master before seeing it as a picture, one sees a Modernist painting as a picture first. This is, of course, the best way of seeing any kind of picture." For modernists, progression became associated with the discovery of solutions to formal problems, ideally carried out in autonomous works of art through the experiments of abstract expressionists and later practitioners of post-painterly abstraction, among others. Following Greenberg's formulations, Michael Fried (1964) suggested that mid-twentieth-century painters had moved away from the concerns of society to take up the visual problems set out by their immediate predecessors and therefore to become exclusively involved in a criticism of art itself. These are the concepts associated with modernity that art historian Rosalind E. Krauss (1996, 5, 12) has identified as "the stare's detachment from the field of purpose," both scholars and artists "thinking they can bracket it off from the world, from its context, from the real." Therefore, opacity and difference were not emphasized in this period. The foregrounding of culture-specific phenomena was simply not considered in relation to the hot pursuit of equality until the much later advent of the postmodern.[1]

The proposed reduction of art experience to a preoccupation with form, and the presumed universality of some aspects of visual communication, affected the study of Native American and Canadian First Nations art as well (see Bunn-Marcuse, this volume). The "literary" or ethnographic component of non-Western traditions, which had been considered primary by preceding generations, was temporarily subordinated to the study of form and aesthetics for the purpose of submitting the visual products of these traditions to scrutiny and appreciation by international art audiences. In this regard, one particularly influential exhibition was *Indian Artists of the United States*, organized by Frederic Douglas and René d'Harnoncourt for the Indian Arts and Crafts Board of the US Department of

the Interior at the Museum of Modern Art in New York in 1941. According to W. Jackson Rushing (1992), the curators wished to present works in the exhibition, particularly those that had been recovered from prehistoric civilizations of North America, that were distinguished for their visual qualities alone. Interestingly, many of the stylized design strategies in works that were highlighted in the exhibition were evaluated as primary, as if they were works of abstract art, a concept with implications for the modern art world. If the visual expressions of Native cultures could be considered as parallel to more familiar fine art projects by artists of Euro-American descent, they could be accessed and appreciated the world over (see Dawn, this volume; Mauzé, this volume). Under these circumstances, knowledge of history and culture-specific practices was not necessary for the appreciation of Native art – all that was required was a keen eye (Ostrowitz 2009, 109-42).

In Northwest Coast art studies, efforts at comprehension were carried out by a systematic approach to the visual (see Watson, this volume). As is now well known, Bill Holm's studies were central for this purpose, beginning with *Northwest Coast Indian Art: An Analysis of Form* (1965) [15.III, 16.II]. Holm had examined many works of art from the region in museum collections and selected four hundred of them for his study. He isolated the design characteristics of these works, coded them, and entered them as data on computer Keysort cards. This enabled him to describe categories of "formline" composition and to provide terms for the design units within them – ovoids, eyelids, U forms, etc. In this case, McLuhan was correct. "Electric technology" provided access for the eager eyes of a broader constituency.

Holm's efforts to delineate stylistic criteria for three-dimensional works and to develop some coherent style area analyses soon followed (Holm 1972). His additional analytic work was related to the identification of formerly anonymous "master hands" by virtue of stylistic cues; these too became seminal studies. For example, his volume about the work of Kwakwaka'wakw artist and chief Willie Seaweed (1983c) adapted methods developed for Western art historical practice to the study of Indigenous artists. Other scholars followed suit (Wright 1983, 1992, 1998; S.C. Brown 1987, 1994). It is important to note that these Northwest Coast art specialists were in fact extremely familiar with the cultural practices of the region. Holm, for example, is a very knowledgeable participant in some traditional ceremonial practices. However, his insights about form were more influential for the field of Northwest Coast art studies for the duration of the twentieth century. This emphasis on the formal aspects of Northwest Coast art, which may be thought of as the "media" of artistic expression for this tradition, appeared to become its content for a time – or, in McLuhan's terms, its "message."

These developments were simultaneous with the creation of educational curricula for artistic practice and new styles of pedagogy introduced in the Northwest Coast region (Ostrowitz 2009, 109-42). Traditional apprenticeship-style training relationships with master artists were no longer available in many areas. Art education programs, often developed with the cooperation of non-Native art professionals, retained some aspects of apprenticeship but operated, at least in part, as schools. For example, although it began as a workshop and not a training program, the carving shed in Thunderbird Park, on the grounds of the British Columbia Provincial Museum, was established under the supervision of Chief Mungo Martin in 1952 and eventually became a training ground for a number of Northwest Coast Native artists [16.1]. The Kitanmax School of Northwest Coast Indian Art, associated with the replicated Native village called 'Ksan in Hazelton, initiated training classes in the late 1960s (although the school was not officially established on site until 1970), and the Arts of the Raven carving program run by Chief Tony Hunt in Victoria began in 1969. They were all meant to accommodate a range of students from different Northwest Coast traditions in the same learning environments.[2] The vocabulary for the description of formal elements of the northern graphic tradition and the identification of criteria for the correct execution of three-dimensional styles, which had first been developed by Holm, became central to this type of instruction as well as to the dialogues of artists from a variety of Native groups and a few artists of non-Native descent. Many of them converged around the schools as well as the museums and galleries that exhibited their works in Victoria, Vancouver, and Ottawa. A number of these artists went on to become instrumental in the dissemination of Northwest Coast art to worldwide audiences. In addition, the focus on form, rather than discrete traditional affiliation, made it possible for a few artists of non-Native descent — such as Holm; Duane Pasco, an influential teacher at the Kitanmax School; and John Livingston, trained by the Hunt family — to become proficient in these art traditions as well.

It is also useful to understand that systematic analyses of elements for the comprehension of various cultural phenomena, not just the formal analysis of works of art, were in widespread vogue during this period and can be associated with the projects of a range of social scientists. It is interesting that anthropologist Claude Lévi-Strauss, scholar/practitioner of structuralism, had a particular interest in Northwest Coast cultures (see Mauzé, this volume; Campbell, this volume) [11.IV, 19.IX]. In *Structural Anthropology* ([1958] 1963), Lévi-Strauss credited the field of linguistics with the development of some of his most useful methodologies. For example, he proposed a conceptual relationship between the systematic analysis of the elements of language, or "phonemes," with his

own delineation of kinship terms and culture-specific attitudes. In a similar manner, Holm's search for underlying organizational phenomena in Northwest Coast art was greatly validated for historians and art aficionados of Western descent by such a structural and "scientific" approach. It was as if a linguistic code had been broken, fulfilling the historically specific desire for access. Holm had processed his material in an interdisciplinary manner, operating as astute artist, scholar, and even computer technician who had managed to become literate with the electronic information technology of the period. This systematic process and this media savvy were directed to a broader understanding among observers and intellectuals of both Native and non-Native descent, to promote equity and cross-cultural dialogue consistent with ideals for democracy in this period.

For the art and culture of the Northwest Coast region, these egalitarian ideals were ironic. Exclusivity and hierarchy in relation to property, territory, aristocratic title, and the accompanying right to artistic representation, rather than democratic concourse, have long been understood as the hallmarks of traditional practices (see Kramer, this volume). It is important to make a distinction here between the legibility permitted by the conventionalized crest art system as opposed to its application for the expression of exclusive prerogative (see Townsend-Gault, Chapter 27, this volume). Until this point, these forms were used in works of art to denote the *limits* of access to specific territory and proprietary Indigenous histories. In the second half of the twentieth century, the comprehension of conventionalized form was applied differently. It was most useful for connoisseurship of unique works of fine art, carved tourist masks, and serigraph prints that were being produced in great number for increasing international consumption (see Duffek, this volume). These works served very new purposes: providing essential income for artists, establishing the opportunity to preserve some aspects of traditional identity at home, while informing those farther afield about some aspects of Northwest Coast art and culture.

The non-Native scholars who guided these projects influenced artworks and provided venues for them, not usually in reference to exclusive histories and territories but in relation to the visual standards that had been delineated in this period. Less cultural information, or the esoterica gathered in the tomes of salvage anthropologists just a generation earlier, was provided for modern audiences (Clifford 1988b). For example, Doris Shadbolt's foreword to the catalogue that accompanied the 1967 exhibition *Arts of the Raven* is excerpted below [16.III] because of the stance that curators Wilson Duff, Bill Holm, and Bill Reid took concerning the rightful place of Northwest Coast works as visually distinguished and worthy of comparison with fine art traditions the world over. As will be shown

below, curators of the period also emphasized the individuality and superiority of specific recognizable hands, delineated in the literature as a methodology to identify master artists. The exhibition catalogues from *Form and Freedom* [16.IV] and *The Legacy* [16.VI] reflect the same curatorial approach. Works were evaluated throughout according to their relative adherence to the recently explicated criteria for proper form reiterated in these volumes. By 1983, even tourists seeking guidance for wise purchases of contemporary Northwest Coast art were advised, by a buying guide published by the University of British Columbia's Museum of Anthropology in Vancouver, to develop an "appreciation of the forms and rules of the art style, and also some aspects of traditional Northwest Coast Indian culture" (Duffek 1983c, 1). Recommended reading for this type of education included Holm (1965) [16.II]; Duff (1967); a new edition of the original *Form and Freedom* (Holm and Reid 1975a); and Macnair, Hoover, and Neary's *The Legacy* (1980) [16.VI]. Only two of the thirteen books recommended in this guide were primarily about Northwest Coast culture (Duffek 1983c, 27-28).

Although the "democratizing" concepts or the relationships between access and worldwide equality discussed here originated in the West, several cultural activists of Native descent operated on the assumption of common ground as well. Key among them were the artists engaged with museum environments as cited above, especially those at the Thunderbird Park carving shed, which became an extremely popular destination for non-Native visitors. Mungo Martin, Charlie James, Ellen Neel, and Willie Seaweed (all Kwakwaka'wakw) also participated in the early construction of a commercial art market. They were engaged in dialogue with museums as advisors, were spokespersons for other public projects, and at the same time were involved in the production of important works for traditional purposes (see Black, this volume). By the 1960s and 1970s, Doug Cranmer (Kwakwaka'wakw), Bill Reid (Haida), Nathan Jackson (Tlingit), Robert Davidson (Haida), Tony Hunt (Kwakwaka'wakw), and Art Thompson (Nuu-chah-nulth), among other prominent artists, were frequently engaged with institutions outside their home territories [16.V]. These individuals and others became active in negotiating public spaces for the arbitration of those aspects of Indigenous identity that were to be presented to the general public. By the end of the twentieth century, Northwest Coast artists and chiefs were increasingly invited to travel in order to participate in public dialogues about their own traditions.

The modern period on the Northwest Coast clearly began with certain outreach agendas. Gradually, in the 1990s, some doors were closed again in response to emerging issues of sovereignty and a greater interest in the preservation

of rightful authority by those with proper lineage. This increase in effective self-representation was no longer directly related to the application of form. At the turn of the twenty-first century, social context for Northwest Coast art and, in fact, a greater delineation of cultural difference has resulted from increased Native consultation for museum exhibitions and architectural projects, progress with claims for the repatriation of artworks, as well as the achievement of some goals in land claims (see Bunn-Marcuse, this volume; White, this volume; Kramer, this volume; Black, this volume; Townsend-Gault, Chapter 27, this volume).[3]

However, the literature selected for this section, publications dating from 1953 to 1984, predates these developments. As was characteristic of intellectual, scientific, political, and artistic concepts of the modern period, many influential theorists insisted upon democratizing strategies, as they have been defined here. For a brief time, a focus on form permitted access to and comprehensibility of a broad range of viewers, and this process was considered by many to be most useful for the re-evaluation and increased appreciation of Northwest Coast art.

**16.I.  Wilson Duff. 1953. "Potlatch Transcript. Mungo Martin's Thunderbird Park Potlatch, December 13-15, 1953."** Unpublished typescript. Royal British Columbia Museum, Victoria, n.p.

Although transcribed by anthropologist Wilson Duff (1925-76) for the British Columbia Provincial Museum (now the Royal British Columbia Museum in Victoria), the proceedings of this potlatch must be understood as authored by the Kwakwa̲ka̲'wakw artist and cultural activist Chief Mungo Martin (ca. 1879-1962). The potlatch had been outlawed in Canada since 1885, although this prohibition was not strictly enforced until the 1920s. After much strife, the law was dropped from public record with the revision of the Indian Act in 1951. It was in this context that Martin "tested the waters," stepping forward to represent both his own interests and those of the Kwakwa̲ka̲'wakw in general. He hosted a potlatch in the traditional-style house built under his supervision as chief carver at Thunderbird Park, on the museum's grounds (traditional Coast Salish territory) (Figures 16.1 and 16.2). The house, called *Wa'waditla*, which translates as "he orders them to come inside," was built to resemble one once owned by Mungo's uncle, Chief Naka'penkim of the Ma'mtagila tribe, whose name Mungo had acquired. The potlatch was certainly a mode of outreach for the education of both First Nations and non-Native guests but also constructed by Mungo as an assertion of domain. Circumstances allowed a broader selection of witnesses to acknowledge the traditions of the Kwakwa̲ka̲'wakw than his ancestors could ever have anticipated.

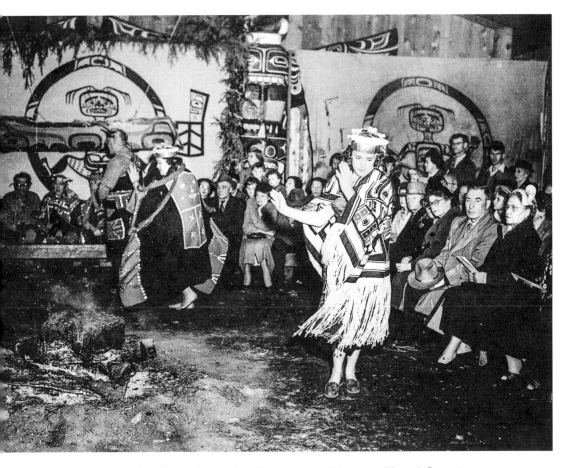

**FIGURE 16.1** Mildred Hunt, a Kwakwa̱ka'wakw woman, participates in a Woman's Dance in 1953, wearing a Chilkat robe. BC Archives, I-26805.

**FIGURE 16.2** Mungo Martin working on a totem pole in Thunderbird Park, in Victoria, BC, 1957. Martin spent a number of years working at Victoria's British Columbia Provincial Museum (now Royal British Columbia Museum) and around Thunderbird Park, restoring old totem poles and carving new poles to be erected in the area. Jim Ryan, photographer; image courtesy of Royal BC Museum, BC Archives, I-68316.

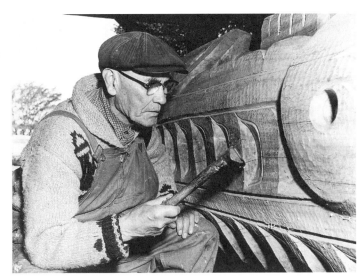

A description of the rehearsals and the "Indian Day" (Dec. 13), with translations of the speeches. Tape recordings were obtained of these events, and the descriptions are related back to the tapes by notations in the margin.

MUSEUM TAPES: PRI, PR2, PPL, PP2.

*WILSON DUFF*

The *fourth mourning song* carries over on to this tape. Following that is the *fifth and last mourning song.*

Tom Omhid picks up the "speaker's staff" and makes a long speech in the Kwakiutl language (see below). He is acting as Mungo's speaker. Dan Cranmer gets up and interprets in English (because most of the Indians here do not understand Kwakiutl, let alone the whites). The speech began by welcoming the guests. Then he described the house, saying that it is a copy of old Nakapenkim's house at Fort Rupert. He explained why the mourning songs had to be sung, and announced that the next ceremony would be "the rocking of the cradle."

After a pause, Dan Cranmer spoke again in English, telling more about the mourning songs.

Then Omhid spoke, and Dan interpreted, describing the Cradle Ceremony to follow.

(The quality of this tape is poor.)

Omhid's speech following mourning songs (Translation: Helen Hunt). "We are finished now. We are finished now, Kwakiutl. We have no reason not to say this, because this is what we have inherited (mourning). It is true that it makes you feel better. We have no other way to do this, my people. If we didn't bring this up about our chief, our chief (chief they mourned for), we wouldn't want to keep sad feelings in us, my people (?). So, I say this.

"You have come in to listen to this, all you tribes.

"Come now. Come now and listen to all the different things I (Meaning Mungo, Omhid is speaking for Mungo) am going to go through. I have come to lead my respected children (Helen Hunt and Mrs. Moon, who were sitting dressed in button blankets, and were the chief mourners). These two sitting here. These are the two you are listening to. These are the ones that are mourning. (George Scow's voice in background repeats "They are mourning.") These are my respected (ones). I did not pick just anyone out of all my children. This (Mrs. Moon) is the oldest one of my children. She is mourning. What we call mourning. What we call mourning.

"All during this ceremony we have been interpreters, Kwakiutl. We have taken it up, what was said about Naqapenkim (presumably Spruce Martin, the previous Naqapenkim). We have taken only a little bit out of what we do. It would take all day

if we followed it. It would take all day if we went into all the different parts of the great chief's gi'gagit (chiefly accomplishments). (All the proper mourning songs would take too long. e.g.: When Helen Hunt's father, a Kingcome chief, died, it took all day and all night. Each other Kingcome chief sang four songs and each other tribe sang four songs).

"*t'ayag-ʸilog*ʷ*a* is mourning. (That is Mrs. Moon's "mourning name.") You call her Tayagilokwa. Listen carefully. *p'i'p'adẓiudẓemga* (This is Helen Hunt's mourning name, being bestowed on her at this time). She too is mourning. She is the one who is using us to speak for her.

"Pipaziuzemka is her name. And Tayagilokwa (now referring to Mrs. Moon). All right, my children, you can move back now (to two mourners). You are relieved now, relieved (of your sorrow).

"The other one is *g*ʷ*'ə'ntilak*ʷ, the wife of *pe'lnak*ʷ *ə la* (Dan Cranmer's winter dance name. Omhid is now naming other main mourners). However she is not sitting with us because she did not come. She did not come. *Gw ə ntilakw* is still her name (meaning that they are not giving her a new name at this time).

"And *Xi'linuk*ʷ, she too is mourning. That one sitting over there (He is referring to Mildred Hunt. This name is the same as Helen Hunt's name).

"This is what you call crying (*g*ʷ*a'sa*), crying over the chiefs. And they have been relieved now, what you have heard, all you chiefs. (Now there is a pause).

"You would never want me to stop, all you tribes, if you understood what I am saying. You would want me to go on, if you understood every little part of my speech.

"Now you must be careful, my people. We'll move to a different part now. The sad thing we have just done is over and we are going to move now. You are confident in your knowledge of the different parts of what we perform. We shall do it now."

TAPE 3 KWA-T-027C

Has the *complete cradle ceremony;* first the *song and monologue* (which Dan interprets in part), then the explanatory *speeches*. First Omhid makes his speech, then Dan Cranmer interprets. "The diaper to keep this child from getting cold has already been bought," he says, referring to Mungo's copper. "There is a copper here for her diaper, and its value is going to be distributed to you people " (Such figures of speech are common in Kwakiutl speeches).

Mungo speaks, and Dan interprets. "Now he will name the baby who is supposed to be in this cradle." He gives her two names: a'lamk'yala and He'msəndalaxʷa. Her white man's name is Dorothy Martin, and she is one of Mrs. Martin's grandchildren.

At this point 50 cent pieces were given out to everybody in the house.

Then Omhid speaks, and Dan Cranmer interprets, telling more about the cradle ceremony.

There is a period of about 10 minutes during which nothing is happening, and then Omhid begins the rattling and singing that mark the beginning of the winter dances.

DETAILS OF CRADLE CEREMONY:

Mungo calls out:

"Do not cry, you

hami'ida (some kind of spirit over there)

Dsunuqwa over there (moo)

Baxbakwalanuksiwa over there" (hap)

(Helen says that there are many different Baxbaks. They tell children not to go out at night because they are liable to be around. She said that the word means "it has the power over every thing," but she would call them "ghosts with power." So they have something to do with, ghosts – *lo'l inux* is ghost, *lalu'l əlaɫ* is "ghost dance" – and perhaps something to do with souls *baxwane'*. "This thing rules over all the souls of the ghosts.")

After the cradle song, *Omhid speaks*:

"Be prepared (*awi'ko ɫ la*) Prepare yourselves to go and see what has been born to our friend. What is it?"

Dan Cranmer: "I have been to see the baby. It is a girl."

*Omhid:* "It is all ready now, that which has been prepared. The softest of all blankets. This person that has the great name (Mungo) has already bought it. The price of it is enough to distribute out to all you tribes. That is why it can never be cold, for the newborn baby – It starts its life by keeping warm."

*Dan Cranmer* now speaks in English: "The diaper (Helen insists that it was blanket that was mentioned) is already bought. This is going to be distributed to you people."

*Mungo:* (in Indian):

"The name is *a'ləmk'ʸala* for my grandchild, the child of my son" (that is, Dorothy Martin, Dave's daughter).

*Dan Cranmer,* in English

"Now he will name the baby. An Indian name: a'ləmk'ʸala. This is the name. One of her (Abaya's) grandchildren. She is supposed to be in this cradle. (Prompted by others he goes on.) Her other name will be he'msəndalaxʷa in our language. White man name: Dorothy Martin.

"Of course that is what the chiefs are struggling for, to name their sons. Because we are different from the white people. We don't say 'What's your name?'"

*Omhid:* (in Indian) "and now we are going to distribute out, even if it is only ten cents, to follow the rules. Because it is a *k'i'su* (an owned performance). Because it 'belongs to the nu'yəm' ("family story" or "tradition")."

*Dan* (English) tells that the cradle should have had a string on it, but they are giving out money, but that the money is regarded as the cradle string.

TAPE 4

Opens with the ceremony which precedes the handing out of cedarbark headbands marking the official beginning of the winter dance season. Then the headbands are passed around to the people in the house.

There is a short angry *speech* by Mungo. (One of the visiting anthropologists came in late, and Mungo thought that the door was being opened to the public).

Dan Cranmer explains about the red cedarbark, and about how strict the rules of these dances were in the past. Then he explains about the down being passed out – it means peace.

After the headbands and down are passed out, it is time to have the *Hamatsa dancer show himself briefly*. Omhid sings and rattles, and David Martin is led out and around the house by his attendants, then behind the curtain. Omhid makes a speech. Dan interprets: "Everything is now ready behind the curtain. Now we are ready for the red cedarbark dances."

Then meal tickets are passed out for dinner.

TAPE 9

*This* tape begins with the continuation of Mrs. Moon's ceremony. Omhid makes a speech explaining that she has just danced to the same song she once danced to in old Naqapenkim's house – an interesting link between the two houses – and then Mungo gives her the same name as he had bestowed on her on that previous occasion.

*Omhid's speech* (translated by Helen Hunt) –

"You have seen now. You have seen, all you tribes. This was one of Naqapenkim's greatest performances, the one that you saw just now. Seen by all the tribes. Because this was a great plan. Because the chief Naqapenkim had great powers, the owner of the house. This is where she used to dance, even as a child. What has been sung is her song, she owns it. I am letting you see what the chief has prepared. You have seen it. There are not many differences in the dances. Our dances are just about the same, all you tribes, to the copper.

"That is la'kʷela ogʷa (Mrs. Moon). That is her name. The one on this side is Xakʷeł. *łalibalismaga* is the older sister of Xakʷeł. That was the name of Naqapenkim's mother.

"Oh for the chief (old Naq.) to come and stand here now! To stand right here so that you could hear the way he made his speeches. His speeches really touched you. A chief facing both ways, a chief that made your breathing stop. Take a look at the

blood on the floor" (Mungo's voice is heard in the background: "We are being careful. We are holding our strength").

This is the last tape. It has the conclusion of the dance of the animals, then another song as the animal dancers come out and dance without their masks. After this dance is finished, Mungo makes a long speech. Then the potlatch is over.

*Mungo's speech.* (translated by Helen Hunt. A few parts of the tape were not clear enough to translate).

"You have been able to see this now. My ancestors were lucky to get this (animal dance) from a'bsegyu.

"Me, I am absəgʸu. I am part absəgʸu. I am part absəgʸu. I am one tribe being a kʷikʼʷsutiʼnux. That is why I have this, because of my grandparent's father, my *gagəmb məmʼmxʸuyʼ ugʷa*, formerly yakuXasmaʔi. These are his names ... That is why I have it. That is why I stretch out to my children (says two names ) ... These are the names of the women so that they will stand as men in case anybody asks. And I am fortunate to be here. That is what we take, our family story (nuʼyəm) when [we] stand up. Proudly holding it up.

"This has been a success. I the supernatural tribes. I the Kwiksutenuk. I am supernatural, tribes. I have never been seen through (failed). I have never lost, I have no reason not to go through every detail. Why shouldn't I go through every detail when I have taken it up? It has been displayed, even now. Four times now, four times.

"This is one way I do not like to speak. To count things. I don't like to speak this way. I have never liked to boast of the few things I have done. I don't want them (his children) to be afraid. (He means afraid that he is always going to boast of their potlatches. Helen tells of an old man at home who boasts about his potlatches, drawing with a stick on the ground, every time he gets a chance. He is very boring, and his children purposely give potlatches elsewhere or when he is away, although this is insulting to the old people.) This has gone to my grandson, the one you call Pete (David's oldest boy) (referring to the cave where this dance was originally done by the animals). It never fades away. It is not gone yet. My family story. You can still see it today. It has a door, and it has a back door, and it has a maʼʷeł (screen). The drum has rotted away now. It did have a drum, it is not very long since it rotted.

"I am saying all this because of what has been said to us Indians [baʼkʷəm]. 'You just came to this country. You are a Chinaman, you are a Japnee'. That is what all us tribes are called. Take a look at what you can see of what our people used to eat in the olden days. Clamshells as deep as this. Those are clamshells. That is what our old people used to eat. Today you will find great big trees growing over them, so big that these trees are old themselves. Those (shells) are not made by the white man. They

eat different things. The white people are different. The reason I am saying all this is because of what the white people say about us.

"Haven't they done enough now. Look at us, our houses are right out to the water's edge. My family story really tells that they are not what they call us. My family story (nu'yəm) tells. It has not just been made up recently.

"I am going to talk about some of my other children. I am going to name them.

"This is a new baby girl. This was the name of my grandparent, mother of my father *gʷa'gʷadaxala*. Gwagwadaxala to the new baby ... I am the only one left alive to carry out (the end of the sentence is understood).

"And now to this. The child of my brother (ne'miut), the child of Wilson Duff. I am going to give a name, as I don't consider us to be two men (rather, as one or related). As you can see now, he is looking after the people as they come in (I was at the door). I am going to name now. *Xakʷa'ił*, to her. The child of Duff, Xakʷa'ił. Why shouldn't I take my niece? (Harriet Martin) ...

"And now the other one. I have a lot of grandchildren. Giving the name *xa'n I ussəmega*, the name of my grandparent. Giving the name *ma'xʷəc*, the new baby of my niece (Harriet Martin) ...

"I am going to name another one, my new great-grandchild, the newborn to my granddaughter (Mrs. Lawrence Jacobson, who is a daughter of Mrs. Alfred Nelson, who is Mungo's daughter by a former marriage), *ya'yagalis*, being a boy, Yayagalis.

"And now to the one that you all see walking around (Helen). I have great reasons for the way I feel to her. She looks after me. I am depending on her to look after me if I should grow to be old. The one you call Teen. I really consider her my own daughter. I have brought her up. She has the feeling to look after me.

"The reason I say this is for the youngest of her children. *e'waqalas*, Ewaqalas to the youngest of her children. There is no end to my grandchildren. There are a lot of them. There are almost forty that I am not naming. (As a humorous "aside," he adds). For the ones I have forgotten, they will just have a card hanging on their back with their names. (Laughter)

"The name *Xa'Xəłəmalogʷa*. This was the young sister of *hs'gʷooəmga*, *hs'kʷa* (Mrs. Frank Assu) has taken the name before. *Xa'Xəłəmalogʷa* was her young sister's name. And now it is going to the youngest one. *Xa'Xəłəmalogʷa*, and you shall call her this.

"This is what I have forgotten until now. Wilson Duff, *Xi'łilelakʷ*, the name of my father. *Xi'łilelakʷ*."

*Omhid speaks:*

"You have been listening. You have listened to my chief. This is why he keeps the courage, so that the speeches can come. For this reason he has started naming our grandchildren. While you listen. You *li'gʷiłdaxʷ*, understanding one another. Taking

his names for each one of them. For this reason he has the strength, he has the strength. He does not want them to go without names.

"We can never change and be different, all you tribes. 'No more potlatch' say the young men of today. What tribe are we going to be when we stop potlatching (ba'sab). We are Indians. You yourself try to forget the fact that you are an Indian. You yourself leave your name. You will have people call you chief for nothing, leaving your real name behind.

"We will distribute. You must not move around. You must not move around. This man who is giving is getting impatient and is starting to move around now. You must be seated. You will receive your gifts."

**16.II. Bill Holm. 1965. *Northwest Coast Indian Art: An Analysis of Form.*** Thomas Burke Memorial Washington State Museum Monographs 1. Seattle: University of Washington Press, 8-13, 35-45.

Bill Holm's (b. 1925) *Northwest Coast Indian Art* appeared at a most fortuitous moment, as if the perspectives and abilities of this artist and art historian had been specifically honed to meet the requirements of a tradition that had already begun an energetic process of renewal. Some Northwest Coast artists, many of whom were being trained in non-traditional environments (as outlined in the introductory essay to this chapter), chose to make use of the study as a tool. Today, several of them emphasize that the tradition would have flourished in any case, as a result of the efforts of Native artists alone. Nevertheless, Holm's study supplied vocabulary and concepts that enabled expanded cross-cultural dialogue about Northwest Coast art among artists from different traditions within the region as well as among outsiders. For example, most non-Native art professionals of the modern period were highly appreciative of abstraction and familiar with the concurrent preoccupation of artists and critics with form. Holm's study was "legible" to these outsiders and therefore a boon to the connoisseurship of the tradition (see Bunn-Marcuse, this volume) [15.III].

The important role that symbolism plays in Northwest Coast Indian art is readily apparent to the casual observer. With a little familiarity he will recognize that certain design elements, or "symbols" as they are often popularly known, seem to occur again and again. "Eyes," "joints," "ears," and "feathers," delineated with broad black lines, suggest the existence of a "Northwest Coast" style. Increasingly careful scrutiny reveals that, during the period that produced most of the familiar examples of this art, several more or less distinct styles flourished. It soon becomes apparent that the artists in the area stretching roughly from Bella Coola to Yakutat Bay had a highly developed

system of art principles that guided their creative activity and went far beyond the system of conventional animal representation described in the literature, most notably in the works of Franz Boas.

Boas and others recognized that there were other principles important to the character of the art, but only those directly concerned with representation have been adequately covered. These were summed up by Adam to include (1) stylizing, as opposed to realistic representation, (2) schematic characterization by accentuating certain features; (3) splitting; (4) dislocating split details; (5) representing one creature by two profiles; (6) symmetry (with exceptions); (7) reducing; and (8) the illogical transformation of details into new representations, All these elements are important and basic to Northwest Coast Indian art, but they are, with the exception of number 6, principles of representation rather than of composition, design organization, or form.

Haeberlin indicated a direction for research and analysis in the composition of this art. In reference to the well-known principles of "unfolding" (Adam's "splitting") and the "whole" animal, he wrote, "These important principles refer still to the contents of the representations of this art, not really to the relations of forms, for which it would seem to me the term 'artistic' is properly reserved." Boas pointed out the importance of recognizing this aspect of art in general. He said, "It is essential to bear in mind the twofold source of artistic effect, the one based on form alone, the other on idea associated with form. Otherwise the theory of art will be one-sided."

## SYMBOLIC AMBIGUITY

That even the most abstracted box or Chilkat blanket design is representative in a symbolic sense has long been known, and the principles of representation have been investigated and published. The more highly abstracted the design becomes, that is, the more nearly the represented creature, by distortion and rearrangement of parts, fills the given space, the more difficult it becomes to interpret the symbolism accurately. This difficulty is graphically illustrated by the many contradictions in the explanations by Indian informants of the meaning of Chilkat blanket designs, particularly in the lateral panels. Figure 16.3 illustrates a blanket that is nearly identical to that shown in Emmon's figure 564A, of which the lateral fields are said to "represent a young raven sitting, at the same time the sides and back of the whale."

It is also very difficult to explain satisfactorily the meaning of designs that are fragmentary in character. The designs painted on Haida gambling sticks are of this type. A set of seventy of these sticks is illustrated by Swanton and again by Boas. The effect that seemingly insignificant detail can have on interpretation is illustrated by an explanation by Charles Edensaw, an outstanding Haida artist, of No. 34 of these gambling stick designs. The intent seems quite obviously to be the head and foot of an eagle, but "Edensaw was rather inclined to consider the design on the left as intended

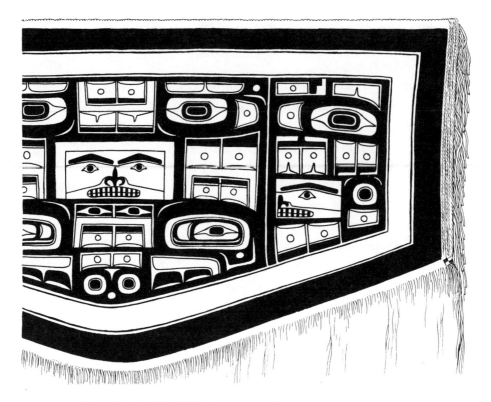

**FIGURE 16.3** Woven blanket, Chilkat. This drawing shows how figures and images were abstracted and reshaped to fit the sections of the blanket. From Bill Holm, *Northwest Coast Indian Art: An Analysis of Form,* Thomas Burke Memorial Washington State Museum Monographs 1 (Seattle: University of Washington Press, 1965), 10, Figure 5A. Courtesy of Bill Holm.

to represent the raven's wing, because it has no tongue, and because it is not the proper form of head belonging with the foot on the right!" From these examples it can be seen that the formal element of the designs very often takes on such importance as to overshadow the symbolic element to a point where the symbolism becomes very obscure.

To meet the requirements of space filling demanded by traditional design principles, the artist must introduce decorative elements so "that it is not possible to assign to each and every element that is derived from animal motives a significant function, but ... many of them are employed regardless of meaning, and used for purely ornamental purposes."

### DEGREE OF REALISM

Northwest Coast art can be divided into a number of general categories, according to the degree of realism in the design. Practically no examples of Northwest two-dimensional art are realistic in the ordinary sense. Paintings on shamans' paraphernalia

frequently approach representational realism, but even these figures are in the Northwest Coast idiom. The different degrees of realism in this art seem to result not from a variety of concepts of representation but from the artist's preference (more or less strictly bound by tradition) in handling the given space. In each case individual parts of the creature represented assume their conventional form, and the degree of realism (that is, resemblance to the visual form of the creature in nature) achieved is due to the arrangement of these conventionalized body-part symbols.

Three rather loose categories of design can thus be defined for which I use the terms *configurative*, *expansive*, and *distributive* – terms that I believe to be descriptive of the actual handling of the design elements.

1.  When the animal to be represented is shown with an essentially animal-like silhouette, perhaps occupying a great part of the decorated field but not distorted so as to fill it entirely, and still exhibits the characteristics of the art style, it can be considered an example of *configurative design* (Fig. 6 [Figure 16.4]).

2.  When an animal is distorted, split, or rearranged to fit into a given space, but the identity of the essential body parts is apparent and to some extent their anatomical relationship to one another is maintained, the resulting arrangement can be considered an example of *expansive design* (Fig. 7 [Figure 16.5]).

3.  When the parts of the represented animal are so arranged as completely to fill the given space, consequently destroying any recognizable silhouette and ignoring natural anatomical relationships, the arrangement can be called a *distributive design*. Though it may represent a particular animal and may consist of elements representative of that animal, the requirements of space filling have so distorted

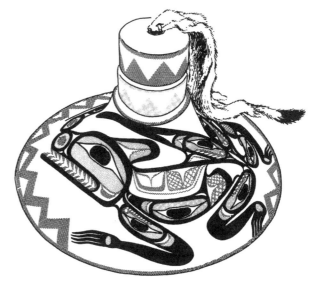

**FIGURE 16.4**  Drawing of a woven spruce hat, Haida. In his book, Bill Holm delineated some of the stylistic elements that can be observed in the Northern Northwest Coast graphic tradition. This drawing of a woven Haida spruce root hat was used by Holm to illustrate "a configurative design of a split wolf." From Bill Holm, *Northwest Coast Indian Art: An Analysis of Form*, Thomas Burke Memorial Washington State Museum Monographs 1 (Seattle: University of Washington Press, 1965), 12, Figure 6. Courtesy of Bill Holm.

it that it is difficult or impossible to identify the abstracted animal or the exact symbolism of the parts (Fig. 8 [Figure 16.6]).

It is the purpose of this book to describe some of *those stylistic characteristics of Northwest Coast Indian* art which have heretofore escaped analysis. None of the principles of representation that have been so well described in the literature will be reviewed, except as they relate directly to organization and form.

...

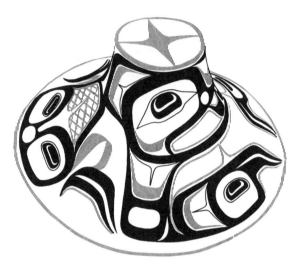

**FIGURE 16.5** Drawing of a woven spruce root hat, Haida. This Haida hat was painted with the highly stylized image of a beaver. It was drawn and used by Holm as an illustration of what he called "expansive design." From Bill Holm, *Northwest Coast Indian Art: An Analysis of Form,* Thomas Burke Memorial Washington State Museum Monographs 1 (Seattle: University of Washington Press, 1965), 12, Figure 7. Courtesy of Bill Holm.

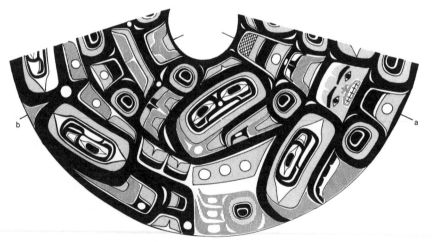

**FIGURE 16.6** Drawing of a woven spruce root hat, Tlingit. Slightly more than half the design is shown as if flattened out. The short lines extending from the rims indicate (a) the front and (b) the back of the design. From Bill Holm, *Northwest Coast Indian Art: An Analysis of Form,* Thomas Burke Memorial Washington State Museum Monographs 1 (Seattle: University of Washington Press, 1965), 12, Figure 8. Courtesy of Bill Holm.

FORM

*THE FORMLINE*

One of the most characteristic features of Northwest Coast art is the use of the formline. To call it line only would be to minimize its importance as a formal element. The constantly varying width of the formline gives the design a calligraphic character, and one is tempted to assume that this was achieved by varying the direction of the brush as a modern sign writer manipulates his one-stroke brush. A careful examination of Indian paintings reveals, however, that the formlines have been outlined and filled in, a method consistent with the well-known use of bark templates and corroborated by Mungo Martin in conversation with the writer. Interestingly, of the hundreds of bark templates seen, none was a pattern of a formline. Consequently, when templates have been used, the primary formlines are negative in the sense that they are the spaces between patterns. This gave the artist considerable control over the formlines themselves, but he had always to hold uppermost the concept that they were, in the end, the positive delineating force of the painting, and that they must also conform to somewhat rigid characteristics.

Formlines swell and diminish, rarely retaining the same width for any distance. Generally they swell in the center of a given design unit and diminish at the ends. The width of a formline usually changes with a major change of direction. These changes of width are governed by the specific design unit formed and its relation to adjacent units.

Formlines are essentially curvilinear. The curves are gentle and sweeping, breaking suddenly into sharper semiangular curves and, immediately upon completing the necessary direction change (usually around 90 degrees), straightening to a gentle curve again.

*OVOIDS*

The most characteristic single design unit in the art is the formline ovoid used as eyes, joints, and various space fillers. It has been variously termed a rounded rectangle, an angular oval, a bean-shaped figure, and other more or less descriptive names. Although the term ovoid is no more accurate than these others, it is short and handy and will be used herein to signify this design unit. Swan, in 1874, gave an interesting Haida account of the origin of this design, linking it to the elliptical spots to be seen on either side of the body of a young skate. The ovoid takes a very specific form which can, however be varied in proportion. In each case the individual elements of the design unit enclosed in the ovoid are proportionately lengthened or shortened to fit and preserve the varying width of the tertiary space.

An ovoid is always convex on its upper side and at its ends. If it appears concave on the upper side it is upside down, and, if it represents an eye, the head of the creature of which it is a part can be considered to be upside down. Joints may be shown either way, depending upon the space-filling requirements.

The lower side is usually concave, but with less curvature than the upper side so as to retain the greatest width in the center. In general, the shorter the ovoid the less concave the lower side, until in extremely short forms the lower edge may even be convex. In such cases the ovoid may actually be a circle. The formline is widest on the upper side, tapering slightly at the upper corners, then diminishing further to the lower corners, and sometimes swelling slightly to the middle of the lower side. The swell of the lower side is not pronounced enough to prevent the enclosed shape from having its greatest width at the center. The ovoid is invariably horizontally symmetrical, and ovoid templates are often made by folding the bark down the middle before cutting. This symmetry is not so apparent on the outer edge of the formline ovoid as it is usually modified by contact with other design units.

The corners of ovoids are points of tension, as are all formline corners. Junctures with other forms and with formlines usually take place near the corners. Elaboration of the form due to the presence of transitional devices takes place at the corners. The lower corners, because of the rather sudden change from convexity to concavity, are most angular and hence the points of greatest tension. In practice an ovoid, except for the inner ovoid of eye or joint designs, is practically never free-floating, but is attached to other formlines at one or more points. Most of the exceptions are in relatively modern pieces, such as those atypical paintings mentioned in the discussion of continuity in primary design. There are very few exceptions to the rule that inner ovoids are free-floating. A few northern examples show joints in the form of the "salmontrout's-head" ovoid attached directly to adjacent forms. Although this is not the usual procedure, the elaborated ovoid may be considered analogous to the similarly organized face designs, which are not free-floating. There are numerous southern Kwakiutl specimens with joints identical to typical inner ovoids, attached directly to adjacent units, one of the ways in which the Kwakiutl version of two-dimensional art differs from its northern counterpart.

*EYELIDS*

Closely associated with the ovoid and as characteristic of this art is the eyelid shape. It is familiar to anyone who has ever looked at an example of Northwest Coast Indian art as a somewhat lenticular shape, rounded in the center, pointed at the ends, and enclosing a round or oval spot suggesting the iris of an eye. It is not surprising that the shape of this eyelid unit follows fixed rules. The length and width of the unit are in proportion to the enclosing ovoid, that is, eyelids within a short ovoid are short and

wide; those within a long ovoid are long and narrow. The shape of the eye seems to be determined to some degree by the type of creature represented, and this also affects the shape of the surrounding ovoid or eye socket. The rule for the shape of the eyelid is as follows. The line forming the lids follows closely along the upper and lower sides of the enclosed ovoid (iris). At the corners it breaks, or curves more sharply inward. Since the outer corners of the eyelid are slightly below its center, the lines extending from the upper breaks to the outer corners are almost straight, while the lines connecting the lower breaks with the outer corners may be slightly concave. The lower curve typically breaks at the corners of the inner, or iris, ovoid and then quickly breaks again in a reverse curve, from which it proceeds in a nearly straight line to the outer corners. These curves are not completely smooth but show definite directional changes at the points indicated. It is this firm handling of curves which gives the best Northwest Coast work such surety and force, and the lack of it which so often brands the work of copyists of Indian design.

The whole eyelid unit is placed above the center of the surrounding tertiary space, and often the eyelid line is drawn closer to the iris ovoid at the top than at the bottom. This illustrates an important principle of the art which can be termed *nonconcentricity* and which will be discussed more fully in the section on "principles."

The iris ovoid is almost without exception black, and the eyelid line is generally black also, although a few red examples have been noted. Elaborations of the ovoid, such as the "salmon-trout's-head" and the "double-eye" are also black.

### U FORMS

The U form and its variants are as characteristic as the ovoid. U forms result when both ends of a formline turn in the same direction and each tapers to a point at their inevitable juncture with another formline. They can be very long, thin, feather like figures or wide, solid forms enclosing little or no negative or tertiary space. They occur in all three design classes, often one within the other. Typically the U form is thick on the end and thinner on the sides or legs. In the primary form the legs of the U have thickness comparable to that of other formlines in the design. Secondary and subsecondary U's may have legs as thin as true line, in which case the wide end of the U may be cross-hatched rather than solidly painted, depending on the requirements of design weight and detail. The legs may be of almost any length, or they may be nearly eliminated and the U form solidly colored. A single specimen may show a bewildering variety of primary, secondary, and tertiary U's. Solid secondary U's are often arranged in pairs within another formline U, frequently separated from it by a tertiary element also of U form.

A peculiar form is occasionally seen (21/400) which seems to violate the rules since the end of the U is narrower than its sides and it encloses an ovoid. This ovoid is a

clue to the unusual shape of the U. Examination shows that this U form is derived from the tertiary space above the upper eyelid line in a typical eye design; a tertiary modified into a secondary unit – the only case where the inner ovoid has no outline, attesting to the tertiary function of true line.

If the closed end of the U is very thick it may be relieved with a negative ovoid. It is sometimes further elaborated with a point which is an extension of one of the sides and is relieved at its juncture with the end of the U by one of a group of transitional devices.

There is a variety of tertiary U forms. Commonly the space enclosed in a typical primary or secondary U may be recessed, painted blue-green, outlined, or all three, as a tertiary unit. Very often a solid tertiary U is separated from the formline at its base by a narrow, crescent-shaped space. This kind of separating space and others related to it occur frequently and will be treated more fully under the heading of "Transitional Devices."

The tertiary split U, elaborated with a "pointed double curve, like a brace," which nearly splits the unit into two parts, also occurs frequently (272/400). It, like the closely related solid U, is typically enclosed by a primary or secondary formline U and may be either merely outlined, outlined and hatched in black or red, or solidly painted blue. There is also a primary-secondary version of the split U, but it is always red or black, never blue-green, and always on the plane surface, never recessed. It is much less common than the tertiary split U (50/400). Very infrequently a red-painted, although otherwise typical, tertiary split U appears (15/400). Some of these are in the ears of carved figures and may relate in color to the naturalistically carved ears in some masks which are typically painted red.

Some split U designs show an even curve from the corner of the base to the apex of the split. Most split U's, and especially those in specimens of fine workmanship, show a strong break in the curve at the base of the split, which itself is narrow and nearly straight-sided. On flat paintings the split itself is done in red or black line, and even in designs that are both carved and painted with blue-green split U's, the split may be outlined in black or occasionally red. The outer edge of the split U unit, in flat paintings, may also be shown in a line of the same color as the split. Frequently, however, the unit is defined by the inner edge of the enclosing primary or secondary formline. This seems to be the rule if the enclosing formline U is hatched rather than solidly painted. Split U's with and without outlines are found in the same paintings. Their use appears to have been left to the discretion of the artist, probably depending upon the need for elaboration in the area of the painting involved. The split makes the U design look something like a feather, and it is an important element in feather designs. It, like all other U forms, is never free-floating, but is always joined at the base to a formline.

Since tertiary units are, in the main, fillers between primary and secondary formlines, they assume many forms. Most common are the solid tertiary U's and the closely related split U's already described. Of frequent occurrence is the tertiary U separating a primary form-line U and the enclosed secondary or pair of secondary solid Us. This tertiary U differs in form from the usual primary and secondary formline U in that its thickness is nearly constant from one end to the other. As in the case of other tertiary units in flat paintings, it is outlined in red or black. In relief carvings it is recessed and, if painted, is blue-green.

Often the tertiary space left between primary and secondary units or complexes takes an S shape, or a nearly rectangular form, with one pair of diagonal corners rounded and the other pair pointed. Another relatively common tertiary unit is a modified U separating primary and enclosed secondary U's in an area which tapers to one end to the extent that one leg of the tertiary U is eliminated, giving it an L-like form. There are occasions when the usable space between primary and secondary formlines assumes a more complex shape, but the tertiary unit enclosed is rarely elaborated beyond those described.

**16.III. Doris Shadbolt. 1967. Foreword. In** *Arts of the Raven: Master Works by the Northwest Coast Indian.* Edited by Wilson Duff. Vancouver: Vancouver Art Gallery, n.p.

Doris Shadbolt (1918-2003) wrote this text for the catalogue of the *Arts of the Raven* exhibition, held at the Vancouver Art Gallery in 1967 in honour of the one-hundredth anniversary of the Canadian Confederation. Other projects and celebrations that served to consolidate a sense of Canadian identity during this period included Indigenous people as well, as if to substantiate the place of Native nations in Canada. In British Columbia, for example, centennial celebrations one year earlier had included the "Route of the Totems" art competition. This resulted in the installation of several important carved works of Northwest Coast art at the ferry terminals of the region (Ostrowitz 2009, 32-37).

As Shadbolt made clear, the exhibition was meant to validate Northwest Coast art traditions as "world class." In the introductory paragraph to the works in Gallery 5, called "Flat Design," for example, a clarion call to world audiences encouraged viewers to consider this art compatible with the creativity and individuality that identified the larger modernist project. Scholars emphasized that, despite the strict design rules of the art form, "it permitted an infinite amount of subtle originality within the conventions," a concept rephrased and published for decades to come as a corrective to the perception of these works as so traditional as to appear formulaic. Just as importantly, the Haida artist Charles

Edenshaw was introduced as an individual master hand. Note as well that the three "consultants" who made selections for the exhibitions and wrote the essays in the catalogue were Wilson Duff, Bill Holm, and Bill Reid, the influential individuals who participated in almost every project cited here as key to the developments of the period.

> The shift in focus from ethnology to art has been slower of accomplishment in the sculpture, painting and related arts of the Indians of the Northwest Coast than in other primitive cultures perhaps because of the relatively small and compact nature of the culture and its geographical isolation.
>
> The intent of this exhibition is to make an explicit and emphatic statement contributing to this shift: this is an exhibition of art, high art, not ethnology. It proposes to bring together many of the masterworks of this art, to show the wide range and aesthetic excellence of its forms, and to explicate and establish its claim to greatness.
>
> Interpretation is accomplished by organizing the show around themes essentially plastic or expressive in nature. Specifically, an interpretation is made of the northern two-dimensional surface style and a demonstration of its blending with complex sculptural forms. Perhaps for the first time, the work of one master artist is singled out for recognition – Charles Edenshaw (1839-1924). The arts of the Kwakiutl are presented for their full impact of theatricality, and the direction of the arts as continued today is suggested. A special gallery bringing together masterworks from various categories invites assessment of the Indian genius. Although the exhibition includes the more or less distinct styles of several tribes, the main distinction made is between the austere and intellectual elegance of the Haida, Tlingit and Tsimshian, and the flamboyant histrionic style of the Kwakiutl. For stylistic reasons, neither the Nootka nor Coast Salish are represented, nor is prehistoric stone art included.
>
> Some, though by no means all, of the works have been exhibited or published before. A search was made of public and private collections the length and breadth of this continent but it was impossible to include European and other foreign collections within our scope. Inevitably certain of the works sought were unobtainable but to the many lenders who responded to the ideal of the show with loans of irreplaceable items we express our deep appreciation.
>
> The three consultants who worked with the Gallery from the beginning on the project had the responsibility for the exhibition itself: its conception, the search for and selection of the works comprising the show, their thematic organization within the exhibition, and the catalogue. The content of the exhibition represents their criteria of excellence. They are Wilson Duff, Department of Anthropology, University of British Columbia; Bill Holm, teacher and author of NORTHWEST COAST INDIAN ART; and Bill Reid, Haida craftsman and authority on the Indian arts.

The latter two are also practising artists whose work is represented in the last section of the exhibition. Mr. Duff played the major role in the preparation of this publication, editing the catalogue entries, writing the introductory texts and notes for the various sections in addition to his own introductory essay. Together these three men represent a unique concentration of accumulated knowledge and of active study in the area of this culture.

The organization of so large an undertaking of course involved the help of many people. The president of The Vancouver Art Gallery Association, J.R. Longstaffe, and members of its Council, gave full support from the start. The entire Gallery staff worked long hours to make the venture a success; Maija Bismanis and Susan Childs of the research department were responsible for the basic preparation of catalogue entries and Norah Kembar for publicizing the exhibition. Robert Boal was designer of the exhibition installation which called for a major transformation of the Gallery's space, and John Breukelman was photographer for the catalogue. Several of the photographs are by J.E. Horvath.

The support of those foundations, agencies, corporations and individuals whose contributions made the exhibition and this publication a reality, is thankfully acknowledged.

Finally, to the Indian people of the Northwest Coast, past and present, the high achievement of whose culture is represented in this exhibition which is intended to do them honour, we acknowledge our respect and admiration.

Doris Shadbolt, Acting Director

**16.IV. Bill Holm and William [Bill] Reid. 1975.** *Form and Freedom: A Dialogue on Northwest Coast Indian Art.* Houston: Institute for the Arts, Rice University, 32-40.

*Form and Freedom* was also published to accompany an exhibition of works of Northwest Coast art from the collection of Dominique de Menil (1908-97). Her son-in-law, anthropologist Edmund Carpenter (b. 1922), invited Holm and Reid (1920-98) to discuss these works, and they did so as artists, approaching their task with relish that resulted in a series of informal and unabashedly subjective evaluations. Their insights into technique and composition could only have resulted from their many years of experience with both making and looking at Northwest Coast art. Holm and Reid practised the unobstructed "gaze" that the scholarship of the period had invited outsiders to develop and apply.

Carpenter (1976) wrote an introduction to the catalogue as well [11.VII], and it is not surprising that he credited outsiders with impressive connoisseurship – from the sailors who amassed curios at the end of the eighteenth century to the fine perceptions of the Surrealists, who admired these works without any clear

understanding of the cultures that had produced them (see Mauzé, this volume). *Form and Freedom,* as an exhibition and as a book, was a celebration of those aspects of Northwest Coast art that these authors supposed to be universal, perceptible through intellect and observation.

*Reid:* Aside from being an intriguing piece [Object #1 not shown here], I don't think its overall form reads as a great unity. What really interests me is that it has all these things going on. It was made as a virtuoso piece. The fact is, it was a hell of a hard thing to build this little figure inside the other. That has nothing to do with aesthetic appreciation or anything else, just that so much care was spent in doing that particular thing, which wasn't really necessary, but had this relationship between the person who made it, what he was doing, and the owner's joy at possessing a virtuoso carving.

*Holm:* I agree. I don't see this as quite the unified composition some others are, but it has all these different things going and each part works out really well. They do go together, though they break into different units.

What strikes me and really excites me about such pieces is their impact. That gets me first. Then, surely because of my interest in the structure of this art, I see the great organization, not only in the whole, but in every detail of every part. This one shows it. They all do. Here we have this composition of the whole silhouette and the parts that make up the bird, and the other figures joined with it: this little thunderbird-like face which dovetails with the main figure, and the little bird, or whatever he is, on the breast. Also, the way all the details are put together – for instance, this two-dimensional business on the wings. Every little part follows the "Northern style" of Northwest Coast art. It just works out.

Another thing that gets me is the rich surface, the color, the inlay.

*Reid:* Suppose we try to project ourselves into this carving. Both of us have carved and know how carving works: you have an idea and you make a form.

In Northwest Coast art, perhaps more than in any other art, there's an impulse to push things as far as possible. Here the carver probably first outlined the bird's wings and the figure projecting from its belly. You can just see him cutting deeper, finally almost separating the two figures altogether. He must have spent hours getting inside, eliminating all nonessentials, leaving nothing but the whole power and impact of the essential unit and the disparate parts that make up its whole.

*Holm:* There was a functional aspect of all this carving, too. The carver took weight away. That was part of it. There was no real purpose in hollowing out this little head on the breast, although it's nice to be able to see these shapes through it.

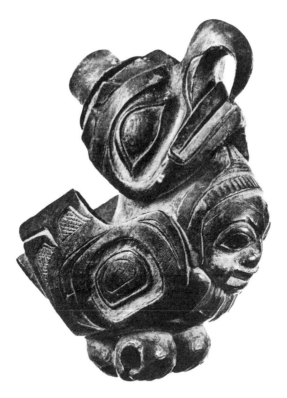

**FIGURE 16.7** Pipe carved in the form of a raven. Wood, abalone inlay, 9.8 x 4.1 x 24.1 cm. This is one of the images (Object #2) included in the exhibit catalogue *Form and Freedom: A Dialogue on Northwest Coast Indian Art* in 1975. The Menil Collection, 67-15-DJ.

Hollowing the main head was basically just relieving weight, but done as part of the design. I see this widely in rattles, backs of headdresses, and so on.

There're so many things we could say about each piece, but let's leave this one for a time.

*Holm:* The same thing happens to me when I see this next pipe [Object #2, Figure 16.7]. First, I see this great little bird with an almost human face, its beak jutting out, curving back, combining with another figure.

Then I see this great organization over the whole thing, the detail of the wings, the way the little figure on the breast is compressed into his face.

What about some of the other information, aside from just the artist approach? What about the pieces themselves, what they are, what they represent, their period? Do you want to get into that? It's part of it.

*Reid:* I'm sure it is, but I'm also sure that's your field almost exclusively. I'm not an historian, not a scholar. History will never be my primary interest.

*Holm:* I'm interested. It's something I like to think about when I look at these things. They have historical meaning to me. I get an impression of that.

Both these pipes, I think, are pretty darn old. They have that feeling. They resemble – in detail and structure – well-documented argillite pieces from the early 19th century, at least from the first half of the 19th century. Probably the same people who made these pipes made argillite carvings.

The first pipe, #1 [not shown here], looks very Haida to me, probably because it resembles, in structure, argillite pipes that came from the Haida. This pipe seems less Haida, more Tlingit. What first suggests that to me is this little man, although there are plenty of little men in Haida carvings. But something about the modeling of the face resembles well-known Tlingit carvings.

Then, as you go up into the main face, it's more difficult to pin down, but even that has characteristics more Tlingit than Haida: a little more roundness and softness, chunkier, more compressed, less crisp.

If this were a known Haida piece, one we could be positive was made by a Haida, I wouldn't argue it, because it's not clearly one or the other. But, that's my feeling and my main reason for thinking these two pipes aren't from the same hand. They're from the same period, the same general region, the same basic art tradition, but different. The first looks like the work of a Haida slate carver; this one doesn't.

What's your impression of this little guy? [Object #2, Figure 16.7]

*Reid:* A feeling of tremendous power. It's no more than 5-by-4 inches – a small thing, formed of playful elements. Yet it adds up to a monumental piece.

This is what makes Northwest Coast art: this tremendous, compressed power, tension, monumentality, in all the good pieces, no matter what the scale.

The fact is, this is a pipe, not an important ceremonial or religious object, yet it has its own intrinsic importance, its own being.

I'm looking at it now from the belly side – this little man is all tensed up like coiled spring. Somehow, through this, the whole intricacy and precariousness (perhaps that's not the right word, but it comes to me all the time), the precariousness of the society is expressed. It was a society that had been highly structured over a long period and had developed to a point where all its parts had to fit together perfectly to function as it did. This comes out in the works of the great carvers.

*Holm:* It had to be that way for these things to happen this way.

I was soaking up this little face which combines with the tail feathers of the raven. It's a very structured, organized patterning of the face planes, closely

related to flat design. One thing that often happens, so beautifully in these pieces, is the way various planes relate to one another, all in an organized way. In this case, the recessed eye socket comes merging on into this powerful beak, then curves on around to the lip. That plane – as it comes out of the eye socket and bends around the beak – produces a nose that, to me, is just a wild thing. It's so strong and works so perfectly in closing that nostril and then comes right into the broad, flat, direct lips.

Those kinds of things, to me, have great power and meaning. All the little details go together to make a total mask. You can see this face, with that same kind of plane relationship, in a big totem pole. It's part of that scale picture you were talking about.

*Reid:* That's really what it's all about. That's why so much contemporary revival doesn't work. You have to push a carving to the ultimate, beyond what seems immediately logical. You work it down to a certain level, where you think it ought to be, only to find that the real object you are looking for is still further underneath. And you keep pushing and pushing until you finally arrive at that point where it all comes together, where one area relates perfectly to another. And that point, some-how or other, determines itself. It's this crazy mystique of the object inside the wood, which of course is madness, yet it's never been explained in a better way.

*Holm:* If you don't understand that or can't feel that, you can never reach that point. You have to feel the piece in there. I don't like to compare these masterpieces with contemporary attempts but, just from a very practical view, unless you visualize that piece and know what's in there, you can spend an awful lot of time working from the surface down, trying to get there. The artist has to see that form in there.

*Reid:* Words are inadequate in these discussions, but the word that comes to my mind (when talking to others about this and thinking about it in terms of what I do myself) is courage: the courage to take it beyond the point your mind tells you is logical.

In the first pipe, #1, that's what the carver did. He had it safe at one point when he was working on it, and then he threw safety away and came up with something which – technically, aesthetically and in every way – is a masterpiece, in spite of an overall form which, though it works, isn't quite satisfactory.

*Holm:* I've seen a photograph of #1. It works better in actuality than in a photograph. It seems to have more unity, whereas in a photograph its silhouette has a broken feeling.

You spoke of the courage it takes to carry this art beyond its logical conclusion. What constantly amazes me about these pieces is the balance between the courage to go beyond logic and, at the same time, to hang in there with tradition. Sure, anybody could go beyond it – there're lots of wild things one could do. What we've got here is something that fits in that notch so clearly there's nothing else you can say. The detail of this wing follows a set of clear rules: it doesn't violate one. Yet it's unique, all part of this courageous act on the artist's part.

Apparently there was a third figure, on the rear, but its head has broken off.

*Holm:* The pipes we've seen are really remarkable for their quality. Here's another fine one [Object #3 not shown here] – a little fish with a musket barrel set in the back for a bowl. It's made of alder, I believe, and inlaid with abalone shell. I'd identify it as a fish, probably a sculpin from the broad head and the "spines" extending back from the head and along the backbone. These little triangular inlays are an unusual shape – they represent the sharp spines of the fish.

The grooves filed in the bowl resemble the decorative molding on the trade musket barrels used in many of these pipe bowls. The artist not only incorporated this exotic material in his pipe, but also borrowed a decorative element from it. Some pipes using gun-barrel bowls have evenly spaced grooves filed around them to simulate the effect of basketry cylinders on crest hats.

*Reid:* A beautiful feeling of strength and simplicity, yet decoratively very rich. And beautifully made. Northwest Coast carvers set eyes in carvings in ways that really show imagination, as well as knowledge of anatomy. These eyes are particularly fine.

*Reid:* Another pipe [Object #4 not shown here]. In this case the carver wasn't interested in saving weight – this is a chunky piece of wood in the form of a raven. It has a huge tobacco container made of copper, hand-formed probably. Its condition isn't particularly good – wear or dry rot or something has removed some of the detail, but enough remains. It was never a fine, detailed carving like #1 and #2. Here we have just plain, raw, concentrated power. It would be a strong man who smoked that pipe.

It adheres strictly to conventional form, with variations which distinguish the artist. Beautifully tapered eyebrows or eye sockets. Heavy-lidded, very humanoid eyes. Powerful, blunt beak. Short, stubby wings, patterned in simple, straight-forward Northwest Coast flat design. I don't understand what he was trying to do with the body of the bird except ...

*Holm:* ... I think that's just the backbone. He's carrying through his chunky, bold style here to an extreme degree.

*Reid:* There's a rather crudely carved face which is part of the tail. He obviously wasn't all that concerned about detail, although two little faces, projecting from either side of the beak, are nicely done. But the overall effect isn't one of exquisite purity of technique. Just concentrated power.

*Holm:* To go back to the question of these carvings as objects in time, I wonder if we aren't awfully conservative in dating them. This pipe must be post-contact, of course, if tobacco was post-contact, and the copper looks like sheet copper, not copper hammered out of nuggets. But I think this pipe is very early. I just can't imagine it acquiring that surface in a short time. Even if you've had pieces around for years and handled them a lot, they still don't have surfaces like this. This surface accumulated over a long period. I think this piece goes way back.

    Its style is very different from #1 and #2, yet the same tradition is so strong, in each, we find the same shapes, same details, and same progression of shapes from primary formlines on down through various details. Yet the whole is so different that no one, not even someone totally unfamiliar with Northwest Coast art, could imagine these as carved by the same person. All are simply products of a very strong tradition.

    This pipe differs from #1 and #2, not only in detail and lack of refinement, but in overall shape – this big, wide, massive thing with bold forms coming out. Yet, take it apart, detail by detail, and it shares the same basic structure and concept as the others.

    It's going to be fun when we start looking at that Salish spindle whorl, #13, and see where it fits in with this thing. Because, it fits there; it has a place in the whole scheme. I think we're going to talk about a lot of things on a single piece, and some of those comments and feelings and ideas can splash over onto others.

**16.V. E.Y. Arima and E.C. Hunt. 1975. "Making Masks: Notes on Kwakiutl 'Tourist Mask' Carving."** In *Contributions to Canadian Ethnology.* Edited by David Brez Carlisle. National Museum of Man Mercury Series. Canadian Ethnology Service Paper No. 31. Ottawa: National Museum of Canada, 105-8, 120-24.

In the 1970s, many Northwest Coast artists were preoccupied with the production of masks and other works of art for sale to non-Natives. They worked simultaneously to preserve the art form and to support autonomous lifestyles. Many of their more elaborate works were commissioned and purchased by museums and knowledgeable collectors. However, in this article, artist and chief Tony Hunt (b. 1942), together with anthropologist Eugene Arima, instructed readers about the carving of "tourist masks," made for consumers who were not as well informed about Northwest Coast art and tradition. Hunt had been a carving

instructor at the Kitanmax School in 1968 and for his own *Arts of the Raven* educational program, which he began in 1969. He had carved in public for many years at the shed in Thunderbird Park and for projects farther afield – for example, at the Canada Pavilion at Expo '67. Hunt became one of several emissaries for Northwest Coast art practice during this period, giving out a good deal of information but also arbitrating what was to be held back.

This guide began with detailed instructions for making proper tools, and throughout the text the authors were extremely frank about the necessity of working in a simplified manner in order to produce maximum profits. Clearly, many works of the period were produced for a broader audience and an expanded marketplace.

### B. FORM

Only a limited number of the extensive traditional repertory of mask characters are commonly produced in the tourist series. Historical accident no doubt has played a part in the establishment of the regular production of and demand for certain characters rather than others, but formal reasons for this selective development may be speculatively considered. Two formal factors that come to mind as being probably influential are the ease of production of a particular character's form and the customer's interest in particular characters by their forms. The latter factor seems the more important since simplification and standardization of form is done for even the bear which is relatively complex and difficult to fit into the flat-faced tourist mask format.

The non-Indian customer's interest depends in part on familiarity with the character. Man is universally familiar and of interest, of course. Similarly, the closely related Chief is readily recognized as the socially high ranking with his crown-like cedar bark ring headdress being an easily understood attribute. But a more specific chief figure prominent in Kwakiutl mythology *q'o:moqwa* or the "Wealthy One" ruler of the sea has not been adapted to tourist mask production. Formally, the character would be just a humanoid face to the mythologically ignorant customer unless some distinctive feature like the sometimes depicted sucker-like holed protuberances were included. Since such a feature could be adapted to a simplified form in the rapid production mode of tourist mask carving, the non-inclusion of the *q'o:moqwa* mask form, which can be strikingly exotic with those sea-evoking protuberances, may be a simple case of neglect or of assimilation into the more generalized chief form. If the character was included in the tourist mask series with those protuberances, their symbolism would have to be explained to the buying public. This lack of visually self-evident explanation, even an incorrect one, may be a factor in the neglect of the *q'o:moqwa*, a major character in Kwakiutl mythology and ceremonial. It's [sic] mythical significance as chief of the sea, which would bring associations with Neptune, should be no more

difficult to comprehend than the Wild Woman's as a child-stealing ogre. Both Wild Woman and Wild Man have the special rounded and everted mouth that entails more carving effort than any other feature in the tourist mask series. Yet it must be precisely this time-consuming feature that interests the customer because of the misinterpretation of a representation of a characteristic cry (at least for the Wild Woman) as the secondary sexual activity of kissing. In the Wild Man there is the additional complication of the nose going into the mouth which must fascinate by its odd and extreme anatomical configuration, but it would be incautious to suppose that sexual associations are generally evoked. The exaggerated nose form of the Wild Man does distinguish it more obviously from the Wild Woman than its masculine narrowing of the face as a whole. Further discussion of the nose is given below.

The delineation in myth of the typical attributes of its characters are the basis of their concrete representations in the masks. As Codere says,

> myths were at the heart of Kwakiutl culture ... [and are] the sanction for social position and the source of its crest symbology in ritual, rhetoric, and art.

The comparison of the tourist mask characters to their traditional ceremonial counterparts will be made by relating distinctive formal features of the latter to their mythological bases and noting their embodiment, or lack thereof, in the derived handicraft versions. Relevant mythological accounts may be found in Boas, Boas and Hunt and Curtis. There are many books illustrating traditional Northwest Coast art, but the most relevant to the present discussion are Curtis's *The Kwakiutl* and Hawthorn's *Art of the Kwakiutl Indians*.

### MAN AND CHIEF

That said about the mythological basis of the masks, the first characters to be compared in traditional and tourist versions, the Man and the Chief, have no especial mythological characterization. Although they constantly appear in myth interacting with mythological figures, they are not such personages themselves but remain human, ordinary or extraordinary. The traditional Man and Chief masks often depicted specific ceremonial and social roles, but took the natural human face as their formal model, adding expressions and decorations appropriate to [the] personages depicted. There is, of course, an outstanding mythical chief in *q'o:moqwa*, the ruler of the sea, discussed above. If the tourist mask Chief is related to that character, then it simply fails to represent him specifically. So too with the special human ceremonial roles which have certain human form masks, the tourist Man mask does not depict any one of them in particular. Compared to these traditional human masks, however, it may be said that the tourist Man and Chief masks are less representational of natural human

features. Because they are not worn, the mouth, eyes and nostrils on the tourist masks are not openings going through the mask wood as in many of the traditional masks. For the same reason it has been possible greatly to simplify the back hollowing of the tourist mask, curving it in only one dimension, whereas the traditional worn masks are usually hollowed out with more complexity and effort, even if only leaving a top ledge intact to rest a little on the top of the head. Many have parts of the back hollowed out further to accommodate protruding parts of the face better. Enlarging the eye and other apertures to the back surface also permits a wider angle of view through them while preserving a small concealing opening in the front. Also lightness of weight being desirable in worn masks, they are carved proportionally thinner than the tourist masks which do not have this weight consideration.

...

### D. ECONOMIC CONSIDERATIONS

Simplification and standardization of materials and form occur in the tourist masks as compared to the ceremonial ones because monetary profit from their sale on a mass market is the prime motive for their production. The principle of "maximum gain with minimum effort" is followed with moderate success, no great wealth accruing from tourist mask carving, but the activity returning a worthwhile subsidiary income. In some cases, tourist mask carving provides a full income for limited periods. Since fishing and lumbering, the major industries for the Kwakiutl, tend to be seasonal, two or three individuals usually engaged in those occupations have at times taken up tourist mask carving in Victoria during the off season. The existing market is too limited, however, to provide an adequate permanent living by tourist mask carving alone.

The prices paid by handicraft dealers vary over the years and by the bargaining of the moment, but the wholesale price of the small tourist masks was generally set, during the 1960's at least, at the rate of "a dollar an inch," a six-inch mask thus being six dollars. Carved poles, whether argillite, miniature or full-size, are often priced by length and are the probable source of the quantification of price by height of the tourist masks. The larger masks, eight or nine to 12 or more inches tall, are priced more individually. Being full-sized and often painted, they ostensibly are close reproductions of real ceremonial masks, and are more highly priced, wholesale rates working out to roughly three dollars per inch, although this quantification is not explicitly applied. Retail prices are usually about double the wholesale price. Direct purchases by the final customer from the carver are made at the same rate as by the handicraft dealers except that the latter often bargain harder to beat the price down while some individual customers are willing to pay more than the dollar-per-inch rate. Some stores have retailed at substantially more than double the original direct purchase. A large department

store once priced six-inch masks as high as $38. Although the particular masks were more carefully made than is usual, the retail prices were considered outrageous by the carvers who were concerned not only at the apparent excessive profiteering but also that overpricing would hurt their market. As may be expected there is a rough idea of fair prices, both wholesale and retail. But as with the Haida argillite carvers, the older craftsman tends to set prices lower than the younger one who enters the field now when prices are rising. The two may differ over the matter, the older carver considering the current inflated prices to be excessive and eventually bad for steady sales while the younger man thinks the former undersells himself. As mentioned before, a practised expert can carve a six-inch tourist mask in half an hour. That time, however, would not include the preparation of the semi-cylindrical base block or the oiling and smoking. A four-inch mask can take almost as long to carve as a six-inch one. The four inch mask being smaller, less wood has to be cut to define the forms but the latter are not any simpler than the six-inch mask. Indeed, one rough carver finds it more difficult to carve a small mask than a larger one. Theoretically, a carver could turn out a dozen small tourist masks in a day. In practice he produces far less, and to carve a half-dozen six-inch masks in a day would be high production. A large mask can be carved in half a day, but again the actual rate of production is much lower. It would be drudgery to turn out quantities of tourist masks day after day.

Tourist mask carving is good training for becoming a full-fledged carver of more finished works. It is actually a good second stage of accomplishment, if developmental steps can be set for a modern carver's career. Tony Hunt as a boy was first set to whittling miniature canoe paddles by his grandfather Mungo Martin. Facility in using the knives was thus gained. Boys whittle early on their own as well, often making model boats. In traditional times this activity could develop into real canoe making. Canoes were, of course, very important in Northwest Coast life. Henry Hunt also starts his younger sons on tourist paddle making if they are interested. Face designs, usually animal profiles, are painted on the blades starting the novice on his way to mastery of the Kwakiutl graphic style. The humble profit gained by selling these little paddles is rewarding encouragement to continue carving. Also the beginner wants to carve better things, of course. The next stage, tourist mask making, increases knife use ability, especially in carving into the wood since the paddle making was essentially a controlled smoothing of flat surface. With the tourist masks, the apprentice begins to do sculpture and learns the basic forms in Kwakiutl masks exclusive of the long-snouted or beaked ones. These latter may be considered perhaps the third stage of learning to carve. At this point there are also miniature poles and full figures, introducing body parts. The Thunderbird or Eagle appears to be a popular first subject for full figure work, no doubt because of their appeal to both producers and consumers.

There is also the carving of decorated utilitarian objects such as bowls at this stage. Finally, the carver is able to tackle monumental wood sculpture in the form of large single figures, house posts and the full-size "totem poles."

Thus tourist mask carving, crude and crass as it may appear, can be an important stepping-stone to more accomplished carving. Illustrated is a Bee mask (Plate 20A) by Tony Hunt which, although made to order for the Museum, is a second version of a mask made for use. Tony, entitled to be a Bee Dancer, has carved a "real" mask which reflects his earlier training in tourist mask carving. The carving was started with the semi-cylindrical base block. The mouth is basically shaped in the same manner as in a man mask. The nose is shaped much like that of the tourist Bear, with, of course, the important addition of many stingers. The nose-mouth region, following the flat-faced humanoid proportions of the tourist mask format, is much shorter than in the older ceremonial Bee masks which have well-projecting mammal-type snouts, with the exception of a distinctive round-faced variety which is perhaps more faithful to nature. Tony's Bee belongs to the former longer type, and so would have been closer to traditional form if given a more projecting snout. The eleven stingers are separate pieces, of course, as is common in traditional masks. They are detachable to facilitate storage and transportation. Also separate pieces, and of different material, are the eyes. Made of bubble type plastic sun glasses popular at the time of manufacture, the eyes are very apt innovations in material and mechanical function in the best traditional fashion. The first Bee mask by Tony, now in the British Columbia Provincial Museum, also has the traditional cougar skin attached to cover the head and the back, if not the whole body as was ideal in the past. The mask is painted, as is traditional, but the usual white base is omitted as in most painted handicraft products. The painting, however, is done more carefully than is usual with traditional Kwakiutl masks because of the conscious effort to produce an art object by the western standards of the "still contemplation in a gallery" type.

### E. SUMMARY AND CONCLUDING REMARKS

The way to make Kwakiutl tourist masks has been described closely from the materials and tools used through the steps of carving the seven common characters: Man, Chief, Wild Woman, Wild Man, Man From the Sea, Beaver and Bear. A comparison has been made of these masks with their traditional ceremonial counterparts analyzing in detail the similarities and differences in form. Two tendencies, simplification and standardization, have been emphasized as being generally characteristic of tourist mask carving, both in process of manufacture and in resultant form. The two principles are closely related and overlap at times, so that often what is simplification is also standardization and vice versa. They have been considered to be operative in tourist mask carving because of an economic work principle of minimum effort to

achieve maximum profit, or, phrased less monetarily, of efficient production of acceptable artifacts.

Although simplification is very evident in the tourist masks as a minimal representation of forms, the standardization aspect is perhaps the more interesting. First, the limited number of mask characters selected for this type of production is part of the standardization. These seven characters are fitted into a format uniform in material, size and basic shape, the semi-cylindrical base block. Within the seven characters there are further assimilations so that the Man and Chief, for instance, are made the same except for the headdress of the Chief. Wild Woman and Wild Man are made the same except for a more complex nose-mouth configuration and narrower face in the male of the pair. Beaver and Bear have their features laid out in a similar way, the ears being identical. Standardization also occurs in details such as the distinguishing of secondary nasal wing areas in the main mass of the nose in all characters, except the Bear, even when in the Man From the Sea and the Beaver they are added unnecessary complications (here standardization is not consonant with simplification). The mouth is made with the same lip oval in all characters except Wild Woman and Wild Man who have another mouth form in common. Then there are the same exaggerated upper central incisors in Beaver and Man From the Sea.

Representation of features is already quite conventionalized in a number of ways in traditional carving, of course, but the tourist masks carry the conventionalization much further along the route to simplified and standardized abstraction. Comparing Kwakiutl handicraft carving, of which the tourist masks are an especially standardized part, with the other major native handicraft carving in Canada, Eskimo soapstone carving, one is immediately impressed by the much greater formal freedom of the latter. This difference is accountable by the very different art traditions behind the two kinds of handicraft carving. Kwakiutl art, like most of Northwest Coast art, was highly formalized to begin with, emphasizing symmetry, stressing the head, conventionalizing features and so forth. The Eskimos did not have so many formal rules for artistic representation. Indeed, there is rather little aboriginal tradition behind the modern Canadian Eskimo carving. Humans and animals are the subjects of both art traditions. A major difference in treatment, however, is that Kwakiutl carving, past and present, favours static, symmetrical frontal presentations while modern Canadian Eskimo carving (but not the traditional) emphasizes action and asymmetry, even to the point of forced contortions in some cases. The market-encouraged emphasis on depicting action and on difference (ideally "no two pieces are the same") gives Canadian Eskimo carving more variety and makes it appear unstandardized, but the art style is quite highly conventionalized and repetitious although the conventions are not as obvious as in the very uniform Kwakiutl tourist mask series. Modern Alaskan Eskimo ivory carving has more readily discernible standard conventions.

Simplification and standardization is to be expected in all native handicraft art that is produced rapidly and in volume, i.e., in mass production. But the products must sufficiently, if minimally, represent the traditional "real art," to be valued as good "curio art" associated with a distinctive historic, or prehistoric, cultural tradition.

**16.VI.  Peter L. Macnair, Alan L. Hoover, and Kevin Neary. (1980) 1984. *The Legacy: Tradition and Innovation in Northwest Coast Indian Art.*** Vancouver: Douglas and McIntyre; Seattle: University of Washington Press, 93-96. First published as *The Legacy: Continuing Traditions of Canadian Northwest Coast Indian Art.* Victoria: British Columbia Provincial Museum.

This is the third exhibition catalogue excerpted in this section. This increase in the public presentation of Northwest Coast art invited a great range of visitors to become better-informed observers of form, with somewhat less emphasis on the context of Indigenous cultural practices. All of these exhibitions foregrounded works judged to be the best of their kind. *The Legacy* was perhaps the most explicit in this regard, identifying the characteristics of past form considered to represent the zenith of Northwest Coast art tradition for each group.

This selection provides evaluations of specific works, for the most part in reference to the artists' understanding of "ancient Tsimshian form." Authors Macnair, Hoover, and Neary also provided a brief history of the Kitanmax School. Although they explained the economic conditions addressed by the program and the entire 'Ksan project, it is clear that they believed most of the work by its students had "missed the mark" according to formal criteria that were more clearly established now than they had been before the scholarly studies of the period cited in the introductory essay above.

It is also important to note the authors' discussions of the cross-cultural training and dialogue that took place in museums and carving programs at this time. These locations fostered exchanges of information about style and technique that had formerly been more specific to the practices of each discrete culture group in the region. Art education programs, as well as the contemporary scholarship, encouraged broader discussion and increased connoisseurship of Northwest Coast art among scholars, artists, and their patrons (Ostrowitz 2009, 109-42).

TSIMSHIAN

The subtle nuances which combined to create the great masterpieces of Tsimshian sculpture and painting passed from practice about 1910, although a handful of craftsmen continued to produce rough facsimiles of the old art into the 1940s. However, so little had survived by then that the art was, for all intents and purposes, lost. The most

visible reminders of past artistic achievements were seen in the many totem poles which still stood in a cluster of villages on the upper Skeena River. Concern for these, and the heirloom ceremonial regalia still in the possession of native families, spurred local residents, both Indian and white, to establish a museum in the centrally located village of Hazelton. Founded in 1958, the Skeena Treasure House was later to become the focal point for a craft village devoted to the revival of Tsimshian arts.

Severe economic and social problems faced residents of the area and in 1966 an ambitious plan was devised to revitalize the community. The result, opened in 1970, was a craft, museum, interpretation, and recreational centre called 'Ksan. There, student-artists were formally trained at the Kitanmax School of Northwest Coast Indian Art. The aim of the training programme at this school was unique in that it sought, almost exclusively, to offer a comfortable livelihood for graduates. Once in full operation however, the potential to serve the Indian community became obvious and, in time, students produced regalia and totem poles for native use.

Because there were no knowledgeable Tsimshian artists living, no semblance of the old apprenticeship system was possible. Qualified instructors, both Indian and non-Indian, were brought in to instruct under relatively formal conditions. Unfortunately none of the teachers had full command of Tsimshian artforms, especially the sculpture, and, as a result, three-dimensional objects produced at 'Ksan lack the tranquil refinement of older pieces. Nonetheless the style developed by 'Ksan artists is entirely within the Northwest Coast tradition and has the potential to grow when a full understanding of classic forms is reached.

The eagle woman mask, carved by Walter Harris is a good example of the training approach undertaken at 'Ksan; students learned by copying older pieces. This was an entirely acceptable traditional means of instruction, so poses no conflict. The original is in the Portland Art Museum and is undocumented as to meaning, requiring the artist to find an explanation for his sensitive interpretation of the original.

Walter Harris's killer whale headdress is an important ceremonial item, representing one of the artist's principal crests. It was worn at a pole-raising ceremony in his home village of Kispiox; during the event rain fell onto the carving, causing the highly waxed finish to become mottled and subdued, adding character to the piece. The headdress provides another insight into the cross-fertilization of image and form which results from a training programme employing instructors from another tribal group. While the graphic design elements are certainly Northern, the concept of a large horizontal headdress like this is not typical for the Tsimshian.

The format reflects the fact that it was made under the instruction of Kwakiutl artist Doug Cranmer whose people carved and used masks similar in shape to this. When used, the lower jaw, pectoral fins, and fluked tail, may all move when strings operated by the wearer are pulled. This headdress has special status for when it was

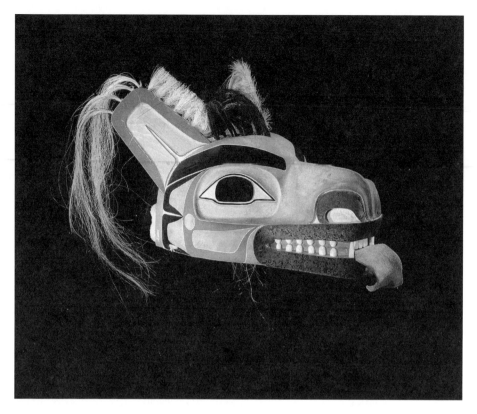

**FIGURE 16.8** Earl Muldoe, Tsimshian Wolf headdress. 1970. Wood, copper, bone, leather, and hair, 41.8 x 19.6 x 19.1 cm. Royal British Columbia Museum. Courtesy of Earl Muldoe, Gitxsan; image courtesy of Royal BC Museum, RBCM 13917.

used to demonstrate a family privilege at the pole-raising, money was "fed" into the whale's open mouth.

Harris and Earl Muldoe were among the first graduates of the 'Ksan training programme, and they have continued to play an important role as instructors at the Kitanmax School. The latter also produced his first accomplished work by copying old examples. The prototype for Muldoe's wolf headdress (figure 82; see Figure 16.8) is also in the Portland Art Museum and is illustrated in Gunther. Interestingly, the copy exhibits much greater precision of finish than the prototype.

Under the instruction of Duane Pasco, the 'Ksan students learned to manufacture and decorate bent wood boxes and they became skilled in this art. They also learned to work precious metal; in the example illustrated in figure 83, Earl Muldoe has replicated one of these boxes in silver and in miniature form. Of all the instructors who taught at 'Ksan, Pasco had the greatest influence, remaining there for about two years during the critical early period of development. While his cultural origins are far from those of the Northwest Coast Indian, his long interest in and mastery of the

artform made him a most appropriate teacher. It should be noted, however, that Pasco's personal style was not fully developed at this time, and while the 'Ksan artists essentially practice in his 1970 mode, he himself has moved far beyond this.

The chest created by Vernon Stephens, shown in figure 84a, illustrates the thin, somewhat angular, formline practiced by Pasco while teaching at 'Ksan. The primary design on the long side is based on the standard chest as seen in figure 2d. But in Stephens' example, the artist has elected to introduce a narrative dimension, filling the width of the upper section with two beavers facing one another, separated by a grizzly bear. This kind of innovation has characterized the attitude at 'Ksan; artists there feel compelled to produce something different in every piece. The end panel design is again a departure from the norm. Four separate creatures are represented in each quadrant; starting in the upper left corner and moving clockwise they are bear, eagle, beaver, and wolf. Compressing four distinct and complete designs into a rectangular design field is a device favoured by 'Ksan artists; in this panel the result is additionally successful as there is movement in the arrangement. The entire panel appears ready to rotate in a counter-clockwise motion.

Formal classroom instruction has led to a heavy dependence by 'Ksan artists on templates and other draftsman's techniques. While the traditional painter relied on templates to some extent, there came a time in his career when he abandoned his continuous need for them. This allowed a more individual expression to evolve. While the chest in question certainly is innovative in terms of gross design layout, a certain repetitiousness is evident. Part of this reflects the artist's dependence on a single template to produce either the inner or outer lines of fourteen out of sixteen profile formline heads on the chest. Thus, expected subtle changes in shape and size do not occur and, as a result, the heads of a variety of birds, mammals, and fishes exhibit a somewhat unimaginative similarity.

Robert Jackson is another artist trained at 'Ksan but since his graduation he has studied on his own; as a result, his formline designs are much more rounded and fluid than those of his fellow students. This is evident on his mask where the graphics approach the flow and feeling of those seen on the classic bent bowl in figure 10. Jackson has also attempted to recreate more accurately traditional sculptural forms and has come near to this in his handling of eyes and eyesockets.

While he has lived in the Hazelton area, and is thus obviously aware of the 'Ksan style, Phil Janzé received little formal training there. He turned to the work of Robert Davidson and other Haida artists for inspiration and, like Jackson, has captured the subtle roundedness of classic Northern design in his own work as can be seen in the silver bracelet illustrated in figure 86.

Of all the contemporary Tsimshian artists, Norman Tait of the Nishga, or Nass River, division has come closest to duplicating ancient Tsimshian sculptural forms. In

1970 he studied with Freda Diesing but continued, on his own, to experiment in the Tsimshian genre. Careful examination of the three faces on his eagle bowl demonstrates his understanding of classic Tsimshian sculpture. Tait has carved a number of totem poles in the past decade, the most significant of which he completed with his father in 1973. His monumental sculpture also comes much closer to approximating classic Tsimshian carving than does the work of other contemporary Tsimshian carvers.

NOTES

1  Interestingly, the International Council of Museums published a policy statement on "Museums and Cultural Diversity" that resulted from the report of the Working Group on Cross Cultural Issues in 1997. It emphasized the relationship between the proper representation of *cultural democracy* and equality in an effort to increase recognition of cultural pluralism. This document included, as a strategic initiative, the resolve to "develop a framework for understanding and engaging diverse notions of aesthetics in art museums," distinct from notions, popular in the modern period, about the unity and legibility of all art traditions. See http://archives.icom.museum/diversity.html.

2  It is important to note, however, that the Kwakwaka'wakw were most prominent for many years at Thunderbird Park and that the Kitanmax School trained more students of Gitksan descent than those from other traditions.

3  In the early 1990s, exhibitions that included the significant advice of Native representatives as consultants included *A Time of Gathering: Native Heritage in Washington State* at the Burke Museum in 1991 and *Chiefly Feasts: The Enduring Kwakiutl Potlatch,* which opened in New York at the American Museum of Natural History the same year. Consultation meetings for the First Peoples Hall at the Canadian Museum of Civilization in Hull, Quebec, began in 1992, although the hall did not open until 2003. Similarly, regional meetings to gather advice for the planning documents, with some information on display strategies, for the National Museum of the American Indian in Washington, DC, began in 1991, although the museum itself did not officially open until 2004.

AARON GLASS

# 17 | History and Critique of the "Renaissance" Discourse

Since the 1960s, the increasing visibility of First Nations arts and cultures from the Northwest Coast has been couched in a prominent rhetoric of "renaissance" and rebirth. This appeal to a category of Western history in order to describe developments in Indigenous culture is not as neutral as it might seem and has been only one of many discursive models used to understand the recent history of Northwest Coast Native societies. Beginning around the 1940s, when the salvage paradigm of ethnographic research began to wane (Gruber 1970), anthropologists and sociologists shifted their attention to processes of culture change, focusing on transformations to Aboriginal societies in the wake of colonialism rather than trying to occlude those changes in order to reconstruct portraits of a more "authentic" past. The primary concern was to reveal patterns of both cultural disruption and continuity and to characterize the tensions involved as Native peoples negotiated their options from sites of intercultural contact and political marginalization (for entry into this literature, see Spicer 1961). The dominant (and often technical) language of this analysis was framed in terms of culture loss ("acculturation") and cultural survival or revival ("revitalization"). Such terms, however, circulated largely through the halls of academia and had little impact on public understanding or appreciation of First Nations culture. Attention to developments in the realm of visual art (and to a lesser extent dance, music, and ceremony) encouraged the application of the term "renaissance" to suggest a return to Indigenous cultural production after a period of hiatus. This was a more publicly accessible and colloquial term than those used by scholars, and the notion of a renaissance became the dominant framework for discussing and promoting the budding interest in and production of Native art on the Northwest Coast in the 1960s and 1970s.

The term, however, bears its own weight of conceptual baggage and suggests particular values surrounding the dynamic relationship between historical disruption and continuity. All renaissance discourses – describing anything from the Italian Quattrocento to Harlem in the twentieth century – imply two primary

phenomena: a period of socio-cultural inactivity (often framed in terms of death) and a subsequent period of intense cultural activity (often made in reference to some posited and prior – if also largely imagined and idealized – Golden Age). In order to contextualize this phase of Northwest Coast art discourse, it is necessary to attend to the assumptions of its authors, to their use of the renaissance metaphor itself, and to the values (cultural, economic, and political) that this language confers on First Nations art and artists as well as on the academics who were the primary patrons at the time.

The term "renaissance" has been used historically in at least two overlapping senses (see Panofsky 1972; Summers 2004; Glass 2004b). The first describes a mode of social action with reference to the past, a *process* that participants in the "rebirth" undergo and contribute to. The generic label "a renaissance" connotes a universally positive cultural value and implies a *history of cultural production*, often recorded and celebrated at the time and by its contributors. The second sense describes a bounded period of time seen in retrospect, an *event* observed and described by later scholars. A more specific term, "The Renaissance" circumscribes persons, processes, and places into a coherent whole, creating a generalized epoch with internal consistency. This sense implies a *history of reception*, a shifting field whereby the past is consumed, interpreted, and appropriated in the present. Given this semantic variability, scholars have suggested the need to historicize deployments of the term "renaissance," to attend to the social, economic, and political bases for both any cultural transformation and its later academic reconstructions (Ferguson 1948; Kristeller 1965). In examining the writing about Northwest Coast art, it is important to identify which authors describe actual shifts in Indigenous production and which reflect transitions in reception among the larger society, which authors use "a renaissance" as a general metaphor and which make a more limited analogy to "The Renaissance."

In the early decades of the twentieth century, there was a common assumption that Indigenous peoples were fast disappearing, either as a result of forced assimilation under colonial policy or through a natural process of disintegration when confronted with more "advanced" societies. Whether such beliefs were motivated by evolutionary scholarship, government agenda, modernist and avant-garde aestheticism, or humanistic concern, they guided the collection, display, and discursive characterization of much Indigenous art (Stocking 1985; Clifford 1988b). It was not until the mid-twentieth century that a strong network of regionally located scholars, critics, institutions, funding agencies, and Aboriginal artists coalesced into a stable movement to transform the value of Northwest Coast arts in particular. In general, participants in this movement (primarily Erna Gunther and Bill Holm at the University of Washington and Audrey

Hawthorn, Wilson Duff, and Bill Reid at the University of British Columbia and the British Columbia Provincial Museum) shared both assumptions about cultural decline (with the lingering need to salvage authentic art and information) and aspirations for artistic revival (through the expansion of awareness, appreciation, and markets) (see M. Ames 1992a, 59 and passim).

Writings at the time reveal the deep conviction that Northwest Coast cultures had fully decayed under the weight of colonialism. The arts were spoken of in the past tense (Hawthorn and Hill-Tout 1955; H.B. Hawthorn 1961; Duff 1954, 1967; Gunther 1962, 1966). During the 1950s and 1960s, most scholarly mention of living artists was in the context of salvage and restoration projects. For instance, Kwakwaka'wakw chief Mungo Martin – hired by the University of British Columbia to restore totem poles in 1949 – was held to be the last real totem carver (A. Hawthorn 1952; Duff 1959b), and he was valued as the last repository of traditional Aboriginal culture on the coast (Glass 2006c). Martin was initially privileged as the "artist and craftsman" most responsible for a recent "flowering" of totem carving (A. Hawthorn 1964), although Haida radio personality and silversmith Bill Reid was introduced in the context of pole replication as "a living Haida *craft*" (A. Hawthorn 1963a; emphasis added). Catalogues and newspaper reviews of exhibitions from 1956 to 1974 make no use of the renaissance metaphor, though Martin is repeatedly celebrated as a transitional "bridge" figure engaged in artistic practices that were often generalized from his own Kwakwaka'wakw communities to those of the entire region. In fact, Gunther (1962, 340) compared art in "traditional" (i.e., prior to European settlement) Northwest Coast societies to the totalizing culture of the medieval church; for her, the Middle Ages represented not decline and death (the Dark Ages before the Renaissance) but a model of cultural integration before modern fragmentation.

It was only after 1970 that a discourse of renaissance became prevalent. In 1971 alone, Audrey Hawthorn memorialized Mungo Martin (by then deceased for nine years); Bill Reid (with Adelaide de Menil) published *Out of the Silence*, his nostalgic tribute to ancient Haida culture and artistry; *The Legacy* exhibition of contemporary Northwest Coast art opened at the Provincial Museum; and Clive Cocking published "Indian Renaissance: New Life for a Traditional Art" [17.1]. Cocking's colloquial use of the term emphasized the "resurgence of pride" and a "thread of continuity," but Cocking ultimately eulogized the passing of authentic Aboriginal culture. It was with Bill Reid's 1974 solo exhibition at the Vancouver Art Gallery that the renaissance discourse was elaborated (with Reid replacing Martin as the initiating genius), and Northwest Coast material was firmly imbued with the status of high art. In the catalogue to that show (Vancouver Art Gallery 1974), Reid was celebrated by Claude Lévi-Strauss for giving "rise

to a prodigious artistic flowering" and was said by Bill Holm to be like a "shaman bringing art back to life." In response, Susan Mertens (1974) distanced Reid from previous craft connotations, announcing "Haida art alive again." In 1975, Joan Vastokas published the seminal article "Bill Reid and the Native Renaissance" [17.11], which would forever cement Reid's association with the increasingly taken-for-granted artistic rebirth. Despite Ames's misgivings about the renaissance metaphor (in A. Hawthorn 1979), narratives of decline and rebirth remained the norm, especially regarding visual art if not culture in general (see Macnair, Hoover, and Neary [1980] 1984; Burnaby Art Gallery 1980; Nuytten 1982). Such a discourse was deployed for its colloquial ability to grant value to new artistic productions by relating them directly to past forms held to be culturally or aesthetically authentic.

By the 1980s, the earlier discourses of craft and artifact (and the celebration of Martin) as well as those of modernist art (and the celebration of Reid) were beginning to give way to a trend toward participatory ethnicity (and the celebration of Robert Davidson) (Figure 17.1). Amid the rising tide of First Nations political activism and multicultural policy, at least in Canada, the renaissance metaphor came under criticism. Karen Duffek (1983d) [17.111] presented the first nuanced view of the matter, suggesting that the art being produced was emerging from a complicated social network of values, institutions, and interests far removed from the practice of traditional Indigenous life. This was in no way a move to invalidate contemporary art but an attempt to argue that there was no rebirth of some ancient past. With the return of frequent potlatching, highly publicized cases of repatriation, and active treaty and land-claim negotiations, scholars separated a focus on fine arts from socio-cultural activity broadly speaking (Day 1985; DeMott and Milburn 1989). Reid himself was quoted as saying, "I never believed in this so-called renaissance of Northwest Coast Indian culture"

**FIGURE 17.1** *(facing page)*  The three "renaissance" men, authenticated in their ceremonial regalia, at public presentations of their totem poles to civic and university dignitaries. The top photo shows Mungo Martin, a Kwakwa̱ka̱'wakw chief and master carver, dressed in a button robe, at the opening dedication of the University of British Columbia's Totem Park in 1951. Seated are Hunter Lewis (far left), who was dedicated to reviving Native art in the public sphere, UBC chancellor Eric Hamber (behind Martin), and UBC president Norman A. Mackenzie (far right). In the bottom photo, Haida artists Bill Reid (left) and Robert Davidson (right), along with Audrey Hawthorn, the first curator at the University of British Columbia Museum of Anthropology, and Jean Drapeau, the mayor of Montreal, participate in the closing ceremony of the Northwest Coast exhibit at Man and His World in Montreal, Quebec, 1970. *Top:* courtesy of the Audrey and Harry Hawthorn Library and Archives, UBC Museum of Anthropology, #2005.001.645; *bottom:* courtesy of the Audrey and Harry Hawthorn Library and Archives, UBC Museum of Anthropology, #2005.001.1029.

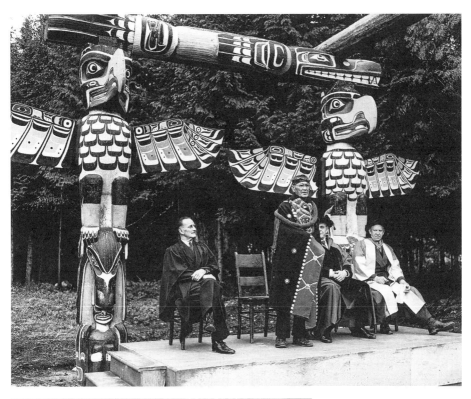

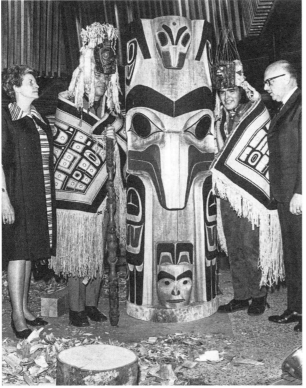

(Wyman 1986). Although Macnair (1993) still spoke of artistic decline and expansion, he had replaced the dominant death/rebirth language with a more processual view. However, despite the recent trend toward more nuanced historical accounts of the period in question (Dawn 1981; Hawker 2003), and the qualification of the term itself (see the essays in Part 3 of Duffek and Townsend-Gault 2004; Jacknis 2002b; Jonaitis 2006; Jonaitis and Glass 2010), the legacy of the renaissance discourse remains quite apparent (e.g., Kowinski 1995).

In the case of the Northwest Coast, what has been labelled a renaissance in Aboriginal production may be more accurately described as the emergence of a new field of evaluation for Indigenous objects, a new mode of perception and appreciation, a new Northwest Coast art world (Glass 2002). Critics of the renaissance discourse have thus suggested that the emergent context for Indigenous art in the 1960s was not a *rebirth* but completely new – something clearly articulated with mainstream tastes, markets, and socio-political agendas (B. Reid 1976; Duffek 1983b, 1983d; M. Reid 1993). In addition, the language of revival tends to generalize the historical experience of what are in reality diverse cultural groups with very different histories of contact and colonization. More importantly, it assumes a reality of cultural decimation and radical discontinuity as observed and evaluated by non-Native society and which most Native peoples today deny for their own historical experience (M. Crosby 1991; Jonaitis 1993) [17.IV]. Finally, in attending to the ideological values of the Northwest Coast renaissance discourse, we must ask who was looking at whose historic art and for what purpose. Many First Nations artists and activists rejected the imposition of yet another colonial category on their own cultural lives, even if such positive appreciations were meant to be laudatory (Ḵi-ḵe-in 1991) [17.V]. Although contemporary Aboriginal art production is characterized in part by a Native sense of historicity (Ostrowitz 1999), the discourse of renaissance – fundamentally a historical and an evaluatory language – was largely projected by consumers of Indigenous art onto its producers, whose locus of authenticity is typically imagined to be in the past (see Fabian 1983).

The comparison of Italian Renaissance and Northwest Coast renaissance discourses is complicated by serious structural differences, limiting the analogy as an explanatory model of cultural florescence. The two periods/phenomena/discourses are marked by variable criteria (temporal versus cultural) for the "distance" between art producers and consumers; vastly different time depths of the period of rupture (centuries versus decades); and diverse political relations between the societies establishing the historical relationship (intra-European versus colonial). But if we recognize the true force of the renaissance discourse

as applying more to shifts in contemporaneous reception than to fundamental transformations in First Nations societies, it may be possible to maintain a more limited historical comparison. During the period from 1950 to 1990 (peaking between 1965 and 1985), the Northwest Coast art world became elaborated according to socio-economic patterns established during the Italian Renaissance. Parallel histories of Native production and non-Native reception conspicuously converged during this time in the network of social relations among patrons, producers, scholars, and the public; in the negotiation of new values for Indigenous objects; and in the changing modes of both creation and perception needed to validate and market those objects.

Along these lines, there are at least eight arenas in which the expansion of the Northwest Coast art world was *reminiscent of* The Renaissance (many of these themes are treated in more detail elsewhere in this anthology): (1) the intense mobilization of national and regional identities, defined in large part through unique art styles (see Kramer, this volume); (2) the role of private and civic patronage in the growth of contexts for art production (see Hawker, this volume; Watson, this volume); (3) the influence of museums, universities, and other educational institutions in expanding public awareness of and appreciation for art (see Jonaitis, this volume); (4) the rise of art historical studies that defined regional and temporal styles, provided a vocabulary for analyzing visual arts, and elevated the ancient (or precolonial) past as the locus of cultural authenticity (see Bunn-Marcuse, this volume); (5) the emergence of art criticism, theories of interpretation, and the expertise of the connoisseur; (6) the expansion of markets for both old and new art objects, along with the diversification of media and styles (see Duffek, this volume); (7) the development of artists' studios and commercial collectives and the ideal of apprenticeship as a model of cultural transmission; and (8) the public celebration of individual genius, with its accompanying recognition of personal style and attribution.

Approached as such a limited analogy, it becomes clear why the assumptions of cultural value that accompany any renaissance discourse would have appealed to the authors most responsible for promoting a Northwest Coast renaissance. Both American and Canadian societies at mid-century were concerned to articulate unique national identities in an age of cultural pluralism, to expand tourism-based economies, and to resolve some of the colonial predicaments surrounding their Aboriginal populations. Support for Indigenous cultural production and increased awareness of and appreciation for Native "art" were seen to benefit these projects. They also allowed non-Natives to take a vital role in the renaissance process – above all, that of patron and educated consumer. A Native

renaissance would further imply that colonial destruction was reversible, that Indigenous people could claim their proper place at North America's (multi) cultural banquet.

Such a narrative may not have had obvious value for Indigenous people themselves, and most would likely deny its implicit assumption of cultural death. It may be true that the revitalized production of Native arts contributed to larger efforts to articulate a unique (and often oppositional) Indigenous identity. However, most First Nations would likely argue that they were attempting this in numerous ways throughout the twentieth century and that after the 1950s they decided to use their cultural capital (in lieu of financial or political resources) to help voice their concerns for sovereignty. On the one hand, Native people may have resented the strong implication of cultural death associated with the renaissance metaphor; on the other hand, they may not have wanted to allow national governments to think that the trials of colonialism were over just because non-Natives finally appreciated their art.

For both Aboriginal producers and non-Native academics, advocates, and consumers, the positive connotations of a renaissance discourse helped the process of valuing Northwest Coast materials as fine art during the decades in question. Whereas such values may have been broadly cultural for a pluralistic North American society and largely economic for an emergent market, they were also markedly political for the First Nations purportedly undergoing this revival. Increased recognition for the value of Indigenous arts helped to foster appreciation for Native "culture," a public acceptance that would prove vital to winning support for land claims and treaties. Yet the historical model applies only to a limited extent, as the social, political, and semiotic relations involved in the discursive constructions remain quite distinct. Renaissance Italians may have invoked rebirth to distance themselves and their artistic productions from their own medieval past, but First Nations invoke their traditional culture in part to distance themselves from contemporaneous Canadian and American societies (even as those societies continue to appropriate Native heritage as their own). So while the emergence of a Northwest Coast art world parallels, in some interesting ways, similar social developments during The Renaissance, and while the common values of such a discourse played an important role in that emergence, to call the period "a renaissance"– with all of its colloquial baggage and technical inaccuracy– ultimately does a disservice to diverse First Nations in their continuing struggle against colonial injustice.

**17.I. Clive Cocking. 1971. "Indian Renaissance: New Life for a Traditional Art."** *UBC Alumni Chronicle* 25, 4: 16-19.

Journalist Clive Cocking (b. 1938) was the first (to my knowledge) to publicize the term "renaissance" in reference to Northwest Coast art. In this article, he was responding primarily to *The Legacy* (an exhibit produced and circulated by the BC Provincial Museum) as well as the restoration work of Mungo Martin and the 1969 raising of a totem pole in Masset by the young Haida carver Robert Davidson. Despite his mention of a resurgence in Native pride and community participation, Cocking concluded with a note of pessimism from First Nations artists, a regret that the old ways were gone and that the new art was simply a pale imitation of past form without meaningful cultural context or content. Appropriate to its publication venue, this article also gave recognition to the centrality of UBC as a primary exhibit venue, patron, and educational force within the so-called renaissance.

> Two summers ago, Bob Davidson, a Haida carver and artist, took it into his head to return to his home village of Masset on the Queen Charlottes and carve a 40-foot totem pole for the village. His fellow Haida greeted the idea with what seemed like silent disbelief.
>
> "There was no reaction when I first went up there," said Davidson. "I went up and said that I was going to carve a totem pole for the village but they didn't react. Nothing. But when it was finished, it was really great. The whole village came together and supported everything. The pole was raised manually by the men and there was a big potlatch and everybody came out in their costumes and danced around the pole. I don't know, I can't describe it. It was just really fantastic."
>
> It was fantastic. And the people of Masset had reason to not react when they first heard Davidson's plan. For this was the first totem pole to be carved and raised in the Queen Charlottes in 85 years – since 1884. Clearly an event worthy of great celebration.
>
> The raising of that totem pole symbolized the current resurgence of pride among the native Indians of British Columbia. But more than that. It presented tangible evidence of an Indian renaissance – a renaissance of the arts, crafts and culture of the northwest coast Indians.
>
> What was once virtually dead, has lately been reborn in the hands of young Indian artists. And not all of the new art is being bought up by affluent white society, more and more artists – like Davidson – are returning it to the villages through renewed traditional ceremonies and totem pole-raisings. Since Davidson raised his pole at Masset in 1969, others have been raised at other villages – two more at Masset this past summer.
>
> The new contact with their art in the villages stirs Indian pride, but it also evokes a sense of loss. Ron Hamilton, a 22-year-old Nootka carver, has noticed this: "When I

go home and take a brooch I've carved out of my pocket and show it to the old ladies, they get a funny sort of whiny sound in their voices – I think, in a little way, it hurts their feelings. If I show it to an older woman, she remembers when her mother came home from potlatches with three bracelets on that were given her, and it jogs her memory; it hurts them that Indian art isn't around all the time."

The ultimate proof of this renaissance was presented this fall at the provincial museum in Victoria with a centennial exhibit of specially-commissioned works by contemporary Indian artists called "The Legacy." A special committee, composed of Peter McNair [sic], BA'64, curator of the museum's ethnology division, Dr. Wilson Duff, BA'49, UBC associate professor of anthropology, and Mrs. Gloria Webster, BA'56, assistant curator of UBC's anthropology museum, selected the artists.

They were agreeably surprised by the overall high quality of the work. "Without question," said Peter McNair, "many of the pieces in the exhibit are, in my estimate, as good as any that have ever been done."

That is saying something. For Indian art, prior to the decline, had evolved over thousands of years to a very high standard. "All scholars of primitive art," said Mrs. Audrey Hawthorn, UBC anthropology museum curator, "would rate northwest coast art as among the great tribal achievements of the world and that includes, according to the French anthropologist Claude Levi-Strauss, the ancient cultures of Egypt and Greece."

The Legacy collection, which is still on display, is an impressive indication of the number and talent of contemporary Indian artists. Where three years ago the Tsimshian people – Indians of the Skeena Valley region – had no carvers of note, in The Legacy they burst on the scene with several, offering realistic, finely carved masks and boxes. The Nootka from west coast Vancouver Island display a similar rebirth of carving skill. Salish weavers from the Fraser Valley contributed thick, bright woolen blankets. From the Kwakiutl tradition – the Indians of northeast Vancouver Island and mainland opposite – there are haunting, vivid-colored masks. The Haida, whose tribal home is the Queen Charlotte Islands, are well-represented with fine argillite and wood carvings, silver jewellery and utensils and a beautifully-wrought gold box.

Historically, art was an integral part of the social and ceremonial life of the B.C. Indians. "The art went beyond mere decoration, it was tied up with the social struc-ture," said Alan Hoover, assistant curator of ethnology at the provincial museum. "In a similar way that the European aristocracy had their heraldic crests, the northwest coast Indians had their heraldic crests on totem poles, with basically the same function and purpose." This was particularly true of the Haida and Tsimshian people, whose symbolic carvings on totem poles – and everyday objects – proudly told of the lineage or origin of the family or tribe.

But the art was also tied up with the religious beliefs and practices of the native peoples. The Kwakiutl, particularly, concentrated on carving masks representing the human figures and supernatural creatures in their myths. These were used in the winter religious ceremonies.

The potlatch was vital to the social and artistic life of the Indians. Traditionally, potlatches were celebrations of important events which would involve the host giving away gifts – the more he gave, the more prestige he acquired. The potlatch, accordingly, was a regular stimulus for artistic activity.

The climax of this rich artistic and cultural tradition coincided with the first contacts with the white man – the fur traders. The fur trade period of the late 18th and early 19th centuries brought new wealth to the Indians and, consequently, a flowering of artistic activity.

That ended with the coming of white settlers to B.C. Indian population, for one thing, declined drastically under the impact of introduced diseases. But the real death blow to native art and culture resulted from what can only be described as blind, unthinking cultural imperialism on the part of the white man. "When the white settlers, missionaries and Indian agents came to set up administration, there was a period of actual suppression by law – and by all other kinds of coercion – of Indian culture, including Indian arts," said Dr. Wilson Duff, UBC associate professor of anthropology. "And that really did have serious effects. The Haida, for example, suddenly stopped carving totem poles about 1884." The potlatch was seen as turning Indians into lazy, penniless people and was outlawed.

But the missionaries' drive to turn the Indians away from "heathenism and idolworship" had the most devastating effect. "Under the influence of the missionaries," said Hoover, "the Indians burnt their totem poles, they burnt ceremonial paraphernalia, they gave it away, the missionaries took it and sold it. And they were told that if they used this stuff, they would suffer forever in hellfire and brimstone." That, he believes, is the main reason the art and culture all but disappeared for several generations.

Why the revival of Indian art today? Well, the importance of the artists' creative drive, of course, cannot be discounted. But clearly it is also tied up with the new pride in being Indian. "It reflects," said Ron Hamilton, "a strong desire in Indian people to announce to the world that we're going to try and get some more Indian things happening and not so much getting into this white world."

But, in the final analysis, the revival was made possible because a few people kept the thread of continuity with the past from breaking completely. Knowledge of the techniques, styles and meaning of the traditional physical arts was consciously kept alive during the long period of decline. Just barely kept alive.

There was, it is true, a complete break in the artistic traditions of the Haida and Tsimshian peoples in which for two or three generations nothing was done. Nor was anything done among the Nootka and, what is worse, evidence of that culture has virtually disappeared. But the Kwakiutl succeeded in keeping alive some semblance of their old artistic and ceremonial practices – occasionally by secretly defying the anti-potlatch law – and this link essentially made revival possible.

UBC has played an important part in this process of preservation and revival. But an even more vital role was played by one man, the late Mungo Martin, Chief Nakapenkem of the Fort Rupert Kwakiutl and a famous carver.

The university began playing a caretaker role with Indian culture in 1947 with the arrival of anthropology professor Dr. Harry Hawthorn and his wife Audrey, and the beginnings of an Indian collection and a totem pole restoration program.

In 1949, Mungo Martin, at the age of 70, came to UBC to repair and paint several old Kwakiutl poles and to carve two originals, which subsequently were erected at Totem Park. Mungo taught the nearly-lost art to Doug Cranmer, a Kwakiutl, and to Bill Reid, a Haida. Then, between 1960 and 1962, the university commissioned Reid and Cranmer to create a section of a Haida village at Totem Park. For his part, Mungo went to work in Thunderbird Park, Victoria, until his death in 1958, There he passed the skill on to his son, David Martin and to Henry Hunt, of Kwakiutl descent.

This began a chain of apprenticeships which extends up to today and which has been so important to the Indian art revival. Bill Reid, for example, passed on his knowledge of Haida art and wood and silver-curving techniques to Bob Davidson, now a well-known Indian artist. At Thunderbird Park, Henry Hunt now has his son, Tony, working with him and apprentices, Ron Hamilton and Ron Wilson. All these artists have work exhibited in "The Legacy." They also assisted in the training program for young Indian artists at the Ksan project, near Hazelton.

"Mungo Martin was a very significant figure in the revival of Indian culture," said Dr. Duff. "He never really gave it up. He was one of the few members of his generation who not only valued the old ways, but took it upon themselves to preserve them. He was a kind of thin thread that kept the thing going over that dark period of time and he did it with such pride and dignity that everybody admired it."

The university's planned new Museum of Man will enable UBC to more effectively help Indians recover their past culture. The museum, to be built with a $2.5 million federal centennial grant, will be a centre for continuing northwest Indian studies serving the academic community, native Indians and other members of the public. It will enable Indian artists to copy some of the 10,000 items in UBC's Indian art collection for ceremonial use – or be stimulated by them to new original work. And it will provide a facility where Indians can do research into their culture and be trained as curators of their own museums.

But despite these developments, despite the revival of Indian art, there isn't a great deal of optimism noticeable among many young Indian artists. There is a feeling, among some of them, that they are working in limbo, producing art without the reasons for doing so that their forefathers had. For example, the potlatches, which have come back in recent years, are not the long, elaborate celebrations they once were, capable of stimulating a vast artistic outpouring. Nor are they an integral part of the Indian way of life anymore. The point, said Ron Wilson, is that "it's a whole way of life that's gone."

Gone is the old social structure, the old ceremonies. Gone too are the old myths with their haunting supernatural element. They are all gone as integral parts of an Indian's life, and with them have gone the old reasons for art.

"Where," said Hamilton, "is the belief that would stimulate me enough to go out, sit in the bush for four months and write a fantastic song, carve a mask, or train a bunch of boys to do a dance. It's just not there. I can sort of copy or imitate what they've done before, but that's not new, that's not going on today. So I say the reasons aren't there for the art to live unless we get stuff like – I'd like to see a dance of the Indian agent. Fantastic. A mask of the Indian agent. A half-breed mask, an anthropologist mask, a reporter mask. Caricaturize them. That kind of stuff. If it was modern, made to-day, it would be really great."

That may just be a clue as to the way Indian art will develop in future. It seems, like artists everywhere, these young Indians are searching for new themes. And if they decide to speak of the modern-day experience of the Indian, we can't expect them to be complimentary to white society.

**17.II. Joan Vastokas. 1975. "Bill Reid and the Native Renaissance."** *Artscanada* 32: 12-21.

With permission of Dr. Joan Vastokas, Professor Emerita, Trent University.

Writing in a special issue of *Artscanada* on the artist as historian, Joan Vastokas (b. 1938) was the first to flesh out the renaissance analogy and to apply it specifically within the context of European fine arts. This was part of a larger effort to celebrate Bill Reid – and, with him, Northwest Coast art, both historic and contemporary – in the terms (and venues) of modernist art. Although she recognized some of its limitations, and tended to conflate the histories of production and reception, Vastokas – an art historian and critic – clearly articulated the apparent relevance of The Renaissance period as a model for Northwest Coast cultural activity. She emphasized artistic rebirth based on the valuing of past forms despite the serious removal from previous cultural vitality. Although Vastokas largely employed a limited technical comparison to the European Renaissance, many subsequent authors simply ran with a colloquial – and misleading – version of the metaphor.

In 1884 what seemed the final death-blow to native West Coast art and culture was the passing of Bill 87 by the federal government, a bill which abolished the traditionally all-important potlatch. Upon this well-known institution had hinged a great deal of the social, economic, spiritual and artistic life of the villages and its prohibition served to further disintegrate the already weakened fabric of Northwest Coast society. Bill 87 came during an all-time low in native West Coast history, a low that reached its ultimate depths in the 1920s and 1930s, one that had clearly resulted from contact and interaction with the overwhelmingly powerful and aggressive culture of Euroamerican traders, missionaries and colonists. Indeed, from the perspective of native peoples themselves, the impact of the "white man," particularly in the "Colonial Period," 1849 to 1871, may, with considerable justification, be compared to the cultural shock and breakdown experienced in Europe during the "Barbarian" invasions or the "Black Death" of the fourteenth century. Besides the relentless pressures exerted upon native peoples to conform to "white" culture, native population itself was drastically reduced by a series of epidemics, the most serious of which swept the coast in 1862, eliminating almost overnight some one-third of the native population. By 1929, it has been estimated, the number of coastal peoples had been reduced by some 60%. The resultant demoralization of a once proud and independent people led to the further complication and disintegrative effects of alcoholism. All of these adversities seemed symptomatic of an eventual death of what was once one of the richest of all native American cultures.

Native art on the West Coast reflected this pattern of decline. The earliest years of Euroamerican contact (1774-1849) had at first brought about what has come to be known as the "Golden Age" of Northwest Coast art. Although the essential character of West Coast style and imagery had been established well before contact, at least as early as some 2,500 years ago, the initial economic stimulus afforded a still vital native culture by the fur trade resulted in increased material wealth, in competition for new social status by *nouveau riche* chiefs, and, as a consequence, in greater ceremonial and potlatch activity. Increased potlatching required vaster quantities of art works – crest poles, masks, costumes, rattles, ceremonial spoons and elaborately carved dishes – works which could be more easily and quickly produced with the aid of newly acquired and more efficient metal tools. This was a period, too, when non-traditional art forms were introduced to supply a new economic market, most notably the famous Haida argillite carvings so popular with tourists and collectors.

During the period of colonization, however, traditional art forms began to disappear with the disintegration of traditional patterns of culture and the production of "arts and crafts" for tourist consumption came to dominate the output of native craftsmen. By the early twentieth century, traditionally high standards of workmanship as

well as traditional reasons for making art had almost entirely disappeared. Only a few artists and craftsmen of merit were working during the artistic ebb of the second quarter of the twentieth century. Decline in general quality as well as quantity may be attributed in large part to the loss of cultural meaning attached to the art works, since, for the most part, they came to serve no internal social purpose, but were geared instead toward an external cash market. Indeed, by 1954, the West Coast anthropologist, Wilson Duff, could write in *Canadian Art* of "A Heritage in Decay."

But suddenly, overnight as it were, that seemingly inevitable trend toward the death of West Coast art has been reversed and vital signs and symbols of cultural and artistic renewal have manifested themselves. Perhaps most symptomatic and significant is the fact that totem-poles are once again being raised and potlatches being given in coastal villages. Moreover, they are no longer being raised solely as retrieval or restoration projects by governmental and educational institutions, but by the native peoples themselves as symbols of their new optimism. In the summer of 1969, for example, Bob Davidson, a young Haida carver in his twenties, carved and raised a new pole in his native village of Masset, the first pole to go up on the Queen Charlottes since that fateful year of 1884. The erection of this pole has been heralded as a miraculous sign of rebirth for native culture as a whole. Now, instead of mourning the decline and death of West Coast traditions, writers have begun to proclaim a native renaissance. As Clive Cocking wrote in 1971, "The raising of that totem pole symbolized the current resurgence of pride among the native Indians of British Columbia. But more than that. It presented tangible evidence of an Indian Renaissance – a renaissance of the arts, crafts, and culture of the Northwest Coast Indians. What was once virtually dead, has lately been reborn in the hands of young Indian artists."

This "Renaissance" of native art and the renewal of pride in native culture is not a phenomenon limited to the Haida, but is evident along the entire British Columbia coast. It includes cooperative groups of craftsmen, as in the case of the remarkable 'Ksan carving project in the Hazelton area, as well as numerous young artists of various tribal origins working on their own, primarily in the Vancouver-Victoria region. What has been happening among native artists in the past ten years or even less undoubtedly constitutes one of the more vital and creatively important developments in Canadian art today.

One of the largest and most seminal roles in this renewal of the Northwest Coast heritage has been played by Bill Reid, a craftsman of Haida descent, who is something of an unexpected phenomenon in himself. His recent retrospective – indeed, his first one-man show – at The Vancouver Art Gallery (from November 6 to December 8, 1974) gave abundant testimonial to the reasons for his pivotal influence and inspirational effect upon numerous younger artists of native origin.

...

A large and free-standing screen of laminated cedar wood ... gives an illustration of Reid's adaptation of traditional Haida imagery and design to a new, contemporary purpose. Taking advantage of the inherent adaptability of Haida imagery to objects of any size and to a wide variety of surfaces and shapes, Reid has expanded the pierced technique and overlapping organization of nineteenth century argillite carving to a monumental, architectural format. A comparison of this screen with one of Reid's own slate pipes reveals the fundamental similarity of form between two objects of widely differing scale. Within the square bounds of this large sculpture are contained characters from a number of separate mythological narratives. By now (1968), however, Reid has assimilated the iconographic content and the underlying formal principles of traditional Haida art and is able to combine these disparate figures in an unprecedented manner. Although the screen is now a museum piece itself (British Columbia Provincial Museum), it is Reid's view that there is no reason why traditional Haida art, because of its adaptability to both miniature and monumental formats, could not be applied to contemporary architectural design in the form, perhaps, of dividing walls or balustrades.

Another noteworthy example of Reid's use of traditional imagery and its transposition to new functional purposes is a gold brooch representing the Eagle, executed in 1970, and a personal favourite of Reid's. The pin is inlaid with iridescent abalone shell and hammered most finely over its entire surface to create an extremely rich and varied texture. In terms of craftsmanly care this must be considered one of the finest pieces of the artist's career. In addition to rendering almost every feather in painstaking detail, he has also taken care to place the shell so that the greenish-pink abalone inlaid at the tail-feathers gives way to purple-blue shell in the uplifted wing. It is a most vibrant and scintillating piece, full of formal tension created by the asymmetrical articulation of the Eagle's body. Yet the intended movement outward is checked by the controlling ovoid of the brooch's outline.

An instance of both technological as well as iconographic innovation within Haida tradition is most abundantly provided by what must be recognized as the masterpiece of Reid's retrospective, a gold dish or container depicting the Haida myth of Bear-mother.

...

It is impossible not to invoke, in comparison, the name and major work of yet another master jeweller, that of the Italian, Benvenuto Cellini (1500-1571), whose famous salt-cellar seems the only suitable referent for Reid's masterpiece. Cellini had been the most noted goldsmith of his day, whose distinctive contribution to the art of his period was "his treatment of detail and his technical skill." Like Cellini's salt-cellar, whose subject-matter was similarly derived from mythological sources, Bill Reid's container

is a supreme achievement of metal-smithing, a work that is the product of several jeweller's techniques. The woman's figure, the two suckling bear-cubs, the large bear's head and feet, are all cast by the lost wax process; the bowl itself and the lid on which the woman kneels are executed by repoussé or by hammering and pressing the metal over a mould; while surface details such as the woman's delicately lined hair, are engraved. As such, this work represents the culmination of Reid's aim to transpose European jewellery techniques to the Haida tradition, an achievement in which he surpasses even Charles Edenshaw (1839-1924), the master Haida jeweler of the late nineteenth and early twentieth centuries, who had restricted his metal-craft to engraving. At the same time, however, this piece seems a tribute to Edenshaw who had been particularly devoted to the portrayal of the Bear-mother theme. In thus expanding the traditional craft earlier mastered by Edenshaw, Reid carries it forward to new technical as well as aesthetics heights and into the twentieth century.

...

Of all the pieces in the show, however, Bill Reid would single out as his most important work a diminutive, yet powerful and monumentally conceived carving in boxwood, the only piece of that material in the exhibition. Representing the Haida tale of *Raven Discovering Mankind in a Clamshell,* this work also stems from his Montreal period and was carved in 1970 from a piece of boxwood sent from France by a friend. In Haida mythology, Raven or *Yehl,* has a most important place, and tales of his endless wandering and numerous adventures rank among the favorites. Raven is a trickster but at the same time he is the culture-hero of the Haida. It was Raven who stole the sun from a box, for example, and threw it into the sky to shine for the benefit of mankind, and like Jonah and the Whale, it was Raven who was swallowed by Halibut. Most important, however, Raven created mankind.

...

When first viewing the carving at the exhibition, the writer was immediately reminded of yet another boxwood carving of small scale, that incredible piece of microscopic sculpture in the Cloisters Collection of the Metropolitan Museum of Art, an early sixteenth century Flemish rose bead. The bead opens – like a clamshell, one is tempted to say – to reveal scenes from the Birth and Death of Christ, the Nativity carved in the upper half of the bead, the Crucifixion in the lower. It was, indeed, surprising to learn subsequently that Reid himself frequently referred to this very object, which he had seen on visits to New York. Such conjunctions may not be purely accidental; there must be latent in that rosary bead and Bill Reid's Creator Raven some underlying, cross-cultural and universal meaning that accounts for Reid's own fascination with that sixteenth century piece and which, somehow, has infused itself in his sculpture. Apart from the technical virtuosity of the diminutive Flemish work, could it be that both works celebrate the theme of creation and the promise of resurrection after death?

Reid's role in the current native renaissance, as he himself so frankly puts it, is only that of "somewhat Haida." He was born William Ronald Reid on January 12, 1920, in Victoria, B.C. of a Scottish-German father from the United States and a Haida mother with considerable Anglo-Saxon cultural training. The family travelled a good deal and Reid attended American as well as Canadian schools in Alaska and British Columbia. "As a result of these early associations," Reid writes, "my American teachers and peers, my American father, and my Indian mother, whose cultural values came somewhat from her native ancestry, but much more from her colonial English Anglican church education, I have always felt much more a native of all English speaking North America than of any particular political division of it." In fact, as Reid continues, "My interest in my maternal ancestors began quite late in life ... I was actually in my early teens before I even became conscious of the fact that I was anything other than an average Caucasian North American."

...

In 1951 Reid returned to Vancouver where he established a basement workshop for the production of jewellery. "And with my return to the coast," Reid writes, "my interest in Haida art gained more stimulus, and I began to devote all my creative activities to applying the European techniques I had learned to an expanded application of the old Haida designs to jewellery." It was in Vancouver in the early 1950s that Reid himself fell under the influence of Charles Edenshaw's works, which he admits to having "shamelessly copied." But it was this very copying and careful study of the works of that "Old Master" of the Haidas which communicated to Reid "something of the underlying dynamics of Haida art which later permitted me to design more original pieces while still staying within the tradition."

Reid also soon became involved with several of the totem pole restoration programs launched by the British Columbia Provincial Museum and by the Department of Anthropology at the University of British Columbia. He learned to carve in wood under yet another "Old Master," the famous Kwakiutl carver, Mungo Martin (1880-1962). From 1958 to 1962 Reid, along with another Kwakiutl artist, Douglas Cranmer, helped to re-create the section of a Haida village on the UBC campus. By this time Reid had left radio and was working full-time as a craftsman. He had also become something of an historian and critic of native West Coast art, and in 1966 he assisted Wilson Duff and Bill Holm in the preparation of the successful *Arts of the Raven* exhibition, mounted as a centennial project by The Vancouver Art Gallery. Indeed, the role of The Vancouver Art Gallery itself in helping to stimulate and proclaim the current resurgence of contemporary Northwest Coast art should not be overlooked. It is the one major art gallery in the country that has consistently, and over the years, mounted first-rate exhibitions of both traditional and contemporary native art.

...

To a very large extent, then, Bill Reid's role in the restoration of West Coast art may be described as a process of self-discovery, of finding his own creative center in the roots of tradition, and of growing and developing outward from that cultural core.

Despite his intensely creative exploration into the technique, form and iconography of both Haida and European traditions, concerns more generally associated with the "high" or "fine" arts, Reid tends to view himself primarily as a jeweller and a craftsman and prefers not to be referred to as an artist. This preference may be part of his very real and sincere modesty; but it may also be influenced by current thinking about "art," a point of view that has been with us for about a century and which has had the effect of intimidating many "craftsmen" into thinking they are not "artists." The view holds that craftsmen emphasize techniques, that they tend to reiterate and to do things that others have done before. They are not "artists" because an artist must be absolutely unique and must develop a style not shared, preferably, by anyone else. An artist, in short, must be discontinuous with other artists, with tradition, and with anything that might be described as utilitarian or practical. Bill Reid himself identifies the essential ingredient of an artist as someone who breaks the rules, the established conventions of art, and develops "a distinctive style that sets him apart from all others." These are contemporary aesthetic values that would thus define the essence of creativity as a process of change and historical discontinuity.

We tend to forget, however, that art, at base, is essentially craft and that the downgrading or devaluation of craft inevitably signifies and results in debasement of art. It is craft that provides the mechanism for communication of the ideas and meanings so important to "art," yet craft itself, in the sense of sheer technique, constitutes, as well as communicates, aesthetic value. The regard or disregard for technique, the kind of technique chosen, the degree of accomplishment in technique, and more, all these embody aesthetic meanings. Without craft, there is no art, a fact recognized by Reid and other native artists who, in order to restore native art, first chose to restore native techniques and traditionally high standards of craftsmanship. With these considerations in mind, it would seem that Reid is a creative artist indeed.

Bill Reid's example and his development have been influencing and inspiring younger artists in the traditions of West Coast art. His most notable impact to date has been upon Bob Davidson, a Masset-born Haida, in his turn already acknowledged as a master carver. Davidson's own maternal grandfather had been Charles Edenshaw himself, but aside from a year at the Vancouver School of Art, his only formal training was a year and a half apprenticeship with Bill Reid. Now, almost echoing the aspirations of Reid, Bob Davidson says that he "wishes to achieve the artistic standards of the old carvers, then to reinterpret Haida art in contemporary forms, and to help educate others about Northwest Coast art."

But Bill Reid, while amazed and pleased at the talent of many of the younger artists, is also concerned that their fame and success has come too easily and too fast. Reid feels that many of these young people are insufficiently patient about acquiring facility in new techniques, that the future of contemporary native art lies in the ever increasing improvement and expansion of technique which would assure a living, rather than an archaic, vocabulary of expression. He fears that young artists may become too limited by merely reviving traditional modes of workmanship.

Reid is also very sensitive to the fact that this renewal, this native renaissance of West Coast art, including his own development as a jeweller, began in a truly academic, antiquarian fashion, that is, by copying museum pieces. In this regard, it should be pointed out that both the Provincial Museum of British Columbia and the Department of Anthropology at the University of British Columbia have also been instrumental in bringing about this cultural rebirth, mainly through their restoration projects which required that younger artists being trained for these tasks study and copy actual museum pieces. In fact, part of Reid's intended program in Europe during 1968 had been to study and photograph Northwest Coast items in European collections. Reid seems of two minds over this fact and is frequently apologetic for the antiquarian basis of his work, referring to himself, for example, as a mere copier, indeed, on occasion, as "a white artifaker." He maintains, on the other hand, that through the study of museum pieces, he aimed to "discover the underlying design principles of his ancestors," in order to "determine what dictated that style and apply it in our own way." He states that "the art was dying so I went back to the museums and books and tried to plug into this art form when it was at its height." At one time Reid expressed the fear that by restoring and copying, he would become "a living monument" rather than an artist with something vital to contribute to the twentieth century.

Reid's concerns are indeed valid and are indicative of the major dilemma facing native artists throughout the country today. Many, of course, are merely riding the current tide of popularity and producing works that merely imitate the past or produce technically mediocre works for the almost voracious market for "Indian arts and crafts." The more serious native artists, like Bill Reid, Bob Davidson and numerous others, are struggling with this issue, since the current values of contemporary "universal" art, as Reid describes it, would reject anything that smacks of antiquarianism, history or tradition. Indeed, to be "influenced" by anything outside one's immediate personal and existential self is frowned upon: innovation, discontinuity with history, and absolute uniqueness are dominant aesthetic values. It is no wonder that native artists in our time, striving to express their own identities both as individuals living in the twentieth century and as participants in a specific cultural heritage are being ideologically torn in two. As artists, their struggle must be recognized as a monumental

one. However, it might provide native artists with some comfort, considerable justifi-cation, and perhaps a degree of inspiration were it pointed out that what they are experiencing as creative individuals has happened before in the history of world art and that those earlier experiences often resulted in overwhelmingly successful resolutions.

The decline of West Coast art and culture during the nineteenth century, for example, has already been compared with the cultural breakdown experienced in Europe during the Black Death of the fourteenth century, a period that marked the final destruction of the Mediaeval world order. During this period contemporary authors wrote of the "dire state of mankind," apocalyptic feelings ran rampant, the death of civilization was felt to be imminent, and the last Judgment was, for them, at hand. That period of cultural near-death, however, was almost immediately followed by what is often considered the peak of achievement of Western art, the Italian Renaissance of the fifteenth century. Themes of death, decay and destruction were replaced in literature and art by those of resurrection, growth and restoration.

Most important for our analogy, however, is that part and parcel of the fifteenth century Renaissance was its essential historicism. Combined with the fundamental idea of cultural rebirth after a Mediaeval death was the revival of classical, pre-Christian antiquity and all the aesthetic values attached thereto. Classical antiquity was viewed by men of the Renaissance as the "Golden Age," an "age of pure radiance." Indeed, in Vasari's eyes, the Renaissance of art was entirely "due to a return to clas-sical antiquity." That tradition was seen as something valuable in the past as a cultural phenomenon discontinuous with the present as something that had been interrupted and which required resuscitation. Artists knew the culture of the past was dead, that it was "a totality cut off from the present," but nevertheless, it was an ideal and a stan-dard to be emulated. Artists sensed that in order to go forward, they must first go back-ward, that they must restore values and standards that had been lost. They began by making detailed studies of archaeological remains, copying works of art from classical sources and adapting them to new purposes. Some of the greatest innovators of the Renaissance period began and even continued in this way. As the Renaissance special-ist Michael Levey points out, even the later art of Lorenzo Ghiberti "reflects an almost bewilderingly rich amount of antique prototypes, derived largely from sarcophagi." And, when Levey declares that although "the final result of study of the past is imita-tion," it is not necessarily "lifeless copying but the imitation which is art in itself and also a bridge back, attaching the present to the great achievements of the past." So, too, in the case of the painter Mantegna, described essentially as "a historian," as an artist who "achieved such remorseless intensity in evoking the past." Does not Bill Reid also serve as a bridge to the achievements of the past, and, as Boccaccio has said of the painter Giotto, did he not bring art and craftsmanship "back from the grave?"

Analogies with the Italian Renaissance, of course, cannot be carried too far, for unlike the case of the fifteenth century cultural rebirth, the renewal of Northwest Coast art is, this far at least, not a renewal involving an entire period of civilization, but a minute portion of it. Indeed, if we follow Panofsky's argument, we may in the end more correctly describe the present phenomenon as a mere "renovatio" or "renascence." Yet, from the generalizing perspective of anthropology, which would examine the broader patterns of cultural dynamics, the structural parallel between the renewal of native art and culture today and that of the Italian Renaissance of the fifteenth century, is not entirely unjustified. Indeed, it may be a general law of cultural as well as psychological and biological growth that the death of the old order must first take place and that the subsequent rebirth must lodge its roots, its structure, its pattern, in the soil of the past to receive nourishment for a new cycle of creation, evolution and, again, decay. It is only when those roots have been finally severed that death remains permanent.

**17.III.  Karen Duffek. 1983. "The Revival of Northwest Coast Indian Art."** In *Vancouver: Art and Artists 1931-1983*. Vancouver: Vancouver Art Gallery, 312-17.

In this volume, dedicated to assessing the history of the art scene in Vancouver and the singular contribution of the Vancouver Art Gallery to its development, the presence of this essay signalled the centrality of the renaissance metaphor by the 1980s. Karen Duffek (b. 1956), following her master's thesis in anthropology on the rise of the Northwest Coast art market (1983b), paid particular attention to the broader social scaffolding for the emergent trends in art consumption as well as production. This perspective allowed her to qualify the use of the renaissance language as it was more frequently – and naïvely – applied to shifting patterns of First Nations cultural practice.

In the 1960's a revival of Northwest Coast Indian art began to take place that has continued to develop and flourish. Following upon a decline in art production that lasted several decades, this artistic revival has emerged most prominently in the marketplace, where Northwest Coast Indian art is produced primarily to sell to a non-Indian consumer public. Contemporary Northwest Coast Indian art derives from centuries-old native traditions, yet it has now been appropriated to a large extent by non-Indians, for whom it has become a part of their own culture and is used variously as art, heritage, souvenir, and investment.

Although more and more art objects are now produced for a revived native ceremonial context, the production of art for sale to non-Indians is an integral aspect of the meaning of contemporary Northwest Coast art. In attempting an understanding

of the contemporary context for Northwest Coast Indian art production, it is vital to recognize that the revival of the art has involved not only the artists who create the objects, but also the consumers, anthropologists, museums and dealers, who have participated with the artists in the development of an audience and a market to support art production, and in a reconstruction and redefinition of "Indianness" and tradition. Northwest Coast Indian art has taken new forms and functions relevant to the changed social context in which it is now located, and Northwest Coast traditions have acquired a new significance for both the consumer and native societies.

## TRADITIONS IN DECLINE

Art in the traditional Northwest Coast context was an integral part of the culture, expressing social and ceremonial privileges, and manifesting beliefs about the relationship of man to his universe. Much of the art was centred around the winter potlatch ceremony.

Almost from the time of first contact in the 1770's, the European presence on the coast affected the traditional art and culture ... With the deterioration of the traditional social structure that had supported art production and given the art meaning, most tribal groups lost the knowledge, skills, and resources needed to sustain a viable, evolving art tradition. While some production of traditional art (particularly among the Kwagiutl) continued through the early decades of the 20th century, the death of a native culture based on strong traditions seemed certain.

## AN ARTISTIC REVIVAL

It was not until the 1960's that a new audience and consumer and a new economic and social support system began to develop that could replace those of the past and support a high degree of art production. What is often termed the "renaissance" or revival of Northwest Coast Indian art began in part as a response to social, economic, and political factors both internal and external to native society. The last two decades have witnessed continuing Indian political activity, which has contributed to a realization of the value of heritage and tradition for native people. A new public interest in ecology and "the people of nature" also emerged as part of a growing worldwide interest in primitive traditions. On the Northwest Coast, it is evident that traditional Northwest Coast Indian culture has become an element of the identity and heritage of not only the native people themselves, but also of the non-Indian people who have made the area their home.

In 1949 a Royal Commission on National Development in the Arts, Letters and Sciences recommended that a national arts and crafts programme be established as an essential aspect of the development of Indian social and economic welfare. It was suggested that a revival of native arts would promote common understanding and be

a valuable contribution to Canadian culture. In the 1960's federal government funding programmes for artists were established as a response both to these recommendations and to a renewed search for a national culture and identity.

The Kitanmax School of Northwest Coast Indian Art at 'Ksan, located in the Hazelton area of British Columbia, is an example of a cultural and economic project that received funding from provincial and federal levels of government. The artists' training programme was created both to revive an interest in Tsimshian art and cultural traditions, and to provide graduates with a means of making a livelihood.

In 1967, Canada's centennial year, Indian artists along with other Canadian artists were commissioned and subsidized by the federal government to contribute to the formation of a national culture and image. A centennial project important in the revival of Northwest Coast Indian art was the Vancouver Art Gallery exhibition *Arts of the Raven*, organized by Doris Shadbolt with the assistance of anthropologist Wilson Duff, art historian Bill Holm, and Haida artist Bill Reid. On exhibit was a selection of fine pieces of traditional and contemporary Northwest Coast Indian art. The intent of the exhibition was to present Northwest Coast art as fine art or high art, not simply – as they were more commonly considered – as curios or ethnographic objects. The exhibition has been regarded by some as a turning point for Northwest Coast art appreciation, and, by implication, for values of Northwest Coast art in the art market.

Despite the intentions of *Arts of the Raven*, the connection between Northwest Coast art and primitive or tourist/curio art remains dominant. This is reflected in the general attitudes of art galleries toward collecting or exhibiting native art. Reluctant to accept it, or assess it, simply as contemporary art, they relegate it to its "proper" place, the ethnology museum.

Museums and galleries in British Columbia and elsewhere have, however, held many exhibitions of Northwest Coast art since 1967, often with contemporary pieces included. These exhibitions have all played a role in the development of an appreciative audience for the art. The opening in 1976 of the new University of British Columbia Museum of Anthropology, which features Northwest Coast Indian art and displays it as fine art, was probably the strongest proclamation to date of non-Indian recognition and museum legitimization of the value and significance of traditional Northwest Coast Indian art and culture. Almost concurrent openings of permanent Northwest Coast ethnology galleries at the British Columbia Provincial Museum and the National Museum of Man further reflected the degree to which Northwest Coast Indian culture was now considered worthy of aesthetic appreciation and financial support.

NORTHWEST COAST ART IN THE CONTEMPORARY CONTEXT

By the late 1970's, the Northwest Coast Indian art market had become a several-million dollar industry, involving a few hundred native artists, and supported by a

primarily non-Indian consumer public. As a result of unprecedented collector demand, the art had emerged in a new social context, reflecting the significance of Northwest Coast cultural traditions to both producer and consumer.

A commonly-held perception of contemporary Northwest Coast Indian art is that the art functions to preserve a traditional culture that would otherwise be lost. In this sense the art may be viewed as a mere copy or reminder of the genuine, and evaluated as ethnographic art. This contrasts with a perception of the art as a means of transforming the past cultural tradition into a living one, in which contemporary expressions and innovations build on traditions of the past, and the art may be evaluated aesthetically as fine art within its new cultural context.

...

In attending to the issue of "archaism" in the contemporary art, it is important to note that the revival of Northwest Coast Indian art has depended largely on a process of reconstruction, reinvention, and reinterpretation of traditions that had, for most tribal groups, died out or at least remained dormant for several decades. Not only the styles and forms, but also the traditional meanings and contexts of the art are now reconstructed by artists, anthropologists, and art historians from such sources as museum collections, ethnographies, photographs, and memories. Bill Reid's and Bill Holm's art, studies, and teaching, and in particular Holm's book *Northwest Coast Indian Art: An Analysis of Form* have proved particularly influential in providing the groundwork from which many succeeding artists have gone on to learn and create in the northern style. The production of art for a revived native ceremonial context has, in addition, resulted in the re-creation of an artistic channel through which knowledge can be transferred from the old people to the young.

Contemporary artists who wish to learn Northwest Coast design can now choose among three basic methods of training: they can learn on their own, using the sources mentioned above; they can apprentice to other artists; and they can learn in a formal training setting such as 'Ksan. Kwagiutl artist Tony Hunt is probably the only artist in his age group "to have been trained as a youngster by a master [Mungo Martin] whose understanding of the art reaches back to when traditional culture was still dominant." For many young artists, contemporary reconstructions of Northwest Coast design have become the established "tradition" to be passed on to current and succeeding generations of artists.

This process of reconstruction has resulted not simply in a copyist approach toward Indian art, but in new expressions of Northwest Coast traditions. Yet when the terms "Indian" and "authentic" are applied to contemporary art, they usually refer to the degree to which the art still adheres to the use, meaning, materials, techniques, form, and subject matter of the "traditional" art of the 19th century. Books, articles, and museum exhibits tend to present the contemporary art either as a continuation of

older traditions (with some changes resulting from culture contact), or the older traditions are lumped into a single category of "traditional Indian art" from which the contemporary art has grown.

Traditional culture and traditional art were never closed or static systems. That traditions are handed down from older to younger generations implies that change is part of the transmission process. Artistic innovations can be considered part of this process, since they use the traditional as a base from which to respond to the knowledge being passed down. On the Northwest Coast, tradition is the essential basis of contemporary art production, to which innovations and new interpretations refer.

...

The structure of Northwest Coast Indian art, particularly northern two-dimensional design, is based on a system of formal design principles. Because of this characteristic of the art, viewers often judge design quality on the basis of its adherence to convention. In fact, experts and accomplished Northwest Coast Indian artists continually stress the importance of achieving a full understanding of the formal principles of the art before successful innovation can occur. Bill Reid, for example, feels that "The formline is the basis of all the art. It is the essential element that sets the art from the north coast apart from any art in the world. If you don't conform to it you're doing something else [i.e., something other than Northwest Coast Indian art]." Haida artist Robert Davidson has expressed his recognition of the importance of traditional form, stating: "I became aware of the great level that the Haida artists reached in the 1850's, and felt that once I had attained that level, I could go on to my own directions – to innovate." He has also said that "I am not content to 'recycle ideas.' I recognize the need for continued growth and now feel I must go beyond the accepted limits of the art set by masters of the past. I want to expand my ideas and create boundaries that are my own." Reid has remarked, "When I felt impelled to do something radically different I went outside the Northwest Coast field altogether."

The emphasis placed on the traditional as process by Davidson and other artists differs from the emphasis on tradition found among some experts and consumers, which seeks to restrict native artistic expression to a particular historic phase or static form of that tradition. These differing consumer expectations of native art are generally reflected in the marketplace. Surveys of consumers and museum visitors conducted by the author in 1980 suggest that non-Indian viewers respond to and judge the art not only aesthetically, by emphasizing qualities of design and form, but more often contextually, by emphasizing the degrees of "Indianness" or "authenticity" of the art and its perceived meaning or message.

...

Contemporary Northwest Coast Indian fine art has emerged in the commercial art market as a synthesis of two apparent sets of artistic values: on the one hand is an

emphasis on creating native art within centuries-old conventions of form and composition, and on the other hand is a Western academic avant-garde tradition. That these values may be viewed as contradictory brings into focus the current role of Northwest Coast art within the non-native context, and the challenges that face 20th century native artists as they attempt to develop their art while maintaining a continuity with the past.

The success of producing art for a non-Indian consumer within the market context has led to an investigation by some artists into the traditional functions and meanings of the art, and is being accompanied by a revival of art production for the native context. Producing pieces for personal, spiritual, community, and potlatch purposes is a means by which some artists are "putting the life back in" to the contemporary art and participating in a creative continuity of tradition. The amount of work now produced for such purposes, often for little or no economic benefit, is a tribute to the importance such production has attained for individuals seeking to create a more personally significant and culturally relevant context for contemporary Northwest Coast art.

The revival of Northwest Coast Indian art should not be examined and understood only for its success in recreating the past, but more importantly, for its creation of a new understanding of Northwest Coast Indian culture for native and non-native people alike. Much of the art available today assumes a static form marketable on the basis of its reaffirmation of consumer expectations of Indianness and tradition. In the best of the current art, however, Northwest Coast traditions are not simply "artificially preserved" or "restored" remnants. They are used in a contemporary expression that refers to the value of tradition and heritage for the societies of both artist and consumer.

**17.IV. Marcia Crosby. 1991. "Construction of the Imaginary Indian."** In *Vancouver Anthology: The Institutional Politics of Art.* Edited by Stan Douglas. Vancouver: Talonbooks, 279-81.

Like Vastokas's and Duffek's selections above, this article originally appeared in the context of a larger publication dedicated to national or regional art in which attention to Native art was only one contribution; this was all part of the transition of First Nations work from the realm of ethnology to the venues of fine arts. Marcia Crosby, a scholar, curator, and activist of Haida and Tsimshian descent who has also examined the nationalist appropriation of Canada's Indigenous arts (1994), maintained a political and intellectual stance toward the role of art in mediating social, political, and semiotic relations between First Nations and Canada. The selection below is drawn from the conclusion of her analysis of both colonial "salvage" art (Paul Kane and Emily Carr) and the

modernist appropriation of Indigenous art (Jack Shadbolt). Her critique of the renaissance discourse (and the treatment of Bill Reid specifically) stemmed from a rejection of its assumptions about cultural demise and its place in the legacy of allowing non-Natives to define the parameters of authentic Indigenous cultural production. For Crosby, as for many contemporary Native artists and scholars, the politics of identity common to the postmodern art world are inextricable from the larger politics of First Nations sovereignty and self-determination.

Moving from documentary, regional and modernist art rationales for appropriation to the so-called renaissance of Northwest Coast Indian art, I would like to consider another example of how something of "theirs" was made into "ours." Haida artist Bill Reid is identified by Claude Lévi-Strauss as a central figure in this revival: "We are indebted to Bill Reid, that incomparable artist, for having tended and revived a flame that was so close to dying." I would like to take up the myth that Reid was singularly responsible for reviving a dying flame (even though Ellen Neel, Willie Seaweed, Mungo Martin, Charlie James, Robert Davidson Sr. and many others were also carving before that time) to look at some of the political, institutional and economic circumstances from which Reid emerges in the media as the *reviver* of Indian art and the *saviour* of the Haida nation. It is worth noting that Reid himself has identified the academics as the ones who were throwing (and invited to) the party celebrating what he calls the "so-called great revival" of native art, of which he remarks, "The anthropologists jumped on the bandwagon and the academics sponsored the restoration of the poles" – it was a revival "supported by museological and anthropological interests." The question is, why were they throwing the party at that particular time? In this vein, others besides Reid have been cited as saviours of native culture. In *Documents in Canadian Art*, Wilson Duff is identified as "the primary student and conservator of West Coast native art ... [who] saved many of the last remaining Haida totem poles." To begin with, I think it is important to acknowledge the media response to marginalized culture within the postwar context of a global cry for decolonization and independence by non-Western nations. In other words, a profusion of voices of "other" cultural and national groups are now speaking in the first person through the media and visually through the arts, demanding recognition of their personal and political sovereignty. In the arts, concepts of internationalism, humanism, and universalism are emerging from a world horrified by fascism, the war and the bomb. These many components, together with a multiplicity of personal, political, public and private interests, figure in the construction of the Northwest Coast "renaissance," which the constraints of this paper do not allow me to address. Therefore I will consider one of the individuals who participated in the renaissance in order to

begin to deconstruct a myth that has had more to do with Western cultural interests than Northwest Coast native people.

**17.V. Ḳi-ḳe-in (Ron Hamilton). 1991. "Box of Darkness."** In *In Celebration of Our Survival: The First Nations of British Columbia,* edited by Doreen Jensen and Cheryl Brooks. Special issue of *BC Studies* 89: 62-64.

Ḳi-ḳe-in (b. 1948), sometimes known by his English name Ron Hamilton, is a Huupachesath (Nuu-chah-nulth) artist, activist, poet, historian, orator, ceremonialist, and scholar. Educated in his community's language, history, and ritual as well as in anthropology, he is well positioned to comment on the complex colonial entanglements in British Columbia. He approaches his poetic and artistic production as fully consonant with his ceremonial activities and political activism, as means of publicizing and expressing his personal and social identities and the conditions under which First Nations live today. This poem was first published with many others in a special issue of the academic journal *BC Studies* and was later included in an exhibition and catalogue of his work at the University of British Columbia's Museum of Anthropology (Hamilton 1994). From these scholarly and artistic venues, Ḳi-ḳe-in mounted a barbed critique of the colonial institutions and motives behind the so-called renaissance discourse, accusing anthropologists and art historians of maintaining Native marginalization by isolating First Nations as objects of aesthetic appreciation and academic analysis.

BOX OF DARKNESS

Doctors, curators, anthropologists,
Photographers, art historians, directors.
They've created the "renaissance";
They're the Renaissance persons.

They argue, pontificate, posit,
Hypothesize, theorize, assert, affirm,
Maintain, declare, confirm, ratify,
Present, contend, propose, indicate,
State, put forward, announce, validate,
Verify, corroborate, prove, substantiate
Debate, avow, state, reveal, make clear,
Enlighten, inform, explain, proclaim,
Clarify, imply, deny, establish,
They claim, they take.

These are not the friends of "the Indian";
These are The Friends of the Museum.
These are the golddiggers, gravediggers.
These are the new colonists.

They show our most treasured ...
They reveal our sacred symbols.
They undress our spirits.
No chief has as warm a fire.

 Not ours such hospitality.
Not ours to display, to pickle,
To interpret.
Or not.

Lately the rule is, "Don't interpret!"
It's all art now.
But that's an interpretation,
Not ours.

Sure, they can find a token taker,
Or two.
Brown mouths mouthing white words;
Brown faces posing for promotional shots.

"We are striking up a new relationship
With the First Nations Peoples."
"We are questioning our role in ...  "
"What we have here is the Native voice."

What you have there is
A reservation for symbols.
No dancing spirits reveal themselves
There.

Your hallowed halls are hollow.
You strive for pithy strident
Statements revealing a story,
Not yours.

You have the money;
You lack wealth.

You have the food,
And no servers to offer it.

Concrete, glass, video camera.
Visible, and invisible, Indians,
First Nations people.
In fact, you have control.
Sort of.

Voices without songs to sing;
Dancing robes and masks without dancers.
Symbols without spirits.

You live and work in our graveyard.
Picking the last remnants of flesh and blood
From my mother's bones.
This is your secret, not mine.
Don't offer me candy for silence.

Take your sweaty palm from my face;
Stand where I can see you.
Take your plastic defender's mask off.
The masquerade is stale, finished.

Let the political prisoners you hold,
Let them go.
Let me batter down your walls,
And set you free of your own
Captivity.

Crimes against the self,
Crimes against others,
Crimes against the state,
Crimes against Humanity,
Crimes against all Creation,
Which of these
Is the greatest?

*Summer 1980, at UBC's Museum of Anthropology*

# 18 | Starting from the Beginning

When we were chiefs in the beginning of this our world.

— *From "Wail of 'Tłat'łakwasąla, a Gwa'sąla Woman"*

The word *ethnography* stems from the Greek words *ethnos* = "people" and *graphein* = "writing" and refers to the study of human cultures. Ethnography is a component of ethnology and refers to an academic tradition developed in anthropological research that promoted the notion that "a social system is best understood on the basis of all its parts" and that this understanding is best relayed through as direct a means as possible. Therefore, ethnography became heavily reliant on first-hand observation, a relationship of the observed (cultures) and the observer (the ethnographer). This relationship initially appears to have been unilateral. Ethnographers collected stories on behalf of western European-based institutions, not for the benefit of the First Nations who were the subjects of study. In the late nineteenth and early twentieth centuries, First Nations culture, as subject matter, appeared to be pinned beneath the gaze of a microscope, immobilized, inert, and failing. However, the relationship between First Nations and ethnographers was far more dynamic and complex. Those who were the subject of study were not always impartial participants but at times used the ethnographic interaction as opportunity. It is these relationships — ethnographic interaction from the point of view of the observed — that I consider here, in particular the history of "auto-ethnography" in which the Kwakwaka'wakw have been involved. I then seek to explain, as we move into contemporary times, that the historical positions of observer (ethnographers) and observed (subjects) are actively being reversed.

In the emerging enterprise of ethnography in the nineteenth and twentieth centuries, anthropologists and academics, armed with pen and paper, boarded ships; rode trains, carts, and horses; and sometimes hired canoes to take them into the territories of the culturally unfamiliar. They were fuelled by the belief that the cultures they chose to study were on the verge of extinction. Franz Boas,

George Dawson, Edward Curtis, and Charles Newcombe were a few of the early ethnographers to enter Kwakwa̲ka̲'wakw territory in pursuit of cultural information. Of them, Boas would prove to be the most avid collector. His own letters home reveal some of his experiences while travelling through the coastal communities of British Columbia during the late 1800s and into the early 1900s (Rohner 1969). In these letters, he combined personal reflection with ethnographic information, clearly delineating his relationship to the events he was observing as both an ethnographer and an individual. The following excerpt is taken from a letter he wrote to his wife in 1894 while he was in Tsax̲is (Fort Rupert).

> Sunday, November 18: I do not work too much here because the whole day is taken by feasts and dances. My time is well spent, however. I get quite a different impression of these feasts, witnessing them, from that I had formed only hearing of them. I also hope to get a number of photographs this week, and if I do I can write a nice article for an illustrated magazine. I should like to do this as the topic is really attractive.
>
> I am just coming from a feast at which a new bear dancer was initiated. The entry of the secret societies is very interesting. The whole house is full of people all adorned with cedar bark ornaments. The door opens and in comes two bears in dancing coats with huge bear paws over their hands. Then comes the Tsonogwa woman dancer, who, according to legend, is always sleeping. She acts as though she were sleeping; instead of walking to the right around the fire, as the dancers should, she walks to the left. Then the "Fool dancers" come. While they are dancing one can hear a loud noise outside. The Nutlamamtl (Fool dancers) hide their heads under their garments and flee to the rear. Then the "Finback Whales" [Killer Whales] enter – colorfully painted men with huge fins on their backs, huffing loudly and turning this way and that. They leave and come back again as Ducks, also turning this way and that and running back to their places. New songs are sung which were composed today in the woods and eighteen women dance at the same time ...
>
> ... This noon there was a big seal feed in which I also participated. I ate only the meat because I do not like the cooked blubber. I am going to these feasts in a blanket and headring, since I am on very friendly terms with the people. (Rohner 1969, 179-80)

Boas's account gives us a vivid example of how ethnographic information (along with material culture) was being gathered by anthropologists, who then

transferred this information to the masses through museums and academies. A certain territorialism even emerged between collectors working for different institutions.[1] Such was the flood of information and objects that museum collections across the world burgeoned in the late nineteenth and early twentieth centuries (see Laforet, this volume; Miller, this volume; Jonaitis, this volume).

During the frenzy of the early decades of the twentieth century, the narrative account of individual lives became identified by ethnographers as a source of valuable cultural information. Some of this was driven by the desire to document and assess the effects of cultural change due to the influence of western European culture, as rapid acculturation had been occurring on the coast since the mid-1800s. Grafting the individual (*auto* = "I") onto ethnography gave birth to "auto-ethnography," an English word describing the collection of personal reflections concerning their culture gathered from members of a society and based on their life experiences. The "auto" highlights the fact that the information is a first-hand account of one's own experience, while "ethnography" highlights the western European academic tradition. Three primary participants emerged from this situation: the storyteller, the ethnographer, and the ultimate readers and consumers of such information. The telling of the story, along with the documentation of that information, tended to occur at a single point in time: the moment of collection. The consumption and assessment of these stories remain ongoing.

In reviewing this history, I imagine the researcher, perhaps in the 1920s, pen and notebook in hand, and, if we are lucky, a recording device. The researcher sits with an individual of interest, someone knowledgeable in his or her own traditions, and takes down his or her story. This story is then disseminated to the world through archives and publications. In itself, this appears to be a simple act: an individual taking down the life story of another. In fact, without the baggage of academic history, with all its colonial issues of power and control, this act of speaking and listening seems to be merely human.

Having established the context for the institutional motives and mindset of the ethnographers, my question is "what were the informants thinking?" Were they participating for the same reasons as the ethnographers? This is highly doubtful in the early part of the nineteenth century but certainly possible for the latter generations, who would have had a better understanding of the western European culture that was overwhelming their traditional way of life. Is it possible that early participation was guided by purposes aligned with their own worldview? It is possible that the early auto-ethnographic accounts taken from First Nations informants up and down the coast were in fact extensions of their own traditions and that the act of telling one's own story was an act consistent

with traditional cultural norms and deeply rooted in the creative production of material culture.

From inside a Kwakwa̲ka̲'wakw understanding of the world, the telling of one's own life story had tremendous and all-encompassing effects on cultural production. Ultimately, most artistic activity among the Kwakwa̲ka̲'wakw and on the Pacific Northwest Coast generally was autobiographical. Almost all expressions of dance, song, and artwork were created in order to "tell one's own story," both individual and communal. While the auto-ethnographic focus tended to begin at the point of the informant's birth or entry into this world, in the Kwakwa̲ka̲'wakw mindset an individual's beginning is set much earlier in time, when an original ancestor was transformed into a human. Telling this story in a public forum where it would be both witnessed and validated by others embodied Kwakwa̲ka̲'wakw artistic cultural production. The stories were and continue to be the foundations of all masks, dances, and ceremonies. For example, Imas is a ceremony conducted at the beginning of Kwakwa̲ka̲'wakw potlatch ceremonies. In it, a masked dancer appears at the front entrance of the ceremonial house. This masked dancer moves across the floor and disappears behind a curtain at the back. The masked dancer represents the original ancestor of the family hosting the potlatch or the return of the spirit of the dead in a memorial context. So the ceremonies are always symbolically anchored to a beginning far beyond the physical manifestation of contemporary activity.

## 'TŁAT'ŁA̲KWASA̲LA: THE FEAT OF MEMORY

Perhaps one of the earliest auto-ethnographic accounts documented among the Kwakwa̲ka̲'wakw was recorded by George Hunt around 1916 (Berman 1996). He recorded the crying song of 'Tłat'ła̲kwasa̲la, a Gwa'sala woman who was mourning the death of a relative (Boas 1921, 836-85). She was able to recite a family narrative anchored by the origin story of her family that travelled twenty-two lifetimes, beginning with the original transformation of her ancestor from a whale into a man and ending with her current generation. What 'Tłat'ła̲kwasa̲la committed to memory within the framework of an oral culture Hunt committed to paper within the framework of ethnography. Traditionally, her story would have been passed on to her descendants, each generation adding to it. This process was broken due to active cultural suppression of the Kwakwa̲ka̲'wakw by the Canadian government. Ironically, the western European culture that was facilitating this breakdown of traditional information was also working to preserve her story through academic ethnography. The following excerpt is the introduction to her story.

*Wail of 'Tlat'lakwasala, a Gwa'sala Woman*

Haha hanane! Now I come to think of my forefathers and of my great-grandfathers. Now I will tell the story of my house when we were chiefs in the beginning of this our world.

Haha hanane! Yakala'nala (II 1)[2] went about spouting. He was my chief in the beginning of the world. He traveled about in his canoe, a whale; for he was a whale, the ancestor of my people the Gwa'sala; and he went into Nagitl. He saw that there was a good beach, and he went ashore there; and Yakala'nala (II 1) built a house and came out of his whale body. Now, the whale-canoe of Yakala'nala (II 1) lay crosswise on the beach. Then Yakala'nala (II 1) gave a name to the village, and called it Gwikalis. (Boas 1921, 836)

'Tlat'lakwasala then goes on to explain the marriage of Yakala'nala and the generations resulting from that marriage. She provides the names and treasures that each marriage brought into her lineage. Only the narrative as a whole gives the true magnitude of the feat of memory required. Hunt's text of this particular narrative covers forty-nine pages. In his letters exchanged with Franz Boas (see Laforet, this volume) [6.vii, 6.xix, 6.xx], Hunt indicates that her story, told in the form of a "cry song" (*lagwalam*), lasted from "7 o clock until nearly 3 o clock" (Berman 1996, 233), a remarkable eight hours. The following excerpt is 'Tlat'lakwasala's conclusion:

When T'lakwaga (XXII 1) was old enough she married Hewakalis (XXII 2), chief of the numaym Tsit'samilekala of the Nakwaxda'xw, and Tlakwaga (XXII 1) had a son. Then Hewakalis (XXII 2), gave a name to the child, and he named him Gwayusdidzas (XXIII1) ... Gwayusdidzas (XXIII1) is now three years old.

Now, I really began at the very end of our ancestors with the whale, Yakalanlis (II 1), and came down to Gwayusdidzas the son of T'lakwaga and there are twenty-three men, beginning with Yakalanlis, coming down to Gwayusdidzas (XXIII1). I did not mention that all of them had two or three wives, and some had four wives, and a great many children, and the younger brothers and sisters of those whom I have named. Now, this great matter is at an end. (Boas 1921, 884-85)

'Tlat'lakwasala's life would have been included in future narrations of the family story if the tradition had been kept alive by her descendants. It is possible that

remnants of her existence still linger in the current ceremonies and songs of the Kwakwa̱ka'wakw, but they are but a shadow of their former execution. Already, even before the collection of her story by Boas and Hunt, the oral traditions of recall and narrative had rapidly begun to break down. The Kwakwa̱ka'wakw's culturally defined collective comprehension of the self, as exemplified by 'Tłat'ła̱kwasa̱la's position within her oral narrative, had begun to cave in to the Western, European-influenced, concept of the individual.

## GEORGE HUNT: "DUAL ROLES" – THE COMBINING OF INFORMANT AND ETHNOGRAPHER

One of the most interesting cases of auto-ethnography is George Hunt himself (Figure 18.1). Hunt was Franz Boas's informant and supplied Boas with much of the vast amount of information he collected on the Kwakwa̱ka'wakw (see Berman 1994, 1996; Cannizzo 1983; Jacknis 1991). He acted as an intermediary for Boas among the various tribes and collected information as requested. At times, he acted as both informant and ethnographer simultaneously (the observer and the observed) (see Berman, this volume, on Tlingit cultural intermediary Louis Shotridge). Some of Hunt's submissions were actually autobiographical, and Hunt would sometimes refer to himself in the third person as he documented events and occurrences within which he was an actual participant. In particular, he documented his acquisition of positions (upheld by songs, dances, and masks) through marriage and the establishment of his children in positions of social significance among the Kwagu'ł (Berman 1996, 228-29). While acting as ethnographer, he was able to acquire the information that Boas requested of him. At the same time, the documentation of his own family's rites and privileges served to position his family history in the public domain, providing validation as required by traditional Kwakwa̱ka'wakw law. As the traditional storehouse of memory marked by ceremony continued to deteriorate under legislated oppression by the Canadian government, perhaps ethnographic documentation became an alternative way to maintain the stories and publicly validate histories. In the following passage, Hunt uses his own experience as an example of ceremonial procedure.

> The reason why I know all this is that when I gave a winter ceremonial, the old chiefs did just this way for me. It was Nuxwnemis who spoke, because he paid my marriage debt and he gave me a cannibal dance, whose name was Lying-Down-on-Beach (Yagwis), and a Ka̱nḵalatła̱la, whose name was Healing-Mouth-in-the-World (Hilegaxstega̱lis), and a Nunłtse'stalał, whose name was Nunłtse'stalał, and a 'Nanaḵawalił. These ceremonies

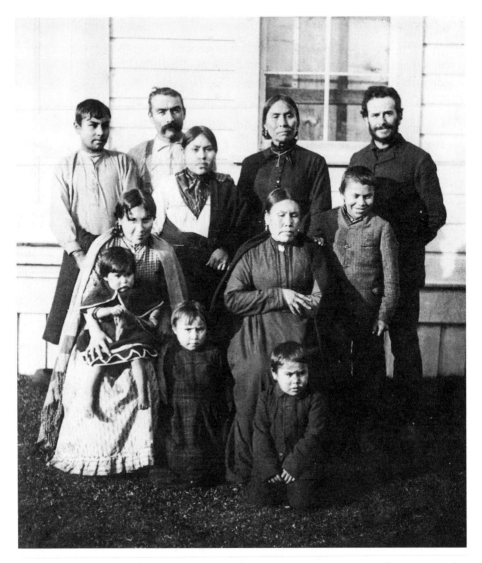

**FIGURE 18.1** George Hunt (second from left at rear), with his family and Franz Boas (far right at rear) in Fort Rupert, in a photo taken in 1894 by O.C. Hastings (1846-1912). Hunt, of Tlingit descent, worked closely with Boas, helping him with ethnographic recordings and documentation of oral histories. O.C. Hastings, American Philosophical Archives, APSimg2448, Franz Boas Papers, Mss. B B61.

were given to him by his Bella Bella wife and he gave them to me when I married his sister. My seat also was given to me by the Sint'ɬam. (Hunt in Boas 1966, 256)

In documenting his family histories, Hunt ('Maxwalagalis) documents the lineage of his sons through his marriage to their mother, Lucy Homiskanis (T'ɬaliɬilakw). In this section, he does not refer to himself directly but speaks

about himself in the third person using the name 'Maxwalagalis, which was given
to him by his wife's brother Nuxwnamis. This is the same Nuxwnamis that he
refers to above.

> Then T'laliłilakw (VIII 1) married 'Maxwalagalis; and to him went the name
> 'Maxwalagalis and also the cannibal dance and the name Yagwis and the
> fire dance from the brother of T'laliłilakw (VIII 1), who was Nuxwnamis
> (VIII 3) in the winter dance, and Umx'id in the secular season. Now
> T'laliłilakw (VIII 1) had (four sons) a son named Ṅamugwis [David Hunt]
> (IX 1), and his younger brother Ugwilaggame' [Sam Hunt] (IX 2), and
> his younger brother Kwakwabalisame' (IX 3), and his younger brother
> Łiłalgamlilas [Stanley Hunt] (IX 4). (Boas 1921, 1001-2)

The narratives corroborate each other despite formal difference in execution.
Hunt provided much personal information within the texts he submitted to Boas
but was not always explicit about his position as both narrator and participant, as
in the following section:

> In the evening the father of Yagwis gave the promised feast, in which he
> was going to pay for the ecstasy of his son. The blankets which he was about
> to distribute actually belonged to his mother. When the people were as-
> sembled in the ceremonial house of the Kwagu'ł, she came in first, crying
> "hu, hu, hu," which indicated the weight of the blankets which she was go-
> ing to distribute. She was followed by the father of Yagwis, who entered
> singing his secret song. He was followed by his son Yagwis, the cannibal
> dancer, and by his sister, Tlastusalas, who was the assistant (*kankalatlala*) of
> the former. Then the members of his clan followed, carrying the blankets
> which he was going to distribute.
>
> ... Then the father of Yagwis arose, and the people shouted, "Speak,
> chief; speak yourself; not through a speaker." Then he said, "Friends, look
> at me; look at me well, because I want to tell you who I am! This is my way
> of doing. Five years ago you heard much about what I was doing. Then
> I gave my Cannibal dance first to Yagwis ... My name is T'lakwagila,
> on account of the copper which I had from my grandfather. My name is
> Ḵumugwe, on account of the ermine and abalone shells which I have from
> my grandfather. Do you want to know how I obtained my Cannibal dance?
> I opened my box and took out my dances, which I received from my
> brother-in-law, Nuxwnemis. Therefore I am not ashamed of my cannibal
> dance. Now I ask you one thing – do not call me Gwetalabidu'.[3] It is well

when I live like one of you, and it is well if I act like one of the northern
tribe, because my mother was of high blood among her tribe. I do not give
this festival so that you may call me a chief. I give it in honor of these two
who are dancing here, that the words of their enemies may not harm them.
For this purpose I build an armor of wealth around them." (Boas 1966,
190-91)

The reasons for the discrepancies are not clear,[4] but it does provide us with a
fascinating perspective on Hunt's positioning of himself as both a deeply in-
volved participant and an outside observer of culture.

### Charles Nowell: The Merging of Genres

Charles James Nowell, a Kwexa from Tsaxis (Fort Rupert), was a contemporary
of George Hunt (Figure 18.2). His life story was documented by Clellan Stearns
Ford in 1941 [18.1]. At the time, Charlie was in his seventies, placing his birth
around 1870, approximately sixteen years after Hunt, who was born in 1854.[5]
Unlike Hunt's more traditional narratives, which attempted to express
Kwakwaka'wakw culture without explicating cultural change and adaptation,
Nowell's narrative is candid and revealing of the radical changes taking place
over his lifetime. As well, while the formal delivery of 'Tłat'lakwasala's and
Hunt's narratives are expressed in a more traditional Kwakwaka'wakw narrative
style, Nowell's story is told in a way more akin to a western European biograph-
ical genre. It begins with his birth and in a linear manner follows the milestones
in his life. While this is most likely the influence of Ford, the ethnographer, it is
also a reflection of changing times. Regardless of its format, there are times
throughout his story when the traditional Kwakwaka'wakw narratives are both
referenced and brought to the fore. In the following excerpt, Nowell emphasizes
the efforts of his dying father to instill in him the knowledge of his family origin
and regrets that these teachings were not embedded in his memory as defin-
itively as they would have been in prior generations.

Maybe I was twelve years old when my father took sick. He wanted to have
a talk with me, so my brother came and took me out of school ... I went to
Fort Rupert, and, as soon as I get there, my father calls me to go to his bed-
side, and told me he is going to leave us, and told me to remember what he
taught me regarding potlatches ... "Most of all I want to say is, I know you
have been to school, and I think the only way for you to remember the main
positions and all the ancestors is for you to write them down, for it seems to

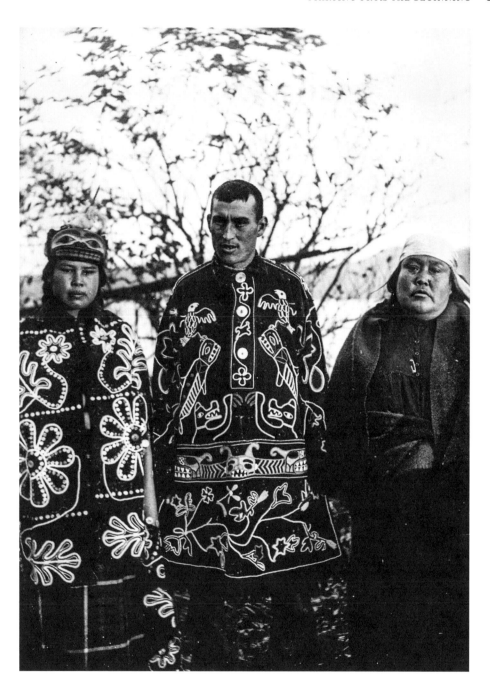

**FIGURE 18.2** Charles James Nowell (centre), shown here with his wife and mother-in-law, worked alongside European ethnographers to collect data and record histories. He was a Kwexa from Tsax̲is (Fort Rupert), and his narratives vary from those of his contemporary George Hunt. Unlike Hunt's accounts, Nowell's narratives directly address the effects of colonialism by using a typical European biographical style. BC Archives, AA-00072.

> me that everybody is forgetting all their ancestors and names. I have often heard people make mistakes ... The first thing, you will write down our ancestors till now." So I did – all our ancestors right down to him. Then he told me to write down the names we should use, and told me about the positions in our clan, and he told me who had that position, and why we should use it. Then he begin to talk about the dances and the dance names, and, when he finish that, he lay down and slept. He lose his breathe talking to me, and, when he lay down to sleep. He died. He was going to talk about our relatives, but before he finished his breathe gave out, and he died.
>
> What became of those papers I wrote I don't know. It was my brother who looked after it. (C.S. Ford [1941] 1968, 107)

Even Nowell's father stressed that, in the changing times, Charlie should write down what previously would have been committed to memory.

Despite Ford's western European setup of the ethnographic inquiry, the old Kwakwaka'wakw narrative style still emerged at times. It is significant that Nowell chooses to conclude his autobiography with a traditional narrative. In the same way that Hunt chose to document the inheritance of his children through his wife, Nowell concludes his autobiography with a narrative of his first wife's ancestor. It is important to him because, in his opinion, it tells of how his son Alfred would inherit this crest. This inclusion of traditional narrative broadens his story beyond the individual self and extends his existence through to his son and grandchildren from his father-in-law. While Charlie is near his physical end at age seventy, his continued existence is guaranteed through his *sasạm* (one's own children).

> Before I stop I want to tell you about how the ancestor of my first wife got his crest. This is a true story of what happened in the past.
>
> Yaḵudłasạmi', the ancestor of the Gixsạm, the second clan of the Kwakiutl – which means "where you believe you are going to get the blankets from that were used in the early days" – went out hunting, not with gun but with spear and harpoon. He went northward on Vancouver Island, and then he went past Shoshade Bay to a nice beach and camped there. Early the next morning, before daybreak, he heard a sound in front of him in the water that made a terrible noise. He knew when he heard it, that it was a hok-hok – a bird kind of like a crane. (C.S. Ford [1941] 1968, 244)

Nowell goes on to narrate the entire story of how this crest is acquired by his wife's family. He concludes the narrative with the following observations:

> That painting of Alfred now is the hok-hok on the top of that totem pole. My wife is a descendant of this man through her mother, for her mother was a Gixsạm, and her mother's father was a Gixsạm. Her mother's mother was a Ławit'sis. The old man called Wakias of that clan told my wife and me about this when I got married to her. And he told my wife to remember it all. At nights he used to tell that over and over again, so we would have it straight. That is the way the old people used to do in the nighttime when there is nothing else going on, so the stories won't be forgotten. (C.S. Ford [1941] 1968, 248)

Attached to the story is a painting. It illustrates how artworks were manifestations of the ancient stories. The rights to use certain crests and images were entirely dependent on the ability to recite and explain the origin and descent line of the prerogative. The stories and the artworks were intimately interrelated (see Ḳi-ḳe-in, Chapter 22, this volume).

These examples provide one perspective on the life stories collected by ethnographers in the last 150 years. They shed a little light on what may have motivated some individuals to share their stories in early accounts. As acculturation has progressed, the motives behind autobiography appear to have shifted. The world is now considered the global stage, and some biographies have addressed it as such. I have maintained my focus on the Kwakwạka'wakw because those are my own people and the history and culture I know best. Under traditional protocols, it is only "one's own story" that a person has the right to tell, a form of traditional copyright. However, with publication and acculturation, the ideas around stories and their relationship to the public realm have changed (see Sewid-Smith, this volume, and Kramer, this volume, on tensions over various ideas of copyright). 'Tłat'łạkwasạla, George Hunt, and Charlie Nowell all chose to place portions of their stories in the public realm beyond the ceremonial. Their decision to do so may have partly been to occupy a new public space (publication) for traditional purposes. These three are but a small sampling of the auto-ethnographic documentation of First Nations lives that emerged throughout the twentieth century. Among the Kwakwạka'wakw, the story of James Sewid (1913-88), "Guests Never Leave Hungry," is told with the help of James Spradley [18.IV], and the story of Harry Assu (1905-99), "Assu of Cape Mudge," is told with the help of Joy Inglis [18.III]. The spans of these two published auto-biographies cover most of the twentieth century.

One significant biography of recent publication is that of Agnes Alfred ('Axuẇ), a Kwakwạka'wakw woman of Ḳwiḳwasuṫinuxw descent, edited by Martine Reid and Daisy Sewid-Smith [18.II]. This autobiography, titled *Paddling*

*to Where I Stand: Agnes Alfred, Qwiqwasutinuxw Noblewoman,* is significant in that it orders the information 'A͟xuw̓ provided in a more traditional format reflective of Kwakwa̱ka'wakw narrative concepts amalgamated with a western European format. This familial relationship places Sewid-Smith in a position similar to that of George Hunt, simultaneously both ethnographer and subject. Alfred's autobiography begins with "mythological" stories, followed by historical narrative and personal life experiences. The introduction also contains an excellent analytical essay on the complexity of Native American autobiography, under the heading "Writing Down as-Told-to Autobiographies." Other significant biographies beyond the Kwakwa̱ka'wakw include William Beynon of the Tsimshian (edited by Anderson and Halpin) [18.v], Florence Edenshaw of the Haida (edited by Blackman) [18.vi], and Simon Baker from the Squamish (Kirkness 1994).

All of the autobiographies of the BC coastal First Nations' experiences, covering the past 150 years, provide valuable information. Today, both the younger generations of members of the communities and the general public have access to these stories. They cannot be taken at face value, however, and must be understood within the contexts and times within which they were created. The following excerpts exemplify the diversity of style, the depth of historical framework, and the variability of experience that shaped some of the lives on the Pacific Northwest Coast. Like the origin stories of old times, these autobiographies help members of the younger generations, like me, to piece together a history that has come down to us interrupted by cultural change and yet ingeniously delivered in new ways. Contemporary Kwakwa̱ka'wakw are now convoluting the prior relationship of the observer and the observed. By reviewing ethnographic publications, manuscripts, archival and legal records, and material collections with a critical eye, we now occupy the position of the observer.

As a contemporary Dzawada̱'enuxw, born in 1969, my understanding of Kwakwa̱ka'wakw culture comes from a blend of oral transmission from community members, audio recordings, photographs, archives, and ethnographic accounts. It is, however, my early memories of sitting at a table after dinner and being told family histories that provide me with the emotional and psychological drive to know more. The impression given to me by the generations preceding mine was that this information was important, a vital part of both our collective and our individual identities. Like 'Tła̱t'ła̱kwasala, of the Gwa'sala, who lived one hundred years ago, my own understanding of myself still lies within the communal history of the Musga̱makw Dzawada̱'enuxw and, by extension, of the Kwakwa̱ka'wakw. In the same way as the narrators found a new forum in ethnography for the traditional practice of telling their own stories, artists have

been creating works that serve the same purpose within the public museum and gallery system. My own work has been a reflection of this: an old concept executed in a new way. While modern western European canons of art production have been embedded within the glorified notion of individual ingenuity, traditional Pacific Northwest Coast Native canons are embedded within notions of continuity and the maintenance of norms and standards. These ideas, while apparently polar, can be negotiated. However, to negotiate a balance between individual ingenuity and personal expression within tradition requires a solid knowledge base of the traditional system first.

Given the interrelation of art and story, and the extension of identity beyond the individual self, contemporary Pacific Northwest Coast Native artists are faced with the imperative to be knowledgeable. In order to create works, one must know the stories. In order to know the stories, one must know the genealogies. Knowledge of formal executions (the "how-to" component of art making) must be accompanied by cultural and historical knowledge (the "why" component of art making) in order to be consistent with traditional concepts. Without this relationship, contemporary Pacific Northwest Coast Native art production becomes simply an amalgamation in a western European economy of art objects, in which innovation remains limited to formal executions (see Sewid-Smith, this volume; Ḵi-ḵe-in, Chapter 22, this volume).

In order for my generation to move forward, we must look back. We must return to the beginning and learn our origins. Where oral transmission has broken down, we can seek written information. Thanks to 'Tłat'łaḵwasala of the Gwa'sala, George Hunt, Charles Nowell, Agnes Alfred, and others like them who had their stories recorded, the Kwakwaḵa'wakw have access to information that might help us to put together the missing elements of our oral histories. Ethnographers such as Franz Boas, Edward Curtis, Philip Drucker, and Wilson Duff left vast collections of information on the Kwakwaḵa'wakw dances, ceremonies, and family histories in museums and archives. The Department of Indian Affairs, as well as Statistics Canada, maintain genealogical information that can supplement and validate oral histories. Ironically, it is through records, that which was written and recorded, that we can piece together some of the information that our current generation is missing because of the breakdown of our oral tradition. It is a tenuous task that requires an extraordinary commitment of time and is rarely paid for. It becomes an act of passion; the desire to know is the driving imperative. The reward is the ability to answer the question "why?" When faced with a new generation who will ask us "why?" it is important to have an answer. If we are careful, we can bring back dances that have not been performed in years. We can create masks that have fallen out of use. We can

re-establish old family connections we had forgotten. We can do these things if we are considerate and thorough, if we seek validation for information from more than one source, if we pair ethnographic information with elder knowledge. This endeavour will be tenuous and overwhelming, rewarding and validating, yet everything learned grants us a greater understanding of ourselves as Kwakwa̱ka̱'wakw and as individuals. What it comes down to is simply knowing who you are. This supplementation of formal artistic skills with knowledge becomes the responsibility of every artist who aims to create works embedded in Pacific Northwest Coast First Nations traditions. So the apparently simple act of telling one's own story is ultimately revealed to be a complex, engaging, cross-cultural, and lifelong enterprise.

The following excerpts are samples of various auto-ethnographic texts that have been published.

### CHARLES NOWELL – KWAKWA̱KA̱'WAKW (1870-1956)

**18.I.  Clellan Stearns Ford, ed. (1941) 1968. *Smoke from Their Fires: The Life of a Kwakiutl Chief.*** Hamden, CT: Archon Books, 187-90.

Charles Nowell worked for Charles F. Newcombe (1851-1924) as a guide and informant throughout the first quarter of the twentieth century. In 1904, he travelled to St. Louis in the United States to participate in the World's Fair. His account of a Hamats'a performance revealed the misconceptions of the public in their response to Northwest Coast art forms as spectacle.

> When we first come to Alert Bay, I start working in the sawmill. Whenever Dr. Newcombe comes, I stop working in the sawmill and go around to other villages with him. Sometimes we were away for a month and sometimes for a couple of months. When we come back, I go down to Victoria with him, and then we will put the names and story of all the things that he bought, and he write down a list of what he needs so I can find it when I come back. When I come home I find those things that he wants and buy them and put them in boxes and send them down. Sometimes somebody will be in the sawmill taking my place while I am working for Dr. Newcombe. I never know when he is going to call me. I'll find a letter in the post office, and he might ask me to come down to Victoria, or if he will be on the boat, he say, "I want you to go with me to Bella Coola," and I just go on the boat. Sometimes we would go to Quatsino.
>
> It was Dr. Newcombe that took me and Bob Harris from here, and three men and two women from the West Coast to the States. We went first to St. Louis to the

Exposition. The men was doing some carvings there to sell; the women was doing baskets and mats. We had three or four Indian dances there. We used to make the people that came to see the dance pay so much to come in.

There is a good story about one thing in our dance at St. Louis. At the time all the big people of the Fair came to see us, we was given notice about a week beforehand that they were going to come. So we got everything ready – our dancing blankets, and a headdress with ermine skins on the back, and Bob Harris made everything ready for himself, because he was a Hamatsa. We kept Dr. Newcombe busy at that time, getting all the stuff that we wanted. There was a little African pygmy that used to come and see us. He liked to come because we always had bananas, and this little fellow loved bananas. He didn't seem to want to eat anything else; as soon as he come in, he look at the bananas hanging up and say, "Huh – Banana!" Bob Harris wanted to make a little man just like him, so I told him to come in every day and sit down and eat bananas while Bob Harris was making a little man with some bones and mutton flesh. He made it just like him, and when it was finished it was put in an oven, and Bob Harris looked after that while it was baking. Bob Harris take it out and hold it up alongside of the little man, and the little fellow would offer it a banana. Bob Harris was making a whistle; he pinch the little fellow to make him squawk, until he made a whistle that sounded just like him. He made the mouth of this thing to move; when he pinch the little fellow, he watch how he open his mouth, and he put the whistle under the skirt of the little fellow he made, so that every time he presses where the whistle was, he make the right noise. He filled the inside with a tube of blood.

We went to the place where all the people was – they say there was about twenty thousand people that came that time. We was put to start first. We had a screen that was painted in a square – about eight feet square. We told the little fellow how it was going to be done, and not to tell his friends about it or we won't give him any more bananas. We had this baked mutton as a man inside the screen, where all our dresses are. We begin with a Bella Bella dance; the West Coast people all knew the songs, and they was singing while Bob Harris and I was dancing. When we got nearly through with one song, Bob Harris made a mistake in beating, and then he says, "Hap-hap-hap." I got behind the screen and dressed as an Indian and came back and told the people in English that the Cannibal is mad now, because they made a mistake in beating the board, and we don't know what he is going to do, because he is so fierce. The two young men from West Coast came and held him – trying to keep him from going toward the other people. Bob Harris up and ran away. They were scared, thinking he was only the dead that was eaten up, and he holler out to them, telling them that he is alive and not a ghost.

Bob Harris had a girl from the Mexican women whom he used to go and lay with. I had another girl in the same tent. Next day we went to see them. When we got into

the tent they just rushed out and ran away. They didn't want us to come near them – a man-eater. Bob was called "man-eater" after that.

When we went in to sleep, Dr. Newcombe come in and ask us questions about it and try to find out how we did it. Although he brought the bones and the mutton, he didn't know how we did it. I guess he thought we wanted to eat the mutton right away. I tell him, "I don't know; nobody knows." I didn't let him know until he came back to Victoria how it was done. Then we told him all the story. He told Bob that he had thought he was going to be hanged.

### AGNES ALFRED – KWAKW<u>AKA</u>'WAKW (1890-1992)

**18.II. Agnes Alfred. 2004. *Paddling to Where I Stand: Agnes Alfred, Qwiqwasutinuxw Noblewoman.*** Translated by Daisy Sewid-Smith. Edited by Martine Reid. Vancouver: UBC Press; Seattle: University of Washington Press, 94-97.

Agnes Alfred narrated her life story in her native language, Kwak'wala, and the modality of her communication is traditional Kwakwaka'wakw. Her words have been translated by her granddaughter Daisy Sewid-Smith. One of the few auto-biographies of Northwest Coast women, this section deals with the procedures and protocols around the onset of menstruation and the birth of her first child.

I was being prepared for womanhood. The elders surrounded me and performed the necessary rituals. I was secluded from the rest of the household; I had to sit in a corner of the room in our house at Yəlis concealed by a curtain. This is where I stayed during the total length of my period – twelve days. Women decorated the room, putting many button blankets all over the walls, surrounding me with them. They also surrounded me with all the goods they were going to *p̓əsa* with – including bracelets [*k̓uk̓ʷəla*] – after the end of my seclusion so that I would be wealthy. That was the symbolic meaning of all the things that were surrounding me. I sat there day after day, the entire length of my period. I was wearing the hat [*giqəmł*] reserved for nobility, the same type of hat that Daisy wore at her wedding. It was adorned with strips of white mountain goat pelts. I was wearing strips of mountain goat wool made into rings on some parts of my body. They say mountain goat wool is good [*lamaduẃ*] because the goats are gentle animals. Mountain goat pelts were covering all the important parts of my body – my head, my wrists, and my ankles – so that I would not have a bad temper, I was not permitted to stretch my legs. They made me sleep in a very short bed. I really do not know why they did that to newly menstruating girls. I was steeping on a bed of *k̓ak̓iƛama*, bulrushes. I was really petite in stature. While I was wearing my noble hat, they fed me very little. They would not allow me to drink

any water; this was so I would not become a glutton. Being a glutton is improper. They also bathed me. They hired three old women to bathe me. Oh! My poor mother, she was really following the traditional ways. I did not always like it either. She sewed strips of black wool cloth around my ankles to guarantee that I would have beautiful legs. All the girls in the same situation wore it around their ankles. Only recently did they stop making young girls wear black cloth around their legs so that they would not have wrinkled legs. Oh! Our old people, they were really something!

During my pubescent isolation, they took really good care of me. Q̓agʷoł's mother [Johnson Cook's mother], whose name was ʔIxčəmǧa, was hired to pluck my eyebrows. Qʷaxilowǧa and a third woman, Ǧana, who was a *pəxəla* [shaman], were hired to bathe me. The female shaman chanted. The three women were always around me, looking after me. They woke me up early every morning and sat me up with my back straight and wearing my noble hat. Thus I would sit rigid and motionless. Every day, at dawn, they ritually bathed bathed me. They performed exactly the same things as they used to during the four phases of an initiation ritual. They heated four rocks in the fire, which they then threw into my bathwater. They did not really bathe me. They sprinkled water over me, like during baptism [ʔAx̌uw̓ says "baptism" in English]. They would do it four times, sprinkling warm water over me four times. The last day of my purification they brought a large red cedar-bark [*kəlxsəm*] neck-ring [*ƛ̓aǧək*ʷ]. They held it above my head and sprinkled white eagle down all around it. Then they lowered it down and put me through the hoop [*kəlxsəm*]. I went through the red cedar-bark neck-ring.

Ǧana was chanting. She put me through the red cedar-bark ring the first time. This is what we call *qəxa*, the first step of the *weliqa* [the first of the four steps performed during a purification ritual]. Then I went through the hoop the second, third, and fourth time. Then, at dawn of the final day of my seclusion, the shaman woman took the ring, rubbed it all over my body, and then threw it in the fire [*lax̌ʷƛənd*]. The ceremony of my puberty ritual was then complete; it happened at dawn.

When my period was over, the mother of Johnson Cook plucked my eyebrows. This was to make me beautiful. It was really painful. This was when my period was over. They cut my very long hair short. I really did not like to have my hair cut. All this meant was that my first period was now over, and I could resume my normal social life.

As soon as my puberty ritual was finished, my mother took my mattress and soaked it in a puddle outside Nulaǧa's house [ʔAx̌uw̓'s half-sister, Florence Knox]. This was done so that it would put some weight on me. [Laughter from Daisy, Flora, and ʔAx̌uw̓.] That was my purification ritual; our way of acknowledging the passage of girls of noble descent from childhood into womanhood.

### I GIVE BIRTH TO MY CHILDREN

ƛalis [Alvin] was born first [*mayuƛa* = to give birth]. I delivered him at the house of
Q̓ʷəmxuduw̓. Many people had gone to a feast at Campbell River, so we were all alone
here, at Yəlis. It was New Year's time [ʔAx̌uw̓ says "New Year's" in English] when I
gave birth to ƛalis. My mother was really following the Indian way. During the deliv-
ery, she and the other women bathed me by sprinkling warm water all over me. The
women were upset because they wanted your grandfather to walk very fast up and
down the village during my labour pains, and he really did not want to do that. It was
thought that if he would do so, it would help me give birth quickly. So the poor man
did what he was told. This was the custom in the old days [laughter], to have the
husband run back and forth in the village to ensure his pregnant wife a fast delivery.
The women sprinkled warm water all over me and put *cixməs* [mountain ash bark],
*ƛ̓əq̓ax̌uliy̓* and *q̓ax̌amin* [other barks] in the water. They rubbed water and bark all over
my body. This was done three days after the birth of ƛalis. They sat me in warm bath-
water to melt the milk in my breasts. Then they took the *cixməs* again, cut them up,
and put them in a pail of water. They heated a rock, and I held it against my breast to
melt my milk. The milk then thawed and began to drip. It seems that women were
stronger in the early days than they are now.

When a woman had no breast milk, they used *maɬəney̓*, horse clams, as a soother
[*ƛ̓ig̓ʷəx̌stey̓*]. The siphon of the clam was sucked by the baby whose mother had no
milk, I also ate *k̓umaciy̓*, Indian celery. Eating Indian celery helps you to have more
milk [*dᶻam̓a:* breast-feeding]. My midwife always prepared it for me hot and with
some rice ["rice" is said in English]. Only during my first pregnancy did I have a lot
of milk; it just slowly diminished as I gave birth to more children. I eventually had to
give my babies a bottle when I could not breast-feed them anymore.

During my pregnancies I went through rituals but they did not consist of eating
birds' eggs, as you said Boas mentioned. My mother was a real traditionalist: she used
to do all kinds of things following the Indian ways. She would catch these little birds
called *c̓əx̌uw*, which existed in great numbers on the beach, and fed me with their
breasts so that I would have many children. She used to make me swallow the breasts
of these little birds that lived on the beach. She probably did this in the hope that she
would see many of my children. But she only saw three of them. My mother lived
to see ƛalis [Alvin], ʔAda [Flora], and K̓ʷamax̌əllas [Georgie]. She saw three of my
children before she died. She did not live long enough to see all her other [ten]
grandchildren.

She also performed the ritual of the seal on me. After someone had shot a pregnant
seal, she would remove the fetus and come with it towards my back. She did this four
times in order to make my delivery easier. And surprisingly, it did. I always had an

easy time during delivery. Oh! My mother was a real traditionalist. She always used many Indian medicines. She oiled my stomach with dᶻiꝁ̌ʷis, ratfish oil, when I was pregnant. She rubbed my stomach to prevent me from having a difficult labour.

Two midwives attended me. Their names were Ċiꝁ̌ʷa [Seagull Woman] and Wayoł [Old Dog]. These women were our doctors for pregnant women. These two women were able to handle successfully the highly feared breech birth. There were only a few midwives who knew what to do in this situation. They could feel your belly and tell if the baby was in the wrong position. They would manipulate your belly in order to put the baby in the right position. Yakoyoğʷa was also a midwife, and she was also capable of handling a breech birth. She was a *pax̌əla*, a shaman. These midwives were called *pax̌əla*, medicine women. Ċiꝁ̌ʷa was the wife of Ȼax̌ʷsəm [Red Cod]. She was a Nəmğis woman. They used to call her Ğana. Wayoł was Daca's [Billie Sunday Willie's] mother. She was one of the last midwives who attended me.

I went through another set of practices. My mother used to stir up *nax̌ʷaskən* [soap-berries] and pour them down my throat when I was overdue. The worst medicine of all consisted of *qʷalobəs* [ashes] mixed in my drink. This was supposed to help me have a swift delivery. The midwives asked Moses to walk back and forth really fast, up and down the street; this was also to help me have a quick delivery.

## HARRY ASSU – KWAKW**A**K**A**'WAKW (1905-99)

18.III. **Harry Assu and Joy Inglis. 1989.** *Assu of Cape Mudge: Recollections of a Coastal Indian Chief.* Vancouver: UBC Press, 103-4.

Harry Assu's father, Billy Assu, participated in the outlawed potlatch ceremony held on Village Island in 1921 that resulted in the incarceration of twenty-two Kwakwaka'wakw in Oakalla prison (see Sewid-Smith, this volume; Cranmer Webster, this volume). Of particular interest is the unusual bargaining agreement that was negotiated with the Indian Agent William Halliday, who also acted as magistrate in the court cases. Those convicted were granted their freedom if they would voluntarily give up their potlatch regalia and masks. Several families chose to do this, and the collections were disseminated between a private collector (George Heye) and museums in Ottawa. The conviction of so many Kwakwaka'wakw at this time was a turning point in their ability to sustain traditional practices in the face of such extreme government persecution.

### RENEWAL OF THE POTLATCH AT CAPE MUDGE

Many of the Kwagiulth people were arrested for taking part in a big potlatch given by Dan Cranmer on Village Island in 1921.

My father and brother were arrested. Charges were laid against them under a law that had been on the books for a long time. They were told they would go to jail unless they signed a paper that said they wouldn't potlatch any more. They were told that our people would have to hand over everything they used for the potlatch, whether they were there or not. Anybody arrested who didn't give up their family's masks and other things went to jail. Twenty-two of our Kwagiulth people went to Oakalla. They were prisoners from two months to six months ...

I saw it [the scow carrying the masks] pull out across Discovery Passage to the Campbell River side where more stuff was loaded on the *Princess Beatrice* for the trip to Alert Bay. Alert Bay was where the potlatch gear was gathered together. It came mainly from our villages around here and from Alert Bay and Village Island. It was sent to the museum in Ottawa from Alert Bay by the Indian agent. Our old people who watched the barge pull out from shore with all their masks on it said: "There is nothing left now. We might as well go home." When we say "go home," it means to die ...

In 1978 the National Museum in Ottawa returned the part of the collection they still held because they knew it was wrong to force us to stop our custom of potlatching and take all our goods away from us. But early on Indian Affairs had gone ahead and loaned around 135 pieces of our masks and regalia to the Royal Ontario Museum, and it took us much longer to get that museum to return what is ours. This is our family inheritance I am talking about. You don't give up on that! Finally, in 1987 the Royal Ontario Museum returned what they had taken.

**JAMES SEWID – KWAKW̱A̱KA'WAKW (1913-88)**

**18.IV.  James P. Spradley, ed. (1969) 1972. *Guests Never Leave Hungry: The Autobiography of James Sewid, a Kwakiutl Indian.*** Montreal: McGill-Queen's University Press, 236-37. Originally published by Yale University Press.

In the 1960s, after the ban on the potlatch had been removed from Canadian law, a renewed interest in traditional arts began to emerge among the Kwakwaka'wakw. Part of the motivation appeared to be economic, as outside society had developed an interest in Aboriginal cultures, and there was an opportunity to reap profits from tourism. Outside economic incentives continue to be a major driver of artistic production today. In this excerpt, James Sewid describes his early involvement in the establishment of the Kwak'wala Arts and Crafts Society and the inception of the building of a traditional community house in Alert Bay in 1965.

Like any other nation, I would like to preserve the arts and crafts of the Indian people because I think they are beautiful. Those old people who really knew how to sing and

dance and carve were dying off and I felt that something should be done to preserve those good things from the old way. When I first moved to Alert Bay, Simon Beans and I used to talk together about building an Indian community house. We talked to the older people of that village about it because we wanted to show the kind of house that we lived in when we were little boys at Village Island. In those days there was nothing but Indian community houses there. All we did was just talk about it. Some of the people thought it was too hard, and some of them thought it couldn't be done because building a community house wasn't like building a modern home. It was very easy to build a modern home because you could look at the plans and then order all the lumber and things cut to the right size. The people who we used to talk to about it all died and just Simon Beans and I talked of it together. When Henry Speck moved to Alert Bay we talked of it some more and began to feel that it was time that we did something to carry out our ideas. I felt it would be good to build one of those big houses and try to do something to preserve the arts and crafts of our people.

Finally in 1963 I had brought it up to my council and told them my idea. I told them that it would be a good place for the tourists to go and look around when they visited our village. It would be nice for the people who could do a little carving to have a place and for the women who had been making rugs and baskets with Indian designs on them because they could sell them to the people who came. We could have a workshop in the back and provide tools for those who didn't have any, and the people could go there to work and it would be a little income for them. I told them that it would belong to the Nimpkish people but that we could form an organization and anybody who wanted to belong to it from the different villages could. It should be open to all the Kwakiutl people from the other villages. So Robby Bell made a motion that we set aside some land up near the ball field to build a community house. The council passed that motion and appointed me to be in charge of getting the building started. Right away I formed a building committee of Henry Speck, Simon Beans and his wife, Charlie George, Max Whanock, Arthur Dick, Billy McDougal, my daughter Dora, and my wife Flora. Then I went and talked to the Indian agent and explained to him what I wanted to do. Mr. Roach was the agent at the time and he encouraged me to go ahead with building that community house. I asked him if we could get a few dollars from the winter works program which provided jobs for some of our people. We got permission to use some of that money so we were ready to start to work.

Before we did anything more I made my plans. I made a little office for myself down in the basement of my house and started making all the plans for the building. It had always been my hobby to build things like houses and I had built quite a few but they were all modern homes. I had no idea how to build this community house because I had never seen it done before. I made the plans according to the early ones

that I had used to live in when I was a little boy. We had to have four big house posts for the frame and I got the building committee together to decide what we should carve on those totem poles. We decided to use the most outstanding crests from several of the different tribes rather than just the Nimpkish crests. The front house posts were to have the Grizzly Bear crest at the bottom and the Qolus, which was a large supernatural bird, at the top. Both of the poles were to be just alike. The back house posts were to have the Tsunuqua or wild creature of the woods at the bottom and the Thunderbird at the top. The small cross beams were to have the Sisiutl or double-headed serpent carved on them. Most of the houses that I had seen in the early days had just put a plain log there without any carving on it but we decided to put the Sisiutl on it. I was to be responsible for the architecture and engineering, Henry Speck was responsible for advising us on the artistic part of it, and Charlie George was to direct the carving of the house posts and cross beams.

### WILLIAM BEYNON – GITKSAN (1888-1958)

**18.V. Margaret Anderson and Marjorie Halpin, eds. 2000. *Potlatch at Gitsegukla: William Beynon's 1945 Field Notebooks.*** Vancouver: UBC Press, 55-56.

William Beynon was born in Victoria to a Welsh father and a Tsimshian mother in 1888. He spent the early part of his life on the lower coast and reconnected with his mother's people in Port Simpson in 1913, at the age of twenty-five. At this point, his focus became the study of traditional lifestyle, and he began to work with Marius Barbeau (1883-1969) under the auspices of the Canadian Centre of Folk Culture Studies. By 1945, when he wrote his field notes on the potlatch procedures he participated in at Gitsegukla, his former ignorance of procedure had been enlightened. The following section of these notebooks outlines the difficulties encountered as older and younger generations dealt with cultural adaptation of tradition at that time.

During the previous years 1943 and 1944 a strong feeling sprung up among the Gitksæ̱n villages on the Upper Skeena. Three poles were taken from the remains of the flood of 1936 when most of the totem poles were destroyed. The same happened in the lower villages of Gidzagu̇kla, and Gitwn̓qax. It created a revival of feelings among the Gitksán to try and save the remains of these poles and, where these had been totally destroyed, to replace them. The Hazelton House of G̱anóa took up their pole, which had drifted out, and erected it at what is now the park, and Spəhóx took his pole from the river bank and was followed by Ni·k'æt'en – Ganhada (T'én). These Houses in some instances were assisted by their own organization rather than clan assistance. In the case of the group of G̱anaó, they financed it themselves.

Soon after these, in 1943, the Gitwənqáx̱ people re-erected many of their poles that had fallen during the same flood and [the] next year many of the Kitwinkul poles were re-erected. At each of these villages similar ceremonies as had been done by the Gidzagukla people [as described here] were used and patterned after the older procedures.

This at first started a controversy among the younger thought and the remnants of the older thought. The younger men, feeling that as they were now in modern times and that these totem poles were simply a reminder to the coming generation of what the rights and uses of the totem poles were and that aside from being just a memory of the past [they] also showed the art. These wanted to adopt new methods of erection ceremonies, which were to send out to the invited guests written invitations advising the guests to come at a certain date.

The older men felt that they were reviving more than a memory. This did not simply mean the erection of the pole, but also a display of the many naxnoxs in the possession of each of the Houses, these to be dramatized and their songs sung by the members of the House and if necessary all of the village would assist in the rendering of these songs. These olden chiefs also claimed that the dirge songs would have to be sung, also narratives explaining what crests were to be shown on these poles and also as they would be in full costumes, the guests also should come as invited in full regalia and thus show an acceptance of the rights of each pole erected in the same manner as they [had] formerly done. At Kitwankool and Gitwanga the older thought very soon overcame the protests of the younger groups, and messengers they sent out went in groups to represent the clans of the people giving the feasts. That is, the G̱yisqahéss group of Gitwn̄gáx̱ sent their own men, and the G̱anhada and Laxsḵí·k and Laxgibu sent their own, inviting the people of Gitwn̯lkú·l. These were dressed according to their rank and standing, each clan chief being accompanied by his own group.

Now this idea was not acceptable to the younger people of Gidzagyukla who wanted that the ceremonies should be all combined and gotten over with in a few days. Most of the younger chiefs were with this plan and wanted to do everything in a modern way: that no messengers be sent out; and further there would be no formal Indian dancing, that all the dancing would be modern; and no word of mouth invitation. The majority of the younger chiefs wanted this. The older thought said nothing, thus signifying their disapproval to this modern suggestion.

**FLORENCE EDENSHAW DAVIDSON – HAIDA (1896-1993)**

**18.VI.  Margaret Blackman and Florence Edenshaw Davidson. 1985. *During My Time: Florence Edenshaw Davidson, a Haida Woman.*** Seattle: University of Washington Press; Vancouver: Douglas and McIntyre, 126-28.

The story of Florence Edenshaw Davidson, daughter of the renowned artist Charles Edenshaw, was one of the earliest published accounts of a Pacific Northwest Coast First Nations woman's life. While the majority of her time was devoted to the care of her family, Davidson also participated in the artistic activity around her. Later in life she worked with cedar and spruce root, producing hats and baskets. Her life story unveiled the cultural expectations of her generation along with her opinions regarding women's engagement in art practice.

### PAINTING A CANOE

Way before I began making blankets, in 1939, I painted a Haida canoe. A man from the States had ordered the canoe from my husband and his older brother. My brother-in-law was an old man then; he supervised the work and my husband and son Alfred made the canoe. I used to go and watch them work on it, and my brother-in-law said to me, "Florence, you paint our canoe; your dad was clever, you must be clever." I told him I'd paint it. I was just joking but he believed me.

Someone happened to give me a picture of a small canoe with a painted bow so my husband and I started copying it on paper. "We'll make the pattern here at home and we'll go there to put it on the canoe when everybody's sleeping," I said. We measured the bow and made the pattern, on cardboard, in the house. It looked all right. I tacked it on the canoe with thumbtacks and drew a line around each pattern piece. I finished quite a bit and when I started painting it looked real nice. My husband was happy. Every time I finished one part of the pattern, like an eye, he said, "xwuhl." He was proud of it.

I don't think women ever used to draw designs in the old days, just men. That's why I was scared when I started painting the canoe. I used to get up early in the morning before anyone else was up. I was ashamed if they saw me doing that and made fun of me, that's why. When it's possible for me, I can do it. All the people were surprised when I was done. Older people came around and said, "Of course, of course, her dad was clever."

When the canoe was finished the ones who ordered it didn't want it, I guess. Someone else came to see it and bought it. My husband and his brother got just five hundred dollars for that big thing. It was very sad. We didn't have enough money for our food and they had spent so much time making that canoe.

### WEAVING BASKETS AND HATS

I don't know how old I was when I started weaving small baskets. When I was young I wove one little basket with a cover for my cousin Josie to keep hairpins in; that was the first one. I learned by watching my mother weave. After I got married I wove a little bit at North Island. Emily Thompson, my husband's cousin, gave me a big

bundle of spruce roots. She told me to soak it and she'd help me split it. I made a small basket with a fancy stand and a handle. Emily Thompson gave me grass to decorate it with, too. I made a design with the grass, something like leaves, and sold it to a mainland woman for a dollar. After a while I started making little baskets with covers on them and I sold them to Alfred Adams for his store. In the summertime he moved his store to North Island where the people camped. He paid me $1.25 for each one. I was so happy when I sold him two baskets and brought $2.50 home, I still had some roots, but I didn't make any more baskets because I started knitting sweaters.

My husband was still living when I began to weave cedar bark. I told him I wanted to start a basket and our daughter Myrtle took us along the highway to get some bark. We got lots, but I didn't touch it for two years. When my friend Selina came in I gave her two rolled-up bundles of bark. "Why don't you start weaving," she asked. I knew how to weave but I got no time to do it. Selina started a little hat for me one afternoon. I started working on it and really enjoyed it. Then I made tea while she worked on it. We kept on taking turns and finished it at two o'clock in the morning. We were just like little kids we enjoyed it so much. I made Claude paint the hat and I sold it for thirty-five dollars. I was so happy I felt like I got three hundred dollars for my hat. The next hat I made all by myself. In the old days they used to make hats just out of spruce roots.

### SIYE'EMCHES TE YEQWYEQWI:WS (FRANK MALLOWAY) – STÓ:LŌ (B. 1935?)

**18.VII. Keith Thor Carlson, ed. 1997. *You Are Asked to Witness: The Stó:lō in Canada's Pacific Coast History.*** Chilliwack, BC: Stó:lō Heritage Trust, 13-15.

This interview with Stó:lō chief Frank Malloway was conducted in June 1996 by Heather Myles and Hychblo (Tracey Joe). Malloway's process of sharing information involved relating the oral histories that had been relayed to Malloway by his father. His narrative expressed an older generation's understanding of a concept and the process of passing that information on to the next generation. This process of cultural understanding has become difficult with language loss and radical change in lifestyle, yet it can still surface through conversation.

*Frank Malloway:* My dad said whenever fishing season came they had a leader in that area too, and he'd take charge of everybody.

*Heather:* He'd take charge of the family or the village?

*Frank Malloway:* All the working people. All the people that were able to go fishing – he was their leader. He was concerned with the preservation of salmon. And hunting too. The main family leader picked the best hunter – he was a *Si:ya:m* [of the

upper classes] as well – they called the hunting leader *Tewit*. The *Tewit* would take the people out hunting and he was the leader for that period of time – during the hunting season. The same for plant gathering. That was mostly the ladies' work you know. The forest was our garden, and women went out and taught the young people the different uses of all the plants out there.

There were leaders for the Spirit Dancing too. My dad said, "You young people start singing in October and you go continuously till late February. In the old days we didn't have a continuous season. We'd start singing in November and then during the month of January it got real quiet. Then in February we'd start singing again until the end of February when we finished. Now you young guys go right through January." The way my dad explained it, the power of *Syu'we'l* [winter dance spirit power] is in the mountains, and in the fall when the snow has come *Syu'we'l* comes down to the warmer climate and it starts hitting the people. *Syu'we'l* hits people and then they wake up and start singing; and *Syu'we'l* goes around the world. And I used to wonder, "what do you mean it goes around the world? Goes right around to China and comes back?" And then I was looking at a map of the Coast Salish Territory and it sort of goes in a circle: Sechelt, Nanaimo down to Victoria, across to Neah Bay, you know, and up to Nooksack and it comes back, and it's almost like that's the only world the Coast Salish knew. And I was thinking "that's how the Elders described their territory, the Coast Salish territory: around the world." And the Coast Salish are the only people who practise Spirit Dancing, if you go out of the territory to the north they don't practice, they don't have it. You go too far south and they don't have it. So he says, "When *Syu'we'l* is in the Island there's not much *Syu'we'l* here, it's all over in the Island, and when it's coming back and going to the mountains, that's when you wake up again. Then it goes back to the mountains and you're finished – you have to wait for another season. That was the *Syu'we'l* season, the dancing season." In January we didn't hardly ever sing because that's when the *Syu'we'l* was over at the island, and that's when they used to start, in the beginning of January. Now they start in September [laughter].

## DELGAM UUKW (EARL MULDOE) – GITKSAN (B. 1936)

**18.VIII. Delgam Uukw. 1992. "Delgam Uukw Speaks."** In *The Spirit in the Land: The Opening Statement of the Gitksan and Wet'suwet'en Hereditary Chiefs in the Supreme Court of British Columbia.* Gabriola, BC: Reflections, 7-8.

Much of the Pacific Northwest Coast has yet to resolve its land claims. In 1987, one of the vital court cases outlining the legitimacy of such claims to be recognized at the Supreme Court level concerned the Gitksan and Wet'suwet'en territories. So much of traditional culture is embedded in a land base. In his

testimony, Delgam Uukw, one of the Gitksan chiefs, outlined this connection through traditional oratory.

DELGAM UUKW SPEAKS

Smithers,
Gitksan and Wet'suwet'en Territories,
May 11, 1987

My name is Delgam Uukw. I am a Gitksan Chief and a plaintiff in this case. My House owns territories in the Upper Kispiox Valley and the Upper Nass Valley. Each Gitksan plaintiff's House owns similar territories. Together, the Gitksan and Wet'suwet'en Chiefs own and govern the 22,000 square miles of Gitksan and Wet'suwet'en territory.

For us, the ownership of territory is a marriage of the Chief and the land. Each Chief has an ancestor who encountered and acknowledged the life of the land. From such encounters come power. The land, the plants, the animals and the people all have spirit – they all must be shown respect. That is the basis of our law.

The Chief is responsible for ensuring that all the people in his House respect the spirit in the land and in all living things. When a Chief directs his House properly and the laws are followed, then that original power can be recreated. That is the source of the Chief's authority. That authority is what gives the 54 plaintiff Chiefs the right to bring this action on behalf of their House members – all Gitksan and Wet'suwet'en people. That authority is what makes the Chiefs the real experts in this case.

My power is carried in my House's histories, songs, dances and crests. It is recreated at the Feast when the histories are told, the songs and dances performed, and the crests displayed. With the wealth that comes from respectful use of the territory, the House feeds the name of the Chief in the Feast Hall. In this way, the law, the Chief, the territory, and the Feast become one. The unity of the Chief's authority and his House's ownership of its territory are witnessed and thus affirmed by the other Chiefs at the Feast.

By following the law, the power flows from the land to the people through the Chief; by using the wealth of the territory, the House feasts its Chief so he can properly fulfill the law. This cycle has been repeated on my land for thousands of years. The histories of my House are always being added to. My presence in this courtroom today will add to my House's power, as it adds to the power of the other Gitksan and Wet'suwet'en Chiefs who will appear here or who will witness the proceedings. All of our roles, including yours, will be remembered in the histories that will be told by my grandchildren. Through the witnessing of all the histories, century after century, we have exercised our jurisdiction.

**DAVID GLADSTONE – HEILTSUK (1955-2006)**

**18.IX.   Doreen Jensen and Polly Sargent. 1986. "David Gladstone."** In *Robes of Power: Totem Poles on Cloth.* Museum Note 17. Vancouver: UBC Press in association with the UBC Museum of Anthropology, 40-41.

David Gladstone (Figure 18.3) was a member of a contemporary generation of artists and cultural workers who exemplified current attempts to revitalize Aboriginal histories. In this excerpt from *Robes of Power,* he explains how as a young man he was left to actively seek out this information as the traditional paths of knowledge dissemination had broken down, along with traditional modes of familial care. His story also showed the willingness of elders to take on the responsibility of teaching others beyond immediate family members in order to keep traditional knowledge alive.

The very first button blanket I was able to make was with the help of a foster mother. I had been in foster care at the time. I used that blanket until it was destroyed in a fire. Because I was removed from my people for quite a while when I was a teenager, I was drawn to know more about my culture. It was always my goal to be a historian and a singer. I'm not sure how early this happened: it might have been when I was seven. I knew this would be my career, one of the goals of my life, to take the leadership of the dancing system, not knowing then that there were strict rules of entry. In Bella Bella, you could not just get up and dance: you had to go through initiation and pot-latches, and be of sufficient rank in the village to dance, even to the point of excluding the younger brothers of chiefs. Fortunately, I was born into a family that had the right to do things like that (which I found out later), and I did receive some training.

The late Tommy Hunt and his wife Emma discovered me, a lost boy, a boy who really wanted to know about his culture. They brought me into it. I continued this habit of being adopted. I wandered around the country, talking to elders who were very understanding of my desire to learn. Besides the elders, I went to anyone who wanted to teach me. Some would, some wouldn't. The ones that did were very generous in giving me knowledge that, to them, was very strictly guarded.

The button blanket is one form of gift, and I've received three. I received names from the same people who gave blankets. Sometimes it was names, and sometimes it was knowledge that they gave me. They also trusted me with songs for the use of their descendants.

The blanket is a symbol – a visible, tangible symbol of the giver's esteem for the recipient. The name is another gift. It's intangible, but highly valued by us. When people give you a name, it's a mark of their esteem for you. The blankets are in the same category.

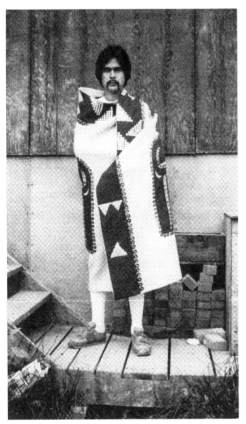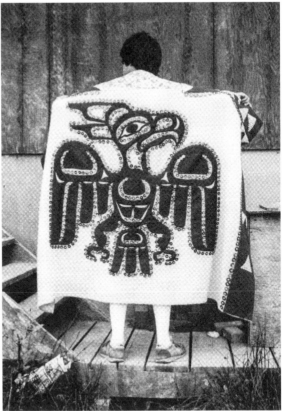

**FIGURE 18.3** David Gladstone of the Heiltsuk Nation, wearing a button robe. Mother-of-pearl buttons are often used on button robes to create designs of family crests and act as symbols of identity and status. From Doreen Jensen and Polly Sargent, *Robes of Power: Totem Poles on Cloth* (Vancouver: UBC Press, in association with the UBC Museum of Anthropology, 1986), 41, Figures 28 and 29. Photo courtesy of the estate of David Gladstone.

Another teacher of mine, another adopted mother, was Dorothy Hawkins of Kingcome Inlet. She made me a blanket with her own personal crest, her family crest. I thought I shouldn't wear her crest, because I wasn't of her blood. She said no, she wanted me to use that crest, the Thunderbird and Sisiutl. She was more knowledgeable than me in protocol. Later, I learned that I had ancestors from Turnour Island. The reason they were bestowing favour on me and reacting so positively was that I was a relative. It was a great thing to find out.

I was given a button blanket by Chief Sandy Willie, even though I wasn't at that potlatch. I responded by giving him a blanket covered with money and jewellery at a following potlatch. I passed to his wife the right to use a Chilkat blanket. It was a painted blanket, and this was in return for having given me a blanket and many other acts of generosity on their part.

I was Chief Sandy Willie's student. He sang songs that I recorded and learned. He told me that his wife was actually a blood relative of mine on both sides of my mother's family. They gave me one blanket then, and at Paul Willie's last potlatch he gave me another blanket.

I design button blankets for a lot of people. Many of the blankets in use at Bella Bella were designed by me. Nowadays, I usually cut out the design and baste it on. I've since discovered you can tack down the design with Speed Sew [adhesive] and the sewers can go to work on it. They usually know the family crests ahead of time or they will bring it up at meetings, a meeting of elders, and discuss the crests that belong to their parents and grandparents. They take crest affiliations from their fathers and mothers, depending on the names they have received. Several names will get several crests.

NOTES

1   See Wardwell (1978, 32) for an example of the competition in collecting between the Chicago Field Museum and the American Museum of Natural History in 1902 as well as a listing of the collection activities of the American Museum of Natural History from 1892 to 1963.

2   The alpha-numeric notation after the name signifies the generation as mapped out by Boas for clarity.

3   In the original text, a footnote is inserted here that reads "son of a foreign tribe, because his mother belonged to the Tongas of the coast." It is this footnote that confirms that the father of Yagwis is indeed George Hunt, though his identification is not made explicit.

4   J. Berman (1996) has suggested that the lack of identification may have been a way to protect George Hunt from being prosecuted for his participation in ceremonies considered illegal by the Canadian government.

5   This is confirmed by BC Archives Vital Statistics, which records Charles Nowell's birth date as 1870 and his birth place as Fort Rupert.

**19** | **Shifting Theory, Shifting Publics**

*The Anthropology of Northwest Coast Art in the Postwar Era*

To Northwest Coast anthropologists, Rosalind C. Morris's claim that the Northwest Coast "has been utterly central to the anthropological imagination" (1994, 19) hardly seems to be an overstatement. After all, Northwest Coast cultural materials, particularly monumental sculptures, circulate widely as key iconographic representations – totemic figures, perhaps, of both the Northwest Coast-as-region but also anthropology-as-discipline (Duff, cited in Jacknis 2002a, 201; Jonaitis 1989; Townsend-Gault 2004a; Jonaitis and Glass 2010). Morris's words are also hardly unfamiliar, echoing as they do Kwakwa̱ka̱'wakw scholar Gloria Cranmer Webster's well-known claim that the Kwakwa̱ka̱'wakw are the most anthropologized people in the world (Olin 1983). In remarking that the Northwest Coast is where "so many of the discipline's now-commonplace tropes were developed," Morris (1994, 19) surely had in mind Franz Boas's long involvement in the region (see Miller, this volume; Briggs and Bauman 1999), the central role of potlatching in Marcel Mauss's still-influential treatise on gift exchange (Mauss 1954; see Gell 1998; Weiner 1992; C. Roth 2002; Miller, this volume; Kramer, this volume), and Ruth Benedict's famous edict on the "ecstatic Dionysian" nature of Kwakiutl culture (Benedict 1934, 173-222). Morris's text is but one example of the considerable critical historiographic attention devoted, in recent years, to the location of the Northwest Coast within histories of anthropology and colonialism (Bracken 1997; Briggs and Bauman 1999; Clifford 1997a; Darnell 2000; Halpin 1994; Harkin 1996; Jacknis 2002a; Mauzé, Harkin, and Kan 2004; Meuli 2001; Morris 1994).

Miller's and Kramer's chapters in this volume both amply demonstrate how central Northwest Coast cultural materials were to the development of anthropological thought in both the Americanist and the French traditions in the late nineteenth and early twentieth centuries (see also Jonaitis 1995). This chapter traces the sharply declining prominence of Northwest Coast materials within anthropological theory in the postwar period. In the pre-war period, the

development of Northwest Coast art studies and anthropological theory were deeply intertwined. It is striking that, with the exception of French structuralism, few theoretical movements in postwar cultural anthropology, particularly from the 1960s through the 1980s, figured in any sustained way in anthropological treatments of Northwest Coast "art." These movements include interpretive anthropology (Geertz 1973), political economy (Wolf 1982; Mintz 1985; Graburn 1976), feminist anthropology (Lamphere and Rosaldo 1974; Reiter 1975; Weiner 1976; Strathern 1981), and practice theory (Bourdieu 1977; Ortner 1984). How to account for the absence of these movements in the anthropological study of Northwest Coast art?

In accounting for the lack of attention paid to Mauss (1954) in the Northwest Coast literature, Marie Mauzé (2004a, 75) has suggested that "it may well be that the post-Boasian [Northwest Coast] anthropologists have always grounded their research empirically, thus distrusting critical analysis." With her remarks in mind, it may be fruitful to trace the ongoing tension between "empirically" and "critically" grounded analyses. In this chapter, I examine why anthropological theory shifted away from the centre of Northwest Coast art studies and why, conversely, Northwest Coast art likewise shifted from the centre of anthropological concerns to occupy the position of "commonplace trope" and totemic figure. Concomitantly, I address why regional specialists often exhibit such a skeptical and dismissive eye regarding the works of anthropological and literary theorists such as James Clifford, but also Morris, who are eager to once again make Northwest Coast cultural materials central to broader theoretical concerns within anthropology and critical theory (Harkin 1999; Harris 2002, xvii). Ultimately, I point to a historical paradox that has broader disciplinary relevance at a moment when many scholars seek to align their research interests with those of the communities in which they work: the postwar anthropological study of Northwest Coast art, through its general reluctance to engage with anthropological theory, has in fact presaged some of the more politically progressive currents in cultural anthropology: namely, the widespread recognition and inclusion of Aboriginal people's knowledge and ways of knowing into anthropological practice.

A division of labour in Northwest Coast anthropology emerged in the postwar era, which saw a substantial number of acculturation studies on one hand (Hawthorn, Belshaw, and Jamieson 1955; Drucker 1958) and a preoccupation with what were termed "classic," or precontact, Northwest Coast cultures on the other. While public figures as diverse as Alice Ravenhill, founder of the BC Indian Arts and Welfare Society (see Hawker, this volume; Watson, this volume),

and Ellen Neel, Kwakwa̱ka̱'wakw carver, promoted Aboriginal art production as a vehicle for Aboriginal economic development and self-determination (Jonaitis 1989; Hawker 2003) [13.1], Northwest Coast art as a topic for anthropological inquiry was located within the "classic" culture literature until the mid-1970s (Blackman 1976; Kaufmann 1976; Adams 1981, 380-84; although see Barbeau 1957; Kaufmann 1969). Although deeply engaged with local communities, anthropologists ignored contemporary Northwest Coast art production and other representational practices when they did not fit the traditionalist guidelines for art production promoted through the "Northwest Coast art renaissance" (27.XVIII; Glass, this volume; Macnair, Hoover, and Neary [1984] 2007, 85). The exclusion of works such as George Clutesi's (Nuu-chah-nulth) mural at the landmark Indians of Canada pavilion at Montreal's Expo '67 from anthropological consideration can be attributed in part to prevailing attitudes that Northwest Coast art was autonomous from (contemporary) Aboriginal political life – at least in urban spaces. The Indians of Canada pavilion formed a key moment in both Aboriginal political self-representation and the presentation of Native modern art on both the national stage and the world stage. Curated by Tom Hill, the pavilion bluntly exposed the effects of ongoing colonialism and systematic racism on Aboriginal peoples, especially youth. In so doing, it cast a dark shadow on the universalistic agenda that Expo '67 ("Man and His World") promoted – and that undergirded the Northwest Coast art "renaissance" (see Figure 17.2).

Whereas late-nineteenth- and early-twentieth-century research was disseminated principally to an academic audience – indeed, Boas (1907) famously denounced the "public" museum as a vehicle for scientific education – anthropologies of Northwest Coast art in the postwar era have increasingly addressed mainstream and Aboriginal publics. Most anthropologists of Northwest Coast art have published short, generalist texts directed to the mainstream public. Until recently, few have published ethnographic monographs or articles in leading anthropological journals. For the most part written within the region, these texts are intertwined with and responsive to regional political movements, including the mid-century reformist movement led by Ravenhill (see Watson, this volume) and present-day Aboriginal calls for self-determination (see Townsend-Gault, Chapter 27, this volume).

## REGIONALIZING THE ANTHROPOLOGY OF NORTHWEST COAST ART

Under Boas's students Melville Jacobs and Erna Gunther, the Department of Anthropology at the University of Washington became the thriving centre for

Northwest Coast studies in the mid-twentieth century. Its shift in focus away from Northwest Coast studies in the late 1960s to early 1970s coincided with Bill Holm's joint appointment in 1968 to the Burke Museum and University of Washington's School of Art (see Bunn-Marcuse, this volume). During this period, the University of British Columbia's Department of Anthropology and Sociology underwent rapid expansion, followed shortly thereafter by the 1976 construction of that university's Museum of Anthropology, with its dedicated interest in Northwest Coast cultural materials.

Since the mid-century, locally based publishers, such as UBC Press, University of Washington Press, Douglas and McIntyre, and Talonbooks, have published the lion's share of monographs and edited collections on Northwest Coast art. The local public's voracious interest in Northwest Coast art has been fostered by the distribution of these publications throughout the academic and public book worlds, the Northwest Coast focus of the region's major ethnographic museums, the development of local art markets (see Duffek, this volume), and the emblematic status of Northwest Coast art in local public cultures. The Burke Museum at the University of Washington, the University of British Columbia Museum of Anthropology, and the Royal British Columbia Museum have become major centres of scholarly and artistic activity through their development of Northwest Coast art exhibitions and their central role in Northwest Coast art revival projects (see Glass, this volume). Cultural and museum anthropologists have long worked intensively with, and often for, nearby First Nations and Native American tribes through a number of field schools that have been in place since 1930, when Melville Jacobs began his field school on the Umatilla reservation in Washington State. Over the past fifty years, Aboriginal/non-Aboriginal academic relations have been irrevocably transformed by Aboriginal people's increasing participation in academic conferences (see Duffek and Townsend-Gault 2004; Commonwealth Association of Museums and University of Victoria 1996) [13.1], in museum programs (see Black, this volume), as community-based and academic researchers (Sewid-Smith 1979; A. Alfred 2004; D. Kew 1974; Cranmer Webster 1991; Dauenhauer and Dauenhauer 1987, 1990, 1994; Jensen and Sargent 1986a; Jensen and Brooks 1991) [19.XII], as students and colleagues in anthropology departments and museums, and as trenchant critics of anthropological practice (M. Crosby 1991; Sewid-Smith 1997; Todd 1992; see also Wolcott 1997) [18. IV, 18.v].

Particularly over the past twenty-five years, the politics of what many now term "decolonizing anthropological research" has been at the forefront of museum and cultural anthropological research agendas (see L.T. Smith 1999). As early as 1981, Michael M. Ames optimistically declared that regional museums in

British Columbia had effectively overturned relationships of power and patronage between themselves and First Nations, once these museums' subjects, now their patrons [19.VIII]. The proximity of non-Aboriginal scholars and Aboriginal scholars, critics, and community, combined with the circulation of Northwest Coast anthropological scholarship through local networks, has certainly contributed to a broad and difficult reworking of the relations of power that structure anthropological and representational practices. Paradoxically, while Northwest Coast scholars have become leaders in decolonizing research, the fairly restricted circulation of their scholarship within these local networks has prevented them from being widely acknowledged as such within anthropology.

## 1943-67: Aboriginal "Art" and Applied Anthropology

Claude Lévi-Strauss's (1943) rhapsodic presentation of Boas's Northwest Coast halls in the American Museum of Natural History [11.IV] has been credited as agenda setting and canon forming in the museological representation of Northwest Coast art (M.M. Ames 1975; Townsend-Gault 1998). While this text galvanized the surrealists' interests in Northwest Coast art (see Mauzé, this volume), the paucity of references to it among contemporary Northwest Coast scholars (i.e., until *The Savage Mind* appeared; see Lévi-Strauss 1966) indicates a lack of awareness of Lévi-Strauss's experimental and romantic lyricism, if not indifference to it or dismissiveness.

Erna Gunther's scholarly, curatorial, and public anthropological work exerted a far wider influence in the immediate postwar period, particularly through her mentoring relationship with Bill Holm (Holm 1965; see Bunn-Marcuse, this volume; Glass, this volume). Her work is Boasian insofar as it emphasizes the integral role of art within Aboriginal social structures and is undergirded by assumptions that Northwest Coast art forms a material representation of cultural ideas, namely crests. Yet and in contradistinction to Boas's Native American scholarship, it is a Boasian project informed by distinctly public and applied concerns.

Gunther's formal research in Northwest Coast art began in the 1940s, a period when her intellectual interests moved away from theoretical concerns of import to anthropology as a whole and toward local ethnohistory and art (Garfield and Amoss 1984, 396). This was a period when the anthropology of art formed part of "applied" rather than "academic" or theoretically motivated anthropology (Inverarity 1955). During this time, exhibitions, including *Indian Arts in the United States and Alaska* at the 1939 Golden Gate International Exposition, for which Gunther was an advisor, and the successive 1941 Museum of Modern Art

exhibition *Indian Art of the United States* (Douglas and d'Harnoncourt 1941), helped to move Northwest Coast cultural materials into the fine art world.

To contemporary readers, Gunther's work might seem to follow the tropes of salvage anthropology, dependent on creating unbreachable rhetorical distance between the anthropological author and audience on one hand and the Aboriginal objects of inquiry on the other (see Fabian 1983). Indeed, Gunther was not alone in confidently claiming that the relationship between the (purported) precipitous decline in Aboriginal social structures since the late nineteenth century and the (alleged) degeneration of Northwest Coast material culture production in the same period was causal [19.III] (see Halpin 1981, 30). Yet her interest in Northwest Coast art cannot be viewed apart from her desire to develop a publicly engaged anthropology at the University of Washington/Washington State (now Burke) Museum. This desire – which created tensions with Gunther's colleague Melville Jacobs – was fuelled in part by economic necessity in the 1930s to generate local public support for anthropology in order to ensure the department's survival and growth. In view of both her political support and advocacy for Aboriginal peoples (Garfield and Amoss 1984) and her interest in developing and promoting Aboriginal art as an important form of economic development for Aboriginal peoples, it is likely that the work Gunther undertook was intended less to bemoan the loss of traditional cultures than it was motivated by applied concerns. Nevertheless, while Gunther recognized a relationship between the representation of Northwest Coast art and the general public's perception of contemporary Northwest Coast people, her work was oriented to helping Aboriginal people meet non-Native people's aesthetic expectations [19.II].

In Canada, Audrey and Harry Hawthorn of the University of British Columbia engaged in public, applied anthropological research on Northwest Coast arts and crafts through two major publicly funded studies. The first was requested by the Royal Commission on National Development in the Arts, Letters and Sciences [12.xx]; the second, a wide-ranging study commissioned by the federal minister of Citizenship and Immigration, "focused on [British Columbian Aboriginal people's] adjustments to the Canadian economy and society" (Hawthorn, Belshaw, and Jamieson 1955, 1). In the latter report, Hawthorn et al. focused on "the crafts which furnish a saleable product" (515), although they did devote some attention to totem poles and other monumental wood carvings. The distinction they drew between arts and crafts was informed not only by the kinds of objects that were located in the non-Native marketplace but also by a lengthy statement by Haida artist William (Bill) Reid, which explicitly decried the decline of Northwest Coast art since the late nineteenth century [14.x]. Later works by Audrey Hawthorn (1967, 1979), then director of the UBC Museum of

Anthropology, focused on Kwakwa̱ka'wakw ceremonial art in that museum's collection. Like much of Gunther's writing, these texts situated the objects in the historical context now recognized as the "ethnographic present." These sumptuously produced and richly illustrated works were attempts to construct a "museum without walls" (Hawthorn 1967, x) in order to enhance the accessibility of the collection – Michael Ames (1979, v) later noted that this "principle of accessibility became the cornerstone of the museum's operating philosophy." The success of *The Art of the Kwakiutl Indians and Other Northwest Coast Tribes* (Hawthorn 1967) led to an invitation to exhibit Northwest Coast art at the *Man and His World* exhibition in Montreal in 1969-70 (see Figure 17.2).

Marius Barbeau was also a museum anthropologist whose prolific output included a substantial number of works penned for a general audience (see Dawn, this volume). If Gunther's writing projected a generic "Indian" and was concerned with "art," Barbeau's later (postwar) writings on Haida argillite production exhibited a profound interest in individual artists, lineages, and, to a limited extent, cultural property, processes of cultural change, and historicity [19.1] (cf. Nurse 2001). That Barbeau found considerably less influence among his contemporaries was perhaps due to his disciplinary location in folklore at a time when folkloric inquiries and analyses had become marginal to social and cultural anthropology. It surely also resulted from Wilson Duff's (1964a) trenchant critique of his oeuvre. Duff acknowledged the depth of Barbeau's fieldwork in Tsimshian territory (see also Halpin 1973, 1994; Harkin 1996) but excluded his later work on argillite to focus narrowly on and dismiss his earlier diffusionary analyses (see Dawn 2006 and in this volume).

In the following years, Barbeau's work was subject to the uniform critique within anthropology and art history that held that, while Barbeau was an exemplary collector who provided very detailed documentation of the objects he collected and their familial histories, the analyses he produced were often faulty and not infrequently contradicted by the evidence he collected. The influence of this critique was, in George F. MacDonald's (1990) view, sufficient to prevent the National Museum of Man from reprinting Barbeau's two-volume *Totem Poles* – then its best-selling publication – for over twenty years. The question of the validity of Barbeau's analyses continues to loom over the limited discussions of his work (Kaufmann 1969; G.F. MacDonald 1990; Halpin 1994; Harkin 1996, 3-4).

While anthropologies of art were at this time primarily descriptive, anthropologists examining exchange relations in potlatches were more centrally concerned with the roles objects and property played in the political machinations of Northwest Coast communities (see Kramer, this volume). Helen Codere (1950) famously argued that the British suppression of traditional warfare led to the

expansion of Kwakwaka'wakw potlatch exchange. While taking issue with the functionalism inherent in her text (how *did* potlatching come to replace warfare?), Harkin (1996, 5) remarked that Codere's analysis, which emphasized the effects of colonization and the introduction of immense wealth to Aboriginal societies, made it impossible to envision Aboriginal societies as either romantic vestiges of the precontact past or on the verge of extinction. Nevertheless, the anthropological literatures on art and exchange were distinct at that time and remained so until very recently – the former circulating locally and to broad audiences via museum exhibitions and catalogues, the latter finding academic audiences through prestigious specialist journals. However, as is the case more generally in the anthropology of art, the voluminous literature on exchange has pointed to crucial areas of inquiry (see Weiner 1992; Gell 1998; Myers 2001a; Strathern 1988). Nevertheless, exchange-centred analyses of Northwest Coast potlatches tend to take objects to be fairly inert things that become the vehicles and subjects of social processes but whose particular materialities do not contribute to, impede, or interfere in these processes. A notable exception is Kwakwaka'wakw scholar Daisy Sewid-Smith's *Prosecution or Persecution* (1979), which outlined why particular objects, as property, matter a great deal within exchange relations occurring during a potlatch or, in this case, between Aboriginal people and the state (see Kramer, this volume).

In few of the works from this period was the category of "art" and its boundaries put into question (see Hamilton, this volume). In his popular volume *Indians of the Northwest Coast*, Philip Drucker ([1955] 1963) included a chapter on art that aimed to outline the basic tenets of "northern" (Haida, Tsimshian, Tlingit) and Wakashan (Kwakwaka'wakw) styles. Elsewhere in the volume, however, he also took a uniquely instrumental approach to material culture that undercut the segmentation of art from the rest of Northwest Coast people's material lives. He accomplished this by tracing the techniques and uses associated with a given material – for example, cedar bark – across a range of Northwest Coast societies. His fast-moving text, however, conflated differences among First Nations, provided little contextualization, and clung to a diffusionary framework and set of questions about the northern "origin" of Northwest Coast art that captivated some of his contemporaries (Holm and Reid 1975a; cf. 19.VI).

1967-83: FROM ART (NOT ETHNOLOGY) TO ETHNOGRAPHIES OF ART

Ethnographers in the late 1960s and early 1970s found these earlier, descriptive treatments of Northwest Coast art lacking in explanatory power and searched

for theoretical models with which they could better understand the relationship between art and society.

Lévi-Strauss's (1967) structuralist analysis of the Tsimshian story of Asdiwal renewed international attention to Northwest Coast cultural materials and generated intense local interest in structural analysis (M. Reid 1981; see also Maranda 2004) [5.IX]. Given how Lévi-Strauss's figure looms so large over how anthropologists imagine 1970s Northwest Coast ethnography, it is noteworthy that one finds in the literature very few structural analyses of Northwest Coast *art* (cf., e.g., Rosman and Rubel 1971 on potlatch exchange). The literature on art remained dominated by descriptive museum catalogues directed to a more general public than anthropologists and, notably, an increasingly art-buying public.

When evaluating the impact of Lévi-Straussian structuralism on the study of Northwest Coast art, Marjorie M. Halpin, who completed a PhD at the University of British Columbia under Wilson Duff and curated and taught at that institution, offered the most sustained engagement with structural analysis and its explanatory possibilities. Halpin's (1973) detailed analysis of the relationship between Tsimshian crests and social structure was stimulated by Lévi-Strauss's writing on totemism (1966, esp. 100-190). In his model, totemic classification not only serves to distinguish individuals, as Lévi-Strauss suggests is the case within Western societies, but more frequently works to create alliances between the human and natural (often animal) worlds that demarcate differences among social groups (107-8). Halpin's analysis turned on Tsimshian "monster" crests, which confound the natural/social division on which Lévi-Strauss's understanding of totemism rests and which serve to integrate social units, rather than differentiate among them, as Lévi-Strauss would have it (see also Halpin and Ames 1980). Therefore, Halpin argued (1973, 249), Lévi-Strauss's model proves inadequate on the ground that it was too inflexible to account for the suppleness of Tsimshian social organization in the face of historical fluctuations in descent groups, population, and residence, particularly as they intensified in the postcontact era [19.V].

By the mid-1970s, structuralism in anthropology faced fierce criticism for its ahistorical, apolitical, and universalist mode of inquiry and its lack of attention to ethnographic particularities and agency (Geertz 1973). Indeed, Halpin expressed skepticism of the conclusions to which an unfettered structural analysis could lead (Halpin 1973, 134; 1981; see Rosman and Rubel 1971; Duff 1975). Lévi-Strauss attempted to respond to the charge of ahistoricism in *The Way of the Masks* (1982b) [19.IX], in which he took on the question of the relation of Coast Salish materials to Wakashan materials. This had been raised earlier by Drucker ([1955] 1963, 162, 181), who saw Coast Salish art as derivative of Wakashan art.

Lévi-Strauss compared and contrasted Coast Salish and Kwakwaka'wakw Xwaixwe and Dzonokwa masks and narratives in order to demonstrate (1) that the Kwakwaka'wakw Dzonokwa is the structural opposite of the Salish Xwaixwe and (2) the relevance of a structuralist approach to myth and material culture to culture history. *The Way of the Masks* represents the apex of structuralist approaches to Northwest Coast art, although the English translation appeared when structural anthropology in North America was undergoing a precipitous decline. It had only a negligible impact on the field of Northwest Coast studies. In any case, Halpin's work more adroitly complicated dominant critiques of structuralism by centrally addressing historical change. It was a groundbreaking, but underrecognized, attempt to analyze how Northwest Coast art and crest systems not only represent, but also respond to, social practices.

Like Lévi-Strauss in *The Way of the Masks*, Wayne Suttles (1987) was concerned with culture history. His response to an emergent question (Holm and Reid 1975a) – why did the Coast Salish produce much less art than the Northwest Coast people to the north? – took aim at then-dominant diffusionary analyses that (1) assumed a northern origin for Northwest Coast art, (2) disparaged Salishan production (e.g., Drucker [1955] 1963, 87), and (3) tacitly assumed that a uniform set of socio-cultural processes governed artistic productivity. Suttles's paper was significant in its departure from what had become the standard museological mode of analyzing Northwest Coast art, which dwelled on formal characteristics and was directed to explicating the cultural ideas that a given object represented. Suttles argued that analyses of the meaningfulness of art needed to be grounded in other cultural concepts and values and understood through ethnographic research rather than the analysis of material culture or myth (see also Halpin 1994). By situating art within a wider complex of concerns about wealth and relations of authority within Coast Salish cultures, Suttles provided one of the first moves toward an *ethnography* of art production [19.VI; see also 19.XVI].

Still, as Margaret B. Blackman (1976) would point out, social anthropological treatments of Northwest Coast art mostly remained concerned with "classic" Northwest Coast cultures or those that endured before the vast changes induced by contact and colonialism. The few that were concerned with the "arts of acculturation" (at this point studies of Haida argillite – see Kaufmann 1969; Duff 1964b; Gunther 1956; Barbeau 1957) mourned postcontact social disintegration (Blackman 1976, 390; see Rosaldo 1989). Blackman's argument that acculturation is a profoundly creative and culture-building process formed an important critique within the Northwest Coast literature [19.VII]. However, it lacked the

political economic edge of Nelson H.H. Graburn's landmark collection *Ethnic and Tourist Arts: Cultural Expressions from the Fourth World* (1976; see Phillips and Steiner 1999), which grounded the global development of the arts of acculturation in processes of commodification and touristic desire for alterity (see also MacCannell [1976] 1999). Furthermore, as a number of Kwakwaka'wakw intellectuals (Sewid-Smith 1979; Wheeler 1975) made clear, the question of celebrating or lamenting historical change and acculturation is somewhat beside the point. Their locally produced works, taking their Potlatch Collection (see following sub-section) as a case study, demonstrate that Aboriginal art is entangled within history, colonialism, and the mechanisms of (social) justice.

Native/non-Native relations formed the central analytic framework of an interdisciplinary wave of Northwest Coast research that emerged regionally in the late 1970s and early 1980s and focused on the histories and continuing effects of contact and colonization on Aboriginal peoples (Duff 1964b; Fisher 1977; Knight 1978; Cole 1985). Ethnographic projects that were part of this movement often took a political anthropological and political economic focus. Karen Duffek's unpublished MA thesis (1983b), a study of the mechanisms by which the Northwest Coast art market generates value for Northwest Coast objects, marked the first political economic treatment of Northwest Coast art [19.XI]. That it remains one of few studies of art markets in this region (see also Blackman 1992; K.C. Duncan 2000; cf. Mullin 2001; M'Closkey 2002; Phillips and Steiner 1999; Howes 1996) is no doubt due to the continuing role of the museum catalogue essay – a generally laudatory and increasingly biographical genre – as a primary venue for Northwest Coast art scholarship (see Duffek, this volume).

### 1983 TO PRESENT: ABORIGINAL ART/ABORIGINAL POLITICS: DECOLONIZING RESEARCH IN THE "CONTACT ZONE"

After the international distribution of the U'Mista Cultural Centre's films *Potlatch: A Strict Law Bids Us Dance* (Wheeler 1975) and *Box of Treasures* (Olin 1983) (see Dowell, this volume), the seizure and subsequent (1980) repatriation of the regalia used at Dan Cranmer's 1921 potlatch ("the Potlatch Collection") became a key historical cipher in anthropological treatments of Northwest Coast art. Over the next fifteen years, no fewer than a dozen analyses concerning Kwakwaka'wakw potlatching, and primarily Cranmer's potlatch and the repatriated collection, have appeared in a wide range of international venues (Bracken 1997; Cranmer Webster 1992b; Hawker 2003; Loo 1992; Masco 1995; Clifford 1997a; Jacknis 1996b, 2002a; Saunders 1997a, 1997b; Mauzé 2003; see

also Day 1985; Cranmer Webster 1985). In the wake of increasing Aboriginal political mobilization (see Townsend-Gault, Chapter 27, this volume) and the high visibility of the repatriated Potlatch Collection, anthropologists could no longer disentangle Aboriginal art from political action.

Of these, the publication of James Clifford's essay "Four Northwest Coast Museums: Travel Reflections" (1997a) in the landmark collection *Exhibiting Cultures: The Poetics and Politics of Museum Display* (Karp and Lavine 1991) catapulted Northwest Coast art to the forefront of the "crisis in representation" literature, bringing it, once again, to international attention [19.XII]. Harkin's critique of that article [19.XIII] gave public voice to a widely held view that Clifford's "site-visit" approach, ungrounded in long-term ethnographic research, neglected the particular political, social, and economic struggles that structure everyday life in Aboriginal communities. This critique speaks to an ongoing concern with the politics of academic production in a region where building collaborative research relationships with Aboriginal people has become widely accepted, even institutionally entrenched (see Black, this volume).

That being said, in a period when the politics of representation and identity emerged as a pressing transdisciplinary concern across the humanities and social sciences (see, e.g., Clifford and Marcus 1986; Bennett 1995; Hooper-Greenhill 1992; Kirshenblatt-Gimblett 1998), museums and art galleries once again became the central hub for anthropological scholarship concerning Northwest Coast cultural materials (though see Morris 1994). Inspired by postcolonial analyses of the history of museums as colonial institutions, and of anthropology as a colonial discipline, numerous scholars cast critical attention on collecting practices and classification schemes (Cruikshank 1995; Cole 1985; Jonaitis 1999; see also Thomas 1991; Phillips 1995, 1998), repatriation (Clifford 1997a; Glass 2004a; Harkin 2005; Kramer 2004; Cranmer Webster 1992b; see also White, this volume) [23.XII], and the role that Indigenous culture brokers have played in these processes (Glass 2006c). In *Cannibal Tours and Glass Boxes: The Anthropology of Museums,* Michael Ames (1992a) extended museological critique beyond museum walls to a wide range of representational venues [15.V, 24.I]. Remarkably, although Northwest Coast scholars have followed the deconstructive assessments of primitivism and the criteria that prior generations of scholars used to confer the status of "art" and "authenticity" (M.M. Ames 1992a; see also Clifford 1988b; Price 1989; Torgovnick 1991; Errington 1998), and the subsequent turn toward previously ignored forms of cultural production, including tourist art and performance (see Phillips 1995, 1998; Phillips and Steiner 1999), their own projects have, by and large, continued to focus on Northwest Coast "fine art."

During this period, Boas's research practices and enduring influence over the assumptions scholars bring to Northwest Coast art have come under significant scrutiny (Briggs and Bauman 1999) [19.XIV, 19.XV]. Jonaitis (1995) renews attention to Boas's historical particularism; Halpin (1994) suggests that Boas's representational understanding of crests was far too limited to account for the ambiguities of Northwest Coast art. The classic Boasian "culture area" concept has also come under intense scrutiny, particularly by scholars pursuing research in the Coast Salish world, which transcends the British Columbia/Washington border (B.G. Miller 1996, 2007; Bierwert 1999). Differing histories of colonialism and treaty settlements have given rise to substantial differences among Native American and First Nations governance, political aims, and cultural politics, despite significant enduring ceremonial, economic, and kin ties. With respect to Northwest Coast art scholarship, transnational difference in stances toward cultural property, appropriation, and collaboration are significant and can no longer be ignored.

Concerns introduced by Aboriginal scholars have inflected the debates on race, culture, indigeneity, and cultural property that have periodically surfaced in Northwest Coast art scholarship, especially concerning art forms that developed postcontact. In 1964, Wilson Duff, himself an occasional producer of "Native-style" art, proclaimed that the art forms that developed postcontact were hybrid and therefore not genuinely Aboriginal [19.IV]. The notion that ethnicity is peripheral to Northwest Coast art production exemplifies the modernist argument that art is a universalistic endeavour. This argument legitimized non-Aboriginal "Native-style" production (see Duff 1967) and perhaps informed the inclusion of US Native-style artists Duane Pasco and Barry Herem in Hall, Blackman, and Rickard's (1981) text on Northwest Coast printmaking [19.X; see also 19.XI]. The universality of Aboriginal art production has since been renounced by a range of Aboriginal and non-Aboriginal artists, scholars, and critics and is now a view held by few. Nevertheless, that Native-style artists continue to hold a substantial degree of power over the production and circulation of Northwest Coast art warrants critical attention. Their art practices and relationships with Aboriginal artists and communities – especially in western Washington Coast Salish communities – complicate what have become received notions about the relationships between Northwest Coast art and Indigenous identity (Bierwert 1999; Campbell 2004) [20.III, 20.VII].

Scholars have begun to pursue ethnographic and critical analyses of the production and circulation of Northwest Coast art (see Marcus and Myers 1995). Nicholas Thomas's (1999) influence pulses through anthropological and art

historical analyses of how the colonial appropriation of Indigenous motifs across a range of monumental and quotidian objects forms a crucial part of civic, commercial, and national identity projects (Dawn 2006; Hawker 2003; Kramer 2006; Watson 2004). Jennifer Kramer's *Switchbacks: Art, Ownership, and Nuxalk National Identity* (2006) [19.XVII] bridges these concerns with art, representational politics, and national identity – her concern is art and Nuxalk nationhood – and more recent concerns with the role of objects and materiality in mediating social relations (see B. Brown 2004; Gell 1998; D. Miller 2005a; Myers 2001a; Pinney and Thomas 2001). Nicholas Thomas's (1991) earlier attention to how objects intimately entangle colonizing and colonized populations has been particularly influential in this regard, as has Marcus and Myers's (1995) call for critical ethnographies of art production. As is the case more generally in the anthropology of art, Alfred Gell's (1992, 1998) argument that art objects, as extensions of social agency, transmute and distribute that agency throughout the social world has generated considerable interest (Glass 2004a; Kramer 2004; Townsend-Gault 2004a). In a series of papers, Charlotte Townsend-Gault (1997, 2004a) has sought to move the locus of inquiry out of discrete sites, such as Aboriginal communities and museums, to the spatial trajectories – civic, commercial, and domestic – through which objects and indices of "Aboriginality" circulate [20.XI]. Her work signals a broader concern to move beyond "art," narrowly construed, to examine the broader properties of materiality and, consequently, the immaterial property to which material forms of property are always inextricably linked (see Weiner 1992; Kramer, this volume). The recognition that a discrete focus on "Northwest Coast art" objects obscures the social and political lives of things has similarly impelled anthropologists to consider how a wider range of aesthetic practices, including Indigenous media production (Dowell 2006) and the production and distribution of potlatch T-shirts (Glass 2008), affects Aboriginal and intercultural social relationships.

## CONCLUSION

Northwest Coast art scholars, long located in regional museums, have actively negotiated the demands of multiple publics, including keenly interested local residents, collectors, tourists, the Aboriginal people whose work they study, and, of course, the public and private funding agencies who support their work. Over the past twenty years, Aboriginal people have become an increasingly important audience for anthropological scholarship. Northwest Coast anthropologists, working within and outside museum contexts, have been pioneers in developing collaborative, ethical research relationships with Aboriginal people.

The development of these relationships – which might be seen to echo Gunther's earlier advocacy efforts – is certainly due to anthropologists' increasing will to decolonize their knowledge production practices. That being said, it is questionable whether this shift could have occurred without the moral and financial support of Northwest Coast anthropology's other publics.

One of the hallmarks of the recent postcolonial critiques of museum representation has been the analysis of how anthropological representational practices have served imperial practices. In the wake of these critiques, collaboration and community consultation have often been heralded as solutions to inequities in representation. The ethos of collaboration has become not only a key part of Northwest Coast anthropology's modus operandi but has also become entrenched in a range of public and private institutions across the Northwest Coast. One of the features of multiculturalism in millennial British Columbia is that collaboration between any number of civic and commercial bodies and First Nations has become cause for uncritical celebration. Public and private organizations such as the Vancouver Opera and the Vancouver/Whistler Olympic Organizing Committee (VANOC) acquire significant currency and cultural capital by developing collaborative projects with First Nations. In this political climate, critical attention might be productively directed to analyzing the relationship between collaboration and capital across a range of academic and non-academic ventures.

Emergent efforts toward this end resonate with Michael Ames's (2006) claim that Aboriginal people's sovereign right to self-representation may well be compromised by the *realpolitik* of collaborative projects. At the same time, Northwest Coast art scholars are increasingly articulating their work with broader theoretical developments in the anthropology of art and material culture while retaining a deep commitment to ethical knowledge production. Coupled with the regional market that has sustained the anthropology of Northwest Coast art since the mid-century, this current makes the anthropology of Northwest Coast art a unique prism through which to view the intersection of theory and ethical practices at the nexus of private, public, academic, and Aboriginal agendas and concerns.

**19.1. Marius Barbeau. 1957. *Haida Carvers in Argillite.*** Ottawa: National Museum of Canada, 1. © Canadian Museum of Civilization.

Marius Barbeau (1883-1969) was a folklorist and ethnologist who joined the Victoria Memorial Museum (later National Museum of Canada; now Canadian Museum of Civilization) in 1910. He actively promoted the view that Northwest

Coast cultural materials were art and ought to be considered an integral part of Canada's cultural heritage. To this end, he helped to organize the 1927 exhibition *Canadian West Coast Art, Native and Modern* (see Dawn, this volume). In addition to his long-term collaborative work with William Beynon, a Tsimshian hereditary chief (see Anderson and Halpin 2000), Barbeau had an intense interest in Haida argillite carving and its historical development. In the following excerpt, he advocated taking an art historical approach to Haida argillite carving and criticized dominant anthropological approaches that viewed North American Aboriginal arts as timeless and anonymous.

Forming part of aboriginal utilities in daily life, the manual arts of the North American Indians belonged to a multitude. Anthropologists in their studies of this subject have seldom resorted to the methods long familiar in the history of art in Europe and America. On the whole, they have not sought the identity of the native workers who were personally responsible for the progress of their craft. A haze of generalities from their pens and insufficient data leave whoever consults them under the impression that every activity among the Red Men was shared by all on the same communistic level. This criticism applies also to the ethnographic publications on the plastic arts of the North Pacific Coast – of the Haida, Tsimsyan, and Tlingit in particular. Few carvers, except perhaps Edensaw, were ever portrayed or even mentioned by name in their own setting. The totem poles and other forms of heraldic and decorative arts in that category seemed to have sprung up anonymously from nowhere precisely. The lack of information leads one to believe that form and pattern had come down there ready-made, out of prehistory. For instance, a fine Haida totem pole now in the park at Prince Rupert in British Columbia, that of the Bear Mother of Kyusta, was labeled as being 200 years old, when actually it was much less than a hundred, and the name of its maker could have been secured for the asking and duly recorded for posterity.

Haida art, like that of neighbouring nations, can be studied and presented under its true colours. It is the product of individual effort at the hands of craftsmen whose activities and careers were well known to their contemporaries at Skidegate and Massett, down to the present. Their talents and skills were rated as they deserved by their fellow-workers at home and by their casual patrons outside. Their inventiveness and progress developed from 1820 onwards and reached a peak only during the last four decades of that century.

The proof of this seemingly bold assertion is made plain in my own publications on Totem Poles and Haida Myths. The present *Haida Carvers* further sets forth the names and achievements of more than forty Skidegate and Massett artisans and illustrates their extraordinary progress within the memory of man. If one decides to learn at first hand about them, nothing will be out of focus, for neither would anonymity

satisfy a French historian of the Barbizon school of painters concerning Millet, Rousseau, and their impressionistic contemporaries. Likewise, in this book on Haida argillite work, we shall look into the recent lives and achievements of William Dixon, Tom Price, John Cross, Charlie Edensaw, Isaac Chapman, and others of the same native school. All of them were contemporaries of our own Constable, Turner, Courbet, Millet, Gauguin, and Cezanne. Their splendid isolation, beyond the barrier of the Rockies, at the edge of the Pacific, is all that has safeguarded their originality and independence during the all-too-brief span of the last hundred years (1820-1940).

**19.II. Dorothy Bestor. 1965. Oral History Interview with Erna Gunther for the Smithsonian Archives of American Art.** Conducted at the University of Washington, 23 April. http://www.aaa.si.edu/collections/oralhistories/transcripts/gunthe65.htm.

Erna Gunther (1896-1982) was director of the Washington State (now Burke) Museum in Seattle and the first female head of an anthropology department in the United States – the Department of Anthropology at the University of Washington – from 1929 to 1955. Although her scholarship on art did little to inform and shift the theoretical categories that anthropologists have brought to bear on Northwest Coast art, her deep public engagement and political commitment to Aboriginal social welfare set the stage for the public and political priorities of many later Northwest Coast art scholars.

Gunther was invited by Alice Ravenhill and the BC Indian Arts and Welfare Society to participate in their 1948 conference on Native social welfare in British Columbia, and she curated many exhibitions in western Washington. The excerpt from the 1948 conference [13.1] reveals Gunther's political interest in promoting art as a vehicle for economic development. While some of her contemporaries advocated the development of acculturative arts by applying Northwest Coast design, Gunther worried about the social and political effects on Aboriginal people if they were producing and distributing low-quality art objects. In her view, producing Northwest Coast art as a marketable commodity would enhance the general public's view of Aboriginal people. Nevertheless, her project entailed hearkening back to an image of Northwest Coast art in an ethnographic present, as can be seen in the second excerpt from the 1966 catalogue of the Rasmussen collection at the Portland Art Museum.

Today I never hesitate to say to people, "This is a piece of Northwest Coast Indian art; but this is not just something an Indian made, it is a piece of art." And it is reasonably accepted. But what you were talking about in connection with the baskets, that happened in connection with one of our local fairs here, where a woman in charge

of the Woman's Building asked me to bring something for display because she hadn't gotten enough crocheted doilies, and I brought a show of Indian baskets because they are also made by women and I felt that they would be right in a woman's building. But she did not want them. I told her, "That or nothing at all," and finally she took them. I went down to the Fair several times to see how they were being received and every time, if there was anyone in the building, they were standing at the case with the baskets. It is really surprising to find so many people who have had baskets tucked away in the attic and who suddenly find now that they are being shown in museums. So they bring them out, for now they have a piece of art.

...

The unfortunate thing is that so many places [Aboriginal communities], the only future they see for Indian art are things to sell and sell quick. And this does things to the artists and to the public's image of art. It is harmful not only to art, but also to the artist.

DB: Yes, it certainly is, and to the public's image of the Indians, too.

EG: And the public image of art.

**19.III. Erna Gunther. 1966.** *Art in the Life of the Northwest Coast Indian: With a Catalog of the Rasmussen Collection of Northwest Indian Art at the Portland Art Museum.* Portland: Portland Art Museum, 2.

The art was thus intimately bound up with the social structure, a fact which accounts for its great strength but also for its rapid decline in the 20th century; for when the society became disorganized through the impact of acculturation to white customs, the art lost all motivation. Moreover, the traditional forms could not easily be adapted to the uses of outsiders, other than in the degenerate form of curios. Thus Northwest Coast Indian art must be regarded as a thing of the past, even though the peoples who created it still survive.

**19.IV. Wilson Duff. 1964.** *The Indian History of British Columbia.* **Volume 1,** *The Impact of the White Man.* Anthropology in B.C. Memoir No. 5. Victoria: British Columbia Provincial Museum, 76-77.

Wilson Duff (1925-76) was curator of anthropology at the British Columbia Provincial Museum (1950-65) and associate professor of anthropology at the University of British Columbia (1965-76). Duff is best known as one of the curators of the 1967 exhibition *Arts of the Raven* and curator of the exhibition *Images: Stone: BC.* While at the Provincial Museum, Duff wrote the first volume of what he intended to be a three-volume history of Aboriginal peoples in British Columbia. Published two years before *Arts of the Raven,* which included a number of Native-style artists in its "The Art Today" gallery, Duff's writing

on material culture, arts, and crafts aimed to historicize Aboriginal art production. His emphasis on delineating Aboriginal (understood as precontact) forms and techniques articulated, and ultimately legitimized, the widely held universalist view at the time that "Indian arts and crafts," as "present-day products," were open for all to produce.

> The material goods made and used by the Indians have changed so completely since the arrival of Europeans that most aboriginal forms may now be seen only in museums (which incidentally is one good reason for the existence of museums) ... Indian arts and crafts are present-day products which have evolved directly or indirectly from old native forms, and which have enjoyed a continued development because of a demand for them in the larger culture ... Their appeal lies partly in their identification with the Indians and with the local region, but it is also the appeal of skilled hand craftsmanship in an age of standardized machine-made products. Most of these crafts have evolved a long way from their aboriginal prototypes; in fact many of them (beadwork, silverwork, argillite carving, knitting) are not aboriginal at all, but of mixed Indian-white origin. Since it is in the larger culture that these crafts are actually used, and since the demand from the larger culture influences their forms, they are just as much products of the material culture of modern North America as they are products of Indian culture.

**19.V. Marjorie M. Halpin. 1973. "The Tsimshian Crest System: A Study Based on Museum Specimens and the Marius Barbeau and William Beynon Field Notes."** PhD diss., University of British Columbia, 1, 5, 249-50, 252.

Marjorie M. Halpin (1937-2000) was associate professor of anthropology and curator of anthropology at the University of British Columbia. This excerpt, from her 1973 doctoral dissertation, represents the influence of French structuralism on Northwest Coast studies in the late 1960s and 1970s. Halpin's study was exemplary within this literature for the analytical rigour with which it tested structural models – here Lévi-Strauss's model of totemism developed in *The Savage Mind* (1966) – against ethnographic, historical, and material evidence of the changes in Tsimshian crest systems over time.

Halpin ultimately found Lévi-Strauss's model inadequate on the ground that it was too inflexible to account for the suppleness of Tsimshian social organization in the face of historical fluctuations in descent groups, population, and residence (Halpin 1973, 249). Moreover, she concluded that the Tsimshians' later (postcontact) use of the human face as the dominant image in their art indicated that they had exhausted the possibilities of totemism (252).

In order to make any kind of concrete fact meaningful – whether it be event or thing – it is necessary to interpret it in terms of a theoretical construct or analytical framework. This basic structure of science has been overlooked by most anthropologists who write about objects in museum collections, with the result that we have a great many catalogues which increase our familiarity with particular pieces, but do little to increase our understanding of them.

...

Tsimshian crest art was a special use of artistic images to make Tsimshian social structure visible. This suggests that art, at least totemic art, is more than aesthetic design; it is an intellectual or cognitive process by means of which man explores his world and renders it meaningful and intelligible. As Lévi-Strauss has argued, the so-called primitive artist, and those who commission and use his art, are more cerebral than many have thought.

...

I began this study by investigating Tsimshian crests as a totemic system, such as defined by Lévi-Strauss. It soon became evident that the model did not prove adequate to the Tsimshian case. The ethnographic acts I was attempting to explain did not all fit.

For totemism itself had become an inadequate classification scheme for the Tsimshian. Totemism is a statement of the "human order as a fixed projection of the natural order by which it is engendered"; it is a "static model of a likewise static diversity between human groups."

Tsimshian society has not been in a static condition since European contact, and probably had not been so for long before then, as attested to by their traditional histories. These tell of a great many local groups, who began wandering in search of new lands and who eventually settled in their historic territories, where they found other people with whom they amalgamated as clan kinsmen or with whom they formed enduring affinal relationships. We do not know when the Tsimshian began to organize themselves into matrilineal descent groups, but their own histories begin with clans already in existence. If, for the Tsimshian, the clans existed from the beginning, so did totemism. The histories tell of adventuresome ancestors whose exploits kept adding more and more crests to the glory of their houses.

At some point, the "static model" of nature was no longer adequate, and the ancestors began changing the animals they borrowed from it to be crests of their houses. Surely, it was intentional when they changed the Frog into a Copper Frog and then into a Flying Frog. Indeed, it may have been an artist who first suggested that the old forms were tired and inadequate.

That the images of nature were inadequate is clear – for the Tsimshian were changing them. The argument of this study has been that they were inadequate because Tsimshian social organization was outgrowing them. As clanship became criss-crossed

and overlaid by non-kin forms of associations and sodalities, as rank distinctions between people grew and solidified into status levels, and as chiefly power grew, the Tsimshian needed new metaphors for the shape of human society. They worked on the ready-made categories of nature, abstracting and recombining them, and created new images to suit their new needs. The most powerful images they created – the monsters – expressed new unities that were forming among them, perhaps as a reaction to the economically stimulating but profoundly disturbing presence of the white man.

Eventually, there were many hundreds of images – old and new – in the inheritance of the Tsimshian houses. Yet there were only two basic rules by which they had been created.

...

The first principle of elaboration in this system is that differentiation in the basic totemic axis is increased by the action of operators upon the crest animals. A number of these actions or operations, although not all of them, can be subsumed under the general process Levi-Strauss calls "detotalization," or the decomposing of the animal into parts.

The converse process, that of "retotalization," is a second structural principle accounting for the creation of monster crests. This is the process by which detotalized or dissociated parts are recombined – retotaled – into a new kind of animal, a monster. I have argued that this was an integrative process, one in opposition to the basic totemic function of differentiation.

In the end, however, the monsters were still too constraining as images. Nature can only be manipulated so far before she gives way altogether. An art of ecology, which is one way of conceptualizing totemic art, has its limits. The Tsimshian artist reached these limits most clearly in the amhala'it. Beaks and wings and flukes finally fell away and a more appropriate image – the human face – became the dominant Tsimshian image.

This had been happening in Tsimshian art since at least early contact times. In masks and in totem poles, a major distinguishing feature of Tsimshian aesthetic expression is the human face. I am suggesting that one reason there are more human motifs in Tsimshian art is that they, more than other people on the Northwest Coast, had taken totemism as far as it would go.

**19.VI. Wayne Suttles. 1987. "Productivity and Its Constraints: A Coast Salish Case."** In *Coast Salish Essays.* Vancouver: Talonbooks, 103-5, 131-32.

Wayne Suttles (1918-2005) was an eminent scholar of Coast Salish ethnography, best known for his studies in environmental anthropology. The essay

excerpted below was his only foray into the anthropology of art. Not unlike Boas at the turn of the century, whose arguments about Northwest Coast art were central to his debunking of social evolutionism in anthropology, his analysis was not directed to anthropologists of art. Rather, Suttles analyzed the cultural restrictions on Coast Salish artistic productivity to argue against dominant diffusionist understandings that routinely privileged Haida, Tlingit, Tsimshian, and Wakashan "creativity" and denigrated Coast Salish "imitativeness" (1987, 102). Like Halpin, he sought to understand art within the social relations of, and the cultural restrictions on, its production.

> During the nineteenth century the Central Coast Salish [the speakers of Halkomelem and Straits] carved and/or painted ceremonial paraphernalia of several kinds, house pots and (in some places) house fronts, grave monuments, and several kinds of implements of practical value. Discovering what this art meant to the people who made it and used it is now very difficult. But perhaps we can make a start by sorting it out by its association with some Native concepts. It seems to me that, while some Central Coast Salish art may have been purely decorative, much of it can be related to four sources of power and prestige – the vision, the ritual word, the ancestors, and wealth ... I shall discuss these four sources of power and prestige first and then return to the kinds of things that were carved and painted.
>
> The vision was the unique experience of the individual, the source of his or her skill at subsistence activities or crafts, and the essential basis of professional status as warrior, seeress, or shaman. In theory, though not always in practice, the exact nature of the vision experience was something one ought to keep secret, perhaps until old age. The vision experience inspired a unique individual performance in the winter dance, but its nature was only hinted at by the words of the song and the movements of the dance. Any other representation of the vision experience we might expect also to be vague, ambiguous or covert.
>
> The ritual word was for some purposes more important than the vision. It too was an aid in subsistence and crafts and was the basis of a profession, that of "ritualist" (Barnett's term; Jenness says "priest"). The ritual word was the heart of the first salmon ceremony, of incantations to quell wounded bears and sea lions, and of the "cleansing rites" used at life crises and to wipe away shame. These cleansing rites included the use of masks, rattles, and several illusions – one in which stuffed animals appeared to climb a pole, another in which a basket appeared to float in the air, etc. The ritual word was also associated with designs, which the ritualist painted with red ochre on those he protected or purified. The rites and the designs were the property of individuals, who kept to themselves the knowledge of the ritual words that made

them efficacious, but they could be used on behalf of descendants, descent being reckoned bilaterally, of an ancestral owner.

The ancestors, for the Central Coast Salish (perhaps with a few exceptions), had always had human form. Some of these first humans dropped from the sky at the beginning of the world. Others seem simply to have been here. In a few myths they were created by the Transformer. Some animal species are the descendants of people, as the sturgeon in Pitt Lake came from the daughter of the first man there; some are the affines of people, as the sockeye salmon are for the Katzie through a marriage of another first man. But people are not the descendants of animals. In the most common kind of myth, when the Transformer came through the world and brought the Myth Age to an end, he transformed some of the First People into animals but left others, who pleased him, to become founding ancestors of villages. Some of these founders received, from the Transformer or from other sources, the ritual words, incantations, and ritual paraphernalia of the cleansing rites, which have been transmitted generation after generation to their present owners.

The value of the vision, the ritual word, and the ancestors was reflected in wealth. In Native theory, they were responsible for one's having wealth, and so having wealth demonstrated their presence and efficacy. Giving wealth, as Barnett and others have pointed out, was a necessary step in validating claims to status, ultimately confirmed by being given wealth. Wealth for the Central Coast Salish included slaves and dentalia obtained from elsewhere but consisted mainly of items made within the area by skilled craftsmen and, more importantly, craftswomen. Probably the most important item of wealth was the blanket woven of mountain-goat and/or dog wool. These blankets had several advantages as wealth; they were made of materials of practical value and available in large but finite amounts and they were divisible and recombinable, since they could be cut up or unraveled and the material rewoven into new ones.

...

Why did the Central Coast Salish produce some great works of art yet neither the range of kinds of things nor the quantities of things produced farther north? Were there constraints at work here restricting and channelling productivity? It seems to me that there were. Clearly there were limits on the representation of visions ("guardian spirits"). In Native theory, everyone (or every male perhaps) ought to "train" and have a vision. But it was dangerous to reveal too much about it. If you talked about it, you could "spoil" it: it might leave you or even make you sick or it could be taken away from you by an enemy shaman. Yet eventually you wanted others to know that you "had something." Probably all of us who have worked in the area have heard hints and half-revelations about what people "have." Possession by a song

at the winter dance is, of course, evidence that you "have something" and the words of the song and movements of the dance may hint at what it is. But it must be tempting to hint in other ways, though dangerous to go too far ...

The dangers that lie in portraying a vision too clearly may have affected artistic expression generally unless it was clearly identifiable with some other source of power. It may be that men refrained from decorating tools and weapons in order not to suggest even falsely the source of their vision powers.

With art related to the power of the ritual word, the constraints must have been different. The viewers of a rattle or mask know that its efficacy depends not on the private experience of a vision but the private knowledge of ritual words that have inherent power. That power cannot be diminished by concrete representation. You can only lose it through revealing (or forgetting) those carefully guarded words. Yet you may want to suggest their power or that you are the possessor of esoteric knowledge ...

In the portrayal of ancestors there may have been a still different kind of constraint – fear of ridicule. When the man carved the house post at Musqueam portraying the ancestor confronting the bear, a Musqueam friend told me recently, he introduced something into the carving that was a covert insult to the subject. Whether this is true or not I do not know. Nor is the truth important for my argument. Covert insults were certainly a part of Native life. When the sxwayxwey is dancing, an old Lummi friend told me years ago, if the dancer shifts his scallop-shell rattle even for a moment to his left hand it signals to the spectators who have received the proper "advice" that the person for whom they are dancing has some lower-class ancestry. In the old days, I suppose, a man thinking of having a carving made of an ancestor must have had to consider whether he had the wealth or influence to protect that carving from slurs. In Native society, leadership was specific to an activity; there were no all-purpose leaders and no great concentrations of authority. Perhaps few men could live without fear of ridicule.

## IMPLICATIONS FOR PREHISTORY

I have tried to show how the people of one region had different forms of art related to different concepts and limited by different constraints. It appears to me that within the region there were local differences in the degree to which each of these concepts might be expressed, depending on the strength of fears about the harmful consequences of concrete representation versus desires for the useful consequences. These constraints are such that they may have varied in intensity through time and so may account for variations through time in kind and amount of artistic output. We need not, therefore, interpret qualitative or quantitative changes in prehistoric art as evidence

of cataclysmic culture change or population replacement. They may have been the result of shifts in importance, back and forth, between the power of the vision and the power of the ritual word or shifts in the concentration of wealth and authority.

**19.VII. Margaret B. Blackman. 1976. "Creativity in Acculturation."** *Ethnohistory* 23, 1: 391, 394, 407, 409, 410. © 1976, American Society for Ethnohistory. All rights reserved. Reprinted by permission of the publisher, Duke University Press.

Margaret B. Blackman (b. 1944) is an ethnographer of the Haida who specializes in oral history, life history, and contemporary Aboriginal art and teaches anthropology at SUNY-Brockport. Her 1976 article "Creativity in Acculturation" took a critical stance on the salvage paradigm that had hitherto dominated the study of art and acculturation in Northwest Coast anthropology. Blackman's argument that the acculturation models regional scholars were using were twenty years behind mainstream social science warned of the pitfalls of a deeply regionalized scholarly discourse. When it first appeared, this article was groundbreaking for placing Aboriginal people's creativity and agency at the centre of Northwest Coast art studies.

The creative genius within Northwest Coast cultures of the recent past is most explicitly documented in the acculturation of art, architecture, and ceremony. Much of this innovation is tangible, recorded in turn-of-the-century photographs and evident in the material collections of museums. Concomitant social reorganization and the incorporation of new concepts and objects into the native languages point to whole socio-cultural systems which, through innovation, were able to adapt to a rapidly changing and expanding world.

Traditionally, the native groups of the Northwest Coast were receptive to certain kinds of externally introduced innovations, a characteristic of their cultural makeup which proved adaptive in later phases of acculturation. Not only were certain kinds of innovation accepted, but in many instances, innovation was a distinctive feature of high rank.

...

Traditionally, totem poles were but one medium through which crests were given artistic expression. With acculturation, new media for crest display became available as introduced materials were turned toward native ends, given meanings and functions consonant with traditional social systems. The most salient examples of the "new" crest art are seen in gold and silver jewelry, button blankets, and stone mortuary carvings ...

The bulk of the new jewelry, however, was manufactured for internal use. Disdained (and in some cases forbidden) by missionaries, the use of disfiguring labrets and nose rings and the practice of tattooing passed from fashion as markers of high rank to be superceded by gold and silver bracelets, brooches, pendants, and earrings depicting crest art. These items, worn by native women, became a new measure of rank and status.

...

The most tangible innovation in late nineteenth century potlatches, the new, nontraditional potlatch wealth, is strikingly documented in photographs of potlatch displays ... Though the goods were alien, the attitude towards them was traditional. As potlatch wealth they were not utilitarian. "They think low of you if you use what you receive," Haida informants told me. The new potlatch wealth, like the old, was simply recycled, to the point where the white Hudson's Bay blankets reputedly became gray from so much handling ... Several of the new potlatch goods readily lent themselves to the expression of quantity and expansiveness, salient features in Northwest Coast ethos.

...

Much of the acculturation that occurred throughout the Coast in the late nineteenth and early twentieth centuries can be viewed as a culture-building process in contrast to the more commonly held view that this period of time was predominantly one of disorganization, decline and disruption.

...

This is not to deny that the cultures of the Northwest Coast experienced severe strain in recent phases of acculturation; many aspects of the traditional cultures were disrupted; social disorganization did occur. But equally important, internal creativity was abundantly in evidence. The turn-of-the-century cultures of the Pacific Northwest, in their fascinating and complex blend of native and Euro-American elements, were viable socio-cultural systems in their own right, systems which have continued during recent years to adapt to the changing external world through the processes of internal innovation.

The Northwest Coast is not unique in this respect. After all, more than twenty years ago, the Social Science Research Council on acculturation concluded that acculturation generally could be considered a creative process. Anthropology would be well served if this generalization were documented for other native peoples. Such documentation would result in a more balanced view of acculturative processes than one which has stressed the harmful or undesirable effects of culture change.

**19.VIII.  Michael M. Ames. 1981. "Museum Anthropologists and the Arts of Acculturation on the Northwest Coast."** *BC Studies* 49: 3, 4, 11.

Michael M. Ames (1933-2006) was professor of anthropology and director of the Museum of Anthropology at the University of British Columbia. Like those of his colleagues at the British Columbia Provincial Museum (see Black, this volume), Ames's museum practices focused on increasing access for Aboriginal peoples to study and work in museums – at all levels – and transforming the institution through collaborative museology and Aboriginal self-representation. Ames also theorized and wrote prolifically on the politics of representation, particularly in museums. The paper excerpted below represents one of his first attempts to articulate and theorize the politics of representation in the settler colonial museum.

> Museum anthropologists now recognize the importance of the arts of acculturation – those produced for export by colonized tribal societies – as proper objects of research and collection. An equally interesting but neglected topic of study is of the museum anthropologists themselves as agents of this acculturation process. Through their various curatorial and research activities they are actively contributing to the development of the very phenomenon they are now so busily acquiring and studying.
>
> ...
>
> Museum anthropologists influenced Indian art and craft industries on the Northwest Coast in three ways at least: through their reconstructions of the meaning of Northwest coast art; by promoting and legitimating art and artists, as patrons to clients; and by inverting the relationship between anthropologists and Indians, so that the patrons become clients.
>
> ...
>
> Some museum anthropologists are inverting the relationship between anthropology and the Indian.
>
> In contrast to the traditional role of museums, which was to collect from Indians to show to whites, this new role involves collecting from whites to show to Indians. A striking example is provided by the efforts of the B.C. Provincial Museum and the National Museum of Man to compete in high-priced international art markets to purchase and repatriate to Canada prized pieces of earlier manufacture. Another example is provided by the Ethnology division of the B.C. Provincial Museum. This division has drawn upon Indian resources to prepare exhibits for the museum's galleries, in the manner that museums have traditionally done. In addition, however, the division has become more and more involved in drawing upon its own resources to cater to the cultural needs of Indian communities. Provincial Museum anthropologists have become the clients and the Indians the patrons, though the anthropologists (or, more correctly, their institution) continue to pay the bill.

**19.IX.   Claude Lévi-Strauss. 1982. *The Way of the Masks.*** Translated by Sylvia Modelski. Seattle: University of Washington Press; Vancouver: Douglas and McIntyre, 12-14. Originally published as *La voie des masques* (Geneva: Skira, 1975).

Claude Lévi-Strauss (1908-2009) was an anthropologist and leading theorist of structuralism with a long-standing interest in Northwest Coast cultural materials and forms (see also Mauzé, this volume). His earlier publications, notably "The Story of Asdiwal" (1967), principally concerned Northwest Coast oral traditions. In *The Way of the Masks,* Lévi-Strauss attempted to show the utility of the structural analysis of myth to the analysis of material culture. Published in English in 1982, *The Way of the Masks* had little influence on the field of Northwest Coast art studies, which had largely abandoned structural approaches in favour of assessing the social relations of contemporary art production [19.VIII, 19.XI).

As is the case with myths, masks, too, cannot be interpreted in and by themselves as separate objects. Looked upon from the semantic point of view, a myth acquires sense only after it is returned to its transformation set. Similarly, one type of mask, considered from the plastic point of view, echoes other types whose lines and colors it transforms while it assumes its own individuality. For this individuality to stand out against that of another mask, it is necessary that the same relationship exist between the message that the first mask has to transmit or connote and the message that the other mask must convey within the same culture or in a neighboring culture. From this perspective, therefore, it should be noted that the social or religious functions assigned to the various types of mask, which we contrast in order to compare, have the same transformational relationship with each other as exists between the shaping, drawing, and coloring of the masks themselves when we look at them as material objects. Each type of mask is linked to myths whose objective is to explain its legendary or supernatural origin and to lay the foundation for its role in ritual, in the economy, and in the society. My hypothesis, then, which extends to works of art (which, however, are more than works of art) a method validated in the study of myths (which are also works of art), will be proven right if, in the last analysis, we can perceive, between the origin myths for each type of mask, transformational relations homologous to those that, from a purely plastic point of view, prevail among the masks themselves.

To fulfill this program, it is important that we study first the type of mask that I have found so puzzling. We must reassemble the data available about it: that is to say, everything known about its aesthetic characteristics, the technique of its fabrication, its intended use, and the results expected from it; and, finally, about the myths accounting for its origin, the way it looks, its conditions of usage. For it is only after this

all-inclusive documentation has been gathered that we may be able to compare it with other records.

**19.X.  Edwin S. Hall, Jr., Margaret B. Blackman, and Vincent Rickard. 1981. *Northwest Coast Indian Graphics: An Introduction to Silk Screen Prints.*** Vancouver: Douglas and McIntyre, 140.

In this passage from their book on Northwest Coast prints, Hall, Blackman, and Rickard explicitly divorced Northwest Coast art production from race and ethnicity. They also revealed different ways that scholars have drawn on discourses of history and universalism to support Native-style art production.

> A considerable number of silk screen print editions of Northwest Coast Indian designs have been done by non-Indians or by Indians from other than Northwest Coast groups. The identification of individuals as "Indian" or "non-Indian" involves exceedingly complex legal and emotional issues. Correspondingly, mixed emotions surround the creation of Northwest Coast Indian designs for commercial purposes by non-Northwest Coast Indian artists. We agree with one artist interviewed who feels that Northwest Coast art has so much inherent power, integrity, and beauty that, in terms of aesthetics at least, squabbles over the ethnic identity of its creators are unimportant.

**19.XI.  Karen Duffek. 1983. "The Contemporary Northwest Coast Indian Art Market."** MA thesis, University of British Columbia, 87-88, 91.

Karen Duffek (b. 1956) is curator of Contemporary Visual Arts and Pacific Northwest at the University of British Columbia Museum of Anthropology. An anthropologist and critic of contemporary Northwest Coast art practices, she has long examined the ongoing construction of the categories "traditional" and "modern" and the ways in which Aboriginal artists negotiate, challenge, and subvert them. Her master's thesis on the Northwest Coast art market, excerpted below, was heavily influenced by Nelson H.H. Graburn's volume *Ethnic and Tourist Arts* (1976) and signalled an early interest in the contemporary social relations of Northwest Coast art production. It represented the first systematic scholarly attempt to detail the influence of non-Native communities in Northwest Coast art production, particularly concerning the construction of authenticity, and to unpack the racial relations that underpin the production and circulation of Northwest Coast art.

> Probably the most important and seemingly obvious criterion of authentic native art for many buyers, viewers, and artists is that the object must be created by an Indian.

But there are a number of non-Indian artists, perhaps twenty, creating and selling Northwest Coast style work. Of these, several have established reputations as being among the best contemporary Northwest Coast artists – two examples are John Livingston of Victoria, and Duane Pasco of Seattle. Bill Holm is not only the foremost expert on Northwest Coast art but is also a top ranking artist. Sensitive to his position as a non-Indian, however, he does not sell his work.

While the marketing of non-Indian made Northwest Coast style art will be discussed in Chapter Three, the issues surrounding the question of whether the authenticity of Indian art should rest on the ethnicity of the artist will be discussed here. This ethnic criterion in turn raises two primary questions: first, how should the Indianness or authenticity of the artist himself be defined and determined; and second, what kind of Indian is the "right" kind? With regard to the first question, who qualifies as a legitimate Indian artist: a status Indian, a non-status Indian, someone who is half Indian over someone who is one-sixteenth? Other definitions may include a requirement that the artist have a good knowledge about Northwest Coast art and culture. In discussing this question, one Vancouver dealer of Northwest Coast art stated that "Three-quarters of the artists don't understand the cultural traditions behind the art. John Livingston knows more about Kwagiutl culture than most Kwagiutl carvers do."

Duane Pasco has stated that "Some non-Indians are more culturally involved than Indians are. I feel more Indian than non-Indian – I'm an assimilated white." Pasco, like Livingston, Steve Brown, and several other non-Indian artists, participates in dancing and other native cultural activity when invited to do so. As mentioned earlier in this chapter, he has played a major role as a teacher of Northwest Coast Indian art at 'Ksan, and he continues to teach carving and design in Seattle and Alaska. Despite such contributions, however, the expertise and experience in Indian culture for non-native artists is restricted primarily to interpreting the artistic traditions of a culture to which they do not have ancestral connections, and does not extend to the contemporary experience of being Indian within North American society. Some native artists, on the other hand, may not possess the same degree of expertise in traditional Northwest Coast art that Pasco or Livingston have, but feel that the right to create Northwest Coast art should belong only to those whose heritage the art represents.

...

This examination of the three major criteria by which authenticity is defined in the market context – adherence to tradition, the ethnicity of the artist, and the purpose for production – suggests that the "Indianness" of the art is its defining quality. It is the successful presentation of this Indianness, according to the criteria of the viewer, rather than the aesthetic qualities of the work alone, that forms the basis for judgements of the quality and authenticity of most contemporary native art.

**19.XII. James Clifford. 1997. "Four Northwest Coast Museums: Travel Reflections."** In *Routes: Travel and Translation in the Late Twentieth Century*. Cambridge, MA: Harvard University Press, 110, 121-22. With the permission of Smithsonian Books.

James Clifford (b. 1945) is a prominent historian of anthropology and teaches in the History of Consciousness graduate program at the University of California at Santa Cruz. In this essay, Clifford offered a critical reflection on museological strategies at four BC museums – all of which challenge, in different ways, the dominant systems of value that classify objects as "art" or "cultural." By drawing on the entanglements of "dominant" and "Indigenous" Northwest Coast museums, Clifford complicated the art/culture system that he had examined in earlier texts (1988b), suggesting that the system can no longer be considered without reference to specific geographies of collection, repatriation, and exhibition. Nor can it be considered as separate from the intersection of local and global concerns.

I had come to British Columbia expecting to focus on the two Kwagiulth tribal museums, but I found I could not ignore the province's "major" displays of Northwest Coast work in the museums at UBC and Victoria, which are responding in their own ways to the evolving context ... All four museums display the same kinds of objects – ceremonial masks, rattles, robes, and sculpture, as well as work produced for the curio and art markets. In four different contexts, these objects tell discrepant stories of cultural vitality and struggle. All four museums register the irruption of history and politics in aesthetic and ethnographic contexts, thus challenging the art-culture system still dominant in most major exhibitions of tribal or non-Western work. All mix the discourses of art, culture, politics, and history in specific, hierarchical ways. They contest and complement one another in response to a changing historical situation and an unequal balance of cultural and economic power.

...

The two tribal museums in my collection suggest another comparative axis. Along this axis, the aesthetics-oriented UBC museum and the history-oriented Victoria museum are more alike than different, both sharing an aspiration to majority status and aiming at a cosmopolitan audience. By contrast, the U'mista Cultural Centre and the Kwaguilth Museum are tribal institutions, aiming at local audiences and enmeshed in local meanings, histories, and traditions.

Viewed schematically, majority museums articulate cosmopolitan culture, science, art, and humanism – often with a national slant. Tribal museums express local culture, oppositional politics, kinship, ethnicity, and tradition. The general characteristics of the majority museum are, I think, pretty well known, since any art or ethnography

collection that strives to be important must partake of them: (1) the search for the "best" art or most "authentic" cultural forms; (2) the interest in exemplary or representative objects; (3) the sense of owning a collection that is a treasure for the city, for the national patrimony, and for humanity; and (4) the tendency to separate (fine) art from (ethnographic) culture ...

The tribal museum has different agendas: (1) its stance is to some degree oppositional, with exhibits reflecting excluded experiences, colonial pasts, and current struggles; (2) the art/culture distinction is often irrelevant, or positively subverted; (3) the notion of a unified or linear History (whether of the nation, of humanity, or of art) is challenged by local, community histories; and (4) the collections do not aspire to be included in the patrimony (of the nation, of great art, and so on) but aim to be inscribed within different traditions and practices, free of national, cosmopolitan patrimonies.

The oppositional predicament of tribal institutions is, however, more complex than this, and here the tribal experiences recall those of other minorities. The tribal or minority museum and artist, while locally based, may also aspire to wider recognition, to a certain national or global participation. Thus, a constant tactical movement is required: from margin to center and back again, in and out of dominant contexts, markets, patterns of success. Minority institutions and artists participate in the art-culture system, but with a difference. For example, the U'mista Cultural Centre produces and exploits familiar "museum effects." But as we shall see, it also questions them, historicizing and politicizing positions of viewing. On the one hand, then, no purely local or oppositional stance is possible or desirable for minority institutions. On the other, majority status is resisted, undercut by local, traditional, community attachments and aspirations. The result is a complex, dialectical hybridity, as Tomas Ybarra-Fausto shows for much of contemporary Chicano art and culture. This mix of local and global agendas, of community, national, and international involvements, varies among tribal institutions.

**19.XIII. Michael E. Harkin. 1999. "From Totems to Derrida: Postmodernism and Northwest Coast Ethnology."** *Ethnohistory* 46, 4: 819-20. © 1999, American Society for Ethnohistory. All rights reserved. Reprinted by permission of the publisher, Duke University Press.

Michael E. Harkin (b. 1958), an anthropologist and ethnohistorian at the University of Wyoming, has principally worked with the Heiltsuk. His critique of Clifford's "Four Northwest Coast Museums" is an especially clear articulation of the criticisms many Northwest Coast scholars have of postmodern theorists of representation: their analyses may have a global reach but are rarely grounded in a rich historical and ethnographic understanding of a particular area.

The reader expects more from a chapter titled "Four Northwest Coast Museums," although the subtitle "Travel Reflections" induces a sinking feeling. Clifford himself agrees with, and thus tries to forestall, most possible criticisms. He says the piece is "closer to travel writing than to ethnography or historical research" (108) and that he views the museums as "variants within a unified field of representations." He admits this assumption is "questionable" (110) ... For Clifford each museum fills a space in a semiotic square. The University of British Columbia Museum is oriented toward the majority culture, with a presentation that is aesthetic and mainly ahistorical. The Royal British Columbia Museum is majoritarian and historical, with a unilinear reading of diachronic change. The two tribal museums are oppositional, with the U'mista Cultural Centre in Alert Bay accentuating a collective, political-historical presentation and the Kwagiulth Museum at Cape Mudge emphasizing the aesthetics of individual objects and their links to specific families. This is more or less true with respect to the majority museums.

The differences between the two Kwakwak'wakw museums is more subtle, however. Clifford stresses the presence of family identification at Cape Mudge with the lack of it at U'mista, which is true and makes for a different sort of presentation. Moreover, the U'mista display is permeated with the history of Dan Cranmer's potlatch, making every object subservient to this central theme. The Kwagiulth museum connects with history as well, however, including information about specific potlatches and especially about Harry Assu, the traditional Kwagiulth chief. A drawing of his fishing boat, the *BCP 45*, which was portrayed on the reverse side of the Canadian five-dollar bill, is prominently displayed. Obviously, a different orientation to the Canadian state than U'mista's is evident. This does not equate with an ahistorical or apolitical stance; rather, it equates with a different history and politics. One point entirely left out is the fact that Cape Mudge is a much different community than Alert Bay: prosperous, even by local white standards, and just across a narrow channel from Campbell River, a pretty, medium-sized city that draws many summer tourists. One of the problems such a community has is how to represent in cultural terms the wealth that derives from outside of the community. This explains concern with individual family crests and privileges. The museum functions to connect present elites with their ancestors, distinguishing between them and the nouveaux riches. The assertion that the Kwagiulth museum is somehow parochial, however, is simply not true. Once when I was in the museum, I trailed along behind a tour group of German visitors who were following a young Kwagiulth tour guide. The guide was giving them a tour in good German.

Clifford chooses to see these museums, justifiably, as marks of the "irruption," tears in the historical fabric. As these objects are no longer used in their original ceremonial

context, this represents an objectification of certain cultural practices that become in essence diacritical markers of cultural boundaries (and in many cases of status distinctions among families and individuals) ... The argument is a little too neat, however. There is never an absolute break with the past, although certain events (such as the prosecutions after Dan Cranmer's potlatch) mark turning points. They are likely to be remembered as epitomizing events that condense the changes that occurred rather more gradually. Moreover, as symbols these events (and the objects associated with them) have the potential for continued action. In all four of these museums, pieces are available to aboriginal artists who wish to copy or learn from them. The majoritarian museums contain recently made pieces. Clearly, there is a continuing movement back and forth between these institutions and the aboriginal communities, just as there is between aboriginal communities and their own pasts.

**19.XIV. Aldona Jonaitis. 1995. "The Boasian Legacy in Northwest Coast Art Studies."** In *A Wealth of Thought: Franz Boas on Native American Art.* Seattle: University of Washington Press; Vancouver: Douglas and McIntyre, 327-28, 330, 331.

In the mid-1990s, another facet of postmodernism in the anthropology of Northwest Coast art and representation involved the critical re-evaluation of the Boasian legacy of Northwest Coast art studies and its location in the Northwest Coast art canon. Aldona Jonaitis (b. 1948), a contributor to this volume and the director of the Museum of the North at the University of Alaska, Fairbanks, argued for the continuing relevance of Boasian scholarship in informing postmodern understandings of Northwest Coast art. Even though his Northwest Coast art scholarship was marked by what Jonaitis termed a "purity paradigm," she argued that his attention to history prepared the ground for the critical analysis of the arts of acculturation.

> I began this book by suggesting that Boas's art history warrants serious consideration as a classic corpus resonant with contemporary intellectual trends. An underlying theme of postmodernism is its critical challenge to the hierarchical assumptions of white male privilege that have in the past informed much scholarship. If we accept the premise that ideas should be judged within the contexts of their times, it is evident that Boas was posing a similar challenge. In his art historical as well as his anthropological writings, Boas succeeded in validating Native cultures during a time when many judged these cultures as inferior ...
>
> Much of the literature on Northwest Coast art that Boas inspired either implicitly or explicitly used art to promote the equality of Indians and whites ...

The last decade of the twentieth century is forcing scholars to confront critical questions: Who has the right to speak? What can that speaker speak about? With the discrediting of the sole voice of white authority, it is for some no longer acceptable for a non-Native scholar to speak, as the unquestioned authority, for Native people. As Jeannette Armstrong asserts, in a call for Native self-determination:

> ... imagine the writer of [the] dominating culture berating you for speaking out about appropriation of cultural voice and using the words "freedom of speech" to condone further systematic violence, in the form of entertainment about your culture and your values and all the while yourself being disempowered and rendered voiceless through such "freedoms."
>
> ... Imagine interpreting for us your own people's thinking towards us, instead of interpreting for us, our thinking, our lives, our stories. We wish to know, and you need to understand, why it is that you want to own our stories, our art, our beautiful crafts, our ceremonies, but you do not appreciate or wish to recognize that these things of beauty arise out of the beauty of our people.

... While no simple answer to this complex question presents itself, we can take Boas once again as a challenging departure point for promoting the cause of serious and ethical scholarship. Certain topics suggestive of future research are those that combine an acceptance of the privileged position of the Native voice with an ongoing effort to deconstruct the grand narratives that maintain the asymmetrical position of native peoples in the postcolonial world.

...

Boas's efforts to salvage what was disappearing sometimes led to his dismissing what remained. Adherence to what I might call the "purity paradigm" prevented him from recognizing some very creative responses to the acculturative process ... Although he said that he privileged history in his interpretation of culture, he sometimes chose to ignore the history that continued after contact with non-Natives. Although he himself was unable to envision the perpetuation of the Indian cultures he and his colleagues studied, he did lay the groundwork for later investigations of how artworks reflect ongoing Native accommodation to the situation in the colonial and the postcolonial world.

...

Although Boas did not celebrate acculturated art, an analysis of such art is by no means foreign to his perspectives on culture history. Indeed, including such works would be a logical step in his historical project, which characterizes the creative process as, on the one hand, originality within the constraints of culture and, on the other hand, a response to ongoing external influences.

**19.XV. Marjorie M. Halpin. 1994. "A Critique of the Boasian Paradigm for Northwest Coast Art."** *Culture* 14, 1: 6, 7-8, 13.

Halpin, in contrast to Jonaitis in 19.XIV, directly contested the Boasian tradition of understanding Northwest Coast art, concentrating on how Boasian scholars understood crests. Informed by postmodern perceptions of the instability and polyvocality of symbols, Halpin called into question the capacity for outsiders to claim any kind of expertise.

> Boas's work on Northwest Coast art was coloured by his preconceptions, and his need to order and systematize Sapir's "genuine, difficult, confusing, primary sources." ... In contrast to the Boasian rule-based paradigm, and with specific reference to Tsimshian-speaking peoples, Northwest Coast Native art is ambiguous, imaginative, unstable, poetic, endlessly variable, changing, and productive of the new, the unexpected. Of paramount importance in my analysis is the relationship between crest art and the oral tradition that still gives it meaning, a relationship that Boas did not understand.

...

> The thinking I am reviewing lies, as Johannes Fabian argues, at the heart of the Platonic or representationist tradition of Western thought (see also Caputo on the hermeneutics of suspicion):

>> ... the idea of representation implies the prior assumption of a *difference* between reality and its "doubles." Things are paired with images, concepts, or symbols, acts with norms, events with structures. Traditionally, the problem with representations has been their "accuracy," the degree of fit between reality and its representations in the mind.

>> ... The Boasian Northwest Coast art discourse assumes that Native images are inaccurate attempts to re-present or double the reality of the natural world. The work of the analyst is to correct for what are believed to be distortions of realistic animal forms caused by stylization and space-filling requirements.

...

> What Boas did in 1897 was to create a model of a system of rules about Northwest Coast art that permitted him and successive generations of anthropologists to write and lecture about it *without connecting it to the family stories told about it in the Native context* ... By artificially separating Northwest Coast art from its stories, by creating a system of rules for the art so that it could be interpreted without reference to these stories, Boas and the anthropologists who followed him, and they are many, seriously

misunderstood it. Furthermore, by separating art from its stories, Boas and his followers separated art from the community context which gave it meaning and life, and, finally, obscured the vital connection between art and the land which, whether intentional or not, was part of the colonial enterprise of separating Natives from their lands.

The purpose of this paper ... was to call into question the representationalist reading of Northwest Coast art. The meanings of art are contextual and communicate with those who are co-cultural with its creators. As scholars, we can grasp those meanings to the extent that we grasp that context. Our ability to be "experts" on Northwest Coast art is necessarily considerably diminished under this mandate, for it can no longer be a function of learning and applying simple rules to complex phenomena.

**19.XVI. Kirk Dombrowski. 2002.** *Against Culture: Development, Politics, and Religion in Indian Alaska.* Lincoln: University of Nebraska Press, 1-3, 7-8.

Kirk Dombrowski (b. 1967) is associate professor of anthropology at John Jay College and a specialist in political economy, historical anthropology, and religion in southeast Alaska. Most anthropologists of Northwest Coast art have focused their attention on the continuing production, repatriation, and preservation of Northwest Coast art. Dombrowski's narrative about the destruction of traditional regalia by Aboriginal Pentecostals provided a crucial reminder that the value of Northwest Coast art within Aboriginal communities, and what counts as cultural revival, remain contested and deeply imbricated with relations of power and capital.

In the autumn of 1992, in a village located along the Southeast Alaska panhandle, several converts of an all-native, native-led Pentecostal church started a bonfire of "non-Christian" items from their pasts as a way to demonstrate their new membership in the church and their "spiritual rebirth in Christ." Only those at the bonfire (who are still reluctant to speak about it) knew exactly what was burned, but rumors spread quickly that Indian dancing regalia had been thrown into the fire. Within a day or two, these rumors had reached every village and town in the region, and reporters were calling or visiting the host village in search of more details, and more drama. In the weeks that followed, people as far away as Seattle were listening to radio programs and reading newspaper stories about the demonstration, and almost all the coverage focused exclusively on the reports that native regalia had been burned. For months afterward, tensions between churches and native dance groups remained high throughout the region, and even today most native residents of Southeast Alaska are reluctant

to speak about the burnings or their inspiration for fear of dredging up still sensitive issues and hurt feelings ...

Whether or not any older cultural or dancing regalia was actually burned remains a point of contention. Charred bits of cloth were found in the fire, as were coffee cups and windbreaker jackets bearing the logo of the local ANCSA (Alaska Native Claims Settlement Act) or "native" corporation – an intertwined raven and eagle in Northwest Coast style, representative of the two moieties found among most Southeast Native villages. It is unlikely that any older cultural heirlooms were burned, if only because in most villages such items are now so rare that few of the young people attending would have had access to them. Some who sifted through the ashes reported seeing burned buttons – the remains of the type of buttons used on contemporary button blankets – and bits of felt, possible from the same type of item. Button blankets are much more common than the older heirloom pieces. Virtually all are recently made by members of village dance groups, and some are made as part of native culture classes taught in village schools.

Despite the lack of clear evidence, the regalia issue dominated the reaction that followed, becoming the central focus of people's conversations on both sides. And while none of the revival preachers would say whether any cultural items were burned – and none, it seems, could have known firsthand as none attended the burning – all defended a firm stance against certain cultural practices. This included, especially, a condemnation of the kind of native dancing that had become very popular in recent years, and which included the making and wearing of costumes – primarily button blankets and headdresses – that featured stylized designs of old clan symbols, laid out as in classical Northwest Coast art.

On the other side, non-church members (especially those involved in the current village culture movement) found the events reminiscent of a past incident in the village. For in this same village, early-twentieth-century converts to Christianity had convinced other residents to burn the nineteenth-century totem poles that stood in front of many of the village homes. The recent burnings, therefore, were eerily reminiscent of past attacks on native culture – and the people who supported it – by outsiders and their converts. Many culture-group members were led to ask, "Have we made no progress in the last ninety years?"

...

The similarities between the two situations did much to galvanize after-the-fact resistance to the 1992 burnings and to [Pentecostal leader Flo] Ellers – resistance that was used to mobilize support against Ellers and to cancel several future appearances she and others had planned for the revival ...

Yet much about the two sets of burnings is not the same, and these differences can help us to understand why the mere suspicion of regalia burning became the central

issue in the Flo Ellers incident. To begin, the culture movement of today is very much the public face of this and other villages. Supported by native corporations, village dance groups perform at most major village and regional social events. The work they do in teaching and performing contemporary versions of traditional cultural practices plays a large role in the symbolic representation of local identity – *much as early-twentieth-century Christians had sought to do* with the clothing, singing, and social groups associated with early Presbyterian and Salvation Army churches as well.

And just as the original totem-pole burnings had been quietly opposed by a group of non-Christians (primarily drawn from the community's more marginal segments), so too have today's born-again Christians quietly resisted the construction of a contemporary native identity by village culture groups and corporate elites. As mentioned above, these born-again Christians are themselves drawn from among the more marginal segments of the community, as were traditionals of the past.

If anything, the two situations mirror each other in the most literal sense, as seemingly identical events reversed in orientation. Today's culture movement may have much more in common with the past Christian identity movement than many people would normally suppose. The same is true for today's church members, whose closed ranks seem more like the traditionals of the past than they do the flamboyant Christians of the earlier era.

There are, however, ways in which these similarities and differences do not form such neat opposition. Clearly the two sets of burnings do not represent the same problem, and certainly not the same stakes. Much has changed in the villages, and today's divisions are very different from those of the past. Rather, in comparing the two I seek only to dismantle the easy explanations offered by many at the time – that the burnings were simply the result of long-standing, wrongheaded beliefs or bad theology on the part of the Christians who continue to fail to understand the nuances of native belief systems. There is much more to the recent burnings and confrontations than this.

**19.XVII. Jennifer Kramer. 2006.** *Switchbacks: Art, Ownership, and Nuxalk National Identity.*
Vancouver: UBC Press, 5-6, 14-15.

Jennifer Kramer (b. 1969), an editor of this volume, is a cultural anthropologist and curator at the University of British Columbia who has pursued research on collaborative museology and on the cultural dynamics through which Nuxalk art has become central to Nuxalk national identity. Ironically, though her text *Switchbacks* was the first explicitly postmodern ethnography of the Northwest Coast, it turned attention away from the dominant postmodern concern with the ongoing construction of (Aboriginal) objects as they circulate interculturally [see

19.XII]. Rather, in the first part of the excerpt, Kramer draws on Gell (1998), Townsend-Gault (1997), and Halpin (1994) [19.XV] to argue for Northwest Coast art as a multivocal social agent. The second part of the excerpt follows a description of the harrowing drive into the Bella Coola valley. It echoes Munn's (1986) and Tsing's (1993) work (in Melanesia and Indonesia, respectively) in addressing how external regimes of value and recognition animate the production of art and identity in an "out of the way" Aboriginal community.

> As many anthropologists have concluded, art represents identity, both individual and national. Many have written about the art of the Northwest Coast as property (objects) that tells us about the ownership of clan names, land, resources, responsibilities, and/or honours. Although I view this interpretation of the function of Northwest Coast art as important and valuable, this is not the focus of *Switchbacks*, which, rather, rests upon the idea that art is not principally about objects but about actions. As a result of my research I have come to think of "art" as a verb. If we accept this definition, I believe we gain a deeper and more nuanced understanding of what art can do. "Art as argument" is what Charlotte Townsend-Gault calls this kind of cultural production.
>
> Art as argument is both a process and an invitation to engage in dialogue. As such, it both taunts and intrigues; harangues and incites reaction; incurs apology and, perhaps, most important, brings recognition. Yet art also feints when it represents. It is both tangible and intangible, alienable and inalienable. Its power is its ability to walk this line of uncertainty, and this line of uncertainty – this ability to be never all/never nothing, always shifting – is its strength. For this reason it cannot be pinned down, no matter how hard people try to do so. Labels of national art styles or names of components such as "ovoid" or "formline" do not do it justice. Such terms, which describe a predictable, unifying, static form, cannot capture and make still the movement of art. The power of art lies in this shifting quality, which allows it to be many things to many different people. First Nations Northwest Coast art's strength is its ability to be meaningful yet never totally known. The argument will never be resolved. Art opens the door to a place of entanglement and transformation.
>
> ...
>
> Over time, I became more and more intrigued by the dialectic involved in identity formation in Bella Coola. Nuxalk identity formation is not a one-sided process that occurs in isolation from the outside world; rather, it involves a series of switchbacks ... The Nuxalk move between essentialist categories of modern and traditional, Western and "Indian," just as travelers on a switchback move from left to right but never stay in one place. The Nuxalk oscillate between the historical and the contemporary, between culture with a capital C invented by anthropologists and between postmodern culture, which is always in process. This movement can cause anxiety,

just as traveling the hill causes moments of hesitation, fear, and loss of direction; and yet the Nuxalk do move towards their goal of creating a strong, cohesive Nuxalk identity ...

Just as visitors to the valley, frightened of traversing the hill, reinforce a Nuxalk sense of self, so non-Nuxalk outsiders, who are in a kind of switchback relationship with the Nuxalk, are able to create a sense of Nuxalk ownership with regard to their identity and culture. This process was noted by some Nuxalk themselves. As one Nuxalk woman told me when discussing tourists coming to the Bella Coola Valley, "It takes outsiders to see wealth." She was referring to the bounty and beauty of the Bella Coola Valley itself, which most occupants take for granted. People only seemed to recognize the special qualities of their place when they encountered the reactions of others – for example, when visiting campers, hikers, and other tourists told of how surprised they were when everyone they passed on the road waved to them as they drove by ... [It] is important to valley residents to see themselves through visitors' eyes, and this vision is a good one – one that recognizes value. I highlight this point as it is crucial later on. One of the central theses of *Switchbacks* is that, for the Nuxalk, external recognition is needed if they are to truly appreciate their own natural and cultural environment.

# 20 | Value Added

*The Northwest Coast Art Market since 1965*

In October 2006, the Sotheby's auction sale of the "Dundas Collection" – seventy-seven works of Northwest Coast art, almost all Tsimshian – sold for a record-breaking US $7 million. One mask alone fetched an unprecedented $1.8 million. This marked a watershed moment in the international market for historical Northwest Coast art, and the astonishing prices caught the world's attention. The sale had involved lengthy and then, in the final days, urgent negotiations. Canadian private collectors, public museums and galleries, art dealers, the federal government, First Nations leaders and cultural representatives, and the media struggled to ensure that the most important objects from this coveted private collection, assembled in Metlakatla in 1863 by the Reverend Robert J. Dundas, would be "repatriated" to Canada from their exile in Scotland. Less than a year after the auction, a sumptuous book was published, edited by art dealer Donald Ellis (2007), with contributions by three former curators, a journalist, and a Tsimshian artist. Moreover, having already made a 150-year passage from "curio" to "national heritage," the artifacts that had been successfully purchased by Canadian individuals, dealers, and museums were taken on a cross-Canada tour. Once again, the objects' journey began in traditional Tsimshian territory, this time at the request of the hereditary chiefs of the Allied Tsimshian Tribes of Lax Kw'alaams and Metlakatla. As the chiefs celebrated their treasures' real (if temporary) homecoming, they brought into focus not only the difference between rights of ownership and the privilege of possession but also – and perhaps paradoxically – the entanglement of Indigenous cultural currency, mediating institutions, and art market values.

Together, these events describe a process that, in the language of economics, may be termed "value added": the contributions of production and marketing to enhancing or transforming the value of a product. The story of the Dundas Collection tells of objects circulating through local and international markets and venues, networks of players and institutions, parallel and colliding systems of value, and struggles over contexts and classifications. It reveals the articulations

of museums and markets, of art and commodity, of patronage and pedigree. And it makes clear that the "value" of things is not only a function of artistic intent and the material object itself but also generated by the broader social, institutional, and discursive contexts through which the object travels. As such, the story serves to introduce the evolving and still-variable discourses that have been constructed in and around the market for, and value of, Northwest Coast art since 1965 and that are the subject of this chapter. The references and excerpts cited here include texts that document, critique, or attempt to shape market reception; that propose, assume, or resist certain criteria for determining hierarchies of value and quality; and that demonstrate the routes and intersections of objects and players in the production, mediation, circulation, commodification, and consumption of Northwest Coast art.

The published materials that could be chosen for this chapter overlap considerably with texts demonstrating the discursive development of the broader Northwest Coast art world – particularly in the areas of artistic revival, exhibitions and institutional patronage, the revaluation of artifacts as fine art, and their further revaluation beyond "art" (e.g., M.M. Ames 1992b; Bringhurst 2000; S.C. Brown 1998; M. Crosby 1991, 1994; Duff 1967; Duffek 1983d; Glass 2002; Holm 1965; Holm and Reid 1975b; Macnair, Hoover, and Neary [1980] 1984; Nuytten 1982; H. Stewart 1979a; Townsend-Gault 1994). A search for literature and other materials relating specifically to the Northwest Coast art market, however, soon shows that texts directly documenting or analyzing market expansion since 1965 are almost as rare as was the still-intact Dundas Collection before it was placed on the auction block. Books about Northwest Coast art probably circulate more widely than the objects they both praise and appraise. Many are written by anthropologists, yet few approach the market anthropologically (as social organization) or examine how the texts and discourses they invoke are implicated in it. More commonly, the publications are intended to mediate between producers and consumers. And by conferring value on certain artists or selected categories of objects, they (and their authors) participate in the market alongside carvers, art dealers, collectors, museums, and other players (see Campbell, this volume; Kramer this volume).

As market players, the words used to name, describe, classify, and appraise Northwest Coast objects since 1965 have themselves been shaped by changing anthropological and art historical paradigms and remain engaged in a process of negotiation with Indigenous critiques and theories of aesthetics and value. Indeed, much of the discourse about the market for Northwest Coast art has set about defining criteria of value rooted in either anthropological or art historical perspectives (ignoring, until recent decades, Indigenous perspectives) and so has

often established opposing categories that are more fruitfully seen to be entangled. Critical investigations of the movement of objects across inscribed cultural, institutional, and geographical zones have therefore helped to shift the study of Northwest Coast art from the isolated object and the separate "Other" to a focus on encounter, circulation, and exchange within and through markets and "regimes of value" (e.g., Appadurai 1986; Becker 1982; Bourdieu 1993; Graburn 1976, 1999; Marcus and Myers 1995; Myers 2001a; Phillips 1998; Phillips and Steiner 1999; Thomas 1991). By approaching the market (or, more correctly, the diverse markets that make up the Northwest Coast art world) in terms of the intercultural production and circulation of culture, we are led to ask the questions that need to be central to its analysis. Who is the market? Who are the audiences? Who sets the criteria of value and for what purposes? Recent studies of art markets focusing on, for example, Aboriginal Australian art (Morphy 1995, 2000; Myers 2002) and Native American art of the Southwest and across the United States (Dubin 2001), moreover, provide comparative frameworks within which we can place the Northwest Coast art market in relation to changing global contexts (see Claxton, this volume).

In his study of the art market in Australia, Howard Morphy (2000, 136) observed that

> the marketing of Aboriginal art involves its movement from one context of production and consumption to another. Historically, there has been great resistance to this movement. The resistance has come less from Aboriginal artists than from Western practitioners, theoreticians, art dealers and analysts. For long, Aboriginal art was squeezed between the values of the art market and the radical critique of the art market, neither of which was willing to give Aboriginal art a place.

On the Northwest Coast, similar processes of resistance and persuasion have long been part of the production and reception of objects. If the 1950s marked the beginning of an institutionally driven shift in the categorization of Northwest Coast objects from ethnography to fine art (Hawker 2003), ensuing decades have seen struggles over discourse and value classifications continue, driven not only by dealers, collectors, and institutions but also by the artists and their communities. Indeed, the 1950s and 1960s were a time, writes Doreen Jensen (1996, 97), when "First Nations artists took the contemporary practice of traditional Northwest Coast art out of hiding and began a dialogue with non-Native culture."

Wilson Duff's (1964b) province-wide survey of Indian arts-and-crafts econ-omies in the early 1960s offers a starting point from which to explore the forms this "dialogue" took as the market began to diversify beyond sales of histor-ical materials to encompass more newly made work [20.1]. Already, in 1948, Kwakwa̱ka̱'wakw carver Ellen Neel had spoken publicly and forcefully about the lack of an economic incentive to produce quality carvings with an authentic relation to tradition: "Certainly a great work could be performed amongst the native people if a true appreciation of their work could be instilled into the general public" (in Hawthorn, BC Indian Arts and Welfare Society, and BC Provincial Museum 1948, 14) [13.1]. Duff similarly advocated for governmental, institutional, and public support of Aboriginal initiatives to make the produc-tion of both souvenirs and higher-quality works more commercially viable. His delineation of the terms for market growth focused on economic concerns while recognizing the social validity of changing cultural expressions within Native and non-Native contexts. Aboriginal leaders such as James Sewid made their own voices heard, seeking ways to position their communities to encourage this potential market while benefiting both culturally and economically from it – and, as Sewid (in Spradley 1969) made clear in his autobiography *Guests Never Leave Hungry,* doing so on their own terms [20.11].

Art market growth continued to be promoted in the 1960s as a modern appli-cation of Aboriginal visual traditions for Indigenous economic benefit, tourism, and formation of national identity (Glass 2006b; Hawker 2003; Jacknis 2002a). Such promotions were increasingly centred in urban Vancouver, Victoria, and Seattle, at a distance from rural Native communities, and assumed the inevitable death of a traditional Native context for carvings and other objects (often leav-ing the link between "cultural decline" and assimilation pressures unexplored). The growth of new markets to support continuing production was now seen to depend entirely on the development of an appreciative non-Native consumer public (Duffek 1983b). Expanding more rapidly than the market for Native prod-ucts, moreover, were institutionalized efforts to promote a "fine art" discourse for Northwest Coast art. Between Duff's 1965 study and his co-curatorship with Bill Reid and Bill Holm of the 1967 exhibition *Arts of the Raven* (Duff 1967), published references to the economic realities of cultural commoditization seem to have dissolved in the wake of an increasingly persuasive rhetoric of art and aesthetics (see Watson, this volume).

As is examined in more detail by other authors in this volume (see Glass and Ostrowitz), *Arts of the Raven* arguably remains the single most important exhib-ition and publication of the 1960s, which marked, according to Duff's (1975, 13)

later reflections, the "threshold over which Northwest Coast art has come into full recognition as 'fine art' as well as 'primitive art.'" In the same year, Audrey Hawthorn's *The Art of the Kwakiutl Indians and Other Northwest Coast Tribes* (1967), cataloguing the University of British Columbia Museum of Anthropology's (MOA) significant collection of Kwakwa̲ka'wakw and other Northwest Coast artifacts, also played an influential mediating role: for the public, it helped to bring to attention the historical and cultural value of this rarely exhibited material, thus stimulating market interest; for an emerging generation of carvers, it made images of ceremonial objects removed from communities accessible for study and replication. "Museums and their anthropologists entered the marketplace in full flight," observed Michael Ames (1992b, 60), "buying, evaluating, and promoting contemporary Indian arts and crafts to a remarkable degree." To these two major exhibition and publication projects, along with Hawthorn's further curation of *The Northwest Coast* in 1969 (profiling MOA's collection at Montreal's *Man and His World*), must be added the 1965 publication of art historian Bill Holm's *Northwest Coast Indian Art*. His textual codification of the stylistic principles underlying northern Northwest Coast composition – employing terms rooted in Western art historical methodologies and graphic design vocabularies – had an impact far beyond his intentions. Used by artists and audiences alike as a kind of manual for creating and appreciating the art's distinctive forms, it significantly influenced emerging understandings of this ancient and evolving art. Together with the commercial sector, institutional players picked up on Holm's formal analysis. Their focus on codified elements and "rules" became a means of authorizing the newly sanctioned – and increasingly marketable – field of Northwest Coast Indian art. The book's influence continues today among artists, marketers, curators, and collectors alike, delineating the formal criteria by which quality is judged (Duffek 2005; McLennan and Duffek 2000, 108-14).

We may view the 1960s as a period of increasing articulation of museums and markets, during which Native and non-Native participants worked to expand Northwest Coast art production into regional and international art worlds. Missing from the published texts that promoted a revaluation of the art are less-documented processes of persuasion and resistance, particularly as experienced by artists and dealers. Certainly, tensions over authenticity, traditionalism, commercialization, and pricing were felt in emerging markets. There is little published documentation of how various market players negotiated the relationship between the modernist values of isolating an object from its cultural context in order to enhance its value as art and the simultaneous resistance of the market to accepting such reclassification (Bradley 1975; see Ostrowitz, this volume). Bill

Reid's struggles in the early 1960s to set a price for his metalwork that would adequately cover his cost of materials and labour, and that the fledgling market would bear, are revealed in his personal correspondence with a shop owner who supported his early career. Reid makes light of the situation: "I don't know what to charge for the box ... but it's almost impossible to make one at a reasonable price ... Maybe we should split the mark up and take part of the price in prestige."[1] Here again we may examine the question of whose criteria, and which discourses, came to prevail in the emerging market. Most often the hierarchies of value created for Northwest Coast art, and that held the potential of economic opportunity, were recorded through institutional voices, as was the articulation of the art's value according to criteria of connoisseurship external to Indigenous knowledge and experience. These issues came to the fore more explicitly in the 1970s, when the burgeoning print market became a new focus for public discourse and debate.

A number of scholarly overviews of the history of Northwest Coast art market expansion should be mentioned here because they help to make sense of the routes and intersections of diverse participants through the 1960s and 1970s. It is useful to consider the literature of this period within its social and political context: a time preceding the public reassessments of Native rights over land and sovereignty – and their inseparability from the forms and functions of "art" – prompted by major land-claims cases such as *Delgamuukw* (1997). Michael Ames's "Museum Anthropologists and the Arts of Acculturation on the Northwest Coast" (1981a) [19.VIII] took a critical and reflexive position on the question of how museum anthropologists assisted in the creation, promotion, and distribution of what Nelson H.H. Graburn (1968, 1976) termed "acculturated artifacts." Offering a radical assessment for its time of the institutional position, Ames documented the specific history of museum patronage and involvement in displaying Northwest Coast material culture as "art" through exhibitions from 1956 to 1980, focusing on the major museums and galleries of British Columbia (see also Campbell, this volume). My own unpublished thesis, "The Contemporary Northwest Coast Indian Art Market" (Duffek 1983b) [19.XI], and related publications (Duffek 1983a, 1983d), followed Ames's lead by positing the Northwest Coast art revival as a clear development of the art market and investigating the history of market growth in relation to the values of non-Native consumers. Ira Jacknis, in his 2002 book on the transformation of Kwakwa̱ka̱'wakw ritual objects into works of art, *The Storage Box of Tradition: Kwakiutl Art, Anthropologists, and Museums, 1881-1981*, offered a comprehensive examination of the market within the contexts of cultural and historical exchange and of the construction of anthropological knowledge. Other writers and organizations provided

histories of the Northwest Coast art "revival" that were relevant to market concerns (e.g., Arima and Hunt 1975; Reserve Management 1978), and some took a critical approach to the implications of the renaissance discourse for the place of Northwest Coast art in broader art worlds (e.g., M. Crosby 1991, 1994; Jonaitis 2004; M. Reid 1993). Several publications by Aaron Glass (2002, 2006b, 2006c), who, like Jacknis, focuses his attention on Kwakwaka'wakw cultural production, brought new insights to the shifting intellectual, socio-political, and economic structures under which Northwest Coast materials came to be valued as fine art and a Northwest Coast art world developed. And most recently, in one of very few business-oriented analyses of the Northwest Coast art market, Toby Froschauer (2007) contributed a behind-the-scenes view of the underlying market mechanisms that inhibit or support the growth of the Northwest Coast art world, demonstrating how dealers, auction houses, public institutions, and collectors influence supply and demand, both regionally and internationally.

Silkscreen prints became the most highly visible symbol of market growth throughout the 1970s. Circulated widely to tourists and collectors, advertised as investments, heralded as fine art, dismissed as commercial art, and ritualized as potlatch gifts, prints were promoted as frameable works of art while simultaneously becoming framed within volatile debates about boundaries and classifications. Much of the writing on new Northwest Coast art during the 1970s and 1980s addressed the production and reception of prints, whether in a celebratory manner or by proclaiming a revival gone awry. American anthropologists Margaret M. Blackman and Edwin S. Hall Jr. wrote a number of research papers investigating the ways in which artists used the medium to learn and experiment with the two-dimensional visual traditions, to challenge the dominance of northern-style imagery, and to attempt an expansion of markets and audiences (Blackman and Hall 1978, 1981; E.S. Hall 1980; see Bunn-Marcuse, this volume). Together with the professional printmaker Vincent Rickard, they published *Northwest Coast Indian Graphics: An Introduction to Silk Screen Prints* in 1981 – a popular book that, like art historian Leslie Dawn's exhibition catalogue *The Northwest Coast Native Print: A Contemporary Tradition Comes of Age* (1984), helped to validate the print medium by placing it within a cultural and historical context, recognizing it as in the vanguard of contemporary expression, and demonstrating that prints were worthy of serious attention. Dealers also joined forces with public galleries to document and stimulate market expansion (McKillop 1984; Burnaby Art Gallery 1980). The intersection of market players was further demonstrated by dealer initiatives such as numbering complimentary "Museum Proofs" as part of print editions to ensure the placement of these works in prestigious museum collections – an example of marketing practices documented

only through the original promotional flyers, a kind of ephemera unlikely to be preserved yet valuable as text.

The growing market for Northwest Coast prints became a springboard for a new generation of Native artists to expand the possibilities for reanimating traditional practices and iconographies, whether they chose to restore specific styles, integrate new media, challenge the strictures of modern art, or disrupt prevailing expectations of "Northwest Coast design" (Duffek 1983b; B. Ellis 1978; Halpin 1979; A. Hawthorn 1964; H. Stewart 1979a, 1979b). Inexpensive and widely accessible, prints gained popularity among both artists and collectors to the point that by 1981 nearly a thousand print editions had been produced by over a hundred artists (Blackman and Hall 1981, 55). Yet, according to Edwin S. Hall Jr. (1980, 5), the situation by the mid-1970s "could only be described as chaotic," manifesting dealer concerns about the unregulated distribution of prints to both fine-art galleries and tourist shops and the pricing of works with no relation to artist stature, edition size, or formal quality (D.R. Young 1980). With both the economic and the "fine-art" legitimacy of the medium threatened by such controversy, "quality" and its criteria of judgment became central issues in the print market and its discursive framing – ironically, as Glass (2006b) points out, at a time when issues of craftsmanship and quality were no longer privileged for non-Native contemporary art. The formation of the Northwest Coast Indian Artists Guild was an artist-driven attempt to police standards and thereby control the distribution and reception of high-quality work (David 1978; Vickers 1977). Recognizing the perception that the authenticity of their art was challenged by its link to the commercial, Guild artists worked to simultaneously enhance their prints' commodity value while shifting the discourse of evaluation: first toward measurable standards of "quality," later toward the art's cultural-use value and even spiritual connection [20.III, 20.IV].

The debates that focused on silkscreen prints, but also extended to carvings and other "traditional" art forms, may be seen as part of ongoing, broader efforts to create a discourse with which to evaluate the value, quality, and authenticity of works circulating cross-culturally and created for intercultural contexts (Duffek 1983c). The tensions, of course, arose from the question central to this essay. From whose point of view are the criteria defined? Media critiques of market growth – often constructed in terms of an opposition between authenticity and market success – highlighted the apparent chasm between an art aspiring to inclusion in global art worlds and an art tied to cultural practice and tradition [20.v]. Even as prints were becoming prominent in the market and, as Bill Reid (2000c, 162) wryly observed, "an increasing area of the earth continues to be covered with formlines and ovoids," concurrent events in local and

international venues countered any notion of consensus on determinations of value. During the 1970s, Northwest Coast art, in all its diversity, was claiming a place at art exhibitions and community potlatches, Native-run shops and carving programs, weavers' cooperatives and craft fairs, totem pole raisings from Hamburg to Kispiox, the new Gitanmaax School of Northwest Coast Indian Art at 'Ksan, and the new Museum of Anthropology in Vancouver (Duffek 2004a; Haberland 1979; King 1997; National Museum of Man 1972; Steltzer 1976, 1984; Vancouver Art Gallery 1974). Inclusion within the arena of modern art remained a goal and a site of struggle for many artists. But as the critical examinations by Hal Foster (1983) and Fredric Jameson (1998) of modern and postmodern art testify, by the 1980s "'culture' was returning to an art discourse that had long since occluded it in the hopes of encouraging the pure aesthetic appreciation of indigenous materials" (Glass 2006b, 703). That is, while "culture" did not necessarily need to be rediscovered within Indigenous discourses about their own visual traditions, it was returning to the Western gaze, pushed into view by prominent artists such as Tony Hunt, whose practice had long traversed the border zone between gallery and bighouse [20.VI].

 "Who is to validate the Native artist and his or her work," asks Michael Ames (1992a, 82), "the museum, the critic, the market, the anthropologist, or Native tradition as interpreted by the elders or political leaders? Native artists, in their desire to escape ethnological museums, may end up as captives of the art galleries and their curators instead, and still be subject to the external validating procedures of the dominant society." Here Ames inserts a sharp and still resonant critique into a changing and apparently progressive discourse, revealing that questions about criteria of value, and who sets them, had not been resolved. Although Northwest Coast art was now, to an increasing extent, entering the domain of fine-art markets and mainstream art institutions, it was not yet clear whether Indigenous epistemologies could or should encompass, or be encompassed by, Western art frameworks. The strengthening and renewal of cultural and ceremonial practices within communities were forcing a rethinking of the costs of such inclusion [20.VII]. And in the art gallery context, there was emerging uncertainty about approaching the work of contemporary Northwest Coast artists as autonomous art: the limitations of aesthetic appreciation alone could be further compounded by limited translation of the meaning an object held within Native cultural practice (Townsend-Gault 1992).

The almost frenzied production and consumption of prints through the late 1970s, with accompanying calls for market controls, had shifted by the mid-1980s – the beginning of a period of maturing for an art market now established (and validated) through institutional patronage, a mainly regional demand for

Northwest Coast art, and the local development of a formal commercial gallery system (Froschauer 2007). The "idea" of Northwest Coast art, however, has not remained stationary in the midst of still-expanding and continually contested discourses among audiences, makers, and mediators regarding hierarchies of value. And while the changing discursive frameworks surrounding Native art in museums and the collector market are well represented in the literature, the parallel, growing, and sometimes intersecting potlatch economy – which must also be considered a "market" for the contemporary art – continues to be understood and remembered by community members and recorded in family videos but has little publicly available documentation (see Nicolson, this volume). 'Namgis artist and ceremonialist William Wasden Jr. reports that notebooks are kept by some Aboriginal families to record financial transactions, ceremonial names given, and gifts (including art) distributed (personal communication, 27 November 2007; see also Claxton, this volume). Jacknis (2002a, 205) has placed the potlatch market in a broader context, adding that

> over the past century there has been a profound change in the professional production of such ceremonial art. No carver can now support him- or herself solely by this means. In fact, the influence goes the other way. The robust white market has allowed Native artists to become full-time professional specialists, who can then turn their attention to the much fewer, less lucrative, but more meaningful ritual commissions. Without this essentially foreign market, one wonders if the current ceremonial revival would have been quite so vital.

In terms of the discursive construction of Northwest Coast Native art, then, it is worth recognizing the interplay (and relative positions) of economies in refiguring regimes of value: unevenly recorded at best and more frequently absent from the prevailing institutional documentation.

Exhibition catalogues, by contrast, are among the most widely accessible texts documenting and shaping the Northwest Coast art world and its fields of reception. Here institutional and market discourses may be seen as complicit with one another. Such publications function as mediators between producers and viewers/consumers, whether the catalogue is created to accompany an exhibition in a public museum or a commercial venue. "Even as the museum removes art from the market, it is implicated in that market," notes Kirshenblatt-Gimblett (2001, 264-65). "Museum exhibitions increase the value of particular works simply by exhibiting them," arresting "the commodity stage of particular objects while stimulating the market for related work." *The Legacy: Continuing Traditions*

*of Canadian Northwest Coast Indian Art* (Macnair, Hoover, and Neary 1980) may be unsurpassed in the impact of its institutional validation of contemporary Northwest Coast art for a worldwide audience, at a time when the new work was not widely appreciated. This was the first book to survey Northwest Coast art in terms of historical and stylistic developments while also highlighting newly commissioned, contemporary works as individual expressions of living cultural traditions. The criteria by which artists were selected are clearly laid out in the text: Northwest Coast Native ancestry, a thorough understanding of the old styles, and cultural participation. As standards of value and cultural authenticity, these criteria defined a new kind of connoisseurship for non-Native institutions to adopt, based not on formal qualities alone but on recognition of Aboriginal values regarding the artist's responsibilities to cultural practice. They also delineated a discursive framework that continues to mark the boundaries of the Northwest Coast art market: a set of criteria that emphasizes the legitimate place of tradition-based practice in contemporary art worlds but fails to address the validity of art that struggles against the market's boundaries or the commoditization of traditional forms. Peter L. Macnair elaborated on the same criteria in 1994 for a commercial gallery publication [20.IX]. Liaising with museums is a common strategy of private galleries and is not surprising in a "field of cultural production" in which symbolic capital needs to be accumulated by dealers as well as institutions (Bourdieu 1993). The curators' authenticating texts transform the now-established privileging of institutional authority into a "value-added" component of the artworks being offered for sale.

Of the countless exhibition catalogues and similar publications produced in recent decades by public institutions and commercial galleries, a number of genres can be identified, based on the thematic criteria by which objects and their makers are selected for inclusion: broad surveys of either historical or contemporary art, or combinations of old and new works, or groupings of Northwest Coast with other Native or non-Native works; smaller groupings of selected artists or types of media; volumes featuring a single artist, past or present; highlights of museum or private collections; and items being sold at auction or in a special commercial show (e.g., Arnold, Gagnon, and Jensen 1996; Augaitis 2006; Blanchard and Davenport 2005; S.C. Brown 2006; Coe 1986; Gallery of Tribal Art 1992; Gerber and Katz-Lahaigue 1989; A. Hawthorn 1963b; Holm 1983c; Jensen and Sargent 1986a; Macnair, Joseph, and Grenville 1998; Yuxweluptun, Townsend-Gault, and Watson 1995; Thom 1993; Vancouver Art Gallery 1974; Wyatt 1994, 1999, 2000). These, along with the many other books on Northwest Coast art now available, address Ellen Neel's earlier challenge of 1948 to instill "a true appreciation" of Native art among the public in order to

help constitute an informed audience and foster increased demand for quality work. Sometimes analytical but often promotional, with little critical examination of their historical contexts, such books have nevertheless become a tool for disseminating knowledge, contributing to rising connoisseurship and the definition of standards against which other works are judged. Catalogues provide a new kind of visibility to art forms and styles previously excluded from the formal canon of "Northwest Coast art," such as basketry and Salish-style work. Books featuring "masterpieces" of historical art emphasize the scarcity of objects, moreover, simultaneously influencing market demand for old pieces and for similar works by new generations. And among contemporary artists, the solo-exhibition catalogue – particularly if produced by a major art museum – offers the rarest and arguably most desirable form of market distinction. Froschauer's research (2007) showed how the Museum of Anthropology's 2004 exhibition of Robert Davidson's art, without being directly involved in sales, resulted in new price levels for this artist's work, the values being enhanced by the promise of a tour to several venues, the presence of a catalogue (Duffek 2004b), and a showing at the National Gallery of Canada.

In contrast to permanent museum displays, the temporary exhibition has consistently been the "vanguard of changing attitudes toward Native arts," Jacknis (2002a, 118) has suggested, because of its ability to "respond quickly to shifting points of view." Catalogues, with their textual permanence, form an archive through which future analyses of that vanguard may be made. Here, too, questions about the relative positions of market players and their criteria of value need to be asked. How have exhibitions delineated the category of "Northwest Coast art"? Whose were the voices heard, what was being documented, and for whom? Certainly, the changes in meaning that occur as objects shift contexts and move into frameworks of consumption are rarely made explicit, whether by museums or by commercial galleries. Even where consumption is the purpose of a show, this fact is usually addressed only by way of a separate price list that is not bound into the catalogue text. (Such lists themselves are important documents for collectors and curators alike, used to track and compare market values.) The intercultural contexts for Northwest Coast art also receive uneven attention (compare, for instance, the approaches taken by Coe 1986; Wyatt 1999; and Yuxweluptun, Townsend-Gault, and Watson 1995). Instead, through both image and text, the formal qualities and "ethnographic" contexts of objects tend to be privileged, as is an attempt to define the new in terms deriving from the old. Increasingly, artists' statements are included, often describing the legendary character or supernatural creature represented in the work. These reference and perform cultural continuities and teachings as well as ongoing rights to specific

hereditary privileges. At the same time, they mostly leave unasked (and un-answered) any questions about how individual artists negotiate the relationship of their work to contemporary economies, art world discourses, and Indigenous criteria of value. Examples of refreshingly contrarian approaches are demonstrated by Ḵi-ḵe-in [20.IX] as well as the Haida artists Robert Davidson, Michael Nicoll Yahgulanaas, and Don Yeomans in Augaitis (2006, 155-69).

"At each point in its movement through space and time," Christopher B. Steiner (2001, 224) has noted, "an object has the potential to shift from one category to another and, in doing so, to slide along the slippery line that divides art from artifact from commodity." But the processes of boundary making, and the shifts in value that accompany recategorization, involve more than a trajectory along which objects may slide. On the Northwest Coast, tensions arise as artists seek to participate in, and navigate between, the articulated realms of cultural communities and local and regional economies (Neufeld 2002). The commercial purpose of much Northwest Coast art, moreover, is often seen to counter its "authenticity," echoing a critique of commoditization common to global discourses on art and its circulation through art markets. "Sometimes the scandal is that art and money are linked when they are culturally constructed as contrasting forms of value," Myers (1999, 265) observed, "sometimes the scandal is that certain styles or categories of objects are valued not because they represent transcendent value but because they embody the tastes of a particular class." Critics and observers of the art's commodification may attribute artists' adherence to traditional motifs and iconographies as being market driven – as responding to consumer expectations of Native authenticity that reinforce colonial relations and stereotypes of the unchanging Native (Duffek 1983a; Hennessy 2005; Linsley 1991; O'Hara 1999; J. Scott 1985; Townsend-Gault 2006; Watson 2004). Yet some of the same kinds of objects, such as masks, have a simultaneous presence in community use, where their functional role belies any assumption that the institutionalized art world and its urban markets mark the "centre" in which value and reception are determined. "Some of the great artists had two classifications for creating artistic objects," according to Andrea Sanborn (2005, 33-34), the late executive director of the U'mista Cultural Centre in Alert Bay.

> One was for creating for cultural ceremony and the other was creating for economic trade much like they still do today ... Young people are instructed by their teachers and their families to learn the protocols of the two worlds, the world of public audience and the world of the audience at our sacred ceremonies. Both worlds are very important to our people. We learn from both.

The idea of the commodity has been re-evaluated in recent decades by schol-
ars such as Arjun Appadurai (1986), Ruth B. Phillips (1998), and others, who
approach commodification as a dynamic process in which an object may shift
between having use value and exchange value and between being considered
alienable and inalienable. In her research on the buying and selling of Nuxalk
art, Jennifer Kramer (2006, 61) argued that the Nuxalk "tend to use their art as
an inalienable commodity," viewing it as a kind of patrimony from which they
can never be severed, even when sold outside the community; she added that
"the Nuxalk are aware of the value of their art and that this value, while not es-
sential, can be deployed strategically through the sale of art for profit, political
visibility, or even the creation of tourist ventures." Charlotte Townsend-Gault
(2004a) extended the seemingly contradictory notion of "inalienable commod-
ities" into a segment of the Northwest Coast art market that is more commonly
assumed to epitomize the alienable and commoditized: the often mass-produced
trinkets and other "non-trivial trivia," featuring designs and motifs derived from
crest imagery, that she suggested now circulate as declarations of what is inalien-
able from aboriginality – that which is beyond the reach of the consumer and
"can be displayed but cannot be exchanged" [20.XI].

The useful confusion of categories that characterizes recent scholarship on
the circulation of Aboriginal art through "regimes of value" takes another form
in the ephemera through which the market represents itself. Commercial gallery
advertisements in specialized magazines such as *American Indian Art*, flyers and
other promotions, websites, invitations to openings, and gallery labels and price
tags (or, for the more exclusive shops, a meaningful absence of pricing informa-
tion) make visible the terms and taxonomies by which different kinds of outlets
seek to distinguish themselves, their intended clients, and the kinds of art works
they sell. Here distinctions between the historical and the contemporary, the
souvenir and the collectible, and various degrees of authenticity continue to
matter despite their overlaps and intersections. Geographically speaking, the
market for contemporary Northwest Coast art is a regional one; its agents are
striving to reach farther afield and follow the now-global diaspora of historical
objects into international arenas, yet to date the market remains firmly centred
in the Pacific Northwest: Vancouver, Victoria, and Seattle. The market for his-
torical works, particularly for the oldest and most highly valued artifacts, is
based in the established auction centres of New York and Toronto (Milroy 2006).
Froschauer (2007, 8) differentiated these markets as together comprising three
platforms: the "primary" market for works available to the public for the first
time (usually newly made works and occasionally historical objects such as those
sold as part of the Dundas Collection); the "secondary" market, which is the

most lucrative segment and mainly involves the sale of historical works; and the "tertiary" or auction market, also primarily for historical works. Each platform is defined in relation to the other, staking its claim to particular audiences, ways of valuing, and methods of distribution [20.XII, 20.XIII]. Each is also, therefore, a location at which the boundaries may be contested between what is and is not contained within the "Northwest Coast art market" as a whole.

The question of boundaries remains vital in an art market characterized by a history of struggles over inclusion and exclusion — in and from criteria of value as well as the discourses that name them. Artists are increasingly creating a presence for their own work on the Web, providing sites for display, interaction, and self-curation that challenge established routes for market entry and relations of reception. Others are working to define criteria by which the "authenticity" of both artists and cultural art forms can be determined and protected in the market – an often contentious project requiring the negotiation of legal understandings of copyright, Indigenous protocols, collective cultural property, and individual artistic expression (K. Harrison 2002; Roth 2013; Sanborn 2005; Sheffield 1997). The limitations of the market and its discourses of authenticity are resisted, moreover, by artists who identify with their specific cultural traditions yet practise outside the still-prevalent mediums of carving, printmaking, and jewellery described by Duff in 1965. They raise the following questions. Does serious critical consideration of their art within the broader contemporary art world require their move outside the boundaries of the "Northwest Coast art market" altogether? And, again, who has the authority to decide?

The record-breaking sale of the Dundas Collection at auction in 2006 became a talisman of market expansion and success and so provided a platform on which the spectacular values could be simultaneously acknowledged and overridden. A rhetoric of high art and masterpiece was performed at the exhibition openings by Native and non-Native participants alike. Yet, through the voices of the Tsimshian chiefs who honoured the events by speaking publicly about their treasures, the collection also came to symbolize that which was not encompassed by the market: the ownership of rights to the histories and hereditary privileges the objects represent. The words that were spoken focused attention on the objects and their place in the living community. They also pointed to the importance of considering the cultural practices of art markets and the challenges brought by new (and old) articulations of value. As Marjorie M. Halpin (1978, 59) observed, "regardless of what such things do to the market, they need to be said." How Northwest Coast objects and their markets are understood will continue to be shaped by debates over discourse: the words through which the art is named, "value-added," and thereby transformed.

**20.I.  Wilson Duff. 1964. *The Indian History of British Columbia.*** Volume 1, *The Impact of the White Man.* Anthropology in B.C. Memoir No. 5. Victoria: British Columbia Provincial Museum, 76-77, 80, 83.

During the period from 1950 to 1965, while Wilson Duff (1925-76) was curator at the British Columbia Provincial Museum (now the Royal British Columbia Museum) and before he took up an academic position in the anthropology department at the University of British Columbia, he was involved in ethnographic research among Aboriginal peoples in British Columbia and participated in the salvage and preservation of totem poles from abandoned village sites. His contributions to the study and analysis of Northwest Coast art are most often recognized in the seminal *Arts of the Raven* (1967) and *Images: Stone: BC* (1975), both of which marked his growing and shifting engagement with Northwest Coast objects (M.M. Ames 1981b; M. Roth 1999). Preceding those publications was the first of his planned but unfinished series of volumes on the Aboriginal history of British Columbia, from which the following excerpts are drawn. A scholarly work written for non-specialist audiences, the book has been reprinted multiple times and continues to be an important reference on the impact of non-Native settlement on Aboriginal peoples in British Columbia.

Here Duff contributed a picture of the state of Native arts-and-crafts production in 1964 and described the challenges that producers were then facing to make their work economically viable. He clearly located production in an intercultural present, acknowledging the legitimacy of the work even though its forms and purposes had accommodated a non-Native audience. Duff's later use of a modernist language of universal, "fine-art" appreciation was noticeably absent here; rather, Duff presented arts-and-crafts production as adaptive, evolving, and locally situated within a context of Native/non-Native relations. At the same time, he reaffirmed oppositional categories such as "Aboriginal forms" and "not Aboriginal at all," or "handicrafts" (the work of women) and "Indian art" (the work of men), with which the market and its discursive frameworks were being established and against which they have continued to struggle.

> The material goods made and used by the Indians have changed so completely since the arrival of Europeans that most aboriginal forms may now be seen only in museums (which incidentally is one good reason for the existence of museums). A few modifications of such old forms as moccasins and dugout canoes still find occasional use in some of the native villages. But on the whole the technology of the Indians was rendered obsolete and replaced by the technology of the white men. And as a general rule the degree to which the Indians have adapted themselves to modern North American material culture is the degree to which they have been successful in finding their way in today's world.

Indian arts and crafts are present-day products which have evolved directly or indirectly from old native forms, and which have enjoyed a continued development because of a demand for them in the larger culture. White men have been buying useful Indian wares and "curios" since the time of first contact, and continue to do so. Although these are removed from their original native contexts, they still satisfy real needs. Handicrafts such as baskets still find uses in the modern home. Indian arts such as wood carving are much in demand by modern interior decorators. Their appeal lies partly in their identification with the Indians and with the local region, but it is also the appeal of skilled hand craftsmanship in an age of standardized machine-made products. Most of these crafts have evolved a long way from their aboriginal proto-types; in fact many of them (beadwork, silverwork, argillite carving, knitting) are not aboriginal at all, but of mixed Indian-white origin. Since it is in the larger culture that these crafts are actually used, and since the demand from the larger culture influences their forms, they are just as much products of the material culture of modern North America as they are products of Indian culture.

...

### ARTS AND CRAFTS

The special skills which have persisted or developed from the old Indian cultures fall into two groups: "handicrafts," which are usually the work of women, and "Indian art," which is usually the work of men. There is a tendency for some of the more difficult and time-consuming skills, like basketry and weaving, to be relinquished with the passing of the older generation, but other skills such as carving, painting, and knitting seem to be more than holding their own. In practically every part of the Province, Indians add to their cash incomes by practicing one or other of these skills as a full- or part-time occupation. Conscious attempts have been made by non-Indians to preserve and stimulate native arts and crafts. In 1939 in Victoria the Society for the Furtherance of B.C. Indian Arts and Crafts (later changed to B.C. Indian Arts and Welfare Society) was established, and its founder, Dr. Alice Ravenhill, published a book of designs called "A Cornerstone of Canadian Culture." This organization and others, such as the Canadian Handicrafts Guild, have maintained a constant interest in native crafts. It seems to be generally agreed that these skills could yield much higher returns to the Indian people if more efficient procedures were introduced to procure raw materials in bulk, give instruction to craftsmen, educate the buying pub-lic, and improve marketing arrangements. Some non-Indian retailers have found it good business to assist Indian craftsmen along these lines. The Indians themselves have been less successful in trying to organize the production and sale of crafts, and to date they have had little in the way of assistance from the Indian Affairs Branch or other government agencies.

The arts and crafts which at present contribute significantly to Indian income are the following:

Basketry and weaving.
Skinwork and beadwork.
Birchbark baskets.
The Cowichan knitting industry.
Argillite carving.
Silverwork.
Jade jewellery.
Wood carving and painting.
Totem pole restoration projects.

...

## WOOD CARVING AND PAINTING

The coast Indians have, of course, been master wood-carvers for many centuries, and the art style they evolved was essentially a wood-carvers' style. Most objects of Northwest Coast art were of carved and painted wood: totem poles, canoes, masks, rattles, staffs, dishes, spoons, and so on. It is not surprising that something of this emphasis has persisted, and that a large proportion of the objects made for sale by the coastal tribes today are of wood.

The totem pole has attained the status of the symbol or trademark of the entire area, and totems, large and small, good and bad, are the most common of the objects made. Full-sized poles are seldom attempted except in formal programmes of totem pole restoration, but a few individual carvers accept contracts for poles from 5 to 15 feet in height. Small models ranging in size from a few inches to 2 feet are made by the thousand: these formed no part of the aboriginal cultures but originated in response for the demand for curios; some (mostly Kwakiutl) reveal fine craftsmanship in an established tribal art style; but most represent the individual styles of carvers of the southern coast tribes who had little or no traditional background of totem poles, and are "garish and meaningless little souvenirs." The talented Indian carver has to choose between volume production and low-priced souvenir poles (called by some "idiot sticks") and works of high quality which must be sold for high prices. The demand for excellence is growing, and the few carvers who develop their own skills to the point where they are producing fine works of sculpture are also in effect extending their own tribal traditions.

Masks are also carved in large numbers for sale, and are often finished in plain modern styles (sometimes sand-blasted to emphasize the grain of the wood) rather than painted in the old fashion. Feast dishes, spoons, paddles, plaques, and single

animal figures are also made in numbers and, like masks, make striking furnishings for modern interiors.

The painting of Indian designs on paper, fabrics, or wooden panels has enjoyed a recent revival among Kwakiutl artists. In part this was stimulated by sets of paintings which were done for the Provincial Museum and the University of British Columbia by Mungo Martin, in part by private dealers in Vancouver. The effect has been the production of a surprising variety of designs which, though not slavish copies of old designs, are purely Kwakiutl in style. Though times have changed, that style is still evolving.

Indian designs have also been adapted by non-Indian craftsmen for the decoration of wooden and ceramic bowls and other objects. Some of these are quite attractive, but most (especially in ceramics) lose something of the character of the original designs.

**20.II.   James P. Spradley, ed. (1969) 1972. *Guests Never Leave Hungry: The Autobiography of James Sewid, a Kwakiutl Indian.*** Montreal: McGill-Queen's University Press, 240-42. Originally published by Yale University Press.

James Sewid (1913-88) was an influential political and cultural figure, holding positions of high rank among the Kwikwasutinuxw and Mamalilikala and becoming the first elected chief on the 'Namgis Reserve at Alert Bay. Committed as much to revitalizing the potlatch as to modernizing his community, Sewid worked to strengthen Kwakwaka'wakw sovereignty within the political economy of British Columbia. In the late 1960s, he collaborated with anthropologist James Spradley to publish his autobiography, part of a research project designed by Spradley to examine individual adaptations to culture conflict and negotiations between the Native and non-Native social and cultural worlds.

The following excerpt is drawn from the final chapter of the book, in which Sewid described his efforts to preserve aspects of the "Indian way of life" that had become threatened as a result of anti-potlatch legislation. He began by referring to his construction of a bighouse in Alert Bay together with Henry Speck, Simon Beans, and others – a building he envisioned for community ceremonial purposes as well as for the economic potential of performing dances for tourists and selling arts and crafts. By the late 1960s, the growing Indian-arts market was no longer dominated by sales of old artifacts. Sewid saw that the revival of art-and-craft production offered a much-needed source of employment but required Native agency in negotiating the intercultural power relations behind market development. His advocacy for revival, therefore, extended beyond cultural preservation and visual tradition toward greater Kwakwaka'wakw control of their own representations, their cultural property, and the production and circulation of objects in expanding art worlds.

In the back of my mind one of the main reasons for building that community house was to have a place where we could try to preserve the art of my people. I knew that it was going to be lost if we didn't try to pick it up and it wasn't just because the people were losing interest. The main reason that our customs, dances, and art were dying out was that they had been forbidden by the law against our will. In fact, many of our people had been put in prison for refusing to give up their way of life. Old Herbert Martin had gone to jail for that and it was people like him that were responsible for preserving many of the old customs. After we had started with the carving and building I called a general meeting of the Nimpkish band and told the people that we thought it would be wise to form an organization of some kind to revive the arts and crafts and work in the community house when it was completed. We decided on the name "Kwakwala Arts and Crafts Organization." In order to get the people to belong to it and take an interest in it we printed up membership cards and charged each member a dollar a year to join it. I told them when the building committee was finished with the house we were going to dissolve that committee and call a meeting of all the members of the Kwakwala Arts and Crafts Organization to appoint the directors.

Then I sent this letter to all the other villages in the Kwakiutl agency:

> Box 245
> Alert Bay, B.C.
> February 11, 1964

TO CHIEFS AND COUNCILLORS OF THE KWAWKEWLTH NATION

Dear Chief and Councillors:

This is to inform you that an organization has been formed at Alert Bay for *all Kwawkewlth Natives.* The name of the group is the Kwakwala Arts and Crafts Organization. The aim of this group is to revive the Arts and Crafts as well as the dances of our people.

To be a member of this organization you must be of Native Indian *Descent.* A fee of $1.00 to be forwarded to Mrs. Dora Cook, Alert Bay, B.C.

A Community House is, at present, being constructed at Alert Bay. When completed it will be used as a workshop for those who cannot afford the required tools, etc. and of course it shall also be used for the performance of our Native Dances. The members who are unable to work at Alert Bay are requested to forward the articles they wish sold to the Organization and they will be sold for them. This Organization is also formed to stop exploitation of those who have tried to sell their articles to dealers themselves and have not received the full value of their work.

It is very important that we back this organization for it is for your benefit. There is a great demand for our Arts all over the world. Letters have been coming in from numerous people requesting different articles when they heard about our organization. If we do not take a firm stand now, we shall lose our dances, carvings, etc. to the non-Indians as well as to the other Nations. These people know the great demand and value of our Arts for they have already begun to learn and produce them. These are ours and our people should be the people to benefit from them. Let us not lose our Arts like we did our lands, for if we do we shall regret it.

As you know unemployment is getting worse each year. Let us help one another and start an industry of Arts and Crafts for our people.

Your support would be greatly appreciated. We would request that you read or pass the information in this letter to your people. Any comments would be welcome.

Yours truly,

James Sewid

**20.III. Roy Henry Vickers. 1977. Introduction. In *Northwest Coast Indian Artists Guild: 1977 Graphics Collection.* Ottawa: Canadian Indian Marketing Services, n.p.**

Roy Henry Vickers (b. 1946) came to prominence in the burgeoning Northwest Coast print market of the 1970s after spending two years studying at the Gitanmaax School of Northwest Indian Art at 'Ksan. Of mixed Tsimshian, Heiltsuk, and British ancestry, Vickers became recognized early in his career for his merging of Christian and Tsimshian mythological motifs using a 'Ksan graphic style. He moved away from Northwest Coast iconography in later works, creating silkscreen prints in a more illustrative or narrative genre. In addition, he has worked on a monumental scale in wood. Vickers played a leadership role in forming the Northwest Coast Indian Artists Guild in 1977; today he remains active in the market as one of the few Aboriginal artists who operate their own commercial galleries, and he has authored three books about his art and life (1988, 1996, 2003).

The following excerpt introduced the catalogue accompanying the first release of Guild prints. With the contemporary Northwest Coast Indian art market already well established, and with prints rising in popularity, Vickers and other artists identified a new challenge accompanying rapid market growth: the need to reduce consumer uncertainty in differentiating between high- and low-quality work. The Guild, therefore, was formed not only to produce fine-art serigraphs but also to help create a niche market by controlling their distribution and reception. Here Vickers promoted a discourse of quality, authenticity,

and enforceable standards – defined in measurable terms by edition size and craftsmanship, though less readily by "quality of design" – in order to demonstrate the works' collectability and commodity value.

Stemming from a long tradition of two dimensional design, the art of the Northwest Coast Indians is now flourishing in a new direction and in a relatively new medium, the silkscreened print. In less than ten years, this form of personal and tribal expression has developed into a major art form competing in popularity with the more traditional wood and argillite carvings.

The handful of artists that once worked independently often found it difficult to sell their prints to the public, still on the edge of acceptance of this new art form, but as the public appreciation grew steadily over the decade, so did the number of artists making prints. Many talented people developed their design, style and skill through apprenticeship, art training or pursuing study on their own.

Some, lacking the required knowledge and skills, saw the growing market for native prints and did their best to help supply the need. A few non-native artists jumped on the bandwagon, particularly in areas south of the Canadian border, which did not have a tradition of the high art form found largely in British Columbia. The result was an ever increasing supply of prints, many in numbered editions, with a wide spectrum in quality and price. This led to confusion among the buying public, as well as among visitors experiencing the art for the first time. While high quality retail outlets handled signed, limited edition prints by some of the top artists, department stores and some tourist shops frequently offered inferior work or fakes at low prices. Such prints often lacked the complex and sophisticated structure that is the very essence of the art of the Northwest Coast, resulting in poor standards of design and misrepresentation of the art.

Concerned over the future of numbered edition prints in a steadily increasing market, some of the more established artists joined with me in trying to find the answer. We invited others to join us in this endeavour, and eventually, after a year's work and the kind support of interested outsiders, the Northwest Coast Indian Artists Guild was incorporated as a society on February 14, 1977.

The aim of the Guild is to establish, develop, promote, foster and maintain national and international recognition of the art of the Indians of the Northwest Coast of British Columbia. Our purpose is to preserve high quality, both in design, craftsmanship, and materials, and to encourage members to study and work in the art style of their own particular regional culture. Each print meeting these standards bears the embossed stamp of the Guild, a stamp that will help the general public to recognize quality art of the Northwest Coast Indian people, and assure them of its authentic native origin.

The formation of the Guild is a major step in the continuing evolvement of this new tradition of two dimensional design. It has elevated the work of the quality graphic printmaker to the level of fine art. We recognize that other Indian artists are rapidly rising in the field of good printmaking, and in time we expect to expand membership in the Northwest Coast Indian Artists Guild.

1977 members to date:

Joe David
Robert Davidson, Vice-President
Ron Hamilton
Roy Hanuse
Richard Hunt
Gerry Marks
Larry Rosso
Russell Smith
Norman Tait
Roy Vickers, President
Francis Williams

**20.IV.  Joe David. 1978. Introduction. In *Northwest Coast Indian Artists Guild: 1978 Graphics Collection.*** Ottawa: Canadian Indian Marketing Services, n.p.

Tla-o-qui-aht artist Joe David (b. 1946) was a member of the Northwest Coast Indian Artists Guild in both 1977 and 1978 and provided the catalogue introduction excerpted below for its second, and final, graphics collection. Raised at Opitsat on Meares Island and in Seattle, David studied graphic design in Texas and worked as a commercial artist before deciding to focus on Northwest Coast art. He credits his paternal grandmother and his father, Hyacinth David, as his first and most important teachers of Tla-o-qui-aht cultural history and practice; later he researched the art in books and museum collections and eventually studied with both Bill Holm and Duane Pasco. On his return to British Columbia from Seattle in 1975, he was encouraged by his cousin Ḳi-ḳe-in (Ron Hamilton) to strengthen his understanding of Tla-o-qui-aht art and culture. One of several artists to revitalize Nuu-chah-nulth art for both community use and the market, David has gone on to expand his approach to encompass his personal experience with other Indigenous spiritual traditions.

Where the previous year's Guild catalogue emphasized indicators of print quality such as edition size, technical standards, and authentic style, David shifted the discourse of evaluation to make room for an apparently less market- and object-centred criterion: the commitment of the artist to cultural and spiritual

practice. By asserting the art's connection to the supernatural, and the artist's duty to understand that connection, he gave precedence to the place of Northwest Coast visual expression within Native community-based values. Yet his discourse also satisfied the desire of non-Native consumers for their own connection to the spiritual content of culturally authentic art. As a result, while David emphasized the non-commodified or spiritual aspects of art making, he simultaneously implied enhanced market value for the work of artists who demonstrated their cultural knowledge and practice.

> The development of the Guild, and its actions to date, stem from a group of people convinced of the necessity for such a society, convinced of a need to establish a social organization of reputable construction, and to further educate people to a proper frame of mind and spirit.
>
> It is necessary to understand the spirituality of Indian culture, and its expression in art, to sense the integrity of these artists' works. Each artist's designs represent detailed accounts of personal communication with the wisdom and harmony of high order.
>
> Words are not our medium; our two and three dimensional art is our language, and we speak of sacred beliefs. We are the philosophers, prophets, and poets. We are the recipients and workers of supernatural powers, and we are the voice of the nature of things.
>
> It is each artist's task to interpret these supernatural and natural laws, to train himself and strive for perfection in these interpretations. I for one recognize this fate. I respect this decision of high order. I strive for the perception of higher consciousness. I bathe in sacred waters, I sing sacred songs and I recite words. The answers and results are reflected in my paintings and carvings; my actions reflect my convictions.
>
> I am convinced of the truth of these things, and it is the duty of Indian artists to see that responsible action is taken to fortify these teachings. I recognize that this is a great responsibility. It is for the Guild to protect and project a positive image. It is for the Guild to recognize themselves as a council of representatives of a powerful culture. This culture commands our respect and energies, and to anyone seeking an alliance with my art and wisdom, I relay this command of respect.
>
> Ignorance and rejection of these supernatural and natural laws of creation, is no less than a rejection of life.
>
> Artists for 1978:
>
> Joe David
> Robert Davidson
> Roy Hanuse
> Gerry Marks

Larry Rosso
Norman Tait
Roy Vickers
Don Yeomans

**20.V. Ashley Ford. 1979. "Indian Art Attracts Investment Interest."** *Financial Post,* 3 November, W5.

The response of the mainstream media to the growing Northwest Coast art market can be tracked through exhibition reviews, articles on Native art as investment, profiles of particular artists or dealers, and promotions of public and commercial gallery events. As well as offering a record of temporary occasions that otherwise go unrecorded, these documented changing popular discourses about Northwest Coast art and influenced perceptions of value that adhered to objects and their makers.

In the following two newspaper articles, writers Ashley Ford and Art Perry addressed commodification and consumption in 1979 – a period when sales of Northwest Coast art were reaching new heights. Written for a general readership, the articles nevertheless echoed and implicated institutional discourses and debates about the circulation of contemporary Indian art among non-Native audiences. Here the new work was judged not as autonomous and modern but as either filling a void in the market left by historical artifacts or emptied of the authentic meaning that the old works held. Both articles took part in the active and slippery process of negotiating the categories within which new Northwest Coast art might be understood and valued – categories the writers assumed were now largely determined by non-Native buyers, sellers, and experts.

While gold continues to hold the world in its hypnotic embrace, the art of the B.C. West Coast Indian is beginning to cast a similar spell on a growing number of aficionados and investors.

The reasons are many, but this art form, a latecomer to the galleries and boutiques of Canada, is rising in value at a considerable rate and is considered an excellent hedge against inflation.

"It is the last great primitive art tradition to be recognized in the world," says Marjorie Halpin, curator and assistant professor of the Museum of Anthropology at the University of British Columbia.

A specialist in Northwest Coast Indian art, Halpin has been heavily involved in reclassifying Indian specimens into collectible art pieces. She readily concedes the reclassification has helped to stimulate demand in the marketplace, and has led to the hefty price increases.

While most purchasers buy for artistic reasons, there is a growing number of speculators in the market, who expect to capitalize on the demand.

In fact, such has been the increase in value, that older, antique pieces are too pricy for the average collector. They are fetching thousands of dollars, and Halpin says that even the museums cannot afford them.

Now it is the work of contemporary artists, working in carving, jewelry and silk screen, who are creating excitement.

For instance, the work of Bill Reid, which only a few years ago sold for very modest prices, now fetches thousands of dollars per piece. His prints could have been bought for $40, but now are in the $750-$2,000 bracket.

And, he is not the only one getting high prices for his work. The growing band of highly successful Indian artists includes Robert Davidson, Joe David, Art Thompson, Norman Tait, Henry, Tony and Richard Hunt, and Doug Cranmer. And these are only a few whose work is considered collectible.

David Young, director of the Bent Box gallery in Vancouver (considered one of the top galleries for West Coast Indian art), says there are many young up-and-coming artists who will do well.

"It is not uncommon to find many of these top artists now earning $50,000 a year," he says.

Those who make jewelry have seen their products stretch for higher prices as well. (Reid, for instance, sold a gold bracelet a year ago for $3,000.)

Young says the jewelers are benefiting in two ways – from the increase in the price of gold and silver, and from the demand for their work.

Halpin and Young acknowledge there are speculators in the marketplace, but maintain most people are buying the art because they like it, and because it is a highly graphic link with a culture that is virtually extinct.

That speculators and get-rich-quick practitioners are in the market is confirmed, however, by Halpin, who says that reproductions are now starting to appear.

Young, of the Bent Box gallery, says the phenomenal growth in interest is unfortunately also leading to an increase in the number of low-grade junk shops catering largely to the high-volume Japanese tourist industry.

There are some antique and other dealers who have not got very good names, Young says. "They are the door-knocker types who go around the (Indian) villages asking if any old pieces are for sale. They pay a minimum sum for a piece and then sell it for thousands."

Halpin says this breed of dealer is slowly being recognized by Indian communities, and recalls with some satisfaction the story of one such dealer who was asked promptly to leave the village and then given a helping hand – into some nearby water.

One of the amazing things about this art form is that it has come into the market-place in a major way only in the last decade.

In fact, Young believes there is still an element of patronization in its popularity: "Some people still probably buy the art as a means of helping out the Indian."

And, until recently, it was highly regionalized. Few galleries outside the Pacific Northwest had ever heard of, let alone shown interest in, this art.

All that has changed, and increasing numbers of works now are being sold in galleries and shops in Eastern Canada and the U.S., and in Europe and Asia.

Claude Levi Strauss, the well-known anthropologist, predicted in 1943 that "West Coast Indian art would move from anthropology to art alongside the great art forms of Egypt, Persia and the Middle Ages."

His prediction has been slow in coming true, but it is happening, nevertheless, Halpin believes.

**20.VI. Art Perry. 1979. "West Coast Prints: For Soul or for Sale?"** *Vancouver Province,* 22 November, D1.

There are some basic problems when viewing West Coast native prints, and chief among them is the fact that prints are now a commodity medium used by the contemporary Indian artist.

The Haida, Tsimshian, Nishga, Gitksan, Nootka and Kwakiutl have only been making prints since the mid-1960s in an attempt to fuel an anxious audience of speculating collectors and anthro-fetishists. The audience for native art has shifted from the inner community of one's village or tribe into an international art market.

The "new wave" of Haida printmaker is championed by Bill Reid and Robert Davidson. Reid, the mature master carver of those magnificent mortuary poles outside UBC's Museum of Anthropology, is much older than the 33-year-old Davidson. Nonetheless, they do work together, as with Reid's 40-foot totem pole for the Skidegate Band Council offices on the Queen Charlotte Islands in 1977.

Their respect and dedication to the masterful designs of the Haida tradition holds no peers. Yet the question that arises from their prints is whether or not the soul, or the spiritual essence of the work, still carries into the mass-produced editions of silk-screened prints that enter an almost exclusively non-native market.

It can be argued that the designs of contemporary prints by Reid and Davidson go far beyond their 19th-century forerunners, so it is not the quality of the art that's in question; it's the purpose.

Of course, here I'm treading on ice as thin as the prints themselves. How can I assume to calculate the spirituality of any work of art? But my question is a basic one. Has the original potency of the Haida animal mythology washed itself into a colorful

pattern of red and black lines? Or does the tradition of Haida spirituality for which the original art was produced still live in these slick market-oriented prints?

Recently, Robert Davidson has had two major acknowledgements come his way for an artist still in his 30s: A large exhibition of his prints was mounted by the UBC Museum of Anthropology, and Hilary Stewart has just written a book on these same silkscreens.

In discussing the UBC exhibit with Marjorie Halpin, the museum's curator of ethnology, it became apparent that Davidson is both historically and publicly setting his place in the tradition of Haida art. At least, this is what is hoped.

I would not question such a claim with the carvings he has done for his people in the Queen Charlottes. The majestic totem pole he carved for the village of Masset in 1969 did much to regenerate a sense of artistic and spiritual awareness in the Haida community. On this level Davidson is keeping to the heart of the art and the content of his people's heritage.

But what of the prints? When Hilary Stewart writes that a Davidson print of 1972, "now framed, was priced at nearly 80 times its original value," is this not a comment on the market's thirst for ethnic eccentricity (as opposed to that modern abstraction)?

Another quote from Stewart tells of a print Davidson named Haida Abstract: "It didn't sell. So he changed the name to Killer Whale Fin and it sold out."

It is not the native people who caused the commercial escalation of Davidson's and Reid's prints; it was the demand of an investing non-native market.

Going through the UBC exhibit with Marjorie Halpin, and discussing the Davidson book with Hilary Stewart, I could not help but sense a loss of direction. As beautiful and refined as Davidson's prints may be, do they speak to an audience that can understand their soul? Davidson and Reid obviously believe in their art. They believe it is a viable part of a living tradition.

But a tradition is a continuation of beliefs. An icon is only an icon if the message for worship or belief enters the viewer. This does not mean that a viewer merely understands a native print – anyone can say that this or that print is an eagle with a fish in its belly – but only when a viewer believes in the eagle with the fish in his belly will the work be a true part of a tradition.

In other words, are Davidson's commodity prints a reflection or are they an incorporation of the great Haida tradition of mythologies and spirituality?

Like the worldwide mania for the sacred gold objects from Tut's burial chamber, are the exhibited and collected prints of Davidson more show than soul? And in the end, is it possible to ever hope that the non-native viewer can enter into either the solemn ritual of Egyptian burials or the complex myths of the Pacific Coast Indians?

Both may well have entered the realm of anthro-decoration where taste and tradition become one and the same.

**20.VII. Tony Hunt and Jo-Anne Birnie Danzker. 1983. "Personal Perspectives."** In *Vancouver: Art and Artists 1931-1983*. Vancouver: Vancouver Art Gallery, 266-68.

In 1983, the Vancouver Art Gallery marked its move to the Robson Square site with an exhibition and book focusing on its fifty-year history and the creative developments during this period that contributed to, or challenged, cultural and artistic attitudes surrounding art production in Vancouver. Included in the book is the interview excerpted below between Kwagu'ł artist Tony Hunt and then-curator Jo-Anne Birnie Danzker. Hunt, born in Alert Bay in 1942, built a career based on his strong rootedness in the cultural practice taught to him by his grandfathers, Mungo Martin and Jonathan Hunt, and by his father, Henry Hunt. Like his prominent elders and ancestors, Tony Hunt also played a leading role in shaping the intercultural contexts for Kwagu'ł art and performance (Glass 2006b). As artist, dancer, ceremonialist, teacher, and operator of his own commercial gallery (Arts of the Raven, established in 1972 in Victoria), he helped to shift public reception of Kwakwaka'wakw visual culture from ethnology to art while simultaneously strengthening its place within the contemporary potlatch.

The dialogue between Hunt and Birnie Danzker demonstrates the ongoing tensions among formalist, anthropological, and community-based approaches to appreciating (and validating) Northwest Coast art. Hunt advocated a "fine-art" gaze as appropriate to the purposes and position of the non-Native consumer. He also critiqued Native artists who produce works for the market alone without demonstrating a commitment to community-based cultural and formal standards. By discursively separating artistic and ceremonial values, Hunt proposed a way to support the art's place in global art worlds without compromising the integrity of Aboriginal intellectual and cultural property.

> *TH:* When I was learning in the early fifties there were approximately six artists on the Northwest Coast. Today there are probably over four hundred. That's why it's higher profile now. It's in the best interest of museums and curators and anthropologists to promote people's work because it benefits both the artists and the museums ...
>
> The Northwest Coast artists are probably the only artists in the world under anthropologists and museums, not recognized as fine artists across the country. In the early fifties and sixties that was true. Now I think it's becoming more and more acceptable that the art produced today is equivalent to any of the fine contemporary art that you see.
>
> The problem is that most curators of galleries don't know what fine Northwest Coast Indian art is. If you've never studied it, if you're not an anthropologist who has made a particular study of the Northwest Coast, then you wouldn't know.

*JBD:* If in fact, you have to undertake highly specialized training in the field of anthropology, in the terminology of anthropology, in order to gain sufficient information about the work, then you are talking about applying a different set of values. If, for example, I assess your work on purely formalist values (design, colour, for example) but that work is a ritual piece, or it carries other levels of significance, then I feel that I'm not doing that work justice. On what basis would you want me to assess your work?

*TH:* The work can be assessed purely on its artistic value. Certainly if you're a curator of art, of fine art, you should be able to tell the quality of the piece, whether it be in silver, gold, wood, or painting ... Potlatch objects mean something only to the people that wear them and use them. So objects presented in an exhibition should be accepted only for their artistic value.

If you walk through this gallery (Arts of the Raven) you can pick out what we call production-type pieces – one or two pieces a week by an artist, a kind of mass production. You can walk to the next mask and identify it as a piece that would be, or could be, used in a traditional ceremony. I don't think, as a curator of a contemporary gallery, you could tell whether the artist made a particular piece for a potlatch, or of the same type or quality that *could* be used in a potlatch. There are some differences, however, in the quality level of pieces that are made strictly for sale and would not be used in a potlatch ...

*JBD:* To a large extent, I think the non-Indian community is afraid of not understanding the values in the work, afraid of interfering in and misrepresenting Indian culture, afraid that we're not qualified, either to make an intelligent assessment of the work, or to present it.

*TH:* Any gallery that wants to exhibit contemporary Northwest Coast art or traditional art (traditional art being pieces that will be used in potlatches, or a whole potlatch collection) as long as you are dealing with an artist who knows what the pieces are used for, then you're qualified because you have his assistance. If you go to a museum or an anthropologist who specializes in Northwest Coast, then they'll tell you that you are not qualified. If you ask the Indians, as long as they're assisting you and helping you, then you're qualified ...

*JBD:* What has been the effect of the print industry during the seventies?

*TH:* Well, if they've done anything, it is to promote Northwest Coast on a larger scale. But prints have also been the most abused by the new artist, for example, in the seventies. Artists who had never carved or designed anything in their lives came out with designs in editions of six hundred or a thousand. The price was $50 and $100, regardless of the quality of the design. I think it was abused by the

Indian artists and it shows in today's market because the general public is now more knowledgeable. People who bought in the seventies can't get rid of what they bought because they now realize it was very average or bad.

I know a lot of artists, maybe fifty, but there are probably two hundred artists who produce only for the sake of production. They don't care what the mask is used for. They don't care what it is that they're making as long as it looks like a raven, a wild woman mask, or a wild man mask, that's it. They don't care to know when it was used or how it was used. I think those artists are, well I'm not sure what to call them, but there's not that much difference between them and white artists that are producing (and the white artist may know more about the mask). A lot of producers in the seventies are no longer working today. I think they achieved a level fast and disappeared fast. I think it will continue perhaps another 15 years then level off so that only serious artists will keep working. Perhaps we are working towards a professional level, I think that's what's happening now.

**20.VIII. Doreen Jensen. 1988. "Commissioned Art Work: Is This the New Standard of Artistic Prominence?"** Paper delivered at the National Native Indian Artists Symposium 4 and transcribed in *Networking: Proceedings from National Native Indian Artists' Symposium IV, July 14-18, 1987.* Edited by Alfred Young Man. Lethbridge: University of Lethbridge, 99-100. © Alfred Young Man.

Doreen Jensen (1933-2009) was a Gitxsan artist, historian, writer, curator, and community activist who was born in Kispiox, British Columbia. Her Gitxsan family name, Hahl Yee, belongs to the Killer Whale crest from the House of Geel, Fireweed clan – her mother's lineage. A founding member of the 'Ksan Association as well as the Society of Canadian Artists of Native Ancestry (SCANA), Jensen became a respected and vocal proponent of the reclamation by Indigenous artists of their traditional practices and of the need for national art institutions to recognize that contemporary Native art was as worthy of serious critical attention as non-Native art. Her exhibitions and publications contributed significantly to promoting the self-representation of Aboriginal people through art and literature (Jensen and Sargent 1986a; Jensen and Brooks 1991; Jensen 1996).

The fourth National Native Indian Artists Symposium, at which Jensen delivered the paper excerpted below, brought together Aboriginal artists from across Canada with the primary goal of evaluating and strengthening their relationship with Canada's major art institutions (see also Farber and Ryan 1983). Here Jensen chose to problematize the symposium's focus on gaining market and institutional inclusivity, asking her audience to consider the implications for Native artists and their communities of allowing criteria of value to be externally defined. She situated the commissioning of art as an Indigenous practice historically, not only a feature of the contemporary art market, with the difference being non-Native

control of the latter. On whose terms, her speech implied, should Aboriginal people engage with the "creative economies" of our broader society?

Commissioned art, simply and clearly, has always been a standard of prominence. From earliest times recognized artists were commissioned to do work for important occasions and ceremonies. What is different today is who is doing the commissioning. Primarily it is a non-Indian consumer market. This change is one which poses important questions and which demands that artists consider, individually and collectively, the responses to those questions.

To begin, is the pursuit of commissions a correct and worthy goal, and where in the long term will the pursuit of this goal take Indian art and artists? Comparison of past and present situations may help in the consideration of these questions. In the past, artists living in their own communities were trained in a holistic fashion encompassing spiritual, philosophical and technical skills. Their personal lives and their work were linked to the activities of the people of their community. Their roles and responsibilities were defined by the community so that all functions of the interdependent communities were carried out. The artists' work was judged by the chiefs, the elders, and the community. Everything that was done in relation to the artists and their work sprang from a common set of values and an understanding of the traditions and an adherence to well-defined social roles. The artists were trained, supported and nurtured by their communities. In turn they gave back to their people as was required.

All have heard the stories of the breakdown of our communities and lifestyles. This transitional period will not be covered in any detail here, only to note the new players who became involved in the preservation and use of the arts, namely the anthropologists, arts commissions, museums, dealers, patrons, and so on, the significant majority of whom are non-Indian.

This brings us to the present art and artists. Most have been educated by a combination of Indian and non-Indian systems and institutions. Large numbers live in urban settings closer to the markets and different standards of living. The greatest emphasis in training artists today is on technical skills. The personal lives and work of the artists are linked to larger, more diverse communities and audiences. Roles and responsibilities no longer set by the Indian community are now being defined by the artists themselves and by the consumers. The work of Indian artists is being judged and interpreted by a body of self-defined specialists in the field, very few of whom are totally immersed in the value, principles, and traditions of Indian people. The artists themselves are more isolated from their own communities and are not fully accepted or recognized by the "mainstream" arts community. They are as yet not fully part of a larger supportive and nurturing body ...

As the art and artists have become separated from the communities and traditional roles, many of the functions receive little or no attention. This is having, and will continue to have, profound effects on the art, artists, and Indian culture. To determine whether artists can or wish to influence these effects, many questions must be considered. Some are raised and partially answered here.

What are the goals of Indian artists? Self expression? Communication of their, or another, reality? Recording family history or culture? A way to earn self respect? Economic survival? Maybe it's all of those. And what are the needs and how can they be filled? What are the needs of these artists? Support, and what kind, since we no longer have traditional support systems? Training in Indian philosophy and culture? Recognition, and by whom? What kinds of responsibilities do these artists have, and to whom? To themselves, the Indian community, family, arts community, the past and the future? Who and what influences will develop future Indian artists? The market, Indian communities, art schools, Indian artists themselves, museums, or the literature? What do my people or community need from me as an artist? Recognition of Indian art and culture, apprenticeship and training, ceremonial involvement? Who has the responsibility for maintaining artistic traditions and passing on the skills? Who will define the standards and importance of Indian art and how? Curators, historians, and the purchasers, other artists, Indian communities? And what is needed to ensure Indian art remains linked to the culture? Maybe it needs to be researched by, for, and with Indian people, with our Elders, recording and documenting the philosophy of Indian art. We have very few publications on the philosophy of Indian art by Indians. In fact, I don't know of any. What will halt the high mortality rate amongst our artists? What kind of support systems do we need? Do we need a lot more communication among one another, more networking with other artists across the country? Without the traditional support systems how will Indian art survive? Developing new mechanisms, whatever they may be? Artists monitoring and analyzing the developments of the arts? Criticism and recognition by Indians as well as the larger art community?

Without considering these questions and others which you may pose, it is not important to answer whether "commissioned art" is the new standard of prominence. What is important to answer is how will Indian art and artists survive as distinct peoples and art forms if they continue to allow only outsiders to define their roles, reflect their images of Indians, interpret the importance and value of the art, and influence future generations of Indian artists? I'll leave it here and leave it up to the rest of you to think about. Thank you!

**20.IX.  Peter L. Macnair. 1994. "Northwest Coast Indian Art for Sale: A Long Tradition."** In *Life of the Copper: A Commonwealth of Tribal Nations.* Victoria: Alcheringa Gallery, 5-6.

A widely recognized expert on Northwest Coast art, Peter L. Macnair (b. 1940) held the post of curator of ethnology at the Royal British Columbia Museum (RBCM) from 1965 to 1997. In those years, which encompassed the rise of the Northwest Coast art market, Macnair guided the RBCM as it became a major institutional patron of present-day Native artists. He also supported, through museum commissions, the renewed carving of ceremonial regalia – items that could be borrowed back by community members for use in the potlatch. Macnair has curated and co-curated numerous important exhibitions at the RBCM and for institutions across North America (e.g., Macnair, Hoover, and Neary 1980; Macnair, Joseph, and Grenville 1998), helping to establish the legitimacy of new generations of art and artists in museums and Native communities as well as in the wider market.

While still a curator at the RBCM, Macnair wrote the following essay for the catalogue accompanying a show of works for sale at a local commercial gallery. He offered advice to potential collectors of contemporary Northwest Coast art, delineating criteria of judgment that he and his museum colleagues had been promoting institutionally since 1970 through influential exhibitions such as *The Legacy* (1980). Underlying these criteria was the assertion that contemporary artists may be validated through their participation in traditional ceremonial life and their understanding of traditional art forms. Macnair's advocacy of standards of value centred on Aboriginal cultural practice marked a significant move away from an art discourse based on "decontextualized" aesthetics determined by and for non-Native interests. His essay left unproblematized, however, the entanglements between ceremonial and commercial production, Indigenous agency and market economies, and museums and taste making. A still-vital discourse of tradition was reinforced, yet it marginalized other contemporary art strategies – including those that involve the purposeful separation (or protection) of traditional practice from art market production.

Early explorers and traders on the Pacific Northwest Coast acquired "artificial curiosities" from native people which they took back to their home ports at journey's end. Many of these objects of human manufacture (as opposed to "natural curiosities," i.e. exotic botanical and zoological specimens) became the basis of local and national museum collections. Most objects gathered in the late 18th century were items made by aboriginal people for their own use. These ranged from the utilitarian (tools, utensils, every day clothing) to the exotic (ceremonial items including masks, headdresses, rattles, decorated blankets, feast dishes).

By the 1820s there was such a demand for objects that indigenous artists began to create works specifically for sale. These included artifacts in new media with

non-traditional images, formats and themes, such as the argillite carvings produced by Haida Indians. Increasingly, masks, bowls, headdresses and model canoes, produced in classic forms, were introduced to the collector's market. While indistinguishable from ethnographic specimens, these objects for sale were never used or intended for use in a traditional context.

Most of these 19th century artworks were every bit as accomplished, in aesthetic terms, as the ethnographic specimens. However, minimally trained carvers recognizing a potential market, began to produce carvings which competed with the well-crafted examples. By 1900 the production of these lesser works was well established. Although it has not been extensively described in the literature on Northwest Coast Indian art, tension developed between the established artists and those interlopers who could not meet the standards set by the knowledgeable artists. Uninformed or indifferent purveyors of the art made little attempt to establish or promote high standards; as a result some of the better traditionally trained artists were overlooked by dealers and collectors bent on promoting curiosities at any cost.

In the 1950s, several attempts were made to reintroduce the artistic standards and technical skills which had characterized the art form in the past. One of the most successful of these was a project where Kwakiutl Chief Mungo Martin was brought, in 1952, to the Royal B.C. Museum in Victoria, to demonstrate old skills and to train potential artists. His influence and that of his most successful apprentices set the standards for a renewal of the art which blossomed in the 1970s and reached full fruition in the 1980s.

Today it is impossible to visit the Pacific Northwest and not to be aware of the resurgence of Northwest Coast art. Sculptural and graphic works abound. A plethora of two dimensional designs decorate tee shirts; upscale galleries offer prints and paintings which combine landscape designs with traditional crest images. A sometimes confusing array of sculpted works faces the viewer and these can range from small elegant spoons to overpowering transformation masks.

The dilemma that has faced the collector of Northwest Coast art for a century has survived to the present days. The challenge remains: how can the viewer distinguish between an accomplished piece with real artistic merit and a perhaps flamboyant but generic Northwest Coast carving which reveals little understanding of the subtle rules and forms of an established tribal style? In nearly every case the aspiring collector should ask the following questions:

1   Has the artist been trained by an acknowledged master who is fully aware of his/her particular tribal style?
2   Has the artist mastered the use of traditional tools?

3 Is the artist able to contextualize his/her work through an understanding of or participation in traditional ceremonial life?

4 Does the work, even though it might be innovative, exhibit an unequivocal understanding of traditional form?

Even if the above criteria are met, there is never an absolute guarantee a work will reach even minimal aesthetic standards. And it is always difficult to offer advice on a matter that many consider to be entirely subjective. However, there is no question whatsoever that the great Northwest Coast artists of the past engaged in dialogues on aesthetics with one another. The master sculptors, painters and weavers were always prepared to comment on the degree of accomplishment of a given artwork. Their critiques were based on an understanding of traditional form and a willingness to support informed innovation within a somewhat restrictive tradition.

When examining the merits of contemporary work, we need to employ a similar approach. If we can learn the basic standards and recognize true innovation, we can ultimately make both an objective and subjective decision about the merits of an artwork. The facility to make an educated judgement is usually hard won. There is little substitute for long experience and a familiarity with reliable publications and commentary.

However, if the four crucial questions listed above are asked, and if a satisfactory answer can be delivered, the aspiring collector can have some confidence that he or she is on the right track. In the case of this exhibition of contemporary Northwest Coast art, the four critical questions have already been posed. By and large, the featured artists meet the criteria so that the objective standards of the artform have been effectively assured.

Thus the viewer can have confidence in the status and technical accomplishment of the artists represented. This leaves the potential collector with the wonderful opportunity to select his/her favourite piece on a totally subjective basis. In this instance the viewer only has to decide what he or she likes best, secure in the knowledge that the exacting standards of form and tradition which may not yet be entirely familiar, have already been delivered by the inclusion of only leading and accomplished artists in this presentation.

**20.X.  Charlotte Townsend-Gault. 2000. "A Conversation with Ki-ke-in." In _Nuu-Chah-Nulth Voices, Histories, Objects and Journeys._** Edited by Alan L. Hoover. Victoria: Royal British Columbia Museum, 219, 223.

Hupacasath cultural historian, artist, and intellectual Ḳi-ḳe-in (Ron Hamilton) was born in 1948 at Aswinis, in Nuu-chah-nulth territory. He describes his work in these words:

I'm not interested in a commercial market but simply in making noise. Making noise and being heard and being seen and, hopefully, touching people in a way that they can say they've heard from the mind of a Kuu-as [Aboriginal person], that at least one Kuu-as was able to touch people in a way that's unbidden ... I have a need to say something about who I am and what I believe and I'm going to continue doing that whether by composing music, singing, dancing with masks, writing poems, doing drawings, or by giving public lectures. (1994, n.p.)

In the following excerpt, from an extensive conversation with Charlotte Townsend-Gault, Ḳi-ḳe-in pointed our attention to both the intersection of, and the distance between, the "Northwest Coast art market" and the production, circulation, and consumption of objects by and for the Nuu-chah-nulth community. Unwilling to participate in an externally mediated and object-centred discourse, Ḳi-ḳe-in instead centred the object within Indigenous social relations. In so doing, he refuted assumptions about market-driven values — such as collectability, authenticity, and aesthetic quality — being central to the terms of reference by which the "art" — and his "noise" — were made and understood.

And it used to be so nice to see men in our community who could take a silver dollar or a gold coin and with a hammer and a piece of metal, make a beautifully engraved bracelet ... It spoke about our way of doing things. "I make baskets. I sell my baskets to tourists. I get money and when I have enough money, I go to this man and I give him a silver dollar. What he does, in his time, with his hands and his tools, is return to me a beautiful bracelet for my baby daughter." There are very few places where people are able to do that anymore ... There's the localness of it, the appropriateness of it, but there's the *social thing* that there's a man in my community who does that, and he's my uncle. I go to my uncle and say, "Uncle, I really want a bracelet for my daughter." He takes the silver dollars, and bang, bang, bang, and then you have a silver bracelet ...

...

It seemed to me that somewhere between 1970 and 1978 was the high point of playing to the external world, and we still see flourishes of it. There was this time ... I remember First Nations artists carving masks, a whole crew carving masks, when I was in Victoria. Blocks of wood shaped like masks had painted and carved designs on them. Then someone said, "If you cut the mouth through, pierce it, pierce the nostrils, cut the eyes through, we'll give you this much more." Then someone said, "If you do all of that and have ears on it, I'll give you this much more." Then someone said, "There

seems to be a trend here, so I'll start in-laying abalone as well." Then someone else said, "I'll peg hair into it." So you've got a mask with abalone, pierced mouth, nose, eyes, and ears, and hair on it. Somebody else said, "Well, I'm going to do all of that, but I'm going to put straps of copper on the eyebrows." Then somebody else said, "I'm going to engrave the eyebrows. It will have copper eyebrows but mine will be engraved." Then another artist said, "I'm going to use silver on mine, not copper. I'm going to use silver." Somebody else said, "I'm going to make a mask and have it gold-plated and put it in the Canadian Museum of Civilization with a laser beam on it."

It's *all* gymnastics for the people who pay. I pays the piper and I names the dances. External control over a conversation that really is all *out there*, and isn't about this place at all. Isn't about where we live, and how we relate to the world, and where we come from, and where we go when we die. If we need to pretend that, we'll bring that in too, and we'll say, "It's been danced. It's been potlatched. It's been used by my son."

**20.XI. Charlotte Townsend-Gault. 2004. "Circulating Aboriginality."** *Journal of Material Culture* 9, 2: 185-86, 197.

As one of the editors of *Northwest Coast Native Art*, Townsend-Gault requires no further introduction here except to place the following excerpt in the context of her research interests. These interests concentrate on, and have raised challenging questions about, the social relations that inform and are formed by the reception of First Nations objects and imagery in contemporary British Columbia. In "Circulating Aboriginality," Townsend-Gault turned our attention to a little acknowledged, often dismissed, yet highly visible aspect of commercial Native imagery: the mass-produced souvenirs and ephemera that, she argued, represent more than the "commodification" of Northwest Coast art – and that may be more usefully examined as "non-trivial trivia."

That these multiples are generally unregulated, machine made, disposable, of questionable authenticity, possibly appropriated, and marginalized in the Northwest Coast art market does not deny their visibility and agency. Townsend-Gault adapted Annette Weiner's (1992) notion of keeping-while-giving to "withholding while giving" in order to demonstrate how such widely circulated images may be seen as evoking limits of access to the inalienable symbols of the invisible and unrepresentable that they reference. She suggested that the objects subvert prevailing Native/non-Native power relations. From this perspective, they also force an expansion of art market discourses beyond matters of quality, value, and aesthetic standards.

The post-contact history of what is now British Columbia, Canada's westernmost province and most of it unceded native land, is threaded through with policies to control and assimilate native people. A perverse consequence has been the tendency to make aboriginal cultural production a remote spectacle, typically referred to as Northwest Coast "art." The point I shall try to make here is that on the Northwest Coast unassimilated aboriginality is now in vigorous circulation, less remote, more ubiquitous, more accessible, than ever before.

However, the idea of circulation along ever-expanding social networks might seem to suggest further vulnerability to assimilation, to further transcultural "entanglement," while the circulation of "cheap" or "degraded" or "commercialized" versions of objects or signs once highly valued might be taken as proof. Such material is often characterized as having been secularized, democratized, normalized – with the implication that something has been reduced. But I want to argue that, on the contrary, something has been extended. Walter Benjamin, so stern about loss of aura, was also thrilling about the polymorphous multiplicities of the metropolitan sensorium enabled by modern technologies. Following Benjamin, Christopher Steiner has identified the fascination with mechanical replication as a force in the reception of native-made artifacts. As multiples, he argues, they have the capacity to reassure: the more the better, the more "really" native for the purchaser.

In just such uniform variety this material is everywhere in Vancouver, Victoria and other urban centres of British Columbia. It is accessible to all: to Japanese tourists for whom a miniature totem pole is simply something Canadian; to a local couple exchanging rings engraved by a native silversmith with creatures – a hummingbird, a frog, a raven – in which they find some personal meaning; to students buying a totem bottle-opener as a politically incorrect joke. How can it be trivial when thousands of quotidian micro-performances cycle such imagery between public and private realms? The agency of motifs is palpable, or, they motivate a response, which often leads to action. That is to say that they help determine a consumer choice, sway a plebiscite, or mark a rite of passage. In these ways they are making tangible yet another shift in native/non-native relations. But the infiltration is accompanied by some disentanglement, because, in detectable ways, the circulation is curtailed, translation withheld and access limited. A palpable tension counters the proliferation.

...

As the Treaty Process proceeds or falters, an expanded field of sensory figuration makes evident full native participation in the modes of display, promotion and marketing of the late capitalist liberal democracy. Simultaneously, it maintains limits – protecting renewed definitions of aboriginality – by offering meanings that are both tangible *and* opaque.

Those non-natives caught in the circulation, typically exercising what they think of as their rights to freedom of access (buying a fridge magnet, a graduation gift, an engagement ring), are led towards previously much less accessible, more intractable forms of "evidence" for aboriginality. However, monitored by First Nations exercising their sovereign rights, it – the "trivia" – becomes, not without an ironic readjustment of power relations, an impregnable line of defence, a no go sign. In this sense the most ephemeral, apparently valueless, items are gifts characterized by keeping-while-giving and declarations of the inalienable. The history of suppression has worked on native and non-native alike. While non-natives know they cannot discern everything – ownership, status, privilege, family, rights, obligations – nor do they necessarily or particularly care to – what they do know is that they don't know, or that they can't know. The inalienable remains beyond them, beyond their reach. If this is so then protectionism can be effective.

What is it that makes people chance their property, treasures, their most valued possessions, to the vast heaving mass of ephemeral and disposable forms? Well, yes, they imagine that they will be an effective advertisement for some good service or cause.

When asking what features an object must have in order for "imaginary representations of life, wealth, and power to become projected onto and invested in it," Godelier comes up with the following: "The strength of objects lies in their capacity to materialize the invisible, to represent the unrepresentable. And it is the sacred object which most completely fulfils this function." Is it too much to suggest that these scraps of card, small display ads in newspapers or the yellow pages, flimsy three-winged brochures from sheets of A4, the abrasion on the glass, or the copper tissue paper and the sticker, all contain little slivers of the invisible and the unrepresentable? That they are, for that reason, tokens of the magico-religious? For it is the sacred that is reserved, that is held back, that can be displayed but cannot be exchanged. The purchaser, the recipient, appears to have acquired some coveted fragments of sacro-animist imagery that they do not understand, something aboriginal. Something, in other words, that in British Columbia today, comes close to *defining* the aboriginal.

**20.XII. Harmer Johnson. 1981. "Auction Block."** *American Indian Art Magazine* 6, 4: 20-21. Courtesy of *American Indian Art Magazine,* Scottsdale, AZ.

Since the late 1970s, Harmer Johnson, an independent appraiser, dealer, auctioneer, and *Antiques Roadshow* expert, has been writing quarterly auction reports for *American Indian Art Magazine.* Two of these reports are excerpted below, one separated from the other by over twenty-five years of developments in the market for Native American materials. During this period, the increasing scarcity of

well-provenanced historical objects available for purchase (a lament, incident-
ally, that Cole [1985] documents was already common among museum collectors
in the late 1800s), combined with growing connoisseurship and expanded insti-
tutional promotion, helped Northwest Coast art to gain a stronger foothold in
international auctions of "tribal art and antiquities."

The purpose of Johnson's reports is to compile highlights of recent US and
international auctions of Native American artifacts, including prices realized.
The focus is wholly on the economic exchange of works, with the relative suc-
cess of an auction marked by high returns and new price records established.
Johnson emphasizes the pedigree of auction houses and of the collections being
sold (the latter distinguished by documentation of their previous, usually non-
Aboriginal, owners), while the identity of the new buyers remains confidential.
There are occasional interruptions in this market-oriented discourse by Fish and
Wildlife regulations, museum reclamations, and export laws regarding cultural
property. But it is the *lists* of items auctioned, seemingly neutral and logically
ordered, that best illuminate market taxonomies. Here objects are identified by a
terminology and a format that enable global market comparisons: price realized,
followed by general tribal attribution, object type and material ("polychrome"
stands for "painted"), and size. Often lost, always unstated, are Indigenous cat-
egories, such as an object's original and possibly ongoing affiliation with specific
clans and communities.

> On April 25, Sotheby Parke Bernet, New York, held an auction of 399 lots which net-
> ted $800,665, with unsold items accounting for twelve per cent of the gross proceeds.
> Prior to the auction there were two interesting legal occurrences. A very fine Tlingit
> steel and wood knife with killer whale handle, formerly in the Heye Foundation and
> sold in the Sotheby London auction of May 9, 1977, was withdrawn from the sale at
> the instigation of the Museum of the American Indian. The museum is ardently search-
> ing for material that was traded or sold from its collection when de-accessioning was a
> common, if questionable, practice. Sotheby Parke Bernet was also visited by United
> States Fish and Wildlife officials hunting for feathered items. They proceeded to pluck
> eagle and flicker feathers from two kachinas, but no lots were withdrawn from the sale.
>
> Nevertheless, the sale was a spectacular success, with thirty-five lots each fetching
> over $5000. Only the 1975 C.G. Wallace auction, organized by Sotheby Park Bernet
> and Harmer Johnson, exceeded this in gross sale proceeds ...
>
> The following results show clearly the great quantity of important material in
> the auction. *[Note from KD: I have included only the ten highest Northwest Coast (NWC)
> values from the list of twenty-seven objects (nineteen of them NWC) that realized over
> $5,000].*

| $23,000 | Tlingit steel and bone knife, 14 ⅞" long. |
|---|---|
| $21,000 | Haida wood grizzly bear rattle, 8 ½" high. |
| $21,000 | Haida wood chief's chair, 37 ¾" high. |
| $20,000 | Tlingit ivory knife finial, 6 ⅛" high. |
| $20,000 | Tlingit wood raven helmet, 17" long. |
| $17,000 | Haida black trade cloth tunic with shells, 44" long. |
| $17,000 | Haida wood model totem pole. |
| $15,000 | Northwest Coast wood hawk, 72" wide. |
| $14,000 | Chilkat wool and cedar bark blanket, 65" wide. |
| $14,000 | Northwest Coast wood totem, 37 ½" high. |

The American Indian auction scene has certainly changed dramatically since the first Parke Bernet sale of exclusively American Indian and Eskimo art was held on January 31, 1970. That 146 lot auction, consisting of material primarily from the Jay C. Leff Collection, realized $69,090. In the sale were several fine Northwest Coast masks and rattles that sold for between $750 and $4500 ... Such an auction in today's inflated market would certainly realize over $250,000.

**20.XIII. Harmer Johnson. 2007. "Auction Block."** *American Indian Art Magazine* 32, 2: 34.

The star event of the season was unquestionably the Sotheby's New York October 5 sale of the Dundas Collection of Northwest Coast American Indian Art. Believed to be the last known field collection of Northwest Coast material still in private hands, it was assembled by the Reverend Robert J. Dundas in 1863 on the shore of Metlakatla, British Columbia. Lieutenant Commander E.H. Verney, who navigated the voyage of the *H.M.S. Grappler* to Metlakatla, also acquired significant artifacts on the trip, many of which now reside in the British Museum, London. The Dundas Collection was passed down through the Dundas family, finally settling in 1960 into the appreciative hands of Professor Simon Carey, the Reverend Dundas's great-grandson.

The collection formed the fifty-seven lots of the Sotheby's catalog, and sold for an astounding $7,030,600. A Tsimshian polychrome wooden face mask with trance-like expression reached $1,808,000, establishing a world auction record for an American Indian object. The following were the many astonishing items in the sale [*Note from KD: I have included only the top ten NWC items out of fifty-seven lots*]:

| $1,808,000 | Tsimshian polychrome wooden face mask, 7 ¾" × 7" × 4 ¾". |
|---|---|
| $940,000 | Tlingit or Tsimshian elk or caribou antler club, 18 ½" long. |

$600,000    Tlingit polychrome wooden clan hat, 9 ¼" × 13".

$430,000    Tsimsham [sic] wooden shaman's rattle, 11" × 6".

$340,800    Tsimshian polychrome wooden mosquito headdress, 7 ⅓" × 21 ½" × 8".

$318,400    Tsimshian polychrome wooden chest, 18 ½" × 31 ½" × 17 ¾".

$273,600    Tlingit or Tsimshian polychrome wooden bear or wolf headdress, 7 ½" × 14" × 7 ½".

$251,200    Tsimshian polychrome wooden crouching shaman with human hair, 11" high.

$204,000    Tsimshian wooden comb, 4 ½" × 3 ½".

$168,000    Tsimshian bone implement, 7 ¾" long.

NOTE

1  Letter from Bill Reid to Bessie FitzGerald, owner of Quest for Handicrafts shop, April 1965 (Museum of Anthropology, Parallel Accession File #1341, Collections Department, University of British Columbia Museum of Anthropology).

DOUGLAS S. WHITE

*Kwul'a'sul'tun (Coast Salish name) / Tlii'shin (Nuu-chah-nulth name)*

21 | ## "Where Mere Words Failed"

*Northwest Coast Art and Law*

A few years ago I happened upon a short essay by Tseshaht artist George C. Clutesi (1947), my late great-uncle from Vancouver Island's west coast, published in an early edition of the *Native Voice* under the headline "The Urge to Create" [21.1]. It was an impassioned plea to Northwest Coast Indigenous peoples "to reawaken and foster back to life the urge to create, to embellish, to sing and to dance." Potent words that sound like an oration transcribed for print – an invocation that has been taken up with astonishing enthusiasm and energy, as evidenced by the magnificent and abundant Northwest Coast art being created today. Yet this soaring and procreant imperative came with a shocking parenthetic statement buried a few lines later:

> Remember the heritage your ancestor left you, the ability and the earnest desire to create, to paint beautiful native designs, to sing, to dance in your own true way when occasion demands. (Please do not misunderstand, I am not advocating potlatches; personally I am opposed to them.) You can still sing and dance or practice the fine points of oratory and give nothing away.

George Clutesi opposed to potlatches? For me, this was just as absurd as if Babe Ruth said he was against baseball or Winston Churchill claimed to oppose victory. Stunned by what I had read, I admit my immediate response was anxiety, confusion, and an ill feeling in my stomach. How could Uncle George disavow the potlatch? This was utterly irreconcilable with my personal knowledge and experience of Uncle George. When I was a young boy, I attended potlatches where he was a major participant! He was the author of *Potlatch*, after all – a book written to share knowledge of the *Tl'uukwaanaa* (one of the major forms of Nuu-chah-nulth potlatching) with the world at large! I looked to the newspaper again, seeking an answer to this paradox, and saw that the year the essay was published was 1947. I realized the significance at once. In 1947, participating in – or even merely encouraging someone to participate in – a potlatch was

criminalized and prohibited as a statutory offence under Canada's federal Indian Act and had been since 1885 [21.II, 21.III]. This prohibition against one of the most basic institutions of the Northwest Coast remained the law of Canada until 1951, when Parliament dropped the provision when it revised the act that year. It was unsettling to see that this law could have had such an impact upon my uncle's voice – and difficult to believe and comprehend from my vantage point more than half a century later. Still feeling uncertain about all of this, I referred to *Potlatch* [21.IV], published in 1969, in search of further understanding and found there an explicit explanation from Uncle George himself in the opening words of his introduction:

> The author of this story attended and participated in the last Tloo-qwah-nah when he was a very young man. It was then unlawful to entertain a feast or a potlatch by a decree of the Indian Act. Indeed his own kin was arrested for having staged such a Tloo-qwah-nah. It is then with trepidations that this "eye-witness" account is given and it is because of this lingering fear that actual names have been omitted.

The law banning the potlatch created trepidation and fear, authorized the arrest and imprisonment of participants, and created conditions that promoted the destruction and confiscation of cultural property [21.V]. The prohibition operated during a time when Canada's assault on Indigenous peoples and cultures was in full swing, achieving the displacement of Indigenous voice and authority; imposing a single "Indian" identity upon what is an astonishingly diverse set of Indigenous identities; dispossessing Indigenous nations' territory; removing children from their very culture, language, and way of life and subjecting them to the residential school experience – all of which formed the foundation for myriad other social and economic obstacles for the First Nations peoples of Canada. In this context, isolating causal effects to any particular colonizing program is difficult. However, a common thread that runs through all the programs is the use of the law to ground their authority. Parliament's Indian Act (and similar American legislation and other Canadian legislation) were (and remain) central in this. But so too were other aspects of law, such as international law, in its continuing refusal to recognize full international legal personality for Indigenous peoples to protect territorial sovereignty and self-determination rights; the common law, with judicial decisions (in both American and Canadian courts) that have developed an impoverished body of jurisprudence that has failed to achieve meaningful reconciliation regarding Aboriginal rights and title or to provide strong recognition of treaty rights; and executive power that has largely failed

to be honourable in its policies for and treatment of Indigenous peoples and their rights.

Each of these institutions has used its authority and powerful voice to impose foreign legal systems, identities, and values on Indigenous peoples and thereby devastate their nations, authorities, and voices. The encounter between law and Northwest Coast art can be considered one in which contests over voice – the power and authority to narrate meaningful stories – are central. Our stories, whether they are oral or text-based or non-linguistic compositions of visual or symbolic content, make us who we are.

These contests appear to have had a profound effect on what Uncle George was willing to say openly in a newspaper or a book about his culture and his core beliefs. Even so, a close reading reveals that his essay provides guidance to resist and avoid state oppression of the potlatch. The Indian Act provision in effect in 1947, when Uncle George published his essay, reveals the connection:

> Every Indian or other person who engages in, or assists in celebrating or encourages either directly or indirectly another to celebrate, any Indian festival, dance or other ceremony *of which the giving away or paying or giving back of money, goods or articles of any sort forms a part, or is a feature,* whether such gift of money, goods or articles takes place before, at, or after the celebration of the same, ... is guilty of an indictable offence and is liable to imprisonment for a term not exceeding six months and not less than two months. (Indian Act, R.S.C. 1906, c. 81, s. 149; emphasis added)

Based on this language, it seems clear that, when Uncle George wrote that "you can still sing and dance or practice the fine points of oratory and give nothing away," his words reflected a careful reading of this provision. He cautiously drafted the article to protect himself (and anyone heeding his advice) from what he perceived to be a real danger of prosecution by explicitly disavowing the potlatch (at least the Indian Act definition of potlatch – of which, the legislative excerpt above tells us, "giving away" is key).

The present essay and associated readings offer a brief consideration of the encounter between law and art[1] on the Northwest Coast[2] that gave rise to the strange dissonance found in George Clutesi's essay. The relationship between law and art is rarely so direct and explicit as it is in the case of the Indian Act prohibition of the potlatch, which amounts to censorship of the fundamental "meta-event" of Northwest Coast culture.[3] That this particular relationship, in this context, is explicit and direct may not be clear to everyone, and for that reason I will explain my view that the prohibition of the potlatch amounts to a

prohibition of Northwest Coast art, since the potlatch is the context within which the majority of what we call Northwest Coast art finds its home, its original context, and its fullest expression and meaning. Indeed, in "The Urge to Create," Clutesi appeared to identify the potlatch as a primary source of the artistic and creative impulse of Northwest Coast people. Once my view of the connection between potlatching and art is made clear, I will provide Uncle George's view on the role of artists and art in the Nuu-chah-nulth world to offer a clear picture of the deep integration of Northwest Coast art in the identity, authority, and voice of Northwest Coast peoples. To further illuminate these basic ideas, I will discuss aspects of the history of Nuu-chah-nulth potlatch screens more closely. Finally, I will turn again to the institutional voices set out above so I can discuss further their impacts on Northwest Coast art and show how what has often been a destructive narrative can potentially be changed to one that supports and upholds Northwest Coast art.

## POTLATCHES AND ART

For Northwest Coast peoples, a potlatch is a special and temporary space within which essential frameworks of meaning are animated and operationalized. These powerful spaces are articulated and formed to enable some specific transformation of individuals, families, and nations or to mark a significant event. An individual can come of age or become a chief or wife or husband or receive a name or a seat in the longhouse. Families assert and pass on rights and prerogatives. Nations express and give voice to their identities, proclaim their leaders, tell their histories, and form alliances with other nations. Ancestors are present. Likewise, supernatural beings appear. In this way, a potlatch is a sacred space within which temporal and cosmological boundaries are transcended. Art is an essential element in the creation and articulation of this space and the events, rituals, and transformations that take place within it. Without this understanding of the nature and role of a potlatch in the life of a Northwest Coast people, it is not possible to fully appreciate the impact of its prohibition by the Indian Act or the adverse impacts that the disarticulation of this central institution has had on Northwest Coast artists and art.

I will provide a few examples of art's role in these meta-events below, but first the great cultural and linguistic diversity throughout the Northwest Coast peoples requires that I situate my own experience with potlatches and art. My perspective is that of a person who grew up in the last quarter of the twentieth century as a member of both Coast Salish (Snuneymuxw at Nanaimo) and Nuu-chah-nulth (the Takiishtakamlthath ["Earthquake"] House of the Tlikuulthath

of the Huupacasaht at Port Alberni) families and nations, whose cultural, spiritual, and ceremonial life continues to be rich, colourful, and finely textured. As a young boy, I was taken by wolves in a *Tl'uukwaanaa* initiation potlatch on the west coast of Vancouver Island. I've witnessed and participated in many potlatches where *Hinkiits* (Lightning Snakes) danced as well as many other creatures. Many years ago I witnessed a great *Schnaem* (the late ritualist Isadore Tom) from the southern Coast Salish world (on the US side of the border) use his *Skawneelich* (a certain kind of wooden board, used, in part, by shamans for spiritual cleansing) to cleanse the Snuneymuxw longhouse. I've seen people grabbed and clubbed with *Kwutcmiin* (dancer's staff and rattle), then taken away to be initiated into the *Syowen* world. I've heard the sound of sacred and ancient *kuxmin* (Nuu-chah-nulth rattles) carefully and momentarily brought out to accompany the chanting of a *Ci'aas* (sacred chant) to the universe. The sound of ancient *Shulmuxwtsus* (a form of Coast Salish rattle) accompanied my oldest son Sxw'thame (Eliot) into his naming feast, as he was packed in to the hall sitting in a cedar canoe, wrapped in a Coast Salish blanket woven by my sister Tracey with mountain goat wool. I married my wife Anisa through my family's *Sxwayxwey* (Coast Salish sacred masked dance) ceremony in which the magnificent and powerful masks, pectin shell rattles, cedar boughs, and other regalia were used. My family bestowed upon my wife Anisa the name Tlikuulthaksa, upon my son Eliot the name Kwaayas, and upon my son Ethan the name Kwaawiina in front of our families' newly painted *Thliitsapilthim* (muslin potlatch screen), which I and my sons helped to paint. My baby twins Willem and Charles were recently named Hun'cow'iyus and Sxw'thame with the *Sxwayxwey* as well. I've seen my grandmother paint her face with *Tumulh* (red ochre) and dance in a Coast Salish longhouse as her ancestors have always danced – and I know that, when enough drummers slam their drumsticks into the sacred deerskins of their drums, the combination of the drums and their massive singing voices creates such a force that it feels like the very shape of the universe is changing and brings everyone present into shared experience.

In all of these events, Northwest Coast art was inextricably bound up with and intertwined in the ceremony, ritual, and sacred work of my family and nations. The art is animated by these varied events, and, in a reflexive fashion, the art also forms and animates the events. They sustain each other.

## Art, Artists, and Northwest Coast Society

This deep integration between art and the potlatch was recognized in Northwest Coast societies. The importance of the creators of this art, and their role in

Nuu-chah-nulth culture, was directly expressed in *Potlatch*, in which Uncle George, also an artist (among other roles he played in the Nuu-chah-nulth world and beyond),[4] provided a description of the role of Nuu-chah-nulth artists and art when discussing what he called Kings' Councils:

> Out of the council there emerged a tribunal to resolve and settle all disputes of consequence, oftimes including those of wars. From this council, too, came the ushers, whose business it was to know which particular seat belonged to whom; the advisers to the king; the mentors; the teachers; the storytellers; the historian; and the orators who presented the message, articles of agreement and oftimes an ultimatum also.
>
> An artist was sometimes inducted into the tight organization when and if he merited that honor because he was able to think profoundly and create forms with which to show the people and thereby to stimulate, encourage, provoke and win over to ideas and principles where mere words failed. (Clutesi 1969, 32)

Here the role of artists and their art was described as nothing less than to assist in the formulation and expression of the philosophical and normative foundations underlying the sovereignty and constitution of Indigenous nations. Therefore, any colonial attack on the substance of Nuu-chah-nulth sovereignty and values directly impacted their art.

This art continues to be produced and used in a similar fashion to this day. I have described some of my experiences with it above. However, the distance between this art and the commodities that are found in tourist shops today may not be apparent in form but is staggering when considered in relation to substance.

## THE EXAMPLE OF NUU-CHAH-NULTH POTLATCH SCREENS

As a more specific example of some of these ideas, I will discuss the potlatch screens of the Nuu-chah-nulth. There are three named types of ceremonial screen in Nuu-chah-nulth culture. The first is called *Kiitsaksuu-ilthim* ("interior partition with marks made in a meaningful way") and comprises large wooden screens made of planks taken from old-growth trees. The second is *Thliitsapilthim* ("easily movable interior partition"), which refers to the cloth screens made of muslin cotton in the twentieth century. The last is *Aytsaksuu-ilthim* ("girl's first period movable interior partition"), which refers to the screens used in the girl's puberty ceremonies of the Nuu-chah-nulth, which are called *Aytstuulthaa*.[5]

Evidence of the ancient use of these screens was provided some years ago by a discovery at Ozette, an archaeological site in northwestern Washington State in the territory of the Makah Nation, who are part of the same whaling culture as the Nuu-chah-nulth. Ozette was a Makah village buried instantly by a massive mudslide five hundred years ago. As a result, it is a rare "wet-site" that has been saturated with water since the slide. Because it was covered by this mud, material such as wood, which does not normally survive in non-wet archaeological sites, was preserved in relatively intact form. One of the objects recovered in the excavation was a large screen depicting a *Iihtup*, or humpback whale, and two serpent-/wolf-like creatures. This screen was and is a *Kiitsaksuu-ilthim*. It was constructed of several large, split red cedar boards, which were sewn together with cedar withes. The screen was found in context in one of the main houses of Ozette.

*Kiitsaksuu-ilthim*, in their form, what they depict, and their use in potlatches, reflect and contribute to the formation of the Indigenous legal systems and cosmology articulated through potlatches. The laws they reflect and influence include, among others, the laws of marriage, naming, initiation, standing, and chiefly prerogative. As well, laws similar in substance to intellectual property laws address the ownership and use of names, songs, and depictions of certain beings and the right to tell histories. *Hawilth suu'is*, the God from Beyond the Horizon, has several representatives or messengers, one of which is *Iihtup* (humpback whale). By representing this messenger on their screens, and the Thunderbird hunting the whales, chiefs depict the right, which only they have, to hunt these whales and their affinity with *Hawilth suu'is*.

The screens also function to physically separate the *Ma'as* ("house" or "where everybody is"), referring in this context to the public ceremonial space of a potlatch, from the *Tl'uukwaanaa p'at* ("doing *Tl'uukwaanaa* space" or "private space" or "space for initiates of the *Tl'uukwaanaa*"), referring to the private organizational or logistical space, where the hosts of the potlatch prepare for the various aspects of the ceremonies. This could include activities such as getting ready for a dance (e.g., putting a headdress or mask on); storing items (e.g., masks) that will be used in the ceremony; or storing items that will be given to the guests during the course of the potlatch.

In some cases, the screens themselves play a direct role in a specific ceremonial event, such as when a chief holds a particular right to a song and a mask related to a screen. The song is sung from behind the screen, giving the impression the singers' voices emanate from beyond the ceremonial space, and the mask is lifted from behind the screen to be visible to the guests in a way that extends the

substance and meaning of the screen to include the mask for the duration of the song. Also, other songs can be sung from behind the screen. One example is the *Ci'aas* (a sacred chant), sung with a rattle by a ritualist. One function of the *Ci'aas* is to transform everyday space into ritual space. These songs are considered to be the most ancient of all the various classes of song sung by the Nuu-chah-nulth. They are often simple chant-like and melodic vocalizations that do not contain specific words as other songs do, and they are often accompanied by the use of *kuxmin* (Nuu-chah-nulth rattles). A further, and associated, method of transforming space into ceremonial or sacred space is the spreading of eagle down on the floor in front of the screen that is to be used in the ceremonies. This eagle down is called *Tsiilth'thin* and is not simply eagle down but symbolically represents both clouds and snow, both considered to originate in the Realm beyond the Horizon. These are just some of the many ways in which the Nuu-chah-nulth symbolically reconstruct their cosmology in their ceremonial activities, and the screens are a critical element in the creation of this space.

Importantly, the screens also represent some aspect of the host's identity and prerogative rights to the guests and act to situate the host in the Nuu-chah-nulth community and world. One *Aytsaksuu-ilthim* I've seen used at Ahahswinis depicted the *topaati* (prerogative games and rituals) held by the host's family related to the *Aytstuulthaa* ceremony. While many of the screens depict generic humpback whales and thunderbirds (which are universal crests available to any Nuu-chah-nulth person), some of them depict named whales and thunderbirds that are associated with the host's family and ancestors. The screen is a portrayal of a specific whale or thunderbird owned by certain families. These thunderbirds are specifically named and have nests in specific territories, and the right to depict them is owned and controlled by specific families as part of their basic identity.

Beyond the context of a Nuu-chah-nulth potlatch, these screens cease to be animated with their basic purpose. I experienced the effect of this decontextualization in my first art history class in university. The course text was H.W. Janson's *The History of Art*, 3rd edition (1986) [21.VI], which reproduced part of a potlatch screen that belonged to my Huupacasaht family – an old *Kiitsaksuu-ilthim* that was last owned by my great-great-grandfather Chuuchkamalthnii (see screen to right of boy in Figure 21.1; see also Figure 22.4). The screen, reproduced in Janson's chapter on "Primitive Art," had been purchased, along with its counterpart, by the American Museum of Natural History from the collector Lieutenant George T. Emmons in 1929.[6] Janson, who acknowledged that the screen "do[es] not form a meaningful scene unless we happen to know the context of the story," nonetheless told us that the Nuu-chah-nulth had "large

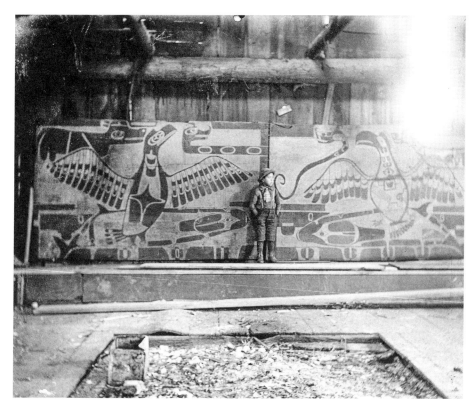

**FIGURE 21.1** A boy stands in front of potlatch screens, ca. 1920. The screens belonged to this author's great-great-grandfather Chuuchkamalthnii and are shown here in situ at Ahahswinis prior to collection by George T. Emmons (see also Figure 22.4). This Nuu-chah-nulth *Kiitsaksuu-ilthim* was painted in the Nootka style, using images that represented family histories and ownership of certain legends and stories. The screen on the right was reproduced in H.W. Janson's *The History of Art,* 3rd ed. (New York: Harry N. Abrams, 1986). Vancouver Public Library, Special Collections, VPL 9284.

wooden houses with walls of smooth boards which they liked to decorate with scenes of tribal legend." In addition to his mischaracterization of the screen as a decoration, he misidentified the humpback whale as a killer whale, an error that anyone with even a rudimentary knowledge of Nuu-chah-nulth culture would not make. I was struck by what Janson saw, by what he did not perceive, and by what he could understand outside the context of one of my family's potlatches. The meaning of the "marks made in a meaningful way" on the *Kiitsaksuu-ilthim* was utterly indecipherable to Janson.

How did these screens fall out of the possession of my family? I do not know the specific history, but I know that there is no simple answer. I would suggest that the law's prohibition of the potlatch, combined with other aspects of coloni- alism, attacked and undermined the essential purpose of my family's screens. The effect of this was to undermine the meaningfulness of the marks on the cedar

*Marks on the wood* 

— that which speaks where mere words fail — and thereby enabled their transformation from Chuuchkamalthnii's *Kiitsaksuu-ilthim* to decontextualized commodities that could easily find their way far from the Huupacasaht village of Ahahswinis to a New York City museum, where they would be seen by foreign eyes as mere decorations. Perhaps Chuuchkamalthnii, like Uncle George, was engaged in a strategic resistance against this oppression when he gave up his screens. After all, the screens' very use, by definition, amounted to a statutory offence. Perhaps he had new screens made up to replace them that could be used in a less conspicuous way. I will discuss this possibility below.

What of the screens in New York City? Could something of the *Kiitsaksuu-ilthim* remain there? I had always hoped to see the screens, but they are not part of any permanent display and are kept in storage. On my most recent trip to New York City, my sister Tracey and I went to the American Museum of Natural History. Because of the last-minute nature of the trip, I had not had a chance to contact the museum to arrange to view the screens, so we resigned ourselves to seeing the *Totems to Turquoise* exhibit of Northwest Coast and Southwest jewellery. In the back of the exhibit space, my attention was drawn to a display of Bill Reid's early non-Northwest Coast jewellery, and I peered down into the case. When I stood up, I saw what was on the back wall, serving as a backdrop to the show: one half of Chuuchkamalthnii's *Kiitsaksuu-ilthim!*

My sister and I were stunned and deeply moved. After standing in front of the screen for five minutes, intently examining it, we took refuge from the intensity of the experience in the gift shop around the back of the wall. There we stood, emotional, asking each other what we should do. At one moment, we came close to simply walking away, but we realized we had to do something. I told my sister that we should go back to the screen, and I would sing one of our family's potlatch songs, and she should dance. She agreed. We went back into the exhibit space and looked around at the crowds of people and the security. I was concerned that there would be a disturbance during the song that would cause me to break from singing. We proceeded. I sang and Tracey danced — for a full five minutes — tears streaming down our faces at the emotional and spiritual impact of an unexpected reconnection with such a critical part of our family's existence and the experience of simply being in front of the *Kiitsaksuu-ilthim* that had been a part of so much of our family's history. No one disturbed us, not even the security guard, who came close by but did not intervene. I believe that, like so many of our ancestors before us, my sister and I were transformed that day by the experience of singing and dancing in front of our screen — in a different way than in the past but transformed nonetheless. We walked out of the museum onto Central Park West feeling rocked by what had transpired.

Janson's view, to this point at least, has prevailed – the screen has become a mere decoration, a backdrop to an exhibition. For a moment, though, my sister and I repatriated our family's *Kiitsaksuu-ilthim*, we brought it home, across the continent to a different ocean and shore, a different context, when we sang that song it had heard long ago, danced in the space in front of it, and recognized the meaningfulness of the marks made upon the ancient cedar boards.

The *Thliitsapilthim* are essentially *Kiitsaksuu-ilthim* made out of muslin cotton cloth instead of old-growth planks. The two differently named screens are used for the same purposes, but their form was changed in the late nineteenth century. I suggest that one dimension of this change in form arose in response to the potlatch prohibition. First, the investment a family needed to create a *Thliitsapilthim* was far less. Therefore, the loss, should they be confiscated, was far less. Second, they could also be taken down and hidden in a way that the *Kiitsaksuu-ilthim* could not. The change in form from *Kiitsaksuu-ilthim* to *Thliitsapilthim* provides evidence for an argument that the Nuu-chah-nulth were engaged in a strategy of cultural resistance to the potlatch prohibition. By making the screens in a form that could be used in potlatches but then taken down and put out of sight, there would be no evidence of potlatching on display whenever the Indian Agent or another official stopped by. Of course, many other changes contributed to this shift in form: loss of access to old-growth cedar; a change in residential patterns from longhouses to single-family dwellings that could not contain *Kiitsaksuu-ilthim;* simple cost; and so on. However, I think that it is fair to suggest that the Indian Act potlatch prohibition was a contributing factor.

## STORY, AUTHORITY, AND LAW

Law's role in the history of the Northwest Coast peoples, in both Canada and the United States, has been extensively discussed in recent years (see Fisher 1992; Tennant 1990). This has not always been the case. In particular, British Columbia's legal establishment for much of the nineteenth and twentieth centuries denied outright the legality of the claims made by Indigenous peoples in relation to Aboriginal title. Law was not seen to be at issue in relation to these claims.[7] However, from the Indigenous view, colonial and Canadian law has always been explicitly engaged in, and at the forefront and foundation of, the ongoing colonial project to dispossess them of their sovereignty, law, lands, waters, cosmology, worldview, identity, and voice. Because art is so deeply embedded in all of these aspects of Northwest Coast society, it, too, has been impacted. Of this view and experience, the Crown has provided only limited recognition. Meaningful reconciliation between the sovereignty of Indigenous peoples and the assertion

of Crown sovereignty remains a challenge, in large part, because of the continuing impoverished Crown recognition of Indigenous peoples. Of course, this is not to say that the Crown has not had anything to say about Indigenous peoples or their lands and resources. The Crown has engaged in a deep way, using every available voice to proclaim its own views on the matter.

As discussed earlier, there are three institutions in Canada endowed with this special voice or power to articulate and express Canada's authoritative and significant legal narratives – to exhort legally compelling stories. They are the executive, the legislative, and the judicial. Contained within the English legal tradition are powerful stories of the Crown and sovereignty and fictions such as the doctrine of tenures, with which the "Crown" has organized Canada's land laws and that form the basis upon which the "Crown" claims title to Indigenous territory (see Borrows 1999). Much of this law was not even articulated here in Canada but was first developed in England as part of England's constitutional law, statutory law, and judicial law (the jurisprudence arising through the courts of equity and the common law, among other sources). Canada's colonists brought these narratives and stories with them from England, and for a time England's Parliament and courts remained the most authoritative voice of Canada. For example, the Constitution Act, 1867, formerly known as the British North America Act, Canada's founding constitutional document, was enacted by the Imperial Parliament in London.

Canada is also home to the civil law tradition in Quebec, which does not concern us on the Northwest Coast, other than to provide a key example of the different sources of law and legal tradition in Canada. Canada is a multijuridical state, of which legal pluralism is a basic feature. The Northwest Coast is home to many Indigenous legal orders and traditions as well. Coast Salish, Nuu-chah-nulth, Kwakwa̲ka̲'wakw, Bella Bella, Bella Coola, Tsimshian, Haida, Tlingit, and the rest all have Indigenous legal orders and traditions, in which Indigenous art plays a key role. The following sections contain examples of how Canada's legal order and tradition have been enlisted in ways that have had an impact on Northwest Coast art.

## THE EXECUTIVE VOICE: PROCLAMATIONS AND TREATIES

The Royal Proclamation of 1763 [21.VII] is one of the basic statements of Crown policy and the law related to Indigenous rights in Canada. Essentially, this proclamation recognized the existing Indian Nations and protected and reserved their lands to them. It stated, in part,

And whereas it is just and reasonable, and essential to our Interest, and the Security of our Colonies, that the several Nations or Tribes of Indians with whom We are connected, and who live under our Protection, should not be molested or disturbed in the Possession of such Parts of Our Dominions and Territories as, not having been ceded to or purchased by Us, are reserved to them, or any of them, as their Hunting Grounds.

The proclamation contained one of the most important early uses of the term "Indian" in what has become Canada. It also reflected the obligation of the Crown to enter into agreements in relation to territories and was the basis of the Crown policy to execute treaties with Indigenous peoples prior to settlement. In British Columbia, this imperative was only followed briefly in the mid-nineteenth century on Vancouver Island. There fourteen agreements, or treaties, known commonly today as the Douglas Treaties [21.VIII], were made between the Hudson's Bay Company, as representative of the Crown, and the Indigenous peoples around Victoria, Nanaimo, and Fort Rupert. On the American side of the border, in Washington State, the policy was also followed in the treaty making that took place there in the mid-nineteenth century.

The Douglas Treaties secured to the Aboriginal groups title to their "village sites and enclosed fields" and the right "to hunt over the unoccupied lands, and to carry on ... fisheries as formerly." It is arguable that the title to these village sites and enclosed fields amounted to a unique or *sui generis* title to the land unlike that of other Indian Reserves in British Columbia, which were made under statutory authority. Such a title would bring these lands under the protection of section 35(1) of the Constitution Act, 1982, as an existing treaty right.

What does this have to do with Northwest Coast art? Notwithstanding the Crown's breaches of honour and fiduciary duty in relation to the implementation of treaties over the past 150 years, the treaties continue to provide a solid foundation for First Nations jurisdiction and ownership in relation to their territories and resources. Chief Justice Beverley McLachlin of the Supreme Court of Canada stated in the *Haida Nation* decision (2004) that "treaties serve to reconcile pre-existing Aboriginal sovereignty with assumed Crown sovereignty, and to define Aboriginal rights guaranteed by s. 35 of the *Constitution Act, 1982*."[8] This is a clear recognition of what is at stake in treaties. Treaties are the clearest example of Crown recognition and acceptance of the Indigenous peoples and their title and rights. If the spirit of that recognition were fully implemented, treaties could have the effect of strengthening the purpose and function of Northwest Coast art within Northwest Coast society.[9] Rather than being mere

decoration, as Janson has seen it, Northwest Coast art would regain its fullest meaning – as an essential element of the constitution of Indigenous nations – and this meaning would be protected within the treaty relationship and under section 35 of the Constitution Act, 1982, as an existing treaty right. This, of course, has not been the historical conception of a treaty relationship embraced by the Crown. Yet it remains a conception open to Indigenous peoples and the Crown as a basis of meaningful reconciliation.

The Douglas Treaties also provided for the recognition of Indigenous hunting and fishing rights. The territories and resources of treaty hunting grounds and fisheries are critical to the creation of Northwest Coast art. How can a drum be made, painted, and used in ceremonies and rituals if there is no access to deer? The same deer provide the hooves used in rattles and *Kwutcmiin*. Similarly, fulfillment of treaty promises is critical for the production of some Northwest Coast art. For the Snuneymuxw, one of the Indigenous peoples who signed a Douglas Treaty, the treaty right to fish as formerly includes the right to participate in a critical first salmon ceremony that takes place at a petroglyph at Jack's Point, near Nanaimo. Petroglyph images are an essential component of this ceremony, all of which should be protected as a treaty right. The right to create Snuneymuxw art, and to have it protected, in support of the exercise of treaty right activities, should be recognized by the Crown. While this matter has not been argued or decided in court, it illustrates the nexus between art and law that this chapter strives to illuminate. Snuneymuxw artists should demand the recognition of these, and related, rights to practise their art and culture.

### THE LEGISLATIVE VOICE: THE INDIAN ACT AND THE CONSTITUTION

Canada's most powerful and authoritative voice – its constitutional voice – established Canadian federalism by dividing legislative jurisdiction between the federal government and provincial governments. As an essential aspect of that division of powers, section 91(24) of the Constitution Act, 1867, granted the federal government an unusual and exclusive (to the exclusion of the provinces) legislative jurisdiction in relation to "Indians, and Lands reserved for the Indians." "Indians" became a constitutional concept and category, and thereby reinforced and deepened the entrenchment of the use of the concept of "Indian," earlier expressed in the Royal Proclamation of 1763 [21.IX], to the exclusion and displacement of Indigenous identities. This constitutional power is the basis of the federal Indian Act. More recently, the constitutional voice of Canada once again spoke in section 35(1) of the Constitution Act, 1982, and this time said that "the existing aboriginal and treaty rights of the aboriginal peoples of Canada are

[Handwritten margin note: Hunting rights provide access to animal hides for art / ceremonies]

hereby recognized and affirmed" [21.x]. "Aboriginal" is now an additional constitutional identity and category, defined to include the Indian, Inuit, and Métis peoples of Canada.

In the first instance, the constitutionalized concept of "Indian" identity has been imposed upon and across the great diversity of Northwest Coast peoples' Indigenous identities and has served to undermine and weaken them. How has this affected the art of this region? Once again, there is no simple answer, but it has certainly tended to have the effect of dispossessing or at least interfering with personal and national identity and political structure. If we accept the premise that one of the roles of art is to express these things to the world, then the damage is clear.

In the second instance, the constitutional recognition and affirmation of the existing Aboriginal and treaty rights of the Aboriginal peoples of Canada expressed in section 35(1) of the Constitution Act, 1982, have been, like the treaties discussed above, aimed at reconciling the pre-existence of Aboriginal societies with the assertion of Crown sovereignty. The entrenchment of Aboriginal and treaty rights in the Constitution protects those rights from unjustified infringement by federal or provincial legislation. Attempts by either federal or provincial governments to enact laws inconsistent with Canada's Constitution are invalid, as the Constitution is the supreme law of Canada. The interpretation of this provision has been the focus of much attention in the courts over the past quarter century. Its potential to constitutionally protect Aboriginal and treaty rights to practise art, and the Aboriginal intellectual and cultural property jurisdiction, will be discussed below.

The debates leading up to the enactment of the law against the potlatch indicated that Parliament had been persuaded by missionaries and Indian Agents from British Columbia that potlatching was a debauchery that needed to be eradicated for the betterment of the Northwest Coast peoples. In addition to the prohibition of the potlatch, the Indian Act functioned in many ways to undermine the identity of Northwest Coast peoples. This included, among other provisions, its definition of "Indian"; the authorization of residential schools; the imposition of band council political structures that interfered with, or displaced, traditional governance systems; and a prohibition (that operated from 1927 to 1951) against the raising of money to pursue claims against the Crown.

## THE JUDICIAL VOICE: THE COMMON LAW

Courts are the sites of contestation over law and the interpretation and application of law. As mentioned above, Aboriginal peoples' access to the courts was

restricted by the Indian Act from 1927 to 1951. It was not until a Snuneymuxw Douglas Treaty hunting rights case, known as *R. v. White and Bob*, was successfully appealed to the Supreme Court of Canada in 1965 that Indigenous peoples in Canada really began to use the courts to fight for their own voice and story about who they are, their territories, and their relations with the Crown. Thomas Berger, the lawyer who argued *R. v. White and Bob* on appeal, described it as "the first shot fired by the Aboriginal peoples of Canada in their campaign to reclaim aboriginal and treaty rights" (Berger 2002, 87). The lengthy decision by the BC Court of Appeal relied upon both American (the Marshall trilogy of the American Supreme Court) and Canadian jurisprudence in its decision. To date, most disputes have been centred on Aboriginal title to land, Aboriginal rights to resources, and the interpretation of treaty rights. Only recently have disputes in the courts involved issues related to Indigenous identity and self-government rights. Even so, the most basic features of a potential Aboriginal right to self-government remain undefined by the courts. The development of the law of Aboriginal and treaty rights continues to be dynamic, and much of the law is still nascent and underdeveloped.

Aboriginal title is considered a special form of Aboriginal right. We know from *Delgamuukw* that Aboriginal title is an exclusive right to the land itself, which is held communally, and includes the right to choose how to use the land and to benefit economically from it. While this particular right has been the focus of major decisions of the Supreme Court of Canada going back to *Calder* and *Delgamuukw*, Aboriginal title remains only a legal concept – it has not been determined to exist in any specific place in Canada by a court. Not one grain of sand in Canada has been declared by a court to be Aboriginal title land. The opportunity for Northwest Coast art to convey legal facts and meaning in the courts should not be overlooked. In Australia, Aboriginal paintings that depict territories and encode Indigenous knowledge and law have been entered as evidence of Aboriginal title in court in a process similar to the way that totem poles were used by the Gitksan and Wet'suwet'en. To prove Aboriginal title in Canada, the Aboriginal group claiming the right must demonstrate that it was in exclusive possession and use of the territory at the time of the assertion of Crown sovereignty. In British Columbia, the relevant time has been established as 1846, when Britain and the United States finally determined the location of their respective sovereignties through the Oregon Treaty. What better physical evidence exists in relation to Aboriginal title than Nuu-chah-nulth *Kiitsaksuu-ilthim* or totem poles?

The basic test to recognize an Aboriginal right was established in the *Van der Peet* decision, which states that the activity amounts to "an element of a practice,

custom or tradition integral to the distinctive culture of the aboriginal group claiming the right."[10] For the most part, the disputes that have ended up in court have involved hunting and fishing and other resource use rights. But what about the possibility of asserting and arguing the existence of an Aboriginal right to practise Northwest Coast art and jurisdiction over Northwest Coast art? Certainly, there are Indigenous laws that control the use and display of some forms of Northwest Coast art. This fact fits nicely into the test, set out above, for proving an Aboriginal right. It seems likely that such an Aboriginal right could be the basis of a form of intellectual property law. The Supreme Court of Canada, in *Sappier and Gray* [21.XI], provided some commentary on the current state of Canadian Aboriginal rights jurisprudence and the role of the concept of culture within it.

The recent *Haida Nation* decision established that the Crown is under a duty to consult whenever it contemplates a decision that might adversely affect a potential Aboriginal right. Key in the *Haida Nation* arguments was the centrality of cedar to the Haida people's way of life. The connection to the production of Northwest Coast art is clear. And should Northwest Coast peoples present a strong claim to an Aboriginal right to practise and control Northwest Coast art, they could gain a stronger foothold in intellectual property discussions with the Crown that affect Northwest Coast art.

## INTERNATIONAL LAW

The potential role of international law has become clearer with the United Nations Declaration on the Rights of Indigenous Peoples, adopted by the General Assembly in September 2007 [21.XII]. With this declaration, the voices of Indigenous peoples began to find some degree of standing on the international stage, although they remained outside the chorus of voices that matter most in that arena – those of the nation-states. The declaration itself did not legally bind nation-states. However, to the extent that it reflected underlying and emerging customary international law, it promised a different future for Indigenous peoples and provided political and moral direction for the disputes between Indigenous peoples and governments within nation-states. Canada, the United States, Australia,[11] and New Zealand were the only nation-states to vote against adoption of the Declaration, although all four have since changed their positions and signed the document.

After twenty years of complicated negotiations, the United Nations agreed, in Article 11 of the Declaration, that

1. Indigenous peoples have the right to practise and revitalize their cultural traditions and customs. This includes the right to maintain, protect and develop the past, present and future manifestations of their cultures, such as archaeological and historical sites, artefacts, designs, ceremonies, technologies and visual and performing arts and literature.

2. States shall provide redress through effective mechanisms, which may include restitution, developed in conjunction with indigenous peoples, with respect to their cultural, intellectual, religious and spiritual property taken without their free, prior and informed consent or in violation of their laws, traditions and customs.

## CONCLUSION

The deep integration of art with other aspects of Northwest Coast society discussed above accounts for the indirect nature of the impact of Canadian and American law on Northwest Coast art. The full force of colonialism was rarely aimed directly at Northwest Coast art, but it always, because of the deep integration, had significant impacts when it was aimed elsewhere – such as at authority, identity, land, or resources.

Northwest Coast art has been affected by laws expressed by both Canadian and American governments. The way of life, the culture, the very world within which Northwest Coast art arises and finds its home have been mercilessly attacked by colonialism. The basic structures of Indigenous society that provide meaning, identity, values, and principles have been undermined. Access to basic resources of Indigenous territories, such as old-growth cedar, that are required for the production of much Northwest Coast art has been denied by systematic dispossession and subsequent resource extraction by governments. Treaty promises have been broken. The honour of the Crown has not been upheld. The astonishing costs of litigation, and difficulties that courts encounter when grappling with these extremely complicated issues, have left the Indigenous peoples of the Northwest Coast with limited remedy or recourse in courts. Yet there is hope. The laws of Aboriginal rights and title, of treaty rights, and of international law can form a partial basis, in conjunction with continuing Indigenous legal systems, for a strong foundation to protect and uphold Northwest Coast art – to allow the voices of Indigenous peoples to speak and be heard once again where mere words fail.

**21.I. George C. Clutesi. 1947. "The Urge to Create."** *Native Voice: Official Organ of the Native Brotherhood of British Columbia* 1, 7: 14.

George C. Clutesi (1905-88) was a member of the Tseshaht First Nation and a seminal figure in the development of twentieth-century Northwest Coast art. As a leading cultural figure in the Nuu-chah-nulth world on the west coast of Vancouver Island, he played many key roles as a writer, actor, poet, singer, historian, ritualist, orator, activist, advocate, and artist. "The Urge to Create" was published in *Native Voice*, a newspaper published by the Native Brotherhood of British Columbia, the primary vehicle for the expression of arguments for Aboriginal title and rights during this era.

Much has been accomplished, for you, towards the bringing back of our ancestral pride and heritage. Movements of sympathetic and understanding men and women are well underway, and with encouraging results, all through this province to reawaken and foster back to life the urge to create, to embellish, to sing and to dance, which very unfortunately and unwisely had been allowed to lapse and become dormant.

Much like any other race, our ancestors thrived in their own social environments. One of which consisted of creating simple, and yet very powerful designs of bird and animal life. So much so that it has been acclaimed by modern writers and authorities on anthropology as among the most singular and unique primitive art in the world. We do not seem to understand the fullness and the immensity of that acknowledgment. It is time that we did and begin very earnestly to recapture the urge to create, artistically; to sing, to dance, and once again to practice oratory as did our forefathers. It has been as I mentioned in the beginning, rekindled for us and it is now up to us to carry on.

It is well and good to adopt the ways of our white brethren, providing you still remember the heritage your ancestor left you, the ability and the earnest desire to create, to paint beautiful native designs, to sing, to dance in your own true way when occasion demands. (Please do not misunderstand, I am not advocating potlatches; personally I am opposed to them.) You can still sing and dance or practice the fine points of oratory and give nothing away. The old philosophy or belief of our ancestors of giving does not fit into the pattern of life today in this mad world of grab, grab, grab! We must adjust ourselves to this new way of life. We must learn how to save, to build and keep in repair what we do build for the future. The simple necessities the Great Spirit provided our ancestor at his very door is no more. To live and to survive in this new era we must save, we must store up for the future.

Civilization is an awe-inspiring and soul-tearing culture. It brings wonderful miraculous wonders; steamers as big as islands, trains that travel a mile a minute, wonderful cars, iron-birds that fly at unheard of speeds, etc., etc. – to mention but a few of the better known products of civilization – but in its very wake, it also brings destruction! It brings disease, ailments never before known to our people, we, the aborigines of this beautiful new world. The sooner we realize this, the better we shall be prepared

to cope with what has engulfed us so efficiently and so completely, the sooner shall we realize that we must as individuals prepare ourselves to do our bit to meet this overwhelming onslaught of civilization. The only logical solution, I believe, is to learn as quickly and as efficiently as possible the concepts of this new culture. Reach for and acquire higher education. Without it we are lost, we are like chattels. As long as we are useful we are tolerated; become weak, then we are cast aside.

Therefore, thirst after wisdom. Reawaken the desire to administer unto your own in this new culture, prepare yourselves to become doctors, nurses, nurses' aids, teachers, ministers of the Gospel, etc., and when you have accomplished these come back to us. For we are in need of you most urgently. I know that.

We all can't be doctors, nurses, teachers, ministers, artists, basket weavers, etc., but we certainly can try harder to awaken a great deal more ambition within ourselves. Ambition is the keynote, the secret of all accomplishments; without it you are but a very unstable chattel with no security for the morrow. With it you can soar to heights without restraints and the most logical and the most needful place to impart your newly acquired wisdom is right here amongst your own people. We cannot all accomplish these great things but we can awaken and foster a little more ambition even if it is to follow a hobby. But learn, and do something. Yes, it is good to adopt our white brother's mode of life, but I repeat, remain the Native North American Indian that you are, the Great Spirit made you so. Be proud of His creation.

**21.II. Government of Canada. 1884. House of Commons Debate on Indian Act Potlatch Prohibition.** 24 March, 1063, 7 April, 1399.

The Indian Act is an astonishing piece of legislation that, perhaps more than any other Canadian statute, has had enormous adverse impacts on Indigenous peoples across Canada and the Northwest Coast. Such was the totality of its impact and effect that we must consider how the function and purpose, production, and, in some cases, very form of Northwest Coast art were affected by it. Based in part on pre-Confederation statutes, and first enacted in 1876, the Indian Act has included provisions that imposed a generic "Indian" identity across Canada's diverse Indigenous peoples, prohibited the potlatch (1885-1951), and prohibited raising money to pursue land claims (1927-51), among others. The excerpts that follow, taken from the official records of the House of Commons, document the legislative debate on the criminalization of the potlatch, led by Prime Minister Sir John A. Macdonald.

March 24, 1884
Indian Act Amendment

*Sir JOHN A. MACDONALD* ... The third clause provides that celebrating the "Potlatch" is a misdemeanour. This Indian festival is a debauchery of the worst kind, and the departmental officers and all clergymen unite in affirming that it is absolutely necessary to put this practice down. Last year the late Governor General issued a proclamation on the advice of his Ministers warning Indians against celebrating this festival. At these gatherings they give away their guns and all their property in a species of rivalry, and go so far as to give away their wives; in fact, as I have said, it is a great debauch. Under this Act to celebrate the Potlatch is to be guilty of a misdemeanour.

April 7, 1884
Indian Act Amendment

*Sir JOHN A. MACDONALD.* This is a new clause for the purpose of putting down the Indian festival known as the "potlatch" which is the cause of a great deal of misery and demoralization in British Columbia. The representations made to the Government on this subject, not only by the Indian agent but by the clergy are very strong. They say it is utterly useless, especially on Vancouver Island, where the "potlatch" principally exists, to introduce orderly habits while it is in vogue. They meet and carry on a sort of mystery; they remain for weeks, and sometimes months, as long as they can get food, and carry on all kinds of orgies. It is lamentable to read the accounts given by the clergy of British Columbia, and they urge that some legislation on the subject should take place. It was suggested by the clergy there that it would have some effect if the Governor General should issue a proclamation, warning the Indians against this unhappy custom, and though it did have some effect, it was not at all commensurate with the expectations which were founded upon it, and so it is proposed to introduce this clause. I have here a number of statements from both the Catholic and the Protestant missionaries, showing the awful effects of this custom, but I need not trouble the House by reading them.

*Mr. BLAKE.* I think anybody who has read descriptions of this feast will not doubt that it has a very demoralizing tendency in a great many ways. I have had accounts of men of apparently very considerable financial and commercial power among the Indians of British Columbia, some of whom I believe have accumulated considerable wealth, and it is all dissipated in the insane exuberance of generosity which seems to be encouraged by these meetings. But the custom is a very old and a very inveterate one amongst them; and without at all saying that the case is not ripe for the passage of such a clause as this, it seems to me that one should be very cautious in attempting suddenly to stop, by the harsh process of the criminal law, the known customs and habits of these tribes. I would therefore strongly recommend the hon. Gentlemen,

with reference to the minimum punishment of two months, to alter the clause, so that for the first two years an almost nominal punishment might, if the authorities thought it expedient, be imposed in the first instance. The point to be attained is to the getting the Indians gradually to see that this practice is contrary to the law; and by the force of the trial and a very trifling punishment the first time, with a warning that would spread amongst them that a much severer punishment might be inflicted on the next occasion, would perhaps repress the practice. But the necessity of inflicting two months' punishment might turn out to be a calamitous necessity.

*Sir JOHN A. MACDONALD.* I will accept the hon. gentleman's suggestion and strike out the words "nor less than two," leaving the maximum, but not the minimum.

*Mr. BLAKE.* I have another suggestion with reference to the extreme looseness of the provision making those liable to indictment who directly or indirectly encourage an Indian to celebrate the festival, and liable to six months' imprisonment. This is certainly a very vague offence to bring a man for six months to gaol.

*Sir RICHARD CARTWRIGHT.* Does the hon. gentleman know whether this practice prevails universally in British Columbia?

*Sir JOHN A. MACDONALD.* It pervades some of the tribes – I think not all; but Vancouver Island is the chief scene of these disorders. Mr. Lomas, who is a very intelligent agent on the west coast of Vancouver Island says:

> The two customs are intimately connected, because without a donation (potlatch) of food, a dance is never held, and these dances have been sadly on the increase during the present winter, and many young men have impoverished themselves and their families because they had not the moral courage to oppose the customs. Indeed this want of courage or inability to withstand the sneers of the old people always forms one of the greatest drawbacks in the advancement of the native races on the coast. But in the event of any law being passed, it would be advisable to allow a fixed time for its coming into force, as potlatches are in reality a spending of a certain amount of property which has to be returned at an uncertain date with interest, or rather with an additional amount, which at some future date has also to be returned either by the recipient, or if he be dead, by some of his sons. Thus, young men themselves opposed to the custom are often drawn in it, but besides the expenses of the potlatch, *i.e.*, food, firewood, and attendance on the guests, a large amount of property is always thrown away, to be scrambled for by the invited guests. Local traders derive a benefit from these gatherings, and often encourage the Indians to keep them up, forgetting that were these Indians working their lands, they would be a constant source of profit

instead of being, as now, only an occasional one. A few days ago I called a meeting of all the leading men of Cowichan, Chemainus, and Saanich bands, on the above subject, and the matter was well discussed, but I regret to say only a few had the courage to stand up and say they would give up both customs, and do their best to influence their relatives to do so. Since that time several others have been to request that their names be added to this list; and as several of these have had land allotted to them, I would suggest that they be supplied with their location tickets at once.

The clergy are exceedingly strong on this subject. Mr. Donckele, the Catholic priest at Cowichan says:

For many years I have entertained the hope that these heathenish practices would have disappeared as soon as the young people adopted the habits of the whites, and applied themselves to the pursuits of various industries; but now I am sorry to state that many of the young men, who for years had improved their fertile lands, built houses and barns on them, and made for themselves and their families an almost independent life, have abandoned their farms and become again the adepts of super-stition and barbarism. The evil reached its climax last winter, when some of the most prominent dancers insulted some of their Indian Chiefs, because they insisted on their subjects assuming the habits of the whites and giving up the savage life of their ancestors. With a view to ameliorate the condition of the Indians and provide them with comfort and happiness, I respectfully request you, Sir, in the name of the civilized Indians, to beg the Indian Department to have a law to stop the disastrous practice of potlatching, and especially dancing, as it is carried on by the Indians of Vancouver Island. I am thoroughly convinced that unless stringent measures be taken, every effort will be fruitless; for parents bring up their children in such a way that it is impossible for anyone to inculcate in their minds any moral, social, or industrious knowledge. The only training parents bestow upon their children is concerning the potlatches and dances. During the whole winter, schools are deserted by all those children whose parents attend the dances. When the winter is over they have squan-dered all their summer earnings, and are compelled to leave their homes and roam about in their canoes in search of food, and thus neglect cultivating their lands and sending their children to school. In the summer they leave again for several months, working abroad to earn a few dollars, in order to give a dance in the winter. I have lately visited the Indians residing between Cowichan and Nanaimo, and in every tribe where dancing is kept up there was a general complaint of sickness; and, alas, how could it be otherwise, when for about two months they hardly take a night's rest, and when they indulge whole days in ceaseless vociferations.

His statements are very grievous with respect to the chief dances, and I think we must have stringent legislation to put them down.

*Mr. SHAKESPEARE.* Not only is it the wish of the clergy that these dances and potlatches should be done away with, but it is the desire of a large number of the Indians of Vancouver Island. Last year I presented a petition to the right hon. the leader of the Government from several hundred Indians on Vancouver Island, expressing the wish that the Government would take some steps to do away with these potlatches, as they were demoralizing in the extreme.

**21.III. Indian Act. 1884. Potlatch Prohibition Provisions.** 47 Vic., c. 27, s. 3 (1884); R.S.C. 1906, c. 81, s. 149.

The Indian Act first prohibited the potlatch in the first law excerpted below, which came into effect in 1885. As related in Cole and Chaikin (1990), the law was made a dead letter by the refusal of the chief justice of the Courts of British Columbia, Sir Matthew Begbie, to convict a Kwakiutl man, Hamasak, due to the uncertainty of the meaning of the word *potlatch*. This was addressed in an amendment to the provision, made in 1906, to prohibit "any Indian festival, dance or other ceremony of which the giving away or paying or giving back of money, goods or articles of any sort forms a part, or is a feature." Sir John A. Macdonald's promise not to include a minimum two-month sentence in the legislation, made in the House of Commons debate of 1884, was clearly not fulfilled. In 1918, a further amendment was made to allow conviction by summary proceedings rather than indictment.

[47 Vic., c. 27, s. 3 (1884):]

CHAP. 27.

An Act further to amend "The Indian Act, 1880."

[Assented to 19th April, 1884.]

In further amendment of "The Indian Act, 1880," Her Majesty, by and with the advice and consent of the Senate and House of Commons of Canada, enacts as follows: –

3. Every Indian or other person who engages in or assists in celebrating the Indian festival known as the "Potlach" or in the Indian dance known as the "Tamanawas" is guilty of a misdemeanor, and shall be liable to imprisonment for a term of not more than six nor less than two months in any gaol or other place of confinement; and any Indian or other person who encourages, either directly or indirectly, an Indian or

Indians to get up such a festival or dance, or to celebrate the same, or who shall assist in the celebration of the same is guilty of a like offence, and shall be liable to the same punishment.

[R.S.C. 1906, c. 81, s. 149:]

149. Every Indian or other person who engages in, or assists in celebrating or encourages either directly or indirectly another to celebrate, any Indian festival, dance or other ceremony of which the giving away or paying or giving back of money, goods or articles of any sort forms a part, or is a feature, whether such gift of money, goods or articles takes place before, at, or after the celebration of the same, and every Indian or other person who engages or assists in any celebration or dance of which the wounding or mutilation of the dead or living body of any human being or animal forms a part or is a feature, is guilty of an indictable offence and is liable to imprisonment for a term not exceeding six months and not less than two months; but nothing in this section shall be construed to prevent the holding of any agricultural show or exhibition or the giving of prizes for exhibits thereat.

> **21.IV.  George C. Clutesi. 1969.** ***Potlatch.*** Sidney, BC: Gray's Publishing, 9, 10, 31-32, 36.

Clutesi published *Son of Raven, Son of Deer: Fables of the Tseshaht People* in 1967 to wide acclaim. Two years later he published *Potlatch,* which contained an introductory comment on the Indian Act's prohibition of the potlatch. Also excerpted here is a description of the role of artists and art in composing and constituting the Nuu-chah-nulth worldview, laws, and sovereignty.

INTRODUCTION

The author of this story attended and participated in the last Tloo-qwah-nah when he was a very young man. It was then unlawful to entertain a feast or a potlatch by a decree of the Indian Act. Indeed his own kin was arrested for having staged such a Tloo-qwah-nah. It is then with trepidations that this "eye-witness" account is given and it is because of this lingering fear that actual names have been omitted.

...

For years prior to a Tloo-qwah-nah the principal and his councillors began to plan and to accumulate various articles that he would give away — sea-otter robes; whaling canoes, sleek sea-otter and fur-seal hunting canoes and the smaller fishing and utility canoes. These canoes required harpoons, lanyards, thongs, buoys, paddles, spears, bailers, water containers, paints and pigments with which to treat and preserve them. Then there were the smaller articles such as cooking utensils and chattels of many kinds.

The most important gift one could give was the bestowal of a song together with its dance and the ornate paraphernalia needed to show any subsequent ceremonial presentations.

Territories, fishing and hunting rights and the right to keep all game caught within these territories and all flotsam found therein was on extraordinary occasions included in the bestowal of gifts and only then was the recipient able to give a feast in his own name. He was also granted a place in the seating arrangement of guests and so became eligible for a subsequent seat in the senate.

...

III

Along the entire coast of Vancouver Island established areas were acknowledged to belong to tribes, with kings who exercised plenary authority over that area.

In many cases the areas included meadows for rootstocks, bulbs, berries and so on; hunting grounds for wild game; rivers and streams for salmon; shorelines for mollusks, crustaceans; shallows, reefs and shoals for rock fish and finally seaward areas bounded by established lines relative to and abiding by landmarks. Complete rights to these areas were sustained tenaciously and any infringement of hunting laws were severely dealt with. It was the law to take the first of any seasonal food to the residing king so that all members of his tribe might taste and partake of the food as it came in for the first time.

The council for a domain consisted of the chief and his subordinate chiefs. Influential seats in the council or senate were allotted to leaders according to their wisdom and abilities, men with proven wisdom, strength of character, and who were virtuous and impartial. It was these leaders who taught the masses and it was believed that good example did what any amount of admonition or set of secondary rules would not. Moreover, the strength and continuance of power depended greatly, if not entirely, on these qualities. Indeed, kings were known to disown an heir and revoke all pretensions, rights and claims that would normally have been his inheritance. However, this occurred only when such heir consistently showed weaknesses of morality or total rejection of inter-tribal laws.

Out of the council there emerged a tribunal to resolve and settle all disputes of consequence, oftimes including those of wars. From this council, too, came the ushers, whose business it was to know which particular seat belonged to whom; the advisers to the king; the mentors; the teachers; the storytellers; the historian; and the orators who presented the message, articles of agreement and oftimes an ultimatum also.

An artist was sometimes inducted into the tight organization when and if he merited that honor because he was able to think profoundly and create forms with which to

show the people and thereby to stimulate, encourage, provoke and win over to ideas
and principles where mere words failed.

...

IV

The speaker for the House stood a little to one side of the residing king. In his left
hand he held the Talking Staff. He held the stick to display the ornate carvings that
adorned the top portion that represented his office and indeed was the official symbol
for the speaker of the tribe.

**21.V. Douglas Cole and Ira Chaikin. 1990.** *An Iron Hand upon the People: The Law against*
*the Potlatch on the Northwest Coast.* Vancouver: Douglas and McIntyre, 175, 176-77, 183. © 1990 by
Douglas Cole and Ira Chaikin, published by Douglas and McIntyre, an imprint of D&M Publishers Inc.
Reprinted with permission from the publisher.

Douglas Cole (1938-97) and Ira Chaikin provided a thorough consideration of
the law against the potlatch in *An Iron Hand upon the People.* Excerpted below is
an explanation of how Northwest Coast art came to be confiscated in the admin-
istration of the Indian Act prohibition against the potlatch, even though the
Indian Act itself did not provide for such confiscation. Cole and Chaikin also
provided their consideration of the impact of the prohibition on the Northwest
Coast.

> On 16 February 1922 thirty-two people (two were ill) appeared in Halliday's school-
> house courtroom for the beginning of the most decisive legal action against the pot-
> latch. The charges stemmed from Dan Cranmer's potlatch, the largest ever recorded
> on the central coast ...
>
> After several adjournments caused by storms that prevented first the witnesses, then
> Angermann [the arresting sergeant], from getting to Alert Bay, proceedings finally
> commenced on 27 February ... First to appear were second offenders Moses Alfred,
> Nahok and Johnny Drabble. The testimony of four Crown witnesses, along with that
> of Alfred and Drabble, quickly established the strength of the prosecution's case.
> Murray [counsel to the indigenous defendants], prepared for this, abruptly altered all
> pleas to "guilty." He asked for the leniency of the court on the basis of an agreement,
> already signed by all defendants and some fifty others, to potlatch no more.
>
> Once again, the offer to sign an agreement seems to have been motivated by the
> desire to avoid imprisonment ... The sergeant insisted upon more than another piece
> of paper; he wanted "some tangible evidence of good faith." His suggestion that
> the whole Kwakiutl agency make a voluntary surrender of all potlatch property was

accepted by the court. The case was remanded for a month pending acceptance of the terms by the defendants.

A new agreement was drawn up. It contained an acknowledgement not only of the law but of the fact that it was to be strictly enforced, with no expectation of amendment or repeal. Signatories agreed to obey the law, to do all in their power to see that others kept it, and even to assist authorities in its observation. Furthermore, they agreed, as a "token of our good faith," voluntarily to surrender to the department "all our potlatch paraphernalia" by 25 March. Halliday and Wastell agreed that those signing the agreement and surrendering their property would receive suspended sentences and that the minister of justice would be asked to pardon the three second offenders.

The decision now rested with the Kwakiutl: to sign and surrender their material or go to prison. That choice rested not just with the thirty-four offenders but also upon the three hundred or so others who had attended Cranmer's potlatch. Angermann stood ready to pounce on a good number more against whom he had evidence.

Halliday did his best to persuade all to sign and surrender. He read the letter from Scott that stated the department's intention of retaining Section 149 unaltered. The Indians, he felt, "realized themselves the hopelessness of a fight against the law." Having spent in the vicinity of $10,000 on legal fees and deputations, they now felt that they had thrown it all away. Most did not object to signing – they had themselves suggested the agreement – but did object to losing the coppers and the great value behind them. "I tried to show to them," Halliday wrote, "that as they could not use these coppers anymore in the potlatch that [they] were useless property" and should be viewed as any person would see "a foolish or unsound investment."

On the morning of 31 March, the answer was clear. Virtually all Cape Mudge Lekwiltok, Village Island Mamalillikulla and Alert Bay Nimpkish accepted the agreement and turned in their coppers and dancing gear. Condemned prisoners from the three complying groups were given, as agreed, suspended sentences; second offenders were granted a stay pending an appeal for parole to the Department of Justice. The appeal was granted six months later.

Other groups, notably the Fort Ruperts, refused to sign. Seven offenders – Jim Hall of Karlakwees and six Fort Ruperts, including the alleged police informant Kenneth Hunt – received two-month sentences. Angermann executed his threat of further prosecutions, summoning seventeen more Cranmer potlatch participants as well as issuing summonses against three others for offences in January and February on Harbledown Island. On 7 and 8 April all were found guilty ...

The surrendered potlatch regalia and coppers from those accepting the agreement were gathered in Halliday's woodshed, then moved to the parish hall and put on exhibition. They numbered over 450 items, including twenty coppers, scores of hamatsa whistles and dozens of masks. Halliday was directed to ship the material to the

National Museum in Ottawa for evaluation, but a lack of time and the summer shortage of labour delayed crating for several months. In the meantime, George Heye, founder of New York's Museum of the American Indian, called in and wanted to buy "a considerable amount of the stuff." Halliday, feeling that Heye's prices were exceptionally good, sold him thirty-five pieces for $291. The agent, certain that "no one but a very enthusiastic collector would have given as much," viewed his action as consistent with the object of securing as much money as possible for the Indians. The department, however, was angered at this "unwarranted action."

The remaining material, seventeen cases, went to Ottawa where museum anthropologist Edward Sapir appraised it at a value of $1456, without the coppers. Cheques were sent to Halliday in April to be given to the former owners. Some Kwakiutl do not remember receiving payment, and there were accusations of omissions, but there can be no question that the cheques were issued and sent, since the matter was the point of an auditor general's inquiry. Halliday did record that the Indians considered the compensation "entirely inadequate." No compensation was ever paid for the coppers. (The bulk of the collection was kept by the National Museum with a portion donated to the Royal Ontario Museum in Toronto. Both have since returned their portions to native museums in Alert Bay and Cape Mudge where they are displayed with stunning appropriateness.)

The loss of masks and coppers hurt, but the crackdown on the potlatch hurt more. In all, during April 1922, fifty-eight Kwakiutl had appeared before Halliday's makeshift bench. Nine cases were dismissed, twenty-three received two-month suspended sentences, and four were given six-month sentences, although three were later paroled. But twenty-two people served two-month sentences ...

Halliday felt he could be lenient because the potlatch had now been killed. The Indians were "inspired by a wholesome fear of the law." There might occasionally be minor affairs, but there was "absolutely no danger of any great potlatches ever taking place again."

...

It is tempting, in considering the history of the potlatch, to argue that the law, for all its symbolism, had little to do with what actually happened between 1885 and 1951. After all, there was only one successful prosecution (and that a minor one) before 1914, and almost all convictions came in eight years from one agency. A good case could be made that the law really had little effect. It was left unenforced for most of its time in existence and attempts at enforcement were more often futile than not. The potlatch, in any easily recognizable form, disappeared from sight in most of the province without the law being a demonstrable cause in its demise. Moreover, in American sections of the Northwest Coast, where no statutory provisions against the potlatch existed, the ceremony withered and died at least as soon as in Canada.

Comparisons between Canada and the United States are difficult. While no law against the potlatch existed south of the border, agents and their extralegal courts often acted as if one did, and American missionaries, who had a quasi-official authority, exercised the same zeal as their Canadian counterparts. It seems true, however, that among the Coast Salish, the last potlatch on the American side of the border was held about 1905 and on the Canadian side about 1915. The Makah of Cape Flattery retained theirs less than did their Nootka kinsmen on Vancouver Island. More instructive, in Alaska, where American Indian legislation did not apply and where there were, therefore, no Bureau of Indian Affairs agents, the potlatch died away soon after the turn of the century. In Canada, on the other hand, the potlatch, despite the law, continued among the Gitksan and expanded among the Kwakiutl. One could even argue (as Drucker and Heizer have) that the law created among some Indians a kind of rebellious backlash that promoted the potlatch's perpetuation.

...

While an argument could be made that the law had, on balance, no real effect upon the potlatch, the story is much too complicated to accept such easy generalization. The law was there and it made some difference to Indian conduct. Missionaries, as Vowell reported, used it "as a lever of no inconsiderable force" in their efforts to eradicate the potlatch. Even Agent Neill, who avoided any prosecutions under the law, urged that it be retained. Even unenforced, "its moral influence is considerable," he wrote; "The teachings of Missionaries & the warning of the Indian officials backed up by the Knowledge that sec. 114 could be called on, have had a good effect." The law, ineffective as it may ultimately have been, did affect the Indians, their feasts and their dances, and did fester among many as both a real and a symbolic grievance. However, it does seem that the potlatch law has been given a symbolic importance far exceeding its actual impact. "The relative effects of the potlatch law," concludes Rolf Knight, "seem often overexaggerated."

The law was probably considerably less significant than writers and others, white or Indian, have tended to think. That may well have been the consequences of timing. Scott's enforcement of antipotlatch legislation in the early 1920s came at a time when the potlatch, as a system interrelated with traditional marriage, customary rank and increasing wealth, may have already been breaking down. That the enforcement coincided with accelerating acculturation and the decline of the Kwakiutl economy may well have excessively highlighted the role of the potlatch law in the unquestionable decline of the potlatch itself. Focussing on the potlatch ban, writes Knight, misdirects attention from more fundamental legislative restrictions, disregards the differing interests within Indian society by the 1920s and "glosses over the fact that by that late date, much more drastic changes had occurred."

...

Yet it must be remembered that the Indians were not supine victims of white legisla-
tion. That the law went largely unenforced was in great measure a result of native
resistance, even defiance. In this resistance, local sympathies lay largely with the
Indians. The federal government had to overcome these sympathies, especially as
evinced by judges and juries. And, once enforcement measures seemed perfected, the
natives, certainly both the Kwakiutl and the Gitksan, devised stratagems that defeated
further attempts at enforcement. In the contests over the law – at Comeaken, before
Begbie's bench, in the suspended sentences and dismissals following Scott's 1913
enforcement attempts, in the native inventiveness that led to the frustration of agents
and superintendents after 1927, and, ultimately, in the dropping of the law in 1951 –
the Indians won at least as often as they lost.

**21.VI. H.W. Janson. 1986. *The History of Art.*** 3rd ed. New York: Harry N. Abrams, 35-36, 50-51.

In his standard textbook *The History of Art*, H.W. Janson (1913-82) discussed
"primitive art," locating a Nuu-chah-nulth *Kiitsaksuu-ilthim* (potlatch screen)
within that category (see 21.1 for Clutesi's reference to Northwest Coast art as
"among the most singular and unique primitive art in the world"). Janson ac-
knowledged that the meaning of a painting was inaccessible when the painting
was out of its Indigenous context. First published in 1962, this edition was pub-
lished in 1986.

### PRIMITIVE ART

There are, as we have seen, a few human groups for whom the Old Stone Age lasted
until the present day. Modern survivors of the Neolithic are far easier to find. They
include all the so-called primitive societies of tropical Africa, the islands of the South
Pacific, and the Americas. "Primitive" is a somewhat unfortunate word: it suggests
– quite wrongly – that these societies represent the original condition of mankind,
and has thus come to be burdened with many conflicting emotional overtones. Still,
no other single term will serve us better. Let us continue, then, to use primitive as a
convenient label for a way of life that has passed through the Neolithic Revolution
but shows no signs of evolving in the direction of the "historic" civilizations. What
this means is that primitive societies are essentially rural and self-sufficient; their social
and political units are the village and the tribe, rather than the city and the state; they
perpetuate themselves by custom and tradition, without the aid of written records;
hence they depend on oral tradition for their own history.

The entire pattern of primitive life is static rather than dynamic, without the inner
drive for change and expansion that we take for granted in ours. Primitive societies
tend to be strongly isolationist and defensive toward outsiders; they represent a stable

but precarious balance of man and his environment, ill-equipped to survive contact with urban civilizations. Most of them have proved tragically helpless against encroachment by the West. Yet at the same time the cultural heritage of primitive man has enriched our own: his customs and beliefs, his folklore, and his music have been recorded by ethnologists, and primitive art is being avidly collected and admired throughout the Western world.

...

PAINTING

Compared to sculpture, painting plays a subordinate role in primitive society. Though the technique was widely known, its use was restricted in most areas to the coloring of wood carvings or of the human body sometimes with intricate ornamental designs. As an independent art, however, painting could establish itself only when exceptional conditions provided suitable surfaces. Thus the Nootka Indians of Vancouver Island, off the northwest coast of North America, developed fairly large wooden houses with walls of smooth boards which they liked to decorate with scenes of tribal legend. Figure 50 [not illustrated, this volume] shows a section of such a wall, representing a thunder bird on a killer whale flanked by a lightning snake and a wolf. The animals are clearly recognizable but they do not form a meaningful scene unless we happen to know the context of the story. The owner of the house obviously did, so the painter's main concern was how to combine the four creatures into an effective pattern filling the area at his disposal.

It is apparent that these animals, which play important parts in the tribal mythology, must have been represented countless times before; each of them is assembled in accordance with a well-established traditional formula made up of fixed ingredients – small, firmly outlined pieces of solid colour that look as if they have been cut out separately and laid down one by one. The artist's pattern-consciousness goes so far that any overlapping of forms embarrasses him; where he cannot avoid it, he treats the bodies of the animals as transparent, so that the outline of the whale's back can be seen continuing right through the lower part of the bird's body, and the feathers of the right wing reveal the front legs of the wolf.

**21.VII. George III. 1763. Royal Proclamation.** Reprinted in *A Collection of the Acts Passed in the Parliament of Great Britain and of Other Public Acts Relative to Canada.* 1824. Quebec: P.E. Desbarats, King's Printer, 26, 32, 34.

King George III (1738-1820) issued the Royal Proclamation of 1763 following the Treaty of Paris that concluded the Seven Years War. This document, which has been described as the Magna Carta of Indian Rights, expressed the Crown's

policy in relation to Indian lands by stating that, unless the Indian lands had been ceded to or purchased by the Crown, they remained reserved to the Indians.

Whereas We have taken into Our Royal Consideration the extensive and valuable Acquisitions in America, secured to our Crown by the late Definitive Treaty of Peace, concluded at Paris the 10th Day of February last; and being desirous that all Our loving Subjects, as well of our Kingdom as of our Colonies in America, may avail themselves with all convenient Speed, of the great Benefits and Advantages which must accrue therefrom to their Commerce, Manufactures, and Navigation, We have thought fit, with the Advice of our Privy Council, to issue this our Royal Proclamation ...

...

And whereas it is just and reasonable, and essential to our Interest, and the Security of our Colonies, that the several Nations or Tribes of Indians with whom We are connected, and who live under our Protection, should not be molested or disturbed in the Possession of such Parts of Our Dominions and Territories as, not having been ceded to Us, are reserved to them, or any of them, as their Hunting Grounds – ...

And We do further declare it to be Our Royal Will and Pleasure, for the present as aforesaid, to reserve under our Sovereignty, Protection, and Dominion, for the use of the said Indians, all the Land and Territories not included within the Limits of Our said Three new Governments, or within the Limits of the Territory granted to the Hudson's Bay Company, as also all the Lands and Territories lying to the Westward of the Sources of the Rivers which fall into the Sea from the West and North West as aforesaid. And We do hereby strictly forbid, on Pain of our Displeasure, all our loving Subjects from making any Purchases or Settlements whatsoever, or taking Possession of any of the Lands above reserved, without our special leave and Licence for that Purpose first obtained.

And We do further strictly enjoin and require all Persons whatsoever, who have either wilfully or inadvertently seated themselves upon any Lands within the Countries above described, or upon any other Lands which, not having been ceded to or purchased by Us, are still reserved to the said Indians as aforesaid, forthwith to remove themselves from such Settlements.

And whereas great Frauds and Abuses have been committed in the purchasing Lands of the Indians, to the great Prejudice of our Interests and to the great Dissatisfaction of the said Indians; in order therefore, to prevent such Irregularities for the future, and to the end that the Indians may be convinced of our Justice and determined Resolution to remove all reasonable Cause of Discontent, We do, with the Advice of our Privy Council strictly enjoin and require, that no private Person do presume to make any purchase from the said Indians of any Lands reserved to the said Indians within those parts of our Colonies where We had thought proper to allow Settlement:

but if at any Time any of the Said Indians should be inclined to dispose of the said Lands, the same shall be Purchased only for Us, in our Name at some public Meeting or Assembly of the said Indians, to be held for that Purpose by the Governor or Commander in Chief of our Colony respectively within which they shall lie: and in case they shall lie within the limits of any Proprietaries, conformable to such Directions and Instructions as We or they shall think proper to give for that Purpose.

...

Given at our Court at St. James's the 7th Day of October 1763, in the Third Year of our Reign.

GOD SAVE THE KING

**21.VIII. Douglas Treaties. 1851.** In *Papers Connected with the Indian Land Question: 1850-1875.* 1875. Victoria: Richard Wolfenden, Government Printer, 12.

The Crown established Vancouver Island as a proprietary colony in 1849, granting the island to the Hudson's Bay Company (HBC), tasked with its settlement. Following policy first stated in the Royal Proclamation of 1763, the HBC was expected to recognize the Aboriginal title of the Indigenous peoples of Vancouver Island. In light of this policy, fourteen treaties were recorded between the HBC, as Crown agent, and the Indigenous peoples around Victoria, Fort Rupert, and Nanaimo between 1850 and 1854. After 1854, no further treaties were negotiated in British Columbia until the Nisga'a Treaty of 2000. This has left the vast majority of British Columbia without a treaty relationship between Indigenous peoples and the Crown. The failure to recognize Aboriginal title, and the practice of proceeding with settlement and development notwithstanding Aboriginal title, form the basis of the "Indian land question." The following excerpt is an example of the text of the Douglas Treaties. To properly apprehend the full treaty relationship, however, requires consideration of Indigenous oral history of the negotiations to determine the common intent of the negotiations.

### QUAKEOLTH TRIBE — FORT RUPERT.

Know all men, we, the chiefs and people of the Tribe called Quakeolths, who have signed our names and made our marks to this deed on the eighth day of February, one thousand eight hundred and fifty-one, do consent to surrender, entirely and for ever, to James Douglas, the agent of the Hudson's Bay Company on Vancouver Island, that is to say, for the Governor, Deputy Governor, and Committee of the same, the whole of the lands situate and lying between McNeill's Harbour and Hardy Bay, inclusive of these ports, and extending two miles into the interior of the Island.

The condition of or understanding of this sale is this, that our village sites and enclosed fields are to be kept for our own use, for the use of our children, and for those who may follow after us; and the land shall be properly surveyed hereafter. It is understood, however, that the land itself, with these small exceptions, becomes the entire property of the white people for ever; it is also understood that we are at liberty to hunt over the unoccupied lands, and to carry on our fisheries as formerly.

We have received, as payment, Eighty-six pounds sterling.

In token whereof, we have signed our names and made our marks, at Fort Rupert, Beaver Harbour, on the eight day of February, one thousand eight hundred and fifty-one.

(Signed) WAWATTIE his x mark
and 15 others.
Witnesses,

(Signed) WILLIAM HENRY McNEILL, C. T., H. B. Co.
CHARLES DODD, Master, Steamer Beaver.
GEORGE BLENKINSOP, Clerk, H. B. Co.

**21.IX. Constitution Act. 1867.** 30 & 31 Victoria, c. 3. (U.K.).

The federal government was granted exclusive legislative jurisdiction over "Indians, and Lands reserved for the Indians" by section 91(24) of the Constitution Act, 1867, formerly known as the British North America Act. It was, and remains, an imperial statute of the United Kingdom. With these words, the category "Indian" became one of the founding concepts of Canada's constitutional life. "Indian" was, constitutionally speaking, born with Canada and was a powerful first strike in the colonial project of obliterating Indigenous conceptions of self, such as Salish, Haida, or Heiltsuk. Canada used this constitutional power to enact the Indian Act.

(Consolidated with amendments)
An Act for the Union of Canada, Nova Scotia, and New Brunswick, and the Government thereof; and for Purposes connected therewith

[29th March 1867.]
Whereas the Provinces of Canada, Nova Scotia, and New Brunswick have expressed their Desire to be federally united into One Dominion under the Crown of the United Kingdom of Great Britain and Ireland, with a Constitution similar in Principle to that of the United Kingdom:

...

## VI. DISTRIBUTION OF LEGISLATIVE POWERS

*POWERS OF THE PARLIAMENT*

91. It shall be lawful for the Queen, by and with the Advice and Consent of the Senate and House of Commons, to make Laws for the Peace, Order, and good Government of Canada, in relation to all Matters not coming within the Classes of Subjects by this Act assigned exclusively to the Legislatures of the Provinces; and for greater Certainty, but not so as to restrict the Generality of the foregoing Terms of this Section, it is hereby declared that (notwithstanding anything in this Act) the exclusive Legislative Authority of the Parliament of Canada extends to all Matters coming within the Classes of Subjects next hereinafter enumerated; that is to say,

...

24. Indians, and Lands reserved for the Indians.

**21.X. Constitution Act. 1982.** Being Schedule B to the Canada Act 1982 (U.K.), 1982, c. 11, s. 35.

Canada repatriated its Constitution from the imperial government in the United Kingdom in 1982. Section 35, reproduced below, constitutionally entrenched the existing Aboriginal and treaty rights of the Aboriginal peoples of Canada. As the Constitution is the supreme law of Canada, the executive and legislative bodies are constrained by the recognition and affirmation contained here. Any law inconsistent with Canada's Constitution is of no force or effect.

PART II

*RIGHTS OF THE ABORIGINAL PEOPLES OF CANADA*

35. (1) The existing aboriginal and treaty rights of the aboriginal peoples of Canada are hereby recognized and affirmed.
    (2) In this Act, "aboriginal peoples of Canada" includes the Indian, Inuit and Métis peoples of Canada.
    (3) For greater certainty, in subsection (1) "treaty rights" includes rights that now exist by way of land claims agreements or may be so acquired.
    (4) Notwithstanding any other provision of this Act, the aboriginal and treaty rights referred to in subsection (1) are guaranteed equally to male and female persons.

**21.XI. Supreme Court of Canada. 2006.** *R. v. Sappier; R. v. Gray,* [2006] SCC 54, paras. 20, 22, 23, 33, 42-45.

Justice Michel Bastarache of the Supreme Court of Canada revisited the definition of Aboriginal rights in Canadian jurisprudence. In doing so, he discussed the complexity of dealing with the concept of culture that was first introduced by the Supreme Court in its "distinctive culture" test in *R. v. Van der Peet* (1996).

> In order to be an aboriginal right, an activity must be an element of a practice, custom or tradition integral to the distinctive culture of the aboriginal group claiming the right: *R. v. Van der Peet* ... The first step is to identify the precise nature of the applicant's claim of having exercised an aboriginal right ... In so doing, a court should consider such factors as the nature of the action which the applicant is claiming was done pursuant to an aboriginal right, the nature of the governmental regulation, statute or action being impugned, and the practice, custom or tradition being relied upon to establish the right ...
>
> ...
>
> Section 35 of the *Constitution Act, 1982* seeks to provide a constitutional framework for the protection of the distinctive cultures of aboriginal peoples, so that their prior occupation of North America can be recognized and reconciled with the sovereignty of the Crown ... In an oft-quoted passage, Lamer C.J. acknowledged in *Van der Peet* ... that, "the doctrine of aboriginal rights exists, and is recognized and affirmed by s. 35(1), because of one simple fact: when Europeans arrived in North America, aboriginal peoples were already here, living in communities on the land, and participating in distinctive cultures, as they had done for centuries" ... The goal for courts is, therefore, to determine how the claimed right relates to the pre-contact culture or way of life of an aboriginal society. This has been achieved by requiring aboriginal rights claimants to found their claim on a pre-contact practice which was integral to the distinctive culture of the particular aboriginal community. It is critically important that the Court be able to identify a *practice* that helps to define the distinctive way of life of the community as an aboriginal community. The importance of leading evidence about the pre-contact practice upon which the claimed right is based should not be understated. In the absence of such evidence, courts will find it difficult to relate the claimed right to the pre-contact way of life of the specific aboriginal people, so as to trigger s. 35 protection.
>
> Second, it is also necessary to identify the pre-contact practice upon which the claim is founded in order to consider how it might have evolved to its present-day form. This Court has long recognized that aboriginal rights are not frozen in their pre-contact form, and that ancestral rights may find modern expression ...
>
> ...
>
> Flexibility is important when engaging in the *Van der Peet* analysis because the object is to provide cultural security and continuity for the particular aboriginal society.

This object gives context to the analysis ...

...

This brings us to the question of what is meant by "distinctive culture." As previously explained, this Court in *Van der Peet* set out to interpret s. 35 of the Constitution in a way which captures both the aboriginal and the rights in aboriginal rights. Lamer C.J. spoke of the "necessary specificity which comes from granting special constitutional protection to one part of Canadian society" ... It is that aboriginal specificity which the notion of a "distinctive culture" seeks to capture. However, it is clear that "Aboriginality means more than interesting cultural practices and anthropological curiosities worthy only of a museum" ... R.L. Barsh and J.Y. Henderson argue that as a result of the *Van der Peet* decision, "'culture' has implicitly been taken to mean a fixed inventory of traits or characteristics" ...

Many of these concerns echo those expressed by McLachlin J. (as she then was) and by L'Heureux-Dubé J. in dissenting opinions in *Van der Peet*. L'Heureux-Dubé J. was of the view that "[t]he approach based on aboriginal practices, traditions and customs considers only discrete parts of aboriginal culture, separating them from the general culture in which they are rooted" ... McLachlin J. opined that "different people may entertain different ideas of what is distinctive," thereby creating problems of indeterminacy in the *Van der Peet* test ...

Culture, let alone "distinctive culture," has proven to be a difficult concept to grasp for Canadian courts. Moreover, the term "culture" as it is used in the English language may not find a perfect parallel in certain aboriginal languages. Barsh and Henderson note that "[w]e can find no precise equivalent of European concepts of 'culture' in Mi'kmaq, for example. How we maintain contact with our traditions is *tan'telo'tlieki-p*. How we perpetuate our consciousness is described as *tlilnuo'lti'k*. How we maintain our language is *tlinuita'sim*. Each of these terms connotes a process rather than a thing" ... Ultimately, the concept of culture is itself inherently cultural.

The aboriginal rights doctrine, which has been constitutionalized by s. 35, arises from the simple fact of prior occupation of the lands now forming Canada. The "integral to a distinctive culture" test must necessarily be understood in this context. As L'Heureux-Dubé J. explained in dissent in *Van der Peet*, "[t]he 'distinctive aboriginal culture' must be taken to refer to the reality that, despite British sovereignty, aboriginal people were the original organized society occupying and using Canadian lands ... " The focus of the Court should therefore be on the nature of this prior occupation. What is meant by "culture" is really an inquiry into the pre-contact way of life of a particular aboriginal community, including their means of survival, their socialization methods, their legal systems, and, potentially, their trading habits. The use of the word "distinctive" as a qualifier is meant to incorporate an element of aboriginal specificity.

However, "distinctive" does not mean "distinct," and the notion of aboriginality must not be reduced to "racialized stereotypes of Aboriginal peoples."

**21.XII. United Nations. 2007. Declaration on the Rights of Indigenous Peoples.** UN General Assembly, 107th plenary meeting, 13 October, Resolution 61/295.

After nearly twenty years of negotiations, the General Assembly of the United Nations passed Resolution 61/295 – the Declaration on the Rights of Indigenous Peoples. As will be seen in the excerpts below, it is an expansive statement on Indigenous peoples' rights and addresses many of the issues of colonialism that have been discussed and set out in this chapter's essay and readings. The resolution was adopted nearly unanimously, with only Canada, the United States, Australia, and New Zealand voting against it.

*The General Assembly,*

*Guided* by the purposes and principles of the Charter of the United Nations, and good faith in the fulfilment of the obligations assumed by States in accordance with the Charter,

*Affirming* that indigenous peoples are equal to all other peoples, while recognizing the right of all peoples to be different, to consider themselves different, and to be respected as such,

*Affirming also* that all peoples contribute to the diversity and richness of civilizations and cultures, which constitute the common heritage of humankind,

...

*Concerned* that indigenous peoples have suffered from historic injustices as a result of, inter alia, their colonization and dispossession of their lands, territories and resources, thus preventing them from exercising, in particular, their right to development in accordance with their own needs and interests,

*Recognizing* the urgent need to respect and promote the inherent rights of indigenous peoples which derive from their political, economic and social structures and from their cultures, spiritual traditions, histories and philosophies, especially their rights to their lands, territories and resources,

*Recognizing also* the urgent need to respect and promote the rights of indigenous peoples affirmed in treaties, agreements and other constructive arrangements with States,

*Welcoming* the fact that indigenous peoples are organizing themselves for political, economic, social and cultural enhancement and in order to bring to an end all forms of discrimination and oppression wherever they occur,

*Convinced* that control by indigenous peoples over developments affecting them and their lands, territories and resources will enable them to maintain and strengthen their institutions, cultures and traditions, and to promote their development in accordance with their aspirations and needs,

*Recognizing* that respect for indigenous knowledge, cultures and traditional practices contributes to sustainable and equitable development and proper management of the environment,

...

*Solemnly proclaims* the following United Nations Declaration on the Rights of Indigenous Peoples as a standard of achievement to be pursued in a spirit of partnership and mutual respect:

### ARTICLE 3

Indigenous peoples have the right to self-determination. By virtue of that right they freely determine their political status and freely pursue their economic, social and cultural development.

### ARTICLE 4

Indigenous peoples, in exercising their right to self-determination, have the right to autonomy or self-government in matters relating to their internal and local affairs, as well as ways and means for financing their autonomous functions.

### ARTICLE 5

Indigenous peoples have the right to maintain and strengthen their distinct political, legal, economic, social and cultural institutions, while retaining their right to participate fully, if they so choose, in the political, economic, social and cultural life of the State.

...

### ARTICLE 8

1. Indigenous peoples and individuals have the right not to be subjected to forced assimilation or destruction of their culture.
2. States shall provide effective mechanisms for prevention of, and redress for:
   (a) Any action which has the aim or effect of depriving them of their integrity as distinct peoples, or of their cultural values or ethnic identities;

(b) Any action which has the aim or effect of dispossessing them of their lands, territories or resources;

(c) Any form of forced population transfer which has the aim or effect of violating or undermining any of their rights;

(d) Any form of forced assimilation or integration;

(e) Any form of propaganda designed to promote or incite racial or ethnic discrimination directed against them.

*ARTICLE 9*

Indigenous peoples and individuals have the right to belong to an indigenous community or nation, in accordance with the traditions and customs of the community or nation concerned. No discrimination of any kind may arise from the exercise of such a right.

*ARTICLE 10*

Indigenous peoples shall not be forcibly removed from their lands or territories. No relocation shall take place without the free, prior and informed consent of the indigenous peoples concerned and after agreement on just and fair compensation and, where possible, with the option of return.

*ARTICLE 11*

1. Indigenous peoples have the right to practise and revitalize their cultural traditions and customs. This includes the right to maintain, protect and develop the past, present and future manifestations of their cultures, such as archaeological and historical sites, artefacts, designs, ceremonies, technologies and visual and performing arts and literature.

2. States shall provide redress through effective mechanisms, which may include restitution, developed in conjunction with indigenous peoples, with respect to their cultural, intellectual, religious and spiritual property taken without their free, prior and informed consent or in violation of their laws, traditions and customs.

*ARTICLE 12*

1. Indigenous peoples have the right to manifest, practise, develop and teach their spiritual and religious traditions, customs and ceremonies; the right to maintain, protect, and have access in privacy to their religious and cultural sites; the right to the use and control of their ceremonial objects; and the right to the repatriation of their human remains.

2. States shall seek to enable the access and/or repatriation of ceremonial objects and human remains in their possession through fair, transparent and effective mechanisms developed in conjunction with indigenous peoples concerned.

*ARTICLE 13*

1. Indigenous peoples have the right to revitalize, use, develop and transmit to future generations their histories, languages, oral traditions, philosophies, writing systems and literatures, and to designate and retain their own names for communities, places and persons.

2. States shall take effective measures to ensure that this right is protected and also to ensure that indigenous peoples can understand and be understood in political, legal and administrative proceedings, where necessary through the provision of interpretation or by other appropriate means.

...

*ARTICLE 19*

States shall consult and cooperate in good faith with the indigenous peoples concerned through their own representative institutions in order to obtain their free, prior and informed consent before adopting and implementing legislative or administrative measures that may affect them.

...

*ARTICLE 25*

Indigenous peoples have the right to maintain and strengthen their distinctive spiritual relationship with their traditionally owned or otherwise occupied and used lands, territories, waters and coastal seas and other resources and to uphold their responsibilities to future generations in this regard.

*ARTICLE 26*

1. Indigenous peoples have the right to the lands, territories and resources which they have traditionally owned, occupied or otherwise used or acquired.

2. Indigenous peoples have the right to own, use, develop and control the lands, territories and resources that they possess by reason of traditional ownership or other traditional occupation or use, as well as those which they have otherwise acquired.

3. States shall give legal recognition and protection to these lands, territories and resources. Such recognition shall be conducted with due respect to the customs, traditions and land tenure systems of the indigenous peoples concerned.

...

*ARTICLE 31*

1. Indigenous peoples have the right to maintain, control, protect and develop their cultural heritage, traditional knowledge and traditional cultural expressions, as well as the manifestations of their sciences, technologies and cultures, including

human and genetic resources, seeds, medicines, knowledge of the properties of fauna and flora, oral traditions, literatures, designs, sports and traditional games and visual and performing arts. They also have the right to maintain, control, protect and develop their intellectual property over such cultural heritage, traditional knowledge, and traditional cultural expressions.

2. In conjunction with indigenous peoples, States shall take effective measures to recognize and protect the exercise of these rights.

…

### ARTICLE 33

1. Indigenous peoples have the right to determine their own identity or membership in accordance with their customs and traditions. This does not impair the right of indigenous individuals to obtain citizenship of the States in which they live.

2. Indigenous peoples have the right to determine the structures and to select the membership of their institutions in accordance with their own procedures.

### ARTICLE 34

Indigenous peoples have the right to promote, develop and maintain their institutional structures and their distinctive customs, spirituality, traditions, procedures, practices and, in the cases where they exist, juridical systems or customs, in accordance with international human rights standards.

…

### ARTICLE 37

1. Indigenous peoples have the right to the recognition, observance and enforcement of treaties, agreements and other constructive arrangements concluded with States or their successors and to have States honour and respect such treaties, agreements and other constructive arrangements.

2. Nothing in this Declaration may be interpreted as diminishing or eliminating the rights of indigenous peoples contained in treaties, agreements and other constructive arrangements.

### ARTICLE 38

States in consultation and cooperation with indigenous peoples, shall take the appropriate measures, including legislative measures, to achieve the ends of this Declaration.

…

### ARTICLE 43

The rights recognized herein constitute the minimum standards for the survival, dignity and well-being of the indigenous peoples of the world.

NOTES

1 *Law* and *art* are, of course, variously defined words. Within the confines of this chapter, I cannot address the complexity of these debates about definition. My focus is the adversarial effect of Western law, both Canadian and American, and the British law ancestral to both. Nonetheless, a basic premise of this chapter is that Indigenous law and legal systems are deeply implicated in much of what we call Northwest Coast art. Indigenous law contains imperatives that are always at issue in relation to Northwest Coast art.

2 The "Northwest Coast" is an area of northwestern North America, including parts of the United States and Canada, that is home to diverse Indigenous peoples and cultures.

3 I take the description of the potlatch as a "meta-event" from my uncle Ḳi-ḳe-in (Ron Hamilton), who uses this term to describe the integrative role of the potlatch to bring together the political, legal, social, economic, cosmological, religious, and sacred dimensions of life in one place.

4 The unique role that he held in the community of BC artists is evidenced by the fact that, when Emily Carr no longer had a need for the basic tools and media of her art (the paintbrushes and blank canvases she used to illuminate British Columbia), she bequeathed them to Uncle George in her will.

5 This information comes from my uncle Ḳi-ḳe-in.

6 Personal communication with Peter M. Whiteley, curator of North American Ethnology, Division of Anthropology, American Museum of Natural History, 26 November 2007. The screens have AMNH catalogue numbers 1892a and 1892b.

7 Three well-known examples are found in (1) the policy of denial of Aboriginal title by British Columbia's chief commissioner of Lands and Works, Joseph Trutch, during the late nineteenth century; (2) Premier Smithe's dismissal of a delegation of chiefs (who had arrived to claim Aboriginal title and self-government and to request a treaty) from the steps of the provincial legislature in 1887 by telling them that, "when the whites first came among you, you were little better than the wild beasts of the field" (BC Legislature, *Sessional Papers*, 1887, 264); and (3) a century later the 1991 trial decision of the late Chief Justice Allan MacEachern in *Delgamuukw v. British Columbia*, in which he dismissed an Aboriginal title claim and infamously declared that "it would not be accurate to assume that even pre-contact existence in the territory was in the least bit idyllic. The plaintiffs' ancestors had no written language, no horses or wheeled vehicles, slavery and starvation was not uncommon, wars with neighbouring peoples were common, and there is no doubt, to quote Hobbes, that aboriginal life in the territory was, at best, 'nasty, brutish and short.'"

8 *Haida Nation v. British Columbia (Minister of Forests)*, [2004] 3 S.C.R. 511, para. 20.

9 Of course, history has shown that for the most part neither governments nor courts, at least in Canada, have viewed treaties in this way.

10 *R. v. Van der Peet*, [1996] 2 S.C.R. 507, para. 46.

11 On 3 April 2009, the government of Australia changed its position on the declaration and signed it. New Zealand adopted UNDRIP in April 2010. Canada endorsed it in November of 2010 and the United States followed in December of the same year.

# 22 | Art for Whose Sake?

When we sing our songs,
when we show our masks and headdresses,
we invoke the presence of our ancestors.
We are collapsing time.

> — *Ḳi-ḳe-in, quoted in Martha Black*, *"HuupuK*ʷ*anum · Tupaat —*
> *Out of the Mist: Treasures of the Nuu-Chah-Nulth Chiefs"*

This chapter provides readers with some of the words written by early Europeans in reaction to a range of the creative expressions they encountered in Nuuchaa-nulth. territory. It also provides comments, published by several Nuuchaanulth authors, that will give readers a sense of the richer context that was mostly missed by those Europeans. I do not pretend that my comments and my excerpts are in any way appropriate to other First Nations on the Northwest Coast. My interest and my knowledge and, therefore, my concern in this chapter are with Nuuchaa-nulth culture only. Of course, the information presented here will have some implication for and applicability to other First Nations; it remains for members of those First Nations to determine.

One of the questions that arose early in our discussions leading to this book was for whom was all of this voluminous writing produced? It is important when looking back with a critical eye on a large body of literature, with an aim to deeper understanding, to ask who is the audience and who is meant to benefit from the writing? I, as a Nuuchaanulth person, am of the opinion that people from my community were of little or no importance in all that has been written about our creative output. The earliest texts that deal with my people were composed by explorers with a clear eye to profit and possible colonization. For example, al-though British captain James Cook collected a wide range of Nuuchaanulth ma-terial in 1778 (now scattered among major museums in Europe and private collections around the world), he said almost nothing in his voluminous journals about these objects (see Beaglehole 1967; Kaeppler 1978a). Almost a century later

the colonial enterprise was well under way, with colonial agents such as Gilbert Malcolm Sproat creating records that were clearly not intended for, nor advantageous to, Nuuchaanulthat-ḥ. The ignorant, intemperate, and belligerently racist tone in writings of this time is all too clear. Professional scholars, in search of material to get them through a doctorate or some advancement in their professional careers, generated a third class of texts of interest in this chapter. This is not to say that all scholars were solely self-interested. The fourth group of texts discussed here are the works of Nuuchaanulth people themselves. Now, more and more, we speak for and about ourselves. Our voices are being heard through the medium of published texts, the Internet, websites, and other forms of electronic publishing.

## Explorer and Collector Texts

Among the many explorers who met and traded with the Nuuchaanulthat-ḥ, Captain James Cook (see Kramer, this volume; Jacknis, this volume) [4.II, 23.1], Captain John Meares, naturalist José Mariano Moziño [4.VIII], and Captain Johan Adrian Jacobsen all kept journals and made observations of their time spent with us in the late eighteenth century to the late nineteenth century.

On 13 May 1788, Captain John Meares arrived at Friendly Cove (Yuukwaat) with a mission to construct the first trading ship built anywhere on the Northwest Coast. Although, in the preface to his account of his voyages, Meares (1790, vii-viii) wrote that

> I do not pretend to be the rival, – but rather consider myself an humble follower of those eminent navigators whose reputation has become part of the national fame; and though I may be permitted, as it were, to envy their superior talents and advantages, I most sincerely add my feeble testimony to that merit, which has ranked them among the illustrious names of my country,

he proved himself to be both boastful and a liar. That said, his observations remain rich and worthy of our attention. His description of Wickaninnish's big-house during a feast he and his men attended is full and phantasmagoric [22.1]. Meares informed us that he was in a remote corner of the world and that he admired the ingenuity of the architecture. He also said that Wickaninnish's family consisted of no less than eight hundred persons, which is highly unlikely. However, we may guess that at the particular time there may have been eight hundred people in the village of Opitsaht, the capital of Wickaninnish's territory.

José Mariano Moziño's writings were also biased and shaped by comparative evolutionary ideas. I give Moziño credit for attempting to learn the Muu-ach'at-ḥ language and understand the culture, but in spite of all evidence to the contrary he still evaluated it as uncivilized [22.II].

Norwegian-born captain Johan Adrian Jacobsen travelled the Northwest Coast widely to collect Native artifacts for a number of institutions, including the Berlin Ethnological Museum. Some have considered him an ethnographer (Kincade 1990, 103), although he had no formal training. During his multiple trips to and from the Northwest Coast in Canada and Alaska, Jacobsen collected over seven thousand pieces. An account of these trips was published in 1884 as *The Alaskan Voyage 1881-1883: An Expedition to the Northwest Coast of America* (reprinted 1977) [22.V]. During his journeys, he stopped at places along the west coast of Vancouver Island and purchased various articles of interest to him. He wrote about how the masks always came from and represented local spirituality. I like the fact that, in a moment, Jacobsen moved from observing the sacred object in motion during a potlatch to the just-collected artifact, with the act of purchase being the point of transition. Regardless of his personal appreciation of the spiritual roots of these Nuuchaanulth objects, Jacobsen made clear that his intention in collecting them was to send them to a foreign government's institution as representatives of exotic humanity far from home in a different world.

Interestingly, Jacobsen had a greater impact on anthropology than he probably ever knew. With the assistance of his brother Fillip, he was instrumental in introducing the Bella Coola (now known as the Nuxalk) to Germany in 1885. It was while studying Jacobsen's Nuxalk people and culture collection at the Berlin Ethnological Museum that Franz Boas decided to make his own first trip to North America.

## Nineteenth-Century Colonial Agents

In the 1860s, Gilbert Malcolm Sproat went to Alberni, a recently founded deep-sea harbour at the head of Barkley Sound, in order to manage one of the first sawmills in British Columbia. He later became an agent of the colonial government. In 1868, he published *Scenes and Studies of Savage Life*. He wrote in the most strident language about the process of removing the local people from their traditional territories [22.III]. Sproat was undaunted in his damnation of all things Native. He had no sympathy for the ritual or ceremonial life of the Nuuchaanulthat-ḥ when he was living near them. He wanted the people to move physically away from their village sites so that European settlers could move in and enjoy the waterfront. He wanted them to leave their traditional lifestyle and

be content with the role of cheap labour. This was his intended goal for my ancestors.

Sproat had enormous influence and in 1878 became the Indian Reserve Commissioner, representing both the federal and the provincial governments. He established Indian reserves, with the rest of the land being understood as "Canadian." Historical geographer Cole Harris (2002, 136) wrote that "in a sense he had become the front man, the point of articulation on the ground, for the whole process of colonial dispossession and repossession in British Columbia."

At least for Nuuchaanulth communities, the vast majority of what is now called Northwest Coast Native art was made for the purpose of bringing to life contacts with the spirit world during ceremonies and rituals. Sproat assumed the role of demonizing these activities. He saw Nuuchaanulth people specifically, and Northwest Coast peoples more generally, as inherently inferior to white men. Sproat's case shows that it is impossible and historically inaccurate to divorce the detailed analysis of form and use from the framing attitudes of the time and place of the collectors.

Sproat's 1868 book, on one hand, is about Nuuchaanulth life and culture, but on the other it is about his seemingly distant racist attitudes. His aggressive condemnation of our ceremonies and rituals, and his efforts to eradicate them, are important. As a result, Sproat and others brought about a seventy-year period in which ceremonies and rituals were explicitly against the law. (The Canadian Indian Act forbade potlatching from 1884 to 1951.) Significantly, during that period of suppression, there was an unquestionable loss of skills and knowledge about carving, painting, singing, dancing – creative expression.

James G. Swan lived among the Makah (Tlaa'asat-ḥ) and other groups of the Olympic Peninsula between 1859 and his death in 1900. He was one of the earliest long-term resident white men on the Northwest Coast. He acted in a number of official capacities while living at Port Townsend and Neah Bay. He had facility in the Makah language and spoke the Chinook trade language. He was an Indian Agent, postmaster, customs officer, reservation school teacher, and representative in many different ways of the US colonial government. He was also a man who was very sensitive to the Makah – the people among whom he lived. And he liked many of those people. I have no reason to regard anything he wrote about them as false – I think he was very honest. At the time, when Canada was trying to dispatch Indians, to get us out of the way so the onslaught of industry and capital could proceed (an attitude well exemplified by Sproat), Swan demonstrated a different attitude in Washington State.

Swan saw the humour inherent in the disparities of the colonial situation and appreciated it. Although he thought many of the Makah behaviours were

Fig. 1.

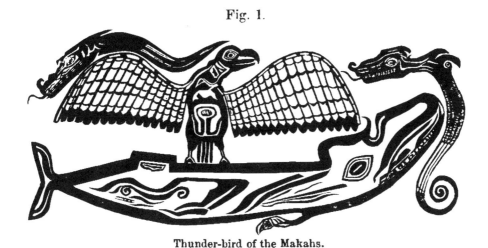

Thunder-bird of the Makahs.

**FIGURE 22.1**  James Gilchrist Swan, "Thunder-Bird of the Makahs," 1870. Original line art. James Gilchrist Swan drawing of a Makah screen painted by a Tla-owkwii-at-ḥ (Clayoquat Indian), Chā-tic (Chartick). From James Gilchrist Swan, *The Indians of Cape Flattery, at the Entrance to the Strait of Fuca, Washington Territory,* Smithsonian Contributions to Knowledge, Vol. 16, article 8 (Washington, DC: Smithsonian Institution, 1870), 9.

laughable, he enjoyed their foibles. As an Indian Agent, Swan was both fascinated by, and appreciative of, the Makah ceremonies. He participated in their ceremonial life and himself created images that were used in ceremonies. For instance, at one point he was shown an unpainted mask, which the Makah brought to him knowing he was a willing participant. They wanted him to decorate their things in ways that were "different." They didn't appear to care what they looked like as long as they were decidedly different from the decorations on the masks of their rival chiefs [4.XVIII, 22.IV].

A brief look at his motives is instructive: "My object in painting for them was to see if they had any historical or mythological ideas" (Swan 1870, 10). He concluded:

> I am satisfied so far as this tribe is concerned, that, with the exception of the Thunderbird drawings all their pictures and drawings are nothing more than fancy work, or an attempt to copy some of the designs of the more northern tribes; and as they have always evinced a readiness to explain to me whatever had significance, I had no alternative but to believe them when they say they attach no particular meaning to their paintings. [See Figure 22.1]

Swan's sympathy and respect are clear in his writing. Swan was a true friend of the people. During my many visits to see relatives at Neah Bay, I have never heard a single negative thing about Swan. His observations were direct, and he was a doer rather than a theorizer. I believe that what he wrote was true for him.

I have always wanted to try to establish which pieces labelled "Makah" might have actually been decorated by Swan. It would be interesting to discover a single Makah object that Swan indisputably had a hand in decorating, which could potentially verify his statements. I am intrigued that there are several characteristics of painted design that have been popularly noted as distinctively Makah. Perhaps one or more of these characteristics are in fact the work of James G. Swan. Connoisseurs and other specialists have often given us the sense that a wide range of objects is distinctly or exclusively recognizable as coming from a given First Nation, village, or even individual. Swan's writing gave us a view that muddied this idea of authenticity and cultural particularity (see Figure 22.2).

## EARLY ETHNOGRAPHERS

While the journals of explorers Cook, Meares, Moziño, and Jacobsen were meant to tell us the cultural situation of the "Nootka" at the time of the first century of contact, and Sproat and Swan gave us the state of affairs during the colonial era, Philip Drucker and Edward Sapir reported on the state of affairs of American anthropology in the first half of the twentieth century.

Drucker, an American anthropologist, ethnologist, and assistant curator did his first fieldwork at Nootka Cannery near Yuukwaat between 1935 and 1936. The Nuuchaanulthat-ḥ congregated there from various villages to work on fish lines, scows, and fishing boats. Drucker's work *The Northern and Central Nootkan Tribes,* published in 1951, remains the standard reference on the Nuuchaanulth [22.VII].

Sapir, a student of Boas trained in anthropological linguistics, was the first director of the anthropology division of the Canadian Geological Survey between 1910 and 1925. He worked as an ethnographer among our people and lived

**FIGURE 22.2** *(facing page)* James Gilchrist Swan included drawings of the various styles of Nuuchaanulth masks in *The Indians of Cape Flattery.* Many of the masks were made by the Clayoquot and Nittinat Indians and then sold to the Makahs, who painted them with their own designs. Masks such as these remain hidden away until the time of performances and ceremonial dances. Many of the stories they animate are sacred narratives and can only be danced or sung by certain members of the community. From James Gilchrist Swan, *The Indians of Cape Flattery, at the Entrance to the Strait of Fuca, Washington Territory,* Smithsonian Contributions to Knowledge, Vol. 16, article 8 (Washington, DC: Smithsonian Institution, 1870), 69, Figures 35-41.

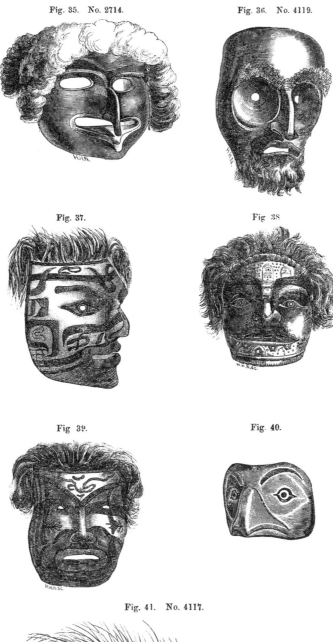

Fig. 35.   No. 2714.

Fig. 36.   No. 4119.

Fig. 37.

Fig 38

Fig 39.

Fig. 40.

Fig. 41.   No. 4117.

with my grandfather, Waa'miish, Hamilton George (later changed legally to George Hamilton), who was one of his informants and translators, at Aswinis (the main village of the amalgamated Huupach'esat-ḥ at this time). Sapir used Native people as informants, interviewing them in our own language. My mother, Naaskuu-isaks, Nessie Watts, said he spoke Nuuchaanulth fluently and flawlessly and was never heard to have tripped on our tongue.

Sapir considered that he had collected enough texts for ten published volumes. A world war and government red tape intervened and slowed the process down. In 1939, the year of his death, Sapir published, with his former graduate student, Morris Swadesh, *Nootka Texts: Tales and Ethnological Narratives, with Grammatical Notes and Lexical Materials. Native Accounts of Nootka Ethnography* was published posthumously in 1955. Invaluable as the staggering amount of collected texts generated by Sapir's fieldwork has been for my community, nowhere in his writing was there any mention of the total absence of children other than infants. Less than a hundred yards from the house of one of his two key informants, and on the other side of a barbed wire fence, were hundreds of Nuuchaanulth children held against their will and the will of their parents at the Alberni Indian Residential School.

Building upon Sapir's groundbreaking work, newer orthographies and Nuuchaanulth texts and dictionaries have emerged, such as A. Thomas and E.Y. Arima's *T'a:t'a:qsapa: A Practical Orthography for Nootka* (1970) and *The Origin of the Wolf Ritual. The Whaling Indians: West Coast Legends and Stories* (Arima, Klokeid, and Robinson 2007). Steadily, more Nuuchaanulth have authored such linguistic works – for example, the Barkley Sound Dialect Working Group's *Nuu-chah-nulth Phrase Book and Dictionary* (2004).

## ART HISTORIANS/ARTISTS

For years, whenever anyone asked for a good introductory reference on Northwest Coast Indian art, I would steer them toward Robert Bruce Inverarity's 1950 book *Art of the Northwest Coast Indians.* Inverarity surveyed the subject effectively and included many illustrations of representative works from all groups in the core area. He did not burden his reader with a lot of analysis or excessive verbiage; rather, he provided great numbers of illustrations of many things and let his readers draw their own conclusions about the illustrated works. Inverarity's intention was to orient his readers so they could see for themselves the excellence of any particular painting, textile, or sculpture [22.VI].

Bill Holm is the most highly regarded and knowledgeable scholar in the field of Northwest Coast art, and rightfully so. His *Northwest Coast Indian Art* (1965)

has been referred to by Robert Davidson, currently the most prominent Haida artist, and by others as "the bible" and remains the point of entry for most new students in this field (see Bunn-Marcuse, this volume).

While serving as director of the Burke Museum at the University of Washington, Holm curated the exhibition *Box of Daylight: Northwest Coast Indian Art*, held at the Seattle Art Museum from 1983 to 1984. This exhibit gathered works held by private collectors around Seattle, including material from well-known collectors such as John H. Hauberg, John Putnam, and Holm himself. In his acknowledgments and introduction in the museum catalogue, Holm thanked a long list of people, current possessors of this beautiful material, for loaning it and highlighted their generosity. He talked about the history of collecting in Seattle and how through their largesse they were casting daylight over the city [22.XI].

All of this *ha'wilthmis*, these chiefly treasures, were created for very specific times and places of display by the most gifted sculptors and painters to mark the wealth and generosity of their original owners and, it was hoped, to further enhance their social status as chiefs. Traditionally, it is understood that all of this *ha'wilthmis* would pass from parent to child or from grandparent to grandchild and continue to function in maintaining the status of the clan or lineage. In this catalogue, however, Holm attended to and emphasized the importance of the current possessors of these items rather than their proper owners. Little has been written about the difference between possessing and owning. I believe that there is a fundamental difference between possession and ownership. Museums and private collectors around the world possess much Nuuchaanulth *ha'wilthmis*. However, we Nuuchaanulth people continue to own both the objects and all of the complex ideas, beliefs, practices, resources, and territories that *ha'wilthmis* makes real (see Townsend-Gault 2000).

Both Holm and his former student Steven C. Brown describe the same Huupach'esat-ḥ dance headdress, possessed by John H. Hauberg (Figure 22.5). On one hand, we have Holm's description in *Box of Daylight* [22.XI]; on the other, Brown (1995) described the headdress in his museum catalogue for the exhibition *The Spirit Within: Northwest Coast Native Art from the John H. Hauberg Collection* [22.XII], but they are similar in their formal analysis and description. I'm going to describe the headdress again in my own way.

I am talking about two dramatically different ways of seeing and discussing these beautiful things. In the first place, my community knows them as *ha'wilthmis*, chiefly treasures of the greatest meaning to a single clan, lineage, or family. In their proper places, these Nuuchaanulth masks, rattles, feast dishes, painted curtains, et cetera were made to be seen and used in front of crowds of

*ḳuu-as,* real living human beings, each with their own particular names. *Ḳuu-as* of all ages come from near and far to gather in communal bighouses with the sound of fires crackling and smoke filling the air with the delicious aroma of blubber and fresh fish cooking. There is a background of people visiting relatives they haven't seen for a long time, accented by long speeches extolling the virtues of past chiefs, historians, doctors, whalers, and other great people. There is the expectation that they are going to be fed well, that the history of the host family will be exposed, and that a great quantity of wealth in many forms will be distributed. All of this takes place in an atmosphere of respect and, at times, great hilarity, even while serious business is being conducted, in the presence of spirits of our ancestors. The place that these things come from is the Nuuchaanulth feasting potlatching system, in which the popular expression *histaḳshitl ts'awaatskwii,* "we come from one root," takes on its most profound meaning.

That is our reality, and I want to contrast it with the reality that Holm, Brown, and others have created by removing our *ḥa'wilthmis* from these vital circumstances, the places of their necessity. They have helped to create a new setting, where much of the richness and many of the complex meanings faded away, the superficial details are stressed, and decoration seems to be the focus. *An Analysis of Form* indeed. Such writing seems to be about connoisseurship. I think that Holm and Brown want to be experts – the sharpest, most critically astute, the most knowledgeable, the cutting edge of Northwest Coast scholarship. Now, such scholars seek connections to Native people in one way or another. For example, Brown included a photograph of a dance headdress worn in Port Alberni, British Columbia, circa 1951. But he did not discuss or reveal the name of the man who made the headdress, when it was made, where it was made, whom it was made for, how it came to be in the Huupach'esat-ḥ community, when it was sold, nor its recent history outside our community.

My feeling is that the healing process that my community is going through today, using ceremony and ceremonial paraphernalia, is good and deserves to be documented and discussed. Yet there has been a tendency among exhibition curators to find the whole matter too controversial. Although I was not involved in any way with the creation of Brown's *The Spirit Within* exhibition, nor had I ever seen most of the material in it, I was asked to write something for the exhibition catalogue. I wanted to write about the use of our ceremonies in our communities, helping our people to heal from sexual abuse forced on their Indian residential schools and sexual abuse perpetrated by members of our communities on their own relatives as a result of Indian residential school attendance. I hoped to broaden the scope of what was being written about our *ḥa'wilthmis,* in terms both of function and of contemporary use, and therefore show the

expanding meaning of our *ḥaʾwilthmis*. This writing would then, of course, reflect both what is really happening to people in my community and the new roles played by our *haʾwilthmis* today. This parallels my experience writing for the book of essays *Nuu-Chah-Nulth Voices, Histories, Objects and Journeys* (Hoover 2000a), which accompanied the Royal British Columbia Museum (RBCM) exhibition *HuupuKʷanum · Tupaat – Out of the Mist: Treasures of the Nuu-Chah-Nulth Chiefs*. It was suggested to me that institutions, such as the RBCM and the Burke Museum, would not tolerate this subject matter in their publications. These experiences over the years confirm that formalism has served to detach and sanitize *haʾwilthmis* from our communities, whereas in fact our *ḥaʾwilthmis* continues to serve us in important ways today.

## Museum Exhibitions and Nuuchaanulth Objects

I want to say something about the language adopted by the RBCM. Years ago the provincial museum made a huge noise about being in a partnership with the Frank family of Clayoquot when they brought back a *thliitsapilthim* (ceremonial curtain) from the Warhol collection (see Hoover and Inglis 1990). The museum claimed to be in an "equal partnership," but how many days have the Frank family had possession of their *thliitsapilthim* and how many times have they displayed it? The provincial museum staff talked about the curtain as if they owned it. Where are the Frank family members when the RBCM staff discuss their family's *thliitsapilthim*?

   Similarly, the publicity for the exhibition *HuupuKʷanum · Tupaat – Out of the Mist*, which opened in 1999 at the RBCM, described it as a "groundbreaking exhibition," an "amazing collaboration," a "great experience." The exhibition's central theme showed that the objects and ritual practices are chiefly possessions, and the museum arranged the exhibition under headings such as *Hahuuli* (This land and these rivers belong to us), *ʔUusimch* (Spiritual preparation in sacred places), and *Pachʾitl* (Feasts mark the progress of a person's life), but from my point of view there was disappointingly little text. The RBCM collaborated with the Nuu-chah-nulth Tribal Council (NTC), but as the members of the NTC are politicians, not necessarily culturally informed, and they had to be cautious to arrive at a consensus, it was difficult for them to provide much text (see Black, this volume) [22.xiii]. I would have liked every inch of wall space covered with text, because we have a lot to say about those things, they have a lot of meaning, a lot of use, they represent a lot of people in the hands of the chiefs who own them. They represent the wealth of the territory, of the *hawilth'*. I reviewed the exhibition catalogue in *BC Studies* 2000-1 [22.xiv].

NUUCHAANULTH AUTHORS

Now the tide has finally turned, and, following the lead of my uncle, George Clutesi, one of the first Nuuchaanulthat-ḥ to publish his writings, many other Nuuchaanulth have published contextualized, intimate understandings of Nuuchaanulth culture, often using the format of the autobiography. Although I will only comment specifically on two such authors (George Clutesi and Luke F. Swan, who wrote with David Ellis), I cannot leave out mentioning Richard E. Atleo (2004); Gloria Jean Frank (2000); Earl Maquinna George (2003); Chief Charles Jones with Stephen Bosustow (1981); Chief Louie Nookmiis and other Huu-ay-aht, whose words were edited by Kathryn Bridge (2004); and Peter S. Webster (1983), to name only a few.

Clutesi, one of my paternal uncles, was born of high-status parents shortly after the turn of the twentieth century and was sent to the Alberni Indian Residential School while H.B. Curry was principal. My uncle was a witness to Curry's savage whipping of Willie Mitchell, a school mate, who subsequently died. He and another boy were forced to mop up what he told me were "blood clots that were like pieces of liver."

When he was released by the school, his father, Ts'aawulthanulth, a renowned Maaḵtlayat-ḥ song leader, sat him down and said, "I want you to start learning our songs, our dances, and all of the history associated with them. Who owns them, where do they come from, what do they symbolize." My uncle told me that he answered his father by exclaiming, "Bull. Shit!" Ts'aawulthanulth (who spoke no English) knew by his tone of voice and facial expression that his son had no interest in doing any such thing. My uncle made clear to me that this was the consequence of his time at the residential school. Over the next several decades, Uncle Georgie acted as what we used to call a "holy-roller preacher."

My uncle said that in 1948 he appeared in front of the federal government's joint House of Commons and Senate Committee on Indian Affairs, charged with rewriting the Indian act. He said he made a presentation about how the potlatch should be legalized again. Also in 1948, he began applying for government financial assistance to prepare what he called "costumes" to be used in "performances" for the non-Native public. A highlight of this period in his life was the performance filmed by Wilson Duff in 1951 when the then Princess Elizabeth visited Victoria.

Clutesi worked on packers and as a skipper on trollers. He met Emily Carr and when he broke his back in 1957, he moved to Victoria to open a little gallery, where he sold his paintings. He became involved with the British Columbia Indian Arts and Welfare Society and began to move in the cultured circles of the

city, where he was encouraged to write. He often spoke on CBC Radio about topics on Westcoast culture. In this way, he became connected to influential white people and their art world. My uncle began to be called an artist.

He came home to Port Alberni and worked in a pile-driving crew until he fell and broke his back in 1957. Clutesi always worked for white people, and for that reason people in our own community didn't trust him very often. He was much gossiped about. People were jealous of him. And he really was materially wealthy.

I think my uncle was seethingly angry. He loved to play the mild, doting, pleasant, profoundly intelligent, deeply spiritual Indian on television shows and movies – the healer of the white people. I found all of that so distasteful, but, in answer to who he was, he was a former Indian residential school student. He was an intelligent man, but, if there was anything that wasn't recognized about him, it was the worth of people like himself. For this reason, my uncle was angry.

In 1967, Clutesi published *Son of Raven, Son of Deer,* a collection of Nuuchaanulth stories. This was followed (posthumously) in 1969 by *Potlatch* and in 1990 by *Stand Tall, My Son*. What is significant about *Son of Raven, Son of Deer* and *Potlatch* is that they were the first works of the first Nuuchaanulth writer published. In the truest sense of the expression, they were the works of "an emerging voice," that of George Clutesi and at the same time that of Nuuchaanulth people. *Potlatch* was written for a white audience. He wrote *Potlatch* to try to make white people like us, which I think was his game all of his life. He struggled to be someone and something that white people could respect and still know as an Indian. My uncle worked tirelessly promoting himself and trying to build a more positive image of our people. Before his death, he had become known through an endless stream of public talks, stints on CBC Radio, and acting in film. Various institutions and governments recognized his efforts, and he eventually received the Order of Canada in 1973. He used his notoriety to expose and decry a range of social injustices. He hated Indian residential schools and what they did to our people. I believe my uncle wanted his writings to function for the benefit of all Native people in this country. He saw himself as a leader with the ability to affect the public's opinion. He was all of that and much more.

As I have explored here, prior to 1967 there was a massive literature on Nuuchaanulth people: journals of early sea captains; numerous anthropological works; writings of colonial functionaries, including early Christian missionaries; and travelogues abound. With the publication of *Son of Raven, Son of Deer,* the rest of the world had its first opportunity to hear and read a Nuuchaanulth voice [22.VIII]. My uncle's writing was the beginning of the true story of the masks, rattles, bowls, poles, ladles, and other artifacts almost universally written about

as "Northwest Coast Indian art." Now one can read what Nuuchaanulth people have to say about any aspect of their ceremonial and ritual life, thanks to Clutesi leading the way.

Clutesi opened his second book, *Potlatch*, with a disclaimer: "This narrative is not meant to be documentary. In fact it is meant to evade documents" (1969, n.p.). Where *Son of Raven, Son of Deer* focused on what Clutesi (1967, 9) referred to as "quaint folklore tales," *Potlatch* was clearly intended for the adult reader and was ostensibly an account of the *tluukwaana,* the most protracted and complex Nuuchaanulth potlatch, lasting up to twenty-eight days [22.IX]. Clutesi explained how the business of chiefly responsibilities was to provide for guests. Ownership is key to what I am talking about in this chapter, but it is also about interconnectivity and interdependence.

It is clear that Clutesi's writings are about our upper class, those of high birth and royalty. What white people call "art" today was made for the royalty of our communities so they could exert themselves and their status. Every time those treasure boxes were shown, they could re-establish all those symbols of wealth and authority. And included in their layers of symbolism was the fact that that wealth was going to be shared. It was their responsibility to redistribute wealth in such a way that everybody would get their share. What we call a potlatch is *Maatlmaaya* ("given in the house"), meaning resources are being given into the house. The central distribution is called *P'aatlp'aaya* from *p'ach'itl,* which means "to throw." Platforms are built up so that people of royalty can elevate themselves above their guests by fifteen to twenty feet (Figure 22.3). This *P'atsaatsakamey* ("elevated place") is where the chiefs distribute wealth by throwing things down to their guests. The one in Moziño's plate is decorated obviously with a painted and perhaps carved screen. The *P'atsaatsakamey* shows where creative genius is being put to a political use, and that political use is about a whole range of authorities that includes ownership over land and resources.

As Clutesi (1969, 10-11) wrote,

> when the business of estimating of goods and chattels began all members and relatives of the prospective host were honor bound to help in every way possible. Let it be understood that all guests had to be housed and fed throughout the entire duration of a Tloo-qwah-nah which must last at least fourteen days or a maximum of twenty-eight days, the full phase of a moon.

Traditionally, every year most houses held a *tluukwaana*. Initiation of children was part of it. Children's names were given, and some established member of

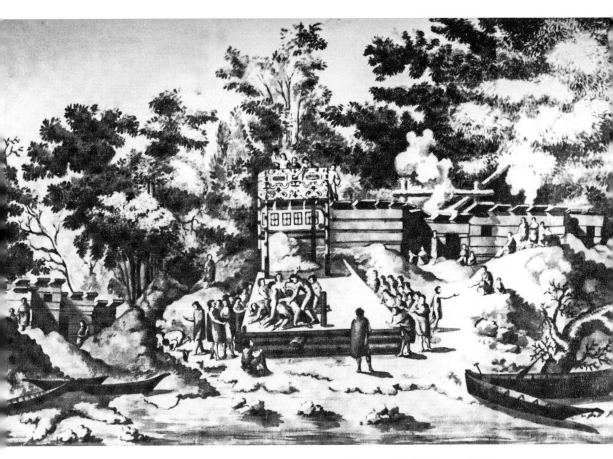

**FIGURE 22.3** *P'aatlp'aaya,* from the word *p'ach'itl,* is the central means of distributing goods during Nuuchaanulth potlatch feasts or *Maatlmaaya.* In our language, *p'ach'itl* means to both throw and give. This image shows people throwing things as a way to spread wealth and resources. From José Mariano Moziño, *Noticias de Nutka: An Account of Nootka Sound in 1792,* translated and edited by Iris Higbie Wilson, Monographs of the American Ethnological Society 50 (Seattle: University of Washington Press, [1803] 1970), Plate 11. Courtesy of the University of Washington Press.

that society claims them. Establishing who are full members of our communities is very serious work that is done at the *tluukwaana.* So that's a very powerful thing [22.IX].

I want to show that we have a system of government in place, and included in that government are laws, including laws of ownership. Our ownership is refined to such a point that it had Captain Cook in awe [23.I]. The symbols of this authority, during a *tluukwaana,* are the masks, the rattles, the feast dishes, and so on.

*Ha'wa'sats,* feast dishes, are particularly important symbols, representing a valley or drainage system feeding a river. The rim of the *ha'wa'sats* represents

the height of land that bounds the valley. The bowl of the *ha'wa'sats* symbolizes the valley bottom. The liquid served out of the *ha'wa'sats* represents the rivers and streams flowing through the valley. Often this liquid is sea mammal or fish oil. The sharing out of the *ha'wa'sats*, during a potlatch held in your territory, represents all the resources and territory of the bowl's owner.

Another insider description of my people comes from Luke Francis Swan, who co-wrote, with David W. Ellis, *Teachings of the Tides: Uses of Marine Invertebrates by the Manhousat People,* published in 1981 [22.x]. Swan was a source of both information and illustrations.

## CONCLUSION

I count myself very lucky because at a very young age I began singing and dancing and liked it. I loved it not because it was Indian but because it was what I liked doing. I then, from that age on, consistently have sought information about the things that matter to me. And I've tried to capture those things, those stories that matter so much to me, in these drawings and carvings and things that I've done. I've done bracelets with stories on them. I've done dance shawls that illustrate a particular family's story. I've tried to do things that represent very complex and very powerful moments in history in such a way that perhaps a hundred years from now someone will look at them and remember me talking about that somewhere and say I know what that is about.

**22.I. John Meares. 1790.** *Voyages Made in the Years 1788 and 1789 from China to the North-West Coast of America.* London: Logographic Press. (Reprinted 1967, New York: Da Capo Press), 138-39.

Irishman John Meares (ca. 1756-1809) was a rogue navigator and explorer best known for his role in helping to initiate the crisis that led to the Vancouver Expedition and the Nootka Convention, establishing Britain's claims to all of our traditional territories on the Westcoast. Although his claims that he discovered the Northwest Coast were much exaggerated, he did trade off the Alaskan coast without proper licences from 1786 to 1787. He was rescued from starvation by George Dixon's ship and promised never to trade there again. However, in 1788, Meares started a new expedition to explore Nootka Sound and the neighbouring coasts of present-day British Columbia. He bought some land from the local chief, Maquinna, and built a trading post. With the aid of Chinese carpenters he had brought along, he built the ship *Northwest America*, the first European ship

launched in British Columbia. Despite his maverick activities, Meares was made a commander in the British Royal Navy in 1795.

On entering the house, we were absolutely astonished at the vast area it enclosed. It contained a large square, boarded up close on all sides to the height of twenty feet, with planks of an uncommon breadth and length. Three enormous trees, rudely carved and painted, formed the rafters, which were supported at the ends and in the middle by gigantic images, carved out of huge blocks of timber. The same kind of broad planks covered the whole to keep out the rain; but they were so placed as to be removed at pleasure either to receive the air and the light, or to let out the smoke. In the middle of this spacious room were several fires, and beside them large wooden vessels filled with fish soup. Large slices of whale's flesh lay in a state of preparation to be put in similar machines filled with water, into which the women, with a kind of tongs, conveyed hot stones from very fierce fires, in order to make it boil: – heaps of fish were strewed about, and in this central part of the place, which might very properly be called the kitchen, stood large seal-skins filled with oil, from whence the guests were served with that delicious beverage.

The trees that supported the roof were of a size which would render the mast of a first-rate man of war diminutive, on a comparison with them; indeed our curiosity as well as our astonishment was on its utmost stretch, when we considered the strength that must be necessary to raise these enormous beams to their present elevation; and how such strength could be found by a people wholly unacquainted with mechanic powers. The door by which we entered this extraordinary fabric, was the mouth of one of these huge images, which, large as it may be supposed, was not disproportioned to the other features of this monstrous visage. We ascended by a few steps on the outside, and after passing this extraordinary kind of portal, descended down the chin into the house, where we found new matter for astonishment in the number of men, women, and children, who composed the family of the chief; which consisted of at least eight hundred persons. These were divided into groups, according to their respective offices, which had their distinct places assigned them. The whole of the building was surrounded by a bench, about two feet from the ground, on which the various inhabitants sat, eat and slept. The chief appeared at the upper end of the room, surrounded by natives of rank, on a small raised platform, round which were placed several large chests, over which hung bladders of oil, large slices of whale's flesh, and proportionable gobbets of blubber. Festoons of human sculls, arranged with some attention to uniformity, were disposed in almost every part where they could be placed, and were considered as a very splendid decoration of the royal apartment.

When we appeared, the guests had made a considerable advance in their banquet. Before each person was placed a large slice of boiled whale, which, with small wooden

dishes, filled with oil and fish soup, and a large muscle-shell, by way of spoon, composed the economy of the table. The servants were busily employed in preparing to replenish the several dishes as they were emptied, and the women in picking and opening the bark of a tree which served the purpose of towels. If the luxury of this entertainment is to be determined by the voraciousness with which it was eaten, and the quantity that was swallowed, we must consider it as the most luxurious feast we had ever beheld.

**22.II. José Mariano Moziño. (1803) 1970.** *Noticias de Nutka: An Account of Nootka Sound in 1792.* Translated and edited by Iris Higbie Wilson. Monographs of the American Ethnological Society 50. Seattle: University of Washington Press, 9, 24-25, 48-49, 53, 57-58. Courtesy of the University of Washington Press.

José Mariano Moziño (1757-1820?) was a naturalist from New Spain (modern-day Mexico). He studied at the Seminario Tridentino de México and graduated in philosophy in 1778. In 1787, he became part of the scientific expedition of Martin de Sessé and travelled across New Spain, eventually reaching British Columbia and Alaska. During his journey, he created one of the most important collections of his times. Although he was the most famous American naturalist of the colonial period, he died in Spain poor and blind. In these writings, he gave an outsider's perspective on the government and religion of the Nuuchaanulth.

Our residence of more than four months on that island enabled me to learn about the various customs of the natives, their religion, and their system of government. I believe I am the first person who has been able to gather such information, and this was because I learned their language sufficiently to converse with them.

...

The government of these people can strictly be called patriarchal, because the chief of the nation carries out the duties of father of the families, of king, and high priest at the same time. These three offices are so closely intertwined that they mutually sustain each other, and all together support the sovereign authority of the *taises.* The vassals receive their sustenance from the hands of the monarch, or from the governor who represents him in the distant villages under his rule. The vassals believe that they owe this sustenance to the intercession of the sovereign with God. Thus the fusion of political rights with religious rights form the basis of a system which at first glance appears more despotic than that of the caliphs and is so in certain respects, but which shows moderation in others. There is no intermediate hierarchy between princes and commoners. This latter condition includes all those who are not brothers or immediate relatives of the *tais,* and they are known by the name of *meschimes.* The former are called *taiscatlati,* that is to say, brothers of the chief.

The moderation of this system consists in the fact that the monarch, in spite of being convinced of the value of his orations, does not fail to recognize that these would be unfruitful for the sustenance of himself and his subjects if they did not also employ their working efforts in fishing, hunting, lumbering, and so forth. This obliges him to arm them like sons to defend themselves from their enemies at all risk, and to alleviate as much as possible the hardships of life. It would be very boring to express in detail the deeds that substantiate what I have referred to; suffice it to say that in Maquinna I have always observed inexpressible feeling over the loss of one of his subjects by death or flight; that his subjects treat him with familiarity but maintain at the same time an inviolable respect.

...

Hunting provides them with land animals and shore birds. For this purpose nothing is worth more to them today than the gun, and it is very clear that this has replaced, only to their advantage, the ancient use of the arrow.

Since their dances often represent this kind of activity, I observed in one of them the preparation of nets and also the imitation of animals plunged into a pit covered over with slender canes that could be broken by the weight of the body. I have seen complete heads of bears and deer well-prepared for being placed over their own heads. This made me think that they follow the same strategy with which the Californians guarantee their shots by disguising themselves with the appearance of the beast they are trying to kill.

...

The extensiveness of this language can be estimated by the degree of civilization this tribe has attained, since I think the rule is generally true that the wiser the nation, the richer is the language they speak. Consequently, that of Nootka is very poor, since it cannot have greater breadth than the ideas the Nootkans have been able to form.

...

They are all generally fond of singing, either because the music enters into part of their rituals, or because it constitutes one of the demonstrations of their courtly cere-monies. Their natural voices create the harmony in unison on the octave. They are accompanied, in place of bass, by a noise which the singers make on some boards with the first solid object they find, and by some wooden rattles whose sound is similar to that of the Mexican *ayacaʒtles* [Aztec gourd rattles]. One of the singers constantly gives the tone and all the others follow it successively, forcing their voices unevenly, in almost the same manner customary in the Gregorian chant of our churches. From time to time one of the musicians abandons the chant and gives enormous shouts, repeating the theme of the song as if in summary.

These are ordinarily hymns to celebrate the beneficence of Qua-utz, generosity of their friends and good relations with their allies. This noble purpose of music and

poetry ought to serve as an example to us, who flatter ourselves that we have been born in cultured countries and educated in the bosom of the true religion. One day Quio-comasia heard some stanzas sung at a certain meeting which we had with the English and the natives. At the conclusion of the song he asked me what had been its subject, to which I replied that it was the absence of a lady. Afterward other Spaniards and Englishmen sang their respective songs, and the gathering was brought to a close with a beautiful anacreontic ballad, the grace of which enhanced the soft and melodious voice of the young Irishman who sang it. The *tais* kept asking me the meaning of each piece. The first were purely love songs (I told him), and what he had just heard was a eulogy to wine and pretty girls. To this he replied, "do not the Spanish or the English have a God, since they celebrate only fornication and drunkenness? The *taises* of Nootka sing only to praise Qua-utz and ask for his help."

**22.III. Gilbert Malcolm Sproat. (1868) 1987. *The Nootka: Scenes and Studies of Savage Life.*** Edited and annotated by Charles Lillard. West Coast Heritage Series. Victoria: Sono Nis Press, xxiii, 5, 46-47, 49.

Gilbert Malcolm Sproat (1834-1913), a Scottish-born Canadian businessman, opened one of the first sawmills in British Columbia in 1860 in Alberni. He served as justice of the peace for the colony of Vancouver Island from 1863 to 1865, then returned to England after the sawmill burned down. From 1872 to 1876, he represented the province of British Columbia as agent general in London, until he returned to British Columbia. From 1876, he served on the Indian Land Commission but resigned in 1880 when his reserve decisions were unpopular with the European colonists. In the preface to his book, Sproat authenticated his own voice as methodologically scientific and thereby denied any other point of view.

> My private and official business on the west coast of Vancouver Island gave me an advantageous position for studying the natives themselves, and also the effect upon them of intercourse with civilized intruders. I lived among the people and had a long acquaintanceship with them; I did not merely pass through the country. The information which I give concerning their language, manners, customs, and ways of life, is not from memory, but from memoranda, written with a pencil on the spot – in the hut, in the canoe, or in the deep forest; and afterwards verified or amended by my further researches.

Sproat further self-aggrandized and reified his position of power by re-creating the dialogue of possession taking. He was essentially saying that we Nuuchaanulthat-ḥ

had no right to our lands and that we were a threat to the English. When this attitude prevailed, it became all too easy to also dispossess us of our ceremonial treasures, which are so significant for our spiritual well-being.

"My great chief, the high chief of the King George men, seeing that you do not work your land, orders that you shall sell it. It is of no use to you. The trees you do not need; you will fish and hunt as you do now, and collect firewood, planks for your houses, and cedar for your canoes. The white man will give you work, and buy your fish and oil."

"Ah, but we don't care to do as the white men wish."

"Whether or not," said I, "the white men will come. All you people know that they are your superiors; they make the things which you value. You cannot make muskets, blankets, or bread. The white men will teach your children to read printing, and to be like themselves."

"We do not want the white man. He steals what we have. We wish to live as we are."

Interestingly, given his racism, Sproat described us as being superior public speakers to the English.

I had no expectation of finding that oratory – the queen of human gifts – was so much prized among this rude people. It is almost the readiest means of gaining power and station. The Clayoquot excel in public speaking. Individuals sometimes speak at festive or political meetings for more than an hour, with great effect upon the hearers. My not being able always to follow the words enabled me perhaps more to notice the graces of action which the speakers exhibited. The blanket is a more becoming garment to an orator than a frock coat. The voices of one or two noted chiefs are very powerful, yet clear and musical, the lower tones remarkably so; their articulation is distinct, and their gestures and attitudes are singularly expressive. I have been tempted sometimes to cheer them.

There is a noticeable difference, I may mention, between the voices of the Aht and those of Englishmen. I never more distinctly observed this than when a savage replied to Governor Arthur Kennedy on his addressing an assembly of natives in front of the Government House at Victoria, soon after his arrival in the colony. The governor is a soldier-like man, with a resolute, handsome face, and firm voice; but the contrast was striking between his measured voice and talk, and the deep careless tones of the savage, as his utterance in reply burst on the relieved ears of the audience. There is a pitch in an Indian's speech altogether, in voice, manner, and meaning, that startles one accustomed to the artificial declamation of English public meetings. It has occurred to me, while hearing savage oratory, that an actor or artist who wished to know what natural earnest manner in public speaking really is, should visit Clayoquot Sound, and hear

Seta-Kanim on his legs. Viewing the matter artistically, it is quite a treat; but, from another point of view, the picture is saddening, even to one ignorant of the language, to see a savage in the open air, pleading, under a sense of injustice, for some object he has much at heart – perhaps his native land. There is nothing to be seen in England like it. We Englishmen converse well indoors across green tables, but out of doors the savage beats us in public speaking beyond compare.

...

Hardly an evening passes in winter without a dance in some part of the encampment, and if no one has a party, the chief invites some of the young men to dance at his own house.

**22.IV. James Gilchrist Swan. 1870.** *The Indians of Cape Flattery, at the Entrance to the Strait of Fuca, Washington Territory.* Smithsonian Contributions to Knowledge, Volume 16, article 8. Washington, DC: Smithsonian Institution, 7-10, 12, 17, 69-71.

James Gilchrist Swan (1818-1900) was an Indian Agent in Washington State who lived among the Makah in Neah Bay from 1859 until his death. He wrote the first ethnography of the Makah, published in 1870. The lengthy excerpt below is illuminating in so many ways. We learn that a white man, ostensibly an agent of American colonialism, was sympathetic to the Makah need for ceremony. We learn that Swan enjoyed decorating ceremonial paraphernalia for the chiefs. We learn that the Makah recognized their own Thunderbird in the "Babylonian cherubim" featured in the book he showed them. They saw an absolute parallel between the part-human/part-animal images and their Thunderbird, noting that the biblical cherub had human feet and not a bird's claws. Swan encouraged us to share the Makah enthusiasm for new and interesting images that were somehow understandable to them and that they were able to use for their own purposes. "It was perfect, they said" (Swan 1870, 9).

Picture Writing. – In almost every lodge may be seen large boards or planks of cedar carefully smoothed and painted with rude designs of various kinds. With one exception, however , I have found nothing of a legendary or historic character, their drawings being mostly representations of the private totem or tamanous of individuals, and consisting of devices rarely understood by their owners and never by anyone else. The exception referred to is a representation of the thunder-bird (T'hlu-kluts), the whale (chet-up-uk), and the fabulous animal supposed by the natives to cause lightning (Ha-hék-to-ak). This painting is on a large board in the lodge of one of the chiefs of Neeah Bay, and was executed by a Clyoquot Indian named "Chá-tik," a word signifying painter or artist. A painting is termed Cha-tái-uks, and writing Chá-tātl.

The coast Indians, as well as those I have conversed with, living on Puget Sound, believe that thunder is caused by an immense bird whose size darkens the heavens, and the rushing of whose wings produces peals of thunder. The Makahs, however, have a superstition which invests the thunder-bird with two-fold character. This mythological being is supposed by them to be a gigantic Indian named, in the various dialects of the coast tribes, Ka-kaitch, T'hlu-kluts, and Tu-tutsh, the latter being the Nootkan name. This giant lives on the highest mountain and his food consists of whales. When he is in want of food, he puts on a garment consisting of a bird's head, a pair of immense wings, and a feather covering for his body; around his waist he ties the Ha-hék-to-ak or lightning fish, which bears some faint resemblance to the sea horse (*hippocampus*). This animal has a head as sharp as a knife, and a red tongue which makes the fire. The T'hlu-kluts having arrayed himself, spreads his wings and sails over the ocean till he sees a whale. This he kills by darting the Ha-hék-to-ak down into its body, which he then seizes in his powerful claws and carries away into the mountains to eat at his leisure. Sometimes the Ha-hék-to-ak strikes a tree with his sharp head, splitting and tearing it in pieces, or again, but very rarely, strikes a man and kills him. Whenever lightning strikes the land or a tree, the Indians hunt very diligently with the hope of finding some portion of the Ha-Hék-to-ak, for the possession of any part of this marvellous animal endows its owner with great powers, and even a piece of its bone, which is supposed by the Indians to be bright red, will make a man expert in killing whales, or excel in any kind of work. Those Indians, however, who pretend to possess these fabulous relics carefully conceal them from sight, for they are considered as great "medicines," and not to be seen except by the possessor. A tale was related to me, and religiously believed by them, respecting the possession of a quill of the thunder-bird by a Kwinaiult Indian, now living, named Neshwats. He was hunting on a mountain near Kwinaiult, and saw a thunder-bird light on a rock. Creeping up softly, he succeeded in securing a buckskin thong to one of its wing feathers, fastening the other end at the same time to a stump. When the T'hlu-kluts flew off, the feather was drawn from the wing, and kept by the Indian. The length of this enormous feather is forty fathoms. Neshwats is very careful that no person shall see this rare specimen, but his tale is believed, particularly as he is very expert in killing sea otter, which abound on that part of the coast.

I saw an instance of their credulity on an occasion of a display of fireworks at Port Townsend a few summers since. A number of the rockets on bursting displayed fiery serpents. The Indians believed they were Ha-hék-to-ak, and for a long time made application to the gentleman who gave the display, for pieces of the animal, for which they offered fabulous prices. So firm is their belief in this imaginary animal, that one chief assured me if I could procure him a backbone he would give two hundred dollars for it. One of the principal residences of the T'hlu-kluts is on a mountain back of

Clyoquot, on Vancouver Island. There is a lake situated in the vicinity, and around its borders the Indians say are quantities of old bones of whales. These, they think, were carried there by the T'hlu-kluts, but they are very old, and it must have been many years ago. I have not seen these bones, but have heard of them from various Indians who allege that they have seen them. If they really do exist as stated, they are undoubtedly the fossil remains that have been deposited there at a time when that portion of the continent was submerged, and respecting which there is a tradition still among them. The painting above described, although done by an Indian, does not fully represent the idea of the Makahs respecting the T'hlu-kluts. But, having by me a copy of Kitto's Cyclopaedia of Biblical Literature, I showed some of the chiefs the cut of the Babylonian cherubim, which came very near their idea of its real form. It was perfect, they said, with the exception of not having the Ha-hék-to-ak around its waist, and of having feet instead of bird's claws, which they think are necessary to grasp whales. But when I informed them that there were no whales in Babylon, they were fully persuaded that the identity was the same, claws being given to the T'hlu-kluts who live near the water, and feet to those living in the interior. Of their religious belief in this thunder-bird, I shall make further mention in their ta-ma-na-was ceremonies. In the design the T'hlu-kluts is represented as holding a whale in its talons, and the accompanying figures are the Ha-hék-to-ak. These animals the bird is supposed to collect from the ocean, and keep concealed in its feathers.

Among the most remarkable specimens of their paintings which I have seen, was a design on the conical hats worn during the rain, and another on a board in a chief's lodge, afterwards placed at the base of a monument erected over his body. The circular design for the hat was said to represent a pair of eyes, a nose, and mouth. The other was a rude one, in which eyes are very conspicuous. The form of these designs is a distinctive feature in Indian painting, but I never could learn that they attached any more meaning to them than we do to designs on a shawl border, or the combination of a calico pattern artist ...

I have painted various devices for these Indians, and have decorated their ta-ma-na-was masks; and in every instance I was simply required to paint something the Indians had never seen before. One Indian selected from a pictorial newspaper a cut of a Chinese dragon, and another chose a double-headed eagle, from a picture of an Austrian coat-of-arms. Both these I grouped with drawings of crabs, faces of men, and various devices, endeavoring to make the whole look like Indian work; and I was very successful in giving the most entire satisfaction, so much so that they bestowed upon me the name of Cha-tic, intimating that I was as great an artist as the Cha-tic of Clyoquot. In the masks, I painted, I simply endeavored to form as hideous a mixture of colors as I could conceive, and in this I again gave satisfaction.

I have noticed in Indian paintings executed by the northern tribes, particularly the Chimsyan, Haida, and others north of Vancouver Island, a very great resemblance in style to that adopted by the coast Indians. Whether or not these tribes have any legend connected with their pictures I have no means of ascertaining. There are, however but very few persons among the coast Indians who are recognized as painters, and those that I have met with, either could not or would not give me any explanation. My object in painting for them was to find out if they really had any historical or mythological ideas which they wished to have represented, and I have invariably inquired on every occasion; but I never could get any other information than that they wished me to pant something the other Indians could not understand. I am satisfied, so far as this tribe is concerned, that, with the exception of the thunder-bird drawing, all their pictures and drawings are nothing more than fancy work, or an attempt to copy some of the designs of the more northern tribes; and as they have always evinced a readiness to explain to me whatever had significance, I have no alternative, but to believe them when they say that they attach no particular meaning to their paintings.

...

Every day a speech was made, and every night songs and dance were performed.

...

A Makah belle is considered in full dress with a clean chemise; a calico or woollen skirt; a plaid shawl of bright colors thrown over her shoulders; six or seven pounds of glass beads of various colors and sizes on strings about her neck; several yards of beads wound around her ankles; a dozen or more bracelets of brass wire around each wrist; a piece of shell pendent from her nose; ear ornaments composed of the shells of the dentalium, beads and strips of leather, forming a plait three or four inches wide and two feet long; and her face and the parting of the hair painted with grease and vermilion. The effect of this combination of colors and materials is quite picturesque, which is perhaps the only praise that it merits.

...

Every evening during the ceremonies, excepting those of the first few days, is devoted to masquerade and other amusements, when each lodge is visited and a performance enacted. Some of the masks are frightful objects ...  They are made principally by the Clyoquot and Nittinat Indians, and sold to the Makahs, who paint them to suit their own fancies. They are made of alder, maple, and cottonwood; some are very ingeniously executed, having the eyes and lower jaw movable. By means of a string the performer can make the eyes roll about, and the jaws gnash together with a fearful clatter. As these masks are kept strictly concealed until the time of the performances, and as they are generally produced at night, they are viewed with awe by the spectators; and certainly the scene in one of these lodges, dimly lighted by the fires which

show the faces of the assembled spectators and illuminate the performers, presents a most weird and savage spectacle when the masked dancers issue forth from behind a screen of mats, and go through their barbarous pantomimes. The Indians themselves, even accustomed as they are to these masks, feel very much afraid of them, and a white man, viewing the scene for the first time, can only liken it to a carnival of demons.

Among the masquerade performances that I have seen was a representation of mice. This was performed by a dozen or more young men who were entirely naked. Their bodies, limbs, and faces were painted with stripes of red, blue, and black; red bark wreaths were twisted around their heads, and bows and arrows in their hands. They made a squealing noise, but otherwise they did nothing that reminded me of mice in the least. Another party was composed of naked boys, with bark fringes, like veils, covering their faces, and armed with sticks having needles in one end; they made a buzzing noise, and stuck the needles into any of the spectators who came in their way. This was a representation of hornets. These processions followed each other at an interval of half an hour, and each made a circuit round the lodge, performed some antics, sang some songs, shouted, and left. Another party then came in, composed of men with frightful masks, bear-skins on their backs, and heads covered with down. They had clubs in their hands and as they danced around a big figure blazing in the centre of the lodge, they struck wildly with them, caring little whom or what they hit. One of their number was naked, with a rope round his waist, a knife in each hand, and making a fearful howling. Two others had hold of the end of the rope as if to keep him from doing any harm. This was the most ferocious exhibition I had seen, and the spectators got out of their reach as far as they could. They did no harm, however, excepting that one with his club knocked a hole through a brass kettle; after which they left and went to the other lodges, when I learned that they smashed boxes and did much mischief. After they had gone the owner examined his kettle, and quaintly remarked that it was worth more to him than the pleasure he had experienced by their visit, and he should look to the man who broke it for remuneration.

**22.V. Johan Adrian Jacobsen. (1884) 1977. *The Alaskan Voyage 1881-1883: An Expedition to the Northwest Coast of America.* Translated by Erna Gunther from the German text of Adrian Woldt. Chicago: University of Chicago Press, ix-x, 44-46, 63-64.**

Norwegian-born captain Johan Adrian Jacobsen (1853-1947) travelled the Northwest Coast widely to collect Native artifacts for a number of institutions, including the Berlin Ethnological Museum. During his 1881-83 trip to Alaska, Jacobsen stopped at various places along the west coast of Vancouver Island and purchased articles of interest to him. He wrote about how the masks always came from and represented local spirituality. Regardless of his personal appreciation

of the spiritual roots of these Nuuchaanulth objects, Jacobsen made clear that his intention in collecting them was to send them to a foreign government's institution as representatives of exotic humanity far from home in a different world. In the following excerpts, he discussed how he collected Nuuchaanulth objects and described the ethnological information he received from a Catholic priest and Gilbert Malcolm Sproat.

The first excerpt is a preface by Adrian Woldt, Jacobsen's German translator (translated from the German by Erna Gunther).

Year by year ethnologists are becoming increasingly aware that European culture is engulfing and destroying the native peoples left in the world. Their customs and habits, legends and memories, weapons and artifacts are rapidly disappearing and there will soon be new and different developments in a large part of the human race. The oral history of these people will be lost and scientific knowledge in philosophy, medicine, and natural history will suffer from it.

Mankind must therefore make every effort to collect, as the most valuable of the ancient past, all the objects pertaining to the development of culture, for they are documents for the future writing of the "Book of Mankind." But, instead, we are watching while this basic information is allowed to be destroyed ... By rights the ethnological museums are the ones that should send collectors out to answer this call and salvage what can still be saved.

With his worldwide knowledge Professor Bastian, the director of the Berlin Museum, is the proper person to send out this call. After each extensive journey he has returned convinced of this need.

As long as mankind has existed there has been no greater and more devastating revolution than the present one. As powerful as were the changes of the Stone Age and the Iron Age, they seem minor compared with this period when the whole world is populated by the carriers of modern culture, which wipes out every stage of the past.

...

The island where we sought protections was inhabited in summer by the Indians from the Village of Eckult, whose winter village was at the east end of Barclay Sound. Since there was a trading post of the Warren Company at Eckult, it was our destination, which we reached after a four-hour trip. While the captain attended to his business I engaged two Indians and a canoe and went with them to the Indian village of Oheiaht [Ohiat] to the south. Here there was a Catholic mission with the Belgian priest Father Justus in charge. I must gratefully acknowledge here the unusual support I received from him and all others of his faith whom I met on my travels.

After a friendly personal welcome, Father Justus went with me to the Indian village and helped me select the rarest objects, giving me the correct information about their usage. I obtained many pieces and went on the same day back to Eckult.

...

Mr. Sproat, the head of the mill, lived here for four years and gathered full information about the local Indians that is published in his well-known work *Scenes and Studies of Savage Life*. Sproat included all the Indian tribes on the west coast of Vancouver Island between Cape Flattery and Cape Cook, whom he called the Aht [Nootka] tribes. The reason for this name seems to be based on the use of "aht" as the customary final syllable in many of their village names. The inhabitants of the west coast compose an isolated ethnological unit ...

Close by are the villages of the Tsisaaht and Opettisaht [Hopachisat]. Immediately after we landed I visited these two villages, but ... I did not have good results. Nevertheless, I did secure a number of blankets made of cedar bark and one very valuable old sword-shaped war club of whale bone. The weapon is not in use today; it closely resembles the war club of the Maori in New Zealand. I found only three examples on the whole west coast and secured them all ...

There were very few masks used on the evening I attended but among the last dances a worthwhile drama was shown, with the great eagle or firebird (Hotloxom) and the thunder (Tootosch) represented. The head, the tail and both wings of these birds consisted of wood while the body in which the dancer was hidden was covered with cloth, and in the half-darkness the whole presented an eerie appearance. Such presentations always suggest their supernatural beliefs. Another noteworthy dance performed at the same time showed how little preparation was really necessary to create illusions for these audiences. Three naked Indians represented wolves, and for this the first held a well-carved wolf's head in his hand while the other two covered themselves with a canoe sail and stood bent over. This represented the body of the wolf. The third man, half-naked, was at the end of the sail and held in his hand an iron handsaw, a so-called fox tail, which he held behind him and moved like a tail. This three-legged figure moved in unison, looking like a six-legged being. This giant wolf opened and shut his mouth and ran toward the audience, which fled from him in terror all through the house.

**22.VI. Robert Bruce Inverarity. 1950.** *Art of the Northwest Coast Indians.* Berkeley: University of California Press, 38-39, 47, 49. Copyright 1971 by University of California Press – Books. Reproduced with permission of the University of California Press – Books via Copyright Clearance Center.

Robert Bruce Inverarity (1909-99) was born in Seattle. Throughout his life, he was involved in a broad range of art-related activities as an administrator, academic, artist (illustrator, printmaker), and photographer. He was a leading

museum administrator and an authority on Northwest Native American paint-
ing and sculpture. He was director of the WPA Federal Arts Project in Washing-
ton State from 1936 to 1941. His career as a museum director began in 1949 when
he became the founding director of the Museum of International Folk Art in
Santa Fe, New Mexico. He served as director of the Adirondack Museum in Blue
Mountain Lake, New York, from 1954 to 1965. He then served as director of the
Philadelphia Maritime Museum from 1969 until his retirement in 1976. He sold
his extensive personal collection of Northwest Coast artifacts to the British
Museum in 1975. The first excerpt below is a massive generalization fifteen years
ahead of Bill Holm and others. At that time, the public knew even less about
Northwest Coast peoples and our cultures than they do today.

> Socio-religious elements. – In all Primitive societies the socio-religious factor is the
> prime mover in the life of the individual and the channel through which most artistic
> society is expressed. With some exceptions, the near identification of religion and art
> is less apparent in more advanced cultures. The wide use of animal and other forms in
> nature as symbols and as design elements in primitive art is a natural outcome of the
> prevalence of animistic beliefs in primitive society.
>
> Form and content. – In the study of art the relation between form and content is
> not often enough considered; the tendency is to place undue emphasis on one or the
> other. Most works of primitive art show a highly satisfactory combination of form and
> content. However, it is true that contemporary observers are more likely to derive
> enjoyment from the form, since the content is lost in the symbolization of the culture
> in which the work was created.

The fact that Inverarity provided us with so many illustrations made this a valu-
able book for the new student of the creative expressions of Northwest Coast
peoples.

> So far then, I have surveyed the culture which produced the conventionalized and
> highly symbolic art of the Northwest Coast Indians and discussed briefly the more
> important features of this art. The intention has been to orient the reader so that
> he can, in studying the examples shown in the plates, perceive for himself the excel-
> lence of the art and evaluate it in relation to that of other culture areas.

I am also biased in favour of Inverarity because he illustrated two finely painted
ḵiitsaḵsuu-ilthim, ceremonial screens (Figure 22.4), which my late paternal aunt
Winifred David informed me were once structurally integral in her grand-
father's, my great-grandfather's, bighouse at Aswinis (Taḵiishtaḵamlthath).

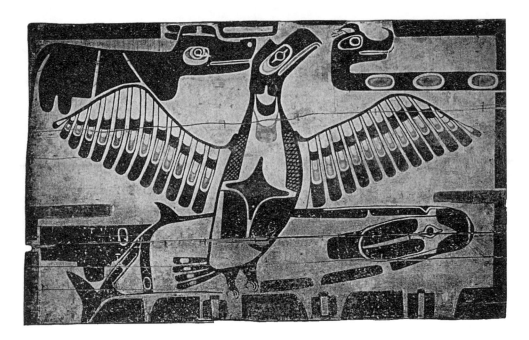

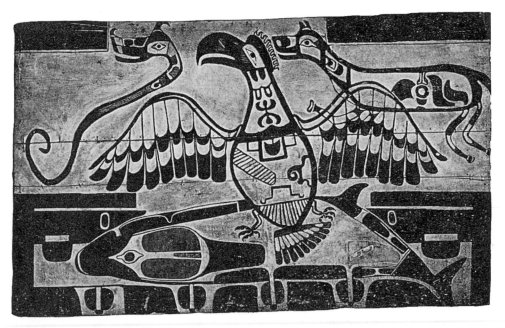

**FIGURE 22.4** This illustration of two finely painted ḳiitsaḳsuu-ilthim, or "ceremonial screens," was included in Robert Bruce Inverarity's *Art of the Northwest Coast Indians* (1950). Before they were collected and taken to museums across the continent, these screens belonged to Ḳi-ḳe-in's paternal great-grandfather, Chuuchḳamalthnii, and were integral to the structure of his bighouse, Taḳiishtaḳamlthath (Earthquake House), at Aswinis (see Figure 21.1). From Robert Bruce Inverarity, *Art of the Northwest Coast Indians* (Berkeley: University of California Press, 1950), Plates 10 and 11.

**22.VII. Philip Drucker. 1951.** *The Northern and Central Nootkan Tribes.* Smithsonian Institution Bureau of American Ethnology Bulletin 144. Washington, DC: US Government Printing Office, 1, 118.

Philip Drucker (1911-82), an American anthropologist trained at the University of California, Berkeley, received his PhD in 1936. In 1940, he became an assistant curator at the United States National Museum and anthropologist for the Bureau of American Ethnology. He served in the military between 1942 and 1945. After he was decommissioned, he returned to his position as ethnologist for the Bureau of American Ethnology at the Smithsonian Institution. From 1948 to 1952, he was a staff anthropologist for the US Navy in Micronesia. Between 1955 and 1966, he ran a farm in Mexico and raised a family. He served as a professor at the University of Kentucky, University of Colorado, and Baylor University between 1966 and 1979. He visited the Westcoast in 1935-36, collecting data for his opus, *The Northern and Central Nootkan Tribes.*

> The material for this report was collected in 1935-36 with the assistance of a pre-Doctoral Research Fellowship granted by the Social Science Research Council. The research problem was to determine the bases of social stratification. I had no intention of diverging from the specific problem to collect data for a general ethnography, but I soon found that the societal factors could not be isolated without forcing the material ... Before long I found that my quest for the basic forces of social organization were leading me into all phases of the culture: economy, technology, ceremonialism, and the rest, so I ended up trying to round out the picture. The aim, however, was always to relate these topics to the problems of the social structure.
>
> ...
>
> Every important step along life's road, including the life crises, called for a public announcement and festivities. Of course, the extent to which this was done varied with the person's rank.

**22.VIII. George Clutesi. 1967.** *Son of Raven, Son of Deer: Fables of the Tseshaht People.* Sidney, BC: Gray's Publishing, 9-10. Courtesy of George Clutesi, Jr.

George Clutesi (1905-88), a Tseshaht, was born in Alberni. He became an artist, actor, and writer as well as an expert spokesman on Native Canadian culture. As an adult, he worked at occupations such as fisherman and pile driver in order to support his wife and six children. With the encouragement of friends, he began to paint in oils and to exhibit his work during the 1940s and 1950s. Emily Carr was so impressed with his work that, in her will, she left him her brushes, oils, and unused canvases.

In 1947, he began to contribute essays to the Native Canadian newspaper the *Native Voice*. While recovering from an on-the-job injury, he met Ira Dilworth, the chief of the Canadian Broadcasting Corporation in the Vancouver area. With Dilworth's encouragement, he told stories from his heritage on CBC Radio. He then wrote a play about the culture of the First Nations peoples, *They Were a Happy Singing People*. In 1961, he addressed the British Columbia Historical Association on Northwest Coast Native art, urging the preservation of Native culture, and he was commissioned to paint a mural for Expo '67 in Montreal. Clutesi became one of British Columbia's first Native writers to gain recognition. His *Son of Raven, Son of Deer*, published in 1967, was one of the first books written about First Nations culture by a First Nations person. *Potlatch* followed in 1969, portraying Nuuchaanulth ritual. In the late 1970s, he appeared in three movies – *Dreamspeaker, Nightwing*, and *Prophecy*. His achievements and commitments to Native causes earned Clutesi numerous accolades: in 1959, the British Columbia Centennial Award; in 1967, the Canadian Centennial Medal; in 1977, a Canadian Film Award for his portrayal of a Native shaman in *Dreamspeaker*. In 1971, the University of Victoria granted him an honorary doctorate of laws, and in 1973 he was made a member of the Order of Canada.

In this, his first publication, my uncle introduced the public to the "Indian" and seemed almost apologetic. In the first paragraph of the introduction, he wrote the following.

> This series of Indian folklore tales will not be just another attempt to portray the past and the sometimes romantic aspects of a nearly forgotten culture of a once carefree, happy, singing people. Instead, it will be an attempt to approach from the back door, as it were, to an apparently rich and cultured society. The series will endeavour to reach the more sensitive, the more sympathetic and the more reasoning segment of the non Indians, who may have some willingness to study and understand the culture of the true Indian whose mind was imaginative, romantic and resourceful.

Clutesi wrote *Son of Raven, Son of Deer* in 1967. It was the summer of love. In this book, he was trying to do two things. On the one hand, he wanted to provide "quaint folklore tales" that white people would like. On the other, he somehow began to feel a bit comfortable with who he was and how people saw him as an Indian. Not as a good Indian, but as an Indian.

> Quaint folklore tales were used widely to teach the young the many wonders of nature; the importance of all living things, no matter how small and insignificant; and

particularly to acquaint him with the closeness of man to all animals, bird life, and the creatures of the sea. The young were taught through the medium of the tales that there was a place in the sun for all living things.

This resulted in a deep understanding and love of man for all animal life. This was so prevalent that an Indian would show remorse and do penance on the spot whenever he even killed an animal for meat. This practice prevailed throughout all the coastal region of British Columbia.

**22.IX. George Clutesi. 1969.** *Potlatch.* Sidney: Gray's Publishing, 10, 20-21, 31-32, 129-30, 131, 132-33, 178-80. Courtesy of George Clutesi, Jr.

In this excerpt, Clutesi described how it took years to plan and carry out a great feast or potlatch and how the most important gift was that of a song with its dance and regalia.

For years prior to a Tloo-qwah-nah the principal and his councilors began to plan and to accumulate various articles that he would give away – sea-otter robes; whaling canoes, sleek sea-otter and fur-seal hunting canoes and the smaller fishing and utility canoes … Then there were the smaller articles such as cooking utensils and chattels of many kinds.

The most important gift one could give was the bestowal of a song together with its dance and the ornate paraphernalia needed to show any subsequent ceremonial presentations.

Territories, fishing and hunting rights and the right to keep all game caught within these territories and all flotsam found therein was on extraordinary occasions included in the bestowal of gifts and only then was the recipient able to give a feast in his own name. He was also granted a place in the seating arrangement of guests and so become eligible for a subsequent seat in the senate.

In the excerpt below about the Tluu-kwaa-na, Clutesi consciously began with "the emissaries" because he wanted to clearly say that, when the *ḥa'wiiḥ*, the chiefs, announced they were going to do something, from now on, their business was to work for you, to support you, to make sure you're not in need. What I'm trying to show is the interdependency. My mother used to say *ḥa'wiiḥ* are nothing without the support of their people. And a community is nothing without its leadership. That *ḥa'wilth* may be a hereditary chief, but if he doesn't have the skill to manage all this his community would suffer. He needs enough intelligence to say, "here's the person who does this well, I'll put him on your council." It was important for Clutesi that people could see that, in our community,

carvings and paintings had a particular kind of meaning, a particular use, and the rest of the time they were in boxes, not hung up on the wall as decorations.

> The emissaries returned home under cover of darkness again. The business of the Tloo-qwah-nah had begun. All things that needed to be done from then on must be performed in secrecy. Everything from now on must be done with the utmost gravity, solemnity and urgency. There was to be no more procrastination. All things must be done now and done promptly. All men and all women associated with the immediate House of the giver of this Tloo-qwah-nah must from now on and until the whole business was completed, give all his time and energy towards its success and grand culmination. This was the expected thing to do. This was the time when all ties of kinship were encouraged to grow, expand and extend beyond the mere security of relationship. This was the time when co-existence exemplified itself beyond the mere desire to be tolerant, to live and let live. This was the time to share your good fortune, wealth and affluence with your fellow-man be it your worldly belongings, your food or your goodwill. This was the time when tribes of different dynasties were drawn together in one common bond – fellowship.

My uncle was talking about the complexity, the sophistication, the workability of our own traditional government. He was saying, traditionally, this is how we lived.

> Along the entire coast of Vancouver Island established areas were acknowledged to belong to tribes, with kings who exercised plenary authority over that area.
>
> In many cases the areas included meadows for rootstocks, bulbs, berries and so on; hunting grounds for wild game; rivers and streams for salmon; shorelines for mollusks, crustaceans; shallows, reefs and shoals for rock fish and finally seaward areas bounded by established lines relative to and abiding by landmarks. Complete rights to these areas were sustained tenaciously and any infringement of hunting laws were severely dealt with. It was the law to take the first of any seasonal food to the residing king so that all members of his tribe might taste and partake of the food as it came in for the first time.
>
> The council for a domain consisted of the chief and his subordinate chiefs. Influential seats in the council or senate were allocated to leaders according to their wisdom and abilities, men with proven wisdom, strength of character, and who were virtuous and impartial. It was these leaders who taught the masses and it was believed that good example did what any amount of admonition or set of secondary rules would not. Moreover, the strength and continuance of power depended greatly, if not entirely, on these qualities. Indeed, kings were known to disown an heir and revoke all pretensions,

rights and claims that would normally have been his inheritance. However, this occurred only when such heir consistently showed weakness of morality or total rejection of inter-tribal laws ...

Out of the council there emerged a tribunal to resolve and settle all disputes of consequence, oftimes including those of wars. From this council, too, came the ushers, whose business it was to know which particular seat belonged to whom; the advisers to the king; the mentors; the teachers; the storytellers; the historian; and the orators who presented the message, articles of agreement and oftimes an ultimatum also.

An artist was sometimes inducted into the tight organization when and if he merited that honor because he was able to think profoundly and create forms with which to show the people and thereby to stimulate, encourage, provoke and win over to ideas and principles where mere words failed.

Moreover, inter-tribal consensus iterated that a tribe was the total image of its king and he was himself as strong as his council. Indeed the council possessed so much influence that it did, on isolated occasions, bear and compensate for the foibles and weaknesses of a timid, irresolute king. Howbeit, it was not long before that unhappy situation became common knowledge among other tribes. This would greatly jeopardize the king's position – so much so that influential tribes have been known to rapidly lose both power and position when the key figure in that senate was removed by death or other misfortune.

...

The senior men together with the young men of the tribe stood one hundred strong in front of the Head's quarters, each facing away from the throng. They made a human curtain for what was to come.

...

The human wall or curtain had remained standing, their backs still towards the throng. From behind this the song leader's voice was again heard, now intoning the opening lines of the song that was to be sung for whatever was yet to come ...

As the thunder-drums boomed forth the line of men that made the screen parted in the middle to display a mural for the king, a great thunderbird was predominant in the centre carrying in its talons Mah-uk, the whale, and superimposed on the top corners were the form of the wolf. These were the symbols of his House. The mural was original, showing the form, the bone structure and a discreet innard to balance the design that made the mural.

What I'm trying to capture here is the complexity of ownership and its relationship to authority. Clutesi was writing about title to land and resources, not directly about material resources.

Thus a seat at the council and the right to occupy it was considered to be the highest award for the aspirant. Having once acquired a seat, and in order to continue, leaders guarded their offices with vigilance bordering on jealousy ...

This restricted control of policies by the ruling class did create distinct stratas of social orders but it also prevented ambitious, conniving pretenders from usurping power from recognized rulers. Though succeeding rulers were hereditary, if an heir was known to be morally weak the sire's nephew, his eldest sister's son, took precedence over his own sons. Unhappy situations such as this did occur but they were relatively isolated. The good of the tribe was considered above the rights of heirs.

...

All four fires were being stoked and replenished with dry cedar wood. The flames grew rapidly, licking upwards and sending out great sparks onto the earthen floor of the lodge. As the light in the end area increased the song leader emerged with his right arm raised high cleaving the air and beating time with his eagle feather which gleamed in the firelight. He was followed by his battery of drummers, eight in all. Four marched slowly to the far end on the left while the other four remained at the right end. The white feathers cleaved the air silently.

The singers, all men, filed into the now lighted area moving slowly until the entire end was filled with the large company of men. When the gleaming white feathers plummetted violently the battery of thunder-drums struck simultaneously with resounding, continuous beat and the new song, never before heard, stole forth into the still, tense atmosphere. The song began on a low note but gradually rose in pitch and in volume as the white eagle feathers rose higher and higher and the drums boomed louder and louder. After a few more vigorous beats the fan-shaped white feathers plunged down and there was complete silence in the lodge.

Now waist high the feather fan remained in motion and when it dropped the song resumed again on the low note, gradually building up and up. Well above the rest of the voices, in a penetrating pitch, the keeper of the song intoned, "Do the chorus now, you will now do the chorus. This you will say – "

> Swirling dust in the air
> From the road to my lodge never sets
> The seashell-flakes on the path to my door
> By the tread of coming men never sets.

Throughout the chorus the thunder-drums had lessened in volume until they were barely audible above the intoning voice. When the chorus had run its course the voice broke in again. "Repeat, you will repeat the chorus."

> Swirling dust in the air ...

As the second round of the chorus commenced a wisp of down floated in on a current of air about knee high above the earthen floor. Without warning or words a figure draped in a robe of sea-otter eased himself from behind the screen of singers. He sidled and bobbed low on his haunches, his back was to the onlookers. Springing lightly, keeping time in accordance with the fast beat of the drums, the figure sidled to his left and rose gradually as he traversed the earthen floor until he was upright. As he turned the gaudy headdress of a sea-serpent, ornate with inlays of abalone shell for eyes, teeth and other markings, was revealed into the full light of the now blazing fires.

Boom-boom-boom-boom-boom. The dancer glided lightly on the balls of his feet. The sea-serpent figure proud and aloof, his head held high, surveyed the mythical seas to the horizon, looking, searching the four corners of the winds – the north, the south, the east and the west. Each movement of its head billowed out delicate clouds of down of the wild swan that floated up and around the dance area before being wafted down onto the earthen floor of the lodge. The dancer reached the far end of the area by moving anti-clockwise and when he turned to face the light showed the bold stroke of black paint upon his cheeks which extended into the hollow area of his deep-set eyes. He took rapid short steps as he glided along the hard packed floor, his movements simulating the fluid sinuous motility of the legendary serpent upon the surface of the sea. A proud and stately figure, gaudy, colorful in his markings, masterful in his mien. The message was bold.

<p align="center">I am Master of All That I Survey.</p>

Again the song was repeated twice more until the full four times were complete when the whole presentation ended most abruptly and most vigorously.

**22.X. David W. Ellis and Luke Swan. 1981. *Teachings of the Tides: Uses of Marine Invertebrates by the Manhousat People*.** Nanaimo: Theytus Books, 97-99.

Luke Swan (1893-1976), a Nuuchaanulthat-h̲ and no relation to James G. Swan, was a direct descendant of the leading chief of the Maa'nuusat-h̲, a people who were defeated in war and then assimilated by the Aahuusat-h̲. Swan's father was a noted master carver, and in his lifetime Luke Swan did wonderful carvings and paintings. Like the writings of my uncle, George Clutesi, this book provided description from inside our own community. It provided an interesting foil to the writings by non-Nuuchaanulth quoted above.

SEA SERPENT

H̲IYITL'IIK, (FROM H̲IITLH̲IIYA, "TO MOVE BY WIGGLING BACK AND FORTH")

Sea serpents were rarely seen, especially in recent times. Mr. Swan's father had come upon one when he and another man were hunting for sea otter near Hesquiat Point.

He shot an arrow at it, but missed. He wanted to pursue the beast and kill it, but his partner, who was sitting in the stern of the canoe, fainted from fear. Mr. Swan's father watched the beast crawl onto a beach and disappear into the forest. If he had succeeded in killing it, he would have become a very great man, for nobody has ever killed a sea serpent on the west coast of Vancouver Island.

In the past, a sea serpent lived near sharp Point (called Ch'aa7ayapi, "fresh water point," because there is often a great deal of surf here. Mr. Swan wondered, however, why the word for fresh water, rather than the word for salt water, was incorporated into this place name). Sharp Point is at the east side of the entrance to Hotsprings Cove. The sea serpent that lived there was considered very dangerous, and people paddled as quietly as possible when rounding this point. If they made too much noise, the creature might harm them. But nothing has been heard of this monster for many years, especially since noisy power boats have begun entering the cove. The waters around Sharp Point are often rough and dangerous, especially during winter. The water is shallow, and the waves, especially when they meet an outgoing tide, break easily.

In the legend of "Mink Kills a Sea Serpent," Mink sets off to slay one of the beasts. He sharpens a pole at both ends, and props open a sea serpent's mouth with it after inducing the monster to swallow him. Once inside, he cuts up the insides of the sea serpent and kills it. After four days, the dead monster washes ashore and the people of Flicker's tribe go down to the beach and butcher it. Sea lion gets the longest piece of intestine, and that is why he can stay underwater for such a long time today. (Apparently, creatures that dive or live underwater were believed to store air in their intestines.) In the legend, Surf scooter also gets quite a long piece of intestine, and that is why today it can dive underwater for so long. Ratfish gets the smallest piece of intestine because he is so slow in getting there, having wasted too much time trying to fix the "bow" on top of his head. When they cut open the stomach of the sea serpent, they discover that the heat caused Mink to go bald.

Sea serpents were said to be about seven or eight feet long. They moved very quickly, both on land and in water. They had legs, but when traveling on land, used their bodies more than their legs for propulsion – moving like snakes. They were said to have a "sharp belly." Near Yuuyaas (from yuulh "a landing place for a canoe"), where the canoes were kept on Kanim Lake near Hisnit, a sea serpent had scraped the bark off one side of a spruce tree with its belly. Mr. Swan's great-uncle had explained to him that the sea serpent had "grown wings" as it went up this tree, later flying away.

The sea serpent was considered responsible for causing lightning. When the thunderbird, tutuut-sh, went offshore to hunt for whales, the sea serpent hung onto this big bird's neck. When the thunderbird made its thundering sound, the sea serpent would spit fire, and make the lightning. On their way offshore, the pair would make a

great deal of thunder and lightning, and the weather would become stormy. On their return to the mountains they would make less commotion and the storm would abate somewhat.

In the sea serpent, then, we have an incredibly versatile creature, at home in the mountains, at the bottom of the sea, and in the air. This creature was described as being snake-like, with a large head in proportion to its body. It had legs, a "sharp belly," and, apparently, wings that it could grow at will. Its head and back were covered with long hair, as is represented with strips of dyed red cedar bark on the sea serpent mask.

This mask, hinkiitsm, was worn by a Manhousat chief when he performed the sea serpent dance. This dance was performed before the head-chief distributed goods in a gift-giving ceremony or potlatch. Lower-ranking chiefs could also perform the dance, providing, of course, that they had the "privilege" of using a special song that went with the dance.

The sea serpent dance was usually performed at the gift-giving ceremony which always took place after the tluukwaana, or wolf dance. But it could, on occasion, be performed at a separate potlatch gathering in the chief's honour. If the chief was a really old man, his nephew or son could dance for him. First, the chief danced and sang, all the while shaking chopped bird down (usually swan down) from the top of the mask onto the floor. When the dance was over, the ts'iilhin (after ts'iilhaa, "chopped bird down") began. The man giving the potlatch began calling out, in order of rank, the names of people who were to receive goods. At one time, a wealthy chief might have given one dentalium shell to each of the "high" chiefs. In recent times, modern clothing was considered one of the finest items to receive. Porcelain dishes also became a prestigious gift.

**22.XI. Bill Holm. 1983.** *Box of Daylight: Northwest Coast Indian Art.* Seattle: Seattle Art Museum and University of Washington Press, 1, 46. Courtesy of Bill Holm.

Bill Holm (b. 1925) is a US artist, author, and art historian, specializing in what are referred to as the visual arts of Northwest Coast Native Americans and First Nations, as well as a practitioner and teacher of the Northwest Coast art style. He is a professor emeritus of art history and a curator emeritus of Northwest Coast Indian art at the Burke Museum of Natural History and Culture. His 1965 book *Northwest Coast Indian Art* has been considered by some "the bible" on northern Northwest Coast formline, but others have seen it as the moment when non-Native people took too much agency in defining the carving and painting styles of others. In the introduction to his catalogue for the exhibition *Box of Daylight*, Holm began with the story of a Nass River chief called Nas shuki yehl, Raven at the Head of Nass, who guarded daylight in a box. Yehl, or Raven, who coveted the

light, turned into a hemlock needle and was swallowed by the chief's daughter. She became pregnant, and Raven was born as the chief's grandson. The chief indulgently allowed Raven to play with the box of daylight, and Raven stole the light, throwing the box of daylight open for the world. Holm used this metaphor to praise the generosity of the collectors who lent their objects for this exhibition.

> In western Washington state, centered on Seattle, but scattered over the area, are treasures that are kept, like Nas shuki yehl's box of daylight, in the homes of people who prize them for their great beauty, visual power, or ability to evoke the rich native heritage of the Northwest Coast ... To the credit of their owners, no hemlock-needle tricks nor temper tantrums were needed to gain access to their collections and to throw open this great Box of Daylight in the Seattle Art Museum.
>
> ...
>
> 55. Dance Headdress
> Westcoast, Ahouset, early 20th century
> Red cedar, brass tacks
> L: 25 in. (63.5 cm); H: 9 ½ in. (24.3 cm); D: 8 ½ in. (21.5 cm)
> Collection of John H. Hauberg

> Flat-sided, constructed forehead masks are unique to the tribes inhabiting the west coast of Vancouver Island and the adjacent western shore of Washington's Olympic Peninsula. They are not simply lesser substitutes for sculptured masks, but make up a special class of ceremonial objects that traditionally take this form. All the people who use flat-sided masks also make fully sculptural ones. None were collected before the middle of the nineteenth century. Most of the known examples represent the supernatural wolves, the principal creatures of the Westcoast Winter Ceremonial. Some however are made to represent the lightning serpent, the belt and harpoon of the thunderbird. There are also thunderbird masks made in the same technique of very thin wooden boards joined together and a framework of light slats and rods intended to hold the shape and fit the dancers' heads. This lightness allows the use of very large masks.
>
> Characteristic of these masks is the elaborate fretwork along the top and rear edges, and complex painting in circles, U forms, and curvilinear, formline-like shapes. This one is painted with red, black, blue, and grey on a white ground, with accents of brass tacks.

**22.XII. Steven C. Brown. 1995. "Observations on Northwest Coast Art: North and South."** In *The Spirit Within: Northwest Coast Native Art from the John H. Hauberg Collection.* Edited by Steven C. Brown. New York: Rizzoli; Seattle: Seattle Art Museum, 266, 267. Courtesy of Steven C. Brown.

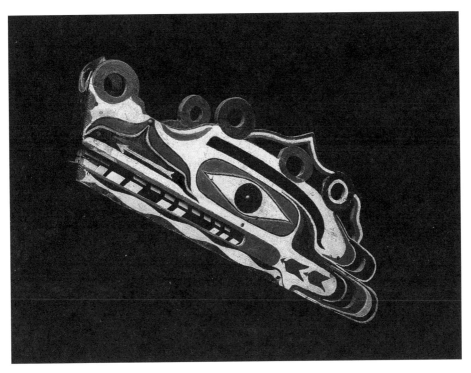

**FIGURE 22.5** Huupach'esat-ḥ dance headdress, one of a matched pair. Red cedar, brass tacks, paint, 24.1 x 21.6 x 63.5 cm. This is a Hinkiits headdress made by Hamtsiit, a Yuulthuu-ilthat'ḥ master carver. It was part of the marriage dowry of Annie Tleḥwituu-a when she married Chief Kwitchiinim of Huupach'esat-ḥ, ca. 1910. The mask is described here by Bill Holm [22.XI] and Steven C. Brown [22.XII]. It is currently in the collection of the Seattle Art Museum, listed as *Nuu-Chah-Nulth Hinkeets mask (Hinkeet'sạm)*. Seattle Art Museum, 91.1.25, gift of John H. Hauberg.

Steven C. Brown (b. 1950) is a carver of wood and a jeweller in the Northwest Coast art style. He studied under Bill Holm, whom he met while a student at the University of Washington. He did canoe making with the Makah in the 1970s, was an associate curator of Native American art at the Seattle Art Museum, and now makes a living doing contract exhibitions, writing catalogues, and selling Northwest Coast-style art that he creates.

100. *Hinkeet'sạm*
*Hinkeet̲s* Mask
Nuu-chah-nulth, Tseshaht band, ca. 1910
Red cedar, brass tacks, paint
9½ × 8 ½ × 25 in (24.1 × 21.6 × 63.5 cm)
91.1.25

Employing a white background for greater contrast, the artist has painted the surface of this lightning serpent mask with flowing, harmonious shapes. The painting on each side of the mask differs slightly, a common feature of masks from this area, which can be seen as a reflection of the subtle asymmetry of the natural world. As the dancers move, sweeping their heads from side to side in serpentine motions, a different aspect or personality of the masks is displayed by the variations in each side of the painting. The precise piercing of the wood found in these headdresses gives a feeling of lightness and delicacy, which is also conveyed by the quick, light steps of an expressive performer in the dancing house.

**22.XIII. Nuu-chah-nulth Tribal Council. 1999. Quoted in *HuupuKʷanum · Tupaat – Out of the Mist: Treasures of the Nuu-Chah-Nulth Chiefs*.** Edited by Martha Black. Victoria: Royal British Columbia Museum, 17.

Martha Black (b. 1945) was the curator of the Isaacs Gallery in Toronto for twenty-five years. She received her PhD in art history from the University of Victoria in 1998 and published her master's research as *Bella Bella: A Season of Heiltsuk Art* in 1997. She presently is curator of ethnology at the Royal British Columbia Museum in Victoria and adjunct assistant professor in the Department of History in Art and the Cultural Resources Management Program at the University of Victoria. Besides collaborating with the Nuu-chah-nulth Tribal Council on the exhibition *Out of the Mist,* Black curated *'Nḷuut'iksa Ḷagigyedm Ts'msyeen: Treasures of the Tsimshian from the Dundas Collection* in cooperation with the Allied Tribes of Lax Kw'Alaams and the Museum of Northern British Columbia in 2007 and was associate curator of *Kaxlaya Gvilas: "The Ones Who Uphold the Laws of Our Ancestors"* in 2000. The following excerpt contains the only words provided by the Nuu-chah-nulth Tribal Council for *Out of the Mist.*

The people of the west coast of Vancouver Island used to be called Nootka by Europeans. We know ourselves as Nuu-chah-nulth, which can be translated as "along the mountains" and refers to our traditional territories.

The sea and the creatures of the sea, the beaches and the islands and the seafood on them, the rivers and all the fish that go up the rivers, the mountains, the forests – everything that keeps us alive belongs to the haw'ilth [chief]. He looked after all this for his people.

The territorial rights of the chiefs are their hahuulthi. Through many generations, the hahuulthihi have been recounted and reinforced in the oral traditions at feasts and other cultural gatherings.

**22.XIV. Ḳi-ḳe-in. 2000-1. "Book Review of *Out of the Mist: Treasures of the Nuu-Chah-Nulth Chiefs* by Martha Black."** *BC Studies* 128: 107-8.

Ḳi-ḳe-in (b. 1948) is a Nuuchaanulth creator, storyteller, poet, writer, and historian living at Emin on the Tl'ikuulth Reserve. The nephew of artist and writer George Clutesi, Ḳi-ḳe-in has forty years of practice as a speaker and ritualist. His essays have appeared in numerous publications, including *Listening to Our Ancestors: The Art of Native Life along the North Pacific Coast* (2005) and his work in exhibitions such as *The Legacy* (RBCM, 1979), *In the Shadow of the Sun: Perspectives on Contemporary Native Art* (Canadian Museum of Civilization, 1993), and *Out of the Mist* (RBCM, 1999).

> In her preface the author declares the museum show chronicled in this book to be the first ever exhibit of Nuu-chah-nulth arts and cultures. This statement is as bold as it is ignorant. Nuu-chah-nulth peoples have used great paintings and carvings, beautiful robes, strong songs and dances, eloquent speakers, and a broad range of ceremonies to proclaim our place and authority along the west coast of this island since time immemorial. We have been exhibiting our culture to Europeans since 1778, when Captain Cook first visited our shores and attended a potlatch. Witness the Nuu-chah-nulth woman pictured weaving at the 1904 World's Fair. She was part of a group who went to demonstrate various traditional skills and to entertain the public. Witness the Tla-o-qui-aht Ha'wiih ranged in front of the Wikkaninnish's curtain in 1928. They were greeting Lieutenant-Governor Lord Willingdown in Tofino. Witness the truckloads of Nuu-chah-nulth men and women decked out in their crest masks and head-dresses for the Alberni Dominion Day parade in 1929. They are trying to make a point: "We are still here. In spite of all that you've done to wipe us off the face of this earth, we are still here." Black has chosen to use these images, but she has missed much of the very culture and history the book claims to offer.

## 23 | "Fighting with Property"

*The Double-Edged Character of Ownership*

In *The Social Organization and the Secret Societies of the Kwakiutl Indians,* Franz Boas (1897b, 358) described a double mask surmounted by a bear, whose "outer mask shows Nō'lis [a clan ancestor] in a state of rage vanquishing his rivals; the inner side shows him kindly disposed, distributing property in a friendly way" (see Figure 23.1). This drawing of the closed and open mask is an ethnographic artifact from a distinct anthropological moment but also an image for further productivity. Let it stand in for the potentialities and risks of property language as it is crafted and employed for Indigenous rights claims or imposed by post-colonial states under the guise of recognition and representation.

Property has been a ubiquitous category in the writings on the cultures of Northwest Coast peoples from the earliest explorer texts to the most recent land-claims and treaty processes. Yet it was largely ignored as a tacitly under-stood or naturalized term until the 1990s, when critical literature by Native and non-Native authors began to draw attention to differing interpretations of prop-erty and its culturally constructed meanings (A. Alfred 2004; gii-dahl-guud-sliiaay 1995; Hann 1998; Kasten 2004; Kramer 2004; Milburn 1997; Naxaxalhts'I 2007; Noble 2007; Strathern 1999, 2006; Todd 1990; Tsosie 1997; Verdery and Humphrey 2004). These texts highlighted the heteroglossic quality of the cat-egory "property" that arises from various knowledge systems and demonstrated the strategic uses to which its protean character can be employed.

Recent scholarship on Indigenous cultural rights has moved away from pro-ducing definitions of property and instead chosen to analyze when, where, and how property language is used and to whose benefit (Kasten 2004; Nadasdy 2002; Strathern 2006; Verdery and Humphrey 2004). Discourses about prop-erty, or property language, have been mobilized to support claims to ownership, social status, and identity maintenance. However, property language has also been viewed as detrimental to such claims. Marilyn Strathern (2006, 450), an anthropologist recognized for her work in the Pacific on exchange theory, has called this the "double-edged character of property" because it is "at once a

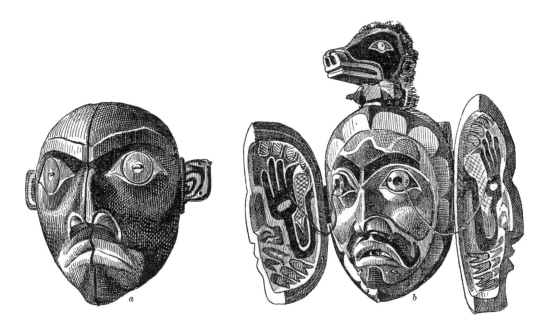

**FIGURE 23.1** Mask of Nō'lis 1897, Kwakwa̱ka'wakw. Original line drawings. From Franz Boas, *The Social Organization and the Secret Societies of the Kwakiutl Indians. Based on Personal Observations and on Notes Made by Mr. George Hunt,* in *Annual Report of the US National Museum for 1895* (Washington, DC: US Government Printing Office, 1897), 357, Figure 5.

highly moral and highly duplicitous construct." Anthropologist Elizabeth A. Povinelli (2002) exposed the "cunning of recognition" when Australian Aboriginal peoples must consent to be limited by alien categories of property and identity in order to have their resources returned by the state. Much contemporary research has focused on the illusory benefits to Indigenous peoples of employing European-based property concepts and terms in order to be heard by settler society governments, the legal systems they engender, and the citizens they produce (e.g., T. Berman 2004a, 384; 2012; Coombe 1997, 91; Geismar 2013; Nadasdy 2002, 258; Povinelli 2004, 193).

The phrase "fighting with property," borrowed from the oratory of Kwagu'ł chiefs and their speakers during an 1895 potlatch in Fort Rupert, is employed as a potent metaphor for this chapter. Anthropologist Helen Codere first popularized the term in her 1950 work *Fighting with Property: A Study of Kwakiutl Potlatching and Warfare, 1792–1930* [23.VII]. Codere's memorable thesis argued that competitive Kwakwa̱ka'wakw potlatching expanded after British settlers banned Native warfare and new wage economy opportunities made goods more easily purchasable. Quoting a Kwakwa̱ka'wakw man from Boas's field notes, she wrote

that "we do not fight now with weapons: we fight with property" (Boas 1897b, 601; Codere 1950, 118-19). Although there is saliency to her suggestion that rival potlatching replaced warfare, scholars who followed have questioned her certainty (cf. Drucker and Heizer 1967, 125-29; Kan 1989, 223-24; Walens 1981, 39).

Regardless of the historical suitability of describing potlatching as "fighting with property," this idea has been resilient on the Northwest Coast. In one sense, this trope expresses the way in which anthropologists have deployed property language in their attempts to support Native rights. It also captures Native critiques, which suggest that employing a European-derived property discourse that has its roots in Lockean, individualist thought can never accurately or productively represent Native ideas of possession and stewardship. The use of property language is an alternative "regime of value" (Appadurai 1986; Myers 2001b) to the modernist strategy of valuing Northwest Coast cultural creations as fine art (see Duffek, this volume; Ostrowitz, this volume). And, significantly, what has been commonly valued aesthetically by non-Native people is now more and more being asserted as cultural property by Native people in order to (a) better express their interrelated spiritual, social, and moral epistemologies; (b) make claims for repatriation of material culture lost from Native possession; or (c) fight appropriation and secure greater control over the proliferation of others claiming their designs, stories, songs, etc. (see Townsend-Gault, Chapter 27, this volume).

## FIGHTING WITH PROPERTY IN EARLY EXPLORER AND ETHNOGRAPHY TEXTS

The culturally constructed meaning of the term "property" does not generally emerge in the writings of early explorers and ethnographers because the writers themselves took the meaning of property for granted, as an objective term requiring no explanation or discussion. In more recent writings, however, the divergent understandings of property held by Native people and North Americans of European descent are more evident, implying that Native people continue to fight with property within the present context, albeit in a different form. Nonetheless, property discourse retains its double-edged character by making its possessor both powerful and vulnerable.

From the very first exchanges between European explorers and Native peoples on the Northwest Coast, there is evidence that property was a contentious issue. In an early interaction with the Nuu-chah-nulth in 1778, British captain James Cook expressed his surprise that they had a complex understanding of property ownership [23.1]. Cook's wonder arose from his unstated assumption that "Indians"

would have no understanding of property whatsoever, an assumption rooted in European constructions of "the noble savage" that were popular in his day.

European explorers, of course, were not the only ones to write about the relationship of Northwest Coast Native peoples to property. Early ethnographers attempted to decipher the motivations for and meanings of the movement of property within the ceremonial complex generically referred to by the Chinook word *potlatch*. In fact, understanding and explaining the potlatch has been one of the longest-standing concerns of anthropologists of the Northwest Coast. Some of the explanations of its central function have been that it increases the social status of the hosts who give away their possessions; enhances the economic security of the group through reciprocity; establishes a spiritual or religious connection to ancestors and supernatural beings; acts as a strategy to amass political power; and is a symbolic display of art to represent and unify family and clan identities (see Adams 1973; Barnett 1938, 1968; Boelscher 1988; Drucker 1939, 1951; Drucker and Heizer 1967; Emmons 1991; Garfield and Wingert 1951; Goldman 1975; Kan 1989; Jonaitis 1991; Olson 1954; Rosman and Rubel 1971; Walens 1981).

The potlatch has also been the focus of obsessive negative interest by Euro-Canadian missionaries and Indian Agents, who were horrified at what they saw as the excessive expenditure of food and goods on potlatch guests (Bracken 1997; Cole and Chaikin 1990). From the perspective of many nineteenth-century Christian sects, giving away wealth to the point of penury flew in the face of the Protestant work ethic and expectations of industry and saving that were the logical avenues for achieving status both on earth and in heaven. Europeans and North Americans of European descent were equally mystified by Native people who left salaried jobs in order to spend weeks on end potlatching, which often involved dancing in ceremonies that seemed "cannibalistic" or "barbaric" and occurred in conditions viewed as unsanitary and threatening to the health of children and elders. For all these reasons, the potlatch was a much misunderstood and maligned institution in terms of European perceptions and was outlawed by the Canadian Indian Act from 1884 to 1951 (see Cranmer Webster, this volume; Ḳi-ḳe-in, Chapters 2 and 22, this volume; Sewid-Smith, this volume; White, this volume).

Anthropologists, led by Franz Boas, wrote about art on the Northwest Coast under the broader category of property exchanged in the potlatch ceremonial complex (see Boas 1897a, 1897b, [1927] 1955, 280-81; Jonaitis 1995). Although Boas understood property as a manifestation of the interconnections among social identity, performed privileges, and oral narrative, in his attempts to explain the potlatch in positive terms that would appear rational to a non-Native North

American and European audience, he emphasized the distribution of material wealth, such as food, blankets, canoes, and coppers. In this way, Boas compared the giving away of things at a potlatch to a European-style banking system with loans, interest, and capital gains. While laudable in intent, this strategy focused attention on alienable property and created the erroneous impression that the potlatch was essentially an economic institution [23.11] (see also Miller, this volume, on Boas's mobilization of Northwest Coast art to fight social evolutionary thinking). Despite Boas's failure to successfully "fight with property" on behalf of Native peoples' rights to continue potlatching, his work exposed the competitive nature of the potlatch within Kwakwaka'wakw communities in the late nineteenth century: "Formerly feats of bravery counted as well as distributions of property, but nowadays, as the Indians say, 'rivals fight with property only'" (Boas 1897b, 342-43).

Drawing upon Boas's fieldwork, and working within the "culture and personality" school of anthropology, which classified peoples and cultures in terms of types, anthropologist Ruth Benedict also wrote about fighting with property. In her 1934 work *Patterns of Culture*, she drew upon anthropologists' descriptions of Native cultures around the world and labelled them in terms of cultural temperament. For this task, Benedict employed the Nietzschean categories "Dionysian," which referred to cultures that encouraged the expression of a carefree, aggressive, self-aggrandizing way of being in the world, and "Apollonian," characterized as being more cautious and thoughtful (Nietzsche [1872] 1956). She believed that all human beings possess both sets of traits. However, depending upon the particular culture into which a person is born, an individual will learn to express certain traits and repress others. Benedict cast the Kwakwaka'wakw, and by extension all the peoples on the Northwest Coast, as "Dionysian" because of what she perceived to be their excessive gifting of wealth during potlatch ceremonies [23.IV], even noting that "judged by the standards of other cultures the speeches of their [Kwakwaka'wakw] chiefs at their potlatches are unabashed megalomania" (190).

Although Benedict's intent was not to judge whether a culture was superior or inferior to others based on these classificatory types, her work did little to enhance non-Native perceptions of the peoples of the Northwest Coast. Ultimately, her description of Kwakwaka'wakw exchange practices as observed by Boas during a single potlatch resulted in the negative characterization of an entire people (see Miller, this volume). In this way, property, or, more precisely, the way in which property was used within Northwest Coast cultures, again became a liability for the Kwakwaka'wakw vis-à-vis the non-Native population.

Similarly, Canadian anthropologist Thomas McIlwraith, who worked in Bella Coola in the early 1920s, wrote of the vulnerability of relying on property language. He recounted his experience of inadvertently singing a song he thought belonged to all Nuxalk, only to discover that it was a family-owned prerogative. His action forced an elder to adopt him on the spot, thus granting him the right to sing the song and to avoid the shame she would have incurred from his unwitting theft of her family's property. McIlwraith's two-volume ethnography, *The Bella Coola Indians* (1948), depicts an understanding of how tangible and intangible property ownership and discourse can result in status and power but can also bring instability and risk loss [23.V].

French sociologist Marcel Mauss was the first social scientist to analyze gift exchange cross-culturally in his book *Essai sur le don* (1923-24), first translated into English in 1954 and in 1967 as *The Gift: Forms and Functions of Exchange in Archaic Societies* [23.III]. The Northwest Coast potlatch served as a primary case study for him to ask "why do people feel obligated to reciprocate when they receive a gift?" His analysis of the potlatch as a "total phenomenon" refuted the economically determinist idea that humans value objects only for utilitarian reasons. Although he could be critiqued for combining ethnographic details of specific Northwest Coast peoples into one "system of the gift" on the "American Northwest Coast," his overarching recognition that potlatching was a "total social fact" moved emphasis away from economic or psychological models of culture and toward a more holistic understanding based on social, economic, political, and spiritual models.

While Mauss's *The Gift* became renowned among social scientists and other theoreticians interested in exchange, kinship, and alternatives to capitalist economies, it was not reabsorbed into the writings about the cultures of the Northwest Coast until the early 1970s (see Goldman 1975; Rosman and Rubel 1971) and then only tangentially. However, his work did play a significant role in the French anthropologist Claude Lévi-Strauss's development of structuralism (cf. 1969, 1982; see also Campbell, this volume) and in Georges Bataille's three-volume treatise *The Accursed Share: An Essay on General Economy* (1991), published in French in 1949, which discussed the necessity of the consumption of wealth as opposed to its production [23.VI] (see Mauzé, this volume).

Notably, Mauss's conclusions resonate with more contemporary writings by Native scholars and artists, such as Callison (1995), N. Collison (2006) [15.IX], Dauenhauer (1995) [23.XI], gii-dahl-guud-sliiaay (1995) [23.XII], Todd (1990), and Weavers' Circle (1993) [23.X], on the integrative quality of art and property with Native identity, spirituality, aesthetics, politics, and economy (see Ḳi-ḳe-in,

Chapters 2 and 22, this volume; Sewid-Smith, this volume). In fact, holism has become a favoured discourse of Indigenous authors on the Northwest Coast (see T. Berman 2004b).

Despite the publication of Mauss's book, it was not until 1959 and the work of Canadian museum curator and professor Wilson Duff that the academic and museological establishment began to recognize the importance of property language and holistic understandings of property ownership in relation to First Nations' claims for Indigenous control of land and other aspects of cultural patrimony [23.VIII]. The book *Histories, Territories and Laws of the Kitwancool* (1959a) was an unexpected product of the British Columbia Provincial Museum's attempt to preserve a number of Tsimshian totem poles. As a result of their negotiations with the Kitwancool band council, the integrated nature of Native ideas about property emerged as both different from European-based construction and crucial to Native peoples' self-determination and sovereignty. Contrary to European-derived constructions of property ownership, in which what is owned is viewed as a tangible, independent unit that can be sold, exchanged, or given away without affecting the whole, the Kitwancool totem poles could not be sold, nor could they be separated from the context in which they signified meaning, without compromising or destroying the whole. Although the publication of this book was a significant event in that it presaged the contemporary discourse on the differences in conceptions of property ownership between Native and non-Native peoples on the Northwest Coast, its importance remains underrecognized by scholars.

As this overview of some of the key moments in the historical discourse surrounding property shows, viewed from the perspective of the possessor and/or giver, property has served as a means of enhancing one's status and power among Northwest Coast Native peoples, particularly through the mechanism of the potlatch. Conversely, however, property ownership or receipt also had the power to make one vulnerable, hence the idea of Native people "fighting with property," which appeared in Boas's interviews with potlatch participants and was later highlighted by Codere. The image of the double mask that began this chapter is an apt representation of the double-edged nature of property from this earlier period. "Fighting with property" also describes the efforts of early anthropologists, such as Boas and Benedict, who used their own interpretations of the meaning of property exchange within the potlatch to support the rights of Native peoples and lend respect and validity to their cultures in the eyes of the non-Native world. Yet, despite the best of intentions, Boas's and Benedict's work again exposed the risks involved when one "fights with property"; one

could make the case that, as a result of their arguments, Native peoples experienced further losses of dignity and agency.

## FIGHTING WITH PROPERTY IN THE CONTEMPORARY CONTEXT

There has been a florescence of writings that discuss the differences between property language as it is constructed within the context of European, Lockean traditions and property language that arises from Indigenous customary laws. Those of the former assume notions of "possessive individualism" (Macpherson 1962; Handler 1997) and presume objects can be sold and alienated from their owners as commodities. This results in particular ways of thinking about ownership – for example, those seen in European-derived copyright laws. Indigenous customary laws, on the other hand, reflect different understandings of property, such as communal ideas of property ownership [23.XVI] or the absence of a dichotomy between people and things [23.XI] (but also see Appadurai 1986; M.F. Brown 2003; Godelier 1999; Kopytoff 1986; D. Miller 2005b; Myers 2001b; Strathern 1999; N. Thomas 1991, 1999; Weiner 1992; Sewid-Smith, this volume). Many Indigenous people espouse the view that their possessions are inalienable; they are merely the stewards of objects that cannot be divorced from social identity.

Providing a concrete explanation of this inalienable and inherited connection between people and tangible and intangible things, Tlingit linguist and cultural historian Nora Marks Dauenhauer (1995, 25) explained the centrality of *at.oów* (meaning "an owned or purchased thing or object") to Tlingit life [23.XI]. She described how works of art achieve a status of *at.oów* and are stewarded through subsequent clan generations. *At.oów* must be ritually displayed to show ownership but also remind of the obligation to reciprocate and create balance (see Berman, this volume).

In addition, for Indigenous communities, property language typically encompasses aspects of obligation vis-à-vis ownership, while European-derived property language constructs ownership as a right (Verdery and Humphrey 2004, 6; see also Ḳi-ḳe-in, Chapter 22, this volume). Stó:lō author Naxaxalhts'I (2007) explained how the use of certain fishing sites was traditionally considered a family's shared prerogative by the Salish; however, under pressures from the Department of Fisheries and Oceans to register fishing licences in individual names only, conflicts of ownership and access rights have arisen [23.XVI].

There are aspects of Indigenous property law on the Northwest Coast that assert how the carving, wearing, or display of certain crest designs; the use of certain types of artistic techniques; the performance of certain songs and dances;

and the harvesting of certain resources are connected to exacting measures of ownership – whether they be at the individual, family, clan, or national level. For example, an Indigenous Weavers' Circle, made up of Tlingit, Tsimshian, and Kwakwaka'wakw who possess the inherited rights to create Chilkat weavings, came together in Hoonah, Alaska, to support the members' social and aesthetic endeavours. They felt it necessary to issue a Weavers' Statement in 1993 [23.x] that reclaimed the technique of Chilkat weaving as culturally owned. This strong declaration of ownership encompassed all Indigenous traditional art forms and detailed how art symbolizes Indigenous cultural identity and the right to exercise authority over ancestral lands. The Weavers' Circle admonished non-Native artists to look to their own distinct heritage for aesthetic inspiration (see also Sewid-Smith, this volume).

Despite fundamental differences between Indigenous and European property systems, First Nations on the Northwest Coast and Indigenous people world-wide are obliged to adopt property language that is European derived in order to fight for rights within the legal systems of settler society governments (see Townsend-Gault, Chapter 27, this volume; White, this volume). Haida lawyer gii-dahl-guud-sliiaay (Terri-Lynn Williams-Davidson) (1995) described how First Nations people are forced to use legislative definitions of cultural property that do not articulate their understandings of the objects of which they wish to claim ownership. According to gii-dahl-guud-sliiaay, what non-Native people construe as inanimate art objects are perceived by Indigenous people as animate objects because they exist in relation to the spiritual world [23.xii]. As such, they are not only "art" but also tools for ceremonial use and physical represen-tations of social organization and, hence, privileges. When Indigenous people adopt the property language of an alien system, however, they run the risk that their own understandings will not be heard and the judicial case not won. Ironically, while engagement with non-Native people in claims over cultural patrimony has the potential to offer redress for past wrongs, the forced use of inappropriate, European-derived property language places Indigenous people in a vulnerable position because their claims may not be accurately represented (see Sewid-Smith, this volume).

This problematic fit between European-based property language and First Nations' understandings of their material culture exists in the US 1990 Native American Graves Protection and Repatriation Act (NAGPRA). NAGPRA de-fined "sacred objects" and "cultural patrimony," among other terms, in an at-tempt to sort through the legal morass of ownership issues but inadvertently perpetuated the authority of European-based definitions. gii-dahl-guud-sliiaay (1995, 199) has pointed out that Canada's morally persuasive 1992 report from

the Task Force on Museums and First Peoples, *Turning the Page: Forging New Partnerships between Museums and First Peoples* [23.IX], meant to promote Indigenous access to museums and the repatriation of "objects of cultural patrimony," ended up constructing similar roadblocks. Indigenous people must apply to have their claims to ownership acknowledged and validated by museum professionals before repatriation of their property can occur (see Bell and Collison 2006; Conaty and Janes 1997; Cranmer Webster 1995; Feest 1995; Phillips and Johnson 2003; Worl 1995 on repatriation). Ultimately, trying to offer redress for failing to recognize and respect First Nations culture through means that continue to do so is ironic indeed.

Yet the problems and implications of abandoning European-based constructions and property language are complex, as Andrea Laforet (2004), former director of ethnology and cultural studies at the Canadian Museum of Civilization, has made clear [23.XV]. She discussed various ideas of inalienable property held by both Canadian museums and the Nisga'a as they negotiated for the repatriation of cultural property as part of the Nisga'a Treaty. She expressed how objects in museum collections cannot easily be separated from their commodity status and that this must now be taken into account as part of their cultural biography.

Within this context of confusing and overlapping ideas of property and ownership, it is no surprise that accusations of appropriation of a range of cultural property (from material objects to oral stories and songs, from performance to cultural representation) have arisen (T. Berman 1997, 2004a, 2004b, 2012; M.F. Brown 1998; Kramer 2004, 2006; Riley 2004; Ziff and Rao 1997). This outpouring of Native concerns about cultural appropriation of both tangible and intangible resources (Callison 1995; N. Collison 2006; Todd 1990) has led to an expansion of the idea of "cultural property" to include diverse categories such as material culture, art style, sacred symbols, oral narrative, music and soundscapes, traditional ecological knowledge (TEK), and genetic makeup (M.F. Brown 2003; Coombe 1998; Harkin 2005; Kramer 2004, 2006; Townsend-Gault 1997). This extensive growth implies that the entire spectrum of heritage can now be termed "cultural property" and potentially protected. However, the recognition of this potentiality has perhaps also heightened a sense of vulnerability – a return to the double mask metaphor – as the problem of defining appropriate protocols for use have also become more complex (T. Berman 2004a, 2004b; M.F. Brown 1998, 2003, 2004; Riley 2004; Rowlands 2004).

This is illustrated by poet and linguist Robert Bringhurst's argument that, according to both Native customary laws and European-based copyright laws, his translating and publishing of Haida oral narratives without Haida permission was not a violation of Native rights [23.XIV]. In an interview, Bringhurst raised

the complex question "how do we choose whose laws to apply?" and pointed out that applying both systems at once "gives you cultural gridlock" (Rigaud 2002, 12). However, his stance has not protected him from Haida accusations of appropriation, and his defensive dialogue expresses Native people's renewed sense that their cultural property must be fought for.

In conclusion, it is important to pay attention to the explosion of property language used by and for Indigenous peoples at the same time that some property categories are being exposed as inappropriate for representing Indigenous perspectives (Handler 1997; Rowlands 2004; R. Welsh 1997; see also Ḵi-ḵe-in, Chapters 2 and 22, this volume; Sewid-Smith, this volume). Claims for cultural recognition, the protection of tangible and intangible heritage, and self-determination are being fought using both legal means (e.g., intellectual property rights [IPR] law) and international agreements authored by extra-national governance bodies such as the United Nations Educational, Scientific, and Cultural Organization (UNESCO) and World Intellectual Property Organization (WIPO) (see White, this volume). Katherine Verdery and Caroline Humphrey (2004, 16) offered one explanation of this impasse by observing that writings on property use a language of rights that obscures the obligations of ownership. Lawyers Patrick Walker and Clarine Ostrove (1995) argued that the process of regaining control over cultural property was essential to the cultural survival of Indigenous people and to their retrieving other types of rights, such as the right to self-government [23.XIII]. Thus, it is not a contradiction that the recognition of the problems of using European-derived property language should be accompanied by an escalation of Native claims (see Townsend-Gault, Chapter 27, this volume).

While property language has always been present in the writings on the Northwest Coast, there has been an increase in attempts to illuminate changing meanings of the category "property" and to analyze whose worldview is represented when a particular type of property language is used. The idea of "fighting with property" originated with the Kwakwaka'wakw and the Tlingit (Boas 1897b; Kan 1989) and was later, in a metaphoric sense, retasked by ethnographers, who wrote about Northwest Coast cultures' potlatch systems and in doing so fought with property themselves. In the contemporary context, the original potlatch idea of "fighting with property" is an apt metaphor for the way in which Indigenous authors are now strategically mobilizing property language to fight to protect their rights to the control of all aspects of their culture, self-representation, and self-determination. The power of property discourse has been amplified by the valuing of Northwest Coast cultural production as fine art

but also through Native assertions of the entangled nature of aesthetics with social organization, spiritual belief, customary law, and economics. Thus, although the arenas of struggle have moved from communal bighouses to published ethnographies to Canadian treaty processes, museum collaborations, and the drafting of UN declarations, "fighting with property" remains a productive description of the situation of First Nations people on the Northwest Coast today.

**23.I. John C. Beaglehole, ed. 1967.** *The Journals of Captain James Cook on His Voyages of Discovery.* Volume 3, part 1, *The Voyage of the* Resolution *and* Discovery, *1776-1780.* Cambridge, UK: Cambridge University Press for the Hakluyt Society, Extra Series No. 36, 306.

On his third voyage of exploration to the Pacific, British captain James Cook (1728-79), explorer, navigator, cartographer, and commander of the HMS *Resolution*, landed near Yuquot and recorded in his diaries early exchanges with the Nuu-chah-nulth people he met there. Contrary to some recent postcolonial scholarship that depicts Europeans as immediately laying claim to all things Native and refuting Native ideas of property, Cook's diaries showed his recognition of Native ownership of land and resources.

> Wednesday April 22nd 1778:
> Here I must observe that I have no were [sic] met with Indians who had such high notions of every thing the Country produced being their exclusive property as these; the very wood and water we took on board they at first wanted us to pay for, and we had certainly done it, had I been upon the spot when the demands were made; but as I never happened to be there the workmen took but little notice of their importunities and at last they ceased applying. But maid a Merit on necessity and frequently afterwards told us they had given us Wood and Water out of friendship.

**23.II. Franz Boas. 1897.** *The Social Organization and the Secret Societies of the Kwakiutl Indians. Based on Personal Observations and on Notes Made by Mr. George Hunt.* In *Annual Report of the US National Museum for 1895.* Washington, DC: US Government Printing Office, 341-42, 342-43.

Franz Boas (1858-1942) was a German-born, American pioneer of anthropology. Although he obtained his doctorate in physics and did research with the Inuit of Baffin Island on psychophysics and perceptions of the colour of sea water, he is known for his fieldwork with Northwest Coast Native peoples, especially with the people who were then thought of as the "Kwakiutl Indians." This

excerpt is from what has become the seminal Kwakwa̱ka'wakw ethnography, in which Boas recounted what he learned from experiencing a potlatch in Fort Rupert in 1895.

### III. THE POTLATCH

Before proceeding any further it will be necessary to describe the method of acquiring rank. This is done by means of the potlatch, or the distribution of property. This custom has been described often, but it has been thoroughly misunderstood by most observers. The underlying principle is that of the interest-bearing investment of property.

The child when born is given the name of the place where it is born. This name (g·i′nLaxLē) it keeps until about a year old. Then his father, mother, or some other relative, gives a paddle or a mat to each member of the clan and the child receives his second name (nā′map'axLēya). When the boy is about 10 or 12 years old, he obtains his third name ( б̄ōmiatsEXLā′yē). In order to obtain it, he must distribute a number of small presents, such as shirts or single blankets, among his own clan or tribe. When the youth thus starts out in life, he is liberally assisted by his elders, particularly by the nobility of the tribe.

I must say here that the unit of value is the single blanket, now-a-days a cheap white woolen blanket, which is valued at 50 cents. The double blanket is valued at three single blankets. These blankets form the means of exchange of the Indians, and everything is paid for in blankets or in objects the value of which is measured by blankets. When a native has to pay debts and has not a sufficient number of blankets, he borrows them from his friends and has to pay the following rates of interest:

For a period of a few months, for 5 borrowed blankets 6 must be returned (Lē′k·ō); for a period of six months, for 5 borrowed blankets 7 must be returned (mā″Laxsa Lē′k·ōyō); for a period of twelve months or longer, for 5 borrowed blankets 10 must be returned (dē′ida or g·ē′La).

When a person has a poor credit, he may pawn his name for a year. Then the name must not be used during that period, and for 30 blankets which he has borrowed he must pay 100 in order to redeem his name. This is called q'ā′q'oaxō (selling a slave).

The rate of interest of the Lē′k·ō varies somewhat around 25 percent, according to the kindness of the loaner and the credit of the borrower. For a very short time blankets may be loaned without interest. This is designated by the same term.

When the boy is about to take his third name, he will borrow blankets from the other members of the tribe, who all assist him. He must repay them after a year, or later, with 100 percent interest. Thus he may have gathered 100 blankets. In June, the time set for this act, the boy will distribute these blankets among his own tribe, giving

proportionately to every member of the tribe, but a few more to the chief. This is called Lā′X′uit. When after this time any member of the tribe distributes blankets, the boy receives treble the amount he has given. The people make it a point to repay him inside of a month. Thus he owns 300 blankets, of which, however, he must repay 200 after the lapse of a year. He loans the blankets out among his friends, and thus at the close of the year he may possess about 400 blankets.

...

Possession of wealth is considered honorable, and it is the endeavor of each Indian to acquire a fortune. But it is not as much the possession of wealth as the ability to give great festivals which makes wealth a desirable object to the Indian. As the boy acquires his second name and man's estate by means of a distribution of property, which in course of time will revert to him with interest, the man's name acquires greater weight in the councils of the tribe and greater renown among the whole people, as he is able to distribute more and more property at each subsequent festival. Therefore boys and men are vying with each other in the arrangement of great distributions of property. Boys of different clans are pitted against each other by their elders, and each is exhorted to do his utmost to outdo his rival. And as the boys strive against each other, so do the chiefs and the whole clans, and the one object of the Indian is to outdo his rival. Formerly feats of bravery counted as well as distributions of property, but nowadays, as the Indians say, "rivals fight with property only." The clans are thus perpetually pitted against each other according to their rank ...

I referred several times to the distribution of blankets. The recipient in such a distribution is not at liberty to refuse the gift, although according to what I have said it is nothing but an interest-bearing loan that must be refunded at some future time with 100 per cent interest. This festival is called p'a′sa, literally, flattening something (for instance, a basket). This means that by the amount of property given the name of the rival is flattened.

23.III. **Marcel Mauss. 1967.** *The Gift: Forms and Functions of Exchange in Archaic Societies.*
Translated by Ian Cunnison. New York: Norton, 35-36, 36-37. First published in English in 1954.
Reproduced by permission of Taylor and Francis Books, UK.

Marcel Mauss (1872-1950) was a French Jewish sociologist and socialist interested in comparative religions. He worked closely with his uncle Émile Durkheim, with whom he wrote *Primitive Classification* in 1903 and edited the journal *L'année sociologique* (founded in 1898). His famed book *Essai sur la don,* first published in 1924, offered an analysis of the potlatch complex as a "total prestation," explaining the reciprocal obligations of the gift within social, political, economic, judicial, and aesthetic realms of life.

No less important is the role which honour plays in the transactions of the Indians. Nowhere else is the prestige of an individual as closely bound up with expenditure, and with the duty of returning with interest gifts received in such a way that the creditor becomes the debtor. Consumption and destruction are virtually unlimited. In some potlatch systems one is constrained to expend everything one possesses and to keep nothing. The rich man who shows his wealth by spending recklessly is the man who wins prestige. The principles of rivalry and antagonism are basic. Political and individual status in associations and clans, and rank of every kind, are determined by the war of property, as well as by armed hostilities, by chance, inheritance, alliance or marriage. But everything is conceived as if it were a war of wealth. Marriage of one's children and one's position at gatherings are determined solely in the course of the potlatch given and returned. Position is also lost as in war, gambling, hunting and wrestling. Sometimes there is no question of receiving return; one destroys simply in order to give the appearance that one has no desire to receive anything back. Whole cases of candlefish or whale oil, houses, and blankets by the thousand are burnt; the most valuable coppers are broken and thrown into the sea to level and crush a rival. Progress up the social ladder is made in this way not only for oneself but also for one's family. Thus in a system of this kind much wealth is continually being consumed and transferred. Such transfers may if desired be called exchange or even commerce or sale; but it is an aristocratic type of commerce characterized by etiquette and generosity; moreover, when it is carried out in a different spirit for immediate gain, it is viewed with the greatest disdain.

...

For the potlatch is more than a legal phenomenon; it is one of those phenomena we propose to call "total." It is religious, mythological and shamanistic because the chiefs taking part are incarnations of gods and ancestors, whose names they bear, whose dances they dance and whose spirits possess them. It is economic; and one has to assess the value, importance, causes and effects of transactions which are enormous even when reckoned by European standards. The potlatch is also a phenomenon of social morphology; the reunion of tribes, clans, families and nations produces great excitement. People fraternize but at the same time remain strangers; community of interest and opposition are revealed constantly in a great whirl of business. Finally, from the jural point of view, we have already noted the contractual forms and what we might call the human element of the contract, and the legal status of the contracting parties – as clans or families or with reference to rank or marital condition; and to this we now add that the material objects of the contracts have a virtue of their own which causes them to be given and compels the making of counter-gifts.

**23.IV. Ruth Benedict. 1934. *Patterns of Culture*.** Boston: Houghton Mifflin, 181-84, 188, 189, 190, 193, 222.

Ruth Benedict (1887-1948) was an acclaimed anthropologist of the culture and personality school. A student of Franz Boas, she received her PhD in anthropology from Columbia University in 1923 and immediately took up a position as professor in the same department. Benedict gained attention for her book *Patterns of Culture*. In it, she compared the Puebloan peoples of New Mexico, the Dobu of New Guinea, and the peoples of the Northwest Coast to further her thesis that human cultures could be seen as examples of personality writ large. Translated into fourteen different languages, it became one of the anthropology books most widely read by the public. Benedict noted that what she referred to as "the culture of the Northwest Coast" considered both tangible and intangible wealth to be property, and she wrote of how this pervasive concept was central to the competitive maintenance and manipulation of noble identity.

> The Dionysian slant of Northwest Coast tribes is as violent in their economic life and their warfare and mourning as it is in their initiations and ceremonial dances. They are at the opposite pole from the Apollonian Pueblos, and in this they resemble most other aborigines of North America. The pattern of culture which was peculiar to them, on the other hand, was intricately interwoven out of their special ideas of property and of the manipulation of wealth.
>
> The tribes of the Northwest Coast had great possessions, and these possessions were strictly owned. They were property in the sense of heirlooms, but heirlooms, with them, were the very basis of society. There were two classes of possessions. The land and sea were owned by a group of relatives in common and passed down to all its members. There were no cultivated fields, but the relationship group owned hunting territories, and even wild-berrying and wild-root territories, and no one could trespass upon the property of the family. The family owned fishing territories just as strictly. A local group often had to go great distances to those strips of the shore where they could dig clams, and the shore near their village might be owned by another lineage. These grounds had been held as property so long that the village-sites had changed, but not the ownership of the clam-beds. Not only the shore, but even deep-sea areas were strict property. For halibut fishing the area belonging to a given family was bounded by sighting along double landmarks. The rivers, also, were divided up into owned sections for the candlefish hauls in the spring, and families came from great distances to fish their own section of the river.
>
> There was, however, still more valued property that was owned in a different fashion. It was not in the ownership of the means of livelihood, however far that was carried, that Kwakiutl proprietorship chiefly expressed itself. Those things which were supremely valued were prerogatives over and above material well-being. Many of these were material things, named house-posts and spoons and heraldic crests, but

the greater number were immaterial possessions, names, myths, songs, and privileges which were the great boast of a man of wealth. All these prerogatives, though they remained in a blood lineage, were nevertheless not held in common, but were owned for the time being by an individual who singly and exclusively exercised the rights which they conveyed.

The greatest of these prerogatives, and the basis of all others, were the nobility titles ...

In the first place, these titles were the right of the eldest born, and youngest sons were without status. They were scorned commoners. In the second place, the right to a title had to be signalized by the distribution of great wealth. The women's engrossing occupation was not the household routine, but the making of great quantities of mats, baskets, and cedar-bark blankets, which were put aside in the valuable boxes made by the men for the same purpose. Men, likewise, accumulated canoes, and the shells or dentalia they used as money. Great men owned or had out at interest immense quantities of goods, which were passed from hand to hand, like bank notes to validate the assumption of the prerogatives.

...

Manipulation of wealth in this culture had gone far beyond any realistic transcription of economic needs and the filling of those needs. It involved ideas of capital, of interest, and of conspicuous waste. Wealth had become not merely economic goods, even goods put away in boxes for potlatches and never used except in exchange, but even more characteristically prerogatives with no economic functions. Songs, myths, names of chiefs' house-posts, of their dogs, of their canoes, were wealth.

...

The ultimate reason why a man of the Northwest Coast cared about the nobility titles, the wealth, the crests and the prerogatives lays bare the mainspring of their culture: they used them in a contest in which they sought to shame their rivals. Each individual, according to his means, constantly vied with all the others to outdistance them in distributions of property ... They say, "We do not fight with weapons. We fight with property."

...

This will to superiority ... found expression in uncensored self-glorification and ridicule of all comers. Judged by the standards of other cultures the speeches of their chiefs at their potlatches are unabashed megalomania.

...

The whole economic system of the Northwest Coast was bent to the service of this obsession. There were two means by which a chief could achieve the victory he sought. One was by shaming his rival by presenting him with more property than he could return with the required interest. The other was by destroying property.

...

The segment of human behavior which the Northwest Coast has marked out to institutionalize in its culture is one which is recognized as abnormal in our civilization, and yet it is sufficiently close to the attitudes of our own culture to be intelligible to us and we have a definite vocabulary with which we may discuss it. The megalomaniac paranoid trend is a definite danger in our society. It faces us with a choice of possible attitudes. One is to brand it as abnormal and reprehensible, and it is the attitude we have chosen in our civilization. The other extreme is to make it the essential attribute of ideal man, and this is the solution in the culture of the Northwest Coast.

**23.V. Thomas F. McIlwraith. (1948) 1992.** *The Bella Coola Indians.* 2nd ed. Edited by John Barker. 2 vols. Toronto: University of Toronto Press, 1: 166-67, 179. Reprinted with permission of the publisher.

Thomas F. McIlwraith (1899-1964) was a Canadian who studied anthropology at Cambridge University under the influence of A.C. Haddon and W.H.R. Rivers. He was hired by Edward Sapir, chief of the anthropology division at the Victoria Memorial Museum in Ottawa (later, sequentially, the National Museum of Canada, the Museum of Man, and now the Canadian Museum of Civilization) to undertake fieldwork in Bella Coola. He spent March to July 1922 and September 1923 to March 1924 doing field research and was adopted into Captain Schooner's family in 1923. But he was not able to publish the product of this research, a two-volume tome, until 1948, because it was deemed too sensational for the Canadian public until 1930, and then an economic depression from World War II slowed publication. He became a lecturer at the University of Toronto in 1924, founded the first anthropology department in Canada there in 1936, and taught until his death. He also served as keeper of the Royal Ontario Museum of Archaeology.

The need of validating every ceremonial act by presents can be further illustrated by the following instance. When the writer was in Bella Coola, a non-ceremonial entertainment was given one evening at which several men sang and performed. The writer was asked to sing a Bella Coola song, which he did in the belief that it was not one that was incorporated in the ancestral myth of anyone. Unfortunately, his teacher had erred, and as soon as the song was completed an old woman arose and stated that it belonged to her ancestral family. She avoided the difficulty of its singing by immediately announcing that the singer was her "son." Thus the writer was adopted into a Bella Coola family, a circumstance which aided him considerably in collecting information. This did not alter the fact that a ceremonial song had been sung. Accordingly, the woman gave presents to the guests, thereby legalizing the adoption, and saving

herself from the disgrace of having one of her songs used as if it were a matter of no consequence, free to anyone.

...

In the old days, "wealth" was of two categories: (a) Prerogatives, tangible or intangible, which could be shown, pictorially or dramatically, or could be expounded in words; and (b) Goods which could be distributed for validating such prerogatives. Individual possessions, unsuited for distribution, were hardly considered as wealth; a sewing-machine, a bottle of whiskey, a bed, or some other luxury might give satisfaction to the owner, but did not increase his importance in the eyes of his fellows. The value of objects was only for their use in ceremonial distribution; indeed, prior to such distribution, they were only of potential value. This attitude controlled Bella Coola economics in the early days of contact, and still influences their behavior. A native store-keeper once ruefully commented on the fact that he would gain no advantage from the goods on his shelves, since he hoped merely to sell them, not to give them away.

**23.VI. Georges Bataille. 1991. *The Accursed Share: An Essay on General Economy.*** Volume 1, *Consumption.* Translated by Robert Hurley. New York: Zone Books, 69–70.

Georges Bataille (1897-1962) has been called an archivist, a philosopher, and a Surrealist, but none of those descriptions quite fits. He founded several journals including *Tel quel*. He was attracted to Surrealism and the College of Sociology's desire to explore the sacred in society in 1939 but had a falling out with its founder, André Breton. He was an atheist mystic who wrote about base materialism or a new economic theory. *La part maudite* was published in 1949 and first translated into English in 1988. In this book, he theorized about the need for excess energy to be wasted in luxurious expenditures such as sexuality, spectacle, sacrifice, or warfare and used the Northwest Coast potlatch as an example.

The problem posed is that of the expenditure of the surplus. We need to give away, lose or destroy. But the gift would be senseless (and so we would never decide to give) if it did not take on the meaning of an acquisition. Hence *giving* must become *acquiring a power*. Gift-giving has the virtue of a surpassing of the subject who gives, but in exchange for the object given, the subject appropriates the surpassing: He regards his virtue, that which he had the capacity for, as an asset, as a *power* that he now possesses. He enriches himself with a contempt for riches, and what he proves to be miserly of is in fact his generosity.

But he would not be able by himself to acquire a power constituted by a relinquishment of power: If he destroyed the object in solitude, in silence, no sort of *power* would result from the act; there would not be anything for the subject but a separation from

power without any compensation. But if he destroys the object in front of another person or if he gives it away, the one who gives has actually acquired, in the other's eyes, the power of giving or destroying. He is now rich for having made use of wealth in the manner its essence would require: He is rich for having ostentatiously consumed what is wealth only if it is consumed. But the wealth that is actualized in the potlatch, *in consumption for others*, has no real existence except insofar as the other is changed by the consumption. In a sense, authentic consumption ought to be solitary, but then it would not have the completion that the action it has on the other confers on it. And this action that is brought to bear on others is precisely what constitutes the gift's power, which one acquires from the fact of *losing*. The exemplary virtue of the potlatch is given in this possibility for man to grasp what eludes him, to combine the limitless movements of the universe with the limit that belongs to him.

**23.VII.  Helen Codere. 1950. *Fighting with Property: A Study of Kwakiutl Potlatching and Warfare, 1792-1930.*** American Ethnological Society Monograph 18. New York: J.J. Augustin, 118-19.

Helen Codere (1917-2009) was born a Canadian but moved to the United States in 1919 and became a naturalized citizen in 1924. She obtained a PhD in cultural anthropology at Columbia University in 1950, studying under Ruth Benedict. Her monograph *Fighting with Property: A Study of Kwakiutl Potlatching and Warfare, 1792-1930* gained critical attention when it was published in 1950. She countered this influential work with the 1956 article "The Amiable Side of Kwakiutl Life: The Potlatch and Play Potlatch." Also of significance, she edited Franz Boas's field notes, published as *Kwakiutl Ethnography* in 1966. She was professor emeritus in the department of anthropology at Brandeis University at the time of her death.

"Fighting with property" instead of "with weapons," "wars of property" instead of "wars with blood," are Kwakiutl phrases expressing what has proved to be a fundamental historical change in Kwakiutl life occurring within the period known to history. It has been the purpose of this investigation to trace the various tendencies in Kwakiutl life as they were furthered or inhibited by the pressures of the contact culture and to determine both the binding force and the dynamics of this historical process. The general conclusion is that the binding force in Kwakiutl history was their limitless pursuit of a kind of social prestige which required continual proving to be established or maintained against rivals, and that the main shift in Kwakiutl history was from a time when success in warfare and head hunting was significant to the time when nothing counted but successful potlatching.

This conclusion about Kwakiutl history has emerged from the data and can be explained by them. That some of the Kwakiutl were aware of the historical change in their way of life gives additional confirmation as well as additional insight into the character of these peoples. Most of the Kwakiutl statements indicating this awareness were made within the period of the eighteen day winter dance ceremonial given at Fort Rupert in 1895. The statements themselves are very explicit:

> This song which we just sang was given by the wolves to Ya'xstaL ... when he received the death bringer with which he was to burn his enemies or to transform them into stone or ashes. We are of Ya'xstaL's blood. But instead of fighting our enemies with his death bringer, we fight with these blankets and other kinds of property.
>
> We are the Koskimo, who have never been vanquished by any tribe, neither in wars of blood nor in wars of property ... Of olden times the Kwakiutl ill treated my forefathers and fought them so that the blood ran over the ground. Now we fight with button blankets and other kinds of property, smiling at each other ...
>
> We used to fight with bows and arrows, with spears and guns. We robbed each other's blood. But now we fight with this here (pointing at the copper which he was holding in his hand), and if we have no coppers, we fight with canoes or blankets.
>
> True is your word ... When I was young I have seen streams of blood shed in war. But since that time the white man came and stopped up that stream of blood with wealth. Now we are fighting with our wealth.
>
> The time of fighting has passed. The fool dancer represents the warriors but we do not fight now with weapons: we fight with property.

**23.VIII. Wilson Duff, ed. 1959. *Histories, Territories and Laws of the Kitwancool.*** Anthropology in BC Memoir No. 4. Victoria: British Columbia Provincial Museum, 3, 11-12, 24, 37.

Wilson Duff (1925-76) was a Canadian archaeologist, cultural anthropologist, and museum curator. He obtained his master's degree in anthropology studying under Erna Gunther at the University of Washington in 1950. He was known for his work with the Tsimshian, Gitksan, and Haida. He was curator of anthropology at the British Columbia Provincial Museum in Victoria from 1950 to 1965 and then became a professor in the Department of Anthropology and Sociology at the University of British Columbia until his death in 1976. He was a founding member of the British Columbia Museum Association and was known more for his totem pole preservation work with Harry Hawthorn and Bill Reid in Haida Gwaii in the 1950s than for his 1958 work with assistant curator Michael Kew on the Kitwancool poles recovery project discussed below.

## PREFACE

In the spring of 1958 Wilson Duff and Michael Kew, representing the Provincial Museum and the British Columbia Totem Pole Preservation Committee, visited Kitwancool to negotiate the removal of a small number of totem-poles for permanent preservation. Discussions with representatives of the Kitwancool had been carried on in previous years, but up to that time no totem-pole had ever been removed from the village. The Kitwancool chiefs did not consider it proper, under any circumstances, to sell their totem-poles outright.

Accordingly, we made a new kind of offer: that for each old pole which we removed for preservation, a new and exact copy, carved in Victoria, would be returned and erected in the village. A meeting of the chiefs and people of Kitwancool accepted this proposal, but added one further condition: that their histories, territories, and laws were to be written down, published, and made available to the University for teaching purposes. Since that described precisely one of the functions the Museum is trying to perform, we were happy to agree.

...

## INTRODUCTION

No matter how others may choose to classify them, the Kitwancool think of themselves as an independent and completely autonomous tribe. In matters which affect the tribe as a whole they insist that nobody else has the right to speak for them. Some such feeling of tribal unity is characteristic of the social structure of all the Tsimshian, but the Kitwancool have cemented it still further in recent years by taking formal steps to unite the clans and by appointing a president.

This attitude of independence has been expressed most clearly with reference to "The Land Question." The Kitwancool insist they have never been a party to any agreement to relinquish any of their rights over their territories. They have never made a treaty, nor have they been conquered. They have never admitted that the Government has any right to set aside plots of land for them as Indian reserves. In their view, all of their former territories still rightfully belong to them.

Most of the materials in this book could be said to back up this claim in one way or another. First, the "histories" of the clans are themselves the traditional statements of rights to certain territories, which are accepted as valid by the other clans. The totem-poles stand as visible symbols of these histories (which were related whenever a pole was erected), and in a sense are considered as legal deeds to the territories concerned. Second, the account of the Tse-tsaut wars tells how the tribe acquired the territory around Meziadin Lake. Finally, the territorial claims and concepts of ownership are stated in explicit terms in later sections of the book.

...

### 3. HISTORY OF THE TOTEM-POLE HA-NE-LAL-GAG ("WHERE THE RAVEN SLEEPS WITH ITS YOUNG")

... The chiefs established themselves at Git-an-yow and raised their poles. The poles gave them their power or coat of arms and gave them the right of ownership of all the lands, mountains, lakes, and streams they had passed through or over and camped or built villages in. The power of these poles goes unto the lands they had discovered and taken as their own. The power from the house of this chief and his council goes as far as Getk-kse-dzozqu, the place of the seagull hunter, and includes Ks-gay-gai-net, the "upper fishing station." The power of the pole still goes on and belongs to Shen-dił. Belonging to him also, as a gift, is Wens-ga-łgul ("narrow place").

...

### 2. CHIEFTAINSHIP, RANK, AND POWER

One man is the head of the Wolf clan of the village, the wise man Gwass-łam. Wee-kha is the second man at the head of the clan. These two men come out of the house of Gwass-łam.

The second house of power is Fred Good's house, Mah-ley. In case of trouble, war, or famine, they send Mah-ley to the house of the two wise men to find out what is to be done, as they know how to handle it.

The chiefs are very particular about who wears their crests, ceremonial clothes, and masks, and each clan takes care of its own. If a clan made use of another's clothes, masks, and such things, it would always bring trouble.

When a clan raises a totem-pole and puts their rightful crests on the pole, it means a great deal to them, as every pole has a hunting-ground. They are very particular: a Wolf cannot hunt or trap on a Frog's ground nor can a Frog go on a Wolf's ground. To help put on this feast, the nephews go out to the territory and hunt. A chief who has many nephews and nieces is lucky. The rest of the clan also help. When the chief is going to his hunting-ground, he invites all his household to go with him, and also all the other households of the Wolf clan. They hunt only on the hunting-ground of their crest, until they have enough for the feast. The head of each household is the head hunter over that house.

When the chief of a clan dies, he is laid out awaiting burial. All his clan are there, as well as invited guests. They have a feast, called a feast to choose a new chief. They pick a young man whose life is clean and honest, a good provider, a man who is wise. This is done in the presence of the gathering at the big feast. All the chiefs agree that

he is the right man to choose as a reigning chief. He takes the place and receives the name of the dead chief.

**23.IX.** **Task Force on Museums and First Peoples. 1992.** *Turning the Page: Forging New Partnerships between Museums and First Peoples.* Edited by Tom Hill and Trudy Nicks. Ottawa: Assembly of First Nations and Canadian Museums Association, 8-9.

Native dissatisfaction with the exhibition *The Spirit Sings: Artistic Traditions of Canada's First Peoples*, which opened at the Glenbow Museum in Calgary in 1988, catalyzed the Assembly of First Nations and the Canadian Museums Association to come together in order "to develop an ethical framework and strategies for Aboriginal Nations to represent their history and culture in concert with cultural institutions." After two years of discussions between First Peoples and cultural agencies across Canada, editors Tom Hill (museum director emeritus of the Woodland Cultural Centre) and Trudy Nicks (senior curator in the World Cultures Department, Royal Ontario Museum) distilled the task force's recommendations in *Turning the Page: Forging New Partnerships between Museums and First Peoples*. This document, although not legally binding, established ethical guidelines for repatriation in Canada.

D. REPATRIATION

There was a consensus in favor of the return of human remains and illegally obtained objects, along with certain non-skeletal burial materials and other sacred objects to appropriate First Peoples. In addition, there was some agreement on the return to originating communities of a selection of other objects considered to be of special significance to cultural patrimony.

It was also agreed that First Peoples communities should be able to demonstrate direct prior cultural connection and ownership with regard to collections in question. There should be Aboriginal involvement in determining who is the appropriate person or group to receive any repatriated materials.

There is wide recognition that concepts of ownership vary, therefore, a case-by-case collaborative approach to resolving repatriation based on moral and ethical criteria is favoured rather than a strictly legalistic approach. The "Native American Graves Protection and Repatriation Act," recently passed in the United States, was studied by Task Force members. While not ruling out the possibility of the creation of legislation in the future it was agreed that it was preferable to encourage museums and Aboriginal peoples to work collaboratively to resolve issues concerning the management, care and custody of cultural objects. Proposed guidelines for such a collaborative process follow in the next section.

...

This report considers the disposition of Aboriginal cultural patrimony including human remains, burial objects, sacred and ceremonial objects and other cultural objects that have ongoing historical, traditional or cultural import to an Aboriginal community or culture. The Canadian Museum Association and the Assembly of First Nations should endorse and encourage the adoption of the following guidelines relating to the repatriation of Aboriginal cultural patrimony:

*A. HUMAN REMAINS ...*

*B. OBJECTS OF CULTURAL PATRIMONY*

The treatment, use, presentation and disposition of sacred and ceremonial objects and any other objects of cultural patrimony should be decided on moral and ethical grounds with the full involvement of the appropriate First Nations as equal partners. In the event of disputes between individuals, between an individual and the community or between communities, the onus should be on the First Peoples to resolve the dispute according to customary practice.

Recommended options for this process include the following:

i)   Restitution or Reversion. This includes the return to an originating culture or individuals of any objects that are judged by current legal standards to have been acquired illegally. This process involves the transfer or return of legal title to an originating culture or individual from the museum, based upon existing legal mechanisms for de-accessioning.

ii)  Transfer of Title. Even in cases where materials have been obtained legally, museums should consider supporting the requests by Aboriginal communities and community-based Aboriginal museums for the transfer of title of sacred and ceremonial objects and of other objects that have ongoing historical, traditional or cultural importance to an Aboriginal community or culture. This involves case-by-case negotiation with the appropriate communities based on moral and ethical factors above and beyond legal considerations.

iii) Loan of Materials. Museums should loan sacred and ceremonial objects for use by Aboriginal communities in traditional ceremonies and community festivities, based on mutual agreement on the use and time period in question as well as the risk to the physical object. Again, these decisions should be based on moral and ethical considerations both from the perspective of First Peoples and from that of museum conservation ethics (i.e., respect for the physical and historical integrity of the object).

iv)  Replication of Materials. Museums and First Peoples communities should consider the replication of materials slated either for repatriation or retention by the museum

for the use of the other party. Negotiations should be guided by moral and ethical considerations and the traditional knowledge and authority of the First Peoples involved, as well as the scientific knowledge of academically-trained museum personnel.

v) Shared Authority to Manage Cultural Property. In all cases museums are urged to share management of their collections by involving the appropriate First Peoples in assisting to define access to collections, to determine storage conditions and use of collections, and to recognize traditional authority or individual ownership systems of originating communities.

### C. REPATRIATION OF FOREIGN HOLDINGS

The CMA and the AFN are urged to promote repatriation of human remains and objects of cultural patrimony held outside the country, subject to the same criteria outlined above under 1 and 2, through lobbying efforts in association with national governments, UNESCO, the International Council of Museums and other professional organizations.

**23.X. Weavers' Circle. 1993. "Weavers' Statement, August 1993."** Reprinted in a press release from Nimpkish Wind Productions Inc., 2001, n.p.

A group of Indigenous weavers of Chilkat tradition formed the Weavers' Circle and in August 1993 in Hoonah, Alaska, made a strong statement on the need for Indigenous peoples to restore "our full property rights and jurisdiction." This statement was included as part of a written press release from Nimpkish Wind Productions Inc. on the opening of a film about contemporary Chilkat weavers called *Gwishalaayt: The Spirit Wraps around You* (2001), written and directed by Barbara Cranmer. The film concluded with "the Tlingit keepers of the Chilkat tradition ceremonially return[ing] the Chilkat weaving to the Tsimshian people, originators of the art form" (*First Nations Drum* 2001). This powerful and dignified statement was a claim for recognition of Indigenous property rights and ownership of traditional arts under traditional law.

From August 14-20, 1993 five indigenous weavers gathered at Hoonah Alaska to share knowledge, skills, and values of Chilkat and geometric weaving. The gathering was an exciting positive event tendered upon unity and sharing. Attending were Ann Smith, Tuchone/Tlingit from Whitehorse, Yukon; Donna Cranmer, Kwakwaka'wakw from Alert Bay, B.C.; Clarissa Hudson, Tlingit from Pagosa Springs, Colorado; and Ernestine Hanlon, Tlingit from Hoonah, Alaska.

We traditional indigenous weavers make the following statement; and set forth guiding principles to carry us forward in the restoration of our full property rights and jurisdiction.

We declare our indigenous rights and privileges according to traditional law. In recent times, many of our arts were laid aside because we were taught that our arts were valueless, evil, crude, and only belonged in the hands of museums and collectors as mementos of a dying culture. At one time our art defined and interpreted who we were as Nations, Clans, Families, and Individuals and set the boundaries for our jurisdiction over the land. Many incorrect assumptions have been made about ourselves and our art. Now, we indigenous weavers who have acquired the necessary knowledge and skills from our Elders are ready to help restore the traditional economic, social, and spiritual life of our communities under the guidance of Indigenous law and leadership. We pledge to uphold the wishes of our ancestors and living Elders to regain ownership of our traditional art forms and pledge to strengthen our roles as teacher, artist, and interpreter of our art forms through further gatherings and expanding the circle of weavers.

Respect, love and understanding must be observed and practiced for one another and our culture. Elders, leaders, artists, and our communities should support one another and provide a basis of unity and strength for future generations. Our art symbolizes our people's ties to their ancestral lands and signifies the right to exercise authority over those lands. Our art teaches respect for ourselves and others and helps guide our way thought [sic] the ceremonial and spiritual life of our Nations.

Through our knowledge we will pass on the signs and symbols of our people; and through them we will work towards breaking down the artificial barriers of colonial governments that have attempted to divide the Indigenous Nations and pre-empt traditional boundaries. The importance of traditional art as property to Indigenous people will not be underestimated.

We will educate our people on the traditional laws of ownership which govern certain items. The use of traditional art to enhance the artist's economic well being must be balanced with traditional use and ownership.

We shall encourage non-Indigenous artists who use our art forms to look to their own cultural backgrounds for strength and inspiration. Governments, schools, universities and museums that deal with our art must begin to recognize the inherent property rights of our people as they teach and interpret our art forms. This will lead to real sharing and understanding between all peoples.

This gathering which concentrated on sharing and unity has laid the foundation for future gatherings of artists, Elders and those wishing to learn the traditional arts. An invitation is made to all Indigenous artists who are concerned about the traditional arts and their survival to make contact and share their experience and knowledge.

The Indigenous weavers and teachers who gathered at Hoonah, Alaska feel that it is time for open, honest dialogue to begin. No longer must we let factors of time, distance and history separates us.

**23.XI. Nora Marks Dauenhauer. 1995. "Tlingit *At.oów*: Traditions and Concepts."** In *The Spirit Within: Northwest Coast Native Art from the John H. Hauberg Collection.* Edited by Steven C. Brown. New York: Rizzoli; Seattle: Seattle Art Museum, 21, 24, 25. Used with permission.

Nora Marks Dauenhauer (b. 1927) was raised in a Tlingit-speaking family, earned her BA in anthropology from Alaska Methodist University in 1976, and received an honorary doctorate of humanities from the University of Alaska Southeast in 2001. From 1983 to 1997, she worked as the principal researcher in language and cultural studies at the Sealaska Heritage Foundation in Juneau, but she is also a poet, freelance writer, and consultant. She is best known for her chronicling of Tlingit oral narrative with her husband and partner Richard Dauenhauer in the trilogy *Haa Shuka, Our Ancestors: Tlingit Oral Narratives* (1987); *Haa Tuwanáagu Yís, for Healing Our Spirit: Tlingit Oratory* (1990); and *Haa Kusteeyí, Our Culture: Tlingit Life Stories* (1994).

In the Tlingit tradition, visual art is displayed in action as part of a ritual process that confirms its mythic and spiritual context. Museum display in Western tradition is by nature more static and decontextualized, at best like a movie without a sound track.

Our people acquire works of art with this in mind: that our coming generations will benefit from them, that our grandchildren will have them when we are gone, and that they will use them the way we used them when we were alive. When grandparents pass away, a chosen individual or group is given the piece or collection of art that was in the stewardship of the grandparent. The steward's role is to take care of it, to keep it from going to another clan, and to prevent its being lost, traded, or sold.

The work of art, over time, achieves a status in Tlingit called *at.oów*. (The word is pronounced "utt-oow" and rhymes with "cut two.") It is a fundamental concept in Tlingit culture and basically means: "something that you own." The property can be real or symbolic or both. The object can be (among other things) a geographical place, a name, a story, a song, a spirit, an art design, or an art object.

...

Two main characteristics of Tlingit culture and oral tradition are ownership and reciprocity (properly called "balance"). Songs, stories, artistic designs, personal names, land, and other elements of Tlingit life are considered either tangible or intangible property of a particular clan. The use of *at.oów*, including the form, content, and immediate setting of oral tradition, operates in a larger context of reciprocity or balance. The form and content of verbal and visual art or iconography are congruent

with each other and with social structure. Stated simply, the patterns of visual art and oral literature follow and reinforce patterns of social structure.

...

### THE CONCEPT OF *AT.OÓW*

The word *at.oów* means, literally, "an owned or purchased thing or object." The concepts of thing or object on the one hand, and owned or purchased on the other, are equally important.

The "object" may be land (a mountain, a landmark, a historical site, a place) a heavenly body (the sun, a constellation, the Milky Way), a spirit, a personal name, an artistic design, or a range of other "things." It can be an image from oral literature, such as an episode from the Raven cycle on a tunic, hat, robe, or blanket; it can be a story or song about an event in the life of an ancestor. Ancestors introduced in *Haa Shuká* can themselves be *at.oów* – Kaasteen, Kaats', Duktootl', and others. These are the *léelk'w hás*, the grandparents of a clan. *At.oów* can also be spirits of various kinds: shaman spirits and spirits of animals.

Through purchase by an ancestor, a "thing" becomes owned by his or her descendents. The purchase and subsequent ownership may come through money, trade, or peacemaking; as collateral on an unpaid debt; or through personal action, usually involving loss of life.

Most often, and most seriously, purchase is through human life – giving one's life for the image. In Tlingit tradition, the law is that a person pays for a life he or she has taken. Payment may be with one's own life, with someone else's life as a substitute, or with something of great value. Hence, if an animal (or natural object or force) takes the life of a person, its image may be taken by relatives in payment, and the descendants then own this image.

---

**23.XII. gii-dahl-guud-sliiaay (Terri-Lynn Williams-Davidson). 1995. "Cultural Perpetuation: Repatriation of First Nations Cultural Heritage."** In *Material Culture in Flux: Law and Policy of Repatriation of Cultural Property.* Special issue of *UBC Law Review:* 184-86.

gii-dahl-guud-sliiaay, also known as Terri-Lynn Williams-Davidson (b. 1965), is a member of the Haida Nation from Skidegate, British Columbia. She practises in the area of Aboriginal-environmental law. Williams-Davidson represented the Haida Nation at all levels of court in litigation to protect the old-growth forests of Haida Gwaii (*Council of the Haida Nation and Guujaaw, et al. v. Ministry of Forests, et al.*), and she is currently their general counsel. She was the founding executive director of the charity EAGLE (Environmental-Aboriginal Guardianship through Law and Education). She is also an accomplished singer

and dancer and is an active member of the Rainbow Creek Dancers, who travel and perform locally and internationally.

In my view, repatriation can fill a cultural gap in many First Nations communities; a gap created by the removal of cultural heritage from First Nations. I will examine First Nations conceptions of cultural property to show the importance of cultural objects in current cultural perpetuation programs. Although there are different conceptions of cultural objects, I will draw upon examples from Haida Gwaii to provide a conceptual framework for my discussion of repatriation from a First Nations perspective ...

## A. FIRST NATIONS CONCEPTIONS OF CULTURAL PROPERTY

Given the wide cultural diversity among First Nations, it is difficult to give a single definition of cultural property from a First Nations perspective. Although various legislative definitions have been used from time to time, these do not accurately reflect the meaning that First Nations give to such objects. The problem with many existing legislative definitions of cultural property is that they reflect a Eurocentric dichotomy between animate and inanimate objects. This perspective indicates a belief that mankind controls both the possession of inanimate objects that do not possess life and the destiny of non-human objects that do possess life (such as the Earth and her natural "resources"). This perspective obviously excludes First Nations' conceptions of "inanimate objects and natural objects." Our conceptions recognize that cultural objects possess their own spirits and the creator of these objects is only a medium through which our ancestors speak. This fundamental belief is explained by Robert Davidson, a prominent Haida artist:

> The Haida word for mask is *niijanguu*, which means "to copy." So when I make a mask, it's actually copying an image or an idea from the spirit world. I believe that we're connected to the supernatural or spirit world through our minds. When I create a new mask or dance or image, I'm a medium to transmit those images from the spirit world ... Masks are images that shine through us from the spirit world.

Upon their creation (and conceivably prior to their physical creation), ceremonial cultural objects such as Northwest Coast masks, rattles, dance blankets and regalia possess an independent "life." The creation of these objects represents an unbroken connection to the spirit world – to the spirits of the past, present and the future. The use of these "objects" in ceremonies provides a definite conduit to the knowledge of the past and the future and is an integral part of the meaning and sacredness of cultural objects:

When I began to explore the artform, I didn't realize how closely it was connected to the culture and ceremony. You cannot separate the art from the ceremony. For me, first came the artform, second came song and dance, third came the integration of the artform with song and dance. The fourth I am just starting to understand, and that is ceremony: I feel that it is a very large and important part of being Haida.

In the First Nations worldview, cultural objects do not exist in a vacuum. Cultural objects are inextricably linked with ceremony ...

Cultural objects are of vital importance to First Nations in the preservation and perpetuation of our cultures. Cultural objects are our connection to the spirit world, to the knowledge of our ancestors and to the future. Cultural objects are gifts from the spirit world that cannot be owned by museums, other institutions or individuals. These gifts have been provided to us for the perpetuation of our ceremonies, identity and culture.

**23.XIII. Patrick Walker and Clarine Ostrove. 1995. "The Aboriginal Right to Cultural Property."** In *Material Culture in Flux: Law and Policy of Repatriation of Cultural Property.* Special issue of *UBC Law Review:* 14, 15-16.

Patrick Walker and Clarine Ostrove are both lawyers in the Vancouver law firm Mandell Pinder, specializing in Native law. The Saanich Native Heritage Society hired Walker and Ostrove to argue in court that a Saanich stone bowl named SDDLNEWHALA constituted cultural and intellectual property and should not be sold to a private collector in the United States. In the end, legal proceedings were unnecessary as the Simon Fraser University Museum of Archaeology agreed to purchase the bowl to hold in trust for the Saanich people, but Walker and Ostrove explained their legal arguments in a paper delivered at the conference Material Culture in Flux: Repatriation of Cultural Property, held at the University of British Columbia Faculty of Law in May 1994.

Control of cultural property is central to the struggle of decolonization, aboriginal self government and in some areas, First Nations cultural survival. Aboriginal peoples' attempts to regain control over cultural property are manifested in several ways including self-government initiatives; political lobbying for legislative reform; recognition in modern land claims agreements; negotiations with museums and private collectors; and the development of international standards regarding cultural and intellectual property.

The argument outlined below applies principles from developing aboriginal law jurisprudence to the particular facts of this case. It is based on the recognition of an

aboriginal right to the control of cultural property and on the principle that the federal government has a fiduciary obligation to ensure that legislation does not unjustifiably interfere with unextinguished aboriginal rights.

...

The Saanich people have been at the forefront in asserting their treaty rights and in asserting that their rights to control and protect Saanich cultural property are also treaty rights ...

The Saanich people assert the aboriginal right to control and protect their cultural property. On 21 July 1993 the Saanich Nation comprised of the Tsawout, Tsartlip, Tseycum and Pauquachin tribes, passed a resolution stating that they would "endeavour to stop all sales and exportation" of cultural artifacts. The resolution continues:

> As the Saanich Nation we are against having any commercial value on Archaeological findings, artifacts and human remains because it is putting a price on our heritage. We are the owners of our own Heritage and Artifacts and it is something that cannot be bought or sold.
>
> These are artifacts that have been acquired without permission of the original owners. These artifacts should be returned to the rightful owners and should not be sold to any Provincial, Federal or private interests.

The assertion of this right echoes the articulation of aboriginal cultural rights at the international human rights level at the United Nations' Working Group of Indigenous Populations (WGIP). In particular the assertion of the right is in line with the 1993 *Mataatua Declaration on Cultural and Intellectual Property Rights of Indigenous Peoples*, which endorsed the following declaration:

> We declare that Indigenous Peoples of the world have the right to self determination; and in exercising that right must be recognized as the exclusive owners of their cultural and intellectual property.

**23.XIV. Thérèse Rigaud. 2002.** *Translating Haida Poetry: An Interview with Robert Bringhurst.*
Vancouver: Douglas and McIntyre, 10-12. © 2002 by Robert Bringhurst, published by Douglas and McIntyre, an imprint of D&M Publishers Inc. Reprinted with permission from the publisher.

The pamphlet containing this recorded conversation between poet and linguist Robert Bringhurst (b. 1946) and Thérèse Rigaud was sold as part of the boxed set *Masterworks of Classical Haida Mythtellers*, edited and translated by Bringhurst. The three volumes in this set were the introductory volume *A Story as Sharp as a Knife: The Classical Haida Mythtellers and Their World* (1999); *Nine Visits to the Mythworld, by Ghandl of the Qayahl Llaanas* (2000); and *Being in Being: The*

*Collected Works of a Master Haida Mythteller, by Skaay of the Qquuna Qiighawaay* (2002). In this exchange, Rigaud focused attention on the heated criticisms that Bringhurst received from some Haida for translating and publishing Haida oral narrative without Haida permission, because they view these stories as Haida cultural property. Bringhurst had previously collaborated with Bill Reid on *The Raven Steals the Light* (1984) and wrote, with Ulli Steltzer, *The Black Canoe: Bill Reid and the Spirit of Haida Gwaii* (1991) about Reid's artwork. Bringhurst also edited Reid's *Solitary Raven: The Essential Writings of Bill Reid* (2000).

[TR]  There are some native people who feel that native literature belongs to them alone. Some Haida people have complained to the CBC and the Globe and Mail that you've translated Haida texts without permission or consultation.

[RB]  They're absolutely right. I've translated and interpreted Haida texts without asking anyone's permission, and at times without any consultation. If doing so is a crime, then with all due respect, I promise to reoffend as often as possible.

[TR]  But if you translate a work that's under copyright – if I translate your work into French, for instance – permission is needed, and royalties are paid.

[RB]  The Haida texts that I've translated were dictated in the fall of 1900 and the spring of 1901. Their authors died not many years after. If the normal rules of copyright apply in this case, then the works are now in the public domain. If those rules don't apply, which rules do? The traditional conventions of the Northwest Coast? Under those conventions, stories and songs could be owned in perpetuity, passed along from mother to daughter, father to son, or uncle to nephew – but only within the tribal domain.

A Pachena-Nitinaht headman by the name of Batliisqawa explained the system very clearly to Mary Haas and Morris Swadesh in 1931. He was talking about songs, but the principle applies to stories just as well. I'll read you what he said, as Haas recorded it in her notebook:

A man owns all the songs that he has made up. He can give away one of his own t'abaa [personal songs], but he can never give away the songs that he has inherited, because they belong to all the other descendants of the man from whom he has inherited them, as well as to himself. When a man dies, his songs belong to his children and grandchildren, nieces and nephews, grandnieces and grandnephews ...

Sometimes if someone from a distant tribe heard a Tlokwali song, then he might go home and use it in his own tribe as a dancing song or gambling song or in any way he wished. There is no trouble about this because it is too far

away. In this way the Pachena themselves use Hamatsa songs [learned from the Kwakiutl and allied tribes] as happy songs. Anybody can use foreign songs.

In other words, the traditional system here on the coast gives copyright protection that's potentially unlimited in *time* but circumscribed in *space*. In oral cultures, that principle works well. The European system gives protection that's unlimited in *space* but limited in *time*. That works fine in cultures based on writing. The purpose of both systems is the same: to protect stories and songs. But applying both systems at once gives you cultural gridlock. So what do we do when the two intersect? That question is unanswered, as far as I'm aware. Meantime, I'm proceeding in good faith, trying to honor the principles, the people and the work that I hold dear.

**23.XV. Andrea Laforet. 2004. "Narratives of the Treaty Table: Cultural Property and the Negotiation of Tradition."** In *Questions of Tradition.* Edited by Mark Salber Phillips and Gordon Schochet. Toronto: University of Toronto Press, 46-47. Reprinted with permission of the publisher.

Andrea Laforet (b. 1948) is the former director of ethnology and cultural studies at the Canadian Museum of Civilization. She has her PhD in anthropology from the University of British Columbia. She wrote *The Book of the Grand Hall*, published in 1992 by the Canadian Museum of Civilization, and co-authored with Annie York *Spuzzum: Fraser Canyon Histories, 1808-1939* in 1998. She is an expert in Nuu-chah-nulth basketry. She wrote of her experiences sitting at the cultural table as a representative of the federal government during the tripartite BC treaty process for the negotiation of the Nisga'a Treaty.

This divergence in views concerning the essential nature of specific objects also bears on concepts of property. While concepts of knowledge represent a huge pool lying under treaty negotiations, concepts of property constitute the pivot of decision making. For the museum, the physical object is at the heart of property, where the collection is concerned. The idea that an object, once purchased, becomes the property of the institution is fundamental to the museum's operation. On the north coast, the most important aspects of property are nonmaterial and lie in the rights to produce and use objects that represent historical event and privilege. The north coast and museum paradigms employ contrasting ideas of property to arrive at concepts of symbolic capital that have vastly different implications for the ideal biography of an object and its separability from particular persons. The concept of "inalienable wealth," as outlined by Weiner, is a factor here, but it is too simple and all-encompassing to illuminate fully the original, post contact, and current situations of these objects. Aboriginal and non-Aboriginal treaty negotiators come together to discuss collections that were

assembled through financial transactions, many of them part of a series of trans-actions occurring between Aboriginal vendors and collectors over many years. While the conversion of cultural objects to saleable material may be discussed at the treaty table as an unsought and unwanted consequence of colonization, the concept of com-modity may not be separated easily from the concept of cultural property. In the course of one of the many sets of negotiations in which the Canadian Museum of Civilization is now engaged, it was proposed to both the First Nation and the Museum that the entire body of museum objects originating with the First Nation no longer be considered as commodities. The First Nation and the Museum would each have title to a portion of the collection, but neither would sell the objects remaining in its care. Although both the First Nation and the Museum had concepts that could rough-ly be described as "inalienable wealth," and neither intended to sell the material, they did not consent, on the grounds, quite real in Canadian law, that ownership implies the right to transfer title.

**23.XVI. Naxaxalhts'I (Albert "Sonny" McHalsie). 2007. "We Have to Take Care of Everything that Belongs to Us."** In *Be of Good Mind: Essays on the Coast Salish.* Edited by Bruce G. Miller. Vancouver: UBC Press, 96-98.

Naxaxalhts'I, also known as Albert "Sonny" McHalsie (b. 1956), is currently the cultural advisor of the Stó:lō Research and Resource Management Centre, working on behalf of the Stó:lō Nation and Stó:lō Tribal Council. He has worked for the Stó:lō since 1985. He was a co-author of *I Am Stó:lō: Katherine Explores Her Heritage* (1997), and he sat on the editorial board of and was a contributor to *A Stó:lō-Coast Salish Historical Atlas* (K.T. Carlson 2001). He is a member of the Shxw'owhamel First Nation and continues to fish at his ancestral fishing ground at Aselaw in the Fraser Canyon just north of Yale, British Columbia. In this es-say, Naxaxalhts'I explained how his traditionally family-owned fishing site at Atselaw became marked as individually owned due to the historical legacy of Canadian fishing site registration and Euro-Canadian understanding of prop-erty. While not directly talking about material culture or art, Naxaxalhts'I's writ-ing shows how recognition of cultural ownership has changed through time due to foreign property language.

The ownership of fishing grounds brings about a whole lot of discussion. I talked to the elders about that. Fishing grounds are family owned, not individually owned. Just like an Indian name – it's owned by the family – the individual that has it doesn't own it. The family gives it to him and the family can take it away. So just like the fishing rock, I remember a controversy about my Auntie Rita having the spot where my

grandfather fished. And she said that my grand-uncle Oscar, who was my grand-father's brother, had given it to her mother, who was Oscar's first cousin. You know when I talked to the late Peter Dennis Peters about it, because he understands fishing-ground ownership as family ownership, he couldn't comprehend that and neither could I. He said, "How can someone give away something that belongs to the whole family?" He meant how could Oscar give something away that belongs to the whole family, not just to one person. He can't. Ownership of fishing grounds is through family.

But then you wonder, why do people look at ownership as individual then? What happened there? And then I started to understand, well, back in the late 1800s the Fisheries Act was created and all these different laws were made that didn't allow our people to sell fish any more. They said that only saltwater fish could be sold and that it is illegal to sell anything caught in fresh water. So they took away our economy and, not only that, they wanted to start regulating our fishing. So they imposed the fishing permits on our people. What's on the fishing permit? It doesn't talk about the extended family or family ownership. The Department of Fisheries and Oceans didn't take into consideration the fact that we had our own rules and our own regulations about who has access to fishing grounds and who fishes where. We have our own protocols and our own laws. Instead, they imposed a fishing permit that had an individual's name on it. And it said that individual could fish from such and such place to such and such place. So it's almost as though it is wide open: you can fish anywhere in there. Accord-ing to the government, you can fish anywhere in there. So right away they ignored our own laws and protocols of where to fish. It took the all-encompassing perspective of ownership of fishing grounds – our wide perspective of it – and narrowed it to an individual perspective. So that a lot of our fishers now, up in the canyon, look at their fishing spot as their own. I've heard some of them say, "It's mine and only mine." And, "No one else can fish here, not my brothers, not my sister, not my mom or my dad. This is *my* spot." I couldn't believe it when I heard one of the fishers say that. That's how some fishers think. So they have to change that again.

Not all fishers think like that. You can still go up there and see that wherever there's a dry rack, usually there's a family that owns it there. And the person that's kind of in charge of it, that's what the late Rosaleen George describes as a *Sia:teleq*. The *Sia:teleq* was the person who was appointed by the family to take care of the fishing ground and the access to it, so he was kind of like the co-ordinator of the ground. He wasn't the owner because no individual could own it. But based on his knowledge of the extended family, his knowledge of the various fishing methods, his knowledge of the capacity of the dry rack, his knowledge of the capacity of the camp, of the number of children that extended families had, of the numbers of fishing rocks that were access-ible according to varying levels of the river – with all that in mind, he was able to

co-ordinate. "I'll tell you who can fish now. You should be fishing these rocks now, and this is the number of sticks that you have. And because you have this many children you should be making sure you have this much fish put away." So he kind of co-ordinated all that. From Western society's perspective, somebody who witnessed this would probably assume that he was the owner. But not really, he wasn't really the owner. He was just the person who took care of the site. So looking at some of the contemporary dry rack sites, wherever there's a dry rack and a cabin, I'm quite certain if you talk to the family there, no one is going to claim individual ownership. I'm sure it's a family-owned site, and there may be one of the elders within that site who takes the role of *Sia:teleq*.

## 24 | Museums and Northwest Coast Art

Museums create knowledge about the objects on display by selectively presenting information they think is relevant and omitting that which they determine unnecessary. While at any one time the museum visitor might assume this interpretation represents the "truth" about the object, it is, in reality, only one element in its ongoing history. Every item in a museum exhibit is wrapped in many layers of meanings, interpretations, analyses, and representations that include its original meanings, the process of its acquisition, its exhibition and scholarly history, the type of galleries and museums in which it resides, the attitudes of contemporary First Nations people about it, its economic value, and the relationships visitors have (or do not have) with it. When the understandings of museum objects change radically, as they have over the past thirty years, their previous wrappings do not vanish but instead become enveloped by the new meanings, which resonate in varying ways with the earlier ones. Understood in this way, museum representations of Northwest Coast art remain always centred on the object itself but acknowledge the impermanence of any single perspective on that object.

Museums have been implicated in the study and analysis of Northwest Coast art for well over a century. Because the history of ethnographic museums and the history of anthropological thought parallel one another, any discussion of museums and Northwest Coast art, by necessity, must take into account the broader context of institutional and academic histories. At the turn of the twentieth century, Franz Boas supervised the collection of vast amounts of Northwest Coast material for the American Museum of Natural History. He encouraged George Hunt, his principal field collector, to acquire the oldest objects, along with whatever available stories could be obtained. Adhering to the salvage paradigm, museums tried to exhibit Native people as they had lived prior to Euroamerican contact. The end result was that museum's North Pacific Hall, considered today a classic example of early-twentieth-century ethnographic exhibits.

*[handwritten margin notes: A rattle beside a dinosaur bone is deeply problematic. Isolated from communities. Interpreted by non-Natives. No modern materials gives the illusion of a vanished race]*

That hall also represents a good example of what some First Nations critics find so objectionable about many museum representations of their cultures (see Laforet, this volume). The presence of cultural treasures in natural history museums, alongside dinosaurs and stuffed animals, is itself highly problematic. Objects removed from their communities – sometimes legitimately, sometimes not – are presented within glass vitrines isolated from their origins. Interpretations, written by anthropological "experts," objectify their culture according to non Native and, thus, potentially alien classification systems. And, by presenting First Nations cultures from the past and including nothing of the present, the implicit message is that those cultures have vanished or at least have become so removed from their pure unacculturated past that they have descended into inauthenticity.

For years, museum anthropologists held firmly to the notion that such exhibits were the appropriate and scientifically accurate means of presenting First Nations cultures to the public. But things began changing during the last several decades of the twentieth century, as relationships between Aboriginal peoples worldwide and those who have colonized their lands became realigned. Anthropologists began to scrutinize the essentialist, colonialist statements on class, race, and politics embedded within their supposedly value-free and objective representations. First Nations people began challenging the ways in which they have been represented in museums, objecting to the "museumification" of their cultures and insisting that museums convey the message "we are still here." In addition, they demanded a say in how exhibits represented their cultures. These joint forces from within Native communities and from the anthropological profession led to a profound transformation of museum representations.

This transformation occurred in several stages. Michael M. Ames, director of the University of British Columbia's Museum of Anthropology (MOA), was an early proponent of this paradigm shift. In the 1970s, Ames began urging museums to become more democratic and to welcome First Nations people into exhibit development. Under his leadership, the MOA became internationally recognized as a leader, providing models for consulting with Aboriginal people and involving them in the process of exhibit development. Ames's *Cannibal Tours and Glass Boxes: The Anthropology of Museums* (1992a), based in part on his earlier *Museums, the Public and Anthropology: A Study in the Anthropology of Anthropology* (1986), is a classic text [24.1]. In the excerpt printed here, first presented in 1983, Ames described different types of museums over time as well as the criticisms of museums by First Nations people. He asserted that, since in his opinion museums cannot present the "Native point of view" because there

are many such perspectives, they should stick to what they do best – namely, present information from an enlightened anthropological perspective modified by the participation of Native consultants.

Ames's suggestion to include First Nations consultants in exhibition development began to gain momentum in the 1980s. In 1988, the Smithsonian Institution, in association with the Rockefeller Foundation, held a conference that brought together individuals from all over the world who were engaged in the transformation of museums. In their introduction to the resulting publication, *Exhibiting Cultures: The Poetics and Politics of Museum Display* (1991), editors Ivan Karp and Steven Lavine identified three major changes museums needed to embrace: inviting communities to have a voice in their representations; promoting increased knowledge within mainstream museums of Indigenous cultures; and presenting multiple perspectives in their exhibits.

Museums with significant Northwest Coast collections responded in various ways to these changing values. Some, such as the MOA and the Royal British Columbia Museum (RBCM), already had a history of openness to Native involvement. In 1989, the Burke Museum at the University of Washington organized *A Time of Gathering*, a historic exhibit of Washington Native art, created in collaboration with a Native advisory team and a co-curator. Then, in 1991, the American Museum of Natural History, one of the largest and most prestigious institutions in the United States, brought a team of Kwakwaka'wakw to New York to work on a travelling exhibition, *Chiefly Feasts: The Enduring Kwakiutl Potlatch* [24.11]. That the paradigm shift had not fully taken hold is evident in the fact that *Objects of Myth and Memory*, an exhibition presented at the same time as *Chiefly Feasts* at the Brooklyn Museum, was created with no Native advisors at all.

In 1994, as part of the Commonwealth Games Arts and Cultural Festival held in British Columbia, the University of Victoria and the Commonwealth Association of Museums co-sponsored a symposium, Curatorship: Indigenous Perspectives in Post-Colonial Societies. Unlike the Smithsonian conference, which had very few Native representatives, approximately one-third of the participants here were Indigenous people, who added a strident tone to some of the discourse, a tone arising from deeply held resentments and generations of oppression. Speakers challenged museums to do more to promote Aboriginal involvement in museums, to "cease patronizing indigenous or aboriginal groups by ... speaking [for] them or fighting [their] battles," and to "deconstruct ... the colonial perceptions of museums" (Commonwealth Association of Museums and University of Victoria 1996, vii-viii).

*[handwritten margin note: Many nations built their own museums to control that representation]*

In order to fully control their museum representations, many First Nations communities have established their own museums. In her study of the Native-owned and -operated Makah Cultural and Research Center, Patricia Pierce Erikson (2004) analyzed the application of autoethnography to ensure the primacy of Aboriginal history, culture, and values in First Nations museums [24.III] (and see Nicolson, this volume). Throughout the Northwest Coast, other Native-run institutions shared their cultures in varieties of ways, including the Kwagiulth Museum in Cape Mudge and the U'mista Cultural Centre in Alert Bay, British Columbia; the Suquamish Museum in Suquamish, Washington; and the 'Ksan Historical Village and Museum in Hazelton, British Columbia.

In "Four Northwest Coast Museums: Travel Reflections" (1997a; first published 1991), James Clifford addressed the difference between such tribal museums and mainstream institutions by comparing an art-oriented museum (MOA) and an anthropological museum (RBCM) to two Kwakwaka'wakw museums (U'Mista Cultural Centre and Kwagiulth Museum) [19.XII]. While all have similarities, each institution has its own method of selecting objects for exhibit, interpreting them, and challenging the colonialist history that brought these Northwest Coast items to those museums. That the "Native voice" is not at all unified is revealed by Barbara Saunders (1997a) in her analysis of the differing concepts of ethnic identity expressed in the U'mista Cultural Centre and the Kwagiulth Museum.

By the first decade of the twenty-first century, the inclusion of Native voices had become de rigueur for any exhibit of Native art. *HuupuK"anum · Tupaat – Out of the Mist: Treasures of the Nuu-Chah-Nulth Chiefs*, a historic exhibit at the RBCM in 1999, involved numerous individuals from various communities. Co-curators from up and down the coast participated in *Listening to Our Ancestors: The Art of Native Life along the North Pacific Coast*, which opened at the National Museum of the American Indian in 2006. That year the Vancouver Art Gallery worked with various Haida individuals on *Raven Travelling: Two Centuries of Haida Art*. And in 2008, the Seattle Art Museum, along with a good number of Salish scholars, culture bearers, and artists, produced *S'abadeb. The Gifts: Pacific Coast Salish Art and Artists*. First Nations involvement in their own representations occasionally results in surprises, such as the empty plinths in *S'abadeb* that pointedly did not carry those artworks judged to be too personal or sensitive to be publicly displayed. Here the Salish exploited the ordinary exhibition stand, which in every other museum bears an artwork, to communicate a profound Indigenous cultural message (see Townsend-Gault, Chapter 30, this volume).

Basing exhibit development on collaboration was but one of the changes museums have undergone in recent decades. Repatriation is another. The most

historic repatriation of all on the Northwest Coast was the return of the items appropriated in 1922 by Indian Agent William Halliday, who gave a group of potlatch attendees the choice of giving up their regalia or going to jail. Many chose the former. After the decriminalization of the potlatch in 1951, various Kwakwa̱ka'wakw began petitioning the National Museum of Man (now the Canadian Museum of Civilization) to have those objects returned. They ultimately succeeded when the Kwagiulth Museum and the U'mista Cultural Centre opened in 1979 and 1980, respectively, to exhibit the returned regalia. Since then, additional items from the potlatch collection have been returned to British Columbia from the Royal Ontario Museum and the National Museum of the American Indian.

Among the strongest indications of how profoundly museum polices toward First Nations have changed, as well as the increasing political power of Indigenous people, are the repatriation policies established in both Canada and the United States. In the United States, Congress passed the Native American Grave Protection and Repatriation Act in 1990, which stipulated the conditions under which objects of special cultural or religious significance, as well as human remains and grave goods, were to be returned to their originating communities. The Canadian Task Force on Museums and First Peoples worked together to formulate *Turning the Page: Forging New Partnerships between Museums and First People* (1992), an agreement that recommended closer relationships as well as repatriation policies. Repatriation as a statement of empowerment was forcefully expressed in the Nisga'a 1999 land-claims agreement, which required the return of selected items from both the Canadian Museum of Civilization and the RBCM.

Art and anthropological museums exhibit First Nations art differently. For many years, natural history museums displayed Northwest Coast objects as ethnographic specimens, interpreting their meaning and function from an anthropological perspective. In 1943, Claude Lévi-Strauss visited the American Museum of Natural History and speculated that soon these visually stunning collections could be exhibited in a fine-arts museum. Aboriginal art did begin to appear in various art museums in both Canada and the United States, sometimes in temporary exhibits, sometimes in permanent installations. Changing the designation of a Native object from "ethnographic specimen" to "fine art" elevated its status for some, such as Delores Churchill (2002), who urged galleries to present Native basketry not as ethnology but as fine art [24.IV].

In 2000, the Art Gallery of Ontario and the Vancouver Art Gallery sponsored two interconnected workshops that addressed exhibiting First Nations creations as fine art. Some participants evaluated the acceptance of Native works into art galleries positively, but others insisted that classifying First Nations' works as

"art" imposed inappropriate Western terminology upon Native heritage. Jolene Rickard (2002, 115) presented a nuanced critique in her assertion that "the inclusion of First Nations work in public art museums in Canada represents simultaneously a colonizing act and a decolonizing act."

It is good that previously marginalized people have entered the hallowed halls of art galleries, thus elevating their creations to the higher plane of "fine art." But since those people still do not have economic and political equality, any inclusion of their culture in mainstream institutions obscures their ongoing subordinate position to the dominant society.

*[margin handwriting: Their art may be equal, but they aren't + this elevation can obscure the fact]*

The separation between art and artifact is no longer as rigid as it was in the past, for some art museums contextualize objects, and some natural history or anthropology museums focus on the artistry of pieces. Some museums use both approaches in the same exhibit. Almost twenty years ago, Janet Catherine Berlo and Ruth B. Phillips (1995) reviewed the ethnographically oriented *Chiefly Feasts* and the art-focused *Objects of Myth and Memory*, observing that neither had been able to break out of their respective museological traditions to present works in a genuinely new fashion, despite the volumes critiquing museum representations of Aboriginal people. In many cases, this is still true today.

However, in 2011, two exhibits were installed that represented new ways of exhibiting Northwest Coast objects. *The Power of Giving: Gifts at the Saxon Rulers' Court and the Kwakwaka'wakw Big House* came about as the result of a partnership between the U'mista Cultural Centre and the Dresden State Art Collection in Germany. The small Native-run cultural centre and the large European art museum exchanged objects from their collections to create two interrelated exhibits about the cultural significance of gift giving. Visitors to the Dresden museum viewed Kwakwaka'wakw potlatch masks and regalia, and those in Alert Bay saw the gilded gifts received by the Saxon court during the Baroque era. As Clifford (1997b) has noted, culture can no longer be firmly bonded to a specific time and place, and in order for one group to more meaningfully understand another is to acknowledge that culture travels. William Wasden Jr.'s (2011) comments about the exhibit in the catalogue expressed the value of such "traveling cultures" [24.v].

Mary Louise Pratt's (1992) concept of the "contact zone" as the site for intercultural exchanges and understandings informed the other innovative exhibit of 2011, *Objects of Exchange: Social and Material Transformation on the Late Nineteenth-Century Northwest Coast*. Curator Aaron Glass (2011) [24.vi] selected pieces from the American Museum of Natural History's Northwest Coast collection for display at the Bard Graduate Center in New York City. Instead of focusing solely on the significance of objects within their cultures or their

aesthetic qualities, Glass selected works that demonstrated the effects of the colonial encounter between Native and non-Native individuals. Including the intercultural dimensions of the objects greatly enhanced visitors' understanding of Northwest Coast artworks by recounting their history more completely.

Museum presentations of Northwest Coast art have followed intellectual trends over the decades. When Aboriginal cultures were considered part of "nature," they appeared in natural history museums. When the same cultures became more valued by the dominant society, they began to be on display in art museums. When First Nations people gained political and social power, they became involved in exhibit development and founded their own museums. And today, as the forces of globalization alter the ways in which we think about our relationships with the rest of the world, museums are beginning to develop new ways to express the intercultural forces that created, and continue to create, the art of the Northwest Coast. It will be most interesting to learn what future wrappings will envelop these stunning objects, both old and new, that appear in various institutions, large to small, urban to community focused, and local to international.

**24.I. Michael M. Ames. 1992. "How Anthropologists Stereotype Other People."** In *Cannibal Tours and Glass Boxes: The Anthropology of Museums.* Vancouver: UBC Press, 49, 50, 51-52, 53-54, 55-56, 57-58. (An earlier version of this chapter was presented as a paper at the Royal Society of Canada in 1983.)

Anthropologist Michael M. Ames (1933-2006) was director of the University of British Columbia's Museum of Anthropology from 1974 to 1997 and oversaw many changes in how ethnographic museums represented First Nations cultures. In this excerpt, he reviewed the several different methods by which museums have created knowledge about Aboriginal cultures, including interpretations by First Nations themselves.

> I want to consider the ways in which anthropology, particularly through its museums, structures the ways we think about other cultures. As one of the social sciences, anthropology attempts to produce "objective knowledge" about the world, particularly the world of other cultures. Presumably these objective productions are represented in the exhibitions presented by anthropology museums. When we examine the history of museum exhibitry, however, we discover changes in philosophy and style. What museums once thought was the objective truth subsequently becomes no longer fashionable. Museum exhibitions thus appear to reflect, or to exhibit, the changing images of other cultures that anthropologists have produced during their work. Even though

anthropologist may be engaged in scientific research, they nevertheless also actively help to construct the phenomena they study.

I describe four ways ethnographic collections have been displayed in museums, from the early curiosity cabinets to the most modern exhibitions in major American museums, to illustrate how each approach, both subtly and explicitly, characterizes in a particular manner the arts and crafts of Third World peoples and ethnic minorities, the traditional subjects of anthropology museums. Each exhibit philosophy is derived from a different set of assumptions about what constitutes the proper study of the works of humankind, and each has played an important role in determining how museums present anthropological information through museum exhibitions. These four perspectives may be represented by different museums, by stages in the evolution of a particular museum, or by the separate components of a single large museum.

...

## CABINETS OF CURIOSITIES

The first perspective I want to discuss is usually associated with the foundation of museums and therefore actually precedes the development of professional anthropological perspectives.

Several hundred years ago and more the material properties of tribal peoples were classed with strange flora and fauna, as objects of wonder and delight, to be collected as trophies, souvenirs, or amusing curiosities during one's travels to far and distant lands.

...

## EARLY ANTHROPOLOGY MUSEUMS AND THE NATURAL HISTORY APPROACH

"Cabinets of curiosities" were gradually transformed into organized museums as museum staff professionalized themselves and their conditions of work. By the latter part of the nineteenth century, while anthropology was emerging as a distinctive discipline in the universities, anthropological museums began to take shape as well. Both the profession of anthropology and anthropological museums were outgrowths of the nineteenth-century expansion of Western imperialism and rationalism. A typical objective of early anthropological displays was, therefore, to present artefacts from "primitive societies" as if they were specimens akin to those of natural history. Following the tradition of the cabinets of curiosities, primitive peoples were considered to be parts of nature like the flora and fauna, and therefore their arts and crafts were to be classified and presented according to similarity of form, evolutionary stage of development, or geographical origin ...

## MODERN ANTHROPOLOGY AND CONTEXTUALISM

The modern anthropological approach to museums developed out of this background associated with natural history, and, at least in North America, it owes much to a German immigrant and founder of professional anthropology in the New World, Franz Boas. Boas's first serious involvement with museum work occurred when he supervised the arrangement of ethnological collections for the Chicago Exposition in 1893, collections which subsequently formed the nucleus of the Chicago Field Museum. He next went to the American Museum of Natural History in New York City, where he installed displays in the galleries. Through these installations Boas popularized a different form of anthropological display, exhibiting artefacts in fabricated settings that simulated the original cultural contexts from which they came, rather than as natural history specimens representing some typology or evolutionary sequence. Artefacts should be grouped together to illustrate a way of life, he said, and that way of life – the context – would give the artefacts their meaning ...

## FORMALIST PERSPECTIVE: ETHNOGRAPHIC SPECIMENS AS FINE ART

A fourth way of looking at objects is also attributed to Boas's inspiration, though ironically it seriously challenges the contextualist view he promoted and takes us back to the principle of curiosity. This fourth point of view, which we may call the aesthetic or formalist perspective, looks at the material culture of primitive societies for examples of fine art; form becomes more important than content.

...

Some formalists reject the contextualist approach on the grounds that it is no less an arbitrary arrangement than the old curiosity cabinet, because the simulated context of the exhibition represents the mental reconstruction of the anthropologist further elaborated by the technical artistry of the exhibit designer. Such exhibitions, the formalists suggest, may tell us as much about our own exhibit technology and fashionable theories as they do about the cultures contextualized therein.

The contextualists, however, reject the formalist perspective as being completely inappropriate for a museum of anthropology. Taking specimens "out of context" – that is, displaying them as art objects – is considered immoral by many anthropologists. An eminent British anthropologist, for example, recently dismissed all museums with the damning phrase that they were merely "machines for de-contextualization."

Though the formalists and contextualists hold opposing doctrines, they are usually willing to tolerate differences providing the formalists remain in art museums and the contextualists remain in their museums of anthropology and natural history. Only when boundaries are crossed do people get agitated or confused. If a museum of anthropology displays the material workings of a tribal society as fine art, then a

boundary is violated, categories become mixed, and people are likely to become disoriented and upset.

In summary, I described four different ways museums look at, think about, and present strange objects, and thus attempt as well to structure the way we look at and think about those objects. Museums may present objects as curiosities, as natural history specimens, as contextual elements, or as fine art. Though there are important differences among these approaches, and some are today more popular than others, they nevertheless share common features.

First, all four approaches are comparative. They attempt to place particular objects into wider contexts of intellectual discourse and analysis. However much distortion this comparison involves, it is also a necessary aid to generalization. Second, all four are imperfect. Though each may be fashionable in certain theoretical circles, each represents only a selection of a larger totality. Each is, therefore, chronically incomplete, and even in combination they do not represent the whole. Third, all are outsiders' views looking in at the past of another people. Even contextualists who claim they represent the native point of view are still outsiders who are attempting through their reconstructions to stimulate someone else's experience ... They represent the thinking of outsiders, and this brings us to the fifth perspective: the insider's point of view – "the point of view of the Native."

## THE INSIDER'S POINT OF VIEW

...

History from the "Indian point of view" is the fifth perspective, the added ingredient that is needed in order to think about Indian objects in museums. It is not a matter of either or, an insider versus an outsider monopoly on truth. Nor is it correct to believe that the reconstructed contextualist view of the modern anthropologist is an adequate portrayal of the insider view. Insiders reject that possibility out of hand. It is, rather, a question of how the insider and outsider perspectives might interact and build upon one another in the process of truth-seeking and understanding.

What is this insider perspective, the so-called "Indian point of view"? First, we must immediately recognize that there is no one insider perspective, no one orthodoxy. Views are continuing to evolve, to formulate and to reformulate, as times change and as generations of elders come and go. There are views of the past that may be only dimly remembered; moreover, most objects in museums belong to that dimly remembered past rather than to present generations. This is not unique to the Northwest Coast of North America; what we have here is simply an example which we may consider in order to think about objects in museums and to think about how museums try to structure the way we do that thinking. Second, we must admit that we cannot easily characterize the insider perspectives, because to do so would be to transform

them into our comparative and international languages, thereby reconstructing them like our fabricated exhibitions. Perhaps it is sufficient at this point to learn to listen to them.

...

I do not believe that the University of British Columbia Museum of Anthropology, for example, should attempt to present the "native point of view," which it could never do properly anyway, whether by reconstructed contextualist exhibits or by other means. It is more important for a museum to concentrate on what it can do best, which is to present its own point of view as a professional institution, recognizing the limitations that implies, and to work in partnership with the museums and cultural organizations of the "Native" or indigenous peoples. A museum is only one volume in an encyclopedia of culture that is always being written. No one museum can say it all, nor should it pretend that it can.

LOOKING AT OBJECTS

I have described in this chapter some of the more prominent conceptual schemes museum people use to think about objects and to give meaning to the specimens they display: objects are presented as artificial curiosities, as specimens of nature, as elements or building blocks in reconstructed contexts, as works of fine art, and as fragments of an insider's history.

The perspective one chooses is derived from broader assumptions one holds regarding the significance of the works of humankind and the nature of knowledge. Though a perspective may be presented as the "truth," its appropriateness is determined by a particular theoretical framework. It is not necessary to renounce one's own point of view or to accept the principle of relativism, however, in order to grant the possibility that the other views also make useful contributions to knowledge. It is not a question of there being an infinite number of views with which to contend, but a limited number that may, to a degree, complement one another – providing we are willing to recognize the limitations as well as the strengths of each view.

**24.II. Aldona Jonaitis. 1991. "Chiefly Feasts: The Creation of an Exhibition."** In *Chiefly Feasts: The Enduring Kwakiutl Potlatch*. Edited by Aldona Jonaitis. New York: American Museum of Natural History; Seattle: University of Washington Press, 27, 31, 37, 39.

Art historian Aldona Jonaitis (b. 1948) received her PhD in art history from Columbia University in 1976. An expert in Northwest Coast Native art, she has published several books, was vice-president for public programs at the American Museum of Natural History in the early 1990s, then served as director of the University of Alaska's Museum of the North in Fairbanks and professor of

anthropology at the University of Alaska Fairbanks, where she is now emeritus. In this excerpt, Jonaitis describes the theoretical issues that informed her work with the Kwakwa̲ka'wakw in developing the exhibition *Chiefly Feasts: The Enduring Kwakiutl Potlatch* at the American Museum of Natural History.

### AUTHENTICITY AND TRADITION

Current trends in anthropological research motivated me to reconsider a basic premise of the show ... The primacy of the pristine, the seeking after the unacculturated, was part of an ethnographic legacy established at the turn of the century. Concerned that the Native peoples were "disappearing" as influences from the dominant society destroyed much of the traditional culture, Boas and his generation tried both to salvage what remained, and also to reconstruct what had existed in the past. The publications informed by this paradigm ended up describing not so much what Franz Boas, George Hunt, and others actually observed among the Native peoples of British Columbia (and elsewhere), but instead represented reconstructed cultures as the authors believed they existed prior to white intrusion ... In our western society, so smitten by progress and conscious of history, a people stuck in being, incapable of becoming, is at best to be pitied, and at worst to be disdained. Moreover, this society was destined, we believed, to be modernized and acculturated, processes that by their very nature signified corruption and decay of the pure "primitive" culture.

...

Our own recent disenchantment with many of the fruits of progress and the abatement of our Eurocentrism has permitted ethnographers to realize that they can no longer describe their subjects as remote and timeless. Instead of contributing to the myth of a people without history, the ethnographer must acknowledge the relation between these people and the peoples with whom they share the world and interrelate ...

Within the last ten years, the emphasis of Native American scholarship has shifted from salvage ethnography, with its implication of ahistoricity and decline, to a recognition, and for many a celebration, of the persistence of Native cultures as they respond to outside influences. In the past, many Native arts that manifested clear signs of acculturation, such as the Haida argillite carvings made to sell to whites, or the red yarn sometimes substituted for shredded cedar bark in Kwakiutl rituals, would have been deemed inauthentic, not "really" Indian. We now realize that such romanticizing of the "genuine" Native person immune to historical forces, coupled with the refusal to accept as "Indian" cultural features that draw some elements from the dominant society, is tantamount to separating Native peoples from the common experience of all humanity, in effect, to dehumanizing them. Although there is no question that much

has been lost over the past century, some traditions have been retained and/or transformed in accommodations to the modern world, resulting in developments that are often novel and ingenious.

Today young Kwakiutl children in Alert Bay learn about their heritage by listening to their elders, by practicing songs and dances in the U'mista Cultural Centre, and from attending the potlatches that occur on a regular basis in their communities. Complementing these more traditional methods of educating young people are means appropriated from white society. The Kwakiutl have insisted that their culture become part of the school curriculum. They have also produced a series of Kwakwala workbooks written to educate children about their culture and language ... [They complement and supplement] the living education the children receive at potlatches. In a sense, the Kwakiutl have appropriated an artifact of the western educational system to help educate their children about a tradition central to their culture.

...

Native peoples today are objecting to the attempts by whites to impose alien notions of tradition and authenticity upon their cultures. At a conference sponsored by the Assembly of First Nations, National Indian Brotherhood, in Ottawa in November 1988, entitled "Preserving Our Heritage: A Working Conference for Museums and First People," Indian speakers urged museums not to "museumify" their culture. They want to be shown as they live today, as well as how they lived in the past. The notion that prior to white contact Indians were pure, and afterwards they became "less Indian" is not only untrue, it is unacceptable to Native peoples ...

It is clearly time to reassess what whites perceive as "traditional" Indian art. One of the pieces in this exhibit is an apron made of red cloth and a flour sack. Because it is made from materials acquired in trade with whites rather than the shredded cedar bark or skins of pre-contact times, one might negatively characterize this apron as acculturated. This would not have made sense to the Kwakiutl chief who wore this apron, because for him the garment, regardless of its materials, operated effectively in the Kwakiutl world as an indication of his rank and status. Nowadays much of the art that has been called acculturated and impure is being evaluated as an imaginative response of a people to the disruptive forces of contact with whites. And, as has been pointed out on many occasions, the nineteenth century flourishing of the potlatch which had a great deal to do with white contact, coupled with the trade goods acquired from whites, such as iron tools and commercial paints, were at the heart of what we characterize as "traditional Northwest Coast culture and art."

...

Virginia Dominguez has suggested that it was collectors and ethnographers (such as Franz Boas and George Hunt) who established "tradition" and "heritage" as models for the acquisition, the categorization, and the coherent representation to whites of

Native art; the Indians who made the carvings, pottery, textiles, and paintings certainly never concerned themselves with such issues ...

It was clear to me that I could not tell the story of the Kwakiutl artworks in the museum's storerooms as if they were artifacts frozen in time. Thus, this exhibition had to expand well beyond the art of feasting at the end of the nineteenth century to become a story of the ongoing vitality of the Kwakiutl people. We ended up displaying the potlatch of the 1890s and the potlatch of the 1990s. To tell this story, we needed to refer to all those who participated in the history of this ceremony. Although the Kwakiutl are of course central, whites play roles as well; these include missionaries and government officials who tried to deny the Kwakiutl the right to their ceremonies, agents who arrested potlatch participants and confiscated artworks, merchants whose goods enabled increasingly lavish potlatches to be hosted and more impressive art to be made, and, of course, the participant-observer cum collector George Hunt, and the sympathetic supporter of the potlatch, Franz Boas. As it turned out, by allowing the Kwakiutl their history, *Chiefly Feasts* tells a far richer, more complex, and, ultimately, a more optimistic story.

**24.III.  Patricia Pierce Erikson. 2004. "'Defining Ourselves through Baskets': Museum Auto-ethnography and the Makah Cultural and Research Center."** In *Coming to Shore: Northwest Coast Ethnology, Traditions, and Visions.* Edited by Marie Mauzé, Michael Harkin, and Sergei Kan. Lincoln: University of Nebraska Press, 339, 340, 346-47. By permission of the University of Nebraska Press, © 2004 by the Board of Regents of the University of Nebraska.

In this essay, anthropologist Patricia Pierce Erikson (b. 1962) described the importance of basketry for the Makah of the Olympic Peninsula in the context of an exhibit at the Makah Cultural and Research Center. She analyzed the exhibit from the perspective of Mary Louise Pratt's concept of autoethnography, in which those who have been marginalized and discriminated against create self-made portraits in the contact zone. Erikson worked closely with the Makah and wrote *Voices of a Thousand People: The Makah Cultural and Research Center* (Erikson, Ward, and Wachendorf 2002), a fascinating study of the museum in the Indigenous community.

Why are museums and cultural centers an important aspect of Native American communities today in the Northwest Coast and elsewhere? ... I share here some brief insights from a larger museum ethnography project to argue that the proliferation of institutions such as MCRC [Makah Cultural and Research Center] signals a sea change in Pacific Northwest Coast studies. In short, I would like to call attention to a process, the rise of museum autoethnography among Native American peoples. My review of an MCRC basketry exhibit – a Makah-curated exhibit narrating the place of basketry

in Makah life – intends to provoke scholars to consider the benefits of collaborative research projects based out of these institutions.

...

While driving through town [Neah Bay] with Janine Bowechop, MCRC director, I asked her why she felt the baskets were meaningful to the Makah community. She answered, "Other than whaling, we have defined ourselves through baskets for generations." Whaling has been a significant aspect of historic Makah identity. With the reintroduction of the whale-hunting ceremony, the national and international media have positioned contemporary Makah identity as a high-profile subject in international environmental affairs. Bowechop's statement about the importance of baskets provoked me to go back to the MCRC galleries to listen to and learn from its curatorial voice. I chose Bowechop's statement as the title for this essay to highlight not only the importance of baskets to contemporary Makah identify but the "defining ourselves" process that is facilitated by a relatively new type of tribal institution – the tribal museum and cultural center ...

...

Mary Louise Pratt has argued that those who have been marginalized and discriminated against rarely remain passive like bystanders at the edge of a playing field. Instead they select elements of the dominant culture and create self-made portraits to engage with, accommodate, and negotiate with the dominant culture. She calls these self-made portraits "autoethnography"; the space of colonial encounter and negotiation she calls the "contact zone." She writes that although the centers of knowledge making (museums, for example) tend to understand themselves as representing and determining the periphery, they blind themselves to the way the so-called periphery constructs the center.

... Of interest to Pacific Northwest Coast scholars is that the translation of indigenous autoethnography into museum institutions potentially enriches not only our methodologies but also our interpretive frameworks. For example, like other Native American communities embedded in a Euro-American society, the Makah people historically have had to engage, accommodate and negotiate with a *linear* model of cultural change, one that measures Native American cultural disintegration. This Western model has interpreted Native American communities and their art forms as either rapidly disintegrating or continuing to exist in a somewhat pristine form because of geographic and cultural isolation. Makah baskets – known as trinket baskets or trade baskets – are excellent examples of hybrid arts that embody processes of transculturation. What the curatorial voice of the [*In Honor of Our Weavers*] exhibit communicated to me was that neither the model of cultural disintegration nor the model of isolated cultural purity captures the complexity of Makah historical experience. This is not news to cultural theorists, but ethnographers, museum curators, and

movie producers still struggle to articulate the complexity of historic and contemporary Native American identity amid the received, dominant image of what a Native American is and looks like.

## CENTERS OF COLLABORATION: A TURNING POINT IN NORTHWEST COAST STUDIES

I was recently surprised to hear a prominent sociologist say that anthropology was suffering from so much ethical angst that it had retreated from field work into the archives, especially in North America. What about the anthropologists who are in the field, some of whom are Native American themselves, and are forging new types of working relationships? Whatever the effect of postmodern, post-structuralist, and postcolonial critiques on the rate at which anthropologists are working with Native American communities, the need for substantive dialogue on the future of the anthropological enterprise appears considerable. One of the most pernicious obstacles to improving upon the classic model of field work is the differential in power relations between the anthropologist, ensconced in the academy, and those studied, who (at least prior to the civil rights movement and the "studying up" initiative) were perceived as temporally, geographically, and socially distant from academia.

Critical theory has forced anthropology into a general critique of "representational texts," including ethnographic manuscripts and museum exhibits. The main assertion was that these representations were not simply "records of fact" but rather subjective literary works whose perspective had a history. Museum theorists have argued that while literary criticism has enhanced our understanding of museum subjectivity, there are many ways in which museums are unlike texts. Despite these differences, museum autoethnography can be compared to literary and cinematic projects that assert "oppositional" or "returning" gazes to disrupt dominant ways of seeing. It is perhaps more accurate, however, to acknowledge that tribal museums and cultural centers are creating autoethnographies or representations of themselves while engaging with, struggling against, and accommodating dominant cultural systems.

It is no longer enough to say that museums are "agencies of social control" that reinforce dominant ways of seeing, remembering, and feeling. The dramatic proliferation and relative democratization of museums globally necessitates a more nuanced analysis of museums. Historically, museum ethnology endeavored to salvage "the other" from the "zone of discovery" and reconstruct the other in museum galleries to educate the public. Although the correlation between museums and dominant social sectors remains strong, theorizing of museums must account for the diverse cultural logics that have appropriated the museum model. As a cultural anthropologist who embraced the participant observation method and yet validated Native American

critiques of anthropology, I was impressed with how tribal museums and cultural centers disrupted the anthropologist-Native dichotomy and offered an alternative.

Native American critics in large numbers have bashed anthropology as a rarefied academic enterprise since Vine Deloria's *Custer Died for Your Sins*. Many scholars – Native American and non-Native – have argued that Deloria's critique stereotyped the practice of anthropology in Native American communities, jettisoning the nuance of the relationship.

Christopher Jocks, a Mohawk scholar of religion, has offered a brilliant alternative to the Deloria-style critique: a persuasive argument that scholars should closely consider Native American critiques of anthropology for their hermeneutic value. His article "Spirituality for Sale" offers a five-point model delineating how scholars can forge productive working relationships with Native Americans to provide clear, and comprehensive accounts of the relationship with Indian communities they study. Moreover, the issue of motivation – why they are involved in this work – ought to be considered as an integral part of its justification. Mere curiosity, or filling in lacunae in "the research record," should not be thought of as adequate reasons to probe into peoples' lives. Jocks clarifies for me why the rise of museum autoethnography marks a sea change in Pacific Northwest Coast studies. Who decides what are the "adequate reasons" for ethnographic study? This is where museum and cultural centers often insert themselves into the process of defining research projects.

Many, if not most, Native American tribes in the United States require that scholars formally approach the tribal council or other governing body for prior approval for their research. On the Makah Indian Reservation the Board of Trustees of the Makah Cultural and Research Center reviews requests to conduct research in the community. In my experience, the museum and cultural center had the authority (conferred by the tribal council and sustained through the approval of elders) to insist that anthropology make its research truly relevant and respectful to the community. MCRC staff trained me in their protocols for conducting oral history interviews in the community. Members of the tribal council and MCRC alike made clear to me that my critical audience was not simply a dissertation committee or a book editor; they insisted that they were colleagues, equal actors in Makah historiography who would insist that my work was done properly by their standards.

The Ozette excavation initiated long-term collaborative working relationships between the Makah Tribe and Washington State University, the University of Washington, the Royal British Columbia Museum, and the Thomas Burke Memorial Museum that were ahead of their time. Although this research approach is considered productive and ethical today, collaboration of this sort was still unique at that time. The new kind of collaboration spawned by Ozette reverberated through anthropology

and museology. Through training programs at the Burke Museum and at the Smithsonian Institution, Makah people shifted their position relative to museology from "outsiders" to "insiders" at the crucial time of the Ozette excavation and the planning stages of the Makah Cultural and Research Center. Consequently Makah individuals collaborated with other, non-Makah professionals to shape the subjectivity of MCRC – who it was for, what it communicated, how it did its business. The resulting, alternative notion of Native American community as constituency and audience had broad appeal.

Makah staff members brought their perspectives to a variety of museum training programs whose purpose has been (and remains) not only to provide technical training but to encourage reflection on the mission of cultural centers. Many of these workshops and educational materials are based out of the Smithsonian Institution and taught by Native American faculty. I expect that the increasing number of Native American individuals working as museum professionals, some of them in their own communities, will tangibly affect the nature of future research in Pacific Northwest Coast studies. Certainly collaboration between ethnographers and Northwest Coast Native peoples that generates valuable ethnographic materials is nothing new; George Hunt's collaboration with Franz Boas is one of the older and most famous of these. However, the degree of agency and control involved in tribal museums and cultural centers contrasts starkly with a 19th-century model of collaboration.

A frequent query to my testimony is whether or not Native American museum autoethnography interferes with academic freedom. I choose to re-frame the question. If we acknowledge the hermeneutical dimension of Native American critiques of academia, we can begin to hone a cross-cultural methodology. Collaborative research need not be the albatross to academic freedom; rather, it can challenge us to etch finer-grained, more accurate, and more reflexive ethnographies that respect the way notions of intellectual property rights vary cross-culturally. Native American museums and cultural centers offer Pacific Northwest Coast scholars potential community partners in cross-cultural research design and methodology. The hope is to forge new categories, new interpretive frameworks, and new theories that are relevant to the lives of contemporary people.

**24.IV. Delores Churchill. 2002. "Weaving Stories of Art."** In *On Aboriginal Representation in the Gallery*. Edited by Lynda Jessup and Shannon Bragg. Hull: Canadian Museum of Civilization, 217-20. © Canadian Museum of Civilization.

First Nations' carvings and paintings have largely been accepted into art galleries. However, there are other types of art still considered peripheral. Haida weaver Delores Churchill has challenged art galleries to recognize the value of

women's art and eliminate the hierarchical bias that says such items are "craft" and thus not worthy of installation in their institutions. Churchill, born in Masset, Haida Gwaii, is an internationally celebrated basket weaver and teacher. She was honoured in 2006 with a National Endowment for the Arts National Heritage Fellowship.

In *The Story of Art*, E.H. Gombrich states, "There really is no such thing as art, there are only artists." In the Haida language, there is no word for art, but an artist is called "gifted." Gombrich says very little about Aboriginal art in his books. He does note that "Sometimes they [Native people] even believe that certain animals are related to them in some fairy tale manner and that the whole tribe is a wolf tribe, a raven tribe or a frog tribe." He also writes, "We may see only a jumble of ugly masks, but to the native, this pole illustrated an old legend of his tribe." What of Darwin's theory that mankind evolved from monkeys?

In *Indian Basketry: Studies in a Textile Art without Machinery*, Otis Tufton Mason wrote, "What are the causes that have led to the rapid decadence of the art of basketry? There can be but one broad answer and that is the iconoclastic effect of our civilization upon a simple-hearted people. The Amerind [Mason's name for Indian people] is not far-sighted, his reasoning faculties are not as highly developed as ours." This was written in 1902, at a time when Aboriginal people in Canada were not permitted to go past the eighth grade and no more than four Aboriginal people were allowed in a government building at the same time. It is very difficult to overcome the perceptions that Euro-Americans have documented about Aboriginal art.

There has to be more communication, not just with museums but also with art galleries. As long as Native art remains in museums, it will be thought of in the past tense. Because of my work in basketry, I will try to address a few of many issues that pertain to this art. Yes, basketry is an art form. We will always have weavers who are artists and others who weave just for fun.

The large beautiful baskets of the past will never be replicated. I have known many gifted weavers. When I see a large Tlingit basket, I remember Jennie Thlinaut weaving so fast that her fingers flew across the warp with the weft strands. It was as wonderful as watching a ballet. She started weaving baskets as a small child. She learned Chilkat weaving as a young woman and was the last of the great Chilkat weavers. She was a full-blooded Tlingit. Ida Katashan is a Tlingit basket weaver. She is the last traditional basket weaver. She also learned as a child. To become a great weaver, you must start as a child, just as a great ballet dancer has to start as a child, unless you are as gifted a dancer as Agnes de Mille, who began to study as a teenager.

My mother, Selina Harris Adams Peratrovich, learned to weave from her mother-in-law. She was criticized for teaching basketry, not just by Haidas, but by other Native

people. In fact, when she was going to teach a class in Haida hat weaving at Ketchikan Community College, I cautioned her that she would make more enemies. She insisted that it was important for everyone who was interested to know how difficult it was to harvest and prepare the material and weave. She told me that a gallery owner told her that her prices were too high. She invited the owner to take a class – in fact, she said to that individual, "You might make your own to sell." After taking the class, the gallery owner said: "Selina, you don't charge enough."

There is little understanding of the work involved in producing spruce root basketry. There is an art to material preparation. To get enough spruce root for a small basket (6 cm × 6 cm in height) takes two hours collecting, two hours cooking in a very hot open fire, and then another sixteen hours of preparation before the basket is even started. The spruce root can only be collected where there are no rocks, stones, or other plants and vegetation. The roots must be growing in sand or glacial silt. They are best when collected in early spring. The weaver spends a lot of money to reach those areas. It is getting more difficult to collect basketry material due to regulations on private and public land.

Learning to split and prepare the roots takes many years of practice. The weaver is only as good as her material preparation. Selina made me burn my baskets for five years. She said: "I am well known for my baskets. If you say you learned from me, you better be good." In fact, when I was entering a show, she said: "Put my name on it. You aren't preparing your own material." Needless to say, I did not enter. And when the local community college asked me to teach an evening class, Selina told me that I had to learn material preparation before I could teach. She made me practice for two more years.

What is art and what is craft? Galleries need to learn more about basketry. A basket is an art piece – when the roots are uniform in size, the weaving and tension are uniform. That doesn't mean it has to be twenty warp ends to the inch. It takes longer to learn to split bigger weavers (or weft) and warp than to prepare fine weavers. All you have to do is run the fine root between your thumb and index finger applying pressure several times and it will split in half. The basket must have harmony, artistic form and balance.

Displaying Aboriginal art without the artist's name is a practice that has to stop. Can you imagine a Monet painting without his signature? This is not only the fault of the museum and gallery. I can remember being told by my grandmother not to put my name on my work at school. She said this was a sign of bragging and we had to stay humble. I had to write my mother's resumé without her knowledge. She was appalled to see her name by baskets that were commissioned from her by the Alaska program "Art in Public Places" for the ferry, HM *Taku*.

I watched a juror at a show compare a twined spruce root basket and a coiled grass basket. He held the spruce basket to the light. Of course, he could see a little light through the base. Spruce root shrinks when dry but that same basket will swell and be waterproof with just a sprinkle of a little water. The weavers that make waterproof spruce root baskets use double warp. Then they rub the inner fibres of the basket with a grizzly bear tooth. This rubbing spreads the fibres. The juror disqualified the spruce root basket. It was an exquisite basket with false embroidery design using maidenhair fern (the most difficult material to weave with). He gave the prize to the coiled grass basket. He couldn't see light through that basket. Grass doesn't shrink as much as spruce root. The design on the coiled grass basket was dyed with Kool-Aid.

I once managed a Native art store. Flora Mather, a Tsimshian master weaver, had her baskets in the shop. The customers would go right past Flora's beautiful baskets and buy baskets woven by another weaver. These baskets were lumpy and crude, but the customers called these baskets "primitive."

Native people have an aesthetic sense that transcends the actual object. For instance, the "Mother Basket" from Klukwan is a large basket woven by master weavers, average weavers and some beginners. It is a clan basket. It is thought to be so precious that it is only brought out on very special occasions.

There is a wonderful hat at the Field Museum in Chicago, Illinois. A curator said to me: "Isn't that awful?" I looked at this finely woven spruce root hat and I could picture this Tlingit weaver having a wonderful time replicating a straw hat she probably saw in a catalogue.

Baskets were also used for other purposes than utilitarian. My mother gave me a spruce root hat with two rings on top. She made me promise that I would give a dinner in Massett, the village of her birth, after her death. She also wanted me to have a tea party in Ketchikan, Alaska where she had many friends. I was to give her collection of bone china cups to all her friends. I could not use the spruce root hat until I fulfilled this promise.

Nathan Jackson, a Tlingit master carver, carved a hat for which he commissioned Selina to weave a spruce root ring representing Haida. Then he had me weave the Tlingit spruce root ring and the Tsimshian red cedar bark ring. This hat was presented by the Sealaska Heritage Foundation to Abraham Weisbrott, an attorney who helped win the land claim suit for the Haida, Tlingit and Tsimshian people in Southeast Alaska.

Primrose Adams asked Selina to teach her to weave Potlatch rings. Selina said her eyesight was no longer good enough – she recommended that I teach Primrose. In exchange for the lessons, Primrose wove a spruce root hat for me.

I felt very possessive over basketry until I attended a basketry conference in Toronto called "Basketry Focus." There were weavers from all over the world – Germany,

Japan, Korea, Peru were just a few of the countries represented. I think it is time to include some of these wonderful weavers in galleries, too. You would be surprised at the vitality and contemporary expression of artists such as Ankaret Dean, John McQueen, Jane Sauer, and Cass Schorsch.

I cannot be too harsh on E.H. Gombrich. I remember, as a child, the terror I had of totem poles. No one explained what they were, and the older people cried when they went to Van or Kiusta where the old poles were located. I didn't learn until I was older that many people died of small pox in those villages. It was not until I read Bill Holm's book *Northwest Coast Indian Art: An Analysis of Form* that I finally understood this art form and learned to appreciate it.

And poor old Otis Tufton Mason. I guess he and his contemporaries thought Native people would never learn to read. "As you gaze on the Indian basket maker at work," one of his colleague writes, "herself frequently unkempt, her garments the coarsest, her home and surroundings suggestive of anything, but beauty, you are amazed." My friend Gerri Kennedy came to my house one morning – I hadn't dressed, I was still in my pajamas, I hadn't combed my hair. She said; "Ha, that's when they took those pictures of those poor weavers in those old books."

An Aleutiq spruce root hat sold at a Sotheby's auction for over a hundred thousand dollars a few years ago. Maybe art galleries will finally wake up.

**24.V. William Wasden Jr. 2011. "Talks with the Artists and Pauline Alfred."** In *The Power of Giving: Gifts in the Kwakwa̱ka'wakw Big House from the Canadian Northwest Coast and at the Saxon Rulers' Court in Dresden.* Edited by Claus Deimel, Sarah Elizabeth Holland, and Jutta Ch. Von Bloh. Berlin: Deutscher Kunstverlag, 97. Courtesy William Wasden Jr.

In this interview, William Wasden Jr., a Kwakwa̱ka'wakw from Alert Bay who was involved with the exhibit exchange that brought objects from U'mista to Dresden, and gifts received by Saxon nobles from the Dresden State Art Collection to Alert Bay, described his positive reactions to this historic collaboration. Wasden is very knowledgeable about his nation's traditions, is an active participant in potlatches, and has served as a consultant on a variety of projects involving the Kwakwa̱ka'wakw.

*You heard about our project, exchanging exhibits from Dresden to U'mista, from U'mista to Dresden. What are you thinking about it?*
[Wasden:]  I'm thinking crazy, but I'm thinking, you know, it's like when I do anything outside of my own community, there's a big world out there where we have to be able to learn about it and to be able to function within it and to understand it. Because, whether we like it or not, even our community is moving and changing with

the times. So if there is opportunity for education then our people should go for it. And I think that we shouldn't be holding ourselves back because of fear or ignorance. And I think that this will be a really good opportunity for maybe our young people to see that there's more than just what happens in our little village, that there's a big world out there and there are opportunities out there, if you work hard enough and if you accept the fact that you want to do something about it. It interests me big time. I'm always cautious, always and I'm worried about how it will be perceived, and here as well I'm wondering what the people will think. But I think that's what our ancestors' biggest teachings to us was that when guests come to your villages, we welcome them with open arms. It's been that way since the beginning of time. And to be a good host, and to be gracious and to treat your guests with respect, and to honour them, that's a big teaching to us. That's the oldest custom we have. So if someone comes and wants to share something with us, then pretty much it's our traditions and our culture saying this is what you're supposed to do. To give of yourselves, that's where your respect comes from amongst our people.

**24.VI.  Aaron Glass. 2011. "Objects of Exchange: Material Culture, Colonial Encounter, Indigenous Modernity."** In *Objects of Exchange: Social and Material Transformation on the Late Nineteenth-Century Northwest Coast.* Edited by Aaron Glass. New York: Bard Graduate Center, 5-7, 28-30.

Anthropologist Aaron Glass curated *Objects of Exchange,* an exhibit of historic Northwest Coast artworks from the American Museum of Natural History, at the Bard Graduate Center gallery in New York. In this section from the catalogue, Glass applied theories of intercultural encounters and material culture to the selection and interpretation of objects in the exhibit, pointing to new directions for museum representations. Glass has worked for many years with the Kwakwa̲ka̲'wakw and is currently assistant professor at the Bard Graduate Center in New York City. He is co-author, with Aldona Jonaitis, of *The Totem Pole: An Intercultural History* (2010).

### DISPLAYING CONNECTIONS: TOWARDS A RELATIONAL EXHIBITION

Cannonballs and totem poles are two indelible examples of the diverse ways in which material culture was deeply implicated in the contacts and clashes on the North Pacific Coast of North America in the nineteenth century, from the early fur trade period through the later colonial era. In the intensifying contexts of commerce as well as conflict, we witness the role of objects – construed variously as art, artifact, commodity and souvenir – to mediate shifting intercultural relations of value and recognition, to express and enact mutual mimicry as well as ambivalence, adaptation, and appropriation. In this period, the First Nations of the region built on their earlier cultures

of display and local regimes of value, integrating these precedents into the respective forms emerging from the political economy of colonialism. Aside from the relatively few culturally significant objects that remained as family property on the coast, museum collections today provide the largest repositories of material evidence for the reconstruction of these historical relations, especially when supplemented by archival and published documents and indigenous oral histories.

For much of the past century, however, major Northwest Coast collections have been used to tell rather conservative anthropological and art-historical stories about the social and material coherence or national aesthetic styles of the cultures on the coast. Until recently, the primary goal of scholarship has typically been taxonomic – to classify and assign objects to one cultural (linguistic) group or another based on common stylistic attributions, symbolic content, utilitarian or ceremonial context, and location of manufacture, use or sale. With their stockpile of mid-to-late nineteenth-century objects, museum collections have become the benchmark for establishing and describing "traditional" or "classic" periods in material culture production. It is typically against these canonical prototypes that more recent objects are evaluated in order to determine stylistic or functional fidelity to previous forms, in part to claim degrees of authenticity and thus cultural and market value. All of this tends to presume and perpetuate a fairly static picture of nineteenth-century indigenous societies, even given established interest in so-called tourist arts. Moreover, although academic anthropology has now critiqued the "ethnographic present," in which texts are written in such a way as to dehistoricize the people and objects described, some permanent museum displays (including the famous Northwest Coast Hall at the American Museum of Natural History) maintain encompassing culture-area or aesthetic frameworks that generally rely on inert temporal and sociological generalization and on presumed cultural or geographical independence.

Yet the historical conditions and sociocultural realities of the main museum collection period on the North Pacific Coast (ca. 1870-1930) were characterized by dramatic circumstances of unrest and reconfiguration. Many of the intercultural dynamics that were initiated a century earlier, when Europeans first arrived on the coast, came to full fruition in the waning years of the nineteenth century. It was hardly the picture of static, traditional cultural life that early ethnographic or art-historical texts (and some extant object displays) make it out to be. The middle decades of the nineteenth century on the coast saw the upswing and then the decline of intertribal trade and warfare; the reconfiguration of commerce that accompanied the fur trades and gold rushes, including the increased capacity for wage labor and economic mobility; and the modernization of tools and technology, as well as the incorporation of new media and motifs, resulting in a florescence of art and material culture ... By century's end, indigenous life had been largely remade in the wake of devastating depopulation

caused by introduced diseases, along with resulting migrations and social realignments; the advent of settlers, missionaries, and tourists, each with different agendas for the land and attitudes toward indigenous peoples; the rise of Indian administration bureaucracies, and the creation of reserves (in Canada) and reservations (in the United States); government prohibition of the potlatch and other ceremonialism; and the introduction of assimilation policies such as residential and boarding schools. It was an era in which both people and things circulated widely, encountered new situations, entered into new social, political, and economic relations, adopted new qualities, and adapted to new circumstances.

Like other contexts of frontier encounter, the early colonial period on the Northwest Coast is perhaps best approached as a "middle ground" in which people met to exchange objects and ideas, a "contact zone" in which foreign cultures collided and colluded, a "grinding edge" along which intercultural friction caused both destructive tension and productive complicity. This was the world of great flux into which museum collectors and anthropologists ventured in order to salvage the purportedly vanishing traces of pre-contact aboriginal life; this is the world that is inscribed in the material culture of the period, but that is rarely placed in the foreground in ethnographic or aesthetic exhibition treatment. What is frequently lost in the standard taxonomic project is precisely the kind of boundary object epitomized by the Kwakwa̱ka̱'wakw-bartered cannonball or the transnational Haida totem pole: the mobile, the variegated, the hybrid, the apparently unclassifiable.

*Objects of Exchange* sets out to apply recent interdisciplinary theories of material culture and settler colonialism in order to tell more complicated and historically accurate stories about the capacity for objects to mediate intercultural encounters, to both express and help refigure social relations under highly variable conditions of power. Specifically, this exhibition and catalogue situate late nineteenth-century objects and images from the Northwest Coast within various relational contexts of both intertribal and intercultural production, circulation, and consumption. Such relational contexts and practices take diverse form: *transitions* in stylistic, social, or symbolic systems; *transactions* in highly mobile objects, persons, and materials, both between Native groups and between them and Euro-North Americans; and the physical or cultural *transformation* of things, actions, and beliefs over time and across space. The goal is to marshal historical, ethnographic, aesthetic, and theoretical perspectives to provide a more nuanced and comprehensive view onto the materials in museum collections and to explore the very materiality of objects themselves as a resource for understanding historical experience and adaptive indigenous cultural practice. What emerges is a view of Native cultural production and self-consciousness in the late nineteenth century that reflects the profound, if only then emergent, impact of modernity within the structures of colonial encounter.

In this essay, I lay out the specific thematic concepts that unite the objects in this exhibition and that animate our discussion of the period in question. Along the way, I will outline three contexts for approaching the objects as material evidence: relevant ethnographic features of visual and material culture along the coast; the dynamics of settler colonialism; and practices of museum collection at the time, with particular reference to the American Museum of Natural History (AMNH).

...

### THE FORCE OF TRADITION IN INDIGENOUS MODERNITIES

*Objects of Exchange* examines select aspects of the material culture of the late nineteenth-century Northwest Coast in order to illuminate a particularly dynamic, intercultural moment in North American colonial history. The experimental academic context for the exhibition itself also provides a space to think critically and reflexively about how and why we know what we do about these objects, and what materials are available in order to construct thick-enough descriptions of periods and places and peoples far from the New York City of 2011. Foremost perhaps, this exhibition contributes to challenging the popular assumption that the "traditional" or "classic" period of Native art and culture was in the past – that it is a temporal period at all – and that current cultural production must be evaluated against the stylistic or material tenants laid down in earlier generations. The closer one looks at the material record of this so-called classical era, the messier things look on the ground. On the one hand, this complicates our received curatorial and museological categories for organizing knowledge; on the other hand, however, it gives us a far richer and, I think, more accurate view into the historical reality of indigenous life at the time, and perhaps even today.

Rather than approach the late nineteenth century as the culmination of some purportedly traditional moment in First Nations life on the Northwest Coast, this exhibition suggests that the particular contexts of colonialism demanded the rapid, if sporadic and uneven, entry of Native people into the conditions of modernity – what Baudelaire glossed as "the transitory, the fugitive, the contingent." Modernity, in its common usage, refers to the increase in global flows of capital and people; the rise of industrialization and bureaucratic rationalization; the growth of the nation-state as a political formation and the concomitant redefinition of citizenship; a marked interest in forward-looking innovation, an overt renunciation of the recent past, and the (perhaps secularizing) reinterpretation of origin stories; a particularly nervous and contradictory dynamism characterized by both constant uncertainty and a certain self-consciousness based on faith in human intentionality and achievement. Although most societies, historically speaking, approach modernity slowly and in stages, indigenous people in settler colonies have had modernity thrust quickly and often violently upon

them. This may have been especially true in those places like the Northwest Coast where global capitalism and imperialism arrived quite late in the game. Within the course of about three or four decades, between 1850 and 1890, First Nations on the coast went from being sovereign societies to being subject to church and state: governed and surveilled by Indian administrators; employed (or not) by merchants and industrialists; ministered to and educated by clergy. At the same time, new tools of literacy and technologies of material production and representation refigured the possibilities of economic, political, and cultural existence, not to mention self-consciousness.

The modes of increased intercultural exchange and intensified cultural transition in this period – uniquely inflected for the various indigenous groups in the region – surely resulted in significant alterations to Native means of life and labor, habits of mind and body. Yet there were also certain cultural proclivities, as suggested above, that shaped the particular adoptions, adaptations, and accommodations made by different peoples at various times and under unique social and political configurations. The point is that within the larger contradictions of the modern condition, indigenous artists worked at specific intersections – of different cultural regimes of value and difference, identity and authenticity – some of which are materialized in the objects in this exhibition. If the means of cultural expression were in some ways strenuously constrained – by anti-potlatch laws, by missionary judgments, by military gunboats, by demographic reductions, and by land expropriations – in other ways new, and quintessentially modern, options for self-fashioning arose. Although aspects of colonial culture were certainly imposed upon Native people, they also demonstrated considerable agency in adopting Christianity, wage labor, the English language, and Western clothes, hygiene and burial practices. These options drew selectively and tactically on various moral and material cultures, and artists set out to strike a tenuous balance between constructions of self and other, between ceremonialism (with its stringent hereditary restrictions) and commerce (with its promotion of un-fettered circulation and exchange), between the various values attached to the past, present, and future.

As for others under conditions of modernity, an altogether new discursive and performative formation, something that might be objectified (in both academic and indigenous discourse) as "traditional culture," may have appeared at this time. It would have offered one option among others, including strategic accommodation or outright resistance, to be selectively drawn on as a resource for navigating the trials of the new colonial order. Under modernity, traditional culture – as the production and reproduction of the past, or rather of selective aspects of the past – loses its unconscious, habitual, taken-for-granted status and becomes instead a self-conscious, reflexive, and potentially politicized alternative to "progressive" assimilation. As

with intercultural photography, film, and dance performance in the late nineteenth century, non-Native interest in preservation (or salvage) of the "authentic" past via museum collections actually created a specific market in which Native people were encouraged to perform their own past and thus to maintain traditions through object production as well as other kinds of embodied aesthetic practices. While colonial fantasies of (and occasional nostalgia for) the "vanishing races" may have both presumed and actively promoted total assimilation, the fetishization of the traditional past by anthropologists and tourists simultaneously encouraged its maintenance, if not in ceremonial and spiritual practice then at least in certain forms of expressive culture. Moreover, these kinds of commercial opportunities were actually allowed and encouraged by the governmental and religious administrators – otherwise bent on cultural eradication – as a form of wage labor and a means of self-sufficiency, two hallmarks of the ideal, modern citizen-subject. For the authorities, carefully circumscribed, aestheticized, and commodifiable production of the past was accepted as one minor step toward modernization; for First Nations, such a gap in colonial policy (however contradictory) may have created a space (however marginal) for social and cultural reproduction under new conditions of material flexibility and artistic freedom.

Native people in North America a century ago were expected to be both traditional and modern simultaneously – to adapt to Euro-North American tastes, technologies, habits, and institutions, while at the same time remaining true to at least some of their cultural beliefs and practices, especially as expressed in aesthetic realms, even though such terms were held to be contradictory at the time. This is the fundamental colonial paradox for indigenous people in settler societies, the essential contradiction at the heart of indigenous modernities, even today. The rhetorical and political challenge, to which *Objects of Exchange* hopes to contribute, is to disentangle the semantics of such terms so that they are not in fact perceived as mutually exclusive, but rather as different valences for the evaluation of cultural production – at any historical moment – with distinctive reference to the past or to the present or to the future ... In this exhibition, in these few specific objects of exchange from the Northwest Coast, we may glimpse some material traces of the advent of this condition in the late nineteenth century, which still shapes the limits and laments, the ideals and aspirations, the art and the agency of the First Nations in the twenty-first.

# 25 | Collaborations

## *A Historical Perspective*

Collaboration refers to partnerships, teamwork, relationships, involvement, coalitions, liaisons, cooperation, and mutual support. Its root is the Latin word meaning "to labour," and *The Concise Oxford Dictionary* (1964) offers two definitions. The first is to work in combination with, especially at literary or artistic production; the second is to cooperate treacherously with the enemy. The root and dictionary meanings are revealing when considered in the context of museums and First Peoples working together to achieve mutual or complementary purposes, especially when one knows how this lengthy and complicated process has been portrayed in anthropological, art historical, and museological literatures. Tracking "the intricacies of moving the notion of collaboration from ... 'traitorous cooperation with the enemy,' to something experienced as 'united labour [and] cooperation'" is the theme of much of the voluminous recent literature on this subject (J. Harrison 2005a, 196).

The second dictionary definition – to cooperate treacherously with the enemy – underlies an increasingly formalized discourse based on the articulation of unequal power relationships and the assumption of problematic, often hostile, interactions between two homogeneous and contrasting cultures in the arenas of collections and exhibitions (e.g., Clifford 1997c; Gibbons 1997; Kreps 2003; Krouse 2006; M. Simpson 1996).[1] Typically originating in academia, this perspective seeks to illustrate postcolonial theories of power and is selective in portraying, or ignores altogether, the varied historical relationships between museums and First Nations individuals and institutions. For an overview of this viewpoint, see Kreps (2003, 1-11).

When late-twentieth-century theoretical positions are read backward into historical interactions, relationships between anthropologists and their "subjects" are typically seen as one-way cultural traffic. The active and shifting dialogues and exchanges between creators and collectors, documenters and interpreters, residents and transients, Caucasians and Aboriginals have become standardized through the postcolonial lens, and neither the artistic and literary nature of

*[handwritten margin notes: "Unequal power dynamic btn 2 monolithic groups that simply can't cooperate"; "But there are varied historical relationships"]*

ethnographic writing nor the process of making museum exhibits has generally been recognized. From this perspective, relationships between early anthropologists and collectors and the people who worked with them are manipulative encounters, not collaborations. Interactions between people of different cultures – engaged in the same project but with different methods and aims – have been presumed to be unequal power relationships enacted entirely through interrogation and response (see Martindale, this volume; Miller, this volume). But John Swanton and Charles Edenshaw; Franz Boas, George Hunt, and Dan Cranmer; Edward Sapir, Alex Thomas, and Tom Sa:ya:ch'apis'; Charles F. Newcombe and Charles Nowell; Marius Barbeau and Walter Beynon were working collaboratively on cultural documentation, and the cultural characterizations created in museums and universities were developed with First Nations researchers who took an active role in shaping how cultures were portrayed through objects, images, and texts. For example, George Hunt produced the significant texts that shaped perceptions of the Kwakwaka'wakw and, by extension, other ethnolinguistic groups of the Northwest Coast (Cannizzo 1983); Boas published them and made Hunt's information part of museum documentation. Together, anthropologists, collectors, and their so-called informants constructed museum representations.[2] Each had different, but not necessarily conflicting, agendas. This is not to say, however, that the expectations of First Nations and non-Aboriginal collaborators were equally realized or that the essentially consultative anthropological process was conveyed to and understood by its audiences. Translation is a fundamental and continuing issue in these endeavours: "What collaborative exhibits seek, in contrast to those they replace, are more accurate translations" (Phillips 2003, 166).

Yet, while the collaborative nature of historical anthropological work on the Northwest Coast is increasingly recognized,[3] ideas about working relationships between Northwest Coast First Nations and museums are increasingly codified (see Nicolson, this volume).[4] University anthropologists and others who once concentrated on fieldwork that involved working with Indigenous communities have increasingly turned to studies of museums as encrypted demonstrations of colonialism and cultural politics and, possibly, surrogate and politically safe ethnographic subjects (e.g., Dahl and Stade 2000; Jessup and Bagg 2002; A.L. Jones 1993; Krouse 2006; McCarthy 2007; McClellan 2007; Peers and Brown 2003; Pollock and Zemans 2007; Sherman 2008). As Jonathan Haas (1996, S7) observed, "museums themselves seem to have become as much objects of anthropological study as partners in the anthropological community. In the era of postmodernism, scholars seem to be writing about the anthropology of museums more than anthropology in museums."[5] At the same time, First Nations land

claims and assertions of sovereignty over cultural information and objects have escalated in Canada, focusing attention and commentary on museum collections (see Laforet, this volume).

The Task Force on Museums and First Peoples was formed because of lessons learned by museums and universities from the Lubicon Lake Cree's boycott of *The Spirit Sings: Artistic Traditions of Canada's First Peoples,* an exhibition at the Glenbow Museum during the Calgary Winter Olympics in 1988. The task force's report articulated the need for recognizing and including First Nations authority and decision-making processes in museums. Thomas H. Wilson (1992, 6) reported that

> new issues developed over the course of the [*Spirit Sings*] controversy. Questions of sponsorship, lending and the appropriate stances of anthropologists and museums to the boycott gave way to issues of representation and repatriation after The Spirit Sings opened. Issues include who has the right to represent the arts and cultures of First Peoples and to what extent native peoples should have a say in their own representation ... [as] living cultures ... presentation of sacred objects and repatriation of certain objects ... The Spirit Sings engendered a unique dialogue between museums and native peoples.

The task force, convened jointly by the Assembly of First Nations and the Canadian Museums Association, resulted in a conference in Ottawa, where "discussion focused on issues such as culturally sensitive storage of Native artifacts, repatriation and the role and ability of non-Native society in interpreting Native life, past and present" (J. Harrison 1992b), and in a published report (Task Force on Museums and First Peoples 1992), which has been extensively reported on and discussed ever since (see Jonaitis, this volume).[6]

The task force was unique, as Wilson observed, and it brought about evaluation and codification of institutional policies, but it was not the beginning of consultation processes and collaborations between First Nations and museums. Despite the habit of critical literature to portray cooperative projects, mutually beneficial agendas, and power-sharing processes as new ideas, collaborations have been going on for some time on the Pacific coast.[7] Alan L. Hoover and Richard Inglis (1990, 274) said twenty years ago that, "for most museums, granting Native Peoples a voice in exhibitions is not new; the RBCM [Royal BC Museum] has done it for decades." Although participants and methods have changed from individuals – often First Nations artists – acting as representatives of their cultural communities in museums to formal partnerships between

museums and First Nations institutions, and not all collaborative projects have been equally successful, collaborations between First Nations and museums have been going on for more than fifty years in British Columbia.

In 2006, a group of Nisga'a researchers from the Media Centre at Gingolx came to the RBCM to document a Nisga'a pole (RBCM 14838) that had been donated to the BC Provincial Museum by the City of Prince Rupert in 1963. The Nisga'a chief and carvers filmed the pole and recounted, in Nisga'a and English, its histories and meanings. The museum provided information about the various physical and interpretive modifications imposed on the pole during and after its removal from Gitlakdamix. From all of this material, the Media Centre made an animated film for its website. This short research project is typical of investigations happening at all museums with significant First Nations collections. They are collaborative in the sense that the museum researches and provides collection and archival records, and First Nations representatives bring oral histories, genealogies, and Indigenous geographic information.

The key aspect of the Gingolx Media Centre's research project at the RBCM was that ownership of the pole would transfer to the Nisga'a Lisims Government under the terms of the *Nisga'a Final Agreement*, signed in 2000. Although the pole was then still at the museum awaiting Nisga'a instructions for delivery, the status of the object had changed.[8] The Nisga'a Treaty resulted in a larger collaborative project. A permanent display, *Nisga'a: People of the Nass River*, opened as the concluding gallery in the *First Peoples* exhibition at the RBCM in 2002. Created in partnership with the Nisga'a Lisims Government, the exhibition expresses Nisga'a cultural values and what the treaty means to the Nisga'a people.

As the Task Force on Museums and First Peoples did, treaties formalize existing policy and practice. Unlike the task force recommendations, however, treaties are laws that structure and articulate a new kind of relationship. "A treaty is a form of contract among the Government of Canada, the Government of the relevant province or territory, and the First Nation ... Once ratified in Parliament, treaties can supersede other completing forms of legislation," Andrea Laforet (2006, 10) explained. She went on to note that "Section 18 of the *Nisga'a Final Agreement* provides for the application of Nisga'a *ayuuk* (traditional law and practice), as well as normal museological practice, to objects in the public domain." Treaty making is the contemporary context for collaborative projects between museums and First Nations and an engine for positive change in thinking and acting about cultural objects.[9]

The treaty negotiation process is not without issues and problems, and we do not know how it will progress, but the RBCM's mandate allows transfer of cul-

tural objects outside the treaty negotiation process as well, so the failure of formal treaty talks does not mean that artifacts cannot be returned in another way. This culture of repatriation is the context of political action that now surrounds all collaborative research and exhibit projects.

This chapter calls attention to significant steps in a history of working together in a museum environment, from individual to institutional collaborations with First Nations and from informal to formalized relationships. Examples come primarily from my own institution, the RBCM. They illustrate a development – from ethnographic fieldwork, the absence of consultation, interactions of individuals, institutional collaborations, to complex structured partnerships – and show different ways of understanding what collaboration means and how to do it. The steps in this development are sequential but not mutually exclusive because these relationships (except, it is hoped, lack of First Nations involvement, illustrated in 25.IV) may co-exist, depending on the project and partners involved. The examples chosen are part of the diverse tradition of interactions and partnerships that is shared by many museums and by many First Nations individuals and communities.

Space does not permit a review of the many significant exhibitions and other collaborative projects, both large and small, that have taken place in the past twenty years. The following list of notable examples illustrates the range of collaborative exhibitions in the past two decades.

- *A Time of Gathering: Native Heritage in Washington State.* Thomas Burke Memorial Washington State Museum and representatives of the First Nations of Washington State, 1991 (Wright 1991).
- *Chiefly Feasts: The Enduring Kwakiutl Potlatch.* American Museum of Natural History and U'mista Cultural Centre, 1991 (Berlo and Phillips 1992; Cranmer Webster 1992a; Jonaitis 1991, 1992; Ostrowitz 1999, 83-104).
- *Written in the Earth.* UBC Museum of Anthropology and Musqueam Indian Band, 1996 (Holm and Pokotylo 1997; M.M. Ames 1999).
- *From under the Delta: Wet Site Archaeology from the Fraser Valley.* UBC Museum of Anthropology and Musqueam Indian Band, 1996 (Holm and Pokotylo 1997; M.M. Ames 1999; Shelton 2007).
- *Reciprocal Research Network.* UBC Museum of Anthropology, Musqueam Indian Band, Stó:lō Nation/Tribal Council, and U'mista Cultural Society, started 2002 (Phillips 2005; Museum of Anthropology at the University of British Columbia 2006).
- *Raven Travelling: Two Centuries of Haida Art.* Vancouver Art Gallery and Haida Nation, 2006 (Augaitis 2006).

- *Listening to Our Ancestors: The Art of Native Life along the North Pacific Coast.* National Museum of the American Indian and guest curators from Coast Salish, Gitksan, Haida, Heiltsuk, Kwakwa̱ka'wakw, Makah, Nisga'a, Nuu-chah-nulth, Nuxalk, Tlingit, and Tsimshian Nations, 2006 (Griffin 2006; Joseph 2005).
- *'Nluut'iksa Łagigyedm Ts'msyeen: Treasures of the Tsimshian from the Dundas Collection.* Royal BC Museum, Museum of Northern BC, and Allied Tribes of Lax Kw'Alaams and Metlakatla, 2007 (Hughes, Marsden, and Bryant 2008; Milroy 2007).
- *Coast Salish Weaving* project. Canadian Museum of Civilization (now the Canadian Museum of History) and Squamish First Nation, started 2007 (George and Tepper 2008; Tepper, Chepximiya Siyam, and Skwesimltexw, forthcoming).
- *S'abadeb, the Gifts: Pacific Coast Salish Art and Artists.* Seattle Art Museum and advisors from US and Canadian Coast Salish nations, 2008 (Brotherton 2008).

These exhibitions involved many First Nations people and museum staff working within structured institutional processes, but the collaborations were none-theless based on personal interests and relationships, as all collaborations are. For example, three of the exhibitions – *Chiefly Feasts, Raven Travelling,* and *Listening to Our Ancestors* – were facilitated in part by Peter Macnair, who brought to the projects years of experience and personal connections.[10] The exhibitions listed above were produced by major institutions, but smaller regional museums are active in collaborations as well. The Museum of Northern British Columbia, the Museum at Campbell River, the Nanaimo District Museum, the Alberni Valley Museum, and the North Vancouver Museum and Archives are some smaller institutions that have traditions of cooperative interactions with First Nations.

At the time of writing, the Museum of Anthropology (MOA) at the University of British Columbia was reinventing itself as "A Partnership of Peoples," moving from what has been a very productive and successful series of small collaborations with First Nations artists, students, and First Nations (M.M. Ames 1990, 1994, 1999; Holm and Pokotylo 1997; Phillips 2005; Shelton 2007) to a more systematic collaboration with the communities from which its collections originated (Phillips 2005; Kramer 2007, 2008). Anthony A. Shelton, director of the MOA, reviewed his institution's history of working with First Nations and described the renewal in an article entitled "Questioning Locality: The UBC Museum of Anthropology and Its Hinterlands" (2007). Using as his starting point James Clifford's travelogue-like impressions of two tribal museums and

two mainstream museums in the province (1997a), Shelton (2007, 395, 402) considered British Columbia as "a politically charged locality" and asserted that the MOA's intentions and programs gave the museum "a unique local, provincial, national and international position" as both central and oppositional to that locale. Through institutional collaborations such as A Partnership of Peoples, though, this centre/periphery opposition (with the MOA at the centre) will cease to be relevant or will be reversed as First Nations communities once again become the centres of their worlds and contributing partners in museum projects that suit their contemporary agendas.

A predominant interest of the current academic focus on museums as subjects for cultural critique is public dissection of collaborative projects and their difficulties.[11] All collaborations that become exhibits or have other public manifestations are, by definition, successes in some way. If they were not, they would not have happened. But logistics of communication and failure to reach agreement about methods, personnel, content, programs, finances, copyrights, timelines, publicity, funding, and other realities of museum work may mean that projects do not go forward. Especially with the contemporary model of institution-to-institution partnerships, collaboration in the museum context is an extremely complex process, and some collaborations are more successful than others. For example, an exhibition under development for several years by the Tahltan First Nation, the Canadian Museum of Civilization, the MOA, and the RBCM ended because divergent concepts of the collaborative process and how it should work could not be harmonized. It was difficult to balance First Nations ownership and control of traditional knowledge and the Canadian Museum of Civilization's legal responsibilities to make research results public, for example (P. Brown 2003; see also Laforet 2006). A much smaller community exhibition, *Mehodihi: Well-Known Traditions of Tahltan People*, was developed for the MOA by curator Pam Brown, with Tahltan guest curator Tanya Bob and a Tahltan Exhibit Advisory Committee. Exhibit-related research by Judy Thompson, the Canadian Museum of Civilization's curator on the project, was published in her book on James Teit and the Canadian Museum of Civilization's Tahltan collection (2007). (For other collaborative projects that were not altogether successful in terms of their original conceptions but had positive outcomes nonetheless, see Fienup-Riordan 1999; Kahn 2000.)

Another theme in current analyses of museum projects and exhibits is the search for definition and codification of the collaborative process (see, e.g., Shelton 2008). Richard I. Inglis and Donald N. Abbott (1991, 22) defined collaborations in these terms:

*[handwritten margin note: Collaborative projects have difficulties based on cultural difficulties that prevent exhibits from being shown]*

There is not ... a set formula that can be applied to establishing successful relationships with First Peoples. There are guiding principles: to respect issues raised and those who raise them, to enter into dialogue in a forthright and honest manner, to allow time for mutual trust and respect to develop. It is easy to underestimate the complexity of community concerns. Seldom is there a single viewpoint or a single voice. Our experience with partnerships is that they are ongoing commitments.

Now there is an interest in defining a way of working that might discipline the complex, varied, and highly personal process of collaboration. Ruth B. Phillips (2003, 157) has argued for a dialogic model or models: "The collaborative paradigm of exhibition production involves a new form of power sharing in which museum and community partners co-manage a broad range of activities that lead to the final product."[12] In this enterprise, she wrote (echoing Inglis and Abbott's view of a decade earlier), "there is no one single model of collaboration in exhibit development, as the literature to date seems to imply" (158). Nevertheless, Phillips identified two distinct types of exhibits in the paradigm. One is epitomized by the First Peoples Hall at the Canadian Museum of Civilization, a permanent installation that includes Northwest Coast material and was developed with an advisory committee of First Nations people from across Canada. In the First Peoples Hall, Phillips (2006, 77) saw (or, perhaps more accurately, heard) a "multivocal" exhibit model because "the negotiation of different professional, intellectual, and cultural formations that took place within the CMC during the process of the exhibition development is made part of the exhibition in a self-consciously reflexive section entitled 'Ways of Knowing,' in which the explanatory force of archaeology, ethnology, and traditional indigenous knowledge are juxtaposed and their equivalent authorities asserted." In calling this a multivocal exhibition, Phillips drew on Aldona Jonaitis's discussion of the exhibition *Chiefly Feasts*, a significant collaborative project of the American Museum of Natural History and the U'mista Cultural Centre in 1991. For Jonaitis (1992, 257), *Chiefly Feasts* was an instance of "the contemporary embracing of multivocality in museum exhibitions [that] is a most positive legacy of the anthropological 'crisis of representation' being addressed currently." Phillips contrasted multivocal exhibits with community-based exhibits that are thought to favour a First Nations perspective. She gave *Káx̱ḻáya Ǧvíḻás, "the Ones Who Uphold the Laws of Our Ancestors,"* which the Royal Ontario Museum (ROM) produced in partnership with the Heiltsuk Tribal Council and the Heiltsuk Cultural Education Centre, as an example of the latter kind of exhibition (Phillips 2003, 157, 158, 164).

*Káxḷáya Ǧvíḷás* was under development for a long time. The impetus for it was my own research, begun in the 1980s and published as *Bella Bella: A Season of Heiltsuk Art* in 1997.[13] In 1992, I submitted an exhibition proposal to the ROM. In 1994, the proposal was brought to the Heiltsuk Tribal Council, which passed a band council resolution in support of the project. The tribal council designated Pam Brown as the Heiltsuk curator.[14] I was the co-curator. In 1998, a formal memorandum of understanding established "a partnership between the Royal Ontario Museum and the Heiltsuk Cultural Education Centre" and outlined the roles of each institution. The exhibition concept was to invite contemporary descendants of the late-nineteenth- and early-twentieth-century makers and owners of the objects to enter into a dialogue with their forebears, which is what occurred.[15] In 2002, the exhibit opened at the ROM, and a smaller version opened at the Heiltsuk Cultural Education Centre at Waglisla (Bella Bella), as stipulated in the agreement with the Heiltsuk Tribal Council. The ROM version travelled to Musée McCord in Montreal, to the MOA, and to Grey Roots Museum and Archives in Thunder Bay, Ontario. As is typical of collaborative exhibits, in which cultural performance throughout the entire process is more important than museum texts, especially within the ceremonial space of the museum, sixteen hereditary chiefs and over three hundred Heiltsuk and other First Nations people were in attendance when the exhibition opened at the MOA. Phillips (2003, 156) acknowledged that "the communal values, unique traditions and knowledge of the Heiltsuk people that were being affirmed that evening reflected the success of the collaborative process which had not only effected the transgenerational reunion of the historical objects with the descendants of their original makers and owners, but had also accurately expressed the community's contemporary understanding of itself."

Although the collaborative process was obviously successful from the community's point of view, Phillips thought the exhibition was not multivocal enough for the public, at least at its Toronto venue.[16] She had the impression that "during the initial showing of *Káxḷáya Ǧvíḷás* at Toronto's Royal Ontario Museum ... the non-Heiltsuk visitors who were in the vast majority were frustrated because the lack of standard ethnographic information made it difficult for them to learn what the objects were used for and what the imagery 'meant'" and that some expected "legitimate modes of explanation" were absent and museum personnel not properly acknowledged.[17] "At the Royal Ontario Museum, the text panel identifying the original collector of the objects displayed in *Káxḷáya Ǧvíḷás* and crediting the extensive research conducted by associate curator Martha Black was placed facing a wall at the far end of the gallery. It thus denied visitors an important point of orientation and also denied Black adequate credit for her work." Phillips saw

this failure to acknowledge all authorship as connected with the failure of museums "to disclose their processes fully" (2003, 165, 163). But it is unlikely that any collaborative museum exhibit on this scale, part of an intricate and complex process involving scores of people, could ever disclose its process fully in an exhibit format. Text and object placement in the ROM was dictated to a large extent by space restrictions as well as the Heiltsuk's (and my own) stated purpose: to refocus a circa 1900 missionary collection on Bella Bella circa 2000. *Bella Bella* was readily accessible in the exhibition for those who wanted more historical and ethnographic information about the older pieces; the contemporary pieces were presented with exactly the information the Heiltsuk wanted to convey.

Phillips (2003, 166) has suggested that "museums ... disclose the plural authorities behind the narrative they present, so visitors are left free to evaluate new and possibly discrepant contents and interpretations for themselves," but that position may favour the museum and/or an academic perspective and may not be acceptable to First Nations partners who seek to assert cultural authority over museum collections as hereditary property. What the Heiltsuk valued in *Káxḷáya Ǧvíḷás* was the multiple voices from their own community:

> It is the first ever Heiltsuk exhibit and gives voice to our community, especially contemporary Heiltsuk artists and to the works of our ancestors ...
> That our people should have authority over our "objects" in museums is strongly asserted in the exhibit. (P. Brown 2003, 7)

From their viewpoint, dialectics may not be, as in Phillips's (2003, 165-67) ideal, examples of "more accurate translations" or of a higher "moral authority" in the "representation of the 'other.'" Depending on the protocols established at the outset of an exhibit, it may not always be the museum's call (see Campbell, this volume; Kramer, this volume; Townsend-Gault, Chapter 27, this volume). First Nations participation in anthropological and museum projects has been, and continues to be, strategic. It is designed to further community development, self-governance, and political agendas.[18] No collaborative project is merely a dramatization of anthropological theory; all have applications for lands, resources, and treaties. In the following excerpts, it can be seen that Mungo Martin demonstrated First Nations survival and participation in mainstream society; the Task Force on Museums and First Peoples was rooted in political action; the Kitwancool chiefs were seeking a forum in which to express their interests and information that would support their rights to lands and resources. Museums, too, need these projects to further their own agendas, including fundraising for capital projects, staff, and programs. This does not mean that collaborative

projects are cynical exercises, but they must be understood as strategic actions within the social and political arena of the museum. Successful projects advance the interests of all parties involved.

First Nations representation in museums has been an anthropological subject for decades, and everyone in the field understands the issues. Determining how to translate the principles and policies articulated by the task force, academic critiques, First Nations individuals, and First Nations community partners into practices that work – complex projects that are actually possible to do, not only on paper but also in actuality and within deadlines and budgets – is the project at hand now. As Hoover and Inglis (1990) noted in their discussion of the purchase and display of a Nuu-chah-nulth ceremonial curtain, collaboration goes beyond dialogue and is harder to do than talk (or write) about (see Martindale, this volume; Kramer, this volume).

Collaborative projects, in whatever voice or voices they choose to speak, are no longer the new museology. They are the usual practice, codified by the Task Force on Museums and First Peoples, enacted through treaties, accelerated in the past twenty years to encompass a diverse range of methods and outcomes, and currently the subject of redefinition. Throughout, the collaborative process has continually carried with it responsibilities for continuing engagement and accommodation on both sides. There are precedents and definitions but perhaps no models to follow, for every First Nation and every museum has a different institutional culture, different capacities, and different goals. When these cultures, capacities, and goals are made compatible, positive relationships develop, and new things happen to the benefit of both parties.

## TASK FORCE ON MUSEUMS AND FIRST PEOPLES AND CODIFICATION OF MUSEUM POLICY

**25.I. Richard Inglis, quoted in Robert A. Janes and Martha A. Peever. 1991. "Partnerships: Museums and Native Living Cultures."** *Alberta Museums Review* 17, 2: 15.

The 1990 Alberta Museums Association Professional Development Series workshop in Edmonton included "an update on the activities of the Task Force [on Museums and First Peoples]." In their report of the workshop proceedings, Robert A. Janes, the session's moderator, and Martha A. Peever noted that full community support was identified as a key factor in project implementation: "The attempt to achieve consensus is symbolically important as it signifies the development of a new working relation between First Peoples and museums." At the workshop, Richard Inglis, then head of anthropology at the RBCM, outlined lessons learned from the task force.

It is essential to recognize Native knowledge, authority, and autonomy. Mainstream museums have to relinquish some of their authority and autonomy to accommodate the views of others. They must consider developing collaborative agreements with aboriginal peoples, agreements that govern access to, and the use of, objects that museums own. The Royal British Columbia Museum might serve as a model for developing these agreements, as this museum has several in place.

Museums must make every effort to overcome their stereotypical image of aboriginal peoples. These cultures are dynamic and evolving, which means that we have to make an effort to understand contemporary activities and events.

Museum research must be based on community approval and collaboration. Mainstream museums must recognize that this research requires an ongoing commitment. It does not necessarily have a beginning and an end, which in turn means that museums must be able to accommodate this both administratively and financially.

It is critical to get consensus in a community, from as many people as possible in that community. No one voice can speak on behalf of an aboriginal community, no matter how supportive that voice is. The same range of diversity and complexity exists in an aboriginal community as in any other community.

**25.II. Royal BC Museum. 2004. "Aboriginal Material Operating Policy."** Victoria: Royal BC Museum. First created 1997.

In retrospect, the task force is increasingly seen as the beginning of all consultation. For example, Élise Dubuc (2006, 20, 21) has written that not only was it "a turning point in Aboriginal museology" but also, "twenty years later, we recognize the changes in the development of exhibits by large museums that hold major Aboriginal collections, including the establishment of consultation processes." The task force report was indeed a landmark in First Nations-museum relationships, not only because it clearly articulated First Nations' rights and museums' responsibilities as holders of First Nations cultural materials and engendered so much thoughtful discussion, but also because it offered concrete suggestions for addressing these issues and moving forward in equitable and politically useful relationships. It was a catalyst for the formalization of institutional policy in this area, and its recommendations were formally adopted as policy by many Canadian museums (e.g., according to Phillips and Phillips [2005, 698], they helped to structure a new consultative process for the development of the Grand Hall at the Canadian Museum of Civilization).

The RBCM's "Aboriginal Material Operating Policy" (first created in 1997) was one example of the codification of existing policy following recommendations of the report. Included here is the first page of the document. The policy goes on

to outline procedures for access, cooperative management, repatriation, loans, and interpretation. The complete text is on the RBCM website.[19]

### ABORIGINAL MATERIAL OPERATING POLICY

*BACKGROUND*

The Royal British Columbia Museum has an interest in maintaining a collection of Aboriginal material culture at the Royal British Columbia Museum for scientific, educational and other public purposes. The Corporation also has an interest in maintaining standards of care regarding cultural property acquired with public funds, wherever that cultural property is located.

*POLICY*

The Museum is committed to the involvement of Aboriginal peoples in the interpretation of their cultures as represented in exhibits, education programs, and public programming developed by the Museum. The Museum is committed to a continuous dialogue with Aboriginal communities in British Columbia in relation to its collections, repatriation policies, and co-operative management efforts.

The Museum acknowledges that all Aboriginal materials, including human remains, burial objects, ceremonial objects, communally-owned property, as well as archival record, tapes, films, photographs, and research information is part of the intellectual and cultural heritage of the respective Aboriginal peoples. Therefore, the utmost respect by researchers, curators, and interpreters of those cultures must be maintained.

A case-by-case approach will be used to deal with all issues regarding Aboriginal material, recognizing the need for a collaborative approach to be based on moral and ethical criteria in addition to following legal requirements.

*OBJECTIVES*

The objectives of this policy are to:
- Facilitate the return of human remains, and cultural objects which may have been acquired under circumstances that render the Museum's claim invalid, to originating Aboriginal communities, when it is the wish of those Aboriginal communities.
- Respond to initiatives of the Provincial treaty negotiations.
- Increase involvement of Aboriginal peoples in the Museum's interpretation of their culture and history.
- Enable the Museum to work collaboratively with Aboriginal peoples to co-operatively manage the care and custody of cultural objects of Aboriginal origin in the Royal British Columbia Museum collection.

### INDIVIDUAL COLLABORATIONS IN ETHNOGRAPHY

**25.III. Jay Stewart and Robert Joseph. 2000. "Validating the Past in the Present: First Nations' Collaborations with Museums."** *Cultural Resource Management* 5: 44.

The highly selective and fragmentary information, in the form of texts and artifacts, that underlies the historical anthropological view of Northwest Coast cultures was typically a product of interactions between anthropologists "in the field" and a number of First Nations individuals who, for their own reasons, helped them to record certain aspects of traditions and lifeways. Were these interactions collaborations? Jay Stewart, former director of the Museum at Campbell River, and Kwakwa̱ka̱'wakw (Gwawa̱'enux̱w) chief Robert Joseph, CEO of the Residential Schools Commission of British Columbia, think they were.

> These modern-day museum collaborations have a precedent: in 1904, the ethnographer Charles H. [sic] Newcombe arranged for several Northwest Coast artists to be resident cultural interpreters at the World's [Columbian] Exposition in St. Louis. Masks ... were made at that time by Kwakwa̱ka̱'wakw carver Bob Harris, and these and other artifacts were used in public performances in St. Louis and later incorporated into the collection of The Field Museum in Chicago.

### NON-COLLABORATIVE DISPLAY

**25.IV.** *Victoria Daily Colonist.* **1933. "Propose Novel Indian Village."** 26 August, 1, 2.

When portraits of culture created by these interactions in First Nations communities in the late nineteenth and early twentieth centuries were disseminated through publication and exhibits, though, collaboration typically ceased. Was it that the populations lived too separately for meaningful communication? Were prejudices too comfortably ingrained to be questioned? Were there active agendas of suppression? Selective appropriations and uses of Northwest Coast material culture and traditions by non-Aboriginal individuals, interest groups, and institutions were effected for various decorative, instructional, and political uses, and a number of studies have documented and analyzed many of these projects (a recent notable example being Dawn 2006). From a Victoria newspaper in 1933, here is a graphic illustration of complete non-comprehension that any kind of involvement by First Nations in a proposed display of Northwest Coast life might be appropriate. The proposer, Henry Whittaker (1886-1971), retired as the chief architect of Public Works in 1949.

PROPOSE NOVEL INDIAN VILLAGE

*WOULD PRESERVE ANCIENT ARTS IN ORNAMENTAL CONCRETE FOR POSTERITY*

Henry Whittaker, chief architect for the Province, is responsible for the suggestion that the replica of an Indian village in concrete, be erected at Beacon Hill Park, both as a permanent memorial to the early Indian dwellers of the land, and also as a work of museum value and tourist attraction. He cites the magnificent ornamental concrete pieces at Butchart's Gardens as instances of what can be done with stone in its plastic form.

"It had occurred to me that an object of considerable interest to residents and tourists alike could be created by erecting an Indian village in Beacon Hill Park," stated Mr. Whittaker. "Such an exhibit could easily be erected in concrete and made so realistic that the materials of construction would deceive anyone at a casual glance. This would perpetuate the scenes of the ancient dwellers in this part of the country, who are rapidly following the habits of the white man to the exclusion of their native arts.

"A tableau in concrete of the Indians, their home and mode of life would give a realistic impression to visitors of the older forms of civilization of this continent, and would certainly be a unique exhibit. Sufficient data is in the hand of the Provincial Museum to make the layout true to life, with life-size figures, so colored as to preserve the true aspect of the scene. The cost, I believe, would not be excessive, and the work could be carried out over an extended period, as time and funds permitted," Mr. Whittaker concluded.

## INDIVIDUAL COLLABORATIONS: THUNDERBIRD PARK

**25.V. British Columbia Provincial Museum. 1952 and 1953. *Annual Reports*.** Victoria: Province of British Columbia, Department of Education, B21, B22-B24.

It is not known if Mr. Whittaker's idea played a part in the construction of Thunderbird Park, established in 1941, when a display of monumental carvings from the collection of the British Columbia Provincial Museum (now the Royal BC Museum)[20] was set up on six vacant city lots at the corner of Belleville and Douglas Streets in Victoria. This first version of Thunderbird Park included odd and inauthentic combinations of various monumental carvings from throughout the coast – for example, a pseudo-Northwest Coast bighouse that combined Haida house beams and frontal pole, Nuu-chah-nulth house posts, a Kwakwa̱ka'wakw house post, adzed boards that may have come from a Salish house, and a painted design (executed by a non-Aboriginal worker) very loosely based on either a Kwakwa̱ka'wakw drawing or a Haida house front stood

on the site with several similar pastiches. "The exhibit was basically a 'cabinet of curiosities,'" noted Richard I. Inglis and Donald N. Abbott (1991, 18), "[that] was created primarily as a tourist attraction without consulting Native Peoples or anthropologists."

Changes to Thunderbird Park over the years trace the increasing engagement of First Nations people with the museum's programs and site.[21] The situation at the BC Provincial Museum changed radically and rapidly when Wilson Duff (1925-76) was hired as the anthropologist in 1950 and Mungo Martin (ca. 1881-1962) was hired the next year. These two personalities were "central to the development of dialogue and partnerships with First Peoples at the Museum" (Inglis and Abbott 1991, 19).[22] Martin was initially seen by the museum as an educational resource for the public, a cultural authority, and a sort of living specimen of a vanishing carving tradition. However, as the following accounts in the museum's annual reports for 1952 and 1953 illustrate, over the course of two years, Martin and his family took ownership of a major part of Thunderbird Park, dominated the museum's anthropology department, and completely and permanently transformed the museum's thinking about Aboriginal cultural in contemporary British Columbia. The event that opened Mungo Martin's house in Thunderbird Park was the first legal public potlatch after the ban on potlatching was dropped from the Indian Act [16.1].[23]

Carvers Henry Hunt (1923-85), who married Martin's adopted daughter Helen, and his son Eugene (Tony) Hunt worked with Martin in Thunderbird Park. Funding remained precarious, but the program continued for many years under the leadership of Head Carvers Richard Hunt and Tim Paul, a Nuu-chah-nulth carver.[24] It led to a new kind of collaboration with First Nations individuals: apprentice carvers working in the Carving Studio in Thunderbird Park made versions of museum objects that were loaned for use in ceremonies to First Nations people who held the hereditary rights to use them. These new carvings constituted the Potlatch Collection, a significant outcome of the Carving Program, which furthered the development of First Nations art forms and played a role in the continuation of potlatches and ceremonies. The museum's collection of modern objects benefited, staff learned about First Nations cultural practices and protocols, and ongoing relationships with First Nations people began to be established. The RBCM still loans material for First Nations ceremonial use from time to time but not nearly as frequently as in the past because most people have their own regalia now. The Carving Program, as well as Aboriginal-themed school programs, became a partnership with the Victoria Native Friendship Centre after 1986.

Mungo Martin and the BC Provincial Museum had well-defined roles that became standard in other, later collaborations. The province and various donors provided space, materials, and (somewhat limited) funds, while Martin provided knowledge and direction. His presence was transformative. He and his family developed close personal relationships with museum staff and were sources of information and talismans of authenticity, functioning as a synecdoche for Kwakwa̱ka'wakw culture and by extension all Northwest Coast cultures. Today First Nations individuals still take similar roles in museums even as collaboration has moved beyond informal individual interactions to formalized institutional partnerships.[25]

TOTEM-POLE RESTORATION PROGRAMME

The largest single project undertaken during the year was the launching and direction of the three-year totem-pole restoration programme in Thunderbird Park. The primary purpose of the programme is to replace the present badly decaying exhibits in the park with a permanent and more representative collection – in part new poles, in part exact replicas of old ones – so that the fine original carvings can be preserved indefinitely indoors. By employing native carvers and having its operation in the park itself, the programme accomplished two important secondary aims: to preserve the art of totem-carving and to serve as a unique tourist and educational attraction.

The project was conceived in the knowledge that Mungo Martin, who is without doubt the finest totem-carver remaining, would be available as head carver. Mr. Martin, now 71, is a native of the Kwakiutl tribe of Fort Rupert. He has been carving totem-poles and other objects of native art for more than fifty years, and is an outstanding authority on all aspects of the native culture of his tribe ...

In mid-May Mr. Martin and his family took up residence in Victoria, in a house made available by the Department of Public Works ... [and] worked steadily throughout the year. Attempts to find other suitable apprentice carvers [in addition to Mungo Martin's son, David, and granddaughter, Mildred Hunt] have not been successful ...

As a tourist and education attraction, the project has proven of outstanding success. In two eight-hour days during the tourist season, for example, 2,375 persons watched the carvers at work. Nine hundred and sixty-two of them took pictures, including 196 with movie cameras.

...

TOTEM-POLE RESTORATION PROGRAMME

Administration of the totem-pole restoration programme in Thunderbird Park throughout its second year has been the greatest single responsibility of the Anthropologist.

The main accomplishment was the construction of a full-sized and authentic Kwakiutl Indian house as the "centre-piece" of the park. The opening ceremonies marking the completion of the new house brought the year to a spectacular close ...

### THE NEW KWAKIUTL HOUSE

... This new house is more than just an authentic Kwakiutl house. It is Mungo Martin's house, and bears on its house-posts hereditary crests of his family. It is a copy of a house built at Fort Rupert about a century ago by a chief whose position and name Mungo Martin has inherited and assumed – Naka'penkim ...

### THE HOUSE-WARMING POTLATCH

It was customary among the Kwakiutl to mark the completion of a new house with great ceremonies. At such house-warmings, the owner usually explained his right to the carved and painted crests he had used by relating family traditions. He usually "potlatched" gifts to those who had helped build the house and those whom he had invited to attend. He often took the opportunity to bestow important inherited names upon members of his family, and to display the masked dances and other ceremonies which belonged to his family.

It was understood from the start that opening ceremonies along these lines, with Mungo Martin as host, would mark the completion of this house. Accordingly, plans were made for three days of ceremonies – December 14th, 15th, and 16th. Mungo Martin sent word to the Kwakiutl villages, and certain of the native singers and dancers came to assist – Daniel Crammer [Cranmer], as interpreter; Tom Omhid, the tribal song-leader; George Scow, Charles Nowell, and others. Several rehearsals were held on the nights before the event.

The first day was for Indians only, so that Mungo Martin could perform his traditional ceremonies and display his masks and dances in a setting as authentic as possible. This was a completely authentic and serious affair, not a show for outsiders. It was attended by natives from most of the tribes of the Coast. The only whites allowed in were a few anthropologists from Victoria, Vancouver, and Seattle, who had been invited in accordance with Mr. Martin's wish to have the customs, songs, and speeches recorded. The people gathered at the house in the afternoon. Mourning songs for recently deceased relatives were sung first. Then the ceremony opening the winter dance season was performed: songs were sung, red cedar-bark head-bands were passed out, and down was placed on the heads of guests. A family ceremony – the cradle ceremony – was performed in honour of David Martin's daughter. Then feast songs were sung, and there was a break for dinner, which was provided near by in the Crystal Garden. In the evening many colourful masked dances were performed.

On the second day, in the afternoon, a special series of dances was staged for the press, movies, radio, news-reel, and television. Government photographs obtained 600 feet of colour movies. The television film was shown across Canada on C.B.C. television newscasts. Photographs obtained by the press were published in numbers.

In the evening of the second day a two-hour programme of the ceremonies and dances was presented for an audience of over 200 local and Provincial Government officials, donors of materials, and other guests. Printed invitations and souvenir programmes were prepared for this event.

On the final day, in the afternoon and again in the evening, similar programmes were presented and the general public was invited. Public interest was intense, and although more than 300 were crowded into the house on each occasion, many had to be turned away. In the evening an estimated 1,500 were not able to get in. Because the Indian performers had to return to their homes, it was not possible to stage additional performances.

At a final ceremony in the presence of the Indians, the Anthropologist formally thanked Mungo Martin for building his house here in Thunderbird Park, and promised him that it would be well cared for in the future.

## COMMUNITY COLLABORATIONS: HISTORIES, TERRITORIES AND LAWS OF THE KITWANCOOL

**25.VI. Wilson Duff, ed. 1959.** *Histories, Territories and Laws of the Kitwancool.* Anthropology in BC Memoir No. 4. Victoria: British Columbia Provincial Museum, 3-4.

A totem pole salvage project on the Skeena River was the first formal collaboration between museums and a Northwest Coast First Nation.[26] In 1958, Wilson Duff (1925-76) and Michael Kew (b. 1932), representing the BC Provincial Museum and the Totem Pole Preservation Committee, went to Kitwancool (Gitanyow) to negotiate the removal of a small number of poles (Hawker 2003, 143-69, 177-78). A formal contract, reproduced below, was drawn up and signed.

As stipulated in the agreement, the stories of the poles were recounted in *Histories, Territories and Laws of the Kitwancool,* which the RBCM has kept in print since 1959. Duff was the book's editor but noted (1959, 3) that

> the authors of this book are the Kitwancool themselves, for it contains their own statement of what they consider to be their histories, territories, and laws. It was their idea in the beginning that such a publication should be produced. The subjects dealt with are those which they consider important

enough to include. The manner of expression, as closely as possible, follows their own.

As Inglis and Abbott (1991, 20) have pointed out, "this was a remarkable agreement and publication by a government that only in 1990 agreed to negotiate the land issue in BC [and established] a very different kind of relationship with Native Peoples ... recognizing traditional ownership and authority."

AN AGREEMENT

between

THE PEOPLE OF KITWANCOOL AND THE PROVINCIAL MUSEUM OF BRITISH COLUMBIA CONCERNING CERTAIN TOTEM POLES OF KITWANCOOL

Whereas The Provincial Museum of British Columbia desires to preserve a number of the totem poles of Kitwancool for the use and benefit of future generations of both white and native peoples, and

Whereas The people of Kitwancool also desire to preserve their totem poles and furthermore desire that their authentic history, the stories of their totem poles, their social organization, territories, and laws be written down, published and used in the highest educational institutions of the province to teach future generations of white and native students about Kitwancool,

The parties hereby make the following arrangements: –

The people of Kitwancool hereby agree:

1. To permit the removal of three totem poles to Victoria, B.C. for permanent preservation. The three poles being:
   (a) Chief Wiha's pole now lying beside the house of Mr. Walter Douse.
   (b) Chief Wiha's pole now standing in the old village.
   (c) Chief Guno's pole showing three frogs and now fallen in the old village.
2. To provide authentic information on their history, traditions, social organization and laws to properly qualified persons, so that the information may be written down, published and used in teaching students about Kitwancool. In future to provide such information as is required to properly qualified representatives of the University of British Columbia so that they may further clarify questions which may arise in the course of studying and teaching about Kitwancool.
3. That the conditions listed below, to be undertaken by the Provincial Museum of British Columbia are acceptable to them.

We certify that these conditions are acceptable.

Chief Wiha          Chief Gamlakyelt, per subchief Leseq

The Provincial Museum of British Columbia hereby agrees: –

1. To cause the above described poles to be removed from Kitwancool, to transport these poles to Victoria, B.C. for permanent preservation, to have skilled carvers make exact copies of these poles, to transport the copies back to Kitwancool, construct for them suitable bases and erect them in places to be designated by the Kitwancool people, and to accomplish this by May 30th, 1959.

2. To provide funds to cover the expenses of a person acceptable to both parties to visit Kitwancool for a period of not more than two weeks, to write down the authentic stories of the totem poles and the history and laws of the Kitwancool people as dictated by them ... It is understood that copies of the information so written down will be made available to the people of Kitwancool, the University of British Columbia, and the Provincial Museum of British Columbia.

3. To borrow the map of Kitwancool territory prepared by Mr. Fred Good, to copy it, and to return the original map to Kitwancool.

4. To issue a publication which will embody the information and map referred to above, in sufficient numbers so that it may be obtained by all who are interested.

5. To provide the University of British Columbia with copies of all of the above information and map, and also sufficient copies of the above-mentioned publications for the use of professors and students. Furthermore, to recommend to the officials of the University that these materials be extensively used in teaching the coming generations of students about Kitwancool. And furthermore, to inform the officials of the University that the people of Kitwancool would welcome suggestions for the improvement of their legal position and welfare; and in future may ask the University and the Provincial Museum for information and advice on matters within their competence and concerning the people of Kitwancool.

6. To provide copies of this agreement, for permanent record, to the people of Kitwancool, the Provincial Museum of British Columbia, and the University of British Columbia.

Wilson Duff, Provincial Museum of British Columbia
Walter Derrick, Chief Councillor, Kitwancool Band

Hazelton, B.C.
March 24, 1958

W. Bailey (Authorized under the Indian Act to administer oaths.)
Witness: Peter Williams, President

## COMMUNITY COLLABORATIONS: THE HESQUIAHT PROJECT

**25.VII.  Richard I. Inglis and Donald N. Abbott. 1991. "A Tradition of Partnership: The Royal British Columbia Museum and First Peoples."** *Alberta Museums Review* 17, 2: 21-23. Copyright Alberta Museums Association.

Twenty years before the Task Force on Museums and First Peoples, the BC Provincial Museum entered into a formal partnership with the Hesquiaht First Nation that would become a model for subsequent collaborative projects because of its extent, flexibility, useful results, and First Nations control (Haggarty 1978). Initially concerned with preserving and protecting burials, the project expanded to encompass the documentation of oral traditions, traditional sites, and other cultural information that would become increasingly relevant to land claims. Richard I. Inglis (b. 1948), then head of anthropology at the RBCM, and Donald N. Abbott (1935-2005), then the RBCM's curator of archaeology, outlined the project for *Alberta Museums Review* two decades later.

Michael M. Ames (1990, 161), writing about the MOA's 1988 exhibition *Proud to Be Musqueam*, which employed Musqueam band members as curators on a four-month work placement contract, identified "skill transfer" as one of the concrete things that museums can do to "relax, bridge or mediate between the conceptual and institutional separations they have created." Providing hands-on experience in archaeological methods was an important aspect of the Hesquiaht Project. Community members collaborated in excavating, site documentation, and interviewing, developing skills that would be useful in land-claims and other research. As this excerpt shows, the Hesquiaht Project was partly a strategy to gain control over traditional territories and resources.

In the field of archaeology, the major breakthrough to a new kind of relationship with Native people came about in 1970 when a delegation of Hesquiaht came to the Museum. They were concerned with vandalism of burial caves in their traditional territory and sought assistance from the Museum. They were, however, very suspicious of archaeologists, anthropologists, and officialdom. They insisted on stringent conditions: full control of the project and of all data and artifacts recovered. The Museum would gain only in scientific information and would be able to publish it, subject to the band's right to provide its own interpretations in addition to ours in any cases of disagreement. We unhesitatingly agreed to the conditions. What resulted was a truly innovative project that expanded well beyond the initial concern with protecting burials.

The Hesquiaht formed a Cultural Committee to oversee and direct all activities, from obtaining funds to communicating with non-band professionals hired to undertake research. The partnership developed into a full cultural recovery project

with a language and history recording programme, art, craft and dance classes taught by the elders, and the salvage archaeology programme. All aspects employed Hesquiaht people, both young and old.

Although there is no longer an active field research aspect to this programme, our partnership with the Hesquiaht continues. The artifacts from the excavations and the materials from the language and history recording programme continue to be held by the Museum as a loan from the Hesquiaht. The project has resulted in a number of publications by professional researchers, but a great deal of information remains in archival form. This material is now being used by the band for land-claims research and to provide curriculum materials for the school system. The Hesquiaht partnership has become a model for co-operative projects with other bands.

### INDIVIDUAL COLLABORATIONS: EXHIBITS – FIRST PEOPLES

**25.VIII. Jay Stewart and Robert Joseph. 2000. "Validating the Past in the Present: First Nations' Collaborations with Museums."** *Cultural Resource Management* 5: 42-43.

A provincial museum building had been proposed in the 1950s when the museum was in the legislative buildings, and construction was eventually started in 1968 on lands adjacent to Thunderbird Park. The new *First Peoples* exhibition opened in 1977. The Union of BC Indian Chiefs was invited in 1972 to participate in exhibit planning and appointed Phillip Paul and Simon Lucas to review plans. Mostly, though, collaborations in the *First Peoples* exhibition were personal interactions and involved individuals working on the details of various displays (Hoover 2000-1). An example was the building of the Jonathan Hunt House, based on a formal agreement between the hereditary owner and the museum. The exhibit plan presented an anthropological viewpoint based on ideas about cultural ecology that were popular at the time. There was no formal advisory committee, as there would be today, and First Nations were not involved with the curators and exhibit designers in the initial planning of themes and storylines. Neither was the First Nations participation that did take place made a subject of the display, as is the current convention.

Some contemporary commentators have taken these differences between the practices of thirty years ago and today to discount the First Nations participation. If it is not overtly a subject, rather than a process, of exhibition, then it is deemed not to exist or to be purposefully hidden from museum visitors (e.g., Wickwire 2000-1).

The Royal British Columbia Museum applied a ... protocol in 1977, when the house of Chief Kwakwabalasami (Jonathan Hunt) of the Kwakwa̱ka'wakw Nation (formerly

Kwakiutl) was constructed and installed in a permanent exhibit within the museum. Because the house, and many of its attendant architectural features, came as a dowry through Hunt's wife's uncle, both Hunt and his wife were involved in a contractual arrangement whereby they allowed their rights inherent in the house to be displayed to the visiting public. The terms also ensured that the prerogatives displayed were not alienated from them and their heirs. As with the Mungo Martin House, use of the Hunt House for school and public programs is always negotiated with the current rights holder on an event-by-event basis.

... Singers and orators were hired to record the Hamat'sa and Cannibal Bird songs and recount the history of the house. Excerpts from this ethnographic record are included in the exhibit sound track, incorporating some of the speeches of welcome and songs in Kwakwala (the language of the Kwakwa̱ka'wakw people).

The house was dedicated in a ceremony attended by a small number of Kwakwa̱ka'wakw chiefs, museum staff, and volunteers. The installation of the house as an exhibit meant that it also had to be validated within the wider Kwakwa̱ka'wakw community. At a later event in Alert Bay (a major Kwakwa̱ka'wakw village on Cormorant Island, off the northeast coast of Vancouver Island), Hunt and his wife held a potlatch ceremony to complete the affirmation process.

At the time of the agreement, the museum had the advantage of First Nations artists on staff, notably the son and grandsons of Kwakwabalasami. While these artifacts and ritual privileges are exhibited and are directly accessible to the visiting public – they can enter the house, sit in the settee, and touch the masks – they are not alienated from the heirs of the privileges who continue to exercise authority over them today.

**25.IX. Peter L. Macnair, Bill Reid, and Tony Hunt. 1983. "The Legacy: Through the Eyes of the Artists."** Panel discussion, 24 April. Typescript. *Legacy* exhibit files, Anthropology Section, Royal BC Museum, 31-32. Courtesy of the Royal BC Museum/BC Archives.

At a panel discussion at the RBCM in April 1983 (held in conjunction with the exhibition, *The Legacy: Continuing Traditions of Canadian Northwest Coast Indian Art*), an audience member raised an ever-present issue, addressing it to one of the panel members, artist Tony Hunt, one of the descendants of Kwakwabalasami mentioned above. Hunt's response illustrated that these questions are not the simple us-and-them issues that they are often assumed to be.

[The question:] The subject I was bringing up was exploitation. Of whether ... for instance, it looks good for the British Columbia government, the British Columbia museum, to have your father's or grandfather's house established on the top floor of

their museum. It's curious that a million people every summer should walk through your grandfather's house and have a look around. That's one sort of exploitation which on the surface looks not so good ...

[Tony Hunt's response:] ... I think that house will stand forever as a tribute to the Southern Kwakiutl [Kwakwaka'wakw] people, especially my grandfather's house. I think it's an honour and people forty years from now perhaps will walk up there and listen to the music that was sung by my grandfather and have a house that they can see. I mean who can walk into a Kwakiutl house now and see what the houses must have looked like? That is how they did look. I appreciate the museum giving my grandfather that opportunity to show it.

### INDIVIDUAL COLLABORATIONS: EXHIBITS – THE LEGACY

**25.X. Gloria Cranmer Webster. 1983. "Address, April 15."** Typescript. *Legacy* exhibit files, Anthropology Section, Royal BC Museum. Courtesy of the Royal BC Museum/BC Archives.

*The Legacy: Continuing Traditions of Canadian Northwest Coast Indian Art,* a temporary travelling exhibition of historical and modern Northwest Coast art organized by the BC Provincial Museum (Macnair, Hoover, and Neary 1980), was not a collaborative exhibit in the current sense of partnership either; it was entirely planned and executed by museum staff. At the time, however, it was a significant locus of interaction between the museum and First Nations artists, an example of the working together that is part of the definition of collaboration. Richard I. Inglis (personal communication, 2008) observed that collaboration is defined by large, formal projects, but it is also the day-to-day work, the ongoing little things such as visits, information for and from families, individual friendship, shared agendas, and mutual support between individuals and institutions. In her speech at the opening of the second version of *The Legacy* at the BC Provincial Museum, Gloria Cranmer Webster alluded to the importance of this form of collaboration. The conclusion of her address revealed the ever-present activist social and political agendas that, as noted above in connection with the Hesquiaht Project, underlie First Nations-museums collaborations. (Webster [b. 1931] is a member of the 'Namgis First Nation, an anthropologist, and the former director of the U'mista Cultural Centre at Alert Bay.)

The Legacy continues to stand as an example of this special relationship the Provincial Museum has with Indian people. We in Alert Bay value that relationship and this seems an appropriate time to acknowledge the help given to us by our friends here, especially in the Ethnology and Conservation Divisions ... All of these examples of

support make us feel that the Provincial Museum belongs to us in Alert Bay as much as it belongs to the people who live in Victoria ...

Finally, I ask that when you look at the Legacy exhibit try to appreciate how truly amazing it is that such art can continue to flourish when you consider the conditions on most reserves in this province. Chronic unemployment, inadequate health care and education services are only a few of the things we live with and have lived with for a long time. The impressiveness of the Legacy, and the success of the few artists represented in it, does not mean that all is well for Indians.

### FAMILY COLLABORATIONS: THE SITAKANIM CURTAIN

**25.XI. Alan L. Hoover and Richard Inglis. 1990. "Acquiring and Exhibiting a Nuu-chah-nulth Ceremonial Curtain."** *Curator* 33, 4: 280-81, 285-86.

In 1988, the RBCM purchased a Nuu-chah-nulth (Tla-o-qui-aht) ceremonial curtain from the Sotheby's, New York, auction of the Andy Warhol estate. Although the curtain was described as Kwakwaka'wakw in the auction catalogue, museum staff recognized it as a ceremonial curtain of the Frank (Sitakanim) family of Opitsat because the museum's collection included an earlier version of the curtain. Details of the acquisition, media response, the curtain's history and its relationship to the earlier one, and the public presentation in collaboration with the late chief Alex Frank and his family were recounted by Richard Inglis and Alan L. Hoover. (At the time, Inglis was head of anthropology at the RBCM, and Hoover was chief of anthropological collections.) Relinquishing control over content and process, and the required long-term commitment to unspecified, and often not clearly understood, community dynamics required difficult readjustments and leaps of faith on the part of the museum administration.

During our research [on the curtain after its purchase], we realized that the Museum and the Native families do not share the same concepts of history. History to us is reconstructing past events. We endeavored to trace the chronology of the curtains by answering questions like "How are they related?" and "How did they leave the community?" We were also interested in establishing the meanings of the images depicted and asked, "What are the figures on the poles?" "What do they signify?" These were questions relevant to the academic and museum world and not concerns of the Frank family, who did not respond with much interest to our research. For them, the curtains documented family relationships that are depicted by images on the curtains. The curtains are kinship charts representing the generations of chiefly marriages. History to them is contemporary, embodied in living people who are descendants of these families.

As we shared information about our respective concepts of history as embodied in the curtains we both grew to respect the legitimacy of the other's position and established a meaningful dialogue and partnership. The most fruitful aspect of our partnership was the formal public presentation of the curtain in which both the Frank family and the Museum shared authority in designing the exhibit and arranging for the opening. In September, during face-to-face meetings with the family, we agreed to a division of labor concerning the celebration: the Museum would take responsibility for the exhibit, while the family would organize the events at the opening. Throughout, each group was to keep the other informed of our respective plans. As it turned out, we were able to maintain a very open and honest dialogue ...

...

The success of this event for the public, the Frank family and the Museum was in large measure a result of the nature of the partnership between the family and the institution. During our discussions, dialogue was open and honest. We came to respect each other's areas of expertise and developed a deeper understanding of each other's concerns and agendas. We, for example, came to appreciate the complexity of family relationships and the need to reaffirm them on ceremonial occasions. The Frank family, most of who had never before entered a museum, learned about conservation, exhibition, and the demands of public programming. What museums – particularly those in areas farther from Native communities than the RBCM – need to recognize as they form the kind of partnerships we have described is that the relationship is a long-term one that must continue to address issues brought forward by each partner. Consequently, the Museum must be prepared to assist the family in the validation of their position in the community when the time arrives. This is the measure of an alliance of equals.

### COMMUNITY COLLABORATIONS: EXHIBITS – HUUPUKᵂANUM · TUPAAT – OUT OF THE MIST: TREASURES OF THE NUU-CHAH-NULTH CHIEFS

**25.XII. Martha Black. 2001. "HuupuKᵂanum·Tupaat – Out of the Mist: Treasures of the Nuu-Chah-Nulth Chiefs."** In *The Manual of Museum Exhibitions*. Edited by Lord Cultural Resources. London: Stationery Office; Lanham, MD: AltaMira Press, 35-36, 37-38.

With the permission of Alex Frank (Chief Sitakanim), the ceremonial curtain purchased from the Warhol estate sale was a central object in *HuupuKᵂanum ·Tupaat – Out of the Mist: Treasures of the Nuu-Chah-Nulth Chiefs*, a seven-thousand-square-foot exhibition of over two hundred artifacts from the collections of the RBCM, international museums, and private individuals, including Nuu-chah-nulth chiefs (Black 1999; Hoover 2000a).[27] The exhibition was a partnership between the Nuu-chah-nulth Tribal Council, which represents fourteen

Nuu-chah-nulth nations, and the RBCM. It opened in Victoria in 1999 and trav-
elled to the Denver Museum of Nature and Science and the Gene Autry Western
Heritage Museum in Los Angeles. *HuupuK<sup>w</sup>anum · Tupaat* was the most exten-
sive collaboration that the museum had undertaken. Formal agreements were
set up that clarified expectations and procedures, and the museum and the
Nuu-chah-nulth together embarked on the extensive collaborative process out-
lined below.[28]

> Although the Royal British Columbia Museum (RBCM) has a long tradition of suc-
> cessful co-operation with First Nations, *HuupuKwanum · Tupaat* brought a total re-
> evaluation of how co-operative exhibitions must be done in the contemporary world,
> where issues about land claims and First Nations' rights over cultural property and
> interpretation are foremost. In order to ensure that aboriginal points of view and
> agendas would be present in more than a token way, the RBCM entered into a complex
> set of negotiations and consultations with Nuu-chah-nulth political leaders, hereditary
> chiefs and families. Whereas in the past such exhibits were usually done by a First
> Nations curator (often an artist or academic who was presented as the representative
> of his or her people) and a museum curator, *HuupuKwanum · Tupaat* involved a net-
> work of people throughout the museum and in 19 Nuu-chah-nulth Nations. The
> Nuu-chah-nulth were directly involved with orchestrating protocols for the inclusion
> of Nuu-chah-nulth communities, liaison with the non-native community, sponsorship,
> marketing, exhibit content, exhibit design and organisation, loans, exhibit interpreta-
> tion, educational programmes, cultural sensitivity training for all museum staff, spe-
> cial events, gift-shop stock and sales, and scheduling. This was done primarily under
> the auspices of the Elders' Advisory Committee of the Nuu-chah-nulth Tribal Council
> (NTC) and the Nuu-chah-nulth Exhibition Advisory Committee, a joint RBCM-NTC
> committee. (The NTC is a political body representing most of the autonomous Nuu-
> chah-nulth Nations.)
>
> ...
>
> The NTC instructed us to observe a strict protocol and methodology for permis-
> sions to exhibit, and gave instructions regarding appropriate interpretations of the
> objects ...
>
> Because people living in many communities throughout a large geographic
> area had to be consulted, the RBCM hired contractors to do some of this work. In
> turn, the contractors hired Nuu-chah-nulth people to assist with contacts and
> interviews.
>
> ... Instead of explanatory or descriptive information, we were given prescriptive
> information and directions about whom we should talk to and what should be includ-
> ed or excluded in the display and interpretation. Lineage connections were stressed,

and it became apparent that only those who had the hereditary right to an object could talk about it directly. When histories that related to the objects could be told, the stories did not "explain" the objects. The information that we received from this process of community consultation was combined with cultural information given to us by Nuu-chah-nulth scholars and educators, such as language teachers and artists, and with quotations from Nuu-chah-nulth writings. The "voice" in the exhibit, therefore, is actually a choir of voices, including the non-Nuu-chah-nulth museum, which imparts an anthropological gloss to the exhibition that is not disguised ...

The way the content and text was determined underscores one of the key ideas behind the exhibition: *the museum cannot set itself up as the interpreter of First Nations culture.* This tenet is also expressed in the way the exhibition was interpreted for the public. Nuu-chah-nulth interpreters replaced audio-tours and museum docents in the exhibition. Eight Nuu-chah-nulth interpreters were present in the galleries in Victoria throughout the busy summer months, and two were present during the slower winter season. In addition, several Nuu-chah-nulth people became volunteers in the exhibition. Their considerable skills and their autonomous position with regard to the museum avoided the danger that the interpreters would become living exhibits themselves. They worked for the NTC rather than the RBCM and were supervised by a co-coordinator whose office was in the Museum's Anthropology Department but who reported directly to the NTC. The constant presence of contemporary Nuu-chah-nulth people played a large part in the exhibition's success with the public and with the Nuu-chah-nulth communities that were a very important part of its audience. The Nuu-chah-nulth involvement in the development of school programmes and special events connected with the exhibition was also significant.

Because of the exhibition, we have a new understanding of the continuing cultural context of the RBCM's Nuu-chah-nulth collection, much of which was gathered unsystematically over a century. We have added new works from contemporary Nuu-chah-nulth artists. The Nuu-chah-nulth people have access to the collection and its documentation in a different and more substantive way and are conducting their own research on the objects and their meanings outside of the museum context. The relationship between the RBCM and the NTC continues in a new context because the Nuu-chah-nulth Nations are currently negotiating a Treaty to resolve land claims and other long-standing issues with the Governments of British Columbia and Canada. We expect that some of the objects in the *HuupuKwanum · Tupaat* exhibition will be returned to the Nuu-chah-nulth Nations under the terms of the Treaty. In one way, the exhibition is unconnected with this political process, but in another way it is part of it.

Museum exhibitions, including ethnographic exhibitions, are usually conceptualised as the end products of an institution's collecting endeavours and its curators' research.

In the case of *HuupuKwanum · Tupaat*, we discovered that the exhibition is merely a beginning. We have learned that an exhibition is a process, not a product.

**25.XIII. Julia Harrison. 2005. "Shaping Collaboration: Considering Institutional Culture."**
*Museum Management and Curatorship* 20: 196, 206-8. Taylor & Francis Ltd., http://www.informaworld.com. Reprinted by permission of the publisher.

That *HuupuK^wanum · Tupaat* was successfully mounted on this scale in only eighteen months is, as Julia Harrison (2005a, 205) observed, an indication that "the relationships established worked well." The complementary institutional cultures of the Nuu-chah-nulth and the museum were factors in its success. As Harrison illustrated in her perceptive study "Shaping Collaboration: Considering Institutional Culture," the nature of collaborative relationships depends on the structures and capacities of the institutions involved. Harrison (b. 1953) is associate professor of anthropology and chair of women's studies at Trent University in Peterborough, Ontario.

Laura Peers and Alison Brown in their recent book, *Museums and Source Communities,* suggest that collaborative relationships established between museums and source communities are contingent on three things: the nature [culture?] of the source community; the political relationship between the source community and the museum; and the geographical proximity of museums to these communities (2003:3). I want to add another factor to these three: the unique culture of the individual museum ...

PARALLELING STRUCTURAL HIERARCHIES

There are many things that determine the success (or failure) or a collaborative undertaking. I would suggest that one thing which facilitated the success of the Nuu-chah-nuth/RBCM collaboration was the structural hierarchies which underlay the relationships with both parties.

When I interviewed Willard Gallic [the NTC's protocol officer], he emphasized that he had "nothing but praise for the way the Executive of the museum treated me." Grant Hughes, Director of Curatorial Services at the RBCM, had also noted that he (Hughes) "represented the authority in the institution which matched what a chiefly [Nuu-chah-nulth] family's authority would be." He continued, "It was a mark of respect that I would go out and meet the chiefs and say, 'I represent senior levels of the museum, and we're trying to work with you as chiefly families'." Hughes and Gallic worked together on a wide range of things, including finalizing press releases, talking to the media, and determining which dignitaries – both Aboriginal and non-Aboriginal – would be invited to the opening ceremonies.

The Elders Advisory Board made it very clear that they were not interested in identifying a singular Nuu-chah-nulth individual to work in tandem with Martha Black, who assumed the curatorial role for the exhibition at the museum. As she said, "they wanted [this] to be a relationship between the museum and the Nuu-chah-nulth communities, and they were quite strong in expressing the idea that it would be chiefs who would have the say over what was exhibited and what was said about what." Gallic established the connection to a chiefly family on behalf of the museum, following appropriate Nuu-chah-nulth protocol arrangements, something which he proudly claimed that the museum "followed right to the T." This process stretched the already very tight time constraints on the project for, as Black said, "it took a long time to find out who spoke for the object and what was possible to say, and [then to] balance between ethnographic and current information."

The delay was not a strategy of obstruction; the process of identifying the correct individual was frequently a complex process of elimination, fragmented memory, and loss of oral history due to the cultural disruption experienced by the Nuu-chah-nulth throughout the last three centuries. Nuu-chah-nulth social hierarchies, however, continue to operate and protocols had to be negotiated in tandem with these structures ... It was imperative that the ownership of the appropriate chiefly family be identified before decisions were made about the content of the exhibition. If this was impossible to do because of the loss of cultural memory, then it had to be determined if others could be designated to assist in making the necessary decisions. In the end, however, direction was always given to the museum as to how they should best proceed in the exhibit development process.

The RBCM is itself a hierarchical organization ... [and] in this situation of collaboration, there was a resonance of the importance of recognizing the limitations of any one person's authority within either the framework of either the Nuu-chah-nulth or the museum. No one person was seen to be the spokesperson for either group. Individual connections were made by museum staff with their parallel in the Nuu-chah-nulth communities, and vice versa ...

The important point here is that it was not only the curatorial staff who worked very closely with the Nuu-chah-nulth people, which was in large measure the tradition of the RBCM (see Inglis and Abbott 1991). Rank was matched by rank in establishing the framework for relations between the Nuu-chah-nulth and the museum. It was also important early on in the process that the RBCM worked through the NTC. They represent the Nuu-chah-nulth in many capacities, including for a majority of the Nuu-chah-nulth, and they are their voice in treaty negotiations with the federal government. The process thus began with a formal institution to institution communication.

**25.XIV. Alan L. Hoover. 2000. "Public Policies and Private Worlds: Protocol – 'Telling People What You Are Doing before You Do It.'"** Paper presented at the Boundaries in the Art of the Northwest Coast of America conference, British Museum, Department of Ethnology, 18-20 May.

A 2000 critique of *HuupuK$^w$anum · Tupaat* by Eldon Yellowhorn, a Simon Fraser University faculty member of Piikani descent, found the exhibition defective because it did not have a Nuu-chah-nulth curator, unaware that the Nuu-chah-nulth Tribal Council had considered and rejected this option. Alan L. Hoover, the manager of anthropology at the RBCM, explored the underlying structures of the Nuu-chah-nulth decision.[29]

> The difficulty of a single authority representing a number of traditionally autonomous First Nations is reflected in the outcome of the proposal to establish co-curatorship as a model relationship between the NTC and the Museum. A "museum" requirement was familiarity with western curatorial procedures. I speculate that Nuu-chah-nulth requirements included membership in a chiefly family and good standing with the elected authority. The solution was to assign "curatorial" production to the Museum and "curatorial" authority to a high status member of the NTC executive. [Nelson Keithlah, the NTC co-chair responsible for culture, was identified as the authority the Museum could go to on matters of storyline content and structure.]
>
> Drawing on the work of Yvonne Marshall, it can be suggested that the protocol addressed the reality of current Nuu-chah-nulth polity. The direction given by the protocol sought to mediate between the sovereignty of the constituent Nations and the alliance represented by the NTC as well as the tension between elected and hereditary authority.

**25.XV. Julia Harrison. 2005. "What Matters: Seeing the Museum Differently."** *Museum Anthropology* 28, 2: 38.

"There was one element of the *HuupuK$^w$anum · Tupaat* exhibition that everyone seemed to want to comment on in their interviews with me: the exhibition's opening day," observed Harrison (2005b, 38). She stressed the Nuu-chah-nulth memories of the day-long (almost night-long too) ceremonies that opened the exhibition because they were one of the most important parts of the whole collaborative process. Collaboration typically privileges process over product and performance over installation. The emphasis reveals the continuing importance of museums as symbolically important spaces (C. Duncan 1991; Phillips 2003, 161) and the impossibility of separating museum objects from cultural performance in the present.

In its planning, the museum staff conceptualized the festivities as it did similar events, beginning with a carefully scripted plan and a precise schedule for the order in which the entire event would unfold. The Nuu-chah-nulth had other ideas. All Nuu-chah-nulth First Nations chiefs had been invited, and every one of them came – which in itself was an exciting thing for the Nuu-chah-nulth (and some museum staff as well). But the chiefs were not there to be passive participants in the museum's scripted program. They were there to dance their dances, to sing their songs, and to give their gifts. At any Nuu-chah-nulth celebratory gathering, such as a potlatch, maybe three or four chiefs perform, but on this day fourteen were to be heard from. As one Nuu-chah-nulth woman told me nearly two years after the momentous day, "they all limited themselves to a few dances. They had to, or we would still be sitting there now!" Others noted that they had never known an occasion when the Nuu-chah-nulth chiefs had gathered together in one place, to perform songs and dances. Some speculated that one would have to go back to the time before Captain Cook for such an event to have happened.

**TREATIES**

**25.XVI. Canada, British Columbia, and Nisga'a Nation. 1998. *Nisga'a Final Agreement.*** Ottawa: Government of Canada, Federal Treaty Negotiations Office; Victoria: Government of British Columbia; New Aiyansh: Nisga'a Nation, 223-29. Library and Archives Canada/Canada, Nisga'a final agreement/ Amicus 20259545/Vol. 1, Chapter 17, 223-29. © Government of Canada, Province of British Columbia, and Nisga'a Nation. Reproduced with the permission of the Minister of Public Works and Government Services Canada. Reprinted with the permission of the Province of British Columbia. Reprinted with the permission of the Nisga'a Nation. All rights reserved.

The Nisga'a Treaty was the first modern treaty signed in British Columbia, but today there are over forty tables working in a formalized six-state treaty negotiation process in British Columbia. Agreements in principle contain culture and heritage chapters outlining general terms for sharing and possible transfer of artifacts from the RBCM (the provincial collection) and the Canadian Museum of Civilization and Parks Canada (the federal collections). Five of the Nuu-chah-nulth nations, negotiating together under the name Maa-nulth, have already achieved a final agreement that awaits ratification at this writing. Another Nuu-chah-nulth nation, the Tla-o-qui-aht, is negotiating a treaty separately. The RBCM works closely with the Ministry of Aboriginal Relations and Reconciliation on the culture and heritage chapters of the treaties as they relate to the RBCM. Our completed negotiations for the transfer of Maa-nulth artifacts, and current talks with the Tla-o-qui-aht, have benefited greatly from the experience of doing *HuupuK<sup>w</sup>anum · Tupaat*, as was the Nuu-chah-nulth strategy all along.

The Nuu-chah-nulth nations are familiar with the RBCM's collections from their territories and with museum staff and practices. The museum knows many of the Nuu-chah-nulth treaty negotiators and has a greatly enhanced understanding of their histories, traditions, families, cultural objects, and concerns.

Agreements in principle and final agreements include lists of objects to be transferred to the First Nation and objects that will be retained by the museum, along with a legal structure for the transfer of ownership and physical repatriation. They also include provisions for custodial agreements that codify a new, formal, collaborative relationship between the museums and a First Nation through treaty. Following is the section of the *Nisga'a Final Agreement* culture and heritage chapter (Chapter 17) that pertains to custodial agreements.

CHAPTER 17: CULTURAL ARTIFACTS AND HERITAGE

31. From time to time, at the request of the Nisga'a Nation or British Columbia, the Nisga'a Nation and British Columbia will negotiate and attempt to reach custodial agreements in respect of the Nisga'a artifacts listed in Appendix L-4.

32. Custodial agreements under paragraph 31 will:
    a)  respect Nisga'a laws and practices relating to Nisga'a artifacts; and
    b)  comply with federal and provincial laws of general application, and the statutory mandate of the Royal British Columbia Museum.

33. Custodial agreements under paragraph 31 may set out:
    a)  conditions of maintenance, storage, and handling of the Nisga'a artifacts;
    b)  conditions of access to and use, including study, display, and reproduction, of the Nisga'a artifacts and associated records by the public, researchers, and scholars;
    c)  provisions for incorporating new information into catalogue records and displays of the Nisga'a artifacts; and
    d)  conditions under which Nisga'a artifacts may be permanently removed from the collection of the Royal British Columbia Museum.

34. The Nisga'a Nation and British Columbia may negotiate agreements that:
    a)  establish processes for lending Nisga'a artifacts;
    b)  provide for replication of Nisga'a artifacts;
    c)  provide for professional and technical training for Nisga'a citizens in museum skills and conservation expertise;
    d)  provide for enhancing public knowledge about the Nisga'a Nation through the participation of Nisga'a citizens in public programs and activities at the Royal British Columbia Museum; and
    e)  provide for other matters.

*ACCESS TO OTHER COLLECTIONS*

35. From time to time, at the request of the Nisga'a Nation, Canada and British
    Columbia will use reasonable efforts to facilitate the Nisga'a Nation's access to
    Nisga'a artifacts and human remains of Nisga'a ancestry that are held in other
    public and private collections.

## THE NITTY-GRITTY: A FEW LOGISTICS – MODES

**25.XVII. Anthony A. Shelton. 2008. "Reply: The Curator as Witness."** *Museum Management and Curatorship* 23, 3: 226. Taylor & Francis Ltd. http://www.informaworld.com. Reprinted by permission of the publisher.

A predominant interest of the "new museology" and the academic focus on mu-
seums as subjects for cultural critique is public dissection of collaborative pro-
jects and their difficulties. Anthony A. Shelton, director of the MOA, for example,
is interested in the "relationship between community and critical curatorial ex-
hibition strategies [i.e., performance art and installations by First Nations artists
such as Rebecca Belmore and James Luna] that [he sees] as a prologue for wider
discussion on the relationship between collaborative and critical museologies
themselves."

In Canada, the USA, New Zealand and Australia, the move to democratize museums
and acknowledge the right of indigenous people to represent themselves has been
accompanied by the necessary and reasonable corollary that they be given the oppor-
tunity to translate their ideas into palpable practices. This has been achieved through
a number of curatorial strategies that are broadly expressed under the rubric of col-
laboration. Collaboration in the museological context remains ill-defined. Ruth Phillips
distinguished two principal variants, which she calls the community and the multiple-
voice models. Each of these, I would suggest, have particular modalities. For example,
the community model can be pursued through a dialogical exchange between com-
munity members and curatorial or other voices, so culture itself manifests itself as an
active and generative process. Alternatively, curators may relinquish their tradition-
ally held intellectual and critical responsibilities in favor of fulfilling a facilitative role.
Either of these modalities can be pursued in the context of agreeing that the commun-
ity either alone defines the research project and agenda (participant action research),
or that it is fixed cooperatively between curator and community-based researcher/s.
Or, less acceptably, that it is devised entirely from outside the community. Last, there
is the ethnobiographical approach, a well-established method in American collabora-
tive ethnography, in which history, or a culture, or cultural facet is explicated through

a particular individual. Each of these approaches provides a specific lens, with its own epistemological, ideological and ethical effect, through which cultural, social and political representations can be mediated.

Precision is required when defining what we mean by collaborative museology, if it is to be sustained as an essential strategy for decolonizing museums and heritage sites, and not merely to represent the simple replacement of one orthodoxy by another.

### THE NITTY-GRITTY: A FEW LOGISTICS - METHODS

**25.XVIII. Andrea Laforet. 2008. "'We Are Still Here!' Consultation and Collaboration in the Development of the First Peoples' Hall at the Canadian Museum of Civilization."** In *The Culture of the North Pacific Region: Museum and Indigenous Culture. Proceedings of the 22nd International Abashiri Symposium.* Hokkaido: National Museum of Ethnology, 16, 17.

The planning process for the Canadian Museum of Civilization's First Peoples' Hall included a First Nations curatorial committee of many voices, and the completed exhibition is, according to Ruth B. Phillips's typology (2006, 77), an example of a multivocal exhibit model. The formalized "Principles for the Development of the First Peoples' Hall" (Canadian Museum of Civilization 1998) began with the preamble "we are a group of people of diverse backgrounds, both Native and non-Native, working toward a common goal. We contribute to the discussion on an equivalent footing, always recognizing the particular expertise, knowledge and insights of each member." Andrea Laforet, then director of ethnology and cultural studies at the Canadian Museum of Civilization, was the principal staff member on the First Peoples' Hall project. She revealed that putting these principles into practice in the exhibition was not as straightforward as the typological model might suggest.

CHALLENGES, AUTHORITY, EFFICIENCY AND POWER

Our work on the First Peoples' Hall shed light on both the underlying principles of collaboration and the character of the museum as an institution, particularly where the concepts of authority, efficiency and power were concerned.

*Authority:* The nature of authority in decision-making is central to collaboration. In the course of the first year of its work the committee developed an ethos of collaboration that emphasized inclusive and non-hierarchical decision-making, with decisions based as much as possible on consensus. However, as the planning of the First Peoples' Hall went forward, it highlighted features of the museum's organization and operation that depended on hierarchy and limits to inclusiveness in decision-making. These elements posed unforeseen limits to the scope of the collaboration.

During the first two years of planning the committee operated with a relatively flat organizational structure, with curators and consultants having an equal voice in decisions, and consensus as the ideal objective. In the work of the consultative committee the identity of the participants was important and constantly recognized. Budgets and time frames were part of the discussion, but the role of "management" was implicit in the co-ordinators' role and their authority to proceed with certain actions was drawn from the members. However, as the exhibit moved definitively into the implementation phase, the museum's concept of the exhibit development team became very important. In exhibition teams people from different specialized departments come together. The concept of management of time, money and people is given primary consideration. In speaking of the end result, the individual identity of participants is discounted in favour of the team. The differences between the committee's practice and the practices of the institution became very apparent and somewhat difficult to negotiate.

*Efficiency:* The collaborative process supports a concept of efficiency based on consensus among a wide group of people with differing perspectives. The initial First Peoples' Hall Committee was very large from the Museum's point of view; at times 35 people attended meetings. Like other classically managed organizations, the Museum subscribes to a concept of efficiency that holds that as long as the principal stakeholders are represented the fewer the people involved in any one action or decision, the better the outcome in terms of time and money.

As the project moved from the initial planning stage to the development and implementation of a specific storyline, strong differences of opinion emerged within the committee as to the continuing role of collaboration. Some members, both internal and external, felt that the committee had a strong role to play in this phase, while others believed that the development of the actual content was best carried out by a few people internal to the museum. A smaller storyline committee was developed from the large committee, and eventually this became the *de facto* consultation committee. A difficult moment came when some people who had been regular and committed contributors, both consultants and curators, found themselves no longer invited to every meeting.

Although this was partly redressed in a later phase, another difficult moment came in the transition from the implementation phase, when adjustments were still possible, to closure. At this point, no more changes could be generated through discussion. Any issues that were unresolved had to remain unresolved. Although this is a feature of the development of every exhibition, the narrative that underlay the collaborative process had not included it, and it was very hard for members of the committee without prior exhibit experience to accept.

*Power:* The negotiation of these often conflicting ideas and requirements led to significant concerns on the part of both curators and consultants about access to the decision-making process, access to one another, and the scope to carry out their roles. This concern was heightened by the fact that, as the exhibit developed, it became clear that at different moments power was localized in different sectors of the museum: in the committee; in the office of physical plant, where mechanical systems were concerned; in the office of the comptroller, when additional money was required. None of these intra-museum offices were part of the committee and, with the exception of design, most operated without reference to curatorial control.

Our awareness of these issues grew with the exhibit, and during the last two and a half years of its development, we worked toward balancing the museum's concept of the implementation team with a concept of curatorial ensemble, that enabled people with a range of very particular specialties and knowledge, both external committee members and curatorial staff, to work together in a way that highlighted both coherent outcome and individual identity. The curators continued to work with the committee members outside the museum through direct meetings, teleconferences and email.

### THE NITTY-GRITTY: A FEW LOGISTICS – MEANINGS

**25.XIX. 'Nɫuut'iksa Ɫagigyedm Ts'msyeen: Treasures of the Tsimshian from the Dundas Collection. 2007.** Exhibit text.

The term "multivocal" as applied to a museum exhibit points to the issue of translation that is both the process and the product of a collaborative exhibit. But every collaborative exhibit will probably have some text on the wall that is not readily translatable. *'Nɫuut'iksa Ɫagigyedm Ts'msyeen: Treasures of the Tsimshian from the Dundas Collection* was a 2007 partnership among the RBCM, Museum of Northern BC, and Allied Tribes of Lax Kw'Alaams and Metlakatla. The impetus behind *'Nɫuut'iksa Ɫagigyedm Ts'msyeen* was the sale of the so-called Dundas Collection at Sotheby's in 2006 and the purchase of the majority of objects by Canadian collectors. The objects had been in Britain since they were acquired by Robert J. Dundas, a Scottish clergyman who toured the BC coast in 1863. Many had been purchased at the Christian village of Metlakatla, which had been founded the year before by Tsimshian people from Lax Kw'Alaams and the missionary William Duncan.[30] The exhibit wall and label texts outlined the history of the collection and the cultural context of the objects and were based on interviews as well as ethnographic sources. From the point of view of the Allied Tribes of Lax Kw'Alaams and Metlakatla, a highly significant wall text for the exhibition was a list of the hereditary chiefs and their houses. For non-Tsimshian viewers, this was likely obscure, perhaps unintelligible, information. But, like

the Tsimshian-language title, it was a key part of the message, expressing the continuation of traditions and identity as well as the authority of the Tsimshian people as collaborators and partners in the exhibition.

CHIEFS AND HOUSES OF THE NINE TSIMSHIAN TRIBES OF LAX KW'ALAAMS AND METLAKATLA

| | | |
|---|---|---|
| Gitnaxangiik | John Alexcee (*Wiilaan*) | House of Wa'si'bax/ Liyaa'mlaxha |
| | Garry Reece (*Alamlaxha*) | House of Wiiseeks |
| Gispaxloats | Wayne Ryan (*Xy'uup*) | House of Xy'uup |
| | Marietta Helin (*Di'iks*) | House of Nismootk |
| | Wilfred Sankey (*Xpi'lk*) | House of Nismasgaws |
| | Jean Ryan (*Wiixsgiigmlaxwaap*) | House of Xy'uup |
| Gitsiis | Lawrence Helin (*Nisyaganaat*) | House of Nisyaganaat |
| | Terrance Green (*Moksgmban*) | House of Gwishayaax |
| Gitnadoiks | Ernest Green (*Sats'aan*) | House of Sats'aan |
| | Eric Green (*Nisgwilb'oo*) | House of Sats'aan |
| Gitandoh | Jack White (*Wiigaax*) | House of Gistaaku/Gilasgamgan |
| | Rick Latimer | House of Gistaaku/Gilasgamgan |
| | Marge Latimer (*Gitgitgmlaxsiik*) | House of Gistaaku/Gilasgamgan |
| Gilutzau | Merle Alexcee (*Ha'lit'aamhayetsk*) | House of Nisłgumiik |
| | Ed Alexcee (*'Nisp 'iins*) | House of Nisłgumiik |
| Gitwilgiots | Marvin Wesley (*Ts'maaymban*) | House of Saxsa'axt/Ligiutwaatk and/or Wuts'iint |
| | James Bryant (*Gilax'aks*) | House of Gilax'aks |
| | Murray Smith (*Algmxaa*) | House of Algmxaa |
| Gitzaxłaał | Arnold Brooks (*Nisho'ot*) | House of Nisho'ot |
| Gitlan | Randy Dudoward | House of Nislaganoos |

NOTES

1 Museums have also been positioned as antithetical to the anthropological perspective in general. The keynote address by Frank A. Talbot, director of the National Museum of Natural History, Smithsonian Institution, at the International Conference on Anthropology and the Museum (Taiwan, 1992) was titled "Anthropology and the Museum: Cultures in Conflict," for example.

2 In a well-known example, Franz Boas and George Hunt set up and photographed a demonstration of cedar bark spinning to serve as a visual model for an exhibit at the American Museum of Natural History (Oregon C. Hastings photograph, 1894, AMNH 11604). See Jonaitis (1988, 153).

3 Recent examinations of these complex relationships that offer more nuanced understandings of collaborations between individual people involved in late-nineteenth- and early-twentieth-century anthropological documentation include Arima (2000a); Arima, Klokeid, and Robinson (2000); Anderson and Halpin (2000); J. Berman (1996); Glass (2006a); Jacknis (1991, 2002a); Jonaitis (1992); Thompson (2007).

4 Michael Ames, then director of the Museum of Anthropology at the University of British Columbia, wrote extensively and passionately on strategies and rationales for engaging First Nations people and communities with his museum (see M.M. Ames 1986, 1990, 1992a, 1994, 1999). Paradoxically, Ames's writings have contributed to the predominant perspective on and codification of the history of collaboration. His case studies and view of collaboration were focused primarily, if not exclusively, on his own institution. There is a comparative paucity of accessible information about programs and exhibits of other museums, particularly those outside university settings.

5 Haas cites Ames (1992a), among others, in support of this statement.

6 The volume of comment on the Task Force on Museums and First Peoples indicates its practical – and symbolic – relevance to museums and First Nations studies in Canada. This is only a partial list of the commentary: Bell (1992); Carter (1992); J. Harrison (1988, 1992a, 1993); Harrison, Trigger, and Ames (1988); Hill, Erasmus, and Penney (1992); Tom Hill (1993); A.L. Jones (1993); Nicks (1992, 1995); Phillips (1990); Trigger (1988); V.M.L. Vogel (1990); Wilson (1992).

7 This is the case elsewhere too. In her response to Jonathan Haas's (1996) article on museums and anthropology, Nancy Oestreich Lurie (1996, S15-16) of the Milwaukee Public Museum wrote that, "contrary to Haas's perceptions and whatever the past practices at the Field Museum where he is employed, there are old and widespread traditions of open access to storage/study collection to Indian visitors, who sometimes still turn to museums as safe havens for their cherished heirlooms. Even fully collegial consultation and cooperation with Indian people in the creation of exhibits is much more widespread than Haas's single example would suggest ... and can be documented as early as 1916 in Samuel A. Barrett's work with the Washoe and Paiute."

8 Under the terms of the *Nisga'a Final Agreement,* the RBCM continued to own and store the Nisga'a objects until they were physically moved to the location of the Nisga'a Lisims Government's choosing. The transfer took place with great ceremony on 15 September 2010 at the site of the new Nisga'a Museum at Laxgalts'ap (Greenville). The Nisga'a Museum / Hli Goothl Wilp Adoks Nisga'a (Heart of the Nisga'a House Crests) celebrated its formal opening on 11 May 2011.

9 Treaties make us view the objects differently as well. For example, the idea of a Nuu-chah-nulth First Nation as a single geographic and cultural entity has been replaced by political groupings, which may create conflicting interests in the general Nuu-chah-nulth inventory. Thus, relationships between the RBCM and Nuu-chah-nulth First Nations continue in a new context of treaty making, a political process that has its own research agendas and needs.

10 Macnair was curatorial consultant for *Chiefly Feasts* while employed as curator of ethnology at the RBCM and for *Raven Travelling* and *Listening to Our Ancestors* after his retirement from the museum. He has been an influential figure in the field of collaboration and information

sharing among museums, First Nations individuals, and First Nations communities in British Columbia.

11 Analysis of the various failures and successes of projects is, of course, a standard part of the museum process. But it is important to recognize that, unlike academic publications, which are the responsibility of a single autonomous author or a small number of authors, museum projects are communal responsibilities directed by an executive body, and any failures on the part of museum staff or First Nations community members are internal matters made public at the discretion of the executives involved.

12 Phillips (2003, 157) dated the emergence of collaborative exhibits to the 1990s.

13 This research was for my master's thesis at York University in Toronto, not for a doctoral dissertation as reported by Phillips (2003, 157).

14 Brown, a Heiltsuk band member, is a curator at the MOA, but her role in the exhibition was not formally part of her work there, although the UBC museum was a venue. The RBCM supported my own involvement in the exhibition.

15 The research was for my master's thesis from York University in Toronto, a study of the R.W. Large collection at the Royal Ontario Museum. The Reverend Dr. Richard W. Large, a Methodist missionary and doctor, lived at Bella Bella from December 1898 to December 1910. His collection is unusually well documented in that the names of makers and sources of the objects were recorded. In my thesis, I was able to expand on this kind of specific and personal information.

16 Phillips did not comment on the installation at the MOA in 2002. Institutionally, as director of the MOA at the time, Phillips had the supervisory role for *Káx̱ḷáya Ǧvíḷás* there, although she did not participate in the installation.

17 This evaluation was not based on any exit survey or other data from the ROM's exhibit department but seems to have been a subjective impression of ROM curatorial staff.

18 First Nations have involved themselves with anthropologists who would advocate for Indigenous rights (e.g., Franz Boas, who spoke out against the potlatch ban, and James Teit, who helped with land-claims delegations). Anthropologists continue to be advocates, often now as paid consultants to First Nations educational projects, cultural centres, businesses, and treaty offices.

19 For an overview of the policy in the context of RBCM governance structures, see R.K. Paterson (2007). For a discussion of another Canadian museum's policies and practices reflecting task force recommendations, see Conaty and Janes (1997).

20 The government of British Columbia created the BC Provincial Museum of Natural History and Anthropology in 1886. It became the Royal BC Museum in 1987.

21 Although most of the authentic carvings in Thunderbird Park were well documented for the time (they were purchased directly from First Nations owners in their communities by Charles F. Newcombe, who was careful to record information about his acquisitions that would be useful to museums), there has never been any indication of these interactions or any interpretive signage in the park. In-depth information about the carvings in Thunderbird Park through all its incarnations over the years can be found in the RBCM's (2006) online exhibit *Thunderbird Park: Place of Cultural Sharing*.

22 Mungo Martin, a resident of Tsax̱is (Fort Rupert), came from the University of British Columbia, where he had been hired to work on a totem pole restoration project. Martin

brought Aboriginal knowledge and a desire to share it with museum staff and visitors to the university as well as connections with individuals in Kwakwa̲ka̲'wakw communities from whom the nascent UBC museum was able, with his help, to purchase objects for its developing collection (Glass 2006a, 2006c; Hawker 2003, 127-35; A. Hawthorn 1993).

23  For more information about the building of Wawadit'ła, the Mungo Martin House in Thunderbird Park, see Jacknis (1990) and Royal BC Museum (2006). Ronald W. Hawker (2003, 135-42) and Aaron Glass (2006c) also provide insightful critiques.

24  The *Annual Report* for 1953 (B24) noted that more apprentice carvers were needed: "It is now apparent that on its present scale the programme can support only Mungo Martin and one younger apprentice. An original intention of the programme was to include a school for totem-carving to produce several skilled carvers for the future. Suitable young men are now available, but there are no funds to employ them."

25  Mungo Martin presented items of his regalia to the BC Provincial Museum in 1960 in memory of his son, David Martin. His grandson, Chief Peter Knox, continues to have cultural control over the use of Wawadit'ła and in 2003 celebrated the fiftieth anniversary of the opening of the house with a two-day event based on Mungo Martin's potlatch of 1953.

26  The Skeena River project was a contrast to the Ninstints pole removals of the previous year. In 1957, the Totem Pole Preservation Committee, the University of British Columbia (UBC), and the BC Provincial Museum (BCPM) organized a trip to sran gwaay 'Ilnagaay (Ninstints on Anthony Island) to remove deteriorated totem poles for preservation in Victoria and Vancouver. Wilson Duff from BCPM, Michael Kew from UBC, and the Haida artist Bill Reid were among the members of the expedition. The eleven poles removed from the site went to the MOA and the BCPM. The project was seen at the time as a sort of collaboration with the Haida because of Reid's involvement and the perceived support of the Skidegate Band, which was contacted and understood to have given the appropriate permissions. In retrospect, though, this was a collaborative project that wasn't. Hereditary owners of the poles were not consulted, and the removal of the poles is now understood not to have followed proper protocols (see Hawker 2003, 143-58). More appropriately, from a contemporary point of view, BCPM conservators worked with the Haida to remove vegetation and stabilize poles remaining at the site. Three poles that had originally gone to the Victoria museum, plus two poles from Prince Rupert that had been removed earlier, were sent to the Queen Charlotte Island Museum at Skidegate in 1975. They were all lost in a fire.

27  Hoover and Inglis (1990, 281) noted that "the divergent values of the Museum and the Frank family became clearly evident" in the 1988 public presentation of the two Sitakanim family curtains. At the event, the older curtain was mounted on an angled platform for conservation reasons. This untraditional orientation concerned the Frank family. In *HuupuK*ʷ*anum ·Tupaat*, the curtain was hung vertically beside other objects of the family's regalia. This involved considerable ingenuity and staff hours, but from the previous collaboration with the Frank family the museum administration understood the need to allocate resources so the curtain could be exhibited appropriately. Culturally appropriate conservation of First Nations material has been the subject of a number of conferences and publications, notably Clavir (2002). Because the information conveyed non-verbally in exhibits is as important as, if not more important than, the texts that accompany it, First

Nations must have input into all aspects of a project, including design and other issues of presentation.

28  For a discussion of the importance of the Nuu-chah-nulth interpreters in the exhibit galleries, see Sinclair (2001).

29  For the museum, the decision by the Nuu-chah-nulth Tribal Council not to appoint a Nuu-chah-nulth curator was unexpected because Aboriginal curatorship had been advanced as the ideal method of collaboration between First Nations and museums. In 1986, Gitksan artist and writer Doreen Jensen curated *Robes of Power: Totem Poles on Cloth*, the first exhibition at the MOA to be curated by a First Nations person and an influential precedent (Jensen and Sargent 1986a; M.M. Ames 1990). Peter J. Welsh (1996) noted that "the most visible and immediate change has been in the public area, with exhibits and public programs conceived and developed by native scholars [that] offer a first-person perspective on the interpretation of cultural objects." Curation by one or several specially appointed First Nations curators remains a valuable and important methodology in museums.

30  The exhibit protocol developed with the Allied Tribes of Lax Kw'Alaams and Metlakatla stipulated that the exhibition should open first at the Museum of Northern BC: "The collective decision to take direction from the hereditary chiefs and matriarchs of the Tsimshian was a formal acknowledgement that the cultural authority for the objects remains with the Tsimshian peoples. Once welcomed back to their land of origin among the people who created them and invested them with meaning, the objects would come alive again" (Hughes, Marsden, and Bryant 2008, 21).

## 26 | Pushing Boundaries, Defying Categories

*Aboriginal Media Production on the Northwest Coast*

The vibrant world of Aboriginal media on the Northwest Coast complicates the academic scholarship on Northwest Coast art as well as the culture area approach within the anthropology of Native North America. Writing about Aboriginal media production on the Northwest Coast is difficult because it defies the neat categorization that the phrase "Northwest Coast art" implies while also complicating the culture area approach encapsulated in the "Northwest Coast" label (see Claxton, this volume; Townsend-Gault, Chapter 27, this volume). The term "Northwest Coast" is traditionally used in reference to Indigenous nations whose homelands and traditional territories are in the coastal region from Washington State to southern Alaska. For me the term "Northwest Coast" embodies an inherent bias and is American-centric. It is only from the perspective of the United States that this coast is "northwest"; from a Canadian point of view, it is simply west, and many of the Aboriginal media-makers with whom I have worked use the term "West Coast." However, in deference to this book's engagement with the scholarship of "Northwest Coast art," I will use the term "Northwest Coast" throughout this chapter.

I am also uneasy writing about Aboriginal media production as "Northwest Coast art" precisely because the media-makers who produce it break down this category while creating their work. This is one reason I use the more inclusive term "media-maker" as opposed to "filmmaker" in order to highlight the broad range of media in which Aboriginal media producers now work. Since the advent of inexpensive digital video technology in the 1990s, the majority of Aboriginal media-makers have been working in digital video, new media, and multimedia, although a handful of artists continue to work primarily with 16mm and, rarely, 35mm film.

Additionally, I hesitate to engage in these kinds of categorization because of the issue of genre. What kind of work do Aboriginal media-makers on the Northwest Coast create? Who is their audience? Do they create work primarily for their local communities? How are those communities defined? What makes an

Aboriginal film or video Aboriginal? Is it the presence of an Aboriginal media-maker behind the camera? Do Aboriginal media have to have an Aboriginal storyline or characters? There is much debate in Indigenous media scholarship, as well as among Aboriginal media-makers, about whether Aboriginal media represent a distinctly Aboriginal aesthetic (Masayesva 1995; Singer 2001; Todd 2005; see also Claxton, this volume). Are there multiple Aboriginal aesthetics? Is this media aesthetic rooted in tribal iconography or cultural protocol? To what extent do Aboriginal media-makers reproduce Western styles of filmmaking? Or is their work the product of uniquely Indigenous visions and artistic traditions? These are precisely the questions central to discussions among Aboriginal media-makers, on the Northwest Coast and elsewhere, and are prominent themes explored in the films, videos, and media art they create.

Aboriginal media-makers in the region produce work ranging from the documentation of oral histories and language preservation to documentary films, television shows, feature films, short narratives, experimental video, new media, video installation, and performance art. This tremendous array of genres is indicative of the numerous ways in which practices of media production are embedded within Aboriginal social life on the Northwest Coast. Aboriginal media-makers on the Northwest Coast often work in other artistic expressive forms as well, such as painting, sculpture, or installation art, and it is common to find media art showing up in Aboriginal avant-garde experimental video art and performance art in Vancouver.

British Columbia has long been a centre for Aboriginal activism, and Aboriginal communities in the region have a long history of appropriating new materials into existing artistic practices. So it is no surprise that many Northwest Coast Aboriginal activists chose to take up media technology as a political tool – to tell their own stories, document local histories, and reclaim the right to represent themselves and their communities on screen – but also to reimagine the possibilities of artistic expression within Northwest Coast art traditions.

While Aboriginal media production on the Northwest Coast does not reproduce the formline or the tribal aesthetics found in carving practices or button blankets, there are themes that carry over from more "traditional" Northwest Coast art practices. Kinship, family, community, oral history, and cultural protocol are just as prominent in Aboriginal media on the Northwest Coast as they are in carving, painting, printmaking, and ritual traditions. Aboriginal media-makers on the Northwest Coast are careful to incorporate the cultural protocols that govern and regulate the production of other Northwest Coast art traditions. Protocols of respect, honouring family members and observing traditional rights of inheritance to stories, songs, and images, have been translated to the process

of Aboriginal media-making on the Northwest Coast (see Sewid-Smith, this volume; Cranmer Webster, this volume; White, this volume).

So, although I balk at the categorization of Aboriginal media-making under the paradigm of "Northwest Coast art," I believe that the work Aboriginal media-makers are producing is absolutely crucial for understanding the new directions Aboriginal artists are going as they redefine Aboriginal art, cultural identity, and the politics of representation. The stakes are too high to ignore this new artistic form simply because it defies the academic categories in which Aboriginal artistic expression has historically been analyzed.

In this introductory essay, I will provide a brief history of the shift from film representations of Northwest Coast cultures by non-Native filmmakers [26.ii, 26.iii] to the move toward collaborative projects [26.v] and finally to the rise in media production by Aboriginal media-makers on the Northwest Coast [26. iv, 26.vi, 26.vii]. I will discuss key sources that have analyzed the history and pro-duction of Aboriginal media on the Northwest Coast as well as anthropological theory framing the study of Indigenous media [26.i] and Aboriginal theoretical analyses of Aboriginal aesthetics in Aboriginal video and media art [26.viii, 26.ix]. Because Aboriginal media-making on the Northwest Coast is an emer-gent field, the literature is also new and emergent. It is difficult to highlight conventional academic sources as there is not a vast literature on the subject, and much of the cutting-edge analysis of and discussion about this media are in the form of ephemeral and hard-to-locate texts that appear in film festival catalogues, newsletters from Aboriginal organizations, websites, film descrip-tions, conference papers, and the media projects themselves. Therefore, I have included an eclectic array of sources here, drawing on traditional academic writing about film on the Northwest Coast, interviews with prominent Aborig-inal media-makers working on both sides of the US/Canadian border, and articles about Aboriginal media aesthetics and video installation art. I include several of these more "unconventional" excerpts because they are often inaccess-ible and contain some of the most engaging dialogue from Aboriginal media-makers on the subject of media on the Northwest Coast. These texts represent both Native and non-Native scholarship on the Aboriginal media of the North-west Coast, and they explore the historical and theoretical frameworks for ana-lyzing Northwest Coast Aboriginal media-making.

## EARLY FILM HISTORIES ON THE NORTHWEST COAST

Northwest Coast cultures, like other Native communities in the United States and Canada, have experienced a long history of representation, and often mis-

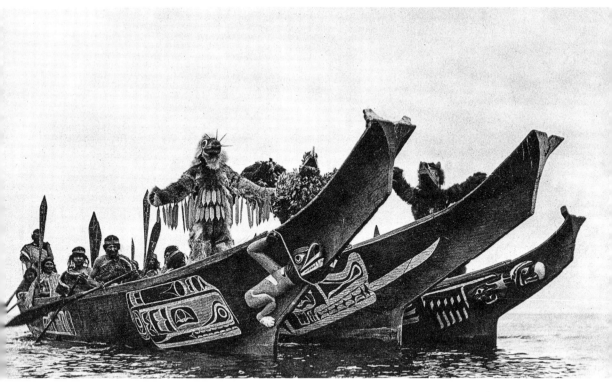

**FIGURE 26.1** A still from *In the Land of the Head Hunters,* a 1914 film about the Kwakwa̱ka'wakw (then Kwakiutl) peoples made by photographer and filmmaker Edward Curtis. In his work, Curtis sought to document the "vanishing Indian" by producing photographs and films such as this, which recorded performances and rituals associated with the potlatch system. Courtesy of the Burke Museum of Natural History and Culture, Ethnology Archives.

representation, at the hands of non-Native filmmakers. Any history of film involving Northwest Coast Native cultures must begin by examining the visual documentation of those cultures by outsiders, including anthropologists, photographers, and government officials. The myth of the "vanishing race" urgently propelled many salvage anthropologists and documentarians of the late nineteenth and early twentieth centuries to capture the vibrant cultural ways of Northwest Coast Native cultures before they "died out." Edward Curtis, photographer, filmmaker, and researcher, dedicated his career and financial resources to documenting the "vanishing Indian" throughout the United States and Canada. Curtis was also known for creating the first major film representation of Northwest Coast Native cultures in 1914, when he released *In the Land of the Head Hunters* [26.II] (see Figure 26.1). Curtis, like anthropologists and other photographers of the era, was struck by the spectacular theatricality of Northwest Coast ritual and the intricate potlatch system. He sought to capture this

*Fiction but believed to be fact*

way of life in what he termed a "photoplay" and what later scholars criticized as an overly melodramatic film, intended as fiction yet read by audiences and critics – much like Robert Flaherty's film *Nanook of the North* (1922) – as ethnographic reality. Curtis sought to erase any presence or influence of Western society in the film and wanted only "full-blood" Native actors in order to convey "authenticity."

*Da fuq?*

In the Land of the Head Hunters was not commercially successful, and eventually the remaining copies of the original prints ended up in several museum collections. The film fell into obscurity until 1973, when it was restored and re-edited by art historian Bill Holm and anthropologist George Quimby, who renamed the film and released it as *In the Land of the War Canoes*. In the process of restoring the film, Holm and Quimby collaborated with the remaining survivors who had participated in the original production and added a Kwakwala voiceover and soundtrack to the film (see the introduction to 26.II for information about a new restoration project of *In the Land of the Head Hunters* by scholars Aaron Glass and Brad Evans).

*Useful for those studying media portrayal + representation*

In her book *New Worlds from Fragments: Film, Ethnography, and the Representation of Northwest Coast Culture*, anthropologist Rosalind C. Morris (1994) adeptly analyzes both *In the Land of the Head Hunters* and the collaborative re-imagined film text *In the Land of the War Canoes*. As discussed in 26.III, this book is the seminal text on the filmic representation of Native Northwest cultures and is an essential source for anyone researching practices of representation of Northwest cultures. It chronicles the representation of Northwest Coast cultural traditions in ethnography, photography, and filmmaking by outsiders from the earliest years of the technology through the 1980s, and it provides an insightful discussion of the ways in which government organizations, such as the National Film Board of Canada and the National Museum of Man, used films about Native Northwest Coast cultures to promote national, provincial, and commercial interests in British Columbia. This text also draws important connections between films about Northwest Coast cultures and other forms of visual representation, such as museum exhibits, ethnographic writing, photography, and World's Fairs. *New Worlds from Fragments* is an invaluable resource for its analysis of the history of representation of Native Northwest Coast cultures by non-Native filmmakers as well as for its discussion of the movement toward self-representation as Native communities began to collaborate with filmmakers in the late 1970s and then took up the camera to represent their own stories in media projects throughout the 1980s.

*Govt used to promote NWC to promote national, provincial, commercial interests*

## Move toward Self-Representation

The legacy of films about Northwest Coast cultures created by non-Native directors left a mediascape littered with misrepresentations of Aboriginal life on the Northwest Coast. This is the mediascape into which Native directors sought to insert their own voices and tell their own stories by creating their own media representations. Influential Makah filmmaker Sandra Osawa discussed the impact of the legacy of misrepresentation in mainstream media in her interview in 26.VII. Osawa is a pioneer in Native American media production whose documentaries and work in public broadcasting opened up a space to articulate contemporary Native American stories to a wider public. Native American filmmakers such as Osawa had to make their own way to break into media production. One of the key differences between the United States and Canada is the lack of state funding and support for Native media in the United States in contrast to the longevity of state support for Aboriginal media production in Canada. The Canadian government has offered over forty years of support for Aboriginal media production, ranging from funding to training programs to support for a national Aboriginal broadcasting channel – the Aboriginal Peoples Television Network (APTN). The National Film Board of Canada has been an incredibly vital cultural institution supporting Aboriginal media production. Several early initiatives set up by the National Film Board of Canada, under the rubric of the Challenge for Change program, brought training in film production to Aboriginal communities in the late 1960s and 1970s, and Aboriginal filmmakers began to assert their right to represent themselves and gained access to the tools with which to do so. The aim of the Challenge for Change program was to "improve communications, create greater understanding, promote new ideas and provoke social change" (National Film Board of Canada 1969).

One of the programs in Challenge for Change was the Indian Film Crew (IFC), a collaboration between the Company of Young Canadians, a government-sponsored youth volunteer organization, the National Film Board, and the Department of Indian and Northern Affairs. The IFC operated between 1968 and 1970, producing several films addressing political and social concerns facing Aboriginal communities. The IFC trained six Aboriginal men and one Aboriginal woman in basic film production skills, beginning with a six-week general cinema course, followed by four days of practical experience on a shoot. They then had three additional months of specialized training in specific film trades (e.g., editing, cinematography, sound) before starting on their projects in the field. The aim of the IFC was to "promote social change by stimulating

dialogue among the various Indian nations living on reserves" (Carriere 1990, 5). One of the participants in the IFC program was Barbara Wilson (Haida), who later became a cultural leader in her community as well as a cultural liaison for the Gwaii Haanas National Park Reserve and Haida Heritage Site, where she continues to use video production in her cultural work. Although none of the Challenge for Change films dealt directly with Northwest Coast cultures (Morris 1994), many of the films were relevant to the struggles of Northwest Coast Aboriginal nations in highlighting Native political struggles with federal and provincial governments around land claims, Aboriginal rights, and treaty rights. The Challenge for Change programs and the Indian Film Crew were significant moments in the move toward developing Native control over self-representation in media and represented an important collaboration between non-Native directors and the Native communities and filmmakers with whom they worked under the auspices of these film training programs.

A significant film from this period is *Box of Treasures* (1983), directed by Chuck Olin, who collaborated with the Kwakwaka'wakw community leaders, including Gloria Cranmer-Webster, involved with the U'mista Cultural Centre's repatriation struggle. *Box of Treasures* marked the shift from films about Northwest Coast Native cultures made by outsiders to the more collaborative approach that developed as it became increasingly problematic to have Native communities represented by non-Native filmmakers. Additionally, this film is important because the filmmakers involved with the project trained local Kwakwaka'wakw community members in basic video production. As a result, alongside the production of *Box of Treasures*, local media-makers were conducting interviews with elders, gathering their life histories, which were archived on videotapes and housed in the U'mista Cultural Centre for community use. Pre-eminent Northwest Coast filmmaker Barb Cranmer ('Namgis) [26.VI] was initially introduced to media production through this project and went on to receive further training in Vancouver at the Chief Dan George Media Training Program at Capilano College. Cranmer has become an important figure in Aboriginal media-making on the Northwest Coast and is an invaluable documentarian, chronicling the cultural traditions, oral history, and Kwakwaka'wakw ceremonial life of Alert Bay throughout her career. Whether documenting the traditional fishing and harvesting labour required to make *t'lina*, a highly valued rendered fish grease traditionally given away at potlatches, in *T'lina: The Rendering of Wealth* (1999); examining the impact of rebuilding the bighouse after an arson in Alert Bay in *I'Tusto: To Rise Again* (2000); or tracing the cultural networks between Aboriginal nations in Canada and across the border in the United

States through the process of building and sailing a traditional canoe in *Qatuwas: People Gathering Together* (1997), Cranmer has been a vital presence in building Aboriginal media production capacity on the Northwest Coast and using this technology to capture cultural traditions and stories of her own Kwakwaka'wakw community, as well as other Northwest Coast Native communities. A tireless advocate for Aboriginal media-making, she has served on several Aboriginal media organizations, including the board of directors for APTN.

*Box of Treasures* is an important film because it represented this shift toward increasing self-determination over the production of images about Native life on the Northwest Coast. The film chronicled the activism around the repatriation of potlatch items removed from the community in 1921. The film also used the potlatch as a symbol of cultural continuity, and I argue that the theme of re-patriation can also be applied to the filmmaking process itself, as Kwakwaka'wakw people reasserted control over their images and the right to represent themselves alongside their efforts to exert control over their objects of cultural patrimony.

## ETHNOGRAPHY OF MEDIA

As Indigenous communities around the globe, including those on the Northwest Coast, began to take up media technology as a way to document cultural trad-itions, anthropologists increasingly focused on these media practices within the broader framework of the "ethnography of media," an emergent arena of an-thropological inquiry that critically examines the social processes behind the production and circulation of media (Ginsburg, Abu-Lughod, and Larkin 2002). The early 1990s saw an intense debate about the impact of the spread of Western technologies across the globe. "Cultural imperialist" models critiqued the introduction of these technologies in developing countries as a form of Western domination leading to cultural homogenization and the erasure of cultural identities (Palatella 1998; Tomlinson 1991). Anthropologists, including Faye Ginsburg (1991, 1997, 2002), Harald Prins (1997), and Terence Turner (1992, 2002), countered by studying the development of Indigenous media, in which Indigenous communities, such as Aboriginal Australians, Maori people in New Zealand, and numerous Native communities in North and South America, used computers, radio, television, and film and video to document cultural practices and tell their own stories. These scholars argued that the use of these technologies did not hasten the "disappearance" of Native cultures but in fact revitalized cultural practices and Native identities (see also Michaels 1994; Weatherford 1996).

Ginsburg's ethnography on Indigenous media has provided an invaluable framework for examining the ways in which Indigenous filmmakers use media technology not only to alter their onscreen representations but also to strengthen and revitalize cultural traditions and community ties off-screen [26.1]. Writing about the emergence of Aboriginal media in Australia, Ginsburg (1991, 94) explained that "I am concerned less with the usual focus on the formal qualities of film as text and more with the cultural *mediations* that occur through film and video works." Challenging critics of Indigenous media who implied that Indigenous communities would be corrupted by the influence of Western media technology, Ginsburg argued that, "when other forms are no longer effective, indigenous media offers a possible means – social, cultural, and political – for reproducing and transforming cultural identity among people who have experienced massive political, geographic, and economic disruption" (94). As one of the first anthropologists to study Indigenous media, Ginsburg created a foundation for the anthropology of media, encouraging scholars to attend to the "stories of the off-screen 'media worlds'" (2003, 827) that enable Indigenous media production to occur. Like the Aboriginal filmmakers in Australia with whom Ginsburg worked, Aboriginal filmmakers on the Northwest Coast use the tools of media production to strengthen and reimagine Aboriginal kinship, social, and community relationships.

NEW DIRECTIONS IN NORTHWEST COAST ABORIGINAL MEDIA

Aboriginal media-makers on the Northwest Coast have pushed the category of "Northwest Coast art" to new horizons as they use media technology to preserve Native languages (*Finding Our Talk*), explore Aboriginal art traditions and aesthetics (*Ravens and Eagles*), document Aboriginal place names and traditional territory (*Writing the Land*), reimagine the iconic totem pole through media technology (*Electronic Totem*), or vividly bring to life traditional Raven stories through animation (*Raven Tales*). Media production has played a role in community projects across reserves on the Northwest Coast, documenting Aboriginal protests and blockades, as well as in the urban centre of Vancouver, where feature films, short narratives, Northwest Coast-themed APTN television programs, and experimental videos are produced.

Vancouver, home to Canada's third-largest urban Aboriginal population (approximately forty thousand members), has become a primary focus of Aboriginal media production on the Northwest Coast and is one of the largest centres for Aboriginal media production in Canada. In my book about Vancouver's Aboriginal media world, *Sovereign Screens: Aboriginal Media on the Canadian*

*West Coast* (2013), I analyze Aboriginal media production as an expression of Aboriginal visual sovereignty on- and off-screen. This book is the first ethnography about Aboriginal media production on the West Coast and provides an in-depth discussion of its history as well as highlights the stories of the Aboriginal filmmakers who produce this inventive media. It further explores the on-screen impact of Aboriginal media but also examines the way in which media production can impact Aboriginal social relationships – fostering intergenerational ties, reconnecting urban individuals with their communities of origin, and building bridges between urban and reserve spaces.

Vancouver's vibrant Aboriginal media world is home to several APTN productions, Aboriginal production companies, Aboriginal media training programs, as well as an active Aboriginal performance art and experimental video scene. The intertribal, urban Aboriginal media world in Vancouver is tremendously diverse, with media-makers from a range of cultural backgrounds. They are just as likely to be Cree, Métis, Anishnaabe, Lakota, or Mi'kmaq as Kwakwaka'wakw, Coast Salish, Nuxalk, or Nuu-chah-nulth – one of the reasons I hesitate to define or describe Aboriginal media-making within the paradigm of "Northwest Coast art." Many media-makers have multiple tribal affiliations or identify as mixed-blood. Some identify as urban and have relatively little connection to their reserve communities, while others grew up rooted in their reserve families and communities. Still others migrate to urban Vancouver as two-spirited individuals seeking membership in both the urban Aboriginal and gay and lesbian communities. There are Aboriginal youth taking up media production to articulate their perspectives and reconnect with their cultural communities. The National Film Board of Canada's Vancouver-based Storyscapes project, in which filmmakers collaborated with three reserve communities and the urban Aboriginal community of Vancouver to tell Aboriginal histories and stories of the Greater Vancouver area, is just one example of the way that media-making has become an increasingly vital means by which intergenerational ties are created and sustained as Aboriginal youth document their elders' life histories (see Nicolson, this volume; Claxton, this volume).

Media production is a social process that involves the mobilization of many individuals to work collectively on a crew that sees a project through from start to finish. In Vancouver, and across the Northwest Coast, this involves the collaborative exchange of ideas, aesthetics, and stories between Aboriginal artists and media-makers drawing on a range of tribal identities and cultural backgrounds. It is this cultural exchange that often leads to the innovation that pushes aesthetic boundaries in the work produced by Aboriginal media-makers. Whether it is the incorporation of media technology in performance art, the

use of animation to reimagine traditional Raven stories, or the use of documentary video to represent traditional Northwest Coast carving techniques, it is evident that Aboriginal media-makers on the Northwest Coast will continue to incorporate technology in their art practices to carve out new spaces for the cultural futures of Northwest Coast Aboriginal nations (see Yahgulanaas, this volume).

**26.I.  Faye Ginsburg. 1991. "Indigenous Media: Faustian Contract or Global Village?"** *Cultural Anthropology* 6, 1: 92-94, 96, 106.

Faye Ginsburg (b. 1958) is the David B. Kriser Professor of Anthropology at New York University, where she is also the founding director of the Center for Media, Culture and History as well as the graduate program in culture and media. In addition to her groundbreaking work on social movements around abortion activism and the politics of reproduction, she has been active for over two decades in work on ethnographic film and Indigenous media and the anthropological study of media practices worldwide.

The literature on Indigenous media is deeply indebted to Ginsburg, whose research has demonstrated that media production is a tool that Indigenous communities can use to organize social action to reimagine cultural identities. Ginsburg (1991, 2002, 2003) argued that, in the multiple contexts of Aboriginal lives, filmmakers negotiate the cultural politics of national and alternative media practices. Although this excerpt is from an article analyzing Aboriginal Australian media, Ginsburg's framework attending to the use of media to strengthen Aboriginal social worlds is applicable to Aboriginal media on the Northwest Coast as well.

### FRAMING INDIGENOUS MEDIA

Over the last ten years, indigenous and minority people have been using a variety of media, including film and video, as new vehicles for internal and external communication, for self-determination, and for resistance to outside cultural domination. The new media forms they are creating are innovations in both filmic representation and social process, expressive of transformations in cultural identities in terms shaped by local and global conditions of the late 20th century. Such alternative "multicultural media" have become fashionable and more visible in the latter part of the 1980s: museum shows in the United States, the Black Film workshop sector in the United Kingdom, and a Special Broadcasting Service (SBS) in Australia are just a few examples of such work focused on productions by ethnic minorities, rather than indigenous groups ...

Efforts to produce indigenous media worldwide are generally small-scale, low budget, and locally based; because of this, their existence is politically and economically fragile, while their significance is largely invisible outside of occasional festivals or circles of specialists. There is very little written on these developments, and what exists comes mostly in the form of newsletters and reports, which are useful, but do not address directly broader theoretical questions regarding how these developments alter understandings of media, politics, and representation. It is particularly surprising that there is so little discussion of such phenomena in contemporary anthropological work, despite the fact that video cassette recorders (VCRs), video cameras, and mass media are now present in even the most remote locales. This is due in part to the theoretical foci anthropologists carry into the field that have not expanded to keep up with such changes. The lack of analysis of such media as both cultural product and social process may also be due to our own culture's enduring positivist belief that the camera provides a "window" on reality, a simple expansion of our powers of observation, as opposed to a creative tool in the service of a new signifying practice.

I want to argue that it is of particular importance, now, that these most contemporary of indigenous forms of self-representation and their creators be considered seriously. They are of critical theoretical and empirical significance for current debates in several fields regarding the politics and poetics of representation, the development of media in Third and Fourth World settings, and the expansion of ethnographic film theory and the canon associated with it ...

...

Because all this work has been particularly innovative in the filmmaking *processes* as much as product, it seems appropriate that analysis should shift as well: I am concerned less with the usual focus on the formal qualities of film as text and more with the cultural *mediations* that occur through film and video works ...

I am proposing that when other forms are no longer effective, indigenous media offers a possible means – social, cultural, and political – for reproducing and transforming cultural identity among people who have experienced massive political, geographic, and economic disruption. The capabilities of media to transcend boundaries of time, space, and even language are being used effectively to mediate, literally, historically produced social ruptures and to help construct identities that link past and present in ways appropriate to contemporary conditions.

...

Indigenous media, like the ethnic autobiographies that Fischer discusses as well as other multicultural artistic production, is a cultural process and product. It is exemplary of the construction of contemporary identity of Fourth World people in the late 20th century, in which historical and cultural ruptures are addressed, and reflections of "us" and "them" to each other are increasingly juxtaposed. In that sense, indigen-

ous media is a hybrid, and (to extend the metaphor), perhaps more vigorous and able to flower and reproduce in the altered environment that Aborigines live in today. Young Aboriginal people who are or will be entering into production are not growing up in a pristine world, untouched by dominant culture; they are juggling the multiple sets of experiences that make them contemporary Aboriginal Australians. Many in this generation want to engage in image-making that offers a face and a narrative that reflects them in the present, connects them to a history, and directs them toward a future as well.

**26.II.  Catherine Russell. 1999. *Experimental Ethnography: The Work of Film in the Age of Video.*** Durham: Duke University Press, 98–103, 113. © 1999, Duke University Press. All rights reserved. Used by permission of the publisher.

Catherine Russell (b. 1965), professor of film studies at Concordia University in Montreal, specializes in experimental documentary, avant-garde cinema, and gender studies. Her seminal book *Experimental Ethnography: The Work of Film in the Age of Video* critically examined the resonance between early ethnographic film and avant-garde cinema. The following excerpt contains an insightful critique of the primitivist impulse of Edward Curtis's film *In the Land of the Head Hunters* (1914) while also examining the implications of the collaborative restored film *In the Land of the War Canoes* (1973). *In the Land of the Head Hunters* lay a foundation for the romanticized misrepresentation of Northwest Coast cultures, providing the backdrop against which later generations of Native film-makers would speak in their own works. Anthropologist Aaron Glass and scholar Brad Evans have recently added to the scholarship on the Curtis film, thanks to their discovery and restoration of lost negatives and score for the original film. In their restoration project, Glass and Evans collaborated with Andrea Sanborn of the U'mista Cultural Society, and descendants of the original Indigenous cast, to present public screenings and performances of this influential film, further enriching an understanding of the implications of its filmic representation of Aboriginal cultures on the Northwest Coast.

"PLAYING PRIMITIVE": PERFORMANCE AND RECONSTRUCTION IN EDWARD CURTIS'S *IN THE LAND OF THE HEAD HUNTERS/WAR CANOES*

In the archives of film history, traces and fragments of disappearing films occasionally surface in "restored" versions. If experimental ethnography relies "on the use of past texts as sounding boards" for a revision of ethnographic method, the restoration and recovery of "lost" films provides a particularly rich site of analysis. In this chapter, one particular film from 1914 will be analyzed as an instance of retrospective ethno-

graphic history. *In the Land of the War Canoes* is an authentically inauthentic text, a restoration of one of the earliest ethnographic films, a film that observes very few principles of objectivity or reliable fieldwork. It is a rare example of a premodern ethnographic film that anticipates many of the elements of postmodern ethnography. To return to it as an experimental film, rather than as an anthropological film, is to trace the effects of fragmentation and historical distance on the representation of culture.

In 1914, Edward Curtis, in close collaboration with the Kwakiutl Indians on Vancouver Island, attempted to make a "photoplay," or narrative drama, that would be both entertaining and educational. An enormous failure on both counts, the film quickly disappeared. In 1973 two anthropologists, Bill Holm and George Quimby, restored the film in collaboration again with the Kwakiutl, adding a soundtrack and changing the title from Curtis's original *In the Land of the Headhunters* to *In the Land of the War Canoes*. We really have two films under consideration, the first of which, *Headhunters,* is virtually unknown and unseen. Its theatrical run was extremely brief, and by the time the film came to be restored, neglect and fire damage had destroyed entire scenes and numerous frames. My remarks on the original are somewhat hypothetical based on the fragmentary glimpses made available in the "restored" film. They are also made with a view toward a redemptive form of ethnography inspired by the virtual reappropriation of *Headhunters* by the Kwakiutl people. The 1973 version of the film features a soundtrack of Kwakiutl dialogue, chanting, and singing – none of it subtitled – as well as drumming and natural sound effects of birds and water. Made in consultation with fifty surviving cast members, the "restored film" functions as a kind of prism through which the 1914 film might be glimpsed in fragmentary form.

*War Canoes* is on one level a kind of repossession of *Headhunters* by and for those whom it was ostensibly "about." However, Holm and Quimby's restoration of the film also destroys the narrative flow of Curtis's original, replacing all of his intertitles with their own, reducing the total from forty-seven to eighteen. Brad Evans, one of the few people to have viewed Curtis's original footage, argues that the reediting of the film destroys its sense of storytelling, "leaving us much more with a 'cinema of attractions' than Curtis ever imagined." The result is a curious hybrid of a "photoplay drama" and primitive cinema, in which the anthropologists have reproduced an earlier cinematic language in the remnants of Curtis's experiments with narrativity. Although Curtis's original film may have had a narrative coherence comparable to the fiction filmmaking of the early teens, in Holm and Quimby's restoration, *War Canoes* still retains the traces of early (pre-1907) cinema ...

The 1973 version is designed to show off as much ethnographic data as possible about Kwakiutl life, and it is very much a process of "showing and telling," which

André Gaudreault has identified as the privileged narrational form of early cinema. In the absence of Curtis's dialogue titles, the native actors lose a great deal of their characterization and become objects to be seen. If for Curtis the all-native cast was a sign of the film's authenticity, in the restoration, the anthropologists have stamped the film with a different sign of authenticity. A long string of credits notes all of the institutional and museum personnel involved, as well as all the native informants and cast members. They have also privileged the canoes as the centerpiece of the film, in order to downplay the savagery implied in Curtis's original title ...

In all his various photography, film, and research activities, Curtis took it upon himself to document the native cultures that he saw as dying, and he perceived his work as an urgent task. His photography of Native Americans is consistently tinged with a romantic sense of loss, but that sense of inevitable decay is significantly absent from *Headhunters*, although to make the film, he undertook a massive recovery project of traditional Kwakiutl culture. All of the architecture, totem poles, masks, and costumes were prepared specially for the film. All signs of nonnative culture were carefully eliminated from the *mise en scène* to create the impression of an untainted Indian culture ...

The inauthenticity of the film's ethnography is not simply due to the incorporation of script, performance, and props. Curtis freely invented names and mixed elements of different rituals and ceremonies together. He spent four years preparing for the film and from his fieldwork produced one volume of his mega-opus, *The North American Indian*, on the Kwakiutl. He did make an effort to reproduce all of the masks, totem poles, canoes, and other objects of Kwakiutl life quite faithfully, and yet the requirements of the photoplay demanded an imposition of a foreign narrative form and a blatant disregard of the subtleties of Kwakiutl culture. The difference between Curtis's meticulous research and his carelessness in film production is indicative of a faith in cinematic representation as a transparency – based partially in the aesthetics of the actuality and partially in those of the new narrative realism. It was presumably enough that the Indians were played by Indians and the props were made by them for the film to be "authentic."

...

Interviewed in *Box of Treasures*, Gloria Cranmer Webster, a Kwakiutl museum curator, points to the monumental canoes in motion as the most valuable aspect of the film, which to her is otherwise "hokey." Obviously, we cannot impute readings or viewings to native audiences, and the playfulness that for me raises the film far above the hypocrisy of so much scientific and aesthetic ethnography may ultimately be just another academic argument. And yet Webster's explanation for why the Kwakiutl so eagerly took part in Curtis's film is that it was, quite simply, a lot of fun. If the film can teach us anything about postmodern ethnography, it might be in the very perversity

of the "photoplay" intertext of entertainment and the "primitive" cinema of attractions. As an antirealist discourse, it frees ethnography from the burden of authority and from the weight of a historiography of loss. *War Canoes* is a many-layered film about a vibrant, living, native community with strong ties to both its colonial and precolonial past [see Nicolson, this volume]. The film, in its many layers and fragmentary survival, is a unique example of a postmodern document of cultural memory. Instead of representing a dying culture, Curtis's film inscribes death into the reenactment of a culture whose cinematic documentation becomes a form of redemption.

**26.III. Rosalind C. Morris. 1994. "Celluloid Savages: Salvage Ethnography and the Narration of Disappearance."** In *New Worlds from Fragments: Film, Ethnography, and the Representation of Northwest Coast Cultures.* Boulder, CO: Westview Press, 43, 59-60.

Rosalind C. Morris is a professor of anthropology at Columbia University whose book *New Worlds from Fragments: Film, Ethnography, and the Representation of Northwest Coast Cultures* is a significant resource for scholars of visual anthropology and for those interested in the use of film and photography as anthropological research tools. It provides an important analysis of the role of early ethnographic films about Northwest Coast cultures in the construction of the category "Northwest Coast" as a culture area within anthropology. This text contains a chronology of the filmic representation of Native Northwest Coast cultures as well as an analysis of the themes within this corpus and a discussion of the distribution and exhibition of these works. The book concludes with an analysis of Native filmmaking and a comparison of the works created by Native filmmakers and the earlier films that reflected the visions of non-Native filmmakers rather than the perspectives of Native communities. Morris discussed the legacy of Franz Boas, both the impact of his ethnographic research in solidifying the anthropological category "Northwest Coast" and his use of filmmaking as a research tool late in his career. In the section included here, she discussed Boas's film *The Kwakiutl of British Columbia* (1930), which remained as raw footage until art historian Bill Holm edited the film in 1973.

The footage for Boas's *The Kwakiutl of British Columbia* (1930) was shot at the end of his long and prolific career, although the postproduction editing was posthumously finalized (by Bill Holm) in 1973. Without wanting to endorse Antonio Marazzi's distinction between ethnographic and anthropological film as that between the pure inscription of field-experience and the subsequently theorized narrative, we must nonetheless acknowledge the problems of authorship that accompany a film such as Boas's. In analyzing *The Kwakiutl*, I consider the film in terms of its content at the

level of the shot and theme, and devote less attention to the question of narrative structuration. In part, my inclusion of the film stems from Boas's involvement with Harlan Smith, but also from a sense that Boas's failure to edit the film himself may reveal something about his own orientation toward film as an anthropological tool. Though time may simply have run out for Boas, the footage of *The Kwakiutl* is formally and substantively so much apiece with his written work that the parallels demand serious attention. For much of Boas's written ethnography reads like the footage for the Kwakiutl: numerous sequences of detailed images strung together one after the other with only minimal overt theorization. Moreover, while he occasionally discussed anthropological uses for the footage, these did not include production of an edited "film." Finally, and perhaps most important, I include *The Kwakiutl* here because of the sheer magnitude of Boas's influence over Northwest Coast ethnography generally. One wants to know how his ethnographic sensibility may have translated itself into film and how its trajectory in that media might have differed or paralleled the tradition to which it gave rise in the written medium.

...

In the final edited version of *The Kwakiutl of British Columbia* we have a mélange of the everyday and of the spectacular. Both the mundane activities of physical survival (in the scenes of weaving, stripping bark, woodworking, etc.) and the elaborate rites of spiritual existence (the dances and shamanic ceremony) are pictured here. Although the titles label the activities, clarifying for the viewer that what might appear to be aggressive hostility is in fact play, and distinguishing among dances that only the tutored Kwakiutl dance enthusiast could recognize, they provide little in the way of contextual information. To be sure, the titles constitute an interpretive gesture, but they are merely the verbal articulation of a particular profilmic analysis and the construction of the profilmic event as a discrete and identifiable object.

When Bill Holm took up the postproduction work for "*The Kwakiutl*," it was necessary not only that he consult Boas's notes and correspondence about the film but also that he call upon Kwakiutl expertise, seeking out the surviving actors from the film and asking them to describe the scenes and the ceremonies of which they were a part ...

It may be said that the constituent sequences of *The Kwakiutl of British Columbia* are all concerned with the "how" of existence in this Northwest Coast culture; they are descriptive or, rather, demonstrative. But to a certain extent, its imagery is free-floating and without context, so that we do not know for what reasons a cannibal dance would be performed or what powers the Shaman is invoking when she carries out her curing ceremony. We cannot be sure when adults might have joined the children in the leisurely pursuit of play, nor what provoked the boasting antics of the two Chiefs. The intentionality of these acts is entirely absent. Taken as a whole, the footage

provides a powerful demonstration of the degree to which photographic and filmic imagery arrests social process, stripping objects from their systems of meaning in the moment of their inscription. It presents us with what John Berger and Jean Mohr have described as the "shock of discontinuity," the sense not only that the image is distanced from its supposed referent but also that what it signifies has been loosened from its moorings in the historical world.

In the absence of Native exegesis, a different kind of interpretation becomes both possible and necessary. From the film's fragmented totality, its rough-hewn montage, we might construct a relatively coherent "picture" of the Kwakiutl or, rather, of the Kwakiutl as Boas imagined them.

**26.IV. Chief Dan George. 1967. "Lament for Confederation."** Canada History website (Canada History Society). http://www.canadahistory.com/sections/documents/Native/docs-chiefdangeorge. htm and http://www.burrardband.com/.

The speech given by Chief Dan George (Tsleil-Waututh) (1899-1981) at Vancouver's celebration of the Canadian centennial in 1967 represented a critical moment in Aboriginal activism and media production. George, an acclaimed actor, was familiar with the misrepresentation of Aboriginal people in Hollywood films and mainstream Canadian media. Asked to give a speech that celebrated the hundredth anniversary of Canadian Confederation, George seized the opportunity to use his position to remind the audience of the oppression that Aboriginal people experienced under the yoke of Canadian colonization and assimilation policies. At the same time, his speech served as a call to Aboriginal people to take an active stance, to take up the "white man's tools" and use them for their own purposes. After this speech, several Aboriginal media training programs developed in Vancouver and across the Northwest Coast, and Aboriginal filmmakers credited this speech with inspiring Aboriginal people to take up the camera to tell their own stories. George's influence on Aboriginal filmmaking on the Northwest Coast was also explored in the documentary about his life, *Today Is a Good Day: Remembering Chief Dan George* (1998), directed by Loretta Todd (Cree/Métis).

How long have I known you, oh Canada? A hundred years? Yes, a hundred years. And many many *seelanum* [lunar months] more. And today, when you celebrate your hundred years, oh Canada, I am sad for all the Indian people throughout the land.

For I have known you when your forests were mine; when they gave me my meat and my clothing. I have known you in your streams and rivers where your fish flashed and danced in the sun, where the waters said come, come and eat of my abundance. I

have known you in the freedom of your winds. And my spirit, like the winds, once roamed your good lands.

But in the long hundred years since the white man came, I have seen my freedom disappear like the salmon going mysteriously out to sea. The white man's strange customs which I could not understand pressed down upon me until I could no longer breathe.

When I fought to protect my land and my home, I was called a savage. When I neither understood nor welcomed this way of life, I was called lazy. When I tried to rule my people, I was stripped of my authority.

My nation was ignored in your history textbooks – they were little more important in the history of Canada than the buffalo that ranged the plains. I was ridiculed in your plays and motion pictures, when I drank your fire water, I got drunk – very, very drunk. And I forgot.

Oh Canada, how can I celebrate with you this Centenary, this hundred years? Shall I thank you for the reserves that are left to me of my beautiful forests? For the canned fish of my rivers? For the loss of my pride and authority, even among my own people? For the lack of my will to fight back? No! I must forget what's past and gone.

Oh God in Heaven! Give me back the courage of the olden Chiefs. Let me wrestle with my surroundings. Let me again, as in the days of old, dominate my environment. Let me humbly accept this new culture and through it rise up and go on.

Oh God! Like the Thunderbird of old I shall rise again out of the sea; I shall grab the instruments of the white man's success – his education, his skills, and with these new tools I shall build my race into the proudest segment of your society.

Before I follow the great Chiefs who have gone before us, oh Canada, I shall see these things come to pass. I shall see our young braves and our chiefs sitting in the houses of law and government, ruling and being ruled by the knowledge and freedom of our great land.

So shall we shatter the barriers of our isolation. So shall the next hundred years be the greatest in the proud history of our tribes and nations.

**26.V. Rosalind C. Morris. 1994. "Remembering: The Narratives of Renewal."** In *New Worlds from Fragments: Film, Ethnography, and the Representation of Northwest Coast Cultures.* Boulder, CO: Westview Press, 118, 120, 124, 133-34, 136.

This excerpt from *New Worlds from Fragments* focuses on the film *Box of Treasures,* produced by the U'mista Cultural Centre. This film chronicled the struggle of the Kwakwa̲ka'wakw community of Alert Bay to have their potlatch items repatriated as well as the building of the cultural centre to house the potlatch objects. This excerpt is included for Morris's analysis of the shift toward

Native self-representation in filmmaking and for her comparison of the subject of *Box of Treasures* to the emphasis on potlatch, ritual, and artistic objects found in earlier ethnographic films by non-Native filmmakers.

Native filmmaking developed well beyond the context of the NFB and the "Challenge for Change" program, both in Canada generally and on the Northwest Coast in particular. With Band funds and federal assistance, filmmakers and Native advisers have taken on the task of representing coastal cultures anew. Among the more active of these have been the Kwakiutl (Kwakwaka'wakw) of Alert Bay, the Nishga, and the Git'ksan and Wet'suewet'en Tribal Councils. The Kwakiutl of Alert Bay – under the leadership of Gloria Cranmer-Webster, who is curator of the Band's museum (the U'mista Cultural Center) – have produced two related films, *Potlatch … a strict law bids us dance* and *Box of Treasures*. The Nishga have been the subjects of four films – *This Land* (1968), *This Was the Time* (1970), *The Nishga: Guardians of a Sacred Valley* (1977), and *The Nishgas: A Struggle for Survival* (1977) – all of which deal with land-claim disputes. The Git'ksan have more recently released their own production, *On Native Land* (1986), and have been the subject of several others. Though cast in ethnographically specific terms, all of these films have a common political and thematic project: the narration of Band struggles with provincial and federal legislative and judiciary systems. All of them provide a justificatory account by which the particular legal claims being made are grounded in an invocation of tradition and origins. And the origins invoked in the films then become the moral basis for both a rejection of externally imposed historical change and a demand for restitution.

…

Much of the recent ethnographic filmmaking on the Northwest Coast has been undertaken in conjunction with Native museums such as the U'mista Cultural Center at Alert Bay. Indeed, *Box of Treasures* chronicles the establishment (in the late 1970s) of the Kwakiutl Museum, which was mandated by the federal government as part of the agreement to return artifacts from the National Museum in Ottawa.

…

*Box of Treasures* attests to the possibilities of alternative taxonomies and an alternative imagination of the time-space relationship upon which all ethnographic museology must ultimately rest. Indeed, it would not be unfair to say that the Northwest Coast Bands have led the way in the redefinition of anthropological museology.

…

*Box of Treasures* addresses this history of reification directly; from the first set of running titles onward, we are aware of the film's intention to rehabilitate the potlatch as a valid and a viable ritual practice in ongoing and changing historical circumstances. This rehabilitation takes place on two levels. The legitimation of the potlatch becomes

essential for the repatriation of potlatch artifacts while, at the same time, these very objects are construed as the prerequisites of a revitalized ritual tradition. Artifacts, from carved masks to the coppers, are themselves seen as repositories of cultural knowledge, and their repossession becomes essential for the relearning of cultural practice, especially artistic practice. Hence the emphasis on the re-creation – the absolute repetition – of design forms: "Once again artists create traditional masks and poles following designs that are centuries old." Although the situation is changing, the Kwakiutl of Alert Bay have perhaps been more vigilant in this pursuit of aesthetic continuity than have other Bands ...

In all of this, the relationship between artifacts and potlatching is crucial, as *Box of Treasures* constantly reminds its viewers. With a certain amount of pathos, this fact is acknowledged in the acts of confiscation that followed Dan Cranmer's potlatch, described idealistically in the film as the most powerful *symbol* of loss. What *Box of Treasures* points out, again and again, is that such objects are the material embodiments of vast sets of social relations: the actual objectifications of personal and social identities, power hierarchies, cognition, belief, and affect. In a language of pragmatic politics and nostalgic recollection, *Box of Treasures* recognizes the importance of the artifact "as the form of natural materials whose nature we continually experience through practices, and also as the form through which we continually experience the very particular nature of our cultural order" (D. Miller 1987:105). In this regard, the film seems to go far beyond the simplistic economism of material cultural studies, which underlay salvage ethnography and its films. Indeed, the U'mista Cultural Center seems to demand a radical rethinking of the processes of cultural objectification.

Accordingly, we might expect the film to recognize itself as an exercise in intentional self-objectification, as an artifact like any other, which materializes and evokes the particular cultural values of its makers. But *Box of Treasures* stops short of this extreme self-awareness – as it must in order to appeal to mainstream viewers. While the film clearly expresses a sense of how complex and multifaceted are cultural artifacts, the artifact as a category remains restricted to artistic and technological production, whose primary context is the potlatch. With regard to the question of film itself, *Box of Treasures* retreats into the assumption of transparency and objectivity that grounded salvage ethnographic film of the earlier eras and continues to form the basis of virtually all documentary. Neither the transparency of film nor the priority of the potlatch is questioned here. This is not surprising given the collusion of older anthropological claims to objectivity and film's claim to transparency in ethnographic film. Of particular interest, however, is the fact that the reconceptualization of artifacts did not undermine the reductionist claims about key symbols, dominant rituals, or cultural patterns. It did not lead the film's producers and directors to reject the written

accounts of salvage ethnography but, instead, allowed them to reinstitute important parts of those narratives into the new film. It is for this reason that repatriation becomes – in *Box of Treasures* but also in other films of the period – the main vehicle of a continued synecdochic reduction; the potlatch is, as the film tells us, a "link with the past," and potlatching objects (recall here that almost any commodity could be "given" in a potlatch) are the symbols of that temporarily "lost link." In many senses, then, recollection is a doubled term.

...

When *Box of Treasures* states that the potlatch was the "key to each family's identity, status and ... link with the past," it effectively repeats salvage ethnography's identification of one brief period in Kwakiutl history as the real expression of essential Kwakiutl culture. That period in which potlatching was only one among many social institutions involving feasting, dancing, and the exchanges of goods vanishes completely from contemporary filmic narratives. *Potlatch ... a strict law bids us dance* and *Box of Treasures* are extreme in the repetition of salvage ethnography's obsessive elevation of potlatching. But this time, there is a twist; this time, the potlatch is to be construed not as an index of disappearance but as a symbol of continuity.

**26.VI.** *First Nations Drum.* **2000. "Barb Cranmer: Messenger of Stories."** http://firstnationsdrum.com/2000/12/barb-cranmer-messenger-of-stories.

Barb Cranmer ('Namgis) (b. 1961) is perhaps the most well-known Northwest Coast Aboriginal filmmaker. Since the late 1980s, she has documented her Kwakwa̲ka'wakw community's history, cultural traditions, and artistic practices. Her documentaries have been screened throughout Canada and internationally, winning numerous awards. Cranmer is deeply committed to opening up a space within the Canadian mediascape to tell Aboriginal stories from Aboriginal perspectives. This excerpt of an interview with her for the Native newspaper *First Nations Drum* reveals the deep connections between her work as a filmmaker and her ties to her 'Namgis community, which has entrusted her with the responsibility to tell its stories.

"I myself am living my own history through the films that I am making," said Cranmer. "The strength, for me, in doing this work, comes from my family, comes from my community. I'm basically working in a non-native world, working and fundraising in Vancouver. The films I direct and co-produce are big-budget documentaries; when I feel I have to be strong, it is the strength of the family and the community that I come from, the community I'm representing, that allows me to carry on. That's critical. Because I have a strong sense of identity, I feel. Both sides of my family still potlatch,

still carry on the tradition that's been passed on to us ... That's what drives my work. I give voice to the community, the native community large" ...

"I have wanted to do this film [*T'lina: The Rendering of Wealth*] for at least six years," Cranmer said. "It became urgent because many of our old people were dying and important knowledge and history were close to disappearing with them. When I made a research trip with my family to Dzawadi in 1996, we witnessed a sharp decline in the eulachon run."

The tiny fish are not used commercially, but have suffered from indiscriminate overfishing as part of the industry's unwanted "by-catch" – fish that are dumped in pursuit of more saleable species. Habitat destruction from logging is also a major concern.

"It was important to do the story right now," said Cranmer. "In ten years we might not be going up there. The eulachon may be extinct."

In Kwakwaka'wakw society, the highest honour a Chief can bestow is to give away, or potlatch, the t'lina. In the t'linagila ceremony, families dance with huge carved feast spoons and bowls, symbolizing the pouring of the oil. Hundreds of bottles of t'lina are distributed to guests who have come to witness the potlatch.

"The families who travel annually to Dzawadi are strengthened by the experience," Cranmer said. "Each year brings something new. It is amazing that in these modern times our people are fortunate enough to be able to go to a place where we can still practice a traditional way of life. It is like travelling back in time as we reaffirm our connection to our traditional territory. We have discovered old houseposts, which supported many bighouses in the Dzawadi area. We can only imagine what it must have been like to live two hundred years ago in the same area.

"This film offers a rare opportunity to share these moments in our community's way of life – for the benefit of the audience today, and for future generations. I believe this film will inspire not only First Nations people, but the general public as well. This film is a tribute to our grandmothers and grandfathers. My only regret is not being able to make the trip to Dzawadi years ago, when more elders were still alive" ...

"I got right into the idea of film right away, being on the video crew at home," said Cranmer. "I knew this was something I was very interested in. With the whole idea that I was tired of seeing negative images of ourselves and I wanted to change that in some way. I wanted to make some sort of career out of it and so far I've been successful" ...

Cranmer regards her work as educational. She complains that native voices are never really heard in Canada: "It's not very often our voices get heard and when they do it is in the mainstream media, which has its own twisted take on everything. You never really hear from First Nations people in that sense" ...

"For me, film is a valuable tool, to be able to have access to this, because it reaches such a broad audience. Much more so than if it were a book. Because everyone has TV at home and can plug it into their VCR. Or they see it at a film festival or on television.

"And it was important for me to get the truth out there, from our own perspective, and do it with the respect and integrity that comes from our community. That's been a driving force, for me."

She pauses. She begins to speak. Her voice has dropped a half-tone; her delivery has slowed. Each word is enunciated clearly, precisely. She wants to be taken seriously. She is.

"For our people, it has been a constant, constant struggle to just be here on this earth. My work is based on the fact that, despite the things that have happened to our people, we are still here. All the powers that be have tried to change who we were, and who we are, and they did not succeed. And I think that is all I have to say on that. I feel strongly about that."

Barb Cranmer creates stories in film: some folk would call this an art form. She also takes care to go deeply into the background of her stories; some folk would call this history.

Cranmer insists she is neither artist or historian.

"I see myself as a kind of messenger of stories. Basically, the way I see it is that I can look at these films twenty years from now and know that I've helped in maintaining the history and the culture of our people."

**26.VII.** **Lawrence Abbott and Sandra Osawa. 1998. "Interview: Sandy Osawa."** *American Indian Quarterly* 22, 1-2: 106-8, 109, 110-11, 114-15. Courtesy of University of Nebraska Press.

Sandra Osawa (Makah) (b. 1941) is a prominent filmmaker who has been producing independent media for over three decades. Osawa was the first Native American to produce for commercial television, with a ten-part informational series on Native Americans for NBC in 1975. She has since produced numerous documentaries as well as videos for tribes, community organizations, and museums. Her works include *In the Heart of Big Mountain* (1988), *Lighting the Seventh Fire* (1995), *Pepper's Pow Wow* (1996), and *Usual and Accustomed Places* (1997), among others. Her work certainly resonates with the documentaries produced by Native filmmakers, such as Barb Cranmer, on the Northwest Coast. I include this excerpt also to acknowledge her prominent role as a mentor to other Native American filmmakers. Her pioneering work in the 1970s and 1980s paved the way for subsequent generations of Native filmmakers in the United States (Singer 2001). Her documentaries seek to overturn stereotypes of Native

Americans by focusing on contemporary voices of Native American experiences with a particular emphasis on political issues, such as treaty and fishing rights, and cultural survival. This excerpt is taken from an interview conducted by Lawrence Abbott, a scholar of Native American art. He focused on her documentary *Usual and Accustomed Places,* an examination of the political struggle for the recognition of fishing rights among Native American tribes in Washington State.

SO [Sandra Osawa]: *Usual and Accustomed Places* is similar in that it focuses on political issues. Politics affects all of us in common as a people. Even though we are separate tribes we are treated politically very much the same. In *Lighting the Seventh Fire* we tracked some of the early fishing rights cases in Wisconsin and *Usual and Accustomed Places* does the same in the Northwest. Another similarity is that we are trying to bring more of a human approach to some of these abstract issues. We've all heard about treaty rights, but often it rings like a dull thud because we don't understand that there is life, emotion, and meaning behind treaties. People have literally fought and died for treaty rights, yet few of us know the history behind them. I also want to show the similarity between the way the buffalo linked the tribes of the Plains and how salmon links the tribes of the Northwest. There have been many stories about how important the buffalo were to the Plains, but a lot of us haven't heard about how important the salmon continues to be for the cultural life of the people here in the Northwest. The film details not only the political aspects of the struggle for fishing rights, but also the importance to our cultures. As in some of the other programs we've done, I'll weave several threads together so that the film isn't simply a one-dimensional story. You see a lot of documentaries that are about current topics where there might be a protest and somebody takes some footage and comes back and does a story. I don't particularly like that kind of documentary because I try to go deeper into the issue. I think that's why it takes us a little bit more time because the research is fairly extensive, utilizing many, many resources to document the legal battles. These battles are still going on, and one thing that we're trying to present is a cycle of history. You often read that Indians began protesting in the 1960s. I hope people will find out, if they have a chance to look at these documentaries, that that is actually not true in the Northwest. The protest started very early. People were protesting about the treaties many, many years ago, realizing that they were not fair. In some cases the language barriers were very great, but the Indian people were still able to understand that in most cases there was not a fair deal. Protests began very early and in my opinion they have never stopped. They have con-

tinued for almost 150 years, from the 1850s to the present time. There has been a long and a continuing series of protests that we hope to document in *Usual and Accustomed Places.*

LA [Lawrence Abbott]: Many of your poems and films are about both cultural loss and survival. Does the theme of loss and survival run through your work?

SO: I've never met anyone who's read my poems before. That's interesting. Oh, boy. Cultural survival and loss. That's very accurate. I am interested in cultural survival. I think I am drawn to cultural stories, such as *Lighting the Seventh Fire,* where you have a strong religion, you have a strong philosophy, and you have strong people standing up for their treaty rights. I am interested in Jim Pepper for the same reason. You have a person who makes great, positive, brilliant use of his own cultural strengths, and certainly in *In the Heart of Big Mountain* you have a strong family as well as an issue of cultural survival at stake. I am also interested in the tensions, the struggle within, and the losses. I think loss is a part of cultural survival and cultural issues because we have seen so much loss. I like to look at that and reflect on that too. Sometimes I think we can't really see the positive until we see the loss, and when we see the loss, we realize what we have to fight for ...

LA: How would you describe your film aesthetic?

SO: It's really difficult to analyze your own work. I'm not quite sure how I would do that except that in each film and wherever I go, whether it's northern Wisconsin, or Arizona, or in my own area in the Northwest, land is very important – a sense of place is very important. I try to draw the viewer into that sense of place by, you might say, using the camera as kind of a highlighter, or an underliner. I like to have people pay attention to the land because that's what helps shape our identity. I think land is what helps define us, you know, our place in time, and so I try to draw attention to particular places and particular aspects of the land. I would say that that's a dominant feature in my films ...

LA: What led you to pick up a camera?

SO: That's another one I wish I knew the answer to, but I have some guesses. I was exposed to the media when I taught at what we called at the time the Clyde Warrior Institute for Native American Studies in Los Angeles. It was a summer project in the late 60s, maybe early 70s, right around then. Here we were, a lot of Native American college students, right there in the center of the film and media world. People never see college-educated Indian people, especially in

those numbers right there at UCLA, and I think that contrast of images helped
me to want to get into the media. Prior to going to L.A., I had worked for my
own tribe during the War on Poverty days, and we started a recreation program
for young people because it was a very small place and there wasn't much to do
there for kids. We started having movie nights. I tried to get some Indian films
and I couldn't really find anything. I did find some anthropological films about
Navajos set in the Southwest, but they were more educational and not very good.
I searched and searched but learned there was just nothing there for us. I began
realizing too that the whole question of self-esteem is really important. I had
written a poem about our tribe just called "The Makahs" and decided to read it
to a group of high school kids during a cultural program. I said that I have a
poem here about the Makahs. I didn't say who wrote it, but just said I would like
to read it. Then somebody, a teenager, said "Who would write a poem about
us?" That question always stuck in my mind, the fact that this person didn't
think we were the type of people who were worthy of being commented on, or
having a poem written for, or much less having a film about. I think that's be-
cause of cause and effect, that we never saw anything about ourselves anywhere
like on TV, or in movie theaters, or in newspapers. So the natural response
would be, well, we're not interesting. We're not worthy enough of being talked
about. The absence of our image was an important factor in motivating me to
do something ...

LA: You've written that "America is so in love with Indians in the past tense that
it is extremely difficult to produce programs featuring contemporary Native
Americans." How do your films bring the image of Native people into the
present?

SO: ... What I try to do is bring out images that aren't the stereotyped images that
you would expect to see. It's really more fun for me to do that and it's better for
the audience to have a more diverse viewpoint. Sometimes that's difficult because
America does have a love affair with our past. The movies have been quite effect-
ive in freezing us in time, perpetuating the idea that for us to be authentic we
must look and act and dress and speak exactly the way we were in 1492 when
the Pilgrims met us ... I hope that we can get to the point where we don't have
to be the frozen images of the past. It's really not healthy for us either to fit into
these pictures because that's what America wants. It's really quite a serious ques-
tion. It goes to the heart of our identity. America has got quite a hold and quite a
grip on our identity. It's a stranglehold at times and very destructive. There are
Native filmmakers out there, and I am not the only one, who are trying to pursue

other visions. With a little help we'll be able to go a long way in correcting some of these images of the past.

**26.VIII. Dana Claxton. 2005. "Re:Wind."** In *Transference, Tradition, Technology: Native New Media Exploring Visual and Digital Culture.* Edited by Dana Claxton, Steven Loft, Candice Hopkins, and Melanie Townsend. Banff, AB: Walter Phillips Gallery Editions, 21–24. © 2005. Used with permission.

Prominent Lakota artist and scholar Dana Claxton (b. 1959) chronicled the history of avant-garde Aboriginal video art in *Back/Flash*, an exhibit she curated at the Walter Phillips Gallery at the Banff Centre. Among the artists included in that exhibit were Vancouver-based Michael McDonald (Mi'kmaq) and Zachary Longboy (Dene). Claxton profiled their media work in this excerpt, describing several of their seminal video installation artworks and their place within the history of Aboriginal media art. I include this excerpt to highlight the diverse ways in which Aboriginal artists incorporate media into their art practice and to illuminate how Aboriginal media as practised on the Northwest Coast move beyond merely documentaries, short narratives, and television production to encompass the experimental and avant-garde.

Mike MacDonald was an early practitioner of video as art in the Aboriginal community. His work has been most aptly described as electronic shamanism. For more than twenty years MacDonald has explored the natural world. His images transcend language and take the observer to a butterfly oasis and delicate gardens of wild plants. In reflecting on his own practice, MacDonald emphasizes the delicate nature of the natural world and demonstrates how traditional Aboriginal philosophies seek understanding of all creation. Curator Scott Watson notes that Mike MacDonald's work raises awareness about the relationship between culture and nature suggesting an analogy between the colonization of Aboriginal people and the erasure of one kind of ecology for the sake of another. Watson further posits that MacDonald's work reminds us that our ways of knowing the world are at stake.

MacDonald's integration of natural beauty with video takes nature inside, while his work seamlessly moves outside through a series of native plant gardens that grow plants for medicine and food. He has created garden projects at the Walter Phillips Gallery (Banff), Presentation House Gallery (Vancouver), and the Winnipeg Art Gallery (Winnipeg) among many others. He grows rare and threatened plants in his own garden, as well as a host of butterfly-friendly plants. As writer Doug Porter has stated, MacDonald's work elegantly bridges the gap between Aboriginal and European cultural discourses relying on a sophisticated use of electronic media with only a conceptual relationship to traditional forms.

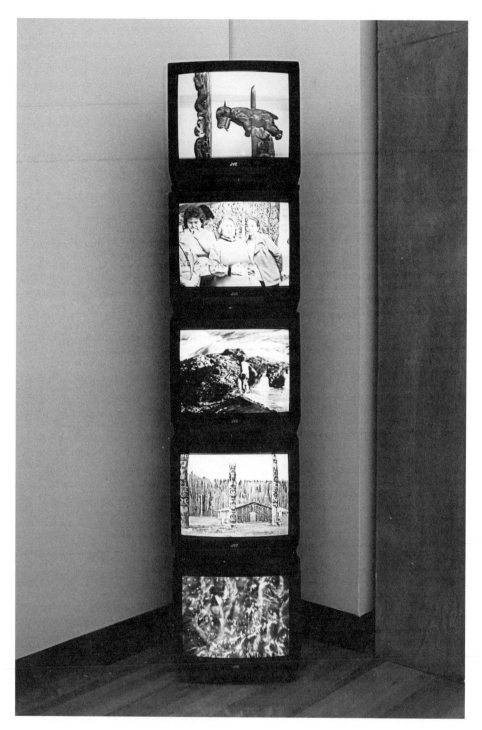

**FIGURE 26.2** Michael MacDonald, *Electronic Totem*, 1987. Many contemporary First Nations artists employ new media technologies to expand the category of Northwest Coast art into new territory, as MacDonald did in his reinterpretation of the iconic totem pole. Courtesy of the estate of Michael MacDonald/Vtape and Kamloops Art Gallery.

Among his most influential works is *Electronic Totem* (1987) [see Figure 26.2]. Comprised of five stacked television monitors, it depicts various elements of the Gitksan-Wet'suwet'en culture of Northern British Columbia – berry picking, singing, and drumming amid images of the Skeena Valley. The work can be viewed as a testament to the inherent rights that belong to the people of this region, including the land and its resources. With Aboriginal knowledge at the centre of this work, the traditions ultimately become the true protector of the land. In living with the land, the traditions embody the knowledge, the way of life.

Curator Helga Pakasaar describes MacDonald's style of video work as "contest[ing] popular notions of mass media technology as necessarily alienating, as only a false reality, rather than a potentially powerful tool for resistance and self-determination." The artist himself describes Aboriginal cultural production with the following words: "Before contact, the Aboriginal people had no word for art – no concept of it as anything separate from everyday life. Art was spoons and bowls, the handles of tools, the clothes people wore, the way they lived life."

Another media artist who incorporates video as a tool for self-determination is Zachery Longboy whose work brings a very personal experience to video making: Longboy, adopted as a child, grew up in a non-Aboriginal home. Within much of his practice, Longboy's videos and installations embody a deep sense of longing and belonging as he wanders the landscape, connecting to the land and the profundity of cultural practices emanating from it. His works reflect an interdisciplinary approach to narrative performance, video, and installation.

In *Confirmation of My Sins* (1995), Longboy incorporates his performance works with additional video footage. An Elder's voice states, "We remember our relatives and family. If we don't continue our customs we will be just like the white man." The sequence cuts to old Hollywood footage and a short interview with his adoptive mother. The main character in this fractured narrative is Longboy. A how-to instructional booklet illustrates how to make Aboriginal items, most of them cliché objects, such as a headdress and a tomahawk. The booklet attests to how young foster children or adoptees would have primarily learned about Aboriginal culture through commercial products such as these. These seemingly *innocent* products continue to harm Aboriginal people, by simply being what they are – static and stereotypical. A voice-over repeatedly says, "I'm sorry. I'm sorry." The voice-over is recorded in real time and also in a painfully distorted rendition. Is he sorry for not being the kind of Aboriginal person you expect him to be? This is the same painful lament sung by so many Aboriginal people whose identities have been usurped through colonialism.

The companion work to *Confirmation of My Sins* is *The Stone Show* (1999). It begins with a voice-over, calling out, "When are you going home?" Longboy uses a split-screen technology to illustrate his identity, his different lives with two families.

Curator James Patten argues that *The Stone Show* examines the complexity of cultural identity in the life of an elderly Aboriginal woman. Poignant in its guileless simplicity, the video suggests the alienation inherent in social change. Andy Fabo has described Longboy's work as painterly, stating that:

> Longboy wields his camera like a paintbrush, creating highly textured images that are layered by the use of sophisticated electronic manipulation. Rarely since the early films of Joyce Wieland have we seen such expressive camera work. Similar to other moving picture makers with extensive fine art backgrounds (Derek Jarman, Wrik Mead, Peter Greenaway), he often uses the screen as a canvas. Sometimes the camera movement replaces the gentle sweep of the brush, sometimes complicated tableaux are created, suggestive of the restless energy often found in Baroque painting.

The elderly Aboriginal woman featured in the video talks about Longboy's natural grandmother, and how she fished. Stories from the trapline are told, along with accounts of following the caribou. His entitlement is the trapline and the caribou.

Longboy's video installation for the exhibition *Out to Dry* (2003) brings together aspects of *Confirmation of My Sins* and *The Stone Show*. The videos are screened on monitors that hang from a tree – the tree of life – his family tree. Metaphorically, Longboy washes and hangs his life out to dry. By doing so, he conveys a cultural dilemma that so many Aboriginal children have endured, a dilemma that has since become a field of study in psychology and, specifically, the theory of acculturation. What really happens when you take children away from their culture, birth parents and family? Many Aboriginal artists have drawn from this experience to make meaningful art that reflects the complexities of adoption. If one does not grow up in an Aboriginal community, can s/he ever become authentically Native? Who defines what Aboriginal is? Longboy touches on a series of debates about authenticity, and in addressing these concerns his work speaks to broader experiences of urban disenfranchisement and dispossession.

**26.IX.  Loretta Todd. 2005. "Polemics, Philosophies, and a Story: Aboriginal Aesthetics and the Media of This Land."** In *Transference, Tradition, Technology: Native New Media Exploring Visual and Digital Culture.* Edited by Dana Claxton, Steven Loft, Candice Hopkins, and Melanie Townsend. Banff, AB: Walter Phillips Gallery Editions, 106-7. © 2005. Used with permission.

Pre-eminent filmmaker and scholar Loretta Todd (Cree/Métis) grappled with the question of what made Aboriginal media distinctly Aboriginal aesthetically in this essay from an edited volume about the diverse uses of media among Aboriginal artists. Todd raised crucial issues here not only about Aboriginal film

aesthetics but also about the relationship among filmmaking, cultural traditions, spirituality, relationships with the land, and influence from dominant media practices. Todd was the first Aboriginal person to attend the film program at Simon Fraser University, and she has been a leader in Vancouver's Aboriginal media world for over two decades. In this essay, she revealed her tremendous knowledge of Western film history and discussed the impact of her Cree and Métis heritage on her attention to "shadow and light" in her filmmaking craft. While Todd did not provide simple answers to the question "is there an Aboriginal film aesthetic?" she raised provocative and important questions for anyone analyzing the formal qualities and cultural connections of Aboriginal media.

And is there even an Aboriginal aesthetic in the film and video Aboriginal people make? Some have answered that last question, saying, "there is no specific Aboriginal aesthetic," and others have said, "yes, there is a way – an Indian way."

When writing about poetry (but he extended his remarks to other arts), poet Duane Niatum stated: "we may not always enjoy seeing ourselves or things from a historical or mythical perspective, but we would be foolish to ignore their important function in the art and society of the past and what hope there is for the present in the future." But, he goes on today, "it is my opinion that there is not a Native American aesthetic that we can recognize as having a separate principle from the standards of artists of Western European and American cultures. And anyone who claims there is encourages a conventional and prescriptive response from both Native Americans and those of other cultures."

There are distinct conventions within Aboriginal art practices, from the ovoids of the West Coast to the meaning of certain colours from red to white – and those conventions influence, and should influence, our media – but for the purposes of this forum, let's talk about media aesthetics.

Filmmaking came almost fully packaged when it arrived in Indian country. Its units of construction – from shots to scenes to sequences, from mise-en-scene to montage – were neatly tied with a bow. Georges Méliès had already embedded ideas about fantasy in his *Le Voyage dans la lune (A Trip to the Moon)* (1902), and the Lumière brothers had long ago shown their early film "documents" for the first time in the Grand Café on the Boulevard des Capucines in Paris in 1895. Flaherty would follow (when making *Nanook of the North* imagine how things would be different if he had given Nanook the camera), and Eisenstein would use the holy trinity off thesis-antithesis-synthesis to create new ideas about editing in *Bronenosets Potemkin (The Battleship Potemkin)* (1925).

From there, film had many revolutions, starting perhaps when Russian filmmaker Dziga Vertov issued the *Kinoks-Revolution Manifesto* (1919). After that came new movement after new movement, epiphany after epiphany: *avant-garde,* cinema eye, *film noir,* abstract narratives, visual poems, Welles, Deren, Renoir, Cocteau, Brakhage, Satyajit Ray, Dogma, *plan-séquence,* elliptical editing, nondiegetic sound, diegetic sound, shot/reverse-shot, synchronized sound, surrealism, neo-realism, new wave, feminist theory, semiotics, experimental, digital, mini-dv, non-linear, and the list goes on.

Of course, no one was handing out film cameras at Treaty Days, but a number of White guys did show up for the ethnographic tour, and later the Western genre train came along with their cameras. Though James Young Deer made films in Hollywood when it was still Hollywoodland, it would be many decades before we were making films. When we did, we were burdened with the tropes, the memes, and the signifiers of other societies, as well as their histories and languages. Present, too, was the colonial imagination – determined to enact its fantasies on the people and the land.

Have we had our manifestos? We didn't invent cinema and its system – neither the camera nor the lights, not the studios or the *auteur* – yet some claim we made it our own. After all, we do have stories to tell. What does distinguish Aboriginal work from all the others, no longer just the American or Canadian styles, but the Japanese, the Iranian, the Diaspora, the queer? And can we have one aesthetic, when, though we share a Postcolonial history, we have distinct languages and governing systems, not to mention origins?

Some would say it is our relationship to land that distinguishes our media, or our connection to the spiritual. But are we spiritual because we say we are spiritual? But what does spiritual feel/look/sound like on screen? What in our image-making is our own?

Have we truly decolonized our imaginations when it comes to how we represent ourselves in media – both in the aesthetics and content of our stories? Have we internalized the images made of us, the idea of "us" by the colonizer – from the camera angles to the editing to the music? Are we their tour guides or even recruiters into their world view? Or is it with subversive intentions, as acts of sovereignty, that we take up the camera and signal forth our presence and our stories? And would proclaiming an Aboriginal aesthetic, or style, become descriptive, limiting our visions?

SELECTED FILMOGRAPHY

I include here a brief selection of films about the Northwest Coast. The vast majority of these films were made by Aboriginal filmmakers, although some of the films were made by non-Native filmmakers in collaboration with Native communities.

*ʔEʔAnx: The Cave*, dir. Helen Haig-Brown. 11 min. Rugged Media, Vancouver, 2009.

*Aboriginal Architecture, Living Architecture*, dir. Paul Rickard. 92 min. National Film Board of Canada, Montreal, 2005.

*Bella Bella*, dir. Barbara Greene. 45 min. National Film Board of Canada, Montreal, 1975.

*Bill Reid*, dir. Jack Long. 46 min. National Film Board of Canada, Montreal, 1979.

*Box of Treasures*, dir. Chuck Olin. 28 min. Moving Images Distribution, Vancouver, 1983.

*Button Blanket*, dir. Zoe Leigh Hopkins. 3 mins. National Film Board of Canada, Montreal, 2009.

*Connected by Innate Rhythm*, dir. Leena Minifie. 8 min. Vancouver, 2003.

*Cry Rock*, dir. Banchi Hanuse. 29 min. Moving Images Distribution, Vancouver, 2010.

*Finding Our Talk*, dir. Paul Rickard. Television series. APTN, Winnipeg, 2001-present.

*From Bella Coola to Berlin*, dir. Barbara Hager. 48 min. Bella Coola to Berlin Productions, Inc., Victoria, 2006.

*From the Heart: The George Manuel Story*, dir. Doreen Manuel. 19 min. Vancouver, 2006.

*Gwishalaayat: The Spirit Wraps around You*, dir. Barb Cranmer. 47 min. Moving Image Distribution, Vancouver, 2001.

*Hands of History*, dir. Loretta Todd. 52 min. National Film Board of Canada, Montreal, 1994.

*Indigenous Plant Diva*, dir. Kamala Todd. 8 min. National Film Board of Canada, Montreal, 2008.

*In the Land of the Head Hunters/War Canoes*, dir. Edward Curtis; eds. Bill Holm and George Quimby. 48 min. Milestone Film and Video, Harrington Park, NJ, (1914) 1972.

*In the Name of the Lord*, dirs. Helmer Mussell and Shawn Mussell. 10 min. Vancouver, 2004.

*I'Tusto: To Rise Again*, dir. Barb Cranmer. 54 min. Moving Images Distribution, Vancouver, 2000.

*Keepers of the Fire*, dir. Christine Welsh. 54 min. National Film Board of Canada, Montreal, 1995.

*The Kwakiutl of British Columbia*, dir. Franz Boas; ed. Bill Holm. 2 reels. Burke Museum, Seattle, (1930) 1973.

*Kichx Anagaat Yatx'i: Children of the Rainbow*, dir. Duane Ghastant' Aucoin. 80 min. Teslin, YT, 2003.

*The Land Is the Culture*, Union of BC Indian Chiefs. 30 min. Vancouver, 1975.

*Laxwesa Wa: The Strength of the River*, dir. Barb Cranmer. 54 min. National Film Board of Canada, Montreal, 1995.

*Legends/Sxwexwxwiy'am': The Story of Siwash Rock*, dir. Annie Frazier Henry. 24 min. National Film Board of Canada, Montreal, 1999.

*Mount Currie Summer Camp*, dir. Alanis Obomsawin. 22 min. National Film Board of Canada, Montreal, 1975.

*Mungo Martin: A Slender Thread/The Legacy*, dir. Barb Cranmer. 18 min. Moving Images Distribution, Vancouver, 1991.

*Native Youth Movement (Secwepemec Chapter): Roadblock*, dir. Nitanis Desjarlais. 30 min. Video Out Distributors, Vancouver, 2002.

*Native Youth Movement: Vancouver Chapter*, dir. Nitanis Desjarlais. 49 min. Video Out Distributors, Vancouver, 1999.

*One Hundred Aboriginal Women*, dir. Amelia Productions. 60 min. Video Out Distributors, Vancouver, 1981.

*One-Eyed Dogs Are Free*, dir. Zoe Leigh Hopkins. 15 min. Blanket Dance Productions, Vancouver, 2006.

*People of the River*, dir. Odessa Shuquaya. 15 min. Vancouver, 2002.

*Picturing a People: George Johnston, Tlingit Photographer*, dir. Carol Geddes. 50 min. National Film Board of Canada, Montreal, 1995.

*Potlatch ... A Strict Law Bids Us Dance*, dir. Dennis Wheeler. 54 min. Moving Images Distribution, Vancouver, 1975.

*Qatuwas: People Gathering Together*, dir. Barb Cranmer. 58 min. National Film Board of Canada, Montreal, 1995.

*Raven Tales: How Raven Stole the Sun*, dirs. Simon James and Chris Kientz. 23 min. Raven Tales Production, Calgary, 2004.

*Raven Tales: A Sea Wolf*, dirs. Simon James and Caleb Hystad. 23 min. Raven Tales Production, Calgary, 2006.

*Ravens and Eagles*, prods. Jeff Bear and Marianne Jones. TV series, APTN, Winnipeg, 2002-3.

*Red Power Women*, dir. Cleo Reece. 60 min. Vancouver, 2000.

*Skwelkwekwelt Protection Center*, dir. Nitanis Desjarlais. 29 min. Video Out Distribution, Vancouver, 2000.

*Stolen Spirits*, dir. Judy Manuel-Wilson. 24 min. Vancouver, 2004.

*Stolen Spirits of Haida Gwaii*, dir. Kevin McMahon. 74 min. Primitive Entertainment, Toronto, 2004.

*The Story of the Coast Salish Knitters*, dir. Christine Welsh. 52 min. National Film Board of Canada, Montreal, 2000.

*Su Naa (My Big Brother)*, dir. Helen Haig-Brown. 11 min. Vtape, Toronto, 2004.

*Take Back the Land: Spirit Lake*, dir. Nitanis Desjarlais. 28 min. Video Out Distribution, Vancouver, 2002.

*T'Lina: The Rendering of Wealth*, dir. Barb Cranmer. 50 min. National Film Board of Canada, Montreal, 1999.

*To Return: The John Walkus Story*, dir. Annie Frazier Henry. 45 min. National Film Board of Canada, Montreal, 2000.

*Today Is a Good Day: Remembering the Legacy of Chief Dan George*, dir. Loretta Todd. 55 min. National Film Board of Canada, Montreal, 1999.

*Totem: The Return of the G'psgolox Pole*, dir. Gil Cardinal. 70 min. National Film Board of Canada, Montreal, 2003.

*Tu Suhudinh*, dir. Helen Haig-Brown. 10 min. Video Out Distribution, Vancouver, 2003.

*Usual and Accustomed Places*, dir. Sandra Sunrising Osawa. 48 min. Upstream Productions, Seattle, 2000.

*The Walk*, dir. Terry Haines. 4 min. Video Out Distribution, Vancouver, 2006.

*Warriors on the Water*, dir. Nitanis Desjarlais. 27 min. Video Out Distribution, Vancouver, 2000.

*Writing the Land*, dir. Kevin Burton. 8 min. National Film Board of Canada, Montreal, 2007.

*Yuxweluptun: Man of Masks,* dir. Dana Claxton. 21 min. National Film Board of Canada, Montreal, 1999.

IMPORTANT WEBSITES

Websites of key institutions that support the production, funding, and distribution of Aboriginal media are listed below. These websites provide more up-to-date information regarding the latest Aboriginal media productions.

Aboriginal Peoples Television Network, http://www.aptn.ca
Aboriginal Perspectives website, National Film Board of Canada, http://www3.nfb.ca/enclasse/doclens/visau/index.php
Aboriginal Peoples, National Film Board of Canada Films, http://www3.nfb.ca/sections/thematique.php?id=114
Banff Centre for the Arts, http://www.banffcentre.ca
Beat Nation: Hip Hop as Indigenous Culture, http://www.beatnation.org
Canadian Broadcasting Corporation Aboriginal, http://www.cbc.ca/aboriginal
Canada Council for the Arts, http://www.canadacouncil.ca
Digital Vistas, National Film Board of Canada, http://www.nfb.ca/playlist/vistas/
"In the Land of the Head Hunters" Film Restoration Project, http://www.curtisfilm.rutgers.edu
grunt gallery, http://www.grunt.ca
ImagineNATIVE Film and Media Arts Festival, http://www.imaginenative.org
Isuma TV, http://www.isuma.tv
RedWire Native Youth Media Society, http://www.redwiremag.com
Telefilm Canada, http://www.telefilm.ca
Video In/Video Out, http://www.vivomediaarts.com
Vtape, http://www.vtape.org
Western Front Gallery, http://www.front.bc.ca

## 27 | Art Claims in the Age of *Delgamuukw*

*[handwritten annotation: 1997 SCC ruling that Title had never been extinguished in BC; oral history is legit evidence]*

For more than two and a half centuries, many claims have been made about the iconography, the style, and the purposes of Indigenous art on the Northwest Coast of North America, of which the claim that it is "art" is only one. The historical diversity of these claims is the subject of this volume. But since *Delgamuukw*, since 1997, *diversity* is not the right word, and the claims are subject to a more stringent validation. Now they are rights based, culturally specific, essentialist. Over the past decade, work (the right word is elusive) – carved, woven, painted, printed, assembled, or engraved work, created before and since 1997 – has been reframed, redirected, and, most significantly, revalidated. If "Northwest Coast art" as a viable generic term is increasingly disputed, the claims made for the potency of the cultural expressions of the region's First Nations have never been stronger.

In December 1997, a Supreme Court of Canada decision stated that Aboriginal title had never been extinguished in British Columbia (*Delgamuukw v. British Columbia*, [1997] 3 S.C.R. 1010 (S.C.C.)) (Culhane 1998; Jackson and Aldridge 2000; Boxberger 2000; Daly 2005). This decision supplemented Canada's 1982 constitutional recognition of the pre-existing rights of its Aboriginal population though not the definition of those rights. In reaffirming an essential characteristic of Canada's Aboriginal peoples, the court affirmed their difference from the rest of the population (Macklem 2001; Mackey 2002). *Delgamuukw*, as the 1997 decision is popularly known, thus points to the publicly obscured but rather crucial fact that most of British Columbia occupies unceded land (see White, this volume). In an attempt to settle outstanding land claims, the province of British Columbia had already joined with the federal government in 1991, and subsequently with municipal governments, in a treaty-making process. Since *Delgamuukw*, those land claims have to be negotiated on a basis that has the potential to match more closely the criteria of those lodging the claims rather than the demands of those to whom the claims are addressed.

But *Delgamuukw* goes further than giving state endorsement to what Native people already know well. It changes the ground rules for evidence by insisting, in a significant reversal of the BC Supreme Court's 1991 ruling in the initial case brought by the Gitksan Wet'suwet'en (in *Delgamuukw*, also known as *Ken Muldoe, Suing on His Own Behalf and on Behalf of All the Members of the House of Delgamuukw, and Others v. Her Majesty the Queen in Right of the Province of British Columbia and the Attorney General of Canada*), that orally transmitted knowledge – cultural memory – must be allowed as evidence in a court of law. The implication is that legitimate evidence may arise from another or different or contradictory epistemology. A progression of legal cases about sovereignty and rights over resources has, since the *Calder* case (1973), tended to find in favour of the Native plaintiffs, for example *Guerin* (1983) and *Sparrow* (1990). These cases have worked to define more exactly the scope of Native rights in Canadian constitutional law. The *Delgamuukw* decision is exceptional in this sequence. It marks a shift from imposing a settlement couched in terms of one system, assumed to be *the* system, to accepting that there is another entirely different, because culturally different, way of conceiving the whole matter in the first place (Mills 2000; Borrows 2002). The implications of *Delgamuukw* reach far beyond the courts, as the texts excerpted here show. Where art is at issue, *Delgamuukw* has the potential to legislate a similarly dramatic effect, redefining "art" by assessing the power of the claims made for it and the authority of those making the claims. It is clear enough that different "regimes of value" (Appadurai 1986; Myers 2001b) come into conflict where Native art is concerned – anywhere in the world (Graburn 1976; Morphy 2007; see also Ḳi-ḳe-in, Chapter 22, this volume). With "art" and "law" now better understood as external systems of interpreting and valuing, "regimes of value" might be amended to "regimes of validation," which implies action. The emphasis needs now to be on the agency of Indigenous people, whether they live in urban or community settings (Doxtator 1996; McMaster 1998; M. Crosby 1997).

The *Oxford English Dictionary* defines "claim" as "a demand for something as due; an assertion of a right to something." There is a link between rights-based land claims and the verbal claims made for First Nations art inasmuch as the rights should make the claims redundant, but they do not. The increasingly evident, and evidently vital, assertiveness in the claims for art can hardly be disentangled from the claims over sovereign rights, if credence is given to such rights. This chapter shows how public discourse on the Northwest Coast over what "art" is, what it does, and what it should do has, in the age of *Delgamuukw*, been inseparable from rights-based claims over land and sovereignty.

Within this context, "art," variously defined, has moved from cultural representation, often of great time-depth, from which much of its value is thought to derive, to being representative of a culture and then deployed as such externally. Indeed, it is an understanding of art as both essential and essentially heterogeneous, arising out of apparently disjunct regimes of value, that is one of the great consequences of attention to the rights of the Indigenous. It may be significant that discussions on what might be global about indigeneity are paralleled by what may, or may not, be global about art history (Summers 2003; Morphy 1995, 2007; Elkins 2007; Price 2007; Schneider and Wright 2008). *Delgamuukw* gives local resonance to renewed debates about the universality of "art." And, if it is not "universal," then are Native and other culturally specific arts something entirely different, requiring unique terms of reference, legitimated in culturally specific ways, essentially distinct regimes of validation, and closed, in some respects at least, to "outsiders"?

Previous chapters in this volume have demonstrated how Native art has been defined in terms dictated by colonial and political expansionism, scientific enquiry, institutional and academic paradigms, aesthetic urgencies from elsewhere, or various kinds of brokered relationships. In the process, the history that has brought some of the art to such prominence has been written. The *Delgamuukw* legitimation derives from different sources (Bob 1999; Sparrow 1998; Nicolson, this volume; Ḵi-ḵe-in, Chapter 2, this volume). For such reasons, diversity, with its contemporary connotations of hybridity and multiculturalism, does not accurately describe a situation that involves cultural disjuncture and inherent conflict (Doxtator 1992; Townsend-Gault 1997). Former provincial court judge Steven Point, the first Indigenous person to hold the office of lieutenant governor in British Columbia, used the term "inherent conflict" in his address at an event honouring Stone T'xwelatse, the first ancestor of the St:olo-Ts'elxweyeqw, on 1 March 2008, at UBC's Museum of Anthropology (see *T'xwelatse: Me T'okw' telo qays / Is Finally Home* 2007). Looking around at the monuments of First Nations culture, Point spoke of the pain of injustice, which his own state-sanctioned position heightens even as it remedies, as does the restitution of the ancestral figure that may or may not need to be, therefore, a work of art. The paradox for the Indigenous person of being both equal and different under the law (Tennant 1990; Point 2001; Macklem 2001; Mackey 2002; B.G. Miller 2003) applies equally to the uneasy status of Indigenous art (Watson 1995; Linsley 1995; Rushing 1999).

Native claims are then made to oppose legislation and override the presumptions and appropriations of institutions and individuals, some well intentioned, some not (P. Deloria 1998; Cole 1985; Harris 2002). They critique non-Native

taxonomies and value hierarchies. Native claims for art now are made within the parameters of a Nativeness set by Native people who are caught up in a legislated Nativeness (Bracken 1997; M. Crosby 1997; Culhane 1998; T. Alfred 1999). This is apparent whether the claims are made by or about First Nations. It is apparent even when different First Nations, or their individual members, make conflicting claims. *Delgamuukw* does not imply consensus, certainly not about art. Doreen Jensen (1996) (Gitksan), a carver, writer, and historian, is among those who have emphasized that the notion of "art" is an alien imposition. Other Native commentators use the term to enhance their claims. E. James Dixon (2000, 55), working on an archaeological project in Alaska, records that "during the summer of 1999 another exciting discovery was made. It was a ground and faceted piece of red ochre, a mineral used to make red paint. This is the earliest evidence for Northwest Coast art. This long tradition of artistic development could be older than 9,000 to 10,000 years!" Not then a period of accord but one marked by the assertion of rights, "the age of *Delgamuukw*" is used here (acknowledging Walter Benjamin [1968]) to recognize that the production and reception of art are inseparable from contemporary socio-political and technological change. It is used here despite Marcia Crosby's (1997, 23) doubt about "whether the issues of self-government, sovereignty, the politics of representation, and aboriginal title can be seamlessly linked together in art practice" [27.IX]. One reason for making the link is to contribute to moving Native "art" out of the trap of timelessness set for the cultural other, of which Crosby has also warned (1997; Levinas 1987; Fabian 1983). However, timelessness, and "spiritual enlightenment," are widely desired and continue to be promoted as values in the market (Sparrow 1998; Kramer 2006; Duffek, this volume). This is another inherent conflict.

*Delgamuukw* is echoed in wider claims concerning the moral imperative to acknowledge the distinctiveness of the globe's Indigenous populations. Critical museology has emerged to contend with the ignorance and hypocrisy with which values, obliterated by history, have been transferred instead to objects and other apparently neutral markers. Paul Chaat Smith (2007, 391), of Comanche descent, a curator of the National Museum of the American Indian in Washington, DC, expresses the historical gap this way:

> The continent is filled with Indian-named streets and rivers, corporations and sports teams, and mountains and cities. This untold past is everywhere, in the landscape and the air we breathe, and it's not even past, and we all know it. Confusingly, millions of Indians are still here too, living all over the place: in cities, jungles, suburbs, in the shadow of pyramids and shopping malls. Everywhere you look, there it is, asking the same question few

ask but everyone still wonders about. What happened here? What really happened, and why?

In 2007, the United Nations General Assembly adopted the Declaration on the Rights of Indigenous Peoples (GA/10612). (The resolution was passed by a vote of 143 in favour, 11 abstentions, and 4 against – Australia, Canada, New Zealand, and the United States – all of them settler colonies.) The declaration "backs protections for the human rights of indigenous peoples and their rights to protect their lands and resources, and to maintain their unique cultures and traditions." During the twenty-five years that the declaration had been under negotiation (de la Cadena and Starn 2007; see White, this volume), artists of Aboriginal ancestry across North America had been working to ensure that the story did not remain "untold." One, Edgar Heap of Birds (Cheyenne/Arapaho), created *Native Hosts* specifically for British Columbia. Situated on the campus of the University of British Columbia, this series of twelve signs reminds residents and visitors to "the Northwest Coast" exactly whose land they are standing on when it confronts them. Helping themselves to divergent contemporary modes, other artists have retold the "untold history," including Robert Houle (Saulteaux) in *Place Where God Dwells* (1990), Dana Claxton (Lakota) in *Red Paper* (1996), and Kent Monkman (Cree) in *Not the End of the Trail* (2005). If Northwest Coast art is to be situated in an international context, it is works such as these that are creating that context. At the same time, scholars such as Charles Taylor (1994), political philosopher; Derek Gregory (1994), social geographer; Cole Harris (2002), historical geographer; and Bruce Braun (2002), geographer, all include a consideration of Northwest Coast art in their attention to the geopolitical and historical context of the region.

In their history of the American Indian Movement (AIM), Paul Chaat Smith and Robert Warrior (1996) show how the (potential) agency of the dispossessed was recaptured for Native empowerment. Gayatri Spivak (1990) was one of the first internationally read cultural theorists to point out that subaltern, marginalized, or Fourth World populations were well positioned to deploy their ethnically rooted, or national, cultures for their own purposes. This notion of "strategic essentialism" connects to much Indigenous activism across North America and beyond (Canclini 2001; Yudice 2003; see also Smith, this volume). But it took the painful exactitude of Brian Jungen (an artist of Dane-zaa and Swiss ancestry) to skewer the conflict of essentialism, which combats racist and exclusionist attitudes while itself being only dubiously attainable and potentially, if not actually, racist in its likely outcome (Shelton 2001). In two untitled drawings of 1997, mordantly chirpy, rustic signposts point, in opposite directions, toward

"First Person" and "Third World" and, in the other, "First Nation" and "Second Nature." Paul Chaat Smith (2007, 382) also pursues a cartographic metaphor for colonialism's chaotic legacy: "We must be really good at reading a really, really bad map."

For reasons that raise interesting questions, more attention has been given to Maori and Australian Aboriginal cultural production than to that of North American First Peoples. Nevertheless, anthropologist Fred R. Myers's *Painting Culture: The Making of an Aboriginal High Art* (2002) is rare in that it gives book-length treatment to a culturally specific Indigenous expressive mode. In charting the transformation of an Australian Aboriginal graphic signifying practice into an internationally recognized art form, Myers treats the category of art itself in a critical fashion, bringing Pintupi cosmology together with the legacy of the Frankfurt School of critical analysis carried through to poststructuralist thought (Arato and Gebhardt 2000). Myers (2002, 7) writes, "I understand that to designate cultural products as art is itself a signifying practice, not a simple category of analysis. This leads me to turn my attention to the institutions and practices that make objects into art." Alert to the complex consequences of cultural contact, Myers, like anthropologists Nicholas Thomas (1991, 1994) and Howard Morphy (1991), has produced work that resonates with a number of cultural anthropologists and social art historians concerned with Indigenous cultures at the University of British Columbia. They suggest, in a similar vein, that the Northwest Coast institutions and practices that "make objects into art" in the late twentieth and early twenty-first centuries are characterized by some uncompromising positions – that, essentially, they are claims based in rights.

There is a back story to irrefutable claims for "art" in the age of *Delgamuukw*. It would need to cover the Kitanmax School ('Ksan), in Hazelton, and the restoration of style allied to the restoration of values that define the cultures from which it derives (Schapiro 1994); the *Legacy* exhibition and catalogue (Macnair, Hoover, and Neary [1980] 1984), with its new emphasis on the work of individual artists, dislodging the norm of anonymous "Native" art; Northwest Coast objects being displayed as art in no fewer than thirty-three major exhibitions between 1956 and 1980 (M.M. Ames 1986, 53-55, table 1). Among responses to the formalized norms of "Northwest Coast art," the back story would need to address those artists, such as Phil McGuire and Doug Cranmer, whose modernism did not fit the canon; Lyle Wilson's subversive *Ode to Billy Holm ... Lelooska ... Duane Pasco ... Jonathan Livingston Seagull* (1980) (Figure 15.2); the bewilderment, from several quarters, that greeted the first showings of the politically charged, surrealist, narrative canvases of Vancouver-based artist Lawrence Paul Yuxweluptun (Okanagan and Coast Salish) at the Bent Box

**FIGURE 27.1** Lawrence Paul Yuxweluptun, *Inherent Visions, Inherent Rights*, 1992. Virtual reality installation (two details). In this installation, Yuxweluptun used virtual reality technology to create a traditional longhouse in which participants could take part in a virtual ceremony. In the collection of the Walter Phillips Gallery, Banff Centre. Courtesy of Lawrence Paul Yuxweluptun.

Gallery from the late 1970s; the sidelining of the still little-known expressionist paintings of Judith Morgan (Gitksan), which did not conform to Northwest Coast stylistic norms; the success of the Native printmakers guild in advancing those norms during the 1970s (Hall, Blackman, and Rickard 1981); Tom Hill writing "The Politics of Indian Art" for the catalogue of *Beyond History* (Duffek and Hill 1989), and the abstract painter Robert Houle (Saulteaux) berating "Northwest Coast" artists for the absence of politics in their work during the symposium, which marked the opening of the exhibition at the Vancouver Art Gallery; "Change and Continuity in Northwest Coast Art" as an often-repeated discursive trope (R.L. Carlson 1983a); Salish weaving at Chilliwack, then at Musqueam, and later with the Squamish, which broke the monopoly of carving – of totem poles in particular – as publicly acceptable fronts for the Native presence; the prescient use of virtual reality in which Yuxweluptun asserts his rights to a new technology, even though in its "primitive" stage, to make the claims *of* a Native rather than the more usual claims *about* the Native in his twenty-minute virtual reality performance *Inherent Visions, Inherent Rights* (1991) (Figure 27.1); the disturbance of the troublesome "traditional" versus "innovative" binary when "Northwest Coast" work by Dorothy Grant, Robert Davidson, and Dempsey Bob was included in *Land, Spirit, Power: First Nations*

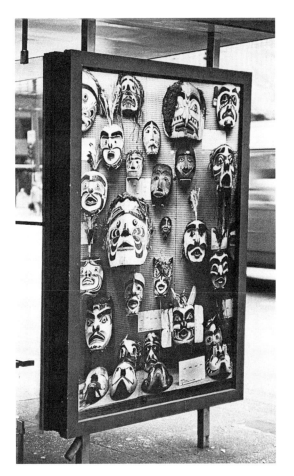

**FIGURE 27.2** Anne Ramsden, *Mask,* 1988. Silver print mounted on a bus shelter. Ramsden's *Mask,* mounted as a bus shelter advertisement in Vancouver, shows masks as they were displayed in the visible storage area at the University of British Columbia's Museum of Anthropology. Photographed by Don Gill. Courtesy of the artist.

*at the National Gallery of Canada* (1992); the exhibitions *It Is Written in the Earth* (1996) and *Under the Delta* (1996-98), for which the Musqueam – on whose traditional, unceded land the University of British Columbia has grown up (see the Musqueam Declaration of 1977) – collaborated with the university's Museum of Anthropology (MOA), showing and saying only as much as they wanted to and keeping their own counsel about everything else – there were to be no publications; and Michael M. Ames (1999), at the time the director of the MOA, in "How to Decorate a House," parlaying that collaboration into a long-overdue recognition of an imbalance between distinct knowledge worlds.

This back story tells something of the turbulence underlying the increased prominence of First Nations art. *Mask* (1988) (Figure 27.2), a work of public art by the non-Native Anne Ramsden, captured the anxieties of the moment about the conflation of spectacle and control, in this case as it occurred in the MOA's visible storage area. *Delgamuukw* marks a shift in authority over how claims for

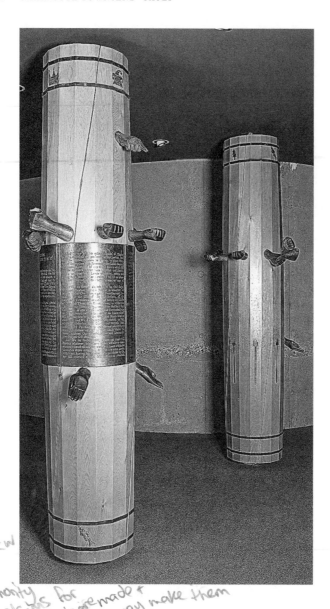

**FIGURE 27.3** Eric Robertson, *Shaking the Crown Bone*, 2000. Permanent installation. Eric Robertson, of Métis and Gitksan descent, created this piece for the University of British Columbia's Museum of Anthropology. It references First Nations' continuing struggle to reclaim control over ancestral land in British Columbia and throughout Canada. Photo courtesy of the UBC Museum of Anthropology, MOA Nb7.346a-b.

*[handwritten marginalia: Delgamuukw marked a shift in authority over how claims for + about Native art are made + who may make them]*

and about Native art are made and who may make them. The confident Native claims arising out of rights that have always existed are made about what art does, and who it is for, as much as about how it looks. Indigenous authority claims to counter a history of federal policies, administrative fiat, juridical decisions, and institutional taxonomizing, even as Indigenous lives continue to be implicated in them. *Shaking the Crown Bone* (2000), a permanent installation commissioned from Eric Robertson by the MOA (Figure 27.3), makes just such a Native claim for the value of the Royal Proclamation of 1763 – and for how it has been traduced. Wilson's *Ode to Billy Holm ...* (1980) and Yuxweluptun's

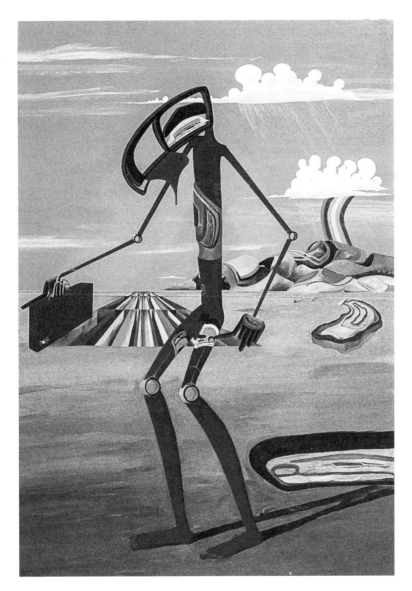

**FIGURE 27.4** Lawrence Paul Yuxweluptun, *Leaving My Reservation and Going to Ottawa for a New Constitution,* 1986. Acrylic on canvas, 249 x 173 cm. Yuxweluptun's politically charged *Leaving My Reservation ...* , like many of his other works, highlights the bureaucracy of the Indian Act and its inaccessibility to the people it most directly affects, the general First Nations population in Canada. Photo courtesy of the artist.

*Leaving My Reservation and Going to Ottawa for a New Constitution* (1986) (Figure 27.4) and *Shooting the Indian Act* (2003) all position the artists in their own protests against betrayal by the systems of power that to some extent define them. In the age of *Delgamuukw,* extremely long-established criteria for validating claims have been renewed by virtue of having been given official, legal recognition.

These criteria are increasingly audible, but they are not without their critics. Oral history seems elusive to those regimes of knowledge that imagine they can function without it (Cruikshank 1994; B.G. Miller 2011).

As an example, Dzawada'enuxw artist Marianne Nicolson (2004, 246) writes of her early perception of the connection between object and meaning, in her mother's village of Gwayi'i on Kingcome Inlet, "at the top [of the pole], younger brother of the Thunderbird, and beneath in descending order, a Whale, a Wolf and a copper. These beings, to me, seemed just as alive as when they had initially emerged from their raw cedar form generations ago. They were animated and infused with spirit." And in accord, breaking down the positivist categorization of the kinds of things that are found in museums, or that become the focus of treaty and restitution negotiations, Andrea Laforet (2004, 42), director of ethnology at the Canadian Museum of Civilization, writes that "narratives and objects are complementary ... contained silently in a single object." In these examples, the distinction between appearance and function has been overruled, superseded, by two different "authorities" – Native scholar and non-Native scholar. This, in turn, affects protocols of viewing in which any audience is implicated (Bourriaud 2002; Townsend-Gault 2004b), for old claims are being made in new ways. At the opening of *Signed without Signature: Work by Charles and Isabella Edenshaw* (November 2010), the descendants of the renowned Haida couple, many carrying photographs of the couple's children from whom they can claim descent, formed an impressive kin group, headed by hereditary chief 7idansuu. For 7idansuu, also known as the artist Jim Hart, with many other artist members of this extended family – Isabel Rorick, Robert Davidson, Michael Nicholl Yahgulanaas among them – this claim was expressed by the inclusion of their own works in the exhibition.

If audience members refuse the mode of address, they miss the point. That the discourse can now be networked among artists' statements in the media, in print, or on websites; in exhibition catalogues (often available online); in scholarly writing; and on social interactive sites reinforces this. Aesthetic considerations are not necessarily ruled out. It is not culture versus art, or ethnography versus aesthetics – binaries typically invoked to describe this situation (Watson 1995; Ingold 1996; Price 2007). It has more to do with a politics of epistemology.

In his widely read book *Entangled Objects: Exchange, Material Culture, and Colonialism in the Pacific* (1991), Nicholas Thomas insisted that transcultural contact be understood as a more complex historical process than the unequal encounter of asymmetrical powers. The premise informs more work in North America and elsewhere than can easily be referenced (e.g., Fisher 1992; Thomas

1994; Phillips and Steiner 1999; Raibmon 2005). The notion of "entanglement" is often used to counteract or complicate essentialism. Nevertheless, tensions are evident globally when it comes to identifying ways of defining the local, the specific, the culturally particular so that they make sense or can be translated in general terms (Appadurai 1996; Gupta and Ferguson 1997). In Canada, particularly, these tensions appear among cultural rights, cultural essentialism, and another kind of right – to assert any meaning, shared or otherwise. Specific claims for a culture emerge from the fact that First Nations in Canada occupy a unique position vis-à-vis the Constitution. Although Native people and communities thereby participate in a wider rights-based activism, in Canada, as elsewhere, this is at odds with the tenets of a rationalist liberal democracy and trepidation about identifying a particular group by its distinct values. Canada's version of the multicultural paradox has been further inflected by the situation of Quebec within Confederation (Handler 1988; Taylor 1994; Tully 1995). It goes without saying that there are those in Canada impatient with the idea of constitutional protection of "Aboriginal rights" – for example, Tom Flanagan (2000); see also Krech (2005). In *The Reinvention of Primitive Society: Transformations of a Myth* (2005), anthropologist Adam Kuper expresses doubts about whether the best way to defend minority interests is in terms too close to the historic invocation of "blood and soil" for anyone's good, and by reconfiguring the tropes of nineteenth-century anthropology, which themselves were erroneous.

Nevertheless, the arguments regarding what Northwest Coast art should look like, or by whom it should be influenced, are subsumed and overtaken by struggles over the rights of Indigenous peoples, their histories, and their place within an apparently globalized economy of values. Since the late 1970s, the wider postcolonial literature has integrated colonial history with political philosophy and, frequently, a psychoanalytically informed theorizing about cultural representations in attending to such issues (Spivak 1990; Bhabha 1994; Povinelli 2002). Indigenous cultural expressions, or art, were brought more explicitly into this critical framework by theorists such as Thomas (1991, 1994) and Appadurai (1996). These debates, in turn, have been inseparable from increased attention to postcolonialism and to colonialism continued or revived (R.J.C. Young 1995; Lazarus 1999; Comaroff and Comaroff 2001).

In the context of these enquiries, the *Delgamuukw* claims highlight what a globalized notion of Indigenous art, its pedigree validated through the sensibilities of other regimes of value (Goldwater 1986; Flam 2003), inevitably overlooks. In the past decade, and within the context of claims of sovereignty and land, where rights and prerogatives concerning the making and display of

**FIGURE 27.5** Susan Point, *Spawning Salmon,* 1996, House of Héwhíwus, Sechelt, BC. This treatment of two exterior walls was commissioned by the Sechelt Indian Band for this administrative building. Photo courtesy of Bob Matheson.

objects and design motifs are shown to be linked in culturally specific ways, *Delgamuukw* has profoundly affected how art is shown and received. Susan Point's use of a salmon motif on the House of Héwhíwus at Sechelt set a precedent (Figure 27.5). It suggests a local resolution to the category or classification problems that have marked the debate for years, a debate famously sparked by Nelson H.H. Graburn's *Ethnic and Tourist Arts: Cultural Expressions from the Fourth World* (1976) (Thomas 1991; Clifford 1988b, 1997c; Phillips and Steiner 1999; McMaster 1999; Myers 2001a; Martin 2004; P.C. Smith 2007). The much-quoted text by Gerald McMaster (1999), "Toward an Aboriginal Art History," showed how to end equivocation. The policies of Canada's cultural institutions appear now to have taken this up, without equivocation.

Since the 1982 Constitution, since the 1996 Royal Commission on Aboriginal Peoples, and increasingly since *Delgamuukw,* cultural policies have been shaped in response to, and have been shaping, the "making," to use Myers's term, of Native art. The Canada Council for the Arts has had an Aboriginal Arts Secretariat since 1983, which works with the Aboriginal Arts Advisory Committee and administers various Aboriginal assistance programs, including an Elder/ Youth Legacy Program, in support of what the council terms "Aboriginal artistic practices." In the United States, the Native American Graves Protection and Repatriation Act (NAGPRA) (1990) and the Indian Arts and Crafts Act (1990) are legislative moves that worked both to protect and, not without controversy, define, but also to circumscribe, Native culture. Canada's Social Sciences and Humanities Research Council was establishing its Aboriginal Research program in the early 1990s. The report of the Task Force on Museums and First Peoples in Canada (1992), although not legally binding, has encouraged museums and other cultural institutions to adopt policies and protocols closer to those of what are euphemistically referred to as "source communities." *HuupuK^wanum · Tupaat – Out of the Mist: Treasures of the Nuu-Chah-Nulth Chiefs* (Black 1999), a collaboration between the Nuu-chah-nulth Tribal Council and the Royal British Columbia Museum, was one of the first large-scale exhibitions to respond to the report (see Black, this volume; Jonaitis, this volume). The National Gallery of Canada has an Indigenous Curatorial Program, and many other funding agencies, provincial and educational, have similarly adopted such policies.

Born out of various kinds of negotiated liberal compromise in Canada's not-yet-postcolonial situation, the above might be seen as an attempt to do something about what Paul Chaat Smith calls "the untold story." All such actions and entities are justified as rights-based and, therefore, theoretically state protected. The same period has witnessed the publicly visible growth of Native-run institutions and organizations that encourage artists, among others, to identify and communicate culturally specific meanings: they include the First Nations University of Canada (2003) in Regina, developed out of the Saskatchewan Indian Federated College, founded in 1976; Aboriginal arts programs at the Banff Centre, founded in 1993; and the National Aboriginal Achievement Foundation Awards, established in 1993, in conjunction with the United Nations' International Decade of the World's Indigenous Peoples. The Indigenous Media Arts Group (IMAG), the annual First Nations Film Festival, Full Circle: First Nations Performance's annual Talking Stick Festival of Aboriginal Performance and Art, and *RedWire* (see Claxton, this volume) make Vancouver a centre for furthering claims, the relationship of which to the idea of "Northwest Coast" may be either central or tangential. And it could be both.

**27.I. Lawrence Paul Yuxweluptun. 1992. "Lawrence Paul Yuxweluptun."** In *Land, Spirit, Power: First Nations at the National Gallery of Canada*. Edited by Diana Nemiroff, Robert Houle, and Charlotte Townsend-Gault. Ottawa: National Gallery of Canada, 121-22.

Yuxweluptun (b. 1957), whose "white man's alias" is "Lawrence Paul," prefers to be known by his Salishan name, which means "Man of Masks." His mother is Okanagan and his father Cowichan Salish. He was raised as an urban Indian, and it is the ceremonial practices of his father's side of the family that inform his work and direct his life. His parents were active in the North American Indian Brotherhood, and his mother led the Indian Homemakers' Association of BC, while his father headed the Union of BC Indian Chiefs. He credits their political activism for his realization that Native art could be activist too. Yuxweluptun's paintings effectively claim that the lives of First Nations people and the state of their cultures were implicated in the injustices of the Indian Act and inaction on long-outstanding land claims. His paintings connect the bad ethics and human suffering of this situation with the suffering of the land. The large, vivid, allegorical canvases, inflected with a Dali-esque surrealism and a nod to kitsch, depict the land as alive and inhabited by its spirits, thereby disclosing more of the cosmology of the Coast Salish than their protective reticence typically allowed. His forceful political language, manifest in titles such as *The Universe Is So Big the White Man Keeps Me on a Reservation* (1989), *Throwing Their Culture Away* (1989), and *Scorched Earth Policy, Clear-Cut Logging on Native Sovereign Lands: Shaman Coming to Fix* (1991), registered strongly even where it was not easily accepted. In a milieu sympathetic to Native art but more accustomed to claims about the persistence of tradition than to denouncements of colonialism, his work was controversial. It made a knowing and conspicuous move into ongoing arguments about what counted as "Native" and "contemporary," a move that, in the 1980s, masks and other carved works were not making. Nevertheless, the paintings that remorselessly expose the human and environmental costs of colonial history, which Yuxweluptun has been making since the early 1980s, are so remorseless precisely because they are repetitive. As tropes that gain from being repeated, they follow a mask format.

> My work is very different from traditional art work. How do you paint a land claim? You can't carve a totem pole that has a beer bottle on it. I find myself coming back to the land. Is it necessary to totally butcher all of this land? The grizzly bear has never signed away his land, why on earth should I, or a fish, or a bird? To slowly kill my ancestral land? All the money in the bank cannot buy or magically bring back a dead

biosystem. I paint this for what it is – a very toxic landbase. This is what my ancestral motherland is becoming. Painting is a form of political activism, a way to exercise my inherent right, my right to authority, my freedom. This is real freedom for me. I am proud these days. I have self-dignity in my art when I paint this world. I see environmental "schmuck," so I paint "schmuck" – art in all its toxicological bliss. I can speak out in my paintings even without the recognition of self-government. I dance around in a long-house, I dance around fires in turn, like my forebears have done since time immemorial. I am a preservationist, continuing my heritage.

**27.II. Lawrence Paul Yuxweluptun. 1995. "Artist's Statement."** In *Lawrence Paul Yuxweluptun: Born to Live and Die on Your Colonialist Reservations.* Edited by Lawrence Paul Yuxweluptun, Charlotte Townsend-Gault, and Scott Watson. Vancouver: Morris and Helen Belkin Art Gallery, 1-2.

Even in 1995, this was one of the first non-commercial, solo exhibitions of a Native artist's work anywhere in North America. It was not until 1985 that the National Gallery of Canada made its first purchase of a work by a Native artist – Carl Beam's *North American Iceberg.* From the local perspective, "Native art" had always belonged in a museum; to find it in an art gallery was either overdue or a mistake – attitudes that did not necessarily follow a Native/non-Native divide. Before their inclusion in *Indigena* (1992) and *Land, Spirit, Power* (1992), Yuxweluptun's paintings had been shown in Vancouver's Bent Box Gallery, where, by making unruly comments on what many have taken to be the "rules" of Northwest Coast art, they disturbed the conventions that had been most recently confirmed by *The Legacy* (1984). Many believed that "Native art" could not absorb the modes of "Western" art and risk assimilation into something non-Native or inauthentically Native. As a consequence, some of Yuxweluptun's important pieces from the 1980s ended up in collections in Germany, Switzerland, and California, where there was less at stake in maintaining the distinctions. In his show at the Morris and Helen Belkin Art Gallery, Yuxweluptun took the opportunity provided by an avant-garde institution to say what he wanted to an art audience. The catalogue included a timeline (compiled by Stan Bolton) that reflected the artist's assertion: "If I am to talk about my work, I will have to start with the past." The timeline emphasized the main episodes of the colonial encounter as experienced by the colonized. This history, and Yuxweluptun's paintings, represent not so much "the insurrection of subjugated knowledge," to use Michel Foucault's (1980, 81) term, as the declaration of a "public secret," to use Michael Taussig's (1999). Foucault and Taussig were theorists favoured by the audience for advanced art at the time.

CONCENTRATION CAMPS = RESERVATIONS
RESERVATIONS = SEGREGATIONS
SEGREGATION = INTERNMENT CAMPS
INTERNMENT CAMPS = THE INDIAN PROBLEM = THE INDIAN ACT

I suppose that, if I am to talk about my work, I will have to start with the past.

By 1900 the genocide of First Nations peoples, the plagues, massacres, murders and wars, left over 100 million victims dead – nations, tribes, villages, families. Concurrently the Great Land Grab was on.

Colonial racist views considered Natives as bestial rather than human, as uncivilized savages without social organization or means by which to govern themselves. I call this the Amnesiac Colonial Collective Denial Credo Ideology.

The ideology of denial was ingrained in the mandate of the church, the government and the military. Its first sign was the simple act of Europeans jumping off a boat, flag in hand, and laying claim to said land.

European intervention into New World territories included treaties based on a Nation-to-Nation position. However, through time, prudent politicians began to deconstruct First Nation governments, Nation by Nation, territory by territory, destroying the foundation of said First Nations. From henceforth I accuse the said Crown and government officials of perjury in the first degree. Living under this despotism First Nations people have always sought an honourable settlement of the said land, British Columbia.

Land claims have always concerned me: fishing rights, hunting rights, water rights, inherent rights. My home, my native land. Land is power, power is land. This is what I try to paint.

Native people have endured too many years in forced concentration camps in B.C. The Department of Indian Affairs has been unsparing of time and lawyerly energies in maintaining a despotism that is backed up by the RCMP, the Canadian army, Canadian airforce, Canadian coast guard, Department of Fisheries and Oceans, game wardens, provincial courts and the Supreme Court of Canada.

Land is far more important than taking monetary wealth from the outlanders. I am tired of our usufructuary rights, I am fed up with being a usufruct person. I am tired of being fruct around by all of you. I would like to see all First Nations people have self-government and be able to protect their rights as Aboriginal people.

I work from the native perspective that all shapes and any elements can be changed to anything to present a totally native philosophy. It allows me to express my feelings freely and show you a different view.

I find that it is very important to record the times in which I live. We all have to live from this land. Your children's children and my children's children will have to live together. The land, this is everyone's responsibility now, so that their hopes and

dreams, their future, can be protected. I hope my children will never have to experience hate and racism just because of the colour of their skin.

Respect the land and care for it. I love this land and hope you can understand all the feelings I have for it because it is all I have to share.

At this point I would like to thank all the teachers I have had, including my Dad, who said to me one day: "Lawrence, be proud of who you are. Take pride in what you do and do not dishonour me, my son."

**27.III. Scott Watson. 1995. "The Modernist Past of Lawrence Paul Yuxweluptun's Landscape Allegories."** In *Lawrence Paul Yuxweluptun: Born to Live and Die on Your Colonialist Reservations.* Edited by Lawrence Paul Yuxweluptun, Charlotte Townsend-Gault, and Scott Watson. Vancouver: Morris and Helen Belkin Art Gallery, 61.

Scott Watson (b. 1950) is director of the Morris and Helen Belkin Art Gallery at the University of British Columbia. The new gallery opened with Yuxweluptun's solo exhibition, *Yuxweluptun: Born to Live and Die on Your Colonialist Reservations.* In his essay for the catalogue (which included "The Salvation Art of Yuxweluptun" by Charlotte Townsend-Gault, the exhibition's curator, and "Yuxweluptun and the West Coast Landscape" by art historian Robert Linsley), Watson, an authority on twentieth-century and contemporary Vancouver art, both supported the political direction of the work and set it into a wider, contemporary frame. Watson had previously written about the roles of Jack and Doris Shadbolt, pioneers of modernism in Vancouver, particularly the latter's work on Emily Carr and Bill Reid, which drew attention to local Indigenous art by taking it seriously as art. In "Construction of the Imaginary Indian," Marcia Crosby (1991) gave a different reading of this history [17.IV, 28.II]. Watson's position was that Yuxweluptun's combative challenge to the history defined Yuxweluptun as part of it. This set a precedent that was to be taken up by Andrew Hunter, curator at the Vancouver Art Gallery [27.VI].

Lawrence Paul Yuxweluptun's polemical works are a challenge to the eye of the dominant culture. They confront the viewer with the social and historical characteristics of a contested territory. They bring something new to the problem of landscape by replacing the theme of "wilderness" with the issue of land claims. Yuxweluptun's work, in this context, is in a dialectical relationship with the entire tradition of Canadian landscape painting. That is, it casts that tradition in a new light as it opposes it. This light searches through the archive of Canadian images and dispels illusions, particularly those that have built up over the years based on the relationship between the land and nationhood.

For the Group of Seven the land was a cradle for the birth of a new Canadian race. For subsequent generations it has been a sign of regional identity, a topography upon which to cultivate identity. The first duty of the Canadian artist, wrote Northrop Frye, is to establish psychic ownership over the land. If we take this injunction literally – the first move in a deconstructive reading – the contestation of ownership and the erasure of Native land claims, cultures and economies becomes the grand unifying "subject" of the Canadian landscape tradition. Yuxweluptun's relation to the Canadian landscape tradition, although oppositional, is also energizing as it demands that we look again at something familiar, something securely and soothingly part of Canadian identity, for signs of conflict, anxiety and doubt. And just as this reawakening to the historical content of the landscape tradition brings forward a shameful legacy of injustice and suffering there appears, albeit etched in a fainter light, the possibility of justice and redress.

Yuxweluptun's work also appears in the not-unrelated context of the First Nations contemporary art movement in Canada and in the context of that movement's own relation to other movements of cultural empowerment. Here the work openly contests what once seemed received and settled versions of, among other things, the revival of the Northwest Coast design and carving tradition. Yuxweluptun interrupts the appeal to timeless form and ancient tradition that that revival nourishes, displacing the aura of native design from carvings or prints of mythological creatures to contemporary objects. In *Haida Hot Dog* (1984), for example, his "Salish" use of Haida ovoid forms to picture a hot dog, aggravates the distance between the Haida arts and crafts movement, its white audience and the icons of popular culture that infiltrate the lives of ordinary Haida as much as they do everyone else.

A small drawing of a car, again using Haida ovoids, both pricks this aura with satire – we are forced to question why the design is inappropriate, to ask what canon it violates, and simultaneously to notice the ovoid's stream-lined, functional design character and to imagine it as a modernist template whose potential has yet to be realized. These simple "cartoons" upset what we already "know": that we place Haida art with "high" decorative art like Japanese coromandel screens, Art Nouveau furniture or Egyptian antiquities, and not with the Bauhaus/industrial design and interventions into mass production. Isn't it their "high art" and low technology that keeps Indians in their place in the first instance? Isn't there, Yuxweluptun seems to ask, a negative stereotype still kept in circulation by the revival of traditional design that serves to keep First Nations people outside the inner circles of modernity?

Yuxweluptun's paintings are the most recent gesture in the decades old attempt to ally the Canadian version of Western Modernism and the revival of traditional native arts and crafts. And his art is the first to bring this relationship into question.

His use of traditional design elements doesn't merely guarantee the "Indianness" of his paintings. As a Salish artist, he disregards the rule that ethnicity must authorize tribal styles by making use of Haida and Kwakwaka'wakaw design in his work. In some quarters his "misuse" of those forms is seen to abrogate the authenticity of his images. Instead, his use is critical in the sense that it restores history and memory to forms that have been received as timeless and universal. He animates the design forms as actors in the historical struggle over land and the fight for human rights.

**27.IV. James Tully. 1995. *Strange Multiplicity: Constitutionalism in an Age of Diversity.***
Cambridge, UK: Cambridge University Press, 19, 21. Reprinted with the permission of Cambridge University Press.

James Tully (b. 1946) is a distinguished professor of political science, law, Indigenous governance, and philosophy at the University of Victoria. At the time of writing *Strange Multiplicity: Constitutionalism in an Age of Diversity*, he was a professor of philosophy at McGill University and had served as an advisor to the 1996 Canadian Royal Commission on Aboriginal Peoples. In this book, first presented as the John Robert Seeley Lectures at the University of Cambridge in 1994, Tully considered the historical formation of contemporary constitutionalism and how it has shifted from what he termed "the empire of uniformity" to the rediscovery of cultural diversity. His study of politics aimed not to develop a normative theory but "to disclose the conditions of possibility of an historically singular set of practices of governance." In an effortless amalgamation of art and ideology, Tully claimed that those conditions must include Indigenous representations such as Haida artist Bill Reid's *The Spirit of Haida Gwaii*. "This amazing work of art ... a symbol of the age of cultural diversity" has played a significant role in the politics of cultural recognition that has followed what Tully, echoing historian David Stannard, termed "the American holocaust." Tully argued that, "as a consequence of the overlap, interaction and negotiation of cultures, the experience of cultural difference is *internal* to a culture." The Supreme Court of Canada's *Delgamuukw* decision of 1997 agreed. Before the 1990s, it was unusual for political philosophy to accord a central role to a Native version of Canada's predicament.

*The Spirit of Haida Gwaii* appeared on the cover of *Strange Multiplicity*, an example that has been followed by a number of books from various fields of scholarship that display Native works, perhaps as a way of inserting the "Native voice," visually, into debates. The iconic status of the work was cemented in 2004 by its appearance on the Canadian twenty-dollar banknote.

Claude Levi-Strauss has said that: "thanks to Bill Reid, the art of the Indians of the Pacific coast enters into the world scene: into a dialogue with the whole of mankind." The question is, what kind of dialogue does Bill Reid's artwork invite humankind to engage in? How is a non-Aboriginal person to approach *The Spirit of Haida Gwaii* in the right spirit, in, so to speak, the spirit of *Haida Gwaii*, in order to try to answer this question? How can a non-Aboriginal person, after centuries of appropriation and destruction of Indigenous civilizations, free himself or herself from deeply ingrained, imperious habits of thought and behaviour and approach this symbol in the appropriate way?

...

Since the early twentieth century and especially since World War II, the Haida and other Aboriginal nations, in the face of appalling social and economic conditions, have sought not only to resist and interact, but to rebuild and reimagine their cultures; to "celebrate their survival." *The Spirit of Haida Gwaii* is both a symbol and an inspiration of this revival and "world reversal," as the Aboriginal peoples call it: to refuse to regard Aboriginal cultures as passive objects in an Eurocentric story of historical progress and to regard them from Aboriginal viewpoints, in interaction with European and other cultures.

**27.V. Wii Muk'willixw (Art Wilson). 1996. Introduction. In *Heartbeat of the Earth: A First Nations Artist Records Injustice and Resistance.*** Gabriola Island, BC: New Society Publishers, 14-15, 36. Courtesy of the author.

In her foreword to this paperback collection of political art cartoons, Buffy Sainte-Marie (1996, 13) wrote of a shifting perspective by which "indigenous people's points of view such as this are seen less as 'minority' and more as practical, mature, obvious and necessary." Each of the forty images by Wii Muk'willixw (Art Wilson) (b. 1948), a member of the Gitksan nation, was accompanied by his own commentary. In black, white, and red, their manner owed something to Lyle Wilson and Yuxweluptun. Although most of the themes concerned local and recent Gitksan histories, they also covered worldwide invasions of Indigenous spaces, territorial and spiritual, and resistance to these invasions – including Oka, Davis Inlet, the James Bay Cree's successful termination of the Great Whale Hydro Project, the Trail of Tears and Wounded Knee, low-flying NATO jets screeching over Innu territory in Labrador, the Chinese occupation of Tibet – and made common cause with the Zapatistas and Movimento Sem Terra (Yes Earth Movement) in Brazil. By asserting issues that have linked Aboriginal peoples worldwide, Wii Muk'willixw's inclusiveness bypassed the habitual insulation, the local/global distinction, that had long prevailed in the purposes of Northwest Coast Native art.

I have been asked on numerous occasions, "Why are you a political artist?" and "Why is your art so sad?"

I was born a member of the Gitxsan nation which is an oral society. Our history has been recorded traditionally through totem poles, button blankets, songs and legends. This tradition continues in my artwork. All of my artwork has been inspired by my Gitksan culture, and the injustices that have happened to aboriginal people all over the world. It has been a way of delivering a message and recording today's history. Through my artwork I hope I can clarify issues at hand.

My work cannot avoid being political and sad because it deals with educating people about the true history of the First Nations. Everyone needs to understand that this continent, along with others, has been built on broken promises and lies. All of the Canadian government's policies for First Nations peoples, for example, have been directed toward our assimilation into modern society and the extinguishment of our title to land. There has been a trail of blatant destruction: massacres, germ warfare, the outlawing of feasts and ceremonies, the destruction of irreplaceable sacred regalia, removing us to residential schools, creating reserves and implementing the Indian Act which set up elected band councils where the chief could even be a white person.

As First Nations peoples we have always resisted these attempts to destroy us with passion and ingenuity, whether in North America, Africa, the Pacific, or elsewhere on the planet.

I feel very strongly that these stories of injustice and resistance need to be recorded in art form because, in general, people have short term or selective memories. A painting stands out as a constant reminder of the atrocities that have taken place. And the language of a painting is universal, understood by all cultures.

Through my paintings, the truth of our history, and the significant events that have marked our determination to survive and overcome colonial oppression will not be forgotten.

**27.VI. Andrew Hunter. 1996. "Thou Shalt Not Steal: Lawrence Paul Yuxweluptun and Emily Carr."** Exhibition text panels at Vancouver Art Gallery, October 1996-May 1997.

In this unpublished text, Andrew Hunter (b. 1963), associate curator at the Vancouver Art Gallery, followed the direction taken by Scott Watson [27.III] and Robert Linsley in the 1995 catalogue and set Yuxweluptun's work in fierce dialogue with Emily Carr's paintings, of which the gallery holds the most important collection. Since then, these ideas have been incorporated into and reworked in a number of publications probing the imbrication of Native art with the Canadian imaginary through the twentieth century, such as Gerta Moray's *Unsettling Encounters: First Nations Imagery in the Art of Emily Carr* (2006) and

John O'Brian and Peter White's *Beyond Wilderness: The Group of Seven, Canadian Identity and Contemporary Art* (2008). It should be noted, however, that in a work from the same year, *The Impending Nisga'a Deal. Last Stand. Chump Change* (1996), Yuxweluptun protested the terms of the Nisga'a Treaty as being too little, too late, and a sell-out of Aboriginal interests, a stance at odds with that of the Nisga'a negotiators themselves.

Lawrence Paul Yuxweluptun and I began a dialogue about Emily Carr, an artist he both values and critiques. We discussed Carr's concern for the environment and her representations of First Nations cultures. We considered the problems of perpetuating Carr's view as an authentic view of "Indianness." In the context of Carr's ongoing presence here at the Vancouver Art Gallery, this installation began as a polite exchange about relationships between the work of Carr and Yuxweluptun, reflecting my initial desire to question some of the assumptions around the work of Carr. Through a juxtaposition of Yuxweluptun's and Carr's paintings, I wanted to raise questions, to use Yuxweluptun's work as a tool to probe around Carr.

In our discussions on the phone and at the studio, it became obvious that Yuxweluptun was not interested in just a simple exchange with Carr, he had no desire to speak "through" Carr. Instead, he wants to communicate his understanding of what the real issues are facing contemporary First Nations peoples (on and off reserves) – land claims, racism, environmental disasters, the control of natural resources, among others. He argued, convincingly, that he has more pressing concerns than just an exploration of his relationship to Carr and insisted that his work also have an independent presence equal to Carr during the installation. It is essential to Yuxweluptun that his paintings be considered directly, not filtered through Carr, and further that a situation be created where the viewer is forced to view Carr through Yuxweluptun. A true dialogue flows both ways.

Through our process, Yuxweluptun has reminded me of my position of control within the institution. He has refused to allow me to use his work strategically and demands that I stick my neck out as he has done through his paintings. Yuxweluptun encourages me to publicly question my own position, attempting to make the power transparent.

*Thou Shalt Not Steal* is the title of the large text painting that boldly declares "Native Land Claims" over top of Emily Carr's paintings in the next room. *Thou Shalt Not Steal* has been lifted by Lawrence Paul Yuxweluptun from the Ten Commandments, a message sent by the god of the Old and New Testaments to Moses as guiding laws for his people. This commandment is now repeated as a harsh reminder of an oath not kept by the European culture that brought these words to this region. Yuxweluptun's title suggests the law but not the punishment – *life for life, eye for eye, tooth for tooth, hand for hand* ... (Exodus, 21:22-25).

In this exchange between artist and curator, "thou" is me. I am implicated in Yuxweluptun's accusations of theft. I try to maneuver out of the way of his accusation, to stand with him, detached from the European explorers/colonizers and their destructive effects on the land and culture he claims as his own. I attempt to separate myself as an individual from this legacy, what Lawrence sees as my legacy, a lineage I cannot avoid as he says he cannot avoid his own. There is no safe position.

Lawrence Paul Yuxweluptun has shown me things that are all too clear, scenes difficult to look upon because I know exactly what they are. Equally, he has displayed things I cannot comprehend, nor ever will. I know the white-coated man teetering in the background of *Red Man Watching White Man Trying to Fix Hole in Sky*. I immediately recognize that hole as the hole in the ozone layer. I am as frightened as Lawrence by its implications, however, where Lawrence feels assaulted and violated by its presence, I feel implicated in its existence.

Looking at *Night in a Salish Longhouse*, I am lost. I have no idea what is being acted out. This is a religious work and there is nothing in my upbringing which I can draw on to make sense of the actions of these three figures (who I believe are giants). I could press Yuxweluptun for "clues" (he has explained that the scene relates to a period of fasting followed by a vision and spiritual union with a bear) but I would never truly understand the symbolism of that dark interior, I am determined to know, but fail to comprehend. Then I encounter *Burying a Face of Racism* (a monumental work in progress to be installed at the Vancouver Art Gallery later this year). The work depicts three figures about to bury a white-faced mask. Here, I am literally confronted by giants and I am, unfortunately, no longer confused. I challenge anyone to claim with a clear conscience that they have never worn that pale racist mask even, if only, for a fleeting moment.

Yuxweluptun's paintings can be both cryptic and brutally direct, in the same way that the Spanish artist Francisco Goya's images are in his series *The Disasters of War* (1812-14). Goya described the Napoleonic occupation of his homeland through journalistic illustrations of torture countered by strange, dreamlike visions.

Yuxweluptun, like Goya, is producing images from what he considers an occupied homeland. Unlike Goya, however, (who initially welcomed his oppressors as deliverers of democracy and, by virtue of his Catholicism, was linked to the reinstatement of the Spanish Inquisition after the war), Yuxweluptun cannot be implicated in the occupation. Through what started as a dialogue about Emily Carr, however, he has clearly articulated my accountability.

So, like the giant figure who stands in the left foreground of *Red Man Watching White Man Trying To Fix Hole In Sky*, Yuxweluptun stands watching as I (the tiny lab-coated man atop the shoulders of a mysterious masked figure) attempt to fill a gap. As in the painting, I have reached a precarious point. Assisted by a structure of

Yuxweluptun's devising, I attempt to manipulate an unruly patch (an exhibition) and to stabilize the scene (the gallery/museum) – to keep this very Western structure intact while engaging the powerful presence of Yuxweluptun's paintings which foreground issues of geographical and cultural sovereignty and challenge traditional definitions of First Nations art and culture.

### POSTSCRIPT

*Thou Shalt Not Steal* – I have returned to the *Old Testament* and found, following the *Decalogue* (Ten Commandments) and *The Book of the Covenant*, the word of "God" which followed the rules that Yuxweluptun refers to, and it is clear that initially these rules were not meant for everyone – they were specific to the community of the "chosen" people. The *Decalogue* may have told this community not to steal, but it also established their relationship to the land, their claim on the land and their right to take the land of others. Lawrence Paul Yuxweluptun may struggle with the contradiction between the rules and actions of the European colonizers, however, the culture of the colonizers was firmly rooted in the following text in which the god of the Old Testament outlined their plans to "cleanse" Canaan of the native population. It is a text, as with much of the Old Testament, open to biased interpretation and possible use as justification for colonialist and racist actions:

> I will send forth My terror before you ... I will send a plague ahead of you ... I will drive them out before you little by little, until you have increased and possess the land ... I will deliver the inhabitants of the land into your hands ... You shall make no covenant with them or their gods. They shall not remain in your land, lest they cause you to sin against Me; for you will serve their gods – and it will prove a snare for you (Exodus, 23:27-33).

### LAWRENCE PAUL YUXWELUPTUN AND EMILY CARR: THE BRITISH COLUMBIA LANDSCAPE

Land claims have always concerned me; fishing rights, hunting rights, water rights, inherent rights. My home, my native land. Land Is power, power is land. That is what I try to paint.

> — *Lawrence Paul Yuxweluptun*

Like Lawrence Paul Yuxweluptun today, in the 1930s and 1940s Emily Carr saw the landscape she knew and loved being decimated by clear-cut logging and mining. In works such as *Above the Gravel Pit* and *Scorned as Timber Beloved of the Sky*, she clearly depicts the effects of industry on the landscape, articulating a distaste for such destruction, while still managing to find an element of hope and beauty within.

In Yuxweluptun's work, the transformation of the landscape by logging, chemical and real estate industries is a constant presence. Like Carr, he also images the destruction, yet there is an added urgency considering the effects of advanced technology inflicted on the environment. Furthermore, Native land rights were clearly not an issue for Carr. For Yuxweluptun, any consideration of the current state and fate of the land is inseparable from land rights and land claims to the point where no depiction of the British Columbia landscape, no matter its intent, can be separated from these issues. The placement of the large text painting *Thou Shalt Not Steal* in the next room is a bold reminder of this fact.

**27.VII. Doreen Jensen. 1996. "Metamorphosis."** In *Topographies: Aspects of Recent B.C. Art.* Edited by Grant Arnold, Monika Kin Gagnon, and Doreen Jensen. Vancouver: Douglas and McIntyre, 91–92, 97, 108, 114, 119. © 1996 by the Vancouver Art Gallery. Published by Douglas and McIntyre: an imprint of D&M Publishers Inc. Reprinted with permission from the publisher.

Doreen Jensen (b. 1933), Gitksan artist, historian, and curator (introduced by Karen Duffek, this volume) [20.VIII], has long been one of the most publicly visible advocates for the broader understanding of First Nations history, in part through her book (with Polly Sargent) *Robes of Power: Totem Poles on Cloth* (1986a) and the special issue of *BC Studies* she edited with Cheryl Brooks, *In Celebration of Our Survival* (1991). A compelling speaker, in Loretta Todd's film *Hands of History* (1994), Jensen made some of the strongest, and most often cited, claims that "art" is not the correct term and that it misrepresents the values ascribed to things such as button blankets and the ongoing cultural work done by them. Claims about aesthetic value are not taken as complimentary or validating but as intrusive and inaccurate.

The section of the exhibition *Topographies* (29 September 1996 to 5 January 1997 at the Vancouver Art Gallery) that Jensen curated, and her essay for the catalogue, were marked by seamless circumvention of the distinctions between traditional and contemporary, art and craft, and of the debate about whether art made in British Columbia by Native artists needs, or does not need, to have the "Northwest Coast look." These distinctions are irrelevant, Jensen argued. She also emphasized the irony that First Nations artists were able to correct the misrulings of (art) history in the gallery that now occupied the former court house and infamous Land Registry Office. Jensen was one of three curators for *Topographies,* with Andrew Hunter and Monika Kin Gagnon. First Nations artists – Mary Longman, Dana Claxton, and Cathi Charles Wherry – were also included in Kin Gagnon's selection. Excerpts here concern the historically underrepresented work of women on the Northwest Coast.

The site of this exhibition in the building we call the Vancouver Art Gallery, evokes the notion of metamorphosis. Just 112 years ago, a powerful rainforest covered the place where the Vancouver Art Gallery now stands. Trees rose 312 feet into the coastal sky. Streams made their way through the woodland where bears, beavers, wolves, elk and other animals made their homes. First Nations people were part of this complex ecosystem. They harvested trees for lumber, cutting slabs from the standing trees in a way and at a season so the trees could continue to thrive ...

The past creates an energy in the present, whether we know it or not. The ancient forest and its metamorphosis into timber, then real estate, is still part of this place ...

Rena Point Bolton was born on the Sumas Reserve at Kilgard in the late 1920s, during the time that the potlatch ban was strictly enforced. From birth, her family recognized and encouraged her as a carrier of her people's cultural heritage. Her grandmother taught her their songs, history, names, art and crafts. This training began when she was only three years old. Bolton learned, and she learned to teach. After the potlatch ban was lifted in 1951, she began actively exhibiting and teaching her cultural heritage, her basketry and blanket weaving.

Learning and teaching is at the centre of Bolton's artistic practice. Her *Tsimshian Chief's Hat,* for example, is a result of fifteen years of research on Tsimshian weaving (which uses wool and cedar bark). After mastering this art, Bolton instructed a twelve-week course on Tsimshian cedar bark basket weaving in 1985. Bolton feels her main accomplishment has been to promote the ancient arts of her people. She has also been instrumental in motivating others to learn and inspiring them to teach the younger generations ...

Freda Diesing also mediates between natural and spiritual realities with her sculptures. Her *Moon Mask* tells how the people of Haida Gwaii travelled to the moon in ancient times. Furthermore, Diesing is herself a mediator between elders and young people, between tradition and postmodernity, and between B.C. and other parts of the world. She studied at both the Kitanmax School of Northwest Coast Indian Art and the Vancouver School of Art. Also, she learned from old masters among the Gitxsan and was influenced by the carver Ellen Neel. Diesing studied art in museums and at the Vancouver Art Gallery. She became both a mentor and a teacher to many of her peers; among her best-known pupils are Dempsey Bob, Don Yeomans, Norman Tait and Alvin Adkins ...

I do not accept academic distinctions between culture and environment. Nor has anything in my experience or education brought me to accept pedantic distinctions between art and craft. Susan Point, taking the spindle whorl from its traditional four- to seven-inch diameter up to an art object three feet wide, shows the fallacy of such distinctions. As Point writes, her work honours the spindle whorl itself as an art form, in addition to the decorative imagery on the whorl's surface.

I do not distinguish between culture and environment, art and craft. Nor can I
believe in categorizing work by living artists as either "traditional" (valid anthropo-
logical artifact) or "contemporary" (valid fine art object). Such distinctions are at
best irrelevant; at worst, they are racist. Isabel Rorick's fine basketry is an example
of the kind of artwork that such academic distinctions would exclude from a fine art
exhibition. And true enough, this art was not taught at colleges and universities,
written up in textbooks of art history, or published in international art magazines.
Instead, Rorick learned from her grandmothers. Rorick comes from a long line of
weavers on both sides of her family. Her mother Primrose Adams taught her how to
make chiefs' hats. Her aunt Delores Churchill encouraged her to weave and to pass
this knowledge on. Her "nonny" (grandmother) Selina Peratrovich was a very im-
portant person in her life. Even though Peratrovich lived in Ketchikan, Alaska, she
visited Haida Gwaii at least twice a year. She would harvest the materials for her
basketry in Haida Gwaii and sometimes would make baskets while her grand-
daughter watched. As Peratrovich worked, she would sing or tell stories – she was
always happy. Rorick remembers:

> When I became interested in carving, my nonny Selina said to me, "You have to
> make up your mind what you're going to do. Carve or weave? If you're going to
> weave, you have to come with me right now." I put down what I was doing. I went
> with her and I never looked back.

Basketry is traditionally a women's art, and although highly regarded in all First
Nations, its practitioners have not been accorded the same status as male artists in the
literature. Rorick's great-grandmother Isabella Edenshaw was rarely recognized for
her fine basketry. Her husband Charles Edenshaw, who painted the woven hats, was
the only one recognized for his artistry. Today Isabel Rorick has achieved internation-
al recognition for her fine contemporary weaving. Occasionally, she hires someone to
paint designs on her chief's hats, and she acknowledges them. In the case of her Haida
Chief's Hat, she hired Charles Edenshaw's great-grandson Reg Davidson to paint the
designs for her ...

Debra and Robyn Sparrow's weaving results from many years of study, trial and
error. They analyse examples of old Salish weavings in museum collections and in
books. The last known weaver before the contemporary revival was the Sparrows'
great-grand-mother. Debra Sparrow says, "At the beginning we had no one to ask
but our own inspiration." The inspiration, Sparrow feels, comes from her ancestors,
whom she describes as

> the women who have passed it on through a silent inner connection to our creation.
> Spirit, intellect responds and sends the message to my hands.

Today the Sparrow sisters have developed the art of weaving to a very high form, with their innovative designs and colour sense. Debra Sparrow says of her weaving:

> What we are doing is still traditional, but it is contemporary ... It's not art as you know it. It is a lifestyle we know.

**27.VIII. David Gladstone. 1997. Exhibition text panels for *Through My Eyes: Northwest Coast Artifacts as Seen by Contemporary Northwest Coast People.*** Vancouver Museum, 21 June 1997–20 September 1998.

This exhibition was based on the premise that very little was known – because very little had been expressed in public – about what First Nations people thought or felt about First Nations objects of all kinds that were held and displayed in museums. The Vancouver Museum, for example, has a notable Indigenous collection. It was the premise of Bill McLennan, photographer and long-time member of the exhibition team at the Museum of Anthropology, that the curatorial role, the selection and framing of the display of these objects, should be passed to First Nations people. Some significant members of British Columbia's First Nations were invited to select from the museum's permanent collection and comment on their selection. This premise was also at the core of the Museum of Anthropology's renewal project and now shapes the policies of many other museums.

Heiltsuk artist and historian David Gladstone (1955-2006) was well known as a carver, painter, jeweller, and designer of textiles and regalia. With his interest in Heiltsuk performing arts and stagecraft, Gladstone facilitated public events and performed as lead singer, composer, and storyteller. He was also a student of Native legal tradition and intertribal relations and a teacher and ambassador of Heiltsuk culture. These texts were approved for use in the exhibition with the artist's signature on 16 June 1997.

> With the guidance and support of my teachers I have become an agent in the revival of traditional knowledge and customs among the Heiltsuk. Our once diminishing culture has awakened, and is being expressed in creative and dynamic ways. The evolving Heiltsuk culture makes demands of its artists and performers. The relationship between the culture and the creative person is very much alive.

> The materials [for baskets] are chosen very carefully and handled in a particular manner. In order to get the harmony in the materials, they would choose, the branches, split them, and discard half the branches because they were bent the wrong way. Bending them in a U-shape, you want to have the outside of the branch on the outside

of the U. So they would discard anything that wasn't like that. This way, there were no opposing forces. [Cat. No. AA506]

These baskets were fairly common when I was a boy. They look just like laundry baskets. They were used to store blankets. This is probably the origin of the current custom of giving baskets at a potlatch: to carry potlatch goods. Boxes would have been used too. So the boxes – and even baskets – would have had a lot of circulation. [Cat. No. AA2064]

**27.IX.  Marcia Crosby. 1997. "Lines, Lineage and Lies, or Borders, Boundaries and Bullshit."**
In *Nations in Urban Landscapes: Faye Heavyshield, Shelley Niro, Eric Robertson.* Guest curated by Marcia Crosby. Vancouver: Contemporary Art Gallery, 23, 30.

As in her widely cited "Construction of the Imaginary Indian" (1991), Marcia Crosby's uncompromising percipience once again pointed to a situation that might have been obvious to many at the time yet, such are the curious silences in British Columbia, was publicly obscured in the ill-articulated political climate. This exhibition and its catalogue drew attention to the situation of the many First Nations people who choose not to live on reserves or who are "non-status" according to the calibrations of the Indian Act. As is often the case, the work of contemporary artists was presented as an exemplar of, or as having, or being given, agency in a socio-political situation. These expectations came from various points on the political spectrum. Crosby curated *Nations in Urban Landscapes* in 1995 at Vancouver's Contemporary Art Gallery, with work by Faye Heavyshield (Kainai of the Blackfoot Nation), Shelly Niro (Bay of Quinte Mohawk), and Eric Robertson (Euro-Canadian and Gitksan). Paul Chaat Smith (1997) contributed an essay to the catalogue, "From Lake Geneva to the Finland Station," and Crosby contributed two essays: "Nations in Urban Landscapes" and "Lines, Lineage and Lies, or Borders, Boundaries and Bullshit." In the latter, she recognized that "the land question as it is represented in the public sphere does affect the way in which the image of the Indian circulates and functions in relation to various audiences." *Reservation X,* curated by Gerald McMaster for the Canadian Museum of Civilization in 1998, developed Crosby's premise further, exploring much important work being done in urban settings with new definitions of "community." Evidence of these energies is reflected in the Vancouver 'zine *RedWire.*

The image of "the Indian" most commonly depicted in mainstream media, and thus in the public sphere, is of First Nations leaders asserting sovereignty over aboriginal lands on the platform of origins and traditional forms of governance and cultural

practice. As such, it creates an illusion that the interests of all peoples of aboriginal ancestry are being addressed through the recognition and resurgence of Native governments. It is an illusion that bears investigation. Can we assert in an exhibition, for example, that "the artists' aboriginality is based on their inherent right to self-government, [as a] context for a sovereign subjectivity in which the politics of representation are *inseparable* from the issue of aboriginal title" [Houle 1993; emphasis mine]. While it is an historical and legal fact that aboriginal peoples do have an "inherent aboriginal right" to aboriginal land and self-government, these "rights" have become a theory which has not ensued in fact for all aboriginal people. In fact, many aboriginal people *do not* have, or may not want, access to aboriginal title of land for many complex reasons.

However, the land question as it is represented in the public sphere does affect the way in which the image of the Indian circulates and functions in relation to various audiences. In this context, all aboriginal people are ultimately affected by the possible meanings that being identified as "Indian," or identifying things as "Indian," at specific historical moments may have. We cannot avoid negotiating how these meanings dovetail with, and inform, art practice. My concern is the way in which the "new" signposts of "Indianness" persist in art practice; that is, as they are determined by aboriginal peoples' "inseparability" from the representation of aboriginal leadership and land, and the conventions of authenticity, origins and tradition. These signposts include transcendent aboriginal cultures and seamless histories that present Indians as natural stewards of the land, and by extension, the Earth; Native "Elders" as the quintessence of tradition; portrait photographs of contemporary Chiefs in sepia-toned timelessness; the artist as shaman, the embodiment of Coyote, Raven or other "Tricksters"; Native peoples as holders of spiritual enlightenment, and so on. Given the hybridity of our histories as evident in the works of HeavyShield, Niro and Robertson (and many other artists of aboriginal ancestry), we are challenged to examine whether the issues of self-government, sovereignty, the politics of representation, and aboriginal title can be seamlessly linked together in art practice.

...

POSTSCRIPT

Acknowledging aboriginal peoples' hybridity is not about assimilation, further loss or naively ignoring injustice. It is about honoring all of our histories, which engenders the confidence necessary to grow in an inclusive (rather than exclusive) way. While much of the preceding discussion has dealt with the power relations between aboriginal peoples, there is a terrible irony to the whole discussion. The reality is, recognition and a willingness to deal with the land question by the provincial and federal

Canadian governments has been tediously slow. There has been little positive socio-economic change for most First Nations communities, and mostly cosmetic policy and program changes in Western institutions.

On a personal level, in the face of the relentless projects of assimilation, I have carefully guarded my "difference." But binding myself, ideologically, to a particular group in binary opposition to the "Others" created too much space for [what Homi K. Bhabha (1990, 300) calls] "the ambivalent identifications of love and hate that binds a community together." This, in turn, left too little space for the hybrid reality of my life. It has become clear that the categories of lover/hater, oppressor/oppressed, traditional/assimilated, and reserve/urban "occupy the same psychic space. [And that any] paranoid projections 'outwards' return to haunt and split the place from which they are made" [ibid.]. In other words, if I use reductive or populist "difference(s)" as a tool for empowerment, it will eventually turn inward, dividing and disempowering my own history, and the places/people I am trying to support.

**27.X.  Joseph Gosnell. 1998. Speech to the BC Legislature on the occasion of the ratification of the Nisga'a Treaty.** Quoted in Alex Rose, ed. 2000. *Spirit Dance at Meziadin: Chief Joseph Gosnell and the Nisga'a Treaty.* Madeira Park, BC: Harbour Publishing, 16-24. Reproduced with the permission of Dr. Joseph Arthur Gosnell, Sr., O.C., O.B.C., LL.D., Sim'oogit Hleek.

This powerful example of oratory from a respected Native leader and negotiator was delivered by Joseph Gosnell (b. 1936), holder of the Order of Canada, wearing a Chilkat robe and ermine-trimmed chiefly headdress, before the BC Legislature in Victoria. In his speech, Gosnell hailed the Nisga'a Treaty as the "end of more than a century of degradation and despair." After 113 years, the bill to ratify the treaty was passed by the House of Commons on 13 December 1999 and ratified by the Senate on 13 April 2000. The treaty was denounced by critics, such as the abrasively reactionary local radio host Rafe Mair, as "an absolutely shocking betrayal of democracy." Gosnell's speech is included here to acknowledge the inseparability of oral, visual, and material testimony. If it appears that little of the content of work made on the Northwest Coast has directly concerned land-claims issues, the apparent omission discounts the political agency of oratory and the contemporary display of privileges, which continues a tradition of display signifying the importance of an occasion and which is used repeatedly to reinforce claims, assert sovereignty, or mark acts of repatriation. Recent instances are recorded in Kevin McMahon's *The Stolen Spirits of Haida Gwaii* (2004) and Gil Cardinal's *Totem: The Return of the G'psgolox Pole* (2003), documentary films that include ceremonies to mark the repatriation of ancestral remains, and other acts of restitution.

The text of Gosnell's speech was widely circulated and was reprinted in an account by Alex Rose of the long process that led to the Nisga'a Treaty. Rose has worked closely with the Nisga'a on two previous books: *Bringing Our Ancestors Home: The Repatriation of Nisga'a Artifacts* (Nisga'a Tribal Council 1998) and *Nisga'a: People of the Nass River* (1993).

Madame Speaker, Honourable Members, ladies and gentlemen.

Today marks a turning point in the history of British Columbia. Today, Aboriginal and non-Aboriginal people are coming together to decide the future of this province. I am talking about the Nisga'a Treaty – a triumph for all British Columbians and a beacon of hope for Aboriginal people around the world. A triumph, I believe, which proves to the world that reasonable people can sit down and settle historical wrongs. It proves that a modern society can correct the mistakes of the past. As British Columbians, as Canadians, we should all be very proud. A triumph because, under the treaty, the Nisga'a people will join Canada and British Columbia as free citizens – full and equal participants in the social, economic and political life of this province, of this country. A triumph because under the treaty we will no longer be wards of the state, no longer beggars in our own lands. A triumph because under the treaty we will collectively own about 2,000 square kilometres of land, far exceeding the postage-stamp reserves set aside for us by colonial governments. We will once again govern ourselves by our own institutions but within the context of Canadian law. It is a triumph because under the treaty we will be allowed to make our own mistakes, to savour our own victories, to stand on our own feet once again. A triumph because, clause by clause, the Nisga'a Treaty emphasizes self-reliance, personal responsibility and modern education. It also encourages, for the first time, investment in Nisga'a lands and resources and allows us to pursue meaningful employment from the resources of our own territory for our own people. To investors it provides economic certainty and gives us a fighting chance to establish legitimate economic independence – to prosper in common with our non-Aboriginal neighbours in a new and proud Canada. A triumph, Madame Speaker and Honourable Members, because the treaty proves beyond all doubt that negotiations – not lawsuits, not blockades, not violence – are the most effective, most honourable way to resolve Aboriginal issues in this country. A triumph that signals the end of the *Indian Act* – the end of more than a century of humiliation, degradation and despair.

In 1887, my ancestors made an epic journey from the Nass River here to Victoria's inner harbour. Determined to settle the Land Question, they were met by a premier who barred them from the legislature. He was blunt. Premier Smithe rejected all our aspirations to settle the Land Question. Then he made this pronouncement, and

I quote: "When the white man first came among you, you were little better than wild beasts of the field." Wild beasts of the field! Little wonder then, that this brutal racism was soon translated into narrow policies which plunged British Columbia into a century of darkness for the Nisga'a and other Aboriginal people.

...

We have worked for justice for more than a century. Now, it is time to ratify the Nisga'a Treaty, for Aboriginal and non-Aboriginal people to come together and write a new chapter in the history of our Nation, our province, our country and, indeed, the world. The world is our witness. Be strong. Be steadfast. Be true.

**27.XI. Debra Sparrow. 1998. "A Journey."** In *Material Matters: The Art and Culture of Contemporary Textiles.* Edited by Ingrid Bachman and Ruth Scheuing. Toronto: YYZ Books, 149, 150, 152-54. Courtesy Debra Sparrow.

Debra Sparrow and her sisters Robyn Sparrow and Wendy Grant-John have been instrumental in reviving Salish weaving at Musqueam since 1986. Their techniques of spinning, dyeing, and weaving combine the inherited and the re-membered with the adapted. The purposes for which the resulting textiles are used mix established values with a variety of contemporary needs and modes of display. Musqueam weaving is prominently displayed in the international arriv-als area at the Vancouver International Airport (YVR) – no mere decoration, they mark the fact (explained on a nearby plaque) that YVR is on unceded Musqueam land. The Coast Salish, who do not allow their masks to be displayed in non-ceremonial settings, were represented in *Down from the Shimmering Sky: Masks of the Northwest Coast* (1998) by two of Sparrow's weavings, which flanked the entrance to the exhibition in the Vancouver Art Gallery. At the same time, the textiles are hung on the walls of private and public collectors as if they are modernist art objects, and they were included in *Topographies: Contemporary Art in British Columbia* (1997) in the section curated by Doreen Jensen, illustrating her adaptation of the definition of "art" [27.VII].

In "A Journey," Sparrow recounted her personal involvement in the process of recovering a tradition that was only a childhood memory for her grandfather's generation. The text is dedicated to the memory of her grandfather, Ed Sparrow. When she was an adult, she expressed her surprise that he had never told her about weaving when she was growing up. She asked him,

"Why didn't you tell me? What do you know?" He said, "What do you want to know?" and I said, "Anything you know. Why haven't you

explained it to me when I have been here before? You've said nothing." And he said, "You didn't ask me." That put a knife in my heart, to realize how much I had to learn. Weaving has done that for me, it has made me realize how important he is, and how important it is to know who I am through him. (Sparrow 1998, 155)

We did not plan on being weavers. We started off on a journey not knowing where we were going. I have gone out many times over the past few years to share the direction and inspirations that we have had as weavers. I have found it interesting to listen to others talk about the worlds they come from, their heritage, their traditions, often a world I know nothing about, a world very far removed from the one I live in. It is not to say that I have not been influenced by contemporary mainstream society, but where I come from is the land of the Salish weavers, and we, in this world, are doing exactly what you were doing in your world in the seventeenth century. I am not a reader and I am not a traveller. As weavers engaged in a process of learning skills we searched within ourselves and in our own culture and I am going to explain how it all began years ago. Then I will return to the weaving we do now.

We all want to know who we are and where we fit in the world. As Aboriginal people we had to assimilate into a society that we felt very afraid of and very threatened by. The education system failed us, religion failed us, and we had failed ourselves because we had lacked belief in ourselves. And we didn't know why this was happening and why we felt a gaping hole in our soul. So we searched, feeling that we were not going to think with our minds, but that something in our spirits was calling for us to pay attention.

...

But every once in a while I felt the gentleness of my grandparents' life. I knew they had something to offer and that eventually I would need it to complete my own life. I would spend hours talking to them, but when it came to talking about my life, I felt frustrated and let down. I wasn't interested in the outside world anymore; I decided the only place I could look was within myself. My older sister and I had many conversations that revolved around the lack of visual reflections of our people. We looked in awe to the north, the south, the east, the west, to all the Native Aboriginal people. Our lifestyle and reflections could not be shared with the outside world because it meant too much to us; it had a spiritual value that could not be seen by the public. As we sat during the ceremonies in our winter longhouses, we knew that this was where we needed to be to start to redefine who we were as Indian people, as Indian women, as Indian children. The rest of our time we spent watching TV, going to McDonald's,

and going so far away from ourselves that we would almost forget who we were. Visiting the longhouse every winter, we began to share a small part of what was left of who we were as Aboriginals.

...

My sisters and I are very passionate about Salish weaving. Through weaving we have tried to understand what it is that we need as Native people and how we might right some of the wrongs that have been done by our ancestors. We need to reintroduce, through weaving and tapestry, a message that can be read by society as a whole. I have this belief – and I've heard other Native people talk about this too – that each blanket, each tapestry, has a message within. If I have to use my hands to reflect a message to people then I will do that, but the messages do not belong to me; they belong to all our people. And we are willing to share, willing to go forward in time and be political, to some degree. We are not trying to make people feel bad about what has happened in the last two hundred years; we want to make sure that our people who lived thousands of years ago will be able to feel justified in their existence by the work that reflects them today. That has been our goal: to be able, on a large scale, to share and reflect with the whole region and the world, the integrity and intelligence of the people who existed in this land prior to the arrival of the Europeans. We were a functioning people with skills and intellect equal to any other.

I think that our search is meaningful to other Aboriginal people throughout the world. If people have to see to believe then we now have our weavings to show, something to share with you. It has been the most exciting journey some of us have taken in our lives. The most important thing is that it has brought a sense of success to our people. As we go about our business and community politics, the weaving represents a success equal to anything that others are doing. It is our saving grace, it is our education system.

**27.XII. Robert Joseph. 1998. "Behind the Mask."** In *Down from the Shimmering Sky: Masks of the Northwest Coast.* Edited by Peter Macnair, Robert Joseph, and Bruce Grenville. Vancouver: Douglas and McIntyre, 19-20. © 1998 by the Vancouver Art Gallery. Published by Douglas and McIntyre, an imprint of D&M Publishers Inc. Reprinted with permission from the publisher.

Robert Joseph (b. 1940) is a Kwakwa̱ka̱'wakw chief, writer, and curator. He is executive director of the Indian Residential Schools Survivors Society and has been involved in First Nations activities at the local, provincial, and national levels. He collaborated with Aldona Jonaitis on *Chiefly Feasts: The Enduring Kwakiutl Potlatch* (1991) and contributed to its chapter "The Treasures of Sewidi." He wrote "An Elder's Perspective" for and was editor of *Listening to*

*Our Ancestors: The Art of Native Life along the North Pacific Coast* (2005). The following is a rare first-hand published account of historic masked dancing.

The masks of the Indigenous peoples of the Pacific Northwest Coast are powerful objects that assist us in defining our place in the cosmos. In a world of endless change and complexity, masks offer continuum for Native people to acknowledge our connection to the universe ... All our powerful statements about our beginnings, about our territories, about our laws, and most importantly about our kinship – how we are related. This recognition of kinship in the broadest sense reaffirms the indigenous commitment to seeking balance and harmony throughout the cosmos.

Masks have an important and significant place in our evolution. Every mask is quintessential to our desire to embrace wholeness, balance, and harmony. In a simple and fundamental act of faith, we acknowledge and reaffirm our union through song and dance, ceremony and ritual.

Because of our strong oral history, these matters of kinship in the immediate and broadest sense are told over and over again. They are told in family settings and recounted through song and dance. Central to this tracking of our origins is the mask. Every song and dance with a mask has a meaning that confirms and accentuates the holistic view. Generation after generation of Kwakwaka'wakw people embraced the entire circle of life through the strong meaning that masks give. Through the repeated use of masks in ceremony, a reverent and spiritual appreciation has evolved to the present.

When I was a boy of about five or six years of age, I became aware of the omnipotent presence of masks. They had a life of their own – sometimes menacing and foreboding, always intrusive. Masks seemed to be everywhere. They were at home in attics and storage spaces or dancing round the fire in the Big House. Other times they would be evident round and about the villages, like the Grizzly Bear and Dzunuk̲'wa – the wild woman of the woods. These two really kept us kids in line. For most of us, as children in the village, it is these masks we remember most, along with Ba̲k'wa̲s – the wild man of the woods and chief of the ghosts. We were told to behave or fall victim to the appetite of these three. Needless to say, generations of Kwakwa̲ka'wakw children behaved themselves as a result of these creatures.

As I grew older, my apprehension about masks changed to awe and a different understanding of their significance. Each mask took on the life and spirit of the persona it represented. Dzunuk̲'wa took on the spirit of womanhood gone mad, one who defied the most primal maternal instinct to protect children and instead threatened them. Ba̲k'wa̲s was always grotesque and utterly frightening. Surely he represented the souls of the men who had lost touch with reality, men who had lost sight of right and wrong, balance and harmony, men who had crossed the fine line into madness.

## THE POTLATCH

In the old days, the Kwakwa̲ka'wakw constantly sought to give meaning and purpose to their existence. As with all civilizations throughout time, they struggled to comprehend their place in the universe and were mystified by the same great riddles. So how did they define in their own human terms the wonder of the universe which is incomprehensible? They interpreted it in song and ritual, dance and ceremony, often through the use of masks.

The sum total of the Kwakwa̲ka'wakw answer to the great mystery was and is rolled up into the Winter Ceremonies, which we call the potlatch – a series of songs, dances and rituals. This Potlatch is the defining instrument of the great order of things past and present and yet to come.

I remember the first time I danced in a mask. It was about the same time that I first encountered Ba̲k'wa̲s and Dzunuk̲'wa. There were few white people around then. The odd logger sometimes came to our village with mad water, mad drinks. A priest might visit from time to time or even live in the village for a while. The priest said our world was wrong. Sometimes a man called Indian Agent would come. Our grandparents didn't like him much, and they said they were afraid of him. Other times, a policeman might arrive. Everyone scurried for cover then or peeked from behind window curtains to see what he was up to. And there were teachers and nurses, as well as doctors and missionaries. They seemed to take over all the things that the old people used to do in caring for the tribe.

The fire roared with brilliance as we prepared to dance the Atła̲k'im, the dance of the Forest Spirits. Excitement and mystery filled the air. I had seen this dance before, and I had seen all its masks. They were beautiful and full of life. Everyone jostled behind a great screen adorned with ancestral images. There were so many dancers, twenty or more, in various phases of readiness. People were talking to each other, getting ready, asking questions, giving instructions. Soon, everyone was fully dressed. Once inside their masks, a hush fell upon the troupe. The Forest has many voices, and sometimes there is deafening silence; such was the moment behind the dance curtain.

As a masked dancer among the Kwakwa̲ka'wakw, I have been in that moment countless times. It is a moment when all the world is somewhere else. I am totally and completely alone. My universe is the mold of the mask. I am the mask. I am the bird. I am the animal. I am the fish. I am the spirit. I visualize my dance. I ponder every move. I transcend into the being of the mask. Younger dancers call it "hyping up." Suddenly, the deafening silence explodes into cacophony – birds sing, animals growl, ferns whistle in the wind. Everyone has a voice. Four times the sounds and silence collide, then the great dance begins.

**27.XIII. Tanya Bob, with Dempsey Bob. 2000. "The Art Goes Back to the Stories: A Source-book on the Work of Tahltan/Tlingit First Nations Artist Dempsey Bob."** UBC Museum of Anthropology, Vancouver. Unpublished.

Dempsey Bob (b. 1948) is Tahltan and Tlingit. He was born into the wolf clan of the Tahltan community of Telegraph Creek on the Stikine River, where many of his relatives still live. Bob has long been one of the most successful and internationally collected of the Northwest Coast carvers. However, he is adamant about claiming a place for his work in a different sphere, since there is "a spirit side to this world" (Nemiroff 1992). Bob has always made it clear that there is a sense in which his masks are alive, that the spirits of the animals or supernaturals that they embody are present rather than represented. It is another uncompromising, and public, assertion of the belief expressed by Robert Joseph [27.XII]. In another register, he shares the widely held belief that the value of a mask or other piece of regalia is enhanced by virtue of its having been "danced" or "potlatched." Although he expresses the matter in different terms, Bob's remarks correspond with similar "overlapping claims" for the work of other First Nations artists, working within other cultural bases, such as Marianne Nicolson and Robert Davidson. The claims made for the value of the work in their own communities do not conflict but rather overlap with the claims made for it in an art world variously (and inadequately; see Elkins 2007) described as Western, Euro-American, larger, geographically distant, non-Native. The position their work occupies in one sphere may enhance, or possibly discount, its status in another.

Now established carvers in their own right, his nephews Stan Bevan and Ken McNeil have learned from Bob, as he in turn learned from his earliest mentor, Freda Diesing, who directed him to the Gitanmax School of Northwest Coast Indian Art, founded in Hazelton in 1972. This old way of learning by watching and apprenticing is perpetuated in the Freda Diesing School, of which, with Rocque Berthiaume, Bevan and McNeil are co-founders and which perpetuates a strict understanding of "Northwest Coast art."

> To really understand our art, you have to dance and feel the drum and you have to understand the stories, because all the sculpture and all the art goes back to the stories. I was lucky that I got some of the stories from my grandmother and my grandfather. If you don't understand the stories, you don't understand the art. That's what I know and that's what I tell my students.

> ...

> The Killer Whale Hat is a sculpture and it's a hat. When I did him, he was different because he is a sculpture on his own but he's also a hat. I did the chief's hat (Eagle hat)

first, and that's a very traditional form. From there, I switched right into sculpture. Like I said, it's a sculptured hat. You can see the form of the killer whale and this is the first time that I actually carved right through [the wood], I cut through the ribs of the killer whale.

...

I used the bear to symbolize the land and the people – that we go together and should help each other. A long time ago, when we were kids, we used to fish at Salmon Creek (near Telegraph creek) and I can remember grandma Eva used to go down to the river and talk to the bears in Tlingit and Tahltan. They wouldn't bother us – they'd leave us alone. We'd be fishing right beside the grizzlies and black bears and everything. She'd tell them in Tlingit that they are our brothers and our sisters and are part of our clan.

...

As carvers, we still do pieces for our own people – like our blankets, our rattles, our talking sticks, our masks. What I feel now is that it is evolving by itself because it is fine art. I'm trying to show that what our people did is fine art. That's how I approach my work and that's how I try to show it. What I feel, too, is that our people knew as much about sculpture as anyone. They were great sculptors and they made great pieces. For me, it's an honour just to be a part of it.

**27.XIV.  Michael Kew. 2000. "Traditional Coast Salish Art."** In *Susan Point: Coast Salish Artist.* Edited by Gary Wyatt. Vancouver: Douglas and McIntyre; Seattle: University of Washington Press; Vancouver: Spirit Wrestler Gallery, 13-23. © 2000 by Gary Wyatt and Michael Kew. Published by Douglas and McIntyre, an imprint of D&M Publishers Inc. Reprinted with permission from the publisher.

Michael Kew (b. 1932), anthropologist and historian of Northwest Coast peoples, and particularly of the Coast Salish, worked as an assistant to Wilson Duff at the British Columbia Provincial Museum before taking up a position in the anthropology department at the University of British Columbia. Kew was an in-married member of the Musqueam band through his marriage to Della Charles. He set an example for engaged and sensitive ethnographic writing, although these qualities have perhaps limited his output. Kew found that the work of Musqueam artist Susan Point encoded meanings and met needs that perpetuated older meanings and purposes. Kew approved this as contemporary artwork that exhibited stylistic traits that could be recognized as continuous (see also Kew 1980). As in his previous writing, he was careful to draw attention to the limits on disclosure that characterize Coast Salish cultures (see also Bierwert 1999), but he insisted that these should not be understood as "constraints" on the artists. In this way, he corrected an impression created by the widely cited article by Wayne Suttles (1987), "Productivity and Its Constraints: A Coast Salish Case,"

which sought to account for the apparent paucity of cultural expression relative to more northerly coastal cultures. The Museum of Anthropology's response was discussed by Michael M. Ames (1999) in "How to Decorate a House: The Renegotiation of Cultural Representations at the University of British Columbia Museum of Anthropology" [27.xx], and the depredations of ideologies driving both early archaeology and twentieth-century urban development were the focus of Susan Roy's (2008) PhD dissertation, "'Who Were These Mysterious People?' The Marpole Midden, Coast Salish Identity, and the Dispossession of Aboriginal Lands in British Columbia."

"Art" as an explicit form of expression and "artist" as a recognised profession were not part of traditional Coast Salish life. But perfection of craft, skill in performance, admiration of pleasing product – these surely were part of everyday experience long ago, just as they are today. The many peoples of the Northwest Coast, from southwestern Alaska to northern California, shared basic patterns of life: dependence upon fishing, highly developed uses of wood and wood fibres for housing and material objects, stratified societies, localized ownership of lands and resources, elaborate rites of wealth display and gift exchange. Within these cultures, artistic and aesthetic appreciation were shaped and developed to create distinct regional styles of art, and these endure in both traditional and modern modes of expression.

Music, dance, storytelling and oratory are often overlooked as forms of art, but among the Coast Salish they might best be called the ritual arts. They have always been important and still are a vital part of community life – although it is not as "art" that they are recognized and given note. Halkomelem-speaking communities are like small islands within their larger tribal territories, now occupied and populated mainly by outsiders, yet they still maintain their own ways of life. Their communities centre on supportive institutions that have survived unbroken from ancient times (Kew 1970, 1990), in which music, dance and oratory thrive. These ritual arts play a central part in religious and ceremonial activities – in keeping with ancient ideas about wellness, and in maintaining family history and social standing. These activities are confined to Salish communities where they are protected from the outside world and secured within the control of the practitioners. By and large, these Coast Salish ritual arts are not for sale, and photographs and sound recordings of them are strictly disallowed. The sacred music and dances are not performed on the public stage; they retain their meaning and continue to be vehicles of instruction through which people learn their own history and their place in their community. For many, these ceremonies are the means of personal fulfillment, focussing and giving strength to individual lives. Growing up within a family and society where such activities are part of daily life has shaped and strengthened Susan Point.

One of the products of everyday Salish life that gained early recognition for excellence and beauty is woven textiles. In 1808, the North West Company explorer Simon Fraser described Stó:lō robes as having "stripes of different colours crossing at right angles. Resembling at a distance Highland plaid." He noted that "they were equally as good as those found in Canada." Made on large two-bar, roller looms, from homespun mountain goat and dog wool, these heavy blankets were woven by women throughout the Coast Salish area. They are now, as in the past, items of wealth to be worn on ceremonial occasions; respected leaders may be wrapped in them after death and wear them to their graves. Salish blankets have enjoyed a recent revival of interest and production, and they are now much prized *objets d'art* (Gustafson 1980).

Much less well known and often not recognized as works of art are basketry, matting and cordage. Like many other traditional products, these have all but passed from Coast Salish life with the introduction of easily obtainable manufactured replacements. For a period of time late in the nineteenth and early twentieth centuries, the making of cedar-root coiled baskets for sale flourished, and museum collections today attest to the skill and artistry of the women who made them. Susan Point's mother, Edna Grant, was one of the last Musqueam women who knew how to make such baskets, as well as the sewn cattail mats that at one time lined the inside walls of Musqueam family houses. From Edna Grant and others of her generation who provided vital links with past knowledge, these skills have been passed on to younger people.

While many products like factory-made cloth and cordage were replacing indigenous equipment over the last century, ancient Salish skills with cordage and textiles found another medium in the introduced technique of knitting. For several generations, the heavy "Cowichan" sweaters knitted from homespun sheep wool have been sought for their warmth, durability and decorative design. They have been official gifts to princes, presidents and other visiting dignitaries as British Columbia "native handicrafts." But the knitters possess a great store of knowledge about wool preparation, blending of fibres for colour, modes of making sweaters with integral collars and sleeves, and critical ideas and refinements of design. Their knitting is more than a handicraft and is rightfully linked with other textile arts.

## MEANING IN COAST SALISH ART

The study of Salish sculpture and engraving poses questions about their meaning. Certainly, much art has always been ambiguous or inexplicit in meaning, whether it consists of images caught with a camera or images depicted from a dream. Any work of art has a meaning to the maker and a meaning to the viewer. The two may agree, but they are not always identical, and they are not prescribed. There is an edge of uncertainty or mystery about the meaning of a work of art, even within a culture.

The possibility of misunderstandings is far greater still when artist and viewer are from different cultures.

Written records of traditional Salish life provide little help in understanding the art. Scant attention was given to the art by outsiders, and the meaning of objects we now regard as art was often not considered a proper topic for discussion by the Salish. It is fair to say that all visual images, in their eyes, contain an implicit reference or a potential connection to the sources of power revealed to an individual in dreams and visions. The Musqueam, like other Coast Salish, hold dreams and visions to be conveyors of power that are fundamental to a full life and capable of imparting extraordinary benefits, yet always dangerous. Thus, for them, visual images have a potential connection to power and danger: to discuss images openly, to treat them casually, to reveal too freely what is known of their origin, is to court danger. Works of graphic and sculptural art were and are treated circumspectly by the Coast Salish, and so they are never easy subjects for ethnographic inquiry.

This sacred and private character of art objects among the Coast Salish, in contrast to a more secular and public place for art among the northern Northwest Coast people, underlies both the differences in those arts and the way in which anthropologists have interpreted them. The Coast Salish probably produced less material art, in quantitative terms, than their neighbours to the north. In addition, the Salish were often less willing to part with objects and much less willing to talk about them. Nor did they adapt their own images and modes of design to the production of curios for sale to outsiders. As a result, very little Coast Salish art was acquired by traders and collectors to stock the shelves of museums. What was collected was overshadowed by the abundant and spectacular art of the northern and central areas of the Northwest Coast, whose forms and styles have mistakenly come to represent the art of the coast as a whole.

The roots of this Coast Salish ambivalence about images – the fact that they are made, used and valued, yet at the same time treated circumspectly – are to be found in their religious beliefs. Humans are considered to be apart from yet dependent upon non-human powers that are mysterious and never completely knowable. These powers may be associated with particular life forms – animals, birds, fish and so on – or natural phenomena and mysterious beings associated with particular places. Because of their influence over human life and, in turn, human dependency upon them, such powers are the foci of ritual prayers or annual events of thanks and renewal. The widespread "first salmon" ceremony of propitiation and thanksgiving is an example of such an event.

These powers can also visit or associate with individuals, providing great benefits like strength, health and good fortune; but they can also bring illness and eventual death. Such dire consequences are guarded against and avoided by learning to understand the teachings and knowledge given by the powers to a human in the form of

dreams or visions. Specialists who are learned in understanding and aiding individuals to manage such power relationships are called upon to assist the ill and to instruct the young.

While such power relationships may come unsought by individuals, such relationships, being a source of strength and therefore valued, are also purposefully sought. This is done in so-called spirit-quests, in which a person fasts, bathes frequently in streams or forest pools, and departs from other humans into mountainous and forested places – in short, cleanses and disassociates the self from humans and human conditions. With success and perseverance, an individual may undergo a religious experience and receive, in a dream or vision, instruction from a spirit power in the form of a song and the movements of dance. These are together an individual's *syewen;* that is to say, the manifestation of "spirit powers."

Details of dreams and visions are entirely private and under ordinary conditions are never talked about or revealed to others. To do so is to violate the power association and to endanger the human partner. Some graphic depictions of such personal powers were sometimes placed upon objects decorating tombs or on personal implements. But like other elements of power experiences, their meaning was not made explicit. Because of the potency of such images and the danger inherent in using them in an offensive or careless manner, images were treated circumspectly and not talked about freely. This may well have curtailed the production of Salish objects of art and would explain the unwillingness of owners to sell decorated objects to collectors or to discuss the meaning of images.

This reticence is especially evident in a group of sacred objects used in ritual acts of cleansing and blessing. Some of these, which were collected by early museum buyers and valued for their artistic merit, continue to hold significance and to be made anew for use in contemporary ritual. Among these are rattles, sometimes made of mountain sheep horn, sometimes wood or copper, and fringed with mountain goat wool. The globular hollow portions of these rattles arc often decorated with block engraved designs, and the handles with sculptured human or animal forms. These rattles, used to accompany special songs, are private property held by families. In keeping with the Coast Salish practice of bilineal inheritance, they are passed down through both the male and the female lines and may be owned by individuals of either gender. The meaning or significance of images on the rattles is, like the instruments themselves, private property, closely associated with the powers that conferred them upon the ancestors.

**27.XV.  Chief Sam Dixon, speaking for Chief Alex Frank Sr. 1999. "The HuupuKʷanum of the Sitakanim (Frank) Family, Tla-o-qui-aht."** In *HuupuKʷanum · Tupaat – Out of the Mist: Treasures of the Nuu-Chah-Nulth Chiefs.* Edited by Martha Black. Victoria: Royal British Columbia Museum, 78.

> HuupuKʷanum is the storage box of the chief, containing all his inherited names, dances, masks, and privileges. HuupuK'anum means all the treasure a chief has within his territories. Tupaat, a Ditidaht word, denotes ceremonial right achieved by spiritual quest and owned by chiefs and commoners ... All historical Nuu-chah-nulth ceremonial objects in the Royal British Columbia Museum and other museums around the world are part of the inherited rights of specific chiefs (hawiih in the north; chaachaabat' in the south).

This is how Martha Black explained the procedures followed in one of the first attempts by a major institution to meet the requirements set out in the report of the Task Force on Museums and First Peoples (1991). Black, curator of ethnology at the Royal British Columbia Museum, collaborated with the Nuu-chah-nulth Tribal Council in curating the exhibition *HuupuKʷanum · Tupaat – Out of the Mist: Treasures of the Nuu-Chah-Nulth Chiefs*. The works were displayed, and the catalogue organized, and the term "art" pre-empted, according to the following Nuu-chah-nulth values:

> ʔUusimch – Spiritual preparation in sacred places
> Hawiih.Chaachaabat' – Our hereditary chiefs represent where we come from
> Pach'itl – Feasts mark the progress of a person's life
> Tluukwaana.Tlukwaali – Awesome and sacred ... going through it changes
>     your life

Each family's HuupuKʷanum Tupaat at the opening and in the arrangement of the exhibition was displayed and announced in turn, as would be the protocol at a "do." The following is the transcription of the declaration of Chief Alex Frank, one of the chiefs whose treasures made up the exhibition.

> The curtain contains all the teachings and the knowledge of our people. It tells of where they came from, where their grandfathers were from, and where their teachings come from. It shows all of the things that a hawil has in his hahuuli, all the things he does in different ceremonies. It is the way our people keep their history, right down the line through the generations to the present generation, which is Chief Alex Frank Sr and his wife, Columba, and their children. Chief Alex Frank Sr walks in the ways of his ancestors and he has that teaching because of this. All the teachings he has received from his grandfathers are right here today – they have stayed with us.

**27.XVI. Joe David, with Karen Duffek. 2000. "*Tla-Kish-Wha-to-Ah,* Stands with His Chiefs: From an Interview with Joe David."** In *Nuu-Chah-Nulth Voices, Histories, Objects and Journeys.* Edited by Alan L. Hoover. Victoria: Royal British Columbia Museum, 353, 360-62.

Joe David (b. 1946), from the Tla-o-qui-aht village of Opitsaht on Meares Island, trained in both commercial and fine arts and attended lectures by Bill Holm at the University of Washington between 1971 and 1973. Welcome figures by David, carved initially for Expo '86 in Vancouver, now stand in the international arrivals area of the Vancouver International Airport. Another welcome figure greets visitors to the Museum of Anthropology. This large figure, initially carved for his village, played a conspicuous role in a well-orchestrated anti-logging demonstration outside the legislative buildings in Victoria in 1984. The protests were ultimately successful, and Meares Island was designated a Tribal Provincial Park.

In this interview, David gave what, at the turn of the century, was still a rare account in its detail for a wider audience, an account in which he could, with as much credence as can ever be given to a truism, "speak for himself" as he talked about contemporary artistic licence.

I'm really fortunate that I was born when Clayoquot Sound was quite isolated. You couldn't get there by road, you had to get there by boat. There were still old people from the last century there – Grandma and Grandpa, uncles and aunties. Some of them lived into the 1980s. In my life, I was able to know them, learn from them and understand who they were. They were very strong people. When you see how emotionally and mentally stable those people were, you can see where that old mask, that old totem pole, that old canoe came from. It's a definite tie for me to the artwork – to know who these people were and how they accomplished what they did in sculpted form and painted form or song and dance. In the next century, it's going to be really hard for people to know and learn the connection.

When I was born in the summer of 1946, my father's mother – she was Ditidaht, she was a very powerful and knowledgeable woman in those days – she prophesied my life. She said, "This little guy is going to be an artist, a carver, a speaker; this little guy is going to want to know – and will know – things about our time, our people. He's going to want to know all these things, so you're going to have to teach him, teach him as an artist." And she said, "In his time, things are going to really change in the world as we know it. It's going to be different. He's going to go away from us and our place quite often; he's going to go out into the world, to a lot of places, and meet people and learn from them as well as share with them. But he'll always come back because he knows his place is here – he belongs here." She prophesied that in her last years. I knew her only as an old lady, about a hundred years old.

...

Some of the art that I've done or that others have done – the wild and crazy things – is it valid? Where does it fit in? We might not be able to explain it now, but in the next

century, the people that study these things will be able to look back and say, "Ah, that's why he did it." Because the art describes everything about life now, as does anything going on in the world around us – like rock-and-roll, motorcycle gangs, art in New York City, the fear of nuclear destruction – it all mirrors our present-day experience. The art I do is just a documentation of my own life and experience. And that happens whether an artist sees it and acknowledges it or not: their body of work is a documentation, a journal of their life. Which is probably why I like portraying Maori and also Lakota.

I went to New Zealand three times. It took me a while to warm up to the Maori art – I didn't understand it and didn't really care for it at first – but then something happened and bang! I couldn't get enough of it. I went through every museum and gallery I could find to see it and study it. I was really inspired by the people, their culture and their art. It was natural that I would want to incorporate some of it into my own work.

When I met the Maori – I heard them speak, I heard them sing, I saw them carve – I saw a culture alive. I saw a continuation of their past in a very wonderful, powerful way. I needed to know that this was happening and was possible in my people – in all peoples. The same with the Lakota Sundance, the sweat-lodge ceremonies. This was my eleventh year with the Sundance, with the Lakota. I meet allies and from this alliance I get strength and direction in my personal work. That's what the old stuff from the last century does for me as well. Of course it shows up in my art.

It's primarily artistic license, unbridled artist's playfulness, like when an artist wants to do something and has to do it. I do a lot of paintings and also leatherwork, things that are very Plains Indian. I've also done two masks that were carved in my very Tla-o-qui-aht style. They're face masks, but they represent a Sundancer. I guess they represent me. I put cedar bark and feathers on them. The painting with all the symbolism represents the Sundance. That's just part of the documentation of my life. I think it's all valid within a culture – we have to redefine the culture in our time.

If I had to say what was my contribution as an artist, I'd want to say that I understood my heritage and I understood my position – that I took responsibility for my tribe, for my people, for our heritage. I want to be remembered as trying to make a reasonable contribution. And also this other wilder part, the modern pieces – I think that's important too.

My brother, George, and I just finished a pole, and we raised it on August 4 1998. It was commissioned by people who knew my Mom and Dad, and wanted to honour them. So the pole that I designed has my Father on the bottom, my Mom at the top, and in between them a Wolf. That Wolf represents the culture – their culture that they came from. The Wolf ceremonies –Tluuk$^w$aana – were very important to our people, the Nuu-chah-nulth, for initiating youngsters into their place in the family,

into society, into the supernatural laws. My parents were the last generation that was properly initiated on the west coast. I tried to carve the pole in that real strong Tla-o-qui-aht style. It's down in Seattle, in the Blake Island State Park. There's a restaurant out there called Tillicum Village, and the family there has been a friend of ours since the beginning of the 1960s. It's quite an important pole for my family and the people. It's not at home, but it's just as important as the welcome figure I carved in 1984, that's now at the UBC Museum of Anthropology.

When my father died in 1976, the old people – my old uncle, my elders – came to me and said, "Well, Joe, what are we going to do?" And they were almost, like, fishing – culturally, not on a personal level. And I said, "Well, I don't know. I'll come and see you in a few days." There had been very few potlatches since the 1940s or early 1950s. Within four days I went back to the old man and said, "We have to give a potlatch." And he lit up – he'd caught a big one! We had to give a potlatch to explain who my Dad was, give his name to one of my brothers, use his songs. So he helped me do that, showed me who to go to in the family, what was the proper protocol for the ceremony. He came out and we recorded the songs we were going to use.

They gave me a name at that potlatch. One of my old Grandmas – she's gone now – was one of the last of the old big queens of Nitinat. She gave me a name that comes from Tla-o-qui-aht. It's *Tla-kish-wha-to-ah*. When I asked my old Tla-o-qui-aht uncle at home, he recognized that name. I said, "What does it mean?" He said, "It means that when the chiefs of our village – the chiefs of the Tla-o-qui-aht – do something ceremonially, whether it's a potlatch or anything, they can't start the proceedings until you stand with them." So a kind of loose translation is, "Stands with his chiefs."

That's pretty much my place, how I want to be remembered: that I stood by them.

**27.XVII. Lynn Hill. 2000. "Curator's Statement."** In *Raven's Reprise.* Museum Note 36b. Vancouver: UBC Museum of Anthropology, 1.

A member of the Cayuga Nation, and a participant in Full Circle, the First Nations curatorial and performance collective founded by Margo Kane, Lynn Hill (b. 1961) was curator-in-residence at the Museum of Anthropology at the University of British Columbia for two years, from 1997 to 1999. She had already curated *Alter Native* (1995) at the McMichael Canadian Collection in Kleinburg, Ontario, and *The Museum Show – Kent Monkman* (1994), for the Royal Ontario Museum in Toronto. Hill brought her experience of the more politicized debates in and around Native art elsewhere in Canada to curating *Raven's Reprise.* Its interventionist mode, which connected it with the Situationists and other disrupters of exhibitionary norms, such as Fred Wilson and Andrea Fraser, was designed to disrupt, even as it maintained, the apparent calm of the

permanent installations. *Raven's Reprise* made manifest a submerged critique of the museum for its part in fixing Native values in the past and, in its Great Hall, giving a one-dimensional if awe-inspiring impression of what tradition looked like. It gave exposure to younger artists whose work was already grounded in tradition and who were self-reflexively enthusiastic about working out what that meant, taking risks even if the results were uneven. Given the wealth of documentation accompanying many more conventional exhibitions, it is unsurprising that funding was not forthcoming for a catalogue that might have done justice to its importance. *Raven's Reprise* sank almost without trace.

> The exhibition is unique in that the works have been installed throughout the museum amidst the permanent collection. This placement has enabled the artists to create a visual dialogue between the contemporary and historic pieces. These juxtapositions provide the viewer with visual references and establish the context from which the contemporary works stem. This exhibition is not meant to disclaim past artistic traditions or scholarly explorations, but rather to offer some insight into current art practices that venture beyond an analysis of forms and genres.

**27.XVIII. Alice Campbell. N.d. "The Spectre of Tradition."** Unpublished manuscript, 16-19.

One of the rare reviews of *Raven's Reprise* was written by Alice Campbell (b. 1978), a PhD candidate in anthropology at the University of Texas at Austin, who at the time of the exhibition-intervention was working toward her MA in the anthropology department at the University of British Columbia. Her text reflected the demands for greater critical reflexivity in museum practice, widely heard at the time if not much published locally, which have subsequently informed the museum's renewal project. Drawing on the theoretical urgencies of the moment and the expectation that the practice of Native artists is, and should be, embedded in political issues, like the exhibition it scrutinized, "The Spectre of Tradition" maintained the notion that social representations are reflective of shared values. It is worth reading as a companion piece to James Clifford's (1997a) "Four Northwest Coast Museums" [19.XII].

DEFACEMENT (SORT OF)

In her introductory panel to *Raven's Reprise: Contemporary Northwest Coast Art*, curator Lynn Hill takes great pains to assert that "the exhibit is not meant to disclaim past artistic traditions or scholarly explorations." Perhaps more positively, it is meant to work with them, to "challenge expectations" of the viewer and "fuse an understanding of Northwest Coast material culture, oral tradition and aesthetics with aspects of

the artists' urban histories and realities that reflect the here and now." It is constructed throughout the Great Hall and Visible Storage as site-specific installations, a form which, along with performance art, typically works to reveal and direct attention to the unmarked ideological, institutional, and performative practices which produce and underwrite space. Lynn Hill's identification of other types of scholarly exploration kindly implies that there is a pedagogy (or several pedagogies) from which *Raven's Reprise* stands apart. The individual pieces do reconfigure the spaces and sights of the museum (without entirely [physically] overhauling them, as *Gathering Strength* does). John Powell's *Sanctuary*, "a homage to those who fought to keep our ways," and Connie (Sterritt) Watts' statement alongside her *Radiant Raven* that she wants "Northwest Coast art to be freed from stereotyping" in particular are strong declarations that critique MOA's exhibitionary practices. In spite of her own disclaimer at the opening of the exhibition, Hill permits noisy traffic among herself and the artists within *Raven's Reprise* to be heard, which signals that there really is much more going on than just the addition of a few more voices and artistic endeavours to the museum's galleries.

Michael Taussig identifies defacement as the projection of a public secret which works to move it "from an excess of invisibility to an excess of visibility." Becoming almost excruciatingly visible, that which defaces often becomes sacrilegious, while correspondingly, the value and sacredness of that which is defaced becomes magnified. Public secrets, in this context, amount less to something quantifiable and easily definable than to underlying broader social processes. As site-specific installations, the works in *Raven's Reprise* reveal momentary flashes of the energy and logic coursing beneath the Museum's framing of Northwest Coast art. A part of this framing is the latent performativity highlighted by Jungen's murals which, with respect to the Museum, implicates the passivity of viewing and moving through the galleries. The works boldly perform against the Northwest Coastian pedagogy informing the permanent Northwest Coast exhibits and, in so doing, illuminate and question its validity. At the same time, their defacement of the space shows up the spectacular unbelievability of "Northwest Coast art" as projected in MOA's Great Hall.

Nevertheless, the defacement *Raven's Reprise* effects depends on two very basic and related public secrets: Northwest Coast art is not anonymous and timeless, and there are contemporary Northwest Coast artists whose work lies outside the boundaries of the "traditional" art the Museum sanctions in its permanent exhibits. The works in *Raven's Reprise* depend on community and often family-specific social histories. The inclusion of these stories within the museum (particularly in Nicolson's and Barkhouse's emulation of Visible Storage in their respective pieces *Waxemedlagin xusbandayu' [Even Though I am the Last One, I Still Count]* and *Four Legs Good)* works to shed light on the institutional effacement of the social lives of the Museum's objects.

Although its critique is somewhat weakened by the anxieties revealed in its micro-geography and apologetic labels, *Raven's Reprise* brings into view the pervasive power of the Northwest Coastian pedagogy at an institution, the Museum of Anthropology, that has long been committed to decolonizing its knowledge production practices. One especially important question remains: are the works in *Gathering Strength* and *Raven's Reprise* really as different as they would seem, and am I, and is MOA, drawing unfair boundaries between them? "Tradition" in Northwest Coast art is highly contested terrain; many stakeholders, including collectors and dealers, have vested interests in defining what tradition is and how it looks. At the same time and ultimately more importantly, the idea of "tradition" is currently and constantly being negotiated and evaluated by contemporary First Nations artists on the Northwest Coast. If discussions about the politics of representation center on issues of power, we must also critically take into account Phelan's argument that increased visibility does not necessarily imply increased power. It can result in precisely the opposite. Ostrowitz hopes that

> Formal definitions of traditional native art and the delineation of design rules that direct its forms might ultimately be dropped from art-historical discourse as incidental to more contemporary concerns for individual expression and advance. Discussions of slight variation and experimentation within the confines of native art traditions, already justified in the literature by Holm and Macnair, and others, might then no longer serve us well enough.

Continuity with "the old forms" and successful execution of formal design elements is clearly important to many contemporary Northwest Coast artists, but it is problematic when taken to be the central indicator in evaluating their work. If the rewriting of Northwest Coast art is to live up to its stated aim of showing how First Nations art is contemporary and dynamic, and if it is to be a decolonizing moment, there must be room for artistic production which bursts from the tight seams of the existing pedagogy. I have argued that this would require, at least in part, a substantial interrogation of the form/context dichotomy that was sedimented in early exhibitions such as *Arts of the Raven and The Legacy*. Otherwise, in a system of analysis and evaluation of Northwest Coast art which reifies continuities with the past while admonishing poorly constructed ovoids and u-forms, no matter how much collaboration and co-authorship occurs, the same pedagogy gets endlessly reproduced and the re-writing of Northwest Coast art becomes a re-inscription.

**27.XIX. Michael Nicoll Yahgulanaas. 2001. "Notes on a Tale of Two Shamans – *Ga Sraagaa Sdang*."** In *A Tale of Two Shamans*. Kelowna: Theytus Books; Haida Gwaii Museum at Qay'llngaay, n.p. Courtesy of Michael Nicoll Yahgulanaas and Theytus Books.

Michael Nicoll Yahgulanaas (the name Yahgulanaas is a family surname, not a Haida honorific) (b. 1954) is a Haida carver, singer, orator, and cartoonist. Between 1990 and 1994, he was the CEO of the Old Massett Village Council of the Haida Nation and, with other Haida leaders, played a prominent role in negotiations during the BC Treaty Process. Detaching himself somewhat from the political immersion of his Old Massett years, he moved to Vancouver, where the Rockin' Raven persona emerged. "I used to think I was on a big mission to explain us to the wider society," Yahgulanaas said recently. "Now it's more as though I'm trying to work out who we are and who we were with any means at my disposal." Haida Manga is his "unique blend of comic and traditional design asking the reader to question pre-existing assumptions and fantasies about the Peoples who produced the morally ambiguous narratives – about Raven for instance." With a certain *braggadocio*, Raven struts his stuff on the rockingraven.com website, boasting a little about his triumphs in Japan and Korea. The website declares that "'art' can be a monument to an Indigenous past, a trophy to a colonial conquest or an entirely new game with new rules." But there is also the caution that the new game of Haida Manga does not imply any lock on where Haida art is going. Yahgulanaas's intransigence is reserved for the innumerable ways in which Haida designs and meanings can be alienated as non-Native cultures are driven to "mimic" the Native. To make this point, he has reappropriated the notion of "colonial mimicry," put into wide currency by Homi K. Bhabha (1994) in "Of Mimicry and Man: The Ambivalence of Colonial Discourse" in *The Location of Culture*.

The main struggle for the Haida has been the defence of their territory against the largely unrestricted logging practices, which tend to put the legal requirement that resource companies consult with First Nations in jeopardy and pre-empt definitions of sovereignty. This is legal according to Canadian rather than Haida law. As far as the Haida are concerned, it is Canadian law that authorizes such destructive practices in the first place. However, there have been eighteen successful court actions linked to tree farm licences, and today the Haida are engaged in a $12 million Supreme Court case over Aboriginal title to Haida Gwaii.

There is a sense in which Yahgulanaas circumvents the now well-rehearsed critique of the museum. Here the objects of collection – the hats and coppers, the canoes and paddles, the person-altering masks – are removed from a destiny as cultural objectifications and positioned in scenarios of cultural action. His work joins others that the institution can tolerate as "institutional critiques."

*A Tale of Two Shamans* is an early foray into Haida Manga and conveys something of the complexity of the old and current Haida stories.

As angry as I can be, and rant as I frequently do against the Canadian colonial experience, I challenge the notion that this is a problem of culture; rather it is the politics of class and the maintaining of hierarchy privilege.

The work that you are about to read is old, much older than any of us still living. It is probably older than anything one could even call Canadian. It preceded us all. Obviously I am not the prime creator of such a narrative, but, as a Haida citizen, it is an ancestral experience. The strength of owning a thing is often expressed as a right to share it. In this re-telling we, the illustrators, editors, linguists, curators and indeed the community of living Haidas and friends, invite you to join with us. Come as a respected guest. Sit at this table and be nourished by our living culture …

This story is a blend of accounts recorded at the turn of the last century in three of the once numerous dialects of the Haida language. I have combined elements from these accounts into a newly constructed whole. Be cautioned that these images are interpretations informed by my own cultural composition and life experiences. This is a contemporary rendering of a worldview first expressed in different times and probably for different reasons. I am not stepping forward to join that dais filled with authorities claiming to represent those different times. I am a Haida whose life experience is probably very similar to that of your own. In many respects the greater distance between the first tellers of *ga Sraagaa sdang* and ourselves, makes us both readers.

**27.XX. Michael M. Ames. 1999. "How to Decorate a House: The Renegotiation of Cultural Representations at the University of British Columbia Museum of Anthropology."** *Museum Anthropology* 22, 3: 41, 46.

Michael M. Ames (1922-2006) was the director of the Museum of Anthropology at the University of British Columbia from 1974 until 1997. In this text, Ames articulated the ways in which the MOA struggled to accommodate its own mandate while encountering variant epistemologies. Anodyne liberal terms such as "partnership" and "collaboration" typically gloss over this difficulty. "How to Decorate a House" is one of the rare texts to attempt to make intellectual sense of arguments such as that between vocal members of the Haida Nation and Robert Bringhurst, which underlie not just disputes over intellectual property rights (see Kramer, this volume) but also anxiety over intractable philosophical distinctions between ways in which humans interrogate their world. "Diversity" is not the helpful term here, and Ames was addressing more than the cultural politics of museums as they attempt to make space for "the cultural other."

The freedom to investigate and publish superior knowledge about serious things is the foundation of the scholarly professions. In Western capitalist societies this principle of

scholarly privilege has been coupled to the idea of private property. Researchers typically not only claim property rights over the knowledge they produce, but also proprietary rights over the subject matter – the field of raw data – from which they extracted their knowledge. This conceptual paradigm continues to be imposed on the world – as a type of vestigial colonialism – long after the decline of those imperial regimes that gave rise to it in the first place.

...

Challenging scholarly privilege is not necessarily a challenge to scholarly research, however. When the Vancouver area First Nations gave their support to the two exhibits [*Written in the Earth* and *Under the Delta*], which they did willingly and out of natural interest in the subject matter, they were not attempting to deny the principle of free inquiry. They wanted to redefine for what purposes inquiry should be free. They are well aware of the value of systematic research and regularly draw upon it. The crucial difference lies in who should determine the direction and use of these empirical investigations.

What occurred as a result of the project negotiations with the principal Band was a realignment of power, achieved through a redistribution of authority.

**27.XXI. Robert Davidson. 2004. "The Present Moment: Conversations with *guud san glans*, Robert Davidson."** In *Robert Davidson: The Abstract Edge.* Edited by Karen Duffek; with essays by Karen Duffek and Robert Houle. Vancouver: UBC Museum of Anthropology, in association with the National Gallery of Canada, 9-10, 26.

As a younger artist, Robert Davidson (b. 1946) took up the Kwakwaka'wakw artist Ellen Neel's 1948 challenge to make Indigenous visual design – long obscured under the repressive force of the Indian Act – as widely applicable, and as widely known, as Neel believed it deserved to be. His designs for Feast Wear fashions and for Chocolate Arts, among others, helped to put Haida visual modes into wide circulation. His work is now positioned in significant public spaces on Haida Gwaii, in Vancouver, in Canada, and internationally, where it serves to assert history, mark memory, and identify places in different ways for different people. With works such as *Nanasimget and the Killer Whale* and the inclusion of *Three Variations of the Killer Whale Myth* (1989) in the Pepsico International Sculpture Garden in New York, he was following Bill Reid in aspiring to make work that is both modern and Haida. However, Davidson's work plays a number of aesthetic, social, and political roles from which his more recent abstract works cannot easily be separated. Karen Duffek, curator of *The Abstract Edge,* referred to the "tension" between the autonomy of the work of art, an idea inseparable from twentieth-century abstract painting, and the cultural

origins and intended cultural functions of his work, about which Davidson is explicit.

His solo exhibition at the Vancouver Art Gallery in 1993-94, *Robert Davidson: Eagle of the Dawn,* went on to the Canadian Museum of Civilization in Gatineau, Quebec. The talismanic importance of contemporary Haida work to the politics of the major national cultural institutions can be gauged by the fact that the tour of *The Abstract Edge* concluded at Canada's National Gallery in Ottawa in 2006. *The Abstract Edge* may have done something to bridge the still-yawning chasm between contemporary art judged compelling to the extent that it participates in an international art world's lingua franca and work that is defined by a culturally bounded aesthetic. One significant "tension" arises from the (im)possibility, given current Native-non-Native social and political relations, of approaching critically work by an artist who is already an iconic figure within the Haida Nation, in Canada and internationally, and who, as such, perpetuates the notion of the Native artist as figurehead, as cultural representative.

There's this amazing movement now to reclaim cultural knowledge. As we reclaim that knowledge – reclaim the names, the songs, the dances, the crests, the clans, the place of chiefs in Haida villages – it's gone the whole gamut to reclaiming the land. They're all one. We're continually rehashing what we know about our culture and what the names of our territories are all about. In doing that, we're able to solidify our knowledge and be more confident. And as we gain confidence there, it becomes more than just the art and the artists. I'm increasingly realizing that I cannot work in a vacuum of art. For a while, we artists enjoyed all the glory and all the attention. But now there's a bigger picture.

My passion is reconnecting with my ancestors' knowledge. The philosophy is what bred the art, and now the art has become the catalyst for us to explore the philosophy. I feel that, for Haida people, it's the art that has helped us to reclaim our place – to reclaim our beliefs, mythology and spirituality. Other facets we're working on are our language and our songs, our dances, our Haida names. What's exciting for me is to express what the art is all about from my experience. My roots are from the village: my roots are creating art for my aunties and my grandmother and her grandmothers. That is the foundation of where I come from. I'm fortunate that I had a grandmother named Florence Davidson who challenged me, in her own subtle way, to learn more about our culture, and who also challenged me in the art. When I go outside the Haida boundaries, I am challenged, too – I want the art to be recognized as a high art form. I feel it is up to the artists to bring it into that arena, to challenge the art world's blinders of "curio" that still define how our art is seen.

...

The word I use is "implied." There are a lot of things that are implied in the art, and it works the same way in speech making, and in the way we were brought up. There are certain things that are not said, but they're implied – they're unspoken, but we're expected to know. The words to a Haida song are really one line, or two lines, and the rest is implied: "Weep all you high ones, the steamboat is leaving." Those are the only words in the song, but there's a long story that goes with that statement. I think that's what abstraction is.

**27.XXII. Robert Davidson. 1991. From a speech originally delivered in Old Massett.** Reprinted in Daina Augaitis, ed. 2006. *Raven Travelling: Two Centuries of Haida Art.* Vancouver: Vancouver Art Gallery; Douglas and McIntyre, 52-53. Courtesy of Robert Davidson.

Davidson has long been both eloquent and active on the importance of culture and ceremonialism for Haida continuity.

Why is it important to rebuild? Why is it important to reclaim our Haidaness? Why are we making such a big issue over a piece of land? Why are we making such a big issue over the raising of totem poles?

Because we have been stripped of our culture!
We have been stripped of our language!
We have been stripped of our identity!
We have been stripped of our dignity!
We have been stripped of our homeland!

In reclaiming our culture we gain strength. We gain a solid foundation from which to grow. In reclaiming our culture, we reclaim our identity. We have many threads connecting us to the past.

**27.XXIII. Miles Richardson. 2004. "On Its Own Terms."** In *Bill Reid and Beyond: Expanding on Modern Native Art.* Edited by Karen Duffek and Charlotte Townsend-Gault. Vancouver: Douglas and McIntyre, 21, 23. © 2004 by the Museum of Anthropology, UBC. Published by Douglas and McIntyre, an imprint of D&M Publishers Inc. Reprinted with permission from the publisher.

Miles Richardson (b. 1955) speaks with the authority of a citizen of the Haida Nation and former president of the Council of the Haida Nation. He has also served as chief commissioner of the BC Treaty Commission, having been a member of the First Nations Summit Task Group and the BC Claims Task Force, whose report and recommendations were the blueprint for the treaty

negotiation process. Here Richardson commended Reid for his questioning understanding that Haida art was "more than art" and his insistence on uncovering and maintaining its critical standards. Both men shared a curiosity about the prominence of Haida social and art forms even as they reasserted them. Other Northwest Coast First Nations queried this position, but there is no doubt that the wide public exposure of Reid's work played a role in confirming the perception. Richardson's text was based on the transcript of comments made at the symposium "The Legacy of Bill Reid: A Critical Enquiry," organized by the Museum of Anthropology and held at the University of British Columbia's First Nations House of Learning, 13-14 November 1999.

HAIDA LAAS, good people: I am Kilsli Kaaji Sting, and I am of the Eagles of Chaatl of the Haida Nation. First thing I'd like to do is acknowledge the Musqueam Nation and the great Salish Nation in whose territory we are gathered this morning.

...

Bill took a really fascinating part of his inheritance and made his entry there. This art, this cultural legacy, fascinated him. I remember that when I was involved in politics and he was also involved, it used to awe him how ten thousand people amongst humanity could get so much attention as the Haida Nation. They have such a reputation and such a presence, he'd say that you'd think they were a far larger population. He took that and he did his best to understand that. It was much more than art to him; it was a way of being; and those manifestations of ways of being represented ways of thinking, every bit as much as they were ways of seeing. You can see that around you. What do those pieces of art mean to you?

He understood that, in order for cultural expression and art to continue to be strong, there had to be standards. You can't represent just anything as Haida art, in his view. He worked to develop high standards, unprecedented in his time, and attempted to infuse that into his work. He took a lot of criticism from Haidas and others for his work and ways. He used to tell me about coming out of Ryerson Polytechnic as a goldsmith: he worked there with this old German, and he'd be on his eighteenth ring, trying to get it right, and he'd think he had it just perfect, and the old guy would take it and pound it back to nothing. It would just break his heart, but he kept on. He developed his standards, and I think that is a really important part of Bill's legacy that the living generation of Haida must continue. That is my understanding of one of the main purposes of the Bill Reid Centre at Qay'llnagaay, at Second Beach: to develop an institution for clarifying and developing standards in Haida art and teaching young artists to carry forward that tradition.

**27.XXIV. Guujaaw. 2004. "Man, Myth or Magic?"** In *Bill Reid and Beyond: Expanding on Modern Native Art.* Edited by Karen Duffek and Charlotte Townsend-Gault. Vancouver: Douglas and McIntyre, 61-62. © 2004 by the Museum of Anthropology, UBC. Published by Douglas and McIntyre, an imprint of D&M Publishers Inc. Reprinted with permission from the publisher.

Guujaaw, a traditional carver, canoe maker, dancer, singer, hunter and gatherer (his own gleeful appropriation of anthropology-ese), expressed a widely shared suspicion that Reid and his work may have been over-analyzed. Here he recognized, however, that Reid's own analytical skills have indeed been influential. Guujaaw's text was based on the transcript of comments made at the symposium "The Legacy of Bill Reid: A Critical Enquiry," organized by the Museum of Anthropology and held at the University of British Columbia's First Nations House of Learning, 13-14 November 1999.

Good people: I think that Bill must be the most dissected thing outside of a laboratory – and when you start chopping things up, the more pieces you put it in, and the smaller it gets, the harder it is to recognize what it originally was ... He figured that the real problem with the earth is that everyone got so civilized that they are losing their humanity ... He wanted me to give them a course in de-civilization ...

When I worked with Bill, he got excited when he was looking at the old poles and pieces – that's what really turned him on. He had a good way of explaining and figuring out what somebody had done. With a totem pole, for instance, he would just show you a deeper thing to consider than what meets the eye. In his own way, he explained the profound logic that underlies the arrangements and interrelationships of the lines of Haida art, and the ways to entrap the tensions. This is one of the world's most regulated arts. A totem pole, when done properly, is a complex assemblage of planes where the rule does not have to be understood in order to be received as proper by the mind's eye. Bill's mission simply seemed to be to try to maintain the standard that the old people had set and that amazed him so much.

**27.XXV. Loretta Todd. 2004. "Beyond."** In *Bill Reid and Beyond: Expanding on Modern Native Art.* Edited by Karen Duffek and Charlotte Townsend-Gault. Vancouver: Douglas and McIntyre, 281. © 2004 by the Museum of Anthropology, UBC. Published by Douglas and McIntyre, an imprint of D&M Publishers Inc. Reprinted with permission from the publisher.

One of Canada's best-known filmmakers (*Hands of History* [1994], *Forgotten Warriors* [1997], *Today Is a Good Day – Remembering Chief Dan George* [1999], *The People Go On* [2003]), Loretta Todd (b. 1960s) (Métis-Cree) is also known for her astute and theoretically informed critical writing. In a piece commissioned

as a coda for *Bill Reid and Beyond: Expanding on Modern Native Art,* she skew-
ered some of the pieties and suggested ways of thinking about the meaning of a
life less trammelled by awe and the conventional praise giving that threatens to
deprive Reid of a credible place in the public imaginary.

> Why is he as he is? And why are we always speculating? Is he a difficult poem? A
> lost son gone home? Northrop Frye meets Michelangelo? Is he the Indian that Pierre
> Trudeau always wanted to be? Maybe he was just a really good jeweller.
>
> I was wondering when he started to sink into the psyche of Canada. Did his voice
> all those years ago on CBC radio carry a subliminal ancestral message? Was he a
> fierce warrior using his power to protect the sovereignty of his nation? Or was he
> a prince of the "New World" – forever making pretty things for the overseers?
>
> And what of the pretty things? He once said that artists always did and still do
> serve elites. Was he railing against Duchamp? Telling the world to stop pretending
> that art can be freed from ruling classes and the object? Or was he cozying up to his
> benefactors – who still, despite their public belief in the democratization of the art,
> secretly long for the tiara?
>
> And now he's gone, though "every shut eye ain't asleep," and certainly Bill Reid
> isn't asleep – if for no other reason than we keep him awake with our racket of specu-
> lation and our need for him to represent – something, somehow. It would seem Canada
> needs some art stars, maybe not quite so tragic and complicated as the American
> master Jackson Pollock, or quite so Marxist and sensual as Diego Rivera, the Mexican
> master. Sure, there are the elusive yet taciturn Seven and the clutterer Emily Carr, but
> here in Reid is the gentleman, country-born but with the bearing of a country squire.
>
> So it would seem he's needed.

**27.XXVI. Aaron Glass. 2004. "Return to Sender: On the Politics of Cultural Property and the
Proper Address of Art."** *Journal of Material Culture* 9, 2: 134-36.

Aaron Glass (b. 1971) is active on a number of fronts as artist, filmmaker, advo-
cate for the use of new media to deconstruct and rehabilitate old media, and
anthropologist committed to engaging with his Indigenous subjects/colleagues.
Following his own fieldwork with the 'Namgis of Alert Bay (recorded in his
2004 film *In Search of the Hamat'sa: A Tale of Head Hunting*), Glass has worked
closely with William Wasden Jr. on the Jacobsen collection of Kwakwaka'wakw
masks and ceremonial objects at the Berlin Museum fur Volkerkunde, a notori-
ous, influential, but little-known part of the global diaspora of Northwest Coast
treasures. With Nelson Graburn, he co-edited a special issue of the *Journal of
Material Culture* that emerged from a panel at the 2002 meeting of the American

Anthropological Association – *Beyond Art/Artifact/Tourist Art: Social Agency and the Cultural Value(s) of Objects.* This was a transgenerational effort to revitalize the Northwest Coast in international scholarly debates on repatriation, exchange, materiality, and the agency of objects. With Crisca Bierwert, Jennifer Kramer, Sharon Fortney, and Kate Hennessy, he is one of a number of younger scholars finding ways to position themselves as participant observers, to maintain close personal links within the communities, and to represent their position outside with considered self-reflexivity, knowing they will be judged.

Glass's text aligned the concerns current in Native communities and in academic and legal work with international issues, in this case the repatriation of Jewish treasures after World War II. A characteristic of this debate is the finessing of the "political," such that the political orientation of the observer adjusts to, even when it cannot accommodate, the political language of the observed. The old problems of anthropology are still the most intractable.

> *The mutability of object value.* Repatriation and restitution discourses invoke a very conservative (legalistic) notion of the identity of objects and people's relation to them. Anthropologists now generally recognize the great mutability of objects; their capacity to take on new values as they travel through different communities and various stages of commoditization (Appadurai 1981; Napier 1997; Thomas 1991). Both social object identity and object alienability are negotiated as part of larger historical and cultural accommodations. For example, declaring that restitution makes "trophy art" into "art" once again (E. Simpson, 1997: 216) implies that the act of return strips from the object the taint of historical persecution, allowing it to reclaim a status of pure culture. This again grants the transformative agency to the returner. But returnees are equally active in transforming object meaning and value, both before its original alienation and following its return. The process of repatriation request may itself suggest new, cultural (re)vitalized values:
>
> > Navajo medicine bundles, for example, are thought increasingly to be powerful of themselves and "tribally owned," whereas in the not too distant past bundles were personal property which were usually handed down to apprentices ... The way in which power is transmitted may also be shifting however, [as] Indian people are now becoming collectors and venerators of the past. (Bernstein quoted in Tabah, 1993: 129-30).
>
> *Historical irony and reversal of fortune.* Requests for object return allow for the assertion of a singular cultural identity, despite local contest, as a response to past attempts to eradicate it. Part of the cruel historical irony of repatriation is that it tends to punish those for whom the assimilation project was most successful. Native groups who

can prove unbroken links of cultural tradition (i.e. those least altered by colonialism) are the ones who get things back, whereas those most harmed (and therefore most in need of ethical redress) have less basis for claims. Yet perhaps we can turn that irony on its head. Perhaps the strong rhetorical language needed to argue claims (partially a residue of Eurocentric language and romantic expectations) actually encourages the strengthening of indigenous practice as well as discourse. As Lowenthal (1996: 238) suggests, "Rhetorical bombast can be its own reward with honor satisfied by ardent petition ... identity is succored more by a quest for lost heritage than by its nurture when regained." Kramer (1999) discusses repatriation as (re) appropriation, as an event around which the Nuxalk mobilized as a community and reflected on their cultural values. And while I would not want to argue that Hitler made the Jewish people stronger, he certainly provided the tragic backdrop in front of which they continue to perform their cultural identity and survival, and assert national and political sovereignty. Thus the claim process itself, regardless of specific outcome, bolsters one's (individual and collective) sense of cultural identity merely through forcing its articulation.

Daniel Miller suggests that material culture (construed as art or artifact, commodity or sacred item) provides a tangible form in which cultural values, individual identity, and historical agency are "objectified" and put "out there" in the world to circulate. Consumption (or active reincorporation) becomes a meaningful practice whereby both personal subjectivities and social relations are negotiated through the medium of objects. Might we approach restitution claims as a process through which both physical objects and social subjects are discursively constituted, through which historical agency and identity is claimed and enforced, through which group boundaries are redrawn and power borrowed? Might we come to see repatriation as they delayed "consumption" of the products of one's own culture? As a vital means of reproducing culture?

### CONCLUSION: CPR AND THE RESUSCITATION OF (A) CULTURE

Most debates over cultural property rights (CPR) reach a certain rhetorical peak, at which point they break down into terminological disarray, contradiction, and contestation, especially cross-culturally. In tracking the discourses surrounding object-return, it becomes clear that there is more at stake than semantic slippage than just miscommunication and politics. Universal values are being confronted by the assertion of local heritage(s); global humanism is challenged by emergent ethnonationalism; the innate spirit of art bends before the recursive politics of representation. The mighty British Museum confronted the challenges to Modernity in a 1983 debate in the House of Lords in how to deal with the Marbles Question:

Should claims for the return of objects of art put forward by an international body, or for that matter anybody else, be encouraged? ... It is very easy to forget that the place where a great work of art is kept is less important than its careful preservation, its accessibility to a wide public and its immortal power to elevate the human spirit. (Viscount Eccles quoted in Greenfield 1989: 120).

Native people may agree that their objects have an immortal power, but they also maintain that preservation and accessibility may be anathema to that power, and that the proper place for art is at home.

Dialogues and discourses of repatriation and restitution suggest that art has the power to address larger social, political, ethical, cultural, financial, and historical concerns. This much is certainly universal. But the language of claims also insists that this power is most active when the object arrives at its original address ...

I would argue ... that increasingly "culture" is something consciously reflected upon and negotiated. To marginalize political discourse as "propaganda" is to ignore the power of language to help constitute a meaningful social life. In these cases, we witness the emphatic reassertion of identities that were previously threatened. Using the power of the law, of political pressure, of ethical persuasion, of cultural objects, and of language itself, Jews and Natives are doing much more than asking for historical redress through fighting for the return of their cultural property. They are fighting to remember histories, remember their societies, and retain the essential properties of their cultures.

**27.XXVII.  Tsaqwassupp (Art Thompson), with Taiaiake Alfred. 2005. "My Grandmother, She Raised Me Up Again."** In *Wasase: Indigenous Pathways of Action and Freedom.* Edited by Taiaiake Alfred. Peterborough, ON: Broadview Press, 170-71, 174-75. Reprinted with permission of the publisher.

In this conversation, Tsaqwassupp (b. 1948), one of the most widely known Nuu-chah-nulth artists, talks about his excruciating experience as a young Native person, about how closely connected it is with his life as an artist, his community's response to his success, and what that bitterness in turn reveals about the demoralized state of too many lives. Art Thompson revealed these details before, since he was one of the first Native people to explain, and name, in public exactly what abuse he, like so many other children, had suffered in church-run residential schools and at whose hands. His revelations led to court cases, to public exposure of the scandal of Indian Act policy, and eventually to public apologies from churches and the federal government's recompense in 2008.

Taiaiake Alfred, who is Kanien'kehaka (Mohawk), holds the Indigenous Policy Research Chair at the University of Victoria. In an earlier book, *Peace, Power, Righteousness: An Indigenous Manifesto* (1999), he proposed philosophical

bases for renewal that grew directly out of a Mohawk ontology. In *Wasase: Indigenous Pathways of Action and Freedom,* a collection of writings and encounters, he met Thompson on common ground – they both believe in art as political resistance, as a way of fighting back.

*Thompson:* My grandmother had told me that being an artist is being the best warrior that you could ever be. She said, "If you don't want to do anything else with your hands, do your arts, because that's what is going to tell people that we haven't died, and prove that they're not going to be able to kill us." She said, "As long as you're alive and doing your arts, people will know that we're not going away."

*Taiaiake Alfred:* Holding onto culture is an act of resistance?

*T:* She trained me that way. She knew about my past in the residential school – I told her everything. She knew of all the troubles I had. She knew I was a resistor of some kind: resistance to the education process, resistance to the school, the supervisors, to anybody with authority. Now I know what she did to me: she humbled me to be a better person, to look at things in a different way, through Native eyes again. I'll always remember her saying, "You've been given white eyes; you look at things through white eyes. You need Indian eyes again, You need to see something better in all of the people; never mind who damaged you, those people will be taken care of somewhere down the road. Don't worry about them."

Through all of that, my inner self was really calming down, but at the same time, the artistic side was coming up. Even at that time, I had the smarts to go down to the museum and look through all the catalogues and find the pieces that belonged to different people and then to reconstruct them in my own mind. When I started doing my art, it really meant a lot to me at potlatch time, when somebody would say, "Can you make me a headdress?" I'd ask him, "Where's yours?" And he'd tell me, "It's in a museum in New York." It's really unbelievable how, as an artist, you can contribute back to the people and give them strength. You can see the pride that they get from getting something back that belonged to their fathers. In the songs that they used those things for, it seemed like they danced better. One of their old treasures had come back, and the women danced with smiles on their faces.

...

*TA:* Thinking about the experience of so many of our people living in the city, it brings up the question of what it really is to be Onkwehonwe, an indigenous person. How do you and your family manage to hold on to such a strong identity living away from the village?

*T:* I think being indigenous is within oneself. You have to have a self-identity. You have to be reassured as a Native person in order to expand as a person and give back

to the culture. If somebody has pride and projects that pride, it makes your people stand up a whole lot better. I'm at a point in my life where I know who I am, and I'm able to give lots back – it may seem really big to other people, what I give back, but in actuality it's not even a thimbleful of stuff. This year, I'm going to be giving back to two potlatches, and they think it's one of the biggest things. When I'm on the art market, I charge thousands of dollars for these things, but when I go back to the village I want 20 halibut and some dried fish, or I say, "Gimme two five-gallon pails of herring eggs." It makes me feel like a king. That's what I always tell my family, "We're like kings, we're eating salmon all the time!" That's the way I was taught: when there was an *atsic* person who could create anything, his goods would be distributed amongst the village first to make them feel big about themselves, to make them stand up in a potlatch and dance, to make these women smile with sparkling Jewellery, to give them a sense of self-pride.

*TA:* You talk about how it is within oneself, but then right after that, you start talking about the connection to community. There's creativity, flexibility, and freedom in what you're saying about being Onkwehonwe, but there's also the need to have a connection with the past, with the culture, and with the community as well.

*T:* I think it's necessary for everybody to interact with the history. We do that anyway; we speak a language, we go to potlatches, we sing songs. That's all touching our grandfathers. That's like breathing the same air as all of your ancestors, and all of your descendants, and all of the people that you're related to. You know, my auntie passed away last year, and when it came time for her burial, my cousins asked me, "What are we going to do?" I said, "Well, you remember what we did when Granny passed away. What did we do then? Are we going to do the same thing with my auntie, your mother, where we argued about all her stuff?" No. Everything got gathered up. They opened up her box and put in all of her silver Jewellery, all of her ceremonial rattles, all of her basket-weaving stuff that she needed. The way the old people talked, she was going to need that wherever she was going. So we buried her, and in death, we gave her dignity back to her. The thing I'm getting at is this: we give pride back to our people when we do these things, when we insist on honour and respect. It's being a different kind of warrior. You stand up for old values, forgotten values.

**27.XXVIII. Marianne Nicolson. 2005. "*Bax wana tsi':* The Container for Souls."** Text written to accompany the first installation of *Bax wana tsi'* at Artspeak, Vancouver.

Marianne Nicolson (b. 1969) wrote this text when her work was installed as a solo exhibition, with the title *Bax wana tsi': The Container for Souls* at Artspeak, Vancouver. The gallery is on the edge of the city's Downtown Eastside, an area indelibly associated with the "disappearance" of Aboriginal and non-Aboriginal

women from its streets. This under-acknowledged public scandal was, in 2005, only beginning to receive the attention it deserved. In this context and at this moment, *Bax wana tsi'*, with its calm and gentle images of young girls and its resuscitation of formline imagery, resonated with the trauma of the lives of so many Native women amid the fog of touristic versions of Native imagery. The piece, now in the collection of the Vancouver Art Gallery, was included in *The Return of Abundance,* Nicolson's exhibition at the Art Gallery of Greater Victoria (Baldissera 2008).

Nicolson distinguishes sharply between work she does amid and for her people, the Muskamakw Dzawada'eneuxw Gwayi'i, and work she does for exhibition and sale. A culture "under severe duress," as she described it in this text, needs protecting from further encroachment. Its distinctiveness can only be maintained by limiting disclosure. Her paintings represent button robes and tunics, make allusions to coppers and protecting treasure boxes, but are never the things themselves. Her strict distinction between ceremony and sale distinguishes her own practice from that of many other contemporary Native artists, who will make the same object for either or both.

> This exhibition consists of a glass "bentwood" chest created in Pacific Northwest Coast Indigenous style. The sides are made of glass, where traditionally they would be cedar. The lid and base are of cedar. Raven designs are etched into the glass on the long sides and owls are etched onto the short sides. Illuminated from the inside by a single halogen light, the raven and owl images are cast onto the walls of the gallery as shadows. Within the raven imagery are included two photographic transparencies; one of a young girl in front of a beach reading a book, the other of two adolescent girls berry picking. These images are cast onto the gallery walls as well.
>
> The work operates on several levels. One meaning is expressed by the title. In traditional Kwakwaka'wakw beliefs the body and the soul are considered integral components of each being. In this exhibition the body is equated with the physical box and the soul is reflected in the shadows.
>
> "The soul has no bone and no blood, for it is like smoke or like a shadow"
>
> *– Boas-Hunt, Kwakwaka'wakw quote from the 1900s*

The work is created partly out of a desire to affirm this belief but also the concern that our traditional culture is under severe duress to survive intact through the 21st century. While our material culture has been widely collected and preserved in institutions across the world, and the contemporary production of such material culture is fostered by a thriving commercial gallery system, the meanings that these physical objects

represented are being lost. Most particular to this is the loss of indigenous languages. It is my belief that our greatest challenge to maintaining cultural distinctiveness lies within the retention of a particular worldview. When objects are integrated into commercial production their meanings change. Objects that once were hidden and whose creation was kept secretive are now displayed in store windows as objects for purchase and artists are filmed working and speaking about their work (myself included).

On another level, the work seeks only to re-assert an old belief in the human balance between the body and soul and asks a question about mortality. The photographic images represent the human body. The little girl is my oldest Aunt, Amy Willie. The photograph was taken when she was four years old and staying at the preventorium for tuberculosis at Alert Bay. She looks down at a book she is reading and does not address the camera. She died in 1994 from complications of arthritis. The other image is of my mother, Gloria Willie, as a young woman. She is with her friend Lizzie Campbell and they are in the process of picking berries. They both address the camera directly with hopeful expressions.

My mother is now 68 and in entering old age is struggling with the inevitable deterioration of her physical abilities. However, traditional Kwakwaka'wakw belief is that while the body deteriorates the soul endures. The soul will reincarnate to occupy the bodies of one's own descendants.

So this work presents the irony of cultural difference. On one hand, a reflection on the current value and focus on the material (the box = the body) and on the other, the traditional Kwakwaka'wakw belief of the dominance of meaning (the spirit = shadow) despite its ephemeral character.

(Oh yes, as well there is deep symbolic meaning to both the owls and the ravens but that would be very lengthy and I'm trying to keep it short.)

**27.XXIX. Cuauhtémoc Medina. 2005. "High Curios."** In *Brian Jungen*. Edited by Daina Augaitis. Vancouver: Douglas and McIntyre, 27-29, 32-33. Courtesy of Cuauhtémoc Medina. © 2005 by the Vancouver Art Gallery. Published by Douglas and McIntyre, an imprint of D&M Publishers Inc. Reprinted with permission from the publisher.

Cuauhtémoc Medina (b. 1965) is an art critic, curator, and historian based in Mexico City. He is a researcher at the Instituto de Investigaciones at the National University of Mexico and associate curator of Latin American Art Collections at the Tate Gallery in London. In Mexico, he is a member of the Teratoma group, in which art critics, curators, and anthropologists consort. It is this combination of roles and interests, now normalized as postdisciplinary, or at least interchangeable depending on GPS, that helped to recommend Medina for the now indispensable outside perspective, enabling a global positioning of Brian Jungen.

## 1. OFFER AND DEMAND

At the end of the 1530s, the Spanish conquerors' effort to enforce Christianity and extirpate the "idolatry of the Indians" in central Mexico reached a feverish state. In their effort to "rescue" the "Indians" from their "satanic" worshipping, Franciscan friars – the new civil authorities and, at times, overzealous colonizers – went through hundreds of towns to uncover and burn all kinds of "idols" and "demonic" books that were hidden in small domestic altars, or buried under the town squares or in remote mountain caves. Although chronicles from the time attest to the Spaniards' apparent success in turning the Aboriginal towns to Christianity – a conversion fuelled by the fear left by the conquest and the epidemics that had recently decimated the Aboriginal populations – they also obsessively describe the hundred and one ways in which the "Indians" refused to abandon their cult objects. To the outrage of the Catholic priests, the Aboriginals paid lip service to the new faith and at the same time dared to conceal their "devils," even under the carved stone crosses and churches being erected all through the friars' new kingdom.

Western iconoclasm created an unequal but nonetheless complex space of violence and negotiation revolving around the value (and lack of value) of the so-called idol. The zeal of the Spaniards had a dual effect, for instead of merely desacralizing the "Indian" objects and turning them into meaningless materials, the targeting of them as "demonic things" frequently reinforced their reputation as powerful objects. At times, in fact, the Spaniards contributed to the perpetuation of idol making in the most paradoxical ways. According to Friar Toribio de Benavente Motolinia, around 1539 and 1540 some Spaniards, "thinking they were doing something," went beyond unearthing corpses and statues to "offer a reward to those that would hand them idols." Some Natives decided to comply and again started producing images of their deities, not for worshipping but to provide them to the new rulers, who enjoyed smashing them;

> And in some places the Indians were rewarded and pestered this way. So they searched all the idols that were forgotten or rotting under the earth to surrender them. And some of the Indians were so molested that in fact they made idols again, and gave them so that they [Spanish priests and soldiers] would stop bothering them.

In the same way that art today may go straight from the artist's studio into the museum collection, the Natives of central Mexico created objects that went directly from the workshop of their maker into the bonfire of the inquisitor despite not having been involved in any religious or magical ceremony. Their only function was to fulfill a paranoid colonial expectation, and they were, in fact, among the first Amerindian objects produced solely for European consumption.

In hindsight, those makers of "idols" – by all appearances of Nahua descent – invented a new strategy of colonial resistance. By effectively producing counterfeits of their ritual objects (the first "pre-Columbian fakes"), they reflected to the priests and soldiers exactly what the colonizers expected to see. In this strategy of over-representation, if the metropolitan subject expects the colonials to attest to his culture's preconceptions, trying to theorize an ambiguous position towards the predicament of westernization will not necessarily build a platform of understanding. In other words, sometimes it is better to use misunderstanding in one's favour by projecting towards the other the myth of the "authentic" First Nations artist, to enact their nightmare and accept the role of the idolatrous anthropophagic monster. If they want masks, why not sell them their own reflection?

Let me add in passing that this anecdote ought to be seen as detailing the true origins of art in the Americas: the production of objective mirages that mediate the interethnic imaginary of both individuals and communities on the North and South American continents. As skewed and convoluted as this "tradition" is by distrust, violent conflict and social struggle, the colonial process turned the making of symbolically charged images and artifacts into a field of negotiation of ethnic Imaginaries. From the substitute sacralization of Christian saints in the native tailoring of cults like the Virgin of Guadalupe to the "shamanism" of Jackson Pollock's painting, from Wilfredo Lam's Afrocuban recapturing of cubism's primitivism to the vindication of antropofagia by Brazilian modernismo, not to mention Emily Carr's fauvist "communion" with the First Nations of the Pacific Northwest Coast, art in the Americas is traversed by the predicament of objects mediating colonial subjects. Sometimes, in fact, their efficacy seems to correlate to their inauthenticity. It may be that instead of representing indigenous history and lived experience, artists in the Americas have been particularly cunning at performing cultural distortions, for these are better able to play a mediating role between communities. Framed by a history of violence and betrayal, these images are more significant for their capacity to activate fear and distrust than as means of reconciliation.

My purpose in beginning this discussion of Brian Jungen's Prototypes (1998-2005) with this anecdote is to show that his art unfolds against a global context of colonial stereotyping. Jungen's work registers the art of his Northwest Coast First Nations ancestors as exoticized and commercialized, and also attends to the argument that this perception may have helped First Nations artists to circumvent the brutal prohibition of the potlatch in Canada from 1884 to 1951 and actually allowed Aboriginal art to survive. I introduce this comparison with the Mexican context to consider his work as an allegory for an entire series of historical transactions between ethnic groups in which colonial categories such as "idolatry," "fetish," "Indian art" or "mask" can be effectively redirected to the colonizer, who, after all, is their original instigator. Brian

Jungen's art can be seen as an example of how to use cultural stereotypes as a means of critical engagement. His works are games that mobilize aesthetic and cultural misunderstandings to explore ways to politicize cultural stereotypes in the age of global capitalism.

...

If Jungen's Prototypes effectively suggest a new intercultural understanding, it is precisely because they are located at the crossroads of a number of racial and cultural mirages in what art history professor Charlotte Townsend-Gault has described as the "wallpapering" of habitus: the incorporation of "native" imagery into "the vast heaving mass of ephemeral and disposable forms" of the society of spectacle. Rather than merely repudiating that process, Jungen amplifies the marketing and stereotyping of Indian culture that allows First Nations peoples to participate in the current economy symbolic landscape and to transform their heritage into a form of capital.

If Jungen's masks are effectively prototypes, it is because they project a futuristic product: a Utopia in which street kids around the world will daydream about becoming Aboriginal dancers with the same gravitas with which they now "become" Michael Jordan when wearing Nike Air Jordan trainers. That is, Jungen's masks confront his mural drawings almost as if they were a market analysis of the very consumers who have been dutifully surveyed in the street to define their interests and desires. Essentially, after decoding what "people expect from Indian art," Jungen set out to design a new commodity that would capture these stereotypical expectations of Aboriginality. His Prototypes are a market fantasy like any other fashion product, a mixture of welltested formulas (Nike trainers + Aboriginal curios) and the pretence of "the new." In other words, they are clearly recognizable as merchandise kept safely within the boundaries of the "Aboriginal culture" brand but with an inbuilt semblance of radicalism that is essential to capture the desires of the street-fashion victim. Instead of opposing the stereotype, Jungen fulfills and exceeds the expectations of the neoethnic market in a single go. The extraordinary success of the Prototypes attests to the feasibility of the entire operation – consumers badly want their fetishes.

**27.XXX. Jennifer Kramer. 2006. *Switchbacks: Art, Ownership, and Nuxalk National Identity.***
Vancouver: UBC Press, 6-8. (See also 19.XVII.)

One of the rare recent ethnographic studies of a First Nations community in British Columbia, *Switchbacks: Art, Ownership, and Nuxalk National Identity* was constructed around a socio-spatial metaphor for the ambivalence that prevails at Bella Coola, a Nuxalk community in a deep valley on the mountainous coast of central British Columbia. Jennifer Kramer (b. 1969) constructed a frame,

part positivist, part hermeneutic, to contend with apparent switches in attitudes toward cultural history, its value, and commodification in relation to external exposure. A notorious local topographical feature also allowed the "outsider" (it may not be incidental that Kramer, like Aaron Glass, was an American, with significant parts of their anthropological training elsewhere) to situate herself in this same ambivalent space. Kramer now has responsibilities for partner communities under the Museum of Anthropology's Reciprocal Research Network, an updated version of a position previously held by Wilson Duff and Marjorie Halpin.

WESTERN AND NUXALK ART WORLDS

Sociologist Pierre Bourdieu wrote: "The work of art is an object which exists as such only by virtue of the (collective) belief which knows and acknowledges it as a work of art." For the purposes of this book, I consciously and strategically define art as that which the Nuxalk believe to be art. This perspective gives agency to the Nuxalk, enabling them to define their own art world. However, this act of Nuxalk empowerment is vulnerable to external definitions of authentic Native art. Inspired by Bourdieu's ideas on the "field of cultural production," in which he examines not only production and its end result, the art object, but also the art object as a category of art within the processes of production, circulation, and consumption, Nuxalk art must be examined within the fields in which it circulates.

I believe that, although Nuxalk artists struggle to self-define the value of their artistic production within Bella Coola, they must recognize the legitimacy that their art garners when it is valued by the Western art worlds of Canada, the United States, and Europe. Philosophers of art, such as Arthur Danto and George Dickie, crucially explicate how art is given value in the Western art world only when it is recognized as such by museum curators, gallery owners, and connoisseur art buyers. Nuxalk artists attempt to refute external definitions of what Nuxalk art should be but, at the same time, are aware of how inherently enmeshed their art is with outsider expectations. I see this as a crucial ambivalence manifested by Nuxalk artists – an insider/outsider dichotomy that creates contemporary Nuxalk identity.

Nuxalk artists' denial of being affected by the Western art world is not so very different from Western artists' often stated desire to avoid the impact of the Western art world. Bourdieu pointed out this ambivalence for Western artists who deny a pecuniary motivation for the production of their art when, in fact, they are involved in the sale of that art and when art gallery owners play a large role in influencing what is considered art. The Nuxalk refute external values being placed on their art via the

finances of the art world and fair market value, but they also play into these valuations. In this way Nuxalk can claim to be defining their own art form while, at the same time, gaining from its external validation.

Bourdieu believes that "the pure theory of art," which claims that true art is created without pecuniary incentive and outside the money economy, actually stems from art created as a commodity for profit within a money economy. He shows, however ironically, that a disinterestedness in money is profitable for artists. Bourdieu refers to the "field of cultural production" as an inversion of the regular money economy. Specifically, art's value in terms of "symbolic capital" is a metaphor of how art becomes valued within subjective, institutionalized structures that determine legitimacy. These structures are mediated by the way in which previous artists and gallery owners have positioned themselves within them and how their actions shape future art production. For example, Western artists' fame accrues profit and is encoded in recognizable names and signatures, which are in turn validated by Western art institutions. In this way, art both reflects already existing beliefs about legitimate value and becomes part of the process of value making. For this reason, as I asserted above, art can be viewed as a verb as well as a noun.

This description of Western individual artists is applicable to Native artists, although the latter may gain notoriety through their indigenous national status as well as through their individual status. Nuxalk artists must deal on both fronts: that of the Western art market (which values Nuxalk artists according to Western standards) and that of the Bella Coola Valley (which values Nuxalk artists according to local standards, perhaps as representatives of Nuxalk national identity).

It is under these anxiety-producing conditions that Bourdieu's theory affects contemporary Nuxalk artists. It is due to this need to refute profit as the motivation for artistic production that Native artists in general have an uneasy relationship with selling their art. In the minds of the non-Native public and the Nuxalk themselves, who value the spiritual side of Nuxalk art, selling Nuxalk art (which is seen as commodifying Nuxalk cultural heritage) can easily be read as a negative act. Nuxalk artists must balance both the art world's general contempt for artists who produce for sale and the more specific contempt of Native artists who, in order to be appreciated as "authentic" are not supposed to profit from their spirituality. According to Phillips and Steiner: "Rather, until recently, both art historians and anthropologists have resoundingly rejected most commoditized objects as spurious on two grounds: (1) stylistic hybridity, which conflicts with essentialist notions of the relationship between style and culture, and (2) their production for an external art market, which conflicts with widespread notions of authenticity."

In *Switchbacks*, I attempt to show the difficulties Nuxalk artists face when commodification is assumed to be a detrimental act that steals contemporary Nuxalk

identity. Even though the Nuxalk have, in part, absorbed negative feelings about selling their art outside the Bella Coola Valley, they do get something positive (other than dollars) from doing so. When non-Nuxalk buy their art, the Nuxalk receive recognition of its positive value, and this functions to legitimize not only what they produce but who they are. Bourdieu might read this as Nuxalk "symbolic capital" (honour, respectability, charisma, authority, legitimacy) produced through commodifying Nuxalk art.

# 28 | Stop Listening to Our Ancestors

In 1854, the Suquamish Chief Seattle gave a speech in reply to the U.S. proposal to buy Native lands around Puget Sound. Working from notes he took at the time, Dr. Henry A. Smith published a translation of Chief Seattle's oratory in the Seattle Sunday Star on October 29, 1887. The modern version by poet William Arrowsmith printed here is preferred by the Suquamish Tribe: www.Suquamish.nsn.us.

> — *Robert Joseph*, Listening to Our Ancestors: The Art of Native Life along the North Pacific Coast *(2005, 186)*

A frameable print of Chief Seattle's speech may be purchased for $15.00 (+ s/h) by mailing to: Suquamish Museum, PO Box 498 Suquamish, WA 98392.

> — *Squamish Tribe website, accessed July 2006*

Paintings and other objects, like people, have careers, lives. These objects have meanings to those who brought them into the world, other meanings to those who worked with or used them, yet others to historians who try to explain them, to curators who organize exhibitions around them. They exist in as many different forms as the number of people who happen to come across them. Objects are not static; they are the accumulation of all their meanings.

Claims of cultural patrimony and calls for the repatriation of antiquities (Italians wanting back ancient art dug up in Italy, Greeks wanting back Greek art) stem from nationalist politics and legal disputes, but they're fundamentally about who gets to assign meaning. A British anthropologist on the panel at Quai Branly mentioned a show of Polynesian art and religion in England. He said the question had arisen, should modern-day Polynesians have say over the show's content?

But which Polynesians? The political activists who might want their idols returned? The religious fundamentalist who might want them burned? They're both native voices. Which gets authority over what the artifacts mean?

> — *Michael Kimmelman, "A Heart of Darkness in the City of Light,"* New York Times, *2 July 2006*

Essentialism is like dynamite, or a powerful drug: judiciously applied, it can be effective in dismantling unwanted structures or alleviating suffering; uncritically employed, however, it is destructive and addictive.

> — *Michael Kilburn, "Glossary of Key Terms in the Work of Gayatri Chakravorty Spivak," 1996*

Strategic essentialism envisions a world in which internal debates among oppressed people can be sealed off from public debates with oppressors. Such a world does not exist.

> — *Paul Brians, "'Postcolonial Literature': Problems with the Term," 1998*

I suggest that the rise of Northwest Coast art is connected to the emergence of what might be called the Indian/Museum/Anthropology Industrial Complex.

And one might say the Indian/Museum/Anthropology Industrial Complex reached its zenith on 21 September 2004, when the Smithsonian's National Museum of the American Indian (NMAI) opened its doors. The National Mall was mobbed by thousands of Indians, including more Indian princesses in full contest regalia than anyone even knew existed.

There's nothing like the smell of burning sage in the morning, and in Washington back in 2004, yes, it did smell like victory. The opening of NMAI realized a dream held by a generation of Indian activists, although few dared imagine an outcome quite so grand: a Smithsonian Museum on America's Main Street.

From the beginning, the NMAI defined itself largely in terms of what it was not, and it was not going to be a natural history museum where white anthropologists ran things and Indians lived in dioramas. NMAI would be different, and it would be different because Indians would be in charge. This view of museums and anthropology, I suggest, was one shaped by Indians (lawyers, activists, educators) who came of age in the 1960s and 1970s and changed little since. That view sees museums as a kind of prison. They teach the world the Indian story is a tale of extinction, and most of us and Indian culture are dead. Their so-called collections hold the bones of our ancestors and sacred objects. Anthropologists are basically prison guards, closely observing inmates and occasionally venturing out to capture new Indians and new objects to study.

This generation of Indian leaders was largely unaware of how museums and anthropology were undergoing major transformation projects of their own. The foundational ideas of NMAI would have been radical and forward thinking in the 1940s, but by 2004 museums had been collaborating with Indians for two decades, and it was normal practice for any major museum, especially natural history museums, to include Indian advisors on their Indian exhibitions (see Black, this volume; Jonaitis, this volume).

Cartooning museums and anthropology served a useful purpose. By framing the discussion this way, NMAI was able to claim a kind of moral superiority to discourses it viewed as deeply flawed, if not inherently exploitative. And of course this argument is not completely wrong: of course anthropology and museology have dishonourable histories and much to answer for. My point is that over the past several decades both fields have made genuine attempts, with some real success, in answering them (see Miller, this volume; Campbell, this volume). The cartoon also did two other things, neither one good. It helped to nurture an anti-intellectual environment in which not just anthropologists were suspect, but

higher education and books themselves were viewed suspiciously. Truth and right weren't found in books, but in the NMAI's fetishized notion of Indian community, which is always a plane trip away, usually on a reservation. The curatorial code says, rhetorically at least, that real Indians out there are always the authority, then educated Indians, and, as a last resort, white experts.

Of course, Indian communities are famously disputatious, and one person's authentic traditional leader is another's brutal tyrant or government quisling. But never mind about all that.

The second thing is that, in order to maintain the spin about being a radically different museum that works with Indian people in ways no one else ever has, NMAI has had to do a lot of pretending. We are a Smithsonian museum whose staff is two-thirds non-Indian and even more overwhelmingly non-Indian at middle and senior management levels. Not only is this true; it is always going to be true. No serious person thinks NMAI will ever be mostly Indian, and I would argue it should never be even if such a thing were possible. NMAI is an interesting and brave venture that has great potential, but it needs to come to terms with what it actually is. It is now and will always be a government agency of mostly white folks (almost none of whom is an anthropologist or, God knows, a museum expert) and a strange collection of Indians like me.

And the funny thing is that most people not only don't care about the museum and anthropology caricatures, they don't even know the storyline. The world is a big and busy place these days, and I read somewhere that the average North American metropolis has school systems that speak a hundred languages. As someone who makes his living deconstructing the master narrative of Indians and America, I'm coming to the very depressing conclusion that lots of people out there don't even know the master narrative anymore.

However, just because the whole Indian/Museum/Anthropology Industrial Complex is showing its age doesn't mean we're likely to abandon it. We've grown accustomed to each other's false faces, you know?

Yes, essentialism has its brutal charms, and her slightly smarter and better-looking sister, strategic essentialism, in a pinch can get you from here to there on the subaltern subway. But those two – I'm sorry, there's no nice way to say this – are dullards, and it's time to ditch them (see Townsend-Gault, Chapter 27, this volume).

I believe contact between the Eastern and Western hemispheres five centuries ago was the most profound event in human history, changed just about everything on the planet, and created the world we live in today. Indians are at the centre of that event, but it doesn't belong to us, and deepening our understanding of our past and present is a human project, not an Indian project. But, you

know, we don't really believe it. How could the Indian experience be that important when everything we see around us says we're kind of a joke? Maybe that's why we're always looking at the biggest story never told through the wrong end of a telescope.

But what if we gave up being the State Museum of the Red Nation?

What would happen if, instead of imagining that we could explain the history of the Cheyenne from the beginning of time to the twenty-first century with a few dozen objects and some wall text that must never exceed seventy-five words, all in a space the size of a small living room, we said just the opposite. That, hey, it would take geniuses to do that, and we're not geniuses, just civil servants! What if we left the Authority and Answer business and joined the more humble, but perhaps more satisfying, Question and Conversation business?

What would happen? I actually have no idea, but I'd love to find out.

But let's face it, hell might freeze over first.

So what should we do in the meantime, in the here and now?

Because in the here and now we're stuck. Probably in a ditch of some sort. It's also dark, and we're not sure how long these cellphone batteries are going to last. This is not an emergency but a time for calm and careful thinking.

We can always panic later.

When I read Marcia Crosby's "Construction of the Imaginary Indian" (1991) [28.11], I admire most just this, her calm and careful thinking. Crosby tells the classic story of learning about her people from a white guy who seemingly has forgotten more about her people than she can ever hope to learn. And she tells it in a completely straightforward and dispassionate way. She is someone you would like to have riding shotgun when your Plymouth rolls silently to a stop in or near a ditch, in the night, with dodgy cellphone batteries.

Speaking as an Indian intellectual, I would say that my side has failed to be as rigorous as the issues demand. We've constructed our own imaginary Indian space, and, yes, sometimes I think all Indian space is imaginary to greater and lesser degrees, because what's the alternative – that my version is actually true? We're all too smart to fall for that.

However, this constructed imaginary Indian space rather too conveniently lets us skate fearlessly over very thin ice, avoid the hardest questions, and it's as if we know the ice covers a wading pool at a miniature golf course. Nothing bad will happen if we fall through this ice.

So we routinely claim to speak for all Indian people, or all members of our tribe, or just ourselves. We have no word for art, or everything we make is art, or actually we do have a word for art, but we're not going to tell you what it is.

What I think we've not problematized is who we, as critical thinkers, are in relation to our community (see Ḳi-ḳe-in, Chapter 22, this volume; White, this volume). And most of the time we're outsiders, known weirdos, freaks.

What strikes me about much of the discussion over the past twenty years is how sentimentally it reads today. There are several overlapping and interconnected discussions going on here. The two I wish to address are Truth and Power and their collision with the issue of Authority.

I will use the Seattle speech of 1854 as a case study. It is an example of my own naïveté (or perhaps my eternal optimism) that I was startled to see it in the book published by the NMAI about a major North Pacific Coast exhibit. Isn't it common knowledge that Seattle wasn't the author of any of the several versions of his speech?

The Suquamish authorities, we can safely assume, are quite familiar with the issues around the Seattle speech. I don't think any of them would seriously argue that text is anything more than a poetic reimagining of what Seattle might have said. Nor would they disagree that the source materials are from white people and not Suquamish or other Indians.

My job as a cultural critic is to problematize things. The Suquamish political and cultural leaders probably feel they have enough problems already. Problems such as maintaining their limited sovereignty to provide jobs and getting more paid admissions into their museum or to visit the Seattle grave site.

The imaginary Seattle fits comfortably into the way our mandatory retraditionalization process is organized. Deconstructing who Seattle really was, or exploring why American poets and screenwriters must be relied on to translate and interpret his words instead of the Suquamish themselves, does not advance this agenda.

Too much of our discourse takes place as if the Indian side is, generally speaking, of one mind about things when it isn't, while also ignoring the political realities. This is also true for the non-Indian curators and scholars and the institutions, particularly large public museums. We speak as if we are seekers of truth, limited only by ideological or historical blinders that we are anxious to identify and correct, unfettered by the political dynamics of who pays our salaries.

It's not true, which is bad enough. Even worse is the fact that people are starting to realize it's not true.

**28.I. Richard I. Inglis, James C. Haggarty, and Kevin Neary. 2000. "Balancing History: An Emerging First Nations Authority."** In *Nuu-Chah-Nulth Voices, Histories, Objects and Journeys.* Edited by Alan L. Hoover. Victoria: Royal British Columbia Museum, 7–10. Excerpted with the permission of Richard I. Inglis, James C. Haggarty, and Kevin Neary.

This is an excellent case study of the Kabuki dance that, over the past two decades, has been the primary way in which museums, and increasingly scholars, go about their work in regard to Indian issues and Indian people. Note the emphasis on process, intent, and goals. Note the casual way it is explained that non-Native people will actually do most of the investigation, documentation, and writing of the history that is meant to correct the errors of the earlier historians, who, we're reminded throughout the essay, were not Native.

Public knowledge of the history of First Nations generally comes from writings by individuals who are not of First Nations ancestry and who typically view First Nations communities and their histories from an "outside" perspective. These histories, often written in words that reflect the values and priorities of the non-aboriginal society, are perceived by many First Nations people as foreign, at best interesting, or simply wrong.

In many of these writings, the First Nations keepers of traditional histories are either not acknowledged or are relegated to the role of cultural advisors, formally referred to as "informants." First Nations have long been critical of the nature of this relationship because it is the "outside" authors, not the knowledgeable community members, who are considered the experts in First Nations history. Further, for First Nations, these written presentations often do not reflect the events, issues and priorities important to the cultural advisors and their communities.

A paradox for First Nations is that while they take issue with many aspects of history written by outsiders they have had to rely on these writings to validate their history in their dealings with governments and the public. This changed in December 1997, when the Supreme Court of Canada decision in Delgamuukw recognized First Nations oral history as a legitimate form of evidence in the legal system. This decision finally acknowledged the First Nations position that oral history can stand as independent evidence and does not need to be validated by outside experts.

The dilemma facing First Nations is that oral history cannot be reduced to the written word without freezing it in time and losing the social context within which it is validated. Oral history is a living tradition that evolves with each presentation. It includes narration, songs, dances and images that are portrayed in a variety of cultural items including masks, baskets, hats, curtains, house posts, and frontal poles.

The issue, however, is not one of oral history versus written history. Rather, the issue is one of balancing histories written from an "outside" perspective with ones written from a First Nations perspective and derived from their oral traditions. Each form of history contributes independent historical information and, taken together, result in a more complete and richer presentation of a First Nations history.

Over the past few decades, First Nations increasingly have been asserting their authority to counter presentations of history by "outsiders." Many First Nations are controlling access to their communities and members by requiring researchers and writers to obtain formal permission to work within their territories, communities or with community members. Other First Nations are forging partnerships with outside individuals and organizations to ensure their views are represented.

Two examples of the emerging authority of First Nations over the presentation of their histories are the following papers: the "Yuquot Agenda Paper" by the Mowachaht-Muchalaht First Nations and the "Kiix?in Agenda Paper" by the Huu-ay-aht First Nations. Both were prepared for presentation to the Historic Sites and Monuments Board of Canada, a federal organization responsible for recommending commemoration of heritage sites of national significance to the Minister of Canadian Heritage.

These two papers emerged from communities that are actively taking control of their own affairs and whose leaders are looking to provide economic opportunities for members of their communities. As a hereditary leader stated: "Dependency under the Indian Act has not served us well. Generations of our people have died poor on our rich lands."

Community leaders are determined that this situation will not continue.

For both the Mowachaht-Muchalaht and the Huu-ay-aht, taking control of their affairs means operating beyond the isolation and exclusion of reserve life, and no longer accepting the status quo. In their own way, each community evaluated the opportunities and resources available, and decided to launch new initiatives with outsiders. Each community turned to their rich history and traditions as a means to provide opportunities for their members. Each chose to seek national recognition for one of their major village sites to enhance economic opportunities in cultural tourism.

To accomplish their goals, each community contracted the authors to work with them in preparing their papers. This was considered necessary to bridge the gap between their traditional ways and the ways of government and academia. Each community established a project team, including representatives of the hereditary leadership and the authors, to research and write the papers.

The process in each community involved a series of public meetings to discuss content for each paper and to seek clarification on controversial issues. At the completion of each stage in the preparation of the papers, both the format and the written text were reviewed formally by the hereditary leadership to ensure that the project team was on track. In this way, each First Nation controlled the presentation of their history, both in terms of what was said and how it was said.

At the completion of this process, each community submitted its paper to the Historic Sites and Monuments Board of Canada. Representatives of the hereditary leadership from each community attended the Board meetings to provide a formal

introduction and traditional speeches to ensure that their written submissions were understood in the context of their oral traditions.

There also are significant differences between the two submissions. In the Yuquot Agenda Paper, the Mowachaht-Muchalaht First Nations wanted to counter previous commemorations of historic events in their territory by the Historic Sites and Monuments of Canada. The earlier commemorations focused on important events of European history of the late 18th century (the presence of Cook, Vancouver and Quadra in the Nootka Sound area) but made no mention of the central role played by the Mowachaht-Muchalaht First Nations in these events, nor of their village, Yuquot, where these events took place. From the Mowachaht-Muchalaht First Nations perspective, these commemorations, and subsequent celebrations, either ignored them completely or relegated them to a bystander's role. They speak often of having to endure these celebrations and the erection of monuments and plaques to honour foreigners at a place that is their own.

The Mowachaht-Muchalaht First Nations have long resented being marginalized in the presentations and celebrations of historically significant events at Yuquot. Their paper needed to correct the perception that they had no role in the significant events of the last 225 years and to seek recognition that their long history at Yuquot was equally worthy of national commemoration. The primary purpose of their paper was to seek balance in the views and presentation of history at Yuquot.

Further, the Mowachaht-Muchalaht First Nations have derived little economic benefit from the many historical celebrations held at Yuquot over the years. This is their place and, as such, they feel justified exerting control over future developments as a means to provide economic opportunities for their community members.

In contrast, the Huu-ay-aht First Nations' Kiix?in Agenda Paper presents, for the first time, the significant history of a Huu-ay-aht village, essentially unknown to the outside world. Although the Huu-ay-aht have been aware of the importance of this place for many decades, they have chosen to seek national recognition for Kiix?in at this time because commemoration is a key element in Huu-ay-aht cultural tourism initiatives. As a site of national historic significance, Kiix?in becomes a special place where the Huu-ay-aht plan to share their history and traditions with others.

The two papers are examples of First Nations taking control over the presentation of their histories. In these papers, both First Nations seek to balance the presentation of written history by "outsiders" by presenting their history from a perspective that originates from within their communities. Both papers present the events of history from a First Nations viewpoint and in words that reflect their values and priorities. Max Savey, a hereditary chief of the Mowachaht-Muchalaht First Nations, commented after reading the final draft of the Yuquot Agenda Paper: "This is the first time I have read in our words, our view of events in history."

These papers, however, are transitional. At the present time, both First Nations determined that contracting outside researchers and writers offered the best means for achieving their respective goals. Similar working relationships will likely continue until the Mowachaht-Muchalaht and the Huu-ay-aht communities fully develop the capacity to present their history in written form.

**28.II.  Marcia Crosby. 1991. "Construction of the Imaginary Indian."** In *Vancouver Anthology: The Institutional Politics of Art.* Edited by Stan Douglas. Vancouver: Talonbooks, 267-68.

Depressingly relevant even after all these years, Crosby's manifesto is notable for directly addressing the internal contradictions of her communities, academia, anthropology, Bill Reid, and herself.

I am going to speak about what seems to be a recent phenomenon in the arts and social sciences – the embracing of "difference." As a component of postmodernism, difference may take the form of the many voices that struggle against the hegemony of the European "master narrative." In the face of popular culture and an ever-shrinking globe, it is also a saleable commodity.[1] Increasingly, we as First Nations people assert our national and cultural differences against the homogenizing affects of academic discourse, mass culture and government legislation.[2] However, interest in First Nations people by Western civilization is not such a recent phenomenon; it dates back hundreds of years, and has been manifest in many ways: collecting and displaying "Indian" objects and collecting and displaying "Indians" as objects or human specimens,[3] constructing pseudo-Indians in literature and the visual arts. This interest extended to dominating or colonizing First Nations people, our cultural images and our land, as well as salvaging, preserving and reinterpreting material fragments of a supposedly dying native culture for Western "art and culture" collections. Historically, Western interest in aboriginal peoples has really been self-interest, and this Eurocentric approach to natives – in all its forms – takes up a considerable amount of space within academic discourse. The purpose of this paper is to refuse the prescribed space set aside for the Imaginary Indian. Despite the West's recent self-critique of its historical depiction of "the other," I am not entirely convinced that this is not just another form of the West's curious interest in its other, or more specifically, the ultimate colonization of "the Indian" into the spaces of the West's postmodern centre/margin cartography. Exposing the self-serving purposes, and the limitations that such cultural maps impose on all First Nations people, is an act of confrontation and resistance. I also consider it an act of affirmation to speak in the first-person singular, refusing an imposed and imaginary difference in order to assert my own voice.

1   Mike Featherstone discusses the new circumstances of the globalization of art and the effect
    of enlightenment on other cultures. What is established is a new situation for the artist,
    product and consumer – polycultural art. Because polyculturalism weakens the established
    Western hierarchies of cultural taste, the intellectuals must adopt a new role as interpreters
    in order to maintain their place in the social and art hierarchies. Featherstone describes the
    exchange value of goods as controlled by the intellectuals, who together with the media have
    established a monopoly in defining legitimate taste, setting themselves up as interpreters,
    thus reinforcing their established positions. In doing so, they are free to create a scarcity of
    goods by responding to consumer demands for cultural diversity and legitimized good taste.
    The criteria for marketing these new polycultural goods may be summarized as follows: the
    religious, political and mythological "use value" of objects within a contextualized setting is
    replaced by "exchange value which privileges the physical and marketable value; 'diversity'
    is encouraged as a marketable asset, but that difference must be socially recognized and
    legitimized; legitimization must come from the intellectuals to establish high market value;
    popularity and expansion of a commodity can lead to devaluation." Mike Featherstone,
    "Lifestyle, Theory, and Consumer Culture," in *Theory, Culture and Society* 4 (1987): 55-70.
2   The legal definition of the term "Indian" was first defined "by statute of May 26, 1874,"
    through "an act providing for the organization of the Department of the Secretary of State
    of Canada, and for the management of the Indian and Ordinance Lands, S.C." *Native Rights
    in Canada*, eds. Peter Cummings, Neil H. Mickenberg, et al. (Toronto: General Publishing,
    1970): 6. This act was preceded by the 1850 Land Act and the 1857 and 1859 Civilization and
    Enfranchisement Act, whose objectives were ostensibly to protect the Indians and the land
    until the Indians were considered "civilized" enough to do so themselves. (*The Historical
    Development of the Indian Act*, Policy, Planning and Research Branch, Department of Indian
    and Northern Affairs, January 1975.) These acts eventually became what is known today as
    the Indian Act, which defines the parameters of those who could be legally defined and
    recognized by the Canadian government as *Status Indians;* at the same time, the government
    defined Indians as *non-persons.* Those who did not meet the criteria were defined as *non-
    status.* The purpose of the legal designation had to do with the intention of the government
    to assimilate all aboriginal people in Euro-Canadian society. It is a paradox that in order to
    make Indians the same as Euro-Canadians, it was necessary to define indigenous people as
    separate and apart from that society. The Indian Act not only legislatively defines all First
    Nations people as a homogenous whole, but wedges us into the confines of a carefully
    constructed legal system, historical setting and geographical place-reserves. The laws
    pertaining to the man nations contained within the large geographical area now called
    Canada address an imaginary singular Indian. Yet, despite our national differences, we are
    bonded together in shared resistance to colonial hegemony. Michael Asch draws attention
    to one of the ways in which the breadth of diversity in native cultures is signaled vis-à-vis a
    change in the name of a national organization to an international one. The National Indian
    Brotherhood was changed to the Assembly of First Nations, symbolizing a confederation of
    distinct, national entities, to counter the legislative language of the Indian Act. However, I
    recognize the accepted usage of the term "Indian" by many First Nations people and respect
    the right of self-definition. Michael Asch, *Our Home and Native Land* (Agincourt: Methuen
    Publications, 1984).
3   "Kayaks with their occupants, often whole families, were unceremoniously picked up in
    open waters by ships of Christian seafaring nations and brought home to be first interviewed
    about their native land and then displayed as self-confessed man-eaters to a grateful public.
    Of an Eskimo [sic] woman and child brought on a tour of Bavaria in 1566 (after the husband

and father had been killed), two handbills announcing their appearance survive ... Live displays of [Inuit] remained a common sight in Germany if we may judge from comments by a seventeenth-century German novelist about recurrent showings of 'Greenlanders and Samoyeds,' and from evidence documenting the practice well into the nineteenth century." Christian F. Feest, "From North America," in *Primitivism in Twentieth-Century Art: Affinities of the Tribal and the Modern* (New York: Museum of Modern Art, 1984): 86.

## 29 | NWC on the Up ... Load

*Surfing for Northwest Coast Art*

Can we make the web, at least our part of it, truly Aboriginal? We need to believe in our own metaphors.

— *Ahasiw Maskegon-Iskwew*

As I begin to write this essay regarding an Aboriginal online presence and Northwest Coast art, I want to first address my own presence. I am an artist and educator of Hunkpapa Lakota Sioux descent, and my work is about Indigenous beauty and about the socio-political and the spiritual. I am curious about the role of art and pedagogy within the realm of justice and equality for Aboriginal people.

My journey into contemporary art began as a poet, and then I began curating. My own art practice followed with the production of my first film, *The Red Paper* (1990-94), and the release of two videos, *Grant Her Restitution* (1991) and *I Want to Know Why* (1994). The video works were inquiries into the treatment of Aboriginal women in Canada (see http://www.danaclaxton.com). Performance artist Skeena Reece also deals vividly with these issues via her presence online. Her Artist's Statement [29.1] concerns her presence/absence as an Aboriginal woman during a performance at the Vancouver Art Gallery in 2009 (see Figure 29.5).

In this essay, I pursue Ahasiw Maskegon-Iskwew's question. "Can we make the web, at least our part of it, truly Aboriginal?" I ponder here what that would look and feel like. Perhaps Aboriginal space on the Web exists as a means to let the ancestors come forward, to let the ancients flow through the production of art and culture. In this way, potential new relationships and teachings related to the meaning of Northwest Coast *belonging/object/art* and the *culture/people/ spirit* could also emerge within larger public discourses.

The *belonging/object/art* refers to that which has been made since time immemorial by Indigenous artists and culture makers. I am suggesting that the cultural belonging is different from the object – which are both different from the

**947**

art. The belonging is for cultural and ceremonial practices. The object may have been a belonging but is now part of a public or private collection and is further used as research. Its function of cultural or ceremonial use is no longer practised – it is not danced, sounded, or used in any capacity according to the original intentions of the belonging. The art, such as a drum/rattle/mask or installation, becomes art (within the Western tradition) when the reception is outside the original intention of cultural or ceremonial use. In most cases, the art never gets danced or sounded and becomes both art and object stripped of its original intentions. Not all cultural belongings become art or object, as they are part of a cultural practice that does not include viewership and research. And not all art or objects are cultural belongings, as they require viewership and research. Of course, there is slippage when the artist blends ceremony and art making. Within the parameters of the market, when does a cultural belonging become art or object? Within the study of Aboriginal culture, when does the cultural belonging become an object to the scholar? Within art, when does the cultural belonging become art to the art historian? Within anthropology, when does the object become a cultural belonging? The use value becomes fourfold: community, market, scholarship, and art.

If one acknowledges and even respects that the belonging or object or art is embodied with a way of life that is full of spirit, a people, a culture, and everything that is, how would their relationship change to the maker and the larger community of Aboriginal people? Can the production and deep reception of Aboriginal art secure respect for Indigenous people and further lead to new paths toward social justice? Or equality? Or love? Does the scholar of specifically North American Indigenous art and culture have an ethical duty to assist with securing justice for Aboriginal people? And how are they implicated in the continued structural dehumanization of Indigenous people?

The Web, as many have suggested, is a place for a desubjugation of sorts – a place to present self. Electronic networking has the ability to bring forth ancient cultural perspectives and connect communities. The reality that networked Northwest Coast art can exist within cultural frameworks of both ancient and contemporary discourses and can then be displayed online for the world to see is a dynamic offering (see Dowell, this volume; Townsend-Gault, Chapter 30, this volume). And the digital realm further pushes to the forefront questions about the meaning or idea of Northwest Coast art not only to itself but also to various publics.

The idea and purpose of art as translated within my mother's first language of Lakota is that it encompasses the very institution of life. So, in some ways, a

carved wooden mask is not rendered meaningless because a collector has purchased it and hung it on a wall. Aside from the experience that the collector may derive from the mask, the amount of spirit that goes into making art, whether it be totem, mask, box, weaving, basket, painting, print, jewelry, video, music, performance, T-shirt design, or coffee table (regardless of the end creation), all of this Northwest Coast cultural production is embodied within the Northwest Coast Aboriginal cultural experience, both ancient and present. Whether the design elements are void of traditional iconography, the makers of these works, which are available online or elsewhere, exemplify a particular cultural history, experience, and expression distinct to Northwest Coast communities (see Nicolson, this volume). Northwest Coast imagery and iconography represent self through design elements exclusive to the region. Ceremonial belongings have a different function in longhouses and spiritual practices, but some of these objects or art are produced for market or digital and performance use, such as rattles, drums, and dance regalia, and all function within the same realm of Northwest Coast art.

*[handwritten margin note:] All cultural production is embodied within the cultural experience*

What is Northwest Coast art? It is that which Northwest Coast Aboriginal practitioners are making due to their location and bloodline. They are not non-Northwest Coast Aboriginals making surrogate art. Only a Nuu-chah-nulth can make Nuu-chah-nulth art. One has to have the bloodline. The art is the culture, and you have to live culture, regardless of acculturation or criminalization (see White, this volume). Using the word *art* to describe Northwest Coast art is to ignore the fact that culture is fluid, shifting, and adapting.

*[handwritten margin note:] Cultural production made according to their location + bloodline*

If Aboriginal thought is to occupy the Internet, I am curious as to how Aboriginal imperatives such as generosity, courage, wisdom, and fortitude will exist in cyberspace. And what of our metaphors, as Ahasiw suggested? Our cultures are rich with Spirit, and we maintain Spirit helpers, Spirit dancers and songs, Shape-Shifters, Transformers, Intercessors, and a host of other supernatural beings that guide spiritual processes. I am curious as to how these realities translate to cyberspace. There is a lot of Northwest Coast cultural production online, and the beginnings of these designs, stories, crests, houses, and dances come from ancient civilizations that still maintain a relationship to the spirit realm. Some of those beliefs, stories, images, and designs are available online in a variety of media, and these images are tied to the cosmology and creation story, and by existing on the Web the ancients are present by the mere production of images that represent their beings and stories.

Through the uploading and posting of self online, the Internet can be a site for self-liberation and self-desubjugation. By creating an Aboriginal presence

*[handwritten margin note: The Internet as a place for self-definition + community info sharing]*

online, the Internet has become a place for self-definition and community infor-
mation sharing and a tool for bringing remote communities closer to ... closer to
what? Capacity building? Clean water? The global village? Each other?

If we consider the state of Aboriginal languages and the idea that culture
comes from the language and that many artists do not speak their native tongues,
then what language do Northwest Coast artists speak? Many artists and com-
munity members are committed to maintaining Aboriginal languages. Some art-
ists speak a language of cultural teachings and worldviews, and they maintain
the meaning of that cultural wisdom by applying it within their art practices.
One does not have to speak a tribal language to be Aboriginal, but the artwork
can embody meanings of the language through traditional iconography, espe-
cially of the Northwest Coast. With the resurgence of language retention, many
artists and community members are revisiting Aboriginal languages as a means
to further understand how these ancient languages and ways of life continue to
inform our existence as Aboriginal people. Fortunately, fluent Aboriginal lan-
guage speakers exist, and the Internet has become one of the apparatuses to
maintain and teach Indigenous languages.[1]

*[handwritten margin note: Language expressed through iconography]*

*[handwritten margin note: Internet good for keeping language alive]*

The Aboriginal Peoples Television Network (APTN) (http://www.aptn.ca)
is committed to First Nations languages as part of the network's mandate to
broadcast programming in every First Nations language in Canada. There have
been discussions among Aboriginal producers to petition the state to reorganize
the Official Languages Act and include, through legislation, Aboriginal language
as a founding language. The intent is not so much to have all government docu-
mentation translated for a particular language group but to acknowledge that
Aboriginal languages are official languages. One of the benefits of such a change
would be that translators would be available in a court of law when needed.[2]

*[handwritten margin note: They discussed pushing Abo. language as a founding lang. to recognize it as official plus translators in court]*

The grunt gallery, located in East Vancouver, has supported Aboriginal art
for over twenty-five years and is one of several non-Aboriginal art galleries that
house collections, or parts of them, online. The grunt's director, Glenn Alteen,
has been instrumental in curating both established and emerging Northwest
Coast artists as well as conceiving and producing online projects (http://www.
grunt.ca). The gallery has commissioned new works and produced online exhib-
itions such as

- the Lawrence Paul Yuxweluptun retrospective (http://www.lawrencepaul
  yuxweluptun.com);
- *The Medicine Project* (which I curated), featuring Northwest Coast artists
  such as Skeena Reece and Marianne Nicolson (http://www.themedicine
  project.com);

**FIGURE 29.1** Peter Morin, "One of the Older Stories." This image by Peter Morin was included in an online exhibition entitled *Two Worlds* in 2006. Curated by Tania Willard, *Two Worlds* was showcased on http://www.firstvisionart.com/ along with two other online exhibits, illustrating the growing importance of a recognizable Aboriginal presence on the Internet. Courtesy of Peter Morin.

- *First Vision,* featuring Peter Morin (see Figure 29.1), Dolores Dallas, Gord Hill (see Figure 29.2), and Skeena Reece (go to grunt.ca and click Projects).

CD-ROM projects include *An Indian Act: Shooting the Indian Act,* which documents Yuxweluptun's performance of actually shooting copies of the Indian Act in England. The online journal *brunt magazine* features work from the grunt's annual exhibitions (http://www.bruntmag.com).

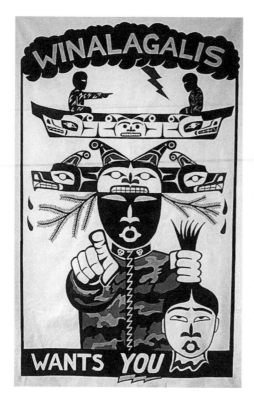

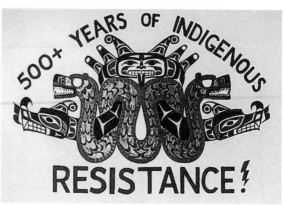

**FIGURE 29.2** Gord Hill, "Winalagalis Wants You" and "500+ Years of Indigenous Resistance!" These images were also included in the online exhibition *Two Worlds* in 2006, http://www.firstvisionart.com. Courtesy of Gord Hill, Kwakwa̱ka'wakw.

Sociologist Mike Patterson (2003) has suggested that, as Aboriginal people become more involved with the Internet, our communities will begin to flow within traditional patterns of cultural protocol [29.v]. We can build alliances online and continue friendly relations with our Aboriginal brothers and sisters on Turtle Island through technology, while maintaining a degree of self-autonomy. This brings to mind an example. At social events, such as the powwow, the MC keeps things on track and moving smoothly. He announces which dance is coming up and when it is time for "Intertribal," when people from all Nations dance in the powwow circle, including the non-Indian. Just as the MC yells out, "hoka, hey! Get ready dancers. Dance your style, dance your own style," I would argue that one of the main Indigenous imperatives is one of self-autonomy — "your own style." Although you have a commitment to the tribe/collective, you have the freedom to be an individual first. Both Patterson and Maskegon-Iskwew support the theory that the Internet provides a freedom space in which you can dance your own style within the Web, and they recognize that Aboriginal youth will play a vital role in maintaining an Aboriginal presence online.

An example of "dancing your own style" is the hip-hop duo Rapsure Risin, from the Stó:lō Nation. Featuring Carrielynn Victor (a.k.a. Numinous) and

Theresa Point (a.k.a. T MelaD), their work can be viewed at music.cbc.ca/#/ artists/Rapsure-Risin. Victor is also a visual artist who works in Northwest Coast iconography (http://www.flickr.com/photos/xemontalot) and produces her own music (http://m.reverbnation.com/artist/1710432 and www.myspace. com/numinousproject). Another innovator with his own style is Ron Dean Harris (Os12) from Musqueam, a music producer and cultural worker (http:// www.myspace.com/ostwelve and http://www.beatnation.org/ronald-harris -ostwelve.html).

The Indigenous youth-driven magazine *RedWire* (see Figure 29.3) can be read in both a print and on online format (http://www.redwiremag.com). The magazine's masthead reads "Free to Native Youth and Inmates. Pulling It Together since 1997." Its editorial mandate is to be a censorship-free zone, providing a much-needed forum for the voices of Aboriginal youth to be heard. The online links section ranges from "Farmed and Dangerous" to "Settlers in Support of Indigenous Sovereignty" as well as links to a host of youth organizations and services. The great achievement of *RedWire* is that it has engaged Aboriginal youth and has provided space for them to articulate who they are.

*(handwritten margin note: Like the internet – self definition autonomy)*

FIGURE 29.3 Cover of *RedWire* magazine (from the 1 October 2008 issue). *RedWire* is a youth-driven magazine published by Indigenous youth. Published both in print and online (http://www.redwiremag. com), the magazine has become an important forum for Aboriginal youth. Courtesy of *RedWire;* artwork courtesy of enpaauk.

Many Northwest Coast communities upload videos, photos, and artwork using social media sites such as YouTube, Flickr, and Photobucket or the Aboriginal version, NativeTube (http://www.nativetube.com). These digital media sectors have created digital social spaces within which Indigenous communities have fully engaged. The Internet not only assists with maintaining cultural traditions, but it also shows you how. You can find anything from footage of a Northwest Coast potlatch to instructions on how to carve a canoe or a bent box, gather cedar, or make a basket. Social media also bring families and communities together, allowing you to post news of what you did on Saturday night or pictures from a cousin's wedding. Aboriginal people who have computers are connected to all these sites and now depend on them for staying connected to one another and to their own and other communities.

*These sites help them stay connected to their own + other communities*

Users of MySpace can view a dozen video works by Duane Gastant' Aucoin (just enter his name in the "Search People" box). Of particular note is his film *My Own Private Lower Post* (2008). The description reads "'My Own Private Lower Post' is the story of Duane Gastant' Aucoin, a two-spirited Tlingit, as he seeks to understand how his mother Vicky Bob's trials at Lower Post Indian Residential School have influenced his life. As she shares her story, he comes to understand how he too is a survivor."

Nicholas Galanin, a Tlingit/Aleut multidisciplinary artist, has posted three videos that encompass the modes of digital culture online and offer new ways to consider what Northwest Coast art is (see http://www.youtube.com/user/ngalanin). In *Who We Are* (http://www.youtube.com/watch?v=lF49l7S6FyM), Galanin has taken single frames of 25,000 traditional Northwest Coast objects and collapsed them into a fifteen-minute video loop. *Tsu Heidei Shugaxtutaan: Part 1* (http://www.youtube.com/watch?v=Ue30aKV1LF8&feature=relmfu) shows a break dancer dancing to traditional Tlingit sounds; *Part II* (http://www.youtube.com/watch?v=Vg2c1jtm590&feature=related) features a traditional dancer in front of a dance screen dancing to hip-hop music in full regalia (see Figure 29.4). These works are otherworldly yet familiar as they push meanings of traditional and contemporary culture, eventually collapsing both into one.

In *Little Dancer* (http://www.youtube.com/watch?v=kgbAgNKiQ44), a young child dances to the eagle song in a performance that encompasses the past, present, and future. As this tiny Northwest Coast dancer moves to ancient sounds, wearing a baseball cap as a mask, he is dancing for his nation, and by doing so he dances for all First Nations. This is the manna of the Internet: it gives us hope that the present will be okay, knowing that we have lots of work to do to ensure that our songs, which embody cultural teachings and a way processing the spirit realm, are maintained and that the children of all nations need

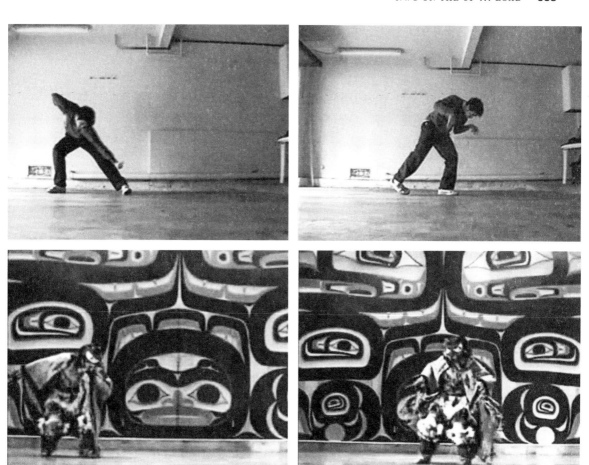

**FIGURE 29.4** Nicholas Galanin, 2006. Stills from *Tsu Heidei Shugaxtutaan,* Parts I and II. Courtesy of Nicholas Galanin.

to be taught their ancient ancestral ways. We see the next generation as this lovely little boy moves to the heartbeat of mother earth as he dances for the people.

**29.I. Skeena Reece. 2009.** Artist's Statement. Personal email.

Skeena Reece (b. 1977) is of Tsimshian-Gitksan and Métis-Cree descent. Her mother is Cleo Reece, a leading activist, educator, arts administrator, and videographer. Her father is Victor Reece, carver, artist, and storyteller. Skeena's multidisciplinary practice includes performance art, spoken word, humour, sacred clowning, writing, singing, songwriting, video art, and arts administration. Skeena was a board member of *RedWire* magazine, director of the Indigenous Media Arts Group (2005-7), and founder of the Native Youth Artists Collective. She released her first self-produced music CD, *Sweet Grass and Honey,* in 2011.

She is concerned with the treatment of Aboriginal women and uses art as a means to address complex and dynamic subject manner. From sexual abuse to the Aboriginal body, Reece brings forth a powerful analysis of history and contemporary issues affecting Aboriginal youth and women. Through her use of humour and her presence, her work forces us to think deeply about the colonial present.

Reece performed as part of FUSE at the Vancouver Art Gallery in March 2009 (Figure 29.5). She began her performance in the lobby of the gallery and was dressed "as an 80s loser" – dotted leggings with white runners and a yellow sweatshirt that she had specially made with a wolf print surrounded by jewels. She played 1980s music on a beat box and had a small stand displaying tacky roach clips with feathers. She had business-sized cards printed that stated "welcome," with the image of a buck deer on one side and a picture of an Aboriginal "buck" man on the other. As passersby walked by, she would say hello and try to hand them a card. Of the dozens of people who walked by, few even acknowledged her. Why?

Was it because she looked like a chubby Indian woman, apparently selling trinkets? Were they too focused on getting into the gallery to see the scheduled performance art, which was her? Or did they not want to "deal" with an Aboriginal woman? Or, simply, did they all just simply not notice her? After an hour in the lobby, Reece cranked up the beat box and walked through the crowd to the other part of her performance upstairs, where a projection of the feature film *Home Stay* was about to play. As she gave a live commentary, the audience roared. Even those who had passed her by.

Reece works within traditional parameters of Northwest Coast art in interdisciplinary ways. I asked her what her idea of her art is. I tell this story of her performance because it means something that I do not fully understand, yet I understand the complexities of being an Aboriginal woman. What I do know is she is a Northwest Coast artist and had an idea to make art and to welcome people, and practically no one wanted to be welcomed. What does that mean? To view this performance and others, go to the Flickr homepage (http://www.flickr.com/) and enter "Skeena Reece" in the search bar.

The purpose of my art is to make people consider me – the most undesirable anti-hero having something of value to offer. Something you can't sell. Life experiences of the most benign nature brought into the context of the desired and the valued to share in contrast, to poke fun at the successful and the antithesis of beauty. I dunno … maybe I'm just doing art so I don't disappear altogether. They say you choose your family before you are born, your body even. If I chose this then I don't remember being so

**FIGURE 29.5** Skeena Reece, 2009. "Welcome Performance" during FUSE at the Vancouver Art Gallery. Skeena Reece's art practice engages complex themes, including the treatment of Aboriginal women in Canada, while also incorporating new media, Northwest Coast iconography, and mixed media, which combined challenge the very idea of what Northwest Coast art is. Courtesy of Skeena Reece.

damned funny. Humour, anti-hero, and trickery are prevalent themes, but sometimes just plain injustice is what's needed in any given show to force people into solidifying their beliefs or at least questioning them. Sacred clowning isn't something that all audiences deserve. Some of my audiences have been given nothing but shit, because they weren't being good, kind or respectful. Other audiences have waited patiently with love in their hearts and received the ancient wisdom taught to me and my father before him. Being a chubby brown Indian girl with no fashion sense was a choice – to

allow me to see. It allowed me to see their downcast gaze, the smile that left them, the disgust on their face, the pain they suffer when they see me. I see it everyday, but this time they saw me, see them. I saw them. I wanted them to be aware. I don't know how many people acknowledged their own behaviour after they knew I was the person they were rushing by ME to see. The medicine woman, the keeper of stories – the backwards shaman. Glances, gestures caught in my memory, caught in my spirit catcher to use later. I felt loneliness, I felt fear, I felt greed and I felt competitiveness and jealousy as I sat watching them walk by in haste to where? To what end? The end? It was funny to me watching them hurriedly – some of them went back and forth several times and I thought, "at least on their 2nd or 3rd pass they could look at me," but nope, it was almost an audible and deliberate slight just for me. That's when I realized that they wanted me to see. Maybe wanted to see me all of their life. Maybe that's what Indians do for them now. We are here so that they don't disappear altogether.

**29.II. Ahasiw Maskegon-Iskwew. 2005. "Drumbeats to Drumbytes: The Emergence of Networked Indigenous Art Practice."** Editorial Addendum, *ConunDrum Online* 1, http://www.conundrumonline.org/Issue_1/home.htm.

Ahasiw Maskegon-Iskwew (Cree-French Métis) (1958-2006) was born in McLennan, Alberta, and graduated in performance art and installation from Emily Carr College of Art and Design in 1985. He was director, exhibition and performance coordinator, and board member at the Pitt Gallery in Vancouver (1988-90). He participated in the Equity Internship Program at the Canada Council for the Arts in Ottawa, where he received training in the media arts and visual arts sections, and the Art Bank (1992-94). Residencies during the internship included the Saskatchewan Indian Federated College, the Circle Vision Arts Corporation in Regina, and the Aboriginal Film and Video Art Alliance at the Banff Centre for the Arts.

Maskegon-Iskwew was program coordinator, acting executive director, and assistant editor of the *Talking Stick First Nations Arts Magazine* for the Circle Vision Arts Corporation, and he was production manager for the SOIL Digital Media Production Suite at Neutral Ground Artist-Run Centre (1996-98). He also worked as the Web editor for the Aboriginal Peoples Television Network (2000-4).

He had articles in the anthologies *The Multiple and Mutable Subject*, edited by Vera Lamecha and Reva Stone (2001), and *Caught in the Act: An Anthology of Performance Art by Canadian Women*, edited by Tanya Mars and Johanna Householder (2004). He was editor of the online Aboriginal arts magazine

*ConunDrum*, which premiered in July 2005, produced by the Urban Shaman Aboriginal Artist-Run Centre in Winnipeg, and he was a founding board member of the Aboriginal Curatorial Collective.

As a cyber theorist, Maskegon-Iskwew considered the Internet as a site of autonomy. His manifesto, an editorial addendum to the first issue of *ConunDrum*, suggested that the Internet offered Indigenous communities a space for potential liberty, a space to engage with Aboriginal communities from around the world, and a space in which the non-Aboriginal could learn about Aboriginal communities. Equally, it is a place for Aboriginal people to learn about each other and from one another. He further suggested that this space of digital freedom could act as a site for creative exploration, in which the technology became the art form, not just a space for uploading or downloading self but also a space to create self. See his online art project at http://www.snac.mb.ca/projects/spiderlanguage/.[3]

Indigenous digital artists around the world are deeply engaged with, and provide important contributions to interdisciplinary and cross-community dialogues about cultural self-determination. Their works explore and bear witness to the contemporary relevance of the histories of Indigenous oral cultures and profound connections to their widely varying lands. They also reveal the creative drive that is at the heart of Indigenous survival. The cultures of animist people require a continual sensitivity to, and negotiation with the cultures of all of the beings and forces of their interconnected worlds. The ancient process of successfully adapting to their worlds' shifting threats and opportunities – innovating the application of best practices to suite complex and shifting flows – from a position of equality and autonomy within them, is the macro and micro cosmos of contemporary Indigenous cultures: a truly networked way of being.

**29.III. Ahasiw Maskegon-Iskwew. 2005. "Drumbeats to Drumbytes: Globalizing Networked Aboriginal Art."** In *Transference, Tradition, Technology: Native New Media Exploring Visual and Digital Culture*. Edited by Melanie Townsend, Dana Claxton, Steve Loft, Walter Phillips Gallery, Indigenous Media Arts Group, and Art Gallery of Hamilton. Banff, AB: Walter Phillips Gallery Editions, 190.

The development of digital networks and new media production has been accompanied by the sometimes controversial, divisive and often globalizing dominance of contemporary culture. But their openness and flexibility has also encouraged autonomous spaces and recognition for self-determined, culturally distinct and diverse sources of creativity, exchange and community building. Indigenous artists and communities are

transforming these networks and digital spaces. They are participating – from a position of self-determined, collaborative reflection on their unique world views – in the international definition of a new set of cultural practices: those evolving within digital art and creative electronic networking. For some, this is the first time since contact and submergence within dominant, pre-existing European cultural practices that their voices and images are being heard, seen, respected and celebrated outside of their own communities. Significantly, it is also the return of creative cultural voices to communities that have experienced the incarceration, starvation or murder of their creative leaders. Networked art practice is becoming a crucial framework for the emerging recognition and empowerment of Indigenous cultures around the globe.

**29.IV. Victor Masayesva. 2000. "Indigenous Experimentalism."** In *Magnetic North.* Edited by Jenny Lion. Minneapolis: University of Minnesota Press, 232, 238.

Raised on Hotevilla on Third Mesa in Hopi, Victor Masayesva (b. 1951) graduated from Princeton University, majoring in literature and studying photography with Emmet Gowin. His work has been exhibited at the 1991 Whitney Museum Biennial, the New Museum in New York, the Museum of American Art in Washington, DC, the Museum of Modern Art in New York, the San Francisco Art Institute, and the Chicago Art Institute. His numerous awards include the American Film Institute's Maya Deren Award for distinguished contributions to film and television; fellowships from the Ford Foundation, the Rockefeller Foundation, and the Southwest Association on Indian Affairs; and honours from the Arizona Commission on the Arts and the Taos Pueblo. Masayesva has been guest artist and artist-in-residence at the School of the Art Institute of Chicago, Princeton University, and the Yellowstone Summer Film/Video Institute at Montana State University. His photographs and films represent the culture and traditions of Native Americans – particularly the Hopi of southwest Arizona.

It is particularly astounding when one considers, in these crowded times, the physical isolation of northern indigenous communities from one another and how they have conceived and adapted communicative devices such as radio, television and the internet. I recollect that the earliest use of the computer technology by indigenous people was by the Yupik Eskimo in the polar north, selling their arts and crafts on the internet.

We take it for granted today that modern technology has prompted a virtual community on the World Wide Web, but the radical position would be to acknowledge that northern people, in their vast landscapes, were among the first to experiment

with these Web links, creating virtual communities through communication technologies as a means for physical and cultural survival.

...

The indigenous aesthetic – like each unique tribal language – is not a profane practice, a basic human protocol, or merely a polite form of etiquette and transaction, but rather it is the language of intercession, through which we are heard by and commune with the Ancients. Indigenous culture – not popular culture – will continue to dominate the North American continent as the clearest manifestation of its soul. Indigenous iconography will influence future generations and will continue to be reinterpreted by artists yet to be born. Even as ghosts, the indigenous people of the Americas pervade and fill the continent's imaginative space, exactly like the winds that blow freely over national borders.

**29.V.  Mike Patterson. 2003. "First Nations in Cyberspace: Two Worlds and Tricksters Where the Forest Meets the Highway."** PhD diss., Carleton University, 249, 251, 253.

Mike Patterson (Métis, b. 1954) completed his studies in sociology at Carleton University in 2003. His dissertation focused on the meeting of two worlds: First Nations in cyberspace. He completed postdoctoral training at the School of Nursing, University of Ottawa, focusing on community health, research grantsmanship, and knowledge translation. Mike has worked with many First Nations elders, communities, and NGOs in fields as diverse as Native music, prophecies (Seventh Fire), HIV/AIDS prevention, injury prevention, and the syncretic weaving of Western and Aboriginal worldviews. He has been a host of Spirit Voice Native radio and was music editor for *Aboriginal VOICES* magazine. He developed the first graduate seminar in Aboriginal health at the School of Nursing, University of Ottawa. Currently, he is adjunct research professor at Carleton, working on a number of projects involving the development of Western/Indigenous wellness models; examination of the implications of telehealth for Aboriginal peoples; gaming and cyberspace; and Métis community health networks. Mike works primarily with qualitative and mixed methods, involving principles found in participatory action and community-based research.

Use of cyberspace should benefit the community by promoting awareness of Native values, helping to gain mainstream respect for spiritual practices and prophecies, and through assisting in the cultural, spiritual, and political process of self-determination. Throughout this country on reserves and in the cities the people still feel the extreme urgency and concern for cultural survival, for the preservation of languages and

teachings, and the restoration of health to the people. As much as this is happening in Akwesasne, it is happening in cyberspace.

...

Are we doomed to revisit the colonial experience in cyberspace? Yes, if access is denied to most of the Native community. No, if First Nations can make a leap forward into the digital world.

...

Cyberspace is rapidly becoming the central communication medium for Natives in remote communities, on the res, and in the cities. It remains to be seen how the people will fare in this new territory, but it is essential to find ways of providing access to IT, and the education to use it. As with the horse, Native peoples have to adopt this new technology, and move into this new space. It is another case of needing to adopt the White man's ways, while maintaining Native traditions – Two Worlds, and the Two-Row Wampum. As with the Seven Generations and Seventh Fire prophecies, pointing to the urgency of forging new relationships and understandings, these teachings are not new, they are finding a new home in cyberspace.

NOTES

1  The website http://www.firstvoices.ca presents information on the subject and language apps.
2  The Union of British Columbia Indian Chiefs website (http://www.ubcic.bc.ca/) provides links to these services for Aboriginal British Columbia.
3  Other links to the work of Maskegon-Iskwew include the following:

> http://ghostkeeper.gruntarchives.org
> http://tracearchive.ntu.ac.uk/Process/index.cfm?article=139
> http://www.snac.mb.ca/projects/spiderlanguage
> http://drumbytes.org
> http://www.stormspirits.ca
> http://www.conundrumonline.org
> http://cyberpowwow.net/CPW2K-bios.html
> http://www.aboriginalcuratorialcollective.org

# 30 | The Material and the Immaterial across Borders

The Northwest Coast is transected by international boundaries at the forty-ninth parallel and at the Alaska/British Columbia border. Native rights have different connotations in the Canadian and American parts of "the Northwest Coast," but in both countries they have been regulated according to the interests of the settler state, with little regard for the history or well-being of the Indigenous people so regulated. In both countries, the regulations have had an impact on cultural expression, whether material and immaterial, in ways tangible and intangible.

For the Coast Salish people in the state of Washington, at the southern reach of the Northwest Coast (Suttles 1990c), incompatible rights are permanently at issue, deeply affecting the ways in which Native people represent themselves and the ways in which others represent them (B.G. Miller 2003, 2007; Raibmon 2005; see also Miller, this volume; White, this volume). If there appears to be a disconnect between this situation and the presentation of Coast Salish art in recent exhibitions, it goes unmentioned in *Contemporary Coast Salish Art* (Brown et al. 2005), where the work is presented as art in an apparently uncomplicated way. The significant difference between this and some of the catalogues published during the 1950s and 1960s – discussed in Chapter 22, "Art for Whose Sake?" – is that the claims made for *Contemporary Coast Salish Art* were expressed by Vi Hilbert, who has earned the status of national treasure in the United States for her work in resuscitating the Lushootseed language. Hilbert's address opens the book:

> Thank you for inviting me to submit a few words to reflect the pride felt by one great, great grandmother. Pride that the Puget Sound Salish culture is also being recognized and included in the world of honored art. For many generations our historians have kept the quiet, elegant, spiritual knowledge of our culture alive through stories and epic legends. With an unwritten culture, our people have managed to persevere. Now our artists continue the responsibility through their gifted talents.

> Traditionally submitted by A Great, Great Grandmother, Upper Skagit
> Elder, Vi (taqwseblu) Hilbert. Thank you for listening. (Brown et al. 2005, n.p.)

Hilbert takes the view that visual art is now helping to fulfill the needs of social cohesion and its expression, needs that would have been differently met in an oral culture. The delivery of her remarks observes the formalities of an oral culture in a situation shaped and enabled by a commercial art gallery, the Stonington Gallery in Seattle. The interests of both artists and gallery, in this case and potentially in others, are advanced in ways that go beyond the usual artist-dealer relationship (see Duffek, this volume). Whether this is tokenism or marks a shift in power relations is continually debatable. In its publishing and other projects that reach beyond exhibition spaces, the Stonington Gallery bears comparison with Spirit Wrestler and Douglas Reynolds in Vancouver, all well-recognized galleries dealing in Native arts.

In Alaska, through the Alaska Native Claims Settlement Act of 1971, Native claims are asserted by being written into the "settlements" of different groups. This is a move that craves the attention of both Michel Foucault and Jacques Derrida, thinkers who, through their respective sustained scrutiny of power relations and the inscription of power into discourse, have in turn informed the work of Indigenous scholars such as Maori cultural historian Linda Tuhiwai Smith (1999) and Mohawk scholar Taiaiake Alfred (1999, 2005). The conflicted situation is illuminated as object specific by Tlingit historian Rosita Worl (2000) [30.I] and as situation specific in the writing of Tlingit artist Larry McNeil (2009) [30.III]. At the same time, the work of artists as different from one another as Art Wilson [27.V] (Figure 30.1), Brian Jungen, and Lebanese-Canadian artist Jayce Salloum in his video work *Terra (In)Cognita* (2005) disturbs and transcends the "traditional" borders of the Northwest Coast. If this is a liberation for some, there are others for whom the international boundary between Canada and the United States has only too real consequences for their ceremonial life (B.G. Miller 1996).

Smith's *Decolonizing Methodology: Research and Indigenous Peoples* (1999), along with Alfred's *Wasase: Indigenous Pathways of Action and Freedom* (2005), found an international audience with younger First Nations (but not only First Nations) scholars and students seeking solutions in ethnically defined difference and insider/outsider distinctions (Martin 2004; Claxton 2005). At the same time, as a number of the texts excerpted here show, it is clear that in working through the connection, or lack of it, between their own epistemologies and debates elsewhere (including virtual elsewheres) First Nations thinkers are inevitably implicated in wider debates over cultural representation and cultural

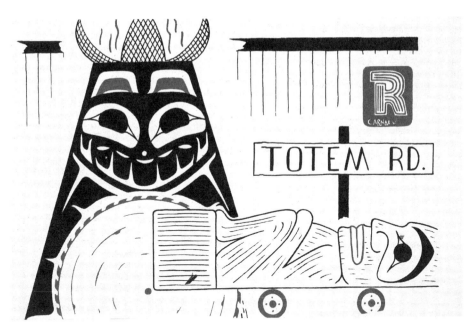

**FIGURE 30.1**  Wii Muk'willixw (Art Wilson), *Mockery,* 1996. Acrylic paint. From Art Wilson, *Heartbeat of the Earth: A First Nations Artist Records Injustice and Resistance* (Gabriola Island, BC: New Society Publishers, 1996), 36. Courtesy of Art Wilson.

ownership (Barthes 1991; Bhabha 1994; Deleuze 1994; S. Hall 1997; Zizek and Daly 2004). The language of the debates turns up in Yuxweluptun's acts of parodic repossession, such as *Shooting the Indian Act:* "Fundamentally my work is about colonial deconstruction and Aboriginal reconstruction" (Yuxweluptun, Townsend-Gault, and Watson 1995, 5) [27.II]. Haida Nation leaders Miles Richardson [27.XXIII] and Guujaaw [27.XXIV] extend the terms of critical social analysis, and show their limitations, by integrating them with Haida terms. This disjuncture appears again when Ḵi-ḵe-in submits the published literature on Nuu-chah-nulth culture to an analysis that seeks to answer the question "art for whose sake?"

If the cumulative effect of this literature, and of these transcultural efforts, is to show that Indigenous art as a distinct category has been "made" by the colonial encounter, it also demonstrates that the coherence that Indigenous art once appeared to have (Goldwater 1986; Hiller 1991; Flam 2003) is illusory.

In what is perhaps a linked response to monolithic classifications, postcolonial theorists have blurred the distinctions between their own fields – cultural anthropology, social art history, cultural studies – hence "postdisciplinarity." Equally, the designation "Northwest Coast Native art" is losing its monolithic status, succumbing to the critique that it has always been an anthropological

designation or propped up by the efforts of non-Natives or the lure of the market. Don Yeomans is one of the artists to speak most clearly about this [30.v]. "Northwest Coast Native art" has been disintegrating, in that it has fragmented and diversified, partly as a consequence of postcolonial critiques, over the past fifteen years. The term "Northwest Coast art" may persist, but most First Nations people, including artists, identify themselves by their own band or nation, not as "Northwest Coast." This essentializing identification is always in tension with the transcultural exchanges and entanglements that have been going on since the first exchanges with newcomers (Thomas 1994; Wright 2001). Nevertheless, on the Northwest Coast, Indigenous art – however variously the designation has been constituted – has become a formidable tool in sovereignty struggles.

The struggle is enhanced by the kinds of powerful, electronically captured images that can be transmitted globally, instantly (see Claxton, this volume). They can hardly be excluded from an account of recent public discourse about First Nations cultural expression. That these double objects, images of images, carry a power accords with old ideas about the transmission of powers through intangible means, but making them visible, displaying them, helps to make them incontrovertible. Ḳi-ḳe-in (this volume) shows how this has always been the case for Nuu-chah-nulth ceremonial screens, to give just one example. Archetypal crest imagery on robes, poles, or headdresses is itself linked to personal and group rights integral to the ceremonial and status hierarchies and social distinctions of Indigenous societies on the coast.

First Nations often claim that form is inseparable from social or ceremonial function. *Robes of Power: Totem Poles on Cloth* (Jensen and Sargent 1986a), which, significantly, does not have the word *art* in its title, opens with a photograph of Louisa Assu and Agnes Alfred walking toward the Kwagiulth Museum at Cape Mudge. The crests on the robes that billow out behind them are displayed to shimmering advantage (Figure 30.2). In a widely reproduced photograph, Ada Yavonavitch, a Haida elder, wearing her crest-bearing button blanket, her "robe of power," blocks access to the forest – exercising her rights – at a blockade against logging on Meares Island, Haida Gwaii. This action inspired Bill Reid to hold back delivery of *The Spirit of Haida Gwaii* (1991) to the site in Washington where it was destined to lend prestige to the Canadian presence in the US capital.

The prominence of the crests in such photographic images is another part of the backstory. The Indian Act suppressed them or tried to. During the drawn-out proceedings of *Delgamuukw v. The Queen*, the culmination of more than a hundred years of claims from the Gitksan-Wet'suwet'en, three individuals held

**FIGURE 30.2** "Louisa Assu and Agnes Alfred at the Kwagiulth Museum, Cape Mudge," 1986. Photographer Alexis Seto Macdonald shows Louisa Assu and Agnes Alfred wearing their button blankets while walking at the Kwagiulth Museum in Cape Mudge. From Doreen Jensen and Polly Sargent, eds., *Robes of Power: Totem Poles on Cloth* (Vancouver: UBC Press, in association with the UBC Museum of Anthropology), Figure 2, n. p. Reproduced with permission.

the name of Delgamuukw. Photographs of the third Delgamuukw in the early 1990s, by then an elderly man, show him impressive in his robe beside the crest-bearing pole that makes the claim better than any words could (Cassidy 1992). In Juneau, Alaska Celebration, a three-day biannual gathering of Native people from across the state and beyond, is an event marked by the re-emergence and public assertion of rights and obligations expressed in the display of crests in many forms. Celebration also marks another rights-based process, another "regime of validation," with the potential to rework the relationship between "rights" and aesthetics. In the first decade of the twenty-first century, works in radically different formats are being made – from painting to digital works – and the very flexibility that the formats allow is taken by many as proof of and justification for confidence in the "Aboriginal reconstruction" to which Yuxweluptun refers.

Yet the very efficacy of such display also serves to confirm what First Nations have always pointed out: emphasis on the visual excludes other important ways of expressing cultural value. Nor should everything "about" a culture be "shown." Cultural displays involving robes, masks, or poles may be status-affirming occasions for social elites, vital in hierarchical societies. They may equally be ways of deflecting attention from restricted or sacred knowledge and practices. Most cultures have such separations and restrictions. Colonialism disrupted or exposed or redirected Indigenous ones. The curators of *S'abadeb. The Gifts: Pacific Coast Salish Art and Artists* at the Seattle Art Museum in 2008 found a way to draw attention to values and intangibles that either could not or should not be shown but that were equal to the values attached to the visible, material objects on display (see Ḳi-ḳe-in, Chapter 22, this volume). Empty but well-lit pedestals dotted the exhibition spaces. The labels explained the absence. One read thus: "Our great chief, Chief Seattle, said: 'There is no death; only a change of worlds.' That's what we believe and that is why we feed, nourish and clothe our ancestors through the agency of fire." Another stated this: "There was always the sound of children – talking softly while picking berries, afraid the Bear People might come; playing a hoop game at the water's edge. Then they were stolen from our embrace and it was quiet."

In Indigenous art, and the discussions about it during the first decade of the twenty-first century, there has been a productive tension between maintaining ways of interacting with, and valuing, objects, images, and modes of expression that have long been powerful for one set of reasons and the need for them to be powerful for new reasons as well. Robert Davidson's "abstract" paintings articulate this tension formally, visually. It is also present in his insistence on the importance of ceremony, evidently a renewable resource for the Haida, as the proper context for the masks, robes, and drums that are also in his repertoire. His drums are interesting. Stretched hide, stretched canvas, what is the difference as a painting surface? He allows them to resonate in ceremony and in art gallery [27.XXII]. Beau Dick's masks were installed at the Contemporary Art Gallery in Vancouver, in 2004, in such a way as to draw attention, unapologetically, to their status as contemporary art (Figure 30.3). The exhibition, curated by Roy Arden, was titled, also unapologetically, *Supernatural*. The time-sanctioned style of bentwood boxes, used for holding cultural valuables, was put to unprecedented use when new boxes were made for the reburial of repatriated Haida ancestral bones on their return from the Field Museum in Chicago, as shown in the film *Stolen Spirits of Haida Gwaii* (McMahon 2004). In Marianne Nicolson's work, Kwakwaka'wakw button robes, crest-bearing tunics, and representations of supernatural beings are formed in new ways, displayed in new venues, using

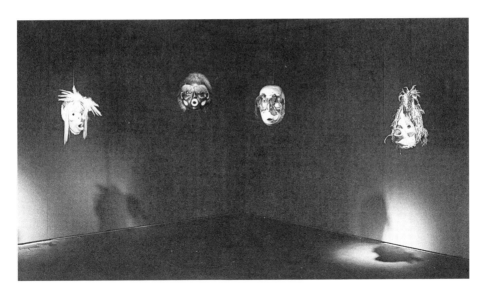

**FIGURE 30.3** Beau Dick, *Masks,* 2004. Installation view of *Supernatural,* curated by Roy Arden at the Contemporary Art Gallery, Vancouver. This image shows Beau Dick's installation at *Supernatural,* an exhibition that joined artists with dissimilar backgrounds to show the similarities among artists working in the contemporary sphere. Courtesy of the Contemporary Art Gallery.

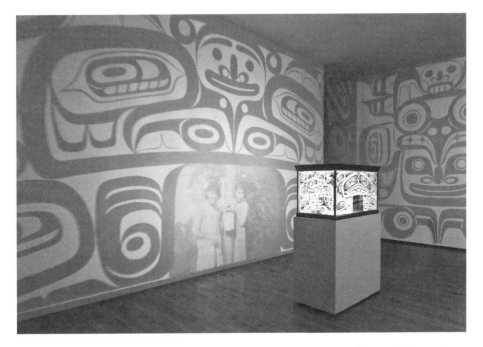

**FIGURE 30.4** Marianne Nicolson, *Baxwana'tsi: The Container for Souls,* 2006. Engraved glass, cedar, light fixtures, 54.4 x 51.0 x 103.0 cm. Nicolson's bent box made of glass envelops viewers in its projection of shadows and invites them to reflect on and honour the images of Nicolson's own ancestors being shown. Collection of the Vancouver Art Gallery, purchased with funds donated by the Audain Foundation; photo: Rachel Topham, Vancouver Art Gallery.

new technologies, but for enduring purposes. *Baxwina'tsi* (2005) and *Tunics of the Changing Tide* (2007) are examples. Kwakwa̲ka'wakw spatial concepts and concepts of value were integral to the display modes of her solo exhibition *The Return of Abundance* at the Art Gallery of Greater Victoria in 2007-8 [27.XXVIII]. The same tension provides the subtext for the exchange between three Haida artists – Robert Davidson, Don Yeomans, and Michael Nicoll Yahgulanaas – and Daina Augaitis, chief curator at the Vancouver Art Gallery, in the catalogue for *Raven Travelling* (2006).

Discomfort with, if not actual hostility toward, the views and values of the non-Native has been a divisive factor in the period. It defines the period as much as the various forms of accommodation and syncretism that have also emerged, such as First Nations' cooperation with the Vancouver Opera Company on its production of *The Magic Flute* (2006) (Figure 30.5) and projects devised collaboratively between the "Four Host First Nations" and the Vancouver Organizing Committee for the 2010 Olympic Games. This volume shows how such views and values have contributed to making both the "Northwest Coast" and Northwest Coast Native "art" the discursively "entangled objects" that they are. Influential assertions – by Franz Boas for "primitive art," by Claude Lévi-Strauss for Northwest Coast art as universalist, by Bill Reid for the wider reach of "classical Haida art" – have been enthusiastically taken up and are now inseparable from the promotional narrative. However, such claims are drawn on recursively by First Nations, as Aaron Glass (2006b) has shown in his study of the historiography of the Kwakwa̲ka'wakw Hamatsa and as Marianne Nicolson demonstrates in her discussion in this volume of the agency of the "observed" in shaping the accounts of ethnographically inclined "observers." The sorts of value famously found by the Surrealists in the art of Arctic and Northwest Coast peoples (see Mauzé, this volume) are, under a different regime of validation, in a sense, false claims. In the words of Musqueam weaver Debra Sparrow, "it is not art as you know it, but a way of life as we know it" (personal communication), or, it might be added, a struggle over rights as we know them [27.XI]. In Yahgulanaas's work *Coppers from the Hood* (2007), the "coppers" are made from copper-shaped, welded car hoods, a jokey gesture at the fine line between the signifier of one kind of value and the signifier of another. The work, part of *Meddling in the Museum*, Yahgulanaas's commissioned response to a transitional moment at the Museum of Anthropology, is sited in the Musqueam neighbourhood, positioned opposite the bronze plaques with declarations from federal and provincial governments commemorating the museum's opening in 1976. "I was struck by the governments' claims. It didn't appear that anybody was

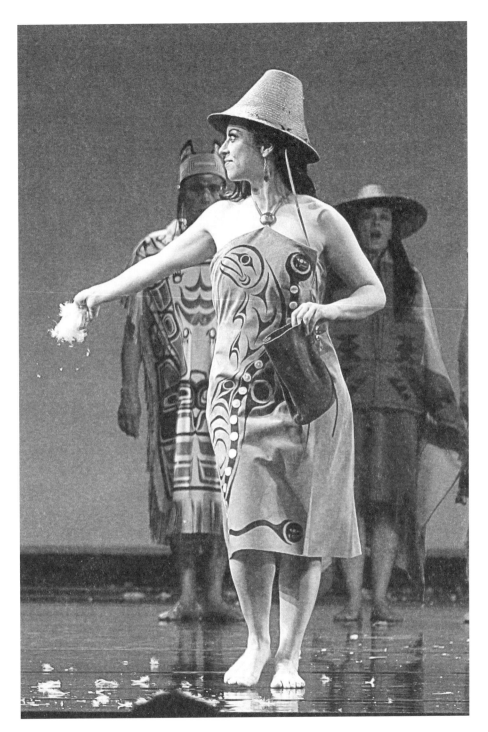

**FIGURE 30.5** Debra Sparrow created the applied image for Pamina's costume shown here in the last act of the Vancouver Opera Company's production of *The Magic Flute*, 2007. Courtesy of Debra Sparrow and the Vancouver Opera Company.

**FIGURE 30.6** Stan Douglas, *Nu·tka·*, 1996. A still from the twenty-minute video installation *Nu·tka·*. Two cameras survey Friendly Cove (so named by Captain James Cook in 1778) in Nuu-chah-nulth territory on the west coast of Vancouver Island, deliberately excluding the Native village of Yuquot. The sound-track combines Douglas's reconstruction of the troubled musings of Esteban José Martinez and James Colnett, captains of Spanish and English vessels, when, in 1778, their countries were virtually at war over the ownership of western North America. Collection of the National Gallery of Canada. Courtesy of Stan Douglas Studio.

reading them as proprietary claims to this place," Yahgulanaas says of his aim to correct this reading. The "real claim to this territory" comes from the Musqueam.

The tension created as distinct regimes of validation ricochet off each other can be measured in the responses of sympathetic observers, acutely aware of the contradictions of a situation in which they are implicated themselves — "the predicament of culture" famously labelled by James Clifford (1988b) and analyzed, in different terms, for different places, by art historian Hal Foster (1999). This dynamic of reception has formed the subject of works by several members of the so-called Vancouver School: Ken Lum's *Mohamed and the Totems* (1991), Stan Douglas's *Nu·tka·* (1996) (Figure 30.6), and Jeff Wall's *Hotels, Carrall Street* (2007) (Figure 30.7). These works variously interrogate a discursive construction of the Native that has always been relational, transcultural. In *Nu·tka·*, a large-scale video projection, and *Nootka Sound* (1996), a sequence of still photographs, Douglas has found ways to picture the Native as the always absent

**FIGURE 30.7** Jeff Wall, *Hotels, Carrall Street,* 2007. Transparency in lightbox, 248.9 x 312.4 x 26.7 cm. One of several of Wall's works – *The Storyteller* (1986) is another – bringing attention to the ways in which signs of the Native are imbricated in the life of the city of Vancouver. Here, Native history in Canada has been condensed into street art motifs, arguably sentimental, insignificant, and over-whelmed by changes to the urban fabric. But it is precisely their presence that enlivens Wall's picturing of the city's own banality. Collection of White Cube Gallery, courtesy of Jeff Wall.

presence in the accounts left by British and Spanish explorers of their sojourns on the coast (see Ḳi-ḳe-in, Chapters 2 and 22, this volume). It is not irrelevant that these internationally acclaimed pieces carry the "public secret" of the un-ceded Northwest Coast into exhibitionary spaces and markets worldwide (Taussig 1999). At the same time, the historical public "invisibility" of Natives where they live, whether on ancestral lands or in cities or both (the subject of subtle and outraged work by Rebecca Belmore and Dana Claxton, Indigenous artists based in Vancouver, and of the often hilariously enraged work of Skeena Reece), is shown up as the catastrophic lie that it has always been (see Claxton, this volume). Yet, even where mediated by First Nations curators, when work is made publicly accessible, the response, sympathetic or otherwise, cannot readily be controlled. An audience is implicated in the cultural and political economy of its moment. The discourse is historically entangled even as essentializing claims work to disentangle it (see Smith, this volume).

Some artists knowingly insert their work into the discussion of epistemological difference. Eric Robertson, for example, said of the process that led to *Shaking the Crown Bone* (2000) (Figure 27.3) that

> I began thinking about the common links between the coastal nations represented in the museum. Lahal, or the "bone game," came to mind, not just for the obvious reason that it winds throughout the coast and beyond, but because it relies on non-verbal communication and brings people together socially. Language, territory and status can limit communication and alienate shared realities. For me, Lahal also symbolizes a connection to time immemorial, a consciousness oblivious to the chaos of colonization. (Museum of Anthropology text panel)

An emphasis on orally transmitted knowledge must also imply knowledge that cannot or should not be transmitted orally – unspoken communication and restricted knowledges. Claims made by Native artists about their work, or claims made about the exactitude of this knowledge of places, objects, and ideas by Native commentators, acquire their authority from spaces inaccessible to the non-Native. By way of counterpoint to postmodernism's engulfing relativism, noted by Nika Collison (2004), a challenge, often a block, confronts the assumption of rights to free enquiry derived from the values of the European Enlightenment. This is not to say that a particular moment in Europe's history can claim a global monopoly of enlightened values or that European values have not often been perverted. The dispute between some members of the Haida Nation and Robert Bringhurst, the poet and translator of Haida texts, attests to this (Rigaud 2002) [23.xiv]. By way of response, increased reflexivity is evident in much recent non-Native writing contending with such warnings, which updates anxieties around appropriation prevalent in the 1990s and is alert to the importance of what Robertson calls "non-verbal communication."

In her exploration of the ways in which a spoken language – Kwakwala – and Kwakwa̱ka̱'wakw visual language might be related, Nicolson works as both linguist and artist to overcome what may be a limiting distinction. Over many years, the work of Nora Marks Dauenhauer and Richard Dauenhauer (1987, 1990, 1994) has brought Tlingit language texts in translation to a wider public. In a collaboratively produced text, "Spoken Literature: Stó:lō Oral Narratives," M. Theresa Carlson (1997) discusses some of the ways, less well known than displays of objects in art galleries, that cosmologies are manifest. Crisca Bierwert (1999), in *Brushed by Cedar, Living by the River: Coast Salish Figures of Power*, carries this further by showing how "figures of power" make specific claims

about a culture's values that the term "art" cannot encompass. Bierwert's book is itself an implied correction of the overemphasis on the tangible/material (see Sewid-Smith, this volume). This could also be said of Julie Cruikshank's (2005) extended work on oral tradition and methodologies of translation, which, although it does not directly concern what is typically thought of as the Northwest Coast, has had a significant impact on its discourses. In *Do Glaciers Listen? Local Knowledge, Colonial Encounters and Social Imagination*, Cruikshank finds ways to write about the intangibles of Indigenous belief systems, the incompatibilities between the very different methods humans devise to explain the workings of their world, and the places to look for their memory traces when entire cosmologies are at risk of being lost in translation, or simply lost. Cruikshank convinces the non-Native reader not just that Indigenous belief systems can be profoundly different but also that they are profound. It would be wrong, however, to imply that the importance of restricted knowledge was not understood in relationships between Native and non-Native at an earlier moment, closer to 1951, when the prohibition of the potlatch and other ceremonies was dropped from the Indian Act. Among the anthropologists alert to the connections between the potency of cultural property/art and the need to protect it were Wilson Duff, Marjorie M. Halpin, and Michael Kew (see Kramer, this volume). Their precedents, and the cautions of their informants, are developed in the recent work of Susan Roy (2002), Ronald William Hawker (2003), Leslie Dawn (2006), and Jennifer Kramer (2006). All acknowledge the need to protect aspects of a culture and the parallel need to disclose or make them manifest in some way to enhance the culture's power and status externally.

Given the defining connection between contemporary cultures and the specifics of their histories and localities, no matter where their members might actually be, how are their expressions to be thought about in relation to a "Western," and an increasingly "global," high art? A tension between autonomous and culturally implicated art marked twentieth-century Euro-American art debates and those about Indigenous cultural production. The situation has long been cast in terms of a conflict between art history and anthropology. This binary now seems exhausted. It is no longer a matter of setting works of art "in context" – both art and context have evaporated to the point where Native "science" may be more rewarding than Native "art" as a route to understanding cultural difference (Cruikshank 2005).

The texts excerpted here show that, increasingly across North America, Native artists and intellectuals are identifying aesthetic, cosmological, or other cultural frameworks that are specifically, essentially, Indigenous and in some sense resistant to global forces (Doxtator 1992; McMaster 1998, 1999; Xwelixweltel

2001; Martin 2004; Rickard 2005; Claxton et al. 2005; Mithlo 2006; Wasden 2006; Askren 2008). The reasons for making, owning, showing, or using are based on rights to do so. In a profound sense, this would seem to conflict with the "freedom" of exploratory or innovative or radical criteria that validate contemporary avant-garde art production (Burger 1984; Foster 1996). However, the art world's regimes of validation are themselves no simple matter and are hardly beyond the reach of socio-political and -economic forces (Myers 2001b; Stallabrass 2004). Rights-based assertions of the purposes and agency of "art" link to assertions about the role and purpose of artworks (Gell 1998; Lazarus 1999; Pinney and Thomas 2001; Yudice 2003). Expressive and visual culture can be turned readily into objectifications of national identity (Smith, this volume), although "identity" scarcely exhausts the work's power and reach.

Artists' strategies may be culturally "entangled" even as they claim space for cultural specificity in a multicultural setting. Yahgulanaas does nothing to hide this. The work of Tanis S'eiltin (Tlingit), expressing the painful predicament resulting from the US regulation of Native people by blood quantum, connects to very different work by elders that brings attention to rights-based issues that affect them all. S'eiltin combines modes of expression that draw on the work of artists such as Eva Hesse and Louise Bourgeois, who have no ostensible connection with her Tlingit heritage, as well as on the work of those who do.

Response and analysis have vacillated between social constructionism and aesthetics (Ingold 1996). This means that there is a permanent hyperactive alertness to whether the artist is empowered or restricted, in public or private, by his or her position within a particular culture. However, recurring themes such as technological change, or culturally specific processes and materials, are all subsumed within the rights-based account and its regime of validation. In the early years of the twenty-first century, it has appeared that First Nations art has its own, rights-based, autonomy. Don Yeoman's long-running inclination to combine the dense sinuosities of Haida form with recursive Celtic design, and his reasons for doing so, resonate here, as does Yahgulanaas's self-licence to range freely around manga style. Both adhere absolutely to the ongoing process of defining and defending an essential Haida uniqueness [30.v; 27.xix].

The critical overturning of previously held values and ways of doing things defined modernism. In using art to make or substantiate their own critical claims, First Nations artists avail themselves of the permission, provided by modernism, to detach themselves from the past and make their own way. At the same time, it is claimed that "art" provides an exemplary way of identifying past values to be preserved and perpetuated. Native modernism is a schizoid thing that never deserved the "postmodern" label and is beginning to receive the attention

it deserves (Rushing 1995; Ostrowitz 1999; Townsend-Gault 2006; Anthes 2006; Mithlo 2006). Like all modern art, it claims its own validity.

As already noted, contemporary Aboriginal art in Australia and Maori art in Aotearoa/New Zealand have been more widely disseminated and discussed through popular media, academic studies, and international exhibitions than Indigenous art from North America (Morphy 1991; Attwood 1994; Thomas and Losche 1999; Myers 2002; Reading and Wyatt 2006). *Manawa* is a Maori word meaning "heartbeat." In 2006, it was the title of a cross-cultural exhibition at Vancouver's Spirit Wrestler Gallery, one in a series of exchanges between Maori and Northwest Coast artists organized by the gallery. It claimed to "highlight the importance of cross-cultural projects and argues that cultural fusion has become the single greatest influence on the evolution of aboriginal art and culture worldwide" (Reading and Wyatt 2006). The Northwest Coast has long been a destination for collectors. It is now, increasingly, a launching pad for the collected. If the worldwide diaspora of Native "art" from the region was followed by a decade-long standstill equivalent to its exclusion from anthropology (see Campbell, this volume), British artist Damien Hirst's recent acquisition of a number of contemporary Haida poles for his personal collection may signal the re-entry of a fairly fixed indigenism into the globalized diaspora of ideas about "art" and about how its "value" is marked financially (see Duffek, this volume). The transcultural fortunes of the region are becoming less insulated than the extensive but still regionally focused literature might suggest.

In British Columbia, the Native as tourist attraction is as old as the totem pole, which is to say that the start date of both is hard to pin down (Jonaitis and Glass 2010). The double-think involved in making the Native the centrepiece of the nation, evident in the installation of *The Spirit of Haida Gwaii* in the Canadian Embassy in Washington, has been refocused with the appearance of the Canadian twenty-dollar bill, showing four works by Bill Reid, in 2000 (Bhabha 1990; Tully 1995). The deployment of First Nations motifs in connection with the 2010 Olympics and other national or transnational heritage or identity projects seems to many to be part of an inevitable collusion of interests in a globalized image economy, protectionist tendencies notwithstanding (Ostrowitz 2009). The disjuncture between the colourful, positive, and highly selective displays of Native art at Vancouver International Airport, or the totem poles in Stanley Park (with three and a half million visitors annually, British Columbia's most-visited tourist venue), and the now widely recognized predicament of life on inadequate reserve land or the extreme difficulties faced by the BC Treaty Process, lead to disquiet about public hypocrisy. Both display and hypocrisy are of long duration (Nuytten 1982; Stanley 1998; Hawker 2003; Dawn 2006), and

comparable situations elsewhere are the subject of Morphy (1991), Price (2001), Taussig (1999), and Povinelli (2002). These and many other instances show that disquiet is increasingly transdisciplinary and transcultural (see, e.g., Bell and Paterson 2009).

Despite the apparent disconnect between spectacle and *realpolitik,* it is often the case that social, educational, economic, and personal projects linked to correcting the (mis)interpretation of histories will be marked with some device that perpetuates "Northwest Coast style": button robes (Jensen and Sargent 1986a), crotcheted doilies (Jonaitis 1991), business cards (Townsend-Gault 2006), or T-shirts (Glass 2008). They generate discussion and argue values, intentions, motives, directions, and logoization. Among the consequences of the greater public visibility of objects and designs by Native people is that Nativeness may be identified through a repertoire of standardized visual cues and a continuously reiterated set of object types. Accordingly, it may be seen as failing, inauthentic. This is only so if, for whatever complex reasons, the claims of contemporary First Nations artists for the legitimacy of their practice are ignored. At the same time, the repertoire yields a vibrant supply of modes and motifs for reworking, re-appropriation, and post-ironic post-pastiche, taken up by Lawrence Paul Yuxweluptun, Brian Jungen (Figure 30.8), Cuauhtémoc Medina [27.XXIX], Larry McNeil [30.III], and Sonny Assu (Figure 30.9) [30.IV]. In an essay that prolongs the postcolonial critique that he has done much to shape, Homi K. Bhabha (Daftari 2006, 15) draws attention to the way in which Brian Jungen makes objects that embody the paradox:

> What is so interesting is how [Jungen] takes the totemic icons of contemporary so-called Western youth culture and reshapes them. He re-fabricates them, translates them, into things which do not simply represent, which are not the motifs of certain aboriginal totemic icons. They are something much more complex, because in the process of transformation, they are continually mobile and itinerant. They are works, which, even at the level of pattern or design, are continually restless and moving. He reconstitutes the Nike shoes in a kind of totem object of a different cultural milieu. But that mask or that totemic icon is also a reflection of the way in which the culture and authority of those aborigines is made consumable, both within the culture itself and for those outside. So it is not a discourse between two cultures at all. It is continually a discourse of two different kinds of cultural iconicity, opening up a whole third area, even a virtual area of representation, which questions or interrogates the larger question of object, culture, consumption and fetishization.

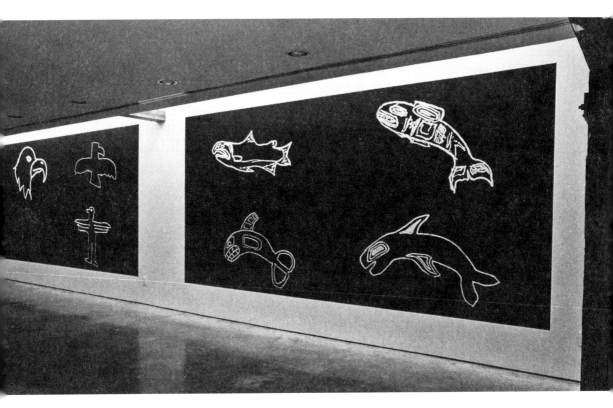

**FIGURE 30.8** Brian Jungen, *Field Work,* 1999. Latex paint, dimensions variable. Installation view at Charles H. Scott Gallery. The figures painted directly on the gallery walls in this installation were scaled-up versions of imagery collected during a street survey in response to the question "what is Indian art?" Courtesy of the artist and the Catriona Jeffries Gallery.

**FIGURE 30.9** Sonny Assu, *Coke Salish,* 2006. Duratrans and lightbox, 56 x 97 x 18 cm. In his work, Assu, a Coast Salish artist, shows the influence of popular culture on contemporary First Nations life, while expanding the accepted definition of First Nations art. Photo Chris Meier. Courtesy of Sonny Assu.

Jungen's strategies contend openly with one consequence of these positions in that his interest in, or capacity for, participating in the contemporary international art world – as distinct from keen participation in the international market for Indigenous art – is limited by commitments to a variety of locally specific, culturally mediated, urgencies (Medina 2005). For Jungen, and many others, these are often political urgencies. For many others, if not Jungen, it may also be that the urgency and local specificity of the claims reduce the translatability of their work elsewhere and may account for the glancing attention that Indigenous art still receives internationally (Mithlo 2006). Significantly, perhaps, aesthetics is re-emerging as a focus for transnational and transdisciplinary study – and it is a mode of enquiry that demands less prying. It may not be coincidental that, among contemporary art historians who try to integrate Indigenous with other strands of transnational art, David Summers (2003) has argued at length that the proper study of art history should be spatial relations rather than visual art.

The power claimed for Indigenous art turns on art's role, art's agency – as materialization of the immaterial; as legitimating evidence; as locus of cultural rights and responsibilities for artists and others; as sites of memory for First Nations people, wherever they live, concerning crests and ceremonial objects and images – and on the cultural significance of specific materials and processes. All of this is continuously reactivated on blogs that buzz with the younger (but not only younger) generations' exchanges over what it's all about; by the emergence of ever more learned or subtle accounts of the meanings of traditionally historically sanctioned knowledge; and by actions that guard against disclosure. Self-reflexive critique connects it with work made internationally that queries history and the construction of knowledge, interrogates dominant narratives, and scrutinizes dominant ways of picturing the world. Connection to a transnational avant-garde may lie here; the positioning of the work and the claims made for it represent an intervention into the apparatus of authentication. Central to the work is its insistence on its right to intervene. The works both participate in global flows of imagery and serve as markers of cultural distinction in a specific political space-time economy that may be working to block the flows. None of this is to say that it should carry Native art out of critical reach. Whose interests would that serve, after all?

**30.I.  Rosita Worl. 2000. "The Dakl'aweidi _Keet Naa S'aaxw:_ A Killerwhale Clan Hat."**

In _Celebration: Restoring Balance through Culture._ Edited by Susan W. Fair and Rosita Worl. Juneau: Sealaska Heritage Foundation, 113-14.

Rosita Worl (Yeidiklats'okw) (b. 1938) is Ch'aak' of the Shangukeidi Clan from the Kawdliyaayi Hit (House Lowered from the Sun) in Klukwan. She has a joint appointment serving as the president of Sealaska Heritage Foundation and assistant professor of anthropology at the University of Alaska Southeast. "Art," variously defined, has come to play a conspicuous role in the display of rights and the assertion of the legitimacy of claims. To the extent to which it can be said that the *Delgamuukw* decision, in a general way, represented a tendency on both sides of the Canada/US border, Worl here deploys the decision retroactively by correcting values ascribed to historical pieces.

*Celebration: Restoring Balance through Culture* (Fair and Worl 2000), published to mark the new millennium, included essays on Tlingit history, oratory, shamanism, ethics, and protocol, emphasizing continuity, and then moved to current issues such as religion and fisheries disputes. As Worl (2000, 25) wrote, in establishing the book's theme of "balance," "it represents a basic philosophical tenet of our [Tlingit] culture, and it draws attention to the disruption experienced by our people during the last millennium. More significantly, it offers hope and direction for the survival and enhancement of our culture and people."

In its careful attention to the history and materiality of one specific object, and, by implication, not to a class of objects, this piece bears comparison to Andrea Laforet's "Ellen Curley's Hat" (2000), Curley being a renowned Nuu-chah-nulth basket and hat weaver. The significance of the making and the wearing of woven hats, as explained by Isabel Rorick, Haida spruce-root hat and basket maker, was published as "Following the Discipline of the Old Masters: Isabel Rorick in Conversation with Jacqueline Gijssen," in which Rorick said that — "to see my work actually being worn for ceremonial uses and for dancing in the context of songs and oral histories — these are so important to the art, that brings me the greatest satisfaction in my work" (2006, 132). Rorick provided a woman's perspective in *Raven Travelling: Two Centuries of Haida Art* (Augaitis 2006), which, given the tendency to account carved wood as sculpture, and given the longer survival rate of wood than the perishable materials used in so many things made by women, was rather important. By adopting "art" as honorific and accolade, "Haida art" can hardly fail to adopt the male bias that many consider entrenched in Western art history. Feminist art historians Griselda Pollock and Roszika Parker (1981) queried the predilection for old masters in *Old Mistresses: Women, Art and Ideology*, and their lead could have been followed here, but it is not usual to find the critiques of Western art adopted along with the Western terms themselves. Crucially, Worl made it clear that, for the Tlingit, the hat is a clan hat first and could just as well be a male privilege.

Following the traditions of their Tlingit ancestors, the Eagle Dakl'aweidi of Klukwan, Alaska, who are known as the Killerwhale Clan, celebrated their Immortality. They memorialized their past leader, Judson Brown, who had died the previous year, and acknowledged the young men from his clan who would assume his role. Over three hundred people gathered on September 7, 1998 at the Alaska Native Brotherhood Hall in Haines, Alaska to witness and participate in the eighteen-hour ancient rite. They came from the coastal villages in Southeast Alaska, from the interior regions in Canada and from as far away as Washington, D.C. and Hawaii.

The Raven L'uknax.adi – the Coho Clan – presented the *Keet Naa S'aaxw* or Killerwhale Clan Hat to the Eagle Dakl'aweidi Clan in honor of Judson Brown who was grandfather to the Coho Clan. To ensure social and spiritual balance within the society, Tlingit members are placed in opposition to one another as members of the Eagle and Raven moieties. In accordance with their rigid cultural protocols, a renowned artist of the opposite clan or a Raven, in this instance, made the new Eagle clan hat.

The artist was Rick Beasley of the Raven Coho Clan and grandson of Judson Brown. He had graduated from the University of Washington and had apprenticed under foremost leading Tlingit traditional artists. Although his art is commissioned by non-Tlingit throughout the world and he is paid handsomely for his work, Beasley saw the clan hat he would make for his grandfather and his clan as far more than a work of arr. He utilized both traditional materials and artistic forms and drew from his cultural heritage for this masterpiece. At the crown of the hat, Beasley carved the sacred crest of the Dakl'aweidi, the Killerwhale. The hat was constructed from alder and in-laid with abalone from Northern California. It was painted with pigments from red iron oxide, black iron oxide, copper and carbonate which were then mixed with dog salmon eggs to bind the ingredients. A Tlingit Eagle from the Teikweidi Brown Bear Clan from the village of Angoon, who was equal in social status to that of Judson Brown, was chosen to donate his hair to adorn the clan hat.

The Killerwhale crest had been obtained by the ancestors of the present-day Eagle clan on their ancient northward coastal journey and during an encounter with the Killerwhale Spirit. It is a crest that is jealously guarded by the Dakl'aweidi clan. Significantly, the hat and crest also link clan members to the animal and spirit depicted on the clan hat and also to the site where the encounter between humans and the animals occurred. The clan hat is worn during ceremonies and is prominently displayed during memorial and funeral services of clan leaders. They are again ceremoniously presented when a new leader assumes the office of clan leader or caretaker.

The stories associated with the origin of the clan crest and the hat itself are retold by clan leaders or significant elders during a potlatch, thereby reaffirming and validating clan ownership and spiritual relationship to the being depicted on the hat. A

grandparent may ceremoniously put his own clan hat on a grandchild who is a member of another clan in order to show his love and elevate the social status of his grandchild.

The clan hat with its crest is a sacred object. It is a living being who must be addressed by clan members in the same manner as they would speak to another Tlingit. When a clan hat is brought out during a ceremony, a clan hat from an opposite clan must also be brought forward to ensure that social and spiritual harmony and the well-being of the Tlingit society are maintained. During the Killerwhale 1998 ceremony, the Eagle host clan distributed $32,000 to the Raven guests in memory of Judson Brown; to acknowledge the assumption of office by John Katzeek, who would serve as the succeeding leader; and to validate the ownership of the Killerwhale crest including the new clan hat which was carved with the Dakl'aweidi primary crest. The Eagles also gave wooden potlatch bowls, wool blankets, silver engraved bracelets and a variety of other goods and food equal to twice the value of the cash disbursement to their guests.

The Killerwhale Hat was ceremoniously placed on Chris McNeil, a Stanford and Yale educated lawyer, who would serve as the caretaker of the hat. Chris had been raised by his maternal uncle, Judson Brown to know both old and new ways. He was given the Tlingit name of his uncle, *Shaakakooni*, and reminded that he must fulfill his responsibilities to his clan members and oversee the care of his uncle's regalia for his clan. McNeil followed the bestowal of his uncle's name by dancing with the Killerwhale Hat, the new Dakl'aweidi *Keet Naa S'aaxw (Killerwhale Clan Hat)* made by Rick Beasley danced in joy and honor of Judson Brown and for future generations of Killerwhale Clan members. The hat will not be displayed as a work of art that others might see only in these terms. It will continue to be stored in safekeeping by its new caretaker, Chris McNeil, who will in the future once again ceremoniously bring the hat out. He and others will retell the great story of Judson Brown, celebrate the ancient history of the Killerwhale Clan as his ancestors have done for thousands of years before him, and reaffirm the spiritual ties that unite humans and animals.

**30.II. Karen Duffek. 2006. "Bridging Knowledge Communities at the UBC Museum of Anthropology."** Paper presented at the annual conference of the International Council of Museums' International Committee of University Museums and Collections (UMAC), New Roads for University Museums, Mexico City, 26-29 September. On the website of ICOM (International Committee of Museums), http://publicus.culture.hu-berlin.de/umac/2006.

Karen Duffek (b. 1956), who has published extensively on the Native art and artists of the Northwest Coast, is curator of art at the Museum of Anthropology, University of British Columbia. This text effectively summarized the efforts of one museum to respond to the macro-level critique that museums have been

subjected to as part of the postcolonial upheaval as well as to its own micro-level scrutiny by source communities over the ways in which its, or their, collections are held, displayed, and identified. Duffek's paper also suggested something of the work of memory, and collective recall, that happens when objects understood as family and community archives are being re-scrutinized and re-evaluated, in this case under the Museum of Anthropology's Renewal Project. In particular, this was an account of the work of the Kwakwaka'wakw-recognized cultural expert William Wasden, as he reframed the history of production, ownership, and display of one mask.

At the University of British Columbia Museum of Anthropology (MOA) in Vancouver, Canada, there is an extraordinary mask on display. Measuring over 2.6 metres long, it is known as a "Great Raven" named Walas Gwaxwiwe. The Museum bought this mask from a Vancouver arts-and-crafts shop in 1962. At that time, we knew that the mask represented a supernatural man-eating bird, and was used in the important Hamat'sa ceremonies of the Kwakwaka'wakw people of northern Vancouver Island. We also knew that this mask was probably made and danced during the years that Aboriginal potlatching and other ceremonial activities were declared illegal by Canadian federal law (1884-1951). But we knew little about the mask's specific history of ownership and use, and there was some confusion about the identity of the carver.

In 2006, more than four decades after MOA acquired the mask, it became the subject of research by a young Kwakwaka'wakw cultural historian, William Wasden, Jr. He was working with us in a training-internship jointly organized with the U'mista Cultural Society at his own community of Alert Bay, British Columbia. One of the projects assigned to him was to research the Great Raven mask and curate a small exhibit about it at MOA. Because of the Museum's lack of documentation on this artifact, William went home to Alert Bay to consult with knowledgeable elders there about the mask's history. He began with questions that were then of interest to the Museum: Who made the mask? When was it made?

Through Wasden's work with community members, the mask soon became re-contextualized within local cultural knowledge. This mask was no "fragment of history" from the point of view of the elders consulted. They still knew what inherited privileges the mask represents. They knew that although the mask itself is in the Museum's collection, the hereditary privileges connected to it are not located there. They knew that the right to use specific masks and their associated dances and songs are still owned by family members and kept alive through display in potlatch ceremonies – even when the original object has left the community. Wasden learned that the Great Raven mask was commissioned sometime around 1920 by the hereditary chief of the Kwikwasut'inuxw (one of eighteen existing Kwakwaka'wakw tribes),

John Scow (1872-1934), to display the privileges he had received as dowry from his high-ranking wife, Tlakwel. Wasden also learned that since the 1920s, several branches of the Scow family have exercised this right ceremonially – and in recent decades by using a newly made version of the mask – so that it will not be forgotten or fade away. [This information about the mask was included in the exhibition text Wasden wrote for *The History of "Walas Gwaxwiwe" – The Great Raven Hamsiwe,* an exhibition at the MOA in 2006.]

The elders' primary concern about the Great Raven mask was how its history, ownership, use, and sale would be respectfully represented within the community and publicly. Cultural protocols, memories, and genealogies became the methodological frameworks by which the community challenged the Museum's focus on the object. Indeed, it was the *privilege* of the Great Raven mask and how it was acquired by the Scow family, more than the physical mask itself, that brought forward a less object-centered research question – even as it helped to centre the object within Kwakwaka'wakw knowledge.

At the same time, the elders made clear their concerns about the need to strengthen understandings among their own people about the proper ceremonial use of such privileges today. They brought to the forefront the question of how a public museum can function as a kind of tool to support community-based initiatives for strengthening Indigenous knowledge and rights to self-representation, for urban as well as on-reserve populations. How, for instance, can community knowledge and cultural practices be appropriately shared with museums to ensure good documentation of the history of objects in the collections? "It is important to research the history of ownership and use of artifacts such as this one," wrote Wasden in his exhibit labels about the mask, "so that it can be recorded correctly and benefit those who are connected to these rights. For if the stories are not properly recorded, they may be lost forever." More than a matter of how museums can access community knowledge in order to improve their own records, therefore, the issue this project raised is how museum information systems and practices can support the very urgent needs of both urban and rural Aboriginal communities for access to their own heritage.

In this paper I will look at some ways in which the Museum of Anthropology is currently addressing the challenges of "un-masking" the prevailing museum frameworks in which objects are named and understood, of building relationships with cultural communities, and of building on those relationships to support respectful and mutually beneficial research. I will highlight a few aspects of a major renewal project that we have recently begun – a project that had its initial impetus in MOA's need to do something about the very limited storage space we have for collections and the lack of adequate research space for staff as well as visiting researchers, artists, and other community members. It is a project that has since moved from the need for

more room toward a much broader, more deeply transformative, and conceptually challenging idea that pulls at the strings binding museum to university, that tangles the definitions of researcher and community member, and that unravels dominant categories and ways of knowing to make room for multiple knowledge systems.

**30.III. Larry McNeil. 2009. *"Fly by Night Mythology:* An Indigenous Guide to White Man, or How to Stay Sane When the World Makes No Sense."** In *Alaska Native Reader.* Edited by Maria *Shaa Tláa* Williams. Durham, NC: Duke University Press, 272-74, 276, 277-78. Courtesy Larry McNeil, Professor.

Larry McNeil (b. 1955), a member of the Tlingit and Nisga'a Nations (from both the United States and Canada), is associate professor of photography at Boise State University in Idaho. In this text, he comments on a new series of prints incorporating language with digital photography. Some of his work was included in *Raven's Reprise* (Hill 2001) [27.XVII].

The title of this series of works is *fly by night mythology* because it is about Raven, or in 'Tlingit, *Yeil,* the trickster. It is fly by night because according to Tlingit mythology, Raven brought light to the world as part of the creation story. The series of art pieces is also about the intersection of cultures between the mainstream and Tlingit people. A lot of absurdities happen in that sometimes inane intersection, and if we can't laugh about it, we'll likely end up as one of the hapless characters we find along the way. I give full credit to our Elders for the spirit of the stories, because all of the work is inspired by them and their gentle, yet biting humor. Now they *knew* humor. They say that humor and tragedy go hand in hand, which is peculiar until you go through the fire of tragedy yourself and find yourself laughing for whatever reason. Humor heals. The Elders knew that crucial yet simple truth, but never actually came out and said it; instead, choosing to make you laugh, or at least chuckle a bit. In this sense, my work is very traditional and aspires to look at what is going on in our world and offers an interpretation that maybe makes a bit of sense in a sometimes-senseless place ...

> ... *after watching a*
> *bird and shadow*
> *dance on a very white*
> *wall, I was going to*
> *cross the street, but*
> *came to a "don't walk"*
> *sign.*
>
> *Finally, the red hand*
> *turned into the figure*

*of a white man walking.*
*Not wanting to offend*
*anyone, I did my best*
*imitation of a white*
*man walking, and*
*crossed the street.*

Journal Entry
Evolved into "fly don't walk" art piece.

The above was about what happens when an Indigenous person is set loose in the big city. The intellectuals like to talk about semiotics, or the study of signs or symbols. As a Tlingit and Nisga'a kid growing up in Juneau, our tribe of kids had our own semiotics that included teasing and making fun of anything and everything; nothing was sacred. Everything and everyone was fair game. Our creation story has *Yeil, or Raven* the trickster doing what kids do naturally; i.e. exploring shiny things, figuring out how things work, teasing people that really need it, overcoming difficult odds, and generally loving life as it presents itself each day, no matter how challenging. Laughing at the ironies that present themselves is a critical part of our identity, and in my opinion, a key reason why we are still here. Whenever I see a red *don't walk* traffic sign, I think of my own brown hand, yet when I see a *walk* sign, I think of White Man and how I actually did get in trouble as a kid for imitating a classmate's walk. I have come to believe that this holdover from being a tribal kid is still pretty lively in me and is really what my art and writing is all about. I tell my son T'naa that I'm the oldest kid in Idaho and he easily believes me, even at almost eleven.

...

What this is all leading to is that my name comes with the obligation to tease Christians until the land is either paid for or returned. In the finest Tlingit tradition, I continue the act of ridiculing – in this instance, our good friends the Christians ...

...

*Kincolith*
*Kincolith, the name of our village*
*translates to*
*place on the beach*
*where our enemy*
*skulls are planted.*

*It helped us live in peace*
*and an added bonus*
*was that we didn't have*

*many Jehovas witness types*
*ringing our doorbells.*
*It was a dark time in our history.*

*Anyone got any spare skulls*
*hanging around?*

*Kincolith killer whales love '59 Cadillacs for some reason*

One of my Nisga'a aunties told me the story of planting skulls on the beach to deter attacks from neighboring tribes (as she was fitting my father with a traditional robe for his potlatch ceremony initiating him as a Nisga'a chief). An uncle disputed the story, clearly a bit put off, but what the heck. I thought it was a great story and I'm sure there is a juicy marbling of truth running throughout the legend. When I first showed the piece to my father, I wasn't sure if he'd be offended and be disappointed in me, or find it a bit amusing. I hardly ever have any apprehension with the creative process, but this piece was the singular exception; although I must say that it just *felt right* while photographing the various parts and pulling it all together. I brought the piece to his house full of apprehension, not sure if I'd have to censor myself for the first time; not a healthy thought for an artist. He put on his reading glasses and quietly studied it for a couple of minutes and looked at me critically. Then he laughed out loud and pointed at one of the skulls and said that it looked like one of the people from the neighboring tribes and howled with laughter again. When he asked for a larger print to put in the center of his wall, I knew things were all right.

**30.IV.  Sonny Assu (Gwa'gwa'da'ka). 2006. Artist's Statement.** Courtesy of Sonny Assu.

Sonny Assu (Gwa'gwa'da'ka) (b. 1975) is a member of the Wei Wai Kai (Cape Mudge) band of the Laich-kwil-tach of the Kwakwaka'wakw Nation. His work was included in *Changing Hands: Art without Reservation 2* (2005), an extensive exhibition mounted by New York's Museum of Arts and Design (the former Craft Museum) that was devoted to correcting the "Western" art/craft hierarchy and in the process offered a chance to assess what might be lost when it was abandoned. His work was brought to public attention when *Enjoy Coast Salish Territory* was included in an exhibition, *As Defined within the Indian Act,* curated by Matthew Hills in 2006 for the Belkin Gallery Satellite in Vancouver. With other pieces that spoofed claims made for breakfast cereals by pitting them against claims made in a different register for First Nations values, *Enjoy Coast Salish Territory* captured the slightly overdue local recognition that Vancouver, where First Nations people lead "normal" lives, is on unceded First Nations territory. Editions of *Enjoy Coast Salish Territory* are now in the collection of the

Vancouver Art Gallery and the Museum of Anthropology. These paragraphs are the artist's preface and statement for the catalogue, which appeared on the reverse of a poster version of what became popularly known as "Coke Salish."

This is my artist statement that pretty much sums up what I was going for with the piece as part of a whole series of work. Coke-Salish is part of my urban totems series, and I see all the signage from businesses and adverts as totemic representation. I was really excited by the exhibition of Fred Hertzog's photographs at the Vancouver Art Gallery. He captured the hey-day of neon signage in Vancouver and it gave me a minor art-attack. I also wanted to bring awareness to the inherent rights of the First People, specifically in Vancouver, through this piece. *Enjoy Coast Salish Territory* was my tongue-in-cheek way of bringing political awareness about whose land this is. I figured that since Vancouver was going to be Olympic-sized, what better way to bring some awareness than through the realm of pop-advertising? Being thanked and paying respect to someone is of major importance to the First People (as I'm sure you are aware). This piece is my thank-you to the Coast Salish People for allowing me, an Urban Indian/Laich-kwil-tach person, to reside in their territory.

*Brand loyalty is the pop culture totem.*
From Coca-cola, to '80s pop culture, branding has become a way of life for many. How we associate ourselves with a particular brand speaks volumes to how we fit within society. For those immersed in the pop culture aesthetic, choosing a brand to represent oneself is to communicate one's personality to the world. It says, "I'm different, but I'm still just like you." In essence, it's choosing conformity to speak about individuality.

My current body of work, the Breakfast series, Personal Totem series and the Urban Totem series, examines how we use everyday consumer items and icons of pop culture to define our personal lineage. Furthermore, it posits how branding, brand loyalty and technology relate to the ideal of totemic representation.

I am a product of pop culture. I grew up in the age of mass media advertising and subliminal adverts. I related to the mythos of Saturday morning cartoons. I am able to combine my pop roots with my traditional Laich-kwil-tach heritage. I learned of my dual identity at the age of 8, and I began to explore and understand that identity at 21. In these past ten years I've been able to juxtapose these polarized cultures to speak about how we all choose icons and objects to define ourselves. By creating the Personal and Urban Totemic Representation imagery, which equally combines wry humour, social, economical, and environmental issues, I speak to the notion of conformity by not conforming to the commonly perceived Indian Identity.
(With thanks to Matthew Hills)

**30.V. Don Yeomans. 2006. "The Impulse to Create."** In *Raven Travelling: Two Centuries of Haida Art.* Edited by Daina Augaitis. Vancouver: Vancouver Art Gallery; Douglas and McIntyre, 160. © 2006 by the Vancouver Art Gallery, published by Douglas and McIntyre, an imprint of D&M Publishers Inc. Reprinted with permission from the publisher.

Don Yeomans (b. 1958) has long been more vocal than most Native artists about the uneasy frictions among the promotion of a culturally specific style, controls exerted by market demands, control of the market, artistic stagnation, and a racially mixed background. Of Haida and Scottish ancestry, Yeomans is known for melding Celtic strapwork with Haida formlines in his graphic work and for portraying animals that are not normally part of the Haida bestiary. In doing so, he delineates the awkwardness that accompanies the contemporary fascination with essentialized form and design. Yeomans refers to a Haida visual language in terms that Bill Reid and Robert Davidson have made familiar and that carry within them echoes of Owen Jones's *Grammar of Ornament* (1910) as well as the linguistic basis of structural analysis. The work of French structural anthropologist Claude Lévi-Strauss ([1958] 1963) turned on the analysis of the informing structure, or language, of a culture's mythology. His subsequent analysis of the mythic structures of the Northwest Coast cultures led to his influential insistence on the international stature of its historic forms and his advocacy of Reid's work. The notion of culturally specific "visual" language continues to be enormously influential and is being pursued intensively by Marianne Nicolson in her study of Kwakwala linguistic and visual connections. The following is taken from interviews between Daina Augaitis, chief curator at the Vancouver Art Gallery, and three artists who represented three different ways of thinking about contemporary Haida work and its relationship to the past: Robert Davidson, Michael Nicoll Yahgulanaas, and Don Yeomans.

> Don Yeomans: I can remember bringing work to the Vancouver Art Gallery twenty years ago and being told no, we don't handle that here. Our work was designated to tourist shops. Just because twenty years later they are featuring a show on Haida art doesn't mean that we are ready to throw open the doors and say everyone can do this. We are just in the caterpillar stages of where we are going.
>
> Daina Augaitis: Don, what do you believe have been the innovations in the development of Haida art?
>
> DY: A lot has happened but most of it has been sociological and economic. The golden age of Haida art ended when Bill Reid died. He was the vanguard; he was the example of contemporary mastery; he understood design and was proficient in every

medium and on every scale; he was the paradigm of my generation. We all sought to be good jewellers, wood carvers and masters of any technology. Because of the success of today's marketplace, many contemporary artists don't have to know all of that, they can pick up anything carve it small and make hundreds of thousands of dollars – it's great but you eventually hit a wall and begin to stagnate. You see it in carvers who copy other people's masks and don't understand how the design works – they get stuck. But today, they don't need to know it in order to make money. It's the age of specialization and that's part of the marketing around our art. When you erase the benchmarks for becoming a master, then everyone becomes a master and it's meaningless.

This has become largely a craft industry. Whether you paint, draw or carve, it comes from the mastery of a specific craft and this is what we have to strive for. If you have the mastery of the craft and understand the grammar you have the potential to create art. We are in a situation now where the market decides. I have made innovative work in the past but the fact is that the market just doesn't want what isn't traditional or part of your culture. There is a fine line between art and Native art. It comes down to what you are selling. Are you selling art or are you selling blood? If you are interested in blood then Haida art is very easy to define. Who has status? Where is your family from? But if you are interested in art like I am, then it doesn't matter who made it as long as the rules are obeyed and there is something to say about the world.

**30.VI. Paul Chaat Smith. 2007. "The Terrible Nearness of Distant Places: Making History at the National Museum of the American Indian."** In *Indigenous Experience Today.* Edited by Marisol de la Cadena and Orin Starn. Santa Fe: School of American Research, 382-83. Reprinted with permission of Berg Publishers, an imprint of A&C Black Publishers Ltd.

This text was originally presented as a paper during a Wenner-Gren Foundation International Symposium on Indigenous Experience Today. Paul Chaat Smith (b. 1954) is an incisive participant observer of, and widely published commentator on, this experience. With Robert Warrior, he co-authored a history of the American Indian Movement (AIM), *Like a Hurricane: The Indian Movement from Alcatraz to Wounded Knee* (1996). AIM is sometimes accounted a political failure, but Smith depicted, in this book and his other writings, a persistent and more complicated movement driven by chronic injustice and entangled in networks of miscommunication and misrepresentation. Smith, now a curator at the National Museum of the American Indian (NMAI), aims to carry the movement forward by working on Indigenous representations. This composite text is about what it was like to be one of the people responsible for the formulation and design of NMAI's opening exhibits. In its greatly enlarged new home, conspicuously

positioned on "Museum Mile" in Washington, DC, close to the Capitol build-
ing, with many millions of visitors every year, the opportunity for reconfiguring
the national narrative about the Indigenous populations of a continent was un-
precedented. Smith's candour about the often tortured processes that led to large
exhibitions is unusual. Race-based anxieties and a remnant political correctness
make it doubly unusual in an "official" context. With coruscating wit, Smith here
shows the hopes and frustrations, expressed in assorted internal documents
through the planning period. "It's a story of extraordinary possibilities, brilliant
mistakes, realized dreams and ultimately failed revolution. It's a story about the
agitprop opportunity of a lifetime" (Smith 2007, 380). Yet "The Terrible Near-
ness of Distant Places: Making History at the National Museum of the American
Indian" is not so much a full, or undiplomatic, disclosure as a demonstration of
intertextuality at work – the downside of print cultures. When he picks up the
phone, Smith simply says, "Indians." He means it.

> Here's the way I read the map: Essentialism is the coin of the realm; Indian intellec-
> tuals have largely abdicated their role of providing critical perspective and building
> an environment that encourages debate and rigorous scholarship; and we've failed to
> provide direction to this new and troublesome idea of the Native Voice. At the same
> time, we should remember it's really just a snapshot of a moment in time, and new
> editions come out frequently. In truth, this map is unfinished and its borders contest-
> ed. This is good news, sort of. The problem is NMAI's mandate is broad and insanely
> ambitious, and furthermore we are instructed to carry out this work "in consultation,
> collaboration, and cooperation" with Indian people. To me, this means, among other
> things, we must be really good at reading a really, really bad map.
>
> Why is all this so hard? Partly because Indian intellectuals have not constructed
> a framework with defined meanings for terms like sovereignty or nation, or built a
> consensus on historical narratives or on any of the broad themes the NMAI's exhibits
> must engage. Compare this to African Americans and you can see what I mean.
> There are a million controversies in African American studies, but there is also broad
> agreement on at least the facts and usually much consensus on the narratives of the
> slave trade, the middle passage, Reconstruction, and the civil rights movement. That
> blacks have an intellectual infrastructure and we don't shouldn't be a surprise: there
> are 30 million blacks and 1 or 2 million Indians. African Americans have much more
> of a shared experience than Indians.
>
> And the story of Indians and the continent is much, much harder. It's the elephant
> in the American living room. Harder not simply because it is unpopular and in con-
> tradiction to what the United States wants to believe about itself, but because the

story is so fantastically complex and largely unknown. Slavery in the Americas and the Holocaust in Europe are hardly simple events and processes to describe, but NMAI is addressing events pre-contact to the present day in Indian societies throughout the hemisphere. The best non-Indian historians know instinctively to stay away from this topic. Indian intellectuals for the most part remain endlessly fascinated in what anthropologists think of Indians, romanticism, and stereotypes and less interested in taking on the larger questions. This is changing, I think, and I was encouraged at the recent AAA [American Anthropological Association] panel of Indian anthropologists. But I still maintain this infrastructure does not yet exist, and this goes a long way in explaining why the NMAI is using the tools, language, and methodology of anthropology to design exhibits of social history. It's all we know how to do.

Because I am arguing we don't have a common language yet for this discussion, I think it's imperative to be as specific as possible ...

**30.VII. Mique'l Askren. 2008. "Memories of Fire and Glass: B.A. Haldane, 19th Century Tsimshian Photographer."** In *Visual Currencies: Reflections on Native American Photography.* Edited by Henrietta Lidchi and Hulleah J. Tsinhnahjinne. Edinburgh: National Museums of Scotland, 99. Courtesy of Mique'l Askren (Tsimshian Nation of Metlakatla, Alaska), PhD Candidate at the University of British Columbia.

The now well-rehearsed critique of the objectifying tendencies of photography is only intensified when the subjects in a photograph are Indigenous. A growing interest in the depictions of Native people by Native people has led to ongoing research by young Tsimshian scholar Mique'l Askren in her home community of Metlakatla, Alaska. Askren (b. 1980) is a direct descendant of the Tsimshians who moved to the new Metlakatla, with William Duncan, in 1887.

In seeking out and studying the work of B.A. Haldane, Askren revealed a visual subtext through which Haldane and his subjects maintained their cultural sovereignty, which had always been present even though, according to "official" accounts, it had been consigned to the past. Askren suggested that Haldane's images should be seen as "performing strategic acts" of what Hulleah Tsinhnahjinnie defined as "photographic sovereignty." In her essay "When Is a Photograph Worth a Thousand Words?" Tsinhnahjinnie (2003) used the concept of photographic sovereignty to articulate the agency of Indigenous people in ethnographic images taken by non-Indigenous photographers.

Two of B.A.'s images of children in Metlakatla are visual testaments to the fact that adherence to clan protocols and participation in our cultural traditions continued to be trans-generational in our community during this period. In his portrait of two little

**FIGURE 30.10**   B.A. Haldane, *Young Girls with Model Totem Pole.* US National Archives – Pacific Alaska Region, Henry Wellcome Collection, ARC 297489.

girls, a model totem pole has been placed in the center to make an explicit visual reference to their clan lineage. The placement of the crocheted garment over the chair in front of the model totem pole conceals the other figures and emphasizes the children's connection to the crest represented at the top. In another of B.A.'s images, also taken outside of a home in Metlakatla, a young boy is shown dressed in a button robe and holding a paddle. The strings of beads hanging off each side of his paddle indicates its use in dancing. Its large size, along with the adult sized button robe, suggests that these are being handed down to him, probably by a matrilineal uncle as is inheritance protocol for Tsimshian men. Unlike the re-occurring props seen in B.A.'s studio, it is clear that the families who commissioned these images brought with them carvings and regalia deliberately to use this new form of visual record for documentation purposes. Considering the activities surrounding clan inheritance and protocols in Metlakatla as recorded by Garfield and in our *adawx* (oral history), the composition of these two images suggests that they were commissioned for internal purposes: to be circulated throughout our community to serve the same function as bringing out crest objects at a potlatch in order to publicly validate ancestry.

# Works Cited

Abbott, Lawrence, and Sandra Osawa. 1998. "Interview: Sandy Osawa." *American Indian Quarterly* 22, 1-2: 104-15.

Adams, John W. 1973. *The Gitksan Potlatch: Population Flux, Resource Ownership and Reciprocity*. Toronto: Holt, Reinhart and Winston.

—. 1981. "Recent Ethnology of the Northwest Coast." *Annual Review of Anthropology* 10: 361-92.

Alfred, Agnes. 2004. *Paddling to Where I Stand: Agnes Alfred, Qwiqwasutinuxw Noblewoman*. Translated by Daisy Sewid-Smith. Edited by Martine Reid. Vancouver: UBC Press; Seattle: University of Washington Press.

Alfred, Taiaiake. 1999. *Peace, Power, Righteousness: An Indigenous Manifesto*. Oxford: Oxford University Press.

—, ed. 2005. *Wasase: Indigenous Pathways of Action and Freedom*. Peterborough, ON: Broadview Press.

Ames, Kenneth M. 1996. "Archaeology, Style, and the Theory of Coevolution." In *Darwinian Archaeologies*, edited by Herbert D.G. Maschner, 109-32. New York: Plenum Press.

Ames, Kenneth M., and Herbert D. Maschner. 1999. *Peoples of the Northwest Coast: Their Archaeology and Prehistory*. London: Thames and Hudson.

Ames, Michael M. 1975. *Indian Masterpieces from the Walter and Marianne Koerner Collection*. Vancouver: UBC Press.

—. 1979. Foreword. In *Kwakiutl Art*, by Audrey Hawthorn. Seattle: University of Washington Press.

—. 1981a. "Museum Anthropologists and the Arts of Acculturation on the Northwest Coast." *BC Studies* 49: 3-14.

—. 1981b. "A Note on the Contributions of Wilson Duff to Northwest Coast Ethnology and Art." In *The World Is as Sharp as a Knife: An Anthology in Honour of Wilson Duff*, edited by Donald N. Abbott, 17-21. Victoria: British Columbia Provincial Museum.

—. 1986. *Museums, the Public and Anthropology: A Study in the Anthropology of Anthropology*. Ranchi Anthropology Series 9. Vancouver: UBC Press; New Delhi: Concept Publishing.

—. 1990. "Cultural Empowerment and Museums: Opening Up Anthropology through Collaboration." In *Objects of Knowledge*, edited by Susan Pearce, 158-73. New Research in Museum Studies. London: Athlone Press.

—. 1992a. *Cannibal Tours and Glass Boxes: The Anthropology of Museums*. Vancouver: UBC Press. Revised edition of M.M. Ames 1986.

—. 1992b. "How Anthropologists Help to Fabricate the Cultures They Study." In *Cannibal Tours and Glass Boxes: The Anthropology of Museums*, 59-69. Vancouver: UBC Press.

—. 1992c. "How Anthropologists Stereotype Other People." In *Cannibal Tours and Glass Boxes: The Anthropology of Museums,* 49-58. Vancouver: UBC Press.

—. 1994. "The Politics of Difference: Other Voices in a Not Yet Post-Colonial World." *Museum Anthropology* 18, 3: 9-17.

—. 1999. "How to Decorate a House: The Renegotiation of Cultural Representations at the University of British Columbia Museum of Anthropology." *Museum Anthropology* 22, 3: 41-51. Reprinted in Laura Peers and Alison K. Brown, eds. 2003. *Museums and Source Communities: A Routledge Reader,* 171-80. London: Routledge.

—. 2006. "Counterfeiting Museology." *Museum Management and Curatorship* 21: 171-86.

Anderson, Margaret, and Marjorie Halpin, eds. 2000. *Potlatch at Gitsegukla: William Beynon's 1945 Field Notebooks.* Vancouver: UBC Press.

Anthes, Bill. 2006. *Native Moderns: American Indian Painting, 1940-1960.* Durham, NC: Duke University Press.

Appadurai, Arjun. 1996. *Modernity at Large: Cultural Dimensions of Globalization.* Minneapolis: University of Minnesota Press.

—, ed. 1986. *The Social Life of Things: Commodities in Cultural Perspective.* Cambridge: Cambridge University Press.

Appelbaum, Stanley. 1977. *The New York World's Fair, 1939/1940 in 155 Photographs by Richard Wurts and Others.* New York: Dover.

Arato, Andrew, and Eike Gebhardt, eds. 2000. *The Essential Frankfurt School Reader.* New York: Continuum.

Arima, Eugene Y. 2000a. Foreword to "Face Paintings from the Sapir Collection," by Douglas Thomas. In *Nuu-Chah-Nulth Voices, Histories, Objects and Journeys,* edited by Alan L. Hoover, 172-74. Victoria: Royal British Columbia Museum.

—. 2000b. "Thoughts on the Nuu-Chah-Nulth Canoe." In *Nuu-Chah-Nulth Voices, Histories, Objects and Journeys,* edited by Alan L. Hoover, 306-29. Victoria: Royal British Columbia Museum.

Arima, Eugene Y., and E.C. Hunt. 1975. "Making Masks: Notes on Kwakiutl 'Tourist Mask' Carving." In *Contributions to Canadian Ethnology,* edited by David Brez Carlisle, 67-128. Canadian Ethnology Service Paper 31. Ottawa: National Museum of Canada.

Arima, Eugene Y., Terry Klokeid, and Katherine Robinson, eds. 2000. *The Whaling Indians, West Coast Legends and Stories: Tales of Extraordinary Experience Told by Tom Sa:ya:ch'apis, William, Dick La:maho:s, Captain Bill, and Tyee Bob.* Prepared by Edward Sapir, Morris Swadesh, Alexander Thomas, John Thomas, and Frank Williams. Part 10 of the Sapir-Thomas Nootka Texts. Mercury Series, Canadian Ethnology Service Paper 134. Hull, QC: Canadian Museum of Civilization.

—, eds. 2007. *The Origin of the Wolf Ritual. The Whaling Indians: West Coast Legends and Stories.* Part 12 of the Sapir-Thomas Nootka Texts. Mercury Series, Canadian Ethnology Service Paper 144. Gatineau, QC: Canadian Museum of Civilization.

Arnheim, Rudolph. (1954) 1974. *Art and Visual Perception: A Psychology of the Creative Eye, the New Version.* Berkeley: University of California Press.

Arnold, Grant, Monika Kim Gagnon, and Doreen Jensen. 1996. *Topographies: Aspects of Recent BC Art.* Vancouver: Douglas and McIntyre.

Asad, Talal, ed. 1973. *Anthropology and the Colonial Encounter.* London: Ithaca Press.

Askren, Mique'l. 2008. "Memories of Fire and Glass: B.A. Haldane, 19th Century Tsimshian Photographer." In *Visual Currencies: Reflections on Native American Photography,* edited by Henrietta Lidchi and Hulleah J. Tsinhnahjinnie, 90-107. Edinburgh: National Museums of Scotland.

Assu, Harry, and Joy Inglis. 1989. *Assu of Cape Mudge: Recollections of a Coastal Indian Chief*. Vancouver: UBC Press.

Atleo, Richard E. 2004. *Tsawalk: A Nuu-chah-nulth Worldview*. Vancouver: UBC Press.

Attwood, Bain. 1994. *A Life Together, a Life Apart: A History of Relations between Europeans and Aborigines*. Melbourne: Melbourne University Press.

Augaitis, Daina, ed. 2006. *Raven Travelling: Two Centuries of Haida Art*. Vancouver: Vancouver Art Gallery; Douglas and McIntyre.

Baldissera, Lisa, ed. 2008. *Marianne Nicolson: The Return of Abundance*. Victoria: Art Gallery of Greater Victoria.

Barbeau, Marius. 1927. "West Coast Indian Art." In *Exhibition of Canadian West Coast Art – Native and Modern*. Ottawa: National Gallery of Canada.

—. 1928. *The Downfall of Temlaham*. Toronto: Macmillan.

—.1929. *Totem Poles of the Gitksan, Upper Skeena River, British Columbia*. Anthropology Series No. 12, Bulletin No. 61. Ottawa: National Museum of Canada.

—. 1950. *Totem Poles*. 2 vols. Bulletin 119, Anthropological Series No. 30. Ottawa: National Museum of Canada.

—. 1957. *Haida Carvers in Argillite*. Ottawa: National Museum of Canada.

Barker, John. 1997. "Way Back in Papua: Representing Society and Change in the Publications of the London Missionary Society in New Guinea, 1871-1932." *Pacific Studies* 19, 3: 107-42.

—. 2007. "Missionary Ethnography on the Northwest Coast." In *Anthropology's Debt to Missionaries*, edited by Leonard Plotnicov, Paula Brown, and Vincent Sutlive, 1-22. Ethnology Monograph 20. Pittsburgh: University of Pittsburgh.

Barker, John, and Douglas Cole, eds. 2003. *At Home with the Bella Coola Indians: T.F. McIlwraith's Field Letters, 1922-24*. Vancouver: UBC Press.

Barkley Sound Dialect Working Group. 2004. *Nuu-Chah-Nulth Phrase Book and Dictionary*. Huu-ay-aht, Ucluelet, Uchucklesaht, and Toquaht First Nations.

Barnett, Homer G. 1938. "The Nature of the Potlatch." *American Anthropologist* n.s. 40, 3: 349-58.

—. 1968. *The Nature and Function of the Potlatch*. Eugene: University of Oregon, Department of Anthropology.

Barthes, Roland. 1991. *The Responsibility of Forms: Essays on Music, Art and Representation*. Berkeley: University of California Press.

Bataille, Georges. 1991. *The Accursed Share: An Essay on General Economy*. Vol. 1, *Consumption*. Translated by Robert Hurley. New York: Zone Books.

Baudrillard, Jean. 1968. *Le système des objets*. Paris: Éditions Gallimard.

Beaglehole, John C., ed. 1967. *The Journals of Captain James Cook on His Voyages of Discovery*. Vol. 3, part 1, *The Voyage of the* Resolution *and* Discovery, *1776-1780*. Cambridge, UK: Cambridge University Press for the Hakluyt Society, Extra Series No. 36.

Becker, Howard S. 1982. *Art Worlds*. Berkeley: University of California Press.

Bell, Catherine. 1992. "Reflections on the New Relationship: Comments on the Task Force Guidelines for Repatriation." In *Canadian Museums Association Legal Affairs and Management Symposium*, 55-84. Ottawa: National Archives of Canada in cooperation with the Canadian Bar Association.

Bell, Lucille, and Vince Collison. 2006. "The Repatriation of Our Ancestors and the Rebirth of Ourselves." In *Raven Travelling: Two Centuries of Haida Art*, edited by Daina Augaitis, 140-45. Vancouver: Vancouver Art Gallery; Douglas and McIntyre.

Bell, Catherine, and Robert K. Paterson, eds. 2009. *Protection of First Nations Cultural Heritage: Law, Policy, and Reform*. Vancouver: UBC Press.

Benedict, Ruth. 1934. *Patterns of Culture*. Boston: Houghton Mifflin.

Benjamin, Walter. 1968. *Illuminations*. Translated by Harry Zohn. New York: Schocken Books.

Bennett, Tony. 1995. *The Birth of the Museum: History, Theory, Politics*. New York: Routledge.

Beresford, William [George Dixon]. 1789. *A Voyage round the World; But More Particularly to the North-West Coast of America: Performed in 1785, 1786, 1787, and 1788, in the "King George" and "Queen Charlotte," Captains Portlock and Dixon*. 2nd ed. London: George Goulding.

Berger, Thomas R. 2002. *One Man's Justice: A Life in the Law*. Vancouver: Douglas and McIntyre; Seattle: University of Washington Press.

Berlo, Janet Catherine, and Ruth B. Phillips. 1992. "'Vitalizing the Things of the Past': Museum Presentations of Native North American Art in the 1990s." *Museum Anthropology* 16, 1: 29-43.

—, eds. 1995. "'Our (Museum) World Turned Upside Down': Re-Presenting Native American Arts." *Art Bulletin* 77, 1: 6-10. Reprinted in *Grasping the World: The Idea of the Museum*, edited by Donald Preziosi and Claire Farago, 708-18. London: Ashgate Press, 2004.

—, eds. 1998. *Native North American Art*. Oxford: Oxford University Press.

Berman, Judith. 1994. "George Hunt and the Kwak'wala Texts." *Anthropological Linguistics* 36: 483-514.

—. 1996. "'The Culture as It Appears to the Indian Himself': Boas, George Hunt, and the Methods of Ethnography." In *Volksgeist as Method and Ethic: Essays on Boasian Ethnography and the German Anthropological Tradition*, edited by George W. Stocking Jr., 215-56. History of Anthropology Vol. 8. Madison: University of Wisconsin Press.

—. 1998. "Building a Collection: Native Californian Basketry at the University of Pennsylvania Museum." *Expedition* 40, 1: 23-33.

—. 2004. "'Some Mysterious Means of Fortune': A Look at Northwest Coast Oral History." In *Coming to Shore: Northwest Coast Ethnology, Traditions, and Visions*, edited by Marie Mauzé, Michael Harkin, and Sergei Kan, 129-62. Lincoln: University of Nebraska Press.

—. Forthcoming. "Relating Deep Genealogies, Traditional History, and Early Documentary Records in Southeast Alaska: Questions, Problems, Progress." In *Sharing Our Knowledge: Essays on the Tlingit and Their Neighbors*, edited by Steve Henrikson, Andrew J. Hope III, and Sergei Kan. Lincoln: University of Nebraska Press.

Berman, Tressa. 1997. "Beyond the Museum: The Politics of Representation in Asserting Rights to Cultural Property." *Museum Anthropology* 21, 3: 19-27.

—. 2004a. "Cultural Appropriation." In *A Companion to the Anthropology of American Indians*, edited by Thomas Biolsi, 383-97. Oxford: Blackwell Publishers.

—. 2004b. "'Long as the Grass Grows': Representing Indigenous Claims." In *Indigenous Intellectual Property Rights*, edited by Mary Riley, 3-26. Lanham, MD: AltaMira Press.

—, ed. 2012. *No Deal! Indigenous Arts and the Politics of Possession*. Santa Fe: School of American Research Press.

Bernstein, Bruce, and Gerald McMaster. 2004. "The Aesthetic in American Indian Art." In *First American Art: The Charles and Valerie Diker Collection of American Indian Art*, edited by Bruce Bernstein and Gerald McMaster, 37-53. Washington, DC: Smithsonian National Museum of the American Indian.

Bhabha, Homi. K. 1994. *The Location of Culture*. London: Routledge.

—. ed. 1990. *Nation and Narration*. London: Routledge.

Bierwert, Crisca. 1999. *Brushed by Cedar, Living by the River: Coast Salish Figures of Power*. Tucson: University of Arizona Press.

Black, Martha. 1989. "Looking for Bella Bella: The R.W. Large Collection and Heiltsuk Art History." *Canadian Journal of Native Studies* 9, 2: 273-92.

—. 1997. *Bella Bella: A Season of Heiltsuk Art.* Vancouver: Douglas and McIntyre.

—. 2001. "HuupuK$^w$anum · Tupaat – Out of the Mist: Treasures of the Nuu-Chah-Nulth Chiefs." In *The Manual of Museum Exhibitions,* edited by Lord Cultural Resources, 35-38. London: Stationery Office; Lanham, MD: AltaMira Press.

—, ed. 1999. *HuupuK$^w$anum · Tupaat – Out of the Mist: Treasures of the Nuu-Chah-Nulth Chiefs.* Victoria: Royal BC Museum.

Blackman, Margaret B. 1973. "Totems to Tombstones: Culture Change as Viewed through the Haida Mortuary Complex, 1877-1971." *Ethnology* 12: 47-56.

—. 1976. "Creativity in Acculturation." *Ethnohistory* 23, 1: 387-413.

—. 1977. "Ethnohistoric Changes in the Haida Potlatch Complex." *Arctic Anthropology* 14: 39-53.

—.1981. *Window on the Past: The Photographic Ethnohistory of the Northern and Kaigani Haida.* National Museum of Man Mercury Series, Canadian Ethnology Service Paper 74. Ottawa: National Museum of Canada.

—. 1992. "Feastwear: Haida Art Goes Couture." *American Indian Arts Magazine* 17: 56-65.

Blackman, Margaret B., and Florence Edenshaw Davidson. 1985. *During My Time: Florence Edenshaw Davidson, a Haida Woman.* Seattle: University of Washington Press; Vancouver: Douglas and McIntyre.

Blackman, Margaret B., and Edwin S. Hall. 1978. "New Directions in West Coast Art." Paper presented at a symposium in honour of Philip Drucker. Southern Anthropological Society Meetings, Lexington, Kentucky, 13 April.

—. 1981. "Contemporary Northwest Coast Art: Tradition and Innovation in Serigraphy." *American Indian Art Magazine* 6, 3: 54-61.

Blanchard, Rebecca, and Nancy Davenport, eds. 2005. *Contemporary Coast Salish Art.* Vancouver: Douglas and McIntyre; Seattle: University of Washington Press, in association with the Stonington Gallery.

Boas, Franz. 1887a. "Museums of Ethnology and Their Classification." Letters to the Editor. *Science* 9, 228: 587-89, 613-14.

—. 1887b. "The Occurrence of Similar Inventions in Areas Widely Apart." Letters to the Editor. *Science* 9, 226: 485-86.

—. 1888a. "Gleanings from the Emmons Collection of Ethnological Specimens from Alaska." *Journal of American Folk-Lore* 1, 3: 215-19.

—. 1888b. "On the Field and Work of a Journal of American Folk-Lore." *Journal of American Folk-Lore* 1, 1: 3-7.

—. 1889. "Preliminary Notes on the Indians of British Columbia." *Report of the British Association for the Advancement of Science* 58: 236-42.

—. 1891. "Physical Characteristics of the Indians of the North Pacific Coast." *American Anthropologist* 4, 1: 25-32.

—. 1896. "The Limitations of the Comparative Method of Anthropology" *Science* 4, 103: 901-8.

—. 1897a. "The Decorative Art of the Indians of the North Pacific Coast." *Bulletin of the American Museum of Natural History* 9: 123-76.

—. 1897b. *The Social Organization and the Secret Societies of the Kwakiutl Indians. Based on Personal Observations and on Notes Made by Mr. George Hunt.* In *Annual Report of the US National Museum for 1895,* 311-738. Washington, DC: US Government Printing Office.

—. 1902. "Some Problems in North American Archaeology." *American Journal of Archaeology* 6, 1: 1-6.

—. 1907. "Some Principles of Museum Administration." *Science* 25: 921-33.

—. 1909. *The Kwakiutl of Vancouver Island.* In *Memoirs of the American Museum of Natural History.* Vol. 8, part 2, Jesup North Pacific Expedition, 301-522. Leiden: E.J. Brill; New York: G.E. Stechert.

—. 1911. *The Mind of Primitive Man*. New York: Macmillan.

—. 1916. Tsimshian Mythology. In *Thirty-First Annual Report of the Bureau of American Ethnology*, 29-1037. Washington, DC: Government Printing Office.

—. 1917. *Grammatical Notes on the Language of the Tlingit Indians*. University Museum Anthropological Publications 8, 1. Philadelphia: University of Pennsylvania Museum.

—. 1921. *Ethnology of the Kwakiutl (Based on Data Collected by George Hunt)*. 2 parts. In *Thirty-Fifth Annual Report of the Bureau of American Ethnology, 1913-1914*, 41-1481. Washington, DC: Government Printing Office.

—. 1927. "Art of the North Pacific Coast of North America." In *Primitive Art*, 183-298. Cambridge, MA: Harvard University Press.

—. (1927) 1955. *Primitive Art*. Cambridge, MA: Harvard University Press; Oslo: J. Aschehoug and Company Reprint; New York: Dover Publications.

—. 1938. "Methods of Research." In *General Anthropology*, edited by Franz Boas, 666-86. Boston: D.C. Heath.

—. 1966. *Kwakiutl Ethnography*. Edited by Helen Codere. Chicago: University of Chicago Press.

Boas, Franz, and George Hunt. 1905. *Kwakiutl Texts*. Vol. 3. Jesup North Pacific Expedition. Leiden : E.J. Brill; New York: G. E. Stechert.

—. 1906. *Kwakiutl Texts*. Vol. 10, part 1. Jesup North Pacific Expedition. Leiden : E.J. Brill; New York: G. E. Stechert.

—. 1910. *Kwakiutl Tales*. Columbia University Contributions to Anthropology 2. New York: Columbia University Press.

Boas, Franz, and George W. Stocking. 1982. *A Franz Boas Reader: The Shaping of American Anthropology, 1883-1911*. Chicago: University of Chicago Press.

Bob, Tanya, with Dempsey Bob. 2000. "The Art Goes Back to the Stories: A Soucebook on the Work of Tahltan/Tlingit First Nations Artist Dempsey Bob." UBC Museum of Anthropology. Unpublished.

Boelscher, Marianne. 1988. *The Curtain Within: Haida Social and Mythological Discourse*. Vancouver: UBC Press.

Bollen, Kenneth A. 1998. *Cross-National Indicators of Liberal Democracy, 1950-1990*. 2nd ICPSR version. Chapel Hill: University of North Carolina [producer]; Ann Arbor, MI: Inter-university Consortium for Political and Social Research [distributor], 2001.

Bolt, Clarence. 1992. *Thomas Crosby and the Tsimshian: Small Shoes for Feet Too Large*. Vancouver: UBC Press.

Borden, Charles E. 1947. *Preliminary Report on the Archeology of Point Grey, British Columbia*. Vancouver: n.p.

—. 1955. "Ancient Coast Indian Village in Southern British Columbia." *Indian Time* 2, 15: 9-19.

—. 1956. "Results of Two Archaeological Surveys in the East Kootenay Region of British Columbia." *Research Studies, State College of Washington (State)* 24, 1: 73-104.

—. 1960. "Dj Ri 3, an Early Site in the Fraser Canyon, British Columbia." *National Museum of Canada Bulletin, Contributions to Anthropology, 1957*, 162: 101-18.

—. 1968. "Late Pleistocene Pebble Tool Industry of Southwestern British Columbia." In *Early Man in Western North America*, edited by C. Irwin-Williams, 55-69. Portales: Eastern New Mexico University Press.

—. 1976. "Water-Saturated Site on the Southern Mainland Coast of British Columbia." In *The Excavation of Water-Saturated Archaeological Sites (Wet Sites) on the Northwest Coast of North America*, edited by Dale R. Croes, 233-60. Ottawa: National Museum of Canada.

—. 1979. "Peopling and Early Cultures of the Pacific Northwest." *Science* 203: 963-71.

—. 1983. "Prehistoric Art of the Lower Fraser Region." In *Indian Art Traditions of the Northwest Coast*, edited by Roy L. Carlson, 131-65. Burnaby: Archaeology Press, Simon Fraser University.

Borrows, John. 1999. "Sovereignty's Alchemy: An Analysis of *Delgamuukw v. British Columbia*." *Osgoode Hall Law Journal* 37, 3: 537-96.

—. 2002. *Recovering Canada: The Resurgence of Indigenous Canada*. Toronto: University of Toronto Press.

Bourdieu, Pierre. 1977. *Outline of a Theory of Practice*. Cambridge Studies in Social Anthropology 16. Cambridge, UK: Cambridge University Press.

—. 1984. *Distinction: A Social Critique of the Judgement of Taste*. Cambridge, MA: Harvard University Press.

—. 1993. *The Field of Cultural Production: Essays on Art and Literature*. Cambridge, UK: Polity Press; New York: Columbia University Press.

—. 1998. *Practical Reason: On the Theory of Action*. Stanford, CA: Stanford University Press.

Bourriaud, Nicolas. 2002. *Relational Aesthetics*. Translated by Simon Pleasance and Fronza Woods. Paris: Les Presses du Reel.

Boxberger, Daniel. 2000. "Whither the Expert Witness: Anthropology in the Post Delgamuukw Courtroom." In *Coming to Shore: Northwest Coast Ethnology, Traditions, and Visions*, edited by Marie Mauzé, Michael Harkin, and Sergei Kan, 323-38. Lincoln: University of Nebraska Press.

Bracken, Christopher. 1997. *The Potlatch Papers: A Colonial Case History*. Chicago: University of Chicago Press.

Bradley, Ian L. 1975. "A Bibliography of the Arts and Crafts of Northwest Coast Indians." *BC Studies* 25: 78-124.

Breton, André. 1924. *Manifeste du surréalisme*. Paris: Sagittaire.

—. 1930. *Second manifeste du surréalisme*. Paris: Éditions Kra.

—. 1985. "Note on the Transformation Masks of the Pacific Northwest Coast." *Pleine Marge* 1: 9-15. Originally published in *Neuf: Revue de la maison de la médecine* (1 June 1950): 36-41. Later published in *Oeuvres complètes*, vol. 3, edited by Marguerite Bonnet (Paris: Gallimard [Bibliothèque de la Pléiade], 1999), 1029-33.

—. 1993. *Conversations: The Autobiography of Surrealism*. With André Parinaud; translated by Mark Polizzoti. New York: Paragon House Publishers.

Breton, André, and Marcel Duchamp. 1942. *First Papers of Surrealism* [Catalogue]. New York: Coordinating Council of French Relief Societies, Inc.

Brians, Paul. "'Postcolonial Literature': Problems with the Term." http://www.wsu.edu/~brians/anglophone/postcolonial.html.

Bridge, Kathryn. 2004. *Extraordinary Accounts of Native Life on the West Coast: Words from Huu-Ay-Aht Ancestors*. Canmore, AB: Altitude Publishing.

Briggs, Charles, and Richard Bauman. 1999. "'The Foundation of All Future Researches': Franz Boas, George Hunt, Native American Texts, and the Construction of Modernity." *American Quarterly* 51, 3: 479-528.

Bringhurst, Robert. 1999. *A Story as Sharp as a Knife: The Classical Haida Mythtellers and Their World*. Vol. 1 of *Masterworks of the Classical Haida Mythtellers*. Vancouver: Douglas and McIntyre; Lincoln: University of Nebraska Press.

—, ed. 2000. *Solitary Raven: The Selected Writings of Bill Reid*. Vancouver: Douglas and McIntyre; Seattle: University of Washington Press.

Bringhurst, Robert, and Ulli Steltzer. 1991. *The Black Canoe: Bill Reid and the Spirit of Haida Gwaii*. Seattle: University of Washington Press; Vancouver: Douglas and McIntyre.

British Columbia Provincial Museum. 1952. *Annual Report.* Victoria: Province of British Columbia, Department of Education.

—. 1953. *Annual Report.* Victoria: Province of British Columbia, Department of Education.

Brotherton, Barbara, ed. 2008. *S'abadeb, the Gifts: Pacific Coast Salish Art and Artists.* Seattle: Seattle Art Museum; University of Washington Press.

Brown, Bill, ed. 2004. *Things.* Chicago: University of Chicago Press.

Brown, Eric. 1927. Introduction. In *Exhibition of Canadian West Coast Art – Native and Modern.* Ottawa: National Gallery of Canada

Brown, Michael F. 1998. "Can Culture Be Copyrighted?" *Current Anthropology* 39, 2: 193-222.

—. 2003. *Who Owns Native Culture?* Cambridge, MA: Harvard University Press.

—. 2004. "Heritage as Property." In *Property in Question: Value Transformation in the Global Economy,* edited by Katherine Verdery and Caroline Humphrey, 49-68. New York: Berg.

Brown, Pam. 2003. "If You Don't Understand the Stories You Don't Understand the Art." Paper presented at the International Expert Meeting, Museums and Intangible Heritage conference, Oegstgeest, Netherlands, April.

Brown, Steven C. 1987. "From Taquan to Klukwan: Tracing the Work of an Early Tlingit Master Artist." In *Faces, Voices and Dreams: A Celebration of the Centennial of the Sheldon Jackson Museum, 1888-1988,* edited by Peter L. Corey, 157-75. Sitka: Division of Alaska State Museums and the Friends of the Alaska State Museum.

—. 1994. "In the Shadow of the Wrangell Master: Photo Documentation of the Work of Two Nineteenth Century Tlingit Artists." *American Indian Art Magazine* 19, 4: 74-85, 104.

—, ed. 1995. *The Spirit Within: Northwest Coast Native Art from the John H. Hauberg Collection.* New York: Rizzoli; Seattle: Seattle Art Museum.

—. 1997. "Formlines Changing Form: Northwest Coast Art as an Evolving Tradition." *American Indian Art Magazine* 19, 4: 74-85, 104.

—. 1998. *Native Visions: Evolution in Northwest Coast Art from the Eighteenth through the Twentieth Century.* Seattle: Seattle Art Museum, in association with the University of Washington Press.

—. 2000a. "Flowing Traditions: The Appearance and Relations of Nuu-Chah-Nulth Visual Symbolism." In *Nuu-Chah-Nulth Voices, Histories, Objects and Journeys,* edited by Alan L. Hoover, 273-91. Victoria: Royal British Columbia Museum.

—, ed. 2000b. *Spirits of the Water: Native Art Collected on Expeditions to Alaska and British Columbia, 1774-1910.* Seattle: University of Washington Press; Vancouver: Douglas and McIntyre.

—. 2000c. "Turning the Tables: The Influences of Nineteenth-Century Southern Design Styles on the Northern Northwest Coast." *American Indian Art Magazine* 25, 3: 48-55.

—. 2005. "A Tale of Two Carvers: The Rain Wall Screen of the Whale House, Klukwan, Alaska." *American Indian Art Magazine* 30, 4: 48-59.

—, ed. 2006. *Transfigurations: North Pacific Coast Art. George Terasaki, Collector.* Seattle: Marquand Books.

Brown, Steven C., Nancy Davenport, Rebecca Blanchard, and Mike Zens, eds. 2005. *Contemporary Coast Salish Art.* Seattle: Stonington Gallery; University of Washington Press.

Burger, Peter. 1984. *Theory of the Avant-Garde.* Translated by Michael Shaw. Minneapolis: University of Minnesota Press.

Burnaby Art Gallery. 1980. *Northwest Renaissance.* Burnaby: Burnaby Art Gallery.

Callison, Cynthia. 1995. "Appropriation of Aboriginal Oral Traditions." In *Material Culture in Flux: Law and Policy of Repatriation of Cultural Property.* Special issue of *UBC Law Review*: 165-82.

Campbell, Alice. 2004. "'About Humanity, Not Ethnicity'? Transculturalism, Materiality and the Politics of Performing Aboriginality on the Northwest Coast." MA thesis, University of British Columbia.

Canada, British Columbia, and Nisga'a Nation. 1998. *Nisga'a Final Agreement.* Ottawa: Government of Canada, Federal Treaty Negotiations Office; Victoria: Government of British Columbia; New Aiyansh: Nisga'a Nation.

Canadian Museum of Civilization. 1998. "Principles for the Development of the First Peoples' Hall." Gatineau, QC: Canadian Museum of Civilization.

Canclini, Nestor Garcia. 2001. *Consumers and Citizens: Globalization and Multicultural Conflicts.* Minneapolis: University of Minnesota Press.

Cannizzo, Jeanne. 1983. "George Hunt and the Invention of Kwakiutl Culture." *Canadian Review of Sociology and Anthropology* 20, 1: 44-58.

Cannon, Aubrey. 1998. "Contingency and Agency in the Growth of Northwest Coast Maritime Economies." *Arctic Anthropology* 35, 1: 57-67.

—. 2002. "Sacred Power and Seasonal Settlement on the Central Northwest Coast." In *Beyond Foraging and Collecting: Evolutionary Change in Hunter-Gatherer Settlement Systems,* edited by Ben Fitzhugh and Junko Hanbu, 311-38. New York: Kluwer/Plenum.

Cardinal, Gil, dir. 2003. *Totem: The Return of the G'psgolox Pole.* Montreal: National Film Board of Canada, 2003. Video-recording, 60 min.

Carlson, Keith Thor, ed. 1997. *You Are Asked to Witness: The Stó:lō in Canada's Pacific Coast History.* Chilliwack, BC: Stó:lō Heritage Trust.

—, ed. 2001. *A Stó:lō-Coast Salish Historical Atlas.* Vancouver: Douglas and McIntyre; Chilliwack, BC: Stó:lō Heritage Trust.

Carlson, M. Theresa, Keith Thor Carlson, Brian Thorn, and Sonny McHalsie. 1997. "Spoken Literature: Stó:lō Oral Narratives." In *You Are Asked to Witness: The Stó:lō in Canada's Pacific Coast History,* edited by Keith Thor Carlson, 182-95. Chilliwack, BC: Stó:lō Heritage Trust.

Carlson, Roy L. 1960. "Chronology and Culture Change in the San Juan Islands, Washington." *American Antiquity* 25, 4: 562-86.

—. 1970. "Archaeology in British Columbia." *BC Studies* 6-7: 7, 17.

—. 1979. "The Early Period on the Central Coast of British Columbia." *Canadian Journal of Archaeology* 3: 211-28.

—. 1983a. "Change and Continuity in Northwest Coast Art." In *Indian Art Traditions of the Northwest Coast,* edited by Roy L. Carlson, 197-205. Burnaby, BC: Archaeology Press, Simon Fraser University.

—, ed. 1983b. *Indian Art Traditions of the Northwest Coast.* Burnaby, BC: Archaeology Press, Simon Fraser University.

—. 1983c. "Method and Theory in Northwest Coast Archaeology." In *The Evolution of Maritime Cultures in the Northeast and Northwest Coasts of America,* edited by Ronald J. Nash, 27-39. Burnaby, BC: Archaeology Press, Simon Fraser University.

—. 1983d. "Prehistoric Art of the Central Coast of British Columbia." In *Indian Art Traditions of the Northwest Coast,* edited by Roy L. Carlson, 121-29. Burnaby, BC: Archaeology Press, Simon Fraser University.

—. 1983e. "Prehistory of the Northwest Coast." In *Indian Art Traditions of the Northwest Coast,* edited by Roy L. Carlson, 13-32. Burnaby, BC: Archaeology Press, Simon Fraser University.

—. 1996a. "Early Namu." In *Early Human Occupation in British Columbia,* edited by Roy Carlson and Luke Dalla Bona, 83-102. Vancouver: UBC Press.

—. 1996b. "The Later Prehistory of British Columbia." In *Early Human Occupation in British Columbia,* edited by Roy Carlson and Luke Dalla Bona, 215-26. Vancouver: UBC Press.

—. 1998. "Coastal British Columbia in the Light of North Pacific Maritime Adaptations." *Arctic Anthropology* 35, 1: 23-35.

Carpenter, Edmund. 1976. "Collecting Northwest Coast Art." In *Indian Art of the Northwest Coast: A Dialogue on Craftsmanship and Aesthetics,* edited by Bill Holm and Bill Reid, 9-27. Seattle: University of Washington Press.

Carriere, Marcel. 1990. "Training at the National Film Board of Canada: Observations '50 Years of Filmmaking Experience.'" NFB Archives, Indian Film Crew box, 5-9.

Carter, Beth. 1992. "Let's Act – Not React: Some Suggestions for Implementing the Task Force Report on Museums and First Peoples." *Alberta Museums Review* 18, 2: 13-15.

Cassidy, Frank, ed. 1992. *Aboriginal Title in British Columbia: Delgamuukw v. The Queen.* Lantzville, BC: Oolichan Books; Montreal: Institute for Research on Public Policy.

Castile, George P. 1982. "The 'Half-Catholic' Movement: Edwin and Myron Eells and the Rise of the Indian Shaker Church." *Pacific Northwest Quarterly* 73, 4: 165-74.

—, ed. 1985. *The Indians of Puget Sound: The Notebooks of Myron Eells.* Seattle: University of Washington Press.

Chalker, Kari, Lois Sherr Dubin, and Peter M. Whiteley. 2004. *Totems to Turquoise: Native North American Jewelry Arts of the Northwest and Southwest.* New York: Harry N. Abrams, in association with the American Museum of Natural History.

Chalmers, Graeme. 1995. "European Ways of Talking about Northwest Coast First Nations." *Canadian Journal of Native Studies* 15, 1: 113-27.

Churchill, Delores. 2002. "Weaving Stories of Art." In *On Aboriginal Representation in the Gallery,* edited by Lynda Jessup and Shannon Bagg, 217-20. Hull, QC: Canadian Museum of Civilization.

Clavir, Miriam. 2002. *Preserving What Is Valued: Museums, Conservation and First Nations.* UBC Museum of Anthropology Research Publication. Vancouver: UBC Press.

Claxton, Dana. 2005. "Re:Wind." In *Transference, Tradition, Technology: Native New Media Exploring Visual and Digital Culture,* edited by Dana Claxton, Steven Loft, Candice Hopkins, and Melanie Townsend, 14-41. Banff, AB: Walter Phillips Gallery Editions.

Claxton, Dana, Steven Loft, Melanie Townsend, and Candice Hopkins, eds. 2005. *Transference, Tradition, Technology: Native New Media Exploring Visual and Digital Culture.* Banff, AB: Walter Phillips Gallery Editions.

Clayton, Daniel W. 2000. *Islands of Truth: The Imperial Fashioning of Vancouver Island.* Vancouver: UBC Press.

Clifford, James. 1986. "On Ethnographic Allegory." In *Writing Culture: The Poetics and Politics of Ethnography,* edited by James Clifford and George E. Marcus, 98-121. Berkeley: University of California Press.

—. 1988a. "On Collecting Art and Culture." In *The Predicament of Culture: Twentieth-Century Ethnography, Literature, and Art,* 215-52. Cambridge, MA: Harvard University Press.

—. 1988b. *The Predicament of Culture: Twentieth-Century Ethnography, Literature, and Art.* Cambridge, MA: Harvard University Press.

—. 1997a. "Four Northwest Coast Museums: Travel Reflections." In *Routes: Travel and Translation in the Late Twentieth Century,* 212-54. Cambridge, MA: Harvard University Press.

—. 1997b. "Museums as Contact Zones." In *Routes: Travel and Translation in the Late Twentieth Century,* 189-219. Cambridge, MA: Harvard University Press.

—. 1997c. *Routes: Travel and Translation in the Late Twentieth Century.* Cambridge, MA: Harvard University Press.

Clifford, James, and George E. Marcus, eds. 1986. *Writing Culture: The Poetics and Politics of Ethnography.* Berkeley: University of California Press.

Clutesi, George C. 1947. "The Urge to Create." *Native Voice: Official Organ of the Native Brotherhood of British Columbia* 1, 7: 14.

—. 1967. *Son of Raven, Son of Deer: Fables of the Tseshaht People.* Sidney, BC: Gray's Publishing.

—.1969. *Potlatch.* Sidney, BC: Gray's Publishing.

—.1990. *Stand Tall, My Son.* Victoria: Newport Bay Publishing.

Cocking, Clive. 1971. "Indian Renaissance: New Life for a Traditional Art." *UBC Alumni Chronicle* 25, 4: 16-19.

Codere, Helen. 1950. *Fighting with Property: A Study of Kwakiutl Potlatching and Warfare, 1792-1930.* American Ethnological Society Monograph 18. New York: J.J. Augustin.

—. 1956. "The Amiable Side of Kwakiutl Life: The Potlatch and Play Potlatch." *American Anthropologist* 28: 334-51.

Coe, Ralph T. 1986. *Lost and Found Traditions: Native American Art 1965-1985.* Vancouver: Douglas and McIntyre, in association with the American Federation of Arts.

Cole, Douglas. 1985. *Captured Heritage: The Scramble for Northwest Coast Artifacts.* Vancouver: Douglas and McIntyre; Seattle: University of Washington Press.

—. 1991. "Tricks of the Trade: Some Reflections on Anthropological Collecting." *Arctic Anthropology* 28, 1: 48-62.

Cole, Douglas, and Ira Chaikin. 1990. *An Iron Hand upon the People: The Law against the Potlatch on the Northwest Coast.* Vancouver: Douglas and McIntyre; Seattle: University of Washington Press.

Cole, Douglas, and David Darling. 1990. "History of the Early Period." In *Handbook of North American Indians.* Vol. 7, *Northwest Coast,* edited by Wayne Suttles, 119-34. Washington, DC: Smithsonian Institution Press.

*A Collection of the Acts Passed in the Parliament of Great Britain and of Other Public Acts Relative to Canada.* 1824. Quebec: P.E. Desbarats, King's Printer.

Collison, Nika. 2004. Foreword. In *Bill Reid and Beyond: Expanding on Modern Native Art,* edited by Karen Duffek and Charlotte Townsend-Gault, 1-2. Vancouver: Douglas and McIntyre.

—. 2006. "Everything Depends on Everything Else." In *Raven Travelling: Two Centuries of Haida Art,* edited by Daina Augaitis, 56-69. Vancouver: Vancouver Art Gallery; Douglas and McIntyre.

Collison, William Henry. 1916. *In the Wake of the War Canoe.* New York: E.P. Dutton.

Comaroff, Jean, and John L. Comaroff, eds. 2001. *Millennial Capitalism and the Culture of Neoliberalism.* Durham, NC: Duke University Press.

Commonwealth Association of Museums and University of Victoria. 1996. *Curatorship: Indigenous Perspectives in Post-Colonial Societies: Proceedings.* Mercury Series. Directorate 8. Gatineau, QC: Canadian Museum of Civilization, with the Commonwealth Association of Museums and the University of Victoria.

Conaty, Gerald T., and Robert R. Janes. 1997. "Issues of Repatriation: A Canadian View." *European Review of Native American Studies* 11, 2: 31-37.

*The Concise Oxford Dictionary of Art Terms.* 2001. Edited by Michael Clarke. Oxford: Oxford University Press (online).

Cook, James. 1785. *A Voyage to the Pacific Ocean, Undertaken, by the Command of His Majesty for Making Discoveries in the Northern Hemishpere (sic)...* 2nd ed. Vol. 2, bk. 4, chaps. 2-3. London: G. Nicol and T. Cadell.

Coombe, Rosemary J. 1997. "The Properties of Culture and the Possession of Identity:

Postcolonial Struggle and the Legal Imagination." In *Borrowed Power: Essays on Cultural Appropriation*, edited by Bruce Ziff and Pratima V. Rao, 74-96. New Brunswick, NJ: Rutgers University Press.

—. 1998. *The Cultural Life of Intellectual Properties: Authorship, Appropriation and the Law.* Durham, NC: Duke University Press.

Corbey, Raymond. 2003. "Destroying the Graven Image: Religious Iconoclasm on the Christian Frontier." *Anthropology Today* 19, 4: 10-14.

Corey, Peter L., ed. 1987. *Faces, Voices and Dreams: A Celebration of the Centennial of the Sheldon Jackson Museum, Sitka, Alaska 1888-1988.* Sitka: Division of Alaska State Museums and the Friends of the Alaska State Museum.

Coster, Esther A. 1916. "Decorative Value of American Indian Art." *American Museum Journal* 1: 301-7.

Coupland, Gary. 2006. "A Chief's House Speaks: Communicating Power on the Northern Northwest Coast." In *Household Archaeology on the Northwest Coast*, edited by Elizabeth A. Sobel, D. Ann Trieu Gahr, and Kenneth M. Ames, 80-96. Ann Arbor: International Monographs in Prehistory.

Cove, John J., and George F. MacDonald, eds. 1987. *Tsimshian Narratives, Collected by Marius Barbeau and William Beynon.* 2 vols. Mercury Series Directorate Paper No. 3. Ottawa: Canadian Museum of Civilization.

Cowling, Elizabeth. 1978. "The Eskimos, the American Indians and the Surrealists." *Art History* 1, 4: 484-500.

Cranmer, Barbara, dir. 2001. *Gwishalaayt: The Spirit Wraps around You.* Vancouver: Moving Images Distribution. DVD/VHS, 47 min.

Cranmer, Doug. 2004. "'Other-Side' Man." In *Bill Reid and Beyond: Expanding on Modern Native Art*, edited by Karen Duffek and Charlotte Townsend-Gault, 175-79. Vancouver: Douglas and McIntyre.

Cranmer Webster, Gloria. 1983. "Address, April 15." Typescript. *Legacy* exhibit files, Anthropology Section, Royal BC Museum.

—. 1985. "North-West Coast Cultural Revival." *Anthropology Today* 1, 6: 26-27.

—. 1991. "The Contemporary Potlatch." In *Chiefly Fiests: The Enduring Kwakiutl Potlatch*, edited by Aldona Jonaitis, 227-48. Vancouver: Douglas and McIntyre; Seattle: University of Washington Press.

—. 1992a. "Chiefly Feasts." *Curator* 35, 4: 248-54.

—. 1992b. "From Colonization to Repatriation." In *Indigena: Contemporary Native Perspectives*, edited by Gerald McMaster and Lee-Ann Martin, 25-37. Vancouver: Douglas and McIntyre.

—. 1995. "The Potlatch Collection Repatriation." In *Material Culture in Flux: Law and Policy of Repatriation of Cultural Property*. Special issue of *UBC Law Review*: 137-42.

Crosby, Marcia. 1991. "Construction of the Imaginary Indian." In *Vancouver Anthology: The Institutional Politics of Art*, edited by Stan Douglas, 266-91. Vancouver: Talonbooks.

—. 1994. "Indian Art/Aboriginal Title." MA thesis, University of British Columbia.

—. 1997. "Lines, Lineage and Lies, or Borders, Boundaries and Bullshit." In *Nations in Urban Landscapes: Faye HeavyShield, Shelley Niro, Eric Robertson*. Texts by Marcia Crosby and Paul Chaat Smith. Guest curated by Marcia Crosby. Vancouver: Contemporary Art Gallery.

—. 2004. "Haidas, Human Beings and Other Myths." In *Bill Reid and Beyond: Expanding on Modern Native Art*, edited by Karen Duffek and Charlotte Townsend-Gault, 108-30. Vancouver: Douglas and McIntyre.

Crosby, Thomas. 1907. *Among the An-Ko-Me-Nums or Flathead Tribes of the Pacific Coast.* Toronto: William Briggs.

—. 1914. *Up and down the North Pacific Coast by Canoe and Mission Ship.* Toronto: Missionary Society of the Methodist Church; Young People's Forward Movement Department.

Cruikshank, Julie. 1994. "Oral Tradition and Oral History: Reviewing Some Issues." *Canadian Historical Review* 18, 2: 147-67.

—. 1995. "Imperfect Translation: Rethinking Objects of Museum Collection." *Museum Anthropology* 19, 1: 25-38.

—. 2005. *Do Glaciers Listen? Local Knowledge, Colonial Encounters and Social Imagination.* Vancouver: UBC Press.

Culhane, Dara. 1998. *The Pleasure of the Crown: Anthropology, Law and First Nations.* Vancouver: Talonbooks.

Cutter, Donald C., ed. 1969. "Journal of Fray Juan Crespi Kept during the Same Voyage [of the *Santiago*] – Dated 5th October, 1774." In *The California Coast: A Bilingual Edition of Documents from the Sutro Collection,* translated and edited in 1891 by George Butler Griffin; re-edited with an emended translation, annotation, and preface, 201-78. Norman: University of Oklahoma Press.

Daftari, Fereshteh. 2006. *Without Boundary: Seventeen Ways of Looking; with an Essay by Homi Bhabha and Prose by Orhan Pamuk.* New York: Museum of Modern Art.

Dahl, G.B., and Ronald Stade. 2000. "Anthropology, Museums, and Contemporary Cultural Processes: An Introduction." *Ethos* 65, 2: 157-71.

Dall, William Healey. 1884. "On Masks, Labrets, and Certain Aboriginal Customs, with an Inquiry into the Bearing of Their Geographical Distribution." In *Third Annual Report of the Bureau of Ethnology to the Secretary of the Smithsonian Institution, 1881-1882,* J.W. Powell, Director, 73-203. Washington, DC: Government Printing Office.

Daly, Richard. 2005. *Our Box Was Full: An Ethnography for the Delgamuukw Plaintiffs.* Vancouver: UBC Press.

Darnell, Regna. 1999. "Theorizing the Americanist Tradition: Continuities from the B.A.E. to the Boasians." In *Theorizing the Americanist Tradition,* edited by Lisa Philips Valentine and Regna Darnell, 38-51. Toronto: University of Toronto Press.

—. 2000. "The Pivotal Role of the Northwest Coast in the History of Americanist Anthropology." *BC Studies* 125-26: 33-52.

Dauenhauer, Nora Marks. 1995. "Tlingit *At.óow:* Traditions and Concepts." In *The Spirit Within: Northwest Coast Native Art from the John H. Hauberg Collection,* edited by Steven C. Brown, 21-29. New York: Rizzoli; Seattle: Seattle Art Museum.

Dauenhauer, Nora Marks, and Richard Dauenhauer. 2003. "Louis Shotridge and Indigenous Tlingit Ethnography: Then and Now." In *Constructing Cultures Then and Now: Celebrating Franz Boas and the Jesup North Pacific Expedition,* edited by Laurel Kendal and Igor Krupnik, 165-84. Contributions to Circumpolar Anthropology 4. Washington, DC: Smithsonian Institution Press.

—, eds. 1987. *Haa Shuka, Our Ancestors: Tlingit Oral Narratives.* Seattle: University of Washington Press; Juneau: Sealaska Heritage Foundation.

—, eds. 1990. *Haa Tuwanáagu Yís, for Healing Our Spirit: Tlingit Oratory.* Seattle: University of Washington Press; Juneau: Sealaska Heritage Foundation.

—, eds. 1994. *Haa Kusteeyí, Our Culture: Tlingit Life Stories.* Seattle: University of Washington Press; Juneau: Sealaska Heritage Foundation.

David, Joe. 1978. Introduction. In *Northwest Coast Indian Artists Guild: 1978 Graphics Collection.* Ottawa: Canadian Indian Marketing Services.

Davidson, Robert. 2004. "The Present Moment: Conversations with *guud san glans,* Robert Davidson." In *Robert Davidson: The Abstract Edge,* edited by Karen Duffek, 9-45. Vancouver: UBC Museum of Anthropology.

—. 2013. "Da. a xiigang, Charles Edenshaw, 'Master Carpenter.'" In *Charles Edenshaw,* edited by Robin Wright and Daina Augaitis. Vancouver: Vancouver Art Gallery, 2013.

Dawn, Leslie. 1981. "K'san: Artistic, Museum, and Cultural Activity among the Gitksan Indians of the Upper Skeena River, 1920-1973." MA thesis, University of Victoria.

—. 1984. *The Northwest Coast Native Print: A Contemporary Tradition Comes of Age.* Victoria: Art Gallery of Greater Victoria.

—. 2006. *National Visions, National Blindness: Canadian Art and Identities in the 1920s.* Vancouver: UBC Press.

Day, Lois. 1985. "Canadian North-West Cultural Revival." *Anthropology Today* 1, 4: 16-18.

de la Cadena, Marisol, and Orin Starn, eds. 2007. *Indigenous Experience Today.* Oxford: Berg.

De Laguna, Frederica. 1972. *Under Mount Saint Elias: The History and Culture of the Yakutat Tlingit.* 3 vols. Smithsonian Contributions to Anthropology 7. Washington, DC: Smithsonian Institution Press.

Delgam Uukw. 1992. "Delgam Uukw Speaks." In *The Spirit in the Land: The Opening Statement of the Gitksan and Wet'suwet'en Hereditary Chiefs in the Supreme Court of British Columbia,* by Gitksan and Wet'suwet'en Hereditary Chiefs, 7-9. Gabriola, BC: Reflections.

Deloria, Philip. 1998. *Playing Indian.* New Haven, CT: Yale University Press.

Deleuze, Gilles. 1994. *Difference and Repetition.* New York: Columbia University Press.

DeMott, Barbara, and Maureen Milburn. 1989. *Beyond the Revival: Contemporary North West Native Art.* Vancouver: Charles H. Scott Gallery.

Derrida, Jacques. 1996. *Archive Fever: A Freudian Impression.* Translated by Eric Prenowitz. Chicago: University of Chicago Press.

Dixon, E. James. 2000. "Archaeological Research Gives Clues about Life in Southeast Alaska Four Hundred Generations Ago." In *Celebration 2000: Restoring Balance through Culture,* edited by Susan W. Fair and Rosita Worl, 55-58. Juneau: Sealaska Heritage Foundation.

Dobkins, Rebecca J. 2004. "Art." In *Companion to the Anthropology of America Indians,* edited by Thomas Biolsi, 212-28. Oxford: Blackwell Publishing.

Dombrowski, Kirk. 2002. *Against Culture: Development, Politics, and Religion in Indian Alaska.* Lincoln: University of Nebraska Press.

Dominguez, Virginia. 1986. "The Marketing of Heritage." *American Ethnologist* 13, 3: 546-55.

Donald, Leland, and Donald H. Mitchell. 1975. "Some Correlates of Local Group Rank among the Southern Kwakiutl." *Ethnology* 14, 4: 325-46.

Dorsey, George. 1899. "Notes on the Anthropological Museums of Central Europe." *American Anthropologist* n.s. 1: 462-74.

—. 1900. "The Department of Anthropology of the Field Columbian Museum – A Review of Six Years." *American Anthropologist* n.s. 2: 247-65.

—. 1901. "Recent Progress in Anthropology at the Field Columbian Museum." *American Anthropologist* n.s. 3: 737-50.

Douglas, Fredric H., and Rene d'Harnoncourt. 1941. *Indian Art of the United States.* New York: Museum of Modern Art.

Douglas, Stan, ed. 1991. *Vancouver Anthology: The Institutional Politics of Art.* Vancouver: Talonbooks.

Dowell, Kristin. 2006. "Indigenous Media Gone Global: Strengthening Indigenous Identity On- and Offscreen at the First Nations/First Features Film Showcase." *American Anthropologist* 108, 2: 376-84.

—. 2013. *Sovereign Screens: Aboriginal Media on the Canadian West Coast*. Lincoln: University of Nebraska Press.

Doxtator, Deborah. 1992. *Revisions: Essays*. Banff: Walter Phillips Gallery.

—. 1996. "Implications of Canadian Nationalism for Aboriginal Cultural Autonomy." In *Curatorship: Indigenous Perspectives in Post-Colonial Societies*, edited by Commonwealth Association of Museums and University of Victoria, 56-76. Gatineau, QC: Canadian Museum of Civilization, with the Commonwealth Association of Museums and University of Victoria.

—. 1997. "'Godi'nigoha': The Women's Mind and Seeing through to the Land." In *Godi'nigoha': The Women's Mind*. Brantford, ON: Woodland Cultural Centre.

Drew, Leslie A. 1971. "Indian Concert Bands." *The Beaver* 302, 1: 26-29.

Driver, Harold E. 1961. *Indians of North America*. Chicago: University of Chicago Press.

Drucker, Philip. 1939. "Rank, Wealth and Kinship in Northwest Coast Society." *American Anthropologist* n.s. 41, 1: 55-65.

—. 1943. *Archeological Survey on the Northern Northwest Coast*. Washington, DC: US Government Printing Office.

—. 1951. *The Northern and Central Nootkan Tribes*. Smithsonian Institution Bureau of American Ethnology Bulletin 144. Washington, DC: US Government Printing Office.

—. (1955) 1963. *Indians of the Northwest Coast*. Garden City, NY: Natural History Press.

—. 1958. *The Native Brotherhoods: Modern Intertribal Organizations on the Northwest Coast*. Smithsonian Institution Bureau of American Ethnology Bulletin 168. Washington, DC: US Government Printing Office.

—. 1965. *Cultures of the North Pacific Coast*. New York: Harper and Row.

Drucker, Philip, and Robert F. Heizer. 1967. *To Make My Name Good: A Reexamination of the Southern Kwakiutl Potlatch*. Berkeley: University of California Press.

Dubin, Margaret. 1999. "Sanctioned Scribes: How Critics and Historians Write the Native American Art World." In *Native American Art in the Twentieth Century*, edited by W. Jackson Rushing III, 149-66. London: Routledge.

—. 2001. *Native America Collected: The Culture of an Art World*. Albuquerque: University of New Mexico Press.

Dubuc, Élise. 2006. "Canada's New Aboriginal Museology." *Muse* 24, 6: 20-25.

Duff, Wilson. 1952. *The Upper Stalo*. Anthropology in BC, Memoir No. 1. Victoria: British Columbia Provincial Museum.

—. 1953. "Potlatch Transcript. Mungo Martin's Thunderbird Park Potlatch, December 13-15, 1953." Unpublished typescript. Royal British Columbia Museum, Victoria.

—. 1954. "A Heritage in Decay: The Totem Art of the Haidas." *Canadian Art* 11, 2: 56-59.

—. 1955. "Unique Stone Artifacts from the Gulf Islands." *Provincial Museum of Natural History and Anthropology, Report for the Year 1955*. Victoria: Province of British Columbia, Department of Education.

—. 1956. "Prehistoric Stone Sculpture of the Fraser River and Gulf of Georgia." *Anthropology in British Columbia* 5: 15-151.

—, ed. 1959a. *Histories, Territories and Laws of the Kitwancool*. Anthropology in BC, Memoir No. 4. Victoria: British Columbia Provincial Museum.

—. 1959b. "Mungo Martin, Carver of the Century." *Museum News* 1, 1: 3-8.

—. 1963. "Stone Clubs from the Skeena River Area." *Provincial Museum of Natural History and Anthropology, Report for the Year 1962*, 27-38. Victoria: Province of British Columbia, Department of Education.

—. 1964a. "Contributions of Marius Barbeau to Westcoast Ethnology." *Anthropologica* n.s. 6, 1: 63-96.

—. 1964b. *The Indian History of British Columbia.* Vol. 1, *The Impact of the White Man.* Anthropology in BC, Memoir No. 5. Victoria: British Columbia Provincial Museum.

—, ed. 1967. *Arts of the Raven: Masterworks by the Northwest Coast Indian.* Vancouver: Vancouver Art Gallery.

—. 1975. *Images: Stone: BC – Thirty Centuries of Northwest Coast Indian Sculpture. An Exhibition Originating at the Art Gallery of Greater Victoria.* Saanichton, BC: Hancock House.

—. 1983. "A World Is as Sharp as a Knife: Meaning in Northern Northwest Coast Art." In *Indian Art Traditions of the Northwest Coast,* edited by Roy L. Carlson, 47-66. Burnaby, BC: Archaeology Press, Simon Fraser University.

—. 1996. *Bird of Paradox: The Unpublished Writings of Wilson Duff.* Surrey, BC: Hancock House.

Duffek, Karen. 1983a. "Authenticity and the Contemporary Northwest Coast Indian Art Market." *BC Studies* 57: 99-111.

—. 1983b. "The Contemporary Northwest Coast Indian Art Market." MA thesis, University of British Columbia.

—. 1983c. *A Guide to Buying Northwest Coast Indian Arts.* Museum Note 10. Vancouver: UBC Museum of Anthropology.

—. 1983d. "The Revival of Northwest Coast Indian Art." In *Vancouver: Art and Artists 1931-1983,* 312-17. Vancouver: Vancouver Art Gallery.

—. 2000. "*Tla-Kish-Wha-to-Ah,* Stands with His Chiefs: From an Interview with Joe David." In *Nuu-Chah-Nulth Voices, Histories, Objects and Journeys,* edited by Alan L. Hoover, 352-62. Victoria: Royal British Columbia Museum.

—. 2004a. "On Shifting Ground: Bill Reid at the Museum of Anthropology." In *Bill Reid and Beyond: Expanding on Modern Native Art,* edited by Karen Duffek and Charlotte Townsend-Gault, 71-92. Vancouver: Douglas and McIntyre.

—, ed. 2004b. *Robert Davidson: The Abstract Edge.* Museum Note 38. Vancouver: UBC Museum of Anthropology, in association with the National Gallery of Canada.

—. 2005. "Indigenous Knowledge and the Formal Analysis of Northwest Coast Art." Paper presented at the conference of the Native American Art Studies Association, Scottsdale, AZ, 26-29 October.

—. 2006. "Bridging Knowledge Communities at the UBC Museum of Anthropology." Paper presented at the annual conference of the International Council of Museums' International Committee of University Museums and Collections (UMAC), New Roads for University Museums, Mexico City, 26-29 September. On the website of ICOM (International Committee of Museums), http://publicus.culture.hu-berlin.de/umac/2006.

Duffek, Karen, and Tom Hill. 1989. *Beyond History.* Vancouver: Vancouver Art Gallery.

Duffek, Karen, and Charlotte Townsend-Gault, eds. 2004. *Bill Reid and Beyond: Expanding on Modern Native Art.* Vancouver: Douglas and McIntyre.

Duncan, Carol. 1991. "Art Museums and the Ritual of Citizenship." In *Exhibiting Cultures: The Poetics and Politics of Museum Display,* edited by Ivan Karp and Steven D. Lavine, 88-103. Washington, DC: Smithsonian Institution Press.

Duncan, Kate C. 2000. *1001 Curious Things: Ye Olde Curiosity Shop and Native American Art.* Seattle: University of Washington Press.

Durlach, Theresa Mayer. 1928. *The Relationship Systems of the Tlingit, Haida, and Tsimshian.* Publications of the American Ethnological Society 11. New York: Stechert.

Duthuit, Georges. 1974. "Le don indien sur la côte Nord-Ouest de l'Amérique (Colombie britannique)." In *Représentation and présence: Premiers écrits et travaux 1923-1952,* 315-19. Paris: Flammarion. Originally published in the Surrealist journal *Labyrinthe* 18 (1946).

Elkins, James, ed. 2007. *Is Art History Global?* New York: Routledge.

Ellis, Bill. 1978. *First Annual Collection, 'Ksan 1978 Original Graphics.* Vancouver: Children of the Raven Publishing.

Ellis, David W., and Luke Swan. 1981. *Teachings of the Tides: Uses of Marine Invertebrates by the Manhousat People.* Nanaimo: Theytus Books.

Ellis, Donald, ed. 2007. *Tsimshian Treasures: The Remarkable Journey of the Dundas Collection.* Dundas, ON: Donald Ellis Gallery; Vancouver: Douglas and McIntyre; Seattle: University of Washington Press.

Emmons, George T. 1903. *The Basketry of the Tlingit.* In *Memoirs of the American Museum of Natural History.* Vol. 3, part 2, Jesup North Pacific Expedition, 229-77. New York: American Museum of Natural History.

—. 1907. *The Chilkat Blanket.* With notes on the blanket designs by Franz Boas. In *Memoirs of the American Museum of Natural History.* Vol. 3, part 4, Jesup North Pacific Expedition, 329-401. New York: American Museum of Natural History.

—. 1916. "Whale House of the Chilkat." *American Museum of Natural History Anthropological Papers* 19, 1: 1-33.

—. 1991. *The Tlingit Indians.* Edited with additions by Frederica de Laguna. Vancouver: Douglas and McIntyre.

Erikson, Patricia Pierce. 2004. "'Defining Ourselves through Baskets': Museum Autoethnography and the Makah Cultural and Research Center." In *Coming to Shore: Northwest Coast Ethnology, Traditions, and Visions,* edited by Marie Mauzé, Michael Harkin, and Sergei Kan, 339-61. Lincoln: University of Nebraska Press.

Erikson, Patricia Pierce, with Helma Ward and Kirk Wachendorf. 2002. *Voices of a Thousand People: The Makah Cultural and Research Center.* Lincoln: University of Nebraska Press.

Errington, Shelly. 1998. *The Death of Authentic Primitive Art and Other Tales of Progress.* Berkeley: University of California Press.

Euripides. 1891. *The Plays of Euripides.* Translated by E.P. Coleridge. London: George Bell and Sons.

Fabian, Johannes. 1983. *Time and the Other: How Anthropology Makes Its Object.* New York: Columbia University Press.

Fair, Susan W., and Rosita Worl, eds. 2000. *Celebration: Restoring Balance through Culture.* Juneau: Sealaska Heritage Foundation.

Farber, Carole, and Joan Ryan. 1983. "Report: National Native Indian Artists Symposium." Unpublished report for symposium at Hazelton, BC, 25-30 August.

Farrand, Livingston. 1900. *Basketry Designs of the Salish Indians.* In *Memoirs of the American Museum of Natural History.* Vol. 1, part 5, Jesup North Pacific Expedition, edited by Franz Boas, 391-99, plus plates. New York: American Museum of Natural History.

Feder, Norman. 1983. "Incised Relief Carving of the Halkomelem and Straits Salish." *American Indian Art Magazine* 8, 2: 46-55.

Feest, Christian. 1980. *Native Arts of North America.* New York: Oxford University Press.

—. 1995. "'Repatriation': A European View on the Question of Restitution of Native American Artifacts." *European Review of Native American Studies* 9, 2: 3-42.

Ferguson, Wallace K. 1948. *The Renaissance in Historical Thought: Five Centuries of Interpretation.* Boston: Houghton Mifflin.

Fienup-Riordan, Ann. 1999. "Collaboration on Display: A Yup'ik Eskimo Exhibit at Three National Museums." *American Anthropologist* 101, 2: 339-58.

*First Nations Drum.* 2000. "Barb Cranmer: Messenger of Stories." December, http://firstnationsdrum.com/2000/12/barb-cranmer-messenger-of-stories/.

—. 2001. "Gwishalaayt – The Spirit Wraps around You." December, http://firstnationsdrum. com/2001/12/gwishalaayt-the-spirit-wraps-around-you/.

Fisher, Robin. 1977. "Missions to the Indians of British Columbia." In *Early Indian Village Churches,* edited by J. Veillette and G. White, 1-11. Vancouver: UBC Press.

—. 1992. *Contact and Conflict: Indian-European Relations in British Columbia 1774-1890.* 2nd ed. Vancouver: UBC Press. First published 1977.

Fladmark, Knut. 1975. *A Paleoecological Model for Northwest Coast Prehistory.* Mercury Series, Archaeological Survey of Canada No. 43. Ottawa: National Museum of Canada.

—. 1979a. "The Early Prehistory of the Queen Charlotte Islands." *Archaeology* 32, 2: 38-45.

—. 1979b. "Routes: Alternate Migration Corridors for Early Man in North America." *American Antiquity* 44, 1: 55-69.

—. 1982. "An Introduction to the Prehistory of British Columbia." *Canadian Journal of Archaeology* 6: 95-156.

—. 1986. *British Columbia Prehistory.* Canadian Prehistory Series. Ottawa: Archaeological Survey of Canada, National Museum of Man, National Museum of Canada.

—. 1990. "Possible Early Human Occupation of the Queen Charlotte Islands, British Columbia." *Canadian Journal of Archaeology* 14: 183-97.

—. 1993. "Changing Times: British Columbia Archaeology in the 1980s." *BC Studies* 99: 140-83.

Flam, Jack, with Miriam Deutch. 2003. *Primitivism and Twentieth Century Art: A Documentary History.* Berkeley: University of California Press.

Flanagan, Tom. 2000. *First Nations? Second Thoughts.* Montreal: McGill-Queen's University Press.

Fleurieu, Charles Pierre Claret. 1801. *A Voyage round the World, Performed during the Years 1790, 1791, and 1792, by Étienne Marchand, Preceded by a Historical Introduction, and Illustrated by Charts, etc.* Vol. 1. Translated by C.P. Claret Fleurieu. London: T.N. Longman.

Ford, Ashley. 1979. "Indian Art Attracts Investment Interest." *Financial Post,* 3 November, W5.

Ford, Clellan Stearns, ed. (1941) 1968. *Smoke from Their Fires: The Life of a Kwakiutl Chief.* Hamden, CT: Archon Books. Originally published by Yale University Press.

Foster, Hal, ed. 1983. *The Anti-Aesthetic: Essays on Postmodern Culture.* Port Townsend, WA: Bay Press.

—. 1996. *The Return of the Real.* Cambridge, MA: MIT Press.

—. 1999. *Recodings: Art, Spectacle, Cultural Politics.* New York: New Press.

Foucault, Michel. 1980. *Power/Knowledge: Selected Interviews and Other Writings, 1972-1977,* edited by Colin Gordon. New York: Pantheon Books.

Francis, Daniel. 1992. *The Imaginary Indian: The Image of the Indian in Canadian Culture.* Vancouver: Arsenal Pulp Press.

Frank, Gloria Jean. 2000. "'That's My Dinner on Display': A First Nations Reflection on Museum Culture." *BC Studies* 125-26: 163-78.

Frazer, James. (1890) 1935. *The Golden Bough: A Study in Magic and Religion.* London: Macmillan.

Fried, Michael. 1964. "Modernist Painting and Formal Criticism." *American Scholar* 33: 642-48.

*From Time before Memory: The People of K'amligihah'haahl.* Ca. 1996. New Aiyansh, BC: Nisga'a Language and Culture Department, School District No. 92.

Froschauer, Toby. 2007. "The Canadian Northwest Coast Indigenous Art Market: An Analysis of Supply and Demand." MA thesis, Sotheby's Institute/University of Manchester.

Gallery of Tribal Art. 1992. *Robert Davidson: A Voice from the Inside.* Vancouver: Gallery of Tribal Art.

Gardner, Helen Bethea. 2006. *Gathering for God: George Brown in Oceania*. Dunedin: Otago University Press.

Garfield, Viola Edmundson, and Pamela Amoss. 1984. "Erna Gunther (1896-1982)." *American Anthropologist* 86, 2: 394-99.

Garfield, Viola Edmundson, and Paul S. Wingert. 1951. *The Tsimshian Indians and Their Arts. The Tsimshian and Their Neighbors*. Seattle: University of Washington Press.

Geertz, Clifford. 1973. "The Cerebral Savage: On the Work of Claude Lévi-Strauss." In *The Interpretation of Cultures*, 345-59. New York: Basic Books.

Geismar, Haidy. 2013. *Treasured Possessions: Indigenous Interventions into Cultural and Intellectual Property*. Durham, NC: Duke University Press.

Gell, Alfred. 1992. "The Technology of Enchantment and the Enchantment of Technology." In *Anthropology, Art, and Aesthetics*, edited by Jeremy Coote and Anthony Shelton, 40-63. Oxford: Oxford University Press.

—. 1998. *Art and Agency: An Anthropological Theory*. Oxford: Clarendon Press.

George, Chief Dan. 1967. "Lament for Confederation." Canada History website (Canada History Society), http://www.canadahistory.com/sections/documents/Native/docs-chiefdangeorge.htm.

George, Earl Maquinna. 2003. *Living on the Edge: Nuu-Chah-Nulth History from an Ahousat Chief's Perspective*. Winlaw, BC: Sono Nis Press.

George, Janice, and Leslie Tepper. 2008. *Coast Salish Weaving*. Gatineau, QC: Canadian Museum of Civilization. CD-ROM.

Gerber, Peter R., and Vanina Katz-Lahaigue. 1989. *Susan A. Point, Joe David, Lawrence Paul: Indianische Künstler der Westküste Kanadas. Native Artists from the Northwest Coast*. Zurich: Ethnological Museum of the University of Zurich.

Gessler, Trisha. 1981. *The Art of Nunstins*. [British Columbia]: Queen Charlotte Islands Museum.

Gibbons, Jacqueline A. 1997. "The Museum as Contested Terrain: The Canadian Case." *Journal of Art Management, Law, and Society* 26, 4: 309-14.

Gibson, James R. 1993. "A Notable Absence: The Lateness and Lameness of Russian Discovery and Exploration in the North Pacific, 1639-1803." In *From Maps to Metaphors: The Pacific World of George Vancouver*, edited by Robin Fisher and Hugh Johnston, 85-103. Vancouver: UBC Press.

Giddens, Anthony. 1984. *The Constitution of Society: Outline of the Theory of Structuration*. Berkeley: University of California Press.

gii-dahl-guud-sliiaay (Terri-Lynn Williams). 1995. "Cultural Perpetuation: Repatriation of First Nations Cultural Heritage." In *Material Culture in Flux: Law and Policy of Repatriation of Cultural Property*. Special issue of *UBC Law Review*: 183-202.

Ginsburg, Faye. 1991. "Indigenous Media: Faustian Contract or Global Village?" *Cultural Anthropology* 6, 1: 92-111.

—. 1997. "'From Little Things Big Things Grow': Indigenous Media and Cultural Activism." In *Between Resistance and Revolution: Culture and Social Protest*, edited by Richard G. Fox and Orin Starn Fox, 118-44. New Brunswick, NJ: Rutgers University Press.

—. 2002. "Screen Memories: Resignifying the Traditional in Indigenous Media." In *Media Worlds: Anthropology on New Terrain*, edited by Faye Ginsburg, Lila Abu-Lughod, and Brian Larkin, 39-58. Berkeley: University of California Press.

—. 2003. "Atanarjuat Off-Screen: From 'Media Reservations' to the World Stage." *American Anthropologist* 105, 4: 827-31.

Ginsburg, Faye, Lila Abu-Lughod, and Brian Larkin. 2002. *Media Worlds: Anthropology on New Terrain*. Berkeley: University of California Press.

Glass, Aaron. 2002. "(Cultural) Objects of (Cultural) Value: Commodification and the Development of a Northwest Coast Artworld." In *On Aboriginal Representation in the Gallery*, edited by Lynda Jessup and Shannon Bagg, 93-114. Hull, QC: Canadian Museum of Civilization.

—. 2004a. "Return to Sender: On the Politics of Cultural Property and the Proper Address of Art." In *Beyond Art/Artifact/Tourist Art: Social Agency and the Cultural Value(s) of Objects*, edited by Nelson H.H. Graburn and Aaron Glass. Special issue of *Journal of Material Culture* 9, 2: 115-39.

—. 2004b. "Was Bill Reid the Fixer of a Broken Culture or a Culture Broker?" In *Bill Reid and Beyond: Expanding on Modern Native Art*, edited by Karen Duffek and Charlotte Townsend-Gault, 190-206. Vancouver: Douglas and McIntyre.

—. 2006a. "The Art of Articulation: The Legacy of Mungo Martin, Kwakwaka'wakw Culture Broker." Paper presented at the American Anthropological Association meeting, San Jose.

—. 2006b. "Conspicuous Consumption: An Intercultural History of the Kwakwaka'wakw Hamat'sa." PhD diss., New York University.

—. 2006c. "From Cultural Salvage to Brokerage: The Mythologization of Mungo Martin and the Emergence of Northwest Coast Art." *Museum Anthropology* 29, 1: 20-43.

—. 2008. "Crests on Cotton: Souvenir T-Shirts and the Materiality of Remembrance among the Kwakwaka'wakw of British Columbia." *Museum Anthropology* 31: 1-18.

—. 2011. "Objects of Exchange: Material Culture, Colonial Encounter, Indigenous Modernity." In *Objects of Exchange: Social and Material Transformation on the Late Nineteenth-Century Northwest Coast*, edited by Aaron Glass, 3-35. New York: Bard Graduate Center: Decorative Arts, Design History, Material Culture.

Godelier, Maurice. 1977. *Perspectives in Marxist Anthropology*. Cambridge, UK: Cambridge University Press.

—. 1999. *The Enigma of the Gift*. Translated by Nora Scott. Chicago: University of Chicago Press. Originally published in 1996 as *L'enigme du don* (Paris: Flammarion).

Goldman, Irving. 1975. *The Mouth of Heaven: An Introduction to Kwakiutl Religious Thought*. Toronto: John Wiley and Sons.

Goldwater, Robert. 1986. *Primitivism in Modern Art*. Cambridge, MA: Belknap Press.

Gough, Kathleen. 1968. "New Proposals for Anthropologists." *Current Anthropology* 9(5): 403-5).

Graburn, Nelson H.H. 1968. "Art and Acculturative Process." *International Social Science Journal* 21, 3: 457-68.

—. 1976. *Ethnic and Tourist Arts: Cultural Expressions from the Fourth World*. Berkeley and Los Angeles: University of California Press.

—. 1999. "Ethnic and Tourist Arts Revisited." In *Unpacking Culture: Art and Commodity in the Colonial and Postcolonial Worlds*, edited by Ruth B. Phillips and Christopher Steiner, 335-53. Berkeley: University of California Press.

Graburn, Nelson H.H., and Aaron Glass, eds. 2004. *Beyond Art/Artifact/Tourist Art: Social Agency and the Cultural Value(s) of Objects*. Special issue of *Journal of Material Culture* 9, 2.

Grant, John W. 1984. *Moon of Wintertime: Missionaries and the Indians of Canada in Encounter since 1534*. Toronto: University of Toronto Press.

Greenberg, Clement. (1960) 1966. "Modernist Painting." In *The New Art: A Critical Anthology*, 100-10. New York: E.P. Dutton.

Gregory, Derek. 1994. *Geographical Imaginations*. Cambridge, MA: Blackwell.

Griaule, Marcel. 1950. *Arts of the African Native*. London: Thames and Hudson.

Griffin, Rachel Goddard. 2006. "The Art of Native Life along the Pacific Coast." *Anthropology News* (March): 42-43.

Gruber, Jacob. 1970. "Ethnographic Salvage and the Shaping of Anthropology." *American Anthropologist* 72, 6: 1289-99.

Gunther, Erna. 1956. "The Social Disorganization of the Haida as Reflected in Their Slate Carving." *Davidson Journal of Anthropology* 2, 2: 149-53.

—. 1962. "Northwest Coast Indian Art." Catalogue of the exhibit at the Seattle World's Fair Fine Arts Pavilion. Reprinted in *Anthropology and Art*, edited by C. Otten, 318-40. Garden City, NY: Natural History Press, 1971.

—. 1966. *Art in the Life of the Northwest Coast Indians: With a Catalog of the Rasmussen Collection of Northwest Indian Art at the Portland Art Museum*. Portland: Portland Art Museum.

—. 1972. *Indian Life on the Northwest Coast of North America, as Seen by the Early Explorers and Fur Traders during the Last Decades of the Eighteenth Century*. Chicago: University of Chicago Press.

Gustafson, Paula. 1980. *Salish Weaving*. Vancouver: Douglas and McIntyre; Seattle: University of Washington Press.

Guujaaw. 2004. "Man, Myth or Magic?" In *Bill Reid and Beyond: Expanding on Modern Native Art*, edited by Karen Duffek and Charlotte Townsend-Gault, 61-63. Vancouver: Douglas and McIntyre.

Gupta, Akhil, and James Ferguson. 1997. *Culture, Power, Place: Explorations in Critical Anthropology*. Durham, NC: Duke University Press.

Haas, Jonathan. 1996. "Power, Objects and a Voice for Anthropology." *Current Anthropology* 37 (Supplement, February): S1-S22.

Haberland, Wolfgang. 1979. *Donnervogel und Raubwal: Die indianische Kunst der Nordwestküste Nordamerikas*. Hamburg: Hamburgisches Museum für Völkerkunde and Christians Verlag.

Haeberlin, Herman Karl. 1918. "Principles of Esthetic Form in the Art of the North Pacific Coast: A Preliminary Sketch." *American Anthropologist* 20: 258-64.

Haeberlin, Herman Karl, James Teit, and Helen Roberts. 1928. *Coiled Basketry in British Columbia and Surrounding Region*. In *Forty-First Annual Report of the Bureau of American Ethnology*, 119-484. Washington, DC: US Government Printing Office.

Haggarty, James C. 1978. Foreword. In *An Earlier Population of Hesquiaht Harbour, British Columbia: A Contribution to Nootkan Osteology and Physical Anthropology*, edited by Jerome S. Cybulski, 3-4. British Columbia Provincial Museum Cultural Recovery Paper No. 1. Physical Anthropology Contribution No. 1 of the Hesquiaht Cultural Committee. Victoria: Ministry of the Provincial Secretary and Travel Industry, Province of British Columbia.

Hale, Horatio. 1846. "Northwestern America." In *Ethnography and Philology*. Vol. 6 of the *United States Exploring Expedition*, 197-225. Philadelphia: C. Sherman.

Hall, Edwin S., Jr. 1980. "The Marketing of a Tradition: The Northwest Coast Indian Artists Guild." Paper delivered at the symposium New Directions in Native American Art History, Albuquerque, 24-26 October.

Hall, Edwin S., Jr., Margaret B. Blackman, and Vincent Rickard. 1981. *Northwest Coast Indian Graphics: An Introduction to Silk Screen Prints*. Vancouver: Douglas and McIntyre; Seattle: University of Washington Press.

Hall, Stuart, ed. 1997. *Representation: Cultural Representations and Signifying Practices*. London: Sage.

Halpin, Marjorie M. 1973. "The Tsimshian Crest System: A Study Based on Museum Specimens and the Marius Barbeau and William Beynon Field Notes." PhD diss., University of British Columbia.

—. 1978. "Some Implications of Connoisseurship for Northwest Coast Art: A Review Article." *BC Studies* 37: 48-59.

—. 1979. *Cycles: The Graphic Art of Robert Davidson, Haida*. Museum Note 7. Vancouver: UBC Museum of Anthropology.

—. 1981. *Totem Poles*. Vancouver: UBC Press.

—. 1994. "A Critique of the Boasian Paradigm for Northwest Coast Art." *Culture* 14, 1: 5-16.

Halpin, Marjorie M., and Michael M. Ames. 1980. *Manlike Monsters on Trial: Early Records and Modern Evidence*. Vancouver: UBC Press.

Hamilton, Ron. 1994. *We Sing to the Universe: Poems by Ron Hamilton*. Vancouver: UBC Museum of Anthropology.

Handler, Richard. 1988. *Nationalism and the Politics of Culture in Quebec*. Madison: University of Wisconsin Press.

—. 1992. "On the Valuing of Museum Objects." *Museum Anthropology* 6, 1: 21-28.

—. 1997. "Cultural Property, Culture Theory and Museum Anthropology." *Museum Anthropology* 21, 3: 3-4.

Hann, C.M. 1998. "Introduction: The Embeddedness of Property." In *Property Relations: Renewing the Anthropological Tradition*, edited by C.M. Hann, 1-47. Cambridge, UK: Cambridge University Press.

Hare, Jan, and Jean Barman. 2006. *Good Intentions Gone Awry: Emma Crosby and the Methodist Mission on the Northwest Coast*. Vancouver: UBC Press.

Harkin, Michael E. 1996. "Past Presence: Conceptions of History in Northwest Coast Studies." *Arctic Anthropology* 33, 2: 1-15.

—. 1999. "From Totems to Derrida: Postmodernism and Northwest Coast Ethnology." *Ethnohistory* 46, 4: 817-30.

—. 2005. "Object Lessons: The Question of Cultural Property in the Age of Repatriation." *Journal de la Société des Américanistes* 91, 2: 9-29.

Harries, Patrick. 2005. "Anthropology." In *Missions and Empire*, edited by N. Etherington, 238-60. Oxford: Oxford University Press.

Harris, Cole. 2002. *Making Native Space: Colonialism, Resistance, and Reserves in British Columbia*. Vancouver: UBC Press.

Harrison, Charles. 1925. *Ancient Warriors of the North Pacific: The Haidas, Their Laws, Customs and Legends, with Some Historical Account of the Queen Charlotte Islands*. London: H.F. and G. Witherby.

Harrison, Charles, and Paul Wood, eds. 1992. *Art in Theory, 1900-1990: An Anthology of Changing Ideas*. Oxford: Blackwell.

Harrison, Julia. 1988. "'The Spirit Sings' and the Future of Anthropology." *Anthropology Today* 4, 6: 6-9.

—. 1992a. Introduction. In *Turning the Page: Forging New Partnerships between Museums and First Peoples*. Task Force Report on Museums and First Peoples. Ottawa: Assembly of First Nations and the Canadian Museums Association.

—. 1992b. "Turning the Page: Forging New Partnerships between Museums and First Peoples Conference – Personal Reflections." *Alberta Museums Review* 18, 2: 10-12.

—. 1993. "Completing a Circle: The Spirit Sings." In *Anthropology, Public Policy and Native Peoples in Canada*, edited by Noel Dyck and James B. Waldram, 334-58. Montreal: McGill-Queen's University Press.

—. 2005a. "Shaping Collaboration: Considering Institutional Culture." *Museum Management and Curatorship* 20: 195-212.

—. 2005b. "What Matters: Seeing the Museum Differently." *Museum Anthropology* 28, 2: 31-42.

Harrison, Julia, Bruce Trigger, and Michael Ames. 1988. "Point/Counterpoint: 'The Spirit Sings' and the Lubicon Boycott." *Muse* 6, 3: 12-16.

Harrison, Klisala. 2002. "The Kwagiulth Dancers: Addressing Intellectual Property Issues at Victoria's First Peoples Festival." *World of Music* 44, 1: 137-51.

Harper, J. Russell, ed. 1971. *Paul Kane's Frontier; Including* Wanderings of an Artist among the Indians of North America, *by Paul Kane.* Edited with a biographical introduction and a catalogue raisonné. Austin: University of Texas Press, for the Amon Carter Museum, Fort Worth, and the National Gallery of Canada.

Hawker, Ronald William. 1991. "A Faith of Stone: Gravestones, Missionaries, and Culture Change and Continuity among British Columbia's Tsimshian Indians." *Journal of Canadian Studies* 26, 3: 80-101.

—. 2003. *Tales of Ghosts: First Nations Art in British Columbia, 1922-61.* Vancouver: UBC Press.

Hawthorn, Audrey. 1952. "Totem Pole Carver." *The Beaver* 2: 3-6.

—. 1963a. "A Living Haida Craft: Some Traditional Carvings for Our Times." *The Beaver* 294: 4-11.

—. 1963b. *Kwakiutl Art: The Art of Chief Henry Speck.* Vancouver: BC Indian Designs.

—. 1964. "Mungo Martin: Artist and Craftsman." *The Beaver* 295: 18-23.

—. 1967. *The Art of the Kwakiutl Indians and Other Northwest Coast Tribes.* Seattle: University of Washington Press.

—. 1971. "Memorial to Mungo Martin." *Beautiful British Columbia* 12, 4: 30-35.

—. 1979. *Kwakiutl Art.* Seattle: University of Washington Press.

—. 1993. *A Labour of Love. The Making of the Museum of Anthropology, UBC: The First Three Decades 1947-1976.* Museum Note 33. Vancouver: UBC Museum of Anthropology.

Hawthorn, Audrey, and B. Hill-Tout. 1955. *Making a Totem Pole.* Vancouver: University of British Columbia. Film, 23 min.

Hawthorn, Harry B. 1961. "The Artist in Tribal Society: The Northwest Coast." In *The Artist in Tribal Society,* edited by M. Smith, 59-70. New York: Free Press.

—, ed. 1966-67. *A Survey of the Contemporary Indians of Canada: A Report on Economic, Political, Educational Needs and Policies, in Two Volumes.* Ottawa: Indian Affairs Branch.

Hawthorn, Harry B., BC Indian Arts and Welfare Society, British Columbia Provincial Museum, eds. 1948. *Report on Conference on Native Indian Affairs at Acadia Camp, University of British Columbia, Vancouver, B.C., April 1, 2 and 3, 1948.* Victoria: Indian Arts and Welfare Society.

Hawthorn, Harry B., Cyril S. Belshaw, and Stuart M. Jamieson. 1955. *The Indians of British Columbia: A Survey of Social and Economic Conditions. A Report to the Minister of Citizenship and Immigration.* Vol. 2. Vancouver: University of British Columbia.

—. 1958. *The Indians of British Columbia: A Study of Contemporary Social Adjustment.* Toronto: University of Toronto Press.

Hennessy, Kate. 2005. "Decolonize Your Mind." http://www.katehennessy.com/decolonize/dindex.html.

Henry, John Frazier. 1984. *Early Maritime Artists of the Pacific Northwest Coast, 1741-1841.* Seattle: University of Washington Press.

Hill, Lynn. 2000. "Curator's Statement." In *Raven's Reprise.* Museum Note 36b. Vancouver: UBC Museum of Anthropology.

Hill, Thomas H., Georges Erasmus, and David W. Penney. 1992. "Museums and First Peoples in Canada." *Museum Anthropology* 16, 2: 6-11.

Hill, Tom. 1993. "Forging New Partnerships between Museums and First Peoples." *Ontario Museums Association Annual,* 19-21.

Hiller, Susan, ed. 1991. *The Myth of Primitivism: Perspectives on Art.* London: Routledge.

Hill-Tout, Charles. 1903. "Kitchen Middens on the Lower Fraser." *American Antiquarian* 25: 180-82.

—. 1912. "Neolithic Man in British Columbia." *American Journal of Archaeology* 16, 1: 102.

—. 1930. "The Great Fraser Midden." *Museum and Art Notes* 5: 75-83.

Hinckley, Ted C. 1964. "Sheldon Jackson as Preserver of Alaska's Native Culture." *Pacific Historical Review* 33, 4: 411-24.

Hinsley, Curtis M. 1981. *The Smithsonian and the American Indian: Making a Moral Anthropology in Victorian America.* Washington, DC: Smithsonian Institution Press.

Hobler, Philip M. 1970. "Archaeological Survey and Excavation in the Vicinity of Bella Coola." *BC Studies* 6-7: 77-94.

—. 1976. "Wet Site Archaeology at Kwatna." In *The Excavation of Water-Saturated Archaeological Sites (Wet Sites) on the Northwest Coast of North America,* edited by Dale R. Croes, 146-57. Ottawa: National Museum of Canada.

—. 1978. "The Relationship of Archaeological Sites to Sea Levels on Moresby Island, Queen Charlotte Islands." *Canadian Journal of Archaeology* 2: 1-13.

Holm, Bill. 1965. *Northwest Coast Indian Art: An Analysis of Form.* Thomas Burke Memorial Washington State Museum Monographs 1. Seattle: University of Washington Press.

—. 1967. "What Makes an Edenshaw (2-D Version)." Unpublished note.

—. 1972. "Heraldic Carving Styles of the Northwest Coast." In *American Indian Art: Form and Tradition: An Exhibition Organized by the Walker Art Center, Indian Art Association and the Minneapolis Institute of Arts,* 77-84. New York: E.P. Dutton.

—. 1977. "Traditional and Contemporary Kwakiutl Winter Dance." *Arctic Anthropology* 14, 7: 5-24.

—. 1981. "Will the Real Charles Edensaw Please Stand Up? The Problem of Attribution in Northwest Coast Indian Art." In *The World Is as Sharp as a Knife: An Anthology in Honour of Wilson Duff,* edited by Donald Abbott, 175-200. Victoria: British Columbia Provincial Museum.

—. 1982. "A Wooling Mantle Neatly Wrought: The Early Historic Record of Northwest Coast Pattern-Twined Textiles." *American Indian Art Magazine* 8: 34-47.

—. 1983a. *Box of Daylight: Northwest Coast Indian Art.* Seattle: Seattle Art Museum and University of Washington Press.

—. 1983b. "Form in Northwest Coast Art." In *Indian Art Traditions of the Northwest Coast,* edited by Roy L. Carlson, 33-45. Burnaby, BC: Archaeology Press, Simon Fraser University.

—. 1983c. *Smokey-Top: The Art and Times of Willie Seaweed.* Thomas Burke Memorial Washington State Museum Monographs 3. Seattle: University of Washington Press.

—. 1986. "The Dancing Headdress Frontlet." In *The Arts of the North American Indian: Native Traditions in Evolution,* edited by E.L. Wade, 133-40. New York: Hudson Hills Press.

—. 1987. *Spirit and Ancestor: A Century of Northwest Coast Indian Art at the Burke Museum.* Seattle: Burke Museum and University of Washington Press.

—. 1990a. "Art." In *Handbook of North American Indians.* Vol. 7, *Northwest Coast,* edited by Wayne Suttles, 602-32. Washington, DC: Smithsonian Institution Press.

—. 1990b. "Kwakiutl: Winter Ceremonies." In *Handbook of North American Indians.* Vol. 7, *Northwest Coast,* edited by Wayne Suttles, 378-86. Washington, DC: Smithsonian Institution Press.

Holm, Bill, and William [Bill] Reid. 1975a. *Form and Freedom: A Dialogue on Northwest Coast Indian Art*. Houston: Institute for the Arts, Rice University.

–. 1975b. *Indian Art of the Northwest Coast: A Dialogue on Craftsmanship and Aesthetics*. Houston: Institute for the Arts, Rice University.

Holm, Margaret, and David Pokotylo. 1997. "From Policy to Practice: A Case Study in Collaborative Exhibits with First Nations." *Canadian Journal of Archaeology* 21, 1: 33-43.

Holmes, William H. 1906. "Decorative Art of the Aborigines of Northern America." In *Anthropological Papers Written in Honor of Franz Boas*, 179-88. New York: G.E. Stechert.

Hooper-Greenhill, Eilean. 1992. *Museums and the Shaping of Knowledge*. London: Routledge.

Hoover, Alan L., ed. 2000a. *Nuu-Chah-Nulth Voices, Histories, Objects and Journeys*. Victoria: Royal BC Museum.

–. 2000b. "Public Policies and Private Worlds: Protocol – 'Telling People What You Are Doing before You Do It.'" Paper presented at Boundaries in the Art of the Northwest Coast of America conference, British Museum, Department of Ethnology, 18-20 May.

–. 2000-1. "A Response to Gloria Frank." *BC Studies* 128: 65-69.

Hoover, Alan L., and Richard Inglis. 1990. "Acquiring and Exhibiting a Nuu-Chah-Nulth Ceremonial Curtain." *Curator* 33, 4: 272-88.

Hopkirk, Peter. 1980. *Foreign Devils on the Silk Road*. London: John Murray.

Houle, Robert. 1993. Introduction. In *Multiplicity: A New Cultural Strategy*. Vancouver: UBC Museum of Anthropology.

Housser, F.B. 1926. *A Canadian Movement: The Story of the Group of Seven*. Toronto: Macmillan.

Howes, David, ed. 1991. *The Varieties of Sensory Experience: A Sourcebook in the Anthropology of the Senses*. Toronto: University of Toronto Press.

–. 1996. "Cultural Appropriation and Resistance in the American Southwest: Decommodifying 'Indianness.'" In *Cross-Cultural Consumption: Global Markets, Local Realities*, edited by David Howes, 138-60. New York: Routledge.

Hughes, Grant, Susan Marsden, and Sampson Bryant. 2008. "Treasures of the Tsimshian from the Dundas Collection: A Successful Partnership." *Muse* 26, 1: 18-31.

Hunt, Tony, and Jo-Anne Birnie Danzker. 1983. Section of "Personal Perspectives." In *Vancouver: Art and Artists 1931-1983*, 266-68. Vancouver: Vancouver Art Gallery.

Hymes, Dell, ed. 1972. *Reinventing Anthropology*. New York: Random House.

Inglis, Richard I., and Donald N. Abbott. 1991. "A Tradition of Partnership: The Royal British Columbia Museum and First Peoples." *Alberta Museums Review* 17, 2: 17-23.

Inglis, Richard I., James C. Haggarty, and Kevin Neary. 2000. "Balancing History: An Emerging First Nations Authority." In *Nuu-Chah-Nulth Voices, Histories, Objects and Journeys*, edited by Alan L. Hoover, 7-10. Victoria: Royal British Columbia Museum.

Ingold, Tim, ed. 1996. *Key Debates in Anthropology*. London: Routledge.

Ingraham, Joseph. 1971. *Journal of the Brigantine Hope on a Voyage to the Northwest Coast of North America, 1790-92*. Edited by Mark D. Kaplanoff. Barre, MA: Imprint Society.

Inverarity, Robert Bruce. 1950. *Art of the Northwest Coast Indians*. Berkeley: University of California Press.

–. 1955. "Anthropology in Primitive Art." In *Yearbook in Anthropology 1955*, 375-89. New York: Wenner-Gren Foundation for Anthropological Research.

Jacknis, Ira. 1985. "Franz Boas and Exhibits: On the Limitations of the Museum Method of Anthropology." In *Objects and Others: Essays on Museums and Material Culture*, edited by George W. Stocking Jr., 75-111. History of Anthropology Vol. 3. Madison: University of Wisconsin Press.

–. 1990. "Authenticity and the Mungo Martin House, Victoria, BC: Visual and Verbal Sources." *Arctic Anthropology* 27, 2: 1-12.

—. 1991. "George Hunt, Collector of Indian Specimens." In *Chiefly Feasts: The Enduring Kwakiutl Potlatch*, edited by Aldona Jonaitis, 177-226. Vancouver: Douglas and McIntyre; Seattle: University of Washington Press.

—. 1992. "'The Artist Himself': The Salish Basketry Monograph and the Beginning of a Boasian Paradigm." In *The Early Years of Native American Art History: The Politics of Scholarship and Collecting*, edited by Janet C. Berlo, 134-61. Seattle: University of Washington Press; Vancouver: UBC Press.

—. 1996a. "The Ethnographic Object and the Object of Ethnology in the Early Career of Franz Boas." In *Volksgeist as Method and Ethic: Essays on Boasian Ethnography and the German Anthropological Tradition*, edited by George W. Stocking Jr., 185-214. History of Anthropology Vol. 8. Madison: University of Wisconsin Press.

—. 1996b. "Repatriation as Social Drama: The Kwakiutl Indians of British Columbia, 1922-1980." *American Indian Quarterly* 20, 2: 277-86.

—. 2002a. *The Storage Box of Tradition: Kwakiutl Art, Anthropologists, and Museums, 1881-1981.* Washington, DC: Smithsonian Institution Press.

—. 2002b. "Toward an Art History of Northwest Coast First Nations." *BC Studies* 135: 47-48, 93-94, 137-38.

Jackson, A.Y. 1927. "Rescuing Our Tottering Totems: Something about a Primitive Art, Revealing the Past History of a Vanishing Race." *Maclean's Magazine,* 15 December, 23, 37.

Jackson, Michael, and Jim Aldridge. 2000. *Aboriginal and Treaty Rights.* Vancouver: UBC Faculty of Law.

Jacobsen, Johan Adrian. (1884) 1977. *The Alaskan Voyage 1881-1883: An Expedition to the Northwest Coast of America.* Translated by Erna Gunther. Chicago: University of Chicago Press.

Jameson, Fredric. 1998. *The Cultural Turn: Selected Writings on the Postmodern, 1983-1998.* London: Verso.

Janes, Robert A., and Martha A. Peever. 1991. "Partnerships: Museums and Native Living Cultures." *Alberta Museums Review* 17, 2: 14-16.

Janson, H.W. 1986. *The History of Art.* 3rd ed. New York: Harry N. Abrams.

Jensen, Doreen. 1988. "Commissioned Art Work: Is This the New Standard of Artistic Prominence?" Paper delivered at the National Native Indian Artists Symposium 4 and transcribed in *Networking: Proceedings from National Native Indian Artists Symposium IV, July 14-18, 1987,* edited by Alfred Young Man, 99-100. Lethbridge: University of Lethbridge.

—. 1996. "Metamorphosis." In *Topographies: Aspects of Recent B.C. Art,* edited by Grant Arnold, Monika Kin Gagnon, and Doreen Jensen, 91-124. Vancouver: Douglas and McIntyre.

Jensen, Doreen, and Cheryl Brooks, eds. 1991. *In Celebration of Our Survival: The First Nations of British Columbia.* Special issue of *BC Studies* 89.

Jensen, Doreen, and Polly Sargent. 1986a. *Robes of Power: Totem Poles on Cloth.* Museum Note 17. Vancouver: UBC Press, in association with the UBC Museum of Anthropology.

—. 1986b. "David Gladstone." In *Robes of Power: Totem Poles on Cloth*, edited by Doreen Jensen and Polly Sargent, 39-43. Museum Note 17. Vancouver: UBC Press, in association with the UBC Museum of Anthropology.

Jessup, Lynda, and Shannon Bagg, eds. 2002. *On Aboriginal Representation in the Gallery.* Mercury Series, Canadian Ethnology Service Paper 135. Gatineau, QC: Canadian Museum of Civilization.

Johnson, Harmer. 1981. "Auction Block." *American Indian Art Magazine* 6, 4: 20-21.

—. 2007. "Auction Block." *American Indian Art Magazine* 32, 2: 26-35.

Johnson, Matthew. 1997. "Towards a World Historical Archaeology." *Antiquity* 71, 271: 220-22.

Johnston, Anna. 2003. *Missionary Writing and Empire, 1800-1860.* Cambridge, UK: Cambridge University Press.

Jonaitis, Aldona. 1981. "Creations of Mystics and Philosophers: The White Man's Perceptions of Northwest Coast Indian Art from the 1930s to the Present." *American Indian Culture and Research Journal* 5, 1: 1-45.

—. 1986. *Art of the Northern Tlingit.* Seattle: University of Washington Press.

—. 1988. *From the Land of the Totem Poles: The Northwest Coast Collection at the American Museum of Natural History.* New York: American Museum of Natural History; Vancouver: Douglas and McIntyre.

—. 1989. "Totem Poles and the Indian New Deal." *Canadian Journal of Native Studies* 9, 2: 237-52.

—, ed. 1991. *Chiefly Feasts: The Enduring Kwakiutl Potlatch.* Vancouver: Douglas and McIntyre; Seattle: University of Washington Press.

—. 1992. "Chiefly Feasts: The Enduring Kwakiutl Potlatch – From Salvage Anthropology to a Big Apple Button Blanket." *Curator* 35, 4: 255-67.

—. 1993. "Traders of Tradition: The History of Haida Art." In *Robert Davidson: Eagle of the Dawn,* edited by Ian Thom, 3-23. Seattle: University of Washington Press.

—, ed. 1995. *A Wealth of Thought: Franz Boas on Native American Art.* Seattle: University of Washington Press; Vancouver: Douglas and McIntyre.

—. 1999. *The Yuquot Whalers' Shrine.* Seattle: University of Washington Press.

—. 2004. "Reconsidering the Northwest Coast Renaissance." In *Bill Reid and Beyond: Expanding on Modern Native Art,* edited by Karen Duffek and Charlotte Townsend-Gault, 155-74. Vancouver: Douglas and McIntyre.

—. 2006. *Art of the Northwest Coast.* Seattle: University of Washington Press.

Jonaitis, Aldona, and Aaron Glass. 2010. *The Totem Pole: An Intercultural Biography.* Seattle: University of Washington Press.

Jones, Anna Laura. 1993. "Politics and Exhibitions." *Annual Review of Anthropology* 22: 201-20.

Jones, Chief Charles, with Stephen Bosustow. 1981. *Queesto: Pacheenaht Chief by Birthright.* Nanaimo: Theytus Books.

Jones, Joan Megan. 1976. "Northwest Coast Indian Basketry: A Stylistic Analysis." PhD diss., University of Washington.

Jones, Livingston F. 1914. *A Study of the Thlingets of Alaska.* New York: Fleming H. Revell.

Jones, Marianne. 1993. "Guud San Glans, Eagle of the Dawn." In *Robert Davidson: Eagle of the Dawn,* edited by Ian Thom, 125-30. Seattle: University of Washington Press.

Jones, Owen. 1910. *Grammar of Ornament.* London: B. Quaritch.

Joseph, Robert. 1998. "Behind the Mask." In *Down from the Shimmering Sky: Masks of the Northwest Coast,* edited by Peter Macnair, Robert Joseph, and Bruce Grenville, 18-35. Vancouver: Douglas and McIntyre; Seattle: University of Washington Press.

—, ed. 2005. *Listening to Our Ancestors: The Art of Native Life along the North Pacific Coast.* Washington, DC: National Museum of the American Indian, Smithsonian Institution, in association with National Geographic.

Joyce, Barry Alan. 2001. *The Shaping of American Ethnography: The Wilkes Exploring Expedition, 1838-1842.* Lincoln: University of Nebraska Press.

Kaeppler, Adrienne, ed. 1978a. *"Artificial Curiosities": An Exposition of Native Manufactures Collected on the Three Pacific Voyages of Captain James Cook, R.N.* Honolulu: Bishop Museum Press.

—. 1978b. *Cook Voyage Artifacts in Leningrad, Berne, and Florence Museums.* Bernice P. Bishop

Museum Special Publication 66. Honolulu: Bishop Museum Press.

—. 1985. "Anthropology and the U.S. Exploring Expedition." In *Magnificent Voyagers: The U.S. Exploring Expedition, 1838-1842,* edited by Herman J. Viola and Carolyn Margolis, with the assistance of Jan S. Danis and Sharon D. Galperin, 119-47. Washington, DC: Smithsonian Institution Press.

Kahn, Miriam. 2000. "Not Really Pacific Voices: Politics of Representation in Collaborative Museum Exhibits." *Museum Anthropology* 24, 1: 57-74.

Kan, Sergei. 1989. *Symbolic Immortality: The Tlingit Potlatch of the Nineteenth Century.* Washington, DC: Smithsonian Institution Press.

—. 1999. *Memory Eternal: Tlingit Culture and Russian Orthodox Christianity through Two Centuries.* Seattle: University of Washington Press.

Karp, Ivan, and Steven Lavine, eds. 1991. *Exhibiting Cultures: The Poetics and Politics of Museum Display.* Washington, DC: Smithsonian Institution Press.

Kasten, Erich. 2004. "Ways of Owning and Sharing Cultural Property." In *Properties of Culture – Culture as Property: Pathways to Reform in Post-Soviet Siberia,* edited by Erich Kasten, 9-34. Berlin: Dietrich Reimer Verlag.

Kaufmann, Carole N. 1969. "Changes in Haida Indian Argillite Carvings, 1820-1910." PhD diss., University of California-Los Angeles.

—. 1976. "Functional Aspects of Haida Argillite Carving." In *Ethnic and Tourist Arts: Cultural Expression from the Fourth World,* edited by Nelson H.H. Graburn, 56-69. Berkeley: University of California Press.

Keddie, Grant. 2003. *Songhees Pictorial: A History of the Songhees People as Seen by Outsiders, 1790-1912.* Victoria: Royal British Columbia Museum.

Kehoe, Alice Beck. 1998. *The Land of Prehistory: A Critical History of American Archaeology.* New York: Routledge.

Keithahn, Edward. 1940. *The Authentic History of Shakes Island and Clan.* Wrangell, AK: Wrangell Historical Society.

—. 1963. *Monuments in Cedar.* 2nd ed. Ketchikan, AK: Roy Anderson.

Kelly, Henry, Susan Marsden, et al. Ca. 1992. *Na Amwaaltga Ts'msiyeen.* Prince Rupert, BC: Tsimshian Chiefs.

Kew, Della. 1974. *Indian Art and Culture of the Northwest Coast.* Saanichton, BC: Hancock House.

Kew, Michael. 1970. "Coast Salish Ceremonial Life: Status and Identity in a Modern Village." PhD diss., University of Washington.

—. 1980. *Sculpture and Engraving of the Central Coast Salish Indians.* Museum Note 9. Vancouver: UBC Museum of Anthropology.

—. 1990. "Central and Southern Coast Salish Ceremonies since 1900." In *Handbook of North American Indians.* Vol. 7, *Northwest Coast,* edited by Wayne Suttles, 476-81. Washington, DC: Smithsonian Institution Press.

—. 2000. "Traditional Coast Salish Art." In *Susan Point: Coast Salish Artist,* edited by Gary Wyatt, 13-23. Vancouver: Douglas and McIntyre; Seattle: University of Washington Press; Vancouver: Spirit Wrestler Gallery.

Ḳi-ḳe-in (Ron Hamilton). 1991. "Box of Darkness." In *In Celebration of Our Survival: The First Nations of British Columbia,* edited by Doreen Jensen and Cheryl Brooks. Special issue of *BC Studies* 89: 62-64.

—. 2000-1. "Book Review of *Out of the Mist: Treasures of the Nuu-Chah-Nulth Chiefs* by Martha Black." *BC Studies* 128: 106-7.

Kilburn, Michael. 1996. "Glossary of Key Terms in the Work of Gayatri Chakravorty Spivak." http://www.english.emory.edu/Bahri/Glossary.html.

Kimmelman, Michael. 2006. "A Heart of Darkness in the City of Light." *New York Times*, 2 July.

Kincade, M. Dale. 1990. "History of Research in Linguistics." In *Handbook of North American Indians*. Vol. 7, *The Northwest Coast*, edited by Wayne Suttles, 98-106. Washington, DC: Smithsonian Institution Press.

King, Eleanor M., and Bryce P. Little. 1986. "George Byron Gordon and the Early Development of the University Museum." In *Raven's Journey: The World of Alaska's Native People*, edited by Susan A. Kaplan and Kristin Barsness, 16-53. Philadelphia: University of Pennsylvania Museum.

King, J.C.H. 1981. *Artificial Curiosities from the Northwest Coast of America. Native American Artefacts in the British Museum Collected on the Third Voyage of Captain James Cook and Acquired through Sir Joseph Banks*. London: Trustees of the British Museum.

–. 1997. "Marketing Magic: Process, Identity and the Creation and Selling of Native Art." In *Present Is Past: Some Uses of Tradition in Native Societies*, edited by Marie Mauzé, 81-96. Lanham, MD: University Press of America.

–. 1999. "The Mowachaht and Captain Cook, 1778." In *First Peoples, First Contacts: Native Peoples of North America*, 122-45. Cambridge, MA: Harvard University Press.

Kirkness, Verna J. 1994. *Khot-La-Cha: The Autobiography of Chief Simon Baker*. Vancouver: Douglas and McIntyre.

Kirshenblatt-Gimblett, Barbara. 1998. *Destination Culture: Tourism, Museums, Heritage*. Berkeley: University of California Press.

–. 2001. "Reflections." In *The Empire of Things: Regimes of Value and Material Culture*, edited by Fred R. Myers, 257-68. Santa Fe: School of American Research Press.

Kloyber, Christian, ed. 1993. *Wolfgang Paalen: Zwischen Surrealismus und Abstraktion*. Vienna: Museum of Modern Art.

–, ed. 2000. *Wolfgang Paalen's Dyn: The Complete Reprint*. Vienna: Springer-Verlag.

Knight, Rolf. 1978. *Indians at Work: An Informal History of Native Indian Labour in British Columbia, 1858-1939*. Vancouver: New Star Books.

Kopytoff, Igor. 1986. "The Cultural Biography of Things: Commoditization as Process." In *The Social Life of Things: Commodities in Cultural Perspective*, edited by Arjun Appadurai, 64-91. Cambridge, UK: Cambridge University Press.

Kowinski, William. 1995. "Giving New Life to Haida Art and the Culture It Expresses." *Smithsonian* 25, 10: 38-47.

Kramer, Jennifer. 2004. "Figurative Repatriation: First Nations 'Artist-Warriors' Recover, Reclaim and Return Cultural Property through Self-Definition." In *Beyond Art/ Artifact/ Tourist Art: Social Agency and the Cultural Value(s) of Objects*, edited by Nelson H.H. Graburn and Aaron Glass. Special issue of *Journal of Material Culture* 9, 2: 161-82.

–. 2006. *Switchbacks: Art, Ownership, and Nuxalk National Identity*. Vancouver: UBC Press.

–. 2007. "Complying with 'Community.'" Paper presented at the CASCA/AES conference, Toronto, May.

–. 2008. "Humuwilas (Place Where We Look) and Kwik'waladlakw (Keeping Hidden): Collaborating with the Dzawada̱'enux̱w at UBC's Museum of Anthropology." Paper presented at the Canadian Museums Association conference, Victoria, April.

–. 2012. *Kesu': The Art and Life of Doug Cranmer*. Vancouver: Douglas and McIntyre; Seattle: University of Washington Press.

Krauss, Rosalind E. 1996. *The Optical Unconscious*. Cambridge, MA: MIT Press.

Krech, Shepherd. 2005. *The Ecological Indian: Myth and History*. New York: W.W. Norton.

Kreps, Christina F. 2003. *Liberating Culture: Cross-Cultural Perspectives on Museums, Curation, and Heritage Preservation*. Museum Meanings Series. London: Routledge.

Kristeller, Paul O. 1965. *Renaissance Thought and the Arts: Collected Essays.* Princeton, NJ: Princeton University Press.

Kroeber, Alfred Louis. 1920. *California Culture Provinces.* University of California Publications in American Archaeology and Ethnology 17, 2. Berkeley: University of California Press.

—. 1923a. "American Culture and the Northwest Coast." *American Anthropologist* 25, 1: 1-20.

—. 1923b. *Anthropology.* New York: Harcourt, Brace.

—. 1937. "Obituary of Thomas Talbot Waterman." *American Anthropologist* 39, 3: 527-29.

Krouse, Susan Applegate. 2006. "Anthropology and the New Museology." *Reviews in Anthropology* 35: 169-82.

Kuper, Adam. 1988. *The Invention of Primitive Society: Transformations of an Illusion.* London: Routledge.

—. 2005. *The Reinvention of Primitive Society: Transformations of a Myth.* London: Routledge.

Laforet, Andrea. 1990. "Regional and Personal Style in Northwest Coast Basketry." In *The Art of Native American Basketry,* edited by F.W. Porter, 281-97. New York: Greenwood Press.

—. 2000. "Ellen Curley's Hat." In *Nuu-Chah-Nulth Voices, Histories, Objects and Journeys,* edited by Alan L. Hoover, 330-38. Victoria: Royal British Columbia Museum.

—. 2004. "Narratives of the Treaty Table: Cultural Property and the Negotiation of Tradition." In *Questions of Tradition,* edited by Mark Saber Phillips and Gordon Schochet, 33-55. Toronto: University of Toronto Press.

—. 2006. "Good Intentions and the Public Good." Paper presented at the Politics of Intangible Cultural Heritage conference, Harvard University, May.

—. 2008. "'We Are Still Here!' Consultation and Collaboration in the Development of the First Peoples' Hall at the Canadian Museum of Civilization." In *The Culture of the North Pacific Region: Museum and Indigenous Culture. Proceedings of the 22nd International Abashiri Symposium.* Hokkaido: National Museum of Ethnology.

Lamb, W. Kaye. 1984. *A Voyage of Discovery to the North Pacific and Round the World ... Performed 1790–1795, with the "Discovery" and the "Chatham" Under Cpt. George Vancouver.* 4 vols. Hakluyt Society; 2nd series no. 163–66. London: Hakluyt Society. First published 1798.

Lemecha, Vera, and Reva Stone, eds., 2001. *The Multiple and Mutable Subject.* St. Norbert, MB: St. Norbet Arts and Cultural Centre.

Lamphere, Louise, and Michelle Z. Rosaldo, eds. 1974. *Woman, Culture, and Society.* Palo Alto, CA: Stanford University Press.

Lawson, Barbara. 1994. *Collected Curios: Missionary Tales from the South Seas.* Montreal: McGill University Libraries.

Lazarus, Neil. 1999. *Nationalism and Cultural Practice in the Postcolonial World.* Cambridge, UK: Cambridge University Press.

Lazell, J. Arthur. 1960. *Alaskan Apostle, the Life Story of Sheldon Jackson.* New York: Harper.

Lee, Molly. 1999. "Zest or Zeal? Sheldon Jackson and the Commodification of Alaska Native Art." In *Collecting Native America, 1870-1960,* edited by S. Kresh and B.A. Hail, 25-42. Washington, DC: Smithsonian Institution Press.

Lemert, Edwin McCarthy. 1955. "The Life and Death of an Indian State." *Human Organization* 13, 3: 23-27.

Levinas, Emmanuel. 1987. *Time and the Other and Additional Essays.* Translated by Richard A. Cohen. Pittsburgh: Duquesne University Press.

Lévy-Bruhl, Lucien. 1922. *La mentalité primitive.* Paris: Alcan.

Lévi-Strauss, Claude. 1943. "The Art of the Northwest Coast at the American Museum of Natural History." *Gazette des beaux arts* 24: 175-88.

—. (1958) 1963. *Structural Anthropology.* Translated by Claire Jacobson and Brook Grundfest Schoepf. New York: Basic Books.

—. 1966. *The Savage Mind.* Chicago: University of Chicago Press.

—. 1967. "The Story of Asdiwal." In *The Structural Study of Myth and Totemism,* edited by Edmund Leach, 1-48. London: Tavistock.

—. 1969. *The Elementary Structures of Kinship.* Translated by James Harle Bell, John Richard von Sturmer, and Rodney Needham. Boston: Beacon Press.

—. 1982. *The Way of the Masks.* Translated by Sylvia Modelski. Seattle: University of Washington Press; Vancouver: Douglas and McIntyre. Originally published as *La voie des masques* (Geneva: Skira, 1975).

Linsley, Robert. 1991. "Painting and the Social History of British Columbia." In *Vancouver Anthology: The Institutional Politics of Art,* edited by Stan Douglas, 224-45. Vancouver: Talonbooks.

—. 1995. "Yuxweluptun and the Canadian Landscape." In *Lawrence Paul Yuxweluptun: Born to Live and Die on Your Colonialist Reservations,* edited by Lawrence Paul Yuxweluptun, Charlotte Townsend-Gault, and Scott Watson, 23-32. Vancouver: Morris and Helen Belkin Art Gallery.

Lister, Kenneth R. 2010. *Paul Kane, the Artist: Wilderness to Studio.* Toronto: Royal Ontario Museum Press.

Lohse, E.S., and Frances Sundt. 1990. "History of Research: Museum Collections." In *Handbook of North American Indians.* Vol. 7, *Northwest Coast,* edited by Wayne Suttles, 88-97. Washington, DC: Smithsonian Institution Press.

Loo, Tina. 1992. "Dan Cranmer's Potlatch: Law as Coercion, Symbol and Rhetoric in British Columbia." *Canadian Historical Review* 73: 125-65.

Loram, C.T., and T.F. McIlwraith, eds. 1943. *The North American Indian Today: University of Toronto-Yale University Seminar Conference (Toronto, September 4-16, 1939).* Toronto: University of Toronto Press.

Lucretius Carus, Titus. 1921. *On the Nature of Things.* Translated by W.E. Leonard. New York: Dutton.

Lundy, Doris. 1976. "Styles of Coastal Rock Art." In *Indian Art Traditions of the Northwest Coast,* edited by Roy L. Carlson, 89-97. Burnaby, BC: Archaeology Press, Simon Fraser University.

Lurie, Nancy Oestreich. 1996. "Comments." *Current Anthropology* 37 (Supplement, February): S15-S16.

Lutz, John Sutton. 2008. *Makúk: A New History of Aboriginal-White Relations.* Vancouver: UBC Press.

MacCannell, Dean. (1976) 1999. *The Tourist: A New Theory of the Leisure Class.* Berkeley: University of California Press.

MacDonald, George F. 1983a. *Haida Monumental Art: Villages of the Queen Charlotte Islands.* Vancouver: UBC Press; Seattle: University of Washington Press.

—. 1983b. "Prehistoric Art of the Northern Northwest Coast." In *Indian Art Traditions of the Northwest Coast,* edited by Roy L. Carlson, 99-120. Burnaby, BC: Archaeology Press, Simon Fraser University.

—. 1984. "Painted Houses and Woven Blankets: Symbols of Wealth in Tsimshian Art and Myth." In *The Tsimshian and Their Neighbors of the North Pacific Coast,* edited by Jay Miller and Carol M. Eastman, 109-36. Seattle: University of Washington Press.

—. 1990. Foreword. In *Totem Poles,* by Marius Barbeau. Hull, QC: Canadian Museum of Civilization.

MacDonald, George F., and Charles Edward Borden. 1969. "Current Archaeological Research on the Northwest Coast." *Northwest Anthropological Research* Notes 3, 2: 193-263.

MacDonald, George F., and Jerome S. Cybulski. 2001. "The Prince Rupert Harbour Project." *Perspectives on Northern Northwest Coast Prehistory* 160: 1-23.

MacDonald, George F., and Richard I. Inglis. 1981. "An Overview of the North Coast Prehistory Project (1966-1980)." *BC Studies* 48: 37-157.

MacDonald, Joanne. 1990. "From Ceremonial Object to Curio: Object Transformation at Port Simpson and Metlakatla, B.C. in the Nineteenth Century." *Canadian Journal of Native Studies* 10, 2: 193-218.

Mackey, Eva. 2002. *The House of Difference: Cultural Politics and National Identity in Canada.* Toronto: University of Toronto Press.

Mackie, Quentin. 2003. "Location-Allocation Modelling of Shell Midden Distribution on the West Coast of Vancouver Island." In *Emerging from the Mist: Studies in Northwest Coast Culture History,* edited by R.G. Matson, Quentin Mackie, and Gary Coupland, 260-88. Vancouver: UBC Press.

Macklem, Patrick. 2001. *Indigenous Difference and the Constitution of Canada.* Toronto: University of Toronto Press.

MacLaren, I.S. 2007. "Herbert Spencer, Paul Kane, and the Making of 'The Chinook.'" In *Myth and Memory: Stories of Indigenous-European Contact,* edited by John Sutton Lutz, 90-102. Vancouver: UBC Press.

Macnair, Peter L. 1993. "Trends in Northwest Coast Indian Art 1880-1959: Decline and Expansion." In *In the Shadow of the Sun: Perspectives on Contemporary Native Art,* edited by Canadian Museum of Civilization, 47-70. Hull, QC: Canadian Museum of Civilization.

–. 1994. "Northwest Coast Indian Art for Sale: A Long Tradition." In *Life of the Copper: A Commonwealth of Tribal Nations.* Victoria: Alcheringa Gallery.

–. 2000. "Tim Paul: The Homeward Journey." In *Nuu-Chah-Nulth Voices, Histories, Objects and Journeys,* edited by Alan L. Hoover, 363-73. Victoria: Royal British Columbia Museum.

–. 2006. "From the Hands of Master Carpenter." In *Raven Travelling: Two Centuries of Haida Art,* edited by Daina Augaitis, 82-125. Vancouver: Vancouver Art Gallery; Douglas and McIntyre.

Macnair, Peter L., Alan L. Hoover, and Kevin Neary. 1980. *The Legacy: Continuing Traditions of Canadian Northwest Coast Indian Art.* Victoria: British Columbia Provincial Museum.

–. 1984. *The Legacy: Tradition and Innovation in Northwest Coast Indian Art.* Vancouver: Douglas and McIntyre; Seattle: University of Washington Press.

–. 2007. *The Legacy: Tradition and Innovation in Northwest Coast Indian Art.* Victoria: Royal British Columbia Museum.

Macnair, Peter L., Robert Joseph, and Bruce Grenville. 1998. *Down from the Shimmering Sky: Masks of the Northwest Coast.* Vancouver: Douglas and McIntyre; Seattle: University of Washington Press.

Macnair, Peter L., Bill Reid, and Tony Hunt. 1983. "The Legacy: Through the Eyes of the Artists." Panel discussion, 24 April. Typescript. *Legacy* exhibit files, Anthropology Section, Royal British Columbia Museum.

Macpherson, C.B. 1962. *The Political Theory of Possessive Individualism: Hobbes to Locke.* Oxford: Oxford University Press.

Malinowski, Bronislaw. 1926. *Myth in Primitive Psychology.* New York: W.W. Norton.

Malloy, Mary. 1998. *"Boston Men" on the Northwest Coast: The American Maritime Fur Trade, 1788-1844.* Kingston: Limestone Press; Fairbanks: University of Alaska.

—. 2000. *Souvenirs of the Fur Trade: Northwest Coast Indian Art and Artifacts Collected by American Fur Traders, 1788-1844*. Cambridge, MA: Peabody Museum Press, Harvard University.

Manuel, George, and Michael Posluns. 1974. *The Fourth World: An Indian Reality*. Don Mills, ON: Collier-Macmillan Canada.

Maranda, Pierre. 2004. "Structuralism at the University of British Columbia, 1969 Onward." In *Coming to Shore: Northwest Coast Ethnology, Traditions, and Visions*, edited by Marie Mauzé, Michael Harkin, and Sergei Kan, 87-90. Lincoln: University of Nebraska Press.

Marcus, George, and Fred Myers, eds. 1995. *The Traffic in Culture: Refiguring Art and Anthropology*. Berkeley: University of California Press.

Mars, Tanya, and Johanna Householder, eds. 2004. *Caught in the Act: An Anthology of Performance Art by Canadian Women*. Toronto: YYZ Books.

Marsden, Susan. 2002. "Adawx, Spanaxnox, and the Geopolitics of the Tsimshian." *BC Studies* 135: 101-35.

Martin, Lee-Ann, ed. 2004. *Making a Noise! Aboriginal Perspectives on Art, Art History, Critical Writing and Community*. Banff: Banff Centre.

Martindale, Andrew, and Irena Jurakic. 2006. "Identifying Expedient Glass Tools in a Post-Contact Tsimshian Village." *Journal of Archaeological Science* 33, 3: 414-27.

Masayesva, Victor. 1995. "The Emerging Native American Aesthetics in Film and Video." *Felix: A Journal of Media Arts and Communication* 2, 1: 156-60.

—. 2000. "Indigenous Experimentalism." In *Magnetic North*, edited by Jenny Lion, 226-39. Minneapolis: University of Minnesota Press.

Masco, Joseph. 1995. "'It Is a Strict Law that Bids Us Dance': Cosmologies, Colonialism, Death, and Ritual Authority in the Kwakwaka'wakw Potlatch, 1849 to 1922." *Comparative Studies in Society and History* 37, 1: 41-75.

Maskegon-Iskwew, Ahasiw. 2005a. "Drumbeats to Drumbytes: The Emergence of Networked Indigenous Art Practice." *ConunDrum Online* 1, http://www.conundrumonline.org/Issue_1/home.htm.

—. 2005b. "Drumbeats to Drumbytes: Globalizing Networked Aboriginal Art." In *Transference, Tradition, Technology: Native New Media Exploring Visual and Digital Culture*, edited by Melanie Townsend, Dana Claxton, Steve Loft, Walter Phillips Gallery, Indigenous Media Arts Group, and Art Gallery of Hamilton. Banff, AB: Walter Phillips Gallery Editions.

Mason, Otis T. 1887. "The Occurrence of Similar Inventions in Areas Widely Apart." Letter to the Editor. *Science* 9, 226: 534-35.

—. 1896. "Influence of Environment upon Human Industries or Arts." In *Annual Report of the Smithsonian Institution for the Year 1895*, 639-65. Washington, DC: Government Printing Office.

—. 1904. "Aboriginal American Basketry: Studies in a Textile Art without Machinery." In *Annual Report of the Smithsonian Institution for the Year Ending June 30, 1902, Report of the US National Museum*, Part 2, 171-548. Washington, DC: Government Printing Office.

Matson, R.G., and Gary Coupland. 1995. *The Prehistory of the Northwest Coast*. San Diego: Academic Press.

Matta Echaurren, Roberto Sebastián. 1987. *Entretiens morphologiques: Notebook no. 1, 1936-1944*. Edited by Germana Ferrari Matta. London: Sistan; Paris: Filipacchi.

Mauss, Marcel. 1954. *The Gift: The Form and Reason for Exchange in Archaic Societies*. Translated by Ian Cunnison. London: Cohen and West.

—. 1967. *The Gift: Forms and Functions of Exchange in Archaic Societies*. Translated by Ian Cunnison. New York: Norton.

Mauzé, Marie. 1994. "Le tambour d'eau des castors: L'art de la côte Nord-Ouest et le surréalisme." *Arts d'Afrique noire* 89: 35-45.

—. 2003. "Two Kwakwaka'wakw Museums: Heritage and Politics." *Ethnohistory* 50, 3: 503-22.

—. 2004a. "When the Northwest Coast Haunts French Anthropology: A Discreet but Lasting Presence." In *Coming to Shore: Northwest Coast Ethnology, Traditions, and Visions,* edited by Marie Mauzé, Michael Harkin, and Sergei Kan, 63-86. Lincoln: University of Nebraska Press.

—. 2004b. "Aux invisibles frontières du songe et du réel. Lévi-Strauss et les Surréalistes: La 'découverte' de l'art de la côte Nord-Ouest." In *Claude Lévi-Strauss,* edited by Michel Izard, 152-61. Paris: Éditions de l'Herne.

—. 2006. "Surrealists in Exile." In *Collection Robert Lebel,* 16-29. Paris: Calmels Cohen.

—. 2008a. "Totemic Landscapes and Vanishing Cultures through the Eyes of Wolfgang Paalen and Kurt Seligmann." *Journal of Surrealism and the Americas* 2: 1-21. http://jsa.asu.edu/index.php/jsa.

—. 2008b. "On the Border of the Supernatural World." In *Art Eskimo et de Colombie-Britannique, Collection James Economos,* 110-13. Paris: Sotheby's.

—. 2012. "Parcours de Claude Lévi-Strauss sur la côte Nord-Ouest." In *Claude Lévi-Strauss, un parcours dans le siècle,* edited by Philippe Descola, 33-60. Paris: Odile Jacob.

Mauzé, Marie, Michael Harkin, and Sergei Kan, eds. 2004. *Coming to Shore: Northwest Coast Ethnology, Traditions, and Visions.* Lincoln: University of Nebraska Press.

M'Closkey, Kathy. 2002. *Swept under the Rug: A Hidden History of Navajo Weaving.* Albuquerque: University of New Mexico Press.

McCarthy, Conal. 2007. "Review Article: Museum Factions – The Transformation of Museum Studies." *Museum and Society* 5, 3: 179-85.

McClellan, Andrew. 2007. "Museum Studies Now." *Art History* 30, 4: 566-70.

McIlwraith, Thomas F. 1948. *The Bella Coola Indians.* 2 vols. Toronto: University of Toronto Press.

McInnes, Graham. 1939. *A Short History of Canadian Art.* Toronto: Macmillan.

McKillop, John A. 1984. "Northwest Coast Indian Printmaking." In *The Legacy Letter: News and Notes from the Legacy Ltd.,* Vol. 2, Nos. 1 and 2. Seattle: Legacy.

McLaughlin, Castle. 2003. *Arts of Diplomacy: Lewis and Clark's Indian Collection.* Cambridge, MA: Peabody Museum, Harvard University; Seattle: University of Washington Press.

McLennan, Bill, and Karen Duffek. 2000. *The Transforming Image: Painted Arts of Northwest Coast First Nations.* Vancouver: UBC Press; Seattle: University of Washington Press.

McLuhan, Marshall. 1964. *Understanding Media: The Extensions of Man.* New York: Signet Books.

McMahon, Kevin. 2004. *Stolen Spirits of Haida Gwaii.* Toronto: Primitive Entertainment. DVD, 60 min.

McMaster, Gerald R., ed. 1998. *Reservation X: The Power of Place in Aboriginal Contemporary Art.* Fredericton: Goose Lane Editions.

—. 1999. "Toward an Aboriginal Art History." In *Native American Art in the Twentieth Century,* edited by W. Jackson Rushing III, 81-96. London: Routledge.

McMillan, Alan D. 1999. *Since the Time of the Transformers.* Vancouver: UBC Press.

McNeil, Larry. 2009. "*Fly by Night Mythology:* An Indigenous Guide to White Man, or How to Stay Sane When the World Makes No Sense." In *Alaska Native Reader,* edited by Maria *Shaa Tláa* Williams, 272-82. Durham, NC: Duke University Press.

Mead, Margaret. (1928) 1961. *Coming of Age in Samoa: A Psychological Study of Primitive Youth of Western Civilization.* New York: Morrow.

Meares, John. 1790. *Voyages Made in the Years 1788 and 1789 from China to the North-West Coast of America*. London: Logographic Press. Reprinted, New York: Da Capo Press, 1967.

Medina, Cuauhtémoc. 2005. "High Curios." In *Brian Jungen*, edited by Daina Augaitis, 27-33. Vancouver: Douglas and McIntyre.

Meillassoux, Claude. 1964. *Anthropologie economique des Gouro de Côte d'Ivoire*. Paris: Mouton.

Mertens, Susan. 1974. "Haida Art Alive Again." *Vancouver Sun*, 8 November, 6A.

Meuli, Jonathan. 2001. *Shadow House: Interpretations of Northwest Coast Art*. New York: Routledge.

Michaels, Eric. 1994. *Bad Aboriginal Art: Tradition, Media, and Technological Horizons*. Minneapolis: University of Minnesota Press.

Milburn, Maureen. 1997. "The Politics of Possession: Louis Shotridge and the Tlingit Collections of the University of Pennsylvania Museum." PhD diss., University of British Columbia.

Miles, George A. 2003. *James Swan, Chā-Tic of the Northwest Coast: Drawings and Watercolors from the Franz and Kathryn Stenzel Collection of Western American Art*. New Haven, CT: Beinecke Rare Book and Manuscript Library, Yale University.

Miller, Bruce G. 1996. "The 'Really Real' Border and the Divided Salish Community." *BC Studies* 112: 63-79.

—. 2003. *Invisible Indigenes: The Politics of Nonrecognition*. Lincoln: University of Nebraska Press.

—, ed. 2007. *Be of Good Mind: Essays on the Coast Salish*. Vancouver: UBC Press.

—. 2011. *Oral History on Trial: Recognizing Aboriginal Narratives in the Courts*. Vancouver: UBC Press.

Miller, Daniel, ed. 2005a. *Materiality*. Durham, NC: Duke University Press.

—. 2005b. "Materiality: An Introduction." In *Materiality*, edited by Daniel Miller. Durham, NC: Duke University Press.

Miller, Jay. 1997. *Tsimshian Culture: A Light through the Ages*. Lincoln: University of Nebraska Press.

Mills, Antonia. 2000. "Three Years after Delgamuukw: The Continuing Battle over Respect for First Nations Interests to Their Traditional Territories and Rights to Work Their Resources." *Anthropology of Work Review* 21, 2: 22-29.

Milroy, Sarah. 2006. "Buy Low, Sell Haida." *Globe and Mail*, 10 June, R4.

—. 2007. "Reflection: The Eagle Down Dance." In *Tsimshian Treasures: The Remarkable Journey of the Dundas Collection*, edited by Donald Ellis, 22-36. Dundas, ON: Donald Ellis Gallery; Vancouver: Douglas and McIntyre; Seattle: University of Washington Press.

Mintz, Sidney. 1985. *Sweetness and Power: The Place of Sugar in Modern History*. New York: Penguin.

Mitchell, Donald H. 1968a. "Excavations at Two Trench Embankments in the Gulf of Georgia Region." *Syesis* 1: 29-46.

—. 1968b. "Microblades: A Long-Standing Gulf of Georgia Tradition." *American Antiquity* 33, 1: 11-15.

—. 1970. "Excavations on the Chilcotin Plateau: Three Sites, Three Phases." *Northwest Anthropological Research Notes* 4, 1: 99-116.

—. 1971. "Archaeology of the Gulf of Georgia Area, a Natural Region and Its Culture Types." *Syesis* 4: 1-228.

—. 1972. "Artifacts from Archaeological Surveys in the Johnstone Strait Region." *Syesis* 5: 21-42.

—. 1979. "Seasonal Settlements, Village Aggregations, and Political Autonomy on the Central Northwest Coast." In *The Development of Political Organization in Native North America*, edited by Elizabeth Tooker, 97-107. Proceedings of the American Ethnological Society. Washington, DC: American Ethnological Society.

Mitchell, Donald H., and Leland Donald. 1985. "Some Economic Aspects of Tlingit, Haida, and Tsimshian Slavery." *Research in Economic Anthropology* 7: 19-35.

—. 1988. "Archaeology and the Study of Northwest Coast Economies." *Research in Economic Anthropology Supplement* 3: 293-351.

Mithlo, Nancy Marie. 2006. "'Give, Give, Giving': Cultural Translations." In *Vision, Space, Desire: Global Perspectives and Cultural Hybridity*, edited by Elizabeth Kennedy Gische, 85-98. Washington, DC: National Museum of the American Indian, Smithsonian Institution.

Moeran, J.W.W. 1923. *McCullagh of Aiyansh*. London: Marshall Brothers.

Moray, Gerta. 2006. *Unsettling Encounters: First Nations Imagery in the Art of Emily Carr*. Vancouver: UBC Press.

Morgan, Lewis Henry. 1851. *The League of the Ho-dé-no-sau-nee*. Boston: Gould and Lincoln.

—. 1877. *Ancient Society: Researches on the Lines of Human Progress from Savagery, through Barbarism, to Civilization*. New York: Henry Holt and Company. Reprinted, Palo Alto, CA: New York Labor News, 1978.

Morphy, Howard. 1991. *Ancestral Connections: Art and an Ancestral System of Knowledge*. Chicago: University of Chicago Press.

—. 1995. "Aboriginal Art in a Global Context." In *Worlds Apart: Modernity through the Prism of the Local*, edited by Daniel Miller, 211-39. London: Routledge.

—. 2000. "Elite Art for Cultural Elites: Adding Value to Indigenous Arts." In *Indigenous Cultures in an Interconnected World*, edited by Claire Smith and Graeme K. Ward, 129-43. Vancouver: UBC Press.

—. 2007. *Becoming Art: Exploring Cross-Cultural Categories*. Oxford: Berg.

Morris, Rosalind C. 1994. *New Worlds from Fragments: Film, Ethnography, and the Representation of Northwest Coast Cultures*. Boulder, CO: Westview Press.

Moss, Madonna L. 2004. "The Status of Archaeology and Archaeological Practice in Southeast Alaska in Relation to the Larger Northwest Coast." *Arctic Anthropology* 41, 2: 177-96.

—. 2010. *Northwest Coast: Archaeology as Deep History*. Washington, DC: SAA Press.

Moulton, Gary E., ed. 1990. *The Journals of the Lewis and Clark Expedition*. Vol. 6, *November 2, 1805–March 22, 1806*. Lincoln: University of Nebraska Press.

Moziño, José Mariano. (1803) 1970. *Noticias de Nutka: An Account of Nootka Sound in 1792*. Translated and edited by Iris Higbie Wilson; foreword by Philip Drucker. Monographs of the American Ethnological Society 50. Seattle: University of Washington Press.

Mullin, Molly. 2001. *Gender in the Marketplace: Culture, Art and Value in the American Southwest*. Durham, NC: Duke University Press.

Munn, Nancy. 1986. *The Fame of Gawa: A Symbolic Study of Value Transformation in a Massim (Papua New Guinea) Society*. Cambridge: Cambridge University Press.

Murray, Peter. 1985. *The Devil and Mr. Duncan*. Victoria: Sono Nis Press.

Museum of Anthropology at the University of British Columbia. 2006. "Reciprocal Research Network: Executive Summary." Typescript.

*Musqueam: A Living Culture*. 2006. Victoria: Copper Moon Communications.

Myers, Fred R. 1999. "Of Objects on the Loose." In *Objects on the Loose*, edited by Kenneth George. Special issue of *Ethnos* 64, 2: 263-73.

—, ed. 2001a. *The Empire of Things: Regimes of Value and Material Culture*. Santa Fe: School of American Research Press.

—. 2001b. "Introduction: The Empire of Things." In *The Empire of Things: Regimes of Value and Material Culture*, edited by Fred R. Myers, 3-64. Santa Fe: School of American Research.

—. 2002. *Painting Culture: The Making of an Aboriginal High Art*. Durham, NC: Duke University Press.

Nadasdy, Paul. 2002. "'Property' and Aboriginal Land Claims in the Canadian Subarctic: Some Theoretical Considerations." *American Anthropologist* 104, 1: 247-61.

National Film Board of Canada. 1969. *Challenge for Change* newsletter. NFB Archives.

National Museum of Man. 1972. *'Ksan: Breath of Our Grandfathers*. Ottawa: National Museum of Canada.

Naxaxalhts'I (Albert "Sonny" McHalsie). 2007. "We Have to Take Care of Everything that Belongs to Us." In *Be of Good Mind: Essays on the Coast Salish*, edited by Bruce G. Miller, 82-130. Vancouver: UBC Press.

Nemiroff, Diana. 1992. "Dempsey Bob." In *Land, Spirit, Power: First Nations at the National Gallery of Canada*, edited by Diana Nemiroff, Robert Houle, and Charlotte Townsend-Gault, 75-101. Ottawa: National Gallery of Art.

Neufeld, Margaret Rachel McKellin. 2002. "An Exploration of First Nations Artists in Alert Bay, BC: Connecting to the Art Market from Home." MA thesis, University of British Columbia.

Newcombe, Charles F., ed. 1923. *Menzies' Journal of Vancouver's Voyage, April to October 1792*. Archives of British Columbia, Memoir No. 5. Victoria: Archives of British Columbia.

Newman, Barnett. 1946. Foreword. In *Northwest Coast Indian Painting*. New York: Betty Parsons Gallery.

—. 2002. "The Ideographic Picture." In *Barnett Newman*, edited by Ann Temkin. Philadelphia: Philadelphia Museum of Art, in association with Tate Publishing. Originally published as the foreword to *The Ideographic Picture* (New York: Betty Parsons Gallery, 1947).

Neylan, Susan. 2003. *The Heavens Are Changing: Nineteenth-Century Protestant Missions and Tsimshian Christianity*. Montreal: McGill-Queen's University Press.

Nicolson, Marianne. 2004. "A Bringer of Change: 'Through Inadvertence and Accident.'" In *Bill Reid and Beyond: Expanding on Modern Native Art*, edited by Karen Duffek and Charlotte Townsend-Gault, 245-50. Vancouver: Douglas and McIntyre.

Nicks, Trudy. 1992. "Partnerships in Developing Cultural Resources: Lessons from the Task Force on Museums and First Peoples." *Culture* 12, 1: 87-94.

—. 1995. "The Task Force on Museums and First Peoples." In *Material Culture in Flux: Law and Policy of Repatriation of Cultural Property*. Special issue of *UBC Law Review*: 143-47.

Nietzsche, Friedrich. (1872) 1956. *The Birth of Tragedy and the Genealogy of Morals*. Translated by Francis Golffing. Garden City, NY: Doubleday Press.

Nisga'a Tribal Council. 1998. *Bringing Our Ancestors Home: The Repatriation of Nisga'a Artifacts*. New Aiyansh: Nisga'a Tribal Council.

Noble, Brian. 2007. "Justice, Transaction, Translation: Blackfoot Tipi Transfers and WIPO's Search for the Facts of Traditional Knowledge Exchange." *American Anthropologist* 109, 2: 338-49.

Nurse, Andrew. 2001. "'But Now Things Have Changed': Marius Barbeau and the Politics of Amerindian Identity." *Ethnohistory* 48, 3: 433-72.

Nuytten, Phil. 1982. *The Totem Carvers: Charlie James, Ellen Neel, and Mungo Martin*. Vancouver: Panorama Publishers.

O'Brian, John, and Peter White. 2008. *Beyond Wilderness: The Group of Seven, Canadian Identities and Contemporary Art*. Montreal: McGill-Queen's University Press.

O'Hara, Jane. 1999. "Trade Secrets." *Maclean's*, 18 October, 20-29.

Olin, Chuck, dir. 1983. *Box of Treasures.* Vancouver: Moving Images Distribution. DVD/VHS, 28 min.

Olson, Ronald L. 1954. "Social Life of the Owikeno Kwakiutl." *University of California Anthropological Records* 14: 169-200.

—. 1967. *Social Structure and Social Life of the Tlingit in Alaska.* Anthropological Records 26. Berkeley: University of California Press.

Ong, Walter J. 1991. "The Shifting Sensorium." In *The Varieties of Sensory Experience,* edited by David Howes, 47-60. Toronto: University of Toronto Press.

Ortner, Sherry B. 1984. "Theory in Anthropology since the Sixties." *Comparative Studies in Society and History* 26: 126-66.

Ostrowitz, Judith. 1999. *Privileging the Past: Reconstructing History in Northwest Coast Art.* Seattle: University of Washington Press; Vancouver: UBC Press.

—. 2009. *Interventions: Native American Art for Far-Flung Territories.* Seattle: University of Washington Press.

Paalen, Wolfgang. 1942-44. "Paysage totémique." *Dyn* 1, 2, 3, 6. Republished in *Pleine Marge* 20 (1994): 35-50.

—. 1943. "Totem Art." *Dyn* 4-5 (*Amerindian Number*): 7-37.

—. 1994. "Voyage Nord-Ouest." *Pleine Marge* 20: 11-34.

Palatella, John. 1998. "Pictures of Us." *Lingua Franca* 8, 5: 50-57.

Panofsky, Erwin. 1972. *Renaissance and Renascences in Western Art.* New York: Harper.

*Papers Connected with the Indian Land Question: 1850-1875.* 1875. Victoria: Richard Wolfenden, Government Printer.

Parkin, Robert. 2005. "The French-Speaking Countries." In *One Discipline Four Ways: British, German, French and American Anthropology: The Halle Lectures,* 157-256. Chicago: University of Chicago Press.

Paterson, Robert K. 2007. "Totems and Teapots: The Royal British Columbia Museum Corporation." *UBC Law Review* 40, 1: 421-37.

Patterson, E. Palmer II. 1982. *Mission on the Nass: The Evangelization of the Nishga (1860-1890).* Waterloo, ON: Eulachon Press.

Patterson, Mike. 2003. "First Nations in Cyberspace: Two Worlds and Tricksters Where the Forest Meets the Highway." PhD diss., Carleton University.

Pearce, Susan M. 1995. *On Collecting: An Investigation into Collecting in the European Tradition.* London: Routledge.

Peers, Laura, and Alison K. Brown, eds. 2003. *Museums and Source Communities: A Routledge Reader.* London: Routledge.

Perry, Art. 1979. "West Coast Prints: For Soul or for Sale?" *Vancouver Province,* 22 November, D1.

Phillips, Ruth B. 1990. "The Public Relations Wrap: What We Can Learn from the Spirit Sings." *Inuit Art Quarterly* 5, 2: 13-21.

—. 1995. "Why Not Tourist Art? Significant Silences in Native American Museum Representation." In *After Colonialism: Imperial Histories and Postcolonial Displacements,* edited by Gyan Prakash, 98-125. Princeton, NJ: Princeton University Press.

—. 1998. *Trading Identities: The Souvenir in Native North American Art from the Northeast, 1700-1900.* Seattle: University of Washington Press; Montreal: McGill-Queen's University Press.

—. 1999. "Art History and the Native-Made Object: New Discourses, Old Differences?" In *Native American Art in the Twentieth Century,* edited by W. Jackson Rushing III, 97-112. London: Routledge.

—. 2003. Introduction to Part 3: "Community Collaborations in Exhibits: Toward a Dialogic Paradigm." In *Museums and Source Communities: A Routledge Reader,* edited by Laura Peers and Alison K. Brown, 153-70. London: Routledge.

—. 2005. "Replacing Objects: Historical Practices for the Second Museum Age." *Canadian Historical Review* 86, 1: 83-110.

—. 2006. "Disrupting Past Paradigms: The National Museum of the American Indian and the First Peoples Hall at the Canadian Museum of Civilization." *Public Historian* 28, 2: 75-80.

Phillips, Ruth B., and Elizabeth Johnson. 2003. "Negotiating New Relationships: Canadian Museums, First Nations, and Cultural Property." In *Politics and the Past: On Repairing Historical Injustices,* edited by John Torpey, 149-67. Lanham, MD: Rowman and Littlefield.

Phillips, Ruth B., and Mark Salber Phillips. 2005. "Double Take: Contesting Time, Place, and Nation in the First Peoples Hall of the Canadian Museum of Civilization." *American Anthropologist* 107, 4: 694-704.

Phillips, Ruth B., and Christopher B. Steiner, eds. 1999. *Unpacking Culture: Art and Commodity in Colonial and Postcolonial Worlds.* Berkeley: University of California Press.

Pinney, Christopher, and Nicholas Thomas, eds. 2001. *Beyond Aesthetics: Art and the Technologies of Enchantment.* London: Berg.

Point, Steven L. Xwel. 2001. Foreword. In *A Stó:lō-Coast Salish Historical Atlas.* Vancouver: Douglas and McIntyre; Chilliwack, BC: Stó:lō Heritage Trust.

Pollock, Griselda, and Roszika Parker. 1981. *Old Mistresses: Women, Art and Ideology.* London: Routledge and Kegan Paul.

Pollock, Griselda, and Joyce Zemans, eds. 2007. *Museums after Modernism: Strategies of Engagement.* Malden, MA: Blackwell Publishing.

Povinelli, Elizabeth A. 2002. *The Cunning of Recognition: Indigenous Alterities and the Making of Australian Multiculturalism.* Durham, NC: Duke University Press.

—. 2004. "At Home in the Violence of Recognition." In *Property in Question: Value Transformation in the Global Economy,* edited by Katherine Verdery and Caroline Humphrey, 185-206. New York: Berg.

Powell, J.W. 1885. "From Savagery to Barbarism: Annual Address of the President." *Transactions of the Anthropological Society of Washington* 3 (6 November 1883-19 May 1885): 173-96.

—. 1887. "Museums of Ethnology and Their Classification." Letters to the Editor. *Science* 9, 227: 612-14.

—. 1899. "Sociology, or the Science of Institutions." Part 2. *American Anthropologist* 1, 4: 695-745.

Pratt, Mary Louise. 1992. *Imperial Eyes: Travel Writing and Transculturation.* New York: Routledge.

Price, Sally. 1989. *Primitive Art in Civilized Places.* Chicago: University of Chicago Press.

—. 2001. *Primitive Art in Civilized Places.* 2nd ed. Chicago: University of Chicago Press.

—. 2007. *Paris Primitive: Jacques Chirac's Museum on the Quai Branly.* Chicago: University of Chicago Press.

Prins, Harald. 1997. "The Paradox of Primitivism: Native Rights and the Problem of Imagery in Cultural Survival Films." *Visual Anthropology* 9: 1-24.

Radcliffe-Brown, Alfred Reginald. 1930-31. "The Social Organization of Australian Tribes." *Oceania* (1930) 1, 1: 34-63; 1, 2: 206-56; 1, 3: 323-41; (1931) 1, 4: 426-56.

Raibmon, Paige. 1996. "A New Understanding of Things Indian: George Raley's Negotiation of the Residential School Experience (Coqualeetza Indian Residential School, Sardis, BC)." *BC Studies* 110: 69-96.

—. 2005. *Authentic Indians: Episodes of Encounter from the Late Nineteenth-Century Northwest Coast.* Durham, NC: Duke University Press.

Raley, G.H. 1935. "Canadian Indian Art and Industries: An Economic Problem of Today." *Journal of the Royal Society of Arts* 83: 999.

—. 1936. "Suggesting a New Industry out of an Old Art: BC Indians Revive Their Dying Skill to Become Revenue-Producing Artisans?" *Vancouver Daily Province*, 9 May.

Ravenhill, Alice. 1938. *The Native Tribes of British Columbia.* Victoria: Charles Banfield.

—. 1942. "Pacific Coast Art: The Striking Aboriginal Art of the Pacific Coast Indians Furnishes Plenty of Inspiration to Commercial Designers of the Present Day." *The Beaver* (September): 4-8.

—. 1944. *A Corner Stone of Canadian Culture: An Outline of the Arts and Crafts of the Indian Tribes of British Columbia.* Occasional Papers of the British Columbia Provincial Museum, No. 5. Victoria: British Columbia Provincial Museum.

—. 1951. *Alice Ravenhill: The Memoirs of an Educational Pioneer.* Toronto: J.M. Dent and Sons.

Reading, Nigel, and Gary Wyatt. 2006. *Manawa: Pacific Heartbeat: A Celebration of Contemporary Maori and Northwest Coast Art.* Vancouver: Douglas and McIntyre.

Reid, Bill. 1967. "The Arts – An Appreciation." In *Arts of the Raven: Masterworks by the Northwest Coast Indian,* edited by Wilson Duff, n.p. Vancouver: Vancouver Art Gallery.

—. 1976. Obituary for Wilson Duff. *Vanguard* (October): 17.

—. 2000a. "The Classical Artist on the Northwest Coast." In *Solitary Raven: The Selected Writings of Bill Reid,* edited by Robert Bringhurst, 115-30. Vancouver: Douglas and McIntyre; Seattle: University of Washington Press.

—. 2000b. "The Legacy." In *Solitary Raven: The Selected Writings of Bill Reid,* edited by Robert Bringhurst, 178-81. Vancouver: Douglas and McIntyre; Seattle: University of Washington Press.

—. 2000c. "A New Northwest Coast Art: A Dream of the Past or a New Awakening?" In *Solitary Raven: Selected Writings of Bill Reid,* edited by Robert Bringhurst, 160-72. Vancouver: Douglas and McIntyre; Seattle: University of Washington Press.

Reid, Bill, and Robert Bringhurst. 1984. *The Raven Steals the Light.* Vancouver: Douglas and McIntyre.

Reid, William [Bill], and Adelaide de Menil. 1971. *Out of the Silence.* New York: E.P. Dutton.

Reid, Martine. 1981. "La ceremonie hamatsa des Kwagul approche structuraliste des rapports mythe-rituel." PhD diss., University of British Columbia.

—. 1993. "In Search of Things Past, Remembered, Retraced, and Reinvented." In *In the Shadow of the Sun: Perspectives on Contemporary Native Art,* edited by Canadian Museum of Civilization, 71-92. Hull, QC: Canadian Museum of Civilization.

Reiter, Rayna, ed. 1975. *Toward an Anthropology of Women.* New York: Monthly Review Press.

Reserve Management Ltd. 1978. *Retail Survey.* Unpublished study prepared for the British Columbia Indian Arts and Crafts Society.

Rettig, Andrew. 1980. "A Nativistic Movement at Metlakatla Mission." *BC Studies* 46: 28-39.

Richardson, Miles. 2004. "On Its Own Terms." In *Bill Reid and Beyond: Expanding on Modern Native Art,* edited by Karen Duffek and Charlotte Townsend-Gault, 21-25. Vancouver: Douglas and McIntyre.

Rickard, Jolene. 2002. "After Essay – Indigenous Is the Local." In *On Aboriginal Representation in the Gallery,* edited by Lynda Jessup and Shannon Bagg, 115-24. Hull, QC: Canadian Museum of Civilization.

—. 2005. "Rebecca Belmore: Performing Power." In *Rebecca Belmore: Fountain,* edited by Jann L.M. Bailey and Scott Watson, 68-76. Kamloops: Kamloops Art Gallery; Vancouver: Morris and Helen Belkin Art Gallery.

Ricoeur, Paul. 2004. *Memory, History, Forgetting*. Chicago: University of Chicago Press.

Rigaud, Thérèse. 2002. *Translating Haida Poetry: An Interview with Robert Bringhurst*. Vancouver: Douglas and McIntyre.

Riley, Mary, ed. 2004. *Indigenous Intellectual Property Rights: Legal Obstacles and Innovative Solutions*. Lanham, MD: AltaMira Press.

Rivers, W.H.R. 1914. *Kinship and Social Organisation*. Studies in Economic and Political Science No. 36. London: Constable.

Robb, John E. 1998. "The Archaeology of Symbols." *Annual Review of Anthropology* 27: 329-46.

Robertson, Leslie, with the Kwagu'l Gixsam Clan. 2012. *Standing Up with Ga'axsta'las: Jane Constance Cook and the Politics of Memory, Church, and Custom*. Vancouver: UBC Press.

Rohner, Ronald. 1969. *The Ethnography of Franz Boas: Letters and Diaries of Franz Boas Written on the North-West Coast from 1886 to 1931*. Chicago: University of Chicago Press.

Rorick, Isabel. 2006. "Following the Discipline of the Old Masters: Isabel Rorick in Conversation with Jacqueline Gijssen." In *Raven Travelling: Two Centuries of Haida Art*, edited by Daina Augaitis, 129-36. Vancouver: Vancouver Art Gallery; Douglas and McIntyre.

Rosaldo, Renato. 1989. "Imperialist Nostalgia." In *Culture and Truth: The Remaking of Social Analysis*, 68-87. Boston: Beacon Press.

Rose, Alex. 1993. *Nisga'a: People of the Nass River*. Vancouver: Douglas and McIntyre.

—. 2000. *Spirit Dance at Meziadin: Chief Joseph Gosnell and the Nisga'a Treaty*. Madeira Park, BC: Harbour Publishing.

Rosman, Abraham, and Paula Rubel. 1971. *Feasting with Mine Enemy: Rank and Exchange among Northwest Coast Societies*. New York: Columbia University Press.

Roth, Christopher. 2002. "Goods, Names and Selves: Rethinking the Tsimshian Potlatch." *American Ethnologist* 29, 1: 123-50.

Roth, Maria. 1999. "A Mystory about Wilson Duff, Northwest Coast Anthropologist." MA thesis, University of British Columbia. CD-ROM.

Roth, Solen. 2013. "Culturally Modified Capitalism: The Native Northwest Coast Artware Industry." PhD diss., University of British Columbia.

Rowlands, Michael. 2004. "Cultural Rights and Wrongs: Uses of the Concept of Property." In *Property in Question: Value Transformation in the Global Economy*, edited by Katherine Verdery and Caroline Humphrey, 207-26. New York: Berg.

Roy, Susan. 2002. "Performing Musqueam Culture and History at British Columbia's Centennial Celebrations." *BC Studies* 135: 55-90.

—. 2008. "'Who Were These Mysterious People?': The Marpole Midden, Coast Salish Identity, and the Dispossession of Aboriginal Lands in British Columbia." PhD diss., University of British Columbia.

Royal BC Museum. 2004. "Aboriginal Materials Operating Policy." Victoria: Royal BC Museum. First created 1997. http://www.royalbcmuseum.bc.ca/Reports_Policy/Collection_Policy.aspx.

—. 2006. *Thunderbird Park: Place of Cultural Sharing*. Online exhibit. http://www.royalbcmuseum.bc.ca/exhibits/tbird-park/index.html.

Royal Commission on National Development in the Arts, Letters and Sciences. 1951. "Indian Arts and Crafts." In *Report of the Royal Commission on National Development in the Arts, Letters and Sciences, 1949-1951*, 239-43. Ottawa: King's Printer.

Rushing, W. Jackson III. 1992. "Marketing the Affinity of the Primitive and the Modern: René d'Harnoncourt and 'Indian Art of the United States.'" In *The Early Years of Native American Art History*, edited by Janet C. Berlo, 191-236. Seattle: University of Washington Press.

—. 1995. *Native American Art and the New York Avant-Garde: A History of Cultural Primitivism*. Austin: University of Texas Press.

—, ed. 1999. *Native American Art in the Twentieth Century: Essays in History and Criticism*. London: Routledge.

Russell, Catherine. 1999. *Experimental Ethnography: The Work of Film in the Age of Video*. Durham, NC: Duke University Press.

Sainte-Marie, Buffy. 1996. Introduction. In *Heartbeat of the Earth: A First Nations Artist Records Injustice and Resistance*. Gabriola Island, BC: New Society Publishers.

Samuel, Cheryl. 1982. *The Chilkat Dancing Blanket*. Seattle: Pacific Search Press.

—. 1987. *The Raven's Tail*. Vancouver: UBC Press.

Sanborn, Andrea. 2005. "Kwakwaka'wakw Spirit: Our Art, Our Culture." *European Review of Native American Studies* 19, 1: 31-34.

Sapir, Edward. 1911. "An Anthropological Survey of Canada." *Science* 34, 884: 789-93.

Sapir, Edward, and Morris Swadesh. 1939. *Nootka Texts: Tales and Ethnological Narratives with Grammatical Notes and Lexical Materials*. Philadelphia: Linguistic Society of America.

—. (1955) 1978. *Native Accounts of Nootka Ethnography*. New York: AMS Press.

Saunders, Barbara. 1997a. "Contested *Ethnie* in Two Kwakwaka'wakw Museums." In *Contesting Art: Art, Politics and Identity in the Modern World*, edited by Jeremy MacClancy, 85-130. Oxford: Berg.

—. 1997b. "From a Colonised Consciousness to Autonomous Identity: Shifting Relations between the Kwakwaka'wakw and Canadian Nations." *Dialectical Anthropology* 22: 137-58.

Schapiro, Meyer. 1994. *Theory and Philosophy of Art: Style, Artist and Society*. New York: George Braziler.

Schneider, Arnd, and Christopher Wright, eds. 2008. *Contemporary Art and Anthropology*. Oxford: Berg.

Schulte-Tenckhoff, Isabelle. 1988. "Potlatch and Totem: The Attraction of America's Northwest Coast." In *Tourism: Managing the Exotic*, edited by Pierre Rossel, 117-47. Copenhagen: International Working Group for International Affairs.

Scott, Duncan Campbell. 1913. "Indian Affairs, 1867-1912," and "The Future of the Indian." In *Canada and Its Provinces: A History of the Canadian People and Their Institutions by One Hundred Associates*. Vol. 7, *The Dominion: Political Development Part 2*, Adam Shortt and Arthur G. Doughty, general editors, 593-626. Toronto: Publishers' Association of Canada.

Scott, Jay. 1985. "I Lost It at the Trading Post." *Canadian Art* 2: 33-39.

Seguin, Margaret. 1985. *Interpretive Contexts for Traditional and Current Coast Tsimshian Feasts*. Canadian Ethnology Service, Mercury Series, No. 98, National Museum of Man. Ottawa: National Museum of Canada.

Seligmann, Kurt. 1939. "The Totem Pole of Gédem Skanish (Gyaedem Skanees)." *Journal de la société des américanistes* 31: 121-28.

Sewid-Smith, Daisy Maýanil. 1979. *Prosecution or Persecution*. Cape Mudge, BC: Nu-Yum-Balees Society.

—. 1991. "In Time Immemorial." In *In Celebration of Our Survival: The First Nations of British Columbia*, edited by Doreen Jensen and Cheryl Brooks. Special issue of *BC Studies* 89: 16-33.

—. 1997. "The Continuing Reshaping of Our Ritual World by Academic Adjuncts." *Anthropology and Education Quarterly* 28, 4: 594-602.

Shadbolt, Doris. 1967. Foreword. In *Arts of the Raven: Master Works by the Northwest Coast Indian*, edited by Wilson Duff, n.p. Vancouver: Vancouver Art Gallery.

—. 1986. *Bill Reid*. Vancouver: Douglas and McIntyre.

Shea, Albert. 1952. *Culture in Canada: A Study of the Findings of the Royal Commission on National Development in the Arts, Letters and Sciences (1949-1951)*. Toronto: Core.

Sheffield, Gail K. 1997. *The Arbitrary Indian: The Indian Arts and Crafts Act of 1990*. Norman: University of Oklahoma Press.

Shelton, Anthony A. 2001. "Museums in an Age of Cultural Hybridity." In *Exhibiting Objects: Museum Collections in Policy and Practice*, edited by C. Braae, M. Harbsmeier, and I. Sjorslev. Special issue of *Folk: Journal of the Danish Ethnographic Society* 43: 221-49.

—. 2007. "Questioning Locality: The UBC Museum of Anthropology and Its Hinterlands." *Ethnografica* 11, 2: 387-406.

—. 2008. "Reply: The Curator as Witness." *Museum Management and Curatorship* 23, 3: 225-28.

Sherman, Daniel J., ed. 2008. *Museums and Difference*. Bloomington: Indiana University Press.

Shotridge, Louis. 1917. "My Northland Revisited." *Museum Journal* 8, 2: 105-15.

—. 1919a. "A Visit to the Tsimshian Indians." Part 1. *Museum Journal* 10, 1-2: 49-67.

—. 1919b. "War Helmets and Clan Hats of the Tlingit Indians." Part 2. *Museum Journal* 10, 1-2: 43-48.

—. 1920. "Ghost of Courageous Adventurer." *Museum Journal* 11, 1: 10-26.

—. 1928. "The Emblems of the Tlingit Culture." *Museum Journal* 19, 4: 350-77.

Silverman, Sydel. 2005. "The United States." In *One Discipline Four Ways: British, German, French and American Anthropology. The Halle Lectures*, 257-347. Chicago: University of Chicago Press.

Simpson, Moira. 1996. *Making Representations: Museums in the Post-Colonial Era*. London: Routledge.

Sinclair, Jane. 2001. "'HuupuKʷanum Tupaat – Out of the Mist: Treasures of the Nuu-Chah-Nulth Chiefs' at the Denver Museum of Nature and Science, Denver, Colorado." *Museum Anthropology* 25, 1: 48-53.

Singer, Beverly. 2001. *Wiping the War Paint off the Lens: Native American Film and Video*. Minneapolis: University of Minnesota Press.

Smith, Harlan I. 1899a. "Archaeological Investigations on the North Pacific Coast of America." *Science* 9, 224: 535-39.

—. 1899b. "Collections of the Provincial Museum of Victoria, British Columbia." *Science* 9, 213: 156-57.

—. 1900. "Archaeological Investigations on the North Pacific Coast in 1899." *American Anthropologist* 2, 3: 535-39.

—. 1906. "Recent Archaeological Discoveries in North-Western America." *Bulletin of the American Geographical Society* 38, 5: 287-95.

—. 1909. "Archeological Remains on the Coast of Northern British Columbia and Southern Alaska." *American Anthropologist* 11, 4: 595-600.

—. 1917. "The Use of Prehistoric Canadian Art for Commercial Design." *Science* 46, 1177: 60-61.

—. 1923. *An Album of Prehistoric Canadian Art*. Ottawa: National Museum of Canada.

—. 1925a. "A Semi-Subterranean House-Site in the Bella Coola Indian Area on the Coast of British Columbia." *Man* 25: 176-77.

—. 1925b. "Totem Poles." *Science* 62, 1597: 134.

—. 1927a. "A List of Petroglyphs in British Columbia." *American Anthropologist* 29, 4: 605-10.

—. 1927b. "A Prehistoric Earthwork in the Haida Indian Area." *American Anthropologist* 29, 1: 109-11.

—. 1927c. "Preserving a 'Westminster Abbey' of Canadian Indians: Remarkable Totem Poles Now under Government Care." *Illustrated London News*, 21 May, 900-1.

Smith, Linda Tuhiwai. 1999. *Decolonizing Methodology: Research and Indigenous Peoples.* London: Zed Books; Dunedin, NZ: University of Otago Press.

Smith, Paul Chaat. 1997. "From Lake Geneva to the Finland Station." In *Nations in Urban Landscapes,* guest curated by Marcia Crosby, 4-8. Vancouver: Contemporary Art Gallery.

—. 2007. "The Terrible Nearness of Distant Places: Making History at the National Museum of the American Indian." In *Indigenous Experience Today,* edited by Marisol de la Cadena and Orin Starn, 379-96. Santa Fe: School of American Research.

—. 2009. *Everything You Know about Indians Is Wrong.* Minneapolis: University of Minnesota Press.

Smith, Paul Chaat, and Robert Warrior. 1996. *Like a Hurricane: The Indian Movement from Alcatraz to Wounded Knee.* New York: New Press.

Sophocles. 1912. *Oedipus Rex.* Translated by F. Starr. Cambridge, MA: Harvard University Press.

Sparrow, Debra. 1998. "A Journey." In *Material Matters: The Art and Culture of Contemporary Textiles,* edited by Ingrid Bachman and Ruth Scheuing, 148-56. Toronto: YYZ Books.

Spicer, Edward, ed. 1961. *Perspectives in American Indian Culture Change.* Chicago: University of Chicago Press.

Spivak, Gayatri. 1990. "Questions of Multiculturalism." In *The Post-Colonial Critic: Interviews, Struggles, Dialogues,* edited by Sarah Harasym. New York: Routledge.

Spradley, James P., ed. (1969) 1972. *Guests Never Leave Hungry: The Autobiography of James Sewid, a Kwakiutl Indian.* Montreal: McGill-Queen's University Press. Reprinted from the earlier Yale University Press edition.

Sproat, Gilbert Malcolm. (1868) 1987. *The Nootka: Scenes and Studies of Savage Life.* Edited and annotated by Charles Lillard. West Coast Heritage Series. Victoria: Sono Nis Press.

Stahl, Anne Brower. 2002. "Colonial Entanglements and the Practice of Taste: An Alternative to Logocentric Approaches." *American Anthropologist* 104, 3: 827-45.

Stallabrass, Julian. 2004. *Art Incorporated.* Oxford: Oxford University Press.

Stanley, Nick. 1998. "The Future of Ethnographic Display." In *Being Ourselves for You: The Global Display of Cultures.* London: Middlesex University Press.

Steiner, Christopher B. 2001. "Rights of Passage: On the Liminal Identity of Art at the Border Zone." In *The Empire of Things: Regimes of Value and Material Culture,* edited by Fred R. Myers, 207-31. Santa Fe: School of American Research Press.

Steltzer, Ulli. 1976. *Indian Artists at Work.* North Vancouver: J.J. Douglas.

—. 1984. *A Haida Potlatch.* Vancouver: Douglas and McIntyre; Seattle: University of Washington Press.

Steward, Julian Haynes. 1950. *Area Research, Theory and Practice.* Bulletin of the Social Science Research Council. New York: Social Science Research Council.

—. 1955. *Theory of Culture Change: The Methodology of Multilinear Evolution.* Urbana: University of Illinois Press.

Stewart, Hilary. 1973. *Artifacts of the Northwest Coast Indians.* Toronto: General Publishing.

—. 1979a. *Looking at Indian Art of the Northwest Coast.* Vancouver: Douglas and McIntyre.

—. 1979b. *Robert Davidson: Haida Printmaker.* Vancouver: Douglas and McIntyre.

—, ed. 1987. *The Adventures and Sufferings of John R. Jewitt: Captive of Maquinna.* Vancouver: Douglas and McIntyre; Seattle: University of Washington Press.

Stewart, Jay, and Robert Joseph. 2000. "Validating the Past in the Present: First Nations' Collaborations with Museums." *Cultural Resource Management* 5: 42-45.

Stewart, Susan. 1984. *On Longing: Narratives of the Miniature, the Gigantic, the Souvenir, the Collection.* Baltimore: Johns Hopkins University Press.

Stocking, George W., ed. 1974. *The Shaping of American Anthropology, 1883-1911: A Franz Boas Reader*. New York: Basic Books.

—. 1985. *Objects and Others: Essays on Museums and Material Culture*. Madison: University of Wisconsin Press.

Strathern, Marilyn. 1981. "Culture in a Net Bag: The Manufacture of a Subdiscipline in Anthropology." *Man* n.s. 16: 665-88.

—. 1988. *The Gender of the Gift*. Berkeley: University of California Press.

—. 1999. *Property, Substance and Effect: Anthropological Essays on Persons and Things*. London: Athlone Press.

—. 2006. "Intellectual Property and Rights: An Anthropological Perspective." In *Handbook of Material Culture*, edited by Chris Tilley, Webb Keane, Susanne Kuchler, Mike Rowlands, and Patricia Spyer, 447-62. Thousand Oaks, CA: Sage.

Stott, Margaret A. 1975. *Bella Coola Ceremony and Art*. Ottawa: National Museum of Man.

Street, Brian V. 1975. *The Savage in Literature: Representations of "Primitive" Society in English Fiction, 1858-1920*. London: Routledge and Kegan Paul.

Sturtevant, William. 1969. "Does Anthropology Need Museums?" *Proceedings of the Biological Society of Washington* 82: 619-50.

Summers, David. 2003. *Real Spaces: World Art History and the Rise of Western Modernism*. London: Phaidon.

—. 2004. "What Is a Renaissance?" In *Bill Reid and Beyond: Expanding on Modern Native Art*, edited by Karen Duffek and Charlotte Townsend-Gault, 133-54. Vancouver: Douglas and McIntyre.

Suttles, Wayne. 1987. "Productivity and Its Constraints: A Coast Salish Case." In *Coast Salish Essays*, 100-33. Vancouver: Talonbooks. Originally delivered as a paper at the Conference on Northwest Coast Studies, 12-16 May 1976.

—, ed. 1990a. *Handbook of North American Indians*. Vol. 7, *Northwest Coast*. Washington, DC: Smithsonian Institution Press.

—. 1990b. "History of Research: Early Sources." In *Handbook of North American Indians*. Vol. 7, *Northwest Coast*, edited by Wayne Suttles, 70-72. Washington, DC: Smithsonian Institution Press.

—. 1990c. Introduction. In *Handbook of North American Indians*. Vol. 7, *Northwest Coast*, edited by Wayne Suttles, 1-16. Washington, DC: Smithsonian Institution Press.

Suttles, Wayne, and Aldona Jonaitis. 1990. "History of Research in Ethnology." In *Handbook of North American Indians*. Vol. 7, *Northwest Coast*, edited by Wayne Suttles, 73-87. Washington, DC: Smithsonian Institution Press.

Swan, James Gilchrist. 1857. *The Northwest Coast; or, Three Years' Residence in Washington Territory*. New York: Harper and Brothers.

—. 1870. *The Indians of Cape Flattery, at the Entrance to the Strait of Fuca, Washington Territory*. Smithsonian Contributions to Knowledge Vol. 16, article 8. Washington, DC: Smithsonian Institution.

Swanton, John Reed. 1905. *Contributions to the Ethnology of the Haida*. In *Memoirs of the American Museum of Natural History*. Vol. 8, part 1, Jesup North Pacific Expedition, edited by Franz Boas, 1-300. Leiden: E.J. Brill; New York: G.E. Stechert.

—. 1909. *Tlingit Myths and Texts*. Bureau of American Ethnology, Bulletin 39. Washington, DC: Government Printing Office.

Task Force on Museums and First Peoples. 1992. *Turning the Page: Forging New Partnerships between Museums and First Peoples*. Edited by Tom Hill and Trudy Nicks. Ottawa: Assembly of First Nations and Canadian Museums Association.

Taussig, Michael. 1999. *Defacement: Public Secrecy and the Labour of the Negative.* Palo Alto, CA: Stanford University Press.

Taylor, Charles. 1994. *Multiculturalism and "The Politics of Recognition."* Princeton, NJ: Princeton University Press.

Teit, James. 1900. *The Thompson Indians of British Columbia.* In *Memoirs of the American Museum of Natural History.* Vol. 2, part 4, Jesup North Pacific Expedition, edited by Franz Boas, 163-392. New York: Knickerbocker Press.

—. 1909. *The Shuswap.* In *Memoirs of the American Museum of Natural History.* Vol. 2, part 7, Jesup North Pacific Expedition, edited by Franz Boas, 437-813. New York: G.E. Stechert.

—. 1928. *Coiled Basketry in British Columbia and Surrounding Region.* In *Forty-First Annual Report of the Bureau of American Ethnology.* Washington, DC: US Government Printing Office.

Tennant, Paul. 1990. *Aboriginal Peoples and Politics: The Indian Land Question in British Columbia, 1849-1989.* Vancouver: UBC Press.

Tepper, Leslie, Chepximiya Siyam (Chief Janice George), and Skwesimltexw (Willard Joseph). Forthcoming. *Salish Blankets: Robes of Protection and Transformation, Symbols of Wealth.* Gatineau, QC: Canadian Museum of Civilization.

Thiébault-Sisson, [François]. 1927a. "La première exposition d'art Canadien à Paris." In *Exposition d'art Canadien.* Paris: Musée du Jeu de Paume.

—. 1927b. "Une exposition d'art Canadien au Jeu-de-Paume." *Le Temps,* 25 March.

Thom, Ian, ed. 1993. *Robert Davidson: Eagle of the Dawn.* Vancouver: Douglas and McIntyre; Seattle: University of Washington Press, in association with the Vancouver Art Gallery.

Thomas, A., and E.Y. Arima. 1970. *T'a:t'a:qsapa. A Practical Orthography for Nootka.* Ottawa: National Museum of Canada.

Thomas, Nicholas. 1991. *Entangled Objects: Exchange, Material Culture, and Colonialism in the Pacific.* Cambridge, MA: Harvard University Press.

—. 1994. *Colonialism's Culture: Anthropology, Travel and Government.* Princeton, NJ: Princeton University Press.

—. 1999. *Possessions: Indigenous Art/Colonial Culture.* London: Thames and Hudson.

—. 2003. *Cook: The Extraordinary Voyages of Captain James Cook.* New York: Walker.

Thomas, Nicholas, and Diane Losche. 1999. *Double Vision: Art Histories and Colonial Histories in the Pacific.* Cambridge, UK: Cambridge University Press.

Thompson, Judy. 2007. *Recording Their Story: James Teit and the Tahltan.* Vancouver: Douglas and McIntyre; Gatineau, QC: Canadian Museum of Civilization; Seattle: University of Washington Press.

Todd, Loretta. 1990. "Notes on Appropriation." *Parallellogramme* 16, 1: 24-32.

—, dir. 1994. *Hands of History.* Montreal: National Film Board of Canada, 52 min.

—. 1992. "What More Do They Want?" In *Indigena: Contemporary Native Perspectives,* edited by Gerald McMaster and Lee-Ann Martin. Vancouver: Douglas and McIntyre.

—, dir. 1997. *Forgotten Warriors.* Montreal: National Film Board of Canada, 51 min.

—, dir. 1998. *Today Is a Good Day: Remembering the Legacy of Chief Dan George.* Montreal: National Film Board of Canada, 55 min.

—, dir. *The People Go On.* Montreal: National Film Board of Canada, 74 min.

—. 2004. "Beyond." In *Bill Reid and Beyond: Expanding on Modern Native Art,* edited by Karen Duffek and Charlotte Townsend-Gault, 281-86. Vancouver: Douglas and McIntyre.

—. 2005. "Polemics, Philosophies, and a Story: Aboriginal Aesthetics and the Media of This Land." In *Transference, Tradition, Technology: Native New Media Exploring Visual and Digital Culture,* edited by Dana Claxton, Steven Loft, Candice Hopkins, and Melanie Townsend, 104-26. Banff: Walter Phillips Gallery Editions.

Toelken, Barre. 2003. *The Anguish of Snails.* Logan: Utah State University Press.

Tolmie, William Fraser. 1963. *The Journals of William Fraser Tolmie, Physician and Fur Trader.* Vancouver: Mitchell Press.

Tomlinson, John. 1991. *Cultural Imperialism: An Introduction.* Baltimore: Johns Hopkins University Press.

Torgovnick, Marianna. 1991. *Gone Primitive: Savage Intellects, Modern Lives.* Chicago: University of Chicago Press.

Townsend-Gault, Charlotte. 1992. "Kinds of Knowing." In *Land, Spirit, Power: First Nations at the National Gallery of Canada,* edited by Diana Nemiroff, Robert Houle, and Charlotte Townsend-Gault, 75-101. Ottawa: National Gallery of Art.

—. 1994. "Northwest Coast Art: The Culture of the Land Claims." *American Indian Quarterly* 18, 4: 445-68.

—. 1997. "Art, Argument and Anger on the Northwest Coast." In *Contesting Art: Art, Politics and Identity in the Modern World,* edited by Jeremy MacClancy, 131-63. New York: Berg.

—. 1998. "Let X = Audience." In *Reservation X,* edited by Gerald McMaster, 41-52. Hull, QC: Canadian Museum of Civilization.

—. 2000. "A Conversation with Ki-ke-in." In *Nuu-Chah-Nulth Voices, Histories, Objects and Journeys,* edited by Alan L. Hoover, 203-29. Victoria: Royal British Columbia Museum.

—. 2004a. "Circulating Aboriginality." In *Beyond Art/Artifact/ Tourist Art: Social Agency and the Cultural Value(s) of Objects,* edited by Nelson H.H. Graburn and Aaron Glass. Special issue of *Journal of Material Culture* 9, 2: 183-202.

—. 2004b. "Feeling Implicated." In *The Challenges of Native American Studies: Essays in Celebration of the Twenty-Fifth American Indian Workshop,* edited by Barbara Saunders and Lea Zuyderhoudt. Leuven, Belgium: Leuven University Press.

—. 2006. "The Raven, the Eagle, the Sparrows, and Thomas Crow: Making Native Modernism on the Northwest Coast." In *Essays on Native Modernism: Complexity and Contradiction in American Indian Art,* 88-101. Washington, DC: National Museum of the American Indian, Smithsonian Institution.

Trigger, Bruce. 1988. "Reply to Julia Harrison's Article 'The Spirit Sings and the Future of Anthropology.'" *Anthropology Today* 4, 6: 6-9.

—. 2006. *A History of Archaeological Thought.* 2nd ed. Cambridge, UK: Cambridge University Press.

Tsaqwassupp (Art Thompson), with Taiaiake Alfred. 2005. "My Grandmother, She Raised Me Up Again." In *Wasase: Indigenous Pathways of Action and Freedom,* edited by Taiaiake Alfred, 162-78. Peterborough, ON: Broadview Press.

Tsinhnahjinnie, Hulleah J. 2003. "When Is a Photograph Worth a Thousand Words?" In *Visual Currencies: Reflections on Native American Photography,* edited by Henrietta Lidchi and Hulleah J. Tsinhnahjinnie. Edinburgh: National Museums of Scotland.

Tsing, Anna Lowenhaupt. 1993. *In the Realm of the Diamond Queen: Marginality in an Out-of-the-Way Place.* Princeton: Princeton University Press.

Tsosie, Rebecca. 1997. "Indigenous Peoples' Claims to Cultural Property: A Legal Perspective." *Museum Anthropology* 21, 3: 5-11.

Tully, James. 1995. *Strange Multiplicity: Constitutionalism in an Age of Diversity.* Cambridge, UK: Cambridge University Press.

Turner, Terence. 1992. "Defiant Images: The Kayapo Appropriation of Video." *Anthropology Today* 8, 6: 5-16.

—. 2002. "Representation, Politics, and Cultural Imagination in Indigenous Video: General Points and Kayapo Experience." In *Media Worlds: Anthropology on New Terrain,* edited

by Faye Ginsburg, Lila Abu-Lughod, and Brian Larkin, 75-90. Berkeley: University of California Press.

*T'xwelatse: Me T'okw' Telo Qays / Is Finally Home.* 2007. Chilliwack: Stó:lō Research and Resource Management Centre. DVD, 29:30 min.

Tyler, Stephen. 1986. "Post-Modern Ethnography: From Document of the Occult to Occult Document." In *Writing Culture: The Poetics and Politics of Ethnography,* edited by James Clifford and George E. Marcus, 122-40. Berkeley: University of California Press.

Tylor, E.B. 1871. *Primitive Culture.* London: J. Murray.

*The Ubyssey.* 1926. "Dr. Barbeau Gives First Lecture: The Plastic and Decorative Arts of the Northwest Coast Tribes," 26 October; "Dr. Barbeau Gives Two Addresses on Indians: Speaks on Social and Economic Life of North American Indians – Origin of B.C. Indians Also Discussed," 29 October; "Lectures Concluded by Dr. Barbeau," 2 November. *Ubyssey* archives, http://ubcpubs.library.ubc.ca/?db=ubyssey.

Usher, Jean. 1974. *William Duncan of Metlakatla: A Victorian Missionary in British Columbia.* Vol. 5. Ottawa: National Museum of Canada.

Vancouver Art Gallery. 1974. *Bill Reid: A Retrospective Exhibition.* Vancouver: Vancouver Art Gallery.

Vancouver, George. 1798. *A Voyage of Discovery to the North Pacific and round the World ... Performed 1790-1795, with the "Discovery" and the "Chatham" under Cpt. George Vancouver.* 3 vols. London: Printed for G.G. and J. Robinson and J. Edwards.

Varenne, Gaston. 1927. Review. *Amour de l'art* (May): n.p.

Vastokas, Joan. 1975. "Bill Reid and the Native Renaissance." *Artscanada* 32: 12-21.

Vaughan, Thomas, and Bill Holm. 1982. *Soft Gold: The Fur Trade and Cultural Exchange on the Northwest Coast of America.* Portland: Oregon Historical Society.

Veillette, John, and Gary White. 1977. *Early Indian Village Churches: Wooden Frontier Architecture in British Columbia.* Vancouver: UBC Press.

Veniaminov, Ivan. (1840) 1984. "Notes on the Koloshi." In *Notes on the Islands of the Unalashka District.* Edited, with an introduction, by Richard A. Pierce. Translated by Lydia T. Black and R.H. Geoghegan, 380-451. Alaska History No. 27. Fairbanks: Elmer E. Rasmuson Library Translation Program, University of Alaska; Kingston, ON: Limestone Press.

Verdery, Katherine, and Caroline Humphrey. 2004. "Introduction: Raising Questions about Property." In *Property in Question: Value Transformation in the Global Economy,* edited by Katherine Verdery and Caroline Humphrey, 1-28. New York: Berg.

Vickers, Roy Henry. 1977. Introduction. In *Northwest Coast Indian Artists Guild: 1977 Graphics Collection.* Ottawa: Canadian Indian Marketing Services.

–. 1988. *Solstice: The Art of Roy Vickers.* Tofino, BC: Eagle Dancer Enterprises.

–. 1996. *Spirit Transformed: A Journey from Tree to Totem.* Vancouver: Raincoast Books.

–. 2003. *Copperman: The Art of Roy Henry Vickers.* Tofino: Eagle Dancer Enterprises.

Vogel, Susan. 1999. "Known Artists but Anonymous Works: Fieldwork and Art History." *African Arts* 32, 1: 40-55.

Vogel, Vanessa M.L. 1990. "The Glenbow Controversy and Exhibit of North American Art." *Museum Anthropology* 14, 4: 7-12. Originally published in *European Review of Native American Studies* 4, 1: 43-46.

Wagner, Henry R., and William A. Newcombe, eds. 1938. "The Journal of Jacinto Caamaño." Translated by Harold Grenfell. *British Columbia Historical Quarterly* 2, 3: 189-222; 2, 4: 265-301.

Walens, Stanley. 1981. *Feasting with Cannibals: An Essay on Kwakiutl Cosmology.* Princeton, NJ: Princeton University Press.

Walker, Patrick, and Clarine Ostrove. 1995. "The Aboriginal Right to Cultural Property." In *Material Culture in Flux: Law and Policy of Repatriation of Cultural Property*. Special issue of *UBC Law Review*: 13-28.

Wardwell, Allen. 1978. *Objects of Bright Pride: Northwest Coast Indian Art from the American Museum of Natural History*. New York: Center for Inter-American Relations.

Wasden, William, Jr. 2006. "The History of 'Walas G̲wax̲wiwe'– The Great Raven 'H̲amsiwe.'" Exhibition text, UBC Museum of Anthropology, in collaboration with the Namgis people and the U'mista Cultural Centre at Alert Bay.

—. 2011. "Talks with the Artists and Pauline Alfred." In *The Power of Giving: Gifts in the Kwakwa̲ka'wakw Big House from the Canadian Northwest Coast and at the Saxon Rulers' Court in Dresden*, edited by Claus Deimel, Sarah Elizabeth Holland, and Jutta Ch. Von Bloh. Berlin: Deutscher Kunstverlag.

Waterman, Thomas Talbot. 1923. "Some Conundrums in Northwest Coast Art." *American Anthropologist* 25, 4: 435-51.

Watson, Scott. 1995. "The Modernist Past of Lawrence Paul Yuxweluptun." In *Lawrence Paul Yuxweluptun: Born to Live and Die on Your Colonialist Reservations*, edited by Lawrence Paul Yuxweluptun, Charlotte Townsend-Gault, and Scott Watson, 25-32. Vancouver: Morris and Helen Belkin Art Gallery.

—. 2004. "Two Bears." In *Bill Reid and Beyond: Expanding on Modern Native Art*, edited by Karen Duffek and Charlotte Townsend-Gault, 209-24. Vancouver: Douglas and McIntyre.

Weatherford, Elizabeth. 1996. "Native Media-Making: A Growing Potential." *Native Americas: Akwe:kon's Journal of Indigenous Issues* 13, 1: 56-59.

Weavers' Circle. 1993. "Weavers' Statement, August 1993." Reprinted in a news release from Nimpkish Wind Productions, 2001.

Webster, Peter S. 1983. *As Far as I Know: Reminiscences of an Ahousat Elder*. Campbell River, BC: Campbell River Museum and Archives.

Weiner, Annette B. 1976. *Women of Value, Men of Renown: New Perspectives in Trobriand Exchange*. Austin: University of Texas Press.

—. 1992. *Inalienable Possessions: The Paradox of Keeping-While-Giving*. Berkeley: University of California Press.

Welsh, Peter J. 1996. "Comments." *Current Anthropology* 37 (Supplement, February): S17-S18.

Welsh, Robert. 1997. "The Power of Possessions: The Case against Property." *Museum Anthropology* 21, 3: 12-18.

Wheeler, Dennis, dir. 1975. *Potlatch ... A Strict Law Bids Us Dance*. Vancouver: Moving Images Distribution. DVD/VHS, 54 min.

Whittaker, Elvi, and Michael Ames. 2006. "Anthropology and Sociology at the University of British Columbia from 1947 to the 1980s." In *Historicizing Canadian Anthropology*, edited by Julia Harrison and Regna Darnell, 157-72. Vancouver: UBC Press.

Wickwire, Wendy. 2000-1. "A Response to Alan Hoover." *BC Studies* 128: 71-74.

Wii Muk'willixw (Art Wilson). 1996a. *Heartbeat of the Earth: A First Nations Artist Records Injustice and Resistance*. Gabriola Island, BC: New Society Publishers.

—. 1996b. Introduction. In *Heartbeat of the Earth: A First Nations Artist Records Injustice and Resistance*. Gabriola Island, BC: New Society Publishers.

Williams, Raymond. 1977. *Marxism and Literature*. Oxford: Oxford University Press.

Wilson, Thomas H. 1992. "Introduction: Museums and First Peoples in Canada." *Museum Anthropology* 16, 2: 6-11.

Wissler, Clark. 1906. "A Psycho-Physical Element in Primitive Art." In *Anthropological Papers Written in Honor of Franz Boas*, 189-92. New York: G.E. Stechert.

—. 1914. "Material Cultures of the North American Indians." *American Anthropologist* 16, 3: 447-505.

—. 1917. *The American Indian: An Introduction to the Anthropology of the New World.* New York: Douglas C. McMurtie.

Wolcott, Harry. 1997. "Open Letter to Daisy Sewid-Smith." *Anthropology and Education Quarterly* 28, 4: 603-5.

Wolf, Eric. 1982. *Europe and the People without History.* Berkeley: University of California Press.

Worl, Rosita. 1995. "NAGPRA: Symbol of a New Treaty." *Federal Archeology* (Fall-Winter): 28-29.

—. 2000. "The Dakl'aweidi *Keet Naa S'aaxw:* A Killerwhale Clan Hat." In *Celebration 2000: Restoring Balance through Culture,* edited by Susan W. Fair and Rosita Worl. Juneau: Sealaska Heritage Foundation.

Wright, Robin K. 1983. "Anonymous Attributions: A Tribute to a Mid-Nineteenth Century Haida Argillite Carver, the Master of the Long Fingers." In *Box of Daylight: Northwest Coast Indian Art,* edited by Bill Holm, 139-42. Seattle: Seattle Art Museum and University of Washington Press.

—. 1985. "Nineteenth Century Haida Argillite Pipe Carvers: Stylistic Attributions." PhD diss., University of Washington.

—. 1991. *A Time of Gathering: Native Heritage in Washington State.* Thomas Burke Memorial Washington State Museum Monographs 7. Seattle: Burke Museum and University of Washington Press.

—. 1992. "Kadashan's Staff: The Work of a Mid-Nineteenth Century Haida Argillite Carver in Another Medium." *American Indian Art Magazine* 17, 4: 48-55.

—. 1998. "Two Haida Artists from Yan: Will John Gwaytihl and Simeon Stilthda Please Step Apart?" *American Indian Art Magazine* 23, 3: 42-57, 106-7.

—. 2001. *Northern Haida Master Carvers.* Seattle: University of Washington Press.

Wyatt, Gary. 1989. *Images from the Inside Passage: An Alaskan Portrait by Winter and Pond.* Seattle: University of Washington Press.

—. 1994. *Spirit Faces: Contemporary Masks of the Northwest Coast.* Vancouver: Douglas and McIntyre.

—. 1999. *Mythic Beings: Spirit Art of the Northwest Coast.* Vancouver: Douglas and McIntyre; Seattle: University of Washington Press.

—, ed. 2000. *Susan Point: Coast Salish Artist.* Vancouver: Douglas and McIntyre; Seattle: University of Washington Press; Vancouver: Spirit Wrestler Gallery.

Wyman, Max. 1986. "New Dawn at Skidegate: Bill Reid and the Haida." *The Beaver* (June-July): 48-55.

Xwelixweltel (the Honourable Judge Steven L. Point). 2001. Foreword. In *A Stó:lō-Coast Salish Historical Atlas.* Vancouver: Douglas and McIntyre; Chilliwack, BC: Stó:lō Heritage Trust.

Yahgulanaas, Michael Nicoll. 2001a. "Notes on a Tale of Two Shamans – *Ga Sraagaa Sdang.*" In *A Tale of Two Shamans.* Penticton: Theytus Books and Haida Gwaii Museum at Qay'llnagaay.

—. 2009. *Red: A Haida Manga.* Vancouver: Douglas and McIntyre.

Yeomans, Don. 2006. "The Impulse to Create." In *Raven Travelling: Two Centuries of Haida Art,* edited by Daina Augaitis, 155-69. Vancouver: Vancouver Art Gallery; Douglas and McIntyre.

Young, David R. 1980. "Contemporary Northwest Coast Indian Art Investment Notes." Typescript. Vancouver: Bent Box Gallery.

Young, Robert J.C. 1995. *Colonial Desire: Hybridity in Theory, Culture and Race.* London: Routledge.

Yudice, George. 2003. *The Expediency of Culture: Uses of Culture in the Global Era.* Durham, NC: Duke University Press.

Yuxweluptun, Lawrence Paul. 1992. "Lawrence Paul Yuxweluptun." In *Land, Spirit, Power: First Nations at the National Gallery of Canada,* edited by Diana Nemiroff, Robert Houle, and Charlotte Townsend-Gault, 220-27. Ottawa: National Gallery of Canada.

Yuxweluptun, Lawrence Paul, Charlotte Townsend-Gault, and Scott Watson, eds. 1995. *Lawrence Paul Yuxweluptun: Born to Live and Die on Your Colonialist Reservations.* Vancouver: Morris and Helen Belkin Art Gallery.

Ziff, Bruce, and Pratima V. Rao, eds. 1997. *Borrowed Power: Essays on Cultural Appropriation.* New Brunswick, NJ: Rutgers University Press.

Zizek, Slavoj, and Glyn Daly. 2004. *Conversations with Zižek.* Cambridge, UK: Polity Press.

# Notes on Contributors

JOHN BARKER is a professor of anthropology at the University of British Columbia. He has published extensively on Christianity, colonial history, art, and environmentalism in Oceania and First Nations communities in British Columbia. He is editor of *Christianity in Oceania* (1990), *The Anthropology of Morality in Melanesia and Beyond* (2008), and, with Douglas Cole, *At Home with the Bella Coola Indians* (2003). His most recent book is *Ancestral Lines: The Maisin of Papua New Guinea and the Fate of the Rainforest* (2008).

JUDITH BERMAN is a research associate at the University of Victoria School of Environmental Studies and an adjunct faculty member in the Anthropology Department. Her Northwest Coast research includes many years' exploration of the Kwak'wala texts of George Hunt and Franz Boas, which has resulted in a number of articles on ethnopoetics, translation, interpretation, the history and scope of their research, and the biography of Hunt. She has also worked extensively on re-documentation of the collection of Tlingit crest art made for the University of Pennsylvania Museum by Louis Shotridge and is editing Shotridge's published and unpublished ethnographic writings. Recent research has investigated the relationship of Tlingit genealogies and clan histories to other forms of historical evidence and, with Aaron Glass, she has embarked on a major project to create new print and digital editions of Boas's 1897 monograph, *The Social Organization and Secret Societies of the Kwakiutl Indians*, incorporating archival object, photography, and cylinder recording collections, along with hundreds of pages of Hunt's unpublished additions and corrections.

MARTHA BLACK has been curator of Ethnology at the Royal BC Museum since 1997. Her graduate degrees focused on both Heiltsuk art and museum collections. Before coming to the Royal BC Museum, she was curator and associate director of the Isaacs Gallery in Toronto. Black has worked on many successful collaborative projects with First Nations and is a specialist in the theory and practice of repatriation within and outside of the treaty negotiation process. She has curated a number of exhibitions at the Royal BC Museum, including *'Nɬuut'iksa Łagigyedm Ts'msyeen: Treasures of the Tsimshian from the Dundas Collection* (2007), *HuupuKʷanum • Tupaat – Out of the Mist:*

*Treasures of the Nuu-chah-nulth Chiefs* (1999), *Nisga'a: People of the Nass River* (2001), and *Argillite: A Haida Art* (2001), and was co-curator of the Royal Ontario Museum's travelling exhibition, *Káxḷáya 'Gviḷás: "the ones who uphold the laws of our ancestors"* (2000). Her publications include two books: *HuupuKʷanum • Tupaat – Out of the Mist: Treasures of the Nuu-chah-nulth Chiefs* and *Bella Bella: A Season of Heiltsuk Art.* Black has developed and taught courses on First Nations art and museum studies, and lectured at universities, colleges, and museums in Canada and abroad. She is an associate member of the Faculty of Graduate Studies and an adjunct assistant professor in the Department of History in Art at the University of Victoria.

KATHRYN BUNN-MARCUSE is assistant director of the Bill Holm Center for the Study of Northwest Coast Art at the Burke Museum and teaches Indigenous art at the University of Washington. Bunn-Marcuse completed her PhD at the University of Washington in 2007, which focused on gold and silver jewellery of the Northwest Coast. Her publications include *In the Spirit of the Ancestors: Reflections on Contemporary Northwest Coast Art at the Burke Museum* (co-edited with Robin Wright, 2013); "Bracelets of Exchange" in *Objects of Exchange: Transition, Transaction, and Transformation on the Late-Nineteenth Century Northwest Coast* (2011); "Kwakwaka'wakw on Film" in *Walking a Tight Rope: Aboriginal People and Their Representations* (2005); and "Reflected Images: The Use of Euro-American Designs on Northwest Coast Silver Bracelets" in *American Indian Art Magazine* (2000). Other publications focus on Indigenous body adornment, cultural tourism, and formal analyses in Northwest Coast art history.

ALICE MARIE CAMPBELL teaches Anthropology and Aboriginal Art History at the University of British Columbia. Her research interests include the role of ethnic and racial relations in the material and discursive production of Northwest Coast art since the 1960s. Her research focuses on intercultural collaboration in the production of Northwest Coast art in British Columbia and Washington State, and the use of Northwest Coast art by public and private agencies to support official multiculturalism.

DANA CLAXTON has investigated the ongoing impact of colonialism on Aboriginal cultures in North America primarily through film, video, and photography. She has exhibited widely, including at the National Gallery of Canada, Vancouver Art Gallery, Museum of Modern Art, Walker Art Centre, Eiteljorg Museum, and the Sundance Film Festival. Recent exhibitions include at the 17th Biennale of Sydney in Australia and *Beat Nation* at the Vancouver Art Gallery. She has been an influential teacher at the Emily Carr Institute, University of Regina, and Simon Fraser University, and is currently in the Department of Art History, Visual Art and Theory at the University of British Columbia. She was awarded the prestigious VIVA Award in 2001. Her work is in major collections, including the National Gallery of Canada, Canada Council Art Bank, Vancouver Art Gallery, and Winnipeg Art Gallery.

GLORIA CRANMER WEBSTER was born in Alert Bay, BC, and is a member of the 'Namgis band. After completing high school, she graduated from the University of British Columbia with a Bachelor of Arts in anthropology in 1956. Her work experiences did not have much to do with anthropology until 1971 when she became assistant curator at the Museum of Anthropology, University of British Columbia, where she stayed until returning home in 1975 to begin working on the U'mista Cultural Centre project. During her years at the Centre, she co-edited a series of twelve Kwak'wala language books, participated in the production of two documentary films, taught Kwak'wala to both adults and children, and recorded oral histories with old people. She did exhibit work with other museums, including the American Museum of Natural History, Detroit Institute of Art, the Museum of Anthropology, and the Canadian Museum of Civilization. She served on the Board of Trustees of the Canadian Museum of Civilization for nine years and was a member of the First Peoples' Hall Advisory Committee there for eleven years. Her current project is identifying a collection of photographs for the Smithsonian Institution.

LESLIE DAWN teaches art history and critical theory at the University of Lethbridge. He received his doctorate from the University of British Columbia where he investigated problems in the construction of Canadian national identities, colonial landscapes, and the representations of Native peoples in Western Canada by the Group of Seven and other artists in the 1920s. Dawn has been active for many years as an art critic and has written numerous catalogue essays for museums and galleries across Canada. His essay "Re:Reading Reid and the Revival" appeared in the anthology *Bill Reid and Beyond: Expanding on Native American Art* (2005) and "The Britishness of Canadian Art" in *Beyond Wilderness: The Group of Seven, Canadian Identity, and Contemporary Art* (2007). His book *National Visions National Blindness: Canadian Art and Identities in the 1920s* was awarded the 2008 Raymond Klibansky Prize. His current areas of research include the ways in which Native groups modified, resisted, and used cultural programs to negotiate spaces for ensuring the continuity of their traditional arts and identities.

KRISTIN L. DOWELL is an assistant professor of anthropology at the University of Oklahoma. She is a visual anthropologist who has conducted research on Aboriginal media for over a decade and is the author of *Sovereign Screens: Aboriginal Media on the Canadian West Coast* (2013). She has worked as an assistant curator at several Native film festivals and teaches courses on visual anthropology, the anthropology of media, and ethnographic video production.

KAREN DUFFEK is the curator of Contemporary Visual Arts and Pacific Northwest at the UBC Museum of Anthropology (MOA). As a student of anthropology in Vancouver during the early 1980s, she became interested in the then-burgeoning market for Northwest Coast art and the participation of museums and audiences in shaping its directions. She went on to do research and publish on this subject and continues to work

with artists from across Canada and internationally on exhibitions, as well as museum- and community-based projects. Among the exhibitions she has curated are *Projections: The Paintings of Henry Speck, Udᶾi'stalis* (with Marcia Crosby, Satellite Gallery, 2012); *Border Zones: New Art across Cultures* (MOA, 2010); *Michael Nicoll Yahgulanaas: Meddling in the Museum* (MOA, 2007); *Robert Davidson: The Abstract Edge* (MOA and the National Gallery of Canada, 2004-7); and *Beyond History* (with Tom Hill, Vancouver Art Gallery, 1989). Her publications include *Peter Morin's Museum* (co-authored with Peter Morin, 2011); *Bill Reid and Beyond: Expanding on Modern Native Art* (co-edited with Charlotte Townsend-Gault, 2004); *Robert Davidson: The Abstract Edge* (2004), *The Transforming Image: Painted Arts of Northwest Coast First Nations* (co-authored with Bill McLennan, 2000); and *Bill Reid: Beyond the Essential Form* (1986).

AARON GLASS is an assistant professor at the Bard Graduate Center in New York City where he specializes in the anthropology of art, museums, and Indigenous people. Among his publications focusing on the First Nations of the Northwest Coast, recent books include *The Totem Pole: An Intercultural History* (co-authored with Aldona Jonaitis, 2010) and *Objects of Exchange: Social and Material Transformation on the Late Nineteenth-Century Northwest Coast* (2011), the catalogue for an exhibition he curated at the Bard Graduate Center. Glass is currently collaborating with teams of scholars and Kwakwa̱ka̱'wakw to restore Edward S. Curtis's 1914 silent feature film *In the Land of the Head Hunters,* and to produce a critical, annotated edition of Franz Boas's 1897 monograph, *The Social Organiᶾation and the Secret Societies of the Kwakiutl Indians.*

RONALD W. HAWKER teaches in the Department of Liberal Studies, Alberta College of Art and Design in Calgary. Formerly, for fifteen years, he was an associate professor in the Department of Art and Design at Zayed University in Dubai, United Arab Emirates. He teaches, researches, and writes about tribal art and architecture and its complex relationship with modernity. He has published *Tales of Ghosts: First Nations Art in British Columbia, 1922-61* (2002) and *Building on Desert Tides: Traditional Architecture in the Gulf* (2008) and is currently writing a book about Kwakwa̱ka̱'wakw artist Charlie James.

IRA JACKNIS is a research anthropologist at the Phoebe A. Hearst Museum of Anthropology, UC Berkeley. Before coming to the Hearst Museum in 1991, he worked for the Brooklyn Museum, the Smithsonian, the Field Museum, and the Newberry Library. His research specialties include museums, film and photography, the history of anthropology, and the arts and cultures of the Native peoples of western North America. Since 1979, Jacknis has been researching the Northwest Coast, especially the work of Franz Boas and George Hunt with the Kwakwa̱ka̱'wakw. More recently, his research and writing have been devoted to Native California, Alfred Kroeber, and the University of California. Among his books are *Carving Traditions of Northwest California* (1995), *The Storage Box of Tradition: Kwakiutl Art, Anthropologists, and Museums, 1881-1981* (2002), and the edited anthology, *Food in California Indian Culture* (2004).

ALDONA JONAITIS is an art historian of Northwest Coast Native art. Her books include *Art of the Northern Tlingit* (1986); *From the Land of the Totem Poles: Northwest Coast Art at the American Museum of Natural History* (1988); *Chiefly Feasts: The Enduring Kwakiutl Potlatch* (1991); *The Yuquot Whalers' Shrine* (1999); *Art of the Northwest Coast* (2006); *The Totem Pole: An Intercultural Biography* (co-authored with Aaron Glass) (2010); and *Discovering Totem Poles: A Traveler's Guide* (2012). She was on the faculty and served as an administrator at the State University of New York at Stony Brook from 1975 to 1989, then became vice president for Public Programs at the American Museum of Natural History, where she stayed for four years. From 1993 to 2010 she was director of the University of Alaska Museum of the North in Fairbanks and in 2013 returned to that museum as interim director.

ḰI-ḰE-IN is now Chuuchḵamalthnii, which signifies that he is Taayii (head of family) of Taḵiishtaḵamlthat-ḥ (Earthquake House), a house within the Tl'ikuulthat-ḥ clan of the Huupachesat-ḥ of the Nuuchaanulth. A scholar and historian, he is also a painter, carver, metal engraver, graphic designer, poet, singer, and illustrator with more than forty years' experience as a speaker and ritualist. He was a co-founder, in 1977, of the Northwest Coast Indian Artists Guild, holds a BA in Anthropology from the University of British Columbia, and worked for the Nuuchaahnulth Tribal Council on a self-initiated study of Indian residential school experience, *Residential Schools: The Nuu-chah-nulth Experience*, which remains the single largest study of Indian residential schools based solely upon interviews with survivors. His printmaking, poetry, photography, and drawing have been the focus of exhibitions at the British Museum, the Museum of Anthropology at UBC, and the Alberni Valley Museum. His work was featured in *Backstory: Nuuchaanulth Ceremonial Curtains and the Work of Ḱi-ḵe-in* at the Morris and Helen Belkin Art Gallery in 2010 and was the subject of an award-winning film, co-directed with Denise Green, *Histakshitl Ts'awaatskwii* (We Come from One Root). His writing has appeared in numerous publications, including *In the Shadow of the Sun: Perspectives on Contemporary Native Art* (1983). Major texts are in progress on Nuuchaanulth *thliitsaapilthim* (ceremonial curtains) and Nuuchaanulth spirituality. Dealing with a brain tumor has hindered his work over the last several years.

JENNIFER KRAMER is an associate professor of anthropology and a curator, Pacific Northwest, at the Museum of Anthropology (MOA), at the University of British Columbia. She holds a PhD in cultural anthropology from Columbia University. Her research focuses on Northwest Coast First Nations visual culture and its entanglements with aesthetic valuation, commodification, appropriation, tourism, legal regimes, and museums. She has worked with the Nuxalk Nation of Bella Coola, BC, since 1994 on issues of cultural regeneration, contemporary identity production, and Native-controlled education, resulting in the book, *Switchbacks: Art, Ownership, and Nuxalk National Identity* (2006). She is also the author and curator of *Kesu': The Art and Life of Doug Cranmer* (2012). Her current collaborative research involves connecting Heiltsuk,

Nuxalk, Wuikinuxv, and Kwakwa̲ka'wakw linguists, cultural teachers, and artists to their historic material culture in museum collections. She is also a research partner for the SSHRC CURA project "Tshiue-Natuapahtetau/Kigibiwidon: Exploring New Alternatives Concerning the Restitution/Recovery of Indigenous Heritage" with two First Nations in Quebec, and a research associate of the "Intellectual Property Issues in Cultural Heritage (IPinCH) Project."

ANDREA LAFORET has worked as a curator at the Royal British Columbia Museum and the Canadian Museum of Civilization. She was Director of Ethnology at the Canadian Museum of Civilization from 1989 to 2002 and Director of Ethnology and Cultural Studies from 2002 to 2009. Specializing in folk history, ethnohistory, and material culture, she has worked with First Nations in both Southeast Alaska and British Columbia. With Annie York, she is the author of *Spuẕẕum: Fraser Canyon Histories, 1808-1939* (1998). In her role at the Canadian Museum of Civilization, she directed the Aboriginal Training Program in Museology, was actively engaged in discussions of repatriation, and worked with colleagues engaged in programs of research and outreach relating to ethnicity, musicology, contemporary art, and popular culture of people across Canada. She retired from the Canadian Museum of Civilization in 2009 and currently works as an independent consultant specializing in First Nations history and material culture, repatriation issues, and museum practice.

ANDREW MARTINDALE is an associate professor in the Department of Anthropology, a member of the Laboratory of Archaeology, and an Early Career Scholar and faculty associate at the Peter Wall Institute of Advanced Studies at the University of British Columbia. He is an anthropological archaeologist whose research and teaching expertise has focused on the Northwest Coast and includes the history and archaeology of complex hunter-fisher-gatherers of western North America, the archaeology and ethnohistory of cultural contact and colonialism, space-syntax analysis of architecture and households, and the use of Indigenous oral records in archaeology. His recent research project explored cultural change among the Tsimshian people of northwestern Canada during the contact era (after AD 1787) and examined how change in post-contact Tsimshian culture was a function of the integration of the European market economy into traditional social relations of subsistence economics. His most recent work goes beyond the structural dynamics of economy and focuses on the agency of individual Tsimshian people as they used material culture to forge new, complicated identities in response to European influences. He is currently engaged in a study of Indigenous history over the Holocene via a comparison of archaeological data and Indigenous oral records.

MARIE MAUZÉ is a senior researcher at the Centre national de la recherche scientifique, Paris, and a member of the Laboratoire d'anthropologie sociale. A cultural anthropologist, she has conducted fieldwork in British Columbia with the Kwakwa̲ka'wakw

since 1980 and visited several other Native communities. In addition to numerous articles published in French, she is the author of *Les Fils de Wakai: Une histoire des Lekwiltoq* (1992) and the editor of *Present Is Past: Some Uses of Tradition in Native Societies* (1997). She co-published, with Marine Degli, *Arts premiers* (2000). She is co-editor, with Michael Harkin and Sergei Kan, of *Coming to Shore: Northwest Coast Ethnology, Traditions, and Visions* (2004). She contributed to the edition of Claude Lévi-Strauss's *Oeuvres* published for the anthropologist's one hundredth birthday (2008). Her current interests include the anthropology of art, the history of anthropology, the history of museum collections, and the relationship between museums and Native peoples.

BRUCE GRANVILLE MILLER is professor of anthropology at the University of British Columbia. His research deals with Indigenous-state relations, particularly contemporary justice initiatives and the concept of Indigeneity. Current research includes the issue of oral histories in court, the circumstances of non-recognized bands and tribes, and phenotype and identity at the international border. His publications include *The Problem of Justice: Tradition and Law in the Coast Salish World* (2001); *Invisible Indigenes: The Politics of Nonrecognition* (2003); *Be of Good Mind: Essays on the Coast Salish* (2007); and *Oral History on Trial: Recognizing Aboriginal Narratives in the Court* (2011).

MARIANNE NICOLSON is a visual artist of Dzawada'enux̱w (Kwakwa̱ka'wakw) and Scottish descent. Her artworks have been exhibited in venues such as the National Gallery of Canada, Vancouver Art Gallery, and National Indian Art Centre, among others, both national and international. In addition to a full-time art career, in recognition of the need to address issues of the Kwakwa̱ka'wakw language and culture revitalization, she is currently pursuing a PhD in linguistics and anthropology at the University of Victoria.

JUDITH OSTROWITZ is the author of *Interventions: Native American Art for Far-Flung Territories* (2008) and *Privileging the Past: Reconstructing History in Northwest Coast Art* (1999), as well as numerous articles about Native North American art. With the support of an Art Writers Grant from the Creative Capital/Warhol Foundation (2012-13), she is at work on a new book with the working title *Contemporary Native American Art: Cosmopolitanism and Creative Practice*. Ostrowitz is an adjunct associate professor who has taught at Columbia University, Yale, New York University, and the City College of New York. She is a contractual lecturer for the Metropolitan Museum of Art and is a former assistant curator at the Brooklyn Museum of Art. She was the recipient of a J. Paul Getty Postdoctoral Fellowship in the History of Art and Humanities for 1997-98.

DAISY SEWID-SMITH was born in 1938 in Alert Bay, BC. Her parents were Chief James Sewid of the Wiumasgum Clan of the Qwiqwasutinux and Flora Alfred, the daughter of Chief Moses Kaudie Alfred of the Sisunglay of the Namgis of Alert Bay and

Agnes Alfred of the Mamaliliqalla of Village Island. Chief James Sewid and his wife Flora had ten children (four boys and six girls) and Daisy was the sixth. The family lived in Village Island and moved to Alert Bay in 1944. Daisy moved to Campbell River in 1973. In 1980 the School District of Campbell River offered her a position as department head of the First Nations Department and to teach First Nations languages. She retired in 2000. She was married to the late Chief Lorne Smith of Turner Island. They had two children – Gloria and Todd – and five grandchildren – Shonna, Jamie, Alice, Erik, and Madison. She received an honorary doctor of law from the University of Victoria for her work as a First Nations educator. She has worked with many professors and students in Canada as well as the United States. She has also authored and co-authored many books and articles, such as *Prosecution or Persecution* (1979) and *Paddling to Where I Stand* (2004). She continues to share her knowledge with many people, especially Dr. Nancy Turner of the University of Victoria.

PAUL CHAAT SMITH (Comanche) is associate curator at the Smithsonian's National Museum of the American Indian in Washington, DC. His projects include the permanent history exhibition at NMAI's museum on the National Mall and the exhibitions *Fritz Scholder: Indian/Not Indian* and *Brian Jungen: Strange Comfort*. With Robert Warrior, he authored *Like a Hurricane: The Indian Movement from Alcatraz to Wounded Knee* (1996). Smith's second book, *Everything You Know about Indians Is Wrong* was published in 2009.

CHARLOTTE TOWNSEND-GAULT is a professor in the Department of Art History and a faculty associate in the Department of Anthropology at the University of British Columbia, and a visiting research associate in the Department of Anthropology at University College London. She has published widely on the history and politics of response to Indigenous arts and culture in North America since the early 1980s, most recently "Not a Museum but a Cultural Journey: Sḵwx̱wú7mesh Political Affect" (2011); "Sea-Lion Whiskers and Spray-Crete: The Affect of Indigenous Status in Contemporary British Columbia" (2011); "Still a Forest, Still Symbols" (2011); and "Outside Things Inside: Relative Status on the Northwest Coast" (2012). Exhibitions curated include: *Land, Spirit, Power: First Nations* (1992, with Diana Nemiroff and Robert Houle) at the National Gallery of Canada; and, at the Morris and Helen Belkin Gallery at UBC, *Yuxweluptun: Born to Live and Die on your Colonialist Reservations* (1995); *Rebecca Belmore: The Named and the Un-named* (2003); *Backstory: Nuuchaanulth Ceremonial Curtains and the Work of Ḵi-ḵe-in* (2010); and, as a member of the curatorial team, *Witnesses: Art and Indian Residential Schools in Canada* (2013).

SCOTT WATSON is director/curator of the Morris and Helen Belkin Art Gallery and professor and head of the Department of Art History, Visual Art and Theory at the University of British Columbia. He is director and graduate advisor for the Critical Curatorial Studies program, which he helped initiate in September 2002. He also sits on

numerous external boards and committees, including the Jack and Doris Shadbolt Foundation. Recent distinctions include the UBC Dorothy Somerset Award for Performance Development in the Visual and Performing Arts, 2005; the Alvin Balkind Award for Creative Curating, 2008; and the Hnatyshyn Foundation Award for Curatorial Excellence in Contemporary Art, 2011. Watson has published extensively in the areas of contemporary Canadian and international art. His 1990 monograph on Jack Shadbolt earned the Hubert Evans Non-Fiction Prize (BC Book Prize) in 1991. Recent writing includes "Race, Wilderness, Territory and the Origins of the Modern Canadian Landscape" and "Disfigured Nature" in *Beyond Wilderness: The Group of Seven, Canadian Identity, and Contemporary Art* (2007); "Transmission Difficulties: Vancouver Painting in the 1960s" in *Paint: A Psychedelic Primer* (2006); and "The Lost City: Vancouver Painting in the 1950s" in *A Modern Life: Art and Design in British Columbia 1945-1960* (2004). Recent and upcoming curated exhibitions include *Exponential Future* (2008); *Intertidal: Vancouver Art & Artists* (2005/06) at the Museum of Contemporary Art in Antwerp; *Stan Douglas: Inconsolable Memories* (2005/6); and *Rebecca Belmore: Fountain* (2005) for the Venice Biennale Canadian Pavilion. His research focus is contemporary art and issues, art theory, and criticism, twentieth-century art history, and curatorial and exhibition studies.

DOUGLAS S. WHITE is the Chief of the Snuneymuxw First Nation in Nanaimo, BC. His Coast Salish name is Kwul'a'sul'tun and his Nuu-chah-nulth name is Tlii'shin. After receiving his BA in First Nations Studies from Malaspina University-College, he graduated from the Faculty of Law at the University of Victoria in 2006. He was elected director of the Indigenous Bar Association of Canada in 2007 and, in 2008, joined Mandell Pinder as an associate lawyer. He was elected Chief of the Snuneymuxw First Nation in December 2009 where a major focus of his work is related to the implementation of the Snuneymuxw Treaty of 1854. In June of 2010, Chief White was elected by Chiefs of British Columbia to lead the First Nations Summit as a member of the FNS Task Group. In that capacity, he advocates for First Nations seeking resolution of outstanding issues with the Crown. He is also a member of the BC First Nations Leadership Council working on common issues with BC First Nations and advocating on their behalf with the governments of British Columbia and Canada. He lectures frequently on Indigenous legal issues at universities.

MICHAEL NICOLL YAHGULAANAS is actively playing with the comfortably familiar lens through which Canada views Indigenous peoples. For three decades he was involved in high-profile successes as an official within the Council of the Haida Nation. This included formally representing a Haida viewpoint within a larger Pacific context. His politics began with an appointment by a senior hereditary leader and his experience as a forestry engineer working in one of the most endangered forest systems in the world, the temperate rain forests of Haida Gwaii. With appreciations to Cai Ben Kwon,

Delores Churchill, Robert Davidson, Jim Hart, Guujaau, Bob Dalgleish, and dear friends, many now departed, Yahgulanaas blends his training in classic design with a highly personal view of the extensive corpus of Haida narratives. His invention of a new genre of graphic narrative – Haida manga – challenges the fetishizing of Indigenous peoples by creating contemporary, accessible, and socially relevant work. His work has been exhibited in Japan, Korea, Australia, Abu Dhabi, and Germany, as well in Haida Gwaii and elsewhere in Canada. Publications include *Flight of the Hummingbird* (2008); *A Lousy Tale* (2004); *The Last Voyage of the Black Ship* (2001); *Tale of Two Shamans* (2001); and *RED, A Haida Manga* (2010). His artwork is in many private collections as well as in the permanent collections of the British Museum in London, the Glenbow in Calgary, and the UBC Museum of Anthropology in Vancouver. Large-scale permanent public works are found at the University of British Columbia, Kensington Park in Vancouver, and in other cities in Canada.

# Index

*Note:* page numbers in **bold** indicate an illustration.

**A**bbott, Donald N., 791-92, 804, 806-7

Abbott, Lawrence, 852, 853-54

Aboriginal media production, 12-13; as art, 855-57; Challenge for Change program, 833-34; Chief Dan George Media Training Program, 834; cultural mediations of, 839; development of, 859-60; digital networks and, 959-60; documentaries, 849-51, 851-55, 852, 895-96; doubles, 585; ethnographic assumptions of, 848-49; filmography, 860-63; framing, 838-40; government support for, 832, 833, 847, 863; legacy of misrepresentation and, 833; Native American, 833, 851-55; new directions in, 829, 836-38, 855-57, 857-58; Northwest Coast, 828-29; as political tool, 829, 857; in US, 833; video installations, 829, 830, 855, 858, **972, 979**

Aboriginal Peoples Television Network (APTN), 833, 950

Aboriginal rights. *See* rights, Aboriginal

aboriginality. *See* Indianness

access, 296, 412; equality and, 444, 446, 448, 449, 628-29; limits of, 448; to museum collections, 818-19, 824n7, 985; public, 530, 555

acculturation, 520; arts of, 559, 573-75, 605-6; autonomous and selective, 846; and culture, 574-75, 575-76, 651-52; effects of, 782-84; theory of, 858. *See also* assimilation

Adams, Alfred, 149-51, 543

aesthetics: Aboriginal, 624-25, 829, 859-60, 961; culture history approach, 208-9; diverse notions of, 486n1; as focus for study, 980; market-driven conventions of, 292; pop culture, 989; potlatch system and, 229-31; theories of, and *l'art négre*, 232; values of, 506-7

agency: acculturation and, 573-75; of art, 980; of auto-ethnography, 529; collaboration and, 773-74; of contemporary artists, 893; of the dispossessed, 868; in ethnographic photographs, 993-94; of Indigenous art, 14; of motifs, 628; of oratory, 895-96. *See also* curators/curatorship, interventionist

Alberni Residential School, 684, 688

Alberni Valley Museum, 790

*Alberta Museums Review,* 795-96, 806-7

Alert Bay, 22, 269, 335, 538-40, 769, 807, 809; *vs.* Cape Mudge, 582. *See also* U'mista Cultural Centre (Alert Bay)

Alfred, Agnes, 15, 529-30, 534-37, 966, **967**

Alfred, Taiaiake, 925-27, 964

*American Anthropologist,* 129, 141-42, 208, 209, 222-23, 225-26, 227-28, 422-23

*American Ethnologist,* 161-62

*American Indian Art,* 603

*American Indian Art Magazine,* 629-31, 631-32

American Indian Movement (AIM), 868, 991

*American Indian Quarterly,* 851-55

American Museum of Natural History, 130, 131-32, 134, 135, 140-41, 141-43, 148-49, 152-57, 486n3, 640, 642, 758, 768; North Pacific Hall, 757; Northwest Coast Indian Hall, 271-72, 286-89, 296, 762-63, 780; and U'mista Cultural Centre, 792

Ames, Kenneth M., 112-14, 116-18

Ames, Michael M., 429-31, 490, 553, 555, 561, 564, 575-76, 594, 595, 598, 871; and exhibit paradigms, 758-59, 763-67, 824n4, 916-17

ancestors, 571, 572, 636, 677, 686

anthropological theory, 549-50; Boasian, 93, 104, 209-10, 554-55, 561, 582-84, 584-85; cultural

comparativist, 163-64, 209-10; cultural evolution-ist, 203, 205-6, 209-10, 213-17, 226-27; culture and personality, 724, 735-37; Durkheimian, 211; and ethnographic museums, 757; historicist, 203; interdisciplinary, 559-60; Northwest Coast, 550-52, 552-53; outdated foci, 772, 839; post-Boasian, 550; and practice, 8, 11, 203-4; recontextualiza-tion, 410-13; relativism, 203; salvage, 554-55, 703-4, 780; shifting paradigm, 487-89; standard fields, 134-35; and their subjects, 785-86 (*see also* collaboration); twentieth-century, 94, 99-100, 102, 227, 549-50, 550-52, 560-63

anthropologists: activist, 550-51; as advocates/consultants, 731-33, 825*n*18; and art markets, 594, 595; and artifact collection, 130; attention to cultural production, 869; field work, 772; as film critics, 832; museum, 758; and Native marginal-ization, 322, 515-17; as participant observers, 923. *See also* individual anthropologists

anthropology: as academic discipline, 49, 205, 213, 225-26; applied, 554-57; and archaeology, 93-95; of art, 556-57; critical theory and, 772; critics of, 773; cultural, 869; decolonization of, 553, 561; epistemological constraints of, 231-33; and ethnog-raphy, 94, 95; field schools, 553; focus of, 134-35, 231, 839; future of, 772; limits of, 102-3, 295-96; and museum exhibitry, 763-67, 786-87, 937; Northwest Coast, 559-60. *See also* ethnography

antiquity, 117; of artifacts, 147-48; of formline conventions, 413; of Krikiet (Keïgiet) pole, 278-79; of mankind, 214; of monumental forms, 51; of Northwest Coast art, 116-17, 288, 299-300; of Northwest Coast cultures, 93; of Tlingit society, 63

Appadurai, Arjun, 603, 875

applied arts. *See* Native arts

appropriation: of Aboriginal design, 101, 313-14, 319, 350, 353-55, 577; anxieties around, 974; of cultural property, 729-30; of cultural voice, 583; of histories/myths, 322, 325-27; of Indigenous motifs, 562; of Native art, 513-14; of Native heritage, 494; reversed, 262-64, 332

archaeological sites: Boardwalk, 113; Clo-oose, 121; Ginakangeek, 121-25; Glenrose, 106; Long Lake, 112; Macoah, 120; Namu, 124; Nanaimo, 120; Nuhwitti, 141, 157; Ozette, 119, 120, 121, 639, 773-74; as ritual places, 119-20; Sproat Lake, 120; T'ukw'aa, 120; types, 119-21; Yuquot, 120

archaeologists, 92, 94-95, 104-5, 123-25, 322; artifact collecting, 130, 131

archaeology, 7-8; and anthropology, 93-95, 98; and art, 7-8, 93, 96-97, 97-98, 100-101; in British Columbia, 105-7, 107-8 (*see also* archaeological sites); contemporary, 98-101, 119-21; early, 92-95, 101; evolutionary approaches, 97-98; and historic sequences, 221; holistic, 107-8; intrusiveness of, 97-98, 322; late twentieth-century, 112-14; mid-century, 95-97; models, 93, 94-95, 104, 116-18; New Archaeology, 94, 95, 97; of symbols, 102-3

architecture, 21-22, 115-16; Central Coast Salish, 83-84; Haida, 65-66, 98-99, 110, 156-57; Kwakwaka'wakw *vs.* Nuu-chah-nulth, 71-72; Lower Chinook, 83; Nuu-chah-nulth, 69, 71-72; traditional, 540; wooden frontier, 260-62

Arden, Roy, 968, **969**

Arima, Eugene Y., 475-82

art: archaeology and, 7-8, 93, 96-97, 97-98, 100-101; *vs.* artistry, 98-99; "Canadian," 305, 882; classification of, 205-6, 218, 219, 602-3, 864-67, 869-70, 930-32; as communication, 108, 588-89; concepts of, xxxvi, 1-2, 94; in context, 217, 231-33, 295; and craft, 891, 904; criteria of value, 620-22; and culture, 15-19, 356-57, 918-19, 948-49 (*see also* objects, ceremonial, as art); *Delgamuukw* and, 865; First Nations contemporary art move-ment, 882; funerary, 240, 263; Indigenous *vs.* non-Indigenous, 16-17, 95, 991; and meaning, 98-99, 111-12; political, 878-79, 879-81, 881-83, 884-85, 911-12, 912-14, 926, 948, 981, 989; possibilities of, 915, 945*n*1; prehistoric, 364-65, 365-66, 367-68; psychological dimensions of, 208, 210; pure theory of, 867, 934; salvage, 513; spirituality and, 422, 613, 616-17; and story, 531, 902; styles, 52; as symbolic representation, 92, 209, 458-67; Vancouver School, 972. *See also* formline art; Native arts

art galleries (Vancouver): Artspeak, 927; Bent Box, 879; Catriona Jeffries, **979**; grunt gallery, 950-51; Morris and Helen Belkin Art Gallery (UBC), 879, 881-83 (*see also* Vancouver Art Gallery); Native-run, xxxiii, 598; Presentation House Gallery, 855; The Talking Stick, xxxiii; Wakefield Gallery, 274

Art Gallery of Greater Victoria, 111-12, 928

Art Gallery of Ontario, 761-62

art history/historians: and art markets, 594; models, 223-25, 445, 583-84, 981; and Native

marginalization, 515-17; New Art History, 410; and Northwest Coast art, 350, 445, 458-67, 564-65, 705-6

art market. *See* market, art

art production: acculturation and, 575-76; Central Coast Salish, 572-73; economic incentives, 538-40, 555, 566, 578-79, 607-8; guidelines for, 551; historicized, 567-68; *vs.* making a living, 360, 361, 362, 478-80; "Native-style," 562, 577; networked, 959-60; new media and, 855; professional, 619-20; and symbolic capital, 600; traditional *vs.* market, 623-25, 626-27; women's engagement in, 542-43

art styles: Abstract Expressionists, 276; cultural differences and, 320; and culture, 25, 222, 228, 254, 255, 301-2, 438-40, 472; individual *vs.* regional, 426-27, 472-75; northern Northwest Coast, **407**; regional, 426-27, 904; tribal *vs.* Northwest Coast, 406; Tsimshian, 406; valorization of, 409

artifacts: aesthetic status of, 50, 52, 272; and cultural knowledge, 403, 848; from "curio" to "national heritage," 590; display of, 764, 765-66, 766-67; documentation of, 212; as documents of culture, 138-39, 141-43; duplicates, 134; as ethnographic representation, 153-54, **154**; first description of, 55-56; glass, 121-25; Heiltsuk, 259-60; market for, 259-60; monumental forms, 52, 322-23 (*see also* house posts; totem poles); as natural history specimens, 764, 766; in new media, 623-24

artists: in the Americas, 931-32; as art critics, 445; codification and, 406, **408**; *vs.* craftsmen, 505; depoliticized, 409; and epistemological paradox, 303; individuality of, 287-88, 422, 423; at 'Ksan, 483-86; Kwakwa̲ka̲'wakw, 243; materials and tools, 374; modernity and, 783-84; new generation of, 597; and new media, 444-45; New York avant-garde, 273-74; non-Native, 447, 578-79, 717; roles of, 637-38, 657-59, 711, 882, 918, 959, 960; southern Kwakiutl, 424-25; Tlingit, 173; training of, 396, 447, 511, 621, 622, 624, 877, 914; Tsimshian, **241**; women, 13

Arts and Crafts movement, 9, 348, 380

*Arts of the Raven* training program, 447, 476

*Artscanada*, 499-508

Askren, Mique'l, 993-94

Assembly of First Nations, 743-45, 787

assimilation, 241-42; and difference, 895; effects of, 593, 628, 898; Massey Report and, 347; object of

policy, 309, 312-13; politicized alternative to, 783-84; success of, 312, 313. *See also* acculturation

Assu, Harry, 529, 537-38, 582

Assu, Louisa, 966, **967**

Assu, Sonny, 978, **979**, 988-89

*at.óow:* defined, 747-48. *See also* crest art; objects, ceremonial; objects, cultural

attribution, 406, 412, 425, 429; formal analysis and, 408-9, 413, 426, 427-29, **428**

audience. *See* publics

authenticity: of art, 359, 402, **408**; certified, 611; criteria for, 511-12, 578-79, 597-98, 604, 832; of ethnography, 842; in market context, 579, 602-3; of postcontact art forms, 562; and tradition, 768-69

authority: and collaboration, 820-21, 827*n*30; custodial, 749-50, 750-51, 751-53, 794, 818-19, 824*n*9, 826*n*25; of First Nations, 941, 942; of hereditary leadership, 942-43; ownership and, 710-12; power/truth and, 940

auto-ethnography, 10-11; in film, 847; in First Nations museums, 760; Gitksan, 540-41, 544-45; Haida, 541-43; Heiltsuk, 546-48; history of, 518-21; Kwakwa̲ka̲'wakw, 518-26, 532-37, 537-38, 538-40; merging genres, 526, 528-29, 530; motives for, 529; museum, 770-74; Nuu-chah-nulth, 688; oral histories and, 523-24; process of, 520-21; Stó:lō, 543-44

autonomy: of art, 298; Internet and, 959; rights-based, 976; of style, 952. *See also* sovereignty

**B**allou, Maturin M., 255-59, 257

Barbeau, Marius, 540, 564-65; and artifact collection, 276, 315; and Canadian museum record, 130, 133, 180; catalogue of poles, 335; on ceremonial poles and crest images, 104-5, 315-17; and concept of "vanishing race," 305, 324-27; influence, 556; and Museum of Anthropology (UBC), 382; and museum record, 324; and Native art, 306, 324, 406; and restoration projects, 322, 323, 330; and *West Coast Art — Native and Modern* (Ottawa), 318, 319-21

baskets: acculturation and, 775; as art, 566; Coast Salish, 254, 255; Heiltsuk, 892-93; importance of weaving, 770, 771-72; materials for, 75, 76, 776, 777; types, 157-59, 776, 777, 905; waterproof, 72-73, 75, 777

Bastian, Adolph, 129, 207, 703

Bataille, Georges, 271, 725, 738-39

Baudelaire, Charles, 289, 297

*BC Studies,* 515-17, 687, 718-19, 889

beargrass, 75, 76

Beasley, Rick, 982, 983

*The Beaver,* 372-78

belief systems. *See* epistemology

Bella Bella, 77, 259-60, 546, 548, 792-93, 825*n*15

Bella Coola, 236, 242, 737-38, 932-35

Belmore, Rebecca, 819, 973

Benedict, Ruth, 228, 549, 724, 726-27, 734-37

Berlin Ethnological Museum, 679, 702, 703

Betty Parsons Gallery, 275, 296, 300-1, 303

Beynon, William, 131, 166, 339, 340, 530, 540-41

Bill Reid Centre at Qay'llnagaay, 920

Black, Martha, 12, 238, 259-60, 412, 718, 811-13, 814-15, 908

Blackman, Margaret B., 559, 562, 573-75, 577, 596

blankets (robes): bearskin, 68; button, 546-48, **547**, 574, **967**; Central Coast Salish, 83-84, **84**; ceremonial, 61; Chilkat, 152-53, **153**, 179-86, 287, 300 (*see also* Chilkat blankets [robes]); deerskin, 67; otter skin, 90*n*8; Salish, 905; Tlingit, 245, 415, **416, 419**; as wealth, 572, 732-33; woven, 51, 55, 56, 63-66, 70, 78, **84**, 459-60

Boas, Franz, 134, **156, 524**; artifact collection, 260; critique of evolutionism, 207-8; critiques of, 164, 218, 223, 410; and culture areas, 204; on dance, 424; debate with Powell, 219; emphasis on history and psychology, 207, 208, 210, 219-21; ethnographic approach, 23-24, 128-29, 131-32, 136-37, 138-39, 518-19; ethnographic film, 843-45; on ethnological collections, 139-43; and formal analysis, 405, 407, 414-22, **416-17, 418, 419, 421,** 430-31, 435, 436-37, 442*n*3, 459; and George Hunt, 131-32, 148-49, 522; influence of, 104, 205, 561; influence on American anthropology, 93, 94, 130; influences on, 206-7; interpretive style of, 414; monographs, 134, 155, 157, **158**; museum work, 765; overtures to formalism, 136-37; on potlatching, 723-24, 726-27, 731-33; salvage paradigm, 757; and Wissler, 210

Bob, Dempsey, 870, 902-3

Bourdieu, Pierre, 933-35, 934, 935

boxes, 151-52; bent, 269; carved, 415, **418,** 420; dovetailed, 69; glass "bentwood," 928, **969**; kerfed, 51, 52, 55-56, 88-89; painted, **421**; transformation in, 288-89

Breton, André, 270, 289, 291-94, 295

Bringhurst, Robert, 436, 751-53, 974

British Columbia (BC): linguistic groups, 309; multiculturalism in, 563-64; relationship with Native peoples, 309-10, 804-5; Totem Pole Preservation Committee, 328-29, 741, 803, 826*n*26; treaties, 628, 645, 666-67, 729, 753-54, 817-19, 915, 977-78; unceded Native land, 628, 864, 867-68, 897; view of artisan skills, 349-50

British Columbia Indian Arts and Welfare Society (BCIAWS), 332, 335, 341-42, 344, 351, 352, **352,** 356, **357,** 362, 363, 377-78, 381, 566, 606, 688; constitution and by-laws, 400; early days of, 396-401; objectives, 395-96; and Raley's ideas, 386; trademark, 359

British Columbia Provincial Museum, 133, 447, 502; collaborative projects, 799-803; Ethnology division, 576; history-oriented, 580; Northwest Coast ethnology galleries, 510; relationship with First Nations, 809-10. *See also* Royal British Columbia Museum (RBCM)

Brooklyn Museum, 272, 758

Brown, Eric, 317, 318-19

Brown, Judson, 982-83

Brown, Pam, 791, 793, 825*n*14

Brown, Steven C., 174, 187, 406, 407, 412, 685, 716-18, **717**

Brown, Walker, 440, 441

*brunt magazine,* 951

Bureau of American Ethnology (BAE), 205-6, 707; domination of anthropology, 205-6

burial, 38-40

Burke Museum, 486*n*3, 553

**C**aamaño Moraleja, Jacinto, 66, 91*n*12

*Calder v. Attorney-General of British Columbia,* 135, 648

Campbell, Alice Marie, 11, 912-14

Campbell, T.B., 322, 329

Canadian Centre of Folk Culture Studies, 540

Canadian Council of Amerindian Studies and Welfare, 347

Canadian Geological Survey, 353, 682

Canadian Handicrafts Guild, 393, 606

Canadian Indian Art and Handicraft League, 372; objectives of, 391-92

Canadian Museum Association, 787

Canadian Museum of Civilization, 145-48, 149-51, 165n4, 754; First Peoples Hall, 486n3, 792, 820-22; Tahltan collection, 791; and treaty negotiations, 817-19

Canadian Museums Association, 743-45

Canadian National Railway (CNR), 327, 380, 385

Cannon, Aubrey, 123-25

canoes, 63; construction of, 70, 86-87; Kwakwaka'wakw, **831**, 842; Lower Chinook, 83, **87**; outsiders' views of, 52; Tlingit, 245

Cape Mudge: vs. Alert Bay, 582. *See also* Kwagiulth Museum (Cape Mudge)

Carlebach, Julius, 271-72, 289, 291, 296

Carlson, M. Theresa, 974

Carlson, Roy L., 96, 97, 107-8, 114

Carpenter, Edmund (Ted), 294-98, 469

Carr, Emily, 313, 318, 319, 325, 341-42, 350, 351, 676n4, 688, 707, 931; Yuxweluptun and, 885-89

carvers, 362; Kwakiutl, 483-84; Kwakwaka'wakw, 307, 343; Samali, **279**, 280; Tsiebása, **279**; Tsimshian, 482-86. *See also* individual carvers

carving, 58, 59, 61, 64-65; apprenticeship, 447, 476, 479-80, 483-86, 498, 801, 826n24, 902 (*see also* Thunderbird Park, totem-pole restoration programme); bowls, 75, **89**, 89-90, 151; ceremonial objects, 267-68, 342, 623; Coast Salish, 254-55, 570; continuity of, 489, 514; dating of, 475; economic incentives, 284, 358, 607-8; as evidence of intelligence, 245; frieze-work, 58; Haida, 82, 384-85, 564-65, 890; Kwakwaka'wakw, 268-69; masterpieces, 240, **241**, 470, 482-86, 903; materials, 82, 86, 106-7, 113, 152, 247; phases of, 106-7; pipes, 470-75, **471**, 472-73; and shell inlay, 55, 502; significance of, 142-43; and spiritual essence, 297; spoons, 55, 75; stone, 113; styles, 279-81, 376, 480-82; talking staff, 21; Tlingit vs. Haida, 472; tools, 53, 65, 121-25, 463-64; Twanas vs. Clallams, 255

cedar, 86, 152, 247

cedar bark, 20, 23, 75, 76, 160

ceremonial activity: and art, 351, 358, 497, 499, 500, 636-37, 750; as context, 968; demonized, 680; and family relationships, 811; and healing, 686-87; Makah, 701-2; in museums, 814, 816-17, 824n8; ritual, 534-35, 536-37, 571, 572; ritual arts and, 904, 907; suppressed, 307, 308, 339-41. *See also* potlatch

Chaikin, Ira, 659-63

Chilkat blankets (robes), **190**, **451**; cultural significance of, **153**, **180**; design of, 202n10, 459, **460**;

eye pattern on, 415, **416**; formal elements of, 437; repatriation of tradition, 745-47; weaving, 152-53, 174, 175, 176-79, 179-86

Chilkat Whale House, 186-90, **190**

Chinook people: architecture of, 83; canoes, 83, **87**; material culture, 75; metal work, 82; Nations, 812-13, 824n9; Nuu-chah-nulth Exhibition Advisory Committee, 812-13; place in writing about, 677-78; potlatch screens, 638-43, **641**, 664, **681**, 705, **706**, 810-11, 908; self-representation, 678; treaty negotiations, 817-19; weaving, 70

Christianity. *See* missionaries

Church Missionary Society (Anglican), 235, 246, 249

churches: independent Native, 235; and Native dancers, 586-87; and revival of Native art, 242-43; in villages, 240, 260-62

Churchill, Delores, 761, 774-78, 891

clan crests. *See* crest images

Clark, William, 47, 74, 76, 91n14

Claxton, Dana, 13, 855-58, 868, 890, 973

Clifford, James, 136, 550, 560, 579-81, 760, 762, 972; critique of, 581-82

Clutesi, George C., xxxiii, 4, 381-82, 551, 633-38, 650-52, 657-59, 676n4, 688-90; on potlatching, 709-13; *Son of Raven, Son of Deer,* 707-9

Coast Salish peoples, 204, 253-55; architecture, 83-84; art production, 572-73; basketry, 254, 255; carving, 254-55, 570; culture, 975; weaving, 83-84, **84**

Cocking, Clive, 489, 494-99

Codere, Helen, 430, 477, 556, 721-22, 739-40

Cole, Douglas, 136, 141, 144-45, 161, 162-63, 659-63

collaboration, 812-13; in anthropology, xxxiv, 223, 561, 841; in archaeology, 119; and capital, 563-64; centers of, 772-74; in curatorship, 816, 827n29; defined, 785, 791-92; in ethnography, 131, 156-57, **158**, 522-26, 532-37, 819; international, 762, 778-79; with judicial system, 267; with missionaries, 235, 260; between museums, 811; with museums, 12, 131, 142, 260, 449-50, 575-76, 687, 718, 743-45, 758-62, 786, 823n2; vs. non-collaborative display, 798-99; in opera production, 970, **971**; Ozette site and, 773-74; politics of, 794-95, 806; in research projects, 787-88, 791, 824n7, 824n11; and self-representation, 832; treaty making and, 788, 818-19; in writing history, 942-44. *See also* partnerships

collaboration process: authority and, 820-21, 827*n*30; changes in, 807; efficiency and, 821; models, 792, 795, 819-20, 820-22; power and, 821-22; protocols for, 815-16, 826*n*26, 827*n*30

collecting, of artifacts, 47, 51, **76**, 77, 82, 90*n*7, 91*n*14; academic analysis of, 135-36, 139; archaeological, 130, 131; as art, 271-72, 286, 295, **354**, 716; of ceremonial objects, 266-67, 537, 640, **641**; context of, 58, 128-29, 141; cultural documentation of, 131, 132-33, 136-37, 140-41, 142-43, 151-52, 159-61, 165*n*3; dilemma of, 624-25; ethnographic, 128-35, 152-53, 259-60, 272, 287, 296-97, 519-20; ethnological, 131, 139-40, 144; ethnological, 161-63, 162, 216, 276; legacy of, 137; by missionaries, 234, 237-38, 249, 253-55, 259-60; for museums, 276, 379, 679, 702-3, 704, 705, **706**, 906; need for haste, 144, 161-62; organization of, 217-18, 219; scientific, 129-30, 141; temporal context of, 135, 780-81

collections: Bella Coola collection, 679; Dundas Collection, 590, 604, 631-32, 822; Heye Foundation, 164*n*1; Northwest Coast collection (UBC), 380; Northwest Coast collection (US), 296; Nuuchah-nulth collection, 813; Potlatch Collection, 559, 560, 581-82, 761, 800; private, 685; R.W. Large Collection, 825*n*15; Snail House Collection, 202*n*1; Tahltan collection, 791; Tlingit collection, 191-201

Collison, Nika (Jisgang), 413, 440-42, 974

Collison, William Henry, 246-48

colonialism: academic analysis of, 135-36; aggressive, 379-80; and appropriation, 513; and archaeology, 97-98; assault on meaning, 641-42; effects of, 54, 489, 500-1, 651-52, 780-81, 869; ongoing, 494, 551, 561; paradox of, 784; Surrealists' stand against, 273

commissioning: of art objects, 307, 333-36, **334**, 351; of baskets, 776; of ceremonial regalia, 623, 777; of installations, 872; as standard of prominence, 621; of totem poles, 307, 333-36, **334**, 910-11; Walas G̱waxwiwe (Great Raven), 984-85; of works for *The Legacy* exhibition, 496

commodification: *vs.* authenticity, 602; and consumption, 614-16; of design motifs, 348, 364-68, 369-71, 371-72, 377-78; as dynamic process, 603; and inalienable treasures, 603, 628-29; and mass production, 627-29; of the past, 783-84; *vs.* value, 934-35

communication: art as, 897, 899; cross-cultural, 125; in cyberspace, 961-62; non-verbal, 445-46, 974; of public secrets, 913, 973; role of form/style, 107-8; symbolic, 96, 115-16; universal, 444-45

community, 37-39, 41-43

Conference on Native Indian Affairs (UBC), 352-53, 355-63, 381-82

Constitution Act (1867), 644; and division of powers, 646-47, 667-68

Constitution Act (1982), 645; Section 35, 6; section 35, 647, 668-71

contact zone, 762-63, 771, 780-81

Contemporary Art Gallery, 893, 968, **969**

*ConunDrum Online*, 958-59

conversion: and destruction of cultural objects, 585-88; and European material culture, 260-61; and new life, 240; as pragmatic choice, 235; on Puget Sound, 253; and repression of culture, 234, 235, 236; and tattooing, 248; and villages, 240

Cook, James, 27-28, 47, 57-59, 90*n*8, 677, 678, 722-23, 731

copyright. *See* law, copyright

Coqualeetza Residential School, 238, 242, 380; curriculum, 390-91

cosmology: and art, 119-21; and artistic logic, 96; ceremonial activities and, 639, 640; cosmic tree, 110; Haida, 31-45, 109-10, 440; and house design, 98-99; Tsimshian, 126

Cranmer, Barb, 834-35, 849-51

Cranmer, Daniel (Dan), 450-55, 453, 537, 560, 659, 802

Cranmer, Doug, xxxiii, 269, 435, 453, 483-84, 498, 504, 869; and art market, 615

Cranmer prosecutions, 266-67, 379

Cranmer Webster, Gloria, xxxiv, 5, 9, 549, 809, 834, 842, 847

creativity: acculturation and, 573-75; ceremonial activity and, 358; individual, 426; political function of, 690-92; potlatch and, 633, 636; as process of change, 505; pure idea and, 303; *vs.* reason, 179; and survival, 959; and the unconscious, 270

Crespi, Juan, 27, 49, 54-56, 90*n*8

crest art, 187, 202*n*4, 496, 546-48, **547**, 698, 727; on blankets, **967**; Boasian understanding of, 584-85; new media for, 574; and oral tradition, 584-85; origins of, 982; and rights claims, 966-67; totemic, 193, 358, 989; and traditional narrative, 170-71, 171-72; Tsimshian, 568-70

crest images, 21-22, 79-80, 98-99, 156-57; as abstract art, 338; Double (Killer) Whale, 180, **181**; Double-Headed Monster, 180, **180**; Eagle, 195-201; generic *vs.* named, 640; on jewellery, 256-57; monster (Tsimshian), 558, 569-70; moral *vs.* mythic associations, 171, 195-201

crest objects: acquisition of, 182-83; Beaver apron, 174, 179, 180, 182, 184-85, **190**; and clan histories, 175; clan regalia, **190**; dating, 172; Eagle staff-head, 191-201; house posts, 188-90; masks, 246, 249-50; photographs as, 994; Rain Storm robe, 179, 183; Rain Storm Screen, 175; Tlingit, 171-72, 174; Whale House house posts, **190**; Whale House Rain Screen, 173, **175**, **190**, 190-91. *See also* Chilkat blankets (robes)

crest poles. *See* totem poles

crests art: heraldic, 105

criminalization, of high art, 351. *See also* ceremonial activity, suppressed; potlatch prohibition

Crosby, Marcia, 5, 13, 409, 442n1, 513-15, 893-95, 939, 944

Crosby, Thomas, 235, 236, 237, 238, 240, 250-53, 260

Cross, John, 427-29, **428**

*Cultural Anthropology*, 838-40

cultural exchange, 2-3, 762; and cultural fusion, 976-77; media production as, 837-38

*Cultural Resource Management*, 807-8

culture: and art style, 421, 598, 975; Canadian, 325; documents of, 130, 141; environment and, 220, 221, 855, 891; ethnographical sense of, 213-14; history, 208-9, 559, 570-73; history of, 219, 220-22; language and, 950; logics of, 94-95, 111-12; loss *vs.* survival/revival, 487-88; patterns of, 212, 228, 771-74, 975-76; as personality, 207-10; predicament of, 972; rights and, 852; shock of discontinuity, 844; transmission of, 117-18, 769

culture areas, 94, 561; applied to sub-Saharan Africa, 212; concept of, 203-4; construction of, 843-45; definitions of, 96-97; *vs.* individual achievement, 227; North Pacific Coast, 204; Northwest Coast, 225-26

cultures: hierarchy of, 204, 205-6, 209-10, 225-26; Indigenous, 961; integration of, 228, 262, 263-64; intersection of, 47, 762-63, 771, 780-81, 986; psychological dimension of, 219-20; representations of, 758; state *vs.* Native, 308-12, 312-13, 319-25, 325-27, 328-29; transference of traits, 222

cultures, Aboriginal: anti-potlatch legislation and, 608-9; attacks on, 308-9, 345, 585-88; circumscribed, 877; contemporary, 344-45, 954; continuity of, 339-41, 949; disappearance of, 315, 321, 325-27; Northwest Coast, 46, 93, 168, 171, 255-59, 339-41, 448, 747-48, 857, 892-93, 903-5; protection and disclosure of, 975; protocols of, 829-30, 994; reclamation of, 234-35, 620-22; reconstruction of, 910, 924-25, 967; suppression of, 234, 497; traditional, 782-84, 954

curators/curatorship: and appropriation, 163; *Arts of the Raven*, 448-49; collaborative, 409, 411, 496; and Indigenous history, 686-87; intent, 446; interventionist, 911-12; museum, 139, 191-201, 226-27, 498, 618-19, 623; principles of, 139; shifts in focus, 406, 431, 911-12. *See also* individual curators

Curtis, Edward, **831**, 840-43

cyberspace. *See* Internet

**D**adens, 62, 64-65

Dall, William Healey, 206, 223-25

dance: and art, 902; Indian *vs.* white man's, 252-53; and possession, 252, 253, 290-91; and two-dimensional art, 424-25, 438, 439; vision quest and, 18-19

dances: ancestral, 19; ceremonial, 15, 22-25, 66-68, 78, 80; chief's, 66-68, 901; death, 250; ghost, 250; Hamatsa, 533; of the hostage, 185-86; Madəm, 23-25; preparation for, 77-78; representing animals, 250, 702; sea serpent, 715; Shaman's, 85; thunderbird, 704

Danzker, Anne Birnie, 618-20

Dark Years, 267, 269

Dauenhauer, Nora Marks, 172, 727, 747-48, 974

David, Joe, 612-14, 615, 908-11

Davidson, Florence Edenshaw. *See* Edenshaw, Florence

Davidson, Robert, **439**, **491**, 439; and the abstract, 440, 917-19, 968; and art market, 615, 616, 874; celebration of, 490; on cultural objects, 749-50; and formalism, 413, 437; on Haida continuity, 919; and Haida formline, 413, 436-440, 443n4; influence of Bill Reid on, 505; *kugann jaad giidii*, 438, 443n5; Masset totem pole, 495, 501; printmaking, 616-17; solo exhibitions, 601, 617, 881, 918

Davidson, Robert Sr., 514

Dawn, Leslie, 9, 350, 596, 975

Dawson, George M., 48, 77, 129, 321

Deasy, Thomas, 383-85

decolonization, 553; of display paradigms, 758-59, 763-67, 781-82, 824n4; of imagination, 859-60; of knowledge production practices, 914, 916-17

decontextualization, 640-43, 663-64, 686; in films, 844; museums and, 758, 765; of visual art, 747-48

decoration. *See* ornamentation

*Delgamuukw:* age of, 867; holders of the name, 966-67

*Delgamuukw* decision: and Aboriginal title, 648, 676n7; and cultural policies, 877; and distinctiveness of Aboriginal culture, 867-68, 883; and rights-based claims for art, 13, 869-73, 866-67, 875-76, 981; and rights, 864; and rules for evidence, 865, 941; and universalist idea of art, 875-76

Deloria, Vine, 773

Department of Indian Affairs, 327, 379-80, 606; paternal policy, 9, 311, 312. *See also* Indian Act

Derrida, Jacques, 6, 964

design: *vs.* representative art, 210; types of, 301, **461**, 461-62, **462**

design motifs, **352**; bird figures, 21; codification of, 430-31; commercialized, 354-55, 364-68, 369-71, 371-72, 377-78, 917-19; eye pattern, 414-18, **416**, **417**, **418**, **419**, 463, 464-65; fragmentary, 459-60; human-animal symbols, 227-28; industrial application of, 348, 394-95; and national identity, 354-55, 977-78; northern, conventions of, 406; origins of, 413; on prehistoric art, 367-68; protection of, 362-63, 371-72; salmon-trout's-head, 464, 465; in school curriculum, 390-91; thunderbird, 698-700, 713-15, 714-15; wing pattern, 420, **421**. *See also* crest images

Dick, Beau, 968, **969**

Diesing, Freda, 486, 890, 902

discourse: of evaluation, 597-98, 612-13, 618-19; institutional and market, 599-600; market, 591-92, 627-29; property (*see* language, of property). *See also* renaissance discourse

diversity, 916; constitutionalism and, 883-84; cultural, 883-84; *vs.* cultural disjuncture, 866; *Delgamuukw* decision and, 883; embracing of, 944; as marketable asset, 945n1

Dixon, George, 60, 90n8

Dixon, Sam (Chief), 907-8

Dixon Entrance, 54

Dombrowski, Kirk, 585-88

Dominguez, Virginia, 161-62, 769-70

Dorsey, George, 129, 132, 141-42

Douglas, Stan, 5, **972**, 973

Douglas Treaties, 310, 645, 646, 666-67

Dowell, Kristin L., xxxv, 12-13

dreams: and creativity, 176-79, 183-84, 191, 195-97, 252, 270, 287; prophetic, 283; and reality, 270-71, 290; and spirit world, 18-19, 298, 571, 572, 906-7

Drucker, Philip, 93, 94, 113, 557, 682, 707

dualism, 111, 293-94, 298, 440

Duff, Wilson: on Aboriginal history, 605-8; and *Arts of the Raven*, 409, 448, 468-69, 593-94; critics of, 514; critique of Barbeau, 556; on cultural revival, 488-89; on cultural understandings, 92, 93, 111-12; and formline components, 443n4; and George Clutesi, 688; on Indigenous population decline, 265; on Kitwancool, 740-43, 803-5; on land claims, 726; praise of Northwest Coast art, 431; support of Native arts and crafts production, 562, 567-68, 593, 605; survey of arts-and-crafts economies, 593, 594; and totem pole removal, 826n26; transcript of Mungo Martin potlatch, 450-58

Duffek, Karen, 11, 433-37, 437-40, 490, 508-13, 560, 578-79, 917

Duncan, William, 235, 237, 240, 249, 312, 822

Dundas Collection, 590, 604, 631-32, 8220

Duthuit, Georges, 289-91

*Dyn,* 273, 282, 298-300

economy: of craft production, 353, 357-59, 359-60, 360-61, 362; of potlatch *vs.* economy of tourism, 369-72

Edenshaw, Charles, 351, 352, 405, 409, 414, 420, 427-28, 459-60, 468, 503, 504, 505, 891

Edenshaw, Florence, 530, 541-43, 870, 918

Eells, Myron, 235, 237, 249, 253-55

7idansuu (Jim Hart), 874

Ellis, David W., 713-15

Emmons, George T., 132, 133, 140, 152-53, **153**, 174, 176, 299; and design names, 415-16; monographs, 134

epistemology: and art, 99-100, 231-33, 497, 705-6; and attitudes towards images, 906-7; and birth, 33-35; and carving, 342; and dance, 704; and death, 38; and ethnography, 26-29; flood, 19-20, 21; and government, 124, 694-95; Indigenous, and Western art frameworks, 1, 598; life, 36-38; life force, 28; Makah, 698-700; and material culture, 26-27; Nuu-chah-nulth, 7, 119-20, 120-21;

significance of, 26-29; and supernatural experience, 22-23; syncretism of, 239-43; Tlingit, 79-81; writing about, 975

Erikson, Patricia Pierce, 760, 770-74

Ernst, Max, 272, 275, 295, 296

essentialism, 104-5, 992-93; *vs.* cultural fusion, 990; *vs.* entanglement, 874-75; strategic, 868, 936, 937-38, 966

ethnicity, participatory, 490, 628-29

ethnography/ethnographers: as allegory, 136; archaeology and, 130; of art, 165n8, 557-60, 559, 570-73, 837; benefit of, 518; changing perspectives of, 768; collaboration in, 732-33, 798; collections and, 134-35, 151-52, 152-53; epistemology and, 26-29; ethnographic present, 555, 566, 780; incidental *vs.* professional, 48-50; and informants, 523-26; Jessup Expedition and, 153-54; Kitwancool, 741-43; Kwakwaka'wakw, 155, 724; and *l'art négre*, 232; Makah, 698-702; of media practices, 835-36, 838-40; methods, 231-33, 840-42, 840-43; by missionaries, 237, 243-44, 248-50, 253-55; phases of, 27, 48, 80-81, 85-89, 130, 134-35, 518-19; photography and, 133, 165n4, 840-42; postmodern, 588-89, 842-43; retrospective, 840-41; salvage, 843-45, 849; and subjects, 520, 768; surrealism and, 212-13, 276-82. *See also* auto-ethnography

*Ethnohistory*, 581-82

ethnology: and archaeology, 104; artifact collection and, 144; assault on Native people, 322; history of, 5-6; limits of, 422-23; object of, 139-40; salvage, 216, 772

evangelists, Aboriginal, 235, 284

Evans, Brad, 840, 841

exhibition catalogues: *Arts of the Raven*, 448-49, 467-69; *Box of Daylight*, 715-16; *Enjoy Coast Salish Territory*, 988-89; *Form and Freedom*, 448-49, 469-75; genres, 600-601; *The Legacy: Continuing Traditions of Canadian Northwest Coast Indian Art*, 599-600; *The Legacy: Tradition and Innovation in Northwest Coast Indian Art*, 482-86, 489-90; *The Northwest Coast Native Print: A Contemporary Tradition Comes of Age*, 596; *Objects of Exchange: Social and Material Transformation on the Late Nineteenth-Century Northwest Coast*, 779-84

exhibitions: American Indian arts and crafts, 372-73; Exposition of Indian Tribal Arts, 330; Man and His World, Northwest Coast exhibit, **491**;

*The Northwest Coast* (at Man and His World), 551, 555, 594; relational, 779-82; World's Columbian Exhibition, 157

exhibitions, gallery: *Arts of the Raven*, 349-50, 409-10, 431, 510, 593-94; *Bax wana tsi': The Container for Souls*, 927-29; Bill Reid, 349; *Box of Daylight: Northwest Coast Indian Arts*, 685; *A Century of Canadian Art*, 337-39, 341; fine art, 165n8, 272, 275, 302-3; *First Papers of Surrealism*, 272, 276; *The Ideographic Picture*, 275, 302-3; *Images: Stone: BC*, 111-12; *The Legacy: Tradition and Innovation in Northwest Coast Art*, 409, 495-96; *L'exposition surréaliste d'objets*, 271, 272; *Northwest Coast Indian Painting*, 275, 300-302; of Nuu-chah-nulth culture, 719; online, 950-51, **951**, **952**; *Raven Travelling: Two Centuries of Haida Art*, 411, 760, 790; Robert Davidson, 617; *S'abadeb. The Gifts: Two Centuries of Haida Art*, 760; selection criteria, 600, 623-25; *Thou Shalt Not Steal: Lawrence Paul Yuxweluptun and Emily Carr*, 885-89; *A Time of Gathering: Native Heritage in Washington*, 486n3; *Topographies*, 889-92; *West Coast Art – Native and Modern*, 306, 317-18, 318-21, 339, 341, 353; *Yuxweluptum: Born to Live and Die on Your Colonialist Reservations*, 881-83

exhibitions, museum: of ceremonial objects, 687; *Chiefly Feasts: The Enduring Kwakiutl Potlatch*, 486n3, 758, 768, 770, 790, 792; collaborative, 786, 789-90, 791, 810-11; criticisms of, 816; *First Peoples*, 788, 824n8; *Form and Freedom*, 294, 470-75; *In Honor of Our Weavers*, 771; *HuupuK*ʷ*anum · Tupaat – Out of the Mist: Treasures of the Nuu-chah-nulth Chiefs*, 687, 760, 811-13, 814-15, 816-17, 826n27, 908; *Indian Art of the United States*, 554; *Indian Artists of the United States*, 445-46; *Indian Arts in the United States and Alaska*, 554; *Káxḷáya Ǥvíḷás, "the Ones Who Uphold the Laws of Our Ancestors,"* 792-94; *The Legacy: Tradition and Innovation in Northwest Coast Art*, 809-10; *Listening to Our Ancestors: The Art of Native Life along the North Pacific Coast*, 760, 790; *Mehodihi: Well-Known Traditions of Tahltan People*, 791; *Mungo Martin: A Slender Thread*, 269; non-verbal information, 826n27; *'Nḷuut'iksa Łagigyedm Ts'msyeen: Treasures of the Tsimshian from the Dundas Collection*, 822-23; *Objects of Exchange: Social and Material Transformation on the Late Nineteenth-Century Northwest Coast*, 762-63, 781-82, 782-84; planning, 992-93; *The Power of*

*Giving: Gifts at the Saxon Rulers' Court and the Kwakwka'wakw Big House,* 762, 778-79; as a process, 812-13; *Proud to Be Musqueam,* 806-7; public criticism of, 824*n*11, 825*n*16; *Raven's Reprise,* 911-12, 912-14; *The Spirit Sings: Artistic Traditions of Canada's First Peoples,* 787; of tribal arts and crafts, 400

experts, cultural: Aboriginal, 166, 207-8, 449, 468-69; outsiders as, 585; wish to be seen as, 686. *See also* individual cultural experts

explorers: age of, 46; American, 47, 48, 54-55, 61-63, 74-77, 81-83; artists as, 49, 90*n*1; English, 47, 48, 49-50, 51, 53, 57-59, 60-61, 71-73; French, 47, 48, 49-50, 51, 53, 63-66; fur trade and, 47; Russian, 47, 53, 78-81; Spanish, 47, 48, 51, 52, 53, 68-71; and transformation masks, 291

fetishization: consumers and, 616, 931-32, 978; of Indian community, 938; of traditional past, 784

Field Museum, 130, 132, 141, 159-61, 777, 798

filmmaking, Aboriginal. *See* Aboriginal media production

films: *Box of Treasures,* 834, 835, 846-49; ethnographic, 838-40, 840-43, 843-45; ethnographic *vs.* anthropological, 843-45; privileged narrative form of, 841-42

*Financial Post,* 614-16

*First Nations Drum,* 849-51

Fleurieu, Charles Pierre Claret, 62, 63-66, 90*n*8, 90*n*11

Ford, Ashley, 614-16

Ford, Clellan Stearns, 526, 528

formal analysis: and art markets, 410-12, 413, 425-29, 433-34, 594; beginnings of, 405-9; context and, 405; critiques of, 429-31, 431-33; defined, 404-5; with exegetic analyses, 437-38; Holmian, 446, 458-67; of language, 447-48; and meaning, 444-45; multidimensional, 434; uses of, 407-8

formalism, 404; critiques of, 410; defined, 405; Greenbergian, 437; influence of, 409-10; and modernist project, 10; and museums, 765-66

formline art: cultural/regional styles, 53, 104-5, 108, 114, 117-18, 127*n*1, 320, 426-27, 440-42, 458-59, 468, 470; as historical medium, 59, 282; idea of, 4, 6-7, 191-201; living, 382; and mainstream Canadian art, 306, 339; market for, 317-18, 318-19, 379; masks, 223-25; mixed attitudes toward, 16, 212-13, 237, 349-50; phases of, 106-7, 112-14; as primitive art, 274, 275, 294,

300-2; principles of, 113, 293, 459; production of, 3; reclamation of, 745-47; and representation, 112, 113-14, 459; role of, 512-13; symbolic ambiguity of, 294-95, 459-60; totemic foundations of, 298-99; uniqueness of, 338-39, 373-74; as "world class," 319-20, 467-69, 488-89. *See also* formline components; formline conventions

formline components, 52, 112-14, 287-88; double curve/U form, 117, **417**, 420, 424, 428, **428**, 430, 432, 434-35, 438, 465-66, 467; eyelids, 464-65; iconographic, 174; joints, 463, 464; meaning of, reconstructed, 430-31; narrow crescent/slit, **418**, 420; origin of eye motif, 176-79; ovoid, 414-18, **416**, **417**, **418**, **419**, 420-21, **421**, 424, 428, **428**, 430, 463-64; space fillers, 463; tri-neg, 438

formline conventions, 52, 112-13; bisection, 301-2, 376; colours, 466, 467; dislocation of parts, 430, 459, 569-70; importance of, 512; and kinetic movement, 423-25, **428**, 428-29, 438, 439; non-concentricity, 465; and northern style, 438; split representation, 208, 430, 459; symmetry, 459

Fort Clatsop, 74

Fort Simpson, 235

Fort Victoria, 83, 91*n*18

Foucault, Michel, 3, 161, 879, 964

Frank, Alex. *See* Sitakanim (Chief)

Frank, Alex Sr. (Chief), 907-8

fur trade, 235, 497

Galanin, Nicholas, 6, **955**

Gallic, Willard, 814, 815

*Gazette des beaux-arts,* 287-89

genealogy: attribution work and, 412; and stories, 531; Tlingit clans, 168, **169**, 179-86

genocide, cultural and physical, 352, 880, 885, 888, 919, 926

Geological Survey of Canada, 93, 101, 129

George, Dan (Chief), 845-46

gift-exchange, 211, 709, 715, 725, 733-34; structure of, 229-31, 571-72; and withholding-while-giving, 627-29. *See also* potlatch

gii-dahl-guud-sliiaay (Terri-Lynn Williams-Davidson), 728-29, 748-50

Gingolx Media Centre, and RBCM, 788

Ginsburg, Faye, 836, 838-40

Gitanmaax School of Northwest Indian Art. *See* Kitanmax School of Northwest Coast Indian Art

Gitksan (Gitxsan) people: auto-ethnography of, 540-41, 544-45; carvers, 484, **484**; collected

artifacts of, 132; culture, 339-41, 857; Git'ksan and Wet'suwet'en Tribal Council, 847; resistance to totem pole restoration, 329-30

Gladstone, David, 546-48, **547**, 892-93

Glass, Aaron, xxxv, 10, 596, 597, 762-63, 779-84, 840, 922-25

Glenbow Museum, 787

Gombrich, E.H., 775, 778

Gosnell, Joseph, 895-97

Graburn, Nelson H.H., 559, 595, 876

Grant, Dorothy, 870, 897

Grant-John, Dorothy. *See* Grant, Dorothy

Great Depression, 380, 382, 383

Griaule, Marcel, 212-13, 229, 231-33

Group of Seven, 305, 317, 321. *See also* Jackson, A.Y.

Gunther, Erna, 4, 361, 423, 488-89, 552, 554-55, 565-66, 567, 702-4

Guujaaw, 921, 965

**H**aas, Jonathan, 786, 824*n*7

Haeberlin, Herman Karl, 157-59, 208-9, 227, 405, 422-23, 459; monographs, 134

Haggarty, James C., 940-44

Haida Gwaii, 54, 64; Haida Gwaii Museum, 440

Haida people, 204, **417**; architecture of, 65-66, 98-99, 110, 156-57; artistic ability, 52; auto-ethnography, 541-43; carving, 82, 384-85, 472, 564-65, 890; collected artifacts of, exhibitions, 411, 760, 790; culture, 919; *Haida Nation* decision, 645, 649; high standards of art, 920, 921; master artists, 425-29, 564-65 (*see also* individual Haida artists); metal work, 143; oral narrative, 751-53; totem poles, 459, 501, 616, 617; transformation masks, 292-93

Haldane, B.A., 993-94

Hale, Horatio, 82-83, 90*n*8

Hall, Edwin S. Jr., 562, 577, 596, 597

Halliday, William, 149, 267, 537, 660

Halpin, Marjorie M., 404, 410, 558, 561, 568-70, 584-85, 604, 614-16, 617

Hamilton, Ron. *See* Ḳi-ḳe-in (Ron Hamilton)

handicrafts. *See* Native arts

Handler, Richard, 136, 163-64

Harkin, Michael E., 556, 560, 581-82

Harris, Bob, 268, 533-34

Harris, Cole, 680, 868

Harris, Walter, 483, 484

Harrison, Charles, xxxv, 237, 248-50

Harrison, Julia, 814-15, 816-17

Hart, Jim. *See* 7idansuu (Jim Hart)

hats, 55, 56; ceremonial, 193-94, 195-201; Killerwhale Clan Hat, 981, 982-83; sculptured, 902-3; skin, **154**, 154-55; weaving, 70, 71, 76; whalers', 75-76, **76**, 161; woven spruce root, **461**, **462**, 777, 778

Hawker, Ronald William, 10, 242, 262-64, 350, 353

Hawthorn, Audrey, 382, 488-89, **491**, 496, 498, 555, 594

Hawthorn, Harry B., 342-43, 356, 360-61, 381-82, 402, 498, 555

Hazelton, 483

Heap of Birds, Edgar, 868

Heiltsuk people: auto-ethnography of, 546-48; basketry, 892-93; collected artifacts of, 259-60; culture, 892-93; Heiltsuk Tribal Council, 792-94; and ROM, 792-94

Hesquiaht First Nation, and BCPM, 806-7

Heye, George, 147, 148, 149, 150, 296, 537, 661

Heye Foundation, 164*n*1, 276, 286. *See also* Smithsonian Institution, National Museum of the American Indian

hieroglyphics, 53, 61, 63, 64

Hilbert, Vi, 963-64

Hill, Gord, **952**

Hill, Lynn, 911-12, 912-13

Historic Sites and Monuments Board of Canada, 942-43

historical media: artists' accounts, 49, 59, **60**, 83-85, **84**; diaries, 282-86; expedition reports, 50, 72-73, 82-83; genres, 50; journals, 54-56, 57-59, 62, 63-66, 68-71, 71-72, 73-74, 75, 77-78; letters, 59; missionary records, 79-81; newspaper stories, 339-41; oral records, 125-27; photographs, 282; picture-writing, 300

historical memory, 61, 64

historical record, 2-3, 12; forms of, 19-25

history: and commemorations, 942-43; of cultural objects, 985; cycle of, 852; divergent concepts of, 810-11; Kitwancool, 742; Kʷakʷakʼawakʷ, 19-25; making, 991-93; material concept of, 205; of Northwest Coast art, 53; outsiders' chronicling of, 941; of painted forms, 437; of potlatching, 739-40; of property discourse, 722-27; of shifting ideas, 1-2; ubiquitous but untold, 867-68, 879-81; unrecorded, 324

holism, 725-26

Holm, Bill, **331**, **407**, **428**, **460**, 717; on aesthetics, 442*n*2; as artist, 87, 578; and *Arts of the Raven*, 409, 431, 468; on attribution, 425-29, 433; and

Bill Reid, 294, 469-75, 490; Boas and, 414; codification of design elements, 413, 430-31, 432, 438, 446-47, 463-67; critique of, 684-85; edit of Boas film, 843, 844, 845; and *Form and Freedom* catalogue, 469-75; and formal analysis, 406-7, 411, 423-25, 430-31, 434-35, 449, 458-67, 715-16; hands-on approach, 87; influence of, 411-13, 433-37, 511, 778; on renaissance of Northwest Coast arts, 488-89; on realism, 460-62; re-edit of Curtis film, 832, 841-42; "scientific" approach, 448; on symbolic ambiguity, 460-62

Holmes, William H., 209-10, 226

Holmian analysis. *See* Holm, Bill, and formal analysis

Hoover, Alan L., 482-86, 787, 795, 810-11, 815-16, 826*n*27

Houle, Robert, 437, 868, 870

house, the: as animal, 289; Chilkat Whale House, 188-90; as communicator, 115-16; community, 538-40, 608-10; of Gédem Skanísh, 278; House of Héwhíwus (Sechelt), 876, **876**; interior, **60**, 693; Killer Whale House, 173-74; as world symbol, 110-11. *See also* architecture

house posts, 103, 110, 540, 693; carving, 255; Chilkat Whale House, 188-90; in Christian context, 263; inside, 156-57; as living pillars, 288; as mortuary posts, 255; Nuu-chah-nulth, 52, 53, 58, 59, **60**, 69; outsiders' views of, 52

Hunt, George, **158**, **524**, **527**, 721; auto-ethnography of, 529; and Boas, 157-58, 731, 768; dual roles, 523-26; ethnographic collector, 130, 132, 757; and ethnographic record, 23-24, 131, 142, 148-49, 207, 223, 521-22, 768, 786; potlatching, 548*nn*4-5

Hunt, Helen, 452, 453, 455-58

Hunt, Henry, 269, 479, 498, 800; and art market, 615

Hunt, Mildred, **451**, 453, 801

Hunt, Richard, 615, 800

Hunt, Tony (E.C.), 269, 447, 475-82, 498, 511, 618-20, 800, 808-9; and art market, 615

Hunter, Andrew, 885-89, 890

hunting, 695, 742

Huu-ay-aht First Nations, 942, 943

iconography, 52-53, 273, 961

identity: and art practice, 99, 588-89, 646-47, 894; by band or nation, 966; and branding, 989; claim process and, 924; communal *vs.* individual, 522, 525-26, 529, 531, 821; confused, 322; construction of, 589, 839-40; cultural, 122-23, 330, 838, 858, 923-24; dual, 989; ethnic, 760; giving back and, 926-27; humour and, 986-88; importance of, 432; Indian Act and, 647, 945*n*2; Indigenous, 646-47; knowledge and, 531-32; land and, 853; of leadership, 122; Makah, 771; monumental art and, 109-11; new media technologies and, 835-36; Northwest Coast art and, 562; Nuxalk, 933-35; politics of, 514-15, 561; potlatch and, 456-58; pride in, 497, 652; redefined, 898-99; split, 857-58; stereotypes and, 854-55 (*see also* misrepresentation); symbols of, **547**, 587-88; syncretic, 262. *See also* national identity

Idle No More movement, 14

*Illustrated London News*, 327-29

imaginary Indian, 939-40, 945*n*2

Indian Act, 11, 135, 633, **873**, 925; amendments/revisions, 308-9, 332-33, 379-80, 385, 634; constitutional power to enact, 667-68; effects of, 647, 652, 945*n*2; end of, 896; potlatch prohibition provisions, 149-51, 656-57

Indian Arts and Crafts Act (US), 329-31, 877

Indian Arts and Crafts Board (US), 377, 445-46

Indian Film Crew (IFC), 833-34

Indian problem, 372; in BC, 308-9, 309-12; cession of territory and, 310, 311; economic, 370; and Indian Affairs policies, 304; state position on, 307

Indian Shaker Church, 235, 253

Indianness, 628-29, 867; of art, 579; forfeited for citizenship, 305, 312-13, 331-32; identification of, 978; signposts of, 894

Indians of Canada Pavilion, 551

Indigenous peoples: hybridity of, 894-95; legal systems, 644; public invisibility of, 973; recognition of, 644; removal of, 679-80; as specimens, 945*n*3; as tourist attractions, 977; as "vanishing race," 831

informants, 523-26, 684; as ethnographers, 532-37; as narrator and participant, 524-26, 548*n*4; worldview of, 520-21

Inglis, Richard I., 787, 791-92, 795-96, 804, 806-7, 810-11, 826*n*27, 940-44

Ingraham, Joseph, 61-62, 90*n*8

Inkameep Reserve School, 398, 399

insiders: and masks, 225; messages to, 115-16; as witnesses, 9

institutionalization: of art, 382, 383-85, 386-94; of Northwest Coast art, 396-401

intellectual thought, Indigenous, 4, 964-65, 992-93. *See also* individual First Nations intellectuals

Internet: and Aboriginal languages, 950; Aboriginal presence in, 949-50, **951**, 961-62; Aboriginal space in, 947; benefit to community, 961-62; and cultural fusion, 954; and cultural traditions, 954; gallery collections on, 950-51; isolated people and, 960-61; magazines, 955-58, 958-59; and self-representation, 948; as site of autonomy, 959

interpretations: of contemporary world, 986-87; contextual, 7-8, 92; of cultural objects, 827n29; curators and, 468-69; decoration vs., 420, **421**; of design elements, **421**; European, 16, 26-27; intellectuals' hold on, 945n1; as justification, 888; limits of, 757; logocentric vs. aesthetic, 102; of ornamentation, 209-10; outsiders', 5, 664; outsiders' vs. community meaning, 685-86; of property, 720-22; rights, 813; of symbolism, 459-60; of totem pole's story, 19-21; universalist, 409, 470-75

Inverarity, Robert Bruce, 684, 704-5, **706**

iron, 53, 56, 61

Jacknis, Ira, xxxv, 7, 599, 601

Jackson, A.Y., 321-25

Jackson, Sheldon, 235, 238

Jacobs, Melville, 552, 555

Jacobsen, Johan Adrian, 129, 130, 141, 207, 679, 702-4

James, Charlie, 268, 351, 358, 514

Jammisit (Chief), 66-68, 91n12

Janson, H.W., 640, 643, 663-64

Jenness, Diamond, 149, 379-80, 385, 398

Jensen, Doreen, 592, 620-22, 827n29, 867, 889-92, 897

Jessup North Pacific Expedition, 93, 130, 140, **153**, 153-57, **154**

Jewitt, John Rodgers, 49, 73-74

Jisgang. See Collison, Nika (Jisgang)

John, Leslie, 348, 353, 362

Johnson, Harmer, 629-31, 631-32

Jonaitis, Aldona, 4, 5, 164, 561, 582-84, 767-70, 792

Jonathan Hunt House, 807, 808-9

Jones, Livingston F., 255-59

Joseph, Robert (Chief), 6, 798, 807-8, 899-901, 936

*Journal de la société des américanistes,* 276-82

*Journal of American Folklore,* 140, 141

*Journal of Material Culture,* 627-29, 922-25

*Journal of the Royal Society of Arts,* 394-95

Jungen, Brian, 6, 868, 929, 931-32, 964, 978, **979**, 980

Jurakic, Irena, 121-25

Ḳaajisdu.áx̲ch, 187, 188-89

Kane, Paul, 49, 83-85, 91n18

*Ken Muldoe, Suing on His Own Behalf and on Behalf of All the Members of the House of Delgamuukw, and Others v. Her Majesty the Queen in Right of the Province of British Columbia and the Attorney General of Canada. See Delgamuukw* decision

Kew, Michael, 741, 803, 826n26, 903-7

Kiix?in Agenda Paper, 942, 943

Ḳi-ḳe-in (Ron Hamilton): "Box of Darkness," 515-17; critique of Martha Black, 718-19; on identity and creativity, 499, 676n3, 677; on identity and knowledge, 431-33; on identity and pride, 497; on language and meaning, 1-2, 6; on loss, 495-96; on self-representation, 7, 11, 625-27; on transmission of culture, 13; on value, 411;

Kitanmax (Gitanmaax) School of Northwest Coast Indian Art, 447, 476, 482-86, 486n2, 610, 869, 902

knowledge: hierarchy of, 3-4

knowledge, Indigenous: and anthropological practice, 550-52; and art making, 531-32; cultural, 16, 401; formal analysis and, 434; historical, 16-17; museums and, 985; objects and, 128; potlatch prohibition and, 680; residential schools and, 688; restricted, 975; and stewardship, 857; suppressed, xxxiii; traditional, 25; transmission of, 7, 546-48, 601, 708-9, 769

Koloshi. *See* Tlingit people

Kramer, Jennifer, xxxiv, 12, 562, 588-89, 603, 924, 932-35, 975

Kroeber, Alfred Louis, 94, 204, 221, 222-23, 225-26, 227

'Ksan Association, 620

'Ksan Historical Village and Museum (Hazelton), 269, 760

'Ksan project, 483-86, 498, 501, 511

Kwagiulth Museum (Cape Mudge), 579-80, 581-82, 760

Kwakiutl people: transformation masks, 292-93

Kwakwa̲ka'wakw (Kʷakʷəkəwakʷ) people: anthropologized, 549; architecture of, 71-72; artists, 243, 424-25; auto-ethnography of, 518-26, 532-37, 537-38, 538-40; canoes, **831**, 842; carvers, 268, 483-84; clans, 20-22; comprehension of the self, 523; cultural heritage of, 15-19, 23-25; culture, 549; displacement of, 268; ethnographers, 732-33; Kwakiutl, 150, 265, **417**, 483-84; Kwakiutl Tribal

Council, 847; memorial poles, 269, **331**; in position of observers, 530; potlatch history, 770; response to missionaries, 265-66; Sitakanim curtains, 810-11, 826*n*27; traditional *vs.* non-traditional, 16-17; transformation masks, 289-91

Kwakwa̲ka'wakw (Kʷakʷaka̲wakʷ) peoples: anthropologized, xxxiv

Kwakwala Arts and Crafts Organization, 609-10

Kwak'wala Arts and Crafts Society, 538-40

Kyeet's Cove, 77, 91*n*15

*Labyrinthe*, 289-91

Laforet, Andrea, 8, 405, 729, 753-54, 788, 820-22, 874, 981

land, 135, 329-30, 412, 413, 450, 676*n*7; and cultural practices, 126, 857; expropriation of, 880; and freedom, 878-79; historical concepts of, 882; inalienable, 741; possession of, 645; as power, 880; and sense of place, 853; unceded, 628, 864, 867-68, 897

land claims: Alaska, 586, 964; art and, 585; denial of title, 676*n*7; denied, 308-9, 379-80; Gitksan and Wet'suwet'en, 544-45; Haida, 915-16; legality of, 643-44; Nuu-chah-nulth, 813; painting as, 878-79, 879-81, 881-83. *See also* treaties; Yuxweluptun, Lawrence Paul

land question: Aboriginal title, 126-27; BC, 628, 864, 867-68, 897; and image of the Indian, 893-95; Indian Land Commission, 696; as inherent conflict, 866, 867; racism and, 896-97

language: and abstraction, 438; Aleut, 243; area, 265; art as, 613; and artistic concepts, 412-13, 443*n*4; and Barkley Sound Dialect Working Group, 684; and civilization, 695; of claims, 924, 925; and culture, 102; and digital photography, 984-86; Haida art as, 437-38; Haida grammar, 249; Halkomelem, 251; Kwakwala, 265; linguistic materials, 77, 82; loss of, 16; of the market, 630-31; and "no word for art," 440-41; Nuuchaanulth, 26-27; Official Languages Act, 950; of painting, 433-37, 435-37; performative, 435-36; political, and political orientation, 923-24; of property, 514-15, 720-25, 727-31, 754-56; of RBCM, 687; of revival, 492; ritual word, 571, 572; spoken and visual, 974-75; symbolic, 92-93; texts, 684; of Tlingit, 415; of totem poles, 318; translation choices, 168, 170, 176, 202*nn*8-9; universal, 64; visual, 990

Large, R.W., 238, 259-60

*l'art nègre*, 212, 231-33

law: and Aboriginal title, 643-44; Aboriginal-environmental, 748-49; and art, 633, 635-36; constitutional, 865; copyright, 529; copyright, limits of, 753; copyright *vs.* customary, 17-18, 727, 751-53; cultural property rights (CPR), 924-25; executive voice of, 644-46, 664-66, 666-67; Haida *vs.* Canadian, 915-16; Indigenous, 676*n*1; intellectual property rights (IPR), 18, 639, 649, 728, 916-17; international, 634, 649-50, 671-75; inter-tribal, 658; judicial voice of, 647-49, 668-71, 865; Kitwancool, 742-43; Kʷakʷaka̲wakʷ *vs.* European, 18-19; legislative voice of, 646-47, 652-56, 656-57, 659-63, 667-68; Nisga'a, 788; and Northwest Coast art, 635; Nuuchaanulth, 29, 691-92; Nuu-chah-nulth, 638; and rights, 633-34; Stó:lō, 754-55; traditional, 745-47

Lax Kw'Alaams (Port Simpson), 237-38, 240, **241**, 387-88, 540, 822

Lévi-Strauss, Claude: artifact collecting of, 272, 276, 295, 296-97; celebration of Bill Reid, 489-90, 514, 884; enthusiasm for Northwest Coast art, 271-73, 286-89, 431, 496, 554; influence of, 211, 761; structuralism of, 293, 296-97, 447-48, 557-58, 576-77, 990; totemism of, 568, 569

Lewis, Meriwether, 47, 74-75, 76-77, 90*n*8, 91*n*14

Livingstone, John, 578, 579

Longboy, Zachary, 857-58

Loran, C.T., 336-37

loss, 24-25, 848, 853, 929; and mourning, 452-53, 452-53, 518, 521-23

Lubicon Lake Cree, 787

Lytton Residential School, 398, 399; curriculum, 398

**M**acDonald, George F., 98-99, 108-11, 114, 556

MacDonald, Michael, 855-57, **856**

*Maclean's Magazine*, 321-25

Macnair, Peter L., 482-86, 492, 600, 622-25, 790, 824*n*10

Makah Cultural and Research Center, 760, 770-74

Makah people: baskets, 770, 771-72; ceremonial activity, 701-2; epistemology of, 698-700; ethnography of, 698-702; identity, 771; jewellery making, 701

Malloway, Frank, 543-44

Manuel, George, 402-3

Maquinna (Chief), 73-74, 695

Marchand, Étienne, 62, 63, 90*n*11

market, art: boundaries of, 600; challenges, 611-12; *vs.* community consumption, 626-27; dealers, 615; discursive frameworks of, 605-6; global context, 592; growth of, 593; growth of, non-Native consumers and, 595-96; international, 616-17, 630-31; for Native handicrafts, 605-6, 606-8; non-Indian, 621-22; Northwest Coast, 591; Northwest Coast art, 592-93; platforms of, 603-4; and potlatch economy, 599; potlatch seizures in, 661; response of media, 614-16; self-presentation, 603; tourist trade, 607-8; values of, 867

Marsden, Susan, 125-27

Martin, David, 498, 801, 826*n24*

Martin, Mungo, xxxiii, 9, 17, 268, 269, 307, 333-36, **334**, 335-36, 358, 382, 447, **451**, **491**, 498, 504, 514; and BCPM, 800, 801, 825*n22*, 826*n25*; celebration of, 489, 490; potlatch, 450-58, 800, 802-3; sale of paintings, 608; and standards of renewal, 624; Thunderbird Park potlatch of, 450-58; and UBC, 825*n22*

Martindale, Andrew, 7-8, 11-12, 121-25

Masayesva, Victor, 960-61

Maskegon-Iskwew, Ahasiw, 947, 952, 958-59, 959-60

masks, 6, 29, 51, 78, 291; artistic license and, 910; Central Coast Salish, 85; ceremonial *vs.* tourist, 477-78, 478-80; as caricatures, 499; cultural evolutionary view of, 223-25; described, 374-75; eagle woman, 483; Haida, 61, 246, 249-50, 284; *Hinkeets,* 716, **717**, 717-18; Kwakwa̲ka'wakw, **721**, 900-901; mythology and, 476, 576-77; Nō'lis, **721**; Nuu-chah-nulth, 53, 57-58, **683**, 704; painting of, 480; petrification of, 80-81; sea serpent, 715; and social evolution, 206; and spirit world, 224-25, 273, 288, 297, 679, 702-3; tourist, 475-82, 476-81; tourist *vs.* ceremonial, 477-78, 478-80; transformation, 273, 289-91, 292-94, 297; Tsimshian chief's, 66-67; used by Makah, 701-2; Walas G̲wax̲wiwe (Great Raven), 984-86; Wolf headdress, 484, **484**

Mason, Otis Tufton, 138-39, 204, 775; monographs, 134

Massey Report, 343-47, 353, 381, 401, 509-10, 555; and Native arts, 307-8

*Mataatua Declaration on Cultural and Intellectual Property Rights of Indigenous Peoples,* 751

material culture, 7; clothing, 59, 258, 701; contemporary production of, 928-29; as creative stimulus, 374; delayed consumption of, 924; descriptions of, 51; disappearance of, 316;

ethnicity and, 130; as ethnographic representation, 155; ethnographic treatment of (*see* collecting, of artifacts, cultural documentation of); European, 260-61; feast dishes, 21, 691-92; late nineteenth-century, 782-84; Lower Chinook, 75; mats, 55, 56, 159-61; Nuu-chah-nulth, 26-28, 29, 57-59, 73-74; platters, wooden, 55; Tlingit, 193, **258**; trolling lines, 155, **156**. *See also* specific items of material culture

Matta Echaurren, Roberto Sebastián, 275-76

Mauss, Marcel, 211-12, 229-31, 549, 550, 725, 733-34

Mauzé, Marie, 9, 550

McCullagh, J.B., 238, **239**

McHalsie, Albert "Sonny." *See* Naxaxalhts'l (Albert "Sonny" McHalsie)

McIlwraith, Thomas F., 239, 336-37, 725, 737-38; monographs, 134

McInnes, Graham, 337-39

McLennan, Bill, 433-37, 892

McLuhan, Marshall, 444, 446

McMahon, Kevin, 895-96

McMaster, Gerald, 876, 893

McMillan, Alan D., 119-21

McNeil, Larry, 6, 964, 978, 986-88

meaning: aesthetic, 505; and anthropology, 102; of art, 95-96; art and, 98-99, 99-100; and artistry, 123-25; in Coast Salish art, 905-7; collaboration and, 822-23; commercial production and, 929; conscious *vs.* non-discursive, 100-1, 102-3; in context, 685-88; cultural, 94-95, 501; culturally constructed, 720-22; ethnological, 296; historical, 472; of Indigenous objects, 380; language and, 4, 102; layers of, 757; in masks, 292-93; of Native objects, 10; out of context, 663-64, 686; perspective and, 810-11; perspectives and, 936; of petroglyphs, 120-21; polyvalent, 113; of the potlatch, 230-31; of power experiences, 907; questions of, 105-6; ritual and, 100-101; symbolic, 107-8, 109-11, 111-12, 534; symbolic, of crest objects, 193-94; of things, 142-43; of traditional and contemporary culture, 954; of tribal art, 295-96

Meares, John, 678, 692-94

Medina, Cuauhtémoc, 929-32, 978

memorial poles. *See* totem poles, memorial

Metlakatla, 235, 261, 590, 631, 822, 993-94

Metropolitan Museum of Art, 503

misrepresentation: of cultural production, 889; in mainstream media, 845-46; and misinterpretation,

978; of Northwest Coast cultures, 830-32, 840-43; overturning, 851, 854-55

missionaries: as artifact collectors, 234, 235, 237-38, 380, 822, 825*n*15; attitudes towards Indigenous art, 234; in central Mexico, 930; and chiefs, 262; and church building, 261-62; and destruction of cultural objects, 585-88; and destruction of Native art, 497; effect of, 316-17; as ethnographers, 237; ethnographies, 243-44, 248-50; interpretation of material culture, 368-69; legacy, 243, **244**; memoirs of, 246-48, 249-50, 251-53, 254-55, 256-59; Native, 235, 237, 239; and Native culture, 263; Native responses to, 262-64; on Northwest Coast, 234-35; and potlatch prohibition, 647, 653, 655, 662; rejected, 265-66; Russian Orthodox, 243-45; and support of chiefs, 240

missionary record, 8-9, 27, 235, 238

modernism: and appropriation, 514; and artistic/cultural revival, 499-508; and Bill Reid, 490; mid-century, 445; Native, 976-77; and Northwest Coast art, 467-69; and outreach agenda, 447-49; and traditional Native arts and crafts, 883; universalist ideology of, 410

modernity, 9-10; conditions of, 782-84; and formalism, 410, 440; and political democracy, 444-45; traditional culture in, 782-84

Morgan, Judith, 381, 870

Morgan, Lewis Henry, 205-6, 214-16, 217

Morin, Peter, **951**

Morris, Rosalind C., 5, 549, 550, 832, 843-45, 846-49

Morris and Helen Belkin Art Gallery (UBC), 879, 881-83

mortuary poles. *See* totem poles, mortuary

Mowachaht-Muchalaht First Nations, 942, 943

Moziño, José Mariano, 27, 49, 68-71, 679, **691**, 694-96

Moon (Mrs.), 452, 453, 455-56

Muldoe, Earl, 484, **484**, 544-45

Musée de l'Homme, 276, **279**

Musée du Jeu de Paume, 317

Musée McCord, 793

*Museum Anthropology*, 163-64, 816-17, 916-17

Museum at Campbell River, 790

museum collections, 623; catalogues, 132, 133; Clayoquot, **151**, 151-52; Coast Tsimshian, 132; critiqued, 136-37; Gitksan, 132; Haida, 132, 142-43, 149, 155-57, 156-57; intention of, 128-29; Interior Salish, 131, 157-59, **159**; Kwakiutl, 142; Kwakw<u>a</u>ka'wakw, 131, 132, 155, 157; Makah

basketry, 131; Nlaka'pamux, 131, 132; Nuu-chah-nulth, 131, 132, 148-49; Thompson River basketry, 146-48; Tlingit, 132, 140-41, 152-53, **153**, 166, 172, **175**, 191-201, 202*n*1; Tsimshian, 143, **175**; value of, 163-64

Museum fur Volkerkunde, 129, 130

Museum of Anthropology (UBC), **175**, **241**; aesthetics-oriented, 580, 581; buying guide for consumers, 449; catalogue, 594; collaborative projects, 758, 790-91, 806-7; dedicated interest in Northwest Coast art, 380, 510, 552; exhibition-intervention, 912-14; and multiple knowledge systems, 984-86; Native involvement and, 758; opening of *Káxḻáya Ǧviḻás*, 793; origins of, 382; Renewal Project, 983-86; and value, 601

Museum of International Folk Art, 705

Museum of Modern Art (MoMA), 274, 372-73, 446

Museum of Northern British Columbia, 790, 827*n*30

Museum of the American Indian, 272, 630, 661

museums, 765; *vs.* anthropological perspective, 823*n*1; and art markets, 594; art *vs.* anthropological, 761; as collaborative spaces, 12, 130, 772-74; colonial institutions, 561; democratization of, 819; and Department of Indian Affairs, 380; ethnographic, 757, 766-67; ethnological, 139-40; exhibit paradigms, 758-63, 763-67, 781-82; exhibits as critiques, 911-12, 912-14; First Nations criticism of, 758-59; functions of, 218; history of collaboration, 789-90; influence on thinking, 766-67; institutional critiques of, 915-16; Kabuki dance of, 941-44; majority *vs.* minority, 579-81, 581-82; natural history, 758; new role of, 576; policies towards First Nations, 760-62; presentation of Northwest Coast art, 411; principles of curating, 139; public criticism of, 819-20; reasons for, 567; regional, 790; representation of Northwest Coast art, 554; in Sitka, 238; studies of, 786-87, 791-95; theories of presentation in, 217-18; tribal, 760, 770-74. *See also* specific museums

Musqueam people (Coast Salish): artists, 870, 897-99, 903, 905, 953; collaboration with UBC, 871; epistemology, 906; and MOA exhibits, 789, 806-7, 871; unceded land, 871, 920, 971-72; weaving, 870, 897-99

Myers, Fred R., 602, 869, 877

mythological beings: sea serpent, 713-15

myths: and art, 497, 503; and creativity, 274; and material culture, 576-77; and painting, 275; significance of, 477; of Temlaham, 325-27

Nanaimo District Museum, 790

National Film Board of Canada, 832, 833-34, 837

National Gallery of Canada, 305, 306, 317, 319, 337, 353, 601; first purchase of Native art, 879; Indigenous Curatorial Program, 877

national identity, 493, 593; concept of cultural mosaic and, 306; conception of, 304; national arts and, 509-10; nationalism and, 313; Native arts excluded from, 329-30; need for background, 323-25; Northwest Coast art and, 307, **334**, 343-47, 354-55, 401; *terra nullius* and, 305

National Museum of Canada, 130, 133, 134, 144, 150, 306, 327, 380, 538, 661

National Museum of Man, 510, 576, 761, 832. *See also* Canadian Museum of Civilization

National Native Indian Artists Symposium, 620-22

Native American Graves Protection and Repatriation Act (NAGPRA), 202*n*1, 412, 413, 728, 743, 877

Native American studies, 768, 853

Native arts, 359, 386; and applied anthropology, 554-57; *vs.* art, 348, 350-51, 606, 774-75, 776; assumed death of, 316, 345; autonomy of, 976; in BC, 373; and Canadian national image, 306, 313, 317, 332; coherence of, 965; as commodities, 307-8, 330-31, 336-37, 476-82, 605-6, 606-7; consumer expectations of, 512; as contemporary, 242; and cultural policies, 343-47; and "curio" market, 10, 17, 344-45, 624; definitions of, 933; extra-aesthetic value of, 349; federal funding for, 332, 333, 346-47; as fine art, 337-39, 409, 761-62; fur trade and, 235; future of, 506-7; government support for, 877; imitation, from Japan, 342, 345, 351, 377, 394; marketing of, 360, 361, 363; modernity and, 346, 367; philosophy of, 349, 622; and political action, 560-63, 760; and regional identity, 353; spinning, 70; state uses of, 350, 351-52; tourist trade and, 376-77; uses of, 381. *See also* weaving

Native arts, communities of origin: Bella Bella, 389; Bella Coola, 389; Campbell River, 389; Cape Mudge, 389; Chilcotin, 389; Fraser River, 390; Haida, 387; Kitamaat and nearby villages, 388-89; Kwakiutl, 389; Naas River villages, 388; Skeena River villages, 388; Stikine River, 388; Thompson River, 390; Tsimshian, 387-88; Vancouver Island, 389-90

Native arts production: bead work, 254, 255, 258; jewellery making, 256-57, 502-3, 504, 574, 701;

knitting, 905; labret disk, 51, 56, 62, 206, 257; regional divisions, 365; tanning, 55, 70; tattooing, 247-48, 257. *See also* baskets; blankets (robes); boxes; carving; painting

Native Brotherhood of British Columbia, 306, 356, 362, 380, 651

Native reform movement, 380, 381-82, 403

*Native Sisterhood*, 363

*Native Voice*, 362, 633, 650-52, 708

Nativeness. *See* Indianness

Naxaxalhts'l (Albert "Sonny" McHalsie), 754-56

Neary, Kevin, 482-86, 940-44

Neel, David, 243, **244**

Neel, Ellen, xxxiii, 17, 343, 352-53, 355, 356-59, **357**, 362, 381, 382, 402, 514, 551, 593, 600

Newcombe, Charles F., 132, 133-34, 145, 156, 159-61, 165*n*3, 398, 532, 533, 534, 798, 825*n*21

Newman, Barnett, 274-75, 296, 300-302, 302-3

Nicolson, Marianne, 6, 10-11, 874, 950, 968, **969**, 970, 990; solo exhibitions, 927-29, 970

*Nisga'a Final Agreement*, 729, 753-54, 817-19, 824*n*8; and repatriation, 761, 788, 824*n*8; views of, 895-97

Nisga'a Lisims Government, 788, 824*n*8

Nisga'a Tribal Council, 847

Nisga'a Museum/Hli Goothl Wilp Adoks Nisga'a (Laxgalts'ap), 824*n*8

Nootka Sound, 54, 57, 68-71

North American Indian Brotherhood, 356, 403

North Vancouver Museum and Archives, 790

Northwest Coast: colonization of, 379; culture groups of, 46, 47; defining, xxxv, 46, 676*n*2; early film histories of, 830-32; European settlement of, 47, 49, 93, 123-25, 187, 235; land claims, 305; non-traditional borders of, 964; notion of, 7; scientific interest in, 138; socio-political definition, 48; Surrealist discovery of, 276; *vs.* West Coast, 828

Northwest Coast art: and Aboriginal media production, 829-30, 837; and abstract thinking, 111-12, 302-3; aesthetic principles of, 422-23; animated, 636-37; anthropological study of, 203, 217-19, 550-52, 551-52; and Canadian artistic heritage, 337-38; and Canadian identity, 9, 307, **334**, 343-47, 354-55, 401; canon, 409, 411, 425-26, 531; claims for, 864; Coast Salish, 904-7, 963; commercial success of, 11, 383-85; composition, 112-13, 113-14, 459; in contemporary context, 510-13, 633, 636, 913-14; debates about, 875; definitions

of, 1-2, 949; disappearance of, 319; displays of, 12, 554; ethnographic, 165*n*4, 165*n*8; *vs.* European art, 290, 300, 887; expression of transformation, 273; fascination with, 238, 552-53; fine arts discourse, 593-94; focus on form, 50-51, 117-18, 409 (*see also* formline components; formline conventions); framing of, 913; fullest meaning of, 646; Haida manga, 915-16; intercultural contexts of, 299, 601-2, 868, 937; interdisciplinary work, 956-57, **957**; international context of, 868; as investment, 614-16; law and, 659-63, 676*n*1 (*see also* potlatch prohibition, and Potlatch Collection); and "Northwest Coast look," 889-90; Nuuchaah-nulth, 680; Nuxalk, 933-35; postdisciplinary, 965-66; prices realized, 630-31, **631**-32; as social agent, 588-89; study of, 557-58, 592; thing of the past, 567; world, 492-93, 591, 592-93, 933-35

Northwest Coast design. *See* design motifs

Northwest Coast Indian Artists Guild, 597, 610; catalogues, 611-12, 612-14; members, 612

Northwest Coast peoples: in artifact market, 142, 149, 162-63; assumed disappearance of, 304-5, 313, 321-25, 488-89; contemporary issues, 137, 886; in cyberspace, 961-62; discourse on style, 412-13, 415-16; ethnographers, 523-26; and ethnographers, 518, 523-26; impact on ethnographic record, 131, 520-21; informants, 524-26, 532-37, 548*n*4, 684; innate artistic skill, 398; intellectuals, 992-93; in labour market, 311-12; musical ability, 251-52; negative stereotype, 882; non-status, 893; populations, 128, 235, 265, 500; role in Canadian nation, 304, 309; social and economic welfare of, 392-94; trading skill, 145, 162-63; Western interest in, 944. *See also* specific Northwest Coast peoples

Northwest Coast studies, 770, 772-74

Nowell, Charles James, 526-29, **527**, 548*n*6, 801

Nuu-chah-nulth (Nuuchaanulth) peoples: aesthetic status of art, 58-59; architecture of, 69, 71-72, 693; art forms, 53, 680; auto-ethnography of, 688; belief systems of, 119-20, 120-21, 694-95, 710-12; carpentry, 69-70; ceremonial objects of, 664, 705, **706**, 810-11, 908; collected artifacts, exhibitions of, 687, 760, 811-13, 814-15, 816-17, 826*n*27, 908; collected artifacts of, 131, 132, 148-49, 813; epistemology, 7; formline art, 53; gallery exhibitions, of culture, 719; house posts, 52, 53, 58, 59, **60**, 69; land claims, 813; language of, 26-27; law, 29, 691-92, 710; masks, 53, 57-58, **683**,

704; material culture, 26-28, 29, 57-59, 73-74; metal work, 56, 70; spinning, 70

Nuu-chah-nulth Tribal Council (NTC), 687, 710-12, 811-13, 827*n*29; Elders' Advisory Committee, 812-13, 814-15; and RBCM, 816; self-representation of, 718

Nuxalk people: art, 933-35; collected artifacts of, 132; identity, 933-35

**o**bjects, 779, 874, 923-24; hybrid, 121-25, 351, 474, 562, 567-68, 769, 780. *See also* material culture

objects, ceremonial, 685-86, 687; animate, 749-50; as art, 599; dance headdress, 716; decorated coppers, 212, 230; drums, 251; exhibits of, 687; historical significance of, 908; inalienable, 685; potlatch screens, 638-43, **641**, 664, **681**, 705, **706**, 810-11, 908; rattles, 85, 252, 300; regalia, 67-68, 78, 80; removal of, 697; Sitakanim curtains, 810-11, 826*n*27. *See also* crest objects; masks

objects, cultural: control of, 750-51, 751-53, 794, 826*n*25; custodial agreements for, 818-19, 824*n*9; demonized, 930; destruction of, 236, 240; repatriation of, 743-45 (*see also* repatriation). *See also* objects, ceremonial

objects, ritual: animate, 230-31, 232; destroyed, 234; Haida masks, 249-50

Olin, Chuck, 5, 834

Omhid, Tom, 450-56, **452**, **453**, 457-58, 801

*Omineca Herald*, 339-40

Ontario Provincial Museum, 238, 260

oral histories, 6-7; and archaeology, 98; and auto-ethnography, 543-44; crest art, 190-91; feats of memory, 521-23, 526, 528-29; genealogical context, 169, 171-73, 187; Kwakw<u>a</u>ka'wakw, 413; and missionary record, 235; and the missionary record, 235; origin stories, 176-79, 179-86, 186-90; *vs.* outsiders, 941-42; ownership of Eagle emblem, 195-201; picture-writing and, 193; piecing together, 531-32; purpose of, 174; and rights, 718; statements of rights, 741; symbolic objects and, 193-95; Tsimshian, 125-27; validation of, 523-24; witnessing of, 545; written, 713-15

oratory, 633; contemporary, 895-97, 920; Dan George's lament, 845-46; Nuuchaahnulth *vs.* English, 697-98; and storytelling, 8, 526, 528-29; views of, 724

ornamentation: composite style of, 226-27; of coppers, 212, 230; explanations of, 209-10;

formal principles of, 420; *vs.* interpretation, 420; of masks, 292-93, 300; Tlingit, 256

Osawa, Sandra, 833, 851-55

Ostrove, Clarine, 750-51

Ostrowitz, Judith, 10, 914

outsiders, 5; admiration for Haida artistic ability, 52, 62; admiration for Kwakiutl art, 7; admiration for Northwest Coast art, 52, 90*n*8; admiration for Nuu-chah-nulth artistic ability, 59; admiration for Tlingit artistic ability, 52, 63-64, 377-78; archaeologists as, 95; critical thinkers as, 937-40; determining value, 620-22; early contact with, 7; as experts, 585; messages to, 115; motivations of, 9, 11; as social reformers, 9-10; views of face painting, 52; views of Haida argillite, 82; views of house frontal painting, 52; views of monumental carving, 85-89

ownership: and authority, 710-12; communal *vs.* individual, 727, 754-56; of formline design, 440-42; of the land, 349, 350; limits of, 752-53; means of acquiring, 748; of Native designs, 17-19; *vs.* possession, 590, 685, 687, 691-92, 716; psychic, 354; and reciprocity, 747-48; as right *vs.* obligation, 727-28, 916; rights, 639; of rights to crest emblems, 194-95, 195-201; of territory, 545; and title, 754; of totem poles, 281-82, 315, 321, 328; understandings of, 721-22, 722-24

Ozette, 119, 120, 121, 639, 773-74

**P**aalen, Wolfgang, 272, 273-74, 282-86, 298-300

painting, **428**; body, 56, 702; a canoe, 542; Central Coast Salish, 570; face, 52, 250, 257-58, 702; colours, 55, 466, 467; dance and, 424-25; face and body, 73-74, 78; Haida, 66; on hats, 61, **461**, **462**; house frontal, 51, 52, 67, 71, 109, 236, 275; inside boxes, 69; on Keïget pole, 280; Makah, 700; for metaphysical understanding, 302; multidimensional view of, 435-36; non-Native market for, 608; northern, 701; as political activism, 878-79, 879-81, 881-83; pure, 275; and realism, 460-61; ritualistic, 301; supernatural power and, 88; *vs.* writing, 698. *See also* formline art; formline components; formline conventions

partnerships: between filmmakers and communities, 834, 837, 844; between governments and First Nations (*see* treaties); international, 762, 778-79; of knowledge communities, 983-86; long-term, 810-11, 811-13, 815; between museums, 792-94; between museums and communities, 787-88, 800, 803-5, 806-7, 810-13, 814-15, 816-17, 822-23, 841, 871; between museums and families, 810-11; between museums and individuals, 798, 799-803, 807-8, 809-10, 816, 823*n*2, 827*n*29; non-collaborative, 826*n*26

Pasco, Duane, 447, 484-85, 562, 578-79

paternalism, 9, 311, 312, 380

Patterson, Mike, 952, 961-62

Peratrovich, Selina Harris Adams, 775-76, 777

Pérez, Juan Hernández, 27, 47

performance art, 819, 829, 837, 913, 947, 956-58. *See also* individual performance artists

Perry, Art, 616-17

petroglyphs, 120-21, 646

Phillips, Ruth B., 130, 603, 762, 792-94, 819, 825*n*12, 825*n*16

*Pleine Marge*, 292-94

Point, Susan, 876, **876**, 891, 903, 904

political activism, 490, 551, 552, 560-63, 688, 811, 812, 813; Aboriginal media and, 829-30; Alaska, 168, 586; and anti-intellectualism, 937-38; art as, 878-79, 879-81, 881-83, 884-85; and artistic revival, 509-10; of artists, 867-68; and collaborative projects, 794-95, 806; cultural, 449; culture of repatriation and, 788-89; and exhibitionary norms, 911-12, 912-14; in film, 852-55; film as, 847; George Clutesi, 708; in Haida Manga, 915-16; in media art, 972-73; media production and, 845-46; through tribal museums, 580-81. *See also* individual activist artists

politics: Aboriginal women's issues, 542-43, 947, 956, 981; of academic production, 560; of art production, 583, 870; of class, 916; of collaboration, 794-95, 806; of collaborative projects, 794-95, 806, 812-13, 817-18, 817-19; of cultural property, 922-25; of cultural recognition, 883; of epistemology, 874; of national cultural institutions, 918; Northwest Coast art and, 380; property and, 556-57; of representation, 561, 575-76, 894, 914; of visual representation, 832

Port Alberni, 696

Port Simpson (Lax Kw'Alaams), 237-38, 240, **241**, 387-88, 540, 822

Posluns, Michael, 402-3

postmodernism, 410; limits of, 581-82; and politics of identity, 514-15; and re-evaluation of Boasian legacy, 582-84, 584-85; relativism of, 974

potlatch, 15, 17, 29, 149-51; and art, 497, 500, 636-37; Bataillian perspective on, 290-91; and

Christian celebrations, 240, 262, 263; defined, 633, 635; definition, 656; demise of, 661-62; described, 77-78, 79-80, 246, 247-48, 339-41, 712-13; effects of contact on, 574, 739-40; and feasts, 29; for Jonathan Hunt House, 808; meta-events of, 636, 637, 658, 676*n*3, 690-92, 709; Mungo Martin's, 450-58, 800, 802-3; Nuu-chah-nulth, 657-59; preparation for, 709-10; protocol, 540-41, 911; and redistribution of wealth, 281, 556-57, 690-92, **691**, 715, 732-33, 738-39; rivalry factor, 293, 721-22, 734; social functions of, 639, 723, 739-40; socio-legal functions of, 229-31; as total social phenomenon, 211, 725, 733-34

potlatch prohibition, 135, 234, 263, 305, 329-30, 358; and arrests/seizures, 266-67, 279, 379, 537-38, 609, 659-63; effects of, 633-34, 661-62; legislative debate on, 652-56; lifted, 308, 344, 847-48; and Native arts, 635-36, 680; and Potlatch Collection, 559, 560, 581-82, 761, 800; resistance to, 267, 268, 643, 723-25; salvage projects and, 355, 356-59

Powell, John Wesley, 205, 206, 216-17, 217-19, 223, 913

power: of art, 925; and authority, 940; and capital, 586; in carving, 474-75; and collaboration, 821-22; of dreams and visions, 906-7; figures of, 974-75; of gift-giving, 738-39; as land, 880; of language, 925; magic, 250; magical, 277; of masks, 6, 288, 293-94, 900-901; merged, 187-88; of Northwest Coast pedagogy, 914; of objects, 240; of Canadian institutions, 644; oratory and, 697-98; political, 761; of potlatch gifts, 211-12; of property discourse, 730-31; rank and, 742-43; realignment of, 916-17; relations of, 115-16, 553, 608-10; of remembrance, 21; shamanistic, 290-91; of shamans, 81; shifts in, 821-22; source of, 545; sources of, 571-72; statement of, 115-16; super-natural, 88, 108, 110; of symbols, 99, 103; symbols of, 19, 108, 110; to tell, 635; of totem pole, 742; transformative, 288-89; transmission of, 966; of uncertainty, 588-89; unequal relations of, 1, 3, 5, 9, 12, 98; of wealth, 733; of winter dance spirits, 544

Pratt, Mary Louise, 762-63, 770

primitive art, 373, 663-64; contemporary, 511; and cultural relations study, 422-23; defined, 294; enthusiasm for, 270-72, 274, 317, 338, 431, 651; formline, 274, 275, 294, 300-2; and modern abstract art, 301; and New York avant-garde, 275

property, 11-12; art and, 725-26; Coast Salish territory, 544; communal *vs.* individual, 736; communal *vs.* personal, 17-19; cultural, 722, 728-29, 736, 749-53, 754-56, 826*n*25; double-edged, 720-22, 726-27; evolution of concept, 215; fighting with, 721-22, 722-27, 727-31, 734, 739-40; Gitksan and Wet'suwet'en, 545; inalien-able, 729, 753-54; language, 720-25, 727-31, 754-56; north coast *vs.* museum paradigms, 753-54; and politics, 556-57; potlatch and, 732-33; ritual paraphernalia, 571; sacralized, 211-12; scholarly privilege as, 916-17, 945*n*1; systems of, 29; tangible and intangible, 732-33, 733-34, 735-37, 738, 747-48; Tsimshian territorial system, 126-27; understandings of, 722-27. *See also* ownership

Provincial Museum of British Columbia, 156, **175**, 506; anthropological collection, 397, 398-99, 400; carver training program, 382; collaborative projects, 804-5, 806-7; totem pole restoration program, 386

publics: academic *vs.* local, 552-53; Clutesi's, 708; cosmopolitan *vs.* local, 580-81; Indigenous *vs.* white, 689-90; ROM, 793, 825*n*15, 825*n*17; writing and, 677-78

**Q**ueen Charlotte Island Museum (Skidegate), 826*n*26

Quimby, George, 832, 841-42

**R**. *v. Van der Peet*, 668-71

*R. v. White and Bob*, 648

racism, 258-59, 385, 679-80, 696-97, 775, 868, 880, 881, 887, 891, 896-97

Raley, George H., 238, 242, 348, 351, 353, **354**, 368-72, 380, 381, 384, 386-94, 394-95

Ramsden, Anne, 871, **871**

Rapsure Risin, 952-53

Ravenhill, Alice, 341-42, 351-52, **352**, 363, 372-78, 381, 395-96, 396-401, 552, 566, 606

realism, 263-64, 288-89, 318, 460-62

*realpolitik*, 8, 977-78; of collaborative projects, 564

reclamation: of art forms, 745-47; of Chilkat tradition, 745-47; of cultural heritage, 748-49; of cultural knowledge, 918-19; filmmaking as, 835; of intellectual property, 728; spiritual, 642-43

*RedWire*, 877, 893, 953, **953**, 955-58

Reece, Skeena, 947, 950, 955-58, **957**, 973

Reid, Bill, **352**, **491**; on art and craft, 505; and art market, 594-95, 615; and *Arts of the Raven*, 409-10,

468; and Bill Holm, 435; on carving, 402; cele-
bration of, 489-90, 499, 507; critics of, 514; and
*Form and Freedom* catalogue, 469-75; and Haida
art, 504-5, 512, 990-91; influence of, 505, 511;
legacy of, 919-20, 922; and national identity, 355,
977; and Ravenhill charts, 352; role in renaissance
of Northwest Coast arts, 349-50, 410, 488-89,
504-5, 506-7; and Robert Davidson, 438, 498,
505; solo exhibition, 489-90, 501-3; *The Spirit of
Haida Gwaii*, 883-84; and totem pole removal,
826*n*26; totem poles, 498, 512, 616; universalist
view of art, 409-10

Reid, William Ronald. *See* Reid, Bill

renaissance of Northwest Coast arts, 10, 501-8;
celebrated figures of, **491** (*see also* Davidson,
Robert; Holm, Bill; Martin, Mungo; Reid, Bill);
context of, 508-13; cultural/political, 403; ele-
ments of, 511; parallels with Italian Renaissance,
492-93, 507-8; process *vs.* event, 487-88

renaissance discourse: assumptions of, 487-89;
critics of, 490, 492, 514-15, 515-17; emergence
of, 495-99; legacy of, 492, 494; modernism and,
499-508; prevalence of, 489-90

repatriation, 538; of ceremonial regalia, 760-61;
claims, 922-24, 924-25, 936; conditions of, 761;
of cultural property, 729, 743-45; debates on,
923-25; of foreign holdings, 590, 745; formal
analysis and, 412; of Haida ancestral bones, 968;
historical irony of, 923-24; of Native art, 450,
576; of potlatch items, 846; RBCM, 797; as
(re)appropriation, 924; treaties and, 743-45,
788, 817-18, 824*n*8; to tribal museums, 661

representations: of Aboriginal leadership, 894;
absence of, 854; academic, xxxiv; effects of
fragmentation and distance, 841-42; filmic, 843-
45; idea of, 584-85; media, 830; of the Native,
972, 973; of Native lives, xxxiv; shared values
and, 911-12; stereotypes, 931-32; totemic, 989;
underrepresentation of women's art, 890-92;
virtual area of, 978

reserve system, 235, 680, 696-98, 880; BC, 310,
311-12; and citizenship, 313; and land claims, 741;
Vancouver Island, 310

residential schools, 27, 238; centralized, 241-42, 266,
268; curriculum, 242, 351, 353; death in, 688;
effects of, 234, **244**, 266, 317, 688-89, 926;
enforced enrolment in, 308; exhibition of work
from BC, 400-1; exposure of abuse, 925; gradu-
ates of, 386; paradox of, 351-52; represented at

All Canada Handicraft Exhibition, 398; sexual
abuse, 686; survivors, 954. *See also* individual
residential schools; specific residential schools

resistance: art as, 926, 981; to cultural domination,
838-40; to Eurocentric view, 944; to invasions,
915-16; Native, 403; to potlatch prohibition, 267,
268, 643, 723-25; and *Spirit of Haida Gwaii*, 966;
strategies of, 931; through film, 852-55. *See also*
political activism

restoration: of Curtis film, 840-43; and generation
gap, 541; Gitksan resistance to, 329-30; of Indian
cemeteries, 323; of totem poles, 322, 323, 327-29,
489, 498, 504, 506, 826*n*26; of values, 869-70;
work of Mungo Martin, 494

revival, 489; art markets and, 595-96; continuity
and, 497-98; cultural, 892-93; of culture, 541;
fallacy of the idea, 343; impossibility of, 345; and
Indigenous identity, 494; language of, 492; of
Native arts, 306, 332, 337-39; problems with,
473; and self-representation, 608-10; as welfare
movement, 386-94; Yuxweluptun *vs.*, 882

Richardson, Miles, 919-20, 965

Rickard, Vincent, 562, 577, 596

Rigaud, Thérèse, 751-53

rights, Aboriginal, 2, 14*n*1, 135, 640, **641**, 642;
Aboriginal Rights Committee, 403; anthropolo-
gists' support of, 726-27; to blankets, 547;
Canadian *vs.* American, 963; and claims for art,
13; communal *vs.* individual, 712; constitutional
protection of, 875; to create, 579; to crests, 529,
547; cultural, 751; to dance, 546; defined by UN
Declaration, 650, 671-75; "distinctive culture"
test and, 668-71; First Nations rights movement,
403; Fisheries Act and, 755; to formline design,
440-42; to freedom of access, 629; to hereditary
privileges, 984-85; to histories and hereditary
privileges, 604; incompatible, 963; of inheritance,
281-82; to intellectual property, 18, 639, 649, 728,
730-31; to jurisdiction over Northwest Coast art,
649; limits of access to, 894; of ownership, 590;
political/religious, 694-95; pre-existing, 6;
property and ownership, 745-47; reclamation of,
648-49; Royal Proclamation and, 644-46; to
self-determination, 583, 634; to self-government,
648; to self-presentation, 450, 551, 564, 575; of
self-representation, 819-20 (*see also* partnerships);
to sell land, 666; social position and, 421-22;
songs and, 712-13; to songs and masks, 639-40;
sovereign, 628-29; to speak, 583; to tell, 529, 639,

812-13; territorial, 634, 696-97, 718; to territory and resources, 710-12; treaty, 645-46, 648, 649, 658, 665, 668, 751, 852-55

Robb, John E., 102-3

Roberts, Daisy, 15, 16

Roberts, Helen, 157-59

Robertson, Eric, 872, **872**, 974

Roblet, Claude, 65-66, 90n11

rock art. *See* petroglyphs

Rorick, Isabel, 874, 891, 981

Roy, Susan, 97, 904, 975

Royal British Columbia Museum (RBCM), **354**, **484**, 553, 623, 760; Aboriginal material policy, 796-97; collaborative projects, 787-88, 791, 807-8, 815-16, 822-23, 825n14; history-oriented, 581; Native involvement and, 758; Nuu-chah-nulth collection, 813; relationships with First Nations, 810-11, 811-13, 824nn9-10; and repatriation, 788-89, 817-18, 824n8

Royal Commission on National Development in the Arts, Letters, and Sciences, 307-8, 343-47, 509-10, 555

Royal Ethnographical Museum of Berlin, 157

Royal Ontario Museum (ROM), 150, 164n1, 238, 259, 267, 538, 661; audience, 793, 825n15, 825n17; collaborative projects, 792-94

Royal Proclamation (1763), 644-46, 664-66, 872, **872**

Russ, Amos, 156-57, 237

Russell, Catherine, 840-43

**S**aanich Native Heritage Society, 750-51

Sacred-One-Standing-and-Moving, 109-10

salmon, 75, 124, 149

Sanborn, Andrea, 602, 840

Sapir, Edward, 130, 133-34, 144, 145-47, 149-51, 150-51, 682-84

Savey, Max (Chief), 942-43

*Science*, 138-39, 140, 144, 217-19, 313-14

Scott, Duncan Campbell, 150-51, 304, 305, 308-12, 312-13, 379-80, 385

sculpture. *See* carving

Seattle (Chief), 936, 940

Seattle Art Museum, 760

Seaweed, Willie "Smokey Top," 17, 268, 269, 514

self-representation, 771, 772; collaboration and, 792-93, 794; in film, 833-35, 839, 847, 860; of histories, 942-43; *vs.* non-Native representation, 993-94. *See also* museums, tribal

Seligman, Kurt, 272, 276-82, **279**, 290, 295

Sewid, James, 529, 538-40, 593, 608-10

Sewid-Smith, Daisy, 5, 7, 529, 530, 534, 557

Shadbolt, Doris, 431, 448, 467-69

shamans/shamanism, 80-81, 108, 121, 250, 637; electronic, 855; homeopathy of, 290-91; and Northwest Coast art, 114; paraphernalia destroyed, 236; and the potlatch, 211; women, 535, 537

Shaughnessy, Arthur, 17, 268, 269

Shelton, Anthony A., 790-91

Shkidlak̲áa, 173-74, 190-91

Shotridge, Louis, 8, **167**, 523; clan histories, 171-75, 176-79, 179-86; ethnographic writings, 166, 171-73, 186-90, 190-91, 191-201, 202n2; interpretive goals, 168; lineage affiliation, 169, 202n3; methodology, 168, 170, 171; Snail House Collection, 202n1; work with UPM, 166, 201n1

silkscreen prints, 596-97; commodity medium, 616-17; effect of industry, 619-20; Haida,"new wave," 616-17; as investments, 617; numbered editions, 610, 611-12

silver, 256, 257

Sitakanim (Chief), 810-11, 811-13

Sitka, 78-81

Sitka Sound, 63-66

Siwallace, Margaret, 242

Skeena Treasure House, 483

Smith, Harlan I.: anthropological research, 134-35, 165n2, 165n4; artifact collecting of, 131, 132, 133, 145-48, 149; vs. Boas, 94; and industrialization of Northwest Coast art, 313-14, 351, 353, 364-68; multiple roles of, 130-31; and national interest in Northwest Coast art, 93, 101; nationalism of, 351, 353, 364-68; and totem pole restoration project, 322, 327-29

Smith, Paul Chaat, 13, 867-68, 869, 877, 991-93

*Smithers Interior News*, 340-41

Smithsonian Institution, 129, 151-52, 157, 759; domination of anthropology, 205; Museum of Natural History, **175**; National Museum of Natural History, 137-38; National Museum of the American Indian, 486n3, 760, 937, 938, 991-93

Social Sciences and Humanities Research Council, 877

social structure, 99; and art, 496, 509, 567; and art production, 570-73, 626-27; commodification and, 627-29; crests and, 558; fur trade and, 235, 497; interdependency of, 709-10; Nuu-chah-nulth, 29, 707, 815; political change and, 122; potlatching

and, 734, 848; status markers, 117, 122, 246, 257, 574; status system, 114, 448, 449-50, 711-12; suppleness of, 558, 568-70, 574-75; technology and, 205; through stages of cultural evolution, 215; through technology, 952; Tlingit, 193; Tsimshian, 568-70, 741

Society for the Furtherance of Indian Arts and Crafts. *See* British Columbia Indian Arts and Welfare Society (BCIAWS)

Society of Canadian Artists of Native Ancestry (SCANA), 620

songs, 55, 519, 547, 639-40; as gift, 546; Madəm, 23-24; and magic, 290; most important gift, 709-13, 712-13; mourning, 452-53, 518, 521-23; Nuu-chah-nulth *vs.* European, 695-96; ownership of, 752-53; religious purpose of, 695-96; types, 251; vision experience and, 572

Sotheby's New York, 629-31, 631-32, 778, 810, 822

sovereignty, xxxv, 449, 494, 514, 634; Indigenous art and, 966; Indigenous *vs.* Crown, 643-44, 645-46, 668; Kwakwa̱ka̱'wakw, 608-10; photographic, 993-94; visual, 837

Sparrow, Debra, 891-92, 897-99, 970, **971**

Sparrow, Robyn, 891-92, 897

spirit world, 69, 126; and art, 906-7, 949; art and, 99, 613; categories of spirits, 108; in cyberspace, 949; and masks, 288, 901, 902; and material culture, 432-33; multiform, 293; Nuuchaanulth, 28; and physical world, 32, 37-39, 41-45; potlatch and, 636, 637; Tlingit, 80-81; Transformer, 571; vision experience and, 571, 572

Sproat, Gilbert Malcolm, 679-80, 696-98, 704

St. Michael's Residential School, 266, 268

Stahl, Anne Brower, 101-2

Steiner, Christopher B., 602, 628

Stevens, Tom, 156-57

stewardship, 755-56; EAGLE (Environmental-Aboriginal Guardianship through Law and Education), 748; of works of art, 747-48

Stewart, Hilary, 99, 617

Stewart, Jay, 798, 807-8

Stó:lō Research and Resource Management Centre, 754

Stoowuḵáa (Chief), **167**, 195-201

Strathern, Marilyn, 720-21

structuralism, 203, 211-12, 557, 576-77; critique of, 568-70

Supreme Court of Canada, 648-49, 668-71; and Aboriginal rights, 645-46

Suquamish Museum, 760

Surrealism/Surrealists, 231, 270; discovery of the Northwest Coast, 276; geography of imagination, 271; goals of, 270; and Northwest Coast art, 212-13; and primitivism, 270; vision of, 289-90; and visual puns, 295; and Western views of Native American art, 273

Suttles, Wayne, 5, 559, 569-73, 903-4

Swan, James Gilchrist, 48, 49, 85-89, **87**, **89**, 90*n*7, 129, 141, **151**, 151-52, 680-82, **681**, **683**, 698-702; collections, 137-38

Swan, Luke, 713-15

Swanton, John Reed, 142, 143, 155-57, 297, 427, 437

symbols, 108; abstract, 301-2; cultural, 102-3; eternal, 274; hierarchy of, 105

**T**ahltan Exhibit Advisory Committee, 791

Tait, Norman, 485-86, 615

Task Force on Museums and First Peoples, 729, 743-45, 761, 787, 877; and codification of museum policy, 795-96

Teit, James, 130, 131, 146-48, 149-51, 153-55, 157-59, **159**; monographs, 134, 152, 153

Thiébault-Sisson, François, 317-18, 320

Thomas, Nicholas, 562, 869, 874, 875

Thompson, Art. *See* Tsaqwassupp (Art Thompson)

Thunderbird Park: Mungo Martin Potlatch, 450-58, 800, 802-3; totem-pole restoration programme, 447, 449, **451**, 476, 486*n*2, 498, 799-803, 825*n*22, 826*n*24

Tlingit people, 204, **416**, **419**; artistic ability, 52, 63-64, 377-78; artists, 173; belief system, 79-81; blankets (robes), **245**, 415, **416**, **419**; canoes, 245; carving, 472; clans, 79-80, 167-68, 187-88; collected artifacts of, 191-201; crest objects, 171-72, 174; crest system, 53; culture, 168, 171, 255-59, 747-48; intelligence, 245; intelligence of, 195, 245; jewellery, 256-57; jewellery making, 256-57; material culture, 193, 258, **462**; metal work, 53, 256, 257; moieties, 79-80, 91*n*17; oral narrative, 747-48; ornamentation, 256; social structure, 193; spirit world, 80-81, 168, 170, 174

Todd, Loretta, 845, 858-60, 921-22

Tolmie, William Fraser, 49, 77-78, 91*n*15

totem poles, 19-21; acquisition of, for museums, 276-77; along Skeena Valley line, 380; carving of, 247; and changing ideas about art, 321-22; commissioned by federal government, 307;

destroyed, 234, 237, 587-88; electronic, **856**, 857; as evidence of title, 648; evolutionary view of, 299-300; Gédem Skanísh (Gyadem Skanees), 276-82; Gitksan, 105, 315; Haida, 62-63, 246-47, 495, 501, 616, 617; as house entrances, 51; house frontal, 62-63, 64-65; at Kitwanga, 328-29; Krikiet (Keïgiet), 276-82, **279**; Kwakwa̲ka'wakw, 157, **158**, 331; and landscape, 338; memorial, 269, 276-82, **279, 331**, 375; model, 268; mortuary, 51, 236, 240, 375; Oanom Keebu, 328-29; in Paris, 276, 278, 290; Prince Rupert, 284; removal/destruction of, 315-16, 321, 826n26; restoration of, 328-29, 385, 386, 740-43, 803, 825n22, 826n26; salvaged, 540-41; and tourist trade, 607-8; Tsimshian, 51, 236, 240, 375; and vanishing race, 321-25; for World's Fair, **334**

Townsend-Gault, Charlotte, 13, 563, 588, 603, 625-27, 627-29, 881, 932

trade: in artifacts, 144-48, 162-63, 259-60, 271-72, 276, 281, 285-86; in artifacts, government control of, 379-80, 385; colonial reconfiguration of, 780; in curios, 260, 337, 351, 383-85; with Europeans, 53-54, 55-56, 60, 61, 122, 235, 265, 316, 497; intertribal, 53, 71, 75, 151-52, 182-83; modern methods, 393; between museums, 133-34; in Native handicrafts, 307-8, 330-31, 332, 333, 336-37, 342-43; and ownership rights, 197-201; political importance of, 173; in souvenirs, 370-71; in totem poles, 335; tourist, 268, 345, 351, 370-71, 376-77, 383-85, 478-79, 539; and trading partnerships, 173-74

tradition, 25; colonialism and, 931; contemporary, 892; as contested terrain, 914; cultural adaptation of, 540-41; in indigenous modernities, 782-84; and innovation, 502, 511, 870-71; as process, 512

transformation: anthropologists' view of, 295; of ceremonial objects, 288-89, 289-90 (*see also* masks, transformation); in cultural identities, 838; of heritage into capital, 932; of the land, 889, 890; of museum space, 912, 913; of museums, 758-63; of Northwest Coast, 782-84; patterns, on square boxes, 420; of space, 640, 642, 816-17; of totemic icons, 978; visual puns and, 294-95

treaties, 645, 666-67, 729, 833-34; functions of, 788-89, 824n9; Hudson's Bay Company and, 309-10 (*see also* Douglas Treaties); museums and, 813; Nation-to-Nation position of, 880; negotiation of, 628, 753-54, 817-19, 915, 977-78; and self-government, 896

Trocadéro museum, 212-13, 231, 290

Trutch, Joseph William, 379, 676n7

Tsaqwassupp (Art Thompson), 615, 925-27

Tsimshian peoples: Allied Tsimshian Tribes of Lax Kw'alaams and Metlakatla, 590, 827n30; art styles, 406; artists, **241**; carpentry, 261-62; carvers, 482-86; chiefs and houses, 604, 823; chief's mask, 66-67; collected artifacts of, 132, 143, **175** (*see also* Dundas Collection); cosmology, 126; crest art, 558, 568-70, 569-70; cultural protocols, 994; funerary art, 240, 263-64; memorial poles, 375; mortuary poles, 51, 236, 240, 375; oral histories, 125-27; social structure, 568-70, 741; territorial system, 126-27

Tully, James, 883-84

Tylor, Edward Burnett, 208, 213-14, 249

*U*BC Alumni Chronicle, 494-99

*UBC Law Review,* 748-50, 750-51

*The Ubyssey,* 315-17

U'mista Cultural Centre (Alert Bay), 150, 269, 580-81, 602, 760, 834, 846, 847; and American Museum of Natural History, 792; and Dresden State Art Collection, 762, 778-79; films, 560; and Museum of Anthropology (UBC), 984

understandings: of art, 204; cultural, 543-44; cultural limits of, 887; of cultural property, 749-50; of First Nations history, 889; general *vs.* culturally specific, 92; impermanence of, 757; inter-cultural, 762-63; of material culture, 728-29; museum catalogues and, 568; of potlatching, 723-26, 731; regimes of value and, 866; treaties and, 824n9

United Nations Declaration on the Rights of Indigenous Peoples, 649-50, 671-75, 676n11; settler colonies and, 649, 868

University of British Columbia (UBC), 238; care-taker role, 498; Department of Anthropology, 506; Museum of Man, 498; Totem Park, **491**, 498; totem pole restoration program, 380, 386; Conference on Native Indian Affairs, 352-53, 355-63, 381-82; Department of Social Work, 363; Youth Training School, 360. *See also* Museum of Anthropology (UBC)

University of Pennsylvania Museum (UPM), 166; Snail House Collection, 202n1; Tlingit Hall, 191-201, 193-95

validation: of an exhibit, 807; of ceremonial acts, 737-38; certification as, 596-97; of claims, criteria

for, 873-74; community-based, 618-20; external, 589, 933-34; of Native artists, 598, 599-600; of Native cultures, 583; regimes of, 865, 967, 970, 972, 976

value: added, 590-91; of art, 260, 343, 402; artistic *vs.* ceremonial, 618-20; ceremonial distribution and, 738, 739; control of, 945*n*1; criteria of, 591-92, 595, 601-2, 620-22, 623-25; cultural, 968; hierarchy of, 595; market, 626, 630-31, 631-32, 661, 778; market and/*vs.* community, 902, 926-27, 928-29, 934-35; marketing and, 990-91; negotiated, 930; perceptions of, 614-16; re-categorization and, 602-3; regimes of, 603, 722, 865-66; repatriation and, 923-24; self-defined *vs.* outsider expectations, 933-34; as symbolic capital, 934, 935; symbolic *vs.* commodity, 383-85; types of, 948; use *vs.* exchange, 945*n*1

*Van der Peet* decision, 648-49

Vancouver, xxxiii-xxxiv, 593, 628; Aboriginal film-making, 13, 836-37, 859-60; Aboriginal media production, 837; art galleries, xxxiii, 274, 598, 855, 879, 927, 950-51, **979**; artistic culture in, 9, 508-13 (*see also* Vancouver Art Gallery); centre for claims, 877; Downtown Eastside, 927-28; and inherent rights, 989; performance art, 829, 837, 947, 956-58; signs of the Native, **973**; Totemland, xxxiii, xxxiv

Vancouver, George, 71, 72-73, 90*n*8

Vancouver Art Gallery, 349-50, 411, 431, 760, 761-62, 885-89, 956, **969**; Bill Reid exhibition, 489-90, 501-3; Marianne Nicolson exhibition, 918; role of, 504, 510

*Vancouver Daily Province,* 368-72

Vancouver International Airport (YVR): Native art displays, 977-78; Salish weaving, message of, 897; welcome figures, 910

Vancouver Museum, 892-93

*Vancouver Province,* 616-17

Vastokas, Joan, 490, 499-508

Veillette, John, 260-62

Veniaminov, Ivan, 78-81, 91*n*17, 243-45

Vickers, Roy Henry, 610-12

Victor, Carrielynn, 952-53

Victoria, 593, 628, 799-803; Native Friendship Centre, 800

*Victoria Daily Colonist,* 798-99

villages: Aswinis, 705, **706**; Bonaparte, 261; Citeyats (Ksidiya'ats), 66, 91*n*12; Eckult, 703; Gitanyow,

802-3; Gitwanga, 541; Gwayi, **331**; Kiix?in, 942, 943; Kincolith, 263, 987-88; Kitwancool, 740-43; Kitwanga, 321, 328-29; Kitwankool, 541, 804-5; Klukwan (Chilkat), 166, 167; Kwakwa̲ka'wakw, 71-73; Metlakatla, 261, 263; Morice Town, 277-82; Ohiat, 703; Opitsaht, 678, 810, 909; rapid expansion of, 123-24; Titlnitsa, 131; Tsax̲is (Fort Rupert), 265, 266, 268, 519, 526; winter, 124; Yuquot, 27, 57, 59, 942, 943, **972**

villages, Haida, 62, 109-11

villages, Nuuchaanulth, 26, 30*n*1

villages, Tsimshian, 66-68, 121-25

virtual reality, **870**

vision experience, 18-19, 571, 572, 906-7. *See also* dreams, and spirit world

*W*ail of 'Tłat'la̲kwasa̲la, a Gwa'sgla Woman, 518, 521-23

Walker, Patrick, 750-51

Wall, Jeff, **973**

Walsh, Anthony, 381, 398, 399

Walter Phillips Gallery (Banff), 855, **870**

warfare, 780. *See also* property, fighting with

Wasden, William Jr., 599, 762, 778-79, 984-85

Waterman, Thomas Talbot, 209, 227-28

Watson, Scott, 9, 855, 885; solo exhibition, 881

weavers: Chilkat, 179-86; Salish, 898; status of, 891; Tlingit, 174, 775

Weavers' Circle, 728, 745-47

weaving, 55; baskets, 255, 542-43; blankets, 83-84, 245; blankets (robes), 70, **84**; Chilkat, 175, 176-79, 745-47; cloth, 255; Coast Salish, 83-84, **84**, 254; and cultural awareness, 898, 899; hats, 543; looms, 70, **84**, 160; materials, 83-84; mats, 159-61; Nuu-chah-nulth, 70-71, 75-76; Salish, 891-92, 899; Stó:lō robes, 905; Tlingit, 152, **153**; Tsimshian, 890

Webber, John, 49, 59, **60**, 90*n*1

Webster, Gloria Cranmer. *See* Cranmer Webster, Gloria

Weiner, Annette, 627-29

welfare movement, 371-72, 386, 509-10; actors, 391; campaign, 391; theory of, 391-94

Wet'suewet'en people: Git'ksan and Wet'suewet'en Tribal Council, 847; memorial poles, 276, **279**; territorial structure of, 545; totem poles, 105, 315

White, Gary, 260-62

Whittaker, Henry, 798-99

Whulk (Xwa̲lkw), 71-73

Wii Muk'willixw (Art Wilson), 884-85, 964, **965**

Wilkes, Charles, 81-82

Williams-Davidson, Terri-Lynn. *See* gii-dahl-guud-sliiaay (Terri-Lynn Williams-Davidson)

Wilson, Art. *See* Wii Muk'willixw (Art Wilson)

Wilson, Lyle, 406, **408**, 499, 869, 872-73, 884

Winnipeg Art Gallery, 855

Winter Ceremonies. *See* potlatch

Wissler, Clark, 204, 210

Worl, Rosita, 964, 980-83

World Wide Web. *See* Internet

Wright, Robin K., 407, 412, 443*n*4

writing: of anthropologists/collectors, 702-4, 707, 723-25; of art historians/artists, 684-87, 704-6, 715-16, 716-18; and artistic paradigms, 433-35; and audience, 677-78; of colonial agents, 679-82, 696-98, 698-702, 723; and cultural change, 429-30; of early ethnographers, 682-84, 723; of explorers/collectors, 678-79, 692-94, 694-96, 722-23; forms of, 20-21; ideographic, 302; of Indigenous scholars/professionals, 727-31; and memory, 526, 528; motivations and, 48-49; of Nuuchaahnulth authors, 688-92, 707-9, 713-15, 718, 719 (*see also* individual Nuuchaahnulth authors); on Nuuchaahnulth people, 689-90; *vs.* orality, 435-36; picture, 15, 64, 88, 170-71, 698; self-image and, 689; and self-representation, 686-87, 707-9, 719; system, 23

**X**'eits'óowu, 173, 190-91

Xixne', James Paul, 131

**Y**ahgulanaas, Michael Nicoll, 7, 602, 874, 914-16, 970, 972, 976

Yeilxáak, 187, 202*n*11

Yellowhorn, Eldon, 816

Yeomans, Don, 602, 966, 990-91

Young, David, 615-16

Yuquot (Yuukwaat), 27, 57, 59, 942, 943, **972**

Yuquot Agenda Paper, 942, 943

Yuquot whalers' shrine, 148-49

Yuxweluptun, Lawrence Paul, 869, **870**, 872-73, **873**, 878-79, 881-83, 884, 950, 951, 965, 978; and Emily Carr, 885-89; solo exhibition, 879-81

*Printed and bound in Canada by Friesens*

*Set in Akzidenz-Grotesk, Zurich and Fournier
by Artegraphica Design Co. Ltd.*

*Text design: Janet Wood*

*Copyediting: Audrey McClellan*

*Proofreading: Dallas Harrison*

*Indexing: Dianne Tiefensee*

*Permissions assistance: Kat Siddle,
Cari Ferguson, and Jane Hope*

*Research assistance: Lindsey Butters,
Alice Marie Campbell, Kelly Gauvin,
Natasha Nobell, Solen Roth, Anna Rucker,
Frederike Verspoor, and Greg West*